AMERICAN ART TO 1900

・ ・ ・ ・ ・ ・ ・ ・ ・ ・

The publisher gratefully acknowledges the generous contribution
to this book provided by the Henry Luce Foundation.

AMERICAN ART TO 1900

A Documentary History | Sarah Burns and John Davis

UNIVERSITY OF CALIFORNIA PRESS

Berkeley Los Angeles London

University of California Press, one of the most distinguished university presses in the United States, enriches lives around the world by advancing scholarship in the humanities, social sciences, and natural sciences. Its activities are supported by the UC Press Foundation and by philanthropic contributions from individuals and institutions. For more information, visit www.ucpress.edu.

University of California Press
Berkeley and Los Angeles, California

University of California Press, Ltd.
London, England

Library of Congress Cataloging-in-Publication Data

Burns, Sarah.
 American art to 1900 : a documentary history / Sarah Burns and John Davis.
 p. cm.
Includes bibliographical references and index.
ISBN 978-0-520-24526-6 (cloth : alk. paper)—ISBN 978-0-520-25756-6 (pbk. : alk. paper)
1. Art, American—Sources. I. Davis, John, 1961– II. Title.
N6505.B87 2009
709.73—dc22 2008042392

Manufactured in the United States of America

18 17 16 15 14 13 12 11 10 09
10 9 8 7 6 5 4 3 2 1

The paper used in this publication meets the minimum requirements of ANSI/NISO Z39.48-1992 (R 1997) (*Permanence of Paper*).

CONTENTS

INTRODUCTION

Words matter.

That simple assertion might seem strange coming from two historians of visual culture, particularly historians who specialize in American art, a field where object-based study and probing essays that examine seemingly every detail of individual works of art have long been scholarly mainstays. However, the word–image relationship has provided some of the most interesting and fruitful scholarly conversations in our field, and the relative importance of text and form, of context and object, is a continuing debate in the larger discipline of art history as well. Reduced to schematic extremes, that debate would align on one side proponents privileging a personal, speculative, and direct reaction to the forms of an object, without undue concern for the documents of the period in which that object was made. In the opposing camp, champions of social history might overlook the meaning inherent in form and ground their interpretations in the realm of texts that surround a work of art, seeking above all else to explicate its conditions of production and circumstances of reception.

However, the majority of students of American art history would probably find these distinctions somewhat artificial. Although it is not true of everything in life, eclecticism and moderation seem best to describe the prevailing practice of American art historical scholarship, which seeks to respond sensitively and intelligently to the visual properties of an object while also understanding it in a contextual manner that utilizes all the available tools of the discipline of history. The best, and most enduring, work thus takes from both the formal and the documentary approaches to interpretation.

In this "blended" model of visual and material history, the voices and thoughts of American artists are understood to be present in the objects we study. But they were also preserved, in a different way, every time one of them put pen to paper. The same is true of their colleagues, teachers, collectors, family members, friends, and enemies. It is this documentary history of American art that is the subject of our volume, and we have conceived of it as a forum for a wide range of historical voices—artists, theorists, patrons, critics, politicians, poets, novelists, reformers, and amateurs. There is nothing quite like reading the actual words written by an artist in his diary, or by a critic responding to a sensational exhibition she's seen, or a poet reflecting on a single work of art, or a group of artists staking out territory in a manifesto. Far from

overshadowing works of art, such texts can infuse them with an immediacy that gives them renewed relevance for viewers today.

The time is right, we think, for *American Art to 1900: A Documentary History*. The past several decades have seen an unprecedented flourishing of scholarship in American art history, which has changed dramatically in its methods and scope. Most of the major museums with collections of American art have undertaken exhaustive catalogues of their holdings. Specialized journals and university presses have expanded their offerings of the best new research in the field. Race, class, and gender have become dominant themes, critical analysis and reception history have replaced celebration, archival work has transformed our knowledge of arts organizations, and the range of topics of interest to scholars and their public has broadened significantly. The major repository of written materials pertaining to art in the United States, the Smithsonian Institution's Archives of American Art, has also grown exponentially in recent years.

A series of exciting new college survey texts have responded to and amplified these developments, but the same is not true of documentary anthologies on American art before the twentieth century. John McCoubrey's excellent *American Art, 1700–1960, Sources and Documents* appeared in 1965. In retrospect, and remembering the comparatively undeveloped field of American art history in the early 1960s, McCoubrey's slim volume was indispensable to generations of scholars and students and instrumental in securing a permanent place for several key texts in the canon. Another volume, Harold Spencer's *American Art: Readings from the Colonial Era to the Present,* was published in 1980. Nevertheless, our field today is quite different from the one that might have been imagined some twenty-five years ago, let alone forty years ago, and there is a need, we feel, for a book that attempts to compile and introduce a larger, broader range of documents pertaining to historic American art. Our book, then, differs considerably from any precedents in its fuller treatment of several themes and issues: women artists, African American representation and expression, regional and itinerant artists, Native Americans and the frontier, popular culture and vernacular imagery, institutional history, criticism, public art, religion, patronage, education, impressionism, nationalism, and internationalism.

The general coverage of this book—painting, sculpture, photography, and prints from the seventeenth, eighteenth, and nineteenth centuries—is defined as much by the present state of the literature as by our own interests. Architecture, though undeniably important to any complete understanding of the visual culture of the United States, is absent here because it has been admirably treated in a large anthology by Leland Roth, *America Builds: Source Documents in American Architecture and Planning,* and more recently by Steven Conn and Max Page in their *Building the Nation: Americans Write about Their Architecture, Their Cities, and Their Landscape.* As for the chronological scope, Patricia Hills's important *Modern Art in the USA: Issues and Controversies of the Twentieth Century* nicely presents this more recent material and effectively gives us our cut-off date of 1900.

We hope that our book will place itself alongside these other volumes and prove enlightening to a diverse group of readers. As teachers, we have tried to be attentive to its pedagogical usefulness. We anticipate that undergraduate and graduate students in American art history will find sources helpful for almost any research project they might contemplate, and *American Art to 1900* may be fruitfully used in tandem with any of the survey texts currently available. The hundreds of separate head notes introduce and contextualize each document or set of documents, allowing faculty to assign them separately or tailor groups of sources to the particular narrative of their courses. Yet this is also a book for scholars—for the college-based historians and museum curators who conduct regular research in the field. We trust that even the

most seasoned professional may, upon perusing these pages, find a previously unknown document that prompts new thoughts and paths of inquiry.

A word about the texts in *American Art to 1900*. If architect Mies van der Rohe's formulation "Less is more" can be seen as a terse encapsulation of the modernist triumph of the twentieth century, it does not serve quite so well as a maxim for earlier time periods, as anyone who has entered a parlor dating from the 1870s can attest. Like one of those layered interiors, our book aims at richness, complexity, texture, and diversity. If we have erred, it is on the side of inclusion. Thus, when we could not print an entire text, we have, when possible, opted for longer rather than shorter excerpts. When there were competing points of view on a given issue, we have tried to feature both sides. If a work of art or a historical occurrence was so important in its day as to receive unusual attention by several authors, we have tried to allot it commensurate space in our pages, always searching for the richest and most representative texts.

ORGANIZATION AND OVERVIEW

Given the sheer critical mass of documents collected for this anthology, the problem of organization almost immediately took on paramount importance. What organizational principles would best guide us, and best serve the reader, in shaping and structuring the contents of this book? Among manifold possibilities, it seemed initially that a thematic approach would serve the purpose well. Accordingly, in its earlier incarnations the table of contents featured monolithic sections on such topics as gender, race, and nationalism, encompassing documents both early and late in our designated time span. It soon became obvious, however, that such divisions disrupted chronological sequence while having the unintended effect of setting their subjects apart from the fullness of historical context. Posing further logistical problems, these sections quickly swelled to an unwieldy bulk as well.

After much further discussion, we concluded that a more straightforward chronological model would best accommodate our criteria of clarity, practicality, and accessibility. Apart from the longer colonial era and the stand-alone decade of the 1860s, each period fell more or less neatly into manageable twenty- to thirty-year segments, within which we could incorporate focused and more manageable thematic subsections. Pertinent documents on race and gender could thus be presented, for example, in relation to antebellum genre painting and then again in the very different context of the late nineteenth century. This structure is not without its own pitfalls, of course. Many landscape painters, identified historically and stylistically with the antebellum years, continued to exhibit and sell their work well into the 1870s or beyond. Should representative *later* documents on such painters be included in a section on landscape painting in the Gilded Age—or under the relevant antebellum subheading? In such cases, logic governed the decision to loosen rigid chronological parameters in favor of good sense and fitness.

Other issues inevitably arose in choosing and grouping documents under one thematic subheading or another, demanding in some cases a possibly arbitrary (but justifiable) call. Thus, in chapters 11 and 12 documents on women artists are found not in a single clump but under categories such as "Art Education," "New Women in Art," and "In the Magazines," the latter including material on women illustrators. One might well argue that Mary Cassatt belongs by right in the "Arch-Expatriates" category with James McNeill Whistler and John Singer Sargent, since she, like them, spent nearly her entire life abroad. At the same time, though, Cassatt was intensely conscious of both her modernity and her transgressive femininity—qualifications that argued for her ultimate inclusion with other "New Women" instead.

Similarly, many of the documents selected for this volume do not necessarily represent the *only* possible choices in any given category. To be sure, there are certain items absolutely fundamental to the project: John Trumbull on the planning and execution of his Revolutionary War history paintings, Thomas Cole's "Essay on American Scenery," James Whistler's "Ten O'Clock" lecture. Beyond such iconic cornerstones, however, there was an almost infinite archive from which to compile this collection. Acknowledging the difficulty, if not futility, of aiming for comprehensive inclusiveness, we have endeavored to select materials fully representative of the historical moment and true to the voices that speak to us from the past.

The chronological framework used to contain and order these materials into fourteen chapters rests on broad divisions of the sort often used to identify and characterize successive eras of American history: the colonial period, the Revolution and early republic, the antebellum decades, the 1860s, the Gilded Age, the cosmopolitan epoch, and, finally, the dawning age of American imperialism.

The colonial, of course, comprises the long provincial period when Americans were still English, or Spanish, or French, or indeed Native; the Revolution and early republic bracket the period of testing and shaping national identity, and of defining appropriate—or inappropriate—roles art might play in a newly made society.

Beginning with the triumph of Jacksonian democracy, the antebellum decades moved into the expansionist 1840s and the bitterly sectional 1850s. Accordingly, the antebellum chapters feature documents illuminating the values and institutions that shaped fresh ideas and ideals for American art and propelled the emergence and rise of landscape and genre painting as prime vehicles for celebrating American identity as well as working out (or smoothing over) vexing and endemic issues of race and class. These chapters further highlight the excitement and the controversies ignited by public and popular art and consider the galvanic impact of the presumption of manifest destiny (with all its social consequences) on a range of genres, from history painting to art on and of the frontier.

Through the documents included here, the 1860s emerge as a decade of identity crisis and of reckoning. Some selections in this chapter highlight the intersection and occasionally heated clash of radical and traditional modes of stylistic expression. Others look at the ways artists confronted (and often declined) the daunting challenge of representing and commemorating a modern and very different kind of war, or of grappling with the subject of the newly emancipated African American. Documents from the closing years of the decade, finally, suggest both regrouping and new beginnings as artists and critics assess the state of art in the wake of a traumatic conflict.

The Gilded Age flings open the door to an era of accelerating modernization that bore manifold consequences for the American art world. Documents in chapters 8, 9, and 10 take up fresh attempts to define, celebrate, and defend an authentically American art in style and subject alike, at a time of intense competition from abroad. The representation of race once again takes center stage during and after Reconstruction, while African American artists struggle to find acceptance and success in an overwhelmingly Euro-American art world. Another group of documents tracks new directions in landscape painting, which once again becomes the site for affirmation of national identity, centering around the two poles of the old Northeast and the increasingly mythic West. A selection of materials also illuminates the formation of new artistic networks, organizations, and institutions; new strategies for marketing art in an increasingly commercial environment; and the epochal Centennial Exposition in Philadelphia, which prompted longings for the past and nourished ambitions for a more glorious artistic future.

Chapter 11, "Cosmopolitan Dialogues," traces the ascendancy of internationalism in American art and looks in detail at the experience of Americans, men and women alike, studying, working, and in notable cases living permanently abroad. Other documents in this and the next chapter chronicle the formation of different and antithetical taste publics as well as new artistic career possibilities, ensuing from the rapid development of the mass media. In chapter 13 cults of beauty and the Americanization of impressionism bear witness to the transformative impact of cosmopolitanism and modernism as the century draws to a close. Chapter 14, "Imperial America," documents the rise of the United States as a powerful new player on the global stage, as suggested by the triumphal World's Columbian Exposition and its instrumental role in generating grand public art projects. The chapter, and the century, close with ruminations on American art past, present, and future, and with the articulation of hopes that American art will, in the twentieth century, come at last into its own.

EDITORIAL CONSIDERATIONS

The primary aim in editing and framing the documents presented here was to facilitate transparency and ease of use, in or out of the classroom. To that end, and as far as possible, we have adopted and maintained a hands-off approach to the originals. For the sake of simplicity, we have chosen the Chicago three-dot method for the use of ellipsis points rather than any of the more rigorous (and complex) systems. In this method, three dots stand equally for omitted words, sentences, or paragraphs. They are not used at the beginning of the first paragraph of the excerpt, regardless of whether the start of that paragraph or the beginning of its first sentence is omitted. In the same spirit, ellipsis points do not appear after the last word of the excerpt, even if the end of the original is omitted. If the first part of a paragraph is omitted *within* the excerpt, however, a paragraph indentation and three ellipsis points appear before the first quoted word; likewise, within each excerpt, three ellipsis points at the end of a paragraph indicate the omission of the end of that paragraph, and possibly additional paragraphs.

Rather than use the word *sic* to indicate orthographic anomalies, we have opted to preserve all original spelling and punctuation without correction or indication, except in cases where we judged the documents so archaic or opaque in their original form as to be largely unintelligible to the modern reader. In such cases, we have chosen to modernize them to the extent necessary in order to facilitate their legibility. Where illegible words appear in our transcriptions of handwritten manuscripts, they are replaced by [illegible] in the text or by a bracketed guess followed by a question mark. We have not in every case consulted the original manuscript source, relying instead on later published versions, in which the editing rules may differ from ours. Whenever possible in such cases, we have given the present location of the original. We owe a great debt to the scholars who first published these manuscripts.

Consistent with our desire to enhance clarity and accessibility, we have endeavored to limit our explanatory apparatus to a functional minimum. Each document, or in some cases each group of documents, appears with a headline and a head note. The head note provides historical context and (where necessary) essential biographical facts. It also offers guidelines for analysis and interpretation, indicating, for example, a given document's aesthetic, social, political, or ideological agenda; alerting the reader to its polemics and rhetorical strategies; or mapping its place in the bigger picture, or narrative, of American art at that time.

Preceding the excerpt itself is the bibliographic citation, consisting of author, title, publisher, and date, or, in the case of manuscript material, data on the archival repository. Bibliographic

entries do not include page numbers, which become complicated in the case of longer articles or books in which excerpts may be culled from widely dispersed pages. Since all other bibliographic information is given, interested readers should encounter no difficulty tracking down the original source.

In the interests of streamlining, we have chosen not to include individual birth and death dates for the thousands of people named in this volume. If known, the dates of any artworks mentioned in the head notes are included, but not other information such as owner or medium. For the reader's interest and convenience, head notes occasionally include cross-references to other, related texts in different sections or chapters. Finally, we have sometimes appended footnotes to identify individuals unfamiliar to contemporary readers, to define obscure terms, or to provide translations of certain passages in French or other foreign languages.

Overarching all of our deliberations and decisions on editing style and explanatory framework has been the intention to highlight each document—and then to step aside. As editors, we have endeavored to construct a threshold beyond which readers may venture on their own to explore and ponder the documentary riches of American art and its many intersecting histories.

AMERICAN ART TO 1900

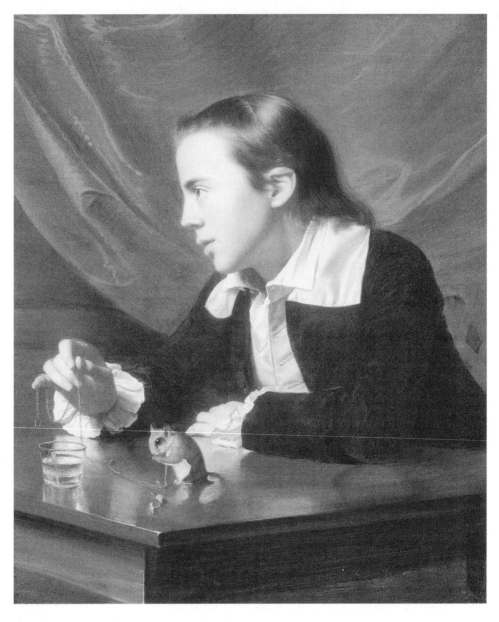

Fig. 1. John Singleton Copley, *Boy with a Squirrel (Henry Pelham)*, 1765, oil on canvas. Museum of Fine Arts, Boston, Gift of the artist's great granddaughter. Photograph © 2009 Museum of Fine Arts, Boston.

1 THE COLONIAL ERA

ART IN AN AGE OF PURITANISM

THE WELL-DRESSED PURITAN

Portraits subscribe to a set of visual codes, and in interpreting American portraits of the colonial period it is necessary to understand the great importance attached to such markers of class and status as costume and hair. The following excerpts from the sumptuary laws of the Massachusetts Bay Colony indicate the degree to which seventeenth-century Puritans worried about vanity and excess. In addition to regulating the use of costly materials, such as lace and gold thread, these laws have much to say about specific styles of dress. Sleeves, for example, must not be too puffy or too short, and they cannot have too many slashes (gathered fabric tailored so as to expose an underlayer of different-colored cloth). Hair should be arranged simply, without ribbons or extensions, and men should wear their own short locks rather than cover their heads with wigs. The latter was particularly worrisome to conservative Puritans. The minister Samuel Willard is known to have had at least one congregant desert his Boston church when his son, Josiah Willard, cut his hair and began wearing a wig in 1701. Those who preached against wigs argued that they constituted a kind of disguise, erasing distinctions of age and sex and marring the handiwork of God. One senses here a need for fixed definitions and categories in society. Indeed, as the law of 1651 makes clear, these regulations existed to maintain class distinctions just as much as they supported religious doctrine. Only families of wealth, education, or municipal office were granted exceptions to the rules. In this light, the decisions about dress that portraitists and sitters were required to make as they composed their images take on unusual significance.

Massachusetts General Court, law passed September 3, 1634.

The Court, takeing into consideracon the greate, superfluous, & unnecessary expences occacioned by reason of some newe & immodest fashions, as also the ordinary weareing of silver, golde, & silke laces, girdles, hatbands, etc, hath therefore ordered that noe person, either man or woman, shall hereafter make or buy any apperill, either wollen, silke, or lynnen, with any lace on it, silver, golde, silke, or threed, under the penalty of forfecture of such cloathes, etc.

Also, that noe person, either man or woman, shall make or buy any slashed cloathes, other then one slashe in each sleeve, and another in the backe; also, all cutworks, imbroidered or needle worke capps, bands, & rayles, are forbidden hereafter to be made & worne, under the aforesaid penalty.

Massachusetts General Court, law passed September 9, 1639.

Hearafter no person whatsoever shall make any garment for weomen, or any of ther sex, with sleeves more then halfe an elle wide in the widest place thereof, & so proportionable for biger or smaller persons.

And for present reformation of imoderate great sleeves, & some other superfluities, wich may easily bee redressed without much prediudice, or the spoile of garments, as imoderate great breches, knots of ryban, broad shoulder bands, & rayles, silk rases, double ruffes, & cuffes, etc.

Massachusetts General Court, law passed October 14, 1651.

Although severall declarations & orders have bin made by this Court agaynst excesse in apparrill, both of men & woemen, which hath not yet taken that efect which were to be desired, but on the contrary we cannot but to our greife take notice that intollerable excesse & bravery hath crept in upon us, & especially amongst people of meane condition, to the dishonor of God, the scandall of our profession, the consumption of estates, & altogether unsuteable to our povertie . . . Yet we cannot but accoumpt it our duty to comend unto all sorte of persons a sober & moderate use of those blessings which, beyond our expectation, the Lord hath been pleased to afford unto us in this wildernes, & also to declare our utter detestation & dislike that men or women of meane condition, educations, & callinges should take uppon them the garbe of gentlemen, by the wearinge of gold or silver lace, or buttons, or poynts at theire knees, to walke in greate bootes; or women of the same ranke to weare silke or tiffany hoodes or scarfes, which though allowable to persons of greater estates, or more liberall education, yet we cannot but judge it intollerable in persons of such like condition; its therefore ordered by this Court & the authoritie thereof, that no person within this jurisdiction, or any of theire relations depending uppon them, whose visible estates, reall & personall, shall not exceede the true & indeferent value of two hundred poundes, shall weare any gold or silver lace, or gold or silver buttons, or any bone lace above two shillings per yard, or silke hoodes or scarfes, uppon poenalty of ten shillinges for every such offence . . . provided, that this law shall not extend to the restraynt of any magistrate or other publicke officer of this jurisdiction, theire wives & children, who are left to theire discretion in wearinge of apparrill, or any settled millitary officer, or souldier in the time of military servise, or any other whose education & imploymente have beene above the ordinary degree, or whose estates have beene considerable, though now decayed.

Massachusetts General Court, law passed November 3, 1675.

Whereas there is manifest pride openly appearing amongst us in that long haire, like weomens haire, is worne by some men, either their owne or others haire made into perewiggs, and by some weomen wearing borders of haire, and theire cutting, curling, & imodest laying out theire haire, which practise doeth prevayle & increase, especially amongst the younger sort,—

This Court doeth declare against this ill custome as offencive to them, and divers sober christians amongst us, and therefore doe hereby exhort and advise all persons to use moderation in this respect . . .

Notwithstanding the wholesome lawes already made by this Court for restreyning excesse in apparrell, yet through corruption in many, and neglect of due execution of those lawes, the evill of pride in apparrell, both for costlines in the poorer sort, & vaine, new, strainge fashions, both in poore & rich, with naked breasts and armes, or, as it were, pinioned with the addition of superstitious ribbons both on haire & apparrell; for redresse whereof, it is ordered by this Court, that the County Courts, from time to time, doe give strict charge to present all such persons as they shall judge to exceede in that kinde.

ICONS AND THE METAPHOR OF PAINTING

One of the common misunderstandings of the Puritans of New England is that they were iconophobic—that they feared or mistrusted all visual images. Puritans certainly recognized the power of images, and it is true that they criticized the Roman Catholic Church for its manipulative use of the visual arts in the practice of worship and the staging of the mass (see "Art and the Spanish Conquest," this chapter). Such a direct, active use of painting or sculpture would never have found a place in a Puritan meeting house. Still, nonreligious imagery, especially portraits, was permitted, as the excerpt from a sermon by Samuel Mather indicates. Mather was the eldest son of an important minister, Richard Mather, and the uncle of Cotton Mather. He graduated from Harvard College in 1643 but subsequently decided to return to England. This sermon, in which Mather distinguishes between the religious and civil use of images, was published in Massachusetts a year after his death.

Edward Taylor, a generation younger than Samuel Mather, graduated from Harvard in 1671 and spent his life as minister in the frontier town of Westfield, Massachusetts. He is considered the most important Puritan poet, and some of the imagery of his verse is found in the descriptive lines of the following excerpt from his sermon "Nazarites by Vow," preached in Westfield. Taylor was greatly concerned with typology, the tracing of signs in the Old Testament that foreshadow the events of the New Testament. He explains these "types" in visual terms, as the God of the Old Testament using words to create "the Portraiture of Christ." Employing rich metaphorical language, Taylor glories in the "fair Colours" set "before our Eyes" in Scripture. His text is a good example of the Puritan tendency to experience the visual through verbal means.

Samuel Mather, A Testimony from the Scripture against Idolatry & Superstition *(Cambridge, Mass.: Samuel Green, 1672).*

Idolatry in general, *is the worshiping of Images or Idols.* Now there be two sorts of Images, and therefore two sorts of Idolatry. First, *against the Object of worship, in the first Commandment.* Secondly, *against the means of worship in the Second.* The idolatry forbidden in the first Commandment is, *when the worship is terminated upon a false Object,* and not upon the True God that made Heaven and Earth. But the Idolatry forbidden in the second Commandment is, *when the worship* is directed to the True God, but *by false wayes and means,* which he had never appointed, and which never came into his heart: we commonly call it for distinction sake, *Superstition . . .*

You may observe briefly these . . . things concerning it.

1. *That it is not meant of Images of Civil use, but for worship; thou shalt not bow down to them, nor serve them.* For the Civil use of Images is lawful for the representation and remem-

brance of a person absent, for honour and Civil worship to any worthy person, as also for ornament, but the scope of the Command is against Images in State and use religious.

2. Neither yet is it meant of all Images for religious use, but only *Images of their own devising,* for God doth not forbid his own Institutions, but only our inventions.

Edward Taylor, "Nazarites by Vow," 1694–95, in Charles W. Mignon, ed., **Upon the Types of the Old Testament** *(Lincoln: University of Nebraska Press, 1989).*

Here we have a Cleare discovery of the Unspeakable Love of God the Father, & his matchless esteem of the Lord Christ. For he paints him out with all the Glorious Colours that may be. If a man draw out the Effigies of an other and take Care, that he be drawn out, & laid in the Wealthiest & most glorious Colours, that the World can afford, it is a Demonstration of the greate, & unspeakeable Love hee beares to him whose Effigies are thus Drawn. Thus doth God do for Christ, & far more. He portrayes him out in the fairest Colours that are to be had in all the Garden of God. Here we have a rich knot of the Choicest Flowers in all the Paradise of the Holy Scripture stande reeching in their transcendent Splendor of Beautious Holiness. And the whole is planted upon this very design, viz, to give fourth the manifestation of the Lord Christ. So that their Holiness in all its Shine is but a dim draught of the Lord Christ in his Holiness. But in that God doth draw out thus the Portraiture of Christ in these fair Colours what doth it Speake but the Love of God towards him. Christ fetches an argument to proove the Love of the Father to him in that he shew'd him all things that he himself did Joh.5.20. accordingly may we gather up the Love of the Father to Christ in that he draws out the very Effigies of his Son upon so many glorious Types & sets them before our Eyes to behold him in as glorious.

COTTON MATHER ON ART

Cotton Mather, a third-generation Puritan minister, was ordained in 1685 and spent most of his life serving the Second Church of Boston, which his father, Increase Mather, had also led. Extremely prolific, Cotton Mather wrote the sermons that were expected of any minister but also history, biography, poetry, and treatises on natural history and medicine. His massive Magnalia Christi Americana *(1702) chronicled the history of the Massachusetts Bay Colony. In his prime, he was considered the preeminent spokesperson for Puritan culture (see "Peter Pelham Scrapes a Mezzotint," this chapter).*

Mather took a greater interest in art than many of his colleagues, but his commentaries are spread widely in his writings and often amount to just a sentence or two within a larger essay. Inasmuch as death was considered the most important accounting of a person's life, a "culminating exercise" in the words of one scholar, much of Mather's writing on art concerns funeral monuments and obituaries. For Mather, "portraiture" was achieved through biography, through the reflection on the earthly acts of the deceased, which, one hoped, would inspire those left behind. Thus, as he suggests in his celebration of John Wilson, the portrait of the deceased is "taken" after his death; a word picture is drawn of him even though he refused to allow an actual artist to take his likeness during his lifetime. Or in his funeral poem to Sarah Leveret, Mather almost facetiously laments that no visual image exists of the great women of history before coming to the realization that Leveret's good deeds and acts stand in for these images, leaving behind a "mould" for us to emulate. Turning again to history in Christianity to the Life, *Mather invokes an anecdote concerning the king of Bohemia to illustrate*

the manner in which his followers should keep a mental "portrait" of Christ before them, without resorting to hanging one up in their homes. Yet when it comes to exemplary mortal men, Mather advocates the contemplation of the actual likeness, as in the brief passages from the Magnalia *concerning John Winthrop, the first governor of the Massachusetts Bay Colony, and John Cotton, Mather's grandfather, who hung a portrait of Richard Sibs, the minister who "converted" him, in his home.*

Cotton Mather, Memoria Wilsoniana, or, Some DUES Unto The MEMORY of the Truly Reverend & Renowned Mr. JOHN WILSON *(Boston: Michael Perry, 1695).*

Mr. *Edward Rawson,* the Honoured Secretary of the *Massachuset-*Colony, could not by all his Intreaties perswade him, to let his *Picture* be drawn; but still refusing it, he would reply, *What! Such a Poor, Vile Creature as I am! Shall my Picture be drawn? I say, No; it never shall!* And when that Gentleman introduced the Limner, with all things ready, Vehemently importuning him to gratify so far the Desires of his Friends, as to sit a while, for the taking of his *Effigies,* no Importunity could ever obtain it from him. However, being bound in *Justice* to Employ *my Hand,* for the Memory of that Person [John Wilson], by whose Hand I was my self Baptised, I have made an Essay, to draw his *Picture,* by this Account of his *Life.*

Cotton Mather, Christianity to the Life, Or, the Example of the Lord Jesus Christ *(Boston: T. Green, 1702).*

There was a King of *Bohemia,* who had a very *Exemplary Father;* and therefore he alwayes carried his *Fathers Picture* about him, which he would often Take out, and Look on, and say, *Let me never do any thing unworthy the Son of such a Father!* Christian, I am sure, thou hast an *Exemplary Saviour;* and in the *Bible* thou hast thy *Saviours Picture* before thee: [Tis a Popish and Sinful Folly to have it otherwise, as too many of our people have it hanging on the walls of their Houses:] Well, often view it, and say, *Let me do nothing, that shall be Condemned by the* Example *of such a Saviour.* When we have any *Duty* to do, Think, *How was this* Duty *done by my Lord Jesus Christ?*

Cotton Mather, Magnalia Christi Americana, or The Ecclesiastical History of New-England *(London: T. Parkhurst, 1702).*

[on John Winthrop]

How prudently, how patiently, and with how much resignation to our Lord Jesus Christ, our brave Winthrop waded through these difficulties, let posterity consider with admiration. And know, that as the picture of this their governour was, after his death, hung up with honour in the state-house of his country, so the wisdom, courage, and holy zeal of his life, were an example well-worthy to be copied by all that shall succeed him in government . . .

[on John Cotton]

But he was, at length, more effectually awakened by a sermon of Dr. Sibs, wherein was discoursed the misery of those who had only a *negative righteousness,* or a civil, sober, honest *blamelessness* before men. Mr. Cotton became now very sensible of his own miserable condition before God; and the *arrows* of these convictions did stick so fast upon him, that after no less than three year's disconsolate apprehensions under them, the grace of God made him a thoroughly renewed Christian, and filled him with a sacred joy, which accompanied him unto the fulness of joy for ever. For this cause, as persons truly converted unto God have a mighty and lasting affection

for the instruments of their conversion; thus Mr. Cotton's veneration for Dr. Sibs was after this very particular and perpetual: and it caused him to have the *picture* of that great man in that part of his house where he might oftenest look upon it.

Cotton Mather, "A Lacrymatory: Design'd for the Tears let fall at the Funeral of Mrs. SARAH LEVERET," 1704, in Denise D. Knight, ed., Cotton Mather's Verse in English *(Newark: University of Delaware Press, 1989).*

Long did I Vex in Vain at Stupid Man,
That e're Men found out Painting, so long Ages ran.
Fain would I *Painted* to the Life have seen
The *Heroines* that in past Times have been.
O could we Present that bright SARAH View,
Who *Mortals* charm'd, and who pleas'd *Angels* too.
Or that brave MIRIAM, She of whom tis said,
The *Israels* Daughters in Devotions *Led:*
Could *glorious* DEBORAH appear agen,
And to true *Glory* Quicken Slothful Men:
Could *Prayerful* Hannah once again be shown,
Prostrate in *Prayer's* before the Sapphire Throne:
Could *Pious* MARY with her inward worth,
And all her *Piety* again come forth:
We'd *Love* the *Painter,* and admire the skill;
But tis our *Grief,* we want that *Painting* Still.
And courteous *Dorcas,* we complain of Thee
We can't thy Face wrought with thy *Needle* see.
But now there is an end of all complaints;
ONE Matron gives a sight of *all* the *Saints.*
Our LEV'RET is of all a curious Draught:
Oh! what an one! by what fine Pencil wrought . . .
Dress well; *Flant* not too high; nor *Change* too fast.
Wear what shall speak you *Sober, Wise* and *Chast,*
And in a *Body* clad with comely Dress,
Soul drest with rich *Robes of Righteousness.*
Thus did our admirable SARAH: Thus
Of *Virgin-Grace* a mould she left for us.

THOMAS SMITH'S REFLECTION ON DEATH

One of the monuments of seventeenth-century Puritan art is the portrait of Thomas Smith, the earliest extant American self-portrait known to scholars. Although the specifics of Smith's biography have proven difficult to pin down, the visual inventory of the canvas, in contrast, seems vivid and tangible. Most prominent is the handwritten poem in the lower-left corner, supremely legible as it hangs over the foreground table. The portrait is unusual in its featuring of such an important, complete, original text, and yet at the same time it is quite representative of the Puritan worldview, disposed to credit words with more emblematic power than images. Indeed, Smith's poem is structured much like a sermon, beginning with a question that prompts public medita-

tion and ending with the assertion of the certainty of death as a triumphant state, a gateway to the perfection of heaven.

Thomas Smith, poem on self-portrait, c. 1680.

Why why should I the World be minding
therein a World of Evils Finding.
 Then Farwell World: Farwell thy Jarres
 thy Joies thy Toies thy Wiles thy Warrs
Truth Sounds Retreat: I am not sorye.
 The Eternall Drawes to him my heart
 By Faith (which can thy Force Subvert)
To Crowne me (after Grace) with Glory.

DISSENTING OPINIONS: ALTERNATIVES TO PURITAN PRACTICE

QUAKER "RULES" ON TOMBSTONES

Puritan doctrine held sway in Massachusetts for much of the colonial period, but else-where other religious traditions gave rise to alternative attitudes about art. In Philadel-phia, the Society of Friends (also known as Quakers) exercised considerable influence, even when they were not in the majority in the region. Founded around 1650 in England, the Quakers rejected all conventional sacraments and priestly offices in the belief that nothing should stand between the individual believer and the divine. Neither the Puritan minister nor his lengthy sermon would have found a place in their meetings. (The Massachusetts Puritans actually executed four Quakers as heretics.) Instead, Quakers sat silently during worship until one of their members, guided by his or her "Inner Light," rose to speak. In their daily living, they aspired to an ideal of "plainness" in dress, furniture, and conduct. In this they went far beyond the Puritans, as is indi-cated by the following "rules" regarding gravestones, adopted in 1706. Whereas the New England churches placed great store in the improving messages found in gravestone texts and images, the Quakers dismissed them as vain and excessive.

Quaker Rules of Discipline *(Philadelphia: Samuel Sansom, 1797).*

This Meeting doth give it as their Judgment, that it is wrong, and of evil tendency to have any Grave or Tomb Stones or Monuments placed at or over any Grave in any of our Burying Grounds; and that those Monuments, either of Wood or Stone, which are already set in the Burying Grounds of Friends should be removed, and no new ones erected; and if any Friend opposes this sense and direction, he or she ought to be dealt with as disorderly.

Although this Meeting early signified their full disapprobation of the vain and superstitious Custom of erecting Monuments of any kind in memory of the Dead, on or near their Graves, yet, with concern we have been informed that Marks of this sort have been placed in our Grave Yards by some professing with us; it is therefore recommended to Overseers and concerned Friends, to admonish the Relations of such deceased Persons, speedily to remove those offen-sive distinctions, as inconsistent with the plainness of our Principles and Practice, and seriously caution them strictly to examine what Spirit they are of, who can thus act contrary to and op-pose the declared sense of the Body, both in Great Britain and these Provinces. And Quarterly

and Monthly Meetings are desired to use their utmost endeavours to prevent the continuance of this Evil, by removing those marks of Superfluity and excess out of our Burying Grounds, where those concerned in putting them there, or the Relations of such, to whose Graves they appear, neglect doing it, after notice for that purpose; that so no cause of uneasiness may remain, or partiality be justly chargeable upon us.

JOHN VALENTINE HAIDT'S THEORY OF PAINTING

Farther west in Pennsylvania, a religious community quite different from the Quakers had established itself by 1741: the Moravian Church (or Unity of Brethren). With origins in the present-day Czech Republic, the Moravian Church was organized in 1457, and after centuries of persecution its missionaries decided to create settlements in North America in the eighteenth century. In practice the Moravians were close to Catholicism, and religious art—especially emotion-grabbing paintings—was highly valued. One of the most important Moravian painters was the Polish-born John Valentine Haidt, who immigrated to Pennsylvania in 1754 after spending time in the London Moravian community. At a later point in his life, he wrote an important treatise on art, portions of which are excerpted here. In what may be the most comprehensive essay on art by a practicing artist in the colonial period, Haidt discusses proportion, line, anatomy, and general aesthetics. He also offers views on the education and training of the artist, several "recipes" for multifigure works such as the Crucifixion, and practical advice on portraiture. Haidt does not neglect the emotional impact of art; indeed, he insists that the most successful religious painting draws out the sympathies of viewers, almost without their knowledge.

John Valentine Haidt, "Treatise on Art," c. 1761–72, Moravian Archives, Bethlehem, Pennsylvania [translated from the German by Vernon Nelson].

Now this is general proportion, which one can well follow, but not always be bound by, since the proportions are subject to change, depending on the different characteristics of the persons one portrays. For example, if one wanted to portray the dear Savior one could well use these proportions but one would have to be especially careful that the members contained something noble in them. On the other hand, if one wanted to paint a Peter, who has strengthened his muscles and bones through hard labor, one would have to work more on strength and therefore increase the thickness somewhat in all the parts.

Now this strength, as well as that which is noble in the first instance, must be perceived in all the members, so that if perhaps a finger or a toe were cut off one would immediately see that it had been part of a noble or a strong figure.

What makes a figure graceful consists in the posture of the figure.

Observe I. A figure that stands completely straight is stiff. Therefore, a Latin S should be found in the figure, and it is most important in this matter to see that the figure rests on one foot, where the shoulder which belongs to the foot on which the figure stands is always lower.

One makes the head look away from the direction of the foot on which the figure stands.

It is most important to note that there must be no sharp angles, either in hands, arms, or feet, e.g., that no rectangle may be in it, but rather, that it bows either to the inside or outside, and to be sure according to the activity of the figure. Each figure must immediately show the

reason why it has been drawn. The distinction must be immediately perceptible between a figure that pulls something to itself, or pushes something away.

A figure that pulls something to itself stretches out its arms. The feet are not completely fixed, because the greatest strength lies in the back and the shoulders. In contrast, in a figure that pushes something away from itself, the arms swell and the feet are set more accurately, to prevent them from being pushed away from their place.

It is a matter of major importance that one must observe all kinds of people as they work, to see what sort of positions they use to do their various activities most effectively and with the most power.

Observe II. In faces it is most important to observe what makes a face graceful.

A face that is completely level and looks straight ahead is not pleasing. Therefore it is necessary to turn it a little to the side. It is also good if the face leans a little.

What also makes a face appear beautiful and pleasing is when its parts have their right sizes— the forehead, nose, eyes, mouth, chin, and cheeks—so that none of the parts is disproportionately small or disproportionately large, e.g., if one should have a large forehead and at the same time a short nose, the all-too-rapid variety would be repugnant to the eyes and therefore unpleasant, etc.

It is very good to make observations that make one thoroughly familiar with the passions and through observation to note well those people in whom a particular passion predominates. For example, if I wanted to portray a soldier, I would have to seek out faces which appear completely without fear and which also show something resolute in their faces as well as swiftness and also stability, and make use of them.

How one must group figures together

When there is one figure and you want to place another beside it, one figure must be seen from the front, the second from the side, and finally the third from behind, which then makes a group.

One can make such observations on all sorts of occasions, perhaps where an accident occurs. One must also observe that a contrast in the figure must always be made, so that when the right arm moves forward, the right leg must go backward. That has an actual reason which one can observe in walking. For if one just lets his arms hang, the above-mentioned rule will properly manifest itself.

It is not at all suitable to the body, and one would hurt oneself, if one wanted to move the same arm and the same foot forward at the same time. Also, then one could not move from the spot.

It is also to be observed in a group of figures that all do not have the same position. If the one is standing, the second can bend down, and the third lie or sit, which makes a pleasant group.

When one wants to portray a historical event, it is most necessary to become correctly informed about the event in all its circumstances. If it is ancient history, one must use the Antiquities, which make known to us the clothing and the instruments used at the time. The Antiquities are the most useful for this.

This is necessary in order to avoid portraying something ridiculous (By ridiculous, I mean this: when one is portraying something for which completely ancient attire is necessary and one wants to use a modern fashion.).

One can also use paintings and copper engravings, of which the most famous are by Raffel,

Anibal Karatsch, Carl Marad, Michel Angelon, Rubens, van Dyck, Niclau Possin, Tintoret, Guido Lares, Paulo Werones, Titian, Lavage, etc.

Now we want to portray with one another a historical event and specifically the Crucifixion of Christ, at the moment when the thief says to Him:

Remember me when Thou comest into Thy kingdom.

The entire historical event can be presented with twelve figures. The main person is the Savior and the thief at His right. NB Therefore, the two figures must be portrayed in such a way that everyone sees them at first sight. The Savior must turn His head toward the thief and the thief look upon the Savior with a humble and longing look in his eye, with his mouth open, as if he were speaking. The Savior, however, looks upon him with eyes of mercy. Near the cross the centurion can stand, with a look of amazement on his face, raising one hand toward heaven, to show that he is declaring that the Savior is the Son of God. In the foreground Mary can be portrayed, how she sinks to the ground and is assisted by the other Mary. A few of His disciples can also be present, who again separate themselves into one group. In their physiognomies and actions one can read something deplorable. Near the cross various Roman soldiers and Jews can also be present. In the soldiers something swift and in the Jews something secretive must be seen. Also, a few of the Jews can be portrayed as if they wanted to hurry away. The sky is dark, and the light is cast on the figures through a flash of lightning in the sky. Also, the light must fall primarily on the Savior. NB One must also utilize all one's powers to portray the suffering body of the Savior as very pitiable, so that at the first sight everyone is moved to feel astounding sympathy. The clothing of the figures must not show any signs of wealth. By richness of clothing, which one must avoid, is to be understood both the colors and the costliness of the fabric and its quantity: no silk, no gold, no silver, also a figure must not have as much drapery (clothing) as might be enough for two or three.

The naked body must show through the drapery, primarily the large parts . . .

What sort of talent is required in an artist, particularly for painting? Rapid comprehension, solid judgment, eagerness to work, rich imagination, a good memory, and a temperament eager to communicate.

What sort of studies belong to this? Languages: to become informed about all historical matters in their original languages. Second: Mathematics, Geometry, the Physics of color, Architecture, Perspective, Anatomy. If a painter who has painted for twenty years should write down the things that have befallen him during that time which still gave him difficulty, one would be amazed that the greater the artist, the more the difficulties that would be found. A small talent is immediately finished with everything. But they do not take it very far because the slightest thing that one paints, even if it should be only a nail in the wall, requires one's deliberation. What sort of books should a painter read? The Bible, Homer, Virgil, Plutarch, Roman and Greek History, the Lives of the Painters, the Antiquities of the Jews, Ovid. He can also read Donquischot. It can keep him within bounds so that he is careful of absurdities. Two matters adhere to painters, namely [illegible] and loose living. Donquischot can help him there. A painter should be at ease in letting people speak about his mistakes, but he must also be in a position to judge immediately whether it is a mistake or not. If it is, he must immediately change it, but if not, then he leaves it as it is. He must be very willing to take direction but never to let himself be led astray. It is not easy to have a true understanding of a subject where more is involved than in painting, and yet there is no other subject where more people assume the right to judge, than in painting. The reason is ignorance and arrogance mixed together. Through such people the painter always has the occasion to feel that therefore he must be certain of his subject or he

would fall into such a state of confusion that he would no longer know if black is white or white, black.

Now we want to say something more in particular about beauty and ugliness. There is a beauty in Maria, and Judith must also be beautiful, but the difference is very great. Maria must have in her all the beauty that can be possibly imagined—a beautiful, not-too-round and not-too-lengthy form of head, a flat forehead, a straight, longish nose, large eyes—whose eyelids are large and inclined downward—the mouth small and full of virtue, the chin middle-sized, the cheeks flat, in which chastity can be read. At the first sight, one must be filled with amazement at her beauty and, at the same time, with respectable reverence and shame in relation to her true holiness, simplicity, and humility. Her holiness must be different from all self-made piety. She must be natural, with nothing affected and, still less, nothing hypocritical. She must look upon the angel who brings her the message as if her heart can say, with humility, "yes" to it, and that she has already felt the working of the same. Judith can be pale white and very well have black hair also, her eyes large but cunning, her nose not too long but rounded, depressions in her cheeks and a mouth that can speak lovely but deceitfully, i.e., it pulls almost imperceptibly more to one side than to the other. Her color pale and reddish because something is going through her for which the result could be fatal. She must have a strong look in her eyes that is enticing but also shows respect. With Maria everything is natural. With Judith everything is pretended, that is, when she is at table with Holofernes.

Now, for once, we want to paint something ugly: an evil woman. The head long, the forehead high in front, a shortened, concave nose, the eyelids are lost in two folds of skin, the forehead is wrinkled, the mouth is large and the corners are pulled downward. The chin and lower lip are united in wrinkles. Her eyes are like a sow's eyes. The jaw teeth large, the cheek bone large, two or three warts in the face, perhaps one on the left eye, with long hairs, the second on the right side of the nose, also with hairs, and two on the chin. There can also be one on the cheek, all hard and tight. Such a one can make one's house narrow. That is the opposite of beauty.

How a painter should spend his time. As soon as coordination of eye and hand is achieved, so that the hand can copy what the eye sees, he should always carry with him, wherever he goes, a small portfolio with paper and red chalk or good lead so that, when he comes upon something special, he can immediately sketch it, be it an unusual face or a landscape or a pretty garden house or a fountain, an unusual tree, a nice sheep, etc. If he sees something in a place where he cannot immediately sketch it, he must keep it in his mind and then put it on paper as soon as possible. If he has blue paper and black and white crayons, this is easy for him because the paper makes the half-shadow, the white the light, and the black the dark shadow.

His company must consist of learned people, which can be very profitable to him and make it easy for him. From them he can be informed about the antiquities of the heathen, how they clothed themselves from Caesar on down to the jailer who does executions, how the priests were clothed for sacrifice, what sort of instruments they used, in what their soothsaying consisted, and the meaning of the sacrifices . . .

Now we also want to say something about a portrait. A portrait is beautiful when it is a correct likeness and when one can see the essence of the person in the face and action. Therefore, painters who want to paint all faces as amiable and force the mouth to smile make a mistake. The painter must look correctly at the person he wants to paint. If he has an opportunity to know the person well, it is a great help to him. He turns the face to the best angle. The fewer shadows he brings in, the fewer critics he will have. But when he gets an especially well-proportioned head in front of him, he cares nothing about the critics because it will result in

a piece of art, and he does it in the way that he thinks should make it the most lifelike and natural . . .

A portrait painter must be swift, so that he grasps everything immediately before the time becomes too long for the subjects . . . He must let children sit more often because their patience soon wears thin. The clothes should be chosen by the painter according to the complexion of the person, as well as the background, but this rule will not be easy to put into practice in the congregation. Therefore, a good portrait can never or at least very seldom be painted there. There, one does as well as possible out of obedience and applies all energy to the face, so that it predominates above all. With hands, it generally goes very poorly for portrait painters. Their mistake is that they do not make drawing a major concern, and so it must go when they begin to play with paints and brushes. But nothing is more certain than that it results only in linen smeared with colors because one should not paint before one is skilled in drawing, and then painting will go well. But painting before drawing is like building a house without a foundation; it cannot stand.

ART AND THE SPANISH CONQUEST

In the geographic areas that would become Florida, Texas, New Mexico, Arizona, and California, a series of military and religious campaigns consolidated colonial power for Spain during the sixteenth, seventeenth, and eighteenth centuries. On the eastern seaboard, the majority of English-speaking settlers wished to live among their own people, preferring to displace or kill Native Americans rather than convert and govern them locally. Things were very different in Florida and the West, where Catholic missionaries aggressively sought the Christianization and "Hispanification" of the local populations they encountered. These friars used art as a tool of conversion, relying on the graphic power of the cross and the colorful impact of images of saints to create persuasive visual affirmations. The Spanish also encouraged a blending of Catholic and indigenous artistic practices, resulting in a hybrid style and a mixed iconography quite different from European religious art.

The following translated documents allow a small glimpse of the difficult, back-and-forth cultural process that unwound over several centuries in Spanish North America. In 1540 the soldier Hernando de Alarcón was dispatched northward from Mexico, sailing up the Colorado River—now the border between California and Arizona. After making contact with a group of Native people along the riverbank, he distributes rude crosses and encourages a kind of worshipful veneration of the symbol, even though he is unable to communicate any notion of its meaning. This was customary for the Spanish, who usually erected crosses and taught Native Americans the physical act of signing themselves long before they learned Spanish. Nearly a century later, Franciscan priest Alonso de Benavides was in charge of all missions in New Mexico from 1626 to 1629. In his "Memorial," presented to Pope Urban VIII in 1634, he gives an account of his work. It includes an encounter with a Xila Apache chief ("Captain Sanaba"), who presents the priest with a painted skin combining Christian and Native imagery, and the conversion of a neighboring Apache tribe thanks to an image of the Virgin they glimpsed "surrounded by many lighted candles, with music playing."

Native communities certainly chafed under Spanish rule, but it was not until 1680 that a major uprising took place, the Pueblo Revolt, organized by a freed Native pris-

oner named Popé, who had taken refuge in Taos Pueblo. In a letter sent to the governor by members of the Santa Fe city council, the displaced Spaniards describe the insurrection and detail the iconoclasm that included the burning, whipping, dismembering, and desecration of icons—actions that mirrored the earlier Spanish destruction of non-Christian objects. Another account comes from an interview with a twenty-eight-year-old inhabitant of Tesuque Pueblo whose name is given as Juan. He describes Popé's iconoclastic campaign and also explains how the revolt was coordinated through the use of coded, knotted cords—an interesting example of indigenous material culture practice. The Spanish managed to retake Santa Fe twelve years after the insurrection, and to some extent life in New Mexico returned to the old type of cultural hybridity of the pre-revolt era. A century and a half later, when German topographical artist Heinrich Baldwin Möllhausen passed through Pueblo territory with the Whipple Railroad Expedition of 1853–54, he marveled at the Spanish-Native mix in the churches he visited (see also "Prince Max and Karl Bodmer among the Mandan," chapter 6). His description of the church at Santo Domingo Pueblo is included below.

Artistic riches were not limited to the Southwest, as the inventory of Florida church furnishings attests. This inventory was coordinated by the Mission of St. Augustine and reflects the possessions of thirty-four churches. The date of 1681 makes it contemporaneous with the Pueblo Revolt and a likely indicator of the types of art objects that were destroyed in New Mexico. The inventory details a sumptuous collection of textiles and liturgical vestments (frontals, amices, palls, corporals, bolses, rochets, etc.), a staggering amount of silver, and more than six hundred paintings and statues, averaging eighteen or so per church.

Narrative of Hernando de Alarcón's voyage up the Colorado River, 1540, in Richard Flint and Shirley Cushing Flint, Documents of the Coronado Expedition, 1539–1542 *(Dallas: Southern Methodist University Press, 2005).*

When I saw that they understood me in every way and that I, likewise, understood them, it occurred to me to see whether by some means I could give a good beginning to a successful outcome of the hopes I had. With some sticks and paper I had some crosses made and, among those others [that is, the ordinary Indians], I made it clear to them that they were things I esteemed most. And I kissed them, suggesting to them they should honor and prize them greatly and wear them around their necks, making them understand that was the symbol of heaven. They took them and kissed them and raised them high. And they showed that they were very happy and glad when they did this. Sometimes I showed [the Indians] great affection by placing them in my *barca*. And at such times I presented them some of the small items I carried. The situation then developed that there was not enough paper or sticks with which to make crosses.

Frederick Webb Hodge et al., Fray Alonso de Benavides' Revised Memorial of 1634 *(Albuquerque: University of New Mexico Press, 1945).*

After the lapse of a few days, I returned there to ascertain the state of that conversion. When Captain Sanaba heard that I had arrived at San Antonio Senecú, he came those fourteen leagues to see me, accompanied by many of his people. After I had welcomed him with honor in the presence of all, he presented me with a folded chamois, which is a dressed deerskin. It is customary among these people, when going to visit someone, to bring a gift. I accepted it to gratify him, although I told him that I did not want anything from him except that he and all his

people should become Christians. He asked me to unfold the chamois and see what was painted on it. This I did and saw that it had been decorated with the sun and the moon, and above each a cross, and although the symbolism was apparent to me, I asked him about it. He responded in these formal words: "Father, until now we have not known any benefactors as great as the sun and the moon, because the sun lights us by day, warms us, and makes our plants grow; the moon lights us by night. Thus we worship them as our gods. But, now that you have taught us who God, the creator of all things is, and that the sun and the moon are His creatures, in order that you might know that we now worship only God, I had these crosses, which are the emblem of God, painted above the sun and the moon. We have also erected one in the plaza, as you commanded."

Only one who has worked in these conversions can appreciate the joy that such happenings bring to a friar when he sees the results of his preaching. Recognizing this gift as the fruit of the divine word, I took the chamois and placed it on the high altar as a banner won from the enemy and as evidence of the high intelligence of this nation, for I do not know what more any of the ancient philosophers could have done . . .

The beginning of the conversion of this tribe was brought about by the continuous intercourse which they have had with the friars in the Christian pueblos, where the Indians came to sell dressed síbola hides, and the friars always talked to them of God. There spread among them the report and fame of the great beauty and reverence for an image of the death of our Lady which I had placed in a chapel in the church in the villa of Santa Fe, where the Spaniards worshipped. The principal captains came to see it, and when they beheld it all were converted and worshipped it. We kept it adorned with much devotion. The first time that they saw it was at night, surrounded by many lighted candles, with music playing. It would be a long matter to relate all my conversations with these captains in regard to their learning how to become Christians. And as to what they said to the holy image while kissing its feet, I refer to my history.

Opinion of the Cabildo (City Council) of Santa Fe, October 3, 1680, in Charles Wilson Hackett, Revolt of the Pueblo Indians of New Mexico and Oetermín's Attempted Reconquest, 1680–1682 *(Albuquerque: University of New Mexico Press, 1942).*

The convocation and plot of the said Indians seems to have been so secret that they perpetrated their treason generally in all the jurisdictions of the kingdom, as was seen, beginning on the night of August 9, when the said Indians took up their arms and, carried away by their indignation, killed religious, priests, Spaniards, and women, not sparing even innocent babes in arms; and as blind fiends of the devil, they set fire to the holy temples and images, mocking them with their dances and making trophies of the priestly vestments and other things belonging to divine worship. Their hatred and barbarous ferocity went to such extremes that in the pueblo of Sandia images of saints were found among excrement, two chalices were found concealed in a basket of manure, and there was a carved crucifix with the paint and varnish taken off by lashes. There was also excrement at the place of the holy communion table at the main altar, and a sculptured image of Saint Francis with the arms hacked off; and all this was seen in one temple only, as we were marching out.

Declaration of Indian Juan, 1681, in Hackett, Revolt of the Pueblo Indians.

Having been questioned according to the tenor of the case, and asked for what reasons and causes all the Indians of the kingdom in general rebelled, returning to idolatry, forsaking the law of God and obedience to his Majesty, burning images and temples, and committing the

other crimes which they did, he said that what he knows concerning this question is that not all of them joined the said rebellion willingly; that the chief mover of it is an Indian who is a native of the pueblo of San Juan, named El Popé, and that from fear of this Indian all of them joined in the plot that he made . . .

Asked how the said Indian, Popé, convoked all the people of the kingdom so that they obeyed him in the treason, he said that he took a cord made of maguey fiber and tied some knots in it which indicated the number of days until the perpetration of the treason. He sent it through all the pueblos as far as that of La Isleta, there remaining in the whole kingdom only the nation of the Piros who did not receive it; and the order which the said Popé gave when he sent the said cord was under strict charge of secrecy, commanding that the war captains take it from pueblo to pueblo. He [the deponent] learned of this circumstance after the kingdom was depopulated.

Asked to state and declare what things occurred after they found themselves without religious or Spaniards, he said that what he, the declarant, knows concerning this question is that following the departure of the señor governor and captain-general, the religious, and the Spaniards who were left alive, the said Indian, Popé, came down in person with all the war captains and many other Indians, proclaiming through the pueblos that the devil was very strong and much better than God, and that they should burn all the images and temples, rosaries and crosses, and that all the people should discard the names given them in holy baptism and call themselves whatever they liked.

Baldwin Möllhausen, **Diary of a Journey from the Mississippi to the Coasts of the Pacific** *(London: Longman, Brown, Green, Longmans, and Roberts, 1858).*

The church was not externally distinguished from most others in the smaller Mexican towns; it had rough walls inclosing a simple hall, and the chief gable was turned towards the square, and projecting a little, was supported by two square clay columns. Between these two was the entrance, and over it a gallery communicating with the choir. On the roof was a kind of stone scaffolding, or belfry, containing the small bell, and surmounted by a cross. Some subordinate buildings in the same style, and an inclosed churchyard, completed the Pueblo church, which evidently owes its origin to Catholic missionaries. The interior was in the same style; there was a kind of altar; and the walls were of smooth clay, on which hung some old Spanish pictures,— the sole decoration, with the exception of some rude Indian paintings, amongst which we remarked the figure of a man on horseback riding over a troop of men: a *Conquestador,* therefore, and evidently an allusion to the Spanish conquest. The Catholic and Aztec religions were evidently blended in these representations; the Holy Virgin is often found in company with an Indian figure denominated Montezuma by the ignorant people of northern Mexico, and under the cross is seen a picture of the caves where the sacred fire was kept burning. In the populous Indian towns on the Rio Grande, and westward of the Rocky Mountains, this "everlasting" fire has long been extinguished; but it appears from tradition (a very uncertain authority, of course), that the holy flame was last cherished near the sources of the Pecos, where ancient ruins still attract the traveller's attention. It is also stated that Montezuma planted a young tree on this spot, and declared that as long as it stood, the descendants of the Aztecs, the present Pueblo-Indians, should form an independent nation; but that when the tree had disappeared, white men should come from the east and overrun their country. The inhabitants of the Pueblos were then to live in peace with these white men, and patiently await the time when Montezuma shall return and unite them again into one powerful race.

Inventory of church furnishings in thirty-four Florida missions, 1681, in John H. Hann, "Church Furnishings, Sacred Vessels and Vestments Held by the Missions of Florida: Translation of Two Inventories," Florida Archaeology 2 *(1986).*

Memorial and specific number of sacred vestments, furnishings, and treasures which the churches of the thirty-four *doctrinas* of the conversions of Florida possess for public worship, all acquired through the solicitude, care, and diligence of the religious ministers. It is the following exactly.

First, forty-seven silver chalices with their patens.

Also seventy-one missals, some new and others used.

Also ninety-two bells to toll for mass.

Also two hundred and thirty-eight little bells, some in circles and others loose to ring for the Sanctus.

Also two hundred and sixty-five brass candlesticks, four of silver, and ten of red ebony.

Also twenty-five silver monstrances.

Also two hundred and fifty-two frontals of diverse colors and goods.

Also three hundred and twenty-one chasubles, similarly of diverse colors and goods.

Also fifty-four choir-copes of silk of diverse color and types.

Also two hundred and ten albs of different linens, some with lace and others plain.

Also one hundred and forty-two amices some with lace and others plain.

Also two hundred and fifty-two different palls.

Also three hundred and seventy-two different corporals.

Also one hundred and seventy-six bolses for corporals of diverse colors.

Also three hundred and ninety-six chalice veils of diverse colors.

Also sixty-four surplices.

Also one hundred and twenty-six rochets.

Also one hundred and seventy-two cinctures.

Also forty stoles of diverse colors.

Also fifteen silver vessels for the deposit.

Also seventeen coverlets of cotton.

Also twenty small silver crosses for giving the blessing.

Also twenty-eight silver containers for administering Viaticum.

Also fourteen thuribles with incense boats and chains of silver.

Also sixteen pairs of silver cruets and fifteen silver plates.

Also fifty-one silver chrism vials.

Also eight silver lamps.

Also six silver crosses for the banners and of the parish.

Also four lamps of brass.

Also seventeen canopies.

Also sixty banners.

Also twenty-seven cloths for giving communion.

Also eleven silk mozzetas of diverse goods for administering the Viaticum.

Also five procession crosses.

Also fifteen covers for the missal-stand.

Also twenty large lanterns and beacons.

Also forty-two hand cloths.

Also one hundred and forty-nine *cornialtares*.

Also seventeen rituals.

Also one hundred and eighty-three statues of Our Lady, Infant Jesus, diverse saints.

Also sixty-nine engravings.

Also four hundred and forty-four pictures and canvases of diverse figures.

Also nine large chests of drawers for storing the vestments in the sacristy.

Also sixteen brass thuribles.

Also thirty-eight cedar-chests for the sacred vestments.

Also thirty-five diverse veils or curtains.

Also five holy water basins, five gilded tabernacles and six mirrors.

Also three altar-pieces, two of them gilded.

Also three vessels of silver for baptizing.

Also twenty-eight silver crowns and six halos

Also five baldachins and three pairs of dalmatics.

Also eleven presses for Hosts.

That which is listed [my lord] is that which is in existence and serviceable rather than that which is worn out with time, and that the rest, which is less finely wrought and of less value is no small amount, though all of it is an indication of the care and zeal of the religious and of what they strove to have in their churches for their adornment and the worship of their God. May he protect your majesty with the blessings that all of us in this convent of the immaculate conception of the *presidio* of St. Augustine of Florida desire and ask for you. On the sixteenth day of the month of June of the year sixteen hundred and eighty-one.

FRAY BLAS DE ROBLES, Minister provincial

ADVERTISEMENTS

PETER PELHAM SCRAPES A MEZZOTINT

The London engraver Peter Pelham emigrated to Boston in 1727, where he later became the stepfather of John Singleton Copley. Pelham's relative cosmopolitanism prompted him to open a "finishing" school and dancing academy for Boston's youth, but his more lasting contribution to American art was a series of fourteen mezzotint portraits of leading Boston citizens. (The mezzotint process employs a metal plate that has been given an overall roughened texture by a rolling tool. The engraver then smooths the parts of the plate that are to appear as white, leaving the pitted sections of the surface to collect ink and translate into the dark areas of the print. This "scraping" process allows for subtly graduated degrees of modeling and chiaroscuro.) As his first specula- tive endeavor in Massachusetts, Pelham cannily chose the famous divine Cotton Mather (see "Cotton Mather on Art," this chapter). Although Puritan ministers generally had an ambivalent relationship to the pictorial arts, ministerial prints had become a Boston tradition, beginning with the early woodcut by John Foster of Mather's grandfather, Richard Mather (1670). These likenesses were seen as moral exemplars—"mirrors" of

piety—and were often displayed in domestic settings. In this notice, Pelham sets out the terms of his proposal, with favorable terms for multiple purchases. He lived up to his promise, delivering the prints in June 1728.

Boston Gazette, *March 4, 1728.*

PROPOSALS, for Making a Print in *Metzotinto*, of the late Reverend Dr. COTTON MATHER, by *Peter Pelham.*

The particular desire of some of the late Doctor's Friends for making a Print in metzotinto, *being Communicated to the said* Pelham; *but as the Author can prove the Charges, in the produce of the work, will run high, Numbers are Requir'd to make it easy: Therefore it's humbly hop'd by the Author to find Encouragement on his PROPOSALS, which are as follow, viz.*

I. THE Copper Plate to be 14 Inches by 10. which is the Common Size of most Plates in *Metzotinto,* by the said *Pelham,* and others.

II. IT shall be done after the Original Painting after the Life by the said *Pelham,* and shall be Printed on the best Royal Paper.

III. EVERY Subscriber to pay *Three Shillings* down, and *Two Shillings* at the Delivery of the Print, which will be begun when a handsome Number of Subscriptions is procur'd: Therefore as the Author hopes to Compleat the work in *Two Months,* he desires all those who have a mind to Subscribe, to be speedy in sending their Names with the first Payment.

IV. FOR the Encouragement of Subscribers, those who take Twelve shall have a Thirteenth *Gratis.*

N.B. *SUBSCRIBERS and others may see some Prints in* Metzotinto, *of the Author's doing by way of Specimen, at his House in* Summer Street, *facing the New South-Meeting, where Subscriptions are taken in, and Receipts given for the first Payment. And likewise Subscriptions taken in at Mr.* Jonathan Barnard's, *in* Cornhil, *facing the Town-House.*

Whereas it is said in the 3d Article or Proposal, the Plate will be begun, &c. This is to assure the Publick, That the Plate is now actually in hand, and shall be proceeded on with all possible diligence.

RUNAWAY "LIMNERS"

Indentured servants and convicts who ran away from their employers or jailers were often tracked through advertisements offering rewards for their capture, much like escaped slaves. In these advertisements from the Pennsylvania Gazette, *three escapees are described as using the alias of a limner, or painter. This makes sense as a cover, for itinerant artists were always on the move, lacked settled habits, and often lived hand to mouth. An additional runaway apparently sought to pass as a "gentleman" rather than an artist, but part of his gentlemanly appearance was the fact that he carried a miniature painting in his pocket. Also included here is an ad for a runaway slave owned by Boston painter John Smibert; the description of the man's breeches indicates an active role in the painter's studio.*

Pennsylvania Gazette, *August 16, 1753.*

Run away on Sunday, the 5ᵗʰ inst. from William Nicholson, Ship chandler, in New York, A German servant man, named Christianus Fredericus Heisterborg, about thirty years of age, smooth

faced, with a small scar between his eyes, has an innocent look, is about five feet six inches high, and walks stooping. Had on when he went away, A light colourcloth jacket and breeches, home-spun striped jacket, check shirt, black stockings, old double channel pumps, and pewter buckles, with brass chapes and tongues. Whoever takes up said servant, and secures him, so as his master may have him again, shall have Five Pounds reward, and all reasonable charges, paid by WILLIAM NICHOLSON,

N.B. He speaks Latin, And but little English, and pretends to be a limner.

Pennsylvania Gazette, *April 8, 1756.*

Run away from Robert Allison of Charlestown, in Maryland, a convict servant, named Edward Bradshaw, a good likely fellow, and has the remains of genteel dress, is a good clerk, professes himself a limner, and is supposed to paint tolerably well, has an uncommon cast in one of his eyes, plays a fiddle well, and generally carries one with him; also went in company with one Joseph Thornton, a convict servant, a thick short fellow, dressed as a sailor, which he pretends to be but is not.

Pennsylvania Gazette, *December 27, 1775.*

Run away, on Saturday, the first of December instant, a tall, personable man, aged about 28, dressed in a chocolate coloured Bath coating surtout coat, with buttons on the sleeves, and has a large green velvet collar, a close coat, jacket and breeches, of dark brown broadcloth, also a pair of blue, red and white narrow striped cotton trowsers, which came down under the shoe straps; in his pocket a miniature picture of a young lady, two pair of ruffles, and a toothpick case; his hair is dressed in the fashionable manner, and his hat in the modern cut.—He has much the appearance of a gentlemen, says he is a doctor, speaks some words in the Scottish idiom, and has passed in the several places he has been defrauding in, by the names of Drummond, Stuart, and Cambell.

Pennsylvania Gazette, *May 30, 1777.*

Run away, the 1st day of March last, from the subscriber, living in Baltimore County, Maryland, near Deer Creek, a convict servant man, named Joseph Pool, but has changed his name to John or Joseph Ensey since he went away; he is about 35 years of age, about 5 feet 4 inches high, a good deal pockmarked, has thin brown hair, his left hand from his wrist, has a large scar in his upper lip, writes a good hand, and calls himself a painter and limner, but served his time to the hattertrade in London; had on, a lightish colored half worn great coat, and waistcoat of the same, half worn leather breeches, and an old felt hat. Whoever takes up the said servant, and secures him, so as his master may have him again, shall have THREE POUNDS Reward, if out of the county, or FORTY SHILLINGS, if in the county, and reasonable charges, paid by THOMAS BLEANY.

Boston Gazette, *October 3, 1737.*

Ran-away on the 26th of this Instant September, from Mr. John Smibert of Boston, Painter, a Negro man Servant named Cuffee, who formerly belonged to Capt. Prince, and understands something of the business of a sailor, he is about 22 Years of Age, and speaks good English, a pretty tall well shap'd Negro with bushy Hair, has on a large dark colour'd Jacket, a pair of Leather Breeches stain'd with divers sorts of paints, and a pair of blue stockings. Whoever shall take up

said Runaway and him safely convey to his abovesaid Master in Boston, shall have Three Pounds Reward and all necessary Charges paid. All Masters of Vessels are hereby warned against carrying off said Servant on penalty of the Law in that Case made and provided.

JOHN DURAND

John Durand, an itinerant painter of colorful, hard-edged portraits, was active in Virginia, New York, Connecticut, and the Caribbean from the late 1760s through the early 1780s. The following advertisement, which he placed in a New York City newspaper, is unusually long and detailed. Oddly, Durand does not mention portraiture in his notice but, instead, provides a mini-tutorial on history painting, an early American treatment of the subject.

New-York Gazette, or the Weekly Post-Boy, *April 11, 1768.*

The Subscriber having from his Infancy endeavoured to qualify himself in the Art of historical Painting, humbly hopes for the Encouragement from the Gentlemen and Ladies of this City and Province, that so elegant and entertaining an Art, has always obtain'd from People of the most improved Minds, and best Taste and Judgement, in all polite Nations in every Age. And tho' he is sensible, that to excel (in this Branch of Painting especially) requires a more ample Fund of universal and accurate Knowledge than he can pretend to, in Geometry, Geography, Perspective, Anatomy, Expression of Passions, ancient and modern History, &c. &c. Yet he hopes, from the good Nature and Indulgence of the Gentlemen and Ladies who employ him that his humble Attempts, in which his best Endeavours will not be wanting, will meet with Acceptance, and give Satisfaction; and he proposes to work at as cheap Rates as any Person in America.

To such Gentlemen and Ladies as have thought but little upon this Subject, and might only regard painting as a superfluous Ornament, I would just observe, that History-painting, besides being extremely ornamental, has many important uses. It presents to our View, some of the most interesting Scenes recorded in ancient or modern History; gives us more lively and perfect Ideas of the Things represented, than we could receive from an historical account of them; and frequently recals to our Memory, a long Train of Events, with which those Representations were connected. They shew us a proper Expression of the Passions excited by every Event, and have an Effect, the very same in Kind, (but stronger) than a fine historical Description of the same Passage would have upon a judicious Reader. Men who have distinguished themselves for the good of their Country and Mankind, may be set before our Eyes as Examples, and to give us their silent Lessons, and besides, every judicious Friend and Visitant shares with us in the Advantage and Improvement, and increases its Value to ourselves.

JOHN DURAND,
near the City-Hall, Broad-street.

WORK FOR WOMEN

Before the Revolution, female practitioners of oil painting were all but nonexistent in the American colonies, although Henrietta Johnston of Charleston worked in pastels, and Polly Wrench executed miniatures in Philadelphia until she was married in 1777. Women's contributions to their visual and material worlds were nevertheless extensive,

as the following advertisements suggest. Elizabeth Courtney's Boston school for young ladies concentrated on fabric arts, and Abigail Hiller's establishment added quillwork, featherwork, and waxwork—all designed to furnish the domestic sphere with refined adornments. The most notable woman artist of the period was cameo carver and wax sculptor Patience Wright, whose London successes are mentioned in the final notice. Wright was born to Quaker parents in New Jersey, but she transcended her humble beginnings to become an international show woman, American patriot and spy, and acquaintance of Benjamin Franklin, Thomas Jefferson, and Benjamin West, among others. However, when future president John Adams saw her works in 1777, he found them "disagreeable," adding, "The imitation of life was too faint, and I seemed to be walking among a group of corpses" (see also "John Adams on the Arts," chapter 2). His wife, Abigail, was even less enamored of the gender-defying Wright when she met her in London in 1784, objecting to the artist's familiar behavior and referring to her as the "queen of sluts."

Boston Gazette, *April 30, 1751.*

This is to notify the Publick, that there is a fine Sett of Wax-work, consisting of Kings, Queens, &c. at full-Length; to be shown by Mrs. *Hiller* in *Cambridge-Street,* leading to West *Boston,* at *Six Pence* a Piece, Lawful Money, for Men and Women, and *four* Pence for Children; where is also to be taught Wax-work, Painting upon Glass, Quill-work, Feather-Work, Filligree and Transparent, Tentstitch and other fine Works; And young Ladies boarded or half boarded.

Boston Gazette, *October 19, 1767.*

To the Young Ladies of Boston. Elizabeth Courtney, as several Ladies has signified of having a desire to learn that most ingenious art of Painting on Gauze & Catgut, proposes, to open a School, and that her business may be a public good, designs to teach the making of all sorts of French Trimmings, Flowers, and Feather Muffs and Tippets, and as those arts above mentioned (the Flowers excepted) are entirely unknown on the Continent, she flatters herself to meet with all due encouragement; and more so, as every Lady may have a power of serving herself of what she is now obliged to send to England for, as the whole process is attended with little or no expense. The Conditions are *Five Dollars* at entrance, to be confin'd to no particular hours or time: And if they apply constant, may be compleat in six weeks. And when she has fifty subscribers, school will be open'd, as not being designed to open a school under that number, her proposals being to each person so easy, but to return to those who have subscribed their Money again, and keep the business to herself.

 N.B. Feather Muffs and Tippets to be had; and Gauze wash'd to look as well as new.

 Please to inquire at Mr. *Courtney's,* Taylor, four Doors below the Mill-Bridge, North-End.

New-York Gazette and the Weekly Mercury, *November 9, 1772.*

We hear from England, that the ingenious Mrs. Wright, whose surprising Imitations of Nature, in Wax Work, have been so much admired in America, by a diligent Application and Improvement in the same Employment, has recommended herself to the general Notice and Encouragement of Persons of the first Distinction in England, who have honoured her with peculiar Marks of their Favour; and as several eminent Personages, and even his Majesty himself, have condescended to sit several Times, for her to take their Likeness; it is probable she will enrich her Collection, and oblige her Friends in America, with a View of the most remarkable Persons

of the present Age, among which will be the immortal, inimitable Garrick,[1] whom she had began; she has already compleated, and sent over to her House in this City, where they may be seen, the most striking Likeness of the celebrated Doctor Benjamin Franklin, of Philadelphia, now in London, and of Mrs. Catharine M'Cauley, so much admired for, her great Learning, Writing and amiable Character.

PUBLIC SPECTACLE

In the pre-museum age, when not even 1 percent of the populace could afford to commission an oil portrait, visual amusements in colonial America were few and far between. The following advertisements describe the remarkable variety of public "art" that occasionally found its way to the larger cities and was usually priced for the pockets of average citizens. These include royal portraits sent to the colonies as a constant reminder of allegiance owed the mother country and a fascinating assortment of "machines" imported from London, which—through dioramas or candlelight projections—displayed architectural, historical, and genre scenes. John Bonnin, the proprietor of the "Philosophical Optical Machine," makes a particularly personal appeal to his fellow New Yorkers in the New-York Gazette *advertisement below, but evidently without much success, as the follow-up notice two years later suggests.*

Boston News-Letter, *October 8, 1730.*

The Pictures of their Majesties King GEORGE II, and Queen CAROLINE, beautifully drawn at length, are put up in the Council Chamber in this Town, and according to the Inscription at the bottom of them, they are the Gift of His Majesty, to this His Province of the *Massachusetts* Bay.

New-York Evening Post, *September 8, 1746.*

To be Seen, the Curious and Surprizing Magick Lanthorn, by which Friar Bacon, Doctor Faustus, and others, perform such wonderful Curiosities, representing upwards of 30 humourous and entertaining Figures, larger than Men or Women; as the Rising Sun, the Friendly Travellers, the Pot Companions, the blind Beggar of Gednal Green and his Boy, the merry Piper dancing a Jigg to his own dumb Musick, the courageous Fencing Master, the Italian Mountebank or famous infallible Quack, the Man riding on a Pig with his Face towards the Tail, the Dutchman scating on the Ice in the midst of Summer; with a great Variety of other Figures equally diverting and curious, too tedious here to mention.

N.B. To begin at 7 o'clock in the Evening.

New-York Gazette, *December 19, 1748.*

To the Publick in general here and hereabouts. Ladies, Gentlemen and every Body else, I am well enough know to all of you, for I am a New-Yorker. I don't pretend to be a fine Scribe; far from it. I have been otherwise employed all my Days, than to have any Time to learn a knack of writing well; but yet I think I am not quite so unlearned, but that I can write so as to be understood; and as I find myself under a Necessity of making my address to you, I hope you will make an Allowance for my manner and Stile.

[1] David Garrick was an eighteenth-century English actor and playwright.

You all know I lately purchased, and many of you have seen my Philosophical Optical Machine, lately invented in, and imported from London. I have hitherto shewed (out of near 100 Prospects) only two Setts, 8 in each of English Palaces, grand Building, and Gardens, &c. Every one who has seen them, has paid me Four Shillings a Piece for each Set; and I must say, they have gone from me well satisfied; their repeated Visits and constant Recommendations of the Machine, convince me of what I assert.

But tho' all my Customers seem well pleased (except a very few who can approve of Nothing they see others do, or with any Thing but what they say themselves or have a Hand in) yet as I understood, there were great Numbers who think much of Four Shillings, and knowing that there are others who really can't afford it, I began last week to show for Two Shillings only, the first eight English Prospects; and determined to have shewn them no more here. But last Week having been so bad weather, for the most Part, that few People cared to stir Abroad, I hereby give Notice, that none may miss an Opportunity of seeing the English Prospects, that every Morning this Week I will continue to shew the first 8, and every Afternoon and Evening, the other 8 of them, to no less than 6 Persons at a Time; but if a lesser Number should come, I will leave it to their own Generosity, according to the Satisfaction they think they receive. The next Monday I will begin to show, on the same easy Terms, nine of the French King's Palaces, and so every succeeding Week different Ones, in different Parts of the World, till the whole be gone through. After that, I intend to go to Philadelphia . . . Jo. Bonnin.

P.S. Any Body who has once paid for seeing a set, is always welcome to see the same again gratis, provided they bring, or come along with a new Company, or when I am showing what they have seen before.

New-York Gazette, *May 14, 1750*.

John Bonin,

Hereby gives Notice to his Friends and Well wishers, That, After having tried many different Ways to support himself and Family, tho' with the utmost Honesty and Care, yet not being attended with desired Success, has now, by the Assistance of some Merchants, opened a Shop in Crown-Street, in the House where Capt. Hewit lately lived, near Mr. Abraham Lott's; where may be had, Rum, Sugar, and most kinds of European Goods usually sold in Shops. As his Creditors, he is fully persuaded, are such from a sincere and hearty Disposition to serve him, and as therefore he has his Goods at the most easy Rates, his kind Customers may depend on buying of him at the lowest Prices; and for their Encouragement, they shall be wellcome to view his famous Optical Machine Gratis.

"The Microcosm," Boston Gazette, *May 17, 1756*.

To be Seen (for a short Time) at the House of Mr. *William Fletcher,* Merchant, *New-Boston;* That Elaborate and Matchless Pile of ART, Called, The MICROCOSM, Or, The WORLD in MINIATURE.

Built in the Form of a Roman *Temple, after Twenty-two Years, close Study and Application, by the late ingenious Mr.* Henry Bridges, *of* London; *who, having received the Approbation and Applause of the Royal Society, &c. afterwards made considerable Additions and Improvements; so that the Whole, being now compleatly finished, is humbly offered to the Curious of this City, as a Performance which has been the Admiration of every Spectator, and proved itself by its singular Perfections the most instructive as well as entertaining Piece of Work in* Europe.

A Piece *of such complicated Workmanship, and that affords such a Variety of Representations*

(tho' all upon the most simple Principles) can but very imperfectly be described in Words the best chosen; therefore 'tis desired, what little is said in this Advertisement may not pass for an Account of the MICROCOSM, *but only what is thought meerly necessary in the Title of such an Account,* &c.

ITS *outward Structure is a most beautiful Composition of Architecture, Sculpture and Painting. The inward Contents are as judiciously adapted to gratify the Ear, the Eye, and the Understanding; for it plays with great Exactness several fine Pieces of Musick, and exhibits, by an amazing Variety of moving Figures, Scenes diversified with natural Beauties, Operations of Art, of human Employments and Diversions, all passing as in real Life,* &c.

1. SHEWS all the celestial Phænomena, with just Regard to the proportionable Magnitudes of their Bodies, the Figures of their Orbits, and the Periods of their Revolutions, with the Doctrine of JUPITER's Satellites, of Eclipses, and of the Earth's annual and diurnal Motions, which are all rendered familiarly intelligible. In Particular will be seen the Trajectory and Type of a Comet, predicted by Sir ISAAC NEWTON, to appear the Beginning of 1758; likewise a Transit of VENUS over the Sun's Disk, the Sixth of *June* 1761; also a large and visible Eclipse of the Sun, the First of *April* 1764, &c.

2. ARE the nine Muses playing in Concert on divers musical Instruments, as the Harp, Hautboy, Bass Viol, &c.

3. IS ORPHEUS in the Forest, playing on his Lyre, and beating exact Time to each Tune; who, by his exquisite Harmony, charms even the wild Beasts.

4. Is a Carpenter's Yard, wherein the various Branches of that Trade are most naturally represented, &c.

5. Is a delightful Grove, wherein are Birds flying, and in many other Motions warbling forth their melodious Notes, &c.

6. Is a fine Landskip, with a Prospect of the Sea, where Ships are sailing with a proportionable Motion according to their Distance. On the Land are Coaches, Carts and Chaises passing along, with their Wheels turning round as if on the Road, and altering their Positions as they ascend or desend a steep Hill; and nearer, on a River, is a Gun-powder-Mill at Work. On the same River are Swans swimming, fishing, and bending their Necks backwards to feather themselves; as also the Sporting of the Dog and Duck, &c.

7. AND lastly, Is shewn the whole Machine in Motion, when upwards of twelve Hundred Wheels and Pinnions are in Motion at once: And during the whole Performance it plays several fine Pieces of Musick on the Organ and other Instruments, both single and in Concert, in a very elegant Manner, &c.

IT *will be shewn every Day, exactly at Eleven o'Clock in the Morning, and again at Three and Five in the Afternoon, at* Four Shillings & Six Pence *each, and Children under Twelve Years of Age, at* Three Shillings (*Lawful Money*) *though Price quite inferior to the Expence, and Merits of this Machine.*

N.B. ANY Person subscribing *Thirteen Shillings and Six Pence,* will be entitled to see the MICROCOSM at the above Hours, during its Stay at *Boston.*

EARLY RESPONSES TO PORTRAITS

Direct American commentary on early eighteenth-century portraits is rare, so, though brief, these three excerpts from letters written in the 1730s to correspondents in England

are particularly valuable. In the first, James Logan, the chief justice of Pennsylvania, writes to William Logan to say that he will not be able to send portraits of his family in exchange for ones forwarded by his brother. In explanation, he mentions Swedish painter Gustavus Hesselius, then resident in Philadelphia, whose work, he reports, is deemed unflattering by the women of Philadelphia. The family was Quaker, and there is also a suggestion that Logan's wife objected to portraiture on religious grounds (see "Quaker 'Rules' on Tombstones," this chapter).

A year later, the governor of Massachusetts would also express reservations about portraits, in this case mezzotint prints (see "Peter Pelham Scrapes a Mezzotint," this chapter). Jonathan Belcher was installed as governor in 1730, and as a reflection of his stature of office he commissioned several oil portraits of himself. Yet when his son, then living in England, engaged printmaker John Faber to copy one of those portraits, Belcher became alarmed. In a letter, he demands that the print and plate be destroyed; Belcher apparently worried that his enemies would criticize him as acting above his station if the prints were issued by a family member. He seemed to recognize the power of the portable work of art, issued in multiples. The son did not, however, carry out the father's order, and a year later, in 1735, Belcher changed his mind and requested the plate and prints be sent to him in Boston, where he could better control their dissemination.

William Byrd also writes to a correspondent, John Perceval, who has sent his portrait to the colonies, in this case to the former's plantation in Virginia. Byrd's fascinating reply shows him to be a man who studies portraits carefully, "reading" them as he would a biblical text. As would be the case for Charles Willson Peale several decades later, Byrd characterizes a successful portrait as one that brings out the moral virtues of the sitter, traits that should be discernible to all intelligent viewers, whether or not the sitter is known to them.

James Logan to William Logan, May 31, 1733, Historical Society of Pennsylvania.

We have a Swedish painter here, no bad hand, who generally does Justice to the men, especially to their blemishes, which he never fails shewing in the fullest light, but is remarked for never having done any to ye fair sex, and therefore very few care to sitt to him nothing on earth could prevail with my spouse to sitt at all, or to have hers taken by any man, and our girles believing the Originals have but little from nature to recommend them, would scarce be willing to have that little (if any) ill treated by a Pencil the Graces never favour'd, and therefore I doubt we cannot make you the most proper Return for so obliging a Present.

Jonathan Belcher to Jonathan Belcher Jr., August 7, 1734, Massachusetts Historical Society.

I see you had received my Picture from Mr. Caswall, I think it is not much like, tho' a good Peice of Paint, Done by Mr. Philips of Great Queenstreet, out of Lincoln's Inn Fields.

I am Surprized & much displeased at what your uncle writes me of Mr. Newman & your having my Picture done on a Copper Plate—how cou'd you presume to do Such a Thing without my Special Leave and Order—You Should be wise and consider the Consequences of Things before you put 'em in Execution, Such a foolish affair will pull down much Envy, and give occasion to your Father's Enemies to Squirt & Squib & what not—It is therefore my order, if this comes to hand timely that you destroy the Plate & burn all the Impressions taken from it.

William Byrd II to John Perceval, Earl of Egmont, July 12, 1736, Virginia Historical Society, Richmond.

I had the honour of your Lordships commands of the 9th of September, and since that have the pleasure of conversing a great deal with your picture. It is incomparably well done & the painter has not only hit your ayr, but some of the vertues too which usd to soften and enliven your features. So that every connoisseur that sees it, can see t'was drawn for a generous, benevolent, & worthy person. It is no wonder perhaps that I coud discern so many good things in the portrait, when I knew them so well in the original, just like those who pick out the meaning of the Bible, altho' in a strange language, because they were aquainted with the subject before. But I own I was pleasd to find some strangers able to read your Lordships character on the canvas, as plain as if they had been physiognomists by profession.

PIONEERING ARTISTS

JOHN SMIBERT DOCUMENTS

Following a three-year study tour of Europe, the Scottish-born painter John Smibert was working in the second tier of London portraitists with little chance of breaking into the top ranks when he met George Berkeley, the celebrated philosopher and clergyman. Berkeley had conceived a plan to establish a college in Bermuda to educate Native Americans, and Smibert agreed to come as a teacher of art. The Berkeley party arrived in Rhode Island in 1728, but the college never came into being. Smibert soon moved to Boston, where he immediately became the preeminent portrait painter. He also set up a "color-shop" to supply art materials, and his collection of paintings, including many copies of old masters from his European tour, remained available for decades after his death, inspiring such later painters as John Singleton Copley, Charles Willson Peale, John Trumbull, and even Washington Allston.

This group of Smibert documents begins with a passage from the notebook of George Vertue, a London engraver who recorded much concerning the local art community. In his choppy entry noting Smibert's departure from England, he summarizes the artist's reasons for embarking to the colonies. Next is a letter from Berkeley written in 1735, after he returned from Rhode Island and became the Anglican bishop of Cloyne, in Ireland. Berkeley paints an enticing picture of the life of an artist in Ireland, obviously hoping to convince Smibert to return from Boston. The artist did not leave Boston, as the later correspondence with his London friend and supplier, Arthur Pond, makes clear. In several letters to Pond, Smibert orders paint, canvas, and prints, asks for news of the London artists, and gives his own. In one list of items requested, Smibert includes a set of prints of ocean vessels, explaining, "These ships I want sometimes for to be in a distant view in Portraits of Merchts etc who chuse such, so if there be any better done since send them. but they must be in the modern construction." Smibert sought the most up-to-date sources for his art, and the same was true of his tea service. Evidently unimpressed by Boston silver, he sends Pond some old cups and spoons as a trade for a new London teapot of the latest style. Another fashion of the day in which he was involved was fan painting. The need for more fans and fan mounts to sell to the "ladies" is a leitmotif of this correspondence, especially when Smibert's nephew, John Moffatt, takes over the business after the painter's death in 1751. In his letter, Moffatt also includes a proposed text for Smibert's grave marker, which is given here in its entirety.

Memorandum, George Vertue Notebooks, in Richard H. Saunders, John Smibert: Colonial America's First Portrait Painter *(New Haven: Yale University Press, 1995).*

In a few days after M^r. Smibert left England, to go to the West Indies. New York. or Bermudas taking all his pictures Effects entending there to Settle. according to a Scheme propos'd by Dean Barclay. to lay the foundation of a College for all sorts of Literature on Bermudas. & professors of several sciences. to Instruct the Indian children in the Christian faith, & other necessary educations. to which end the Dean had made great Solicitations. at Court in the last reign. & had obtain a grant of 20000 pound from some of the plantation revenues to be employ'd in making a settlement there. of a College & several fellows. to which design the Dean had engag'd, or perswaded several gentlemen of fortune & Substance to join with him in this project. 3 or four of them. sett out with (y^e Dean. &) M^r. Smibert. on that account not paid prevented by the Death of the late King—

 M^r. Smybert had very good business here, a great many friends generally all of them dissuaded him from leaving here a certainty. for an uncertainty. but he warm'd with imaginations of the great success of such a design. & the pleasure of a finer Country & Air. more healthfull he being often a little enclind. to indispositions. or hip, or Vapours . . . & also having a particular turn of mind towards honest, fair & righteous dealing—he coud not well relish, the false selfish griping, overreaching ways too commonly practiz'd here. Nor was he prone to speak much. in his own praise. nor any violent ways but a descent modesty. which he thought in such a retirement. as at Bermudas he might live quietly & for a small expence. & make a great advantage. by ready money declaring he rather sought repose, than profitt. he was a good like man. Born at Endenburgh & now about 45. or 6—(furthermore its said that the Dean & Smibert took with them two young Gentlewomen. of good fortunes. both sisters. & married one to y^e Dean.)

George Berkeley to John Smibert, May 31, 1735, in Saunders, John Smibert.

A great variety and hurry of affairs, joined with ill state of health, hath deprived me of the pleasure of corresponding with you for this good while past, and indeed I am very sensible that the task of answering a letter is so disagreeable to you, that you can well dispense with receiving one of mere compliment, or which doth not bring something pertinent and useful. you are the proper judge whether the following suggestions may be so or no. I do not pretend to give advice; I only offer a few hints for your own reflection.

 What if there be in my neighborhood a great trading city? What if this city be four times as populous as Boston, and a hundred times as rich? What if there be more faces to paint, and better pay for painting, and yet nobody to paint them? Whether it would be disagreeable to you to receive gold instead of paper? Whether it might be worth your while to embark with your busts, your prints, your drawings, and once more cross the Atlantic? Whether you might not find full business at Cork, and live there much cheaper than in London? Whether all these things put together might not be worth a serious thought? I have one more question to ask, and that is, whether myrtles grow in or near Boston, without pots, stones, or greenhouses, in the open air? I assure you they do in my garden. So much for the climate. Think of what hath been said, and God direct you for the best.

John Smibert to Arthur Pond, July 1, 1743, in Saunders, John Smibert.

Dear Sir I wrote you the 6th of May by Capt. Bonner & then troubled you with 2 Bills one on Messr; Tyrons for £30 and the other on Messr: Walter Hayter & Sons for £11—the 2d Sett of

which Bills are now inclosed as also a Bill of Lading for eight Guineas & Twenty-five oz and a half of silver plate. I have for a long time intended to send for yᵉ pictures etc which my Nephew left with you, but delayed on act. of the war, which as there is no apearance of being over think, it now best to have them over here again, for as you long ago wrote me you had sold none of them, nor though it likely you should. I am in hopes I shal make something of them here so desires you will order them to be carefully packed up in a good case & sent by the first opportunity for this Port & insure on the Virtu cargo for £150. I must further trouble you to buy me 3 doz 3/4 Cloaths strained, & two whole Length Cloaths which pray order to be good and carefully rolled up & put in a Case. Fann Paper ten Reams this is an article which se shal probably want considerable of so would desire you to write yᵉ mans name you buy it of & where he lives that we may send to him directly without troubling you again. There are many women that paints Fanns for the country use and as they buy the Collours of us the paper has of late come naturally in to be an article in the Shop let it be of the sort commonly used for cheap Fanns & should be glad yᵉ man would Send a Sheet or 2 of the different sorts of paper with yᵉ prices. Lake of the Common midling sort about two Guineas and of good Lake about two Guineas more. Prussian Blew 50 1 2 shillings per pound. Do 6 1 @ 20 shill or a Guinea per pound. Do 6 1 @ 18 shill. per pound. that may be had cheapest of yᵉ maker M Mitchell at Hoxton who you may send to by a peny post letter or a Porter. the old Cups and spoons are a commission from my Wiffe who desires you will be so good as to get her a Silver tea pott of the midle size but rather incling to yᵉ Large and weighty yᵉ fashion she leaves intirely to you only would not have the top with hinges, but to take of. I have sent a Sketch of ye Arms which I know you wil take care to get done by a good engraver with proper Ornaments. I do not expect the old silver wil pay for the tea pott which I would have a pretty one. What remains of ye money after paying for those articles and al charges on Board please to lay out in gold leaf.

I am sorry the State of the Virtu is at so low an ebb. If the arts are about to leave Great Britain I wish they may take their flight into our new world that they may, at least remain in some part of the British dominions. Remember me to al my old friends among the Painters.

John Smibert to Arthur Pond, March 24, 1743/44(?), in Saunders, **John Smibert.**

Dear Sir: I had the favour of yours by Capt. Anstill with the Virtu Cargo and bill. the other things in good order. for your care of which and present of the prints I am much your debtor. You know I was always fond of Landskips so that you could not have sent anything more to my taste and I assure you I esteem them as the finest Collection of Prints in that way I ever saw. The smal sett I have sold and desire you will send 5 setts of the 7 numbers on' the smal paper which with the sett already received wil amount to eight guineas allowing the 20 per cent for those who sell them again. its probable more will sell but we wil try them first, you may send one of every Print you do perhaps some of them may hit the General taste of this place.

All the things you sent are good and bought well. The season for Fann painting is not yet come so there has been no opportunity to try the papers and mounts but no doubt they will answer.

John Moffatt to Arthur Pond, December 28, 1752, in Saunders, **John Smibert.**

Sir,—No doubt you have long ago heard of the Death of Mr. Smibert, and which I ought to have acquainted you of before now, as I know the regard you had for him & yᵉ obligations we are under to you. He had been for many years in a Declining State of health, and for some years unable to paint at al, but to yᵉ last preserved his cheerfulness & serenity of temper, free from al

uneasiness & happy in his family. He has Left a Widow and three sons, y^e eldest is apprentice to a Merchant, y^e second inclines to Painting & seems to me of a Promising Genius, y^e youngest is at y^e Grammar School. My Honest Uncle never was rich, but Lived always handsomely & with great reputation. He hath left enough I hope with prudent management to put his Children in y^e way of doing well in y^e world & which you may easily think I am not unconcerned about.

A friend here who valued Mr. Smibert much, has wrote a Character or Epitah to be put on the Tomb. I have sent you a Copy of it for your opinion & your friends, it wil apear too long and perhaps might be shortned to advantage. I shal be glad of your opinion of it & would acquaint you that ever since Mr. Smibert died I have intended something should be erected to his memory . . .

My Aunt & I Jointly cary on the Collour business & every thing goes on as in my Uncles life time. Gratitude obliges me to do al I can for y^e interest of so worthy a Persons familly as wel as y^e nearnes of my Relation. If this Commission could be made easier to you for y^e future by applying to y^e Fann man & some of y^e other people directly, you wil please to direct me, y^e Bill for fifty pounds is drawn by so good a man as that its certain wil be duly honoured, nor do I doubt y^e other Bill being so too, but in case that should be protested must desire you to get y^e whole of y^e Fann Mounts sent & the remainder in Prussian Blew, for as we are near out of Fann mounts it would be of great advantage could you favour us with them by the first ship after you receive the money, and let the whole value be insured. I wish y^e taste here was good eneough for y^e Prints of your Landskips, etc. but there are few virtuosi here, y^e Roman Ruins pleases & now & then there are a customer for them. Mrs. Smibert with her Sons Joins me in their Respects to you. I shal be obliged for your ordering the cargo particularly the Fan mounts as soon as possible.

Smibert's epitaph, sent in letter by John Moffat to Arthur Pond, December 28, 1752, in Saunders,
John Smibert.

Why should there be shame or limits to the longing for one so dear?—Hor. *Carmina* I, xxiv

In the adjacent tomb are buried the frail and mortal remains of the excellent man, John Smibert, a famous painter, to whose art, even Italy, dear nurturing mother of painting, once recognized that praises were due. In Britain too, you will surely not find his superior, very few who are his equal. It is therefore not strange if in America, which he preferred for health's sake to his native soil, he neither found nor left a rival. Because of their great art and skill, numerous pictures, painted with elegance by his hand, will offer, in the estimate of the best judges, enduring proof of these facts.

But however great this praise of him, it is little compared to his excellent character. Particularly in the cultivation of his character, he combined in felicitous manner zeal and effort, and in all circumstances of life, was an exemplar of true and unadorned virtue. He was a singularly worthy member of the community by reason of his unstained integrity of life, a calm, kindly, and humane nature, together with an affability in behavior, and a pleasing and ingenuous simplicity. He was an affectionate husband and parent, mindful of his duties to each member of his family, friendly, sincerely helpful, loyal, and stable; in sum, his whole life was a sermon. His soul was deeply imbued with reverence and love of God in his greatness and goodness. In his worship he was steadfast and very devoted, with true faith and a living hope in Christ Jesus. Supported by these, happy and at peace, on the second day of April in the year 1751 of our Christian era, his pious spirit was returned to God who had given it.

He was born of honest parents at Edinburgh in Northern Britain on the twenty-fourth day of March in the year 1688. He married his wife, Mary, whom he ever cherished, truly a dutiful woman, worthy of his love, and now, alas, his grief-stricken widow, on the thirtieth day of July in the year 1730. She was the eldest daughter of a reverend and learned man, formerly departed this life, Nathaniel Williams of Boston. Of this union were born seven sons and two daughters, of whom four sons and two daughters rest in the same tomb with their father; the others survive.

Reader, if you can cherish a man such as this and seek to be like him, you will be ever blessed.

BENJAMIN WEST ON WILLIAM WILLIAMS

The interesting career of English-born William Williams might have been lost to history but for a series of coincidences. He does not appear in William Dunlap's comprehensive History of the Rise and Progress of the Arts of Design *(1834), although he spent some three decades in North America working as a portraitist and occasional landscapist. Few paintings survive that can be securely attributed to him, even though he is known to have painted nearly 250. However, Williams was also an author, and his colorful, novelistic (and pseudonymous) memoir of his early years as a seaman in the Caribbean was later promoted by Thomas Eagles, a Bristol merchant who had inherited the few possessions of the impoverished painter after he returned to England and died in an almshouse in 1791. Benjamin West, by chance visiting Eagles several decades later, recognized the memoir as belonging to his first teacher in Pennsylvania, Williams. In the following letter to Eagles, West recounts what he knows of Williams through the filter of his own life and career (see also "Benjamin West: A New World Genius Conquers the Old," chapter 2).*

Benjamin West to Thomas Eagles, October 10, 1810, private collection.

The following will shew you by what circumstances Williams and myself became acquainted, as well as that he was the writer of the above mentioned manuscript. Mr. Edward Pennington a gentleman of high respectability, & of the Society of Friends in the City of Philadelphia was in the habit of annually visiting my Father and family in Chester County Pennsylvania as a relative.—Observing some of my childish attempts at the delineation of domestick objects in colours extracted from roots, herbs & bark of trees; he prevailed upon my Parents to take with him to the City his little cousin for some weeks, as he had never seen that place. This happened in the year 1747 in my ninth year—and was a circumstance most grateful to my feelings—indulging the hope of seeing some pictures in the city.

A few days after I was with Mr Pennington in the city, he bought me colours, & all the other materials for making pictures in oil. My first attempt was then a Landscape—in which were ships, cattle, & other things which I had been accustomed to see; but before I had finished the picture Samuel Shoemaker a neighbour of Mr Pennington & a gentleman also of the Society of Friends, came to see the picture I was painting; & in the conversation which took place between those two gentlemen on the subject of the Fine Arts, Mr Shoemaker informed his friend Pennington that a few days before he had met a person in the street with a picture; & that he requested the person to favour him with a sight of it, which he found to be a Landscape of considerable merit, & painted by the person in whose hands the picture was.—

I learnt from him, said M^r Shoemaker, that his name was W. Williams that he had been recently married to a respectable townswoman of our City, & settled here, & that he followed the business of painting in general; he appeared to me to possess a powerful mind, and a great love for painting; and tomorrow I find he will have finished the landscape I commissioned him to paint for me: when it is sufficiently dry to be moved with safety, I will with thy permission friend Pennington bring both the Painter & the picture to thee, & thy little cousin West to see it.

The palpitation of joy which this conversation produced in my mind when I became certain of seeing it was what I can never forget, nor did hours ever pass slower away than those which intervened until I saw the picture, which in a few days was brought to M^r Pennington's. I believe the blush of joy which overspread my face on the picture being first exposed to view attracted the attention of those present even more than the picture itself altho' a work of considerable merit: it being the first picture I had seen except the small essays I made in the country, and the one I was then attempting to paint in oil.

The attention of M^r Williams still rested on me—while the other persons were beginning to look at his Landscape and to commend it. Soon after M^r Williams addressed himself to M^r Pennington "I am of opinion, Sir, that this youth has the sensibility proper for the studying of painting":—he then turned to me, and wished to know if I had ever read the lives of any of the great Masters of painting—I replied it was the first time I had ever heard of such lives for I had never read any account of great men, but those in the Bible and New Testament, which my Parents directed me to read and remember.

"Well, then," said M^r Williams, "if M^r Pennington will give permission, I will lend you Richardson & du Fresnoy on Painting to read at your leisure." He did so, and those two books were my companions by day, & under my pillow by night. Thus commenced my acquaintance with W^m Williams, which continued without interruption until I embarked for Italy in 1760.

From the year 47 to 60 my attention was directed to every point necessary to accomplish me for the profession of painting; this often brought me to the house of Williams and as he was an excellent actor in taking off Character—he often to amuse me, repeated his adventures amongst the Carribs & Negro tribes in the West Indies . . .

He spoke both the Negro and Carrib tongue, and appeared to me to have lived amongst them for some years.

I often asked him how he came to be with them—he replied that he had been put to the sea when young; that he never was satisfied with that pursuit, & that he took the first opportunity which offered to desert it, by making his way for the West Indies, where he was shipwrecked, & thrown into great difficulties, but Providence had preserved him through a variety of dangers. He likewise informed me that he was a Welshman by birth; but brought up at a Grammar School in Bristol—where his greatest delight was to go & see an elderly artist who painted heads in oil, as well as small landscapes & his greatest wish was to be a Painter; but in that he was disappointed, & bound when young to a Virginia Cap^t who sometimes sailed out of London as well as from Bristol in the Virginia trade.—

"After going the second voyage with him, when in Norfolk, in Virginia—to tell you the truth he said, I left the ship & sailed for the West Indies, where I hoped to be unknown, that I might work my way to some place—& accomplish my wishes as a Painter:—and after some years had elapsed, I was able to come to this city [Philadelphia]—and ever since my arrival, I have studied the science of painting, by collecting the lives of the eminent painters as well as the prints

from their works." This I knew to be the truth, as it was to his books and prints I was indebted for all the knowledge I possessed of the progress which the fine Arts had made in the world, & which prompted me to view them in Italy.

TASTE AND THEORY

OF THE KNOWLEDGE OF PAINTING

These two paragraphs from a Boston journal are unusually interesting in that they describe a personal, pleasurable response to painting, stemming from the simple charm of representation, or the excitement of dramatic visual narratives—rather than the theoretical and moral imperatives of art commonly discussed at the time (see the following address by John Trumbull). The author asks whether only "Painters and Connoisseurs" feel this appreciation, or whether it is available to any "Man of Sense." The majority of the article (not included here) is a translation of a French "dialogue" that considers this question.

"Of the Knowledge of Painting," American Magazine and Historical Chronicle 2 (March 1745).

There is a Sort of Magick in the Art of Painting, which charms by the *Deception* it puts upon us. To have Nature as it were, forc'd from itself, and transplanted upon a Canvas, under the Representation of some delightful Landscape, enrich'd with the grateful Variety of *Sun-Shine, Water, Greens, distant Views,* and interspersed with Figures, that seem *animated,* and in *Motion:* Or else, to have some celebrated Action, express'd with so much Force, that we see *Dignity,* or *Grief, Terror,* or Love, according to the Circumstances of the Story, and are moved as strongly, as if the Persons represented were in Being, and before our Eyes: To see a stabb'd *Lucretia,* or a dying *Cleopatra,* an exposed *Andromeda,* or a forsaken *Ariadne:* To see an irritated Sea, and a Vessel struggling with the Waves, or splitting on a Rock, while Horror and Despair *strike* from the ghastly Looks of the drowning Mariners: It is no longer a dumb Entertainment to the *Eye,* but a *speaking* Image to the Mind, that awakens every Sentiment in it, and hurries the Beholder by an imperceptible Violence, thro' every Passion represented on the *now living* Canvas.

I was in Company the other Day, where a warm Dispute arose, whether the Taste and Knowledge of Painting was confined only to *Painters* and *Connoisseurs,* as they are termed; or whether a Man of Sense may not be as good a Judge of either. I was little better than an Auditor, during the whole Dispute; which, like most Disputes, ended without Conviction on either Side.

THE USE AND ADVANTAGES OF THE FINE ARTS

In 1770 John Trumbull (an older cousin of the painter by the same name) gave the following commencement address at Yale University. In it the twenty-year-old graduate makes an early plea for the importance and intellectual value of music, art, and especially literature alongside the more "solid" branches of learning such as science and mathematics. These latter, he suggests, are occasionally so esoteric in their researches as to "degenerate into meer speculations of amusement." The arts, in contrast, elevate us, give us dignity and refinement, and separate us from the base and the animal, according to Trumbull. After a long section (not included here) examining the history of the

fine arts in ancient Greece and Rome and modern Russia and England, he offers a stirring prediction of future American glory in the arts, contrasting an egalitarian view of education and a vigorous love of independence in the colonies with "the effeminate manners of Britain."

John Trumbull, An Essay on the Use and Advantages of the Fine Arts *(New Haven: T. and S. Green, 1770).*

No subject can be more important in itself, or better suited to the present occasion, and the exercises of this day, than the Use and Advantages of the fine Arts, and especially those of Polite Literature. These studies are perhaps too much undervalued by the public, and neglected by the youth in our seminaries of science. They are considered as meer matters of trifling amusement, and despised in comparison with the more solid branches of Learning . . .

Let us consider the advantages which arise to the world from the study of the liberal Arts.

Mankind in the present state, are extremely liable to be led away by mean and sordid vices, to be attached to the low enjoyments of sense, and thus degraded almost to a level with the brutal creation. As that unceasing thirst for happiness, which is the universal spring of action, must have some object for its gratification; the Divine Being, to raise us above these low desires, hath implanted in our minds a taste for more pure and intellectual pleasures. These pleasures have their sources in the fine Arts, and are more especially found in the elegant entertainments of polite Literature. They ennoble the soul, purify the passions, and give the thoughts a better turn. They add dignity to our sentiments, delicacy and refinement to our manners. They set us above our meaner pursuits, and make us scorn those low enjoyments, which perhaps we once esteemed as the perfection of human felicity. I appeal to all persons of judgment, whether they can rise from reading a fine Poem, viewing any masterly work of Genius, or hearing an harmonious concert of Music, without feeling an openness of heart, and an elevation of mind, without being more sensible of the dignity of human nature, and despising whatever tends to debase and degrade it?

These are the delights, which humanize the soul, and polish away that rugged ferocity of manners, which is natural to the uncultivated nations of the world . . .

America hath a fair prospect in a few centuries of ruling both in arts and arms. It is universally allowed that we very much excel in the force of natural genius. And although but few among us are able to devote their whole lives to study, perhaps there is no nation, in which a larger portion of learning is diffused through all ranks of people. For as we generally possess the middle station of life, neither sunk to vassalage, nor raised to independance, we avoid the sordid ignorance of peasants, and the unthinking dissipation of the great. The heroic love of Liberty, the manly fortitude, the generosity of sentiment, for which we have been so justly celebrated, seem to promise the future advancement and established duration of our glory. Many incidents unfortunate in themselves, have tended to call forth and sustain these virtues. Happy, in this respect, have been our late struggles for liberty! They have awakened the spirit of freedom; they have rectified the manners of the times; they have made us acquainted with the rights of mankind; recalled to our minds the glorious independance of former ages, fired us with the views of fame, and by filling our thoughts with contempt for the imported articles of luxury, have raised an opposition, not only to the illegal power, but to the effeminate manners of Britain. And I cannot but hope, notwithstanding some dangerous examples of infamous defection, that there is a spirit remaining in these Colonies, that will invariably oppose itself to the efforts of usurpation and perfidy, and forbid that Avarice should ever betray us to Slavery.

At a time when portraits were rarely seen outside private homes, their public life could be extended through published poems extolling both the talents of the painter and the beauty of the subject. Such was the case with the anonymous poem inspired by a portrait by Benjamin West, published when the artist was just twenty. Often, though, these verses were devoted to the larger oeuvre of an artist rather than to a single work. A lengthy poem written to John Smibert by Mather Byles (1730, not included here) is a particularly well-known example of the genre. Another, by Francis Hopkinson, a future signer of the Declaration of Independence, was dedicated to British émigré painter John Wollaston, who visited Philadelphia in 1758 and influenced the young West. Today, Wollaston's portraits are sometimes described as stiff and formulaic, but in the excerpt below Hopkinson appears greatly inspired by their artifice, making specific mention of the painter's skill with drapery, for which he was well known. Unusually for this genre, Hopkinson writes about the process of painting the portrait—the gradual building of the likeness on canvas—rather than the finished product.

 Also intriguing is the short poem by Phillis Wheatley, an African-born slave (later freed) who is thought to be the first African American writer of significance. Wheatley became internationally famous, traveling to London in 1773; her work has been compared to that of Alexander Pope. The elegiac poem included here is dedicated to the painter Scipio Moorhead, a Boston slave about whom very little is known, and who may have painted Wheatley (a groundbreaking, engraved portrait of the poet was published with her book of poems in 1773). Wheatley's achievement was often cited by abolitionists as a demonstration of the African's mental equality with Europeans. Moorhead's portraits could have functioned similarly in a more local context (see also "Joshua Johnson Advertises," chapter 2; and "Artists of Color and the Representation of Race," chapter 4). They certainly provided inspiration for Wheatley.

*"Upon seeing the Portrait of Miss **—**, by Mr. West,"* **American Magazine and Monthly Chronicle for the British Colonies** 1 *(February 1758).*

Since *Guido's* skilful hand, with mimic art,
Cou'd form and animate so sweet a face,
Can nature still superior charms impart,
Or warmest fancy add a single grace?

Th'enliven'd tints in due proportion rise;
Her polish'd cheeks with deep vermilion glow;
'The shining moisture swells into her eyes,'
And from such lips nectareous sweets must flow.

The easy attitude, the graceful dress,
The *soft expression* of the *perfect whole*,
Both *Guido's* judgment and his skill confess,
Informing canvass with a living soul.

How fixt, how steady, yet how *bright* a ray
Of *modest Lustre* beams in ev'ry smile!
Such smiles as must resistless charms convey,
Enliven'd by a heart devoid of guile!

Yet sure his flattering pencil's unsincere,
His fancy takes the place of bashful truth,
And warm Imagination pictures here
The pride of beauty and the bloom of youth.

Thus had I said, and thus deluded thought,
Had lovely *Stella* still remain'd unseen,
Where grace and beauty to perfection brought,
Make ev'ry imitative art look mean.
 LOVELACE

Francis Hopkinson, "Verses Inscribed to Mr. WOLLASTON," American Magazine and Monthly Chronicle for the British Colonies 1 *(September 1758).*

To you fam'd *Wollaston!* these strains belong,
And be your praise the subject of my song:
When your soft pencil bids the canvas shine
With mimic life, with elegance divine,
Th'enraptur'd muse, fond to partake the fire,
With equal sweetness strives to sweep the lyre,
With equal justice fain would paint your praise,
And by your name immortalize her lays.

Oftimes with wonder and delight I stand,
To view th'amazing conduct of your hand.
At first unlabour'd sketches lightly trace
The glimm'ring outlines of a human face;
Then by degrees the liquid life o'erflows
Each rising feature—the rich canvas glows
With heightened charms—The forehead rises fair;
And, glossy ringlets twine the nut-brown hair;
The sparkling eyes give meaning to the whole,
And seem to speak the dictates of a soul.
The lucid lips in rosy sweetness drest,
The well-turn'd neck and the luxuriant breast,
The silk that richly flows with graceful air—
All tell the hand of *Wollaston* was there.
Thus the gay flow'rs that paint th'embroider'd plain,
By rising steps their glowing beauties gain.
No leaves at first their burning gloried show,
But wrapt in simple forms unnotic'd grow,
Till ripen'd by the son's meridian ray,
They spread perfection to the blaze of day.—

Phillis Wheatley, "To S.M., a Young African Painter, on Seeing His Works," in Poems on Various Subjects, Religious and Moral *(London, 1773).*

To show the lab'ring bosom's deep intent,
And thought in living characters to paint,
When first thy pencil did those beauties give,
And breathing figures learnt from thee to live,
How did those prospects give my soul delight,
A new creation rushing on my sight?
Still, wond'rous youth! each noble path pursue,
On deathless glories fix thine ardent view:
Still may the painter's and the poet's fire
To aid thy pencil, and thy verse conspire!
And may the charms of each seraphic theme
Conduct thy footsteps to immortal fame!
High to the blissful wonders of the skies
Elate thy soul, and raise thy wishful eyes.
Thrice happy, when exalted to survey
That splendid city, crown'd with endless day,
Whose twice six gates on radiant hinges ring:
Celestial Salem blooms in endless spring.

 Calm and serene thy moments glide along,
And may the muse inspire each future song!
Still, with the sweets of contemplation bless'd,
May peace with balmy wings your soul invest!
But when these shades of time are chas'd away,
And darkness ends in everlasting day,
On what seraphic pinions shall we move,
And view the landscapes in the realms above?
There shall thy tongue in heav'nly murmurs flow,
And there my muse with heav'nly transport glow:
No more to tell of *Damon's* tender sighs,
Or rising radiance of *Aurora's* eyes,
For nobler themes demand a nobler strain,
And purer language on th' ethereal plain.
Cease, gentle muse! the solemn gloom of night
Now seals the fair creation from my sight.

TRAINING AND THE LURE OF EUROPE

JOHN SINGLETON COPLEY: AMBITION AND PRACTICALITY

One of the most celebrated collections of documents in early American art history is the series of letters to and from John Singleton Copley during his years as a portrait painter in Boston and while on his grand tour of Europe in 1774–75. No artist has more clearly articulated the dilemma of the provincial painter of faces—yearning for greater recognition and the opportunity to engage in history painting—who must weigh

guaranteed financial success in America against the unknown of Europe. Copley clearly thirsts for the stimulation of the art of antiquity and the old masters, but he also realizes that his competition in London will far outpace his lesser colleagues in New England. After deliberating for over a decade, he finally decided to travel to France and Italy and settled permanently in London in 1775.

This selection of texts begins with the twenty-five-year-old Copley's letter to Swiss artist Jean Etienne Liotard, in which he optimistically predicts a better day for the fine arts in North America. Next, a series of communications between Copley, Benjamin West, and R. G. Bruce (a sea captain) document the reception of two portraits (Boy with a Squirrel [Henry Pelham], 1765 [fig. 1]; and Young Lady with a Bird and Dog, 1767) sent to London to test the waters and provide some measure of the American's talents vis-à-vis his London competitors. Copley engages in a long-distance conversation about line, stroke, color, media, and the decorum of subject. West urges him to come to Europe to see for himself, but with many financial and familial ties in Boston he hesitates, while still bemoaning his low status there. An example of what may have frustrated Copley is found in the letter of George Livius, of Portsmouth, New Hampshire. Livius commissions Copley to execute copies of two European portraits, which will be sent to England. In the process, he dickers about price and suggests that he is doing the young artist a favor by exposing him to good art. The letter contains a fascinating postscript in which Livius outlines the changes he wants Copley to make while "copying" the original.

Copley also receives advice from his own side of the Atlantic, as William Carson, a resident of Newport, Rhode Island, counsels him to move beyond portraiture to narrative painting. When Copley finally decides to leave for Europe, West tells him what he stands to learn from the Italian masters. At last finding himself abroad, he sends several lengthy letters back to his half-brother in Boston, Henry Pelham, describing what he is learning and struggling to find the reference points that will enable his sibling to understand what he is seeing in the flesh. Included here is a remarkable account of the artist's first attempt at history painting, The Ascension (1775), intended as a lesson for Pelham.

John Singleton Copley to Jean Etienne Liotard, September 30, 1762, in Letters and Papers of John Singleton Copley and Henry Pelham, 1739–1776 *(Boston: Massachusetts Historical Society, 1914).*

This Letter will meet You accompanied by one from the Worthy Coll: 1 Spierring who has been so kind to give me his assistance for the obtaining a sett of the best Swis Crayons for drawing of Portraits. allow me Sir to Joyn my sollicitations with him that You would send as He directs one sett of Crayons of the very best kind such as You can recommend [for] liveliness of colour and Justness of tints. In a word let em be a sett of the very best that can be got.

You may perhaps be surprised that so remote a corner of the Globe as New England should have any d[e]mand for the necessary eutensils for practiceing the fine Arts, but I assure You Sir however feeble our efforts may be, it is not for want of inclination that they are not better, but the want of oppertunity to improve ourselves. However America which has been the seat of war and desolation, I would fain hope will one Day become the School of fine Arts and Monsieur Liotard['s] Drawing with Justice be set as patterns for our immitation. not that I have ever had the advantage of beholding any one of those rare peices from Your hand. but [have] formd a Judgment on the true tast of several of My friend[s] who has seen em.

R. G. Bruce to John Singleton Copley, August 4, 1766, in **Letters and Papers of John Singleton Copley.**

Dont imagine I have forgot or neglected your Interest by my long Silence. I have delayed writing to You ever since the Exhibition, in order to forward the inclosed Letter from Mr. West, which he has from time to time promised me, but which his extreme Application to his Art has hitherto prevented his finishing.

What he says will be much more conclusive to You than anything from me. I have only to add the general Opinions which were pronounced on your Picture when it was exhibited. It was universally allowed to be the best Picture of its kind that appeared on that occasion, but the sentiments of Mr. Reynolds, will, I suppose, weigh more with You than those of other Criticks. He says of it, "that in any Collection of Painting it will pass for an excellent Picture, but considering the Dissadvantages" I told him "you had laboured under, that *it was a very wonderfull Performance.*" "That it exceeded any Portrait that Mr. West ever drew." "That he did not know one Painter at home, who had all the Advantages that Europe could give them, that could equal it, and that if you are capable of producing such a Piece by the mere Efforts of your own Genius, with the advantages of the Example and Instruction which you could have in Europe, You would be a valuable Acquisition to the Art, and one of the first Painters in the World, provided you could receive these Aids before it was too late in Life, and before your Manner and Taste were corrupted or fixed by working in your little way at Boston. He condemns your working either in Crayons or Water Colours." Dont imagine I flatter You. I only repeat Mr. Reynolds's words, which are confirmed by the publick Voice. He, indeed, is a mere Enthusiast when he speaks of You. At the same time he found Faults. He observed a little Hardness in the Drawing, Coldness in the Shades, An over minuteness, all which Example would correct. "But still," he added, "*it is a wonderful Picture* to be sent by a Young Man who was never out of New England, and had only some bad Copies to study." I have beg'd of Mr. West to be copious in his Criticisms and Advices to You. Mr. Reynolds would have also wrote to You himself but his time is too valuable. The Picture is at his House where I shall leave it till I have your Directions how to dispose of it.

Benjamin West to John Singleton Copley, August 4, 1766, in **Letters and Papers of John Singleton Copley.**

On Seeing a Picture painted by you and meeting with Captain Bruce, I take the liberty of writeing to you. The great Honour the Picture has gaind you hear in the art of Painting I dare say must have been made known to You Long before this Time. and as Your have made So great a Progr[e]ss in the art I am Persuaded You are the more desierous of hearing the remarks that might have been made by those of the Profession, and as I am hear in the Midst of the Painting world have the greater oppertunity of hearing them. Your Picture first fell into Mr. Reynolds' hands to have it Put into the Exhibition as the Proformanc of a Young American: he was Greatly Struck with the Piec, and it was first Concluded to have been Painted by one Mr. Wright, a young man that has just made his appearance in the art in a sirprising Degree of Merritt. As Your Name was not given with the Picture it was Concluded a mistake, but before the Exhibition opened the Perticulers was recevd from Capt. Bruce. While it was Excibited to View the Criticizems was, that at first Sight the Picture struck the Eye as being to liney, which was judgd to have arose from there being so much neetness in the lines, which indeed as fare as I was Capable of judgeing was some what the Case. for I very well know from endevouring at great Correctness in ones out line it is apt to Produce a Poverty in the look of ones work. When ever great Desition is attended to they lines are apt to be to fine and edgey. This is a thing in

works of great Painter[s] I have remark[ed] has been strictly a voyded, and have given Correctness in a breadth of out line, which is finishing out into the Canves by no determind line when Closely examined; tho when seen at a short distanc, as when one looks at a Picture, shall appear with the greatest Bewty and freedom. for in nature every thing is Round, or at least Partakes the most of that forme which makes it imposeble that Nature, when seen in a light and shade, can ever appear liney.

As we have every April an Exhibition where our works is exhibitied to the Publick, I advise you to Paint a Picture of a half figure or two in one Piec, of a Boy and Girle, or any other subject you may fancy. And be shure take your Subjects from Nature as you did in your last Piec, and dont trust any resemblanc of any thing to fancey, except the dispositions of they figures and they ajustments of Draperies, So as to make an agreable whole. For in this Consists the work of fencey and Test.

If you should do anything of this kind, I begg you may send it to me, when you may be shure it shall have the greatest justice done it. Lett it be Painted in oil, and make it a rule to Paint in that way as much as Posible, for Oil Painting has the superiority over all other Painting. As I am from America, and know the little Opertunities is to be had their in they way of Painting, made the inducement the more in writeing to you in this manner, and as you have got to that lenght in the art that nothing is wanting to Perfect you now but a Sight of what has been done by the great Masters, and if you Could make a viset to Europe for this Porpase for three or four years, you would find yourself then in Possession of what will be highly valuable. If ever you should make a viset to Europe you may depend on my friendship in eny way thats in my Power to Sarve.

John Singleton Copley to Benjamin West, November 12, 1766, in Letters and Papers of John Singleton Copley.

Your kind favour of Augst. 4, 1766, came to hand. It gave me great pleasure to receive without reserve Your Criticisms on the Picture I sent to the Exibition. Mr. Powell informd me of Your intention of wrighting, and the handsom things You was pleas'd say in praise of that little performance, which has increased my estamation of it, and demands my thanks which previous to the receipt of Your favour I acknowledged in a letter forwarded by Mr. Powell. It was remarkd the Picture was too lind. this I confess I was concious of my self and think with You that it is the natural result of two great presition in the out line, which in my next Picture I will indeavour to avoid, and perhaps should not have fallen into it in that, had I not felt two great timerity at presenting a Picture to the inspection of the first artists in the World, and where it was to come into competition with such masterly performancess as generally appear in that Collection . . . Your c[a]utioning me against doing anything from fancy I take very kind, being sensable of the necessity of attending to Nature as the fountain head of all perfection, and the works of the great Masters as so many guides that lead to the more perfect imitation of her, pointing out to us in what she is to be coppied, and where we should deviate from her. In this Country as You rightly observe there is no examples of Art, except what is to [be] met with in a few prints indiferently exicuted, from which it is not possable to learn much, and must greatly inhanch the Value of free and unreserved Criticism made with judgment and Candor.

It would give me inexpressable pleasure to make a trip to Europe, where I should see those fair examples of art that have stood so long the admiration of all the world. the Paintings, Sculptors and Basso Releivos that adourn Italy, and which You have had the pleasure of making Your Studies from would, I am sure, annimate my pencil, and inable me to acquire that bold free and gracefull stile of Painting that will, if ever, come much slower from the mere dictates of

Nature, which has hither too been my only instructor. I was allmost tempted the last year to take a tour to Philadelphia, and that chiefly to see some of Your Pictures, which I am informd are there. I think myself peculiarly unlucky in Liveing in a place into which there has not been one portrait brought that is worthy to be call'd a Picture within my memory, which leaves me at a great loss to gess the stile that You, Mr. Renolds, and the other Artists pracktice. I shall be glad when you write next you will be more explicit on the article of Crayons, and why You disprove the use of them, for I think my best portraits done in that way.

Benjamin West to John Singleton Copley, June 20, 1767, in Letters and Papers of John Singleton Copley.

Dont impute the long Omition of my not writeing to you [to] any forgetfullness or want of that Friendship I first Shewd on seeing your works. My having been so much ingaged in the Study of my Bussiness, in perticuler that of history Painting, which demands the greates Cear and intelegance in History amaginable, has so intierly Prevented my takeing up the Penn to answer your Several Agreable favours, and the reception of your Picture of the little Gairl you Sent for the exhibition. It came safe to hand in good time. And as I am Persuaded you must be much interested in reguard to the reception it mett with from they artists and Publicks opinion in General, I as a Friend Take this oppertunity to Communicate it to you.

In regard to the Artists they Somewhat differ in Opinion from Each Other, Some Saying they thought your First Picture was the Best, others Say the last is Superior (which I think is as a Picture in point of Exhecution, tho not So in Subject). But of those I shall give this of Mr. Reynolds when he saw it he was not so much Pleased with it as he was with the first Picture you Exhibited, that he thougt you had not mannaged the general Affect of it so Pleasing as the other. This is what the Artists in General has Criticised, and the Colouring of the Shadows of the flash wants transperency. Those are thing[s] in General that have Struck them. I Cant say but the Above remarks have some justness in them, for the Picture being at my house some time gave me an oppertunity of Examining it with more Exectness.

The General Affect as Mr. Reynolds justly Observes is not quite so agreable in this as in the other; which arrises from Each Part of the Picture being Equell in Strenght of Coulering and finishing, Each Making to much a Picture of its silf, without that Due Subordanation to the Principle Parts, viz they head and hands. For one may Observe in the great works of Van dyke, who is the Prince of Portrait Painter[s], how he has mannaged by light and shedow and the Couler of Dreperys made the face and hands apear allmost a Disception. For in Portrait Painting those are they Parts of Most Consiquence, and of Corse ought to be the most distinguished. Thare is in Historical Painting this Same attention to be Paid. For if the Principl Carrictors are Suffred to Stand in the Croud, and not distinguished by light and shadow, or made Conspicuous by some Pece of art, So that the Eye is first Caut by the Head Carrictor of the History, and So on to the next as he bears Proportion to the head Carrictor, if this is not observed the whole is Confusion and looses that dignity we So much admier in Great works. Your Picture is in Possession of Drawing to a Correctness that is very Surpriseing, and of Coulering very Briliant, tho this Brilantcy is Somewhat missapplyed, as for instance, the Gown too bright for the flesh, which over Came it in Brilency. This made them Critisise they Shadows of the Flesh without knowing from whence this defect arose; and so in like manner the dog and Carpet to Conspichious for Excesry things, and a little want of Propriety in the Back Ground, which Should have been Some Modern orniment, as the Girle was in a Modern dress and modern Cherce. The Back Ground Should have had a look of this time. These are Critisisms I should not mak was not your Pictures very nigh upon a footing with the first artists who now Paints,

and my being sensible that Observations of this nature in a friendly way to a man of Your Talents must not be Disagreable. I with the greater Freedom give them, As it is by this assistance the art is reasd to its hight. I hope I shall have the Pleasur of Seeing you in Europe, whare you will have an oppertunity of Contemplateing the great Productions of art, and feel from them what words Cannot Express. For this is a Scorce the want of which (I am senseble of) Cannot be had in Ameri[c]a; and if you should Ever Come to London my house is at Your Service, or if you should incline to go for Italy, if you think letters from me Can be of any Service, there are much at your Service.

John Singleton Copleyto R. G. Bruce[?], undated [1767], in Letters and Papers of John Singleton Copley.

But What shall I do at the end of that time (for prudence bids us to Consider the future as well as the present). Why I must eighther return to America, and Bury all my improvements among people intirely destitute of all just Ideas of the Arts, and without any addition of Reputation to what I have already gaind. For the favourable receptions my Pictures have met with at home has mad them think I could get a better Living at home than I can here, which has been of service to me, but should I be disappointed, it would be quite the reverse. It would rather lessen than increase their oppinion of my Works which I aught by all prudent methods strive to avoide. Or I should sett down in London in a way perhaps less advantagious than what I am in at present, and I cannot think of purchasing fame at so dear a rate. I shall find myself much better off than I am in my present situation. (I would be here understood to speak of the profits of the art only, for as I have not any fortune, and an easy income is a nesasary thing to promote the art. It aught to be considered, and Painters cannot Live on Art only, tho I could hardly Live without it). But As it is not possable for me, Who never was in Europe, to settle sufficiently in my mind those points, I must rely on Your Friendship and Mr. West to inform me. I have wrote You and Mr. West in the plainest and most unreserved maner what the dificultys are, and doubt not Your friendship and prudence will lead You to give all Due weit to the objections I have proposed; and if You think they are still sufficient to keep me in this Country, I shall strive to content myself where I am.

John Singleton Copley to R. G. Bruce[?], undated [1767], in Letters and Papers of John Singleton Copley.

I observe the Critisisms made on my last picture were not the same as those made on the first. I hope I have not in this as in the last by striving to avoid one error fallen into another. I shall be sorry if I have. However it must take its fate. Perhaps You may blame me for not taking anoth[e]r subject that would have aforded me more time, but subjects are not so easily procured in this place. A taste of painting is too much Wanting to affoard any kind of helps; and was it not for preserving the resembla[n]ce of perticular persons, painting would not be known in the plac[e]. The people generally regard it no more than any other usefull trade, as they somtimes term it, like that of a Carpenter tailor or shew maker, not as one of the most noble Arts in the World. Which is not a little Mortifiing to me. While the Arts are so disregarded I can hope for nothing, eith[e]r to incourage or assist me in my studies but what I receive from a thousand Leagues Distance, and be my improvements what they will, I shall not be benifitted by them in this country, neighther in point of fortune or fame.

George Livius to John Singleton Copley, September 14, 1767, in Letters and Papers of John Singleton Copley.

I intend sending the Portraits by Captn. Fernald; he sails tomorrow. As to the price you wrote me it exceeds considerably what was customary with you when I was in Boston two years since,

and at present is more than was expected by some Gentlemen here, especially for a copy; and I need not observe to you the very few opportunities you have of copying from so good a picture as one of them is. However all I shall add on this head is, that it shall be left entirely to your discretion. I have particularly to beg that nothing may be spared to have them as perfect pictures as you can make them for your own honor and the credit of New England, for as good pictures they may be observed in England and further convince many of your merit . . .

The Alterations I woud chuse to have in one of the pictures are, 1st. the hand which holds the baskett of flowers. This I think is very badly foreshortned. The best way to remedy that in the copy may be by letting the mantle cover it, tho' I shoud prefer seeing the hand well fore-shortned. The hair is also badly executed, as it is intended to exhibit hair that has been powder'd, careless in undress, but it looks more like grey hairs in its present dress, which woud be very inconsistant with the air of the picture, which has a youthfull appearance. The person's age was about 30 at the time of taking the picture, and a sure circumstanse that they were not intended for grey is that at the time of her death the hair was light brown, which is the color I woud prefer having it drawn in. Another fault, thought so by those who remember the person, is the prodigious breadth of the picture across the shoulders (I dont mean the fall of the shoulders). This you will observe when you see the picture to be to a degree unnatural, tho I imagine it was intended to express the looseness of the bed gown; but it does not produce that effect. I woud chuse to alter the color of the bed gown from the flaring colour it is of to a more becoming and grave one, to a garnet purple for instance; but this I leave also to your fancy and taste.

William Carson to John Singleton Copley, August 16, 1772, in Letters and Papers of John Singleton Copley.

You are unknown to the world and yourself. Rise but in your own opinion, and you will attempt something worthy of yourself, and then every judge will bestow on you that applause which you justly merit. A painter of faces gains no reputation among the multitude, but from the Characteristick strokes in the outlines. Life and expression require judgement and knowledge. You really are and ought to consider yourself inferiour to no Portrait Painter in England.

I doubt much if there is your superiour in Europe. I use the term generally, as a Copier of nature, from any object, and I consider you can paint a Horse, Cow, Squirrel or fly as justly as a Man or woman from the life. Why do you not attempt it? Strange objects strongly strike the senses, and violent passions affect the mind. To gain reputation, you should paint something new, to catch the sight and fix the attention.

I must think, if you would paint such a piece, as a Child in the Cradle, sick.—the mother applying some remedy, her face and attitude expressing hope and fear, a Sympathizing nurse, officious in her duty, a Doctor standing by, of strong features, and wig in Character, recommending his Nostrums in a Vial, Bolus, or box, some female friend looking on with indifference. Contrasting the objects—Suppose your wife and child, the nurse old and black of complexion, the Physician long visaged, covered under a hideous wig, pale complexion and his baird two or three days old, and such a Young Lady looking on, eligantly dressed, as the youngest Miss Fitch; all, in a bed Chamber with such furniture as to show the mother and child of genteel rank. Such you could copy from the life and from such paintings, only, will your merit be known. Any piece of that kind, altho, it might cost you time and trouble will gain you more money and reputation than all you can get by face painting in Seven years. Send such a piece home before you go, it will be the best recommendation and you will be received there with Eclat. Be not afraid to make the experiment, for you will please and surprise the best judges,

tho you may not immediately please yourself. You'll readily forgive me for my presumption in giving advice, knowing, that I mean well, however unqualified.

I wish to hear of your arrival in England; in the mean time would be glad to hear from you, and to render you every service in my power.

Benjamin West to John Singleton Copley, January 6, 1773, Letters and Papers of John Singleton Copley.

Some days past Your Brother Mr. Clark delivered into my hands your letter of the 8th of Novr., Which informed me of your intended Tour into Italy, and the desier you express'd of receiveing my Opinion on that Subject. I am still of the opinion the going to Italy must be of the greatest advantage to one advanced in the arts as you are, As by that you will find what you are already in possession of, and what you have to acquier.

As your jurney to Italy is reather to finish a studye then to begin one; Your stay in that country will not requier that length of time that would be necessery for an Artist less advanced in the Arts then you are; But I would have that time as uninterrupted as possible. And for this reason I would have you make this Tour without Mrs. Copley. Not that she would be of any great aditional expance, But would reather bring you into a mode of liveing that would throw you out of your Studyes. So my Advice is, Mrs. Copley to remain in Boston till you have made this Tour, After which, if you fix your place of reasidanc in London, Mrs. Copley to come over.

In regard to your studyes in Italy my advice is as follows: That you pursue the higher Exalances in the Art, and for the obtaining of which I recommend to your attention the works of the *Antiant Statuarys, Raphael, Michal Angilo, Corragio,* and *Titian,* as the Sorce from whance true tast in the arts have flow'd. There ware a number of great artist in Italy besides thoss, But as they somewhat formd their manner in paint from the above artists, they are but second place painters. The works of the Antient Statuarys are the great original whare in the various charectors of nature are finely represented, from the soundest principles of Philosophi. What they have done in Statuary, Raphael, seems to have acquiered in painting. In him you see the fine fancey in the arraignment of his figures into groops, and those groops into a whole with that propriety and fitness to his subject, Joynd to a trouth of charector and expression, that was never surpass'd before nor sence. Michal Angilo in the knowledge and graundor of the Human figure has surpass'd all artists. His figures have the apearance of a new creation, form'd by the strength of his great amagination. in him you find all that is great in design. Corragio, whose obscurety in life deprived him of those aids in the art which Michal Angilo and Raphael had, and which prevented his acquiering those Exalances, which so charectoris'd them. But there are other beuties in the art he greatly surpass'd even those in and all others that came after him. Which was in the relieaf of his figures by the management of the clear obscure. The prodigious management in foreshortning of figures seen in the air, The greacefull smiles and turnes of heads, The magickcal uniteing of his Tints, The incensable blending of lights into Shades, and the beautyfull affect over the whole arrising from thoss pices of management, is what charmes the eye of every beholder. Titian gave the Human figure that trouth of colour which surpass'd all other painters. His portraits have a particuler air of grandour and a solidity of colouring in them that makes all other portraits appear trifling.

John Singleton Copley to Henry Pelham, March 14, 1775, Letters and Papers of John Singleton Copley.

I have now been in this City near four months in which time I have studyed and practiced with much application although when I tell you I have only composed the Assention; painted the portraits of Mr. and Mrs. Izard in one Picture, this last not finish[ed] by a fortnight, you will

think I have done but little. howeve[r] you are to reflect that it takes a great deal of time to see the Works of Art in this place. also near one month spent in Naples.

You will be glad to know in what manner an Historical composition is made, so I will give it to you, in that way I have found best myself to proceed. I have always, as you may remember, considered the Assention as one of the most Sublime Subjects in the Scripture. I considered how the Appostles would be affected at that Instant, weither they would be scattered over the Ground inattentive to the Action and converseing with one another, or weither they would croud together to hear the Charge to Peter, and when that was given weither they would not be asstonishd at their Masters rising from the Earth and full of the Godhead Assend up into Heaven. No one who reads the Account in the first Chapter of the Acts can be at a moments loss to decide that they would be so asstonish'd, and after Crouding together to hear what Christ said to St. Peter with vast attention in their countinances, they would (keeping their places) and their attention to the Assending Christ Absorbed in holy Adoration, worship him as he rose from the Earth, and so far from speaking to one another that not one of them would reflect that he had a companion with him. no thought could at that Instant intrude it self into their minds, already fully possessed with Holy wonder. some may naturally be supposed to fall on their knees: others with hands uplifted standing worship him. Some would look steadfastly on him: others would bow their heads and in deep adoration with Eyes fixt on the Ground worship him with hands spread or on the breast but all inattentive to one another. but two Angels stood by them; and spake to them. this would naturally ingage those that were next to them, and as it were awaked from a trans, turn with surprise to hear what they said to them. it would be just to observe that the Appostolick Carracter forbids to make the expression of Asstonishment very great. it should be temperd with Love and contain Majesty of behavour acquired by many times being spectators of the Power of Christ exercised in Miracles of a Stupendious nature. This General Idea being considered, the next thing is for the Artist to Warm his Immagination by looking at some Works of Art, or Reading, or conversing; than with pen or pencil sketch no matter how incorrect his general Idea, and when he has got so far, if he can correct by his Ideas his Sketch, he should do it. but I found it necessary to keep in my Idea the effect of the Whole together, which I determined would be grand if managed in the way I here Sketch it. I determined to carry the figures in a circle which would suppose a place that Christ stood in. this I fixed before I had determined the disposition of a single figure, as I knew it would make a fine breadth of light and shadow, and give a Grand appearance to the Whole: and I am certain Raphael pursued a Method something like this. you see in his School of Athens in perticular that it has a kind of ground plan thus only a little Diversified, but in general it give[s] this Idea. I have taken this kind of figure supposing Christ in the Midst. you will find in the Cartoon of the Death of Annanias, if my memory is good, a figure of this sort in that of Elimus, the Sorcerer, a figure not unlike that in that of the Appostle Paul Preaching this figure. now I have no doubt Raphael formed this general Ground plan before he fixed the disposition of any of his figures, than place[d] them on this ground, and varyed here and there as he found it best to break any stiffness and formallity that would otherwise appear in the work. this I can say I found my advantage in fixing this Idea of the Whole. it lead me to the masses of Light and Shadow and allmost to the disposition of some of my principle Figures. I forgot to mention the Transfiguration. it is in this form, I mean the Lower part of the Picture. When I had got thus far I sketched my figures, keeping the greatest simplicity with a great breadth of Light and shadow, that is I determined the Action of each figure and the manner of wraping the Drapery; than I

took a Layman of about 3 feet high, and with a Table Cloath wet and rung out I disposed my Drapery, and Sketched it with some considerable degree of eligance, and when I was uncertain of the effect of any figure Or groop of figure[s] I drew them of the sise on a peace of Paper by themselves shaded them and traced them on the Paper on which my Drawing was to appear to the Publick, just in the way you have seen me proceed with Draperys, etc., in my portraits. when I had got all my out line correct and clean, for I had traced it all from other sketch[e]s, I began to wash in the Shades with bister. This took me about 3 Days and was a pleasant Work as I had a correct out line and the several peaces from which I traced that out line to Shade from. I found this Ideal Sketching at first dificult and had recourse to the Looking Glass for Actions and by determining the place of heads hands, etc., as well as the propriety of the Action, which should always be determined by feeling it yourself. you will soon dispose your Attitudes so near the thing that you may exicute your Picture from the life without varying from your Drawing much, as I will explain. When I had got my Sketch in the above state I determined to put it in Colours, so that if I should paint it I should have nothing to alter. so I covourd my Drawing squares and a Canvis of a Kitcat sise, and Drew all the outline. than procured a Model to sit for some heads. from the same Model I think I painted 5 heads varying the Colour of the hair, etc.; tho was I to paint it large I should chuse a differant Model for each head; but in this it was not necessary to be so correct. From this model I Painted the heads, hands, feet the Draperys; tho I should chuse to dispose them for a large Picture again and use Cloath rather than linen on a Layman as large as life, yet what I have in my Drawing is abundantly eligant for the painting a small Picture from. I must just observe here that although the Sketch is Ideal, yet 2 or 3 of the figures I could not absolutely determin on without having the life. I frequently studied the works of Raphaiel, etc., and by that kept the fire of the Imagination alive and made it my object to produce a work that might stand by any others. sometimes a fortnigh[t] would pass before I could invent a single figure, and my whole Sketch was once drawn and shaded, when the alteration of one or two figures seemed necessary. on this I traced it all on another paper except those figures, and drew *them* on a paper by themselves, shaded them, and than traced them with the rest, and shaded the whole as above. I have no doubt Raphael pursued this method; it appears so by his differant drawings. I hope you will be profited by this very perticular Account of my proceedings in this my first composition. I should have been happy to have had such a plain account of the process when I was in America, and what may seem trifling to a Man who has not known the want of such information, I know to be of the last importance to one who has not had an oppertunity of knowing the manner the great Masters have pursued their Goddess with success.

CHARLES WILLSON PEALE IN LONDON AND PHILADELPHIA

One of the earliest American pupils of Benjamin West, Charles Willson Peale was sent to London by a group of Maryland patrons who hoped that the skills he would acquire might later be brought to bear on the elite faces of Annapolis and Baltimore. In a letter from one of those patrons, Charles Carroll lectures the young artist about economizing and making the most of his English sojourn. He goes on to counsel Peale against miniature painting (not remunerative) and history painting (no market for it) in favor of conventional oil portraits. Five years later, after his return to the colonies, Peale writes another of those patrons, his friend John Beale Bordley, about his business prospects in Philadelphia. Brushing aside his continental education, Peale essentially confirms Car-

roll's view that portraits of living people, not "Greesian and Roman statues," will be his concern.

Charles Carroll to Charles Willson Peale, October 29, 1767, in Lillian B. Miller, ed., The Selected Papers of Charles Willson Peale and His Family *(New Haven: Yale University Press, 1983), vol. 1.*

It was a Pleasure to me to find by yours of the 17th March last that you were in a way of Acquiring some Improvement in your Profession but I was a Little Surprized to hear from Mr Anderson that you had thoughts of Leaving England to sail for Maryland the November following the Dates of your letters as I supposed you would make your stay in England as Long as Possible to Git all the Insight you Could and as I Calculated the Assistance you Carried from Hence would Enable you to make a Longer Stay but I hope both Mr Anderson and myself were mistaken and that you have Conducted yourself with that Prudence and Frugality that you will not have occasion to hurry away before you have in some measure attained the Ends for which you went—you are to Consider that you will never be able to make up to your self and family the Loss of the opportunity and that those by whom you have been Assisted will be sorry to find their money Thrown away but I hope as I before said that I have been mistaken and those hints are unecessary I have wrote to Mr Anderson and left it to his De[s]cretion in Case he should Judge you Deserving to advance you Eight or Ten Guineas more on my Account

I observe your Inclination Leads you much to Painting in miniature I would have you Consider whether that may be so advantageous to you here or whether it may suit so much the Taste of the People with us as Larger Portrait Painting which I think would be a Branch of the Profession that would Turn out to Greater Profit here you Likewise mention the Copying of good Painting by which I suppose you mean the Study of History Painting This I Look upon as the most Difficult Part of the Profession and Requires the utmost Genius in the artist few arrive at a High Point of Perfection in it And indeed in this Part of the world few have a Taste for it and very few can go thro' the Expence of giving that Encouragement that such an artist would Desire—but after all Consult and be guided by the best of your own Genius and Study that Branch to which your Disposition Leads you and that you Judge most Suitable to your Talents you had better be a Good Painter in miniature than an Indifferent one in Either of the other Branches and be assured that what I have above wrote and mentioned Proceeds from my Desire of your welfare.

Charles Willson Peale to John Beale Bordley, November 1772, in Miller, ed., The Selected Papers of Charles Willson Peale and His Family, *vol. 1.*

I have my hands full. And I believe would allways find a Sufficiency between this and New York— I have many reasons to like the place, but I would wish to be a little beforehand in the world first, and as I have plenty of Bussiness in the Country of Maryland and Virginia in a little while may promise myself to be at least clear of encumbrances—I am paying some debts now, altho I am at a considerable Expence for board and House keeping—My reputation is greatly increased by a Number of New Yorkers haveing been here, who have given me the character of being the best painter of America—that I paint more certain and handsomer Likenesses than Copley— what more could I wish—I am glad I can please But Sir how far short of that excellence of some painters, infinately below that perfection, that even portrait Painting I have seen may be carried to in a Vandyke My enthusiastic mind forms some idea of it but I have not the Execution, have not the ability, or am I a Master of Drawing—what little I do is by mear immatation of what is before me, perhaps I have a good Eye, that is all, and not half the application that I now

think is necessary—a good painter of either portrait or History, must be well acquainted with the Greesian and Roman statues to be able to draw them at pleasure by memory, and account for every beauty, must know the original cause of beauty—in all he sees—these are some of the requisites of a good painter, these are more than I shall ever have time or opportunity to know, but as I have variety of Characters to paint I must as Rambrant did make these my Anticks and improve myself as well as I can while I am provideing for my support.

Fig. 2. Washington Allston, *Belshazzar's Feast*, 1817–43, oil on canvas. The Detroit Institute of Arts, Gift of the Allston Trust. Photograph © 1979 The Detroit Institute of Arts.

2 REVOLUTION AND EARLY REPUBLIC

DEFINING ART

John Adams, the second president of the United States, had a reserved demeanor and a penchant for plain manners and living that his contemporaries associated with his native Massachusetts. He distrusted excess of any kind, whether it was the display of private wealth or the sensuous rituals of the Roman Catholic Church. During the American Revolution, he lived in Philadelphia in order to be active in the Second Continental Congress, and in 1788 he began a decade of service as an American diplomat stationed abroad. These long absences from home prompted an extensive correspondence with his wife, Abigail, and in three letters below Adams makes comments on the arts that were inspired by his novel surroundings.

In the first letter, written from Philadelphia, he recounts a visit to the studio of Charles Willson Peale. Although he displays some Boston pride in rating John Singleton Copley a better portraitist than Peale, Adams appreciates Peale's style, commenting on the "pleasant . . . cheerfulness" and "familiarity" of the large Peale Family *(c. 1770); here he uses words that he often employed as a contrast to overly artful, pretentious behavior. Yet Adams can't resist noting what he perceives as Peale's vanity and "love of finery." The next two letters were written from France, where Adams responds viscerally to the luxury he witnesses. In strong language, he links the arts with aristocratic rule, asserting that the young republic of the United States is not yet ready for them. Some four decades later, his views had not softened. In a letter to John Trumbull, who was engaged in painting his* Declaration of Independence *(1817) at the time, Adams politely wishes him well and then goes on to denounce the arts as "enlisted on the side of Despotism and Superstition" (see also "John Trumbull Paints Revolutionary History," this chapter).*

John Adams to Abigail Adams, letters, Massachusetts Historical Society, Boston.

[August 21, 1776]

Yesterday morning I took a walk into Arch Street to see Mr. Peale's painter's room. Peale is from Maryland, a tender, soft, affectionate creature. He showed me a large picture containing a group of figures, which, upon inquiry, I found were his family: his mother and his wife's mother, himself and his wife, his brothers and sisters, and his children, sons and daughters, all young. There was a pleasant, a happy cheerfulness in their countenances, and a familiarity in their air towards each other.

He showed me one moving picture. His wife, all bathed in tears, with a child about six months old laid out upon her lap. This picture struck me prodigiously. He has a variety of portraits, very well done, but not so well as Copley's portraits. Copley is the greatest master that ever was in America. His portraits far exceed West's. Peale has taken General Washington, Dr. Franklin, Mrs. Washington, Mrs. Rush, Mrs. Hopkinson, Mr. Blair McClenachan and his little daughter in one picture, his lady and her little son in another. Peale showed me some books upon the art of painting. Among the rest one by Sir Joshua Reynolds, the President of the English Academy of Painters, by whom the pictures of General Conway and Colonel Barré, in Faneuil Hall, were taken. He showed me, too, a great number of miniature pictures. Among the rest, Mr. Hancock and his lady, Mr. Smith, of South Carolina, whom you saw the other day in Boston, Mr. Custis, and many others.

He showed me, likewise, draughts, or rather sketches, of gentlemen's seats in Virginia, where he had been, Mr. Corbin's, Mr. Page's, General Washington's, etc. Also a variety of rough drawings made by great masters in Italy, which he keeps as models. He showed me several imitations of heads, which he had made in clay, as large as the life, with his hands only. Among the rest, one of his own head and face, which was a great likeness. He is ingenious. He has vanity, loves finery, wears a sword, gold lace, speaks French, is capable of friendship, and strong family attachments and natural affections.

[June 3, 1778]

There is so much danger that my Letter may fall into malicious Hands, that I should not choose to be too free in my Observations upon the Customs and Manners of this People. But thus much I may say with Truth and without offence, that there is no People in the World, who take so much Pains to please, nor any whose Endeavours in this Way, have more success. Their Arts, Manners, Taste and Language are more respected in Europe than those of any other Nation. Luxury, dissipation, and Effeminacy, are pretty nearly at the same degree of Excess here, and in every other Part of Europe. The great Cardinal Virtue of Temperance, however, I believe flourishes here more than in any other Part of Europe.

My dear Country men! how shall I perswade you, to avoid the Plague of Europe? Luxury has as many and as bewitching Charms, on your Side of the Ocean as on this—and Luxury, wherever she goes, effaces from human Nature the Image of the Divinity. If I had Power I would forever banish and exclude from America, all Gold, silver, precious stones, Alabaster, Marble, Silk, Velvet and Lace.

Oh the Tyrant! the American Ladies would say! What!—Ay, my dear Girls, these Passions of yours, which are so easily allarmed, and others of my own sex which are exactly like them, have done and will do the Work of Tyrants in all Ages. Tyrants different from me, whose Power has banished, not Gold indeed, but other Things of greater Value, Wisdom, Virtue and Liberty.

[May 12, 1780]

To take a Walk in the Gardens of the Palace of the Tuilleries, and describe the Statues there, all in marble, in which the ancient Divinities and Heroes are represented with exquisite Art, would be a very pleasant Amusement, and instructive Entertainment, improving in History, Mythology, Poetry, as well as in Statuary. Another Walk in the Gardens of Versailles, would be usefull and agreable. But to observe these Objects with Taste and describe them so as to be understood, would require more time and thought than I can possibly Spare. It is not indeed the fine Arts, which our Country requires. The Usefull, the mechanic Arts, are those which We have occasion for in a young Country, as yet simple and not far advanced in Luxury, altho perhaps much too far for her Age and Character . . .

I must study Politicks and War that my sons may have liberty to study Painting and Poetry Mathematicks and Philosophy. My sons ought to study Mathematicks and Philosophy, Geography, natural History, Naval Architecture, navigation, Commerce and Agriculture, in order to give their Children a right to study Painting, Poetry, Musick, Architecture, Statuary, Tapestry and Porcelaine.

John Adams to John Trumbull, January 1, 1817, Yale University Library.

Your kind letter . . . has given me more pleasure than it would be prudent or decent for me to express. Your design has my cordial approbation and best wishes. But you will please to remember that the Burin and the Pencil, the Chisel and the Trowell, have in all ages and Countries of which we have any Information, been enlisted on the side of Despotism and Superstition. I should have Said of Superstition and Despotism, for Superstition is the first and Universal Cause of Despotism. Characters and Counsels and Action merely Social merely civil, merely political, merely moral are always neglected and forgotten. Architecture, Sculpture, Painting, and Poetry have conspir'd against the Rights of Mankind: and the Protestant Religion is now unpopular and Odious because it is not friendly to the Fine Arts. I am not, however, a Disciple of Rousseau. Your Country ought to acknowledge itself more indebted to you than to any other Artist who ever existed; and I there fore heartily wish you success.

PUBLIC ART FOR THE NEW REPUBLIC:
CHARLES WILLSON PEALE'S TRIUMPHAL ARCH

We know relatively little about the public art created for festivals and celebrations in the eighteenth century. Structures such as the triumphal arch erected in Philadelphia in early 1784 as part of a "Public Demonstration of Joy" were composed largely of ephemeral materials: wood and hastily executed "transparent" paintings, designed to be illuminated from behind. Charles Willson Peale was engaged to execute the dozen or so paintings, the patriotic imagery of which is detailed in a broadside published by the Pennsylvania Assembly. Unfortunately, disaster struck when rockets ignited the unfinished structure, as Peale explains in a letter to the uncle of his apprentice. Panic ensued, leading to violence and looting. After a three-week bed rest, Peale re-created the paintings for the postponed display, this time minus the fireworks.

Broadside, December 2, 1783, Library of Congress.

The Committee appointed to confer with Council concerning the Public Demonstrations of Joy it may now be proper to authorise in this State, upon the Definitive Treaty of Peace between The

United States *and* Great-Britain, *beg Leave to report, as the joint Opinion of that Board and your Committee*——

That a Triumphal Arch be erected at the Upper End of High *or* Market *Street, between* Sixth *and* Seventh *Streets, to be embellished with illuminated Paintings and suitable Inscriptions; and that some Fireworks be prepared for the Occasion:*

That such an Exhibition, in Point of Elegance, as well as in Regard to the Convenience and Safety of the Spectators, *will prove most generally acceptable; it being intended there should* be no other Illumination in the City: *That these Preparations may be completed in three or four Weeks, and will require, by the most exact Computation they could at present make, about Five or at most Six Hundred Pounds: And therefore,*

RESOLVED, *That a Sum not exceeding Six Hundred Pounds be, and is hereby appropriated for the Purpose of enabling* The Supreme Executive Council *to make Public Demonstrations of Joy upon the Definitive Treaty of Peace between* The United States *and* Great-Britain.

As these Demonstrations of Joy are prescribed and regulated by the Directions and at the Expence of the State, it is expected, that no Person or Persons whatever will presume, in Defiance of the Authority of the Commonwealth, to require or to make any other Demonstrations of Joy upon the Occasion, than those directed and authorised as aforesaid.

A Description of the Triumphal Arch and its Ornaments.

The Arch is fifty Feet and six Inches wide, and thirty-five Feet and six Inches high, exclusive of the Ballustrade, which is three Feet and nine Inches in Height. The Arch is fourteen Feet wide in the clear, and each of the smaller Arches nine Feet. The Pillars are of the *Ionic* Order. The Entablature, all the other Parts, and the Proportions, correspond with that Order; and the whole Edifice is finished in the Style of Architecture proper for such a Building, and used by the *Romans.* The Pillars are adorned with spiral Festoons of Flowers in their natural Colours.

The following Devices and Inscriptions are distributed in to several Parts appropriated by the Antients to such Ornaments.

<div align="center">I.</div>

Over the Centre Arch, the Temple of *Janus* shut—

NUMINE FAVENTE

MAGNUS AB INTEGRO SÆCULORUM NASCITUR ORDO.

By the Divine Favor

A great and new Order of Ages commences.

<div align="center">II.</div>

On the South Side of the Ballustrade, a Bust of *Lewis* the XVI

MERENDO MEMORES FACIT.

His Merit makes us remember him.

<div align="center">III.</div>

On the other Side of the Ballustrade, a Pyramidal Cenotaph to the Memory of those brave Men who have died for their Country in the late War,

OB PATRIAM PUGNANDO VULNERA PASSI.

These received their Wounds for their Country.

<div align="center">IV.</div>

On the South Side of the Frize, Three Lilies, the Arms of *France,*

GLORIAM SUPERANT.

They exceed Glory.

<div align="center">

V.

</div>

On the left of the former, a Plough, Sheaves of Wheat, and a Ship under sail, the Arms of *Pennsylvania,*

TERRA SUIS CONTENTA BONIS.

A Land contented with its own Blessings.

<div align="center">

VI.

</div>

On the left of the preceding, a Sun, the Device of *France*—and Thirteen Stars, the Device of *The United States,*

CAELO SOCIATI.

<u>Allied in the Heavens.</u>

<div align="center">

VII.

</div>

On the left of the last, two Hands joined holding Branches of Olive and the Caduceus of Commerce,

CONCORDIA GENTIUM.

<u>The Concord of Nations.</u>

<div align="center">

VIII.

</div>

On the South Pannel, Confederated *America* leaning upon a Soldier, military Trophies on each Side of them,

FIDES EXERCITUS.

<u>The Fidelity of the Army.</u>

<div align="center">

IX.

</div>

On the other Pannel, *Indians* building Churches in the Wilderness,

PONUNT FEROCIA CORDA.

<u>Their savage Hearts become mild.</u>

<div align="center">

X.

</div>

On the Dye of the South Pedestal, a Library, with Instruments and Emblems of Arts and Sciences,

EMOLLIUNT MORES.

<u>These Soften Manners.</u>

<div align="center">

XI.

</div>

On the Dye of the next Pedestal, a large Tree bearing *thirteen* principal and distinct Branches loaded with Fruit,

ROBORE STIPITIS MATURABUNT.

<u>By the Strength of the Body these will ripen.</u>

<div align="center">

XII.

</div>

On the Dye of the Pedestal, upon the right Hand in passing through the Centre Arch, *Cincinnatus,* crowned with Laurel, returning to his Plough—The Plough adorned with a Wreath of the same—The Countenance of *Cincinnatus* is a striking Resemblance of General *Washington,*

VICTRIX VIRTUS.

<u>Victorious Virtue.</u>

<div align="center">

XIII.

</div>

On the Dye of the next Pedestal, Militia exercising,

PROTEGENTES GAUDEBUNT.

<u>Protecting they shall enjoy.</u>

On the Spandrels of the Centre Arch these Letters, S.P.Q.P. *The Senate and People of Pennsylvania.*

The Top of the Ballustrade is embellished with Figures representing the Cardinal Virtues, Justice, Prudence, Temperance, and Fortitude.

The whole Building illuminated by about twelve hundred Lamps . . .

Any Boys or others, who disturb the Citizens by throwing Squibs or Crackers, or otherwise, will be immediately apprehended and sent to the Work-house.

Charles Willson Peale to George Weedon, January 20 and February 10, 1784, in Lillian B. Miller, ed., The Selected Papers of Charles Willson Peale and His Family *(New Haven: Yale University Press, 1983), vol. 1.*

I have been 2 months so closly engaged in painting an entire building in Transparent colours for the public rejoiceing on the Return of peace that I have not attended as I would otherwise have done in Answering your letters . . .

Feby 10 by a rocket being put too near the paintings (*of the*) above mention: Building they unfortunately took fire and in 10 minutes the work of much pains & study was consumed to ashes, but that was not the worst one or two person[s] was killed and many hurt by (*the going off*) a great number of Rockets taking fire which lay horizontal on the floor of the Building. I was on the Top of the frame and seeing no prospect of extinguishing the fire I endeavored to save myself by desending by a back post & thought myself out of Danger when unfortunately a parcel of Rockets which were below flew on me & burnt my hand [and] head & sett my Cloathes on fire, and drove me from my holt and I fell & received a considerable Contussion on my side, my hurts has been so bad that I have not been able to leave my room until yesterday. These misfortunes will account for my long silence.

THE PLACE OF THE ARTS IN AMERICAN SOCIETY

In the early years of the republic, writers in various sections of the United States began considering the methods and benefits of promoting and sustaining the fine arts. "Rules for Painting," printed in a short-lived Boston periodical, encouraged the gentleman connoisseur to acquaint himself with the specifics of pictorial composition and to consider carefully the relationship of nature and art. The contribution of "Ephebos" to the South Carolina Weekly, *on the other hand, deals more with the utility and influence of art rather than with its mechanics. Ephebos lists the desirable effects that paintings have on viewers: they teach virtue and history, they encourage poetic reflection through associational prompting, they ensure that great men are not forgotten, and they exert a calming influence on the population, reducing partisan anger and curbing violent instincts. This southern author goes so far as to assert the greater evocative nature of images over words—a far cry from the earlier, logos-based attitude of the Puritan North.*

"Rules for Painting. Founded on Reason," Gentlemen and Ladies Town and Country Magazine *1 (November 1789).*

1ˢᵗ. The subject whatever it may by history portrait, land-scape, &c. must be finely imagined, and if possible improved in the painter's hands; he must think well as a historian, poet, philosopher, or divine, and moreover as a painter in making a wise use of all the advantages of his art, and finding expedients to supply its defect.

2d. The expression must be proper to the subject, and the characters of the persons; it must be strong, so that the dumb shew may be perfectly well and readily understood. Every part of

the picture must contribute to this end; colours, animals, draperies, and especially the actions of the figures, and above all the airs of the heads.

3d. There must be one principal light, and this and all the subordinate ones is. The shadows and reposes, must make one in fine harmonious mass; the several parts must be well connected and contracted, so that the whole composition at first view, must be grateful to the eye, as a good piece of music is to the ear. By this means the picture is not only more delightful but better seen and comprehended.

4ᵗʰ. The drawing must be just; nothing must be flat, lame, or ill proportioned; and these proportions must vary according to the characters of the persons drawn.

5ᵗʰ. The colouring, whether gay or solid, must be natural beautiful and clear, and what the eye is delighted with, in shadows as well as tints.

6ᵗʰ. And whether the colours are laid on thick or finely wrought, it must appear to be done by a light and accurate hand.

Lastly, Nature must be the foundation. This must still and ever appear, but nature must be raised, and improved, not only from what is commonly seen to what is but rarely; but even yet higher, from a judicious and beautiful idea in the painter's mind, so that grace and greatness may shine throughout, more or less however as the subject may happen to be. And herein consists the principal excellence of a picture or drawing.

By a proper attention to these rules, the author is confident that a gentleman may become a good judge for painting; but for attaining the accomplishments more perfectly, he think, is necessary, that the connoisseur should be thoroughly acquainted and freely conversant with the works of the greatest master in the art.

"Ephebos," "Some Observations on Pictures: With a Proposal," South-Carolina Weekly Museum *(June 3, 1797).*

The *Fine Arts,* when properly conducted, are a great source of improvement and pleasure to mankind. They have been, indeed, too often perverted to the service of licentiousness and vice, but may be rendered a powerful auxiliary to virtue and religion. If lascivious paintings and statues, with impure poems, have, by their fascinating influence, tended greatly to the corruption of morals and promotion of infidelity; must not the charms of piety, benevolence, gratitude, sympathy, friendship and the other virtues, so amiable and attractive in themselves, become irresistible when joined with those charms of sight which so delight the imagination? When we see the features of illustrious men, whose bodies have long since mouldered into dust, preserved in a painting, executed with justness and skill, we feel a pleasure like that of seeing the dead re-animated. We may, by the limner's aid, be led to understand more clearly an author's writings, and, as it were, commence an acquaintance with persons we have never seen. The view of an agreeable assemblage of rural objects in a landscape, beside gratifying curiosity and affording amusement, is very exhilarating after the fatigue of studious thought, or close application to business. Such an object disposes to peace and tranquillity, and is often occasion of recalling to the mind agreeable scenes that are past. Some great, or affecting action or event, represented in a natural and lively manner, in colours, makes a deeper impression than when described in words; and transports the spectator in idea, to distant ages and countries. Full of the pleasing emotions raised by the object before him, he fancies he hears the shouts of the courageous host, sees their vigorous motions, with the waving banners, and feels valour rising in his soul.

When to view is presented the "poor old man," bent with age and infirmity, begging for charity, he sees his limbs tremble; hears in idea, his faultering voice, and joins in sympathy with the

pitying family. He is struck with awe, and filled with pleasure at the artless innocence and devotion of the infant prophet:* And at seeing Daniel unhurt amid a den of hungry lions.

Emblematical Pictures are a happy medium of conveying silent, wholesome instruction to young minds, and of impressing important truths on the heart. Several pieces of this nature have been well devised and executed: particularly two, composing a set, one of which represents the Christian character by a flourishing tree, watered by an angel, bearing delightful fruit, inhabited by a dove, and receiving from above an effusion of heavenly dew. The other shews a striking contrast—a tree springs from a soil infected by obscene animals, is watered by the spirit of darkness, inhabited in the middle by a coiled serpent, and blasted at the top by lightning—over its roots hangs a lifted axe ready to cut it down.

There is another species of pictures which is calculated to promote *diversion,* without relaxing *virtue;* as when a ridiculous character is aptly drawn, with a display of their ruling passions and their disagreeable consequences. A scene from Shakspeare, of Mrs. Ford and Page cramming Falstaff into a buck-basket, is a pleasant example.

Considering the pleasure and advantage to be derived from a well chosen collection of paintings, I think it would be to the honor of the citizens of Charleston to undertake the establishment of a *picture gallery* in this city. Would it not become the patriotism of public spirited men of taste and fortune, to patronize, if they thought it beneficial and practicable, so pleasing a scheme? Let the collection be made of paintings executed by the most approved and ingenious artists. But let all obscenity be banished—let no naked Venus appear, nor wanton Sappho display her wiles. Let the entertainment be the feast of virtue and of taste; not the promoter of lawless passion. A public room of the nature proposed might prevent much time from going to utter waste among the indolent, and put to silence, for awhile, the tongue of slander. Here the news-monger might pass away a leisure hour without running into the violence of party rage, and hold a conversation with one of opposite politics, without offending good manners. Virtuous emotions and interesting thoughts might be here excited, and taste improved. Here persons of lively imaginations and strong passions might find entertainment, without running into that *excess of riot* which is so destructive to their happiness; and learn, from inanimate teachers, something that may be for their benefit in this life and that which is to come.

AN EARLY SCHEME FOR A MUSEUM OF SCULPTURE

This anonymous proposal, printed in a Philadelphia periodical, is one of the earliest calls for a public museum of art—in this case, one specializing in casts from antique sculpture. The author envisions such a collection as a seed, one that will foster similar museums in cities throughout the United States and nurture young artists, leaving them "less confused on their arrival in Europe among the originals." There is also an interesting passage on rarity and authenticity: the author is squarely on the side of multiples and copies. Public exhibition, rather than private ownership of the precious object, is extolled. In 1805, the very year of this publication, the Pennsylvania Academy of the Fine Arts was founded; it would come to fill a role very much like the one described here.

*Samuel in the temple.

"Plan for the Improvement and Diffusion of the Arts, Adapted to the United States," Literary Magazine and American Register 3 (March 1805).

The scarcity of taste and of skill in the fine arts of painting, sculpture, and architecture, in the United States, is a subject of great wonder to travellers. It is a paradox of difficult, but surely not of impossible, solution, that a civilized, peaceful, free, industrious, and opulent nation, of four or five millions of persons, sprung from one of the most enlightened nations of the globe, and maintaining incessant intercourse with every part of Europe, should have so few monuments of these arts among them, either in public or private collections. There was not a single public collection of this kind in the United States till the establishment of one, a few years since, at New York; and it is well known with what slender encouragement and support the rich have honoured the New York institution.

Under such impressions the following plan is published with little ardour or confidence. But if it has no influence at present, the time may come, and, perhaps, be not very distant, when some of its regulations may be carried into execution.

It is proposed that a subscription be commenced in order to raise the sum of____, which, when completed, application should be made to congress for further assistance; the total of which sums, under their sanction, should be consolidated into a perpetual fund, to which proper trustees may be nominated, for the declared purposes, out of the annual interest, of commencing two galleries, and filling them, as fast as the interest accrues, with plaster casts from antique statues, bas-reliefs, fragments of architecture, fine bronzes, &c. collected not only from Italy, but from all parts of Europe . . .

All fine bas-reliefs, &c. should, if possible, be obtained in moulds, with a cast in them, by which means they not only come the safest from injury, but it would enable the managers to place in the gallery two or three casts of such as best deserved imitation; and then the moulds might be sold to our moulders in plaster of Paris, by which means other cities would be enriched with many fine objects at a reasonable expence, to the great advantage of architects, schools, and the public in general.

There are not wanting people who think that such objects, by being cheaply multiplied, would injure the progress of our artists: but experience teaches otherwise; for those nations which most abound in such things most abound in artists; and the more any thing is multiplied by casts or impressions, the more is the original esteemed; for while the narrow-minded amateur hides his fine Cameo, lest a sulphur should be obtained from it, both he and his ring are forgot; when, on the other hand, the liberal collector, whose chief pleasure it is to gratify all lovers with a copy of the fine originals he possesses, finds, to his surprise, the fame of his antique, and the credit of its owner, increased in the same proportion; and hence we may rest assured, that the multiplication of works of art always ends in a multiplied demand for the labours of artists . . .

Such galleries, when finished, would possess advantages that are wanting in foreign museums; where often, to gratify the love of ornament in the architect, fine bas-reliefs are placed so high, as to be of little use to students, and as traps only to the antiquarian; of which, having with younger limbs, and younger eyes, often followed the enthusiastic Winkelman,[1] I could give many instances.

Here, however, all would be brought to a level, and to light; all the restorations carefully distinguished; and such men of learning, as, without great detriment to their affairs, can never go

[1] Johann Joachim Winckelmann was an eighteenth-century German historian of classical art.

abroad, would hence find daily opportunities of benefiting and crediting their country, as well as themselves, by their erudite remarks on monuments that relate entirely to classic ground.

In a word, well prepared, both by the knowledge and study of these casts, our yet unborn artists would be less confused on their arrival in Europe among the originals; and a much shorter stay would then suffice: lastly, on their return, these galleries would help to perpetuate in their memories the result of their studies; a fund of employment would be afforded to young artists in copying these antiques for foreigners, as well as natives; and our engravers, either native or imported, would here always find objects from whence great works might be executed, equally interesting and much more correct, as well as less expensive, than any that have hitherto appeared in elucidation of antiquities.

SCULPTORS FOR THE CAPITOL

Throughout the first half of the nineteenth century, the Capitol building in Washington, D.C., would be the site of repeated disappointments: artists felt Congress was ungenerous and prone to favoritism in its decorative commissions; members of Congress often disparaged the work that was done by the artists; and a bewildering succession of architects feuded with Congress and each other, ensuring that no single designer was able to establish firm control of the long project (see "The U.S. Government as Patron: Decoration of the Capitol," chapter 5). Benjamin Latrobe was one of those architects, appointed surveyor of the public buildings by President Thomas Jefferson in 1803 and at work on the Capitol until 1811, and again from 1814 to 1817 (see also "Quaker City Arts Organizations, c. 1810," this chapter). In this early letter to Philip Mazzei, an Italian confidant of John Adams, Thomas Jefferson, and James Madison, Latrobe endeavors to hire sculptors to execute the ornamental work he was designing for the building. Latrobe's desire for Italian artists is explained by his harsh assessment of the talents of American sculptors, whom he considers unfit for such an important undertaking. Ultimately Latrobe was successful, securing the assistance of the stonecarvers Giuseppe Franzoni, Giovanni Andrei, and Francesco Iardella. However, his plan to engage the celebrated Italian sculptor Antonio Canova for a large statue of Liberty in the House of Representatives fell through, as did a scheme to hire the Danish sculptor Bertil Thorvaldsen. In the end it was executed in plaster by still another European, Enrico Causici.

Benjamin Latrobe to Philip Mazzei, March 6, 1805, in Charles Fairman, Art and Artists of the Capitol of the United States of America *(Washington, D.C.: Government Printing Office, 1927).*

By direction of the President of the United States I take the liberty to apply to you for your assistance in procuring for us the services of a good sculptor in the erection of the public buildings in this city, especially of the Capitol.

The Capitol was begun at a time when the country was entirely destitute of artists, and even of good workmen in the branches of architecture, upon which the superiority of public over private buildings depends. The north wing, therefore, which is carried up, although the exterior is remarkably well finished as to the masonry, is not a good building. For two or three years after the removal of Congress to this city the public works were entirely discontinued. In the year 1803, however, they were resumed, and under the patronage of the present President and the annual appropriations by Congress the south wing of the Capitol has been begun and carried on. It is now so far advanced as to make it necessary that we should have as early as possi-

ble the assistance of a good sculptor of architectural decorations. In order to procure such an artist the President of the United States has referred me to your assistance, and to enable you to make choice of the person most likely to answer our purpose I will beg leave to describe to you the nature of the work we require to be done. The principal sculpture required will be of twenty-four Corinthian capitals, two feet four inches in diameter at their feet, and open enriched entablatures, of 147 feet (both English measure) in length. There are beside five panels (tavole) enriched with foliage and an eagle of colossal size in the frieze, the distance between the tips of the extended wings being twelve feet six inches.

The material in which this is to be cut is a yellowish sandstone of fine grain, finer than the peperino or gray sandstone used in Rome—the only Italian sandstone of which I have any distinct recollection. This stone yields in any direction to the chisel, not being in the least laminated nor hard enough to fly off (spall) before a sharp tool. It may, therefore, be cut with great precision. The wages given by the day to our best carvers are from $3 to $2.50, or from about $750 to $900 per annum. They are considered good wages, but the workmen who receive them are very indifferent carvers and do not deserve the name of sculptors. My object is to procure a first-rate sculptor in the particular branch of architectural decorations. He should be able to model and bring with him another good though inferior workman as his assistant, to whom we could pay from $1.50 to $2 per day.

It is not my intention to confine you to these prices, but to leave it to you to do the best you can for the public interest both as to the excellence of the talents and the moderation in the wages of the person you may be pleased to select. Should you even (which I do not think improbable) find a man of superior merit willing to come hither on lower terms than those we pay to our very indifferent carvers, it were well to contract with him at the terms with which he will be perfectly satisfied, as he may depend on receiving such an addition to his stipulated salary if his conduct merits it as will place him in proper relation as to salary as well as to abilities with our other workmen. There are, however, other qualities which seem so essential as to be at least as necessary as talents. I mean good temper and good morals. Without them an artist would find himself most unpleasantly situated in a country the language and manners of which are so different from his own, and we should have no dependence upon a person discontented with his situation. For though every exertion would be made on my part to make his engagement perfectly agreeable to him, the irritability of good artists is well known and it is often not easily quieted.

The American consul at Leghorn, who does me the favor to forward this to you, will provide all the expenses and make the arrangements necessary to the voyage of the persons you may select. I think it necessary that he should enter into a written contract to remain with us two years. We will pay all their expenses hither, their salary to commence on the day on which they shall be ready to leave Leghorn, and any reasonable advance to enable them to wind up their affairs at home should be made to them. Single men would be preferred, but no objection would be made to married man, whose family may come over with him. On expiration of the time, and should he choose to return, the expenses of the voyage will also be paid to him on his arrival again in Italy and not before. But this stipulation should not be made unless absolutely demanded. I have a further favor to ask which I hope will give you less trouble than the preceding. It is proposed to place in the Chamber of Representatives a sitting figure of Liberty nine feet in height. I wish to know for what sum such a figure would be executed by Canova in white marble, and for what sum he would execute a model in plaster (the only material I believe in which it could be brought hither), to be executed here in American marble from the model.

If Canova should decline the proposal altogether, as he must now be an old man, what would be the price of such a statue and such a model by the artist he should recommend as in his opinion the nearest to himself in merit?

WERTMÜLLER'S *DANAË* AND "NUDITIES"

The Swedish artist Adolph Ulrich Wertmüller first visited the United States in 1794 and eventually settled on a farm in Delaware in 1800. Wertmüller had studied in Paris, where he painted his most famous work, a life-size Danaë and the Shower of Gold *(1787). The artist brought the painting to America and exhibited it at his farm and, for several years, in New York City and Philadelphia. After he died in 1811, it was reportedly sold for $1,500 and put on display again in John Wesley Jarvis's, and later Henry Inman's, studios. The canvas depicts the nude Danaë on a bed, rapturously receiving her lover Zeus, who has transformed himself into a cloud of gold dust in order to enter her room on beams of light. American viewers had never seen such a monumental and sensuous treatment of the nude, and* Danaë *(along with several copies executed by Wertmüller) tested the limits of public taste and tolerance for several decades.*

Charles Willson Peale wrote to correspondents about Danaë *several times, beginning in 1805, when he visited the Wertmüller farm. Having studied in Europe, Peale was aware of the academic traditions of depicting the nude, but he chafed at its public exhibition. In letters to Thomas Jefferson and his son Rembrandt (who tried unsuccessfully to purchase and exhibit* Danaë*), he relates an interesting story of a Native American reaction to Wertmüller's work, and he advises Rembrandt not to exhibit any nude mythological figures for fear of enraging "religious societies." An indirect example of that intolerance comes in two letters written by William Lowndes of South Carolina to his wife, in which it is clear that she objects to his viewing the painting. Finally, an excerpt from an essay in the Philadelphia* Port Folio *raises the issue of mixed-gender viewings of* Danaë *and concludes that women should view it neither with men nor on their own. This question of setting aside specific viewing times for women would later bedevil Miner Kellogg when he toured with Hiram Powers's* Greek Slave *in 1847 (see "Hiram Powers's* The Greek Slave*," chapter 5).*

Charles Willson Peale to Benjamin Latrobe, May 13, 1805, in Lillian B. Miller, ed., The Selected Papers of Charles Willson Peale and His Family *(New Haven: Yale University Press, 1988), vol. 2, pt. 2.*

In the neighbourhood of Wilmington is a picture painted by Mr. Vertmuiller very well worth your seeing (Danie receiving Jubetor in a shower of Gold). Such subjects may be good to shew Artists talents, but in my opinion not very proper for public exhibition—I like no art which can raise a blush on a lady's cheek.

Charles Willson Peale to Thomas Jefferson, October 14, 1811, in Lillian B. Miller, ed., The Selected Papers of Charles Willson Peale and His Family *(New Haven: Yale University Press, 1991), vol. 3.*

My Son Rembrandt took the portrait of a noted Indian Chief called the Bastard, of a tribe from the upper lakes—he is 70 years old, a fine head, but what lead me to mention him is a striking trait of the Indian Character. As is usial the visiting Indians are shewn every thing that is esteemed curious in the City—A Painting by Vertmullier, Dana & the Shower of Gold now ex-

hibiting for pay—The Indians was led to see it, while the Conductor was arranging matters at the door, the Indian Chief & his Son was sent forward to the room of Exhibition, when the conductor came to the Room he found the old man & his Son setting with their backs towards the picture conversing togather, he then pointed to the piece which they were brought to see, The old man replied, "that was not fit to be seen" and they would not look at it. This exactly corrisponded with another instance of Indian modesty that I noticed before the revolution War, In one [of] my visits to Philada. to paint some portraits, I had my brother James with me and for his improvement I sett him to Copy a Venus coppyed from Titian by West, I finished it & put it in a private room at my lodging, some Indians was brought to see my paintings, this Venus was shewn them, one of the Indians by the Intreperter asked me "for what I painted this picture," he did not think it proper to make such pictures—. However well I love the art of Painting, In my present Idea's I think that we should guard against familiarising our Citizens to sights which may excite a blush in the most modest. The artist may always find subjects to shew his excellence of Colouring &c without choosing such as may offend Modesty. Therefore at our last Exhibition at the Academy of arts, I advised & procured some old pictures of Nudities to be put out of sight.

Charles Willson Peale to Rembrandt Peale, June 4, 1815, in Miller, ed., The Selected Papers of Charles Willson Peale and His Family, *vol. 3.*

I find by your letters to Rubens that you have made some important alterations in the Picture (*Niobe*) of Io., but do what you will with it, still I have my doubts that you cannot be safe in making an Exhibition of any kinds of *nudities.* You know very well that it is all important, to keep clear of every offence to religious societies; you must know that if they take it into their heads that such exhibitions are improper, their inviteracy knows no bounds, and your Establishment of the Museum may suffer irreparable injuries—. Religious ilnature knows no bounds. You may be taxed untill they oblege you to shut it up, I say they because the Corporation is cheifly composed of Prysbetereans & Methodists. If you do exhibit the Venes and the Io, I hope it will not be in your House. I have been much mortified by the Exhibition of them at Ruben's when I heard it said that it ought to be pre[v]ented as a public nuisance.

Perhaps you may get them sold by a raffle, and let them be seen in some other place rather than in your Museum.

William Lowndes to Elizabeth Pinckney Lowndes, April 29, 1812, University of North Carolina Library, Chapel Hill.

I have just returned from seeing, but I ought not to tell you of it, a famous picture, of which I suppose you have heard, by Westmuller.

It is the picture, in a very licentious taste (though the ladies here all go to see it), of Danae, with a shower of gold breaking into her apartment. The gold, and the bars, and the absurdities of pagan mythology are kept out of view, and the attention is absorbed by the figure, not of a divinity,—she breathes too much of human passion,—but of an exquisitely beautiful woman, who has no other dress than a braid of pearls for her hair. I do not mean, however, to give you a description of this fascinating picture, for though it may do you no harm to read, it may do me some to write or think of it. I had so little taste as to think that if the painter had given her a little drapery (as transparent as he pleased) of cambric or lace, so that she might have thought herself covered, the effect of the picture would have been heightened.

William Lowndes to Elizabeth Pinckney Lowndes, May 27, 1812, University of North Carolina Library, Chapel Hill.

I think that you were not in quite as good humour when you wrote your reflections on the Philadelphia "Danae" as I was when I wrote the description. I do not now remember what I said about her, but there is a matronly gravity in your style, which makes me fear that your disgust towards the painter is joined to some little displeasure against the describer of the painting. He must be strangely unreasonable who is not satisfied that his wife should now and then scold him in proof of her modesty. And though I do not require such a proof of yours, yet I think your remarks on the painting, on the ladies who visit it, and the sensualists who admire it, perfectly just, and in a lady of Carolina natural.

T.C., "Remarks on Various Objects of the Fine Arts," Port Folio 7 *(June 1812).*

For some years, there has been exhibited in Philadelphia, a painting by Wertmuller, a Jupiter and Danae. The painting has some merit in point of execution. I highly value the art of painting. It is a source of great pleasure: it is more: it may be employed to the best purposes of public good, by recording great men and great actions, with all the circumstances likely to give effect to the story, and through the eye to speak to the heart . . .

But this noble art is basely perverted and abused, when it is made a pander to those desires, that public expediency requires to be controlled, and when employed to portray those scenes, that public decorum requires to be shut out from the eye of day. Is it any credit to the art, or any credit to the city, that a picture should be publicly exhibited, which no modest woman would venture to contemplate in the presence of a man? and that particular days should be set apart by public advertisement, when the female sex have the exclusive privilege of indulging their culpable curiosity? A curiosity certainly excited rather by the nature of the subject than the merit of the artist.

"NATIVE" SUBJECTS VS. CONTINENTAL TASTE

The following essay, written just forty years after the beginning of the revolutionary struggle, begins by asking why so many American artists leave to pursue careers in Europe. It offers some familiar answers, including a lack of institutional support and a dearth of inspirational collections. The author also points to the uncultivated state of public taste, which leads to some more original comments, especially regarding landscape painting. The uneducated eye, it is argued, prefers simple, transcriptive views, not "the exquisite combinations of the painter." The latter, dependent on European picturesque theory, are intellectual rather than merely instinctual; thus, this higher appreciation requires that the viewer's mind be "instructed how to perceive." None of this is new to aesthetic discourse of the period, but the author goes on to suggest that American scenery—vast and raw—may not be able to provide artists with suitable material for cultivating this higher taste. American nature is unrefined, and it is too familiar to Americans, who will want to see their own preconceptions mirrored in recognizable landscape images. Similarly, American "peasantry" is deemed insufficiently individual and distinctive to occupy painters of genre. In both cases, the author asserts that Americans will be elevated only through a wider experience of artistic subjects, one that includes the history-laden topography of Europe. This view that artists who confine themselves to "native" subjects are necessarily limited would become

anathema to the next generation of critics, who stressed a patriotic celebration of local
subjects, unfettered by European aesthetic filters.

"On the Fine Arts," North American Review 3 *(July 1816).*

There are, perhaps, few subjects more grateful to our national pride, than the progress the fine arts have made under the genius and industry of our countrymen. There is a welcomeness in the reflection, that we have done something in this elevated department of the mind. We feel that we shall live in the works of art we have accomplished, we shall live in the sentiment which for ages has consecrated the canvass, which places the ancient painting in close company with the most elevated and venerable mental labours; which associates the most recent with the most remote age, and which promises to bear us along in perpetual remembrance. We feel a pride in these reflections, because they assure us, we shall not be forgotten: we feel, that when time shall have confirmed the decisions of nature, our age may constitute a venerable antiquity.

It is grateful to know, that in the brightest periods of the mind in earlier times, the fine arts most vigorously flourished. While some men were giving language to thought, and words to nature, by one species of signs; others were occupied with giving character to the marble, or perpetuating passing events, by the species of painting then in use. Now, if with us the arts have preceded literature, it is merely because the peculiar circumstances under which we exist, have prevented great literary enterprise; men of genius have not been able to command foreign efforts of art, but have laboured to supply themselves by their own industry and talent.

But with all our native spirit, and love of the arts, there has not been yet a great deal done, to keep alive the zeal, or to cherish the affection. Before, however, inquiring into the state of the fine arts among us, it would be well to consider some of the motives which have influenced so many of our artists to leave us, and to make European galleries the depositories of their best works. The inquiry is of some importance; for the honour these artists should have reflected on America, has been yielded to other nations. In England, for instance, patronage has superseded birthright. But who will dispute the title to the fame our artists have been instrumental in bestowing on England? Is it not a fair exchange, for the protection that country has afforded our own genius?

There are many reasons why our artists should not have remained at home. One, and that involves all the rest, is the youthfulness of the country. From the total want of appropriate institutions in some places, and their infancy in others, we can hardly be said to possess adequate means of cultivating the arts.

Our artists have gone abroad to contemplate and study the master works of their favourite art, which were not, and could not be afforded them at home. They have gone abroad, to live under the inspection, the discipline, the influence of men who have devoted their lives to the study of the best specimens of art, and who have been eminent patrons of the arts themselves, in their own works. Some have said, we could not support the genius we were vigorous enough to produce. I grant that the cry of poverty may have deterred individuals from hazarding a support, for the uncertain immunities of fame; but if we were possessed of the means of intellectual support, our artists would have run the chances of patronage.

Another important reason why our artists leave us, is, that in this country the publick are somewhat deficient in a refined taste for their labours. The publick with us cannot yet discriminate accurately, between the various specimens of the fine arts presented to them; we speak here of their comparative merits. The artist may therefore fear to trust himself, or rather his works, either to inspection or comparison. They may not please by their own merits, and com-

parison may result in a very unjust and unfortunate award. It is not meant that we want taste, or power of discrimination. Very few people among us can be found at all refined, who are not pleased with just delineations of nature. But the perfection of the perception, and the real enjoyment of what is true to nature, is founded either in a relish of nature itself, or in an habitual contemplation and study of the best picture landscapes. We may love these without ever having studied, or even been delighted with the real landscape. But to love them with a genuine and lasting affection, we must have given our hearts in some measure, to the exquisite combinations of the painter. To that magick of grouping, which brings together in perfect harmony, the beauties of the heavens and the earth, the cloud and the mountain, the stream and the wood. The pleasure afforded by works of art, is thus strictly and purely an intellectual enjoyment. It is not merely an instinctive, or natural perception. The ridiculous, the monstrous, the absurd in art, have ever had the most admirers. The genuine lover of nature, and of delineations of nature, must be one who has observed for himself, or studied the observations of others. If he has not possessed facilities for the study himself, but always have received nature at second hand, his criticisms will not be the less correct, if his standards have not been so. He will very often be a better critick than the mere copier of woods or hills, and detect a fault where every branch is in its place, and a thousand, where every cliff is most geographically detailed. In London men love the landscape, and know how to estimate the labours of Turner. They look at his exquisite skies with delight, not that they have had the most favourable opportunities of studying nature, but chiefly because they have seen fine representations of nature, and are as good criticks of what is natural or not so, as if they had not inspired the eternal fogs and smoke of the city, but had lived forever in the woods or fields. It is not meant here to speak of the perception of what appears after nature in the picture landscape, for many may possess this power, but of the genuine relish of its beauty. If these remarks be correct, it would follow, that to enjoy what is truly beautiful in art, it is necessary that the mind be deeply susceptible of what is beautiful, from habitual observation of it. It would appear, that it is necessary that the mind should have been presented with unequivocal standards of excellence in art, or attentively observed the beautiful in nature. In fine, that the mind should have been instructed how to perceive, if it may be so expressed, by the previous sanctions of taste, that a given production of the fine arts, is, as far as it is susceptible of perfection, perfect.

If then a majority of those who among us at all patronize painting, are only delighted with the resemblance picture landscapes may bear to their conceptions of nature, but are to a degree unsusceptible of those higher pleasures of taste, which flow from a genuine relish and understanding of the effects of genius, operating on the materials offered it by nature, we have an additional reason for the emigration of our artists to other countries . . .

It must not be concealed, that the above remarks are true so far, and no farther, than as we mean in this country to make progress with other nations in the fine arts. If our artists mean to labour with them, they must refer to the same or similar standards, and submit to a similar tribunal. It may however be a favourite project with some of our artists, to labour to give their works an original character, and by striving for a species of individuality in their labours, to found a new school in this country. They may turn from examining the specimens of the Flemish school which may lie in their way, which owe so much of their reputation to their admirable delineations of national manners, and calculate on a similar fame with their authors, if they are as successful in their illustrations of the scenery and pastoral life of their own country. But is there not some hazard in indulging a sentiment so honourable in its final cause, as this appears to be? Have we in fact enough that is peculiar in this country, to trust one's reputation exclu-

sively to its delineation? Our country has, it is true, every variety of surface, and the vegetable productions of all climates. Its mountains are lofty, and its woods majestick—its lakes are lost in distance, before the eye which would paint them. But would not the landscape painter, who should leave the regions of cultivation, to give his pencil to the simple service of nature, be in some danger of returning to us with his canvass loaded with a thousand woods, or washed by an interminable sea? Would there not be some hazard, that amid such luxuriance in nature, such magnificent confusion, an indistinctness of mental vision would be produced, or that the best exertions that genius might make, would be sacrificed to an affected fidelity? Suppose, on the contrary, that an artist, really possessing distinguished talents, to submit his mind to the instructions which the best efforts of genius afford, to lay in fact a foundation in their careful, but independent study, with what clearness of perception, with what powers of discrimination and combination would he approach the scenes just mentioned? Farther, have our peasantry individuality enough to ensure the artist, who may study and delineate their habits, a lasting fame? Is there enough that is peculiar in their costume, their manners, their customs and features, to enable an observer at once to recognize them in a picture? The great claim of delineations of this kind, consists in their striking truth; or in their novelty, their originality. We can ascertain their truth by our knowledge of their originals only. But for them to delight us by their truth and originality, their correctness will perhaps not be taken into the account, they must be new to us, and still bear a resemblance to what has, or does exist. We are interested in the new costume and new countenance, because they in some sort extend our knowledge of human society. And when the foreign artist descends to the detail of the amusements and mechanical occupations, to the domestic economies of his countrymen, we are still more indebted to him for the new acquaintance to which he has introduced us. He becomes in short a most interesting historian, of all that most delights us in the outside of human nature. Now many of these sources of interest must be wanting to the native artist, who confines himself to our own country. His pictures will want novelty—They will not extend our knowledge. And unless we have observed the inhabitants of our villages with more than a casual glance, unless we have caught their faint, but distinctive characteristicks, the whole claim of native peculiarity will be wanting, and the painter, for us, will have gleaned them in vain . . .

These remarks are suggested, not to depress that honourable enterprise, which would detain a man of real genius among the scenes, or manners of his native country; they have been made, because these scenes and these manners have been adverted to by some, as the best studies for the young artist, and because their peculiarities, their originality, have been considered as even better objects for study, than the management of nature in other countries, which fine picture landscapes consist in, and those delineations of foreign manners, which distinguish peculiar schools. It may have been thought, that the painter of our own country would have an easy road to fame. It has been attempted in the above remarks to show, that the labours of genius are efforts of mind, and that he who seeks for reputation in feeble executions, or at best but mechanical skill, is in some danger of being disappointed of his fame. He may be a gainer at home, but he will be a loser abroad; and above all, his fame will not be safe, even in his own country, provided its maturer age be blessed with a better taste.

A PLAN FOR GOVERNMENT PATRONAGE OF HISTORY PAINTING

In 1817 John Trumbull received probably the greatest commission the U.S. government every gave to a painter: four large history paintings in the Capitol rotunda depicting

scenes from the American Revolution, all for the unheard-of price of $32,000 (see "John Trumbull Paints Revolutionary History," this chapter). Although he would be disappointed in his attempts to be assigned the remaining four rotunda paintings, the artist had still other proposals for encouraging government patronage of the arts, as is the case in this letter written to President John Quincy Adams. In a subsequent communication (not included here), Trumbull estimated the cost for each "historical record" of an event (original painting, painted copy, and two thousand engravings) at $6,500, which he confidently suggested the government could recoup through sale of the prints.

John Trumbull to John Quincy Adams, December 25, 1826, reprinted in William Dunlap, History of the Rise and Progress of the Arts of Design in the United States *(New York: George P. Scott, 1834).*

I beg permission to submit to your consideration the following plan for the permanent encouragement of the fine arts in the United States: public protection has already been extended, in a very effectual manner, to various branches of the public industry employed in manufactures of different kinds; and I wish to call the attention of the government to the fine arts, which, although hitherto overlooked, may, I trust, be rendered a valuable, as well as an honourable branch of the national prosperity, by very simple and unexpensive means.

I would propose that whenever an event, political, naval, or military, shall occur, which shall be regarded by the government as of sufficient importance to be recorded as matter of history, the most eminent painter of the time, be ordered to paint a picture of the same, to be placed in some of the national buildings—that an artist of secondary talent be employed to make a copy of the same, which shall be given to the minister, admiral, or general under whose direction or command the event shall have taken place, as a testimony of the approbation and gratitude of the nation.

It appears to me that this would operate as a powerful stimulus to the ambition and exertions of the national servants in their various departments, as well as an effectual encouragement to artists, and an honourable mode of exciting their unremitting endeavours to attain to the highest possible degrees of eminence.

I would next propose, that the most distinguished engraver of the day should be employed to engrave a copperplate from the painting so executed, and that one thousand impressions, first printed from this plate, be reserved by government for the purpose hereafter designated; the remaining impressions which may be printed, to be sold, and the proceeds applied to a fund destined to defray the expense of the plan.

This part of the plan is founded on the experience of individuals who have pursued the business of publishing and selling engravings, many of whom, after paying the painter, the engraver, the paper-maker, the printer, and all the various expenses of publication, have acquired considerable fortunes in reward of their enterprise and exertions . . .

Every minister of the United States, going abroad on a mission, should be furnished with one (or a set) of these reserved engravings, as an article of his outfit; they should be handsomely framed and hung in the most public and elegant apartments of his foreign residence—not so much for the purpose of ornament, as of showing the people among whom he resided, at once an historical record of important events and an evidence of our advance, not only in political, naval, and military greatness, but also in those arts of peace which embellish and adorn even greatness itself.

Every minister of a foreign nation returning home from a residence among us, should also receive one (or a set) of those prints, in a handsome port-folio; and the same compliment might occasionally be paid to foreigners of distinction, visiting the country from motives of curiosity or a desire of improvement, in the discretion of government.

An historical record of memorable events, and a monumental tribute of gratitude and respect to the distinguished servants of the nation, would thus be preserved in a series of paintings of unquestionable authenticity; the principal works adorning the public edifices and placing before the eyes of posterity the glorious examples of the past, and thus urging them to that emulation which may render the future yet more glorious; the smaller works in possession of the immediate descendants of those who had thus received the thanks of the country, decorating private houses with the proud evidence of individual service and of national gratitude, and thus kindling all the talent and energy of succeeding generations to elevate, if possible, at least not to diminish the honour of the name and nation; while the engravings in a more portable, more multiplied and less expensive form would disseminate through the world evidence of the greatness and gratitude of the United States.

Talent for all the elegant arts abounds in this country, and nothing is wanting to carry their votaries to the highest rank of modern or even ancient attainment, but encouragement and cultivation; and although all cannot hope to rise or be sustained in the most elevated rank, still the less successful competitors would become eminently useful by turning their abilities to the aid of manufactures. It is the overflowing of the schools and the academies of France which has given to the manufacture of porcelain at Sevres, and of or-molu time-pieces and ornaments in Paris, that high pre-eminence over the rival attempts of other nations, which drives them almost entirely from the markets of elegance, and thus becomes the source of very considerable wealth to France.

The history of the United States already abounds in admirable subjects for the pencil and the chisel, which should not be suffered to sink into oblivion: the last war especially, is full of them, and it seems to me that this is the proper field for the present and rising artists to cultivate; the field is not only fertile and extensive, but is hitherto untouched, and seems to solicit their patriotic labours and to chide their delay. They are contemporaries and familiar with the actors and the scenes they are called to commemorate, and can therefore fulfil the duty with enthusiasm, a knowledge of facts, and a degree of absolute authenticity, which ensures success and would give real value to their works. Nor should it be forgotten, that the stream of time is continually, though silently, bearing away from our view, objects, circumstances and eminent forms, which memory can never recall.

The public buildings offer fine situations for the display of works of this nature, not only in various apartments of the capitol, but in the house of the president, where the great room now furnishing, would with more propriety and economy be enriched by subjects of national history, executed by our own artists, than loaded with expensive mirrors and all the frivolous and perishable finery of fashionable upholstery.

By giving, in such way as I have here taken the liberty to suggest, a right direction and suitable encouragement to the fine arts, they may be rendered essentially subservient to the highest moral purposes of human society, and be redeemed from the disgraceful and false imputation under which they have long been oppressed, of being only the base and flattering instruments of royal and aristocratic luxury and vice.

CITIZENS: DOCUMENTS ON PORTRAIT PAINTING

BUSHROD WASHINGTON COMMISSIONS A PORTRAIT

Bushrod Washington, nephew of George Washington, was studying law in Philadelphia when he turned twenty-one and decided to have a portrait painted of himself. In these two letters to his mother (the first of which has suffered a loss of some words because of a tear in the manuscript), he rehearses the reasons for his choice of Henry Benbridge over Charles Willson Peale, explains his preference of format, and muses on the success of the likeness. In selecting his artist, he and his wealthy friends Samuel and Elizabeth Powel appear to have been swayed by the Philadelphia-born Benbridge's four-year period of study in Italy. They also may have been persuaded by the fact that Benbridge was considered a "gentleman" by birth, unlike Peale, who was the son of a felon. Interestingly, Washington opted for the smaller "Kit Kat" format (essentially, a half-length view) for his portrait because the larger "Three-Quarter" view would have cut him off awkwardly at the knees. Whether he was an unusually vain young man is hard to say. Nevertheless, it is fascinating to read his thoughts on how well Benbridge has captured his face and personality, a topic he evidently discussed with several acquaintances. This perspective of the sitter and his friends offers a rare glimpse into the consumer end of the portrait transaction.

Bushrod Washington to Hannah Bushrod Washington, April 12, 1783, George Washington Masonic National Memorial Association, Alexandria, Virginia.

I have at length determined to have my picture taken, even before I am able to pay for it—This Resolution was taken . . . [in con-]sequence of many convenient opportunitys which have lately . . . which might easily have conveyed the Picture to Virginia had it be[en] ready—It had been for some time a subject of much doubt with m[e] who I should employ—There were two Painters, whose talents were great, though in some Respects different—I discovered in Peale's paintings the more striking likenesses—In Bembridge's the most elegant and superior Drapery—Whether I should prefer the first of these qualities or the last in a picture, I was not long in determining, since the principal End, is to give an absent friend, or posterity, an idea of a face whi[ch] they had never seen, or If the likeness then is a Bad one, the most perfect drapery will not stamp its value, any more than a Continental Bill which bears on its face the type of *thousand*—But the Question which perpl[exed m]e was, whether, it would not be better to run the risque of Bemb[ridge taking] my likeness (as it is well known that there are traits in . . . if fortunately taken, ensures the success of the . . . the advantage of Drapery, or to be more certain . . . the disadvantages of having it daubed—[I was] at once relieved from my suspence, by the advice of Mr. Powell, whose Judgment in Paintings I was well convinced of—His Reasons were fo[r] Mr. Bembridge was entitled to claim the superiority over any other Man [in] America—To a strong Genius, he has added every improvement which in . . . study, and travelling could procure—He has seen all the finest paintings . . . and his taste could not fail of being highly improved—Besides he has paints brought with him from Italy, which Peale can not procure—

I then determined at all events to fix my choice on him, and I am happy to assure you that the best performance has fully justified the measure—The likeness is so striking that Persons who have never seen me more than once or twice, have discovered immediately the resemblance—I think I can see it myself and that is not very easy—I am sure at least that Peale could not have taken a stronger—And I can venture to affirm than in every other respect he is not equal to it—

I intend to have an Elegant frame put to it—If I Remember well you desired it to be drawn to the knees—But I have ventured to oppose this instruction, and hope my reasons will be satisfactory—In this, I acted from the advice of my friends, as well as my own opinio[n that a] Gentleman if he is drawn below his middle, ought to be . . . because otherwise if you stop at the kn[ees] with the disagreeable idea, of his being cu[t] standing on his stumps—It is not [so with a] woman, becau[se] difference in dress changes the effect—This may be a false taste, b[ut] [I] find it is a very general one—Beside the price would have been much greater, and this is material— In short I hope, and doubt not, but that you will be much better pleased with it, in it's present state—It [is] not yet finished, but will be in a fortnight—Talking ab[out] I cannot help telling you an anecdote which it produced—I was the . . . Day talking with Mrs. Powell on the subject and drawing a compariso[n] between the Virtues of the Painters—Well, exclaimed I, if Mr. Bembridge should be so fortunate as to strike my likeness, it will be a most *Elegant Picture*—Altho' this was innocently said, and only meant that the grand object of likeness being obtained, his superior talents in drapery would make his, (not nature's work) elegant, I soon discovered that I had laid myself open to Mrs. Powell's raillery and that her Readiness to take advantage of the mistake would not permit her to pas[s] in silence—Nor did she—your servant, Sir, I find you ha[ve] a very good opinion of yourself, and vainly suppose yourself a Perfect Adonis—The Reproof had it been serious, or had I deserved it, would have made me sincerly wish that I had been tongue tied—And even coming from Mrs. Powell in the most pleasing raillery, I could not help blushing—However I soon recovered and we had a very hearty laugh at my expence—

Bushrod Washington to Hannah Bushrod Washington, July 1, 1783, Mount Vernon Ladies' Association of the Union, Virginia.

You will now Receive my picture, and I have but one wish respecting it, which is that it may answer your expectations—I shall be anxious to hear your opinion—I have often been asked a question which it has puzzled me to answer from a sense of Delicacy—However to you I will venture to give my opinion freely because I know you will never accuse me of Vanity, a foible which my acquaintances know I least of all possess—Whether the Painter has done me Justice or Not is the Question—I think he has cautiously avoided flattering me, and for this I commend him, but in one respect I hope he has erred on the other hand—He has thrown me into a thoughtful posture which in my opinion rather borders on austerity than intense meditation— Of this however there are a variety of opinions—Some say, that having a Book in my hand which I appear to have been Just reading, that the Countenance is very properly expressed— Some Join with me in thinking that their is a degree of ill Nature in it—But the opinion of my friend Mr. & Mrs. Powel has so much weight as almost to have made me a Convert—They say that the Countenance is not an ill natured one, nor entirely thoughtful, but rather a mixture of thought with Pensiveness, and that they have sometimes seen me in that situation—I believe if I am apt to look so, I did at the time it was taken, for I was so engaged with some favourite subject that I forgot how the time passed—I wish I had avoided it—

GEORGE WASHINGTON: THE IMAGE INDUSTRY

Within his own lifetime, George Washington had become practically deified; contemporaries were repeatedly struck dumb at the mere sight of him. Naturally, portraits of the first president were desirable commodities, particularly if the artist could claim to have been given a life sitting by the great man. Washington had to deal with many

such requests, and in his letter in reply to one on behalf of Robert Edge Pine, he seems to accept his lot with equanimity. Another famous sitting was engineered by Charles Willson Peale in 1795. Peale had all but ceased to paint portraits, but he knew the opportunity to paint Washington from life would be valuable to his sons in their later careers, so he gathered his clan for the occasion—an event humorously related by Gilbert Stuart (see also "Gilbert Stuart: Eyewitness Accounts," this chapter). Several decades later, the early art critic John Neal, an eccentric writer who knew many painters, also refers to that episode in his novel Randolph, *but in his view any portrait by a Peale had long been eclipsed by the notoriety of Stuart's likeness. Rembrandt Peale sought to change that impression by painting a "standard" likeness, the project that became his imposing* Patriae Pater *(1824), a portrait he describes in a letter seeking Thomas Jefferson's approval.*

With Rembrandt's new claim to exclusive authenticity, things had come to such a point that the American Academy of the Fine Arts found it necessary to form a catalogue of the "best" life portraits of the president. This is no neutral document, for in addition to a respectful nod to Stuart's Athenaeum portrait (1796) the work of AAFA president John Trumbull is decidedly praised. Conspicuously absent in the remarks is any mention of the Peales, and there is even a not-so-veiled snub of Rembrandt's assiduously promoted "Certificate" portrait, the Patriae Pater.

George Washington to Francis Hopkinson, May 16, 1785, in William Dunlap, History of the Rise and Progress of the Arts of Design in the United States *(New York: George P. Scott, 1834).*

'In for a penny in for a pound' is an old adage. I am so hacknied to the touches of the painter's pencil, that I am now altogether at their beck, and sit like Patience on a monument, whilst they delineate the features of my face. It is a proof, among many others, of what habit and custom may effect. At first I was impatient at the request, and as restive under the operation as a colt is of the saddle. The next time I submitted very reluctantly, but with fewer flounces: now, no dray moves more readily to the drill, than I to the painter's chair. It may easily be conceived, therefore, that I yielded a ready acquiescence to your request and to the views of Mr. Pine.

Letters from England recommendatory of this gentleman came to my hands previous to his arrival in America—not only as an artist of acknowledged eminence, but as one who has discovered a friendly disposition towards this country—for which it seems he had been marked.

Gilbert Stuart to John Neagle, in Dunlap, History of the Rise and Progress of the Arts of Design.

I looked in to see how the old gentleman was getting on with the picture, and to my astonishment, I found the general surrounded by the whole family. They were peeling him, sir. As I went away I met Mrs Washington, 'Madam,' said I, 'the general's in a perilous situation.' 'How, sir?' 'He is beset, madam,—no less than five upon him at once; one aims at his eye—another at his nose—another is busy with his hair—his mouth is attacked by a fourth—and the fifth has him by the button; in short, madam, there are five painters at him, and you who know how much he has suffered when only attended by one, can judge of the horrors of his situation.'

John Neal, Randolph: A Novel *(1823), in Harold Edward Dickson, ed.,* Observations on American Art: Selections from the Writings of John Neal (1793–1876) *(State College: Pennsylvania State College, 1943).*

You have heard of Copley. He was a strong, homely painter; but some of his portraits have great merit—There is Stuart, too; he has been among you—and you have seen his Washington. I have

seen copies of it in Bengal, done in China. You have seen many. All are like each other; but none are likenesses of Washington. There is too much sublimity in the face. Stuart's Washington, I have heard my father say, who knew him well, was less what Washington was, than what he ought to have been. The painter has infused into it, an amplitude and grandeur, that were never the attributes of Washington's *face*. It is true, that there was a settled majesty;—an oppressive and great steadiness in the countenance of Washington, that awed and confounded men. His passions were tremendous, even in their repose; and it was impossible to become familiar with him, even at his own fire-side. The men that knew him best, and had been much with him, at times, when all mankind are brought into a kind of fellowship; in the field of battle, and at the dinner table; in the senate chamber, and at places of public entertainment; always went around him reverentially, and regarded him, afar off, without approaching; as men might, a sleeping giant, whom it were impossible to contemplate with composure.

Stuart says, and there is no fact more certain, that he was a man of terrible passions; the sockets of his eyes; the breadth of his nose and nostrils; the deep broad expression of strength and solemnity upon his forehead, were all a proof of this. So, Stuart painted him; and, though a better likeness of him were shown to us, we should reject it; for, the only idea that we now have of George Washington, is associated with Stuart's Washington. Yet, why should we complain? It matters not how a picture is painted, so that the copies are multiplied and received (if they resemble *each other*,) as likenesses. There is a Mr. Charles W. Peale, of Philadelphia, who wrought at Washington's face, at the same time with one or two of his sons, and somebody else: all occupied themselves with different views, and different features—and, out of this, has been compounded a picture, no more like *Stuart's* Washington, I confess, than "I, like Hercules." And yet, I am well assured, that it is a better likeness; and, indeed, the *only* faithful likeness of the man, in the world. Judge Washington, himself, I am told, has said this.

How strange it is!—Thus we get accustomed to a certain image, no matter how it is created, by what illusion, or under what circumstances; and we adhere to it, like a lover to his mistress. If George Washington should appear on earth, just as he sat to Stuart, I am sure that he would be treated as an imposter, when compared with Stuart's likeness of him, unless he produced his credentials. At Mount Vernon, there is a picture of him, just after his marriage with Mrs. Custis. I have studied it with attention. It is of an ordinary man. There is not a single feature, or expression of greatness in it. Yet it is said to have been a remarkable likeness. I have often thought of the probable reception which *that* picture would meet with, if exhibited, *now,* as the portrait of Washington. It would be laughed at. I say—of what importance is it, whether Stuart's portrait of him be a likeness or not, so that all the portraits of him, are by Stuart, or copies of Stuart.

Rembrandt Peale to Thomas Jefferson, January 8, 1824, Library of Congress.

The Artist who is devoted to his pencil seldom writes with his pen, yet I am induced to take up mine to inform you that my pencil, which of late was employed in the Court of Death, is now performing the mighty act of resuscitating the form of Washington. Although he sat to me for an original Portrait in 1795, and both my father & Stuart painted him in the same year, yet neither of these Portraits ever satisfied me, nor have they satisfied the friends of Washington——Each possesses something good which the others do not, and each has its own peculiar faults. In addition to those materials, we have Houdons bust, which being made by a mask which was taken from the face of Washington himself, furnishes the exact proportions & the forms of the solid parts, tho it be defective in the expression of the soft parts.

My Portrait is a composition from all these, taking my father's as a base upon which to build—because it is the only one that represents him with his peculiar & Characteristic cast of the head. And I have already advanced so far in it as to satisfy my father that it will surpass everything intended as a representation of Washington. In a few weeks it will be ready to take to the City &, if possible, it is my wish to pay you a visit with it, because if it merit your approbation it not only would afford you some gratification, but your judgment would be of great service in establishing the accuracy of the work which is intended as a National Portrait & standard likeness.

There never was a Portrait undertaken with greater zeal And this is heightened to the extreme point by the conviction that this great work can be accomplished by no one but myself, as I am the youngest of those to whom Washington sat, & the only one who is not prejudiced in favour of his own portrait.

Stuarts portrait is full of dignity & character, but is certainly inaccurate in the drawing & exaggerated—& particularly defective about the mouth, which looks as if it was full of Water. My fathers, tho' expressive in the general Cast of the head & something peculiar about the eyes, is quite unfinished in all the lower part of the face. Mine is more detailed where his is deficient.

The Portrait I am now painting has a grand & imposing aspect & is calculated for public Buildings—But I have designed, to suit the same head, an Equestrian Portrait, with the hope of getting a commission to paint it for the National Hall. This would be particularly flattering to me before I pass to Europe, where I contemplate removing next Summer——indeed nothing but a large commission from the public can delay me. The Arts are not sufficiently encouraged here, whilst London offers everything to stimulate their professors to the greatest exertions. Three times, after visiting Europe, have I tried to be satisfied with the state of things at home——but commerce engrosses all attention—there is no Wealth, leisure nor fancy for the Fine Arts, And I long for a Society in which they are appreciated, employed & rewarded.

American Academy of the Fine Arts, "Original Busts and Portraits of George Washington," Atlantic Magazine *1 (October 1824).*

We shall add a few remarks on the chief characteristics of those sculptured and painted portraits of Washington which were done from life, by artists the most respectable for talents, and which he actually sat for; premising with a few introductory reflections.

It was a wise decree of Alexander the Great, that none should paint his portrait but Apelles, and none but Lysippus sculpture his likeness; we feel the want of such a regulation in the case of our Washington, whose countenance and person as a man, were subjects for the finest pencil, or the most skilful chisel. But we are cursed as a nation in the common miserable representations of our Great Hero; and with the shocking counterfeits of his likeness by every pitiful bungler that lifts a tool or a brush, working solely from imagination, without any authority for their misrepresentations and deceptions, and bolstered up by every kind of imposture.

This evil has arisen to such a height, that it is necessary; for something to be done with a view to rectify the public sentiment, on this point, now so warmly agitated, so as to undeceive posterity. For these reasons we have drawn up this list of artists, who painted and sculptured him from life, as far as is ascertained; and give the various circumstances under which they executed their likenesses, that the public may know where to find the true standard, of what were genuine likenesses of Washington, at the respective periods of his life in which they were done; with a comparative view of those originals most worthy of confidence, which we necessarily limit to six of the best artists, who took his likeness at those periods of his life most interesting

to us; and which at the time they were done, met the decided approbation of the most competent judges, no one ever imagining it necessary to procure a set of certificates, as to their authenticity or genuineness for verisimilitude, with which spurious or imaginary impositions are bolstered up.—Therefore,

1. If we wish to behold the countenance of Washington in his best days, we must look at the bust of *Houdon;* who gives the air of the head and costume of the hair of the day, but with closed lips; in his best manner, and of whose competency to the task he undertook there can be no doubt.

2. If we wish to behold his complexion, and expression of the eye with an averted aspect; let us look at Pine's portrait in military uniform; the excellence of the painting, and its correspondence with the other genuine originals, speaks volumes as to its character.

3. If we wish to behold Washington, not only in his countenance, but the full display of the air of majesty and figure of the man, with eye averted, we shall find it in *Trumbull's brilliant* whole length.

4. If we wish more particularly to see the graceful play of the lips in the act of speaking, and the peculiar expression of the mouth and chin at the same moment, we shall see it in Ceracchi's colossal bust.

5. If we wish to behold Washington, when he began to wane in his latter years, when he lost his teeth, but with full vivacity and vigour of eye, looking at the spectator, we must behold Robertson's; it is somewhat remarkable that Robertson and Stewart only make him look at the spectator.

6. If we wish to see President Washington, as delineated from the life, in 1796, by one of the first portrait painter's of his day, let us look at the original picture in the possession of the artist, G. Stewart, now in Boston. The head only is finished in this picture. The drapery has never been added.

This last differing so essentially from all other portraits, has been the cause of all the dissension about Washington's likeness; although we have not the least doubt the artist gives us a true representation of the man when he sat to him; and thus we explain why we ought to receive all these originals as correct likenesses at the time they were done, for it is impossible that one picture can represent him with his teeth, without them, and with a new set of formidable ones, at the same time.

From whence we conclude, that it is a self-evident absurdity to speak of one picture, as being a standard likeness of Washington; for it must take three originals at least to give a tolerable idea of his looks at three different periods of his life; and the three only competent for this purpose are those of Trumbull, the best by far of those done whilst he had his own teeth; that of Robertson, when he wanted his teeth; and lastly, that of Stewart, when he had this want supplied by a set of artificial ones.

RALPH EARL AND REUBEN MOULTHROP: CONNECTICUT ITINERANT PAINTERS

Ralph Earl and Reuben Moulthrop were among the group of itinerant portraitists who traveled throughout Connecticut during the late eighteenth and early nineteenth centuries (see also "A Folk Artist Overcomes a Disability," chapter 4). This selection of letters and advertisements documents a trip each artist made to the remote northwestern corner of that state.

Earl was born in rural Massachusetts, but by the time he corresponded with Elijah Boardman he had worked in England and New York City as well as New England. His cosmopolitan experience set him apart from the local talent, and Boardman is a good example of a provincial patron who was willing to pay more—and evidently, provide transportation—in order to secure a fashionable likeness. (The less talented competitor referred to in Boardman's letter and the advertisement is probably one of the father-son team of Richard and William Jennys.)

Twelve years younger than Earl, Moultrop began painting portraits around 1788, although the following advertisements indicate that he provided Connecticut residents with more theatrical entertainments as well, through his wax sculptures (complete with tailored clothing) of such subjects as "The King of France Beheaded" and "An Old Maid Whipping Her Negro Girl." Excerpts of letters written to Thomas Robbins, who paid the artist $30 to journey to Norfolk, Connecticut, to execute likenesses of his parents, give an idea of the portrait side of Mouthrop's business. It took a surprising five years for Moulthrop to travel the seventy-five miles to execute the commission. While there, he painted seven portraits in seven weeks, bartering one for oats and blacksmith work for his horse. The arrival of the portraitist was quite an event in Norfolk, according to Robbins's father, who describes a steady stream of curious visitors to his house.

Elijah Boardman to Ralph Earl, April 3, 1795, private collection.

I have promised Mrs. Boardman the pleasure of having her Portrait taken by your inimmitable hand—our little son also—the fetures of neithr ar so ugley as to wound the imagination or cram the hand of the portrayer. After it was reported that you was coming to New Milford, Several Gentn. made application to know if they could depend on your coming here who wanted their Portraits taken perhaps on reason of their inquiry is that a Portrait Painter is here from Boston and has taken several persons and perhaps may more unless they can depend on you. He will not how[ever] paint my family and many other that I know of who are somthig acquainted with Painting. Let me Sir depend on Seeing you here a welcome Friend in my House.

Ralph Earl to Elijah Boardman, September 19, 1795, private collection.

I receved a lottor from you a few days scence, informing me that you would wish for me to com to New milford, for a fue days, Send a hors by the post next and I will com on with him without fails.

Advertisement, Litchfield Weekly Monitor, May 18, 1796.

Mr. Ralph Earle, the celebrated *Portrait Painter,* is now at New-Milford; where he will probably reside for some time. As we profess a friendship for Mr. Earle, and are desirous that the Public avail themselves of the abilities of this able artist, we feel a pleasure in making this communication; many gentlemen in this vicinity, having been disappointed of his services, and several of our friends being driven to accept of the *paultry daubs* of assuming pretenders. Mr. *Earle's* price for a Portrait of full length is *Sixty Dollars,* the smaller size *Thirty Dollars;* the Painter finding his own support and materials.

Advertisement, Connecticut Journal, *September 4, 1793.*

REUBEN MOULTHROP
Artist in PAINTING and WAX-WORK,
Respectfully informs the Public, That he has moddelled in Wax, a striking Likeness of the KING OF FRANCE in the Act of losing his Head, under the GUILLOTINE, preserving every Circumstance which can give to the Eye of the Spectator a realizing View of that momentous and interesting Event. Also

A SPEAKING FIGURE, which, even in its unfinished State, has afforded the highest Satisfaction to the Curious. Also

AN INDIAN CHIEF, being an exact Likeness of a Cherokee, who was at Philadelphia.

These Figures will be exhibited at the Sign of the GODDESS IRIS, in State Street—The Doors will be open on Monday next, at 8 o'clock in the Morning till 9 in the Evening, and for the same Hours in every successive Day.

Admittance One Quarter of a Dollar, and One Eighth for Children.

MR. MOULTHROP hopes that his Exhibition may prove a valuable Addition to the Entertainment of Commencement Week.

N.B. MINIATURE AND PORTRAIT PAINTING as also exact LIKENESSES in WAX, taken by MR. MOULTHROP at short Notice.

Advertisement, Connecticut Gazette, *June 2, 1796.*

MOULTHROP & STREET
Respectfully informs the ladies and gentlemen of New London, that, on Tuesday, May 31, at the house of Mr. Pool, they opened an exhibition of WAX FIGURES, consisting of the following:
The President of the United States
The late Rev. Dr. Ezra Stiles

The late General Butler, who fell at St. Clair's defeat, represented as wounded in his leg and breast, and an Indian rushing upon him with his tomahawk.

The Guillotine, with a perfect representation of the
King of France beheaded,

Dr. Spalding represented as performing a most extraordinary cure of a man who lately attempted to kill himself by cutting his throat in such a manner that his life was despaired of: This is allowed to be the most astonishing piece of art, ever attempted in the practice of surgery. The man cured is now living in the State of Connecticut, in perfect health.

The Sailor and his Girl; or Courtship
The jolly Sailor, with his Bottle
An old maid whipping her Negro Girl, or domestic Discipline
The Romp, chided by her Mother
The Mother's Darling; or a lady with a beautiful Child
The New London Beauty; or a Likeness of one of the most handsome young ladies
The Barber shaving a Clergyman
An Old Hermit

The Exhibition will be open every day from nine o'clock in the morning, until nine in the evening. It will be removed from this town in the course of a few days; therefore all those who wish to see this Collection, must improve the present opportunity.

The Company wil be entertained at all times, when the Exhibition is open, with elegant Mu-

sic on the Organ—Admittance, One Quarter of a Dollar, for grown persons; Half Price for Children.

Reuben Moulthrop to Thomas Robbins, letters, Connecticut Historical Society.

[February 19, 1807]

I received your letter dated Jan. 15th it seems by your letter that you have a wish to have your parents likeness done by me—and you seeme to think that I may have a number in addishon to them. I should be very happy in leting you know when I could come & do them but as I have so many wax figures to make it is quite out of my power at present but if theair is an opportunity in the course of the summer I will inform you. Mrs. Moulthrop joines me in respects to you and your Parents.

[February 21, 1810]

I rcived your letter dated Nov. 1st 1809 but Sir when I was about to grattify your wishes in setting out to Norfolk the next Monday after reciving your letter I was seased with the tipus feaver which lasted me a long time but I have now got to be about as weel as ever through the goodness of God I am very sory to disappoint you so manny times I must now posspone the business untill warm weather and then try to come up and take your parrents liknes if they are living if I do not do any more.

Ammi Ruhamah Robbins to Thomas Robbins, letters, Connecticut Historical Society.

[January 31, 1812]

Mr. Moulthrop has finished your mothers, and will this day finish my likeness—he is constantly in the hall with all his apparatus &c—his work is much admired—I regretted much that you could not be here to direct as to the attitude in which you would have us taken, as the portraits are your property. But I am pretty confident they will suit you. He begins Mr. Battell's tomorrow—and after his and Sally's are finished—he is to take mine again on a larger frame (5 feet square) for Battell & Sally who are very desirous of it and are at the expence—I had no idea that it would take him so long—but he is very nice and critical—why can't you ride up next week or the week after on horseback if not in a cutter—Mr. Moulthrop will be here at least 2 if not 3 weeks longer.

[March 13, 1812]

Mr. Moulthrop was here 7 weeks—my studdy was resigned up and looked like a painter's shop— He finished 7 portraits, mine & yr mother's for you—I paid him 15 dollas wh you may credit me on my note—Natty also 10—the sum you mentioned & that you wd settle with him in April. Natty said he could not pay the 24$ and I was determined he shd not go without; in as much as I owe you. He also took Battell's & Sally's with her two Babes on one frame—Also Esqr Battells— and me at full length for Sally—also Samll by his own offer for keeping his horse with oats every day & geting him shod &c—Our pple came in plenty day after day as into a Museum—all agree that the likenesses are admirably drawn—Mr. M left us last Monday morning for home.

JOSHUA JOHNSON ADVERTISES

Considered to be the first known African American artist with an identifiable body of significant work, Joshua Johnson was born a slave and purchased by his white father

while he was a child. In 1782, when Johnson was a teenage blacksmith's apprentice, his father manumitted him. Little is known about Johnson's development as an artist, although he appears to have been in the circle of the Peale family. He worked as a painter in Baltimore for about three decades beginning around 1795; some eighty extant portraits are attributed to him. His works are very thinly painted, and he seems to have specialized in children's portraits, sometimes with the unusual iconographic element of a large moth. One of only two advertisements the artist is known to have placed, the following text suggests that at the outset of his career Johnson exhibited some pride in having risen above his humble beginnings to the status of a professional painter.

Advertisement, Baltimore Intelligencer, *December 19, 1798.*

Portrait Painting.

The subscriber, grateful for the liberal encouragement which an indulgent public have conferred on him, in his first essays, in *PORTRAIT PAINTING,* returns his sincere acknowledgements.

He takes liberty to observe, That by dint of industrious application, he has so far improved and matured his talents, that he can insure the most precise and natural likenesses.

As a *self-taught genius,* deriving from nature and industry his knowledge of the Art; and having experienced many insuperable obstacles in the pursuit of his studies, it is highly gratifying to him to make assurances of his ability to execute all commands, with an effect, and in a style, which must give satisfaction. He therefore respectfully solicits encouragement. Apply at his House, in the Alley leading from *Charles* to *Hanover Street,* back of *Sears's* Tavern.
JOSHUA JOHNSON.

GILBERT STUART: EYEWITNESS ACCOUNTS

Those lucky enough to spend a few hours with Gilbert Stuart usually remembered the experience well. A legendary conversationalist, Stuart loved to tell a good story; in turn, his witty anecdotes and sly observations prompted others to repeat stories about him long after his death. Indeed, there are probably more accounts of his manners, speech, and behavior (not to mention his practical jokes) than of any other American painter of his era (see "George Washington: The Image Industry" and "President Monroe Discusses American Artists," this chapter). Many writers credited his beguiling social skills for the unusual liveliness he was able to capture in his sitters. Amused and at ease, Stuart's clients let down their defenses and appeared with a more naturally interactive, less posed, demeanor. Yet as the following excerpts make clear, the artist was also armed with considerable technical and theoretical knowledge, which he used to gain the visual effects he desired. His many years of work in Britain, as well, meant that he had a seemingly endless store of commentary on artists such as Joshua Reynolds, Benjamin West, and John Singleton Copley, which Americans eagerly consumed.

Matthew Jouett, a Kentucky-born artist who studied briefly with Stuart in 1816 before returning to practice portrait painting in the West and South, made extensive notations of his conversations with his teacher, as did William Dunlap after a visit with Stuart a decade later. Jouett's long, if scattershot, manuscript is particularly valuable. In it we learn a great deal about Stuart's efforts to secure a bold, living quality in his portraits, along with his disdain for the "mincing" lines of his more punctilious colleagues. We also have glimpses of Stuart's pictorial intelligence, as with his observation that a

simple tracing of the outlines of a work by West would not convey an understanding of the subject or narrative of the painting. Stuart always strove for a less artificial arrangement of forms, "keeping the figure in its circle of motion," as Jouett remembered him phrasing it.

Matthew Jouett, "Notes Taken by M. H. Jouett while in Boston from Conve[r]sations on painting with Gilbert Stuart Esqr.," 1816, transcribed in John Hill Morgan, Gilbert Stuart and His Pupils *(New York: New-York Historical Society, 1939).*

Rude Hints & observations, from repeated Conversation with Gilbert Stuart Esqr. In the months of July, August, Septemb[r] & Oct. 1816 under whose patronage and care I was for the time, and that his singular facility in conversation and powers of illustration may suffer no detriment, I hereby do acknowledge that but in two pages have I given his words: to wit on pages 1 & 5 & upon the subject of light & flesh. Nor have I maintain[d] the order in which he treated the subjects.

Equal colour upon equal surfaces produce equal effects. That in the commencement of all portraits the first idea is an indistinct mass of light & shadows, or the character of the person as seen in the heel of the evening in the grey of the morning, or at a distance too great to discriminate features with exactness. That in every object, there is one light, one shadow & one reflection, and that tis from a judicious entering into & departing from either of them that mark the harmony of a painting. That there are three grand stages in a head as in an argument or plot of any sort: a beginning, middle & end: and to arrive at each of these perfect stages, should be the aim of the painter. Illustrated in three head shewn in a double mirror, or two mirrors, where you perceive the effects of distance upon face.

That too much light destroys as too little hides the colours, and that the true and perfect image of man is to be seen only in a misty or hazy atmosphere. Darkness hides and light destroys colour, and this illustrated in a comparative view of the climates of those countries where the best colourists have lived, for instance in the foggy climates of Germany, or Holland & about Florence & Venice: compar[d] to that of Rome & Paris, where good colouring has never obtain[d]. England on the contrary owing to this in part has produc[d] some good colourists. Where theres too much light there will be too much flesh in the shadows—where too little not enough flesh in the lights—both extremes are dangerous. Look at the climate for the first fault. Drawing outlines without the brush, like a man learning the notes without a fiddle, or learning the notes on a violin without a bow: In his portraits tis all spirited drawing & yet no outline. illustrated in the story of a tracing of Sir B. Wests picture where the trac[d] outline would not give any idea of the painting. Criticism upon Vandalyne[s] colouring, like putrid veal a little blow[d] with green flies . . .

Cry of the English School, sink your drapery Stuart & bring out the flesh; but no let Nature tell in every part of your painting and if you cannot do this throw by the brush. On the lightest parts of your linen drapery, let the light fall brilliantly, on the lightest parts of the flesh let your light fall same: the whitest drapery cannot blaze in a soft light, nor neither can it take away from the swe[e]tness of the flesh. Immense light makes all polish[d] metals alike in the highest polish of gold & silver in a vertical sun tis a reflex of white only. On flesh it has likewise this partial effect and this will serve to illustrate what has before been observ[d] with respect to too much light . . .

Never be sparing of colour, load your pictures, but keep your colours as seperate as you can. No blending, tis destruction to clear & bea[u]tiful effect. it takes of the transparency & liquid-

ity of colouring & renders the flesh of the consistency of buckskin. Be rather pointed tha[n] fuzzy, and rather strong than too feeble. Be decisive in your drawing seize with firmness your idea and put it down with vigour. I owe half my success to this. Every man is a philosopher to a certain extent. I always was possess[d] of an inquisitive turn & would dispute with myself rather than take the opinions of others upon trust. Cry in England Sir Joshua why Stuart you are not a migelpist[2] & whether or no does Reubens shade with body or transparent colours. The story[s] recollect[d] to prove the folly of attending too closely to the mere mechanical processes of the art. Does Reubens paint on a blue or yellow ground. Ans[r] he paints on just what ground he pleases.

Fog colour preferable to any other as a ground for painting. This the opinion of DaVinci & the reason because being of no colour it receives any colour well . . .

In laying in your picture be bold and decisive as to the character, but feeble as to the effect. Short and chopping preferable to a wisping sweeping handling. Wests of the last order of Style. It is apt to blend & toughen the skin, an[d] render wormy.

Flesh is like no other substance under heaven. It has all the gaiety of a silk mercers shop without the gaudiness or glare and all the soberness of old mahogany without its deadness or sadness. Gradation of vast use all his portraits possess this in so eminent a degree that their s[h]adows are of less force that is the shadowing is scarce to be rember[d] when the effects of the paintings are very strong.

Sentiment to be look[d] at, in your subject: character; grace in short you cannot be too particular in what you do to see what animal you are putting down. Most persons in striving after effect lose the likeness when they should go together to produce a good effect you must copy Nature: leave Nature for an imaginary effect & you lose all. Nature as Nature cannot be exceeded, and as your object it to copy Nature twere the hight of folly to look at any thing else to produce that copy.

. . . Head of Perkins his best style of dead colouring. In this head there is all stillness and life and yet it looks like it were in a mist (of *blue blotches*) and is both perfectly in & distinct (at the same time). Avoid dryness above all things, and the licking style. Sir Joshua[s] *cub licking idea*. A little fumbling and rubbing will produc[d] the first and too much wiping the last. The first the want of colour, & the second, a too much smootheing over. My idea is as little colour in the shadows as you can. In the laying in the dead colouring be bold and use the colour freely, but let it be well mixed, on the palate an[d] in the brush that a clear and decissive stroke be made. No fuzzy edges, but liquid and all of one cast: this will give liveliness and a transparency & force to the head. Untill the head is forged out and the character and the drawing be correct, be not solicitous about the beauty of the effect. "I have . . . very often roughen[d] my second & 3[d] sitting that I might be thrown back (M[r] Stuart) and by having to use more colour produce a richer effect. The reasons why my paintings were of a richer character 30 years ago—then it was a matter of experiment—now every thing comes so handy that I put down every thing so much in place that for want of opportunities to lose . . . the richness.["] . . .

One invariable rule to [be] observ[d] in the ma[na]gement of the hand; Give the finger a central twist to the palm of the hand & grace at least ease must follow. Our fingers like the claws of the eagle tend all to the centre, and depend for their grips, upon the great muscle . . .

Back grounds should contain whatever is necessary to illustrate the character of the person. The eye should see the application of the parts to the illustrate of the whole, but without seper-

[2] Megilp: a gelatinous mixture of linseed oil and mastick varnish.

ating or attracting the attention from the main point. Back grounds point to dates and cir-
cumstances peculiarly of employment or profession, but the person should be so portrayd as
to be read like the bible without notes, which in books are likened unto back grounds in paint-
ing. Too much parade in the background, like notes with a book to it, and as verry apt to fa-
tigue by the constant shifting of the attention &c.

Drawing the features distinctly & carefully with chalk loss of time. All studies to be made
with brush in hand. Nonsense to think of perfecting oneself in drawing before one begins to
paint: When the hand is not able to execute the decissions of the mind in some shape a fastid-
iousness ensues, and on the heels of that disappointment & disgust. One reason why the Ital-
ians never painted so well as other schools.

Be over zealous about brea[d]th in painting, & preserve as far as practicable the round blunt
stroke in preference to the winding flirting wisping manner, which is apt to toughen the skin
and render the picture a little alarming. The first drafting of the head or figure compard to a
statuary where the great corners & rude masses are blockd off first, or a carpen[ter] trying up
his timber, or shoe maker cutting out his leather. A strict attention to every manner of me-
chanical thing particular enjoind. Learn the use of all sorts of tools, & the facility of using them.
A man cant know too many to be a painter. Advantages of having the eazle before the sitter. By
so doing you are enabld to embrace both objects at once—the eye travels from the one to the
other with so much rapidity that it at last becomes enabld to embrace both at once . . .

The importance of keeping the figure in its circle of motion. His famous skaiting picture of
Grant as contrasted with Buckminster Preble who turns his body one way his neck another and
his eyes another . . .

Never suffer a sitter to lean against the back of the chair. It constrains the attitude, and the genl
air of the person to be particularly attended without this the best head is of little avail. Some faces
require to be finish up to the very marking with large tools. Thick skin faces of this character. In
all thin and lively skins, the fitch3 much used. By chopping, you shorten the flesh and give it a ten-
derness. (The result of my observations on his pictures—He disdains such system business) In
rubbing in the hair be careful to keep from an edge on the forward difficult to hide very dark paint
with flesh colours. It may hide for a month but a year or two may sink the one & bring out the
other. See the old sign boards made new. The old title after a lapse is apt to shew through . . .

His dispute with West about the wisdom of Providence in making the shin bone so sharp &
skin so tender. Our care for this has saved our necks . . .

Avoid by all means, parralell lines whether they be parallel strait or parallel curve lines. His
extreme judgment and taste, evincd in a slight alteration of a small lock of hair that was a little
parralell with the ear—Mrs Shaws portrait

Miss Pickerings portrait. In this he had to lose the line of the far side of the robe to prevent
a too long parralell with the front edge of the trimming: Whenever a picture is offensive: and
the cause does not at once strike, bethink yourself to look out for parralell lines. These not un-
frequently offend when not seen—that is when not seperately examined. Strait lines to be avoided
to do away the effects of strait lines in a limb or the side of the nose or face recourse must be
had to indenting so as to give rest to the eye, but as there are no strait lines in nature . . .

Drawing the brush up & down in painting monstrous, his charge to me while engagd on the
womans head.

3 Fitch: the hair of the polecat or weasel.

This the proper stroke, but no stroke either to be used or avoided but the liny strokes. Suit the motions of the brush so as to get the effect & give the best shapes to things. To paint with great beauty and freedom endeavour to put down what you see. With out being at all curious as to the shape of your strokes, but the blotching plump round stroke seems to suit with this best and is to be recommen^d because of its appropriateness: this evil half positive and half timid precautionary instruction inten[d]ed to leave you room for experiment, and I thus note them that I may not forget to think and act for myself. One main ingredient to make a bold & lively painter all this to found under the head of decission.

The ingratitude of Copely to West and the good nature of Capt Higgins in offering to loan an indiffer[ent] head of Copely for a study . . . His strictures upon the balance of the human figure and his criticism on Trumbull^s painting in London. They look^d like they were painted with one eye (secret). He loves Trumbull and thinks highly of his talents. He says that Sully is very clever & ingenious, and had he remain^d in London a year or two longer would have recev^d immense advantages & been now at the very head of his profession . . .

The first thing to be sought for in a picture is the balance of the picture then of the composition as a whole then of the composition as individual groups and lastly of the single figures. If these points are met by the artist, incorrect & false design is easily detected for the error will be seen if you at first discover where it is not you have gone a great way toward where it is. Whenever a great picture & indeed a picture is presented to you Should you not understand the subject, before you undertake to develope its beauties be sure that you understand the foundation of it, the thing it is intended to represent. &c. &c. Without a perfect knowledge of this it cannot be suppos^d that you can do either the artist^s or your own skill justice. A subject may be treated in different ways, and the view of the artist may not be understood without fully understanding the whole subject. After understanding the subject you can determine at once the fit means, and go on to the composition design & lastly of the colouring of the picture, but as colouring is not so significant to us as drawing and as it partakes more of common mechanical employment, in a word as it is more closely allied to matter than intelligence, so tis of inferior importance to design. But even colouring is of great use, as without it a complete picture could not be given nor indeed could perfect expression be given without its aid, & for the simple reason that it forms a portion of the necessary thing. The liquid eye the aged pale lip, the wan cheek of care & disease or the rosy bloom of health & joy are as necessary in colour as in line . . .

Expression is but too generally understood to relate to living character. It belongs as much to inanimate as animate being and I take it for granted in landscape painting, the most pleasing expression may be given, & without the introduction of a single animate being. In architecture the more particularly. In short in all natu[re] whether of animate or inanimate there is abundance of character. Or why expands the soul at the sight of old trees & rocks swept over by the raging flood . . .

When one has in view the painting of a picture he should in privacy, digest as well as practicable the subject and previous to his drawing a single figure he should have made in his mind the necessary selection of means. This falls under the head of invention in painting and is expressive of the same idea as invention in poetry, which means nothing more than the necessary materials out of which the picture or poem is to be form^d. Whenever the materials are laid out, then the putting of them together in group or groups. But it is necessary to premise in the first place that one should never design his picture other than his immagination approves. It often happens that an attitude singularly *necessary & proper* is sacrificed to one that is more easy

to the hand. No man can meet his fancy, but tis a general good rule not [to] be contented to treat a subject but as it deserves.

William Dunlap, **History of the Rise and Progress of the Arts of Design in the United States** *(New York: George P. Scott, 1834).*

The following dialogue passed between us, as nearly as I can remember the phraseology: it was when my portrait of Mr. Stuart was in progress, in the summer of 1825. He had stepped out of the painting room, (it was at his own house) and in the mean time, as a preparation for his sitting, I placed alongside of my unfinished portrait one painted by him of Mr. Quincey, the mayor of Boston, with a view of aiding me somewhat in the colouring. When he returned and was seated before me, he pointed to the portrait of the mayor, and asked, 'What is that?' 'One of your portraits.' 'Oh, my boy, you should not do that!' said he. 'I beg your pardon, Mr. Stuart, I should have obtained your permission before I made this use of it; but I have placed it so carefully that it cannot suffer the least injury.' 'It is not on that account,' said he, 'that I speak: I have every confidence in your care: but why do you place it there?' 'That I might devote my mind to a high standard of art,' I replied, 'in order the more successfully to understand the natural model before me.' 'But,' said he, 'does my face look like Mr. Quincey's?' 'No, sir, not at all in the expression, nor can I say that the colouring is even like; but there is a certain air of truth in the colouring of your work which gives me an insight into the complexion and effect of nature; and I was in hopes of catching something from the work of the master without imitating it.' 'As you have heretofore,' said Mr. Stuart, 'had reasons at command for your practice, tell me what suggested this method.' 'Some parts of the lectures of Sir Joshua Reynolds,' which I repeated to him. 'I knew it,' said he; and added, 'Reynolds was a good painter, but he has done incalculable mischief to the rising generation by many of his remarks, however excellent he was in other respects as a writer on art. You may elevate your mind as much as you can; but, while you have nature before you as a model, paint what you see, and look with your own eyes. However you may estimate my works,' continued the veteran, 'depend upon it they are very imperfect; and the works of the best artists have some striking faults.'

"He told me that he thought Titian's works were not by any means so well blended when they left the esel, as the moderns infer from their present effect. He considered that Rubens had a fair perception of colour, and had studied well the works of the great Venetian, and that he must have discovered more tinting, or *separate tints,* or distinctness, than others did, and that, as time mellowed and incorporated the tints, he (Rubens,) resolved not only to keep his colours still more distinct against the ravages of time, but to follow his own impetuous disposition with spirited touches. Mr. Stuart condemned the practice of mixing a colour on a knife, and comparing it with whatever was to be imitated.—'Good flesh colouring,' he said, 'partook of all colours, not mixed, so as to be combined in one tint, but shining through each other, like the blood through the natural skin.' Vandyke he much admired, for the intelligence of his heads and his freedom. He spoke well of Gainsborough's flesh, and his *dragging* manner of tinting; but could not endure Copley's laboured flesh, which he compared to tanned leather."

PRESIDENT MONROE DISCUSSES AMERICAN ARTISTS

It is rare that historians have access to a spontaneous conversation on art that took place nearly two centuries in the past, let alone one in which the president of the United States takes part. But thanks to the careful transcription of Horace Holley, a Boston

Unitarian minister who made a visit to the White House in 1818, the following colloquy between President Monroe, his wife Elizabeth, their daughter Elizabeth Hay, and Holley was preserved. Using initials for each of the participants, Holley ("E.") recounts the meeting in a letter to his wife. Collectively, the group shows a discerning understanding of the work of John Singleton Copley, Gilbert Stuart, and John Vanderlyn—in both matters of expression and details of brushwork. The account demonstrates the degree to which knowledge of portrait painting was common currency among the educated elite of the young republic.

Horace Holley to Mary Holley, April 8, 1818, Clements Library, University of Michigan.

I went in the evening at 7. Mrs. Monroe and her two daughters were at home, Mrs. Hay and Miss Monroe. The latter is about 16, & is not handsome . . .

There is a full length portrait of general Washington in the parlour, painted by Stewart. This lead me to ask Mr. Monroe about the portrait of himself by Stewart. But I think I will give you the conversation as it happened. It is a tedious process to write it, but it is better than any other way, and will amuse you more. I will put P for president, Q for queen Mrs. Monroe, H for Mrs. Hay, & E for ego.———— E. That is a painting by Stewart, I perceive. Q. Yes, and it is a very good one. E. He is the best portrait painter in our country, and probably not inferior, in regard to the face, to any artist in the world. But he paints hands, limbs, and drapery badly. He spends the force of his genius on the characteristic expression of the countenance, and cares little for the other parts of the picture. P. He ought to paint nothing but the head, and should leave the rest to such artists as Copley, who was said to be the painter of collars, cuffs, and button holes. E. Stewart is not ambitious of the distinction acquired in that way. His favorite expression in regard to his portraits, to show that he does as little as possible in the way of drapery, is "that picture has never been to the tailor's." P. I have never heard that before, but the idea is a good one. E. Have you ever received your portrait from Stewart yet? P. No, Sir. It is not his habit to finish a picture and send it home. Have you ever seen it at his room? E. yes, Sir, several times. P. How far it is finished? E. Nothing but the head. Q. Is it a good likeness? E. A remarkably good one. It is the general opinion that it is one of the artist's happiest efforts with his pencil. You will be pleased with it, but will observe immediately, when you see it, that your husband was sun-burnt as a traveller ought to be, and that the artist has been so long in the habit of copying faithfully what he sees that he has given this in the shading of the picture. Q. I shall not like it the less for that. I think Stewart generally makes the color of the cheeks too brilliant, especially in the portraits of men, as in that of general Washington. E. The painting of Mr. Monroe then will meet your taste precisely. Q. Have you seen Vanderlyn's portrait of Mr. Monroe? E. I saw it in Vanderlyn's room in New York three summers ago, when Mrs. Holley and myself went to an exhibition which he had of paintings there. Q. What do you think of it. E. It is very inferior to Stewart's. (While we were talking about this, two portraits were brought in by a servant, and placed on the piano, viz. Vanderlyn's heads of Mr. and Mrs. Monroe.) E. Yours, madam, I have never seen before. The likenesses are about equally good but neither does justice to the original. The ermine, thrown over your shoulders, is well painted, and becomes the wearer, but the spirit of the portraits is very different from that which Stewart gives. Q. There is something remarkable in the head of Mr. Monroe by Vanderlyn. Cover up the eyes and the lower part of the face, and the forehead is a good likeness. Cover the forehead, and all but the eyes, and the eyes are good. Let the mouth and chin only appear, and the likeness is still good. But look at the whole face and head, and the expression is defective. We are not then satisfied with the

portrait. But the painting is very good, so far as mechanical execution is concerned. E. Yes it is, but Stewart produces his effect by touches, and does not work down his colors into an even and spiritless surface. The value of a picture is the expression, and not the mechanical execution, you know. H. I wish he would send home the portrait, and allow us to employ another artist to put on the drapery. E. He may not send it home for some time. He was sick when I left Boston, and does not promise a long life. Have you ever, Mrs. Monroe, sat for Stewart? Q. I never have, nor have I ever seen him. P. He promised to come on here this last winter, or during the session of congress, and to take a portrait of Mrs. Monroe. We are disappointed that he has not kept his word. He is a very sensible man, Mr. Holley, and appears to be well read. E. Yes, Sir, he tells a story extremely well, with great spirit, and with a striking talent of illustration. He must have studied books attentively at one period of life, and he retains his Latin very well. He has taken the portraits of so many of our distinguished men, & has been so much abroad, that he has an immense fund of anecdotes, and has learned characters very extensively. P. When a gentleman sits three or four times for an artist, and each time one, two, or three hours, and is engaged in conversation, traits of character must be strongly exhibited, and much of biography and cast of mind will be furnished to the artist. E. Stewart sometimes gives his anecdotes concerning those who sit for him, but he always regards the limits of honorable treatment in his representations. Q. The habit of taking accurate likenesses is not favorable to the play of fancy, and the efforts of invention, in other departments of painting. Vanderlyn succeeds better in historical paintings than in portraits but has taken the latter for bread. E. It is interesting to travel through the large towns on the Atlantic coast, and visit the exhibitions of pictures, and see the proof of uncommon genius in our countrymen in every walk of this delightful art.

CHARLES WILLSON PEALE'S ADVICE TO REMBRANDT PEALE

Of his many children, Charles Willson Peale had the greatest hope for a successful artistic career for his son Rembrandt. Although Rembrandt had some success at history painting (see "Rembrandt Peale's The Court of Death," *this chapter), it was only through portraiture, his father believed, that he would be able to make ends meet and provide for his family. The year 1823 was a particularly bad one for Rembrandt, when his portrait commissions dried up completely. In a letter, Peale gives advice to his son, suggesting that his characteristic hard, glossy style may not be pleasing to his patrons. Instead, he suggests vigor and rapidity rather than polish and high finish. Peale even goes so far as to preach against glazing, suggesting that it is showy and fugitive in color.*

Charles Willson Peale to Rembrandt Peale, August 25, 1823, in Lillian B. Miller, ed., **The Selected Papers of Charles Willson Peale and His Family** *(New Haven: Yale University Press, 1996), vol. 4.*

I must say something on painting which has employed some of my thoughts, as essential to its painters—which I hope you will take no offence at. Truth is better than a high finish. The Italians say give me a true outline & you may fill it up with Turd. Steward is remarkable for giving a good character in his portraits, a gentill air—& good drawing of the Heads, hands bad enough. Dispatch is absolutely necessary in the painting of portraits, otherwise a languor will sit on the visage of the setter. And very few persons will set for portraits if they hear that they must sett long and often. Therefore I am of the opinion that the portrait painter must dispatch his work as quick as possible, by aiming at good character, truth in drawing & colouring—effect at a proper distance if not so hightly finished may be acceptable with the multitude. I deem it es-

sential for the durability of painting to lay on a good body of Colour, glaising to inrich may please from the present, but paint with only the bonding vehicle will last longer with a good effect. Therefore I wish to dispence with lake as much as possible & all other glaising colours.

CHESTER HARDING, SELF-MADE ARTIST

One of twelve children of a ne'er-do-well inventor, Chester Harding pursued a variety of trades in New York State—including drum making, cabinetry, and tavernkeeping— without much success. After his marriage in 1815, mounting debts forced him to move to Pittsburgh, Pennsylvania, where he took to painting houses. Around 1818 an itinerant artist named Nelson introduced him to portraiture, and over the next few years Harding painted in Kentucky, Ohio, Missouri, and the District of Columbia. By 1823 he was in Boston, where he received an astounding reception and more commissions than he could carry out. His success there was largely owed to his plain mannerisms and reputation as an untaught "primitive" from the frontier, a mythic status upon which he capitalized for years to come in the United States and England. He spent most of his mature career in Boston and is estimated to have painted more than a thousand portraits.

In the following excerpts from his autobiography, Harding writes in colorful language about his initial "conversion" to portrait painting, when he was overwhelmed by the power of mimesis. He describes his early career as a hardscrabble existence, playing clarinet in public to draw attention to his business and churning out one portrait every two days during a six-month period in Kentucky. His "break" came when he painted a likeness of the elderly Daniel Boone, which became something of a sensation and was engraved several times. From that point on, Harding's career was the epitome of savvy cultivation of the press and the public.

Chester Harding, My Egotistigraphy *(Cambridge, Mass.: John Wilson and Son, 1866).*

About this time, I fell in with a portrait-painter by the name of Nelson,—one of the primitive sort. He was a sign, ornamental, and portrait painter. He had for his sign a copy of the "Infant Artists" of Sir Joshua Reynolds, with this inscription, "Sign, Ornamental, and Portrait Painting executed on the shortest notice, with neatness and despatch." It was in his sanctum that I first conceived the idea of painting heads. I saw his portraits, and was enamored at once. I got him to paint me and my wife, and thought the pictures perfection. He would not let me see him paint, nor would he give me the least idea how the thing was done. I took the pictures home, and pondered on them, and wondered how it was possible for a man to produce such wonders of art. At length my admiration began to yield to an ambition to do the same thing. I thought of it by day, and dreamed of it by night, until I was stimulated to make an attempt at painting myself. I got a board; and, with such colors as I had for use in my trade, I began a portrait of my wife. I made a thing that looked like her. The moment I saw the likeness, I became frantic with delight: it was like the discovery of a new sense; I could think of nothing else. From that time, sign-painting became odious, and was much neglected.

I next painted a razeed portrait of an Englishman who was a journeyman baker, for which I received five dollars. He sent it to his mother in London. I also painted portraits of the man and his wife with whom I boarded, and for which I received, on account, twelve dollars each. This was in the winter season: the river was closed, and there was but little to be done in sign-painting.

I shall always remember the friendship of an Irish apothecary, who, at this period of my his-

tory, encouraged me in my attempts at portrait-painting, and allowed me to buy any materials I needed, on credit, from his paint and drug store. I had been painting a second picture of my wife, and asked Nelson the painter to come and see it. He declared it to be no more like my wife than like him, and said further that it was utter nonsense for me to try to paint portraits at my time of life; he had been ten years in learning the trade. To receive such a lecture, and such utter condemnation of my work, when I expected encouragement and approval, was truly disheartening. He left me; and I was still sitting before the picture, in great dejection, when my friend the doctor came in. He instantly exclaimed, with much apparent delight, "That's good; first-rate, a capital likeness," &c. I then repeated what Nelson had just said. He replied that it was sheer envy; that he never painted half so good a head, and never would. The tide of hope began to flow again, and I grew more and more fond of head-painting. I now regarded sign-painting merely as a necessity, while my whole soul was wrapped up in my new love; and neglected my trade so much that I was kept pretty short of money. I resorted to every means to eke out a living. I sometimes played the clarionet for a tight-rope dancer, and on market-days would play at the window of the museum to attract the crowd to the exhibition. For each of these performances I would get a dollar . . .

My brother Horace, the chair-maker, was established in Paris, Ky. He wrote to me that he was painting portraits, and that there was a painter in Lexington who was receiving fifty dollars a head. This price seemed fabulous to me; but I began to think seriously of trying my fortune in Kentucky. I soon settled upon the idea, and acted at once. Winding up my affairs in Pittsburg, I found that I had just money enough to take me down the river. I knew a barber, by the name of Jarvis, who was going to Lexington; and I proposed to join him in the purchase of a large skiff. He agreed to it; and we fitted it up with a sort of awning or tent, and embarked, with our wives and children. Sometimes we rowed our craft; but oftener we let her float as she pleased, while we gave ourselves up to music. He, as well as I, played the clarionet; and we had much enjoyment on our voyage. We arrived in Paris with funds rather low; but, as my brother was well known there, I found no difficulty on that score.

Here I began my career as a professional artist. I took a room, and painted the portrait of a very popular young man, and made a decided hit. In six months from that time, I had painted nearly one hundred portraits, at twenty-five dollars a head. The first twenty-five I took rather disturbed the equanimity of my conscience. It did not seem to me that the portrait was intrinsically worth that money; now, I know it was not . . .

Up to this time, I had thought little of the profession, so far as its honors were concerned. Indeed it had never occurred to me, that it was more honorable or profitable than sign-painting. I now began to entertain more elevated ideas of the art, and to desire some means of improvement. Finding myself in funds sufficient to visit Philadelphia, I did so; and spent two months in that city, devoting my time entirely to drawing in the Academy, and studying the best pictures, practising at the same time with the brush. I would sometimes feel a good deal discouraged as I looked at the works of older artists. I saw the labor it would cost me to emulate them, working, as I should, under great disadvantages. Then again, when I had painted a picture successfully, my spirits would rise, and I would resolve that I could and would overcome every obstacle. One good effect of my visit to Philadelphia was to open my eyes to the merits of the works of other artists, though it took away much of my self-satisfaction. My own pictures did not look as well to my own eye as they did before I left Paris. I had thought then that my pictures were far ahead of Mr Jewitt's, the painter my brother had written me about, who received such unheard-of prices,

and who really was a good artist. My estimation of them was very different now: I found they were so superior to mine, that their excellence had been beyond my capacity of appreciation . . .

In June of this year, I made a trip of one hundred miles for the purpose of painting the portrait of old Colonel Daniel Boone. I had much trouble in finding him. He was living, some miles from the main road, in one of the cabins of an old block-house, which was built for the protection of the settlers against the incursions of the Indians. I found that the nearer I got to his dwelling, the less was known of him. When within two miles of his house, I asked a man to tell me where Colonel Boone lived. He said he did not know any such man. "Why, yes, you do," said his wife. "It is that white-headed old man who lives on the bottom, near the river." A good illustration of the proverb, that a prophet is not without honor save in his own country.

I found the object of my search engaged in cooking his dinner. He was lying in his bunk, near the fire, and had a long strip of venison wound around his ramrod, and was busy turning it before a brisk blaze, and using salt and pepper to season his meat. I at once told him the object of my visit. I found that he hardly knew what I meant. I explained the matter to him, and he agreed to sit. He was ninety years old, and rather infirm; his memory of passing events was much impaired, yet he would amuse me every day by his anecdotes of his earlier life. I asked him one day, just after his description of one of his long hunts, if he never got lost, having no compass. "No," said he, "I can't say as ever I was lost, but I was *bewildered* once for three days."

He was much astonished at seeing the likeness. He had a very large progeny; one granddaughter had eighteen children, all at home near the old man's cabin: *they* were even more astonished at the picture than was the old man himself . . .

While in Northampton, I painted the portraits of two gentlemen from Boston. They encouraged me to establish myself in that city. I did so, and for six months rode triumphantly on the top wave of fortune. I took a large room, arranged my pictures, and fixed upon one o'clock as my hour for exhibition. As soon as the clock struck, my bell would begin to ring; and people would flock in, sometimes to the number of fifty. New orders were constantly given me for pictures. I was compelled to resort to a book for registering the names of the numerous applicants. As a vacancy occurred, I had only to notify the next on the list, and it was filled. I do not think any artist in this country ever enjoyed more popularity than I did; but popularity is often easily won, and as easily lost. Mr. Stuart, the greatest portrait painter this country ever produced, was at that time in his manhood's strength as a painter; yet he was idle half the winter. He would ask of his friends, "How rages the Harding fever?"

Although I had painted about eighty portraits, I had a still greater number of applicants awaiting their turn; but I was determined to go to Europe, as I had money enough to pay for my farm, and some sixteen hundred dollars besides . . .

And now, at last, I took my departure for a foreign land, leaving wife, children, and friends,—all indeed that I had sympathy with,—to cast in my lot, for a time, with strangers in a strange land. My heart was full of conflicting emotions. Scores of my patrons in Boston had tried to dissuade me from taking this step, some urging as a reason, that I already had such a press of business that I could lay up a considerable sum of money yearly; while others insisted that I need not go abroad, for I already painted better pictures than any artist in this country, and probably better than any in Europe. My self-esteem was not large enough, however, to listen to all this, and my desire for study and improvement was too great to be overpowered by flattery. In spite of all advice to the contrary, I sailed for England, in the good packet ship "Canada," on the first day of August, 1823.

ARTISTIC IDENTITY, ARTISTIC CHOICES

BENJAMIN WEST: A NEW WORLD GENIUS CONQUERS THE OLD

In the early republic, artists with lofty ambitions faced often daunting obstacles and challenges. Before and after the Revolution, demand for paintings other than portraits was (to put it mildly) weak, and the lack of an art educational or professional infrastructure made European travel and study an absolute necessity for any artist who wished to aim higher than face painting (see "John Singleton Copley: Ambition and Practicality," chapter 1). In a young country with little art culture, the very identity of the artist was unfixed: should he (or, less likely at that time, she) be a scientist, a poet, an explorer, an entrepreneur, an educator, or an entertainer?

The spectacular rise of Benjamin West provided one powerful and influential model. Born and raised in Pennsylvania, West achieved tremendous success not in his native land but in England. West left colonial America for Italy to study classical and Renaissance art. Moving to London, he was fortunate in his connections, securing a commission from the Archbishop of York in 1768 that quickly put him on the road to success as historical painter to King George III. In 1792 West succeeded Sir Joshua Reynolds as president of the Royal Academy. Throughout his career, he actively mentored and supported young Americans, for whom the elder painter's studio constituted an unofficial but influential academy.

John Galt's canonizing biography of West laid the foundation for the re-Americanization of an artist who might otherwise pass for British in everything but birth. Galt, a Scottish travel writer and biographer, portrays West as a New World naïf, a natural genius from the virgin wilderness across the sea. Schooled by American nature and unencumbered by European tradition, the young West blazes his own trail through Old World culture, seeing the Apollo Belvedere as a Mohawk warrior and insisting on historical truth as justification for the decision to paint a modern military martyr in contemporary uniform instead of the classicizing drapery demanded by academic convention. Even before the American Revolution, West has single-handedly brought about a "revolution in the art."

John Galt, The Life, Studies, and Works of Benjamin West *(London: Cadell and Davies, 1820).*

The first six years of Benjamin's life passed away in calm uniformity; leaving only the placid remembrance of enjoyment. In the month of June 1745, one of his sisters, who had been married some time before, and who had a daughter, came with her infant to spend a few days at her father's. When the child was asleep in the cradle, Mrs. West invited her daughter to gather flowers in the garden, and committed the infant to the care of Benjamin during their absence; giving him a fan to flap away the flies from molesting his little charge. After some time the child happened to smile in its sleep, and its beauty attracted his attention. He looked at it with a pleasure which he had never before experienced, and observing some paper on a table, together with pens and red and black ink, he seized them with agitation and endeavoured to delineate a portrait: although at this period he had never seen an engraving or a picture, and was only in the seventh year of his age.

Hearing the approach of his mother and sister, he endeavoured to conceal what he had been doing; but the old lady observing his confusion, enquired what he was about, and requested him to show her the paper. He obeyed, entreating her not to be angry. Mrs. West, after look-

ing some time at the drawing with evident pleasure, said to her daughter, "I declare he has made a likeness of little Sally," and kissed him with much fondness and satisfaction. This encouraged him to say, that if it would give her any pleasure, he would make pictures of the flowers which she held in her hand; for the instinct of his genius was now awakened, and he felt that he could imitate the forms of those things which pleased his sight . . .

Soon after the occurrence of the incident which has given rise to these observations, the young Artist was sent to a school in the neighbourhood. During his hours of leisure he was permitted to draw with pen and ink; for it did not occur to any of the family to provide him with better materials. In the course of the summer a party of Indians came to pay their annual visit to Springfield, and being amused with the sketches of birds and flowers which Benjamin shewed them, they taught him to prepare the red and yellow colours with which they painted their ornaments. To these his mother added blue, by giving him a piece of indigo, so that he was thus put in possession of the three primary colours. The fancy is disposed to expatiate on this interesting fact; for the mythologies of antiquity furnish no allegory more beautiful; and a Painter who would embody the metaphor of an Artist instructed by Nature, could scarcely imagine any thing more picturesque than the real incident of the Indians instructing West to prepare the prismatic colours. The Indians also taught him to be an expert archer, and he was sometimes in the practice of shooting birds for models, when he thought that their plumage would look well in a picture.

His drawings at length attracted the attention of the neighbours; and some of them happening to regret that the Artist had no pencils, he enquired what kind of things these were, and they were described to him as small brushes made of camels' hair fastened in a quill. As there were, however, no camels in America, he could not think of any substitute, till he happened to cast his eyes on a black cat, the favourite of his father; when, in the tapering fur of her tail, he discovered the means of supplying what he wanted. He immediately armed himself with his mother's scissors, and, laying hold of Grimalkin with all due caution, and a proper attention to her feelings, cut off the fur at the end of her tail, and with this made his first pencil. But the tail only furnished him with one, which did not last long, and he soon stood in need of a further supply. He then had recourse to the animal's back, his depredations upon which were so frequently repeated, that his father observed the altered appearance of his favourite, and lamented it as the effect of disease. The Artist, with suitable marks of contrition, informed him of the true cause; and the old gentleman was so much amused with his ingenuity, that if he rebuked him, it was certainly not in anger . . .

In America all was young, vigorous, and growing,—the spring of a nation, frugal, active, and simple. In Rome all was old, infirm, and decaying,—the autumn of a people who had gathered their glory, and were sinking into sleep under the disgraceful excesses of the vintage. On the most inert mind, passing from the one continent to the other, the contrast was sufficient to excite great emotion; on such a character as that of Mr. West, who was naturally disposed to the contemplation of the sublime and beautiful, both as to their moral and visible effect, it made a deep and indelible impression. It confirmed him in the wisdom of those strict religious principles which denied the utility of art when solely employed as the medium of amusement; and impelled him to attempt what could be done to approximate the uses of the pencil to those of the pen, in order to render Painting, indeed, the sister of Eloquence and Poetry . . .

It was on the 10th of July, 1760, that he arrived at Rome. The French Courier conducted him to a hotel, and, having mentioned in the house that he was an American, and a Quaker, come to study the fine arts, the circumstance seemed so extraordinary, that it reached the ears of Mr.

Robinson, afterwards Lord Grantham, who immediately found himself possessed by an irresistible desire to see him; and who, before he had time to dress or refresh himself, paid him a visit, and insisted that he should dine with him. In the course of dinner, that gentleman inquired what letters of introduction the Artist had brought with him; and West having informed him, he observed it was somewhat remarkable that the whole of them should be addressed to his most particular friends, adding, that as he was engaged to meet them at a party in the evening, he expected West would accompany him. This attention and frankness was acknowledged as it deserved to be, and is remembered by the Artist among those fortunate incidents which have rendered the recollection of his past life so pleasant, as scarcely to leave a wish for any part of it to have been spent otherwise than it was. At the hour appointed, Mr. Robinson conducted him to the house of Mr. Crispigné, an English gentleman who had long resided at Rome, where the evening party was held.

Among the distinguished persons whom Mr. West found in the company, was the celebrated Cardinal Albani. His eminence, although quite blind, had acquired, by the exquisite delicacy of his touch, and the combining powers of his mind, such a sense of antient beauty, that he excelled all the virtuosi then in Rome, in the correctness of his knowledge of the verity and peculiarities of the smallest medals and intaglios. Mr. Robinson conducted the Artist to the inner apartment, where the Cardinal was sitting, and said, "I have the honour to present a young American, who has a letter of introduction to your eminence, and who has come to Italy for the purpose of studying the fine arts." The Cardinal fancying that the American must be an Indian, exclaimed, "Is he black or white?" and on being told that he was very fair, "What as fair as I am?" cried the Cardinal still more surprised. This latter expression excited a good deal of mirth at the Cardinal's expence, for his complexion was of the darkest Italian olive, and West's was even of more than the usual degree of English fairness. For some time after, if it be not still in use, the expression of "as fair as the Cardinal" acquired proverbial currency in the Roman conversations, applied to persons who had any inordinate conceit of their own beauty.

The Cardinal, after some other short questions, invited West to come near him, and running his hands over his features, still more attracted the attention of the company to the stranger, by the admiration which he expressed at the form of his head. This occasioned inquiries respecting the youth; and the Italians concluding that, as he was an American, he must, of course, have received the education of a savage, became curious to witness the effect which the works of Art in the Belvidere and Vatican would produce on him. The whole company, which consisted of the principal Roman nobility, and strangers of distinction then in Rome, were interested in the event; and it was arranged in the course of the evening that on the following morning they should accompany Mr. Robinson and his protegé to the palaces.

At the hour appointed, the company assembled; and a procession, consisting of upwards of thirty of the most magnificent equipages in the capital of Christendom, and filled with some of the most erudite characters in Europe, conducted the young Quaker to view the master-pieces of art. It was agreed that the Apollo should be first submitted to his view, because it was the most perfect work among all the ornaments of Rome, and, consequently, the best calculated to produce that effect which the company were anxious to witness. The statue then stood in a case, enclosed with doors, which could be so opened as to disclose it at once to full view. West was placed in the situation where it was seen to the most advantage, and the spectators arranged themselves on each side. When the keeper threw open the doors, the Artist felt himself surprised with a sudden recollection altogether different from the gratification which he had expected; and without being aware of the force of what he said, exclaimed, "My God, how like it

is to a young Mohawk warrior." The Italians, observing his surprise, and hearing the exclamation, requested Mr. Robinson to translate to them what he said; and they were excessively mortified to find that the god of their idolatry was compared to a savage. Mr. Robinson mentioned to West their chagrin, and asked him to give some more distinct explanation, by informing him what sort of people the Mohawk Indians were. He described to him their education; their dexterity with the bow and arrow; the admirable elasticity of their limbs; and how much their active life expands the chest, while the quick breathing of their speed in the chace, dilates the nostrils with that apparent consciousness of vigour which is so nobly depicted in the Apollo. "I have seen them often," added he, "standing in that very attitude, and pursuing, with an intense eye, the arrow which they had just discharged from the bow." This descriptive explanation did not lose by Mr. Robinson's translation. The Italians were delighted, and allowed that a better criticism had rarely been pronounced on the merits of the statue . . .

. . . Thus, on the 10th December, 1768, under the title of the Royal Academy of the Arts in London, that Institution, which has done more to excite a taste for the fine arts in this country, than any similar institution ever did in any other, was finally formed and established . . .

About this period, Mr. West had finished his Death of Wolfe, which excited a great sensation, both on account of its general merits as a work of art, and for representing the characters in the modern military costume. The King mentioned that he heard much of the picture, but he was informed that the dignity of the subject had been impaired by the latter circumstance; observing that it was thought very ridiculous to exhibit heroes in coats, breeches, and cock'd hats. The Artist replied, that he was quite aware of the objection, but that it was founded in prejudice, adding, with His Majesty's permission, he would relate an anecdote connected with that particular point.

"When it was understood that I intended to paint the characters as they had actually appeared in the scene, the Archbishop of York called on Reynolds and asked his opinion, the result of which was that they came together to my house. For His Grace was apprehensive that, by persevering in my intention, I might lose some portion of the reputation which he was pleased to think I had acquired by his picture of Agrippina, and Your Majesty's of Regulus; and he was anxious to avert the misfortune by his friendly interposition. He informed me of the object of their visit, and that Reynolds wished to dissuade me from running so great a risk. I could not but feel highly gratified by so much solicitude, and acknowledged myself ready to attend to whatever Reynolds had to say, and even to adopt his advice, if it appeared to me founded on any proper principles. Reynolds then began a very ingenious and elegant dissertation on the state of the public taste in this country, and the danger which every attempt at innovation necessarily incurred of repulse or ridicule; and he concluded with urging me earnestly to adopt the classic costume of antiquity, as much more becoming the inherent greatness of my subject than the modern garb of war. I listened to him with the utmost attention in my power to give, but could perceive no principle in what he had delivered; only a strain of persuasion to induce me to comply with an existing prejudice,— a prejudice which I thought could not be too soon removed. When he had finished his discourse, I begged him to hear what I had to state in reply, and I began by remarking that the event intended to be commemorated took place on the 13th of September, 1758, in a region of the world unknown to the Greeks and Romans, and at a period of time when no such nations, nor heroes in their costume, any longer existed. The subject I have to represent is the conquest of a great province of America by the British troops. It is a topic that history will proudly record, and the same truth that guides the pen of the historian should govern the pencil of the artist. I consider myself as undertaking to tell this great event to the eye of the world; but if, instead of the facts

of the transaction, I represent classical fictions, how shall I be understood by posterity! The only reason for adopting the Greek and Roman dresses, is the picturesque forms of which their drapery is susceptible; but is this an advantage for which all the truth and propriety of the subject should be sacrificed? I want to mark the date, the place, and the parties engaged in the event; and if I am not able to dispose of the circumstances in a picturesque manner, no academical distribution of Greek or Roman costume will enable me to do justice to the subject. However, without insisting upon principles to which I intend to adhere, I feel myself so profoundly impressed with the friendship of this interference, that when the picture is finished, if you do not approve of it, I will consign it to the closet, whatever may be my own opinion of the execution. They soon after took their leave, and in due time I called on the Archbishop, and fixed a day with him to come with Reynolds to see the painting. They came accordingly, and the latter without speaking, after his first cursory glance, seated himself before the picture, and examined it with deep and minute attention for about half an hour. He then rose, and said to His Grace, Mr. West has conquered. He has treated his subject as it ought to be treated. I retract my objections against the introduction of any other circumstances into historical pictures than those which are requisite and appropriate; and I foresee that this picture will not only become one of the most popular, but occasion a revolution in the art."

BENJAMIN WEST, PATRIARCH OF AMERICAN PAINTING

In the early 1830s, William Dunlap—theater producer, playwright, artist, and founding member of the National Academy of Design—conceived the ambitious project of writing an authoritative and comprehensive history of American art. Assiduously collecting information, he compiled biographies of some three hundred artists. After a brief overview of the colonial period, Dunlap devoted three substantial chapters to Benjamin West, who had died in 1820. The privileging of West over John Singleton Copley (who did not rate even one whole chapter) suggests that Dunlap, who had studied with West in London, intended to establish him as first patriarch of the American school.

In his biography of West, Dunlap returns several times to the older artist's hospitality and generosity to aspiring artists from across the sea. Treading carefully around the issue of loyalty during the Revolutionary War, Dunlap presses the case for West's neutrality. Finally, he recounts West's efforts to renew his connections and enhance his fame in Philadelphia in order to ensure an enduring legacy in the land of his birth.

William Dunlap, History of the Rise and Progress of the Arts of Design in the United States *(New York: George P. Scott, 1834).*

In the month of June, 1784, the writer of this memoir arrived in England, for the purpose of studying the art of painting, having assurances of the aid of Mr. West, before leaving New-York. When introduced to the painter, he was working on an esel-picture for the Empress Catharine of Russia. It was Lear and Cordelia.

The impression made upon an American youth of eighteen by the long gallery leading from the dwelling-house, to the lofty suite of painting-rooms—a gallery filled with sketches and designs for large paintings—the spacious room through which I passed to the more retired attelier—the works of his pencil surrounding me on every side—his own figure seated at his esel, and the beautiful composition at which he was employed, as if in sport, not labour;—all

are recalled to my mind's eye at this distance of half a century, with a vividness which doubtless proceeds in part, from the repeated visits to, and examination of, many of the same objects, during a residence of more than three years in London. But the painter, as he then appeared, and received me and my conductor, (Mr. Effingham Lawrence, an American, like himself of a quaker family, and no longer a quaker in habits and appearance,) the palette, pencil, esel, figure of Cordelia, all are now before me as though seen yesterday . . .

Previous to the writer's visit to Europe, Mr. West had afforded instruction and the most paternal encouragement to many pupils, American and English. Those of this country will frequently be brought before the reader of this work. Charles Wilson Peale, Gilbert Stuart, Joseph Wright and John Trumbull, were among the American students. Peale was under his guidance from 1771 to 1774; Stuart, Wright and Trumbull, during portions of the American revolutionary war, and the last mentioned was established with him at the time of the visit above noticed, as a pupil, and remained such for some years after.

It has been a subject of speculation with many, to determine how West managed to keep the favour of his friend George the Third, during the contest his ministers and armies were carrying on against the native land of the artist, and at the same time preserve the love of country, and declare his attachment to the cause of liberty . . .

. . . West had been many years from his native land before the contest took place. He had no connexion with, or knowledge of, most of the leaders in his country's cause. He was prudent and known to be an honest man. George the Third was an honest man, and perfectly relied upon the painter's sincerity. Why should he quarrel with him for honest opinions, which did not interfere with his attachment to the sovereign who was his friend, or influence any of his actions? . . .

Of the very many artists with whom we have associated, who had known Mr. West personally, we never heard but one speak otherwise of him, except as of a benefactor and friend, and that one acknowledged that he had been more than a father to him for thirty years. Mr. Allston, in a letter before us, says, he "received me with the greatest kindness. I shall never forget his benevolent smile when he took me by the hand; it is still fresh in my memory, linked with the last of like kind which accompanied the farewell shake of the hand when I took leave of him in 1818. His gallery was open to me at all times, and his advice always ready and kindly given. He was a man overflowing with the milk of human kindness. If he had enemies, I doubt if he owed them to any other cause than this rare virtue, which (alas for human nature!) is too often deemed cause sufficient." . . .

The undaunted painter now between sixty and seventy years of age, commenced a series of great works solely relying upon himself for their success. The first he exhibited to the public was his "Christ healing the sick," designed as a present to the hospital of the metropolis of Pennsylvania, his native state. A noble memorial of his love to the country of his birth, and her institutions . . .

When the "Healing of the Sick" was exhibited in London, the rush to see it was very great, and the praise it obtained very high. "The British Institution," says his English biographer, "offered him three thousand guineas for the work: West accepted the offer, for he was far from being rich,—but on condition that he should be allowed to make a copy, with alterations." This copy, with not only alterations, but an additional group, was received by the trustees of the hospital, and placed in a building erected according to a plan transmitted by the donor, in which it stands a monument to his honour as a man and an artist. The receipts from the exhibition in the first year after its arrival were four thousand dollars . . .

"It ought to be known, if it is not," says Mr. Leslie, in one of his letters to us from West Point, "that at the time Mr. West made his noble present to the Pennsylvania Hospital, his pecuniary affairs were by no means in a prosperous condition. He was blamed by those who did not know this, for selling the first picture he painted for them; but he redeemed his pledge to them, and I can bear witness of his great satisfaction, when he heard that the exhibition of it had so much benefited the institution. He had begun his own portrait to present to the hospital. It was a whole length on a mahogany pannel; he employed me to dead colour it for him. He had also made a small sketch of a picture of Dr. Franklin, to present with it. The doctor was seated on the clouds, surrounded by naked boys, and the experiment of proving lightning and electricity to be the same was alluded to." . . .

Benjamin West was not, (as his biographer has asserted,) above the middle size. He was about five feet eight inches in height. Well made and athletic. His complexion was remarkably fair. His eye was piercing. Of his manners and disposition we have already spoken, but may be allowed to relate an anecdote from one of his pupils. He had frequently a levee of young artists asking advice on their productions, and it was given always with encouraging amenity. On one occasion a Camera Lucida,[4] then a new thing, had been left with him for inspection: it was the first he had ever seen, and Stuart coming in, West showed it to him, and explained its use. Stuart's hand was always tremulous. He took the delicate machine for examination, let it fall, and it was dashed to fragments on the hearth. Stuart stood with his back to West, looking at the wreck in despair. After a short silence, the benevolent man said, "Well, Stuart, you may as well pick up the pieces." This was of course in early life, but old age made no change in him. Mr. Leslie says, "Mr. West's readiness to give advice and assistance to artists is well known. Every morning before he began to work he received all who wished to see him. A friend of mine called at his house the day after his death. His old and faithful servant, Robert, opened the door, and said, with a melancholy shake of the head, "Ah, sir! where will they go now?"

JOHN TRUMBULL PAINTS REVOLUTIONARY HISTORY

Trained by Benjamin West, the Connecticut-born painter John Trumbull enshrined the momentous events of the American Revolution at the very center of his artistic life and pinned all his hopes for fame and success on the series of eight Revolutionary War history paintings that he began in 1785, and which he hoped would establish a great national artistic tradition. As one who had seen action—albeit from a distance— Trumbull was convinced of his right to don the mantle of first national history painter. The failure of his plan to profit by the sale of subscriptions to engravings after those paintings so daunted Trumbull that he gave up painting altogether for several years.

In a letter to Thomas Jefferson, Trumbull announces his wish to commemorate and celebrate great events of the American Revolution as the "noblest series of actions" in the entire history of humankind. Didactic and inspiring, these paintings will also elevate and legitimate the status of the artist. In his memoir, Trumbull describes his elaborate preparations for the series and his tireless pursuit of authenticity. Such details give weight

[4] The camera lucida is an optical device invented in 1807 and used by artists as an aid to correct draftsmanship and perspective.

to Trumbull's assertion that only he is qualified to deliver an authentic pictorial record of the great events of the Revolution—despite the fact that the paintings themselves are highly staged and synthetic reenactments.

Reflecting on the "wretched" nature of his success, Trumbull attributes the failure of his Revolutionary War series to the French Revolution, which has distracted Americans from their own recent struggle. Blighted, Trumbull's "great enterprise" has become the root of an enduring bitterness.

John Trumbull, Autobiography, Reminiscences, and Letters of John Trumbull, from 1756 to 1841 *(New York and London: Wiley and Putnam, 1841).*

In November, 1786, I returned to London; my brain half turned by the attention which had been paid to my paintings in Paris, and by the multitude of fine things which I had seen.

I resumed my labors, however, and went on with my studies of other subjects of the history of the Revolution, arranged carefully the composition for the Declaration of Independence, and prepared it for receiving the portraits, as I might meet with the distinguished men, who were present at that illustrious scene. In the course of the summer of 1787, Mr. Adams took leave of the court of St. James, and preparatory to the voyage to America, had the powder combed out of his hair. Its color and natural curl were beautiful, and I took that opportunity to paint his portrait in the small Declaration of Independence. I also made various studies for the Surrender of Lord Cornwallis, and in this found great difficulty; the scene was altogether one of utter formality—the ground was level—military etiquette was to be scrupulously observed, and yet the portraits of the principal officers of three proud nations must be preserved, without interrupting the general regularity of the scene. I drew it over and over again, and at last, having resolved upon the present arrangement, I prepared the small picture to receive the portraits. Some progress was also made in the composition of some of the other subjects, especially of the battles of Trenton and Princeton, for which I made many studies upon paper . . .

In the autumn of 1787, I again visited Paris, where I painted the portrait of Mr. Jefferson in the original small Declaration of Independence, Major General Ross in the small Sortie from Gibraltar, and the French officers in the surrender of Lord Cornwallis, at Yorktown in Virginia. I regard these as the best of my small portraits; they were painted from the life, in Mr. Jefferson's house . . .

<div align="right">Paris, May 21, 1789.</div>

To John Trumbull, London.

Dear Sir—I have not yet received my leave of absence, but I expect it hourly, and shall go off within an hour after I receive it. Mr. Short will stay till I come back, and then I think he has it in contemplation to return to America . . . if he goes, would you like his office of private secretary? Its duties consist almost entirely in copying papers, and were you to do this yourself, it would only occupy now and then one of your evenings; and if you did not choose to do it yourself, you can hire it done, for so many sous a sheet, as it is rare that there is any thing secret to be copied . . .

I am, with sincere esteem,

Dear sir, your friend and servant,

Thos. Jefferson.

To THOS. JEFFERSON, Esq., &c. &c., at Paris.

DEAR SIR—I have received yours of the 1st, by the last post . . .

If my affairs were in other respects as I could wish them, I should have given at once a positive answer to your proposition. It would have been an answer of thankfulness and acceptance, for nothing could be proposed to me more flattering to my pride, or more consonant, at least for a time, to my favorite pursuit. The greatest motive I had or have for engaging in, or for continuing my pursuit of painting, has been the wish of commemorating the great events of our country's revolution. I am fully sensible that the profession, as it is generally practiced, is frivolous, little useful to society, and unworthy of a man who has talents for more serious pursuits. But, to preserve and diffuse the memory of the noblest series of actions which have ever presented themselves in the history of man; to give to the present and the future sons of oppression and misfortune, such glorious lessons of their rights, and of the spirit with which they should assert and support them, and even to transmit to their descendants, the personal resemblance of those who have been the great actors in those illustrious scenes, were objects which gave a dignity to the profession, peculiar to my situation. And some superiority also arose from my having borne personally a humble part in the great events which I was to describe. No one lives with me possessing this advantage, and no one can come after me to divide the honor of truth and authenticity, however easily I may hereafter be exceeded in elegance. Vanity was thus on the side of duty, and I flattered myself that by devoting a few years of life to this object, I did not make an absolute waste of time, or squander uselessly, talents from which my country might justly demand more valuable services; and I feel some honest pride in the prospect of accomplishing a work, such as had never been done before, and in which it was not easy that I should have a rival . . .

But, while I have done whatever depended upon my personal exertions, I have been under the necessity of employing, and relying upon the exertions of another. The two paintings which you saw in Paris three years ago, (Bunker's Hill and Quebec,) I placed in the hands of a printseller and publisher, to cause to be engraved, and as the prospect of profit to him was considerable, I relied upon his using the utmost energy and dispatch; instead of which, three years have been suffered to elapse, without almost the smallest progress having been made in the work. Instead therefore of having a work already far advanced to submit to the world and to my countrymen, I am but where I was three years since, with the deduction from my ways and means of three years' expenses, with prospects blighted, and the hope of the future damped by the experience of past mismanagement. And the most serious reflection is, that the memory and enthusiasm for actions however great, fade daily from the human mind; that the warm attention which the nations of Europe once paid to us, begins to be diverted to objects more nearly and immediately interesting to themselves; and that France, in particular, from which country I entertained peculiar hopes of patronage, is beginning to be too much occupied by her own approaching revolution, to think so much of us as perhaps she did formerly.

Thus circumstanced, I foresee the utter impossibility of proceeding in my work, without the warm patronage of my countrymen. Three or four years more must pass before I can reap any considerable advantage from what I am doing in this country, and as I am far from being rich, those years must not be employed in prosecuting a plan, which, without the real patronage of my country, will only involve me in new certainties of great and immediate expense, with little probability of even distant recompense. I do not aim at opulence, but I must not knowingly rush into embarrassment and ruin.

I am ashamed to trouble you with such details, but without them, I could not so well have explained my reason for not giving you at once a decided answer. You see, sir, that my future

movements depend entirely upon my reception in America, and as that shall be cordial or cold, I am to decide whether to abandon my country or my profession. I think I shall determine without much hesitation; for although I am secure of a kind reception in any quarter of the globe, if I will follow the general example of my profession by flattering the pride or apologizing for the vices of men, yet the ease, perhaps even elegance, which would be the fruit of such conduct, would compensate but poorly for the contempt which I should feel for myself, and for the necessity which it would impose upon me of submitting to a voluntary sentence of perpetual exile. I hope for better things. Monuments have been in repeated instances voted to her heroes; why then should I doubt a readiness in our country to encourage me in producing monuments, not of heroes only, but of those events on which their title to the gratitude of the nation is founded, and which by being multiplied and little expensive, may be diffused over the world, instead of being bounded to one narrow spot?

Immediately therefore upon my arrival in America, I shall offer a subscription for prints to be published from such a series of pictures as I intend, with the condition of returning their money to subscribers, if the sum received shall not prove to be sufficient to justify me in proceeding with the work; and I shall first solicit the public protection of Congress . . .

If a subscription of this sort should fill in such a manner as to justify me, I shall proceed with all possible diligence, and must of course pass some years in Europe; and as I have acquired that knowledge in this country which was my only object for residing here, and shall have many reasons for preferring Paris hereafter, I shall in that case be happy and proud to accept your flattering proposal. But if, on the contrary, my countrymen should not give me such encouragement as I wish and hope, I must give up the pursuit, and of course I shall have little desire to return for any stay in Europe. In the mean time, viewing the absolute uncertainty of my situation, I must beg you not to pass by any more favorable subject which may offer, before I have the happiness to meet you in America, which I hope will be ere long.

I have the honor to be, very gratefully,
Dear sir, your most faithful servant,
JOHN TRUMBULL.

In 1792 I was again in Philadelphia, and there painted the portrait of General Washington, which is now placed in the gallery at New Haven, the best certainly of those which I painted, and the best, in my estimation, which exists, in his heroic military character. The city of Charleston, S.C. instructed William R. Smith, one of the representatives of South Carolina, to employ me to paint for them a portrait of the *great man,* and I undertook it *con amore,* (as the commission was unlimited,) meaning to give his military character, in the most sublime moment of its exertion—the evening previous to the battle of Princeton; when viewing the vast superiority of his approaching enemy, and the impossibility of again crossing the Delaware, or retreating down the river, he conceives the plan of returning by a night march into the country from which he had just been driven, thus cutting off the enemy's communication, and destroying his depot of stores and provisions at Brunswick. I told the President my object; he entered into it warmly, and, as the work advanced, we talked of the scene, its dangers, its almost desperation. He *looked* the scene again, and I happily transferred to the canvass, the lofty expression of his animated countenance, the high resolve to conquer or to perish. The result was in my own opinion eminently successful, and the general was satisfied. But it did not meet the views of Mr. Smith. He admired, he was personally pleased, but he thought the city would be better satisfied with a more matter-of-fact likeness, such as they had recently seen him— calm, tranquil, peaceful . . .

In 1793 I again went to Boston by the way of Newport and Providence . . . Wherever I went

I offered my subscription book, but wretched was now the success, and rapidly decreasing the enthusiasm for my national work.

The progress of the French revolution was blasting to my hopes; for in four years which had elapsed since my interview and conversation with M. de La Fayette, in Paris, recorded in the preceding chapter, all the evils which he had there anticipated, had been realized. The money of that bad man, *the Citizen Égalité,* had been successfully applied to the nefarious purposes which he (the Marquis) had foretold—the elections had been corrupted—the worst of men had been introduced into the National Assembly—the beautiful theory of those estimable men, the early leaders of the revolution, had been subverted—France had been overwhelmed in crime, and deluged with blood—the king had been beheaded, Lafayette himself had been exiled, and the author of all these calamities had expiated his crimes under the same axe which had fallen on so many virtuous men . . .

. . . The calm splendor of our own Revolution, comparatively rational and beneficial as it had been, was eclipsed in the meteoric glare and horrible blaze of glory of republican France; and we, who in our own case, had scarcely stained the sacred robe of rational liberty with a single drop of blood unnecessarily shed, learned to admire that hideous frenzy which made the very streets of Paris flow with blood . . .

In such a state of things, what hope remained for the arts? None,—my great enterprise was blighted.

WASHINGTON ALLSTON'S SOUTHERN ROOTS

Born on a South Carolina plantation, Washington Allston spent the better part of his life in New and Old England. After graduating from Harvard University, Allston embarked for London, where he joined the circle of Benjamin West and took classes at the Royal Academy. He traveled to Paris and Rome, where he became fast friends with the poet Samuel Taylor Coleridge. After three years in Boston (where he married) he returned to London and launched an ambitious bid for fame as a painter of large-scale, spectacular paintings on sublime biblical themes.

Although he was never identified as a southern painter, Allston imbued his plantation roots with great meaning. In the recollections provided to William Dunlap, he attributes his love for the wild and the marvelous to the slaves' ghost stories that fired his childish imagination. Investing heavily in the days of childhood innocence and fantasy, Allston reveals strongly romantic leanings.

William Dunlap, History of the Rise and Progress of the Arts of Design in the United States *(New York: George P. Scott, 1834).*

Mr. Allston, on being questioned respecting his early efforts at designing, answered his correspondent thus: "To go back as far as I can—I remember that I used to draw before I left Carolina, at six years of age, (by the way no *uncommon* thing,) and still earlier, that my favourite amusement, much akin to it, was making little landscapes about the roots of an old tree in the country—meagre enough, no doubt; the only particulars of which I can call to mind, were a cottage built of sticks, shaded by little trees, which were composed of the small suckers, (I think so called,) resembling miniature trees, which I gathered in the woods. Another employment was the converting the forked stalks of the wild ferns into little men and women, by winding about them different coloured yarn. These were sometimes presented with pitchers made of

the pomegranate flower. These childish fancies were the straws by which, perhaps, an observer might then have guessed which way the current was setting for after life. And yet, after all, this love of imitation may be common to childhood. General imitation certainly is: but whether adherence to particular kinds may not indicate a permanent propensity, I leave to those who have studied the subject more than I have, to decide."

Without assuming to be deeper studied in the subject, the reader will remark, that in these delights of Allston's childhood appear the germs of landscape gardening, landscape painting, sculpture, and scenic composition. Less intellectual children are content to make mud pies, and form ovens with clay and clam-shells as if to bake them in. Even when at play they are haunted by the ghosts of cakes, pies, and puddings.

Allston continued: "But even these delights would sometimes give way to a stronger love for the wild and the marvellous. I delighted in being terrified by the tales of witches and hags, which the negroes used to tell me; and I well remember with how much pleasure I recalled these feelings on my return to Carolina; especially on revisiting a gigantic wild grapevine in the woods, which had been the favourite swing for one of these witches." Here may be perceived the germ of that poetic talent which afterward opened and was displayed both by the pen and the pencil of Mr. Allston . . .

. . . I cannot but think that the life of an artist, whether painter or poet, depends much on a happy youth; I do not mean as to outward circumstances, but as to his inward being: in my own case, at least, I feel the dependence; for I seldom step into the ideal world but I find myself going back to the age of first impressions. The germs of our best thoughts are certainly often to be found there; sometimes, indeed, (though rarely) we find them in full flower; and when so, how beautiful seem to us these flowers through an atmosphere of thirty years! 'Tis in this way that poets and painters keep their minds young. How else could an old man make the page or the canvas palpitate with the hopes, and fears, and joys, the impetuous, impassioned, emotions of youthful lovers, or reckless heroes? There is a period of life when the ocean of time seems to force upon the mind a barrier against itself, forming, as it were, a permanent beach, on which the advancing years successively break, only to be carried back by a returning current to that furthest deep whence they first flowed. Upon this beach the *poetry of life* may be said to have its birth; where the *real* ends and the *ideal* begins."

WASHINGTON ALLSTON AND THE MIRACULOUS SUBLIME

Washington Allston's huge Dead Man Restored by Touching the Bones of the Prophet Elisha *(1814) met with enthusiastic acclaim when exhibited in 1814 at the British Institution, where it won a prize of 200 guineas as the best history painting of the year. In 1815 the Pennsylvania Academy of the Fine Arts in Philadelphia purchased the painting for its permanent collection. Exhibited in 1816 at the Pennsylvania Academy, Allston's painting was the star attraction. The catalogue includes the artist's own description of the scene, highlighting the characters' contrasting emotional states, which range from astonishment to pure, abject terror. For Allston, feeling decisively trumps reason.*

Exhibition at the Pennsylvania Academy of the Fine Arts, of Mr. Allston's Picture *(Philadelphia: John Bioren, 1816).*

Mr. Allston's picture of the dead man restored to life by touching the bones of the prophet Elisha. Size of the Picture 13 feet by 11.

And the bands of the Moabites invaded the land at the coming in of the year. And it came to pass as they were burying a man, that behold, they spied a band of men, and they cast the man into the sepulchre of Elisha: *and when the man was let down and touched the bones of Elisha, he revived.*—2 Kings, chap. xiii. v. 20, 21.

The following description is taken from the pen of Mr. Allston: The Sepulchre of Elisha is supposed to be in a cavern among the mountains; such places in those early ages being used for the interment of the dead. In the fore ground is the man at the moment of re-animation, in which the Artist has attempted, both in the action and the colour, to express the gradual recoiling of life upon death; behind him, in a dark recess, are the bones of the Prophet, the skull of which is *peculiarized* by a preternatural light; at his head and feet are two slaves, bearers of the body; the ropes still in their hands, by which they have let it down, indicating the act that moment performed; the emotion attempted in the figure at the feet is that of astonishment and fear, modified by doubt, as if still requiring further confirmation of the miracle before him, while in the figure at the head, is that of unqualified immoveable terror. In the most prominent groupe above, is a Soldier, in the act of rushing from the scene; the violent and terrified action of this figure was chosen to illustrate the miracle by the contrast which it exhibits to that habitual firmness, supposed to belong to the military character, shewing his emotion to proceed from no *mortal* cause. The Figure grasping the Soldier's arm, and pressing forward to look at the body, is expressive of terror, overcome by curiosity. The groupe on the left, or rather behind the Soldier, is composed of two Men of different ages, earnestly listening to the explanation of a Priest, who is directing their thoughts to Heaven, as the source of the miraculous change; the boy clinging to the old man, is too young to comprehend the nature of the miracle, but like children of his age, unconsciously partakes of the general impulse. The groupe on the right forms an episode, consisting of the Wife and Daughter of the Reviving Man. The Wife, unable to withstand the conflicting emotions of the past and the present, has fainted; and whatever joy and astonishment may have been excited in the Daughter by the sudden revival of her Father, they are wholly absorbed in distress and solicitude for her Mother. The young man with outstretched arms, actuated by impulse [*not motive*] announces to the Wife by a sudden exclamation, the revival of her Husband; the other youth, of a mild and devotional character, is still in the attitude of one conversing—the conversation being abruptly broken off by his impetuous companion. The Sentinels in the distance, at the entrance of the cavern, mark the depth of the Picture, and indicate the alarm which had occasioned this tumultuary burial.

WASHINGTON ALLSTON IN BOSTON

After the death of his young wife, Washington Allston left England for Boston, Massachusetts, in 1818, and became a member of the cultured elite there. As time passed, he abandoned his history painting ambitions and turned to poetic landscapes and dreamy figure paintings. History painting did not abandon him, however: from the time of his return to the day of his death, Allston struggled, episodically and in vain, to complete the vast Belshazzar's Feast *(fig. 2), which he had begun in 1817. The story of his battle with the painting contributed to the belief that Boston—and America more generally—offered ground too barren for the romantic artist to thrive.*

In a letter to the writer Washington Irving, Allston excitedly describes his idea for Belshazzar's Feast. *Like* Dead Man Restored, *the new painting explores extreme states of human emotion in the presence of supernatural power. Allston has the highest hopes*

for the painting, telling Irving that the composition is "the best" he has ever made. The portrait painter Chester Harding recollects Allston's fruitless struggle with Belshazzar's Feast *in the late 1820s and recounts the tale—which became legend—of the flawed perspective that ultimately undid all of Allston's efforts to correct it. In the last letter he ever wrote, Allston tells Mrs. William Ellery Channing that until he finishes* Belshazzar *he cannot undertake any more portraits. Finally, in a private journal, Richard Henry Dana Jr. reports in considerable detail what he found on entering Allston's studio soon after the painter's death. Dana's narrative outlines what would become the myth of Allston as a marginal, neglected, and tragically underappreciated American genius.*

Margaret Fuller's review of Allston's one-man show at Harding's Gallery in Boston indicates that, even before the artist's death, that myth was taking shape. In her thoughtful and detailed comments, Fuller (journalist, transcendentalist, and women's rights proponent) laments that there is no "poetical ground-work" for an idealist like Allston in America. Passing over the history paintings as overblown and uncongenial to the artist's sensibility, she locates Allston's dominion in the realm of the beautiful. Fuller dwells on the delicate, feminine beauties of the figure paintings and proceeds to the landscapes, so "lyrically perfect" that they cannot be translated into words. Implicit in Fuller's remarks is the notion that only the cultivated few can fully appreciate Allston's rarefied visual poetry.

Washington Allston to Washington Irving, May 9, 1817, in Pierre M. Irving, The Life and Letters of Washington Irving *(New York: Putnam, 1864).*

Dear Irving: Your sudden resolution of embarking for America has quite thrown me, to use a sea-phrase, all a-back; I have so many things to tell you of—to consult you about, &c., and am such a sad correspondent, that before I can bring my pen to do its office 'tis a hundred to one but the occasions for which your advice would be wished, will have passed and gone. One of these subjects (and the most important) is the large picture I talked of soon beginning: The prophet Daniel interpreting the *handwriting on the wall* before Belshazzar. I have made a highly finished sketch of it, and I wished much to have your remarks on it. But as your sudden departure will deprive me of this advantage, I must beg, should any hints of the subject occur to you during your voyage, that you will favor me with them, at the same time you let me know that you are again safe in our good country. I think the composition the best I ever made. It contains a multitude of figures, and (if I may be allowed to say it) they are without confusion. Don't you think it a fine subject? I know not any that so happily unites the magnificent and the awful: a mighty sovereign, surrounded by his whole court, intoxicated with his own state—in the midst of his revellings, palsied in a moment under the spell of a preternatural hand suddenly tracing his doom on the wall before him; his powerless limbs, like a wounded spider's shrunk up to his body, while his heart, *compressed to a point,* is only kept from vanishing by the terrific suspense that animates it during the interpretation of his mysterious sentence: his less guilty, but scarcely less agitated queen, the panic-struck courtiers and concubines, the splendid and deserted banquet table, the half-arrogant, half astounded magicians, the holy vessels of the Temple, (shining, as it were, in triumph through the gloom,) and the calm, solemn contrast of the Prophet, standing like an animated pillar in the midst, breathing forth the oracular destruction of the empire! The picture will be twelve feet high by seventeen feet long. Should I succeed in it even to my wishes I know not what may be its fate. But I leave the future to Providence. Perhaps I may send it to America . . .

Wishing you a prosperous voyage, and happy meeting with your friends, I remain truly your friend.

Chester Harding and Margaret E. White, eds., A Sketch of Chester Harding, Artist, Drawn by His Own Hand *(Boston: Houghton, Mifflin and Co., 1890).*

I had now become intimately acquainted with Mr. Allston. His habits were peculiar in many respects. He lived alone, dining at six o'clock, and sitting up far into the night. He breakfasted at eleven or twelve. He usually spent three or four evenings, or rather nights, at my house every week; and I greatly enjoyed his conversation, which was of the most polished and refined order, and always instructive. I sometimes called at his studio. It was an old barn, very large, and as cheerless as any anchorite could desire. He never had it swept, and the accumulation of the dust of many years was an inch deep. You could see a track, leading through it to some remote corner of the room, as plainly as in new-fallen snow. He saw few friends in his room; lived almost in solitude, with only his own great thoughts to sustain him.

Just before I sailed for Europe, he had shown me his great picture of the 'Feast of Belshazzar.' It was then finished, with the exception of the figure of Daniel. I thought it a wonderful picture. I was not to speak of it to any one but Leslie. During the three years of my absence, he did not work on it. I had a fine, large studio; and, when I went to Washington, which I did in the winter of 1828, I gave it to Mr. Allston to finish his picture in. But he did not unroll it. He painted all winter, instead, on a landscape; and, when I came home, I found he had wiped out his winter's work, saying it was not worthy of him. He smoked incessantly, became nervous, and was haunted by fears that his great picture would not come up to the standard of his high reputation. One day, he went to his friend Loammi Baldwin, and said, 'I have to-day blotted out my four years' work on my "Handwriting on the Wall."'

He had discovered some little defect in the perspective, which could not be corrected without enlarging the figures in the foreground. Had he painted this picture in London, surrounded by the best works of art, and in daily intercourse with artists of his own standing, his picture would undoubtedly have taken a high rank among the best works of the old masters. As it is, it is only a monument of wasted genius of the highest order.

Richard Henry Dana Jr., journal entry for July 12, 1843, journal volumes 150–52, Dana Family Papers, Massachusetts Historical Society.

Father & I called upon Uncle Edmund with reference to the picture. We agreed to meet at the painting room tomorrow at 4 P.M., with Mr. John Greenough to assist us . . .

[July] 12. At 4 P.M. we assembled to enter the painting room & "break the seal" of the great picture. An awe had been upon my mind as though I were about to enter a sacred & mysterious place. I could hardly bring my mind to turn the key. We tried to prepare for the worst, so that nothing could dissappoint us. But to enter this solemn place, so long & so lately filled with his presence & the home of his glorious thoughts & his painful emotions, the scene of his distresses wh. no human eye saw, & few human spirits can comprehend! I turned the key & opened the outer door. We stood an instant in the porch; but Greenough, whose enthousiasm & interest far surpassed any awe he might feel, rushed in. There before us was spread out the great sheet of painted canvass,—but dimmed, almost obscured by dust & marks & lines of chalk. The eye ran across the picture for the main figures. Daniel stood erect. The queen was there. But where the king should have been, where Daniel's eyes were fixed, was a shroud, a thickly painted coat, effectually blotting out the whole figure. We stood for some minutes in silence.

"How could he have done it?" said Uncle E., "He told me once he had finished the king & was satisfied with it".

"Oh, in some moment of darkness, he swept it all off". Father looked at it & said, "That is *his shroud*". It was indeed a most solemn tragedy that this revealed. We felt that this had killed him. Over this, he had worn out his enfeebled frame & his paralised spirit, until he had sunk under it. The agonies he had endured here, no tongue can tell! Then in the left of the picture the large figures of three Chaldean soothsayers had been chalked over for alteration, the head of Daniel had been chalked, & there were marks for alteration upon the face of the Queen. A part of the pillars at the left of the picture had also chalk marks upon them. The steps upon wh. he painted were placed so as to bring him against the face of the magicians, & by looking carefully we saw marks of fresh paint recently laid on, upon the face of the magician nearest Daniel. There then had been his last work. To the latest moment he had labored upon this great work. He had almost died with his pencil upon it. Six hours before his death, his pencil was on this picture. The right hand of Daniel was incomplete. He had told both me & my father that this hand was painted open; that Stuart, to whom he had shown the picture, had told him to paint Daniel's right hand clenched, to express more intensity of feeling, & that he had altered it to please Stuart, or in deference to his judgement. But no sooner had he done so than he felt, what he had anticipated at the time, that it destroyed that idea. Daniel was not to be impassioned, or intensely excited. His attitude was to be that of calm sublimity, & in contrast with the varieties of excitement portrayed about him.

The hand writing upon the wall was not finished.

The sight of all this work finished & then destroyed, & the alterations requiring months of labor to complete wh. he had planned & wh. he doubtless felt he never could execute, & above all the shroud over the king, so broke upon my father's already over taxed spirit, that he hastened away behind the picture & hid himself from sight. He was gone many minutes. When he returned he looked very pale but composed.

After examining the picture for some time we opened his closet & took out his unfinished pictures & sketches. Among them we found two sketches of the great picture, one a finished sketch in brown & the other painted, but the latter was merely for color & was done with little regard to form or character. Comparing the sketch with the picture, we found that they differed but little. In the sketch the hand of Daniel was open, as he intended to have it, & the king was completed. Uncle Edmund said Mr. Allston had told him that he had finished the king in the great picture & *was satisfied with* it. John Greenough said that several years ago he had seen a part of the picture thro' the crack of the door, & that the king was then finished.

S. Margaret Fuller, "A Record of Impressions Produced by the Exhibition of Mr. Allston's Pictures in the Summer of 1839," in Fuller, Papers on Literature and Art *(New York: Wiley and Putnam, 1846).*

I have seen most of these pictures often before; . . . The effect they produced upon me was so great, that I suppose it was not possible for me to avoid expecting too large a benefit from the artist.

The calm and meditative cast of these pictures, the ideal beauty that shone *through* rather than *in* them, and the harmony of colouring were as unlike anything else I saw . . . I seemed to recognise in painting that self-possessed elegance, that transparent depth, which I most admire in literature; I thought with delight that such a man as this had been able to grow up in our bustling, reasonable community, that he had kept his foot upon the ground, yet never lost sight of the rose-clouds of beauty floating above him . . .

From time to time I have seen other of these pictures, and they have always been to me sweet silvery music, rising by its clear tone to be heard above the din of life; long forest glades glimmering with golden light, longingly eyed from the window of some crowded drawing room.

But now, seeing so many of them together, I can no longer be content merely to feel, but must judge these works . . .

. . . Here, as elsewhere, I suppose the first question should be, What ought we to expect under the circumstances?

There is no poetical ground-work ready for the artist in our country and time. Good deeds appeal to the understanding. Our religion is that of the understanding. We have no old established faith, no hereditary romance, no such stuff as Catholicism, Chivalry afforded. What is most dignified in the Puritanic modes of thought is not favourable to beauty. The habits of an industrial community are not propitious to delicacy of sentiment . . .

If, like Wilkie or Newton, he paints direct from nature, only selecting and condensing, or choosing lights and draperies, I suppose he is as well situated now as he could ever have been; but if, like Mr. Allston, he aims at the Ideal, it is by no means the same. He is in danger of being sentimental and picturesque, rather than spiritual and noble. Mr. Allston has not fallen into these faults; and if we can complain, it is never of blemish or falsity, but of inadequacy. Always he has a high purpose in what he does, never swerves from his aim, but sometimes fails to reach it . . .

Restoring the dead man by the touch of the Prophet's Bones. I should say there was a want of artist's judgment in the very choice of the subject . . .

. . . A miracle effected by means of a relique, or dry bones, has the disagreeable effect of mummery. In this picture the foreground is occupied by the body of the patient in that state of deadly rigidity and pallor so offensive to the sensual eye. The mind must reason the eye out of an instinctive aversion, and force it to its work,—always an undesirable circumstance . . .

Miriam. There is hardly a subject which, for the combination of the sublime with the beautiful could present greater advantages than this. Yet this picture also, with all its great merits, fails to satisfy our highest requisitions . . .

The Witch of Endor is still more unsatisfactory. What a tragedy was that of the stately Saul, ruined by his perversity of will, despairing, half mad, refusing to give up the sceptre which he feels must in a short time be wrenched from his hands, degrading himself to the use of means he himself had forbid as unlawful and devilish, seeking the friend and teacher of his youth by means he would most of all men disapprove. The mournful significance of the crisis, the stately aspect of Saul as celebrated in the history, and the supernatural events which had filled his days, gave authority for investing him with that sort of beauty and majesty proper to archangels ruined. What have we here? I don't know what is generally thought about the introduction of a ghost on canvass, but it is to me as ludicrous as the introduction on the stage of the ghost in Hamlet (*in his night-gown*) as the old play book direction was. The effect of such a representation seems to me unattainable in a picture. There cannot be due distance and shadowy softness . . .

In fine, the more I have looked at these pictures, the more I have been satisfied that the grand historical style did not afford the scope most proper to Mr. Allston's genius. The Prophets and Sibyls are for the Michael Angelos. The Beautiful is Mr. Allston's dominion. There he rules as a Genius . . .

But on his own ground we can meet the painter with almost our first delight.

A certain bland delicacy enfolds all these creations as an atmosphere. Here is no effort, they have floated across the painter's heaven on the golden clouds of phantasy.

These pictures (I speak here only of figures, of the landscapes a few words anon) are almost all in repose. The most beautiful are Beatrice, The Lady reading a Valentine, The Evening Hymn, Rosalie, The Italian Shepherd Boy, Edwin, Lorenzo and Jessica. The excellence of these pictures is subjective and even feminine. They tell us the painter's ideal of character. A graceful repose, with a fitness for moderate action. A capacity of emotion, with a habit of reverie. Not one of these beings is in a state of *epanchement,* not one is, or perhaps could be, thrown off its equipoise. They are, even the softest, characterized by entire though unconscious self-possession . . .

I will specify two of these pictures, which seem to me to indicate Mr. Allston's excellences as well as any.

The Italian Shepherd boy is seated in a wood. The form is almost nude, and the green glimmer of the wood gives the flesh the polished whiteness of marble. He is very beautiful, this boy; and the beauty, as Mr. Allston loves it best, has not yet unfolded all its leaves. The heart of the flower is still a perfumed secret. He sits as if he could sit there forever, gracefully lost in reverie, steeped, if we may judge from his mellow brown eye, in the present loveliness of nature, in the dimly anticipated ecstasies of love.

Every part of nature has its peculiar influence. On the hilltop one is roused, in the valley soothed, beside the waterfall absorbed. And in the wood, who has not, like this boy, walked as far as the excitement of exercise would carry him, and then, with "blood listening in his frame," and heart brightly awake, seated himself on such a bank. At first he notices everything, the clouds doubly soft, the sky deeper blue, as seen shimmering through the leaves, the fyttes of golden light seen through the long glades, the skimming of a butterfly ready to light on some starry wood-flower, the nimble squirrel peeping archly at him, the flutter and wild notes of the birds, the whispers and sighs of the trees,—gradually he ceases to mark any of these things, and becomes lapt in the Elysian harmony they combine to form. Who has ever felt this mood understands why the observant Greek placed his departed great ones in groves. While, during this trance, he hears the harmonies of Nature, he seems to become her and she him; it is truly the mother in the child, and the Hamadryads look out with eyes of tender twilight approbation from their beloved and loving trees. Such an hour lives for us again in this picture.

Mr. Allston has been very fortunate in catching the shimmer and glimmer of the woods, and tempering his greens and browns to their peculiar light.

Beatrice. This is spoken of as Dante's Beatrice, but I should think can scarcely have been suggested by the Divine Comedy. The painter merely having in mind how the great Dante loved a certain lady called Beatrice, embodied here his own ideal of a poet's love.

The Beatrice of Dante was, no doubt, as pure, as gentle, as high-bred, but also possessed of much higher attributes than this fair being.

How fair, indeed, and not unmeet for a poet's love. But there lies in her no germ of the celestial destiny of Dante's saint. What she is, what she can be, it needs no Dante to discover.

She is not a lustrous, bewitching beauty, neither is she a high and poetic one. She is not a concentrated perfume, nor a flower, nor a star; yet somewhat has she of every creature's best. She has the golden mean, without any touch of the mediocre. She can venerate the higher and compassionate the lower, and do to all honour due with most grateful courtesy and nice tact. She is velvet-soft, her mild and modest eyes have tempered all things round her, till no rude sound invades her sphere; yet, if need were, she could resist with as graceful composure as she can favour or bestow.

No vehement emotion shall heave that bosom, and the tears shall fall on those cheeks more

like dew than rain. Yet are her feelings delicate, profound, her love constant and tender, her resentment calm but firm.

Fair as a maid, fairer as a wife, fairest as a lady mother and ruler of a household, she were better suited to a prince than a poet. Even if no prince could be found worthy of her, I would not wed her to a poet, if he lived in a cottage. For her best graces demand a splendid setting to give them their due lustre, and she should rather enhance than cause her environment . . .

The Landscapes. At these I look with such unalloyed delight, that I have been at moments tempted to wish that the artist had concentrated his powers on this department of art, in so high a degree does he exhibit the attributes of the master; a power of sympathy, which gives each landscape a perfectly individual character. Here the painter is merged in his theme, and these pictures affect us as parts of nature, so absorbed are we in contemplating them, so difficult is it to remember them as pictures. How the clouds float! how the trees live and breathe out their mysterious souls in the peculiar attitude of every leaf. Dear companions of my life, whom yearly I know better, yet into whose heart I can no more penetrate than see your roots, while you live and grow, I feel what you have said to this painter; I can in some degree appreciate the power he has shown in repeating here the gentle oracle.

The soul of the painter is in these landscapes, but not his character. Is not that the highest art? Nature and the soul combined; the former freed from slight crudities or blemishes, the latter from its merely human aspect.

These landscapes are too truly works of art, their language is too direct, too lyrically perfect, to be translated into this of words, without doing them an injury.

WASHINGTON ALLSTON'S "SECRET TECHNIQUE"

In the nineteenth century, a great deal was written about the transcendent, luminous effects of Washington Allston's celebrated glazing technique. Tiny, jewel-like specks of color were said to shimmer through the mellow tones of his many applications of glaze (translucent oil paint that has been thinned and "tinted" with small amounts of pigment). These period descriptions are particularly intriguing since so many of Allston's paintings lost their delicate layers of glazing when they were cleaned or restored at a later date. Much like the mysterious technique of Titian, Allston's methods were not fully understood and were difficult to replicate. This may have been what prompted Miner Kellogg to make such careful notes when Allston explained his working manner to the young artist. An ambitious painter who was about to leave for Europe (where he became the first American artist to travel extensively in the Middle East), Kellogg paid particular attention to the mixing of colors—vermillion, Indian red, lake, and others—and the series of steps from the initial laying in of the "dead coloring" to the final finish (in this, he uses several technical terms such as "megilp"—a gelatinous mixture of linseed oil and varnish). Kellogg ends with Allston's interesting warning against the "dangers" of Rubens and his reluctance to show his unfinished Belshazzar's Feast.

Miner K. Kellogg, journal, January 2, 1841, Smithsonian American Art Museum.

He told me his *method* of coloring—etc—the substance absorbent canvas—drab ground—lay in broad—the character, in *bk and Ind. red.* 2d sitting go over shadows with an olive tint made of *ind. red, ochre & black,* encroaching a little upon light. Then commence with the local tints

of flesh. Pallet—red, blue yellow 3 tints each with white. Ind red—or vermli Naples yellow—ultramarine. Sometimes in *all* the flesh tints he uses ultramarine. Lake etc. lay on with hog hair tool a mass of highest light—thick as butter—shape of light on duly proceed with yellow and red tints, from light to dark—running the last into the olive tint of shadow. After all the broad effects are thus made out which may be done quickly—put in the smaller lines and tints whilst picture is wet. In the darker shadows, as under nose, take a tint of Lake & vern or Ind. red. and touch in, right upon the olive. In this manner he says a luminous effect may be produced which cannot be excelled. Wash picture with water & sponge before painting—use no magilp except for glazing. Instead of magilp he uses gold size—which is made of linseed oil boiled down. He uses this as a *dryer,* it is powerful—sometimes with turpentine: when not required to dry rapidly use a little oil. The painting of hair he said was difficult, and gave me what he had learned from Stewart after the first sitting which merely gives a general foundation (ind red and Blk) proceed with pitch tool to make out broad shadows—next take your local tint (*whatever it may be*) and go over the whole of the rest of the head, leaving however but little color on the lights, just enough to receive the next tint easily then take your darkest carnation, (the deepest red on cheek for instance) and with your pitch tool make out carefully your highest lights. If you cannot paint both face and hair same day, make out the outline or junction of the two carefully before leaving it, for after it is dry it is almost impossible to give a soft and natural effect . . .

He cannot recommend to the young artist the study of Rewbens until he has studied all other masters, for he is dangerous . . .

Regretted he could not invite me into his studio, but he had opened his large picture of Belshazzar's Feast, and he did not even allow his *wife* to see it. If his means had allowed he would have finished it 20 years ago.

WASHINGTON ALLSTON'S IDEALISM

Published posthumously, Washington Allston's Lectures on Art *reveal the romantic artist's preoccupation with feeling, imagination, and transcendence. The essay below distills the painter's philosophy, derived in large part from the poetics of Samuel Taylor Coleridge and William Wordsworth. Rejecting rationalism and objectivity, Allston posits that aesthetic pleasure resides not in the object but in the mind. This is the principle of "Poetic Truth" as opposed to the "truth of things": we experience beauty when the objects we behold reflect back some mysterious inner reality. Related to that notion is Allston's conception of Unity, the harmonious, universal whole embracing alike the smallest grain of sand and the mightiest planet. For the romantic painter, then, the external world is only the touchstone for the mental vision he materializes on canvas. Such inwardness places Allston at a radical remove from painters like Charles Willson Peale, who dedicated his art to the service of enlightenment, education, and republican ideals.*

Washington Allston, "Art," Lectures on Art and Poems *(New York: Baker and Scribner, 1850).*

In treating on Art, which, in its highest sense, and more especially in relation to Painting and Sculpture, is the subject proposed for our present examination, the first question that occurs is, In what consists its peculiar character? or rather, What are the characteristics that distinguish it from Nature, which it professes to imitate?

To this we reply, that Art is characterized,—

First, by Originality.

Secondly, by what we shall call Human or Poetic Truth; which is the verifying principle by which we recognize the first.

Thirdly, by Invention; the product of the Imagination, as grounded on the first, and verified by the second. And,

Fourthly, by Unity, the synthesis of all.

As the first step to the right understanding of any discourse is a clear apprehension of the terms used, we add, that by Originality we mean any thing (admitted by the mind as *true*) which is peculiar to the Author, and which distinguishes his production from that of all others; by Human or Poetic Truth, that which may be said to exist exclusively in and for the mind, and as contradistinguished from the truth of things in the natural or external world; by Invention, any unpractised mode of presenting a subject, whether by the combination of entire objects already known, or by the union and modification of known but fragmentary parts into new and consistent forms; and, lastly, by Unity, such an agreement and interdependence of all the parts, as shall constitute a whole.

It will be our attempt to show, that, by the presence or absence of any one of these characteristics, we shall be able to affirm or deny in respect to the pretension of any object as a work of Art; and also that we shall find within ourselves the corresponding law, or by whatever word we choose to designate it, by which each will be recognized; that is, in the degree proportioned to the development, or active force, of the law so judging . . .

. . . If it be true, (as we hope to set forth more at large in a future discourse,) that no two minds were ever found to be identical, there must then in every individual mind be *something* which is not in any other. And, if this unknown something is also found to give its peculiar hue, so to speak, to every impression from outward objects, it seems but a natural inference, that, whatever it be, it *must* possess a pervading force over the entire mind,—at least, in relation to what is external. But, though this may truly be affirmed of man generally, from its evidence in any one person, we shall be far from the fact, should we therefore affirm, that, otherwise than potentially, the power of outwardly manifesting it is also universal. We know that it is not,— and our daily experience proves that the power of reproducing or giving out the individualized impressions is widely different in different men. With some it is so feeble as apparently never to act; and, so far as our subject is concerned, it may practically be said not to exist; of which we have abundant examples in other mental phenomena, where an imperfect activity often renders the existence of some essential faculty a virtual nullity. When it acts in the higher degrees, so as to make another see or feel *as* the Individual saw or felt,—this, in relation to Art, is what we mean, in its strictest sense, by Originality. He, therefore, who possesses the power of presenting to another the *precise* images or emotions as they existed in himself, presents that which can be found nowhere else, and was first found by and within himself; and, however light or trifling, where these are true as to his own mind, their author is so far an originator . . .

But it must not be inferred that originality consists in any contradiction to Nature; for, were this allowed and carried out, it would bring us to the conclusion, that, the greater the contradiction, the higher the Art. We insist only on the modification of the natural by the personal; for Nature is, and ever must be, at least the sensuous ground of all Art: and where the outward and inward are so united that we cannot separate them, there shall we find the perfection of Art. So complete a union has, perhaps, never been accomplished, and *may* be impossible; it is certain, however, that no approach to excellence can ever be made, if the *idea* of such a union be not constantly looked to by the artist as his ultimate aim. Nor can the idea be admitted with-

out supposing a *third* as the product of the two,—which we call Art; between which and Nature, in its strictest sense, there must ever be a difference; indeed, a *difference with resemblance* is that which constitutes its essential condition.

It has doubtless been observed, that, in this inquiry concerning the nature and operation of the first characteristic, the presence of the second, or verifying principle, has been all along implied; nor could it be otherwise, because of their mutual dependence. Still more will its active agency be supposed in our examination of the third, namely, Invention. But before we proceed to that, the paramount index of the highest art, it may not be amiss to obtain, if possible, some distinct apprehension of what we have termed Poetic Truth; to which, it will be remembered, was also prefixed the epithet Human, our object therein being to prepare the mind, by a single word, for its peculiar sphere; and we think it applicable also for a more important reason, namely, that this kind of Truth is the *true ground of the poetical,*—for in what consists the poetry of the natural world, if not in the sentiment and reacting life it receives from the human fancy and affections? And, until it can be shown that sentiment and fancy are also shared by the brute creation, this seeming effluence from the beautiful in nature must rightfully revert to man. What, for instance, can we suppose to be the effect of the purple haze of a summer sunset on the cows and sheep, or even on the more delicate inhabitants of the air? From what we know of their habits, we cannot suppose more than the mere physical enjoyment of its genial temperature. But how is it with the poet, whom we shall suppose an object in the same scene, stretched on the same bank with the ruminating cattle, and basking in the same light that flickers from the skimming birds. Does he feel nothing more than the genial warmth? Ask him, and he perhaps will say,—"This is my soul's hour; this purpled air the heart's atmosphere, melting by its breath the sealed fountains of love, which the cold commonplace of the world had frozen: I feel them gushing forth on every thing around me; and how worthy of love now appear to me these innocent animals, nay, these whispering leaves, that seem to kiss the passing air, and blush the while at their own fondness! Surely they are happy, and grateful too that they are so; for hark! how the little birds send up their song of praise! and see how the waving trees and waving grass, in mute accordance, keep time with the hymn!" . . .

. . . What do we mean by Human or Poetic Truth?

When, in respect to certain objects, the effects are found to be uniformly of the same kind, not only upon ourselves, but also upon others, we may reasonably infer that the efficient cause is of one nature, and that its uniformity is a necessary result. And, when we also find that these effects, though differing in degree, are yet uniform in their character, while they seem to proceed from objects which in themselves are indefinitely variant, both in kind and degree, we are still more forcibly drawn to the conclusion, that the *cause* is not only *one,* but not inherent in the object. The question now arises, What, then, is that which seems to us so like an *alter et idem,*[5]—which appears to act upon, and is recognized by us, through an animal, a bird, a tree, and a thousand different, nay, opposing objects, in the same way, and to the same end? The inference follows of necessity, that the mysterious cause must be in some general law, which is absolute and *imperative* in relation to every such object under certain conditions. And we receive the solution as true,—because we cannot help it. The reality, then, of such a law becomes a fixture in the mind.

But we do not stop here: we would know something concerning the conditions supposed.

[5] "Another world and yet the same."

And in order to this, we go back to the effect. And the answer is returned in the form of a question,—May it not be something *from ourselves,* which is reflected back by the object,—something with which, as it were, we imbue the object, making it correspond to a *reality* within us? Now we recognize the reality within; we recognize it also in the object,—and the affirming light flashes upon us, not in the form of *deduction,* but of inherent Truth, which we cannot get rid of; and we *call* it Truth,—for it will take no other name.

It now remains to discover, so to speak, its location. In what part, then, of man may this self-evidenced, yet elusive, Truth or power be said to reside? It cannot be in the senses; for the senses can impart no more than they receive. Is it, then, in the mind? Here we are compelled to ask, What is understood by the mind? Do we mean the understanding? We can trace no relation between the Truth we would class and the reflective faculties. Or in the moral principle? Surely not; for we can predicate neither good nor evil by the Truth in question. Finally, do we find it identified with the truth of the Spirit? But what is the truth of the Spirit but the Spirit itself,—the conscious *I?* which is never even thought of in connection with it. In what form, then, shall we recognize it? In its own,—the form of Life,—the life of the Human Being; that self-projecting, realizing power, which is ever present, ever acting and giving judgment on the instant on all things corresponding with its inscrutable self. We now assign it a distinctive epithet, and call it Human . . .

We proceed now to the third characteristic. It has already been stated, in the general definition, what we would be understood to mean by the term Invention, in its particular relation to Art; namely, any unpractised mode of presenting a subject, whether by the combination of forms already known, or by the union and modification of known but fragmentary parts into a new and consistent whole: in both cases tested by the two preceding characteristics.

We shall consider first that division of the subject which stands first in order,—the Invention which consists in the new combination of known forms. This may be said to be governed by its exclusive relation either to *what is,* or *has been,* or, when limited by the *probable,* to what strictly may be. It may therefore be distinguished by the term Natural. But though we so name it, inasmuch as all its forms have their prototypes in the Actual, it must still be remembered that these existing forms do substantially constitute no more than mere *parts* to be combined into a *whole,* for which Nature has provided no original. For examples in this, the most comprehensive class, we need not refer to any particular school; they are to be found in all and in every gallery: from the histories of Raffaelle, the landscapes of Claude and Poussin and others, to the familiar scenes of Jan Steen, Ostade, and Brower. In each of these an adherence to the actual, if not strictly observed, is at least supposed in all its parts; not so in the whole, as that relates to the probable; by which we mean such a result as *would be* true, were the same combination to occur in nature. Nor must we be understood to mean, by adherence to the actual, that one part is to be taken for an exact portrait; we mean only such an imitation as precludes an intentional deviation from already existing and known forms.

It must be very obvious, that, in classing together any of the productions of the artists above named, it cannot be intended to reduce them to a level . . . But admitting, as all must, a wide, nay, almost impassable, interval between the familiar subjects of the lower Dutch and Flemish painters, and the higher intellectual works of the great Italian masters, we see no reason why they may not be left to draw their own line of demarcation as to their respective provinces, even as is every day done by actual objects; which are all equally natural, though widely differenced as well in kind as in quality. It is no degradation to the greatest genius to say of him and of the most unlettered boor, that they are both men . . .

. . . In order, however, more distinctly to exhibit their common ground of Invention, we will briefly examine a picture by Ostade, and then compare it with one by Raffaelle, than whom no two artists could well be imagined having less in common.

The interior of a Dutch cottage forms the scene of Ostade's work, presenting something between a kitchen and a stable. Its principal object is the carcass of a hog, newly washed and hung up to dry; subordinate to which is a woman nursing an infant; the accessories, various garments, pots, kettles, and other culinary utensils.

The bare enumeration of these coarse materials would naturally predispose the mind of one, unacquainted with the Dutch school, to expect any thing but pleasure; indifference, not to say disgust, would seem to be the only possible impression from a picture composed of such ingredients. And such, indeed, would be their effect under the hand of any but a real Artist. Let us look into the picture and follow Ostade's *mind,* as it leaves its impress on the several objects. Observe how he spreads his principal light, from the suspended carcass to the surrounding objects, moulding it, so to speak, into agreeable shapes, here by extending it to a bit of drapery, there to an earthen pot; then connecting it, by the flash from a brass kettle, with his second light, the woman and child; and again turning the eye into the dark recesses through a labyrinth of broken chairs, old baskets, roosting fowls, and bits of straw, till a glimpse of sunshine, from a half-open window, gleams on the eye, as it were, like an echo, and sending it back to the principal object, which now seems to act on the mind as the luminous source of all these diverging lights. But the magical whole is not yet completed; the mystery of color has been called in to the aid of light, and so subtly blends that we can hardly separate them; at least, until their united effect has first been felt, and after we have begun the process of cold analysis. Yet even then we cannot long proceed before we find the charm returning; as we pass from the blaze of light on the carcass, where all the tints of the prism seem to be faintly subdued, we are met on its borders by the dark harslet,[6] glowing like rubies; then we repose awhile on the white cap and kerchief of the nursing mother; then we are roused again by the flickering strife of the antagonist colors on a blue jacket and red petticoat; then the strife is softened by the low yellow of a straw-bottomed chair; and thus with alternating excitement and repose do we travel through the picture, till the scientific explorer loses the analyst in the unresisting passiveness of a poetic dream. Now all this will no doubt appear to many, if not absurd, at least exaggerated: but not so to those who have ever felt the sorcery of color. They, we are sure, will be the last to question the character of the feeling because of the ingredients which worked the spell, and, if true to themselves, they must call it poetry. Nor will they consider it any disparagement to the all-accomplished Raffaelle to say of Ostade that he also was an Artist.

We turn now to a work of the great Italian,—the Death of Ananias. The scene is laid in a plain apartment, which is wholly devoid of ornament, as became the hall of audience of the primitive Christians. The Apostles (then eleven in number) have assembled to transact the temporal business of the Church, and are standing together on a slightly elevated platform, about which, in various attitudes, some standing, others kneeling, is gathered a promiscuous assemblage of their new converts, male and female. This quiet assembly (for we still feel its quietness in the midst of the awful judgment) is suddenly roused by the sudden fall of one of their brethren; some of them turn and see him struggling in the agonies of death. A moment before he was in the vigor of life,—as his muscular limbs still bear evidence; but he had uttered a falsehood, and

[6] Harslet: the exposed entrails of a slaughtered hog.

an instant after his frame is convulsed from head to foot. Nor do we doubt for a moment as to the awful cause: it is almost expressed in voice by those nearest to him, and, though varied by their different temperaments, by terror, astonishment, and submissive faith, this voice has yet but one meaning,—"Ananias has lied to the Holy Ghost." The terrible words, as if audible to the mind, now direct us to him who pronounced his doom, and the singly-raised finger of the Apostle marks him the judge; yet not of himself,—for neither his attitude, air, nor expression has any thing in unison with the impetuous Peter,—he is now the simple, passive, yet awful in-strument of the Almighty: while another on the right, with equal calmness, though with more severity, by his elevated arm, as beckoning to judgment, anticipates the fate of the entering Sap-phira. Yet all is not done; lest a question remain, the Apostle on the left confirms the judgment. No one can mistake what passes within him; like one transfixed in adoration, his uplifted eyes seem to ray out his soul, as if in recognition of the divine tribunal. But the overpowering thought of Omnipotence is now tempered by the human sympathy of his companion, whose open hands, connecting the past with the present, seem almost to articulate, "Alas, my brother!" By this exquisite turn, we are next brought to John, the gentle almoner of the Church, who is dealing out their portions to the needy brethren. And here, as most remote from the judged Ananias, whose suffering seems not yet to have reached it, we find a spot of repose,—not to pass by, but to linger upon, till we feel its quiet influence diffusing itself over the whole mind; nay, till, connecting it with the beloved Disciple, we find it leading us back through the exciting scene, modifying even our deepest emotions with a kindred tranquillity.

This is Invention; we have not moved a step through the picture but at the will of the Artist. He invented the chain which we have followed, link by link, through every emotion, assimi-lating many into one; and this is the secret by which he prepared us, without exciting horror, to contemplate the struggle of mortal agony.

This too is Art; and the highest art, when thus the awful power, without losing its character, is tempered, as it were, to our mysterious desires. In the work of Ostade, we see the same in-ventive power, no less effective, though acting through the medium of the humblest materials . . .

We shall now ascend from the *probable* to the *possible*, to that branch of Invention whose proper office is from the known but fragmentary to realize the unknown; in other words, to embody the possible, having its sphere of action in the world of Ideas. To this class, therefore, may properly be assigned the term *Ideal.*

And here, as being its most important scene, it will be necessary to take a more particular view of the verifying principle, the agent, so to speak, that gives reality to the inward, when out-wardly manifested.

Now, whether we call this Human or Poetic Truth, or *inward life*, it matters not; we know by *its effects*, (as we have already said, and we now repeat,) that some such principle does exist, and that it acts upon us, and in a way analogous to the operation of that which we call truth and life in the world about us. And that the cause of this analogy is a real affinity between the two powers seems to us confirmed, not only *positively* by this acknowledged fact, but also *neg-atively* by the absence of the effect above mentioned in all those productions of the mind which we pronounce unnatural. It is therefore in effect, or *quoad* ourselves, both truth and life, ad-dressed, if we may use the expression, to that inscrutable *instinct* of the imagination which conducts us to the knowledge of all invisible realities.

A distinct apprehension of the reality and of the office of this important principle, we can-not but think, will enable us to ascertain with some degree of precision, at least so far as relates to art, the true limits of the Possible,—the sphere, as premised, of Ideal Invention.

As to what some have called our *creative* powers, we take it for granted that no correct thinker has ever applied such expressions literally. Strictly speaking, we can *make* nothing: we can only construct. But how vast a theatre is here laid open to the constructive powers of the finite creature; where the physical eye is permitted to travel for millions and millions of miles, while that of the mind may, swifter than light, follow out the journey, from star to star, till it falls back on itself with the humbling conviction that the measureless journey is then but begun! It is needless to dwell on the immeasurable mass of materials which a world like this may supply to the Artist.

The very thought of its vastness darkens into wonder. Yet how much deeper the wonder, when the created mind looks into itself, and contemplates the power of impressing its thoughts on all things visible; nay, of giving the likeness of life to things inanimate; and, still more marvellous, by the mere combination of words or colors, of evolving into shape its own Idea, till some unknown form, having no type in the actual, is made to seem to us an organized being. When such is the result of any unknown combination, then it is that we achieve the Possible. And here the Realizing Principle may strictly be said to prove itself.

That such an effect should follow a cause which we know to be purely imaginary, supposes, as we have said, something in ourselves which holds, of necessity, a predetermined relation to every object either outwardly existing or projected from the mind, which we thus recognize as true. If so, then the Possible and the Ideal are convertible terms; having their existence, *ab initio,* in the nature of the mind. The soundness of this inference is also supported negatively, as just observed, by the opposite result, as in the case of those fantastic combinations, which we sometimes meet with both in Poetry and Painting, and which we do not hesitate to pronounce unnatural, that is, false.

And here we would not be understood as implying the preëxistence of all possible forms, as so many *patterns,* but only of that constructive Power which imparts its own Truth to the unseen *real,* and, under certain conditions, reflects the image or semblance of its truth on all things imagined; and which must be assumed in order to account for the phenomena presented in the frequent coincident effect between the real and the feigned. Nor does the absence of consciousness in particular individuals, as to this Power in themselves, fairly affect its universality, at least potentially: since by the same rule there would be equal ground for denying the existence of any faculty of the mind which is of slow or gradual development; all that we may reasonably infer in such cases is, that the whole mind is not yet revealed to itself. In some of the greatest artists, the inventive powers have been of late developement; as in Claude, and the sculptor Falconet. And can any one believe that, while the latter was hewing his master's marble, and the former making pastry, either of them was conscious of the sublime Ideas which afterwards took form for the admiration of the world? When Raffaelle, then a youth, was selected to execute the noble works which now live on the walls of the Vatican, "he had done little or nothing," says Reynolds, "to justify so high a trust." Nor could he have been certain, from what he knew of himself, that he was equal to the task. He could only hope to succeed; and his hope was no doubt founded on his experience of the progressive developement of his mind in former efforts; rationally concluding, that the originally seeming blank from which had arisen so many admirable forms was still teeming with others, that only wanted the occasion, or excitement, to come forth at his bidding.

To return to that which, as the interpreting medium of his thoughts and conceptions, connects the artist with his fellow-men, we remark, that only on the ground of some self-realizing power, like what we have termed Poetic Truth, could what we call the Ideal ever be intelligible . . .

Of the immutable nature of this peculiar Truth, we have a like instance in the Farnese Hercules; the work of the Grecian sculptor Glycon . . .

Perhaps the attempt to give form and substance to a pure Idea was never so perfectly accomplished as in this wonderful figure. Who has ever seen the ocean in repose, in its awful sleep, that smooths it like glass, yet cannot level its unfathomed swell? So seems to us the repose of this tremendous personification of strength: the laboring eye heaves on its slumbering sea of muscles, and trembles like a skiff as it passes over them: but the silent intimations of the spirit beneath at length become audible; the startled imagination hears it in its rage, sees it in motion, and sees its resistless might in the passive wrecks that follow the uproar. And this from a piece of marble, cold, immovable, lifeless! Surely there is that in man, which the senses cannot reach, nor the plumb of the understanding sound.

Let us turn now to the Apollo called Belvedere. In this supernal being, the human form seems to have been assumed as if to make visible the harmonious confluence of the pure ideas of grace, fleetness, and majesty; nor do we think it too fanciful to add celestial splendor; for such, in effect, are the thoughts which crowd, or rather rush, into the mind on first beholding it . . . If I may be permitted to recall the impression which it made on myself, I know not that I could better describe it than as a sudden intellectual flash, filling the whole mind with light,—and light in motion. It seemed to the mind what the first sight of the sun is to the senses, as it emerges from the ocean; when from a point of light the whole orb at once appears to bound from the waters, and to dart its rays, as by a visible explosion, through the profound of space. But, as the deified Sun, how completely is the conception verified in the thoughts that follow the effulgent original and its marble counterpart! Perennial youth, perennial brightness, follow them both. Who can imagine the old age of the sun? As soon may we think of an old Apollo. Now all this may be ascribed to the imagination of the beholder. Granted,—yet will it not thus be explained away. For that is the very faculty addressed by every work of Genius,—whose nature is *suggestive;* and only when it excites to or awakens congenial thoughts and emotions, filling the imagination with corresponding images, does it attain its proper end. The false and the commonplace can never do this . . .

Of Unity, the fourth and last characteristic, we shall say but little; for we know in truth little or nothing of the law which governs it: indeed, all that we know but amounts to this,—that, wherever existing, it presents to the mind the Idea of a Whole,—which is itself a mystery . . .

To return to the objection, that we often receive pleasure from many things in Nature which seem to us fragmentary, we observe, that nothing in Nature can be fragmentary, except in the seeming, and then, too, to the understanding only,—to the feelings never; for a grain of sand, no less than a planet, being an essential part of that mighty whole which we call the universe, cannot be separated from the Idea of the world without a positive act of the reflective faculties, an act of volition; but until then even a grain of sand cannot cease to imply it. To the mere understanding, indeed, even the greatest extent of actual objects which the finite creature can possibly imagine must ever fall short of the vast works of the Creator. Yet we nevertheless can, and do, apprehend the existence of the universe. Now we would ask here, whether the influence of a *real,*—and the epithet here is not unimportant,—whether the influence of a real Whole is at no time felt without an act of consciousness, that is, without thinking of a whole. Is this impossible? Is it altogether out of experience? We have already shown (as we think) that no *unmodified copy* of actual objects, whether single or multifarious, ever satisfies the imagination,— which imperatively demands a something more, or at least different. And yet we often find that the very objects from which these copies are made *do* satisfy us. How and why is this? A ques-

tion more easily put than answered. We may suggest, however, what appears to us a clew, that in abler hands may possibly lead to its solution; namely, the fact, that, among the innumerable emotions of a pleasurable kind derived from the actual, there is not one, perhaps, which is strictly confined to the objects before us, and which we do not, either directly or indirectly, refer to something beyond and not present. Now have we at all times a distinct consciousness of the things referred to? Are they not rather more often vague, and only indicated in some *undefined* feeling? Nay, is its source more intelligible where the feeling is more definite, when taking the form of a sense of harmony, as from something that diffuses, yet deepens, unbroken in its progress through endless variations, the melody as it were of the pleasurable object? Who has never felt, under certain circumstances, an expansion of the heart, an elevation of mind, nay, a striving of the whole being to pass its limited bounds, for which he could find no adequate solution in the objects around him,—the apparent cause? Or who can account for every mood that thralls him,—at times like one entranced in a dream by airs from Paradise,—at other times steeped in darkness, when the spirit of discord seems to marshal his every thought, one against another?

Whether it be that the Living Principle, which permeates all things throughout the physical world, cannot be touched in a single point without conducting to its centre, its source, and confluence, thus giving by a part, though obscurely and indefinitely, a sense of the whole,—we know not. But this we may venture to assert, and on no improbable ground,—that a ray of light is not more continuously linked in its luminous particles than our moral being with the whole moral universe. If this be so, may it not give us, in a faint shadowing at least, some intimation of the many real, though unknown relations, which everywhere surround and bear upon us? In the deeper emotions, we have, sometimes, what seems to us a fearful proof of it. But let us look at it negatively; and suppose a case where this chain is broken,—of a human being who is thus cut off from all possible sympathies, and shut up, as it were, in the hopeless solitude of his own mind. What is this horrible avulsion, this impenetrable self-imprisonment, but the appalling state of *despair?* And what if we should see it realized in some forsaken outcast, and hear his forlorn cry, "Alone! alone!" while to his living spirit that single word is all that is left him to fill the blank of space? In such a state, the very proudest autocrat would yearn for the sympathy of the veriest wretch.

It would seem, then, since this living cement which is diffused through nature, binding all things in one, so that no part can be contemplated that does not, of necessity, even though unconsciously to us, act on the mind with reference to the whole,—since this, as we find, cannot be transferred to any copy of the actual, it must needs follow, if we would imitate Nature in its true effects, that recourse must be had to another, though similar principle, which shall so pervade our production as to satisfy the mind with an efficient equivalent. Now, in order to this there are two conditions required: first, the personal modification, (already discussed) of every separate part,—which may be considered as its proper life; and, secondly, the uniting of the parts by such an interdependence that they shall appear to us as essential, one to another, and all to each. When this is done, the result is a whole. But how do we obtain this mutual dependence? We refer the questioner to the law of Harmony,—that mysterious power, which is only apprehended by its imperative effect . . .

We have thus—and, we trust, on no fanciful ground—endeavoured to establish the real and distinctive character of Art. And, if our argument be admitted, it will be found to have brought us to the following conclusions:—first, that the true ground of all originality lies in the *individualizing law,* that is, in that modifying power, which causes the difference between man and man

as to their mental impressions; secondly, that only in a *true* reproduction consists its evidence; thirdly, that in the involuntary response from other minds lies the truth of the evidence; fourthly, that in order to this response there must therefore exist some universal kindred principle, which is essential to the human mind, though widely differenced in the degree of its activity in different individuals; and finally, that this principle, which we have here denominated Human or Poetic Truth, being independent both of the will and of the reflective faculties, is in its nature *imperative,* to affirm or deny, in relation to every production pretending to Art, from the simple imitation of the actual to the probable, and from the probable to the possible;—in one word, that the several characteristics, Originality, Poetic Truth, Invention, each imply a something not inherent in the objects imitated, but which must emanate alone from the mind of the Artist.

JOHN VANDERLYN'S BID FOR FAME

The first American painter to study in Paris, John Vanderlyn was the protégé of Aaron Burr. Trained in the neoclassical style, Vanderlyn exhibited at the Paris Salon with considerable success. When he returned to the United States in 1815, Vanderlyn brought his two most ambitious paintings—Marius amidst the Ruins of Carthage *(1807) and* Ariadne Asleep on the Island of Naxos *(1809–10), a sensuous ideal nude—and, in a similar vein, a copy after Correggio's* Antiope *in the Louvre. With these works, Vanderlyn hoped to lay the foundation for a great school of American history painting. In his letter to John R. Murray, Vanderlyn discusses his strategy for the* Antiope *(and by extension* Ariadne*). Such titillating subjects, unfit for domestic consumption, will attract both connoisseurs and voyeurs in large numbers. As if to counterbalance the vision of such salacious spectacles, Vanderlyn goes on to describe* Marius *as a moral meditation on the delusions of grandeur that can topple even the most virtuous and powerful. Although Vanderlyn failed to achieve the hoped-for* succès de scandale, *Murray's reaction to the* Antiope, *as reported by William Dunlap, suggests that the painter was at least partially correct in his estimation of American taste, or distaste, for the nude.*

John Vanderlyn to John R. Murray, July 3, 1809, Senate House State Historic Site, New York State Office of Parks, Recreation, and Historic Preservation.

Dear Sir

To begin I will tell you that I have the little project on my return to America to make a small exhibition of my own pictures and with that view I wish to remain here in order to provide myself with a couple more pictures to add to that of Marius—from the success a foreign artist Mr. Wertmuller met with in exhibiting a Picture of Danae in Phila—a few years ago, as I am informed I have reason to form similar expectations, and I have been more encouraged to believe so from the opinion I have consulted of those last from America and I trust you may not think differently—I am now engaged with copying a Picture in the gallery here intended for that purpose, the one I have chosen is Antiope asleep with Cupid and Jupiter in the form of a Satyr you probably recollect the picture its size is about 5 feet some inches by 4 ft. In my opinion it is the best picture of Corregio's in the collection here—possessing in a greater degree the excellencies which distinguish him than any I have yet seen, that breadth of light and shadow and insensible artful unison, one with the other, joined to exquisite harmony and delicacy of tint is here seen in a most conspicuous manner—the subject tis true was favorable to it and

most likely he choose it on that account principally . . . I have already dead colored my Copy which is the size of the original and hope in the course of two months to be able to complete it, however I will spare no time nor pains about it for I aim at making a *good* copy not a tolerable one and will feel mortified if I don't succeed. The subject may not be chaste enough for the more chaste and modest Americans, at least to be displayed in the house of any private individual to either the company of the Parlor or drawing room, but on that account it may attract a greater crowd if exhibited publickly, and the subject may thus invite some who are incapable of being entertained by the merits the picture may possess as a work of art—So soon as I have done this I hope my circumstances will allow me to undertake another picture of my own invention as a pendant to Marius. I have one or two subjects in mind. I hope and flatter myself to be able to accomplish these [illegible] views by next summer and will be anxious to return home immediately after—I am much attached to this project and will lament my fortune if I am prevented from carrying it into effect— . . .

So remains
Respectfully—
your humble servant
J- VANDERLYN

PS. I subjoin you a few lines explaining the subject of the picture of Marius

Gaius Marius on the Ruins of Carthage

This celebrated proscript after encountering a variety of misfortunes and dangers in his flight, at length—arrived in Africa, landed at the ancient Port of Carthage; on the ruins of which city he waited for, and received the answer of the Roman Propretor Sextilius. The interval of the message is the moment of time represented in the picture—The subject exhibits in a double instance the instability of human grandeur: a City in Ruins, and a fallen General—In the countenance of Marius in which there is more of rude and savage nature than dignified—I have endeavored to express the disappointment of ambition, with the meditations of revenge—

William Dunlap, History of the Rise and Progress of the Arts of Design in the United States *(New York: George P. Scott, 1834).*

I first saw this admirable copy [of Correggio's *Antiope*] at the house of John R. Murray, Esq. from whom, I then understood, Mr. Vanderlyn had received a commission to copy a picture for him. Murray admired it, but he said "What can I do with it? It is altogether indecent. I cannot hang it up in my house, and my family reprobate it." The artist had consulted his own taste, and the advantage of studying such a work, more than the habits of his country, or the taste of his countrymen.

It has since been exhibited in the Rotunda of our city.

JOHN VANDERLYN PAINTS AN AMERICAN EPIC

Like the first generation of history painters in the new United States, writers too aspired to define and celebrate national identity in prose and poetry. Joel Barlow, a multifaceted Connecticut lawyer, editor, and diplomat, published a long poem, The Vision of Columbus, *in 1787 and then expanded it to epic scale in* The Columbiad, *which appeared in*

1807. Seeking an illustrator, Barlow approached John Vanderlyn in 1803. Although he agreed to the commission, Vanderlyn subsequently lavished all of his energy on the production of a monumental history painting, The Death of Jane McCrae *(1804), inspired by one episode telling the tragic story of Lucinda, murdered during the Revolution by Mohawks in the pay of the British. Barlow based his narrative on actual historical events involving Jane McCrae, a Loyalist who died en route to a rendezvous with her lover, an officer in General Burgoyne's army. Although the actual circumstances of McCrae's death have never been established beyond dispute, the scenario involving savage Native killers swiftly acquired mythic status. Barlow's stanzas tell the tragic tale in heroic couplets, eroticizing the victim's helpless terror and demonizing the murderers. His elevated verse exemplifies the desire—shared by Vanderlyn—to dramatize and give epic grandeur to distinctively American historical subjects.*

Joel Barlow, The Columbiad, A Poem, *Book VI, lines 615–84 (Philadelphia: Conrad, Lucas and Co., 1807).*

One deed shall tell what fame great Albion draws
From these auxiliars in her barbarous cause,
Lucinda's fate; the tale, ye nations, hear;
Eternal ages, trace it with a tear.
Long from the rampart, thro the imbattled field,
She spied her Heartly where his column wheel'd,
Traced him with steadfast eye and tortured breast
That heaved in concert with his dancing crest;
And oft, with head advanced and hand outspread,
Seem'd from her love to ward the flying lead;
Till, dimm'd by distance and the gathering cloud,
At last he vanisht in the warrior crowd.
She thought he fell; and wild with fearless air,
She left the camp to brave the woodland war,
Made a long circuit all her friends to shun
And wander'd wide beneath the falling sun;
Then veering to the field, the pickets past
To gain the hillock where she miss'd him last.
Fond maid, he rests not there; from finisht fight
He sought the camp and closed the rear of flight.
He hurries to his tent;—oh rage! despair!
No glimpse, no tidings of the frantic fair;
Save that some carmen, as acamp they drove,
Had seen her coursing for the western grove.
Faint with fatigue and choked with burning thirst,
Forth from his friends with bounding leap he burst,
Vaults o'er the palisade with eyes on flame
And fills the welkin with Lucinda's name,
Swift thro the wild wood paths frenetic springs,—
Lucind! Lucinda! thro the wild wood rings.
All night he wanders; barking wolves alone
And screaming night-birds answer to his moan;

For war had roused them from their savage den;
They scent the field, they snuff the walks of men.
The fair one too, of every aid forlorn,
Had raved and wander'd, till officious morn
Awaked the Mohawks from their short repose
To glean the plunder ere their comrades rose.
Two Mohawks met the maid,—historian, hold!—
Poor Human Nature, must thy shame be told?
Where then that proud preeminence of birth,
Thy Moral Sense? the brightest boast of earth.
Had but the tiger changed his heart for thine,
Could rocks their bowels with that heart combine,
Thy tear had gusht, thy hand relieved her pain
And led Lucinda to her lord again.
She starts, with eyes upturn'd and fleeting breath,
In their raised axes views her instant death,
Spreads her white hands to heaven in frantic prayer,
Then runs to grasp their knees and crouches there.
Her hair, half lost along the shrubs she past,
Rolls in loose tangles round her lovely waist;
Her kerchief torn betrays the globes of snow
That heave responsive to her weight of woe.
Does all this eloquence suspend the knife?
Does no superior bribe contest her life?
There does: the scalps by British gold are paid;
A long-hair'd scalp adorns that heavenly head;
And comes the sacred spoil from friend or foe,
No marks distinguish and no man can know.
With calculating pause and demon grin,
They seize her hands and thro her face divine
Drive the descending ax; the shriek she sent
Attain'd her lover's ear; he thither bent
With all the speed his wearied limbs could yield,
Whirl'd his keen blade and stretcht upon the field
The yelling fiends; who there disputing stood
Her gory scalp, their horrid prize of blood.
He sunk delirious on her lifeless clay
And past, in starts of sense, the dreadful day.

JOHN VANDERLYN'S PANORAMA

His hopes floundering in the face of financial reality, Vanderlyn turned to popular enter-
tainment, producing a vast panoramic representation of the palace and gardens of Ver-
sailles, which he exhibited in a rotunda built on borrowed money. When the attraction
failed to turn a profit, Vanderlyn was forced into bankruptcy. Although Congress com-
missioned him to paint The Landing of Columbus *(1839–46) for the Capitol rotunda*

(see "Lobbying for Capitol Commissions," chapter 5), Vanderlyn ended his career a bitter and largely forgotten failure.

Articles from the National Advocate *and* New-York Columbian *pinpoint the problems Vanderlyn faced in attracting the American public. The* National Advocate *is surprised that Vanderlyn has abandoned history painting but concedes that in a young country the scale of taste must be "graduated" to accommodate those with less education. The article also suggests that American battle scenes may prove more profitable. In a similar vein, the* New-York Columbian *complains that the fine arts receive little encouragement in America and notes that Vanderlyn's grand spectacle should be attracting more citizens than it has. Finally, the writer reminds "our citizens" that it is a great deal more tasteful to decorate their homes with American art than with Chinese and Parisian wallpaper.*

"Panorama," National Advocate, April 21, 1818.

Panorama.—Preparations for the rotunda about erecting by Mr. Vanderlyn, for panorama views, have commenced. This building will be at the corner of Chamber and Cross streets, on Park square, and will, no doubt, be completed in a manner so as to be an ornament to the city. Although it was not to have been expected that Mr. Vanderlyn would have left the higher department of historical painting, in which he is so eminent, to devote his time to the more humble, though more profitable, pursuit of painting cities and landscapes—yet, in a new country, taste for the arts must be graduated according to the scale of intellect and education, and where only the scientific connoisseur would admire his Marius and Ariadne, hundreds will flock to his panorama to visit Paris, Rome and Naples. This is to "catch the manners living as they rise," and with them catch the means to promote a taste for the fine arts.

We would suggest to Mr. Vanderlyn now, for fear we should forget it, that panorama views of our battles, such as Chippewa, Eire, New Orleans, Lake Champlain, &c. with the likeness of officers engaged on those occasions, would not only be highly national and popular, but exceedingly profitable.

"From the American. Fine Arts," New-York Columbian, August 31, 1820.

At home the fine arts do not receive much encouragement; few have the taste, and the few who have taste, have not the means, and the cry of Hard Times is constantly raised against any liberal exertion to advance the cause of science or the arts, and yet if Kean or Braham were imported, they would draw crowds, and realize fortunes, while native talent is *"praised and starved."* The insolent inquiry of the Edinburgh Review, of "Who goes to look at an American picture?" if at all applicable, is to those at home, for in London the paintings of West, Copely, Alston, and Leslie, attract the amateur and the fashionable. In our city we have *Marius* and *Ariadne,* by Vanderlyn, and his Panorama of Versailles, a painting in scenic effect not surpassed in Europe; and yet how many of our citizens have never gratified themselves or families with a view of this masterly production . . . It is to be hoped that this apathy is not to be of very long duration; the honors and rewards which American talent is receiving abroad, will, we trust, awaken the pride, and open the purses of our citizens, who should know that the noblest use of "wealth is the encouragement of genius," and that it is more consonant with taste and magnificence to have their walls decorated with the productions of the pencil, than hung with paper of Chinese and Parisian manufacture, or ornamented with colored engravings, the expense of whose frames would purchase a port-folio of them.

*Better known in the wider world as inventor of the telegraph, Samuel F. B. Morse was—
like his friend Washington Allston—an aspiring history painter. Trained in London
at the Royal Academy and receiving lessons as well from Allston and Benjamin West,
Morse, on returning to the United States and taking modern history as his theme, hoped
to attract, educate, and uplift a large, popular audience.*

*In 1821 Morse traveled to Washington, D.C., where he commenced work on his first
modern history painting, a view of the House of Representatives in session. In letters
to his wife, Lucretia, Morse describes his taxing routine, dedicated to life portraits of
every House member and exhaustive study of the monumental interior. Morse confides
his belief that it will be the most popular picture ever exhibited—hopes soon to be dashed
when the painting failed to turn a profit at exhibitions in New York and elsewhere.
Puzzling out reasons for Boston's lukewarm reception, Allston ingenuously attributes
it to lack of interest among the city's lower classes.*

Samuel F. B. Morse to Lucretia Morse, undated, 1822, Samuel F. B. Morse Papers, Library of Congress.

I am up at daylight, have my breakfast and prayers over and commence the labors of the day
long before the workmen are called to work on the Capitol by the bell. This I continue un-
remittingly till one o'clock, when I dine in about fifteen minutes and then pursue my labors
until tea, which scarcely interrupts me, as I often have my cup of tea in one hand and my pen-
cil in the other. Between ten and eleven o'clock I retire to rest. This has been my course every
day (Sundays, of course, excepted) since I have been here, making about fourteen hours study
out of the twenty-four.

This you will say is too hard, and that I shall injure my health. I can say that I never enjoyed
better health, and my body, by the simple fare I live on, is disciplined to this course. As it will
not be necessary to continue long so assiduously I shall not fail to pursue it till the work is done.

I receive every possible facility from all about the Capitol. The doorkeeper, a venerable man,
has offered to light the great chandelier expressly for me to take my sketches in the evening for
two hours together, for I shall have it a candlelight effect, when the room, already very splen-
did, will appear ten times more so.

Samuel F. B. Morse to Lucretia Morse, January 6, 1822, Morse Papers, Library of Congress.

I find the picture is becoming the subject of much conversation, and every day gives me greater
encouragement to believe that it will be more popular than any picture heretofore exhibited;
all that I have asked to sit apparently esteem it a high distinction and honor, and I am evidently
courted by some in hopes of an invitation to sit, I shall indulge all I can, consistently with be-
ing at home the time I mention. I shall paint it on part of the *great canvas* of all when I return
home, that is to say it will be 11 feet by 7 and an half feet; that will divide the great canvas ex-
actly into 2 equal parts on one of which I paint the House of Representatives and on the other
the Senate.

Washington Allston to Samuel F. B. Morse, April 15, 1823, Morse Papers, Library of Congress.

I am sorry to find that you are so low-spirited. You should not give way to discouraging thoughts
so soon; for your Picture can hardly be said as yet to have had a fair trial. If its exhibition here
has not been profitable to your purse, it has yet gained you a full harvest of praise. I believe all

amongst the higher classes have been to see it, and, as far as I can learn, there is but one opinion concerning it—that it does you great honour. I have heard many praise it highly, and *not* a single voice against it. It is especially admired by the best judges—such as Mr. Dutton, Mr. Codman, Dana, and others whose opinions go a great way in the circles where they move. Indeed it is so popular amongst these that I cannot account for its loss of profit except in the circumstance that the lower classes must have been wanting in curiosity; and as they make the mass of the town, if it does not attract them, the receipts must of course be small. But I do not think it likely that the same result will happen in the other great towns—New York, Philadelphia, Baltimore and Charleston. The common people there, if I mistake not, are more accustomed to visit places of public amusement; and those that are in the habit of attending them, I should suppose, would find entertainment in this Picture. Besides, its career is but just begun. Be of good heart then. I have no doubt of your success.

REMBRANDT PEALE'S *THE COURT OF DEATH*

During the first half of the nineteenth century, some American artists (including John Vanderlyn, Thomas Sully, and William Dunlap) painted large, "grand manner" canvases, which they took on tour in an attempt to cultivate a broad, paying audience for mythical and religious history painting. Although most of these efforts were financial failures (see "Samuel Morse's The House of Representatives," this chapter), Rembrandt Peale's twenty-four-foot-wide Court of Death (1820) is an exception; it made thousands of dollars for its creator. The favorite son of his artist father, Charles Willson Peale, Rembrandt had learned much from his parent about promotion and audience cultivation, and his huge painting was well received in the many cities it visited, thanks to carefully planted newspaper items and attention to influential local clergy. Twenty-five years after painting it, Peale described the genesis and reception of his large canvas in a letter that was reprinted several times for publicity purposes. In it, he attributes the success of the enterprise to its "broad and universal" pictorial vocabulary, intelligible to any viewer. A year later, however, a critic writing for the American Whig Review *implied that Peale actually owed his success to a great deal of patriotic "puffery," which blinded audiences to his painting's defects.*

Rembrandt Peale, letter, December 1, 1845, in C. Edwards Lester, The Artists of America: A Series of Biographical Sketches of American Artists *(New York: Baker and Scribner, 1846).*

In answer to your inquiry concerning the Origin of my Picture of the COURT OF DEATH, I shall briefly and simply narrate the process of its invention. Accidentally taking up Bishop Porteus' Poem on Death, poetical as may be deemed his description of the Cavern of Death, and familiar as his personifications may have been to the minds of literary men, it struck me that a Picture thus representing Death as a Monarch with his Ebon sceptre, seated on a Throne, and having on either side, as Prime Ministers, War and Old Age, and sending forth Intemperance and Disease as Agents to execute his will,—would unquestionably present an appalling Scene, better in the description than on the Canvas. I had seen, in Westminister Abbey, ROUBILLIAC'S beautiful Monumental Sculpture, representing a Noble Lady lying on her couch at the close of life, and a Skeleton, wonderfully wrought out of the solid marble, issuing from the Tomb, in an attitude of vigor, but without Muscle, directing his lance towards the heart of the Lady as

his victim, and, with others, felt the absurdity of it. An Angel to receive the parting soul would be better. I had seen WEST's Death on the pale Horse, a most impressive Picture, now in the Academy in this City, but my veneration of the Artist could not reconcile me to his personifications; for though he has given the figure Muscles, they are dried up—to say nothing of the fire from his mouth and the lightning from his hand; yet I had an idea that the case might be more fairly stated on the canvas. I imagined how I should attempt to paint a Subject founded on Porteus' Poem, and immediately began to sketch with my pencil on a piece of shingle which chanced to be in my hand, a figure enveloped in Drapery, which indicated form and power, with a shadowy but fixed Countenance, and with extended Arms, as a Judge issuing a decree. At his feet I drew a prostrate Corpse, and on one side the figure of an Old Man, submissively approaching. I had a faint Conception of War going forth, impelled by his own passions, and of Intemperance, Luxury and Disease; but having no intention to paint such a Scene, I threw my board away and thought no more of it.

A month afterwards one of my little daughters produced the board, with my sketch upon it. I was flattered by imagining there was some merit in it, and I added a few more figures, thus fixing the subject in my mind, which I immediately transferred to a small piece of canvas, and consulted my father, without sending him my design, whether I should paint the Picture in large. His prudent advice was "No." But some months after, being on a visit to me in Baltimore, I showed him my design, when he enthusiastically said, "Begin it immediately!" My Painting-Room was too small, and I had to build a larger one expressly for it, during which I prepared a large canvas, and executed many studies from the life, of figures, heads, hands, &c. My good and venerable Father stood as the representative of Old Age, modified by the Antique Bust of Homer; one of my Daughters stood in the place of Virtue, Religion, Hope; and another knelt to the Attitude of Pleasure, I borrowing a Countenance from my imagination. My friend and critic, John Neal, of Portland, impersonated the Warrior, beneath whom a friend consented to sink to the earth in distress, and thus appeared as the Mother of a Naked Child, which I painted from my then youngest daughter. The Corpse was the joint result of a study from a subject in the Medical College and the assistance of my brother Franklin, lying prostrate, with inverted head, which was made a likeness of Mr. Smith, founder of the Baltimore Hospital; my brother, also, though of irreproachable temperance, stood for the inebriated Youth; my wife and others served to fill up the background. It may be worth while to mention, that for the figure of Famine, following in the train of War, I could find no model, though I sought her in many a haunt of Misery, and therefore drew her from my brain; but strange to say, two weeks after the picture was finished, a woman passed my window, who might have been sworn to as the Original.

I had not employed the Mythology of the Ancients nor the symbols of other Artists. It was not an Allegorical Picture, composed after the examples of LEBRUN, or of any School. I had read some remarks by Pliny on a style of painting which he recommended as capable of embodying thought, principle and character, without the aid of Conventional Allegory, and described one on these principles painted by Apelles, and approved by the Multitude. This picture of the Court of Death is an approach to that style—at any rate, it was the first large Picture, whatever may be its merits or its faults, that has been attempted in modern times, upon the same broad and universal principles. I would lay claim to some little credit for the stand I took in reprobation of Intemperance, before that subject was introduced to popular notice; and the Society of Friends, at least will give me credit for my views of the Glory and Magnanimity of

War; whilst the philosophic Christian must agree with the picture that Death has no terror in the eyes of Virtuous Old Age, and of Innocence, Faith and Hope.

"Something about Our Painters," American Whig Review 4 (August 1846).

But of all the modes adopted to foster the growth of art among us, that of bestowing excessive praise upon, and claiming immunity from criticism for, works produced by native artists, because they are the product of native talent, seems to us not only the most futile, but the most unwise and injurious, to artists and to the national mind. If successful, it causes artists to be satisfied with mediocre attainments, by showing them that they can obtain fame and reward without further effort, and by a meretricious pandering to a morbid national vanity; and permanently injures the public taste by training it to admire as excellence that which is inferiority; and if unsuccessful, it deprives the really deserving artist of the encouragement he merits, and the public of the good they would derive in giving that encouragement to a work which would alike form their taste and gratify their pride; for when those who watch have cried "wolf" so often without a cause, who will run when the real thing appears?

To this style of patriotism a large portion of our journals are very apt to incline, especially if any moral or sacred lesson be attempted by a native artist, and we fear many of them with their eyes open to its injurious effects upon the very arts which they would appear to foster and encourage. Several cases of this kind have occurred lately; but among paintings, none so marked as that of The Court of Death, "The Great Moral Picture," as it was called, by Mr. R. Peale, of Philadelphia.

This picture was exhibited here some twenty-five years ago, and met the approbation of several high public functionaries, who were pleased to signify the same under their own proper hands and seals, besides giving pleasure to the public generally, as we are told. But eligibility to, and even distinction in, civic, executive or military dignity, nor even the being an integral unit in a great and free people just emerging from a successful war, does by no means imply a natural susceptibility to, or an educated taste in, the arts. And though we would implicitly defer to the Mayor and Common Council upon matters of city police, and if under sentence of death should consider the Governor's pardon a very admirable document, we should not consider their recommendation of a picture, an opera, or a poem, as having any virtue *ex officio*. The Court of Death is, we believe, still exhibited in some other parts of the country, and endorsed by paid puffs as "a great American work of art," and all good Americans are called upon to admire it; the more so because the artist was born "upon the anniversary of the natal day of his country." This is the method used to win admiration for a picture which, in spite of two or three good heads, is equally bad in design, drawing, grouping and anatomy, and which has the fatal fault of a complete lack of unity. The design of making Death appear as a stern, inflexible judge, is but feebly carried out, his face is stolid rather than stern, impassable rather than inflexible, and instead of intelligently issuing a decree, he seems to be vacantly gazing upon vacuity. The heads of Old Age and Virtue, which are the best in the composition, are nevertheless hard and woody; and Pleasure, instead of being portrayed with an alluring expression, and of full and graceful figure, is a simpering girl, whose meagre arms give good reason to suppose that her ample, ill-hung drapery conceals that which would not be enticing if displayed. The grouping produces an uncomfortable, uneasy feeling, from its want of proper balance. The drapery is ill hung, stiff and woody, and the light and shade very badly managed, or rather not managed at all. This picture is held up as a miracle of tone, color, grouping, anatomy and design.

THE ESTABLISHMENT OF ARTISTIC CATEGORIES

The hierarchy of artistic categories—most famously laid out in the Discourses *of Joshua Reynolds—was well established by the late eighteenth century. Still, during the colonial period little in the way of painting had been produced that was not a portrait. With the flourishing of the new republic, things began to change. Landscape had received some attention by writers on aesthetic matters, and the earliest American scenic painting took its cues from texts such as those by Timothy Dwight and Charles Brockden Brown. Charles Willson Peale's early attempt at landscape painting was similarly literary and narrative in nature, as his advertisement for his "moving pictures" demonstrates. Philadelphia, where Peale displayed his paintings, was also the birthplace of the first significant still life and genre works, by John Lewis Krimmel and Raphaelle Peale, respectively.*

Landscape

CHARLES WILLSON PEALE'S MOVING PICTURES

Likely inspired by accounts of the "Eidophusikon" of London painter Philip James de Loutherbourg, Charles Willson Peale inaugurated a novel exhibition in spring 1785. It consisted of five "transparent" canvases illuminated from behind by oil lamps equipped with focusing lenses. Curtains and invisible strings introduced movement, and as the lights waxed and waned, songs were sung to delight the viewers. As the following advertisement indicates, the scenes varied from landscapes inspired from literature to recognizable views of the Philadelphia locale.

Advertisement, Pennsylvania Packet, *May 19, 1785.*

Mr. Peale respectfully informs the public, that with great labour and expence, he has prepared a number of *perspective views,* with *changeable* effects, imitating nature in various *movements.* He flatters himself they will please: But how far he has succeeded in his imitations, is submitted to the judgment of the candid public. This manner of exhibiting pictures, imitations of choice parts of natural objects, in which *motion* and *change* is given, is entirely new, at least in this part of the world; and cannot be performed without much complicated and costly machinery.— If the expectation of profit to himself at all, excited Mr. Peale to the laborious undertaking, he assures the public, it was not the sole or principal inducement. A painter, who loves his art, is rather studious of producing pieces that are pleasing to the world, and that give him applause, than of immediately gaining pecuniary advantages—and this passion he greatly feels:—But beyond this, permit him to say, he was further moved by the consideration, that as well as citizens, it might also entertain *strangers,* coming to the city, and add a mite to the agreableness of it, and to their approbation of the place.—This he humbly thinks is an attention becoming every citizen, towards strangers,—and indeed tends to its emolument and character.

Having been biassed to undertake and complete the work, Mr. Peale hopes for the encouragement of the public in rewarding him for his invention and labour (which was far beyond all ideas of it before he began) and induce further introductions of public entertainment in the city. He has fitted up his picture gallery, with raised benches, for ladies and gentlemen who will favour him with their company.

The pieces to be exhibited will be in the following order:

1st, *Night,*—opening with the first dawn, and coming on to broad daylight,—with a view of a country seat.

2nd, a *Street,* viewed in the *evening,* with the coming on of *night;* lamps lit;—day breaks; with a rosy morning: The difference between the evening and morning is plainly distinguished in this eastern view.

3d, a grand Piece of *Architecture,* in a prospective view; clouds gather into a heavy rain;— clear up, with a coming, remaining, and disappearing rainbow.

4th. A View designed from *Milton's description of Pandemonium . . .*

5th. A Mill, near the falls of Schuylkil:—the water falls over the dam, and runs waste through the arches of the bridge, in a lively and pleasing manner.

The first exhibition will be *To-morrow,* at twelve o'clock—the doors to be opened at half after eleven. Admission cards, at seven shillings and six pence each, to be had at the houses of Messrs. Charles and James Peale.

TIMOTHY DWIGHT VIEWS GREENFIELD HILL

Timothy Dwight, grandson of Jonathan Edwards, served as pastor of the Congregationalist church in Greenfield, Connecticut, before becoming president of Yale University in 1795. Dwight was a member of the Hartford (or Connecticut) Wits, an informal group of Federalist elites—including the poet Joel Barlow and the painter John Trumbull— who sought to establish a new national literature based on American subjects. That was Dwight's aim in a long poem, Greenfield Hill, *which describes the village in glowing terms and recites its history, present circumstances, and future prospects. In Part One, the poet stands on a hill, beholding the "Prospect" spread below and evoking, in rhapsodic terms, the beauty and virtue of this pastoral community, embodiment of the American ideal. America is the "New Albion," that is, the new (and improved) England, bringing inherited English values to perfection on untainted soil. Dwight's landscape, tranquil and lovely, is a template for the pastoral visions antebellum painters would transmit to canvas.*

Timothy Dwight, Greenfield Hill: A Poem in Seven Parts, *Part 1: "The Prospect" (New York: Childs and Swain, 1794).*

As round me here I gaze, what prospects rise?
Etherial! matchless! such as Albion's sons,
Could Albion's isle an equal prospect boast,
In all the harmony of numerous song,
Had tun'd to rapture, and o'er Cooper's hill,
And Windsor's beauteous forest, high uprais'd
And sent on fame's light wing to every clime.
Far inland, blended groves, and azure hills,
Skirting the broad horizon, lift their pride.
Beyond, a little chasm to view unfolds
Cerulean mountains, verging high on Heaven,
In misty grandeur. Stretch'd in nearer view,
Unnumber'd farms salute the cheerful eye;
Contracted there to little gardens; here outspread

Spacious, with pastures, fields, and meadows rich;
Where the young wheat it's glowing green displays,
Or the dark soil bespeaks the recent plough,
Or flocks and herds along the lawn disport.
Fair is the landschape; but a fairer still
Shall soon inchant the soul—when harvest full
Waves wide its bending wealth. Delightful task!
To trace along the rich, enamell'd ground,
The sweetly varied hues; from India's corn,
Whose black'ning verdure bodes a bounteous crop,
Through lighter grass, and lighter still the flax,
The paler oats, the yellowish barley, wheat
In golden glow, and rye in brighter gold.
These soon the sight shall bless. Now other scenes
The heart dilate, where round, in rural pride
The village spreads its tidy, snug retreats,
That speak the industry of every hand.
How bless'd the sight of such a numerous train
In such small limits, tasting every good
Of competence, of independence, peace,
And liberty unmingled; every house
On its own ground, and every happy swain
Beholding no superior, but the laws,
And such as virtue, knowledge, useful life,
And zeal, exerted for the public good,
Have rais'd above the throng
. . .
Rough is thy surface; but each landschape bright,
With all of beauty, all of grandeur dress'd,
Of mountains, hills, and sweetly winding vales,
Of forests, groves, and lawns, and meadows green,
And waters, varied by the plastic hand,
Through all their fairy splendour, ceaseless charms,
Poetic eyes. Springs bubbling round the year,
Gay-wand'ring brooks, wells at the surface full,
Yield life, and health, and joy, to every house,
And every vivid field. Rivers, with foamy course,
Pour o'er the ragged cliff the white cascade,
And roll unnumber'd mills; or, like the Nile,
Fatten the beauteous interval; or bear
The sails of commerce through the laughing groves
. . .
. . . Beneath their eye,
And forming hand, in every hamlet, rose
The nurturing school; in every village, smil'd
The heav'n-inviting church, and every town

A world within itself, with order, peace,
And harmony, adjusted all its weal

. . .

. . . In clear, full view, with every varied charm,
That forms the finish'd landscape, blending soft
In matchless union, Fairfield and Green's Farms
Give lustre to the day. Here, crown'd with pines
And skirting groves, with creeks and havens fair
Embellish'd, fed with many a beauteous stream,
Prince of the waves, and ocean's favorite child,
Far westward fading in confusion blue,
And eastward stretch'd beyond the human ken,
And mingled with the sky, there Longa's Sound
Glorious expands. All hail! of waters first
In beauties of all kinds; in prospects rich
Of bays, and arms, and groves, and little streams,
Inchanting capes and isles, and rivers broad,
That yield eternal tribute to thy wave!

THE AMERICAN GOTHIC LANDSCAPES OF CHARLES BROCKDEN BROWN

A Philadelphia Quaker, Charles Brockden Brown was a novelist, magazine editor, and political pamphleteer inspired by the radicalism of William Godwin and the early feminist Mary Wollstonecraft. At the end of 1790s, Brown published four gothic novels in which he probed the undercurrents of the Enlightenment in plots thick with mystery, irrationality, violence, and murder. In Edgar Huntly, *the American wilderness plays a major role as setting and metaphor for the protagonist's traumatic journey of self-discovery. In his preface, Brown notes that gothic castles have no place in an American novel. In their stead, he proposes "the incidents of Indian hostility, and the perils of the Western wilderness." Mirroring the disturbed and fearful mental state of Brown's protagonist, the perilous landscape in* Edgar Huntly *bears the hallmarks of the American sublime. In pursuit of an elusive quarry, Huntly climbs to the summit of a precipice that allows him an unobstructed view of the terrain all around and far below. Like an experienced landscape tourist, Huntly finds "delight" in the contrast between the serene valleys in the distance and the "glooms" through which he has just traveled. In visual terms, early American landscape painters used similar tactics, juxtaposing the sublime and the beautiful and affording themselves and their audiences a commanding view from the top.*

Charles Brockden Brown, Edgar Huntly, or, Memoirs of a Sleep Walker *(Philadelphia: H. Maxwell, 1799).*

The wilderness, and the cave to which you followed me, were familiar to my Sunday rambles. Often have I indulged in audible griefs on the cliffs of that valley. Often have I brooded over my sorrows in the recesses of that cavern. This scene is adapted to my temper. Its mountainous asperities supply me with images of desolation and seclusion, and its headlong streams lull me into temporary forgetfulness of mankind . . .

Thou knowest my devotion to the spirit that breathes its inspiration in the gloom of forests

and on the verge of streams. I love to immerse myself in shades and dells, and hold converse with the solemnities and secrecies of nature in the rude retreats of Norwalk. The disappearance of Clithero had furnished new incitements to ascend its cliffs and pervade its thickets, as I cherished the hope of meeting in my rambles, with some traces of this man . . .

It would not be easy to describe the face of this district, in a few words. Half of Solebury, thou knowest, admits neither of plough nor spade. The cultivable space lies along the river, and the desert, lying on the north, has gained, by some means, the appellation of Norwalk. Canst thou imagine a space, somewhat circular, about six miles in diameter, and exhibiting a perpetual and intricate variety of craggy eminences and deep dells.

The hollows are single, and walled around by cliffs, ever varying in shape and height, and have seldom any perceptible communication with each other. These hollows are of all dimensions, from the narrowness and depth of a well, to the amplitude of one hundred yards. Winter's snow is frequently found in these cavities at mid-summer. The streams that burst forth from every crevice, are thrown, by the irregularities of the surface, into numberless cascades, often disappear in mists or in chasms, and emerge from subterranean channels, and, finally, either subside into lakes, or quietly meander through the lower and more level grounds.

Wherever nature left a flat it is made rugged and scarcely passable by enormous and fallen trunks, accumulated by the storms of ages, and forming, by their slow decay, a moss-covered soil, the haunt of rabbits and lizards. These spots are obscured by the melancholy umbrage of pines, whose eternal murmurs are in unison with vacancy and solitude, with the reverberations of the torrents and the whistling of the blasts. Hiccory and poplar, which abound in the lowlands, find here no fostering elements.

A sort of continued vale, winding and abrupt, leads into the midst of this region and through it. This vale serves the purpose of a road. It is a tedious maze, and perpetual declivity, and requires, from the passenger, a cautious and sure foot. Openings and ascents occasionally present themselves on each side, which seem to promise you access to the interior region, but always terminate, sooner or later, in insuperable difficulties, at the verge of a precipice, or the bottom of a steep . . .

. . . My rambles were productive of incessant novelty, though they always terminated in the prospect of limits that could not be overleaped. But none of these had led me wider from my customary paths than that which had taken place when in pursuit of Clithero. I had faint remembrance of the valley, into which I had descended after him, but till then I had viewed it at a distance, and supposed it impossible to reach the bottom but by leaping from a precipice some hundred feet in height. The opposite steep seemed no less inaccessible, and the cavern at the bottom was impervious to any views which my former positions had enabled me to take of it.

My intention to reexamine this cave and ascertain whither it led, had, for a time, been suspended by different considerations. It was now revived with more energy than ever . . .

. . . I ascended the cliff in my former footsteps, but soon lighted on the beaten track which I have already described . . .

I reached the mouth of the cave . . .

I looked anxiously forward in the hope of being comforted by some dim ray, which might assure me that my labors were approaching an end. At last this propitious token appeared, and I issued forth into a kind of chamber, one side of which was open to the air and allowed me to catch a portion of the chequered sky. This spectacle never before excited such exquisite sensations in my bosom. The air, likewise, breathed into the cavern, was unspeakably delicious.

I now found myself on the projecture of a rock. Above and below the hillside was nearly

perpendicular. Opposite, and at the distance of fifteen or twenty yards, was a similar ascent. At the bottom was a glen, cold, narrow and obscure. The projecture, which served as a kind of vestibule to the cave, was connected with a ledge, by which, though not without peril and toil, I was conducted to the summit.

This summit was higher than any of those which were interposed between itself and the river. A large part of this chaos of rocks and precipices was subjected, at one view, to the eye. The fertile lawns and vales which lay beyond this, the winding course of the river, and the slopes which rose on its farther side, were parts of this extensive scene. These objects were at any time fitted to inspire rapture. Now my delight was enhanced by the contrast which this lightsome and serene element bore to the glooms from which I had lately emerged. My station, also, was higher, and the limits of my view, consequently more ample than any which I had hitherto enjoyed.

I advanced to the outer verge of the hill, which I found to overlook a steep, no less inaccessible, and a glen equally profound. I changed frequently my station in order to diversify the scenery. At length it became necessary to inquire by what means I should return. I traversed the edge of the hill, but on every side it was equally steep and always too lofty to permit me to leap from it. As I kept along the verge, I perceived that it tended in a circular direction, and brought me back, at last, to the spot from which I had set out. From this inspection, it seemed as if return was impossible by any other way than that through the cavern . . .

As I had traversed the outer, I now explored the inner edge of this hill. At length I reached a spot where the chasm, separating the two rocks, was narrower than at any other part. At first view, it seemed as if it were possible to leap over it, but a nearer examination shewed me that the passage was impracticable. So far as my eye could estimate it, the breadth was thirty or forty feet. I could scarcely venture to look beneath. The height was dizzy, and the walls, which approached each other at top, receded at the bottom, so as to form the resemblance of an immense hall, lighted from a rift, which some convulsion of nature had made in the roof. Where I stood there ascended a perpetual mist, occasioned by a torrent that dashed along the rugged pavement below.

From these objects I willingly turned my eye upon those before and above me, on the opposite ascent. A stream, rushing from above, fell into a cavity, which its own force seemed gradually to have made. The noise and the motion equally attracted my attention. There was a desolate and solitary grandeur in the scene, enhanced by the circumstances in which it was beheld, and by the perils through which I had recently passed, that had never before been witnessed by me.

THE EARLIEST GUIDE TO SKETCHING LANDSCAPE

Archibald Robertson, a student of Benjamin West and a Scottish immigrant who arrived in the United States in 1791, opened New York's earliest art school, the Columbian Academy of Painting, that same year. With a few exceptions (such as John Vanderlyn), his students were mainly amateurs, both men and women. With this audience in mind, Robertson wrote the first drawing manual published in the United States, Elements of the Graphic Arts. *Perhaps aware of the developing interest in the American landscape in the early republic, he included an unusually detailed treatment of landscape art in his treatise. In the excerpt below, Robertson stresses the utility of landscape sketching, and he urges careful attention to various types of trees. It is a "hands-on" approach rather than the more typical rehearsal of the aesthetic categories of the sublime, beautiful, and picturesque.*

Archibald Robertson, Elements of the Graphic Arts *(New York: David Longworth, 1802).*

Although Landscape takes an inferior rank in the art of painting, when compared with the nobler style of history; yet of all the departments of painting, this is the most useful, as it is what every man may have occasion for, at one time or another; to be able on the spot, to take the sketch of a fine building, a beautiful prospect, any curious productions of art, or uncommon appearance in nature; is not only a very desirable accomplishment, but a very agreeable amusement. Rocks, mountains, fields, woods, rivers, cataracts, cities, towns, castles, houses, fortifications, ruins, or whatsoever else may present itself to view, in our journey or travels, in our own or foreign countries, may be thus brought home, and preserved for our future use, either in business or conversation: on this part, therefore, more than ordinary pains should be bestowed.

All drawing consists in nicely measuring the distances of each part of the piece by the eye. In order to facilitate this, let the learner imagine in his own mind, that the piece he copies is divided into squares: For example, suppose or imagine a horizontal and a perpendicular line crossing it, in the centre of the picture you are drawing from; then, also, suppose two such lines crossing your own copy; observe in the original, what parts of the design those lines intersect, and let them fall on the same parts of the supposed lines in the copy: We say, the supposed lines, because though engravers and others, who wish to copy with great exactness, divide both the copy and original into many squares; yet this method used by engravers is not to be recommended, as it will be apt to deceive the learner, who will fancy himself a tolerable proficient, till he comes to draw after nature when these helps are not to be had; when he will find himself miserably defective, and utterly at a loss but, in your own drawing, you may always have the advantage of a horizontal line, and a perpendicular, crossing each other in the point of sight, which is always in the centre of your piece from one side to the other. The horizontal line is moveable according to circumstances; but the perpendicular always fixed in the centre.

Though diversity be pleasing, in all the objects of landscape, it is chiefly in trees that it shews its greatest beauty: Landscape considers both their kinds and forms; their kinds require the painter's particular study and attention, in order to distinguish them from each other; for we must be able at first sight, to discover which are oaks, elmes, firs, sycamores, poplars, willows, pines, and other such trees; which, by a specific color or touch, are distinguishable from all other kinds. This study is too large to be acquired in all its extent; and, indeed, few painters have attained such a competent exactness in it as their art requires; but, it is evident, that those who come nearest to perfection in it, will make their works infinitely more pleasing, and gain a good name.

Besides the variety which is found in each kind of trees, there is in all trees a general variety: this is observed, in the different manners in which their branches are disposed by a sport of nature, which takes delight in making some very vigorous and thick, others more dry and thin; some more green, others more red or yellow. The excellence of practice lies in the mixture of these varieties; but if the artist can distinguish the sorts but indifferently, he ought at least to vary their form and colors; because, repetition in landscape, is as tiresome to the eye, as monotomy in discourse is to the ear.

The variety of their characteristic forms, is so great, that the painter would be inexcusable not to put them in practice upon occasion, especially when he finds it necessary, to awaken the spectator's attention. For among trees, the young and the old, the open and the close, tapering and squat, bending upwards and downwards, stooping and shooting; in short, the variety is rather to be conceived than expressed. For instance, the character of young trees is to have long, slender branches, few in number, but well set out; boughs well divided, and the foliage vigorous and well shaped; whereas in old trees, the branches are short, stocky, thick and numerous;

the tufts blunt, and the foliage unequal and ill shaped; but a little observation and genius, will make us perfectly sensible of these particulars.

In the various makes of trees, there must also be a distribution of branches that has a just relation to, and probable connexion with, the boughs or tufts, so as mutually to assist each other, in giving the tree an appearance of thickness and truth. But, whatever their natures or manner of branching are, let it be remembered, that the touch or handling must be vivid and sharp, in order to preserve the spirit of their characters.

Trees likewise vary in their barks, which are commonly grey; but this grey, which in a thick atmosphere, and low and marshy places, looks blackish; appears lighter in a clear atmosphere; and it often happens in dry places, that the bark gathers a thin moss, which makes it look quite yellow. So that, to make the bark of a tree apparent, the painter may suppose it to be light upon a dark ground, and dark upon a light one.

The observation of the different barks merits a particular attention; for, it will appear, that in hard wood, age chaps them, and thereby gives them a sort of embroidery, and that in proportion as they grow old, these chaps grow more deep, and other accidents in bark may arise, either from moisture, or dry grass, green mosses, or the white stains of trees.

Beginners will find in practice, that the chief trouble of landscape, lies in touching or handling trees; and it is not only in practice, but also in speculation, that trees are the most difficult part of landscape, as they are its greatest ornaments.

Painting of landscape, supposes the knowledge and practice of the principal rules in perspective, in order to maintain probability.

And one of the greatest perfections of landscape, is a faithful imitation of each particular character; as its greatest fault is a licentious practice, which brings us to do things by note.

As there are styles of thought, so there are also styles of execution: there are two with regard to execution, viz. the firm style and the polished.

These two concern the pencil, and the more or less ingenious way of conducting it: the firm style gives life to work, and excuse for bad choice, and the polished finishes and brightens every thing; it leaves no employment for the spectator's imagination, which pleases itself, in discovering and finishing things, which it ascribes to the artist, though in fact they proceed only from itself. The polished style degenerates into the soft and dull, if not supported by a good effect; but when these two characters meet, the picture if fine.

Still Life

RAPHAELLE PEALE

Raphaelle Peale is generally considered to be the earliest American master of still life painting. The quiet perfection that is characteristic of his small works seems all the more remarkable given his tumultuous life, which was marked by poverty and sickness. Scholars disagree on the nature and causes of his illnesses, but none dispute the importance of his work. He essentially placed the genre of still life "on the map" in Philadelphia during the early republic.

The copious archive of the Peale family papers gives a picture of Raphaelle's achievement as well as his challenges—seen largely through the eyes of his father, Charles Willson Peale. In the following excerpts from letters (with only one by Raphaelle), one notes a father's pride in his son's artistic achievements as well as unsubtle hints that financial success is not likely to come from the practice of still life. Raphaelle's attempts to sell his still lifes never seem to be enough to keep him afloat, and the texts show a gradual

decline in health. The two reviews from 1813 included at the end of this grouping, in contrast, demonstrate a generally positive critical response to his work—rare words of encouragement from an art world that tended to dismiss still life painting as inconsequential.

Charles Willson Peale to Nathaniel Ramsay, March 13, 1813, in Lillian B. Miller, ed., The Selected Papers of Charles Willson Peale and His Family *(New Haven: Yale University Press, 1991), vol. 3.*

Raphaelle has been unfortunate in some things—and neglectful of himself. He possesses a good heart and is blest with genius and many good qualities—is now very industrious and gives high satisfaction in his art—he has done some pieces of *still-life* equal if not superior to any thing I have seen! I hope and pray that he may continue to conduct himself in future as well as he has done for a considerable time past.

Charles Willson Peale to Benjamin West, September 11, 1815, in Miller, ed., The Selected Papers of Charles Willson Peale and His Family, *vol. 3.*

The bearer of this is Mr. Welford, an Amateur of the fine arts, & I beleive an encourager of that of painting, he carries with him several pieces of Still life painted by my Son Raphaelle which I wish you to see—Raphaelle seems to possess considerable talents for such paintings. He paints in portraits the striking likeness, but does not give them that dignity and pleasing effects which is absolutely necessary to ensure a great demand for the labours of his Pensil.

Raphaelle Peale to Charles Graff, September 6, 1816, Archives of American Art.

My old and inveterate enemy, the Gout, has commenced a most violent attack on me, two months previous, to its regular time—and most unfortunately on the day that I was to Commence still life in the most beautifull productions of Fruit. I therefore fear that the Season will pass without producing a single Picture, I meant to have devoted all my time, Principally, to Painting of fine Peaches & instead of whole Water Melons, merely single Sliccs on which I could bestow a finish that would have made them valuable—. If the disease was only confined to my feet I still would have some hope of doing something, But unfortunately my left hand is in a most dreadfull situation, & my Right Getting so bad as to be scarcely able to hold my Pen—[in] this situation it is necessary to dispose of the Picture the fruit of which you so much admired, any alterations you may desire in the Picture on my recovery I will Exicute with a great deal of Pleasure, my fixt price was & would have been, but for this unfortunate attack, 40 dollars—therefore Sir if you feel disposed to Serve me I make a tender of this Picture to you for 30 Ds.

Charles Willson Peale to Raphaelle Peale, November 15, 1817, in Miller, ed., The Selected Papers of Charles Willson Peale and His Family, *vol. 3.*

I well know your talents, and am fully confident that if you applied as you ought to do, you would be the first painter in America . . . Your pictures of still-life are acknowledged to be, even by the Painters here, far exceeding all other works of that kind—and you have often heard me say that I thought with such talents of exact immitation your portraits ought also to be more excellent—My dear Raph. then why will you neglect yourself—? Why not govern every unruly Passion? Why not act the *man,* and with a firm determination act according to your best judgement? Wealth, honors and happiness would then be your lot!

Charles Willson Peale to Angelica Peale Robinson, September 23, 1818, in Miller, ed., The Selected Papers of Charles Willson Peale and His Family, *vol. 3.*

It is not too late to recover his wanted stamina, provided he will follow my advice and to encourage him to be diligent in painting still life, I will purchase every piece that he cannot sell, provided it is well painted, he tells me he has improved in portrait painting and that he is fonder of doing them than he was formerly. If so I know he will excell in a high degree, if his immitations of the human face is like those faithful tints he produces of still-life. For he has not his equal in that line of painting.

Charles Willson Peale to Rubens Peale and Raphaelle Peale, November 19, 1818, American Philosophical Society Library.

Dear Raphaelle you ought not to expect a high price for every picture you paint. These kinds of pictures would give you a good profit at 15$ provided you employed the greater part of your time in producing them as with constant production you might paint 2 or 3 of them in a week. You can never want subjects to immitate, any common objects grouped together might form a picture, and instead of having only one picture for sale, you might soon have a Dozn, and such a number would be a curiosity of the lovers of the art to see them, . . . I fear you loose as much time in shewing your pictures or more than it would take you to produce them. I feel sensibly for all your difficulties and would be very sorry to say that, which would hurt your feelings, you know my affection for you, How often have I praised your talents? And how often have I given you the best advice in my power, and had I the means I would most gladly relieve you from duns.

Charles Willson Peale to Titian Ramnsey Peale, February 21, 1820, in Miller, ed., The Selected Papers of Charles Willson Peale and His Family, *vol. 3.*

Raphaelle has a tolerable share of work his prices being small—but Mr. Sully complains that he has nothing to do, and it is said that he intends to leave Philada . . .

Returning to family concerns, I now think as I look at your brothers pieces of Still life before me, so perfectly immetated! Why cannot he paint Portrait with same truth of Colouring? As I am emulated to excell in this line, I shall endeavor to make him comprehend my System of tints, & manupleation to produce effect in the easiest mode. Painting is a charming art if employed to display Nature in sentimental & heroic Actions, or native simplicity—To pursue the theme, Portraits are means of drawing closer, Parental or brotherly love.

Can I look on that Portrait and not think of the Virtues of the Original? If a parent, on the care to preserve my health, the pains taken to direct my conduct for future hapiness and prosperity in life. If of a friend, for the aid or advice received to direct my way to avoid danger or difficulties. I often say that I wish never to paint the Portrait of a bad man, as none but the virtuous dese[r]ve to be remembered.

Charles Willson Peale to Rubens Peale, January 19, 1823, in Lillian B. Miller, ed., The Selected Papers of Charles Willson Peale and His Family *(New Haven: Yale University Press, 1996), vol. 4.*

And poor Raphaelle with every exertion he cannot get a support.—He is now painting some fruit pieces to send to Vendues,—He tells me that he has wrote to you to propose to get a sale of his fruit pieces you have by a raffle & he thinks that painting some smaller pieces that each person according to their lott may each have a picture—and he says it may save expence & when you write to me, mentioning your Ideas on the subject.

"Fine Arts," Monthly Recorder 1 (May 1813).

16. *Fruit Piece.* RAPHAEL PEALE. Though this is not the best picture which this artist has exhibited on the present occasion, we will take the opportunity of speaking generally as to his merits and deficiencies. His great merit, and it is a very great one, is the accurate and minute resemblance which he produces of the object before him. It is indeed very near perfection, and parts may be pointed out that defy censure. Let Mr. Peale combine with this truth and clearness those principles of composition which apply to all subjects, and which are elucidated in the still-life compositions of the Flemish masters, let him make, by the disposition of his light, one principal object, and keep the others in due subordination, and let him, in addition to this, give more warmth to his back grounds, making them unite better with his objects, and he may challenge competition in this line of painting.

George Murray, "Review of the Third Annual Exhibition of the Columbian Society of Artists and Pennsylvania Academy of Fine Arts," Port Folio 2 (August 1813).

16. *Fruit Piece.*—Raphael Peale. This is a most exquisite production of art, and we sincerely congratulate the artist on the effects produced on the public mind by viewing his valuable pictures in the present exhibition. Before our annual exhibitions this artist was but little known. The last year he exhibited two pictures of still life, that deservedly drew the public attention, and were highly appreciated by the best judges. We are extremely gratified to find that he has directed his talents to a branch of the arts in which he appears to be so well fitted to excel. We recollect to have seen in the famous collection of the duke of Orleans (that was brought to London and there exhibited in 1790) two small pictures of flowers and fruit by Van Os, that were there sold for one thousand guineas. Raphael Peale has demonstrated talents so transcendant in subjects of still life, that with proper attention and encouragement, he will, in our opinion, rival the first artists, ancient or modern, in that department of painting . . . We have seen fourteen annual exhibitions of the Royal Academy, and one of the Incorporated Society of Artists, in London; and we are bold as well as proud to say, that there were in no one of these celebrated exhibitions, so great a number of pictures on this particular branch of the arts as those now exhibited by Raphael Peale . . .

36. *Fruit.*—Raphael Peale. We have already spoken generally of the works of this artist, as pictures of uncommon merit: some of them, however, are not without defects. The individual objects in this picture are represented with great truth. There appears however a deficiency in perspective; it has too much the appearance of what painters call a *birds-eye view*. We recommend particularly to the attention of this artist the necessity of *foreshortening,* and to make his backgrounds more subservient to the principal objects, and also to make such arrangement in the grouping as will best comport with the harmony of the whole; and to endeavor as much as possible in the formation of his groups, to make the natural colours of the objects represented assist in the general distribution of light and shade.

Genre

JOHN LEWIS KRIMMEL

Born and trained in Germany, John Lewis Krimmel came to Philadelphia in 1810, where he taught drawing and executed portraits. But Krimmel was also a pioneer in American genre painting, even if he was unable to make a living from it. (It would be several decades before such artists as William Sidney Mount and George Caleb Bingham would be financially successful as genre painters—see chapters 4 and 6.)

Krimmel "broke out" into critical favor in 1812 with the exhibition of his View of
Centre Square on the Fourth of July *(1811–12) and the following year with* Quilting
Frolic *(1813). In the following reviews from Philadelphia periodicals, critics weigh in
on Krimmel's technique, which was sometimes characterized as undeveloped. More
interesting are the comments related to the "staging" of the depicted scene, and to
the universal appeal of genre painting, especially when it is humorous and rustic.*

G.M. [George Murray], "The Fine Arts," Port Folio 8 (July 1812).

No. 68, *is a view of the Centre Square on the fourth of July, by Krimmel.* There are few people (if
any) who visit the Academy, who are not perfectly acquainted with the scene of which this is so
familiar and pleasing a representation. It is truly *Hogarthian,* and full of meaning, the figures are
amply varied, and the character highly diversified. The artist has proved himself no common
observer of the tragi-comical events of life that are daily and hourly passing before us, many of
which leave impressions upon the *few* and pass unmarked by the *million.* This picture is crude
in its colouring, and deficient in effect, and disposition of light and shade. In fact, this artist is
greatly wanting in the mechanical part of his art, which, by the by, he has yet had but little op-
portunity of acquiring, and which can only be gained by unremitting industry and application.

"Fine Arts," Monthly Recorder 1 (June 1813).

120. *Quilting Frolic.* J. L. Krimmell. This is an original composition of this young and very prom-
ising artist . . . Scenes of domestic life are more generally interesting, both on the stage and on
canvass, than the higher orders of dramatic or graphic composition. Every one can sympathise
with the cares or the pleasures of middling and rustic life, for *there* all is natural; but the events
which agitate the artificially exalted portion of mankind, whose vices, whose crimes, and whose
misfortunes are above the mass of their fellow men, and are governed apparently by another
code of moral laws, only interest by sympathy a small part of those who witness them. The higher
species of tragedy is not so generally pleasing as comedy, and farce pleases a greater number
than either; but those who are pleased with tragedy are likewise delighted with comedy, and
may be disgusted by farce. Many of the Flemish artists are painters of farce; Mr. Wilkie is a mas-
ter of rustic comedy, which pleases all, disgusts none; we do not at this moment recollect a very
good painter of genteel comedy, though several English and French artists have attempted it;
in the tragic department we have many great examples, and none greater than our illustrious
countryman West. Mr. Krimmell will succeed in rustic comedy. The head of the old man who
holds the mastiff from showing his displeasure too strongly at the entrance of the *Frolickers,* is
very beautiful. The principal lad and lass are highly characteristic; and we see the usual con-
trast in this couple between the clownish constraint of the male rustic and the easy deportment
of the female. The negro fiddler is remarkably true. The vulgar species of beauty which belongs
to all the females, is happily kept; but we have frequently met with a species of rustic beauty
among our farmers' daughters, of a much superior order than any represented in this picture.
The furniture is appropriate, and that part of it which is in front, is artfully disposed to catch,
lead and connect the lights. The colouring is rather glaring.

[George] M[urray]., "Review of the Third Annual Exhibition of the Columbian Society of Artists and Pennsylvania Academy of Fine Arts," Port Folio 2 (August 1813).

120. *Quilting Frolic.*—J. L. Krimmell.
 Throughout the whole of this charming and very interesting subject we can perceive strong

marks of the genius of the painter. The composition, drawing, colouring and effect, display much knowledge of the true principles of art: the style is evidently his own. Mr. Krimmell is a pupil in the *school of Nature,* and he has already given sufficient proofs that he has not studied in vain. His figures are graceful, easy, and well drawn. On first viewing this picture we were inclined to believe that the objects were rather crowded; but on mature consideration, we changed our opinion. The subject represents a sort of entertainment, or *tea-party and dance,* given at the close of what is called a *quilting frolic.* It is very natural to suppose that a small room would not only be full, but crowded, and that every thing wanted on the occasion would be in requisition—the tea-cups, &c. are placed on a small tray close together (evidently for the want of a larger.) The bustle throughout this entertaining scene is very visible, and managed by the artist with great dexterity. The subject is good and executed with great judgment, and if Mr. Krimmell only perseveres in the path he has chosen, we are decidedly of opinion that his labours and talents will contribute largely towards giving a character to the arts in our own country.

EARLY INSTITUTIONS

Philadelphia

CHARLES WILLSON PEALE'S MUSEUM

Of the many projects that occupied Charles Willson Peale during his long life, his museum (opened in 1786) was probably the most impressive. Certainly it took up more of his time—and that of his sons—than any other enterprise. Intended to be a universal museum of the known world, his display included natural history specimens, portraits of eminent personages, other works of art, inventions, and general curiosities. Its first venue was in Peale's own home in Philadelphia, and the journal entry of Manasseh Cutler, a Congregationalist minister visiting from Massachusetts, gives a good account of a visitor's experience. A few years later, Peale published a broadside that conveys his hopes that the collection may have a national impact. Three decades later, his dream of establishing the museum as a publicly incorporated institution was achieved, with the collection now installed in Independence Hall. At the behest of the trustees of the corporation, Peale, at age eighty-one, executed a large self-portrait, The Artist in His Museum *(1822), which summed up his achievement and conveyed the intellectual rationale of the collection. In a series of letters to his sons, Peale describes his work on this important painting.*

Manasseh Cutler, journal, July 13, 1787, in Lillian B. Miller, ed., The Selected Papers of Charles Willson Peale and His Family *(New Haven: Yale University Press, 1983), vol. 1.*

Immediately after Diner we called on Mr. Peele to see his collection of paintings & natural curiosities. We were conducted in to a room, by a boy, who told us that Mr. Peele would wait on us in a minute or two—He desired us, however, to walk in to the room where ye. curiosities were, & shewed us a long narrow entry which led into the room. Dr. Clarkson went first, & as he stepped into the room, I observed, thro'. a glass window, at my right hand, a Gentleman close to me, standing with a pencil in one hand & a small sheet of Ivery in the other, & his eyes directed to ye. opposite side of ye. room, as tho'. he was taking some object on his ivery sheet. Dr. Clarkson did not see this man untill he stepped into ye. room, but instantly turned about, & came back—saying—Mr. Peele is very busy, taking ye. picture of something with his pencil—

we will step back in to ye. other room, & wait till he is at leisure—We returned through the entery—but as we entered the room we came from, we meet Mr. Peele coming to us—The Doctr. started back, in astonishment, & cried out—"Mr. Peele, how is it possible you should get out of the other room to meet us here!"—Mr. Peele smiled—"I have not been in ye. other room, says he, for some time."—"No! says Clarkson—Did not I see you there this moment with your pencil & ivery?"—"Why, do you think you did" says Peele—"Do I think I did? Yes" says ye. Doctr.—"I saw you there, if I every saw you in my life"—"Well, says Peele, let us go & see."— When we returned we found the man standing as before. My astonishment was now, nearly, equal to that of Dr. Clarkson—for, altho'. I knew what I saw—yet I beheld two men so perfectly a like that I could not discerne ye. minutest difference—one of them, indeed, had no motion, but he appeared to me, to be as *absolutely* alive as the other.—& I could hardly help wondering that he did not smile, or take a part in ye. conversation. This was a piece of wax-work wh- Mr. Peele had just finished, in which he had taken himself. So admirable a performance must have done great honor to his *genius* if it had been that of any other person, but I think it is much more extreordinary that he should be able *so perfectly* to take himself. To what perfection is this art capable of being carried!—By this method, our particular friends and ancestors might be preserved, in perfect likeness to ye. latest generation We seem to be able, in some degree, to disappoint ye. ravages of time, and prevent mortality itself, ye. common lot of man, from concealing from us, in its dreary retreats, our dearest connections.

This room is constructed in a very singular manner, for ye. purpose of Exhibitions—where various scenery in paintings is exhibitted in a manner that has a most astonishing effect.—It is very long, but not very wide, has no windows, nor floor over it, but is open up to ye. roof which is two or three stories, & from above ye. light is admitted in greater or less quantities at pleasure. The walls of ye. room are covered with paintings—both portrait & historic. One particular part is assigned for ye. portraits of ye. principal American Characters who appeared on ye. stage during ye. late revolution, either in ye. Councils or armies of their Country. The drapery was excellent, & the likenesses of all, of whom I had any personal knowledge, were well taken. I fancied my self introduced to all ye. General Officers, that had been in ye field during the war, whether dead or alive, for I think he had every one—& to most of ye. members of Congress, & other distinguished characters. To grace his collection he had a number of ye. most distinguished Clergymen in ye. midle & southern States, who had, in some way or other, been active in ye. revolution. In other parts were a number of fine historic pieces, executed in a masterly manner. At the upper end of ye. room Genl. Washington, at full length & nearly as large as ye. life, was placed, as President of this sage & martial Assembly. At the opposite end, under a small gallery, his natural curiosities were arranged in a most romantic & amusing manner. There was a mound of earth, considerably raised, & covered with green turf from which a number of trees ascended & branched out in different directions—on ye. declivity of this mound was a small thicket—& just below it an artificial pond. on ye. other side a number of large & small rocks, of different kinds, collec[te]d from different parts of ye. world—& represented ye. rude state in wh- they are generally found—At ye. foot of ye. mound were holes dug & ye. earth threw up, to shew ye. different kinds of clay—Ochre, Cole, merl, &c., which he had collected from different parts—also various ores and minerals. Around ye. pond was a beach on which were exhibitted an assortment of shells of different kinds—Turtles—frogs—toads—lizards—water Snakes &c.—In the pond was a collection of fish with their skins stuffed—Water-fowls—such as ye. different speecies of Geese—ducks, Cranes—Her[o]ns—&c. &c—all having ye. appearance of life—for their skins

were admirably preserved. On ye. mound were those birds which commonly walk on ye. ground—as ye. Pa[r]tridge—Quail—Heath hen &c—Also different kinds of wild animals—Bear—Dear—Leopard—tyger—Wild Cat—fox—Raccoon—rabbit—Squirrels—&c &c—in the thickets & amongst ye. rocks—land snakes—Rattle snake of an enormous size—Black—Glass—striped—& a number of other Snakes—The bows of ye. trees were loaded with birds—some of almost every species in America—& many exotics. In short, it is not in my power to give any particular account of ye. numerious speecies of fossils & Animals—but only their general arrangement. What highte[ne]d ye. view of this singular collection was, that they were all real—either ye. substance—or skins finely preserved.

Broadside, February 1, 1790, Massachusetts Historical Society.

<div align="center">

To the CITIZENS

of the

United States of America

</div>

Mr. Peale respectfully informs the Public, That having formed a design to establish a MUSEUM, for a collection, arrangement and preservation of the objects of natural history and things useful and curious, in June 1785, he began to collect subjects, and to preserve and arrange them in the Linnaean method. His labours herein have been great, and disappointments many—especially respecting proper methods of preserving dead animals from the ravage of moths and worms. In vain he hath sought, from men, information of the effectual methods used in foreign countries: and after experiencing the most promising ways recommended in such books as he had read, they proved ineffectual to prevent depradations by the vermin of America. But, in making various other experiments, he at length discovered a method of preservation, which he is persuaded will prove effectual: it has a very favourable appearance in practice, and far surpasses all others that have come to his knowledge. Nevertheless, it will be obliging in gentlemen to inform him of the best practices in Europe, or elsewhere.

The difficulties in preserving subjects being thus overcome, and the Museum having advanced to be an object of attention to some individuals—who, it is hoped, may gain from it information, which, with pleasing and elevated ruminations, will bring them nearer to the Great-First-Cause—he is therefore the more earnestly bent on enlarging the collection with a greater variety of beasts, birds, fishes, insects, reptiles, vegetables, minerals, shells, fossils, medals, old coins, and of utensils, cloathing, arms, dyes and colours, or materials for colouring or for physic, from amongst the Indian, African, or other savage people; and all particulars, although but in model or delineation, promising to be useful in advancing knowledge and the arts; in a word, all that is likely to be beneficial, curious or entertaining to the citizens of the new world. But, alas! in compleating the design, a collection of all *animated* Nature, alone (in the infinite variety of which she wonderfully delights—so great—so vast) requiring an age to enlarge it to the full consideration of a national magnitude; and yet these and other subjects are to be unremittingly pursued, and far as possible obtained, by an individual of but slender circumstances.

All the national museums in the world (as far as he is informed) were from beginnings of individuals: the Public are therefore the more chearfully solicited to help forward this tender plant, while it is yet under the nurturing care and anxious attention of its present possessor, and until it shall have grown into maturity, and become a favorite establishment in the hands of the great Public of the American States. He hopes this may be the case: For—"with harmony small beginnings effect great things."

Much might be said of the importance that such a collection and arrangement would be of to society: but the present address means only to give a concise report of the rise and progress of this infant design, and excite exertion in the friends of science, favorable to it: A design that, whilst countenanced by the Public, may grow into a great national museum, or repository of valuable rarities, for more generally diffusing an increase of knowledge in the works of the Creator—God, alone wise!—At all events, MR. PEALE intends to prosecute the design with such means as are in his power. Should it happily receive the smiles of the Public, the progress will be proportionably great; whereas, if it is to depend only upon his solitary efforts, the progress must be so slow, that the whole may fall through, not for want of men [of] so superior abilities, but for a successor equally zealous in building up and enlarging the noble fabric, for the emolument of mankind—a fabric which, with due attention, must be continually improving to the end of time.

Charles Willson Peale to Rembrandt Peale, August 2, 1822, in Lillian B. Miller, ed., The Selected Papers of Charles Willson Peale and His Family *(New Haven: Yale University Press, 1996), vol. 4.*

I had become uneasey at not receiving a letter from you & relieved to day by yours of the 30th ult. I could not account for your silence about a design for this whole lenth Portrait of self. I waited to hear what you would say before I would begin it, and did not mention what I might have done, I mean my first thoughts, which I now give you, and written too late to alter my design. My dress a suit of Black Breeches and silk Stockings—holding up with my right hand a a dark crimson Curtain, to give a view of the Museum from the end of the long room, thus shewing the range of Birds, the revolutionary Characters, and instead of the projecting casses behind me, I contemplate as much & as conspicuous as possible the Skeleton of the Mamoth & perhaps some of the quadrupeds more distant, I may have some Mamoth bones &c at my feet, My Pallet & Pencils near at hand, My left hand in form & view of expaciating & being open & turned alittle back to express as I conceive *fullness* Bringing the beauties of Nature into public view—this is perhaps telling the Story, simple & plain to be understood.

Now for the likeness, I make a bold attempt—*the light behind me,* and all my features lit up by a reflected light, beautifully given by the Mirror! The top of my head on the bald part a bright light, also the hair on each side. That you may understand me, place yourself between a looking-glass & the window your features will be well defined by that reflected light a dark part of a curtain will give an astonishing [illegible] to the catching Lights, and thus the whole figure may be made out with strong shadows and [illegible] catching lights. With this mode I can paint a faithful likeness—as I have prooved by taking a small canvis, the likeness I have made it is said to be better than those I painted for Rubens & Sophonisba.

Charles Willson Peale to Rubens Peale, August 4, 1822, in Miller, ed., The Selected Papers of Charles Willson Peale and His Family, *vol. 4.*

To make tryal of the effect in the perspective of the long room, I drew the lines with my Machine, & I set Titian at work to fill it up with his Water Colours, and he has nearly finished an admirable representation of the long room, the minutia of objects makes it a laborio[u]s work, it looks beautiful through the magnifiers. Coleman seeing it yesterday, says that it deceived him, he thought he was viewing the Museum in the looking Glasses at the end of the Museum. He thinks it might be a good deception, to see it in another room and would have a good effect on Visitors.

Charles Willson Peale to Rembrandt Peale, August 10 and September 9, 1822, in Miller, ed., The Selected Papers of Charles Willson Peale and His Family, *vol. 4.*

I have had some difficulty about the point of sight in the picture—to shew the length of the Room necessarily placed the Horizon higher than I conceive is pleasing. After much study of the several objects to be represented placed rather above the middle of my figure—the Mammoth then placed behind me the lower part only seen the curtain covering above. This Curtain is a dark crimson Colour with damask flowers. It makes a fine relief of the head—I could not bring the base line of the bird casses to the bottom of the Picture, because it would make the room too narrow, but to fill up that vacant space, a measure of about 3 feet, I shall place there one of the 2 steps Stools of the Museum with a fine specimen of our wild turkey, brought by Titian on the Missourie expedition, painted in its full size, and a few of the birds & perhaps one or two of the Portraits of revolutionary characters . . .

[I shall] now give you some account further on my portrait, It is now in train to be finished in a few days—And I wish it may excite some admiration, otherwise my labour is lost, except that [it] is a good likeness. I have introduced a few figures at the further end is a figure of meditation, a man with folded arms looking at the Birds, next a father instructing his Son. He holding his book & lesson open before him & looking forward as attentive to what the Parent says—and a quaker lady, we may suppose entered at the further opening & passing along by the Cases of Birds turns round and seeing the Mammoth Skelleton, is in the action of astonishment, her right foot forward & both hands lifted up—she is dressed in . . . plain rich silk & black Bonnet—I dont know that more figures are necessary these seem to [be] sufficient for the perspective of the room. I mentioned the Wild-turkey to be on a stool—I have placed it on a Mahogany box with the drawer drawn out contain[in]g Tools, Vise Plyers &c. Behind me is a table covered with green baise, on it my Pallet & Pensils, This is the best I can give you without a drawing, but when Titian has got through his present work, he may give you a sketch of the Picture—He has taste & draws very handsomely with dispatch.

THE COLUMBIANUM

In December 1794 the first documented association of American artists was formed in Philadelphia; it would come to be known as the Columbianum. Organizers hoped they might catalyze support for the training of artists and the exhibition of their work, but the effort barely got off the ground, thanks to a political dispute between English émigré and Federalist artists (who wanted President George Washington as the group's titular leader) and Jeffersonian anti-Federalists (who objected to this royalist model). The former group eventually withdrew from the organization, and the Jeffersonian artists staged the one and only Columbianum exhibition in May 1795. Although this exhibition was an important event in the history of American art, the Columbianum did not survive to organize another. Rembrandt Peale, who was seventeen years old at the time, remembers the events of the Columbianum in an essay written in 1855. Notable in his account is the willingness of his father, Charles Willson Peale, to serve as a life model for the two drawing students the Columbianum managed to recruit.

Rembrandt Peale, "Reminiscences," Crayon 1 *(May 9, 1855).*

The epoch of our annual exhibitions naturally suggests the recollection of the *first* artistic exposition in the United States, which took place in the memorable Hall of Independence, in May,

1795, under the direction of an ephemeral society with the quaint name of COLUMBIANUM. Their first document commences thus:—"An association of artists in America for the protection and encouragement of the Fine Arts. We, the undersigned, from an earnest desire to promote, to the utmost of our abilities, the Fine Arts, now in their infancy in America, mutually promise and agree to use our utmost efforts to establish a school or academy of architecture, sculpture, painting, &c., within the United States." Signed by thirty members, of whom fourteen were engravers and painters.

A small attempt was made to organize an Academy, by means of a number of broken statues, belonging to my father, saved from the wreck of his studio and the revolutionary movements. From these plasters, Jeremiah Paul and myself were the only draughtsmen; but a desire to study from the life promised a better attendance, and a fine athletic baker was chosen as a willing model; but, when we were all stationed at the surrounding desks, crayon in hand, and our young baker, though accustomed to some nudity in his bakery, found himself, as he stripped, the object of a dozen pair of scrutinizing eyes, he *hastily* gave up the display; and my father, that the young academicians should not be disappointed, partially disrobed himself, and thus served as the first academical model in America!

A great effort was made to get up an exhibition by contributions of old and new paintings, from Copley and West, down to the Peales, and landscapes by Loutherbourg and Groombridge. Four landscapes by Reinagle, were the chief ornaments of the walls, but were sent back to the artist, not finding a purchaser at a hundred dollars each, such was the low ebb of taste in the capital of America, with the boasted population of ninety thousand inhabitants—now 500,000. In the collection was a fine portrait of Mrs. Governor Mifflin, by Copley, for the hands of which, she told me, she sat twenty times. This tediousness of operation deterred many from sitting to Copley. I have heard Vanderlyn fret that he could only get six sittings for the same purpose.

Philadelphia, then without a rival, imagined itself the Athens of America, but could scarcely support two portrait painters and one miniature painter. *Field* was only a bird of passage—went to Nova Scotia, adopted the surplice, and became a comfortable bishop; and the sculptor *Cerachi,* after making a bad bust of Washington, returned to France to conspire against Bonaparte. It may be worth remembering that the first enamel miniature painted in America was that of my father, and the second, William Bingham, painted by the elder *Birch,* who afterwards could only scrape a living by painting enamel breast-pins for lady patrons; his son *Thomas,* until recently, enjoyed his humble life as a marine painter . . .

It was the only exhibition until the formation of the Pennsylvania Academy in 1805, of which I was the instigator and chief instrument, with much loss of money and time. The *Columbianum* died a natural death, by schisms, and chiefly the resignation, in a body, by eight of its members—Englishmen—occasioned by some republican sentiment uttered by an American.

QUAKER CITY ARTS ORGANIZATIONS, C. 1810

In 1805 two important entities were founded in Philadelphia, the Pennsylvania Academy of the Fine Arts and Port Folio *magazine. The latter became a great cheerleader for the former; indeed,* Port Folio *was the most enthusiastic journalistic proponent of the fine arts in the early republic. By 1810 the Pennsylvania Academy was well established, with its own handsome building on Chestnut Street, an impressive collection of plaster casts from antique statuary, and a collection of European paintings.*

That year Joseph Hopkinson, one of the institution's founders, delivered "the first annual discourse," a hopeful address defending the place of the arts in a democratic society and anticipating advances in American history and landscape painting. His speech is too long for inclusion here, but the introduction in Port Folio, *which published Hopkinson's address, gives an idea not only of the speaker's points but also of the journal's part in encouraging support of the arts.*

That same year another Philadelphia organization came into existence, the Society of Artists of the United States (its name was changed a few years later to the Columbian Society of Artists). The preamble to its inaugural constitution is included below. Unlike the Academy, which was mainly governed by laymen, the Society's membership was composed entirely of artists. Although several discussions of merging the two groups came to naught, the Academy and the Society did sign a cooperative agreement. This friendly spirit did not prevent disagreements from arising between the two groups, but it never approached the bitter feuding that later took place between similar organizations in New York—the American Academy of the Fine Arts and the National Academy of Design (see "The National Academy of Design," chapter 3).

The Society was inaugurated with an address by the English-born engraver George Murray on August 1, 1810. Murray hoped the organization would soon create an art school, and he argues for Nature, rather than copies of antique art, as the primary instructor of the artist. As an immigrant, Murray lauds the American openness to foreigners, and he predicts that, once initial prejudices against the arts are overcome, the United States will be a magnet for free-thinking artists. The following year, when the Society held its first exhibition, the discourse was pronounced by architect Benjamin Latrobe, a vice president in the organization. This oration, longer and subsequently more famous than Murray's, picks up some of the same themes but goes further in its forceful argument for the natural marriage of democracy and the fine arts. Latrobe appears to believe that his fellow citizens need convincing, and he labors to disassociate art and architecture from despotic rulers, wealthy individuals, sensual gratification, and general idleness. In the end he invokes "the spirit of commerce" as a hopeful sign of future private patronage in the United States. It went without saying that a budding collector might find any number of works available for purchase at the Society's annual exhibition, opened just two days before. Latrobe offers his personal assessment of that exhibition in a letter to Thomas Jefferson.

"The Pennsylvania Academy of the Fine Arts," Port Folio 4 (1810), supp.

We congratulate our country on the flourishing state of this institution, which, after struggling with all the difficulties incident to new undertakings, has at length assumed that rank in the public estimation which its unassuming usefulness so richly merits. The first annual discourse was delivered before the academy on the evening of the thirteenth, by Joseph Hopkinson, esquire, one of the directors. On this occasion, the public officers of the city, the foreign ministers, various incorporated societies, and an unusually brilliant assemblage of ladies and gentlemen attested, by their presence, the interest which is felt among all classes, in the success of the Academy. Nor were the high expectations of the public disappointed, by the orator, who, in a very ingenious and imperative discourse, gave a rapid sketch of the history of the Academy, and the astonishing improvements of the country, and after refuting, in a strain of in-

dignant satire, the false imputations cast upon us by foreigners, concluded by urging every topic suggested, by humour or feeling, to subdue the prejudices of those who are either hostile or indifferent to the arts of their country.

After the oration, some of the most distinguished members of the Society of Artists were admitted to fellowships, in the academy, and received their diplomas from the hands of George Clymer, esquire; the President. This ceremony was witnessed with much satisfaction, not only because it exhibited the Academy as already the patroness of native genius, but because it presented thus conspicuously to public notice, so many of our meritorious artists.

Our anxiety to extend the reputation of the academy, has induced us to trespass on our usual limits, by inserting the whole of this eloquent oration. We have been moreover enabled to embellish it with an elegant engraving of the present tomb of WASHINGTON, which the pathetic description of the orator will compel every American to view, with a mingled feeling, of pride for the country which produced such a man, and shame for the thankless nation which leaves him to such a tomb.

On the various subjects touched by Mr. Hopkinson, we forbear to dilate, because the discourse itself will fully reward the public curiosity: but, we can omit no opportunity of commending; with enthusiasm, the liberal purposes of this institution; and of impressing on the country at large, that the cultivation of the arts has far higher objects than the mere indulgence of personal vanity. These should, indeed, be among the first to share the national munificence, since they are always the best and brightest honours of a free people. But to a young nation, at that dangerous age, when the passions are seduced, by recent wealth, over the limits of former temperance, when luxury is added to comfort, and convenience ripening into elegance, at such a moment, it is of fearful importance to fix the wavering taste of the people to wean the misguided passions from habits of low expense, or mean indulgence, to the more liberal and generous pursuits of letters and the arts. If we regard merely individual happiness, these sister studies are the purest sources of enjoyment: they calm the turbulence of political disscussions; like the air we breathe, their influence reaches every object that can contribute to our comfort or satisfaction, till their diffusive light sheds over national manners, a softened beauty, which, like the mellow colouring of the painter, forms no feature of the landscape, but is the charm of the whole. If we seek the glory of the nation, these pursuits will again present us with the most brilliant objects of ambition; they strengthen the infancy of a nation, because they purify its morals; they give lustre to its maturity; they enliven its decay; and cheer even its ruins with the proud vestiges of ancient renown. Are we, then, too young to cultivate the arts, and is it true that their fastidious visits are reserved for the latest stage of refinement? Yet, while some of the richest countries of Europe possess scarcely a single artist, our riper age seems already anticipated by the number and the excellence of the American painters. Are we too poor? The answer may be seen in the growing prosperity which surrounds us, and the expensive habits which have excited the alarms of more timid moralists. Are our numbers too few? But, in the brightest æra of the arts, in those days from which we have received the models whose very fragments excite at once the admiration and the despair of posterity, the free population of Athens did not probably exceed, if it even equalled that of Philadelphia. We are unjust in thus imputing to ourselves these imaginary deficiences. The genius and the materials are abundantly spread throughout our country: they languish only for want of taste, and spirit, and patronage. But the progress of the Academy is a most auspicious omen that we shall soon cease to merit these reproaches; and we again repeat our obligations to that institution, for its zealous labors to diffuse a spirit for the arts, and the liberality with which it fosters the exertions of American artists.

Preamble to the Constitution of the Society of Artists of the United States *(Philadelphia: Thomas L. Plowman, 1810)*.

In the infancy of a country, the energies and talents of its inhabitants, are confined to the exercise of those arts, which are immediately connected with the production and acquirement of the necessaries of life; to the procuring of food, of raiment, and of shelter; to the cultivation of the soil, to the establishment of the coarser manufactures, and to the erection of substantial, but rude buildings. With the progress of society, wealth, and consequently, leisure is acquired; attention is then paid to convenience and comfort, and in process of time to ornament. It is thus, that the Fine Arts succeed those that are merely useful, and thus, a combination is formed, uniting beauty with strength and elegance with utility.

Such at least has been the case in the United States. Our ancestors, on their arrival on this vast and then uncultivated continent, found constant employment in providing against the calls of hunger, the inclemencies of weather, and the attacks of the brave, but ferocious aboriginal nations. Increase of numbers brought safety; and agriculture and commerce soon flourished. The various improvements in the arts, connected with navigation and the culture of the soil, bore ample testimony to the industry and ingenuity of our countrymen. Few of them however, had, until the close of the last century, sufficient leisure to attend to the cultivation of the Fine Arts. Twenty years ago, scarcely a single specimen of American taste, which was worthy of attention, could be produced. Painting was indeed an exception, but even in that branch of the Fine Arts, American genius was dependent on European patronage. Since that period, the change has been wonderful. But, although the progress has been rapid, we are yet far behind other nations. Sculpture and Architecture still languish. Even those arts, in which improvement is most apparent, owe their present advancement to the solitary exertions of individuals. Much indeed has been done, but much remains to do. Some method seems wanting, to encourage exertion, to combine talents, to draw excellence from obscurity, and to display acquirements to the best advantage. To these ends, nothing, it is believed, would contribute more than the establishment of a Society of Artists and Amateurs, founded on liberal principles. Such a society is now formed under the title of "THE SOCIETY OF ARTISTS OF THE UNITED STATES." Into this society, it is intended to admit as members artists and amateurs in all the branches of the Fine Arts.

The immediate objects of this association are to teach the elementary principles of the arts; to encourage emulation by a comparison and communication of ideas; to correct and improve the public taste by stated exhibitions; and to raise a fund for the relief of such members as may be rendered incapable of following their respective professions, or in case of their death, to make some provision for their families.

To carry these objects into effect, it is, in the first instance, proposed to select, as soon as the society is organised, proper persons to teach the first elements of the arts, and particularly to establish a school for drawing in all its various branches. The connection between drawing and all the fine arts is obvious. It is the very soul of Painting and Engraving, and it is indispensable to Sculpture and Architecture. For how can an artist judge of effect, unless he can produce a correct delineation of his design? It is in fact, as necessary to the arts, as writing is to the sciences. Independently of its importance to artists, a school for drawing, in which the youth of both sexes might be instructed at a moderate expense, would be a powerful means of promoting a correct taste. Young persons in the habit of copying works of the best masters, will naturally acquire an accurate perception of their various excellences. Thus the judgment will be matured, the taste improved, and a love for the fine arts gradually extended. Nor is this unimportant. Much of the moral character of individuals, and consequently of the nation, depends upon the

amusements which fill up the hours of leisure. Instances are very rare of fine taste united to depravity of conduct. A young person, possessed of the resources furnished by the arts, has fewer temptations to vice, than one who after the hours of business or of study, is obliged to look abroad for recreation. But drawing may be useful not as an innocent employment merely. Unforeseen events may reduce the most affluent to poverty and a talent for drawing may become not only an elegant accomplishment, but a means of subsistence. Many of the unfortunate victims to the French Revolution, have obtained at least temporary relief from want, by the exercise of that art, which formed one of the amusements of their happier days.

In addition to the Drawing School, it is proposed to establish an annual Exhibition of the works of art. It is not intended to confine, in the commencement, this exhibition to original works, nor to those of American artists. Artists and Amateurs, who have in their collections, works of the foreign schools, or approved copies, or even good drawings and engravings of them, will be invited to exhibit them. It is believed, that such an exhibition will gradually pave the way for one of original American productions; that it will excite a spirit of just criticism: and that it will soon become a source of public gratification, as well as of improvement of public taste.

From the Drawing School and annual Exhibitions considerable profits will probably arise. To these profits, it is proposed to add contributions of the members of the society. These will constitute a fund for the payment of the expenses and for carrying into effect the charitable views of the association.

A society, founded on these principles, will, it is presumed, meet the cordial approbation and support of a great majority of the artists and amateurs of the United States. It is believed that from its nature it will not be liable to those unfortunate schisms which have too often disturbed, and frequently destroyed, institutions established for the improvement of the Fine Arts.

George Murray, "Progress of the Fine Arts," Port Folio 4 *(September 1810).*

To establish a society of artists on liberal principles, and to render the same permanent and useful, is a matter of no small difficulty. Various opinions are entertained respecting the best means of insuring the success of such an undertaking.

It is hardly possible that all the members can be acquainted with each other's real sentiments, and it is very natural to suppose that misunderstandings on many points, and even jealousies will exist among those who, perhaps, are equally anxious to promote the advancement and welfare of this institution.

It appears to be necessary, in the commencement to state clearly what are the objects and prospects of the society; this will tend much to promote harmony and good understanding among the members.

It is well understood that the primary objects of this society are, the establishment of schools in all the various branches of the fine arts; a public exhibition of the productions of American artists; to improve the public taste; and to raise a fund for the relief of decayed members; but the most important object is, to remove existing prejudices, and *to give a character to the* FINE ARTS *in the United States.* To examine with impartiality in what true excellence consists, and to render as simple as possible the means of acquiring a knowledge of the arts.

It has been the practice with all the old academies, to lay too much stress on what may be considered the mere rudiments of art.

A knowledge of drawing, so as to be able to delineate any object with tolerable accuracy, can soon be acquired by persons of even ordinary capacity; and being taught upon mathematical principles, may be considered as purely mechanical; but the superior arts of design, composi-

tion, and the choice of subjects, require all the energy of a reflecting and fertile mind. Many persons possessing fine imaginations and cultivated understandings, are deterred from entering the list of artists, on account of the great length of time generally spent in preparatory studies.

The great school of art is nature; and every artist who expects to become eminent must always be a student there.

If we glance over the history of the arts, we will find that it was in the early ages of the Grecian republics, when the greatest artists flourished; and the monuments of their works which remain, are convincing proofs that they understood well the beautiful simplicity of nature.

The study of the antique, though important to the pupil, has nevertheless been carried much farther than what is necessary, and the great length of time generally bestowed to acquire a knowledge of it, might be more profitably devoted to the study of nature. The works of those artists, who have been so partial to the antique, although allowed to be elegant and graceful, are notwithstanding very monotonous, and destitute of character. The old saying, that "he who follows must always be behind," is very applicable to the arts; and it is a lamentable truth, that we often see *followers of followers,* and *copyists of copyists.*

The greatest artists, both ancient and modern, have studied immediately from Nature. The Dutch and Flemish masters had little or no knowledge of the antique. Claude painted his pictures in the open air; and Hogarth, who may justly be denominated the Shakspeare of painting, drew all his subjects from real life: and no painter has ever furnished us with a greater variety of character, without extravagance; and none has ever exceeded him, either in composition, propriety of design, or choice of subject. The works of Hogarth tend equally to amuse, to delight, and to instruct: he has exposed vice in all its horrid deformities, ridiculed the extravagance and follies of the times, and has done more for the improvement of morals than all the other painters, ancient and modern, put together.

The grand object of this society ought to be, to establish a school of the arts, founded on plain and simple principles; to make a proper use of the antique, only to prepare the students for the more important study of Nature in all her varieties.

An opinion has prevailed, (and in some degree exists at present) that this country is too young to foster the arts; and also, that our form of government is not very favourable to promote their advancement. That there are not sufficient materials to enable the student to pursue his studies to advantage; and also, that there is neither taste to appreciate merit, nor a disposition to reward it; and that it is absolutely necessary for the young American artist to look both for improvement and encouragement to foreign countries.

It cannot be denied that several artists who have emigrated from this country, have become eminent in their professions, and have met with liberal encouragement abroad; but it must also be allowed that there are several artists among us, in the higher branches of the arts, that have not had the advantages of an European education, whose works will bear a fair comparison with those of the most distinguished foreign artists; and it must also be observed, that their merits have not been altogether overlooked by their countrymen.

It has before been observed, that a principal object of this society ought to be directed towards the removal of existing prejudices, and to prove to the world that there are sufficient materials here for the improvement of the young artist; and also, that he has every thing to hope and little to fear, as far as relates to encouragement.

We possess a vast extent of territory, and a variety of climate, affording not only all the comforts and conveniencies of life, but even nearly all the luxuries of the east and west.

Chains of mountains of immense height, gradually rising from the sea, extending through

the country in nearly a parallel direction with the coast, and intersected as they are in many places by beautiful and magnificent rivers, form a vast variety of the most sublime and picturesque scenery in the world. Populous and flourishing cities, towns, villages, and elegant mansions, diversify the whole, and afford an infinite source of materials for the landscape painter.

The rapid increase of population and wealth, promoting the improvement of our cities and public works, call forth the talents of the architect, and insures to him a reward for his exertions.

To commemorate the American revolution, and to place in the most conspicuous point of view, those patriots and heroes, who had the virtue and hardihood to assert, and to secure the independence of their country—to illustrate and perpetuate *their* glorious achievements, belong equally to the painter, the sculptor, and the engraver.

The prosperity and even the existence of a republic depends upon an ardent love of liberty and virtue; and the fine arts, when properly directed, are capable, in a very eminent degree, to promote both.

The encouragement given to engraving within these five years past, and the great improvement in that branch of the arts, is a proof that the American people are far from being without taste.

Several English publications have been copied in a style that even the most prejudiced have acknowledged to be equal, if not superior, to the originals; and it is hoped that the time is not far distant when we will cease to be the mere retailers of European ideas, and that we will act and think for ourselves, and produce original works.

Mr. Wilson's Ornithology is a splendid specimen of American original publication, and is allowed by the best judges, both in London and Paris, to be equal to any thing of the kind that has ever appeared in any country: and the encouragement which that work has met with here is another convincing proof that the American public possess both taste to discover, and disposition to reward merit.

The United States being the only country on earth where the people in general are really independent and happy, is considered by the friends of rational freedom in every country, as *the great strong hold of liberty,* as their last and safe retreat from the horrors of despotism.

The tyranny and rapacity of the sovereigns of Europe have already forced a vast number of their most valuable subjects to abandon their native countries, and to look for their natural rights under our mild and enlightened government. They have brought with them their arts and their industry; many have become rich, and all who possess health have the means of obtaining a comfortable subsistence. The wise policy of the United States in admitting foreigners to all the rights of citizens, has weakened the governments of Europe, and added to this country an inexhaustible fund of wealth.

The political institutions of France as well as Great Britain being founded on injustice, and supported by force, their rulers cannot see with indifference the rapid rise of a young and powerful nation, where the government is both the choice and idol of the people, securing equal rights and privileges to all: a country enjoying so many important advantages, must continue to attract the subjects of foreign despotisms, and finally to rival them in *arts* as well as in commerce.

Both the great contending powers of Europe have made use of every species of intrigue and duplicity to check the growing prosperity of these states. Under the plea of necessity they have been guilty of the most flagrant acts of injustice, in order to destroy the lawful commerce of this country. The consequence of such conduct, however distressing and ruinous to many individuals, has had the effect of opening the eyes of the great mass of the people respecting their

true interest, and has directed all their attention, arts, and industry, to their own inexhaustible internal resources.

At this crisis it is our duty as well as interest to prove by every exertion, that however high we may value the friendship of other nations, we are determined to do without their aid. Manufactures are making rapid progress throughout the union, and a knowledge of the fine arts is of great importance to their improvement.

The Society of Artists look up with confidence to the people of the United States, for the encouragement and support of an institution embracing so many important objects, and capable of being rendered of great public utility.

The Pennsylvania Academy of Fine Arts have shown a very friendly disposition towards this infant institution, and we have every reason to look for their cordial co-operation. The aid, also, of every other similar institution throughout the union is expected.

The Society of Artists are determined, both individually and as a body, to direct their labours, and to use every exertion in common with their fellow citizens, to promote the prosperity, glory, and independence of their country.

B. Henry Latrobe, "Anniversary Oration, Pronounced before the Society of Artists of the United States," Port Folio 5 (1811), supp.

The custom of delivering an annual oration, or lecture, before the members of the academies of Europe, has generally for its object the instruction of the students in the principles of art, the correction of their taste, and the encouragement of their zeal and industry. In these institutions, supported by the government as essential to its splendour, and upheld by the unanimous opinion of the governed as promoting one of the most rational and interesting sources of their pleasure, it is unnecessary, in an annual oration, to point out the advantages that result from the culture of the fine arts. No argument, no declamation, is so convincing or so eloquent as experience. The indolent, the luxurious, even the vicious rich, while enjoying the pleasure which the works of art afford to them, are innocent; while encouraging and rewarding them, are useful: nor is the most wretched of the poor, less happy than they, while admiring or boasting the monuments of art that adorn his native city, or the church of his village. To the feelings of the Athenian, who walked in the Poikile—of the Englishman who visits Westminster Abbey or St. Paul's—or of the Frenchman, before the Arch of Victory, nothing could be necessary to prove, that the arts have been usefully and honourably employed, in recording the courage, the patriotism, or the virtues of their countrymen . . .

But at the opening of this infant institution, instruction in the study, or in the practice of any of the fine arts, is less necessary than the labour of proving that these arts have not an injurious, but a beneficent effect upon the morals, and even on the liberties of our country. For we cannot disguise from ourselves, that, far from enjoying the support of the general voice of the people, our national prejudices are unfavourable to the fine arts. Many of our citizens who do not fear that they will enervate our minds and corrupt the simple and republican character of our pursuits and enjoyments, consider the actual state of society as unfit for their introduction: more dread a high grade of perfection in the fine arts as the certain indication of the loss of political liberty, and of the concentration of wealth and power in the hands of a few. Many despise the arts and their professors as useless, as manufacturing neither food nor raiment, nor gathering wealth by the enterprize of foreign commerce; and still more, ignorant of the delight, innocent as it is exquisite, which they afford, seek employment for their idle hours in the gratifications of sense, and the ostentatious display of riches.

Inasfar as these prejudices, the only real obstacles to the triumph of the fine arts, grow out of the political constitution of society in the United States, the attempt to remove them suddenly by argument will be vain. That such obstacles do exist is certain. On the one hand, the subdivision of wealth, resulting from our laws of inheritance, scatters at the commencement of every generation the funds out of which individual citizens might support the fine arts: and the immense territory over which our population is seeking to spread itself, weakens all combined efforts of private citizens by the separation of distance: on the other, the dread of responsibility in the individual representatives of the people, converting all their notions of good government into the single anxiety to avoid expenditure, withholds that degree of public encouragement, which would give example and fashion to individual favour, and establish a *national* love and pride in the fine arts.

But mere prejudices, whether of habit, of ignorance, or of false reasoning, are to be conquered. In our republic, that which arises from an opinion that the perfection of the fine arts is incompatible with freedom,—while it is the most powerful to retard their progress,—is at the same time the most unfounded in *theory,* and the most false in *fact* . . .

That the wealth and the titles, which arbitrary power has to bestow, will always furnish strong inducements to the cultivation of the fine arts, under monarchical governments, is undeniable. Under a Trajan, an Adrian, a Henry VII., a Charles I. and II., a Louis XIV., a Frederic II., or a Napoleon,—monarchs, who, in the excellence of the arts they fostered, and the general encouragement they gave to men of literature and science, sought a considerable portion of their own immortality—the fine arts have flourished with great vigour. Nor ought we to omit mention of the name of George III., by whose patronage our illustrious countryman, West, has become the first historical painter of the age. But in all these instances, and in others which might be added, it has not been owing to the character of the government, but to that of the individual monarch, that the arts have flourished under these reigns . . .

If then we need not dread the encouragement of the fine arts, as hostile to our best interests, the interests of our morals, and of our liberty, the inquiry, whether the state of society in our country be ripe for their introduction ceases to be of much importance. A propensity to the fine arts is an instinctive property of human nature. To repress it, it is necessary to confine its activity by positive laws, enforced by all the horrors of religious dread. But, where no such restriction prevails, there is no nation so rude, so ignorant, so occupied with the toils and cares of procuring the support of a miserable existence, so harassed by war and rapine, among whom art does not spring up spontaneously, combating the sterility of the soil, and the rigor of the climate, but still struggling and succeeding to exist. The caves of the Hottentot, the deserts of Africa, the rocks of Easter-Island, and the snowy wastes traversed by the Esquimaux and our northern Indians, have their indications of the fine arts; and the club of every savage is carved and painted before it is dyed in the blood of his enemy. Art is a hardy plant. If nursed, tended, and pruned, it will lift its head to heaven, and cover with fragrance and beauty the soil that supports it; but, if neglected, stunted, trodden under foot, it will still live; for its root is planted in the very ground of our own existence. To draw; to imitate the forms around him, is the first delight of the infant; to contemplate and accumulate the productions of art, one of the proudest enjoyments of the polished man; and to be honoured by art with a monument, the last ambition of the dying.

If therefore there exist no prejudice to oppose the growth of art among us, the state of society is always ripe for its introduction. And even where prejudices do exist, as they certainly do among us, the arts themselves, like Hercules in the cradle, will strangle the serpents. Mild,

insinuating, of no political party, all they require is a slight introduction to our acquaintance. Received at first with reserve, they will be cherished by the best of our affections, and find patronage from our most legitimate pride. Our vanity will combat our avarice in their behalf; they will sometimes be disgusted and repelled by ignorance and parsimony, but they will be consoled and attracted equally by liberality and ostentation. Their advancement to that footing of security and reward which is their right, will not be rapid, but it will be certain and durable. The taste for the fine arts when it shall become a national taste, will be as permanent as the national language. It will not be a fashion set by a Charles, or a Louis XIV.; it will be a law to which the economy of our legislatures will bend, and heroic actions will not go unacknowledged, because a statue or a monument requires an appropriation of money . . .

It is a proud circumstance for the fine arts, that among those who have stepped forward with zeal and with talent, with a sacrifice of their time and of their money, to establish the academy of the arts in this city, that profession, in which study, habit and emulation contributes, perhaps more than in any other, to the cultivation of the powers of the mind, and to the correction of the taste and the judgment, has been prominently active and useful: and that among the most distinguished members of the Academy of the Fine Arts, are those men who are the most eminent at the bar. The aid of their talents, of their eloquence, and of their high standing in society, cannot be without their effect, nor will the fine arts, to whom jointly with the poet and the historian, belongs the distribution of wreaths of immortality, be unmindful of their services.

. . . The most effectual patronage which in their infancy the fine arts can receive, is the certainty of employment. The enthusiasm which belongs to genius will do much, but without this inducement to the young who possess superior talents to devote themselves to their cultivation *as a profession,* we shall ever remain mere occasional and unskilful copyists. When Hippocrates lamented that to attain perfection in the medical art, life is too short, he uttered a truth peculiarly applicable to the fine arts. Writers of the greatest genius have denied the existence of that individual native predisposition to eminence which is called genius. But though they fail to prove that education is every thing, and genius nothing, it is very certain that he that is most diligent and persevering, will generally be most eminent. Without encouragement therefore, to look forward to the practice of the fine arts for the means of a competent and honourable enjoyment of the ease and independence which may be procured by trade or agriculture, few, even of those who feel themselves irresistibly impelled by inclination to devote themselves to their culture, will follow the natural bent of their genius.

That subdivision of labour which has been found to produce such surprising effects in other employments, and which has in modern times, pervaded every branch of human activity, has separated the professors of the fine arts into distinct classes. The painters of history, of portraits, of landscape, of cattle, and of sea pieces, are now distinct persons. The sculptor and the architect, and the artist, who, by multiplying, perpetuates the work of all the others, the engraver, have provinces wholly distinct from each other. This subdivision of the labours of the fine arts is highly promotive of perfection in detail. Whether it is in other respects favourable to the formation of great artists, I will not now inquire; but it certainly gives to us, in the actual state of American society and wealth, the choice of honouring, and patronising those branches of the fine arts, which we find most conducive to our pleasures and our wants, and which can most easily attain excellence among us.

I am not of opinion that it would be possible to point out any set of practicable measures, to be adopted by the general or state governments, by which the course of the fine arts towards perfection could be promoted among us, so effectual, and so economical, as the simple system

adopted by the Greeks. If meritorious actions, and services rendered to the state, were commemorated by a portrait, an historical picture, a bust, a statue, a monument, or a mausoleum, the emulation to excel in the fine arts, would grow out of the emulation to deserve well of the country. The establishment of academies and of schools of instruction in the fine arts, calling for expensive buildings, large endowments and a continual expenditure in maintaining the establishment, would be of little effect without employment of the artists educated in them. Academies should be founded in the encouragement of the works of art. Without the slightest favour from the nation or the state, this society has arisen on the basis of private and individual enterprize, giving to the rising artists of the country the means of support, and paving to them the road to eminence. Affection and pride have asked for portraits, literature for embellishment, and science for elucidation, and we already rival Europe in portraits and in engravings. Commerce has called for beauty in the forms and decorations of her ships, and where in Europe is there a Rush.* Let the national legislature honour the hero or statesman of the revolution with busts; and sculptors will not be wanting.—The genius which under exotic influence has given so high a rank to the American pencil of a West, Copley, Trumbull, and Vanderline, would, under domestic patronage, not refuse to inspire the American chisel.—And whence arises it—is it our national ingratitude, our ignorance or our apathy—that those states or municipal bodies, which have endeavoured to erect a memorial to the merits of any of their public men, have confined it to the form of the face or the person; that the majority of the states have not even gone so far, and that the national legislature has absolutely done nothing:—while four American historical painters have attained the highest eminence in Europe, where their talents have been employed in immortalizing the achievements of a lord Heathfield, or of a major Pearson, in the war carried on against us; and where the patriotism of Trumbull, exhibited in his admirable pictures of the death of Warren and of Montgomery, has been obliged to wear the mask of British victory. The annual expenditure which would employ these great artists upon the transactions of our own country, and which would give to them honour and independence, would be as dust in the balance of our public accounts. The national pride, which such records excite, is well worth purchasing at the expense of a few thousand dollars; and, if the example of all the republics that have preceded us, did not authorize the hope, that history will not find us guilty of ingratitude, but only of delay, the national neglect of the memory of Washington would be sufficient to repress every sentiment of patriotism and public spirit. Of this neglect, aggravated by the solemn steps taken by Congress to obtain a right to remove the body of the founder of our liberties to a place of public and honourable sepulture, and the abandonment of that right when obtained, it is painful to speak—nor is it necessary. There is not wanting a general sentiment of the disgrace which the nation suffers while the body of Washington rests upon a trussle, crouded into a damp and narrow vault, in which the rapid decay of the wooden

*Mr. William Rush, of Philadelphia, is at the head of a branch of the arts which he has himself created. His figures, forming the head or prow of a vessel, place him, in the excellence of his *attitudes* and *action,* among the best sculptors that have existed; and in the proportion and drawings of his figures he is often far above mediocrity and seldom below it. The rules of design by which the figures of Mr. Rush are to be judged require a considerable latitude. The great object is general effect.—In this he succeeds beyond competition. High finish would be misplaced. The constrained attitude of a figure on the prow of a ship would appear an insuperable difficulty. With him it is nothing. In looking at his figures in general it would appear that his attitudes were those of choice; so little do they embarrass him. There is a *motion* in his figures that is inconceivable. They seem rather to draw the ship after them than to be impelled by the vessel. Many are of exquisite beauty. I have not seen one on which there is not the stamp of genius. But his element is the water. Ashore, his figures want repose, and that which is his highest excellence afloat, becomes a fault.—The ships' heads of Rush, engraved, would form an invaluable work.

support must in a few years mingle his ashes with those of his worthy but unknown relatives. Exertions, not altogether worthy of the object, but such as the present fashion of finance authorizes, are made, to give to his memory that honour in other cities which is denied him in the metropolis of the union; and this sentiment, becoming daily more active, will reach and animate the halls of our Congress, and the honour paid to Timoleon by the little republic of Syracuse, will not be thought above the pecuniary means, or contrary to the constitutional principles of the American people . . .

I have already detained you far beyond the right which my feeble powers of instruction or entertainment give me. An attempt to remove the prejudices which oppose the establishment of the fine arts among us, appeared to me the most pressing duty of the orator of the Society of Artists. I have fulfilled but a small part of that duty. If it were necessary to do more, I could call up the spirit of commerce to aid me. I could enlist in the cause of the fine arts—that embellish domestic happiness, that charm leisure, that grace generosity, and honour patriotism— I could enlist in their cause, the demons of cupidity, and of avarice. I could show that though they are instructive, faithful, and amusing friends, they may also be made profitable slaves. I could mention the names of Wedgewood, whose pots and pitchers, and cups and saucers, and plates, shaped and decorated by the fine arts, have thus received a passport into the remotest corners of the globe—of Boydell, whose engraved prints are spread over and ornament the whole surface of the earth—of Bolton, and Watt, and of the smiths and founders of Birmingham, who, true sons of Vulcan, have rendered the fables of Homer, and the visits of the arts and the graces in the forges and furnaces of that sooty god, to assist in the design of the armour of the immortals, not only probable, but true. But I need not proceed further. The presence of this assembly shows that it is unnecessary, and its patronage will be more efficient than the most laboured oration.

To the artists and amateurs who compose this society it must be matter of infinite encouragement to view the effect of their collected talents and industry in the exhibition now opened. The novelty of an exertion to bring together and to arrange the productions of art which cover the walls of the academy, must, necessarily, produce some imperfection, both in the collection and in the arrangement. But without asking for any such allowance, have we not reason to be proud of our infant strength:—that it is considerable:—that among the numerous pictures and drawings, there are many which would not dishonour the walls of the London and Parisian galleries, is certain:—And in this is our superiority; that our strength is our own. It is not hot-bedded by imperial and royal patronage, nor even by the nobility of wealth: it is the concentrated force of individual genius and industry, and of the encouragement of private and unproclaimed protection. That this effort of the fine arts may be countenanced by your visits and your approbation, I need not solicit. It is in your power to make your own amusements the foundation of all the eminence to which the most sanguine of us expect to attain; and, as the fair part of this assembly once did in adopting the Grecian dress, to stamp with the sanction of fashion, that which good taste recommends. The success of the exhibition of this year will ensure to you an infinitely superior collection in the next, and not only stimulate the zeal of our artists, but inform them on the best method of accomplishing their object.

In beholding the harmony in which the productions of so many talents are arranged; in considering the general and united effect of all the pictures which cover the walls of the exhibition room, varying as they do in the merit, the manner, the colouring, and the subject of each; I could not help reverting to that moral and social harmony by which the artists of our country might so much improve each other. There is, indeed, in superior genius a gregarious principle,

which naturally brings men of similar talents together. Those who are most susceptible of the beauties of truth and of nature, are also the most susceptible of affection. The enthusiast in art, cannot be cold in friendship, nor can any thing contribute more to mutual improvement and excellence, than that mutual esteem and confidence which embellishes the private associations of artists. Each honest advice, each friendly criticism, each communication of knowledge from one artist to another is a step, hand in hand, in the ascent to perfection. As our political independence was achieved by adherence to this motto, let our independence in the arts grow out of the conviction that *united we stand, divided we fall.*

B. Henry Latrobe to Thomas Jefferson, May 19, 1811, Library of Congress.

Mr. Rembrandt Peale has returned from France much improved. But I do not know how it happens,—the portraits of eminent men in France of whom he has painted I think 20 are much superior to any he has painted here. He has brought over a head of Napoleon of very striking character. He says that it was considered in France as the best portrait of the Emperor in existence. I do not doubt its being a good one. He possesses the talent of catching strong character.— R.P.s portraits are *hard,* at least several that are in the exhibition have *that* fault, which was the great fault of all his early productions.—He professes to *hate* portrait painting & has I think *wasted* much time on a full sized figure of Napoleon on Horseback which he is exhibiting at 25Cts. I regret exceedingly that a young artist of his merit should not go straight forward in the line that good sense points out as the only one leading to wealth & leisure and eminence on this side of the Atlantic, that of portraits, more or less historical, as his principal employ;—& of historical painting of *domestic* subjects as a *speculation* on public liberality.

A Young artist, Thos. Sully,—is certainly the first on the list of our portrait painters, and a copy of West's study of the landing of Telemachus & Mentor on the Island of Calypso shows greater talents than he has as yet been able to bring before the public.

A Young English painter, Jarvis, has an exquisite & speaking portrait of Washington Irving, author of Knickerbocker's history of New York.—

In landscape there are many very good, but no extraordinary pictures in the exhibition. In history nothing great.

Stuart has sent nothing. This admirable painter & worthless man is, I am told, at last making money at Boston. There are some of his old pictures in the exhibition.

New York

THE AMERICAN ACADEMY OF THE FINE ARTS

Although there had been halting efforts to form academies of art in both New York and Philadelphia, it was not until 1802, with the establishment of the New York Academy of the Fine Arts (the name later changed to American Academy of the Fine Arts), that one achieved any kind of lasting status. Founded by a small group of elite New Yorkers— none of whom was an artist—the Academy imported a group of plaster casts and arranged for a series of old master copies to be put on view in their temporary quarters. For more than a decade the Academy led a rather sleepy existence, as its secretary, John Bogert, admits in his short article describing its institutional mission in 1813. Bogert argues that artistic taste, when widely cultivated, will calm the baser passions and elevate the national character (leading to an ordered society that would have pleased the Federalist stockholders in the Academy).

The Academy was seen to move toward that goal in 1816, when its president and the former Federalist mayor of New York, De Witt Clinton, reenergized the institution and helped find it a more permanent home. That year he gave an address marking the Academy's first exhibition in its new home. Clinton was also frank about the organization's troubles, as he was about his own views of the place of the arts in society. His endorsement of the fine arts is actually somewhat grudging; he locates them distinctly below scientific and mercantile pursuits. Still, he paints a picture of an exciting, even astonishing historical moment—fraught with political change and scientific discovery— in which the arts will develop and find their place. Perhaps he betrays his own interests as a politician in specifically arguing for history painting to figure "the deliberations of our statesmen" and for portrait painters to memorialize the important actors on the national scene.

Eight years later, lawyer and politician Gulian Verplanck gave a very different address before the same body. Willing to grant much more importance to the fine arts, Verplanck sees them as necessary to science and the mechanical trades, not mere added polish. A Democrat in politics, his attitude toward the arts was populist, describing a universal language of form that could address "our common nature." Verplanck grew up with a fine portrait of his father by John Singleton Copley, and he rebels against the European denigration of that genre. His defense of portraiture is unusually sensitive, and he also recognizes the power and utility of reproducible forms of art, such as engravings.

John G. Bogert, "Fine Arts," Monthly Recorder 1 (April 1813).

This institution, the existence of which has been frequently announced to the public, has not yet attracted that attention which it merits. This indifference, in a community characterised by a zeal for the promotion of every thing of public utility, can only arise from an imperfect acquaintance with the objects of this academy. An idea has been too generally entertained that this institution is designed merely for the amusement and gratification of a few individuals, and that society is little concerned in its advancement.

But so erroneous is this opinion, that we hesitate not to say that every one, to whom the happiness of the community and the reputation of our country are dear, is deeply interested in the progress of the arts, inasmuch as the cultivation of them contributes very essentially to correct and refine the public taste, improve the public morals, exalt the reputation of our country, and dignify the character of its people.

It is a well known truth, that much of the difficulty and most of the obstacles to improvement in education, most of the vices in society and many of the violations of public law, originate in a corrupt and vulgar taste, a propensity to low gratifications, and an attachment to illiberal pursuits.

An institution then, whose tendency is to elevate the tone of sentiment, to soften the fiercer passions, to inculcate a taste for virtuous employment, to create an admiration of whatever is great and glorious, and to bring into exercise all the finer feelings of our nature, must be an object of primary importance to mankind; and that the cultivation of the fine arts tends to produce these happy effects, no one will deny who has attended to the progress of society, or the advancement of civilization.

But the cultivation of a taste for the fine arts not only conduces to a refinement of the character; it is connected with improvement in all the mechanic arts, inasmuch as the general dis-

person of a correct taste calls for, and produces a nicety, ingenuity, and elegance in every department of manufactures. And it is a well known fact, that no country has arrived to any great perfection in manufactures which had not already made very considerable progress in the liberal arts: even on the supposition, therefore, that no other benefits were to be derived from this institution than what arise from its effects on the general character of the nation, every person must feel amply compensated for his individual exertions in its support.

But it acquires additional importance, when viewed as a school and nursery for genius, in the higher departments of the fine arts.

And that there is a latent talent in the Americans, susceptible of the highest cultivation and improvement, is sufficiently ascertained by the eminence which several of our countrymen have attained—West, Copely, Trumbull, Vanderlyn, Stuart, and Alston, are all natives of this country, and rank amongst the most distinguished artists of the age.

But how much more creditable would it have been to our liberality as a people, to our character as a nation, if, instead of being compelled to cross the Atlantic for instruction, they could have enjoyed the same advantages in academies of our own country? Even if they should have received the rudiments of their art here, they would have had some cause to feel grateful to the land of their nativity, for that eminence to which they have arrived by their own great exertions and the aid of foreign schools.

However, we hope the period is not far distant when our country, by affording greater facility in education, will have higher claims to the gratitude of future American artists.

De Witt Clinton, A Discourse Delivered before the American Academy of the Arts *(New York: T. and W. Mercein, 1816).*

I have complied with your request to open the Academy on this interesting occasion, with great pleasure, but not without unaffected diffidence. You must be sensible, that this Institution has struggled against a succession of serious difficulties from its origin to the present time; that at different periods, it has indeed cheered us with a glimmering light, but that at most times, it has appeared like an expiring taper. The causes are various; the absence of vigorous and systematic exertion—the want of funds—of suitable apartments—of public exhibitions—and of a complete co-operation with our artists—and a consequent indisposition in the public to countenance it under all these embarrassments: and when it was found almost impracticable to obtain even a meeting of the Directors, I did not consider it necessary to attend to their request, to pronounce an eulogium on our late President, until a more favourable condition should enable us to execute it in a manner the most respectful to the deceased, and the most creditable to the Academy. That auspicious period has now arrived. The liberality of our municipality has furnished us with spacious apartments, and the public spirit and taste of a few of our associates, have prepared them for our reception. The collections of the Academy have been drawn from their obscure receptacles, to adorn that edifice, and the rich and various contributions of genius will, it is to be hoped, give elevation to this city, and reflect honour on our country.

It i[s] a subject of deep regret, that the correcting interposition of reason is necessary to remove the strong prejudices which exist against this Institution; for, it is believed by many, that the state of society, and the form of our government, are unfriendly to the encouragement of the Fine Arts, and that they ought to be neglected or over-looked, until more important establishments are endowed by private and public liberality, and until the higher departments of human knowledge are improved to the utmost extent.

If this subject were presented for consideration, as a controversy of preference between the

Fine Arts and the Sciences; or between the polite and the mechanic arts, there would be no room for hesitation. The useful must always take precedence of the agreeable—the accommodations must always be preferred to the luxuries of life; the investigations of science, and the acquisitions of learning must ever take the highest rank in intellectual estimation; but in this case there is fortunately no collision.

The physical, the moral, the intellectual, and the political appearances of the world, exhibit an extraordinary state of things. We have seen within a few years, society torn from its foundations, and governments sanctioned by time, and fortified by prejudice, prostrated and hurled into ruin; we have seen the world in arms, and on a sudden the olive branch of peace extended to mankind; we are witnessing the silent and rapid progress of a great moral revolution, by the extension of the blessings of education and the lights of religion; we have beheld some of the most destructive diseases disarmed of their fury; we have seen endless sideral worlds, which were hitherto impervious to human vision, fully opened to our contemplation; we have applied the most powerful agents to the purposes of analysis and decomposition, and have obtained new views of elementary and compound substances. The sciences which relate to inorganic matter, and to organized bodies, have been cultivated with wonderful ardour; the depths of mathematical and physical knowledge have been sounded, and the most intricate recesses of the human mind have been explored: and yet in the midst of all this intellectual activity—of this scientific elevation, of these moral improvements and political mutations, ample room has been found for the cultivation and encouragement of the Fine Arts. Genius has been cherished; taste has exercised its high endowments; the world has been explored for specimens of art; and the costly and magnificent contributions of the present age, have triumphed over all the enterprises of former times.

It is impossible to restrain the operations of the human mind, within the severe boundaries of science. The direction which nature gives, must be pursued: And, as in the economy of society, it is essential, that a division of labour should exist in the mechanic arts, so it is requisite, in the arrangement of the intellectual world, that different minds should be impelled to different pursuits, in order that every science, and every art, depending for its success upon mental exertion, should attain the greatest perfection. Hence it is, that some will devote themselves to works of imagination, and others to the exercise of the reasoning power; some to the polite arts, and others to the abstract sciences. In the progress of a civilized and enlightened community, all the professions, whether liberal or mechanical, whether depending upon the labour of the mind, or the hands, the exercise of the fancy, or the judgment, must be filled up: and it is the duty of a patriotic government, to encourage all, by dispensing its beneficence, like the dew of heaven; preferring, however, whenever preference becomes necessary, such as are most conducive to general and permanent prosperity . . .

A republican government, instead of being unfriendly to the growth of the fine arts, is the appropriate soil for their cultivation. The ability to promote useful undertakings and beneficial institutions, must exist to a certain extent in every community, and it certainly may be called into exertion with greater potency in a free state than under an arbitrary government, where the money expended for their encouragement is extorted from the people. The privileged orders which prevail in civilized monarchies are hostile to the high prerogatives of intellect. They create a barrier against the ascent of genius to the highest stations, and they cast the most distinguished talents and the most exalted endowments in the back ground of society. And although they sometimes produce herbs of salubrious virtue, and trees of noble growth, yet they in general originate and support those pestilent plants whose seeds, elevated by the winds, are

scattered in every direction, and are propagated by the exhaustion of the most fertile soils, and the destruction of the most valuable productions.

The condition of our community, in relation to manners or education, cannot be urged as an objection against the cultivation of the fine arts. A nation highly agricultural, and the second commercial people in the world—improved by science and abounding in institutions of education, must surely be contemplated as friendly to those arts which polish and refine society . . .

With respect to the comparative advantages or disadvantages of the ancient and modern artists, we stand precisely on the same footing as our brethren of the old world; but we are unfortunately deficient in having but few distinguished models of art.

The professors of the fine arts occupy the same ground with us as other callings. There are some who adorn society by their talents, and are distinguished for their education and virtues. In these respects we are not inferior to those of other times and other countries. And it certainly cannot be alleged that there is an inaptitude in the American genius for the fine arts. On the contrary, from the anecdotes which are related of some of our distinguished painters, it would appear that an irresistible impulse had devoted them to the art. And it is well known that, both abroad and at home, our countrymen (whose names delicacy forbids me to mention in this place) have exhibited powers of genius and of taste, which have commanded not only applause, but admiration . . .

But as almost all our ideas are derived in the first instance from sensation—and as the imitative arts rely, for their field of operation, upon the material world, it must be obvious that the imagination of the artist must derive its power and receive its complexion from the country in which he was born, and in which he resides. And can there be a country in the world better calculated than ours to exercise and to exalt the imagination—to call into activity the creative powers of the mind, and to afford just views of the beautiful, the wonderful and the sublime? Here Nature has conducted her operations on a magnificent scale—extensive and elevated mountains—lakes of oceanic size—rivers of prodigious magnitude—cataracts unequalled for volume of water—and boundless forests filled with wild beasts and savage men, and covered with the towering oak and the heaven aspiring pine.

This wild, romantic and awful scenery, is calculated to produce a correspondent impression on the imagination—to elevate all the faculties of the mind, and to exalt all the feelings of the heart: But when cultivation has exerted its power—when the forest is converted into fertile fields, blooming with beauty and smiling with plenty, then the mind of the artist derives a correspondent colour from the scenes with which it is conversant; and the sublime, the wonderful, the ornamental and the beautiful, thus become, in turn, familiar to his imagination.

America, notwithstanding its infancy, has witnessed events as worthy of the delineation of genius as any that have occurred in the old world. Even in our colonial state, the richest themes exist for the pencil of the painter—but commencing with the Declaration of Independence, and coming down to the events of the present times, what more magnificent subjects could be selected for the graphic art? The painter of history has here an ample field for the display of his powers. The deliberations of our statesmen—the exploits of our heroes may be revived and perpetuated—deeds of mighty import, the offspring of ethereal minds, and the parents of immortal glory—and here the Portrait Painter, the Statuary, and the Engraver, may transmit to posterity the likenesses of those men who have acted and suffered in their country's cause. The portrait collection of this city, by comprising many of the principal heroes of the country, is entitled to great praise in its tendency to stimulate to noble deeds, and to encourage the Fine

Arts, by displaying to advantage the compositions of our best painters, and its merits would be greatly enhanced if it were extended so as to embrace illustrious men, who have done honour to the Arts and Sciences, or who have distinguished themselves in other respects as men of extraordinary talents or virtues. The utmost care ought to be adopted in the selection, as one unworthy preference may disgrace the whole gallery . . .

As the streams and springs which nature has produced, are, when collected into reservoirs, and regulated by skill, rendered subservient to subsistence, accommodation, and pleasure, so will the rays of genius, concentrated in this institution, create and diffuse a taste for the Fine Arts, and elevate our country in the estimation of the civilized world. Its apartments will contain the best models of ancient and modern art, and the most distinguished specimens of all that can occupy the genius, or perfect the taste of our country. To that place, the artist will resort for study and improvement—there he will deposit the fruits of his genius, there he will enter the lists of fame, and there he will attain the palm of glory. How many men are there, upon whom nature has shed her choicest gifts, who, restrained by diffidence, the companion of genius, or prevented by an elevation of sentiment, which, like the celebrated flower of the east, disdains the support of the earth, or bewildered by that ignorance of the world which attaches itself to the man of seclusion and contemplation, linger out an obscure existence, without notice, without patronage, without one smile of comfort, or one word of encouragement. And how many more are there, who feel the divine inspiration of genius, and who possess commanding, ductile and transcendant minds, which might enable them to ascend to the highest, or stoop to the lowest flights of art, but who, for the want of opportunities for cultivation, are either compelled to wander abroad, or to smother the nascent powers of intellect. This Academy will conquer all these difficulties, and surmount all these disadvantages. On these altars, dedicated to the Muses and the Graces, will be offered the choicest gifts of genius, and the most finished specimens of art. Here the temple will be reared—the sacrifice will be made—the fire will be kindled—and no longer shall the votary be compelled to seek under foreign shores, and in distant lands, the objects of his adoration. In this place shall be deposited the portraits, the busts, and the statues of those illustrious men, who have extended the fame of their country, brightened the path of glory, illuminated the regions of knowledge, and exemplified the blessings of religion. Here shall the future great men of America, the guides, the lights, and the shields of unborn generations, repair to view the monuments of art—to behold the departed worthies of former times—to rouse the soul of generous emulation, and to catch the spirit of heroic virtue . . .

And if our artists shall ever expect on eagle wings to penetrate into lofty and untried regions, and to ascend into the highest heaven of invention, let them cultivate that noble enthusiasm, that sublime sensibility, without which exertion is useless; which animated Corregio when he said, *And I also am a painter,* and which fired the bosom of Zeuxis, when he exclaimed, that he designed for eternity. Let them also respect the decencies of life, the charms of virtue, and the injunctions of morality. The most inimitable powers of invention and execution, cannot atone for that perversion of decorum which addresses the sensuality of the imagination, and which loosens the restraints of the moral sense. A great artist ought to be emphatically a good man; illustrating, in his works, the beauties of art, and, in his life, the beauties of virtue.

There are certain mighty pillars which support the complicated fabric of society, and there are distinguished ornaments which beautify and embellish it. Upon agriculture, manufactures, and commerce, upon science, literature, morality, and religion, all associations of the human race must rely for subsistence or support—but the Fine Arts superadd the graces of a Chesterfield to the gigantic mind of a Locke—they are the acanthi which adorn the Corinthian

column—the halos which surround the sun of knowledge; they excite labour, produce riches, enlarge the sphere of innocent amusements, increase the stock of harmless pleasure, expand our intellectual powers, improve our moral faculties, stimulate to illustrious deeds, enhance the charms of virtue, diffuse the glories of heroism, augment the public wealth, and extend the national reputation.

Gulian C. Verplanck, Address Delivered before the American Academy of the Fine Arts *(New York: Charles Wiley, 1824).*

It must be obvious to all, that the arts of design have a direct and positive utility, far beyond their own immediate sphere, arising from the constant and indispensable aid, which they afford to the mechanical arts, to physical science, and to many of the most important pursuits of civilized life. Drawing, engraving, the scientific principles of construction, (as distinguished from those founded in natural or conventional taste,) are of daily use in civil engineering, in military and marine architecture, in preserving and making known the discoveries of the naturalist, the observations of the anatomist, the inventions of the mechanician, and, in general, all the improvements of natural and medical science.

But, that quick sensibility to the beauties of form and proportion, that relish for purity of design and simplicity of execution, which necessarily result from a familiarity with works of taste, have a still broader, and (though less distinctly perceptible in their operation) scarcely a less efficient influence upon most of the arts of civilization, upon commerce and manufactures. The beneficial effects of good taste are to be found, even where you would least suspect its presence. It every where silently excludes wanton superfluity, or useless expenditure in labour or ornament. It inculcates a wise and dignified economy. It prompts art to achieve its ends by the simplest means. It gives to the productions of mechanical skill all the durability and elegance, of which they may be susceptible, by lending to them those forms, proportions, combinations of colours, and agreeable associations, which, because they are most simply and obviously fitted to their peculiar purposes, or are congruous to natural principles of man's physical or moral constitution, have pleased for ages, and will ever continue to please; whilst the caprices of fashion, and the cumbrous splendour of gaudy luxury, are inevitably doomed to become in a very few years, offensive or ridiculous . . .

But to be thus extensively useful, taste must become popular. It must not be regarded as the peculiar possession of painters, connoisseurs, or diletanti. The arts must be considered as liberal, in their ancient and truest sense, *quia libero dignæ,* as being worthy of the countenance and knowledge of every freeman . . .

Let us pass on to the sister Art of Painting. Why should I expatiate on the uses and charms of that, with which all who hear me must be familiar? It is so intimately connected with the elegant literature, the general cultivation, and even the amusements of our times, that those who have no practical skill in it, and who have never seen any original work of the very great masters, have some understanding of its theory, and through conversation, books, engravings, and copies, know and feel much of the extent and majesty of its powers. It is a natural and universal language, the language of description through the eye, in its elements common to all mankind, but susceptible of an indefinite and never-ending improvement, as it becomes instructed by close observation, disciplined by practice, judged of by a quick natural sense of the beautiful or the grand, elevated by moral dignity of thought, or animated by deep intensity of feeling. Through the senses it awakens the imagination, and by her magic aid, reanimates the dead, acts over before us the great deeds of history, realizes to our eyes the most glorious visions of po-

etry, and can transfer to a few feet of canvass the unbounded vastness of nature's scenes, the cheering breath of her airs and heavens, her changes of season, and "glad vicissitudes of night and day."

The great artist moulders in the tomb. But his works still live in the self-sustaining freshness of nature. Age after age passes away, and they still beam forth beauty upon one generation after another. In calm disdain, as it were, of the petty and transitory interests, pursuits, opinions, passions of the day, they continue with undecaying power, as years roll on, to address themselves to the great principles of our common nature, soothing the cares, elevating the thoughts, stirring in the very depth of the heart the thrilling emotions of natural sympathy, or awakening there the sleeping sense of the great, the sublime, or the holy . . .

In all this, what is there but the triumph of mind? It is the separating of the excellent, and fair, and durable, and intellectual, and universally true, from that which is little, and temporary, and sensual, and accidental. It is the stripping off the grossness of sense from the forms of matter, and investing them with the dignity of intellect and the expression of sentiment.

Can we then, as Americans, be content to look with indifference upon the progress of such an art? Can we coolly say, "All this is well for Europe, for the adorning of courts and palaces, for the amusement of princes, or to enable wealth and luxury, wearied out with their own existence, to fill up the languid pauses of life with new gratifications?" Oh, not so. Nothing is unworthy or unfitting the attention of a free and wise people, which can afford scope for the employment of talent, or can adorn or gladden life; least of all, should we be indifferent towards an art, thus admirably fitted for the mixed nature of man, an art at once mechanical, moral, and intellectual, addressing itself to every part of man's constitution, acting through his senses upon his imagination, through his imagination upon his reason and his heart.

But, although it is in the hand of the great epic painter, who fixes upon his canvass the sentiment of religion, or the glowing conceptions of poetic fancy, that the pencil has gained its chief honours, it is in another and much humbler department, that this art appeals more directly to the patronage, the judgment, and the natural affections of all of us. It is perhaps in portrait painting, that we are to look for some of its best and most extended uses.

I have called it an humble department of the art, because such is the rank assigned to it by the aristocracy of European taste, and because it really is so in respect to the narrow field it presents for the exertion of fancy or science; yet Reynolds has pronounced that the power of dignifying and animating the countenance, of impressing upon it the appearance of wisdom or virtue, of affection or innocence, requires a nobleness of conception, which, says he, "goes beyond any thing in the mere exhibition of the most perfect forms."

While, too, our relish and judgment, with respect to other productions of art, are only so far natural as that they are founded in a sensibility, and a power of observation and comparison, common to all men in full possession of their faculties, but which require to be developed, exercised, and disciplined, by experience or study; Portrait appeals more directly to the comprehension of every one. Though it is sometimes applied to the gratification of vanity, it much oftener ministers to the best feelings of the human heart. It rescues from oblivion the once-loved features of the absent or the dead; it is the memorial of filial or parental affection; it perpetuates the presence of the mild virtue, the heartfelt kindness, the humble piety, which in other days, filled our affections and cheered our lives . . .

It is an exalted and sacred office which art discharges, when it can thus administer to the charities of domestic life. But Painting becomes public and national, when it is employed in perpetuating the expression of the mind speaking in the features of the brave, the good, the

truly great—of those whose valour made us free, or by whose wisdom we may become wise; of the heroes of our own country, of the patriots of our own history, of the sages and men of genius of all countries, who have left us those works, which form the intellectual patrimony of civilized man—of the heroes of humanity, of the benefactors of the human race. Then it becomes, indeed, a teacher of morality; it then assists in the education of our youth; it gives form and life to their abstract perceptions of duty or excellence; and, in a free state and a moral community, where the arts are thus made the handmaids of virtue, when the imagination of the young patriot calls up the sacred image of his country, it comes surrounded with the venerable forms of the wisest and best of her sons . . .

We, too, have great men to honour, and talent enough to do honour, to them. In our public places and squares, in our courts of justice, our legislative halls, and seminaries of education, the eye should every where meet with some memorial of departed worth, some tribute to public service or illustrious talent.

Sculpture, in its rudest form, seems to be the instinctive effort of nature, in the early stages of society, to express veneration and to perpetuate honour or gratitude by the help of imitative skill. Nor does it lose its fitness for these uses in the highest stage of refined and cultivated art, although then, in place of the humble imitation of individual nature, it addresses and exercises the imagination, the taste, and intellect. The durability of the material suggests to the mind grand associations of past times, and presents to it in dim and shadowy perspective, the idea of long successions of future generations, who will gaze upon the form now before our eyes, with thoughts and feelings kindred to our own. But at the same time, the severity with which this art rejects the aid of colour and every other adjunct tending to illusion, compels and habituates the rudest mind to an effort of intellectual abstraction, whereby the undivided attention is fixed upon the majesty of expression, or the truth and grace of form.

Though our sculptors may never vie with those of antiquity, in the expression of faultless beauty and ideal majesty, yet they can always find a sufficiently ennobling employment in the commemoration of our great men. Statuary, austere and dignified in its character, is fitted chiefly for public uses, and of all the arts it is that for which private patronage can do least, and which most requires the fostering care of public munificence. Our native sculptors have already given ample proof that we no longer need the chisel of Canova or Chantrey, to commemorate our Washington and Franklin, and the sages who shared their labours, or who may hereafter follow in their footsteps.

We have already successfully called in the aid of Engraving. This is an art of less dignity and fame; but when I consider its multiplied uses to science, letters, and taste, and the various and very peculiar excellencies of which it is susceptible, I can scarcely call it an inferior one; for it is not, as the uninformed are apt to suppose, a purely mechanical occupation. Whilst in itself it affords room for the exercise of no ordinary talent, it stands in the same relation to the other arts, which printing does to Eloquence and Poetry, and by bringing their production within the reach of many thousands, to whom they would have otherwise been wholly inaccessible more than compensates for the loss of immediate impression by wider diffusion and greater usefulness.

When such an artist as our associate Durand, has completed an admirable engraving from one of the greatest scenes of our history,* or of any history, in which the grand truth of the story takes a stronger hold upon the mind, than mere fancy can ever gain, he has not only done

*Editor's Note: Durand's engraving of Trumbull's Declaration of Independence.

honour to his own talent, but he has discharged a part of the debt of gratitude he owes his country. He has enabled every one of us to bring the great scene and the great actors of our Independence within our own doors, to make them as it were, spectators of the blessings they have earned for us, to place them before the eyes of our children—and, when our sons read the history of Grecian heroism, or of English virtue, when their eyes glisten, and their young hearts throb wildly with the kindling theme, we can say to them, "look there, remember that we too had our Epaminondas and our Hampden." . . .

Nor is it only for their indirect effect upon the present or the future state of society, that the Arts should be cultivated and cherished.

They should be loved and fostered for themselves; because they call forth the exercise of a peculiar sort of talent, apparently native to our soil, and every day springing up fresh and vigorous before us. Our Arts have heretofore unfolded and expanded themselves, not in the genial sunshine of wealth and patronage, but in the cold, bleak shade of neglect and obscurity. The taste of our native artists, of whom so many have risen or are now rising, here and in Europe, to the highest honours of their profession, was not formed by contemplating the noble remains of classical antiquity, or the beautiful productions of modern Italy. They had not even the fainter stimulant of listening to the language of that affected and exaggerated enthusiasm, that while it is often wholly insensible to the excellence to which it does outward homage, can sometimes excite in others the warmth it but feigns itself. Nature was their only teacher, her works their great Academy.

Indeed, it is difficult to account for the remarkable fact, that so many of our countrymen should have become thus distinguished, far beyond the natural demand of the country, or even its forced patronage, without allowing the existence of some organic physical cause, or some mental peculiarity, strongly impelling talent in that direction.

In spite of the greatest disadvantages, and with little in our public or social habits, peculiarly fitted to foster the elegant arts, we have already given the most abundant and unquestionable proof of possessing the highest capabilities of success in them.

Boston

JOHN BROWERE'S GALLERY

Among the many attempts to establish a national collection of works of art were efforts by single individuals such as sculptor John Browere. The first American sculptor to seek an education in Paris (1816–17), Browere had earlier studied painting in New York City under Archibald Robertson (see "The Earliest Guide to Sketching Landscape," this chapter). He returned to the United States with a plan to take life masks of eminent Americans—statesmen and cultural heroes as well as representative Native Americans. In this public letter to Bostonians, Browere lays out his plan for his "First American School of Sculpture and Gallery of Eminent Personages," which he hopes will include casts of antique statuary and works by living American artists as well as his own plaster busts. In colorful language, Browere pleads for American support of the arts and for his own "darling project." His enthusiasm notwithstanding, the gallery never received the support he hoped for. Today, many of his life masks are preserved at the Fenimore Art Museum, Cooperstown, New York.

John H. I. Browere, "To the Citizens of Boston," Boston Commercial Gazette, *November 24, 1825.*

Ladies and Gentlemen:—Desirous of handing down to posterity the images of American worthies, and anxious for the spreading and advancement of the Fine Arts, I left my native city, New-York, visited the south, and at present have the proud pleasure of treading that ground, denominated the 'Cradle of American Independence,' and of visiting and associating with men, who, in the 'times that tried men's souls,' proved themselves worthy of the epithet 'Patriots,' and on whose hearts were emblazoned in letters of blood, 'Liberty or death.'

Bostonians! Young, but not inexperienced, I have dared to appear among you. But with no sinister or impure motives. Not to realize an accumulation of the dross—but to give a projectile force to genius, by executing in their presence the portrait busts of our country's benefactors; among the number of whom, is to be ranked, your beloved and venerable father. Ex-President John Adams, he, whom you hitherto have, and at present delight to honour.

By the *public vehicles* you have already perceived that the likenesses or portrait busts of Washington, Lafayette, Jefferson, Madison, J. Q. Adams, Clay, Barbour, Southard, Rush, Franklin, Porter, Brown, etc. etc. are already finished by me, and in my possession, regarded and acknowledged as the only true and correct likenesses of those eminent personages.

To those worthies I have already tendered my most grateful acknowledgment for their condescension and good will to me; therefore a repetition would be superfluous.

To you then gentlemen, Bostonians, I make bold to address a few lines; trusting, from your known urbanity and indulgence to errors, that mine, if any here appear, may meet indulgence and forgiveness; conscious that my intents are pure, and unmixed with grovelling ambition.— Having lately adopted the profession of sculpture and portrait painting, and having an enthusiastic desire of their advancement in my native country, I have adventured to intrude on the public time and patience, by requesting that they will now listen to the description of a plan I have formed of carrying into effect my darling project; hoping, trusting that when they have impartially read my ideas, they too, will do their utmost to aid the progress of the Fine Arts in our beloved country.

In the first place, then, I declare it is my determination, health and strength permitting, to execute not only the portrait busts and full length statues of the most eminent civilized men of our country, but also those of every tribe of our aborigines, the Indians, in their varied attitudes of war and peace; as also the facsimile images of Bolivar, the father of South American Independence, Generals Sucre, Santander, etc. after the completion of which, it is intended that appropriate buildings be erected to receive them, and works of American artists only; and that these buildings shall be open to public inspection.

It is contemplated, that the most celebrated statues and busts of antiquity shall be purchased and arranged in one department, and contrasted with the works of the American nation. In one place the Apollo Belvidere will be opposed to the more perfect form of an Osage warrior; the full length statues of Washington, Bolivar, Lafayette, Hamilton, Franklin, Adams, Jefferson, Madison, Monroe, etc. will there challenge competition with the most admired of their heroes.

The name of this institution to be the 'First American School of Sculpture and Gallery of Eminent Personages,'—to be supported by voluntary contributions, and the exhibitions and sales of the works of native artists—to be at all times open to artists, who shall receive instruction gratuitously, from the most able masters.

By these means, not only the reputation of America will be established as a patroness of the Fine Arts, but that innate genius of her progeny, will become apparent; it is lying now dormant and unknown, only because of the want of due encouragement and patronage . . .

Shall American artists be longer jealous of rivalry? shall we longer submit to the degradation of being fettered by prejudice? Oh, no! Away with vice, and let us unite and rally round the standard of virtue, and she will conduct to the temples of fame, wealth and honour! Let us, at once, leave off following the footsteps of *foreign* worthies, and depend upon our own innate talents; and my life on it we shall, ere long, show to an admiring and astonished world the triumph of virtue over vice.

Bostonians! you must forgive the warmth of a stranger to your city, but not to your valor and worth. In so doing, you will more firmly bind that bond of union we swore to keep in days long past, and recall afresh that love of truth which has become proverbial in the world.

But to the purpose—artists generally, (owing to causes unknown to the public, and not absolutely necessary at present for me to repeat,) are poor, and therefore incapacitated from producing finished works. Either sickness, a numerous family, losses and disappointments interfere to thwart their endeavours, or they become chilled by the public indifference; in despondency and despair, are therefore, no specimens of extraordinary merit is ushered to the world. But let her come forth in the majesty of her might, in the beauty of her holiness; let her extend her hands to the falling, distribute her favours to the deserving, and then, then will ye find that artists can be grateful.

Do but this; for genius cannot brook delay, and the sun of beauteous perfection will arise on our visual and mental horizon, dispelling the darksome clouds of ignorance, superstition and prejudice.

But say you, "we have always been willing and ready to patronize native genius." Hah! In what manner have you expressed your wishes? By deeds? Nay! By words? Yea, truly! But words are wind: even so then artists must live on wind. Have you ever made it your particular business to call on the distressed artist? What said he! Be assured, gentlemen, that true genius is noble, and therefore will never intrude on your purse or praise, unasked, undeservedly.

The way then that I would point out to you, in order to encourage the growth and advancement of the Fine Arts in our country, would be somewhat in the manner following:

Form a committee of able and judicious men. Invite the artists generally to your consultations. Adopt measures to collect contributions, which place in the city banks, till sufficient materials be formed for a Gallery; which can only be done by offering appropriate pecuniary emoluments to artists. The emoluments arising from the exhibitions, or sales of duplicates of these works, in a short time will raise a sufficient sum to defray the expenses of a building, masters to superintend the education of youth in all the varied departments of the Fine Arts, and your work will be complete. Posterity will bless your memory.

In order to evidence my regard to the arts, I tender you an offer of my humble services, and of my works already done.

Fig. 3. Francis Davignon after Tompkins Matteson, *Distribution of Prizes at American Art-Union at the Tabernacle-Broadway, New York, 24 Dec. 1847,* 1848, lithograph. Harry T. Peters, "America on Stone" Lithography Collection, National Museum of American History, Behring Center, Smithsonian Institution.

3 ANTEBELLUM AMERICA

Values and Institutions

ART IN A DEMOCRATIC NATION

THE IMPORTANCE OF THE GENRES

In the third decade of the nineteenth century, regular exhibitions were still infrequent enough that some critics felt it necessary to instruct their readership in the principles of the fine arts before actually engaging in criticism. Here, in two landmark reviews of exhibitions in New York and Boston, the authors repeatedly stress the intellectual basis of high art—for the artist, the viewer, and the critic. Both Samuel F. B. Morse and the unknown reviewer of works shown at the Boston Athenaeum assert that contact with the fine arts will essentially create a larger class of elite thinkers, whose "mental power" will advance the interests of the republic. Their exclusionary views are premised on a graduated valuation of artistic genres that places history painting at the top and the more imitative types of painting at the bottom: landscape, portraits, and still life. Indeed, Morse sets out a complex system of more than two dozen "departments" of art, only some of which he discusses at length. He reserves the lowest level for copies, an activity he describes as bereft of any exercise of genius.

[*Samuel F. B. Morse,*] *"The Exhibition of the National Academy of Design,"* United States Review and Literary Gazette 2 *(July 1827).*

The Second Exhibition of this institution was opened to the public early in May. It consists entirely of works never before exhibited by the Academy, and these are exclusively by living artists. We cannot better introduce a few critical remarks on a display of talent, which does credit to the city of New York and the whole country, than by a few brief observations on the nature of these exhibitions . . .

At the present time all the various exhibitions of art, which have multiplied and are multiplying, especially in England, are crowded by the intelligence and fashion of the metropolis. An exhibition of paintings, sculpture, architectural designs, and engravings, does not attract to it that class of people who are fond of nine days' wonders, *lusus naturæ*, calves with six legs, and kittens with three tails; these are not the frequenters of picture exhibitions; they are the intelligent, the educated, the refined part of a population, who go not merely to please the eye, to

gratify an idle curiosity, but who go to drink in intellectual pleasure as they would from a poem or other fine work of the imagination. Our form of government, while it is founded on the intelligence of the people, while one of its prominent objects is to spread education and information among all classes, is admirably fitted to encourage the arts in the way adopted by the National Academy; for in proportion as that class increases, which only is capable of the refined pleasures of art, in the same proportion will the visiters to their exhibitions, increase. The liberal plan on which this Academy proceeds, deserves the attention, and must, in time, have the patronage of the public. The union of so many artists, associated not for the purpose of individual advantage, at the expense of the rest, but looking for that advantage, by consulting the prosperity of all, cannot fail to win the good will of their fellow citizens; as they said, "although with perfect propriety the receipts of the exhibitions might be divided among the contributors to these exhibitions, yet not a cent is to be distributed to the individuals of the Academy for their private advantage." All, it would seem, is to be expended to build up an institution, which, like its model in London, must, if conducted on the same liberal principles, be a proud monument to themselves and to their country. This union of the artists does away at a blow, a calumny (for such we have always considered it to be) often uttered against them, that they were for ever quarrelling among themselves. We believe that artists, in common with other human beings, have the frailties of human nature, that there are some whose eccentricities unfit them for intercourse among themselves, and that the excitability of that temperament which naturally belongs to men of vivid imagination, may at times be directed against a rival, and furnish ground for cavillers to make complaint; but do not such complainers know that this very temperament is also the fountain of all those generous, noble, and affectionate sentiments, which we instinctively admire in the works of men of genius, and that it is quite as often the parent of the strongest attachment, as of enmity? Where moral principle has held the rein, it has so curbed the extravagances of this irritability, and so checked the too great ardor of feeling, as to subdue to a most delightful harmony the various strong and conflicting qualities which naturally spring from this temperament. From what we have seen in the instance before us, we anticipate with confidence the happiest results; if the same friendly and social feeling, which now exists among the artists, be lasting,—and we would beseech them to guard most cautiously against any occasion to mar it,—we predict for them a glorious triumph over all their discouragements, and the dawn of a brighter day than has yet risen in this country upon the arts.

But to come to the more immediate object of this review. Criticism has two duties to perform, to *censure* and to *praise*. It is the judicious exercise of these two opposite offices, that gives to criticism its power in forming the character of a community. *Too much* censure, or censure *improperly applied*, tends to discourage the young aspirer for public favor, whether it be bestowed in his own case, or in that of others; too much or too indiscriminate praise, also, while it destroys the confidence of the public in the critic, no less disheartens the artist, who feels that his labor has been bestowed in vain, while less receives the full measure of applause which belongs only to the highest efforts. Much depends, also, upon the *manner* or *temper* of criticism; censure may be just, while the manner of administering it may be such as to defeat the end of upright criticism, which is to advance the cause of correct principles; an unfeeling manner will irritate, and lead to despondence, rather than incite to efforts for improvement. Praise also may be just, but too lavishly distributed, or in a way of odious comparison with works of contemporary professors, so as to disgust, and not delight either the favored artist or his friends, and will be sure to create enemies for him among the friends of those above whom he is so invidiously exalted. Without boasting that we shall not ourselves fall into the very error we have proscribed, we will

at least approach the subject with impartiality; our error shall be of the head, and not of the heart. It is no easy task to classify the subjects of criticism in the fine arts, so as to give to each its proper rank and due share of attention. The departments of art are so various, and so disproportioned in their relative value, that it is exceedingly difficult to construct a just scale; and when this is done, the more serious difficulty remains of arranging in each department the various works according to their respective merits . . .

Imperfect as the scale may be, we shall make the attempt at something like a just classification; taking as the leading principle, that that department or that work of art should rank the highest which requires the greatest exercise of mind, or, in other words, that *mental is superior to manual labor*. With this principle in view, we thus arrange the various departments of art, giving examples under each head.

<div align="center">IN PAINTING.</div>

Examples	
1. Epic.	The Sybils and Prophets of M. Angelo.
Dramatic.	The Cartoons of Raphael.
	The Rake's Progress and other pictures of Hogarth.
	The Sacraments of Poussin.
Historic.	The Coronation of Josephine, by David.
	The Death of Chatham, by Copley.
2. Historical or Poetic Portrait.	The Portrait of Mrs. Siddons as the Tragic Muse, by Sir J. Reynolds.
	Buonaparte Crossing the Alps, by David.
3. Historical Landscape.	Saul Prophesying, by B. West.
	Elijah in the Desert, by Allston.
4. Landscape and Marine Pieces, compositions.	Many of the Landscapes of Claude and N. Poussin, and the Sea Pieces of Vanderveld.
5. Architectural Painting.	The interiors of Peter Neefs.
6. Landscape Views and Common Portraits.	
7. Animals, Cattle Pieces.	
8. Still Life.	Paintings of inanimate nature, as furniture, jewellery, &c.
Dead Game.	
Fruit and Flowers.	
9. Sketches.	
10. Copies.	

1. Historical or Fabulous Group, *in the round,* Laocoon and his Sons.

2. Single Statue, *in the round,* Apollo Belvidere.

3. Figures in Alto-relievo. The Metopes on the temple of
 Minerva at Athens.

4. Figures in Basso-relievo. The figures on the Column of Trajan.

5. The Portrait Bust.

6. Ornamental Sculpture. Capitals of Columns, Vases, &c.

1. Original Plans and Elevations of Buildings.

2. Views of Buildings.

1. Line Engraving. 4. Aquatint.

2. Chalk or Dotting. 5. Etching.

3. Mezzotint. 6. Lithographic.

The first department of painting we have divided into three heads, *Epic, Dramatic,* and *Historic.* A few remarks are necessary in aid of the examples, to mark more clearly the distinction. "The Epic plan," says Fuseli, "is the loftiest species of human conception; the aim is to astonish, while it instructs; it is the sublime allegory of a maxim." Its aim is to embody either in a single figure or in a composition some truth or maxim; "If it admits history," continues Fuseli, "for its basis, it hides the limits in its grandeur; if it select characters to conduct its plan, it is only in the genus their features reflect, *their passions are kindled by the maxim, and absorbed in its universal blaze.*"

By the *Dramatic* we do not mean subjects from the drama; it is so called from interesting us by the *actors;* our attention is mostly absorbed in observing their passions and their character, and, whether the painter represents real or fictitious characters, it is the *persons,* and not the *event,* with which we are occupied.

The *Historic,* on the contrary, portrays a *fact,* an *event;* its characters may be ideal, provided truth is observed in time, place, and custom, and that it records an event which has happened; the *event,* not the *persons,* are principal.

The *Historical* or *Poetic Portrait,* and *Historical Landscape,* are placed second and third in rank; but, although generally inferior, the works in these often rise to an equality with some in the higher departments, and require a mind of the same lofty character to produce them; a remark which will apply to all the other various ranks of painting, sculpture, &c. Our comparison is of the best with the best, not of the best in one department with an inferior production in another. We are aware, from the infinite variety of art, and the mixture of various departments often in the same production, how difficult it will be always to classify correctly . . .

We now are to notice the department of *Common Portraits* and *Landscape Views.* These are classed together for obvious reasons; they are both copies of real objects, whether of persons

or things, and generally without much regard to selection. This might be said, indeed, of some of the other lower departments of painting, but the character of the objects delineated influences us in classing the portrait of man, and of the grand or beautiful scenes of landscape, higher than the most faithful delineations of brass pots and kettles and earthen pans, or the more animated subjects of sheep, cows, dogs, and horses . . .

The next department is that of *Still Life, Dead Game, Fruit and Flowers,* &c. In this department there are three productions . . .

The peculiar merit of this class of pictures consists in the *exactness of the imitation.* A single glance proves their success in this excellence; it is one that is always so striking, that most persons think it to be the great end and most difficult attainment of painting; this is a great mistake. It is not the only instance where minor excellencies are exalted above greater. We can only observe, at present, that *exactness of imitation* is not the chief aim of painting, and that, although exceedingly fascinating, it ranks *low* when considered *separate* from other and higher qualities. The department we are considering, although it ranks thus low in the scale of works of art, has always been popular, and for the very obvious reason, that its chief merit is intelligible to all. We hope to see more works of these promising artists at a future day, and in *frames* more becoming to the pictures.

In the department of *Sketches,* we notice the names of *young* artists only, who, of all others, should be the least forward to exhibit pen and ink or pencil sketches; they should be quite as cautious as the young poet in publishing his crude couplets or infant rhymes. The pen and ink or pencil sketch is only interesting from the hand of a master, who, from long practice and perfect knowledge, can give a meaning to a single dash, can embody a thought in a single line, which must necessarily baffle the attempts of a less experienced hand, and which the stripling student should, least of all, essay to produce. Real facility of sketching is acquired only by patient industry and persevering toil, and no careless scratching and flourishing of the pencil will ever pass as valuable with the discriminating connoisseur . . .

One carefully finished object,—if it be but an *apple,*—where attention has been paid to its drawing, its light and shade, and its color, is of more real benefit to the *young* artist, and more certainly indicative of talent, than fifty careless, idle scratches.

We must despatch, in a few words, what we have to say on the department of *Copies,* which we have placed last in the scale of subjects in painting. Copying a picture is purely a mechanical operation; any one can be taught to copy a picture or print with tolerable correctness; some, it is true, better, and with more facility, than others. This facility at copying is often mistaken for *genius* by the fond friends of a youth, and has not unfrequently led him and them to indulge hopes of his future eminence, which are as often disappointed. There is this difference between copying a picture of an object, and imitating the same object from nature; in the latter case the painter uses his own faculties in judging of its perspective, its light and shade and color, and, consequently, represents it as it appears to him; in the former case, the task of all this judgment has been performed for him by the author of the original, and the copyist has merely to imitate the methods by which the first has produced his effect. To which belongs the merit of intellectual labor, we cannot for a moment be in doubt. Copying is, to a certain degree, useful as a means of study; but it may easily be carried to excess, and then it prevents the exertion of original powers. The mere copyist, accustomed to follow in the footsteps of others, finds the labor of striking out a fresh path for himself, through mere habit, too irksome, and he prefers the more easy and slothful method of appearing to the majority of mankind to be doing something, while, in truth, he is doing nothing . . .

Sculpture next demands attention. We intended to remark more fully on this art; but we are admonished, by the length to which we have been already led, that we must be brief.

We have been often taunted by foreigners for the dearth of sculptural talent in the country, and apparently with truth. But much error exists respecting its true nature; some think it consists in the mere working of the stone with the mallet and chisel, and that a bright polish to the marble is one of its chief, if not the very first, of its requisites. Others have thought (oh Taste, where is thy blush!) impressions in plaster, poured upon the face and thumped off with a mallet, quite sufficient to exalt an American plasterman, not only above his European brethren of the same trade, but so far above, as to place him by the side of Phidias and Praxiteles; but let this only be whispered, lest Taste in other parts of the country should doubt our statement, or fresh food for sarcasm be furnished to transatlantic critics. The sculptor has the plasterman in his employ, as the architect has the mixer of mortar; in the case of the plasterman, indeed, there is a little more of dexterity, but no more mind. Does it need an argument to show, that Phidias was not a plasterman?

The sculptor's material is the soft clay, which he first moulds into the form which he has conceived; on this he employs his invention, and finishes it to the utmost of his power; he then calls in the plasterman, to cast in plaster what he has just embodied in the more perishable clay; the plaster model, thus made, passes through the various classes of workmen, to be blocked out, and imitated by mechanical measurement; and when completed, so far as the mechanics in his employment can complete it, the sculptor, with his small chisel and mallet and the rasp, gives to it the last delicate touches and expressive marks. The *first moulding,* and the *last touching,* are the appropriate labor of the real sculptor; all the intermediate process is performed by workmen, and of these the plasterman's duty is least laborious, and least intellectual.

The *Bust* in sculpture holds the same rank as the Portrait in painting: it is elevated in its character by the employment of the same powers of imagination as in portrait painting. If a cast is taken from the face in plaster, it ranks (allowing a little, and but little, in its favor from the difference of material) with *profile-cutting* by a *physiognotrace;* we say nothing of the difference in comfort of the two operations, between being buried *alive* (as the case may be) in a ton of plaster, and the tickling of one's nose and chin with the edge of a wire. Such a cast, or mask, as it is called, is often taken to assist the sculptor in forming his busts, and in Paris they are obtained of the plasterman for about five francs apiece.

"Exhibition of Pictures at the Athenaeum Gallery," **North American Review 33 (October 1831).**

This emanation of mind is the true and only lasting criterion of greatness in the arts. It is all that elevates them above mere mechanical employments. No beauty of design, no splendor or delicacy of color can compensate for the want of this communion of intellect between the artist and those who look on his works; and where these adscititious excellencies seem to be the characteristics of greatness, they are so only because they are united with a higher power. We admire Titian as the greatest of colorists; but who ever gave to portrait, and even to landscape, such fascination of expression? We read and write about the *chiar'oscuro* of Correggio as the wonder of his works; but he was, more than all other painters, a poet in his art; and the magic of his light and shade is but the appropriate, we had almost said the necessary vehicle of the conceptions of a mind of the highest order. Neither color, design, grace, *chiar'oscuro,* nor even expression gave to Raphael the rank of the first of painters; in each he was surpassed by some one of those who yet were all his inferiors in that dramatic power, by which he communicates immediately with the mind of the spectator.

And this exercise of mental power is by no means confined to historical composition. It may and must be put forth in a great degree in landscape and even in portrait-painting, if we would raise them to the dignity of liberal arts. The mere taking of likenesses, whether of persons or places, is a good and useful trade, and, diligently pursued, deserves success like any other honest industry. But let not those who follow it flatter themselves that they are pursuing the Fine Arts, or complain of the want of taste in the public if they are not patronized. A certain quantity of that labor will always be wanted and paid for; but to purchase such works is no proof of taste, and greatly to admire them shows a sad want of it. An artist of genuine power may and often must do much drudgery of that kind for bread; and to do it is no disgrace. But let him remember that the money he gets for it, and the wonder of the ignorant, are all the rewards he is to expect. If he claim a higher recompense, he must bring higher powers into exercise. Let us not be thought to undervalue portrait or landscape painting as branches of the art, nor, least of all, to speak disrespectfully of those who practise them. We merely wish, that a distinction may be made between the different modes of practice; and particularly to call the attention of artists in all departments of educating and exercising the mind as well as the hand, if they would attain any desirable rank in their profession.

We ardently desire to see the Arts flourish in our country. We think much of their influence on the character of those who are merely taught to enjoy their productions, and by that knowledge are led to a closer observation and new perception of the beauties of nature. But the fact that they furnish another object of intellectual labor to those who practise them is, in our minds, a consideration of at least equal importance. We suffer in this country for the want of such employment, and the want is daily becoming more urgent, as the number of educated men increases. The several professions are crowded to suffocation. One who desires that his children may gain a livelihood by the labor of the mind, finds it more and more difficult to select for them a vocation which promises both bread, and the consideration in society which such occupations secure. The difficulty of getting an education sufficient for any of the present pursuits of life, is much less than that of finding what to do with it when obtained. We want objects on which to expend the mental energy we can create; we want places to be filled by those who would devote themselves to the cultivation of the mind; something of a liberal cast besides law, physic, theology and politics. If employments for the well-educated are not multiplied, education will be neglected; because, cheap as it is, it will cost too much if no money can be made of it. Literature and the Arts will in time supply this want here as they have elsewhere. The sooner this can be done the better, and the greater the number that can be supported by them, the greater will be the average of education and intelligence in the community. In this view, as means of increasing the number of educated men, we look on all the liberal Arts as matters of vast importance. To open a new or extend an old field of profitable intellectual industry, is one of the greatest benefits that can be conferred on mankind.

But, much as we rejoice in the progress of the Fine Arts, we confess we care comparatively little about the merely mechanical labor that is sometimes called by that name. We do not think the country would be much benefited or its character much elevated, if our artists could paint brass-kettles as well as Ostade, or dead game as well as Snyders. The painter who copies such things, is indeed likely to be somewhat more refined than the tinker or cook who handles the originals; but he is still further removed in an opposite direction from the artist, who endows with form and color the beautiful objects of his own invention, or embodies in portrait the intellect and character as well as the features of the face. We would not absolutely denounce what is called still-life painting, but we value it very lightly; and we protest against admitting among

productions of the Fine Arts, those works, of which the whole supposed merit consists in an imitation of what is in itself entirely insignificant, and the highest aim of which is to produce a momentary deception.

The other branches of painting, landscape and portrait as well as composition of figures, are properly ranked among liberal arts, because in all of them the success of the artist depends mainly on mental cultivation. We do not mean that it will give him the necessary delicacy of organization, if nature has denied it; for in nothing has she more plainly distinguished between men from their birth, than in their different capacities to acquire the imitative arts. But we mean that all her liberality is thrown away when it falls on the ignorant and uncultivated. As to historical composition, the truth is so obvious, that nothing more need be said; it depends on education for all its materials, as well as for the manner of using them. In landscape it may not appear quite so clear at first, for it may seem that the most uneducated are capable of truly observing and imitating inanimate nature. But even if that were all the art of the landscape painter, the mere manner of execution, and still more the selection of objects, would distinguish at once the rude from the cultivated mind. But when we consider the various sources to which composition in landscape is indebted for its charms, how it must combine, vary and contrast the forms and colors of nature, what wonderful effects may be produced by the mere distribution of light and shade, and, more than all, how it is elevated by historical and poetical associations, we see the immense distance that must separate the educated artist in this department, from the mere observer and copyist of natural scenery. Perhaps this aid of association has become more necessary to give value to this kind of painting, than it was formerly. There is undoubtedly some truth in the remark, though as a complaint it is unreasonable, that we value old pictures partly because they are old. Probably the same things, produced in our own times, would not excite the same enthusiasm, though we think the experiment has not yet been tried. If this be so, the remedy for the artist is, not to complain, but to take advantage of it. Let him, if he thinks the public unduly admire old paintings, contrive to recall them in his own works, not by servile imitation, but by resorting to similar sources in nature. Let him learn to revive in new combinations, forms which have become consecrated objects of taste. All invention consists in new arrangement; and when certain classes of objects have become by association peculiarly agreeable to cultivated minds, as much originality may be displayed and more pleasure imparted by using them as the elements of composition, than by adopting others in which the same interest is yet to be created. It is for this reason, that the most beautiful composition of American scenery is inferior in interest to an Italian landscape; one is a thing of mere natural beauty, while the other combines a high degree of that with objects of other and more intellectual pleasure. We know that some of our artists and of those who love the Arts, entertain a different opinion on this point, and cherish a patriotic predilection for their native scenery; and we have seen them sometimes a little fretful at the preference given to that of other countries. But the best landscape painters of England and France have gone to Italy for the subjects of their best pictures; and we cannot believe that our own artists are to gain any thing but a very temporary popularity, by discarding the aid of associations which add their greatest charm to the works of established reputation.

In portrait painting, there is the same distinction between the artist and the mere mechanic, though there is not the same choice of subject. When a face is to be portrayed that displays intellect and character, the Art rises to a level with the highest. He can have little notion of the power of painting, who does not perceive at once, the necessity of a high degree of mind in one who undertakes to do justice to the originals of some of the portraits in this Exhibition.

Many antebellum treatises devoted to the arts are decorous celebrations of American achievement and potential, usually with an underlying strain of exceptionalism— the view that the American "experiment" is unique in the world. The following essay certainly considers conditions that are specific to the United States, but it does so in an unusually caustic and condemnatory mode. The author sees nothing but practicality, utility, mercantilism, and greed. Poetry is nowhere to be found. Americans are judged to be obsessed with moneymaking and, thus, uninterested in patronizing the arts. Art is seen as the antidote to this preoccupation with business. The former transcends time, while the later is focused only on the moment.

E.C., *"The Fine Arts, versus the Spirit of the Age,"* American Monthly Magazine 4 *(January 1835).*

There may have been more stirring and bustling periods—eras which have called forth more of the fearful energy, and high power of the human character, than that in which we live, but we question whether the world ever wore a more business-like air, than it does in the present age. The course of time has at length brought it down to an epoch when all its schemes, enterprises, and resources are bent into one vast, absorbing, and practical channel. The fabrics of speculative philosophy, and the dreams of poetry have all disappeared—sentiment and romance have become exploded. There is but one spirit—one master passion—one ruling desire, and that is utility.

Of our country this is emphatically true. A tendency to extremes is a peculiar characteristic of her citizens. With them the reigning pursuit is the all-engrossing one, and is followed to the exclusion of much that is valuable. Nowhere else is the spirit of the age carried to such a pitch of enthusiasm. Nowhere have more extended schemes of physical improvement, or mechanical invention, originated, or been carried into execution on a grander scale, and never of consequence has a nation arisen in rank and riches with such unrivalled rapidity.

This is all well. It speaks proudly of the genius, enterprise, and industry of our countrymen. But were it not also desirable that a proper balance of character should be preserved—that the ornamental should be blended with the useful, and taste and refinement keep pace with national greatness and prosperity? That the intellectual and physical should go hand in hand— that science, literature, and the fine arts, and those researches and studies which embellish and improve, exalt and immortalize, should not be neglected? That we should turn occasionally from our projects of great pith and moment—from the toil and sweat of the marketplace, and the forum—from rolling forward the vast and complicated machinery of moral and mechanical improvement, to recreate ourselves in the haunts of the muses and the retreats of the arts?

An exclusive attention to any pursuit, either in nations or individuals, is liable to induce an unfavorable narrowness of mind and peculiarity of character. Especially is this true of those which may be denominated the *money-making* employments. If not relieved by the cultivation of the nobler faculties, they most commonly engender that sordid grovelling, and grasping spirit, which deforms and degrades the mind, and prevents that proper development of its powers, which constitutes the perfection of the human character. But by blending a taste for the productions of genius, and an appreciation of the elegance and beauty of art, with the details and drudgery of business, all professions may become ennobled and ennobling, and exert a highly beneficial influence upon the intellect and spirit of their country . . .

There are those who affect to wonder, that American genius has not in this age produced

any *great* work, either in poetry, sculpture, or painting. For our part, we should deem it far more surprising if it had. The pursuits, sentiments, and feelings of the mass of our citizens, are entirely at variance with the spirit of these professions. There is little taste for their beauties, or desire for their success; and they have sprung up and flourished like exotic plants, in a rugged and uncongenial soil, beneath the neglect of those whose care it should be to nurture them. So long as our painters and sculptors are compelled to seek in foreign lands the patronage which is denied them at home, and our poets to forsake the worship of the muses, for the active avocations of life, it is idle to expect from them exalted excellence . . .

Of painters and sculptors we have but few, and even those few, we believe, find but inadequate support. The difficulties which they encounter are even greater than those of the votaries of their sister profession. Theirs are arts which, unlike poetry, if followed at all, must be followed as professions. They require a long and laborious apprenticeship. The genius for them may be the gift of nature, but to gain the skill by which that genius is properly imbodied and displayed, the artist must make a league with labor, and stand for years upon the threshold of the temple, ere he can penetrate to its shrine. In the study of their profession too, they labor under peculiar disadvantages. Their models cannot be found at hand. They cannot, like those of the poet, be brought to the fireside of home, carried in the pocket, or laid under the pillow. They must be sought and studied in distant lands, and that too with much trouble and expense. It is needless to say that such arts if they flourish must be liberally patronized. And does not that nation mistake its true glory, which permits their votaries to struggle with poverty and neglect; which can measure the blessing of genius—the honor of giving birth to a Phidias or an Angelo, a Raphael or a Reynolds, by the sordid scale of ordinary valuation?

Yet there are those who hesitate not, in the spirit of their age and country, to condemn the fine arts, as frivolous, and unworthy the attention of a thinking and reasonable being. They are addressed to acquired and unnecessary tastes. Their benefits cannot be reduced to the standard of pounds, shillings, and pence,—nor calculated by the rules of arithmetic. There is nought in them to gratify their grasping love of lucre, or feed their passion for present, tangible, substantial utility. With such it were useless to contend, for they cannot appreciate the arguments which might be advanced. Their hearts have never vibrated to the inspired touches of genius; the lyre of the poet can find in them no echo—the beauties of art, no home in their bosoms. To them in vain were upheld those matchless productions of sculpture and painting, on which

"We gaze, and turn away, we know not where,
Dazzled and drunk with beauty, till our heart
Reels with its fullness—there—forever there,
Chained to the chariot of triumphal art,
We stand as captives, and would not depart."

With them a nation's only glory consists in the amount of its capital, and productions—the number and value of its exports; fame is nothing—refinement nothing—immortality nothing, and they look upon the votary of the fine arts but as a gifted trifler, who wastes upon unworthy pursuits, the faculties which heaven has given him for nobler purposes.

Yet do such men believe that the design of our great author is to interdict all pursuits not growing directly out of the wants or necessities of man? That every thing is trivial which does not concern his bodily or sensual gratification, or has not an immediate bearing upon the duties of society and of life? That he who has fixed in unfading colors upon the canvass, or im-

bodied in marble, a conception which millions, yet unborn shall come up to gaze upon, with swelling hearts and exalted emotions—has done nothing for the benefit of the world? Let such look through the universe—let them examine the works of its Almighty Architect—let them gaze upon the earth which he has given them for a dwelling place, and say whether they can find aught there to support their sordid and debasing theory. Is their system of narrow-minded and money-making utility, all that can be discovered in its design and formation?

Is it a wide field to be digged and ploughed—a mart for selling and buying—a scene for political intriguings—and this only? Is it adapted only to one appetite, or set of appetites, and those of the lowest and most grovelling kind? Are men placed here merely to eat and labor, amass and die? For what, then, is all this wondrous display of splendor and magnificence? For what the thousand objects of loveliness—the countless scenes of sublimity, that meet us at every turn?

Why does the mountain rear its snow-crowned top,
To mingle in such grandeur with the clouds?
Why heaves the swelling hill, or sinks the vale,
With that voluptuous grace the painter loves?
Why bloom the fields with flowers, and why through beds
That rival Tempe's classic vale, roll on
A thousand winding streams, with such strange beauty
To the sea?

All this exquisite loveliness—all this divine munificence is not necessary to that mere animal life, of which they are the advocates. No—they were addressed to other and nobler passions— to the taste and feelings—to the intellect and heart.

To these too are the works of the artist addressed. These are the scenes and objects which he imitates. It is from these that he draws his inimitable sketches, and, like these, the study and contemplation of his immortal productions refine, while they gratify the heart. Thus he evinces the divinity of human conception, and hands down to all succeeding time an earnest of his own immortality—an enduring monument to the memory of his country and his age. Such efforts are above all price—above all common standards of value—the property of time—the imperishable heirlooms of the whole human race . . .

Then let the sordid utilitarian, and the enthusiast in the improvements of the day, stand with us and gaze upon the far advancing future. Let him look forward to that period, when time in its onward course shall have added new acquisitions to the circle of the arts—when philosophy, eliciting new principles and arranging new combinations, shall have altered, amended, and raised still higher, the fabric which we have so successfully commenced; and when all our discoveries shall be lost in the flood of more recent inventions—when every monument of our physical art shall have been swept away among the forgotten things of the past. What voices will then break the silence—what light will illumine the darkness, which will brood over this now busy and bustling generation? What will snatch its high and honored names, its lofty deeds, from oblivion? We answer, chiefest and first, the productions of the fine arts. It is these which will give a sacredness to our memory—an eloquent voice to the sepulchres of our dead. The lyre of their poets will ever echo amid the ruins of Rome and Greece, but all the wealth and greatness of Babylon could give her no monument to perpetuate her name.

And should—which may the guardian genius of our institutions eternally avert—should

civil dissension ever lay its unhallowed hands upon the pillars of our national greatness, should the sword of war be drawn to slaughter, and destroy—should the smiling face of this happy land become one waste of ruin beneath the scathing influence of human passions, should our name be blotted from the map of nations, still would men point to the productions of our poets, our painters, and our sculptors—bearing down the stream of time, secure from changes, convulsions, and revolutions, the names of their immortal authors, and the memories of our age.

CHARLES FRASER CONSIDERS ART, SOCIETY, AND THE FUTURE

A specialist in miniature painting based in Charleston, South Carolina, Charles Fraser also executed larger landscape views in oil on canvas. Early in his career he had trained for the law profession, and this predilection for the life of the mind is apparent in the following consideration of the future of the fine arts in the United States. Fraser begins by asking whether the arts should be encouraged through the establishment of academic institutions or simply by allowing them to develop on their own, naturally. He opts for the latter because he does not value academies highly, conceding only that they impart basic technical training. Instead he argues for general education, for a universal American level of knowledge and taste that will, perforce, elevate the arts. If academies are to exist, he prefers that they be run by laymen (an unusual view for an artist, and one that puts him at odds with his colleagues in the National Academy of Design and the Society of Artists of the United States). This will ensure, in his view, that the arts are more fully integrated into society. Fraser seems to oppose any measure that would reinforce art making as a separate, closed profession.

Charles Fraser, "An Essay on the Condition and Prospects of the Art of Painting in the United States of America," American Monthly Magazine 6 *(November 1835).*

Independent of the intrinsic recommendations that accompany the fine arts, and which always ensure them a welcome with the refined and the intelligent, there are moral associations interwoven in their existence and success, that endear them to the patriot and the philanthropist. Whilst the former regards them as the source of pure and elevated enjoyment, directing the mind, like literature and science, to pursuits of endless variety; to the latter they are peculiarly interesting as the evidences of social improvement and national prosperity.

While, therefore, the United States are daily multiplying their resources; and the enterprize of their citizens is directed to the improvement of useful pursuits and profitable objects, every lover of his country must be gratified to observe that a taste for the liberal arts is also cultivated, and that they are, every day, becoming more and more an object of enlightened attention. Institutions have been established in several of our cities, for the express purpose of promoting them: and if some of these have failed, and none of them have led to the results that might have been wished, it is because the zeal in which they originated was in advance of that state of public taste, and those means of encouragement, which could alone prosper the experiment, and crown it with success.

Indeed, it has been questioned whether such institutions are calculated to have a permanently useful effect, either in encouraging a taste for the fine arts, or in advancing their improvement; and whether it would not be better to leave genius to its own energies, to struggle with and overcome the difficulties in its way; with nature before it as the standard of beauty in proportion, of harmony in coloring, and of grace in action, than to offer it instruction under

the name, and with the forms of an academy, without placing in its reach the best models of art and the most approved means of instruction.

If these views are correct, would it not be better, in our comparatively young country, and with our yet limited resources, to consider the cause of the liberal arts as best, though incidentally promoted, with the general advancement of all mental cultivation. For, after all, this is the only solid basis upon which they can hope to rest. Circumstances, foreign or accidental, may sometimes favor the growth, and encourage the progress of the fine arts; but the atmosphere in which alone they can be expected to attain their full maturity and development, is that produced by the genial influence of sentiment, taste, and intelligence . . .

Far be it from me to say one word that would discourage the establishment of schools of instruction in any branch of art or science; for these are the boast and the evidence of modern improvement: and their successful operation distinguishes the age and the country in which we live. But if we read of no Academy of sculpture in that native land of all excellence in the art, how can we account for the perfection of Grecian statuary? How can we account for the profound knowledge it exhibits of every science embraced in the principles and theory of its execution? It would be a mystery beyond the reach of conjecture but for that noble ambition in the pursuit of excellence, which directed all intellectual exertion to the highest standards, and which, whether animating the senator, the philosopher, the poet, or the artist, placed immortality before him as its certain reward . . .

Adopting, then, the inference that these observations might well authorize, we cannot fail to associate excellence in the art of painting with the highest objects of intellectual ambition. We are led also to believe that every effort to diffuse a taste for letters, and to refine the public mind, tends also to the encouragement of the liberal arts. Every college and seminary of learning in our country is preparing the way for them.

The influence thus exercised, it is true, is indirect. But it is like the warmth of Spring, that acts unperceived upon the beauties of vegetation. Without that enlightened spirit which education diffuses insensibly over a community, even wealth with all its fostering means, can never raise the art beyond the level of vulgar ornament. Its patronage may produce artisans, but will never create artists. For wealth without refinement ministers only to the grosser parts of our nature, and not to the culture of the etherial mind. It neither improves the taste—nor enriches the understanding—nor ennobles the heart.

If, then, there is a pledge that painting and its sister arts will ever be encouraged in the United States with that liberality which their resources will assuredly enable them to afford, that pledge is abundantly displayed in the zeal that pervades all parts of our common country in the cause of improvement. Already we begin to be sensible of the tone and character that education has given to society. Talent, to a certain extent, is not without its reward. The public mind is becoming familiarized to standards of intellectual attainment that must inevitably exalt and purify its taste. Let it not, therefore, startle the lover of the fine arts, to hear one, who is himself their ardent admirer, express the belief that more is done towards promoting their interests, in the present state of our country, by literary institutions, than by those professedly established for their encouragement.

As the husbandman in vain bestows his labor upon a barren and unprofitable soil, so does the painter, however liberally endowed by nature, or improved by education, unprofitably devote his time to the cultivation of his art, in a community possessing the amplest means of patronage, but wanting taste and congeniality. Would the names of West and Copley have been added to the lists of fame, if they had not sought encouragement in countries that could ap-

preciate and reward their claims? Has not the failure of Mr. Leslie's recent experiment shown how essential a certain atmosphere of refinement is to the happy and successful exercise of his art? And have we not one artist in this country, who might add fresh attractions to the Sistine, had he been born in other climes, and under other auspices, who is now wasting upon the altar of patriotism the purest flame of genius?

There can be no greater mistake than in the idea that those causes upon which the elegant arts depend for their existence and success, lie upon the surface of society, or arise from light and casual influences. They are too closely allied to science and literature, not to have with *them* a common foundation deeply laid in the moral, intellectual, and even political condition and welfare of a nation. An elevated standard of morality gives to the mind a consciousness of its dignity. Intellectual improvement multiplies and refines its enjoyments. Whilst freedom leaves it to the tranquil and successful exercise of its favorite pursuits, at the same time that it gives it a high moral impulse, and animates it to manly and vigorous exertion.

Let the experience of history, while it tests the truth of these remarks, encourage the hope that the day is not far distant when the United States—exhibiting in their institutions, all of freedom but its licentiousness,—resting their social intercourse upon the basis of sound morals, and displaying in their prosperity the exhaustless resources of industry; shall also be distinguished for the cultivation and rewards of those pursuits that belong to the scholar, the philosopher, and the man of taste.

In thus endeavoring to trace the primary causes that favor the growth, and promote the success of the fine arts, we ought not to disregard those which are more obviously connected with them. It is due, therefore, to the enlightened motives and disinterested exertions by which our academies of art have been established and maintained, to acknowledge that they have had a favorable influence on painting in the United States. Their annual exhibitions have awakened public attention, and improved public taste. They have excited a spirit of emulation among artists, the result of which is a decided and progressive improvement in their works. The very fact of these institutions being composed, for the most part of individuals not connected with the profession, proves the existence of a higher cause, acting through their voluntary efforts upon its interests. And although they may not have been successful as schools of instruction, they have always had just claims to public patronage, as an advance in the great system of improvement. The increased number of artists may be fairly regarded as one of the happy results of the encouragement to which their influence has led. At the time of their establishment amongst us, portrait painting was the only branch of the art practised in the United States, and that but by comparatively few. While at the present day, embracing from their introduction, an interval of less than a half century, there are practitioners in every department of the profession from the highest to the humblest; some of whom are distinguished, and many very respectable for their merits and attainments . . .

This is indeed a bright vision of the future destinies of American art. But its reality may be remote. Prosperous as are the signs, who can venture to predict the period of their accomplishment? Are there no peculiarities in our national character—no circumstances arising out of our institutions, political and social; in fact, no distinguishing feature of the age in which we live, calculated to exert an adverse influence upon the interests of art, and to retard that period when the world shall behold in the United States of America another great era of painting?

In the progress of society, works of magnitude, that seldom occur, are less easily accounted for than those which, frequently happening, are naturally traced to the causes that have produced them. It falls to the lot of no nation to be distinguished by more than one brilliant period

of the arts; and this being connected with the most advanced stages of its improvement, must be the result of causes variously combined, and long maturing. Indeed, the arts are said to be the offspring of the old age of a country. It would be but darkly prophesying, therefore, to assign any period of the future for their abode in the United States. The causes now in operation, however direct their tendencies, may be variously counteracted, and, after all, may depend upon accidental circumstances for their development. There is too little analogy between the present condition of society, and that of any in which the arts have ever flourished, for us to derive much light from a comparison when we consider the variety of objects that now exist to stimulate the enterprize, to engage the interests, and to distract the attention of the public mind, and,—above all, the practical and matter-of-fact character of the age in which we live,—we could not wonder if another great era of art should never again occur.

WILLIAM DUNLAP CHAMPIONS THE ARTS

Near the end of his life, artist and historian William Dunlap gave the following address before the American Lyceum in New York City. It is a rousing speech, filled with spirited language in defense of artists and their creations; he even goes so far as to suggest that the fine arts are an antidote to original sin. Yet, alongside his claims on behalf of "art" in the abstract, he also acknowledges that the particular conditions of "liberty" are important in fostering and sustaining creative expression in the United States. Unusually, he stresses the kinship of painting and sculpture with more practical arts such as typography and furniture design. Dunlap is optimistic about the possibilities of the arts flourishing in a democratic nation, but he finds the American populace to be woefully ignorant—the blind who must be taught to see. He ends with a recurring theme in his writings: the need for artists to control their own organizations. This view is coupled with a stern lecture to the wealthy elite: provide the money that artists need, but don't assume that it entitles you to meddle in their work.

William Dunlap, "Essay on the Influence of the Arts of Design," American Monthly Magazine 7 (February 1836).

Mankind are too much disposed to view the fine arts, their professors and their results, as affairs remote from the ordinary pursuits and enjoyments of life: but such a view of them is taken through a mist of ignorance and consequent prejudice. Seeing, they do not see. To the multitude, seeing with the mind's eye is onerous; and reflection troublesome. It is this disposition to see without observing—this wish to avoid the trouble of examination—that is one great cause of the slow progress of truth. It gives facility to every species of imposture. The Impostor asserts boldly, and relies upon the known disposition to receive without examination all that accords with self-love: his dupes are irritated if their weakness is exposed; and he finally has the hardihood to declare that human reason in the mass of mankind is incompetent to the discovery of truth. The Impostor and the Dupe join to destroy any one who would tear the mask from the first, and open the eyes of the second to his own folly.

From the ordinary path of life which the savage pursues, the fine arts are really remote; but the products of the arts of design surround the civilized man, and are the basis of his ordinary comforts as well as the ornament of his habitual luxuries; while music refines and elevates his thoughts, and poetry enters into the most precious part of his moral education. If he does not duly appreciate them, and pay the tribute of his gratitude to those who cultivate these glorious

arts, it is because they are, like the luminaries of heaven, constantly before him, unnoticed, because familiar; although enlightening his otherwise dark, cheerless, and rugged road through life. From the same great and bountiful source of good proceed the millions of suns and their revolving planets, and those brilliant minds which have enlightened the world by poesy, the strains of the harp and the lyre, the sublime images of the benefactors of the human race, whether male or female, whether produced by sculpture or painting, and the equally sublime edifices erected to protect these works of art and their admirers from injury—yet how prone are we to forget the source of all our blessings, and having ever before us the wonders of the universe, and the emanations from the minds of the most favored of men, we neither see, nor hear, nor understand them. May stronger voices than mine remind you of your obligations to the Giver of all Good; be it my humbler task to call your attention to the blessings conferred on society by the arts of design, and to remind you of the gratitude due to their professors.

Before the benign influence shed upon him by the fine arts, man *existed;* he can scarcely be said to have *lived, as man.* He existed as the native of New Holland exists—as the beasts of the forest exist. He approached to the life of man by the invention of the necessary arts; those which subdued to his rule the objects of the chace, the forest, or the jungle which sheltered them, and even the mighty deep with its inhabitants. With these arts necessary to his existence man may enjoy life as one expelled from paradise, but, as the venerable Richardson has truly said, in other words, the fine arts raise him again to that state of purity, if duly cultivated with thankful heart, which may be likened to his existence when he walked with God, and joined in hymns of love with the host of heaven.

Let the man of easy circumstances and cultivated mind look around upon the objects which present themselves in the streets, in the public edifices, and in his own drawing-room, dining-room, saloon, or study. Every public building owes its usefulness and its beauty, its form and its decorations, to the arts of design. Every private dwelling is equally indebted to the same source. The stately column, the chiselled statue, the memorials of great events recorded by sculpture or painting, the domestic utensils of our hearths and our houses—the urn which smokes on the social board, or the lamp which irradiates the hall, the saloon, the chamber, or the study—the figures of the carpet and the hearth-rug—the mantel-piece and its ornaments—nay, the inkstand, which furnishes the means of inditing our thoughts, and the table that supports it—evince their origin from those who cultivated the arts which deservedly are called *fine* —the arts which have only flourished where mind has been the object of cultivation, and riches considered only as subservient to refinement . . .

We owe to antiquity the blessings of the fine arts, and the foundations of science; but the modern may boast that the art which will perpetuate knowledge and prevent a second deluge of barbarism—the art which is now overthrowing superstition and tyranny is *his,* and due to *his time* alone: the press will secure to the future all the blessings derived from the past—all the glorious improvements with which the *present* teems—and by the progress of civil and religious liberty, the arts of agriculture, commerce, and manufactures, (the latter so much indebted to the arts of design) as well as all the arts which adorn and forward the perfection of civilized life will be secured to the latest posterity.

Books, which secure to man the accumulated stores of knowledge derived from past ages, are indebted to the arts of design for rendering them more acceptable to the reader, and in many instances for illustrations, which not only give delight but elucidate the subject treated—explain the author's meaning—and impress facts and objects indelibly upon the memory. A just idea of many mechanical inventions could not be adequately conveyed to the reader without de-

lineated and engraved representations of the machines and their various parts. Scientific books, and especially those on natural history, would be almost a dead letter if not accompanied by the productions of the pencil and the burin. The arts of design thus give additional life to science, and aid her in the support of that civil liberty to which they owe their perfection—for it is to liberty that the arts are indebted for their past and present perfection.

It is not too much to attribute such a vital influence upon the fine arts to liberty. Periods of despotic rule have been brought forward in argument to support a contrary doctrine: periods of splendid despotism have been adorned by the arts; but they have been periods whose brilliant productions had been prepared by the previous progress and triumphs of republicanism. The age of Alexander had been preceded by Grecian democracy; that of Augustus by the glories of republican Rome. And on the revival of literature and the arts, after the darkness of the middle ages, those works which were the pride of Italy during the despotism of the Medici, were produced by the previous freedom of the Italian States.

Our own happy country shows the influence of liberty upon the arts. Those portions of Europe which are debased by the miscalled legitimate rulers of the earth, who are striving to support an unholy dominion, by what they call a holy alliance, are already showing symptoms of decay in the fine arts; and can only be saved from barbarism, by the influence and efforts of those states whose governments are opposed to despotism, and whose people enjoy freedom of opinion and the freedom of the press . . .

The great experiment of a national democratic government, where the will of the people, expressed by their representatives, is the foundation of all law, is now gazed at by the world, and the people of all nations are standing on tiptoe, eager for the race in which we are leaders. It is to be seen if we shall not be the leaders in arts, as well as in political institutions. Both have to struggle against a current of ignorance—against a disposition to mimic the hereditary nobles of Europe, and against the untaught portion of the populace of our cities, adulterated by the outcast pauperism of the old world. But there is a power in our happy country which ensures the triumph of liberal institutions and of the arts; it resides in an aristocracy of cultivated mind, and is diffused through the community by our public schools, and the ever increasing attention to education.

While we see that the minds of men are alive to the great business of diffusing knowledge—an employment of such vital importance to republicanism—while the despots of Europe are considering by what means they shall satisfy the demands of the people for instruction, and yet so modify it as to continue their bondage—happily a vain hope!—let us turn our attention to the best method of encouraging the progress of the arts in our country, and of stimulating our artists to equal, or excel, the republicans of former days.

As for other branches of knowledge, so for the arts of design, schools are necessary; and *as* in the choice of teachers in other branches of knowledge, those who have studied and profess those branches are alone supposed competent; so professors of the arts of design, it would seem, are the only competent teachers of those arts. This appears so self-evident that it would require an apology for its insertion in this essay, if we did not see intelligent men, at this day, assuming to themselves the office of directors in academies devoted ostensibly to the instruction of students in painting, sculpture, and other fine arts; although conscious that they are not possessed of any requisite for the promotion of those arts, except taste for their products, and the possession of wealth.

Such requisites should be directed to the foundation of schools for the teaching [of] those arts, and the endowment of competent professorships.—To the just appreciation of the works

of artists, and the liberal reward of those who excel.—To the purchase of the fruits of their successful labors, and offers of liberal prices for their productions, without trammelling the artist by indicating the subject.—To the introduction of chef d'œuvres of ancient or modern art, as models and excitements to the artists of our country. Let the wealth and taste of our intelligent men be so employed, and let the schools and academies be governed by those who are acquainted, not only with the history, but with the theory and *practice* of the arts there taught.

Great encouragement to the arts has been, and is now given, by the establishments of buildings in which to deposit the works of genius for public exhibition, and by collecting meritorious specimens of the arts, thereby rewarding the talents of the artist, diffusing a knowledge of art generally, and forwarding the studies of such persons as devote themselves professionally to any of the branches of the arts of design. This is a mode of teaching the nation—forming the minds of a people to taste and civilization—which falls within the province of men of intelligence and wealth, of every profession; but it is only for artists to govern, direct and teach, in academies dedicated to the fine arts . . .

It has been proved that when men of other professions are mingled in the councils of artists, discontent and division has ensued. Such men are generally wealthy, and although well-informed on other subjects, many of them are deplorably ignorant, without knowing it, in respect to the arts, for the benefit of which the association is formed; and strong in the consciousness of their general information, and successful acquisition of property, feel themselves superior to the mere artist, even though that artist possesses science and literature in a measure far above his supposed protector. This feeling of superiority takes place because the poverty of the artist is apparent, too generally, and his influence in society is very limited, from that circumstance, and from his secluded habits, the consequence of his necessary industry, and the nature of his studies.

However liberal the intentions, and great the taste of gentlemen who have not studied the arts of design with a view to being professors, their aid in an academy as *directors* or *mediators* is not wanted: and can only be supposed needful, from the prevalence of notions derogatory to the character of the arts and artists of any country.

Such men should gratify their tastes by employing artists, and by enriching their country with the products of the arts. Such men we have; and it is only by such means that they become patrons of the arts.

RALPH WALDO EMERSON'S LIVING ART

An influential thinker and philosopher, Ralph Waldo Emerson left the Unitarian ministry to pursue a career in writing and public speaking. Passionately invested in the creation of an authentic national identity and culture, Emerson forged an eclectic synthesis of European, Asian, and classical thought into the philosophy of transcendentalism. Romantic and idealist, transcendentalism refuted the rule of reason and upheld innate, individual human capacity for intuition and inspiration. Lecturing and publishing widely on topics as diverse as science, fate, heroism, and politics, Emerson actively sought to promulgate a working philosophy of life that would reflect and sustain the ideals of the American republic.

The essay below sets forth the conditions necessary for art to be meaningful in the modern world. Art must be of its time and yet tap into the universal and the timeless. Its true purpose is the expression of individual sensibility and fundamental humanity. Concomitantly, the individual and not the connoisseur is the best critic, just as the best

art, which abides by no fixed rules, must always be "simple and true." Calling for the dissolution of the pernicious barriers separating art from life, Emerson discovers beauty not in the past but in mundane reality. Seemingly oblivious to the forces of market capitalism, he envisions an America in which genius can grace even the insurance office and the "galvanic battery" with divinity.

Ralph Waldo Emerson, "Art," in Essays, *1st series (Boston: J. Munroe and Co., 1841).*

Because the soul is progressive, it never quite repeats itself, but in every act attempts the production of a new and fairer whole. This appears in works both of the useful and the fine arts, if we employ the popular distinction of works according to their aim, either at use or beauty. Thus in our fine arts, not imitation, but creation is the aim. In landscapes, the painter should give the suggestion of a fairer creation than we know. The details, the prose of nature he should omit, and give us only the spirit and splendor. He should know that the landscape has beauty for his eye, because it expresses a thought which is to him good: and this, because the same power which sees through his eyes, is seen in that spectacle; and he will come to value the expression of nature, and not nature itself, and so exalt in his copy, the features that please him. He will give the gloom of gloom, and the sunshine of sunshine. In a portrait, he must inscribe the character, and not the features, and must esteem the man who sits to him as himself only an imperfect picture or likeness of the aspiring original within . . .

But the artist must employ the symbols in use in his day and nation, to convey his enlarged sense to his fellow-men. Thus the new in art is always formed out of the old. The Genius of the Hour sets his ineffaceable seal on the work, and gives it an inexpressible charm for the imagination. As far as the spiritual character of the period overpowers the artist, and finds expression in his work, so far it will retain a certain grandeur, and will represent to future beholders the Unknown, the Inevitable, the Divine. No man can quite exclude this element of Necessity from his labor. No man can quite emancipate himself from his age and country, or produce a model in which the education, the religion, the politics, usages, and arts, of his times shall have no share. Though he were never so original, never so wilful and fantastic, he cannot wipe out of his work every trace of the thoughts amidst which it grew. The very avoidance betrays the usage he avoids. Above his will, and out of his sight, he is necessitated, by the air he breathes, and the idea on which he and his contemporaries live and toil, to share the manner of his times, without knowing what that manner is. Now that which is inevitable in the work has a higher charm than individual talent can ever give, inasmuch as the artist's pen or chisel seems to have been held and guided by a gigantic hand to inscribe a line in the history of the human race. This circumstance gives a value to the Egyptian hieroglyphics, to the Indian, Chinese, and Mexican idols, however gross and shapeless. They denote the height of the human soul in that hour, and were not fantastic, but sprung from a necessity as deep as the world. Shall I now add, that the whole extant product of the plastic arts has herein its highest value, *as history;* as a stroke drawn in the portrait of that fate, perfect and beautiful, according to whose ordinations all beings advance to their beatitude?

Thus, historically viewed, it has been the office of art to educate the perception of beauty. We are immersed in beauty, but our eyes have no clear vision. It needs, by the exhibition of single traits, to assist and lead the dormant taste. We carve and paint, or we behold what is carved and painted, as students of the mystery of Form. The virtue of art lies in detachment, in sequestering one object from the embarrassing variety . . . For every object has its roots in central nature, and may of course be so exhibited to us as to represent the world. Therefore, each

work of genius is the tyrant of the hour, and concentrates attention on itself. For the time, it is the only thing worth naming to do that,—be it a sonnet, an opera, a landscape, a statue, an oration, the plan of a temple, of a campaign, or of a voyage of discovery. Presently we pass to some other object, which rounds itself into a whole, as did the first; for example, a well-laid garden: and nothing seems worth doing but the laying out of gardens. I should think fire the best thing in the world, if I were not acquainted with air, and water, and earth. For it is the right and property of all natural objects, of all genuine talents, of all native properties whatsoever, to be for their moment the top of the world. A squirrel leaping from bough to bough, and making the wood but one wide tree for his pleasure, fills the eye not less than a lion,—is beautiful, self-sufficing, and stands then and there for nature. A good ballad draws my ear and heart whilst I listen, as much as an epic has done before. A dog, drawn by a master, or a litter of pigs, satisfies, and is a reality not less than the frescoes of Angelo. From this succession of excellent objects, we learn at last the immensity of the world, the opulence of human nature, which can run out to infinitude in any direction. But I also learn that what astonished and fascinated me in the first work astonished me in the second work also; that excellence of all things is one.

The office of painting and sculpture seems to be merely initial. The best pictures can easily tell us their last secret. The best pictures are rude draughts of a few of the miraculous dots and lines and dyes which make up the ever-changing "landscape with figures" amidst which we dwell. Painting seems to be to the eye what dancing is to the limbs. When that has educated the frame to self-possession, to nimbleness, to grace, the steps of the dancing-master are better forgotten; so painting teaches me the splendor of color and the expression of form, and, as I see many pictures and higher genius in the art, I see the boundless opulence of the pencil, the indifferency in which the artist stands free to choose out of the possible forms. If he can draw every thing, why draw any thing? and then is my eye opened to the eternal picture which nature paints in the street with moving men and children, beggars, and fine ladies, draped in red, and green, and blue, and gray; long-haired, grizzled, white-faced, black-faced, wrinkled, giant, dwarf, expanded, elfish,—capped and based by heaven, earth, and sea . . .

The reference of all production at last to an aboriginal Power explains the traits common to all works of the highest art,—that they are universally intelligible; that they restore to us the simplest states of mind; and are religious. Since what skill is therein shown is the reappearance of the original soul, a jet of pure light, it should produce a similar impression to that made by natural objects. In happy hours, nature appears to us one with art; art perfected,—the work of genius. And the individual, in whom simple tastes and susceptibility to all the great human influences overpower the accidents of a local and special culture, is the best critic of art. Though we travel the world over to find the beautiful, we must carry it with us, or we find it not. The best of beauty is a finer charm than skill in surfaces, in outlines, or rules of art can ever teach, namely, a radiation from the work of art of human character,—a wonderful expression through stone, or canvas, or musical sound, of the deepest and simplest attributes of our nature, and therefore most intelligible at last to those souls which have these attributes . . . In proportion to his force, the artist will find in his work an outlet for his proper character. He must not be in any manner pinched or hindered by his material, but through his necessity of imparting himself the adamant will be wax in his hands, and will allow an adequate communication of himself, in his full stature and proportion. He need not cumber himself with a conventional nature and culture, nor ask what is the mode in Rome or in Paris, but that house, and weather, and manner of living which poverty and the fate of birth have made at once so odious and so dear, in the gray, unpainted wood cabin, on the corner of a New Hampshire farm, or in the log-hut

of the backwoods, or in the narrow lodging where he has endured the constraints and seeming of a city poverty, will serve as well as any other condition as the symbol of a thought which pours itself indifferently through all.

I remember, when in my younger days I had heard of the wonders of Italian painting, I fancied the great pictures would be great strangers; some surprising combination of color and form; a foreign wonder, barbaric pearl and gold, like the spontoons and standards of the militia, which play such pranks in the eyes and imaginations of school-boys. I was to see and acquire I knew not what. When I came at last to Rome, and saw with eyes the pictures, I found that genius left to novices the gay and fantastic and ostentatious, and itself pierced directly to the simple and true; that it was familiar and sincere; that it was the old, eternal fact I had met already in so many forms,—unto which I lived; that it was the plain *you and me* I knew so well,—had left at home in so many conversations. I had the same experience already in a church at Naples. There I saw that nothing was changed with me but the place, and said to myself,—'Thou foolish child, hast thou come out hither, over four thousand miles of salt water, to find that which was perfect to thee there at home?'—that fact I saw again in the Academmia at Naples, in the chambers of sculpture, and yet again when I came to Rome, and to the paintings of Raphael, Angelo, Sacchi, Titian, and Leonardo da Vinci. "What, old mole! workest thou in the earth so fast?" It had travelled by my side: that which I fancied I had left in Boston was here in the Vatican, and again at Milan, and at Paris, and made all travelling ridiculous as a treadmill. I now require this of all pictures, that they domesticate me, not that they dazzle me. Pictures must not be too picturesque. Nothing astonishes men so much as common-sense and plain dealing. All great actions have been simple, and all great pictures are . . .

Yet when we have said all our fine things about the arts, we must end with a frank confession, that the arts, as we know them, are but initial. Our best praise is given to what they aimed and promised, not to the actual result. He has conceived meanly of the resources of man, who believes that the best age of production is past . . . Art has not yet come to its maturity, if it do not put itself abreast with the most potent influences of the world, if it is not practical and moral, if it do not stand in connection with the conscience, if it do not make the poor and uncultivated feel that it addresses them with a voice of lofty cheer. There is higher work for Art than the arts. They are abortive births of an imperfect or vitiated instinct. Art is the need to create; but in its essence, immense and universal, it is impatient of working with lame or tied hands, and of making cripples and monsters, such as all pictures and statues are. Nothing less than the creation of man and nature is its end. A man should find in it an outlet for his whole energy. He may paint and carve only as long as he can do that. Art should exhilarate, and throw down the walls of circumstance on every side, awakening in the beholder the same sense of universal relation and power which the work evinced in the artist, and its highest effect is to make new artists . . .

. . . Picture and sculpture are the celebrations and festivities of form. But true art is never fixed, but always flowing. The sweetest music is not in the oratorio, but in the human voice when it speaks from its instant life tones of tenderness, truth, or courage. The oratorio has already lost its relation to the morning, to the sun, and the earth, but that persuading voice is in tune with these. All works of art should not be detached, but extempore performances. A great man is a new statue in every attitude and action. A beautiful woman is a picture which drives all beholders nobly mad. Life may be lyric or epic, as well as a poem or a romance.

A true announcement of the law of creation, if a man were found worthy to declare it, would carry art up into the kingdom of nature, and destroy its separate and contrasted existence. The

fountains of invention and beauty in modern society are all but dried up. A popular novel, a theatre, or a ball-room makes us feel that we are all paupers in the almshouse of this world, without dignity, without skill, or industry. Art is as poor and low. The old tragic Necessity, which lowers on the brows even of the Venuses and the Cupids of the antique, and furnishes the sole apology for the intrusion of such anomalous figures into nature,—namely, that they were inevitable; that the artist was drunk with a passion for form which he could not resist, and which vented itself in these fine extravagances,—no longer dignifies the chisel or the pencil. But the artist and the connoisseur now seek in art the exhibition of their talent, or an asylum from the evils of life. Men are not well pleased with the figure they make in their own imaginations, and they flee to art, and convey their better sense in an oratorio, a statue, or a picture. Art makes the same effort which a sensual prosperity makes; namely, to detach the beautiful from the useful, to do up the work as unavoidable, and, hating it, pass on to enjoyment. These solaces and compensations, this division of beauty from use, the laws of nature do not permit. As soon as beauty is sought, not from religion and love, but for pleasure, it degrades the seeker. High beauty is no longer attainable by him in canvas or in stone, in sound, or in lyrical construction; an effeminate, prudent, sickly beauty, which is not beauty, is all that can be formed; for the hand can never execute any thing higher than the character can inspire.

The art that thus separates is itself first separated. Art must not be a superficial talent, but must begin farther back in man. Now men do not see nature to be beautiful, and they go to make a statue which shall be. They abhor men as tasteless, dull, and inconvertible, and console themselves with color-bags, and blocks of marble. They reject life as prosaic, and create a death which they call poetic. They despatch the day's weary chores, and fly to voluptuous reveries. They eat and drink, that they may afterwards execute the ideal. Thus is art vilified; the name conveys to the mind its secondary and bad senses; it stands in the imagination as somewhat contrary to nature, and struck with death from the first. Would it not be better to begin higher up,—to serve the ideal before they eat and drink; to serve the ideal in eating and drinking, in drawing the breath, and in the functions of life? Beauty must come back to the useful arts, and the distinction between the fine and the useful arts be forgotten. If history were truly told, if life were nobly spent, it would be no longer easy or possible to distinguish the one from the other. In nature, all is useful, all is beautiful. It is therefore beautiful, because it is alive, moving, reproductive; it is therefore useful, because it is symmetrical and fair. Beauty will not come at the call of a legislature, nor will it repeat in England or America its history in Greece. It will come, as always, unannounced, and spring up between the feet of brave and earnest men. It is in vain that we look for genius to reiterate its miracles in the old arts; it is its instinct to find beauty and holiness in new and necessary facts, in the field and road-side, in the shop and mill. Proceeding from a religious heart it will raise to a divine use the railroad, the insurance office, the joint-stock company, our law, our primary assemblies, our commerce, the galvanic battery, the electric jar, the prism, and the chemist's retort, in which we seek now only an economical use. Is not the selfish and even cruel aspect which belongs to our great mechanical works,—to mills, railways, and machinery,—the effect of the mercenary impulses which these works obey? When its errands are noble and adequate, a steamboat bridging the Atlantic between Old and New England, and arriving at its ports with the punctuality of a planet, is a step of man into harmony with nature. The boat at St. Petersburgh, which plies along the Lena by magnetism, needs little to make it sublime. When science is learned in love, and its powers are wielded by love, they will appear the supplements and continuations of the material creation.

Written during a period of knee-jerk celebration of all things American, the following essay provides an unusual, alternate view. The author declares that American subjects (Native Americans, pristine landscapes, nostalgic views of childhood) are too limiting and that artists should strive to be world citizens, aware of the teachings of art beyond the Atlantic shore. Further, the patriotic and indiscriminate cheerleading of critics ("puffery") does not help artists but rather kills their desire to improve themselves. The underlying message is that blind nationalism debases American art, encouraging it to cater to the lowest level of taste.

"The Fine Arts," Knickerbocker 14 *(November 1839).*

We are not among those who are very anxious to see an American school of painting. Schools of all kinds are apt to be wedded to particular styles, and are only really excellent in that which they have adopted as their own. We wish to perceive an endeavor on the part of our artists to arrive at the greatest perfection in every department of the art, whether it be after the Roman, Flemish, English, or French schools. Our painters are too apt to think, and the public are too apt to require, that every work produced on this side of the Atlantic should be peculiarly American, in character and execution. This, we think, is carrying national feelings and prejudices a little too far; it is, in fact, too democratic for our notions, and if persisted in, will narrow down the efforts of our artists to a very small compass. The space we cover, in the history of the world, is as yet very limited; and to confine our painters or sculptors to subjects drawn from this source alone, would produce a monotony, that would be as tedious and chilling, as at length it would be painful and disgusting. Already Indian scenes and Indian subjects have almost surfeited us. Tawny complexions, uncouth drapery, and unvaried expression of figure and countenance, may offer novelty for a while, but a refined mind will soon become wearied with them.

Those who advocate an American school, are constantly crying out to our artists, '*Paint from Nature.*' In this sentiment they seem to imagine that all true excellence consists. We certainly would not condemn the notion of always keeping nature before our eyes, when we attempt to do any thing truly great and original. But there are two ways of looking at Nature. There are those who look at her with a cultivated, and those who look at her with an uncultivated eye. To illustrate this, in a familiar manner, we would instance the landscapes recently published in England, of American scenery, and the views of the same scenery, published by some of our artists in this country. In both we find the same attention bestowed upon the drawing, outline, and perspective, but as unlike each other as possible in tone, color, and effect. One draws it as he would a map, with square and compass; the other, preserving the same fidelity, so arranges the light and shade, as to produce a fascinating and glowing picture. The one gives us Nature in her everyday dress, unvarnished, unadorned, and unattractive; the other seizes her in her happiest moments, when sunshine and gladness clothe her in her richest and most enticing apparel. The power of thus placing nature before us in her happiest moments, is the peculiar prerogative of genius; but of genius cultivated and refined by long study, and an intimate acquaintance with the principles of the picturesque, the sublime, and the beautiful. Intense application to the leading principles of taste, we know is repugnant to the great majority of mankind; and it is on this account that a superficial manner is so universal and alluring. But a superficial manner cannot earn a substantial reputation; and he who aims at popularity by courting momentary applause, will sooner or later find that he has been pursuing a phantom that has led him onward to his

ruins. The idea, therefore, of establishing an American school of painting, by an exclusive study of nature, without first acquiring a knowledge of the great principles of the art, is as idle as it is pernicious and deceptive.

A painter, to become really great, should be familiar with every thing that appertains to human character, as well as with every thing that has form, color, or expression. He must paint for all ages, all times, and all countries. Like Shakspeare, he must address himself to the human heart, be the fashions, language, and notions what they may. To do this, he must be familiar with the works of those who have preceded him in the great race for fame, and whom the world has pronounced as masters in their professions. He must understand clearly and distinctly the principles that have guided them in their career, and never rest satisfied, until he has mastered their most difficult and trying efforts. When this is accomplished, we have no fear of his wedding himself to any particular manner, or identifying himself with any particular school. His field will be the world, and the world will award him the praise, then so justly his due.

Next to having our artists familiar with the principles of taste, the public that patronise and sustain them should not be behind hand in possessing the same knowledge. In England, France, and Italy, the patrons of the arts are, generally speaking, almost as well acquainted with what constitutes a fine painting, as the artists themselves; and this offers to the man of genius a real incentive to redouble his exertions in his efforts to produce great works. To such an extent is this observable to travellers in those countries, that it is an every-day matter to encounter spectators in an exhibition-room, discoursing upon the merits of a work with all the judgment and good taste of the most profound connoisseur. But this is not the case here. If a picture strikes the eye, by its violent contrast of color, or awakens some association of childhood, or is novel in the manner of its execution, we are at once enraptured with its author, and forthwith pronounce him a second Michael Angelo or Raphael. The walls of private dwellings, instead of being enriched with a few works of a choice and rare character, are crowded with wretched portraits, and vile copies of old paintings, that have been purchased merely because they are *cheap!*

To *correct* public taste, we know, is a difficult task; but to *lead it,* is more practicable; and on the part of the artists and the public press, imperative. The system of puffing, so prevalent among us, should be discountenanced at once. It should be understood that no *individual,* no matter how splendid his genius, can produce works truly great, without years of intense labor and study. In the language of Sir Joshua Reynolds, it should be understood that the life of man is too short to enable any one to arrive at perfection, and that nothing but constant practice, great experience, and a powerful mind, can earn an enduring reputation. When the public once understand this, their decision will be more tardy, but more permanent. And so many young aspirants will not appear before us, to pass away like a meteor, leaving not even a trace of their existence behind them.

For some fifteen years past, the writer has been a close and attentive observer of the progress of the fine arts in this country; and during this period has been repeatedly struck with the appearance of new candidates for fame, who, after exhibiting every sign of future greatness, have in a little time passed away, and been lost to us forever. On examining into the cause of this sudden extinguishment of promising talents, it has invariably been found that it is attributable to the extraordinary applause which has been bestowed upon their first efforts. They have been led to suppose that their knowledge of the art was complete, when in fact they were but in its very rudiments. They have reposed upon their fancied perfection, and never discovered their error, until they found themselves supplanted in public opinion by other candidates equally brilliant in their career, for the moment, but doomed to the same short-lived and shadowy reputation.

The press is certainly answerable for much of this disappointment in early genius. We can scarcely take up a journal of the day, but we find in it some extravagant article upon the work of some young tyro in the arts. Whether this is owing to the good nature of our editors, in wishing well to every young aspirant, or whether it arises from ignorance in judging of their works, we will leave it for others to determine. Certain we are, that the effect is most pernicious to public taste, and destructive to the future prospects of the objects of their notice. Articles should be written only by those who are fully competent to judge well and truly; and articles of this character will always carry upon their face an evidence of their value, by the thorough acquaintance they will exhibit of every part of the works they criticize. Instead of applying the general terms, that this is 'beautiful,' or that is 'bad,' they will point out *why* they are beautiful or bad; and thus enable their readers to judge for themselves, and be improved by the examination.

Next to the public press, the artists themselves, who have earned a substantial reputation, should be responsible, in some measure, for the low standard of taste among us. If they will administer to the groveling fancy of the ignorant and pedantic, by painting pictures suited only to inferior imaginations, on their heads must rest the consequences of a superficial taste in the community. The plea that works of this kind will alone find a purchaser, is no excuse, with any reasonable man. Painting then becomes a trade, and those who are compelled to give it this character, had better seek employment in the other walks of life, where a more lucrative, if a less honorable, destiny awaits them. Portraits and unmeaning fancy-pieces may find buyers, but elevated subjects alone will enable Painting to hold her station by the side of her sister arts, Poetry and Music.

JOEL HEADLEY WAVES THE FLAG OF AMERICAN ART

Although New York author and politician Joel T. Headley published a book on his travels in Italy in 1847, his main interests were American history and the American landscape. His nationalistic pride is on full display in the address he gave to members of the American Art-Union in 1845. The sentiments expressed are not particularly original, but his ringing, vigorous language ("native soul . . . native soil") stands out among similar speeches of the era. Headley exhorts artists not to emulate the foreign schools of art lest they be overtaken by them and lose their individuality. Somewhat curiously, he offers marble sculpture as the primary example of American artistic independence (other critics routinely worried that the neoclassical sculptors followed European ideals too closely). He wishes for more government patronage of the arts, using the novel argument that patriotic paintings and monuments will serve as the best inspiration for young soldiers to defend the country in times of war.

J. T. Headley, address before American Art-Union, Transactions of the American Art-Union (New York: 1845).

Every nation, worthy of the name of nation, has its native *soul*, as well as native *soil*—its own peculiar views of all that makes up this life, and its own mode of uttering those views. If this be true as a *general* proposition, it has still more force when applied to this country. If there ever was a people on the face of the earth with peculiar and striking characteristics, it is the American people; and if we could only release ourselves from that strange infatuation about foreign arts and artists, and foreign literature, and foreign every thing, and dare and love to be ourselves, we should soon have an *American* literature, an *American* school of art, as well as a

peculiar form of government. I do not say this from that narrow prejudice and self-love which hates every thing but its own glorification, but from the conviction that every nation, like every man that is worth any thing, has a soul and utterance of its own,—something in *itself* worth showing to mankind; and, indeed, that its true glory and greatness consist in daring to be itself, as in a man in daring to be natural. Our Atlantic coast has such an intimate connection with Europe, that I have sometimes thought we never should have much that was national till the West should give shape and character to the country. It is worth a man's consideration— the fact that an untutored Western man, who has grown up away from all those aids deemed so necessary to the student, is the best living sculptor in the world. Mr. Powers[1] is a forcible illustration of what I wish to say on this point. He went from Cincinnati to Florence, from *no* art to the *seat* and *centre* of art, yet never forgot that *nature*, not the rules of the academy, was to be his guide. Unlike others who are seized with a sudden distrust of their own powers the moment they gaze on the works of the great masters, and merge their individuality in the rules of the academy, he followed the bent of his own genius, and triumphed. He did not despise the glorious lessons the silent statues around him uttered, but he used them as aids to develope perfectly that which was in *him*. He was not *overwhelmed*, but *strengthened*, by the world of art that suddenly opened before him. Hence he became a *creator*, not an *imitator*. All honor to him for the example he has set his countrymen. Fear is no more the curse of the world than the curse of individual man. Afraid of criticism, he speaks so as to pacify *it*, and not so as to utter himself. Our artists, painters and sculptors have taken the first step in nationality; our literature is sadly behind. Powers builds an Eve beside the Venus de Medici, and gives to the world an *American's* conception of a *woman*,—with *intellect* as well as *passion*, with *thought* as well as *feeling*. Clevenger rears his Wild Indian right before Michael Angelo's David, and asks the world to speak out its criticism. Brown moulds his thoughtful Indian Boy beside the Apollino of the Tribune, and leaving the thrice ransacked classics and the gods to the Italians and Greeks, makes a Ruth that wins the admiration of every beholder. These are not merely so many individual, independent *men*—they represent the country. It is American Art standing up amid the art of the classic age, of the palmiest days of Greece and Rome, and comparing features, and form, and grace, and beauty. The academy would have killed these men—overwhelmed all the suggestions of nature with its rigid rules. I must confess there is something cheering in thus beholding Western men on the classic ground of Italy, flinging abroad their arms in the same unrestrained freedom they did on their native soil. We deeply needed this same spirit in our literature. We must be proud of Americanisms, (I do not mean, by that, words and phrases, peculiar expressions, but views, and feelings, and criticisms,) if we would be relieved from thraldom, and take the place art is so rapidly taking. I would that every author, like Powers, should *use* the products of genius and learning of the old world, but not let them *use him*. And why should it not be so? There is good strong Saxon hearts here as ever beat on the soil of England . . .

But I will leave this subject to say a word on the effect of art on national feeling. Some one has said, give me the writing of the *songs* of a country, and you may make its laws. I had almost said, give me the control of the *art* of a country, and you may have the management of its administrations. There can be no greater folly than that committed by our statesmen, when they treat art and literature as something quite aside from great national interests. The tariff, internal improvements, banks, political speeches and party measures, are put paramount to them,

[1] See "Hiram Powers's *The Greek Slave*," chapter 5.

and yet they all together do not so educate the *soul* of the nation. They affect simply its food, and clothing, and money, and offices. In the days of Italian glory, artists and poets were the companions of Kings, and Kings were honored by the companionship. They were fostered not more from taste than from self-interest. Art is too often looked upon as an abstract thing, designed only for men of taste and leisure. The painting or statue which is the embodiment of the ideal perfect in the artist may be so, but there are other more useful departments of art not to be overlooked. Every great national painting of a battle-field, or great composition illustrating some event in our history—every engraving, lithograph and wood cut appealing to national feeling and rousing national sentiment—is the work of art; and who can calculate the effect of all these on the minds of our youth? *Pictures* are more powerful than *speeches.* Suppose that every painting and engraving, whether rude or complete, every monument to human worth, were removed from this country for the next forty years,—what would be the effect on the national taste and feeling? And yet for all that our statesmen voluntarily do for these things, such a burial would take place. They show themselves but half acquainted with the true resources of the nation when they overlook or neglect its genius and refined talent. Patriotism, that noblest of sentiments, for it is a sentiment as well as a principle, and governs more in that capacity than in the other, is kept alive by art more than by all the political speeches of the land. I should like to see the Massachusetts' army that would retreat out of the shadow of Bunker Hill Monument before a foreign foe. Were it necessary in some great crisis of our country's fate to move an audience like this to some heroic resolution demanding peril, and perhaps death—if speech should fail to do it, I would ask only for the canvass to unroll before you, on which was flung, with an artist's hand, the battle of Bunker Hill. I would point to that little redoubt on the crest of the hill, curtained in with the smoke of battle—to the shattered columns breaking down the slope— to the flames of burning Charlestown shooting towards Heaven,—without one word. The artist should speak, and he were a slave that could resist his appeal. Could a man be a coward, fighting in the shadow of a monument to Washington? What American soldier would retire from such a spot, if compelled to retire before a superior force, with the countenance of Washington looking mournfully down on him, without his heart breaking within him? . . .

The youth of every land are educated more by art than by speeches. Let monuments rise from Concord, Lexington, Bennington, Ticonderoga, Yorktown, and Plattsburgh, and Chippewa, and Lundy's Lane, and New Orleans, and as the rail car flies over the country, let these records of our struggles and our victories come and go on the hasty traveller, and noble thoughts and purposes will mingle in the headlong excitement after gain. Let the statues of the signers of the Declaration of Independence line Pennsylvania Avenue, and he who walks between them to the Capitol will be a better man and better patriot. Let great paintings, illustrating our chequered, yet most instructive history, fill our public galleries, and when the country wants martyrs they will be ready. But, alas! I am speaking of what ought to be, and not of what is. I have been appealing, also, to the *self-interest* of the nation, when I ought to have been speaking of the claims on a nation's gratitude. To outward eyes America is the most ungrateful country on the face of the earth. The nation has never yet reared a monument to its father, founder and saviour— WASHINGTON . . .

I have thus spoken on the general topic of art, Mr. President, because I feel that the want of a national feeling on this subject, not only stands in the way of the progress of art among us, but is a grievous wrong to ourselves and our benefactors; and also because I know, from personal conversation with our artists abroad, that they feel this neglect of their country keenly. It would make you sad to hear them speak of the national subjects for great paintings and mon-

uments which they would be glad to undertake. Many of them would work for almost nothing, on commissions of this kind. Our artists wish to do something more than paint landscapes and portraits. Besides, art never can fully develope itself in this country until it embodies the spirit—the sentiment of the nation, and until it is appealed to and honored by the nation. A great mistake is made, even by some of our artists, in supposing that the way for an American artist to succeed is, to become deeply imbued with the spirit of the past—study the works of the old masters till they drink in their spirit—embody their conceptions. But when art expended herself on gods and goddesses, and fauns and nymphs and satyrs, these were the true heroes and poetry of the times—they embodied all that was noble and beautiful in human conception. But another age and another spirit has come, and he that muses and dreams over the past, calling feebly on the classic age to come again, commits a folly that after years can never repair.

ON MECHANICS AND THE USEFUL ARTS

An educational and social movement focused on mechanics—or manual artisans—swept the United States at mid-century. It stressed the utility of the creative trades as well as the intellectual cultivation of their practitioners. Mechanics fairs, designed to showcase American products and prompt consumption, were mounted in many eastern cities. This movement had champions who wrote and spoke frequently on the topic. James Mapes, a chemist and amateur painter who developed techniques for sugar refining, hide tanning, and steel tempering, and who also lectured on the chemistry of artists' materials at the National Academy of Design, argues for the civilizing effect of good design on lower-class mechanics, using such humble examples as iron railings and soup bowls. He suggests that proximity to the arts will improve even the most ignorant mind, almost by osmosis. In an interesting passage at the end of his essay, he lauds design's feminizing influence on such men.

In his address commemorating the seventh exhibition of the Massachusetts Charitable Mechanic Association, George Russell frames the situation differently. Rather than glorify the fine arts and their trickle-down effect to the lower classes, he suggests that painting and sculpture have grown closer to the mechanical arts and no longer occupy a lofty pedestal. He sees the useful "products of the head and hand" as some of the greatest achievements of a free democracy, even suggesting that these material objects will mark America's place in history, much as ancient civilizations are known through their archaeological remains. Instead of arguing for the elevation of the mechanic into the ranks of the fine arts, he worries that young men will be ruined if they are lured from their farms and workshops into the urban artist's atelier.

James J. Mapes, "*Usefulness of the Arts of Design,*" Sartain's Union Magazine of Literature and Art 8 (March 1851).

No error is more common than for those who are engaged in what is denominated the "useful arts" to speak of the fine arts as unnecessary and of secondary utility. Each class of society consider themselves as enjoying the full benefits of civilization, without properly comprehending the advantages and pleasures enjoyed by their more highly-educated neighbours; but, while they lose sight of their own demerits, they pity the lot of those who are unequal to them in mental accomplishments.

Civilization is comparative, and the hard-handed backwoodsman considers himself civilized,

and enjoying more happiness from his greater amount of knowledge than the Indian; while, in truth, his deficiencies, as compared with the well-educated inhabitant of the seaboard, are greater than those which exist between himself and the savage. The very grandeur of the scenery surrounding him is void of beauty to his untutored eye; his hours of leisure are passed in listless idleness; and the very functions which God has given him to secure his enjoyment of the beauties of nature remain inactive and impotent. Had his eye been tutored to admire the picturesque, he could then "look through nature up to nature's God," and be happy. Both the eye and ear may be educated without our immediate volition. Thus the labourer who raises the curtain at an opera house, and who supposes that he has no taste for music, indeed from listless indifference scarcely hears it, still is nightly educating his ear, and, after a short time, discords become unpleasant to him, well-chosen harmonies give him pleasure, and eventually pleasing and well-arranged sounds are necessary to his happiness. He ever afterwards can enjoy the carolling of birds, and even by this slight addition, involuntarily added to his education, his power to enjoy nature is increased, and with this increase others soon follow, until the whole man is improved.

Hogarth has well said that the letter S is the line of beauty; and should any child practise the forming of this letter until he could draw it with ease, certainly he would ever afterwards be enabled to see beauties in nature which would be invisible to the mere definer of straight lines. The French were the first of modern nations to turn this fact to useful account . . .

Even at this late date, we find that more than one million of dollars' worth of French furniture was imported into New York alone during the last year. Does this arise from any superiority of workmanship? Certainly not; for our own cabinet-makers do work of an equal or superior quality. Are the woods more beautiful? No; our woods surpass those of France in beauty. What then gives this French cabinet furniture the preference in an American market? Simply *the elegance of form.* The designs are both novel and beautiful, far surpassing those introduced by our cabinet-makers. There is a peculiar fitness in French designs; each utensil has a form especially adapted for its use, which adds to its value while it imparts beauty of figure. Let those who doubt the necessity of using appropriate forms of ordinary utensils take their soup from a washbowl, or their wine from a saucer, or their tea from a wineglass, and they will soon realize the necessity for adaptation of shape. These adaptations and beauty of figure should pervade the furniture of the lowliest cottage. Taste gives happiness without cost, and the eye of the labourer will soon find pleasure in fine designs, if the furniture of his table be such as to embrace the arts of design; and this improved taste will be manifested in all his creations.

Indeed, all men are rendered happier and better by the power to appreciate fine forms; the mind becomes refined, and with it a gentleness of feeling, and consequent kindness of heart, renders the community happier and less restive in disposition . . .

In our own country we are fast profiting by an improved school of art. But a few years since, and all our manufactures were of the most homely sorts. As a familiar instance, we would name the iron railings in common use. Within our recollection there was not one ornamental iron railing in the United States. A German blacksmith, by the name of Paulus Hedl, was the first to improve this class of manufacture. He had learned the arts of design at home, and could imitate the beauties of his trestle-board on the anvil. He made the iron railing around the grounds of the President's house at Washington, and the demand for his wares soon rendered him rich; and now, instead of the monotonous parallelisms of straight iron rods, pierced through a single horizontal bar and pointed at the top, we have beautiful forms, which give so much elegance to iron railings as to cause us to forget their inhospitable intention. The old square-sided ten-

plate stove has given place to a variety of forms so beautiful as to be desirable for furniture, besides increasing the amount of surface, so as to radiate an increased quantity of heat.

The High School of Philadelphia, and the Free Academy of New York, have established classes in the arts of design; and a few years will find our workshops filled with designers of no mean capacity . . .

Our Academies of Art and Art Unions have done much to improve the public taste, and their influence cannot but prove most beneficial. Engravings are now widely circulated, of the best kinds, and, instead of the grotesque libels on art which formerly were to be found in every house, we now see works of superior merit.

Let not the stoic think that the fine arts have no useful effect, for, in addition to their direct usefulness, as already noted, they give rational and harmless employment to our leisure hours, and many hundreds of our youth are spending hours of leisure in examining fine works of art, who, a few years since, would have been compelled to look for amusement in the tavern, or some worse place. Historical events are fastened on the memory when taught through the medium of pictures; the beauties of nature, before unobserved, are rendered attractive. Our young men associate more with females, and thus the asperities of their nature become softened. Visit the exhibitions of the various Academies and Art Unions throughout the country, and there you will find the youth of both sexes innocently enjoying each other's society, and improving their minds and tastes.

Let those who would argue that the fine arts are unnecessary as a branch of education but carry their argument to the full extent, and they will cut a hole through the centre of a large blanket or skin, to admit the head through to the light, and wear no other clothing; for the mere purpose of keeping out the cold and giving free use to the limbs, this style of dress would accomplish the object, and is fully sufficient for the use of those who cannot appreciate the beauty of the human form, nor the necessity of rising beyond the brute creation.

George R. Russell, **An Address before the Massachusetts Charitable Mechanic Association** *(Boston: Damrell and Moore and George Coolidge, 1853).*

The Exhibition, which is now filling our streets with strange faces, and crowding our halls with eager multitudes, bewildered by the various and novel objects around them, has consequences far more important than the amusement of an hour, or the gratification of mere curiosity. It has a deeper object—a more extended and liberal purpose—affecting results which will endure long after it has passed away. This gathering together the products of the head and hand, showing the affinity between them, and their mutual dependence on each other; this prodigality of ingenuity scattered with a profusion which seems to defy examination; this mingling of everything useful with all that the most refined elegance can covet, satisfying ultra-utilitarianism and fastidious luxury; this assembling, in harmonious intercourse, competitors in every branch of art, and bringing contrasted occupations in contact, that all may feel the fraternal bond which unites them; this lesson, preached from every stand, and table, and corner; on floor, on platform, and through gallery; saying alike to every visitor, from every section of this Union—whether farmer or planter, merchant or mechanic, lawyer, doctor, or divine—Behold this monument of free enlightened labor, this union of mind and matter, the effect of manual skill directed and governed by intelligence. All these are offered with worthy pride, and will be usefully remembered when the present glory has departed, and this passing pageant shall be numbered with its predecessors.

The character of a nation is recorded in its Arts. The secrets of old civilization would be almost wholly unknown to us, were it not for the fragments, gathered at intervals, as time or exploration scantily unfolds the crumbling remnants of ancient art. On the monuments of centuries the deep indentations, as they defeat all effort to discover the mode by which they were inscribed in the eternal granite, give facts of little import and insignificant detail, yet the most that is known of their construction. For thousands of years the hot sun has burned on them; the whirling sands, shrouding them in forgetfulness, have crept upon them, and, entering curve and crevice, are gradually asserting the dominion of the desert, and obliterating even the little that remains to speak to us of the distant past . . .

The distinction of Fine and Mechanic Arts, is in a great measure done away. There was once a broad line between them, and one disdained an alliance with the other. It was supposed that genius could not descend from her etherealized habitation and mingle with her plebeian brother. She is now no longer a resident of the clouds, but dwells on the solid earth. She stands by forge and anvil, loves the clatter of the factory, enters the workshop and presides over the combinations which give soul to matter, lingers in dingy corners where the pale mechanic thinks out the problems which revolutionize art, hovers round the swarthy brow and clings to the calloused hand of labor. She has become democratic, wears homespun, and keeps company with paper caps and leather aprons, as though she were a candidate for office and wanted votes. There was a time when she lived in lordly halls and moved among the mighty of the earth, but her taste and manners have been improved, and she has become, at last, a useful member of society.

There is an *ignis fatuus,* men call genius, which leads them a weary chase over many a quagmire, swamping some and leaving others so begrimed with their unprofitable travel, that no vestige remains of the freshness with which they started. To follow this they abandon the firm ground, for which nature intended them, and, forfeiting the respectibility of mediocrity, sink into hopeless insignificance, after vainly striving for immortality.

Parental pride is aroused when an idle boy, in some unfortunate moment, pinches crumbs of bread unto a likeness of a human face, or disfigures the barn door with a representation of some denizen of the farm-yard, the horns solving the dilemma whether the prodigy is intended for a cow or a horse. A spark of light divine is supposed to have fallen on the family, and the young maker of dough faces must relinquish the hoe for the brush or the chisel. A very competent farmer is spoiled to make a very indifferent artist, and instead of dwelling in his proper sphere, among scenes of nature, he is sent to cover the walls of a city attic with productions which insult and degrade her.

Young man, who art now toiling in thy mistaken vocation, looking for the inspiration which comes not and will never come, resign thy unprofitable task, and leave this daubing of paint and kneading of clay. If thou wert born for the application of colors, it is the covering of clapboards, not of canvas that calls to thee: thy mission may be in stone, but it is the handling of granite, not the chipping of marble—the laying of one fragment upon another, in the elongated and substantial form adopted for land boundaries. Flourish thy palette, cut and carve as thou wilt, the ideal, that is not in thee, cannot be given to the dead things thou art striving to torture into life. After all thy grimaces and contortions, there will only be before thee a piece of party-colored cloth, or a cold, misshapen block. Return to the old homestead; the garden is growing to weeds, and the tumbling fences will rejoice in thy handiwork: or go back to thy old craft, whatever it was, and resume it like a man. It is as honorable as the one of thy adoption,

and will bring, with more lucrative consequences, the consciousness of being once more in a congenial element.

BUILDING INSTITUTIONS

The National Academy of Design

THE FOUNDING

In 1817 John Trumbull became the president of the American Academy of the Fine Arts, the first artist to hold that title. He remained president for nineteen years and benefited from the financial patronage of the institution on several occasions. An imposing and aristocratic figure, Trumbull was deferred to by the majority of the nonartist officers of the American Academy, and the growing number of younger artists in New York City began to think of him as a remote, dictatorial figure, one who acted in his own interests without worrying overly about the profession at large. Things came to a head in 1825, when several painters were prevented from drawing from the American Academy's collection of casts. In his History, *William Dunlap relates the exchange, which became a kind of foundational gospel in American art history, especially Trumbull's quip that "beggars are not to be choosers." Dunlap then describes the creation of a new organization, the New-York Drawing Association, independent of the Academy.*

Another artist who was present at the altercation involving the casts was Thomas Seir Cummings (see "Thomas Seir Cummings on Miniature Painting," chapter 4). In his history of the early years of the National Academy of Design, Cummings describes the attempt of Trumbull to claim the members of the new Drawing Association as Academy students. This led to negotiations to elect six of the independent artists to the Academy's board of directors, a plan that failed when the Academy agreed to seat only two of them. Cummings quotes an unnamed director as saying, "Artists were unfit to manage an Academy . . . Colonel Trumbull says so." For the younger artists, this was the final straw, and under the leadership of Samuel F. B. Morse the members of the Drawing Association decided to form yet another new group, the National Academy of Design. Morse's remarks on that evening, January 14, 1826, as quoted by Cummings, are given here. Although the scheme laid out by Morse to elect the first members of the National Academy did not go exactly as planned (John Vanderlyn, for example, angrily refused his election), this was nevertheless the beginning of the longest-lived artist organization in the United States.

William Dunlap, History of the Rise and Progress of the Arts of Design in the United States *(New York: George P. Scott, 1834).*

I will pass over rapidly what I fear may prove to the general reader uninteresting, (but what must stand recorded) and come to those events which led to the formation of a real academy of fine arts. In the year 1824–5, the American Academy again invited students to draw from the casts, provided they came between the hours of six and nine, A.M. The opportunity was eagerly sought, but it was soon found that the hope of advantage to be derived from the treasures of ancient art, was illusory. There was no keeper or instructor. The young men who attended at six o'clock—at seven o'clock—were sometimes admitted, and sometimes excluded, and gen-

erally had to wait at the door for hours, if admitted, and then were frequently insulted—*al- ways,* if they had presumed to knock. At length a scene occurred which seemed to put an end to the pretence of an academy being open to students. Of this scene the writer happened to be a witness.

I had been accomodated by the common council of the city, with a painting-room in the building, and coming to the place generally before breakfast, to prepare for the labour of the day, witnessed the treatment which those who wished to instruct themselves received. On the occasion alluded to Messrs. Cummings and Agate, even then artists, although young, came to the door and found that it was closed; they were turning away, when I advised them to speak of the exclusion to the directors.—They replied, "that it would be useless," and at that moment one of the directors appeared, coming from Broadway towards them. I urged the young gentlemen to speak to him: but they declined; saying, they had so often been disappointed, that they "gave it up." The director came and sat down by the writer, who mentioned the subject of the recent disappointment, pointing to the two young men, who were still in sight. The conduct of the person whose duty it was to open the doors at six o'clock, A.M. was promptly condemned by this gentleman, and while speaking, the president appeared coming to his painting-room, which was one of the apartments of the academy. It was unusually early for him, although now probably between seven and eight o'clock. Before he reached the door, the curator of the academy opened it, and remained. On Mr. Trumbull's arrival, the director mentioned the disappointment of the students; the curator stoutly asserted that he would open the doors when it suited him. The president then observed, in reply to the director, "When I commenced my study of painting, there were no casts to be found in the country. I was obliged to do as well as I could. These young men should remember that *the gentlemen* have gone to a great expense in importing casts, and that they (the students) have no property in them;" concluding with these memorable words for the encouragement of the curator, "They must remember that beggars are not to be choosers."

We may consider this as the condemnatory sentence of the American Academy of the Fine Arts.

During the autumn of 1825, S. F. B. Morse, Esq. was an active agent in forming what was called a drawing association. He, as well as his brother artists, and all who wished to study the arts of design desired that schools might be established for the purpose. They saw that the institution called the American Academy of the Fine Arts, had nothing in common with any existing academy for the teaching of art, and that from its construction and direction there was no hope that it could be made to answer the purposes of an academy. They saw that it was a "joint stock company," composed of persons of every trade and profession, who thought the privilege of visiting the exhibitions an equivalent for twenty-five dollars—such persons were the *electors* of the directors, and entitled to be themselves elected directors. Artists could only share these privileges by purchasing stock, and might be controlled in every thing respecting their professions by those who were ignorant of the arts. Artists had sprung up who might challenge competition with any in the world, and maintain the challenge.

So circumstanced, Mr. Morse suggested to some artists that an association might be formed "for the promotion of the arts, and the assistance of students." It was merely a plan for improvement in drawing, to be called *the drawing association;* the members to meet a certain number of evenings each week, for mutual instruction and the promotion of union. Each member furnished a small sum for expenses, officers were appointed, and an organized body formed. Casts were produced by the members, and borrowed from the old institution, no enmity was

thought of, and the meetings took place in the unoccupied apartments of the Philosophical Society.

Thomas S. Cummings, Historic Annals of the National Academy of Design *(Philadelphia: George W. Childs, 1865).*

On one of the drawing evenings in December, 1825, Colonel Trumbull, President, and Archibald Robertson, Secretary of the American Academy, entered the room in which the associated artists were drawing, and going directly to the President's seat, took possession of it, and looking authoritatively around, beckoned to the writer, who was in charge of the room, to go to him—producing the matriculation-book of the American Academy, he requested that it should be signed by all, *as* students of that Institution. That the writer, as one, declined, bowed to Mr. Trumbull, and left him, and reported to the members. The Colonel waited some time, but receiving neither compliance nor attention, left in the same stately manner he had entered; remarking aloud, that he had left the book for our signatures, with the additional request, that when signed, it should be left with the Secretary of the American Academy! The circumstance naturally led to a little excitement in the usually quiet Society. Groups gathered together and discussed the proceedings, and finally the Society was called to order, and the questions were presented: "Have we any relation to the American Academy of Arts?"—"Are we their students?" It was promptly determined, "None whatever." "We are not." "They have cast us adrift, and we have started on our own resources,"—and the determination was unanimous, that the names should not be enrolled on the books of the Academy.

At the time there were a few, not exceeding half a dozen in number, of the smaller casts, from which the artists were drawing, which belonged to the American Academy of Fine Arts. That was the *only* connection, and that it was at once determined to sever. On the 14th of January, 1826, the following resolution was unanimously passed:

"*Resolved,* That the casts belonging to the American Academy be returned, and that the thanks of this Association be tendered to the gentlemen of the American Academy for their politeness in loaning them to us." . . .

At a meeting of the New-York Drawing Association, held on the evening of the 14th of January, 1826, Mr. Morse, the President, stated, "That he had certain resolutions to offer the Association, which he would preface with the following remarks:—We have this evening assumed a new attitude in the community: our negotiations with the Academy are at an end; our union with it has been frustrated, after every proper effort on our part to accomplish it. The two who were elected as Directors from our ticket have signified their non-acceptance of the office. We are, therefore, left to organize ourselves on a plan that shall meet the wishes of us all. A plan of an Institution which shall be truly liberal, which shall be mutually beneficial, which shall really encourage our respective Arts, cannot be devised in a moment; it ought to be the work of great caution and deliberation, and as simple as possible in its machinery.

Time will be required for this purpose; we must hear from distant countries to obtain their experience, and it must necessarily be perhaps many months before it can be matured. In the mean time, however, a preparatory simple organization can be made, and should be made as soon as possible, to prevent dismemberment, which may be attempted by out door influence. On this subject let us all be on our guard—let us point to our public documents to any who ask, what we have done, and why we have done it? while we go forward minding only our own concerns, leaving the Academy of Fine Arts as much out of our thoughts as they will permit us, and bending our attention to our own affairs, act as if no such institution existed.

One of our dangers at present is division and anarchy, from a want of organization suited to the present exigency. We are now composed of Artists in the four arts of design, viz.: Painting, Sculpture, Architecture and Engraving. Some of us are professional Artists, others Amateur, others Students. To the professed and practical Artist belongs the management of all things relating to schools, premiums and lectures—so that Amateur and Students may be most profited. The Amateurs and Students are those alone who can contend for the premiums, while the body of professional Artists exclusively judge of their rights to premiums, and award them.

How shall we first make the separation, has been a question which has been a little perplexing—there are none of us who can assume to be the body of artists, without giving offence to others, and still every one must perceive that to organize an Academy, there must be the distinction between professional artists, amateurs who are students, and professional students. The first great division should be, the body of professional artists, from the amateurs and students constituting the body, who are to manage the entire concerns of the new Institution, who shall be its officers, &c. There is a method which strikes me as obviating the difficulty—place it on the broad principle of the formation of any society—Universal Suffrage. We are now a mixed body—it is necessary for the benefit of all, that a separation into classes be made: who shall make it? why obviously the body itself. Let every member of this Association take home with him a list of all the members of it. Let each one select for himself from the whole list *fifteen,* whom he would call professional artists, to be the ticket which he will give in at the next meeting—these fifteen thus chosen, shall immediately elect not less than *ten,* nor more than *fifteen* professional artists, in or out of the Association, who shall (with the previously elected fifteen) constitute the body to be called the National Academy of the Arts of Design. To these shall be delegated the power to regulate its entire concerns, choose its members, select its students, &c. Thus will the germ be formed to grow up into an Institution, which we trust will be put on such principles as to encourage, not to depress the Arts. When this is done, our body will be no longer the Drawing Association, but the National Academy of the Arts of Design, still including all the present association, but in different capacities.

One word as to the name, National Academy of the Arts of Design. Any less name than National, would be taking one below the American Academy, and therefore is not desirable. If we were simply the Associated Artists, their name would swallow us up—therefore, National seems a proper one, as to the Arts of Design: These are Painting, Sculpture, Architecture and Engraving, while the Fine Arts include Poetry, Music, Landscape, Gardening, and the Histrionic Arts. Our name, therefore, expresses the entire character of our Institution, and that only.

THE EARLY YEARS

Sadly, the initial years of the National Academy of Design were marked by continued discord with the American Academy, as exemplified by a series of dueling publications between proponents of each organization. On the occasion of the first anniversary of the National Academy, Samuel F. B. Morse, its president, gave an address, "Academies of Art," in which, drawing on the history of academies in Europe, he made an argument for organizations that were governed solely by artists. In the passages given here, Morse presses for solidarity among the artists and, drawing on his own experience, warns that an American artist seduced by the charms of European study may well be disappointed by the lack of taste and patronage at home.

Six months later, a lengthy, unsigned review of Morse's speech was published in the

North American Review. *Calling into question nearly every one of Morse's assertions (as well as the name of his new organization), the author of "Article X" (i.e., Article no. 10) insists that American artists are not neglected; they receive exactly the attention from patrons that is their due. In a passage that must have infuriated the artists, Morse's reviewer suggests that the taste of laymen might surpass that of young artists who return from Europe with inflated notions of what they have learned. Further, the author argues that the artistic obsession with mechanical skills has produced a generation of American artists who lack poetry. Essentially, the essay is a market-driven meditation on taste: who has it, who is responsible for cultivating it, and how it can be developed in America.*

The excerpts from these two essays give the broad outlines of the controversy, but it hardly stopped there. Morse published a sharp pamphlet response to "Article X" in 1828, and William Dunlap, in a pseudonymous series of seven letters to the Morning Courier *signed "Boydell," stepped up the attack on Trumbull and the American Academy. Five years later, in 1833, the fire was rekindled when Trumbull gave an address that essentially destroyed any hope of a union of the two organizations (a memorandum of agreement had already been worked out by a joint committee). Once again, Morse issued a pamphlet rejoinder. Ultimately, the National Academy would prove the more durable institution. The elderly Trumbull resigned as president of the American Academy in 1836, and a few years later it ceased to exist.*

Samuel F. B. Morse, Academies of Art: A Discourse *(New York: G. and C. Carvill, 1827).*

GENTLEMEN OF THE ACADEMY,

The occasion of our first anniversary furnishes me with an opportunity, which I gladly improve, of explaining to you more at large the nature of those institutions among which we have lately ranked ourselves . . .

We find that all these Academies bear a strong resemblance to each other in their *origin* and in their *most prominent features.*

First: With scarcely an exception, *Artists were the first movers in the establishment of the European Academies of Arts.* This was the case in Florence, in Venice, in Paris, in Madrid, and in London. In *all cases their entire government is entrusted to Artists* . . .

Second: Another prominent feature in all of them, is *Schools for the Students of the Arts,* where not only models and materials are collected for their use, but where they are instructed by the most distinguished artists of the country composing the Academic Body.

Third: Intimately connected with this instruction, a system of *Premiums to incite the students to industry and emulation,* is another prominent feature. To this *all the Academies, without exception, have attached the greatest importance.*

Fourth: Another principal feature, common to all, is *an Exhibition of the works of living artists;* and although respectively modified, in regard to time of exhibition, and to terms of admission, according to the peculiar circumstances by which each is surrounded, there is no evidence that they are composed of any other than the recent works of the artists of the day.

With these examples before us, we formed, more than a year since, our National Academy of Design, and on similar principles. We have incorporated into its constitution those features common to all Academies of Arts. It has been created by the union of most of the principal artists of the city. Our constitution provides for the establishment of the various schools. Our very limited means has allowed us, as yet, only to establish our School of the Antique; and thus

far, unaided from without, (except by the generous, but temporary loan of a room for the school by the Literary and Philosophical Society,) we have sustained this school from the beginning to the present time; we have been enabled to give instruction, *gratuitous instruction,* to about 30 students. Two courses of Anatomical Lectures, illustrating with ability this science as connected with the Arts of Design, have been delivered by our Professor of Anatomy, and the students universally have made laudable progress in drawing, the common grammar, or basis of each of the Arts of Design. With respect to the third feature of Academies, viz. *Premiums,* early in the season, we put into operation this essential part of our plan. The subjects for which they were offered, are adapted to the incipient state of the school, and consequently belong to the lower classes of premiums. We have reserved for a more mature state of our institution, and for works of a higher order of Art, the larger and more valuable prizes.

The plan of *Exhibitions,* as it exists in the English Royal Academy, is that which we have adopted, as better suited to our state of society than those of the Continental Academies . . .

We have taken the English Royal Academy for our model, as far as the different circumstances of form of government and state of taste will admit. It is the most flourishing of all foreign Academies; it has among its members a great variety of talent, embracing all the numerous departments of Art in their most minute subdivisions of subject, and the Annual Exhibitions display a rich and diversified feast to the refined portion of London society . . .

From the facts laid before you, gentlemen, you perceive the course which we must pursue to attain the same noble ends. It is a truth which cannot be too often enforced, and one which each of us should constantly bear in mind, that our *individual prosperity depends on the prosperity of the whole body.* I need not descant to you on the necessity of union, as an indispensible requisite to success. Not only is all history admonitory on this point, but the history of the arts in Britain is especially full of warning to us: their progress seems to have been accelerated or retarded in exact proportion to the prevalence or absence of harmony among the artists themselves. We have felt the beneficial influence of this harmony; and I feel confident that the good which has already resulted will stimulate us all to preserve with care, and to increase this happy disposition. Let no selfish, narrow views interfere with those of a more enlarged and liberal character which we desire to accomplish . . .

We also shall have difficulties to contend with, some peculiar to ourselves, others similar in character to those of our transatlantic brethren; they are the diseases to which infant Art is subject; they must be borne, and with as much patience as possible. But why do I speak to you of difficulties? They are the glory of genius, without which its energy and its brilliancy would pass unnoticed away, like the electric fluid which flows unobserved along the smooth conductor, but when its course is thwarted, then, and only then, it bursts forth with its splendour, and astonishes by its power. Difficulties will yield to perseverance. We must not look for sudden changes in the public mind. They are not to be desired; for they will be as transient as they are sudden. The natural progress of taste in Art is gradual: its advance is slow—urged onward by the constant action and reaction of the artists and the public upon each other, of the works of the former, and the demands of the latter. It is through our Academy, but more especially through our Exhibitions, that the concentrated labours of the artists of the country can be brought to bear upon the public mind: it is here can be seen, as in a mirror, the state of the general taste . . .

In this connexion I cannot forbear a remark on the question of the expediency of an Artist's studying his profession in Europe. However desirable this course may appear on many accounts, especially in its influence on his own real improvement, it is attended with many and peculiar

trials to him who returns to practice his profession at home. Unless he possesses great firmness of nerve, great self-denial, and a share of public spirit that belongs to few individuals in any class of society, he will scarcely be saved from misanthropic seclusion and despair. If the artist improves by his increased advantages abroad, is it not natural that he should outstrip in knowledge the public he leaves behind? When he returns he finds a community unprepared, however they may be disposed, to appreciate him. He has unfolded his powers in a society where the artists, and those that encourage them, have proceeded onward together to a far advanced point in the march of taste; but he comes back to a society which has scarcely begun to move in the great procession; and he sees before him a long, long track over which he has once successfully passed, all to be travelled again, and the whole mass by which he is surrounded must also move with him, ere he reaches again the spot he has left, ere the enchanting prospects which began to open upon him can again be enjoyed. The country may indeed be the gainer by his acquirements, but it will too often be at the expense of the happiness, perhaps of the life of the artist. The soil must be prepared at home. Our own sun must warm into life the seeds of native talent; they must not be planted in a more genial climate until they spread out their blossoms, and promise their fruit, and then be plucked up and replanted in the cold and sterile desert; they will perish by neglect, or be deprived of the nourishment and warmth which is their right, by some pretending weed that springs up and overshadows them. No! the artist may go abroad, but he must not return. He will there show the fruit of American genius fair among the fairest productions of foreign culture, and he will adorn the page of his country's history with a name which future generations will delight to pronounce, when they boast of their country's genius; but he must not return!

One word, before closing, on our responsibilities to the public. We hold a station in which we cannot be neutral. Our Academy of Arts must have some influence upon public morals: we may be of essential aid to the cause of morality, or we may be an efficient instrument in destroying it; we may help to elevate and purify the public mind by the dissemination of purity of taste, and raise our art to its natural dignity as the handmaid of Truth and Virtue, or we may assist to degrade it to the menial office of pandering for the sensualist . . .

If our course is marked with prudence; if, with the desire in our sphere of promoting the general good of society, we preserve our art pure at the fountain in morals and in taste, we shall enlist the affections of our fellow-citizens. Our difficulties will disappear. We shall receive their support; and our Academy having outgrown the weakness of its infancy, and gained strength by the gradual accession of public favour, will eventually become an ornament to the city, and to the nation.

"Article X," North American Review 26 (January 1828).

We hope the name which this Society has assumed, may be found hereafter more appropriate than it appears now. A *National* Academy may be understood to mean a public institution, founded and supported by the nation, or a private association of the first artists of a country. This Academy is of neither of these kinds. It is simply a society of artists in the city of New York, organized for the purposes of exhibition and instruction. As such it is a respectable and praiseworthy beginning; and as we heartily wish success to such an undertaking, we regret the more that they have made so great a mistake in the selection of their name. To call themselves *National Academicians,* is making a claim of distinction which, we must say, is out of proportion to their merits. Nor do we think it is quite time for them to adopt the initials of their institution as a standing title. The N.A. would do very well in the catalogue of their own exhibi-

tions, to distinguish the works of its members, but we find it affixed to their names in that of a private collection, given in a note to this discourse. This, though a trifle, seems to us very ill judged. The practice has been tolerated only in Societies, which have established some reputation; and even in those cases, it is a vanity of which their members begin to be ashamed. What would be thought if Mr Stuart should choose to call himself National Portrait Painter, or Mr Allston should take the style of National Historical Painter, and write accordingly after their names, N.P.P. and N.H.P.? Yet they would but be claiming the rank which others yield to them; while the name of National Academician is as inappropriate to some of those, who have dignified themselves with it, as it is injudicious in its application to the best.

It is unjust, moreover, to the reputation of the country. A foreigner could not be much blamed for judging of the state of the arts in America by the National Academy established in the first city of the Union. Nor could he be expected to examine very carefully by what right such a name is borne by this Society. Yet the Academicians could not be willing, that their works should be thought by strangers among the highest efforts of American art. They have given themselves a name, which means, in the common use of language, the great institution of the United States for the arts of design. What may happen hereafter in this particular, we pretend not to foretell; but at present this new Academy comes somewhat short of deserving such a title.

Mr Morse's Discourse is short and appropriate to the occasion. It consists of a very brief sketch of the origin and constitution of the principal academies of arts in Europe, with remarks, chiefly contained in the notes, on the state and prospects of the arts in this country. We cannot agree with the author in all these remarks. Some of them seem tinctured with a degree of dissatisfaction and jealousy, for which we think there is no occasion. He complains bitterly of the practice of buying old pictures, as tending to the neglect of living merit; insists on the inexpediency of any but professed artists intermedling with the government or direction of academies; and deplores the hard fate of the American artist, who, after cultivating his art in foreign countries, returns to find his own so far behind him in taste, that he is doomed to starve in unmerited neglect.

This is all unreasonable and mischievous. We call upon facts to bear witness for us, when we say, that our artists suffer neither from the neglect nor the interference of others. Not one of them, who could maintain any reputation in Europe (we mean well earned and tried reputation, and not that very precarious one of being a very promising young man), has lost it by a return to America. There is no undeserved preference for the works of old or foreign painters, and no want of patronage for those of our own. We do not pretend to know all the artists of the country, but we take such an interest in the arts, that we think we have heard of all the good ones; and, as far as our information extends, we say, that they have nothing to complain of. The source of the mistake and disappointment of others is this; our artists do but begin their education in Europe; they are sent there as soon as they discover the first symptoms of genius, and before it is well ascertained whether it is worth while for them to go. There they seem at first to be making prodigious advances (for in art, it is not the *premier* but the *dernier pas qui coute*), and, either from impatience or necessity, they hasten home to enjoy prematurely the fruits of their studies. In so doing they underrate the taste of the country, as it is natural enough they should, having left it before their own was formed. Besides, it is so much easier to learn to judge rightly than to paint well, that even with less opportunity, our judgment may at least have kept pace with the progress of their skill. A taste for the fine arts is but of recent, and has, therefore, been of very rapid growth among us. It is quite as likely, therefore, that the young artist, while learning his elements by a short stay in Europe, should fall behind, as surpass the taste of his

countrymen; and it is equally natural, that if there be any interval of separation between them, he will consider himself most in advance . . .

Something in the same spirit, Mr Morse deprecates the intervention of any but professed artists in the management of academies. We doubt whether he is right in this. We are inclined to look on this exclusion, as one cause of those bad effects, which he admits to have proceeded from ill-constituted academies. It tends to the formation of a school; which is little else than a system of errors and deviations from that imitation of general nature, which cannot be too exact even for ideal beauty; there is but one nature, and there can be but one true way of painting. Artists may differ, indeed, in their choice of subjects and circumstances; but independently of these, their peculiar manners are chiefly their peculiar defects. Yet it is exceedingly difficult, in the examination of nature, to overcome the prejudices of a favorite system of art. In the same scene, one painter will see nothing but light and shade, while to another it will seem full of color. Fuseli, no doubt, thought he was painting naturally, when he imitated humanity so abominably; and his students, if they had been confined to his instructions, would have learned to see in nature the contortions and extravagances of their master's imagination. But the fact, that the defects of great masters are apt to mislead learners, is as obviously true in painting, as in everything else. And it can hardly be doubted, that, if academies exercise any influence, those under the sole direction of artists will be more likely to sanction and perpetuate their errors, than those which admit in their government connoisseurs, who may be, at least, more impartial judges of nature than her professed imitators. But even if this be not so, the exclusion is impolitic. Artists cannot establish themselves in defiance of that portion of the public, best qualified to judge of their works; nor hold themselves entirely independent of those, who support their exhibitions, and buy their pictures. It is essential to their success, that they should inspire others with a love of their art, and diffuse as widely as possible the taste necessary to enjoy it. These associations are highly useful in this way, if they are freely opened to all who are desirous of promoting their objects. But if the direction of them is, by the jealousy of artists, confined to their own number, others will soon be weary of their share in establishments, where taxation and representation are so little united . . .

If good American paintings were left unsold, because others of less merit were bought, or for any other cause, we would join heartily in censuring such illiberality. But the fact is not so. The real want in America is not so much of good patrons, as of good painters; and we doubt very much whether Mr Morse could tell us of a single good, not comparatively but absolutely good artist in the country, who does not, or might not by industry, receive a compensation for his labors in full proportion to that gained by other professions. We know of no good pictures left unsold. And if it is supposed, that we ought here to be content with a less degree of merit, and buy pictures which could not be sold elsewhere, we think it is a great mistake. Why should we do so? It would improve neither the taste of the public, nor the skill of the artists, but degrade the one, and retard the other. To spend money in 'employing the humblest artist in the humblest way of his art,' is encouraging national genius, just as much as paying an honest painstaking tinker for spoiling his work, is encouraging national ingenuity. If the artists could do better elsewhere, they would not stay here for the pleasure of complaining; if they could not, they have no cause to complain . . .

The subject on which our artists most need to be admonished, is the cultivation of the mind. Their great deficiency is a want of vigorous and poetical conception. The mechanical process of drawing and coloring is often well done, but the mind seems not to contribute its share to the work. It is owing to this, that so many have failed to redeem the promise of their youth. From

the number who have made good beginnings without instruction, it has been thought, that there was a peculiar talent for the arts in the Americans; but most of these were but examples of that mechanical ingenuity, which certainly is a general characteristic of the people. It may be difficult to convince the artist of this deficiency of mind; but let him place a landscape, for example, of almost any of the living painters by the side of one, of the old masters. He may find the drawing, coloring, and perspective as good, and perhaps better; but the difference between them is, that one is the work of the hand only, the other of the imagination; one shows, perhaps even with less skill in the execution, and often in spite of injury and decay, a fine creation of the mind; the other is a dull copy of what happened to be before the artist, or a composition of commonplace and unmeaning objects. The parts of one seem selected to fill the canvass with picturesque forms and colors, those of the other chosen for the ideas and feelings they are adapted to convey. The difference is like that between poetry, and mere musical verse.

It is natural that as excellence in composition declines, it should be replaced by mere ingenuity; but the attention that is now paid to execution in painting, seems to us to have acted also as a cause in degrading the art. Success in that is comparatively so easy, and satisfies so many minds, that the attention of the artist is drawn from the more laborious task of invention. The common course of study too, gives an undue importance to mere skill of hand. It is all that can be taught by a master, and those who study under distinguished artists, are apt to be content with what they learn of them. This is one bad effect, which we may attribute to all academies. They can but teach the form and manner of the art, and they attach so much importance to them, and reward excellence in them with so much distinction, that the student forgets there is anything else to be acquired . . .

While we speak thus cautiously about the present claims of our artists, we would by no means be thought indifferent to their success. We should be sorry, if anything we have said should in the least abate the liberality of the public towards them. They must be supported and encouraged now, or we can expect no improvement from them. All we mean in the way of caution is, that this encouragement be governed by discretion; and that it be understood as a stimulus to future efforts, and not the reward of present excellence. We have endeavored to repress what seems to us a repining disposition, founded on an overestimate of their actual claims; but we would not be understood to say, that their rewards are beyond their merits. We have felt the more urged to the remarks we have made, because we thought that complaints like those contained in this 'Discourse,' coming from an artist of so much reputation and merit as Mr Morse, at the head of an institution which must exert a considerable influence on those within its immediate neighborhood, might have, if uncontradicted, a most discouraging effect on the younger artists.

GROWING POLARIZATION

The National Academy of Design flourished in the 1840s, and its annual exhibitions became important social events. The flavor of this period, when artists were cultural lions, is captured by the transcripts of toasts made at the opening of the 1851 exhibition on April 5. There were several dozen toasts given that evening, beginning with an upbeat oration by the Academy president, Asher B. Durand (see also "Asher B. Durand Formulates the American Landscape," chapter 4). The speechmaking lasted over three hours. Included here are the tributes given by Jonathan Sturges, a wealthy collector and champion of American art, and Henry Whitney Bellows, the Unitarian minister of the First Congregational Church of New York City. Even in the context of toasts, the

flattery of the artists is extreme. Both men speak to the religious mission of art, but they also remark that artists are "not like other men," "elevated above the level of ordinary men." "I love and respect artists," admits Bellows. "I love even your eccentricities," declares Sturges.

However, it was not always easy to be "the only game in town," and by its third decade the National Academy had begun to be seen by many as staid, insular, and complacent. The second and third essays below are part of a tradition of regular institutional critique of the Academy. Such complaints would continue through the latter half of the nineteenth century. Several themes are sounded: the inability to mount a viable school, unfriendliness to younger artists, meager temporary quarters, and a sameness to the annual exhibition year after year. The writer in Putnam's Monthly *creates a particularly vivid picture of the modern world—railroads, clipper ships, penny papers, calico factories, and the telegraph—in which the high art productions of the Academy seem to have no place.*

"Art and Artists in America," Bulletin of the American Art-Union 4 (May 1851).

Mr. Sturges then responded to the toast of his health as follows: . . .

The thought has often occurred to me, Mr. President, when, year after year, you have opened your beautiful exhibitions to us, What is the object of these exhibitions? Certainly not merely to show the pictures as a sort of advertisement of the artists who paint them. The first inquiry of a wise man is—What ought to be the leading object of my life?—the second, How shall I best accomplish that object? There seems to be quite a diversity of opinion as to what should be the leading object of an artist's life. The opinion was strongly urged in a lecture delivered in this place, a few weeks since, "that it should be no part of an artist's object to teach either morality or religion; and all the pictures, from the earliest history of the arts down to the 'Voyage of Life,' which have been painted with that view, were consigned to utter contempt. An artist should give form to those images of truth and beauty which are impressed upon his soul, without reference to the effect his works are to have upon others. This everlasting struggle between virtue and vice was deprecated as being unnatural. What the spirit of man wants is rest, and to be let alone." I think there is just truth enough in this view of the subject to make the error which is mixed with it dangerous. This everlasting struggle between virtue and vice, and between truth and error, is not an unnatural state, and it will never cease until the nature of man shall change. I know that the spirit of man seeks and longs for rest. The idea is beautifully expressed by that sweet songstress, whose return we hope soon to welcome, whose name I need not mention:—

> In vain I seek for rest
> > In all created good,
> My heart is still unblest,
> > And makes me cry for God;
> At rest, be sure. I cannot be,
> Until my heart finds rest in thee.

She is one of you, though God has given her a different method of showing the soul that is in her. Gentlemen of the Academy, I believe your beautiful talent has been given you for some great purpose, and that you can never rest until you have fulfilled the mission upon which you have been sent. (Cheers.) I never meet you, or associate with you, without feeling that you are not like other men. I love even your eccentricities. I consider it a privilege to be your friend.

(Great cheering.) Therefore am I anxious that you should do great things, that you should cultivate great thoughts, and study to place them in the most effective way before the people. (Hear, hear.) You must not paint merely for the love of it. You must paint to soften, to refine, and to humanize your fellow-men. I believe this to be the great object of your art, and I believe this should be the great object of your exhibitions. Gentlemen, you have done well: I congratulate you—you can do better.

The President then gave—
"Religion, Science, and Art—The Trio that constitute the perfection of humanity."

Rev. Mr. Bellows, being called upon by many voices, said:—You kindly ask me to respond to this sentiment. My only claim to do so is a loud voice. It is a sentiment of all others most needed on this occasion and occasions like this. The great obstacle to art here, is that which makes it succeed in other countries—an obstacle that retards the growth of religion as well as art; it is the prosperity of the country—the fascinations in house-building, moneymaking, the imitation of fashion, the indulgence in public amusements and physical enjoyments. There is no place in the world where it is so difficult to cultivate the beautiful plant of art as in the rich, material soil of America, and nowhere does it require more cultivation, as a medicinal plant, to correct the rank fertility of the country. Evil, indeed, must be the consequences, if these twin sisters—religion and art—do not influence the social condition of our people. They are contending with a tremendous sea of materialism, and, like stout swimmers, they are braving the waves, and are destined to reach the shore in safety. (Great cheering.) I have learned an important fact since I came into the room. This institution was in danger—in debt. Who saved it? Was it public taste and philanthropy? No; it was the artists themselves who came forward to give their pictures—the children of their brains—to the value of $2000, for the purpose of upholding this institution for the benefit of the country. (Much applause.) This generosity I wished to mention, to the honor of the poor artists. Poor did I say? Poor in material wealth, but rich in every good work. I love and respect artists. I owe to them the best social hours of my existence. They are elevated above the level of ordinary men; they are the salt of the earth—an important spiritual influence to counteract materialism. Christianity itself appears to be founded upon art. If I rightly remember, it was Mahomet who forbade that there should be any representation of any living form—particularly the human form. He gave as his reason that in every human body there was a soul, and as the painter could not represent the latter as well as the former, his art was but a mockery. Mahomet must have had a very poor idea of art, when he thought that the human soul could not be put into a human form by the art of the painter. (Laughter and cheers.) If he were here to-night, and looked around upon these walls, he would change his opinion. (Great applause, and cries of "good.") The Academy had done well before. It has done better now. May we not hope it will do still better in the future? (Cheers.) Some say that we have not excelled in other departments of the art as we have in portraits. This, however, is just the best portion of the art—that which we ought most carefully to cherish. It is intimately connected with the domestic virtues; and let us not have any Mahommedan notions in relation to it. (Laughter.) It is the art that brings back the forms of those we loved in private life, and of those who were the most valuable and esteemed members of the community.

"National Academy of Design," New York Tribune, *May 1, 1850.*

Art cannot thrive under the dispensation of indiscriminate praise, whether dictated by ignorance, bad taste or personal partiality. Artists are not benefitted nor the public instructed by

criticism, unless it breathe a manly sincerity, and too earnest a sense of the worth of Art to judge its products by any low standard. Especially is this the case in a community like ours, where Art is in its infancy, and the mass even of cultivated people have not had the benefit of that discipline which is derived from frequent enjoyment of great works, and familiarity with indisputable excellence. Here, in respect of Art, all is in the process of development; the work of education is at best not far advanced, and the National Academy is, or should be, the great educator. It ought, then, to be held up to that mark, and they who seek its welfare must not only exercise a genial appreciation for what is good, but an uncompromising severity toward everything prominent in its productions that is not good. Undoubtedly, the latter is not always pleasant; the honest critic would much rather express his delight at genuine Art, than pronounce condemnation upon its opposite. And yet the harder office is often much the more necessary. A few pretenders, who have succeeded in palming themselves off as men of knowledge and genius, may do more injury to Art and to the public taste than the works and silent influence of fifty competent artists, who have not yet been recognized at their real value, can counteract.

It is, we believe, no secret that the National Academy has for a few years past been in a rapid decline, which has proceeded so far as to cause the suspension of its schools, and seriously to threaten its existence. One cause has been the opening and great popularity of the American Art Union with its free exhibitions and its liberal dissemination of pictures, most of them indeed of very indifferent quality. In fact, we have heard that a profound misunderstanding has arisen between the two institutions, on the merits of which it is now none of our business to enlarge. We must, however, say that the difficulty ought not to have arisen. There need be nothing like competition or rivalry in the cases. And had the Academy been actuated by an active and generous spirit we are persuaded there would have been none. The trouble was—we speak without reserve, for there is good to be done by it—that it had become a close corporation, controlled by a very small number of persons, and so congenial to their private wishes that they did not mean to give any chance for opposition to their management. Meanwhile, there had grown up a generation of younger artists, full of energy, aspiration, talent, industry and knowledge, and every way worthy of a share in controlling the destinies of the Academy. Denied this by the narrow jealousy of the old incumbents, they were unable to do anything toward keeping the institution up with the times, and accordingly it lagged desperately behind.

In this declining state, the Academy became at last roused to the necessity of making an effort to regain its lost position, and render its exhibitions again attractive and profitable. Deliberations were held by its members and directors, but as far as we understand, no radical difference in its policy was determined on, no step which should raise it to the dignity of a real "Academy"—of an institution designed to instruct a people in the knowledge and love of Beauty. A few new members were admitted, and as the tide of fashion was setting up town, it was thought advisable to procure new and more accessible rooms in that favored region, and that was all. After the failure of several plans, three gentlemen came forward, bought a lot on Broadway, loaned money to erect a building, and allied themselves by pecuniary and other ties to the interests of the Academy, and of the Fine Arts in general.

Here, then, we find the Academicans and Council with the means placed in their hands, and full liberty to exercise all the judgment and taste they could combine, in erecting a building at once agreeable to the eye and adapted to the uses of the institution. What have they done?

It certainly is not much to expect of a Society of Artists, which has been in existence a quarter of a century, that their building should be distinguished by outward beauty, and some indication of its origin and purpose. The beholder might look for a granite front; a door-way arched

and supported by columns with carved capitals; on either side niches with sculptured figures each emblematic of Art and Liberty; under the long windows a series of bas-reliefs representing the sister arts, Architecture, Sculpture, Painting and Music and higher up, below the massive cornice, a sculptured frieze representing the history and progress of the institution; with every projection rich and chaste with carving and varied ornaments so that each passer should stop to gaze upon the beauty of the edifice and learn its object. All of this might have been there; something of it, at least, we have a right to expect there. But instead of it what do we see? Nothing but a front of plain red bricks!—It will be said that no more than this was possible with the twenty odd thousand dollars the Academicians had at their disposal, and that is true. But had they entertained a just idea of what the Academy should be, had their views been equal to their position, there need have been no lack of funds for an edifice worthy of such a purpose.

But enough of the exterior; let us enter. Venturing beneath the single huge glass lantern that lights the door, and on which the practised eye might expect to behold the word "Oysters," or "Coffee-House," and through a long, narrow, mysterious passage way, we mount the stairs; but before entering the exhibition-rooms we will notice three studios which are in the upper story front, and were designed expressly for artists, for painters. There is now a great lack of good studios in this city, and it is matter of some interest that good ones should be provided; of course, any arranged by the Academy ought to be perfect. Every artist understands the advantages which always result from a properly constructed room and a good arrangement of light. But your expectations are doomed to disappointment by these singularly contrived attics; and considering that it need cost no more to have had convenient rooms and good lights than it has to have these miserable ones, one must at least feel sorry that they should have been spoiled by ignorance or indifference.

The Exhibition Rooms, as far as their distribution goes, are very well, but the arrangement for lighting them is surprisingly bad and inefficient, and that with the means of having it excellent. Such a thing is unaccountable. There certainly is, or ought to be, judgment and taste enough in the Institution to prevent such worse than blunders. The question then is, Why they were not called into requisition on so important an occasion, when the future prosperity of the Institution was at stake? It looks as if the malign influence to which we have before alluded were still supreme in its affairs. This is a time when success should by all means have been secured, when every private purpose should have given way, the rooms and lights should have been prepared by the most judicious taste and skill, every disposition for artistic and picturesque effect made as perfect as possible, the pictures hung with consummate discretion, and thus the general appearance and arrangement would have impressed with delight not only the public at large, but those who are competent to pass decisive judgment on such matters. But we regret to say that all this has been done badly, very badly, so badly that no known rules and principles are sufficient to explain it.

"Fine Arts," **Putnam's Monthly 1 (June 1853).**

An inspection of the catalogue and a walk through the galleries of the Academy do not excite the highest state of enthusiasm in the lover of "high art," but produce quite a contrary effect. It is a sad truth, but it cannot be helped. Every thing in the New World appears to be progressive; but the art which, by common consent, is called "fine." That, it cannot be denied, is anti-progressive. If it takes no rapid strides backwards, it at least stands still. It is an instructive fact that, on this Twenty-eighth Anniversary of the National Academy of Design, there are no greater promises of progress than there were on the first opening of the Academy in Chambers-street,

in the small chamber above the bath-house, which is now a theatre. The city has more than quadrupled in population, wealth, and refinement, since then; millions of dollars have been expended on artistic productions; a revolution has been effected in our social habits; innumerable "first rate notices" of our artists have been written in the daily papers; hundreds of young painters have been sent to Europe; Art Unionism has grown up and declined; merchants' houses have expanded into brown-stone palaces; ocean steam-navigation has been perfected, clipper ships invented, Gothic architecture has been revived, the Croton aqueduct constructed, the railroad system introduced, fresco painting, and painted windows have come into fashion once more, the Italian opera has become a permanent institution, penny papers have sprung into existence, "pictorials" have become common, the electric telegraph has been discovered, and all the arts that embellish life and add to the pleasures of Christians have been marvellously expanded among us, but the National Academy of Design has stood still while the rest of the world has been rushing forward with breakneck rapidity. It exhibits hardly more, or better "works" now than it did twenty years ago.

It has designed nothing. It has given us no architects; the splendid mansions which have grown up all around us, with their richly sculptured fronts and decorated walls, were not designed by "academicians" . . . It was the first president of the Academy, to be sure, that invented the electric telegraph, but that was not a design which the institution had in view when it was founded. Looking upon the progress of the country in true art, upon its splendid achievements and rapid growth, we cannot detect the influence of our National Academy upon the brilliant period in which it has existed. Among its members are some very clever painters of landscapes and portraits, but the works it has produced have been mere toys in private houses—family portraits and pleasing little landscapes, which are hung up as ornaments in darkened parlors, and with which the nation has no more to do than Patagonia or New Zealand. The Academy, we cannot avoid thinking, is an injury rather than an aid to art; it deludes amiable young men of talent with false theories of "high art," and leads them away from profitable and honest employments, to a sad and wearisome waste of life in the vain attempt to do things which the age does not require, and they have not the ability to accomplish. The days of the pre-Raphaelites may return, but the days of Raphael never. If Raphael and Michael Angelo were now alive—and, for that matter, there is never a lack of Raphaels and Michael Angelos—they would not devote their lives to painting pictures and hewing statues. They would compose operas, write books, edit newspapers, or build ships and houses. They would not give themselves up to a work which nobody would reward, and then go about whining because they were neglected. Raphaels and Michael Angelos never are neglected.

But there are good fellows among our academicians, and their supper on their opening night was a much better one than ever Rome saw in the days of Leo X. The old masters never served up such an entertainment to their patrons and the "gentlemen of the prose," in the palmy days of high art.

We had no idea, when we begun, of discussing the prospects of Art, or the influences of the Academy; all that we intended was to notice the pictures. But on casting our eye over the catalogue, the strange fact suggested itself that this exhibition was like all the other exhibitions of the Academy; there are the same names, the same subjects, the same number of works, and the same sameness of style. We only miss the "portrait of a lady—Ingham." Why has not Ingham a portrait of a lady in the Exhibition? "Does he think it time to quit, after Exhibiting twenty-seven years." But why? there is still the "Landscape—Durand." The same birch tree, the same yellow sky, the same amiable cattle, the same mild trees and quiet water. What a mild, quiet,

and amiable world is this to Durand! It would be a curious study to examine all the catalogues of the Academy, and see how nearly the whole of the twenty-eight pamphlets are alike . . .

They knew nothing of such landscapes as those of Church, Kensett, and Durand in the days of Michael Angelo, for then Art worked in a higher province than that of the mere ornamentalist. Pictures were then painted for the masses, and the artist was the instructor of the people. He embodied upon his canvas, and in his marble, great religious ideas, and made popular the legends of the Church. Our artists cannot do such things. We have no legends, and, what is worse, we have fifty different religions. The people are taught in a different manner, and we do not quarrel with the Academy for not filling its walls with broiling Saints and flayed Martyrs, but because they will persist in a hankering after such things when they are no longer needed.

The Madonna now is *de trop,* in our houses and public places, yet our artists will persist in painting her, when neither they nor their patrons have any longer faith in her. Before Guido went to his easel, he first fell upon his knees before the Madonna della Guardia, and put upon his canvas the image which the little black figure left upon his devout imagination. Our artists cannot do that, but they can go into the dark woods, among the breezy hills, and by the sea side, and reproduce for us the pleasant effects of sunlight and shadow which they see there. It is a good thing to do, and the pictures are good things to have; but they are, after all, mere ornaments of our parlors, and the artist becomes merely a decorator, and not a teacher. If, therefore, the Academy would but tell its acolytes that to be useful men and good citizens, to be good providers for their families, and to give themselves comfortable positions in society, they must abandon all the fol-de-rol which they have been accustomed to hear and read about "high art," and be content to fulfil their true mission, without looking for any other commissions than such as upholsterers, silversmiths, and pastry-cooks receive from the opulent and liberal, they will have a much better time of it than they now have, or are likely to have. An excellent artist, intelligent, skilful, industrious, and amiable, told us, and seemed rather to think he was telling something of which a man of his abilities ought to be proud that, if it were not for the assistance of a kind friend he should starve. They won't buy my pictures, said he; then why not paint such pictures as they will buy, or go into some other business that will give you bread and butter. He only shrugged his shoulders in reply, and felt, we have no doubt, great contempt for our opinions. Yet there we were admiring one of his large pictures in the "high art" style, and he had recently returned from Italy.

What a confession was this from a man of his abilities and acquirements, while waiters in hotels and private coachmen were striking for higher wages! Here is a man who cannot obtain the wages of a flunkey in executing works of high art, while pastry-cooks get the wages of Ambassadors, and Barnum and Beach are advertising for artists to make woodcut drawings for their illustrated paper. It was no wonder that George the Second said, "If beebles will be boets and bainders, let 'em sdarve." Let our artists remember that this is the age of Clippers, and turn their talents into a channel that will pay. It is really one of the saddest spectacles to see so much good honest effort, so much genius, perseverance, and intelligence thrown away, as the Annual exhibition of our National Academy exposes to public gaze. Let the Academy institute a wood-engraving department, a glass-staining department, an architectural department, and a calico-designing department, and Art will flourish here as it did in Rome in the days of Leo X., and as it now does in France in the days of Napoleon III.; for art, literature, and science are nought unless they minister to the public needs and conform with the popular taste. It is now some six years since a most strenuous and encouraging effort was made by an association of our mighty men of wealth, to establish a New-York Gallery of Art; meetings were held, oysters eaten, and

champagne drunk according to the most approved methods; resolutions were passed, and committees formed, and one wealthy enthusiast swore the oath of Uncle Toby that the project should succeed. But it has not succeeded, and the pictures which were to form the nucleus of the great gallery, which was to be the Louvre or Vatican of the New World, are now lying in a very nucleus condition in some dusty chamber of which the world knows nothing and cares less. What of it? were not the mighty men of wealth in earnest? Of course they were, or thought they were; but they lacked the co-operation of the very public, for whose benefit they were laboring, and, therefore, all their oaths, oysters, and efforts came to nothing.

But, since then these very men have built the Erie Railroad at a cost of thirty millions of dollars, and engaged in other great undertakings for the public good, besides increasing their private fortunes, so that they may well be forgiven for not giving us a gallery of paintings. They might as well have attempted to build a pyramid in the style of King Cheops. Picture galleries, pyramids, and railroads, were never intended for the same people and the same century. If we have one we must forego the other, and we are sensible of our good fortune in living in an age which gives the preference to railroads. There is abundant scope for the artistic genius of our people, and rich rewards in store for all who have the good sense to employ their talents in meeting the demands of our countrymen. We send hundreds of millions of value to Europe to pay for works of art which had better be expended at home; and it only needs that the Academy, or some other well-meaning institution, should clear away from the atmosphere of Art in this country the mists of old fogyism, to make us as preeminent in decorative art as we are in the arts of government and ship-building. It is a disgrace to us that all our public buildings which are worthy of notice have been planned and decorated by foreigners. Our National Academy of Design should retrieve itself by designing a calico pattern, the steeple of a church, or the façade of a dwelling-house.

It would surprise a foreigner, we imagine, who should come to New-York and see the prodigal expenditure of our men of wealth in building houses and churches, on going into the Exhibition of the National Academy of Design, not to find a single architectural drawing, nor any indications that we make use of more ornamentation in our dwellings than any other people in the world. It strikes us that the Academy either ought to do something to justify its name, or else abandon it, and call itself a society of portrait and landscape painters.

The American Art-Union

The American Art-Union existed for less than a decade, but its impact on American art was lasting. It was founded in 1844 as a reorganized version of a previously unsuccessful organization, the Apollo Association, and at its peak in 1849 had nearly 19,000 dues-paying members and an annual budget of more than $90,000 to spend on art. It distributed some 75,000 paintings, works of sculpture, and engravings to subscribers around the nation (fig. 3). For several years, it also offered a "Free Gallery" in New York City where any citizen could study hundreds of constantly changing American paintings, an opportunity to be found nowhere else in the country. Among other accomplishments, the American Art-Union catalyzed an entire generation of genre painters, who would have otherwise had fewer opportunities for sales (the membership was particularly fond of such storytelling works of art). Similar organizations were created in Philadelphia, Cincinnati, and Boston. Nevertheless, the Art-Union had its detractors, including writer Nathaniel Parker Willis and James Gordon Bennett's New York Herald. Opposition mounted in 1851, and the following year the New York State Supreme Court

issued a ruling that the Art-Union was an illegal lottery, a violation of an antigambling statute. This brought to an end the nation's most successful effort to disseminate fine art to a broad population.

The group of documents featured here includes the American Art-Union "Plan," which details the organization's procedures, as well as excerpts from its monthly journal, a benefit for all members. In several essays, the Art-Union leadership endeavors to justify its efforts and defend itself from public criticism. The language seems unusually honest—on several occasions the authors admit to the view that much of American art is simply not as good as similar European works.

There is also some uncharacteristically plain speaking regarding their difficulties with artists. Included is a sample letter to an artist informing him that recent work submitted is poor in quality, as well as several sections from a review essay with very specific instructions to landscapists on how to compose their paintings. Such confident pronouncements from laymen cannot have been easy to read for the artists, and the next essay, by figure painter Miner Kellogg, gives a sense of the pique the Art-Union engendered in some corners of the professional community. Other artists, such as Lilly Martin Spencer, never recovered from the economic blow of the loss of patronage; she details the hardships resulting from the demise of the Art-Union in a letter to her parents (see also "Lilly Martin Spencer: Making It in New York," chapter 4).

Statement of purpose from American Art-Union Catalogue *(New York, 1848).*

<div align="center">

THE

AMERICAN ART-UNION,

IN THE CITY OF NEW-YORK,

WAS INCORPORATED BY THE LEGISLATURE OF THE STATE OF NEW-YORK

FOR THE

Promotion of the Fine Arts

IN THE UNITED STATES.

</div>

It is managed by gentlemen who are chosen annually by the members, and receive no compensation. To accomplish

<div align="center">

A TRULY NATIONAL OBJECT,

</div>

uniting great public good with private gratification at small individual expense, in a manner best suited to the situation and institutions of our country, and the wants, habits and tastes of our people, the Committee have adopted the following

<div align="center">

PLAN:

</div>

Every subscriber of five dollars is a member of the Art-Union for the year, and is entitled to all its privileges.

The money thus obtained, (after paying necessary expenses.) is applied,

FIRST.—*To the production of a large and costly Original Engraving* from an American painting, of which the plate and copyright belong to the Institution, and are used solely for its benefit.

Of this Engraving every member receives a copy for every five dollars paid by him.

Members entitled to duplicates are at liberty to select from the engravings of previous years.

Whenever the funds justify it, an extra engraving or Work of Art is also furnished to every member.

Every member also receives a full Annual Report of the proceedings, &c., of the Institution.

SECOND.—*To the purchase of Paintings and Sculpture* by native or resident artists.

These paintings and sculptures are publicly exhibited at the Gallery of the Art-Union till the annual meeting in December, when they are *publicly distributed by lot* among the members, each member having one share for every five dollars paid by him.

Each member is thus certain of receiving in return the value of the five dollars paid, and may, also, receive a painting or other Work of Art of great value.

THIRD.—The Institution keeps an office and *free Picture Gallery,* always open, well attended, and hung with fine paintings, at 497 Broadway, where the members in New-York receive their engravings, paintings, &c., and where the business of the Institution is transacted.

"What Has the American Art-Union Accomplished?" Bulletin of the American Art-Union 2 *(October 1849).*

It is now apparent to all who examine the subject, that a mode has been discovered by which Art may be encouraged to a proper extent as liberally in an economical republic as in a prodigal monarchy. That great moving principle of civilization which has effected such wonders in its application to travelling, to commerce, and to the useful Arts; the principle of the combination of the limited means of many individuals to accomplish some great end, has been found to serve equally well in the promotion of painting, sculpture and engraving, and to be capable when carried out, of supplying to these as generous a support, as they have ever derived from crowned heads, or wealthy aristocracies. The Art-Union is now their steady and reliable patron. It expends a larger sum upon them than all other patrons upon the Continent united; and under its auspices the most ambitious and laborious enterprises in their several departments (with the exception perhaps, of fresco painting,) may be undertaken and accomplished . . .

Does the American Art-Union promote the development of artistic power? does it elevate the taste, and increase the knowledge of the people in matters of Art? We maintain the affirmative of both these questions. To the first of them we say, that the Association has already raised the compensation of artists for works of undoubted excellence, to the rates paid in Europe for similar productions, and is always a ready and willing customer for such works at the advanced prices. It has stimulated many to attempt a higher range of subjects, and to bestow upon their paintings longer preparatory study, and more careful and laborious execution than heretofore. It has brought into notice a considerable number of men of decided ability, who would have remained entirely unknown, or, at any rate, advanced with much less rapidity excepting for this assistance. Great injustice is constantly done both to the Art-Union and the Artists, by comparing the works of the latter, not with their own previous efforts, but either with the elaborate master-pieces of European schools, or with some fanciful standard in the mind of the critic. This comparison is well enough when the abstract merit of our own men is to be estimated, but when the question relates to the progress they have made from year to year, and to the worth of any peculiar influence under which they have labored, a fairer mode is to compare each man with himself, and the exhibitions of 1849, with those of works by the same hands in previous years. It will be found that those who speak most contemptuously of Art-Union pictures, are persons who know nothing of the history of Art in America. They forget that Genius has manifested itself here in many other departments, more conspicuously than in the Fine Arts—that at the time when our Society commenced its efforts, the American School (if it may be so called) showed but little vitality, excepting in landscape and portraiture—that the most, after all, the Art-Union could do, was to offer generous prices and impartial judgments—it could not create Genius, but only provide that Genius, if it existed, should certainly be discovered and as certainly rewarded. Few, indeed, are they who have taste and knowledge enough to entitle their opinions upon these subjects to respect. Many who have formed

their notions of native talent from the declamatory flourishes of public orators, look upon the best exhibitions of it with ignorant eyes and insolently pronounce that to be an evidence of decline, which is in reality a proof of advancement. Others who are fresh from European Galleries, where they have learned for the first time to understand Art, view with changed feelings the works of their countrymen, and ascribe to a falling off on the part of artists, the impression which in reality results from their own increased fastidiousness. Those more wise and enlightened persons, however, who have a just idea of the state of American Art at the time the Institution began to exercise any influence upon it, know well that without comparing it with the German or French or British Schools, there is still in its situation and prospects abundant cause for hope and for pride; that a very marked and general improvement has taken place in it since the period first named, and this improvement is the result in a great degree, of the action of the Art-Union. They can name the men who have delighted the country with their productions, and who have been materially aided and many of them entirely brought into notice by the judicious patronage of this Institution. LEUTZE would assuredly have made his distinguished talent known, whether this patronage had been bestowed on him or not, but his most partial friends will admit, that his progress here has been greatly accelerated by our commissions and purchases, our engraving of one of his pictures, and exhibitions of others, and the paramount place given to his name in many of our publications. DEAS, that brilliant genius of whose light we trust the country is not to be always deprived, first became known to fame upon the walls of our Gallery. BINGHAM acknowledges his indebtedness to us as the first patron of his higher efforts, and his main-stay in all attempts beyond the line of portraiture. BAKER, CHURCH, and KENSETT, owe their present distinguished position, in great part to the encouragement bestowed by the Committee. CROPSEY, GLASS, GRUNEWALD, HINCKLEY, INNESS, MATTESON, MAY, PEELE, STEARNS, WENZLER, and others, have been rapidly advanced by assistance from the same quarter. BURT and JONES and CASILEAR, the engravers, and WRIGHT, the medallist, are under obligations for the high stations they hold in their respective professions in a marked degree, to the liberal commissions given to them by the Society.

The instances are numerous in which artists have been enabled, solely through the judicious encouragement of the Art-Union, to leave portrait painting, to which they would otherwise have been obliged to devote their lives, and attempt higher professional walks. There is a student at present in one of the most distinguished academies of Europe, who is indebted to this Society alone for the means by which he has travelled thither and by which he will support himself while there—means acquired by the sale of clever and carefully finished pictures, but for which he might have waited for years before finding another purchaser. There are others now residing abroad and enjoying the benefit of the highest instruction, who derive nearly their entire support from this Institution. Out of the two hundred and fifty artists, or thereabouts, in all branches, who for the last ten years have participated in the disbursements of the Managers, many might be named who, excepting for this aid, would now be toiling in obscurity, their merits unknown and unappreciated. Some of them, indeed, might long ago, excepting for this, have ceased the unequal struggle with fortune, and gone down in despair to the grave . . .

So much for the question as to what the Art-Union has done to develop artistic power; let us now attend to the equally important inquiry, whether it has not also done much to elevate popular taste and increase the knowledge of the people in matters of Art. To answer this statistically, we may say that in the course of its ten year's existence, the Society has distributed through the whole country nearly thirteen hundred paintings, seven hundred medals, more than fifty thousand engravings, of which about twelve thousand were in mezzotint, and the re-

mainder in line, nearly twenty thousand sets of engravings in outline, and more than fifty-five thousand copies of the "Transactions" of the various years. It has constituted five hundred agencies in different parts of the country. It has kept open nearly ever since its institution, a Free Gallery, in which not only have works been exhibited, which were sent to the rooms to be purchased, but many others also, of the highest merit, belonging to individuals and deposited there for the gratification and improvement of the public. Finally, it has established a Journal of the Fine Arts, which contains original and selected essays and much information respecting the progress of Art at home and abroad. This is given gratuitously to the members, and more than sixty-seven thousand copies of the different numbers have been printed and distributed.

It is well known to all who have studied the subject, that a very general and strongly marked increase of interest in the Fine Arts has manifested itself within five or six years past in the United States. The growing subscription lists of the Art-Union by themselves show this. The letters of the Honorary Secretaries, and the inquiries and conversation at the Rooms prove that something more than the element of chance in the distribution of the purchases, has occasioned these large additions of members. But beside this there are other evidences of increasing interest in Art. Drawing is beginning to be taught in Common Schools. Exhibitions of Paintings and Statuary are more frequent and better attended. A greater number of houses are decorated with objects of taste. A decided improvement in the sale of prints is observed. Illustrated literature is eagerly welcomed and largely purchased. Societies upon the plan of the Art-Union have sprung up in Philadelphia, Boston, Cincinnati and elsewhere. Better taste is exhibited in architecture, both public and private, and in the furniture and adornment of houses. Books relating to Art have been sold in larger quantities than ever before in the same periods, and in parts of the country also where previously no interest had been felt in such matters.

Every unprejudiced mind must connect these novel manifestations with the progress of the American Art-Union, and ascribe to its agency, in a very great degree, this newly awakened interest in the Fine Arts. After making due allowance for the great diffusion of illustrated books and newspapers, which have undoubtedly exercised an important influence, the greatest part of the credit for this movement must be awarded to our Institution. Its Secretaryships, its Free Gallery, its annual distribution of paintings, its various publications of prints and pamphlets have continually attracted public attention to the cause to which it is devoted. A periodical stimulus has been created which year after year has brought the subject freshly and pleasantly before the people . . .

The advantages of the Free Gallery to the inhabitants of New-York and the great numbers of strangers who resort hither, have been too often stated to need a recapitulation in this place. Those of us who day by day witness the throng of school-boys and school-girls, of laboring men and their children, the crowds of all classes and professions who fill these apartments, require no argument to prove the refining and elevating influence of this Institution, or its ability to promote popular taste and knowledge in matters of Art. It is now well ascertained that this attendance is regular and punctual, and varied only by the state of the weather and those occasional disturbing causes which affect all pursuits that are not absolutely essential to everyday life. It is no longer to be ascribed to the novelty of the affair, because the crowds still continue, although two years have passed since the larger of the present Galleries was first opened to the public. It seems to us that these free exhibitions alone, if no other advantage were derived from the Society, would amply repay all the labor and money which are annually expended in its operations. We have upon previous occasions explained at length the principles upon which purchases are made, and why works are sometimes admitted which are deficient in some points

of technical excellence. It is of little importance that every picture here is not perfect in Form and Color and Composition. These very inequalities attract attention and develop critical talent. The mediocre should be studied to enable us to know how much to admire the very best. The poor charlatan in Art must be seen beside the master. Our eyes must be satiated with trickeries and chicaneries before we can fully appreciate the purity and simplicity of true Genius. We must feel by experience how upon each visit the influence of startling effects and extravagant attitudes and forced lights and exaggerated sentiments grows weaker and weaker and at last entirely departs, while that truthfulness of form and color, that unaffected grace, that delicate development of character and feeling, which were not perceived at first, become at last the sole objects of observation and claim our most sincere admiration and respect.

"The Enemies of the American Art-Union," Bulletin of the American Art-Union 2 *(December 1849).*

There is a class of people whom we have frequently mentioned in this Journal, who are dissatisfied with our proceedings chiefly because they are ignorant of the past history of the Fine Arts in this country, as well as of their present condition and prospects. They have extravagant ideas of what has already been accomplished in this department—vague, undefined notions which have been encouraged by Fourth-of-July orators and rhapsodical newspapers. In the opinions of these men, we can immediately take the same rank among the nations of the earth in painting pictures, as in building rail-roads, and distinguish ourselves as much in statues as we do in steam-boats. Michael Angelos and Raphaels languish unnoticed in every village, and if the Art-Union should but apply its large revenues in a proper way, the next year would outshine in artistic splendor the Pontificate of Leo and the Age of the Medici! Not only are these people grossly ignorant of the actual condition of Art in this country, but they entertain also the most incorrect views of its achievements everywhere. Rarely seeing good specimens of it, they form their opinions from books and the inflated language of travellers. They never consider the limitations to its power. They forget that it has its boundaries as well as Music and the Drama—that it has a certain range of expression beyond which it cannot pass. They exact from it more than in the nature of things, it can bestow. They expect miracles from it. When these unreasonable people, so ignorant of Art in general, as well as of its particular manifestations in America, visit our Gallery, they are disappointed at what they see. "Is this the best the country can do?" they ask. The idea seems to them absurd, and they ascribe the deficiencies of the exhibition to the faults of the management. "Why do you not buy better pictures?" they cry, as if there were any better ones to be had—as if a single picture of merit had ever been permitted to be withdrawn which could, with justice to the subscribers, be bought—as if this collection was not really better than any previous one of the same size of American works! We hear the like complaints from these uninstructed people, of the inferiority of the engravings. But can more be done than to employ the best engravers and the best printers in the country—can more be reasonably expected than to make a constant advance in this Art, an advance which we unhesitatingly say is more rapid than was ever made before in the same space of time by any people, and which is beginning to attract the attention of connoisseurs in Europe? Far be it from us to find fault with any dissatisfaction which is founded upon the knowledge of a true standard, and a generous appreciation of difficulties surmounted. Far be it from us to discourage judicious criticism. It is what we need more than almost anything else in Art matters. But these unjust complaints, springing from a spirit of exaggerated nationality and the grossest ignorance, ought to be frowned down by all sensible men.

There is still another class of people who view the Art-Union with indifference, and rarely

speak of its exhibitions without a shrug of the shoulders or an expression of contempt. In all countries there are pretended connoisseurs—men who, without any true feeling for Art, and with but a slight knowledge of its principles, dare to criticise its productions in a supercilious and dogmatic tone. Such persons are more common, perhaps, in America than elsewhere, because here there are not so many well-informed observers who can examine their pretensions and expose their incompetency to the world. They may be found at every dinner-party, in every social circle. Each one of them has a coterie of followers who swear by him through all the moods and tenses—admiring what he admires, and ridiculing what he affects to despise. If he happens to visit Europe—

"Returning from his finished tour,
Grown ten times perter than before,"

his authority as an oracle is established beyond all manner of question. The fact that he has walked through a certain number of galleries and spent a few minutes before each one of the famous works they contain, makes him for the rest of his life a Goethe or a Winkelmann.[2] Henceforward, from his decision there is no appeal. Nobody asks if he has studied the Philosophy of Art, if he knows why one picture is better than another, without which all this perambulation of the galleries is vain and profitless—

"He's *seen* and sure he ought to know,"

is an answer which solves all doubts, and gives him an undisputed seat on the throne of criticism.

These shallow pretenders are incapable of seeing any merit which is not accompanied by a certain dexterity of execution. No matter how sublime may be the *motive* of a composition, if it be not set forth by striking effects of color, or light and shadow, they pronounce it "a daub." The lowest elements of Art are those alone which engage their attention, and even of these their knowledge is limited and confused . . .

The class of which we speak rarely condescend to bestow their praise upon any works which are not brought from abroad. Unlike the others of which we have written, their prejudices are all against their native land. Profoundly ignorant of the difficulties which have hedged in the development of Art in America, they criticise our painters with as great a want of charity as of taste. They overlook the simplicity, the freshness, the unconventional distinctness with which thought has been translated into color here, and observe only the hasty finish, the incorrect forms, the crudity of tones which are more often the result of the want of a proper education than of natural deficiencies. It is easy to gain a reputation for refined fastidiousness by thus affecting to despise everything from the easels of our own artists. It is a very cheap mode to rise above the level of ordinary critics, by assuming this contempt for domestic works, and admiration for those of foreign schools, which, fortunately for these coxcombs, are too far off to allow their ignorance of them to be easily discovered by the uninitiated . . .

The two classes we have described are not the most violent opponents the Art-Union has been obliged to encounter. Enemies far more insidious and persevering have been found—can the reader believe it?—among the body of the artists themselves. Let it not be understood that this hostility characterizes all or the greater number of these gentlemen. With many of them, we are happy to say, the relations of the Art-Union are of a very friendly sort. Others remain in a state of cold neutrality. But there are some who show their ill-will by the most active opposition. Few facts exhibit the perversity of human nature more clearly than this animosity which

[2] Johann Joachim Winckelmann was an eighteenth-century German historian of classical art.

has been manifested by men, to put bread into whose mouths the Committee of Management are making no inconsiderable personal sacrifices. Some of the most furious declaimers in private circles—and we have reason to believe some of the most unscrupulous libellers in the public prints—derive their chief support from the very Institution they are doing their best to destroy.

The cause of this violent conduct on the part of several of these men may be traced, we think, to the complete revolution in the world of Art, which has been occasioned by the great success of our Society. Those who were attached to the old order of things, and installed under it as the chief recipients of honors and rewards, and the arbiters of the fame and fortune of others, naturally look with unfavorable eyes upon a system which they conceive may deprive them of some of their consequence, and place in other hands the power they had so long exclusively enjoyed . . .

There are artists, also, who have taken offence from more trivial and even more mercenary motives. The Art-Union has not bought their pictures at all, or has not paid the price demanded, or has presumed to point out faults; its communications have not been couched in proper language, or it has delayed too long its decision, or hung the works in unbecoming lights. Indeed, the Institution does not always escape when it pays every cent that is demanded and compliments the painter besides. A gentleman, lately, after having received his own price, which, by the way, was the largest ever paid by the Society for a single picture, and after the work had been praised in the Bulletin and elsewhere, in a manner which many thought extravagant, openly proclaimed that the Art-Union was ruining his prospects and driving him into the painting of portraits!

The letters of some of these unreasonable individuals would be treasures to Dickens or Thackeray. Such displays of conceit are not to be found in any other correspondence, and if the writers could only infuse as much spirit in their pictures as they put gall into these epistolary communications, their fortunes would be made.

Sample letter to an artist from an officer of the American Art-Union, **Bulletin of the American Art-Union 2 (December 1849).**

Dear Sir—Your communication, addressed to the Committee of Management, has been received. It is to be regretted exceedingly that you should have been misled by the well-meant action of the Committee in the purchase of the earlier works from your pencil. You, of course, cannot but be aware that one purchase does not necessarily imply that others will be made, unless the productions are likely to answer our purposes. The large picture, submitted early this season, did not at all come within the scope of our wishes. The size was a great objection. We have published in the Bulletin a request that artists who paint for us will not exceed twelve square feet. 'Tis true that we sometimes, for especial reasons, deviate from this rule; but these deviations only serve to make the rule more important to us. The last painting has not as yet been purchased for two reasons: first, because we have, for some months past, been largely in advance of our subscriptions. Last year, at this time, we had purchased 211 paintings, we now have 350. It was a matter of proper discretion for us, therefore, to await the progress of our income before extending still further our responsibilities. The other reason was, that in some parts of the drawing the picture was thought to be faulty. It certainly could not be considered a favorable specimen of your works. Our great desire is, that each successive work we purchase from a young artist should be equal at least, and, if possible, superior to his previous productions. We do not think that in either of those submitted by you this year you have excelled those of

former years. I can assure you of the most friendly feelings on the part of the Committee, and I regret that they have not been able in the present instance to meet your wishes as promptly as formerly. If you come to the city I should be glad to see you, as I think you could easily amend some slight inaccuracies of drawing, and I hope the condition of our resources may enable us to add the picture to our present list.

G.W.P., "Some Remarks on the Landscape Art," Bulletin of the American Art-Union 2 (December 1849).

At the conclusion of our former paper on the exhibition, it was observed that our artists sometimes appeared to neglect the foregrounds of their landscapes, which ought always to be conceived and executed so as to afford repose to the eye. There never should aught unsightly, however exact it may be as a copy of nature, come between the eye and the centre of light and interest. Even where the object of the painting is to fill our minds with some dark or terrible aspect of nature, the artist has no right to ask the beholder to place himself in physically unpleasant circumstances while studying the scene . . .

Another suggestion to our landscape artists naturally succeeds the foregoing. It is, that if the eye requires to be simply pleased in the foreground, how much more must it be *enchained* in the middle ground, or that part of the picture which is the actual centre and life of the scene— the portion where all its effects are collected and sublimed into an expression of the artist's design. Here nothing should come in to conflict with, or even to obstruct the complete union of the elements. Everything should tend one way, and all should be so broadly and openly expressed as to leave the intention not only out of all doubt, but unmistakably clear and earnest . . .

Now, though the composition be not utterly marred by defects in this particular, yet it may be, through a want of perception of the poetic unity of a combination of effects, so *weakened* as to convey but a faint impression. The slopes of the land, the hills, trees, water, may be so thrown together, and under such lights and shadows, as to be either merely interesting for a moment, or quite vapid or absurd.

One of the surest ways to avoid this is to be careful of crowding the centre of the picture. Let there be a wide open passage for the vision, and the surrounding elements and groups which enter into the scene will be much more disposed to combine effectively and harmoniously . . .

The simple outlines of many great landscapes are more impressive from their grand openness than many elaborate paintings with all the advantages of color, but which are crowded, and therefore confused. The distances stretch away to eternity, the broad hillsides bask in the day, and beneath the shadows of overarching but not encroaching trees, Diana pursues her deer, or satyrs and bacchanals hold their revels on the open glades. It is for our artists to group our forest, glades, trees, hillsides, and skies, and to give us from them, in similar manner, scenes from that Land of Beauty of which we all catch casual glimpses in the higher moments of our being.

A few examples, illustrating the necessity of keeping open the middle ground in landscapes, will lead naturally to the principles upon which all our suggestions are based . . .

Here, directly in the centre, between the observer and the sun, a large tree interposes itself, so as to shut out all behind it. One's first impulse is to endeavor to walk aside to get a better view, but the consciousness that it is only a picture, and that the scene cannot be changed gives in a moment a sense of suffocation. The tree plagues the eye: it seems placed there only to be an annoyance: something beautiful is behind it which we are never to see; it is like a horrible false relation coming in the midst of agreeable music. If the design in placing it there had been simply to paint a tree, why distract us with a background which attracts the eye beyond? If to make a landscape, why not let us see it? If to copy nature, why copy one of her discords? . . .

The great principle seems to be that in all landscapes there must be a direct road or air line of attraction, where the eye shall naturally fall, and where it can expatiate with a sense of freedom. Here, gazing in this air line, must the scene tell upon us with its full poetic power; all its beauty or all its grandeur must surround and depend upon this central track of observation; this must be as a grand plot, to which all the incidents, hills, trees, clouds, cattle, groups, &c., must relate, and to carry out the purpose of which they must be introduced. We may have underplots too, so many (as in the *Dream of Arcadia*) that they shall almost overpower the main story—but story there must be, or we have no landscape. It does not follow that a picture may not be made to please in details because it must in this entire effect; where both are handled in the true spirit of the art the soul vibrates between them forever. It looks over the whole and feels the elevation of the artist's grand intention; his inspiration kindles a kindred glow; it then turns aside and revels in beautiful or striking groups and effects, or admires the various qualities of excellence—this color, that form, that freedom and delicacy of handling; again it returns with new zest to feel the union of so many excellencies—and thus the process goes on by which the great landscape artist acquires his niche in the hearts and memory of mankind.

All should combine, in the first instance, to this one central story—the foreground, the middle, and last, though not least, the distance. It mars the effect of a landscape when there is anything interposed which breaks and subdivides the distance in such a manner that we are obliged to take separate *looks* in several directions in order to see the whole . . .

But while the arranging the clouds and landscape in such a manner that the eye shall be urged in a certain direction both by what is above and what is beneath, and at the same time giving the whole the variety and *unconsciousness* of Nature, is the point in a landscape on which it must depend in a great degree for its force, the background and the sky must also be in harmony with the scene, and even in the most rugged views must *attract the eye*. This quality ought to be most insisted on, as it is one which is most often overlooked. There is no pleasure in looking at hard, cold skies, or gray distant mountains, however exactly they may be copied from nature. We want warmth, life, beauty . . .

Those pieces which are purely studies of particular effects, which include a large number of pleasing and often skillfully executed paintings, afford much more that can be used in illustrating principles of composition, than those elaborate, overdone pictures in the French manner, of which all our exhibitions must of necessity (since they are so much admired by the public) contain a sufficient supply.

In quitting our subject here, somewhat reluctantly, for we have glanced at only a single department, we will venture to hope that our remarks may have the effect to aid our young landscape artists in their studies, in return for the enjoyment their works in the Art-Union have afforded us.

[Miner K. Kellogg], "Art-Unions: Their True Character Considered," International Monthly Magazine 2 *(January 1851).*

It is now about ten years since the first Art-Union was established in this city. Others, in various sections, have followed, and all, whatever their peculiarities, have been more or less successful in their chief objects.

Now it is reasonable to suppose, that the result of these ten years' efforts to promote the cultivation of the Fine Arts among us, should furnish some evidence of their capabilities for the accomplishment of so worthy and so great a work. The whole subject of their usefulness resolves itself into the following queries:

I. Has any person of decided genius, who was unknown, friendless, and in need, been sought out by them, assisted, encouraged, and at last added to the effective number of artists who are profitably employed among us?

II. Have those artists who have received the larger share of the patronage of these institutions, shown by their works a corresponding advance in the knowledge and love of excellence and truth in art?

III. Have they furnished any peculiar advantages to artists, as a body, by supplying the means of their improvement, in a free access to books, casts, pictures, or good engravings?

IV. Do Art-Unions promote the interests and reward the labors of those who are most eminently deserving?

V. Do they elevate the pursuit of art, in the minds of the people, and teach them its value, by distributing to them, in return for their subscriptions, *only* the best specimens which they can purchase from the studios of our artists?

VI. Are there a dozen well known artists who will openly testify to a conviction of their usefulness?

It is believed by many that an affirmative response cannot be given to these questions; and if not, then the subject of their influence need be no longer discussed . . .

Numbers rather than quality seem to govern the Art-Unions in their purchases of works, that they may give to subscribers a greater number of *chances* to draw something for their money, and thus encourage them to future *patronage.* This is the principle on which all lotteries live: and when we come to sift the matter to the bottom, we cannot but acknowledge that Art-Unions are nothing else but lotteries, under another and more popular name. Both exist ostensibly for the good of others, who in reality are but the dupes of a most deceitful and vicious system, against which every good citizen should indignantly turn his face. It cannot be justly said in defence of Art-Unions, that they spend more money for art than was ever done in the same period of time, nor that they have distributed works amongst a class of people who never thought of giving money for such things before. They must first prove that this great amount of money which they have collected, has been spent *judiciously,* for the benefit of deserving and meritorious artists, and that the works distributed are such as to elevate the judgment and enlarge the feelings in relation to art, among those who may have received them . . .

In the recent drawing of the American Art-Union there were distributed *one thousand works of art,* making about one prize to sixteen blanks. But where did all these "thousand works" come from? and what are they? Have they all been executed by living American artists? Are they paintings, or sculptures, or engravings, purchased from the artists who made them, and who have received an adequate price for them! We know from their advertisement that *sixty* of them are "impressions from the large engravings after Col Trumbull's pictures of the *Battle of Bunker Hill* and the *Death of Montgomery.*" Now the purchase of these engravings from the pictures of a long deceased painter can be of no possible service to the painters living and laboring among us, nor to the progress of art in any way. As well might the Art-Union purchase for distribution sixty copies of Dunlap's History of the Arts of Design, or of Allston's Lectures on Art, or any object pertaining to the subject that may be procured at any time of the book or print sellers. It is true, they must manage to offer a number of small prizes, the best way they can, that they may in some plausible way meet the expectations of their very extended lists of subscribers, to which, it seems, they never attempt to set a limit. Here is another proof that they are mere speculators upon the labors of artists, and only seek to enlarge their subscriptions, and usurp

a power and control over the great body of artists, which should never, with their consent, be allowed to any, no matter how respectable, body of men . . .

The tendency of these hot-bed methods of cultivating an appreciation of art and of rewarding its professors, has been to discourage artists from any suitable efforts to provide instruction, upon a liberal scale, to those who are seeking for it. Indeed it takes from them the power to do so, by drawing away funds necessary to such an object, which, but for these grand schemes, would be likely to come into their hands. One has but to observe the motives which induce persons to subscribe to an Art-Union, to be convinced that the great majority do so for the sake of self-aggrandizement, that is, to have a chance of getting the works of our best artists for a mere tithe of their value, or in the language of the advertisements, "of obtaining a valuable return, for a small investment;" as they would buy any other lottery tickets: to make the most out of their money. But there are many who subscribe from nobler motives—real lovers of art, whose only object is to lend a helping hand to its interests, and to show a generous sympathy in the struggles and self-denying endeavors of all whose souls are so wrapt up in its pursuit that they scarcely arrive at the knowledge exquisite to a charge of their own pecuniary and worldly affairs. This latter class of subscribers believe they are gratifying this genuine love of the beautiful and good, when they give annually their five dollars to an institution chartered for the express design of protecting and cherishing the interests of art, and of enlarging the field of its labors and usefulness among the people. These genuine *patrons* give, without a hope or thought of drawing a prize, or receiving in any shape a return for their subscriptions. Did they reflect upon, or know, that these funds were worse than misapplied, they would withhold them, and seek in some other way to make a proper appropriation of them . . .

Artists must learn, if they do not know, how to control their own affairs, and if they are determined to succeed, they must not think of trusting their interests to the keeping of those not of their profession, and entirely uneducated in art, and who consequently cannot be qualified to discharge so delicate a duty with judgment and fidelity. It is an old saying, but very applicable to the present instance, that "if you neglect your own business, you need not expect others to attend to it for you." Let artists depend more upon private sales of their works to those who can appreciate them for a just remuneration, than upon the deceptive offers which chartered schemes may hold out to them. They will then, by their worth and their artistic merits, build up about them a solid body of friends and patrons, of whom nothing but death itself can rob them; and the number of whom time will but increase, until they may look forward with well-founded hopes to a peaceful and honorable old age, and a full reward for all their labors.

Lilly Martin Spencer to Angelique Martin and Gilles Martin, December 8, 1851, Archives of American Art.

Though I am so busy it is not so very profitable for Artists are as thick as grass here, and to be able to get work, one must work cheap, and however must endeavor to do better work than the rest, particularly if I wish to eventually raise above them (which is what I want to do!); besides the natural competition arising from the number of Artists, there seems to be a complete stagnation in the way of picture buying among picture buyers. They will not come to the studios, and artists are obliged to send their pictures to stores and pay every percentage, or send them to auctions. I suppose you have heard of the downfall of the Art Union, which, although it was not a very good institution, still it was better than nothing. It needed improvement and alteration in a good many of its arrangements, but instead of that, they have completely smashed it, and the pictures (which were to have been distributed all over the United States) have been

disposed of at publick auction in the City, filling the houses of picture buyers, without one cent's worth of benefit to the Artists, as they had already been paid for to the Artists one or two years before, and although the prices which the pictures brought, particularly some of them, was remarkably good (my own brought pretty good prices being (excepting in the case of one picture) once and a half more than what they gave me), still it only deprived the Artists of just so much money that might have been distributed, by purchasers, among the Artists at their studios. Besides this, and many other private auctions, there is to be another grand auction of pictures (it has taken place since I commenced my letter) at the Art Union buildings, which has been got up (they say) at the solicitation of the Artists, to get rid of pictures that they had painted for the Art Union, but I see that great many private individuals have taken advantage of this sale to slip in pictures of their own that they had won from the Art Union for their five dollar subscription, and disposing of them out of pure Yanky speculation, or bought from Artists years before. Ben [Spencer's husband] took advantage of all this auctioneering and fixed up and varnished a lot of old pictures of mine that were about the house and sent them to auction and got quite nice rates which has enabled us to keep an independent head through all this winter, otherwise I don't know what we would have done, for as to orders—I get none. So you see, this is another thing standing in the way of artists.

COLLECTORS AND PATRONS

THOMAS COLE AND HIS PATRONS

As an ambitious young landscape artist (and an immigrant to boot), Thomas Cole faced the problem of marketing his work in a heterogeneous cultural arena where relatively few had the means or the education to consume the higher-style landscapes he aimed to paint. Groping to secure his market niche, Cole had to perform a balancing act between subordination to demanding patrons on one hand and affirmation of artistic autonomy on the other. The notion of patronage, associated with a corrupt Old World aristocracy, bore unwelcome connotations of traditional, hierarchical society. In an ideally egalitarian republic, artists—freed of their forced dependence on aristocratic largesse—would produce work on an open market, in an open forum. The problem, of course, was that art then became subject to the laws of supply and demand. The artist might make strident declarations of independence, but, if the work failed to sell, he or she had to face the choice of catering to prevalent tastes, courting ruin, or finding some point of compromise.

Cole's challenge was to find buyers for his large-scale serial allegories and religious subjects. Although he had a ready market for landscape views, he chafed constantly under the need to squander his time producing what he considered less exalted and less meaningful work. He also had to negotiate relationships with his clientele, which consisted of old-money Federalist elites like Robert Gilmor of Baltimore and Daniel Wadsworth of Hartford, Connecticut, and members of the new merchant class, notably Luman Reed of New York. Cole's correspondence with these men reveals shifting patterns of ingratiating eagerness and confident self-assertion.

Prominent Baltimore merchant Robert Gilmor Jr. was a well-educated and well-read member of the elite who collected books and served as president of the Library Company of Baltimore. Gilmor also amassed a large collection of old masters and supported modern

American painters, including Thomas Cole. Taking Cole under his wing (and to task) at the very outset of the artist's career, Gilmor in the letters below does not hesitate to critique the fledgling painter's work, urging him to include Native American figures and stressing his preference for "real American" scenes as opposed to idealizing compositions. Assuming entitlement by virtue of his wealth and status, Gilmor patronizes young Cole in every sense of the word.

Daniel Wadsworth was one of Cole's most important early patrons and a lifelong supporter of the artist. A descendant of Puritan settlers of Connecticut, Wadsworth was the son of the enormously wealthy Jeremiah Wadsworth, who took him as a young boy on the grand tour of Europe. During that trip, Daniel Wadsworth imbibed English landscape theory, which formed his taste for the sublime, the beautiful, and the picturesque and sparked a lifelong interest in landscape tourism. Introduced to Cole in 1825 by his wife's uncle, John Trumbull, Wadsworth commissioned five paintings, the subject of one being the view from his hilltop country estate, Monte Video. A cultivated, generous art lover, Wadsworth was for Cole an ideal patron. Their correspondence, however, suggests a subtly uneven relationship in which Cole—younger by a generation— assumes an attitude of deferential gratitude to his benefactor even while feeling sufficiently at ease to fret about his financial woes and grandiose aims.

Robert Gilmor Jr. and Thomas Cole, correspondence, Courtesy of the New York State Library, Manuscripts and Special Collections, Thomas Cole Papers, 1821–63.

[Gilmor to Cole, August 1, 1826]

I have this moment received your letter on the subject of my picture, and lose no time in acceding to your wishes that a different one should be selected. When I chose Catskill Mountain house as seen from the road below, and connected with the mountain scenery above it, the romantic rock below it, and the perspective situation of the strait lines, (otherwise offensive in a picture) I was governed by my recollection of the scene, as well as by your very happy sketch of it, which induced me to believe that by a faithful copy of the natural foliage & your own good taste in executing it, that it would make a pleasing picture. The want of distance to give air to the picture struck me at the time. I now leave you at perfect liberty to select your own subject either there or anywhere else in the course of your late tour. I have too great a reliance on your correct taste & judgment in doing me ample justice in the choice . . . Judging from your very charming picture of the lake and decayed trees at Mr. Hone's (which does you infinite credit) Salvator's style would be that you would be most likely to adopt. In addition to the one I ordered you will oblige me by executing a companion for it, though I do not mean it should be a *similar* subject exactly. I would rather it should evince your talent in two kinds of subjects. Water should be introduced at least in one, and would be well in both, one being *falling* water, & the other *still*, lake, water, reflecting the tints of sky, foliage, grass & shewing the play of light on a slight motion of part of it, which may be also effected by introducing deer or cattle drinking, or a canoe with Indians paddling on it. The boat race in Mr. Cooper's last novel would be a happy introduction particularly if the scenery of Lake George, about Roger's Rock, or the islands was selected for your picture. It would give animation & interest to the whole. I should like also in the other some *known* subject from Cooper's novels to enliven the landscape. Your own good taste will suggest the fittest for the purpose.

I trust you will not from the preceding, suppose I mean to dictate a choice of subject or the

manner of disposing of it. I merely throw out these hints for your reflection & adoption if they meet your own ideas. An artist in my opinion should never be trammelled by those for whom he is endeavoring to do his best, and is in almost all cases, the only true judge of what ought to be done. I feel perfectly satisfied you will justify my opinion of your character in the fidelity of your work, and I shall have much pride in exhibiting to my friends what you may send me, as well as endeavoring to secure their patronage. Should it be a convenience to you to receive a half or the whole of the price of these pictures, your draft on me for what you may require will be immediately honored.

I do not wish by any means to hurry you, but merely remark that I shall be glad to receive the pictures when you have finished them, which I trust will not be longer than suits your own convenience.

If you will let me know what I am indebted to you for the picture & the expense of case etc. I will remit you the amount.

[Gilmor to Cole, December 13, 1826]

I am glad to perceive by your letter that my picture is finished, and I shall look for it by the first packet. Whenever you send anything to me by these vessels, be so good as to send me by post the receipt of the Captain for the box, that I may look out for its arrival.

I have no doubt that I shall like the scene you have painted, if the desolate wildness of American nature is truly painted, which I am sure it is, judging by Mr. Hone's lake scene. I differ however with you in approving the omission of figures, which always give character & spirit even to solitariness itself, but it depends upon their propriety—an Indian Hunter judiciously introduced (even in shadow behind a tree, with a catching light on a *red* plume or mantle) with his rifle levelled & one or two deer crossing an open space, would not defeat your object, but rather assist the idea of solitude. If you have not already dispatched your picture, and think with me that such an addition would improve it, you can govern yourself by the preceding hints. I do not wish by any means to confine you to subject.

The idea of a *red* plume or mantle suggested itself to me by an observation of Morland's, who always introduced he said something red into his pictures, as it had the happiest effect. Yet I would have nothing done to destroy the *principle* of your view. As you say it is taken near the headwaters of the Delaware, I am in hopes you have given at least a glimpse of the river, if no more in it. Water always adorns a picture, whether it is the calm deep toned stream, scarcely distinguishable from the foliage whose shadows have daubed it with their own tints, or the sparkling gleam of light which penetrates even a *forest* to dance upon the smooth, or the rippling current, not to speak of lakes, reflecting both wood & sky, which balances & animates a scene which would otherwise appear heavy & monotonous. Ruysdael, whose landscapes are among the finest we know, never failed to introduce it when he could, and whenever you give me the pleasure of seeing you here I will show you two or three instances of the kind in my own collection.

Above all things however, *truth* in *colouring* as well as in *drawing* the scenes of our own country is essential, & it is for that reason that I have an objection to your proposal of making your next picture a *composition* to meet my wish of a scene from Cooper in it. As long as Doughty *studied & painted* from nature (who is always pleasing however slightly rendered in drawings or paintings made on the spot) his pictures were pleasing, because the scene was real, the foliage varied & *unmannered,* and the broken ground & rocks & moss had the very impress of being after *originals,* not *ideals.* His *compositions* fail I think in all these respects, & have now so

much uniformity of manner in them that they excite no longer the same agreeable feelings in me that his very *earliest* sketches did . . .

Believing that an artist should be left as much to himself as possible, I will not shackle you in executing your next picture, and it is for this reason that I always prefer purchasing a picture of any master, ancient or modern, after having *seen it,* because then I can judge how far he has conformed or deviated from the principles I lay down in its execution. I will only repeat what I formerly said (in my last letter) that I prefer *real American* scenes to compositions, leaving the distribution of light, choice of atmosphere, & clouds & in short all that is to render its *natural effect* as pleasing & spirited as the artist can feel permitted to do, without violation of its *truth.* Your judgment in Col. Trumbull's & Mr. Hone's pictures gives me every ground of hope & expectation that I shall not be disappointed in leaving all this to you. I must also say, that if a fine picture of Lake George can be executed I should almost prefer it to any other, even if the boat scene cannot be introduced. At all events a judicious placing of the *steamboat,* if not at variance with the scenery would give life & animation to it. I do not however confine you to this scene or subject, particularly as you have laid it by, but leave you at full liberty to select from your numerous sketches what you think you can best render to please yourself, but if one of Cooper's scenes, both as to *locality* & *action* can be selected to satisfy *yourself,* I shall be quite content to receive it.

[Cole to Gilmor, December 25, 1826]

I received your letter with pleasure, and must thank you for your opinions respecting the introduction of figures, &c, into pictures . . .

I hope you will pardon me if I make a few remarks on what you have kindly said on paintings & compositions. I agree cordially with you about the introduction of water in Landscapes: but I think there may be fine pictures without it. I really do not conceive that compositions are so liable to be failures as you suppose, and bring forward an example in Mr. Doughty. If I am not misinformed, the finest pictures which have been produced, both Historical and Landscape, have been compositions: certainly the best antique statues are compositions. Raphael's pictures, & those of all the great painters, are something more than imitations of Nature as they found it. I cannot think that beautiful landscape of Wilson's in which he has introduced Niobe and children an actual view; Claude's pictures certainly not. If the imagination is shackled, and nothing is described but what we see, seldom will anything truly great be produced either in Painting or Poetry. You say Mr. Doughty has failed in his compositions: perhaps the reason may be easily found—that he has painted from himself, instead of recurring to those scenes in Nature which formerly he imitated with such great success. It follows that the less he studies from Nature, the further he departs from it, and loses the beautiful impress of Nature which you speak of with such justice and feeling. But a departure from Nature is not a necessary consequence in the painting of compositions: on the contrary, the most lovely and perfect parts of Nature may be brought together, and combined in a whole that shall surpass in beauty and effect any picture painted from a single view. I believe with you that it is of the greatest importance for a painter always to have his mind upon Nature, as the star by which he is to steer to excellence in his art. He who would paint compositions, and not be false, must sit down amidst his sketches, make selections, and combine them, and so have nature for every object that he paints. This is what I should endeavor to do: and I think you will agree with me that such a course embraces all the advantages obtained in painting actual views, without the objections. I think that a young painter ought not to indulge himself too much in painting scenes, yet the cultivation of his

mind ought not to be neglected, it is the faculty that has given that superiority of the fine over the mechanic arts.

[*Gilmor to Cole, December 5, 1827*]

I approve highly of your intention to go to Europe, & recommend you prepare yourself with original sketches of our scenery, particularly such as is known & remarkable, which you can make pictures of abroad to be disposed of to the collectors of American scenes & subjects; but do not carry *pictures,* as you will have to pay a heavy duty on them on landing. I believe the lowest is 6 guineas or about 30 D.s for everything under three feet. By studying the works of the English artists, particularly Turner, you will be able to improve your style, though I should be sorry you should depart from expressing nature in the manner you do, which is *without manner at present,* and consequently pleases more generally than a regular habitual way of rendering objects. Let me know sometime before you go, as it may be in my power to render you some services.

P.S. I wish you could see two *modern* pictures I have lately received from Holland. One is a green landscape & the other a winter scene, and the *truth* in both is rendered with such beauty of *finish,* with all the spirit [illegible] that they would probably give you some hints of value, which even the English school would profit by—they are not yet hung up.

Daniel Wadsworth to Thomas Cole, December 4, 1827, Courtesy of the New York State Library, Manuscripts and Special Collections, Thomas Cole Papers, 1821–63.

You will rejoice with me to hear, that the Pictures have arrived in safety & although they have been on the road ever since last Saturday from the time they left the Shipwreck'd Steam Boat they do not appear injured except in a very slight degree.——One of the two that were placed face to face not being fastened was slightly mark'd not far from [the] Edge but I think not so that it will be noticed,—and when wash'd & a little varnish is applied.—As they did not arrive by the Oliver Ellsworth, I attempted to make out the few words in pencil on your letter, as accounting for it, but they were so obliterated as to explain nothing—but I presume *now,* that they were to communicate something.—When I heard of the misfortune of the Linius, I could not but fear that the pictures were on board—but before I could be sure of it they arrived at my door—& I opened them with fear & trembling.—I now hasten to inform you of their safety as [soon as] possible, for I think you will feel apprehensive for their fate, after [seeing?] my last letters by the Mail & hearing of the Steam Boat accident.—The Box arrived this afternoon before Dark,—& we had an opportunity of seeing its contents, tho' by a very Cloudy Sky—I think the Cascade is very much improved by what you have done to it, & the varnish.—The Mount Washington Picture,—a most beautiful scene, & will when varnished, & in its frame, be greatly improved—but of the "Last of the Mohegans", I can hardly express my admiration, the Grand & Magnificent Scenery,—the Distinctness with which every part of it, is made to stand forward, & speak for itself.—The deep Gulfs, into which you look from *real* precipices,—The heavenly serenity of the firmament, contrasted with the savage grandure, & wild Dark Masses of the Lower World,—whose higher pinacles only, catch a portion, of the soft lights where all seems peace,—The calm & lovely lake, which seems to lead the eye to regions far, far, off—till it is lost among the pale blue mountains, & "is left to stretch on to infinitude"—

—And all these objects so exquisitely finished, that it appears as if each one had been the object of particular care,—blending the Whole perfectly—rendering it at once to hold you so

soft,—so striking yet so harmonious—that seen near, as at a moderate distance it gives equal pleasure.—You speak of "Varnishing *The Picture*" do you mean The White Mountains or the—"Mohegans"—it seems to me that *nothing* can improve the last.—Is the scene of the Mountains from near Crawfords house?—or where,—& how far west of the Notch?—as I shall wish when ask'd to say distinctly.—Are the Obscure yellow lines under the snowy point of Mount Washington the traces of the slides.—A few words explanatory of this scene—I shall be glad of.—To look at the two Pictures that *are not* in the Frame I have placed them before the one that is, & they appear to grate advantage.—And I have exhibited them thus in succession, leaving the "Mohegans" for the last.—Letting no one see them in any other order.—But the spectators have yet been few—as the arrival was late.—The frame is extremely handsome, & I am [illegible] you have had it made to your own taste.—I shall have the same [proportions] & boldness to the frames I have [made?] here—but not as much ornament.—Will you let me know the size of the Canvas on which the Cascade is painting that I may order the frame accordingly.—

Thomas Cole to Daniel Wadsworth, June 5, 1828, Watkinson Library, Trinity College.

Your letter of the 30th of May afforded me great pleasure—I was happy to hear of your safe return, and also to learn that your excursion was fraught with enjoyment, notwithstanding the unfavourable season in which it was made—Many times during your absence, fancy has placed me by your side in that region of sublimity—I have beheld you amidst the ruins of mountains in the Notch, gazing awe-struck, and amazed on its death-like desolation—I have pictured you watching the dense clouds that enveloped M Washington and waiting as anxiously for their unfolding as for the revealing of a mystery—A mystery, these things are all mysteries—He who beholds the mountains, lifting their dark heads far in the trackless blue, will feel his mind, called to the contemplation of the power that raised them, and must acknowledge its might—but the hour, the season when the work was consummated, when these vast fabrics were set on their deep foundations whether by the gradual mutation of the elements: or by some sudden convulsive effort of nature is unknown—time has blotted out the record—and we are impressed with the sense of our own blindness, and littleness, and with the greatness of the Creator. Your prospect from Ascutney must have been delightful I would have given much for the same enjoyment—I am in hopes you made a number of sketches and if you did I am anxious to see them—

You have kindly asked me what are my plans for the summer: and about my proposed voyage—I had laid plans for my Summer's study, and I may say enjoyment: and for *that* which for years I had looked forward to with longing anxiety, I mean my voyage to Europe for the purpose of Study—But I am afraid I am about to be disappointed—circumstances are such that I cannot leave N York as I intended, even in this delightful season—this is to me a great privation—Every tree I see; every patch of grass that bears the tints of Spring reminds me of it—and I am ready to say to myself sometimes "why am I wasting these precious moments in the barren City—all nature is now clothed in her most charming attire, now is the time I ought to be studying her; and storing in my mind the remembrances of her beauty"—Though I have been labouring hard for many months past trusting that by doing so I should accomplish my voyage—I begin to think I shall have to content myself under a disappointment—You know I have spent much time in the execution of the two pictures, the Edens, they are not sold: when I began the first I hardly expected to sell it: but afterwards, owing to the high encomiums it received, I formed higher hopes, and painted another—I was perhaps unwise in taking such subjects, but I felt

them, and was led away—without calculating on what I might lose—I was offered $600 for my Garden of Eden by a gentleman of Boston, before the Picture went to exhibition—but he wished to have it for the Boston Exhibition—And I had promised it to the National Academy; and had to make a sacrifice—I of course hope to sell it here, or I might of got free from the engagement I had made—Thus the labour of several months is on my hands; and my expenses have been unexpectedly great this year—My plans are in great measure frustrated—I am gratified to hear the Schoharrie pleased you—it wants Varnish—but it will be well to leave it one month longer—one coat will be sufficient—Your two little pictures are not yet finished, but I hope they will be in a short time—I think they promise well—Gen. Van Rensselaer likes the Winnipiseogee it was originally painted for him—The Last of the Mohigans is as it was—I am afraid you will think I have been idle since I saw you—but when I see you (which I hope will be before long) I hope I shall show you to the contrary—I have heard nothing more from the engraver about engraving The Last of the Mohigans. I shall therefore send the pictures home—in the beginning of July, at which time the Exhibition will close—They have been much admired—and look much better than when you saw them—I am wishful to see you. I want to know something more of your picturesque tour, and to see some of your sketches—Notwithstanding I have spoken so despondingly about the frustration of my plans, I have still [hole in the paper] my health continues good that I may by [hole in the paper] great exertion accomplish much if not all of [hole] I intended—I am afraid I am writing a tedious tiresome letter; but I hope you will excuse me, I have been rather in low spirits for some time past—and I feel some relief in being permitted to unburthen a little of my mind to one who always seems to take an interest in my welfare—I should like very much to see the sunset from the top of your house—but that pleasure is for the present denied me—I expect to be in town for several weeks, most likely till the closing of the Exhibition—I should be happy to see you within that time—I hope Mrs Wadsworth enjoys good health, do not let her forget me—I got the Cash for the draft you sent me: for which you have my thanks—

My sheet is almost filled and I am compelled to conclude, or I do not know how much more I should write. I hope you will write soon as a letter from you is always a source of pleasure to your respecting friend.

THOMAS COLE LAMENTS THE TASTE OF THE TIMES

Compounding the problems of patronage and marketing, artists in a freewheeling democratic society found themselves increasingly in the court of public opinion. In Jacksonian America, art criticism was by and large the province of amateurs and enthusiasts who may or may not have had specialized training in the fine points of connoisseurship. Thomas Cole fulminated against the power of anonymous, vulgar critics to judge him and his work, often (he thought) unfairly. Writing to his patron, Luman Reed, in 1836, Cole makes his case, declaring that henceforth he will no longer labor to please the critics but only exert himself for the discerning few who possess the taste and judgment to understand his work. Cole's tone with Reed is decidedly less deferential than with his more aristocratic patrons such as Daniel Wadsworth and Robert Gilmor. Nonetheless, Cole appeals to Reed's vanity by including the wealthy self-made grocer among the select few who are capable of appreciating the moral and philosophical aims of his art.

As the letter to Reed suggests, the marginality of lofty ideals in a land of low taste

preoccupied and distressed the painter. Cole clung steadfastly to the vision of art as a beacon, leading American society to higher planes of moral, religious, and aesthetic consciousness. Nonetheless, to his chronic dismay, he noted a downward trend in the democratic marketplace, where the lowest common denominator of taste ruled the day. In the letter and journal entries below, Cole deplores the abysmally degraded American taste that he holds accountable for his own feelings of marginality and complains that the necessity of painting for money has shackled his imagination. Still, in true entrepreneurial spirit, Cole forges ahead with plans for his ambitious (and uncommissioned) new series, The Cross and the World, *which remained unfinished at the time of his death in 1848.*

Thomas Cole to Luman Reed, March 6, 1836, Courtesy of the New York State Library, Manuscripts and Special Collections, Thomas Cole Papers, 1821–63.

I trust that you do not fear that exaggerated praise can affect me with pleasure and lead me to see nothing but beauty in my productions but on this subject I will open my mind to you as my best friend and hope that by so doing although I may run the risk of being egotistical I shall dissipate any lingering doubt that may remain in your mind. Formerly my love of approbation rendered me very sensitive even to the flimsiest newspaper praise but I always turned away from fulsomeness and exaggeration with disgust. My love of approbation still exists perhaps as strong as ever; but the sources from which it is fed are changed. Newspaper paragraphs in praise or dispraise affect me with no more than a momentary feeling. I have ceased to labour to *please* the multitude of cricticks and it may be said of me as the Italian epitaph has it. "implore pace" he asks peace. My stimulants to exertion are now the approbation of the few in whose taste and judgments I have confidence—the desire to obtain a reputation beyond the reach of a newspaper squib and a love for the beauty and excellence of the art I profess which of itself brings enjoyment and is entirely independent of the approbation of the world. Newspaper praise is often injudicious and much of it can be purchased by meanness even for mediocrity but the *praise* of the few who possess true feeling knowledge and taste is a sure and what gives zest to it a quiet reward. These with *my necessary* pecuniary wants and an inclination to contribute my mite towards the refinement and well being of society are the causes that stimulate me to exertion will you excuse me if I say that I am afraid that you will be disappointed in the reception and notice my pictures [the five-part *Course of Empire* series painted for Reed] will receive from the publick let them be exhibited to ever so good advantage—they will be a subject for the whole pack of mongrel critics. They may be attacked unjustly as well as unjustly praised, some will see nothing but beauty, others nothing but their faults. There may be fulsome panegyrics and odious comparison and very few will understand the whole scheme of them the philosophy there may be in them. I hope I am prepared for all this. My leading hope is that when they have passed through the ordeal I shall find your esteem for them and for myself undiminished. I have worked at the pictures with a strong desire to make them worthy of note hereafter and that your name shall never be mentioned as of one whose generosity and taste was misapplied . . .

I am expecting to hear from you daily and shall now be anxious to hear from you. The copper hearted barbarians are cutting *all* the trees in town in the beautiful valley on which I have looked so often with a loving eye this throws quite a gloom over my spring anticipations. Tell this to Durand not that I wish to give him pain; but that I want him to join with us in maledictions on all dollar-godded utilitarians.

Thomas Cole, "Thoughts and Occurrences," May 19, 1838, New York State Library, Thomas Cole Papers, 1821–63.

Winter has indeed departed and Spring nay Summer has burst upon us suddenly though not unexpectedly for we have waited long & anxiously. The birds fill the air with musick. The fruit trees are clothed in blossoms & the fields offer their grassy slopes whose transparent juicy green tempts the eye to delightful repose. The grass of the pastures of this season of the year is exceedingly beautiful in colour, tender though strong, soft & melting though intense it possesses that due proportion of shadow that softens the crudeness of great masses of green without destroying its brilliance & when sprinkled with the golden drops of the dandelions seen between the spectator and the sun it has the most charming effect of colour that nature possesses in her wide & varied range. But alas the painter falls far short in imitating it—he has not the materials and with all the skill in the world must fail.

When I remember & read of the multitude of great work produced by Raphael, Michelangelo, Domenichino & other great masters how paltry & insignificant seem the productions of my own pencil & how unpromising the prospect of ever producing pictures that shall delight & inform posterity & be regarded with the admiration & respect that the works of those masters do. Is it my own deficiency or the defect of the times & society in which I live? This I know, I have the ambition, the desire & industry sufficient to do as much as any man has done, the capacity I may not have but that [illegible] has not yet been tried. No sufficient field has yet been opened to me. I do feel that I am not a mere leaf painter—that I have loftier conceptions than any mere combination of inanimate and uninformed Nature. But I am out of place every thing around except delightful Nature herself is conflicting with my feelings. There are few persons of real taste & no opportunity for the artist of Genius to develop his powers. The utilitarian tide sets against fine arts.

Thomas Cole to Maria Cole, January 29, 1843, New York State Library, Thomas Cole Papers, 1821–63.

I have just received a letter from you which is a matter always looked for and always acceptable. I received your last just after I had sent off mine. I am sorry to hear that Theddy has the jaundice but hope he is better before this time. Tell him I think he ought to take medicine like a little man as I am away. I shall be glad to receive his letter. I am sorry the winter is so disagreeable with you it is certainly so with us and very unfortunate for the Exhibition . . . The weather is exceeding cold now and clear. I am much grieved about Mr. Phillips going away I can scarcely believe it. But there is heartlessness in the community that seems increasing. It is my impression that pictures do not have the influence on society that they did have some years since—they are too quiet for these times of excitement—some claptrap concern some humbug lecture is now the talking thing. I have found out that a subject from scripture particularly if a figure of Christ is introduced or even supposed is disgustful to the popular taste.

Thomas Cole, "Thoughts and Occurrences," January 1, 1846, Courtesy of the New York State Library, Manuscripts and Special Collections, Thomas Cole Papers, 1821–63.

Another of our years is fled & more than a year it is since I wrote in this book. I cannot write this new date without being thankful to God for the many blessings which has shed upon me during the past year and for those which I now enjoy. My wife & children are in good health & I have no ailments sufficient to interfere with my business or enjoyments. My business may not be complained of although I long for the time when I can paint whatever my imagination would

dictate without fear of running into pecuniary difficulties. This painting for money & to please the many is sadly repulsive to me. Thoughts & conceptions crowd upon me at times that I would fain embody, but I am kept from them by necessity. And like one who, traveling through a desert, comes to a deep stream beyond which he sees green fields & fruits & flowers fears to venture in the rushing waters. But I am about to venture & I have determined to commence in a short time (indeed I have already commenced drawing on the canvasses) a series of five pictures. The subject is the Cross and the World. I have no commission for the work & my means are scarcely competent for me to accomplish so great an undertaking, but the work I trust is a good one & I will venture in faith and hope.

WILLIAM SIDNEY MOUNT CHOOSES A SUBJECT

Like Thomas Cole, popular genre painter William Sidney Mount found his market among affluent urban business and professional men, who demanded and eagerly consumed his humorous, topical images of rustic American types. In dealing with such patrons, Mount had to maintain a delicate balance between compliance and self-assertion, subservience and autonomy. His correspondence with Jonathan Sturges, the late Luman Reed's business partner, illuminates that process, though his diary entry is a good deal more candid.

Letters between Jonathan Sturges and William Sidney Mount, William Sidney Mount and Mount family papers, 1830–1947, owned by the New-York Historical Society; microfilmed by the Archives of American Art.

[Sturges to Mount, February 22, 1839]

I am desirous of having a picture from you to match the one you painted for me. I should prefer an interior. Perhaps you may have a subject in your mind that might be connected with the first picture and still be an *interior* scene. I should not object to a kitchen scene. I only throw out the above hints to give you something of my views, without intending to restrict you to any particular subject should you find it convenient to paint me such a picture between now and the Spring Exhibition I should be pleased to have you do so. Please let me hear from you upon the subject on receipt of this.

[Mount to Sturges, February 28, 1839]

I have received your letter of the 22nd inst with a request that I shall paint you a picture to match the one I painted for you. It will afford me pleasure to paint you a picture sometime during the Season.

I should like to have a picture for you in time for the Spring exhibition but I am afraid the time is too short to do justice to any group I might take in hand at this late hour, besides I am at present painting a picture (an out of door scene & c) which will take a good deal of my time.

I might possibly paint you an interior with a single figure in time, that, perhaps might please you.

[Sturges to Mount, March 2, 1839]

Your esteemed favor for the 28th Feby. in so saying you thought the time too short to paint the picture for me before the Spring Exhibition. My only reason for wishing it in time for the exhibition was to see a good picture from you there—not having seen you for some time I did

not know whether you was painting any pictures that would be there or not. I wish to have you take your own time to do it I have only to say I should like to have it by Sept or Oct next. I should prefer a group to a single figure. Your head is full of just such subjects as I want. Your pencil can put them on canvas. I hope to see something of yours in the spring—we must stir people up a little I have been all winter at a Western Gentleman to send you an order. I hope to see a picture of yours in his possession yet. There is nothing new here in the way of pictures.

William Sidney Mount, journal, May 29, 1863, Long Island Museum of American Art, History and Carriages.

I hope never to paint for private individuals, or for the government, unless my heart goes with the order, Therefore I had rather select the subject to be painted and thoroughly understand it before the work is commenced.

To paint simply to make money I cannot do it, a painter should know his own ability and have regard for his reputation.

W.S.M.

A man should know himself and keep at work—if he really deserves to accomplish much in painting in any undertaking.

Have courage under all difficulties and positions in life—W.S.M.

INSTRUCTIONS FOR COLLECTORS

It seems natural to praise the early efforts of collectors such as Robert Gilmor and Luman Reed to purchase works from struggling artists, and so the following remarks from the American Monthly Magazine *come as something of a surprise. The writer cautions against equating patronage with heroism, suggesting that it is simply a natural commercial transaction, akin to buying meat. Moreover, patronage of a developing talent can sometimes hinder, rather than help, according to this critic.*

Such views notwithstanding, by 1846 Americans had begun to hope for a larger group of art patrons to emerge from the prosperous U.S. economy. The "hints" below were intended as a primer to instruct such potential collectors. The author assumes an interest in both European and American painting, but there is a decided preference for historical subjects related to the United States. Warnings are issued against a taste for frivolous "fancy" pictures, literary and dramatic genre, and precious, overrefined "album faces." The piece ends with a handy checklist of artistic categories for the consideration of neophyte buyers: subject, beauty, composition, drawing, light and shade, color, and the like.

"Fine Arts in America," American Monthly Magazine 5 *(June 1835).*

We have ever been of opinion, that, as good wine needs no bush, so good painters require no patrons save their own industry and talent; and further, that more youths of promise are sunk to absolute inferiority, than are raised from mediocrity to excellence, by any other patronage than that, which, being founded on the real merits and intrinsic value of their works, is no patronage.

All this talk of patronizing, is humbug—loathsome humbug. If we go to see a new actor, we patronize him, and he, forsooth, is to be obliged to *us;* to be *our* very grateful humble servants; and for what? that nature has given to him powers which she has not been pleased to bestow upon us; that she has endowed this person with the faculties of exciting our feelings, calling

forth our laughter, leading our imaginations whithersoever he will; which faculties he is willing to exercise for our entertainment and his own profit. We go to see him, because we expect to derive some gratification from his talents, and, if we fail in doing so, we go away, and keep our *patronage* for some one who does give us that of which we are in search. Now, in the name of all the gods at once, what has this to do with patronage? In the fine arts, we are informed that such a man is a liberal patron of the fine arts, and that the painters, whose works he purchases,—perhaps to turn them by some speculation or other into actual profit, but, at the best, because they please his eye, and gratify his fancy,—should be very grateful to the purchaser! As well might the butcher be expected to exhibit gratitude, that we condescend to grow fat upon his beef and mutton; as well might the tailor be deemed a heartless being, who did not manifest the excess of his sensibilities in our behalf, because we have been so peculiarly obliging as to shield ourselves from the wintry storm behind his broadcloth! To such an extent has this inconceivable folly of patronage begun to prevail, that we really believe, there are persons who think that an Irving ought to be grateful to the public, because they read his books; that Simms ought to bow down and worship the people, because they have been so condescending as to buy up two editions of the Yemassee. Oh! out upon such drivellers! It makes our very hearts turn sick within us, to hear the simple name of patronage; we wish it could be expunged from the language of our free country—for with freedom it can have nought in common—by an act of Congress.

"Hints to Art Union Critics," **American Whig Review 4 (December 1846).**

Collectors of pictures in Europe, time out of mind, have employed professed connoisseurs to select for them; for to do this successfully, is a consequent of much experience and many mistakes. In lieu of a connoisseur, one may abide by the following rules, which are to be found scattered through the best treatises of art:

1. The first impression is not usually the one by which we are to choose. Pictures, like poems, strike deeper than the sense, and address faculties which a slight weariness, a fit of indigestion, a critical humor, or the presence of another, may obscure, and lay quite asleep. To buy successfully, it is prudent to ponder well, and, above all, to judge independently, by the rule of our own secret inclination.

2. The design chosen should be suitable to the place for which we intend it: a plate of fruit, for example, will not be agreeable in a bed-room, nor a head of the Saviour in a dining-room. Winter pieces show best near a fire-place, and forest scenes by the windows of a portico: the first degree of artistical pleasure being in resemblance.

3. Very large and very small pictures are rarely good; those of medium size, and which represent some simple scene, with few figures, are most likely to give permanent pleasure. An infant St. John embracing a lamb, a half length figure of the mother of Christ, a bit of forest view, a fight between two dogs, the illustration of a fable, usually contain more of pleasure to the pictorial taste than a crowded theatrical or military composition, filled with monotony and violence.

4. So called fancy pieces, with such titles as this, "The Hat and Feather," "The Kid Gloves," "The Unopened Casket," "The Request," "The Love Whisper," &c., &c., usually disgust after a short acquaintance, however beautifully executed. They are a kind of album pictures, for the most part feeble and flashy. A picture must have a serious, or, at least, a comic, idea in it, to continue long agreeable: a shallow, smirking thing seems to insult you when once you are weary of its prettiness.

5. If a picture is excessively striking and gentlemanly, full of high foreheads, whiskers, sack coats, and the like, I would buy it for a present to my tailor, but not for my drawing-room.

6. Very German, very French, very American, or *very* Italian pictures are possibly not the best. Handsome men and women seem to be much alike the educated world over. Though national peculiarities may not go quite as far as portraiture toward injuring the pleasure of a picture, they go far enough notwithstanding.

7. Illustrations, particularly of Shakspeare and Milton, must be most excellent to be good at all; and if they are in the book, they are apt to mar the reading. The stage seems to be fatal to painting. It is even possible that if the Drama had arisen in Italy before Painting, as it did in England, Art would have been in Italy the same subordinate, theatrical, dangling thing it has been in France and England.

8. Barefaced imitations of any one artist, ancient or modern, seldom please long.

9. It seems not to have been observed that some designers, of Byron beauties and the like, are just now beginning to resort to little artifices to heighten the effect of their faces. Some make the eyes nearly as large as the mouth, with lashes as long and as large as bristles. This is to give an open and liquid expression. Others invariably turn up the angle of the mouth; others as invariably turn them down. Some delight in fingers so taper and regular, you fancy they have slender cartilages instead of joints in them. The composition of these album faces is extremely easy, and requires only a very moderate ability. If they must have a place, we may consign them to the Cockney school of design—an academy that is very large and flourishing. The chef-d'œuvres of this school come to us from London in such works as the "Children of the Nobility," and its congeners. As it is not to be questioned but that the English nobility will have the best artists in England to design their children, these works may be taken, perhaps, to show what we are to expect from the late enthusiasm in England regarding art and artists. Some have had the audacity to say that America is quite as likely to produce a school of genuine art as either England or Germany . . .

This German school, says an English critic, consider color a hindrance to the art, and restrict themselves, for the most part, to outline. Their pieces, of which engravings are becoming frequent in this country, have a profoundly serious expression; to attain which, they omit the upper eyelids of their figures, and put in the least possible detail in other parts. Here you may see very German Fates, Goddesses and Virgins, sitting in dull attitudes, as though their bodies were composed of some uniformly soft material. They look upon nothing in particular but seem (no matter what the action of the piece may be) to be absorbed in some internal sensations.

It may be assumed without much fear of contradiction, that any pleasure to be reaped from pieces imitative of this school, or of Perugino, will not be of the very enduring character.

10. As far as prejudice may be allowed to bias a choice, the connoisseur will be likely to prefer subjects of our own history; not only because they furnish the noblest artistic moments but because they cherish love of country and respect for our ancestors. But even here, the patriotic artist will sometimes err in his design through excess of patriotism and present us the revered image of our Washington in undignified and affected attitudes. He will be engaged, like a symbolical figure of some Hindoo Deity in doing one thing with one hand, and something else with the other: he will point to heaven with one finger and to his sword or the earth with other; so that we wish him provided with several more of those graceful organs, to perform as many diverse symbolical actions which we might study out at our leisure with the aid of book.

11. To discover each particular excellence in a piece, it may be regularly taken to pieces and criticized in detail, a process which discovers every beauty and gives the feeling of security to one's choice. To begin them in order: the first thing to be considered is perhaps the *subject:* whether it be serious or comic, beautiful or sublime, fanciful or grotesque, satirical or allegorical. Caricatures are common enough, good and bad; but there are no morally satirical designs but Hogarth's, and these require to be studied with a book. Of *sublime* designs, instance the Deluge of Nicholas Poussin, and his Sacrifice of Noah, Titian's Assumption of the Virgin— and above all, Raphael's Transfiguration. Among smaller pieces, Albert Durer's Hypochondriac, and Christ Crowned with Thorns, have a kind of sublimity. Indeed pictures of this class are frequent, and seem to characterize European art. Of Michael Angelo's sublimity every one has heard.

Beauty of design comes next in order. Of this, instance the productions of Greek art, and modern classical pieces. There is a kind of relaxed beauty in Sir Thomas Lawrence's children's heads. Works of this class are frequent, and apt to be feeble; for the artist to gain beauty sacrifices strength.

Grace, in pictures, is extremely rare, but best seen in Raphael's Cartoons, and his works generally; in these, grace in the design predominates over all other qualities: it seems to be comparatively easy to attain beauty of form; but grace being the happy union of strength and proportion, requires perhaps more power to express it than either sublimity or dignity alone. In the infinite variety of subjects, these *human* qualities of grace, beauty, and sublimity, will of course appear only in the faces and attitudes of the persons represented. It is common to speak of a beautiful landscape, a sublime scene, a graceful animal; but it is evident this is merely figurative language. In animals, the passions and affections, mirth, cunning, rage, fear and love, may be made to appear in the most surprising manner; but never, of course, any of those qualities which flow out of *character;* much less, then, in a landscape. To sum up all the particulars of this head, we look in a picture of the highest order, first for an Idea to be expressed; as of meditation, holy rapture, enterprise, victory, or the like; complicated as much as you will, and in as many figures, but always with grace, or beauty, or sublimity, in the principal persons. Who does not look for grace and sublimity together, in a Washington? and for beauty and sublimity in a Cordelia or an angel?

Then for the composition. The figures to be arranged so as all to represent one idea, or event, in which all are powerfully concerned, but differently; as in the picture now on exhibition of Cromwell's Iconoclasts destroying the ornaments of a Cathedral; a piece in which the unity of action is as admirable as it is varied; the *Idea,* a holy hatred of idolatry, prevails throughout; heightened even, by the half cunning, half terrible, face and attitude of the preaching soldier. Under this head, too, we consider the *attitudes,* whether they be natural, and not like those of a jointed doll, and whether the draperies are so arranged as not to slip off from the figure on the least change of position; as, for example, in a Daniel addressing King Belshazzar, whether, when he lowers his arm, his robe would not fall about his legs. That the figures be perpendicular upon their legs is very important: else we dread their falling over.

In the *drawing* of hands and feet, the skillful draughtsman may be easily recognized. The hands in Copley's portraits are an important feature, and express the character as natural hands do.

Light and Shade, or clear-obscure, as it is sometimes called, has three qualities, *to wit:* depth, breadth, and hardness and softness. By depth is meant intensity of shadow, and such a gradation, shade within shade, as to give an effect of *depth;* as in the hollows of rocks, foliage, and interiors of mansions. *Breadth* is sometimes defined to be a bringing of the shadows into broad

spaces, and causing them to invest the great central mass of light. The principle of this is evident. Hardness and softness may be seen in any drawing or engraving; in delicate or harsh interruptions, and an unnecessary blackness or lightness in the outlines. In engravings of the first order, defects of hardness, wateriness, coldness, and the like faults of light and shade, are carefully imitated from the originals. Excessive softness and blending is as disagreeable in the outline of a face, as the contrary fault of a hard, edgy effect.

It remains only to notice points of color; and here the natural feeling for color will be our only guide. To notice harmony of color, which is the placing of the tints so that brown shall not border upon green, nor purple on orange, nor blue upon green, nor red upon blue, nor yellow upon mere red, without some intervening or transitional tint. But *blue* upon *orange,* red upon soft green, yellow upon purple or clear brown, are always agreeable. Harmony includes also the distribution of the colors, not to have too much of any one tint, and to balance them one with another, that the eye be not fatigued. *Contrast* in color is of equal importance, and is accessory to harmony;—as when two tints are contrasted (as red with blue) on opposite parts of the canvas. *Transparency* has been dwelt upon in the former part of this essay. *Clearness,* or the absence of mixed muddy tints, is noticed by the best writers as an essential quality of a good picture. Last of all, to notice the *handling,* which is a merely technical matter; but it is said that the very best pieces of coloring in the world (Titian's for example, and Correggio's) discover no particular kind of handling. You cannot tell whether the colors were laid on with a short or a long brush, by 'stippling,' 'driving,' or 'scumbling'—and the like terms of the workshop, of which the connoisseur takes no particular heed, being chiefly occupied in the result, and suffering the painter to handle his brush as he pleases. *Tone* is of the first importance; a picture should have a clear agreeable green, brown, yellow, or purple tone over the whole, or it will not please, for it is so in all pleasing effects of nature.

Of course, in the three points of Expression, Light and Shade, and Color, which include all that can be said of a picture, from the idea to handling, the expression will be *first* in importance and the color *last;* but to fail in color is to fail at least in the point most likely to be observed, and to give pleasure. If a picture has any natural expression at all, it must be *good;* if the light and shadow are skillfully and powerfully managed it is *effective;* if to these a good, clear, transparent color can by any skill be added, it is delightful. But, in the reverse order, the series will not hold for the color may be exquisite, the drawing incorrect and wretched, and the idea wanting or detestable; but who will pronounce a picture good in which there is no idea?

JAMES FENIMORE COOPER COMMISSIONS A STATUE

In 1829, while traveling in Europe, writer James Fenimore Cooper had his portrait bust done by Horatio Greenough, one of the first American sculptors to take up residence in Italy; in the process Cooper grew interested in promoting the work of American artists. Almost as an act of charity, he asked Greenough to do an ideal group of putti, taken from Raphael's Madonna del Baldacchino *in the Pitti Palace, Florence. This group,* Chanting Cherubs *(now lost), became the first commission of an ideal marble sculpture for an American artist. As Cooper details in a letter to a friend, James De Kay, he had hopes that his order would not only create a reputation for Greenough but also jump-start the plastic arts in the United States. Although well received by the cogno-*

scenti, Chanting Cherubs *surprised some viewers with its nudity, prompting its exhibitors in Boston to add tiny aprons to the angelic figures. Many newspaper critics were appalled at this prudery, as was Greenough, who wrote to Washington Allston in defense of his "boys."*

James Fenimore Cooper to James Ellsworth De Kay, May 25, 1829, Yale University Library.

I have something to say, in all gravity, and if you think it will answer, you can cause the next paragraph of my letter to be published—You will see that the object is to serve the artist. Though it may wear the air of a puff, I assure you, it is literally true.

"At Florence, I met with Mr. Horatio Greenough, of Boston. He is on his second visit to Italy, where he is pursuing his studies as a sculptor. Mr. Greenough expressed a wish to make my bust, and his success was so encouraging, that I was induced to make him an offer for a groupe. He had frequently modelled figures, though never grouped, and, in no instance, I believe had any of them been sufficiently wrought up to be cast. With a diffidence, that did as much credit to his principles, as to his modesty, Mr. Greenough consented to undertake the task, on condition that unless both of us were pleased, the order should be null, and the work considered merely as one of his studies.

With this understanding of the terms, we began to look about us for a subject. There is a picture in the Pitti Palace, that is called La Madonna del Trono. It has the reputation of being by the hand of Raphael, though connoisseurs affect to see the pencil of one of his pupils in the principal figure. The virgin is seated on a throne, and angels are blowing trumpets near. There are several of the latter, two of whom, (perhaps I should call them cherubs) stand at the foot of the throne, singing from a scroll, that is held by a hand of each. We took these two figures for the chisel. They have been modelled in clay, cast in plaister, and are now cutting in the stone at Carrara. I need not tell you, that the latter operation is little more than mechanical, with the exception of a few finishing touches, which require the talents and knowledge of the artist.

These cherubs are thirty inches in height. The arm of one is thrown negligently over the shoulder of the other, and his head is bowed, as if he found more difficulty than his companion, in managing the music. Nothing can be more beautiful than the infantine grace, the attitudes, and the character of their expression. They are the beau ideal of childhood (and) mingled with that intelligence which may be thought necessary to compose a heavenly being of this character. The wings give them an ethereal look. There is a great deal of nature in their postures, and as much distinctness and diversity in the expression as the subject requires. In short, taking the beauty of the design and the execution together, I scarce know a more pleasing piece of statuary, for the size.

The work has been seen by many artists and connoisseurs. I hear but one opinion of its beauty. Bartolini speaks of it with high approbation. For myself, I confess I am delighted.

I believe this is the first piece of regular statuary, *in groupe,* that has been executed by an American artist . . .

The merit of Mr. Greenough is confined to the execution, in some degree, since the subject is certainly from Raphael. Still a good deal should be said in explanation. In the first place, the picture is faded, and much of the detail is wanting. Painting can show only one of its sides. The backs of the cherubs are entirely original, and this includes the wings and the disposition of the arm that is thrown across, which gave more difficulty than all the rest of the group-

ing. Then the attitudes are slightly varied, for postures that did well enough in accessories, would have destroyed the harmony of the groupe, when the figures came to be principals. This change has induced others, none of which, in my poor judgment, have impaired the beauty of the design. The two arts, though sisters, produce their effect by means so very different, that it subtracts but little from the glory of one when it copies from the other. This is perhaps truer with statuary than in a painting, since the resources of the latter are much the most complete . . .

In a country like ours, the acquisition of a good sculptor is no trifle. Of all the arts that of the statuary is perhaps the one we most want, since it is more openly and visibly connected with the taste of the people, through monuments and architecture than any other. Your lovers of political economy should not affect to despise the labors of the chisel and the pencil. There is an intimate connexion between all the means of National prosperity. We have a glorious foundation for greatness, in the diffusion of a certain degree of intelligence, but taste can exist without Grammars and Dictionaries and Arithmetics . . .

I intend to send these Cherubs home, as soon as finished, and I hope they may be the means of bringing patronage and encouragement to the artist. I have no more doubt, in my own mind, of his ability to execute an equestrian statue, than of his ability to do that which I know he has done. It would cost him time, and study, and great labor; but his chance of success would be equal to that of artists, whose reputations being established here, care little what people think of them in America. It is time that delusion on the subject of Europe, had an end, on our side of the Atlantic."

Horatio Greenough to Washington Allston, October 1831, Massachusetts Historical Society.

I see by some of the papers that some well intentioned persons have been shocked by the nudity of my cherub-boys—I had thought the country beyond that—There is a nudity which is not impure—there is an impurity which pierces the most cumbrous costume—Let my group be compared with hundreds of prints which are to be seen in the English french and american annuals and which are put into the hands of our sisters and wives and I leave it to any conscientious man to say whether I have gone to the full length of the letter with which modern delicacy has measured the range of art.

ART AND PRIVATE PROPERTY

Thomas G. Cary was a Harvard graduate (1811) who went on to work in New York in the cotton trade before returning to Massachusetts as a manufacturing executive in Boston and Lowell. He was also elected a Massachusetts state senator. Cary's mercantile interests reveal themselves in this unusual address, in which he connects patronage of the fine arts with a defense of private property. The specter of the revolutionary overthrow of individual capital (a political concern in some European countries at the time) lingers in the background of his essay, in which he links anticommunitarian sentiment with the freedom to patronize the arts. Luman Reed is Cary's example of American patronage, which he characterizes more as a business transaction than an act of cultural benevolence. In his mind, this "consumption" locates itself within a stable, self-correcting market, one that respects the "private rights" of the rich, who have earned their wealth honestly.

Thomas G. Cary, The Dependence of the Fine Arts for Encouragement in a Republic, on the Security of Property *(Boston: Little and Brown, 1845).*

Among the objections that have been urged against our system, it has been asserted that the Fine Arts can never find support among us; that the wealth and leisure, which can only be found among a privileged class, an aristocracy, are indispensable to their support; and that, therefore, it is rather desirable that we should *not* succeed, with our present frame of government, because we are likely to be wanting, as a nation, in what tends to the refinement of the human race.

Is the imputation of such a want likely to be found just? This is the enquiry that I now propose to pursue; and to answer it, requires a reference to some interesting particulars in our modes of life.

Have we an *inclination* for those arts that belong rather to the ornament than the necessities of life; or are we likely to have it?

If we have the inclination, are we likely to have the *means* to foster these arts?

Is it true, that all our acquisitions of property are in danger, occasionally, of being swept away by what is called here "a crisis," or in England "a critical conjuncture?"

Can the extent of dangers arising from such a crisis be ascertained and marked with some certainty, so that we may know what is to be left standing, after it has passed?

Can the failures that usually accompany it be traced to certain causes, and particularly to three or four leading causes, which, the more clearly they are understood, are the more likely to be removed?

If we are likely to have the inclination and the means necessary for the support of arts which are thought to ennoble our nature, are we likely to be left undisturbed in the free use of those means? Is *property secure* among us? Have we that just consideration for the rights of each other that leaves every one at liberty to use the fruits of his own industry according to his own will, as our theory of government professes that he may? . . .

About twelve years since a favorite American artist, who was then pursuing his studies in Italy, received from Mr. Luman Reed, a grocer in New York, the dimensions of a room in the house which he was then building for himself, with a request that he would prepare to fill the panels with such paintings of his own as he should design for the sum of three thousand dollars.

The painter was just then perplexed by accounts of pressing want from those who were dependent upon him at home, and had found himself obliged, with deep regret, to prepare for an immediate return to this country. The magnitude of the commission which he then received, and the liberality of the terms, at once relieved him from difficulty, and enabled him to remain in Italy as long as he had intended, for the purpose of studying the models of the great masters there; and when the work which he was then desired to undertake was completed, the three thousand dollars had been extended to five thousand.

Here, then, was an instance of such support to the fine arts as they are likely to receive in the United States.

It is very probable that for the same sum of money pictures of greater merit, and certainly of more celebrity, might have been purchased from the works of the old masters. But here was vital succour to the living artist, encouragement to continue his efforts when it was most acceptable. It was such aid as would have gladdened the heart of Coreggio; perhaps have prolonged his life, and enlarged the number of the treasures which he left to the world.

It was an act corresponding to what is called patronage in other countries; and yet it was not

patronage. It was free from all claim of the irksome deference that is usually felt to be due to the patron. It was performed in the spirit which cordially acknowledges a full equivalent, in the work, for the price paid; and which leaves the spirit of the artist unshackled by dependence . . .

The fine arts, then, are likely to receive such support among us that no egregious failure in respect to them will be eventually charged upon us, if we are likely to have the means to encourage them.

And are we so? A *crisis,* as it is called, comes over us, and our new world seems to be coming to an end in common bankruptcy. But our experience, thus far, enables us to say that if the troubles have no immediate connection with any general change of public policy, they soon pass away.

The earth gives forth her increase annually. It is to be prepared for use and taken for consumption; and that makes up the great business of the year, all over the world, and, in the main, this business is always done. But occasionally there is too much of one thing or too little of another, or some portion has been put in a wrong position, and there is temporary inconvenience, perhaps great alarm. But it is soon over.

When the derangement arises from a change in the policy of the government which requires a corresponding change in the habits of the community, great prudence and care are, certainly, required, for a time, to avoid serious embarrassment. Yet those who have conducted their business on certain sound principles, which every person of common sense can understand, and who mean to adhere to those principles under all circumstances, are generally able to stand firm through the whole . . .

There is, on the whole, encouragement to believe that we shall have men enough hereafter, who will know how to acquire the means necessary to spare a liberal allowance for the indulgence of taste and the encouragement of the Fine Arts.

But if we are likely to *acquire* the means, are we likely to be left in the undisturbed use of them, and allowed to enjoy them as we wish? Is *property secure* among us, in the possession of the owner? We have freed ourselves from the oppressions of the great. We have no titles of hereditary power, none that imply anything more than office in the gift of the people; which office must cease with the term fixed by the laws of the land, unless the community see fit to renew it. Yet we hear complaints among us of monopolies, of overgrown fortunes, of aristocracy, of something like wrong done, by somebody or other, to those who have to work for their daily bread.

There is cause to apprehend that men who have been summoned to act as jurors upon oath, or been chosen to enact laws, have suffered themselves to be misled by empty declamation on these subjects, and have inflicted deep injustice upon private rights, or tarnished the character of our mode of government, by disregarding those established rules of property that are essential to its security. And this is done through what they suppose to be a laudable jealousy of the rich; the *rich!* almost every one of whom was once as poor as his neighbors, and has become rich just because he has been industrious, frugal, and upright; who, when he dies, is to leave his property to be divided among children, who are very unlikely to add much to their portions; and whose children after *them,* must work for their living . . .

The encouragement of the Fine Arts, among us, then, depends, in a great measure, upon the security of property; and as general intelligence and common sense are sufficient to ensure that, the cause of the arts probably rests upon a safe support. Who of us are to have the means, and to enjoy the pleasure of being foremost to cherish them hereafter, it is impossible, amid the vicissitudes of life, to foretell. Those who act on the principles that have just been considered

may, at any rate, be happy under almost every variety of circumstances. On any other principles, it must be by mere chance, and for short periods, if we find happiness in any way.

This is said to be "a hard world," and the passing hour does not admit of any attempt at its defence. But one thing seems to be almost certain. For all purposes that are necessary to develope those qualities in our nature that best deserve admiration, and to bring them into such action as will diffuse beauty and delight around us, it is just as good a world as if its general character were more favorable, in some respects, than it is.

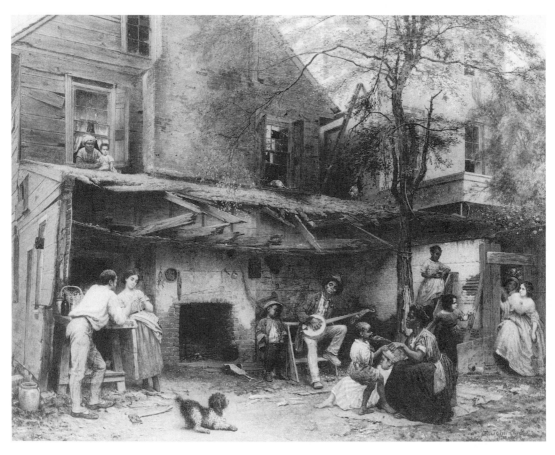

Fig. 4. Eastman Johnson, *Negro Life at the South,* 1859, oil on canvas. The New-York Historical Society, Robert L. Stuart Collection on permanent loan from the New York Public Library.

4 ANTEBELLUM AMERICA

Landscape, Life, and Spectacle

THE AMERICAN LANDSCAPE

Literary Landscapes

JAMES FENIMORE COOPER'S FOREST PRIMEVAL

As the United States strove to define itself in the early decades of the republic, the land itself emerged as a stage where debates and tensions about national identity—and its representation—played out. One enduring trope was that of America as an agrarian nation, made up of self-sufficient yeomen farmers whose virtue was rooted in the soil they tilled. In this construction, the ideal was a landscape in which nature and culture existed in perfect, unchanging equilibrium. Counterpoised to this was wild nature— that which existed beyond the limits of civilization. In the colonial era, the exigencies of survival and settlement left little time or energy for wilderness appreciation; the wilderness, indeed, harbored dangerous enemies.

Writers and artists of the early republic, however, began to ponder the American wilderness as a key element in defining national identity, in particular with reference to the Old World. Europe had no wilderness; America was wilderness (see "The American Gothic Landscapes of Charles Brockden Brown," chapter 2). The wilderness connoted newness and futurity for a nation poised on the threshold of history. But there lay an obdurate dilemma: history, expansion, progress, and prosperity were bound to change and ultimately destroy what made America unique. Such tenuous prospects made the untamed landscape all the more precious and meaningful.

James Fenimore Cooper made vivid and dramatic use of the wilderness frontier landscape in his Leatherstocking novels, among which the most famous, The Last of the Mohicans, *provided inspiration to the painter Thomas Cole (see "Thomas Cole and His Patrons," chapter 3). Modeling his narratives on Sir Walter Scott's Waverley novels, Cooper elevated the conquest of the wilderness to an epic of romance, adventure, and tragedy. The action in* The Last of the Mohicans *occurs in the Lake George region of upstate New York in 1757 during the English territorial war against the French (the so-called French and Indian War). Still untouched and pure, the American wilderness is*

an actor in the dramatic unfolding of the story. In it are all the signifiers of sublimity, anchored in topography specific to the actual place. Such is the precipice from which members of the scout Hawk-Eye's party behold an almost infinitely expansive vista of mountain ranges stretching into the far distance beyond limpid Lake Horican (Lake George) a thousand feet below. This is American space: vast, rugged, and spectacular. Cooper's scene painting teaches readers to stand in awe before such sights, which exemplify the unique power and splendor of the Native view.

James Fenimore Cooper, **The Last of the Mohicans: A Narrative of 1757** *(Philadelphia: Carey and Lea, 1826).*

Hawk-eye soon deviated from the line of their retreat, and striking off towards the mountains which form the western boundary of the narrow plain, he led his followers, with swift steps, deep within the shadows that were cast from their high and broken summits. The route was now painful, lying over ground ragged with rocks, and intersected with ravines; and their progress proportionately slow. Bleak and black hills lay on every side of them, compensating in some degree for the additional toil of the march, by the sense of security they imparted. At length the party began slowly to rise a steep and rugged ascent, by a path that curiously wound among rocks and trees, avoiding the one, and supported by the other, in a manner that showed it had been devised by men long practised in the arts of the wilderness. As they gradually rose from the level of the valleys, the thick darkness which usually precedes the approach of day began to disperse, and objects were seen in the plain and palpable colors with which they had been gifted by nature. When they issued from the stunted woods which clung to the barren sides of the mountain, upon a flat and mossy rock that formed its summit, they met the morning, as it came blushing above the green pines of a hill that lay on the opposite side of the valley of the Horican . . .

"See, and judge with your own eyes," said the scout, advancing towards the eastern brow of the mountain, whither he beckoned for the whole party to follow: "if it was as easy to look into the heart of man as it is to spy out the nakedness of Montcalm's camp from this spot, hypocrites would grow scarce, and the cunning of a Mingo might prove a losing game, compared to the honesty of a Delaware."

When the travellers reached the verge of the precipice, they saw, at a glance, the truth of the scout's declaration, and the admirable foresight with which he had led them to their commanding station.

The mountain on which they stood, elevated, perhaps, a thousand feet in the air, was a high cone that rose a little in advance of that range which stretches for miles along the western shores of the lake, until meeting its sister piles, beyond the water, it ran off towards the Canadas, in confused and broken masses of rock thinly sprinkled with evergreens. Immediately at the feet of the party, the southern shore of the Horican swept in a broad semicircle, from mountain to mountain, marking a wide strand, that soon rose into an uneven and somewhat elevated plain. To the north, stretched the limpid, and, as it appeared from that dizzy height, the narrow sheet of the "holy lake," indented with numberless bays, embellished by fantastic headlands, and dotted with countless islands. At the distance of a few leagues, the bed of the waters became lost among mountains, or was wrapped in the masses of vapor that came slowly rolling along their bosom, before a light morning air. But a narrow opening between the crests of the hills pointed out the passage by which they found their way still further north, to spread their pure and ample sheets again, before pouring out their tribute into the distant Champlain. To the south stretched the defile, or rather broken plain, so often mentioned. For several miles in this di-

rection, the mountains appeared reluctant to yield their dominion, but within reach of the eye they diverged, and finally melted into the level and sandy lands, across which we have accompanied our adventurers in their double journey. Along both ranges of hills, which bounded the opposite sides of the lake and valley, clouds of light vapor were rising in spiral wreaths from the uninhabited woods, looking like the smokes of hidden cottages; or rolled lazily down the declivities, to mingle with the fogs of the lower land. A single, solitary, snow-white cloud floated above the valley, and marked the spot beneath which lay the silent pool of the "bloody pond."

EDUCATING THE GAZE: BENJAMIN SILLIMAN ON MONTE VIDEO

In 1819 Yale professor of chemistry and natural history Benjamin Silliman traveled from Hartford to Quebec with Daniel Wadsworth, whose sketches en route became the illustrations for Silliman's published memoir of their tour. Not simply a description of natural beauties and wonders, Silliman's narrative forges vital links between landscape and national identity. American scenery, in all its richness and variety, is both source and mirror of American character, values, and moral feeling. At the same time, Silliman privileges a mode of seeing that connotes visual mastery and dominion. From the fifty-five-foot tower on Monte Video, Wadsworth's hilltop estate, Silliman beholds a "grand Panorama," which affords a sweeping, unobstructed view of a ninety-mile arc. From high above, the spectator gazes down at an infinite "kingdom"—of the all-seeing eye. For Thomas Cole and his contemporaries, this mode of spectatorship becomes the template for grand pictorial vistas of the American scene.

Benjamin Silliman, Remarks, Made on a Short Tour, between Hartford and Quebec, in the Autumn of 1819 (New Haven: S. Converse, 1820).

Before the close of the journey, these remarks, although written hastily, in public houses, and in steam-boats, became too extensive for the object first intended. For reasons, with which it is, perhaps, unnecessary to trouble the reader, it has since been thought advisable to print them, after due revisions, in the form in which they now appear.

The geological notices, are, with few exceptions, placed under distinct heads, and may, without inconvenience, be omitted, by those to whom they are uninteresting. But, the geological features of a country being permanent—being intimately connected with its scenery, with its leading interests, and even with the very character of its population, have a fair claim, to delineation, in the observations of a traveller; and this course, however unusual with us, is now common in Europe. I regret, that my limited time did not admit of more extended and complete observations of this nature, and I cannot flatter myself that they are always free from error . . .

. . . The tower is a hexagon, of sixteen feet diameter, and fifty five feet high; the ascent, of about eighty steps, on the inside, is easy, and from the top which is nine hundred and sixty feet above the level of Connecticut river, you have at one view, all those objects which have been seen separately from the different stations below. The diameter of the view in two directions, is more than ninety miles, extending into the neighbouring states of Massachusetts and New-York, and comprising the spires of more than thirty of the nearest towns and villages. The little spot of cultivation surrounding the house, and the lake at your feet, with its picturesque appendages of boat, winding paths, and Gothic buildings, shut in by rocks and forests, compose the foreground of this grand Panorama.

On the western side, the Farmington valley appears, in still greater beauty than even from the lower brow, and is seen to a greater extent, presenting many objects which were not visible from any other quarter. On the east, is spread before you, the great plain through which the Connecticut river winds its course, and upon the borders of which the towns and villages are traced for more than forty miles. The most considerable place within sight, is Hartford, where, although at the distance of eight miles in a direct line, you see, with the aid of a glass, the carriages passing at the intersection of the streets, and distinctly trace the motion and position of the vessels, as they appear, and vanish, upon the river, whose broad sweeps are seen like a succession of lakes, extending through the valley. The whole of this magnificent picture, including in its vast extent, cultivated plains and rugged mountains, rivers, towns, and villages, is encircled by a distant outline of blue mountains, rising in shapes of endless variety . . .

Indeed, the full illustration of the beauties of this mountain, would require a port folio of views, and would form a fine subject for the pencil of a master.

THE GLORY OF AN AMERICAN AUTUMN

Of all the seasons, autumn held pride of place as the most typically and uniquely American. Painting in London for a British audience, the American Jasper Cropsey specialized in autumn scenes so spectacularly brilliant that doubters allegedly demanded proof in the form of genuine American autumn leaves before they accepted the veracity of Cropsey's vision. Susan Fenimore Cooper's paean to this all-American season appeared, fittingly, in the Home Book of the Picturesque, *a collection of essays and engravings by noted authors and artists celebrating the distinctive wonders and beauties of the American landscape. In her fanciful and romantic account, Cooper extols the gaiety of the landscape on a typical Indian summer day, noting, however, that the spectacle is most beautiful, and most American, when cultivated fields and "cheerful dwellings" are part of the picture.*

Susan Fenimore Cooper, "Autumn," Home Book of the Picturesque *(New York: G. P. Putnam, 1851).*

Autumn is the season for day-dreams. Wherever, at least, an American landscape shows its wooded heights dyed with the glory of October, its lawns and meadows decked with colored groves, its broad and limpid waters reflecting the same bright hues, there the brilliant novelty of the scene, that strange beauty to which the eye never becomes wholly accustomed, would seem to arouse the fancy to unusual activity. Images, quaint and strange, rise unbidden and fill the mind, until we pause at length to make sure that, amid the novel aspect of the country, its inhabitants are still the same; we look again to convince ourselves that the pillared cottages, the wooden churches, the brick trading-houses, the long and many-windowed taverns, are still what they were a month earlier.

The softening haze of the Indian summer, so common at the same season, adds to the illusory character of the view. The mountains have grown higher; their massive forms have acquired a new dignity from the airy veil which enfolds them, just as the drapery of ancient marbles serves to give additional grace to the movement of a limb, or to mark more nobly the proportions of the form over which it is thrown. The different ridges, the lesser knolls, rise before us with new importance; the distances of the perspective are magnified; and yet, at the same time, the comparative relations which the different objects bear to each other, are revealed with a beautiful accuracy wanting in a clearer atmosphere, where the unaided eye is more apt to err.

There is always something of uncertainty, of caprice if you will, connected with our American autumn, which fixes the attention anew, every succeeding year, and adds to the fanciful character of the season. The beauty of spring is of a more assured nature; the same tints rise year after year in her verdure, and in her blossoms, but autumn is what our friends in France call "une beauté journalière," variable, changeable; not alike twice in succession, gay and brilliant yesterday, more languid and pale to-day. The hill-sides, the different groves, the single trees, vary from year to year under the combined influences of clouds and sunshine, the soft haze, or the clear frost; the maple or oak, which last October was gorgeous crimson, may choose this season to wear the golden tint of the chestnut, or the pale yellow of duller trees; the ash, which was straw-color, may become dark purple. One never knows beforehand exactly what to expect; there is always some variation occasionally a strange contrast. It is like awaiting the sunset of a brilliant day; we feel confident that the evening sky will be beautiful, but what gorgeous clouds or what pearly tints may appear to delight the eye, no one can foretell.

It was a soft hazy morning, early in October. The distant hills, with their rounded, dome-like heights, rising in every direction, had assumed on the surface of their crowning woods a rich tint of bronze, as though the swelling summits, gleaming in the sunlight, were wrought in fretted ornaments of that metal. Here and there a scarlet maple stood in full colored beauty, amid surrounding groves of green.

A group of young oaks close at hand had also felt the influence of the frosty autumnal dews; their foliage, generally, was a lively green, worthy of June, wholly unlike decay, and yet each tree was touched here and there with vivid snatches of the brightest red; the smaller twigs close to the trunk forming brilliant crimson tufts, like knots of ribbon. One might have fancied them a band of young knights, wearing their ladies' colors over their hearts. A pretty flowering dogwood close at hand, with delicate shaft and airy branches, flushed with its own peculiar tint of richest lake, was perchance the lady of the grove, the beauty whose colors were fluttering on the breasts of the knightly oaks on either side. The tiny seedling maples, with their delicate leaflets, were also in color, in choice shades of scarlet, crimson, and pink, like a new race of flowers blooming about the roots of the autumnal forest.

We were sitting upon the trunk of a fallen pine, near a projecting cliff which overlooked the country for some fifteen miles or more; the lake, the rural town, and the farms in the valley beyond, lying at our feet like a beautiful map. A noisy flock of blue jays were chattering among the oaks whose branches overshadowed our seat, and a busy squirrel was dropping his winter store of chestnuts from another tree close at hand. A gentle breeze from the south came rustling through the colored woods, and already there was an autumnal sound in their murmurs. There is a difference in the music of the woods as the seasons change. In winter when the waving limbs are bare, there is more of unity in the deep wail of the winds as they sweep through the forests; in summer the rustling foliage gives some higher and more cheerful notes to the general harmony; and there is also a change of key from the softer murmurs of the fresh foliage of early summer, to the sharp tones of the dry and withering leaves in October.

There is something of a social spirit in the brilliancy of our American autumn. All the glory of the colored forest would seem displayed for human eyes to enjoy; there is, in its earlier stages, an air of festive gayety which accords well with the cheerful labors of the season, and there is a richness in the spectacle worthy of the harvest-home of a fruitful land. I should not care to pass the season in the wilderness which still covers large portions of the country; either winter or summer should be the time for roaming in those boundless woods; but with October let us return to a peopled region. A broad extent of forest is no doubt necessary to the magnificent spec-

tacle, but there should also be broken woods, scattered groves, and isolated trees; and it strikes me that the quiet fields of man, and his cheerful dwellings, should also have a place in the gay picture. Yes; we felt convinced that an autumn view of the valley at our feet must be finer in its present varied aspect, than in past ages when wholly covered with wood.

Romantic Nature

FOR THE BIRDS: JOHN JAMES AUDUBON AND AMERICAN NATURE

In his perception of the natural world, John James Audubon fused scientific focus and romantic rapture. Born in Haiti and raised as a gentleman in France, Audubon came to the United States in 1803, in part to avoid conscription in Napoleon's army, and spent a decade as a dry-goods merchant in Henderson, Kentucky. Bankruptcy catalyzed Audubon's decision to go back to nature; he would track down, document, and paint every species of bird in North America. With gun, paint box, and an assistant, he set off down the Mississippi to commence his quest. Unable to find an American publisher, Audubon went to England, where his romantic frontier persona made him a celebrity. Birds of America, *published in four volumes between 1827 and 1838, contains 435 hand-colored plates of life-size birds, accompanied by Audubon's vivid commentaries.*

Audubon's field notes on the Louisiana warbler exemplify the naturalist's systematic empiricism: he records every partially digested caterpillar in the bird's gizzard. In "Account of the Method of Drawing Birds," Audubon clinically explains his system of posing birds using a wire armature, with the aim of reproducing "nature as it existed" with maximum fidelity. In Audubon's published descriptions of birds, however, one senses his romantic immersion in the natural world. His description of courting hummingbirds is particularly suggestive. The male is aggressive, the female delicate and passive. Their mating seals a "blissful compact" in which the male promises faithfully to care for and bravely defend his mate. Projecting his own values onto animal behavior, Audubon implicitly naturalizes the nineteenth-century social order.

John James Audubon, entry of August 4, 1821, Mississippi River Journals, *by permission of the Ernst Mayr Library, Museum of Comparative Zoology Archives, Harvard University.*

Louisianna Warbler. Sylvia Ludovicianna

I Shot this morning the same Bird or one of the same kind that I pursued yesterday So eagerly and then without success—and Was Much pleased to discover in it a New Species—during my Chase of yesterday it flew briskly from one tree or small bush to another, Not as if afraid of me, but as if Anxious for food, hanging its Wings very much like the Hooded fly Catcher and constantly keeping its tail Much spread like the American Red Start the Only Note it repeated every time it left a place for another Was a simple soft single *Tweet,* All its Movements extremely quick gave Me much trouble to shoot it—this Bird I Never have Met before, and of Course I Consider it as a Very Scarce One, its Note attracted me as that of all New Species do; More of its habits I would Like to know—Total Length 5. Inches Breadth 8—Whole upper part of a rich Olive Yellow—deeper on the Shoulders & back, Wing feathers Black edged with bright Olive—tail Much rounded, composed of 12 Feathers the 3 first exterior on each side Outwarding edged with brownish black and Yellow inwardly these edges broadening more as they goes to the Midle

feathers that are of a dark brown nearly black edged with Olive—Under wing Coverts rich yellow—under tail Coverts the same, very long—

Eyes full, Irids deep brown, bill the true Warbler horn col^d above and Clay below, very Sharp with a few black bristle, tongue forked & slender—Legs feet & Claws, Yellowish Clay. it proved on dissection a Male, extremely fat—Gizzard containing, remains of Caterpillars, Small beetles and diferent kinds of Small flies with a few fine Clear Sands—

John James Audubon, "Account of the Method of Drawing Birds," Edinburgh Journal of Science 8 (1828).

Having studied drawing for a short while in my youth under good masters, I felt a great desire to make choice of a style more particularly adapted to the imitation of feathers than the drawings in water colours that I had been in the habit of seeing, and, moreover, to complete a collection not only valuable to the scientific class, but pleasing to every person, by adopting a different course of representation from the mere profile-like cut figures, given usually in works of that kind.

The first part of my undertaking proved for a long time truly irksome. I saw my attempt flat, and without that life that I have always thought absolutely necessary to render them distinguishable from all those priorly made; and had I not been impelled by the constant inviting sight of new and beautiful specimens which I longed to possess, I would probably have abandoned the task that I had set myself, very shortly after its commencement.

Discoveries, however, succeeded each other sufficiently rapidly to give me transient hopes, and *regularity of application* at length made me possessor of a style that I have continued to follow to this day.

Immediately after the establishment of this style, I *destroyed* and disposed of nearly all the drawings I had accumulated, (upwards of 200,) and with fresh vigour began again, having all my improvements about me.

The woods that I continually trod contained not only birds of richest feathering, but each tree, each shrub, each flower, attracted equally my curiosity and attention, and my anxiety to have all those in my portfolios introduced the thought of joining as much as possible *nature as it existed.*

I formed a plan of proceeding, with a view never to alter it very materially. I had remarked that few works contained the females or young of the different species; that in many cases, indeed, those latter had frequently been represented as different, and that such mistakes must prove extremely injurious to the advancement of science. My plan was then to form sketches in my *mind's eye,* each representing, if possible, each family as if employed in their most constant and natural avocations, and to complete those family pictures as chance might bring perfect specimens . . .

My drawings have all been made after individuals fresh killed, mostly by myself, and put up before me by means of wires, &c. in the precise attitude represented, and copied with a closeness of *measurement* that I hope will always correspond with *nature* when brought into contact . . .

I have *never* drawn from a stuffed specimen. My reason for this has been, that I discovered when in museums, where large collections of that kind are to be met with, that the persons *generally* employed for the purpose of mounting them possessed no further talents than that of filling the skins, until *plumply formed,* and adorning them with eyes and legs generally from their own fancy. Those persons, on inquiry, knew nothing of the anatomy of the subject before them; seldom the true *length* of the whole, or the *junction* either of the wings and legs with

the body; nothing of their *gaits* and *allurements;* and not once in a hundred times was the bird in a natural position.

John James Audubon, "The White-Headed Eagle" and "The Ruby-Throated Hummingbird," Ornithological Biography *(Edinburgh: Adam and Charles Black, 1831).*

White Headed Eagle

The great strength, daring, and cool courage of the White-headed Eagle, joined to his unequalled power of flight, render him highly conspicuous among his brethren. To these qualities did he add a generous disposition towards others, he might be looked up to as a model of nobility. The ferocious, overbearing, and tyrannical temper which is ever and anon displaying itself in his actions, is, nevertheless, best adapted to his state, and was wisely given him by the Creator to enable him to perform the office assigned to him . . .

. . . The Eagle is seen perched, in an erect attitude, on the highest summit of the tallest tree by the margin of the broad stream. His glistening but stern eye looks over the vast expanse . . . His mate is perched on the opposite side, and should all be tranquil and silent, warns him by a cry to continue patient . . . The next moment . . . the wild trumpet-like sound of a yet distant but approaching Swan is heard . . . The Eagle has marked her for his prey. As the Swan is passing the dreaded pair, starts from his perch, in full preparation for the chase, the male bird, with an awful scream, that to the Swan's ear brings more terror than the report of the large duck-gun.

Now is the moment to witness the display of the Eagle's powers. He glides through the air like a falling star, and, like a flash of lightning, comes upon the timorous quarry, which now, in agony and despair, seeks, by various manœuvres, to elude the grasp of his cruel talons. It mounts, doubles, and willingly would plunge into the stream, were it not prevented by the Eagle, which, long possessed of the knowledge that by such a stratagem the Swan might escape him, forces it to remain in the air by attempting to strike it with his talons from beneath. The hope of escape is soon given up by the Swan. It has already become much weakened, and its strength fails at the sight of the courage and swiftness of its antagonist. Its last gasp is about to escape, when the ferocious Eagle strikes with his talons the under side of its wing, and with unresisted power forces the bird to fall in a slanting direction upon the nearest shore.

It is then, reader, that you may see the cruel spirit of this dreaded enemy of the feathered race, whilst, exulting over his prey, he for the first time breathes at ease. He presses down his powerful feet, and drives his sharp claws deeper than ever into the heart of the dying Swan. He shrieks with delight, as he feels the last convulsions of his prey, which has now sunk under his unceasing efforts to render death as painfully felt as it can possibly be. The female has watched every movement of her mate; and if she did not assist him in capturing the Swan, it was not from want of will, but merely that she felt full assurance that the power and courage of her lord were quite sufficient for the deed. She now sails to the spot where he eagerly awaits her, and when she has arrived, they together turn the breast of the luckless Swan upwards, and gorge themselves with gore . . .

In concluding this account of the White-headed Eagle, suffer me, kind reader, to say how much I grieve that it should have been selected as the Emblem of my Country. The opinion of our great Franklin on this subject, as it perfectly coincides with my own, I shall here present to you. "For my part," says he, in one of his letters, "I wish the Bald Eagle had not been chosen as the representative of our country. He is a bird of bad moral character; he does not get

his living honestly; you may have seen him perched on some dead tree, where, too lazy to fish for himself, he watches the labour of the Fishing-Hawk; and when that diligent bird has at length taken a fish, and is bearing it to his nest for the support of his mate and young ones, the Bald Eagle pursues him, and takes it from him. With all this injustice, he is never in good case, but, like those among men who live by sharping and robbing, he is generally poor, and often very lousy. Besides, he is a rank coward: the little King Bird, not bigger than a Sparrow, attacks him boldly, and drives him out of the district. He is, therefore, by no means a proper emblem for the brave and honest Cincinnati of America, who have driven all the *King Birds* from our country; though exactly fit for that order of knights which the French call *Chevaliers d'Industrie.*"

Ruby-throated Humming Bird

Where is the person who, on seeing this lovely little creature moving on humming winglets through the air, suspended as if by magic in it, flitting from one flower to another, with motions as graceful as they are light and airy, pursuing its course over our extensive continent, and yielding new delights wherever it is seen;—where is the person, I ask of you, kind reader, who, on observing this glittering fragment of the rainbow, would not pause, admire, and instantly turn his mind with reverence toward the Almighty Creator, the wonders of whose hand we at every step discover, and of whose sublime conceptions we everywhere observe the manifestations in his admirable system of creation?—There breathes not such a person; so kindly have we all been blessed with that intuitive and noble feeling—admiration! . . .

The prairies, the fields, the orchards and gardens, nay, the deepest shades of the forests, are all visited in their turn, and everywhere the little bird meets with pleasure and with food. Its gorgeous throat in beauty and brilliancy baffles all competition. Now it glows with a fiery hue, and again it is changed to the deepest velvety black. The upper parts of its delicate body are of resplendent changing green; and it throws itself through the air with a swiftness and vivacity hardly conceivable. It moves from one flower to another like a gleam of light, upwards, downwards, to the right, and to the left. In this manner, it searches the extreme northern portions of our country, following with great precaution the advances of the season, and retreats with equal care at the approach of autumn.

I wish it were in my power at this moment to impart to you, kind reader, the pleasures which I have felt whilst watching the movements, and viewing the manifestation of feelings displayed by a single pair of these most favourite little creatures, when engaged in the demonstration of their love to each other:—how the male swells his plumage and throat, and, dancing on the wing, whirls around the delicate female; how quickly he dives towards a flower, and returns with a loaded bill, which he offers to her to whom alone he feels desirous of being united; how full of ecstacy he seems to be when his caresses are kindly received; how his little wings fan her, as they fan the flowers, and he transfers to her bill the insect and the honey which he has procured with a view to please her; how these attentions are received with apparent satisfaction; how, soon after, the blissful compact is sealed; how, then, the courage and care of the male are redoubled; how he even dares to give chase to the Tyrant Fly-catcher, hurries the Blue-bird and the Martin to their boxes; and how, on sounding pinions, he joyously returns to the side of his lovely mate. Reader, all these proofs of the sincerity, fidelity, and courage, with which the male assures his mate of the care he will take of her while sitting on her nest, may be seen, and have been seen, but cannot be portrayed or described.

Roughly a decade after his first foray into landscape painting, Thomas Cole wrote his definitive essay on American scenery. Having spent his first eighteen years in England, Cole came to America with an educated English eye. He was deeply versed in the aesthetics of the sublime, the picturesque, and the beautiful, as well as their pictorial sources: the overwrought landscapes of Salvator Rosa, the Arcadian pastorals of Claude Lorrain, and the rustic landscapes of seventeenth-century Dutch painters. Like early writers on the American landscape, Cole viewed American scenery through eyes schooled in eighteenth-century theory. At the same time, he embraced the landscape of his adopted home, coming to identify himself with it wholeheartedly and absolutely.

In his essay, Cole proclaims the wilderness a sacred and beautiful place where one can still speak to God. Lacking historical associations, the American landscape—unlike that of Europe—boasts the glory of uncorrupted nature. In often rapturous tones, Cole enumerates those "peculiarly American" features, pointing out what makes selected sites sublime, beautiful, or picturesque. He closes, however, by lamenting the depredation of the wilderness in the face of progress, while resigning himself to its inevitability. At least there remains nature enough, he says reassuringly: "We are still in Eden."

Writers and painters in Cole's circle ardently embraced his vision of the American wilderness as the source of pride, spiritual uplift, moral value, aesthetic rapture, and—above all—the nation's unique and special identity. So enthusiastically did early admirers celebrate Cole as the shining star of American landscape painting that his determination to see Europe and immerse himself in its history prompted the poet and editor William Cullen Bryant to pen the admonitory sonnet reproduced here. Adumbrating Cole's more fully elaborated views in "Essay on American Scenery," Bryant's message is clear: Europe is encrusted with the detritus of civilization past and present. In America, by contrast, there is nothing but wild, abundant, endless nature—Cole's true and only turf.

Thomas Cole, "Essay on American Scenery," American Monthly Magazine *n.s. 1 (January 1836).*

The Essay, which is here offered, is a mere sketch of an almost illimitable subject—American Scenery; and in selecting the theme the writer placed more confidence in its overflowing richness than in his own capacity for treating it in a manner worthy of its vastness and importance.

It is a subject that to every American ought to be of surpassing interest; for, whether he beholds the Hudson mingling waters with the Atlantic—explores the central wilds of this vast continent, or stands on the margin of the distant Oregon, he is still in the midst of American scenery—it is his own land; its beauty, its magnificence, its sublimity—all are his; and how undeserving of such a birthright, if he can turn towards it an unobserving eye, an unaffected heart!

Before entering into the proposed subject, in which I shall treat more particularly of the scenery of the Northern and Eastern States, I shall be excused for saying a few words on the advantages of cultivating a taste for scenery, and for exclaiming against the apathy with which the beauties of external nature are regarded by the great mass, even of our refined community.

It is generally admitted that the liberal arts tend to soften our manners; but they do more—they carry with them the power to mend our hearts.

Poetry and Painting sublime and purify thought, by grasping the past, the present, and the future—they give the mind a foretaste of its immortality, and thus prepare it for performing

an exalted part amid the realities of life. And *rural nature* is full of the same quickening spirit—it is, in fact, the exhaustless mine from which the poet and the painter have brought such wondrous treasures—an unfailing fountain of intellectual enjoyment, where all may drink, and be awakened to a deeper feeling of the works of genius, and a keener perception of the beauty of our existence . . .

There is in the human mind an almost inseparable connexion between the beautiful and the good, so that if we contemplate the one the other seems present; and an excellent author has said, "it is difficult to look at any objects with pleasure—unless where it arises from brutal and tumultuous emotions—without feeling that disposition of mind which tends towards kindness and benevolence; and surely, whatever creates such a disposition, by increasing our pleasures and enjoyments, cannot be too much cultivated."

It would seem unnecessary to those who can see and feel, for me to expatiate on the loveliness of verdant fields, the sublimity of lofty mountains, or the varied magnificence of the sky; but that the number of those who *seek* enjoyment in such sources is comparatively small. From the indifference with which the multitude regard the beauties of nature, it might be inferred that she had been unnecessarily lavish in adorning this world for beings who take no pleasure in its adornment, who in grovelling pursuits forget their glorious heritage. Why was the earth made so beautiful, or the sun so clad in glory at his rising and setting, when *all* might be unrobed of beauty without affecting the insensate multitude, so they can be "lighted to their purposes?"

It *has not* been in vain—the good, the enlightened of all ages and nations, have found pleasure and consolation in the beauty of the rural earth. Prophets of old retired into the solitudes of nature to wait the inspiration of heaven. It was on Mount Horeb that Elijah witnessed the mighty wind, the earthquake, and the fire; and heard the "still small voice"—that voice is YET heard among the mountains! St. John preached in the desert;—the wilderness is YET a fitting place to speak to God. The solitary Anchorites of Syria and Egypt, though ignorant that the busy world is man's noblest sphere of usefulness, well knew how congenial to religious musings are the pathless solitudes.

He who looks on nature with a "loving eye," cannot move from his dwelling without the salutation of beauty; even in the city the deep blue sky and the drifting clouds appeal to him. And if to escape its turmoil—if only to obtain a free horizon, land and water in the play of light and shadow yields delight—let him be transported to those favored regions, where the features of the earth are more varied, or yet add the sunset, that wreath of glory daily bound around the world, and he, indeed, drinks from pleasure's purest cup. The delight such a man experiences is not merely sensual, or selfish, that passes with the occasion leaving no trade behind; but in gazing on the pure creations of the Almighty, he feels a calm religious tone steal through his mind, and when he has turned to mingle with his fellow men, the chords which have been struck in that sweet communion cease not to vibrate.

In what has been said I have alluded to wild and uncultivated scenery; but the cultivated must not be forgotten, for it is still more important to man in his social capacity—necessarily bringing him in contact with the cultured; it encompasses our homes, and, though devoid of the stern sublimity of the wild, its quieter spirit steals tenderly into our bosoms mingled with a thousand domestic affections and heart-touching associations—human hands have wrought, and human deeds hallowed all around . . .

In this age, when a meagre utilitarianism seems ready to absorb every feeling and sentiment, and what is sometimes called improvement in its march makes us fear that the bright and tender flowers of the imagination shall all be crushed beneath its iron tramp, it would be well to

cultivate the oasis that yet remains to us, and thus preserve the germs of a future and a purer system. And now, when the sway of fashion is extending widely over society—poisoning the healthful streams of true refinement, and turning men from the love of simplicity and beauty, to a senseless idolatry of their own follies—to lead them gently into the pleasant paths of Taste would be an object worthy of the highest efforts of genius and benevolence. The spirit of our society is to contrive but not to enjoy—toiling to produce more toil—accumulating in order to aggrandize. The pleasures of the imagination, among which the love of scenery holds a conspicuous place, will alone temper the harshness of such a state; and, like the atmosphere that softens the most rugged forms of the landscape, cast a veil of tender beauty over the asperities of life . . .

There are those who through ignorance or prejudice strive to maintain that American scenery possesses little that is interesting or truly beautiful—that it is rude without picturesqueness, and monotonous without sublimity—that being destitute of those vestiges of antiquity, whose associations so strongly affect the mind, it may not be compared with European scenery. But from whom do these opinions come? From those who have read of European scenery, of Grecian mountains, and Italian skies, and never troubled themselves to look at their own; and from those travelled ones whose eyes were never opened to the beauties of nature until they beheld foreign lands, and when those lands faded from the sight were again closed and for ever; disdaining to destroy their trans-atlantic impressions by the observation of the less fashionable and unfamed American scenery. Let such persons shut themselves up in their narrow shell of prejudice—I hope they are few,—and the community increasing in intelligence, will know better how to appreciate the treasures of their own country.

I am by no means desirous of lessening in your estimation the glorious scenes of the old world—that ground which has been the great theatre of human events—those mountains, woods, and streams, made sacred in our minds by heroic deeds and immortal song—over which time and genius have suspended an imperishable halo. No! But I would have it remembered that nature has shed over *this* land beauty and magnificence, and although the character of its scenery may differ from the old world's, yet inferiority must not therefore be inferred; for though American scenery is destitute of many of those circumstances that give value to the European, still it has features, and glorious ones, unknown to Europe.

A very few generations have passed away since this vast tract of the American continent, now the United States, rested in the shadow of primaeval forests, whose gloom was peopled by savage beasts, and scarcely less savage men; or lay in those wide grassy plains called prairies—

"The Gardens of the Desert, these
The unshorn fields, boundless and beautiful."

And, although an enlightened and increasing people have broken in upon the solitude, and with activity and power wrought changes that seem magical, yet the most distinctive, and perhaps the most impressive, characteristic of American scenery is its wildness.

It is the most distinctive, because in civilized Europe the primitive features of scenery have long since been destroyed or modified—the extensive forests that once overshadowed a great part of it have been felled—rugged mountains have been smoothed, and impetuous rivers turned from their courses to accommodate the tastes and necessities of a dense population—the once tangled wood is now a grassy lawn; the turbulent brook a navigable stream—crags that could not be removed have been crowned with towers, and the rudest valleys tamed by the plough.

And to this cultivated state our western world is fast approaching: but nature is still predominant, and there are those who regret that with the improvements of cultivation the sublimity of the wilderness should pass away; for those scenes of solitude from which the hand of nature has never been lifted, affect the mind with a more deep toned emotion than aught which the hand of man has touched. Amid them the consequent associations are of God the creator—they are his undefiled works, and the mind is cast into the contemplation of eternal things.

As mountains are the most conspicuous objects in landscape, they will take the precedence in what I may say on the elements of American scenery . . .

American mountains are generally clothed to the summit by dense forests, while those of Europe are mostly bare, or merely tinted by grass or heath. It may be that the mountains of Europe are on this account more picturesque in form, and there is a grandeur in their nakedness; but in the gorgeous garb of the American mountains there is more than an equivalent; and when the woods "have put their glory on," as an American poet has beautifully said, the purple heath and yellow furze of Europe's mountains are in comparison but as the faint secondary rainbow to the primal one.

But in the mountains of New Hampshire there is a union of the picturesque, the sublime, and the magnificent; there the bare peaks of granite, broken and desolate, cradle the clouds; while the valleys and broad bases of the mountains rest under the shadow of noble and varied forests; and the traveller who passes the Sandwich range on his way to the White Mountains, of which it is a spur, cannot but acknowledge, that although in some regions of the globe nature has wrought on a more stupendous scale, yet she has no where so completely married together grandeur and loveliness—there he sees the sublime melting into the beautiful, the savage tempered by the magnificent.

I will now speak of another component of scenery, without which every landscape is defective—it is water. Like the eye in the human countenance, it is a most expressive feature: in the unrippled lake, which mirrors all surrounding objects, we have the expression of tranquility and peace—in the rapid stream, the headlong cataract, that of turbulence and impetuosity.

In this great element of scenery, what land is so rich? . . .

I would rather persuade you to visit the "Holy Lake," the beautiful "Horican," than attempt to describe its scenery—to behold you rambling on its storied shores, where its southern expanse is spread, begemmed with isles of emerald, and curtained by green receding hills—or to see you gliding over its bosom, where the steep and rugged mountains approach from either side, shadowing with black precipices the innumerable islets—some of which bearing a solitary tree, others a group of two or three, or a "goodly company," seem to have been sprinkled over the smiling deep in Nature's frolic hour. These scenes are classic—History and Genius have hallowed them. War's shrill clarion once waked the echoes from these now silent hills—the pen of a living master has portrayed them in the pages of romance—and they are worthy of the admiration of the enlightened and the graphic hand of Genius . . .

I will not fatigue with a vain attempt to describe the lakes that I have named; but would turn your attention to those exquisitely beautiful lakes that are so numerous in the Northern States, and particularly in New Hampshire. In character they are truly and peculiarly American . . . Embosomed in the primitive forest, and sometimes overshadowed by huge mountains, they are the chosen places of tranquility; and when the deer issues from the surrounding woods to drink the cool waters, he beholds his own image as in a polished mirror,—the flight of the eagle can be seen in the lower sky; and if a leaf falls, the circling undulations chase each other to the shores unvexed by contending tides.

There are two lakes of this description, situated in a wild mountain gorge called the Franconia Notch, in New Hampshire. They lie within a few hundred feet of each other, but are remarkable as having no communication—one being the source of the wild Amonoosuck, the other of the Pemigiwasset. Shut in by stupendous mountains which rest on crags that tower more than a thousand feet above the water, whose rugged brows and shadowy breaks are clothed by dark and tangled woods, they have such an aspect of deep seclusion, of utter and unbroken solitude, that, when standing on their brink a lonely traveller, I was overwhelmed with an emotion of the sublime, such as I have rarely felt. It was not that the jagged precipices were lofty, that the encircling woods were of the dimmest shade, or that the waters were profoundly deep; but that over all, rocks, wood, and water, brooded the spirit of repose, and the silent energy of nature stirred the soul to its inmost depths . . .

And now I must turn to another of the beautifiers of the earth—the Waterfall; which in the same object at once presents to the mind the beautiful, but apparently incongruous idea, of fixedness and motion—a single existence in which we perceive unceasing change and everlasting duration. The waterfall may be called the voice of the landscape, for, unlike the rocks and woods which utter sounds as the passive instruments played on by the elements, the waterfall strikes its own chords, and rocks and mountains re-echo in rich unison. And this is a land abounding in cataracts; in these Northern States where shall we turn and not find them? Have we not Kaaterskill, Trenton, the Flume, the Genesee, stupendous Niagara, and a hundred others, named and nameless ones, whose exceeding beauty must be acknowledged when the hand of taste shall point them out?

In the Kaaterskill we have a stream, diminutive indeed, but throwing itself headlong over a fearful precipice into a deep gorge of the densely wooded mountains—and possessing a singular feature in the vast arched cave that extends beneath and behind the cataract. At Trenton there is a chain of waterfalls of remarkable beauty, where the foaming waters, shadowed by steep cliffs, break over rocks of architectural formation, and tangled and picturesque trees mantle abrupt precipices, which it would be easy to imagine crumbling and "time disparting towers."

And Niagara! that wonder of the world!—where the sublime and beautiful are bound together in an indissoluble chain. In gazing on it we feel as though a great void had been filled in our minds—our conceptions expand—we become a part of what we behold! At our feet the floods of a thousand rivers are poured out—the contents of vast inland seas. In its volume we conceive immensity; in its course, everlasting duration; in its impetuosity, uncontrollable power. These are the elements of its sublimity. Its beauty is garlanded around in the varied hues of the water, in the spray that ascends the sky, and in that unrivalled bow which forms a complete cincture round the unresting floods.

The river scenery of the United States is a rich and boundless theme. The Hudson for natural magnificence is unsurpassed. What can be more beautiful than the lake-like expanses of Tapaan and Haverstraw, as seen from the rich orchards of the surrounding hills? hills that have a legend, which has been so sweetly and admirably told that it shall not perish but with the language of the land. What can be more imposing than the precipitous Highlands; whose dark foundations have been rent to make a passage for the deep-flowing river? And, ascending still, where can be found scenes more enchanting? The lofty Catskills stand afar off—the green hills gently rising from the flood, recede like steps by which we may ascend to a great temple, whose pillars are those everlasting hills, and whose dome is the blue boundless vault of heaven.

The Rhine has its castled crags, its vine-clad hills, and ancient villages; the Hudson has its wooded mountains, its rugged precipices, its green undulating shores—a natural majesty, and

an unbounded capacity for improvement by art. Its shores are not besprinkled with venerated ruins, or the palaces of princes; but there are flourishing towns, and neat villas, and the hand of taste has already been at work. Without any great stretch of the imagination we may anticipate the time when the ample water shall reflect temple, and tower, and dome, in every variety of picturesqueness and magnificence.

In the Connecticut we behold a river that differs widely from the Hudson. Its sources are amid the wild mountains of New Hampshire; but it soon breaks into a luxuriant valley, and flows for more than a hundred miles, sometimes beneath the shadow of wooded hills, and sometimes glancing through the green expanse of elm-besprinkled meadows. Whether we see it at Haverhill, Northampton, or Hartford, it still possesses that gentle aspect; and the imagination can scarcely conceive Arcadian vales more lovely or more peaceful than the valley of the Connecticut—its villages are rural places where trees overspread every dwelling, and the fields upon its margin have the richest verdure.

Nor ought the Ohio, the Susquehannah, the Potomac, with their tributaries, and a thousand others, be omitted in the rich list of American rivers—they are a glorious brotherhood; but volumes would be insufficient for their description.

In the Forest scenery of the United States we have that which occupies the greatest space, and is not the least remarkable; being primitive, it differs widely from the European. In the American forest we find trees in every stage of vegetable life and decay—the slender sapling rises in the shadow of the lofty tree, and the giant in his prime stands by the hoary patriarch of the wood—on the ground lie prostrate decaying ranks that once waved their verdant heads in the sun and wind. These are circumstances productive of great variety and picturesqueness—green umbrageous masses—lofty and scathed trunks—contorted branches thrust athwart the sky—the mouldering dead below, shrouded in moss of every hue and texture, form richer combinations than can be found in the trimmed and planted grove. It is true that the thinned and cultivated wood offers less obstruction to the feet, and the trees throw out their branches more horizontally, and are consequently more umbrageous when taken singly; but the true lover of the picturesque is seldom fatigued—and trees that grow widely apart are often heavy in form and resemble each other too much for picturesqueness. Trees are like men, differing widely in character; in sheltered spots, or under the influence of culture, they show few contrasting points; peculiarities are pruned and trained away, until there is a general resemblance. But in exposed situations, wild and uncultivated, battling with the elements and with one another for the possession of a morsel of soil, or a favoring rock to which they may cling—they exhibit striking peculiarities, and sometimes grand originality . . .

. . . Time will not permit me to speak of the American forest trees individually; but I must notice the elm, that paragon of beauty and shade; the maple, with its rainbow hues; and the hemlock, the sublime of trees, which rises from the gloom of the forest like a dark and ivy-mantled tower.

There is one season when the American forest surpasses all the world in gorgeousness—that is the autumnal;—then every hill and dale is riant in the luxury of color—every hue is there, from the liveliest green to deepest purple—from the most golden yellow to the intensest crimson. The artist looks despairingly upon the glowing landscape, and in the old world his truest imitations of the American forest, at this season, are called falsely bright, and scenes in Fairy Land.

The sky will next demand our attention. The soul of all scenery, in it are the fountains of light, and shade, and color. Whatever expression the sky takes, the features of the landscape

are affected in unison, whether it be the serenity of the summer's blue, or the dark tumult of the storm. It is the sky that makes the earth so lovely at sunrise, and so splendid at sunset. In the one it breathes over the earth the crystal-like ether, in the other the liquid gold. The climate of a great part of the United States is subject to great vicissitudes, and we complain; but nature offers a compensation. These very vicissitudes are the abundant sources of beauty— as we have the temperature of every clime, so have we the skies—we have the blue unsearchable depths of the northern sky—we have the upheaped thunder-clouds of the Torrid Zone, fraught with gorgeousness and sublimity—we have the silver haze of England, and the golden atmosphere of Italy. And if he who has travelled and observed the skies of other climes will spend a few months on the banks of the Hudson, he must be constrained to acknowledge that for variety and magnificence American skies are unsurpassed. Italian skies have been lauded by every tongue, and sung by every poet, and who will deny their wonderful beauty? At sunset the serene arch is filled with alchymy that transmutes mountains, and streams, and temples, into living gold.

But the American summer never passes without many sunsets that might vie with the Italian, and many still more gorgeous—that seem peculiar to this clime.

Look at the heavens when the thunder shower has passed, and the sun stoops behind the western mountains—there the low purple clouds hang in festoons around the steeps—in the higher heaven are crimson bands interwoven with feathers of gold, fit for the wings of angels— and still above is spread that interminable field of ether, whose color is too beautiful to have a name . . .

I will now venture a few remarks on what has been considered a grand defect in American scenery—the want of associations, such as arise amid the scenes of the old world.

We have many a spot as umbrageous as Vallombrosa, and as picturesque as the solitudes of Vaucluse; but Milton and Petrarch have not hallowed them by their footsteps and immortal verse. He who stands on Mont Albano and looks down on ancient Rome, has his mind peopled with the gigantic associations of the storied past; but he who stands on the mounds of the West, the most venerable remains of American antiquity, *may* experience the emotion of the sublime, but it is the sublimity of a shoreless ocean un-islanded by the recorded deeds of man.

Yet American scenes are not destitute of historical and legendary associations—the great struggle for freedom has sanctified many a spot, and many a mountain, stream, and rock, has its legend, worthy of poet's pen or the painter's pencil. But American associations are not so much of the past as of the present and the future. Seated on a pleasant knoll, look down into the bosom of that secluded valley, begirt with wooded hills—through those enamelled meadows and wide waving fields of grain, a silver stream winds lingeringly along—here, seeking the green shade of trees—there, glancing in the sunshine: on its banks are rural dwellings shaded by elms and garlanded by flowers—from yonder dark mass of foliage the village spire beams like a star. You see no ruined tower to tell of outrage—no gorgeous temple to speak of ostentation; but freedom's offspring—peace, security, and happiness, dwell there, the spirits of the scene. On the margin of that gentle river the village girls may ramble unmolested—and the glad school-boy, with hook and line, pass his bright holiday—those neat dwellings, unpretending to magnificence, are the abodes of plenty, virtue, and refinement. And in looking over the yet uncultivated scene, the mind's eye may see far into futurity. Where the wolf roams, the plough shall glisten; on the gray crag shall rise temple and tower—mighty deeds shall be done in the now pathless wilderness; and poets yet unborn shall sanctify the soil.

It was my intention to attempt a description of several districts remarkable for their pic-

turesqueness and truly American character; but I fear to trespass longer on your time and patience. Yet I cannot but express my sorrow that the beauty of such landscapes is quickly passing away—the ravages of the axe are daily increasing—the most noble scenes are made destitute, and oftentimes with a wantonness and barbarism scarcely credible in a civilized nation. The wayside is becoming shadeless, and another generation will behold spots, now rife with beauty, desecrated by what is called improvement; which, as yet, generally destroys Nature's beauty without substituting that of Art. This is a regret rather than a complaint; such is the road society has to travel; it may lead to refinement in the end, but the traveller who sees the place of rest close at hand, dislikes the road that has so many unnecessary windings.

I will now conclude, in the hope that, though feebly urged, the importance of cultivating a taste for scenery will not be forgotten. Nature has spread for us a rich and delightful banquet. Shall we turn from it? We are still in Eden; the wall that shuts us out of the garden is our own ignorance and folly . . .

May we at times turn from the ordinary pursuits of life to the pure enjoyment of rural nature; which is in the soul like a fountain of cool waters to the way-worn traveller; and let us

"Learn
The laws by which the Eternal doth sublime
And sanctify his works, that we may see
The hidden glory veiled from vulgar eyes."

William Cullen Bryant, "To Cole the Painter Departing for Europe" [1829], in Bryant, Poems *(New York: E. Bliss, 1832).*

Thine eyes shall see the light of distant skies;
Yet, Cole! thy heart shall bear to Europe's strand
A living image of our own bright land,
Such as upon thy glorious canvas lies;
Lone lakes—savannas where the bison roves
Rocks rich with summer garlands—solemn streams—
Skies, where the desert eagle wheels and screams
Spring bloom and autumn blaze of boundless groves.
Fair scenes shall greet thee where thou goest—fair,
But different—everywhere the trace of men,
Paths, homes, graves, ruins, from the lowest glen
To where life shrinks from the fierce Alpine air.
Gaze on them, till the tears shall dim thy sight,
But keep that earlier, wilder image bright.

THE POETRY OF LANDSCAPE: THOMAS COLE IN VERSE

Like such other romantic artists as Joseph Mallord William Turner and Washington Allston, Thomas Cole put his feelings about life and landscape into verse, composing more than one hundred poems. All but a handful of these remained unpublished during his lifetime. Cole's verses offer insight into his analogical construction of landscape as a mirror of his own internal emotional states. The early, untitled poem below likens the poet's mind to a stormy ocean and his destiny to a cloud in the sunset sky.

Although these metaphors may strike the twenty-first-century reader as hackneyed, they fully represent Cole's tendency to anthropomorphize scenery and identify with its expressive features. In the poem from 1835, Cole paints a word picture of landscape in which change is life: storms "bring beauty in their train," and darkness enhances the poet's joy when he once more beholds the sun. Here too, nature models and validates the cycles of the poet's own emotional life.

Thomas Cole, untitled poem [c. 1825], in Marshall Tymn, ed., **Thomas Cole's Poetry** *(York, Pa.: Liberty Cap Books, 1972).*

Thy gloom O twilight suits my soul
For pensive sadness dwells with thee;
And deep thoughts rise by thy controul
Like swells upon a tranquil sea—

Yes! on the ocean of my mind
Which has been lash'd by the tempests rude
That are gone by; but leave behind
The silent heaving of the flood—

I wander slowly there to mark
The sunlit heavens fading fast
Like youth's own visions growing dark
Too lov'd, too beautiful to last—

There is a cloud upon the sky
And it hath ta'en the saddest hue
No kindred clouds are floating by
Sojourning in the trackless blue.

An emblem of my destiny,
In that low cloud perhaps I find
Companionless like it to be
When fortune's sun hath sad declin'd.

Cole, untitled poem (January 25, 1835), in Tymn, ed., **Thomas Cole's Poetry.**

I sigh not for a stormless clime,
Where drowsy quiet ever dwells,
Where purling waters changeless clime
Through soft and green unwinter'd dells—

For storms bring beauty in their train;
The hills that roar'd beneath the blast
The woods that welter'd in the rain
Rejoice whene'er the tempest's past.

Their faces lifting to the sky
With fresher brightness, richer hue;
As though the blast had brought them joy,
Darkness and rain dropp'd gladness too—

So storms of ill when pass'd away
Leave in our souls serene delight;
The blackness of the stormy day,
Doth make the welcome calm more bright—

THOMAS COLE AND THE COURSE OF EMPIRE

Although Thomas Cole's ambition was to raise landscape painting to the level of history painting, he was frustrated by the difficulty of marketing such work in America, where taste ran more toward what the artist considered prosaic, literal views. In Luman Reed, Cole found a patron willing to commission the artist's ambitious scheme for The Course of Empire *(1833–36), a grandiose landscape epic charting the rise and fall of an ancient civilization. Well-versed in the currently popular cyclical theory of history, Cole describes the five-part series in which landscape structures the narrative of civilization over the course of a day from dawn to dusk. Having contemplated this grand theme for years, Cole is ready to provide Reed with a highly detailed resume. His descriptive language vividly evokes each scene and shows how the landscape is calculated to correspond exactly with each stage of civilization, even to the precise character of the light and shade. Emphasizing his programmatic conception of the whole, Cole then specifies the arrangement of the paintings on a designated wall in Reed's New York townhouse.*

For all his imprecations against art critics, Cole found much favor in their eyes, as exemplified by the New-York Mirror*'s glowing response to* The Course of Empire *when it was exhibited in 1836. At the same time, the critics' views sometimes ran counter to the artist's own. Writing in considerable detail about Cole's monumentally ambitious series, the* Mirror *completely misses or chooses to ignore the painter's warning that history repeats itself in successive cycles. Instead, the journal's writer trumpets the unswerving progress of modern (and implicitly American) civilization. Similarly, squelching Cole's lofty aim to paint high-minded landscape allegories, the* Mirror *strongly prefers his all-American wilderness views.*

Thomas Cole to Luman Reed, September 18, 1833, Courtesy of the New York State Library, Manuscripts and Special Collections, Thomas Cole Papers, 1821–63.

The desire you expressed that I should paint a picture to fill one of your rooms has given me much pleasure and I have made some rough drawings (which I send you) of the arrangement that appears to me most suitable and in accordance with the subjects I should wish to paint. I mentioned to you a favorite subject that I had been cherishing for several years in the *faint* hope that some day or other I might be able to embody it. Your liberality has opened an opportunity and I trust that nothing will now prevent me from completing what I have so long desired. In the drawings you will perceive that I have taken one side of the room for this subject and as my description to you of my plan was very imperfect, I will now take the liberty of making an extract from my memorandum book of what I have conceived of the subject.

A series of pictures might be painted that should illustrate the history of a natural scene as well as be an Epitome of Man—Showing the natural changes of landscape and those affected by man in his progress from Barbarism to Civilization to Luxury to the Vicious state or state of destruction and to the state of Ruin + Desolation.

The philosophy of my subject is drawn from the history of the past wherein we see how na-

tions have risen from the Savage State to that of Power + Glory and then fallen and become extinct. Natural scenery has also its change, the seasons of the day and of the year, sunshine and storm, these justly applied with fine expression to each picture of the series I would paint. It will be wise to have the same location in each picture, this location may be identified by the introduction of some striking object in each scene, a mountain of peculiar form for instance—this will not in the least preclude variety. The scene must be composed so as to be picturesque in its wild state, appropriate for the cultivation and the site of a sea-port. Then must be the sea, a bay, rocks, waterfalls and woods. The first picture representing the savage state must be a view of a wilderness the sun rising from the sea and the clouds of night retiring over the mountains. The figures must be savage clothed in skins and occupied in the chase. There must be a flashing chiaro-scuro and spirit of motion pervading the scene, as though nature was just springing from Chaos. The second picture must be the Pastoral state. The day farther advanced than the first light clouds playing about the mountains—the scene partly cultivated a rude village near the bay, small vessels in the harbour, groups of peasants either pursuing their labours in the field, watching their flocks or engaged in some simple amusements. The chiaro-scuro must be of a milder character than in the previous scene; but yet have a fresh and bright effect. The third must be a noonday, a great city girding the bay, gorgeous piles of architecture, bridges, aqueducts, temples—port crowded with vessels, splendid processions and all that can be combined to show the fullness of prosperity the chiaro-scuro broad. The fourth should be a Tempest, a Battle and then burning of the city. Towers falling, arches broken, vessels wrecking in the harbour, in this should be a fierce chiaro-scuro masses and groups swaying about like stormy waves. This is the scene of Destruction, or vicious state. The fifth must be a sunset, the mountains, rivers, the city a desolate ruin, columns standing isolated amid the encroaching waters, Ruined Temples, broken Bridges, Fountains, sarcophagi and—no human figures—a solitary bird perhaps. A calm and silent effect. This picture must be as the funeral knell of departed greatness and may be called the state of desolation.

You will picture what an arduous task I have set myself but your approbation will stimulate me to conquer difficulties. These five pictures with three similar ones above and two others by the fire-place will occupy all that side of the room. The three high pictures will be something in character with the picture over which they hang. You will see in the drawing that I have arranged the compartment on the right different from that on the left, we may hereafter decide which will be better. On the right there is a space of 6 in round each picture that may be covered with green or crimson on the left the compartments entirely filled—it makes a great difference in the size of the pictures. The middle compartment will be best filled entirely. The frames I have calculated to be about 6 in wide, plain and shallow.

"The Fine Arts. Mr. Cole's Five Pictures," New-York Mirror *14, no. 17 (October 22, 1836).*

We hope that when treating of the arts and of artists, we have shown so decided a determination to give merit its due, and to exclude from our columns all notices of mediocrity, that we may claim attention to any criticism we may give on the works of an eminent painter, (such as Mr. Cole has proved himself,) although we should, by our love of truth, appear to deal in exaggerated encomium.

The *five* pictures which Mr. Cole has now opened to the publick, in the exhibition room of the National Academy of Design, at Chaton Hall, were announced by us more than a year ago as in a state of early progress. The series has cost the painter more than two years' labor; and when viewed by anyone who knows the difficulties of the art, and can appreciate its triumphs,

the only expression connected with the time in which they have been executed, must be, that so much could be done within the period.

The *design* of this truly magnificent *series,* marks the painter as a poet of the first order; and the execution shows a knowledge of nature, and of the philosophy of history, which places the artist on a much more exalted eminence than could be obtained by even *his* skill in mere landscape painting.

The five pictures represent *so many* epochs in the history of the human race. The savage, or *hunter's state* (with all its wild accessories of untamed wilderness, uncultivated soil, river, forest, and mountain rough as their roaming tenants) forms the first *tableau;* and the rising sun indicates the morning of society.

The second picture shows the *shepherd state,* with the incipiency of agriculture and the arts. Here the landscape is as lovely as the healthful period of man's infancy. All is joy.

The third period is *maturity.* Every object glows in a meridian sun. *Art* is in perfection. The same nature which we have seen in savage roughness and in pastoral felicity, is now dressed in the richest garb of architectural perfection; exhibiting all the treasures of Grecian genius; and man—*proud man,* arrayed in every gorgeous colour, passes over monumental arches adorned with trophies, in a triumphant procession that seems to defy destiny.

But the fourth period arrives. The late scene of triumph is converted into a display of all the horrours of strife. To the arts of peace succeed those of destruction. The same proud city is covered with armed combatants; its bridges broken down under the weight of ruthless enemies; its river, late so pellucid, and reflecting the proud ships of its merchants, or of strangers, bringing riches to its banks, is now stained with blood. Man has declined to a barbarian, in consequence of pride and ambition.

The fifth scene closes the eventful history with a twilight and a rising moon, showing the wreck of human happiness through human depravity. The same mountain which looked down upon the hunter, the shepherd, the triumphant monarch, and the struggle of murder and blood—looks tranquilly upon the shattered ruins of palaces, aqueducts, trophies, and all the vain monuments of man's folly or wisdom; and the same river reflects from its quiet bosom a picture of desolation, where before was seen every object with which the creator and the creature had *decorated* or *deformed* its banks.

The painter has given a sublimity to nature by representing her *unmoved and the same* during all the changes of man's progress. His conception is beautiful and poetick. He has accomplished his object, which was to show what *has been* the history of empires and of man. Will it always be so? Philosophy and religion forbid! Although such as the painter has delineated it, the fate of individuals *has been,* still the progress of the species is continued, and will be continued, in the road to greater *and greater* perfection. When the lust to destroy shall cease, and the arts, the sciences, and the ambition to excel in all good shall characterize man, instead of the pride of the triumph, or the desire of conquests, then will the empire of love be permanent.

"The Fine Arts. National Academy of Design," New-York Mirror 15, no. 49 (June 2, 1838).

View of Schroon Mountains. T. Cole.—In our opinion, this is the best of Mr. Cole's pictures in the present exhibition. It has greater breadth of effect, and is not so much cut up into separate parts as his other pictures. The whirlwind that has just passed over, reminds us of Mr. Cole's more early pictures, which, to our taste, were always the best, from their truly American feeling. His Arcadias and other scenes from the imagination, have not that originality and truth-telling force which his native pictures have. As a colourist, or designer, Mr. Cole ought not to

expect to rival Claude, or Salvator Rosa; but, as a true lover of his own native land, and as a faithful and bold delineator of all her wild scenery, he stands, and will, we think, continue to stand, unrivalled and alone.

American Sites: Tourist Literature

TOURISTS IN THE LANDSCAPE

Along with James Fenimore Cooper's novels, Thomas Cole's first forays into the Catskills anticipated what would become an increasingly popular American pastime: picturesque tourism. Prior to Cole's emergence as visionary of the American wilderness, engravings of characteristic American scenery in books and magazines had been in circulation for some time. This visual culture helped to pique interest in America's most celebrated sights, and once a rudimentary infrastructure was in place travelers began to seek out the spectacles they had seen in books or galleries. As a consequence, during the antebellum period the guidebook industry flourished, along with colorful memoirs recounting adventures in the wilderness. Books, prints, and paintings all were critical in educating travelers, telling them not only what to see but how to see it. The dominant work ethic of the day discouraged frivolous and unproductive leisure. Therefore, travelers sought experiences that could be justified on grounds of moral improvement, spiritual elevation, or patriotism.

With its high-quality steel engravings after drawings by the renowned topographical illustrator William Henry Bartlett, Nathaniel Parker Willis's American Scenery *showcased everything worth looking at in the northeastern United States—built monuments as well as natural wonders. Willis celebrates the New World as an "Eden" of limitless resources, a land of the "future." He extols the unparalleled beauty of the famous view from Mount Holyoke, and in his description of the Horse-Shoe Fall at Niagara he attempts to match in linguistic drama what he calls the "sublimest thing in nature."*

For the practical traveler, The New York State Tourist *offers advice on transportation to sights in the Catskills. The writer links the name of Thomas Cole with the now-celebrated places his works have brought "to public admiration." The succeeding descriptions of the landscape emphasize its pictorial qualities and point out features that are particularly spectacular and sublime.*

Nathaniel Parker Willis, American Scenery: or, Land, Lake, and River Illustrations of Transatlantic Nature, *vol. 2 (London: George Virtue, 1837).*

Preface

It strikes the European traveller, at the first burst of the scenery of America on his eye, that the New World of Columbus is also a new world from the hand of the Creator. In comparison with the old countries of Europe, the vegetation is so wondrously lavish, the outlines and minor features struck out with so bold a freshness, and the lakes and rivers so even in their fulness and flow, yet so vast and powerful, that he may well imagine it an Eden newly sprung from the ocean. The Minerva-like birth of the republic of the United States, its sudden rise to independence, wealth, and power, and its continued and marvellous increase in population and prosperity, strike him with the same surprise, and leave the same impression of a new scale of existence, and a fresher and faster law of growth and accomplishment. The interest, with regard to both the natural and civilized features of America, has very much increased within a few years; and

travellers, who have exhausted the unchanging countries of Europe, now turn their steps in great numbers to the novel scenery, and ever-shifting aspects of this.

The picturesque views of the United States suggest a train of thought directly opposite to that of similar objects of interest in other lands. There, the soul and centre of attraction in every picture is some ruin of the *past*. The wandering artist avoids every thing that is modern, and selects his point of view so as to bring prominently into his sketch, the castle, or the cathedral, which history or antiquity has hallowed. The traveller visits each spot in the same spirit—ridding himself, as far as possible, of common and present associations, to feed his mind on the historical and legendary. The objects and habits of reflection in both traveller and artist undergo in America a direct revolution. He who journeys here, if he would not have the eternal succession of lovely natural objects—

"Lie like a load on the weary eye,"

must feed his imagination on the *future*. The American does so. His mind, as he tracks the broad rivers of his own country, is perpetually reaching forward. Instead of looking through a valley, which has presented the same aspect for hundreds of years—in which live lords and tenants, whose hearths have been surrounded by the same names through ages of tranquil descent, and whose fields have never changed landmark or mode of culture since the memory of man, he sees a valley laden down like a harvest waggon with a virgin vegetation, untrodden and luxuriant; and his first thought is of the villages that will soon sparkle on the hill-sides, the axes that will ring from the woodlands, and the mills, bridges, canals, and railroads, that will span and border the stream that now runs through sedge and wild-flowers. The towns he passes through on his route are not recognizable by prints done by artists long ago dead, with houses of low-browed architecture, and immemorial trees; but a town which has perhaps doubled its inhabitants and dwellings since he last saw it, and will again double them before he returns. Instead of inquiring into its antiquity, he sits over the fire with his paper and pencil, and calculates what the population will be in ten years, how far they will spread, what the value of the neighbouring land will become, and whether the stock of some canal or railroad that seems more visionary than Symmes's expedition to the centre of the earth, will, in consequence, be a good investment.[1] He looks upon all external objects as exponents of the future. In Europe they are only exponents of the past.

There is a field for the artist in this country (of which this publication reaps almost the first-fruits) which surpasses every other in richness of picturesque. The great difficulty at present is, where to choose. Every mile upon the rivers, every hollow in the landscape, every turn in the innumerable mountain streams, arrests the painter's eye, and offers him some untouched and peculiar variety of an exhaustless nature. It is in *river scenery*, however, that America excels all other lands: and here the artist's labour is not, as in Europe, to embellish and idealise the reality; he finds it difficult to come up to it. How represent the excessive richness of the foliage! How draw the vanishing lines which mark the swells in the forest-ground, the round heaps of the chestnut-tops, the greener belts through the wilderness which betray the wanderings of the watercourses! How give in so small a space the evasive swiftness of the rapid, the terrific plunge

[1] Captain John C. Symmes devoted much of his life to promulgating his theory that the earth was hollow and potentially habitable.

of the precipice, or the airy wheel of the eagle, as his diminished form shoots off from the sharp line of the summit, and cuts a circle on the sky! . . .

View from Mount Holyoke

Probably the richest view in America, in point of cultivation and fertile beauty, is that from Mount Holyoke. The bald face of this mountain, which is turned towards Northampton, is about one thousand one hundred feet above the level of the Connecticut river, (or Quonnecticut, as pronounced by the Indians,) and commands a radius of about sixty miles. The ascent at the side is easy; and it is a fashionable climb for tourists, whose patronage of ginger-beer and sunrises maintains a shanty and a hermit on the top, and keeps in repair a series of scrambling but convenient ladders at the difficult points of the enterprise. The view immediately below presents a singular phase of the scenery of the river, which seems here to possess a soul for beauty, and loiters, enamoured and unwilling to flow on, in the bosom of a meadow which has no parallel in New England for loveliness and fertility. Four times the amorous stream turns to the west, and thrice to the east, threading its silver tide through the tender verdure as capriciously as a vein in the neck of beauty, and cheating twelve miles of direct course into twenty-four of coil and current. The meadow is almost entirely unfenced, and the river is fringed in all its windings with weeping elms, wild flowers and shrubs, while up toward the town the fields rise in slightly swelling terraces—forming a foreground to one of the most sunny and cheerful villages in Massachusetts . . .

Horse-Shoe Fall, at Niagara

It is necessary to remember the extent of the waters which feed Niagara, to conceive, when standing for an hour only on the projecting rocks, how this almighty wonder can go on so long. Even then,—that these inland seas lie above, tranquil and unexhausted, scarce varying their high-water mark perceptibly, from year to year, yet supplying, for *every* hour, the "ninety millions of tons," which, it is estimated, plunge over the cataract,—it affords you a standard for the extent of those lakes, to which the utmost stretch of the mind seems scarcely competent.

The accompanying view from Goat Island is of course only partial, as the American fall is entirely left out of the picture. The Horse-shoe Fall, as a single object, however, is unquestionably the sublimest thing in nature. To know that the angle of the cataract, from the British shore to the tower, is near half a mile in length; that it falls so many feet with so many tons of water a minute; or even to see it, as here, admirably represented by the pencil; conveys no idea to the reader of the impression produced on the spectator. One of the most remarkable things about Niagara is entirely lost in the drawing—its *motion*. The visitor to Niagara should devote one day exclusively to the observation of this astonishing feature. The broad flood glides out of Lake Erie with a confiding tranquillity that seems to you, when you know its impending destiny, like that of a human creature advancing irresistibly, but unconsciously, to his death. He embraces the bright islands that part his arms for a caress; takes into his bosom the calm tribute of the Tonewanta and Unnekuqua—small streams that come drowsing through the wilderness—and flows on, till he has left Lake Erie far behind, bathing the curving sides of his green shores with a surface which only the summer wind ruffles. The channel begins to descend; the still unsuspecting waters fall back into curling eddies along the banks, but the current in the centre flows smoothly still. Suddenly the powerful stream is flung with accumulated swiftness among broken rocks; and, as you watch it from below, it seems tossed with the first shock into the very sky. It descends in foam, and from this moment its agony commences. For three miles it tosses

and resists, and, racked at every step by sharper rocks and increased rapidity, its unwilling and choked waves fly back, to be again precipitated onward, and at last reach the glossy curve, convulsed with supernatural horror. They touch the emerald arch, and in that instant, like the calm that follows the conviction of inevitable doom, the agitation ceases,—the waters pause,—the foam and resistance subside into a transparent stillness,—and slowly and solemnly the vexed and tormented sufferer drops into the abyss. Every spectator, every child, is struck with the singular deliberation, the unnatural slowness, with which the waters of Niagara take their plunge. The laws of gravitation seem suspended, and the sublimity of the tremendous gulf below seems to check the descending victim on the verge, as if it paused in awe.

The New York State Tourist. Descriptive of the Scenery of the Mohawk and Hudson Rivers *(New York: A. T. Goodrich, 1840).*

In many points of view, it may be considered one of the most important streams in the world for its extent, and only, if at all, inferior in usefulness to the Ohio and Mississippi Rivers, but superior to them for steam-boat navigation, viz in the most remarkable circumstance, and exclusively characteristic of the Hudson River from every other stream in this country—its penetrating through the chain of highlands, and being affected by the tides as far as Troy, 160 miles north, thus carrying the oceanic influence far into the interior, and yielding the greatest facilities to commerce . . .

The width of the river for 25 miles N. from New-York, is about one mile, bounded on the west by precipices of trap or green stone, from 200, and rising gradually to 500 feet in height. Beyond these, there is an expansion of the river to the width of 4 miles, called Tappan and Haverstraw bays, with the mountains on the western shore rising boldly to 700 feet in height.

The traveler then enters into the romantic region of the highlands, where the river is contracted into narrower limits, but is of greater depth, and the mountains rise on both sides with abruptness from nine to sixteen hundred feet in height. At West Point, the river turns suddenly, at right angles, to its previous course, and soon displays an opening between the mountains on the north, beyond which the country subsides into a fertile, but hilly region, which continues for a hundred miles, with a noble view of the Catskill, or spur of the Allegany Mountains, at the distance of 8 or 10 miles.

Such are the attractions possessed by this noble river, that it annually allures thousands of strangers, and this, in connection with the canal navigation, the summer visiters to the Springs, the Lakes, and to the Falls of Niagara, causes the sum of one or more millions of dollars to be expended in this state every year, and forms a very considerable item in the prosperity and resources of the city and country . . .

Excursion up the Hudson River

On leaving the city in any of the steam-boats for the north, the traveler for pleasure should, if on his *first trip,* by all means prefer the *morning* boats, at 7 A.M.; for the sake of enjoying the splendid scenery in perfection, and select on the upper deck a suitable position near the after part of the boat, and facing to the north, so as to glance readily at objects that may attract his attention on either shore.

For twenty-five miles after leaving New-York the river is very near one mile in width, and then for the next twenty expands to three or four times that width before entering the portals of the Highlands . . .

The boat comes to the landing at West Point and discharges and takes in passengers, and al-

lows time enough for the passing traveler barely to see the *capital hotel* on the brow of the hill . . . The view from the observatory on the top of the hotel is peculiarly fine in all its parts, but especially on the north, looking down upon the Hudson and towards Newburgh, and the remote chain of Shawangunk mountains in the dim blue distance towards the north-west . . .

In receding from, or advancing towards West Point, the finest panoramic view is beheld of all the public buildings on and around the plain, and also of the ruins of fort Putnam, still lording it over the plain and river below.

The passage through the Highlands is sometimes perilous for sloop navigation, owing to the sudden and impetuous gusts or flaws of wind that come pouring down between the lofty hills and deep gorges and ravines . . .

Catskill . . . [is] on the west shore, one hundred and eleven miles from New-York. This has long been an important landing-place for visitors to the great hotel on the *table rock* of the Catskills, known as the *Pine Orchard,* and frequented by thousands of travelers. Carriages are always in waiting on the dock to accommodate those that wish to ascend. Travelers can proceed by the rail-road to *Canajoharie,* a town on the Erie Canal and banks of the Mohawk River, about seventy miles in a north-west direction up the valley of the Catskill river, through Green and Schoharie counties, and over and along the north-eastern slopes of the mountains, saving, perhaps, a little time and distance, but losing the view of Hudson, Albany, and Troy, and of the delightful rail-road route along the Mohawk, from Schenectady to the intersection of Canajoharie . . .

Besides the view from the table rock before alluded to, there are other inducements for travelers disposed for a time to seek out gratification and amusement, to visit the falls and other spots that the magic touches of Cole the artist have brought to the public admiration; and as coaches run regularly to and from the mountain, and are so adjusted as to meet the steam-boats at various hours, and also to enable the public to visit the different falls, there is every facility afforded the traveler; the price is one dollar to ascend to the mountain house—the time required, about four hours, distance twelve miles—but half the time suffices to return. The road for nine miles from the landing is uneven, and for the last three, a steep ascent in a zig-zag course, doubling on the track, that soon places the traveler in a peculiar position, rather trying to the nerves of the timid.

The *Clove road* that ascends the Catskills, a mile or two south of the road to the Pine Orchard, should by all means be seen as one of the wonders of the vicinity. It enters upon the ascent where the Kauterskill emerges into the light of day, from the deep and overshadowed ravine, where the raging and force of the tumultuous waters have thrown large masses of rock into every imaginable and confused form, pile on pile, among which, the tumbling waters are sometimes seen bursting forth from narrow channels, or crevices, or swelling and boiling up from some syphon or upper source, or forming cascades of an endless variety of forms, and giving forth sounds of its raging and uncontrolled power, that, as the traveler follows up the arduous, and endless, and truly fatiguing ascent, becomes less and less audible, as the road takes the other side of the gorge, by crossing a rude bridge.

Several tremendous precipices of sandstone rock, of several hundred feet in perpendicular height, strike one with awe and delight,—and when nearly at the end of the ascent, the traveler will pause and look back to the east, through the narrow vista of the towering rocky masses of the mountain on either hand, at a plunging and rapid sweep of the eye, at the distant fields and farms far down in the vale below, and beyond the Hudson, on the east shore, well in the interior, towards the Massachusetts and Connecticut lines, the diversified colors of the cleared and cultivated lands, green lots, and the yellow harvest ripening for the sickle and the scythe, with

all the hues of the fading distance, and at the deep and full green of the American forest predominating over the landscape, the whole presented at such a visual angle and as distinctly exhibited in its details, as a vast map, or page, in the sublime volume of nature.

The entire view, from the twilight dimness of objects in the gorge, and the concentration of the eager gaze of the beholder, and the brilliant lighting up of the remoter squares and divisions of the farms, dwindled into diminutive size at the end of this grand gallery of nature, seems of itself to be a perfect picture, set with a most gigantic and appropriate frame, and underneath the blue canopy of the o'er-arching expanse of heaven, is in admirable keeping and harmony. When resuming the advance, and attaining to the summit of the *gap,* in a short distance there is a clearing and a log-house or two, and you can begin your view westward; the extreme summit of the round top still appears to be at a toilsome distance. The residents near this spot are accustomed to conduct up those seeking their aid to attain the crowning summit of the Catskills, three thousand eight hundred and fifty-six feet high. While here, get the guides to conduct you to the ravine near by, where the western branch of the Kauterskill presents a most beautiful cascade into the deep and narrow amphitheatrical walls of a secluded receptacle, hollowed out and excavated into pools or reservoirs, most admirable for a pure clear bath, where nought but a small opening like a sky-light admits a sufficiency of exposure to exhibit the exquisite drapery that clothes the steep sides and the encircling rim or verge of this sanctuary of nature, that must be sought and won with considerable toil and muscular exertion, and that so richly repays the explorer. This is one among a number of the hitherto secret and hidden beauties of nature, that man has seldom beheld in this portion of the mountain; others exist farther to the interior . . .

The hotel on the table rock was built by the citizens of Catskill, and cost twenty-two thousand dollars; it is one hundred and forty feet in length, four stories high, with a piazza extending across the front, and a colonnade. There are about six acres of naked rock surface around the hotel, with ample room for outbuildings. The hotel is placed at a safe distance from the verge of the sheer descent of the precipice, to allow coaches to draw or drive up in front, to deliver and receive passengers, and for visiters to promenade about, and peer over the dizzy, toppling crags, into the deep valley under the eye of the spectator, here at an altitude of two thousand five hundred feet above the Hudson, and fifteen hundred above the open meadow at the immediate base of the precipitous descent. The Hudson river appears distinctly at intervals, for forty or fifty miles, dotted over with numerous islands, and the white sails of the river craft, and the steamers, with their long trains and curling volumes of smoke, that may be easily distinguished by the naked eye, urging their powerful course over the placid surface of the river, that in the morning sun gleams brilliantly and dazzles the eye with its effulgence . . .

The remains of the Windham turnpike, made some twenty or thirty years since, across this mountain, may be followed towards the west, passing the two *lakes* that are two thousand feet above tide water, one mile long, and form the cascade of the Kauterskill Falls, that will now be described:—the lakes are repulsive in their aspect, the one on the north, with broad lobed-leaved aquatic plants floating on the surface, and bordered by tangled shrubbery,—but the other has a cleaner margin, and the waters of both are connected by a brook passing under the bridge. The supply of water is small, and preserved with care, and let off for hire, to increase the mass of the fall when a party of strangers arrives. Following a winding, stumpy, rugged, and at times muddy road, for about a mile through the woods to the south-west, we arrive at an opening of six hundred feet in circumference, that yawns before us to a profound depth, and arrests our progress by its deep semi-circular or amphitheatrical aperture or form, open only towards the

south or south-west, and exposing the deep ravine, richly clothed round with trees, and varied with foliage of different colors, retreating steeply down a quarter of a mile or more towards the *clove road,* and from the foot of the ravine west of the clove, rises in one majestic curtain or slope, extending a mile or two heavenward, the full body of the vast *round top,* that fills an angle of thirty or forty degrees above the level of the eye of the beholder, filling him with admiration at the noble grandeur of the effect. The run, or outlet that discharges the water of the two small lakes, rushes across the mass of sand-stone composing the precipice, and leaps into the gulf; and, exhausting itself in foam and spray, falls upon the debris one hundred and seventy-five feet, is again collected on the floor of the rock, and within a short distance takes another plunge of seventy-five feet, and follows the dark, and over-arched, and deeply-shaded depth and windings of the ravine to the valley below.

After studying this grouping of the mountains and ravine from above, the traveler should by all means follow the circuitous path that will conduct him down about ninety feet, and then take a horizontal direction, passing under the rock into a semi-cave behind the water-fall, with the vast rock above that supports the falling sheet of water, and impends over as the stooping and groping explorer walks on the crumbled debris of the red rock, while the water is falling twenty or thirty feet clear of the standing-place, and forms a curtain of snowy spray in front of this deep recess, that serves partly to veil the deep blue sky, and adds much to the charms of this fearful and wonderful place; even the rainbow at certain times appears from above, floating on the bosom of the mists of the falling spray for a moment, vanishing and circling away. Those that omit to view this fall from below lose much that will cause regret . . .

Not the least of the gratifications derived by an observant person, or a lover of nature, from a visit to this mountain eyrie, the most remarkable and elevated in the United States, are the changes in the atmosphere, produced by clouds, fogs, thunder-storms, and the charming and sublime shadows and lights passing rapidly over the plain; also the appearances produced by the early morning sun, or evening twilight, or the softer radiance of full moon, or by the clearing off and rising of the morning mist from the plains below; or what is still better, to be so fortunate as to witness the gathering of a heavy thunder-storm, and to see the lowering volumes of dark vapors come sweeping over the western crest of the mountain, bringing in its train the forked lightning, the loud thunder, and *the pelting hail, shaking the firm foundations* and reverberating among the echoes of the everlasting hills; and then to see, as the writer has done, the surcharged clouds subsiding and sinking into the valley, and then again to see the bright flash, and hear the roar of the storm that is raging beneath your feet, while over your zenith all is clear and calm as a summer's morning, and you see beyond the range of the storm, at ten, twenty, or forty miles distance, the clear powerful rays of the sun pouring with unmitigated intensity upon a tract parched with drought; and then to finish and grace the scene, as the atmosphere is clearing away, pillars of rainbow-hues are seen in the east on the face of the retreating cloud, and all is hushed, and the refreshed face of nature once more assumes its wonted appearance. A traveler in Europe present at the time, acknowledged that a scene equal to that in sublimity had only once gratified him,—Mont Blanc at sun-set.

THE RAILROAD IN THE LANDSCAPE

While many landscape lovers, notably Thomas Cole, deplored the railroad's disastrous impact on the sacrosanct American wilderness, others hailed it as the embodiment of a

new technological sublime, fit complement to the scenes through which it transported landscape tourists in unprecedented ease and comfort. Fully in agreement with such proponents, the popular travel writer Bayard Taylor offers an exhilarated account of an excursion on the Erie Railroad, whose titanically powerful yet poetic steam engine takes passengers on a roller coaster ride through rugged mountains and across daring viaducts while the scenery—alternately wild and pastoral—unrolls in an endless, spectacular panorama.

Bayard Taylor, *"The Erie Railroad,"* Home Book of the Picturesque *(New York: G. P. Putnam, 1851).*

With the rapid progress and wider development of the great locomotive triumphs of the age, steam travel and steam navigation, the vulgar lament over their introduction is beginning to disappear. Sentimental tourists who once complained that every nook where the poetry of the Past still lives—every hermitage of old and sacred associations—would soon be invaded by these merciless embodiments of the Present and the Practical, are now quite content to take their aid, wherever it may be had, between Ceylon and the North Cape. The shriek of the steam whistle is hardly as musical as the song of the sirens, and a cushioned car is not so romantic as a gondola, yet they pass Calypso's isle with the sound of one ringing in their ears, and ride into Venice over the bridged Lagunes in the other. The fact is, it was only the innovation which alarmed. Once adopted, its miracles of speed, comfort, and safety, soon silenced the repinings of those who depend on outward circumstances and scenes to give those blossoms of thought and sensation, which, without these, their minds are too barren to produce. We now more frequently hear of the power and poetic mystery of the steam-engine. We are called upon to watch those enormous iron arms and listen to the thick throbbings of that unconscious heart, exerting the strength of the Titans and the Anakim[2] to beat down the opposing waves and bear us forward in the teeth of the terrible winds. We have been told, till the likeness has grown commonplace, of the horse that, snorting fire and smoke from his nostrils, and his neck "clothed with thunder," skims over the plain and pierces the mountain's heart, outrunning the swift clouds and leaving the storm in his rear. We shall learn, ere long, that no great gift of science ever diminishes our stores of purer and more spiritual enjoyment, but rather adds to their abundance and gives them a richer zest. Let the changes that must come, come: and be sure they will bring us more than they take away.

No similar work in the world could contribute more to make the Railroad popular with the class referred to, than the New-York and Erie Railroad. This is by far the most striking enterprise of the kind which has yet been completed. Exceeding in length any single road in the world, the nature of the country through which it passes, the difficulties to be overcome in its construction, and the intrinsic character of the work itself, invest it with an interest and grandeur which few mechanical enterprises of ancient or modern times possess. Its course represents, on a small scale, the crossing of a continent. It belts four dividing ridges of mountains, separating five different systems of rivers and streams. From the level of tide-water at New-York, it rises to a height of 1,366 feet on crossing the main ridge of the Alleghanies, and yet throughout its whole extent of four hundred and fifty miles, there is neither an inclined plane nor a tunnel. The first direct line of communication between the Atlantic and the great Lakes of the North,

[2] The Anakim: a pre-Canaanite tribe of giants.

it has brought them within the compass of a summer's day. The traveller who sees daybreak glimmer over the waters of New-York Bay, may watch the last tints of the sunset sink behind the horizon of Lake Erie.

The history of the Erie Railroad, is like that of all great undertakings. It began with a failure; it ended with a triumph. The first charter for its construction was granted in 1832, fixing the stock at ten millions of dollars, but for several years little was done except to survey the route. It was originally proposed to construct the road on piles instead of solid embankments, and the ruins of many miles of such skeleton-work still stretch along the valley of the Canisteo. The difficulties which beset the enterprise during the first decade of its existence, were innumerable, and would have discouraged less courageous and less enthusiastic men than its projectors. The natural obstacles to be overcome required an enormous outlay; the consent of Pennsylvania was to be obtained to the building of those parts of the road which lay within her borders; owners of capital hesitated to invest it in an uncertain scheme; and to crown all, came the commercial revulsions of 1837, which for a time prostrated it wholly. After the country had recovered from this shock, another effort was made. The State came to its relief, and after a season of toil and anxiety the work was recommenced and kept alive till the prospect of success brought all the wealth to its aid which had hitherto been held back. Ten years more, and the President of the United States and his Cabinet, with the highest dignitaries of the City and State, were whirled from station to station, from the Ocean to the Lakes, amid the thunder of cannon, the peal of bells, and the shouts of an inauguration grander even in its outward aspects than the triumphal processions of old Rome. The cost of this stupendous work was more than twenty millions of dollars.

What distinguishes the Erie Road above all other railroads is its apparent disregard of natural difficulties. It disdains to borrow an underground passage through the heart of an opposing mountain, but climbs the steeps, looks over the tops of the pines, and occasionally touches the skirt of a stray cloud. It descends with equal facility, with a slope in some places startingly perceptible, throws it bridges across rivers, its viaducts over valleys, and sometimes runs along the brink of a giddy precipice, with a fearless security which very much heightens the satisfaction of the traveller. Let us put the airy car of our memory on its track, and we shall run over the whole line before one of its locomotives could pant out fifty of its asthmatic breathings.

From Piermont, on the Hudson, the road stretches out an arm, a mile in length, into the Tappan Bay, and receives us from the boat. Behind the village there is a notch in the arc of hills embracing the bay, and through it we pass into the old fields of Rockland, with their old walls and old, red, Dutch farmhouses. A few miles—and the long, sweeping outline of Ramapo Mountain rises before us; the beautiful Ramapo Valley lies below, and the title village, with its foundries and forges, nearly two centuries old, stands in the mouth of the only pass whereby the mountain is pierced in all its extent—the Clove of Ramapo. Through this pass, of eight miles in length, winds a rivulet, now spreading into a tiny mountain lake, now fretting over the rocks, and leaping hither and thither in a chain of linked cascades. The road follows the rivulet into the grazing farms of Goshen—rich, upland meadows, dotted with trees and breathing of the cream and milk and butter that load a daily train to the metropolis. This region is passed and again the mountains appear, the Catskills blue in the north, but the rugged Shawangunk lying across our path. Up, up we go, fifty feet to the mile, and are soon high on the side, looking over its forests into the deep basin of the Nevising, which pours its waters into the Delaware. Port Jervis, a station on the line, seems at our feet; it is five hundred feet below us, but sliding down ten miles in almost so many minutes, we are there.

The road now crosses the Delaware into Pennsylvania, and for a distance of seventy or eighty

miles follows the bank of the river through wild and rugged scenery. For several miles the track has been laid, with immense labor and cost, on the top of a precipice nearly one hundred feet in height and falling sheer to the river. Much of the country is the primitive wilderness, which has never yet been reclaimed. Finally, at Deposit, not far from the source of the Delaware, the road turns westward and crosses the Alleghanies to the valley of the Susquehanna. Between the two rivers there is also a complete wilderness, uninhabited except by the workman belonging to the road. Notwithstanding a summit cut of 200 feet deep, which cost $200,000, the ascending and descending grades are very heavy, and some of the most remarkable portions of the work are to be found at this point. After striking the Susquehanna, our journey lies for nearly one hundred and fifty miles in the rich and picturesque valleys of that river and its tributaries, the Tioga and the Canisteo, passing through the flourishing towns of Binghamton, Owego, Elmira, and Corning. Overlooking the superb meadows and rolling grain-fields, the Alleghanies or spurs of them are always in sight, and on either side we have a rapidly unrolling panorama of such rural beauty as would have bewildered old Cuyp and Rysdael. Another dividing ridge, less steep and rugged than the previous, and we descend through virgin forests, some of which are swept away by fire to make room for the settler, to the Alleghany River. Hence, to Lake Erie, our course is mainly through a wild and uncultivated region, or seeming so, after the bountiful valleys we have left. We cross the Indian Reservation; catch a glimpse of some aboriginal idlers in wampum and moccason; again climb a range of hills, several hundred feet in height, from whose sides we overlook valleys and levels of wild woodland, and at last reach a curve, where, beyond the far sweep of the dark forest, we see the edge of the sky crossed by a line of deeper blue and know that we behold Lake Erie. Is not all this enough for a summer's day?

The bold design of this road involved the necessity of a number of grand and costly works. The track itself, in the Pass of Ramapo, and along the Upper Delaware, frequently cost upwards of $100,000 per mile. The Starucca Viaduct, an immense structure of hewn stone, crossing the valley at Lansingburg, is the finest work of the kind in this country. It is 1,200 feet long, consisting of 18 arches 114 feet in height, and was erected at a cost of $300,000. Next to this, in point of importance, and more remarkable in its character, is the bridge over Cascade Ravine, which is crossed in the descent from the summit ridge of the Alleghanies to the Susquehanna. The mountain is here interrupted by a deep gorge or chasm, through the bottom of which a small stream tumbles in its foamy course. Across this gulf, 184 feet in depth, a single arch of 280 feet span has been thrown, its abutments resting on the solid crags. This daring arch, which, to the spectator below, seems hung in mid-air, was eighteen months in building, and cost $70,000. A little to the north the gorge opens into the Valley of the Susquehanna, disclosing through its rugged jaws the most beautiful landscape seen on the road.

It was the good fortune of the writer to be one of the guests in the first train which passed over the Cascade Ravine Bridge. At the close of December, 1848, the line was opened from Port Jervis to Binghamton, a distance of one hundred and twenty-five miles. The incidents of that first journey by steam through the wilderness, in the depth of winter, will not soon be forgotten by those who took part in it. The Shawangunk Mountains were topped with snow as we passed them, and on taking the new track, beyond Port Jervis, the flakes began to fall thick and fast. The Delaware ran at the foot of the wild bluffs choked with masses of ice, and each of its many windings disclosed a more drear and wintry prospect. The hemlocks bent under their white load; the river ran cold and dark; the frozen cascades hung from the rocks, like masses of transparent spar. For many a mile there was no sign of human habitation—nothing but the grand and desolate solitude of the mountains. And yet—wonder beyond the tales

of Scheherazade!—our superb train carried a heart of luxury into that savage realm. We sped along, swiftly as the bird flies, in a warm and richly furnished chamber, lounging on soft seats, half arm-chair and half couch, apparently as disconnected from the landscape as a loose leaf blown over it by the winds. In that pleasant climate of our own we heard the keen air whistle without, and the light patter of the snow against the windows, with a sense of comfort rendered doubly palpable by the contrast.

At the little villages on the route, triumphal arches of fir and hemlock boughs were built for us, upon which antlered bucks, brought in by the hunters, stood straight and stiff. Every town which could boast a cannon, gave a hearty salute, and as the early nightfall came on, bonfires were lighted on the hills. It was after dark when we left Deposit, and the snow was a foot deep on the track, but with two locomotives plowing through the drifts, we toiled slowly to the summit. After we had passed the deep cut and had entered on the descending grade, it was found that in consequence of the snow having melted around the rails and afterwards frozen again, the breaks attached to the cars would not act. The wheels slipped over the icy surface, and in spite of the amount of snow that had fallen, we shot down the mountain at the rate of forty miles an hour. The light of our lamps showed us the white banks on either hand; the ghostly trees above and the storm that drove over all: beyond this, all was darkness. Some anxiety was felt as we approached the Bridge over Cascade Ravine; the time was not auspicious for this first test of its solidity. Every eye peered into the gloom, watching for the critical spot, as we dashed onwards. At last, in the twinkling of an eye, the mountain-sides above and below us dropped out of sight, and left us looking out on the void air. The lamps enabled us to see for an instant, through the falling snow-flakes, the sharp tops of pines far below. For a second or two we hung above them, suspended over the terrible gulf, and then every one drew a deep breath as we touched the solid rock which forms the abutment of the arch. But our course was not checked till we reached the Susquehanna Valley, where we sped on past bonfires blazing redly over the snow, till the boom of minute-guns and the screams of our strong-lunged locomotives startled the inhabitants of Binghamton at midnight.

On our return, the following day, we reached the Cascade Ravine in the afternoon, and a halt was made to enable us to view the bridge from below. Scrambling through the snow, down the slippery declivities, we at last reached the bottom of the gorge and looked up at the wonderful arch, which spanned it as lightly as a rainbow. Firm-set on its base of eternal granite, it gave not the slightest quiver when our train passed over. Although made of perishable materials, it will last as long as they hold together, for its mountain abutments cannot be shaken. Seen from below, the impression it makes upon the eye is most complete and satisfactory, combining the extreme of lightness and grace with strength and inflexible solidity. A few yards further up the mountain, the cloven chasm, over which the gnarled pines hang their sombre boughs, widens to a rocky basin, into which falls a cascade seventy feet in height, whence the ravine takes its name. The accompanying engraving, from the view taken by Mr. Talbot, though it may appear exaggerated to one who has never beheld the reality, conveys no more than a just idea of the bold and striking character of this work.

Transcendental Nature

EMERSON'S TRANSCENDENT NATURAL WORLD

In Ralph Waldo Emerson's transcendental universe, nature plays a crucial, central, indeed all-powerful role, detailed in the essay below. Nature for Emerson is the sole

source of truth and revelation. In nature, Emerson, a "transparent eyeball," loses him-
self in a feeling of mystical union with God, the creator. So deeply does the spiritual
infuse the material that the whole world of natural facts is charged with value as sym-
bol of the divine. Yet this universe of symbols is no abstruse code needing clerical medi-
ation. The natural world is an "open book" that any sincere seeker of harmony, truth,
and virtue can read. Although Emerson and his transcendentalist circle were almost
without exception literary men and women, his model of spirit in nature closely paral-
lels and amplifies the vision of Asher B. Durand and other mid-nineteenth-century
landscape painters.

Ralph Waldo Emerson, Nature *(Boston: James Munroe, 1836).*

Our age is retrospective. It builds the sepulchres of the fathers. It writes biographies, histories, and criticism. The foregoing generations beheld God and nature face to face; we, through their eyes. Why should not we also enjoy an original relation to the universe? Why should not we have a poetry and philosophy of insight and not of tradition, and a religion by revelation to us, and not the history of theirs? Embosomed for a season in nature, whose floods of life stream around and through us, and invite us by the powers they supply, to action proportioned to nature, why should we grope among the dry bones of the past, or put the living generation into masquerade out of its faded wardrobe? The sun shines to-day also. There is more wool and flax in the fields. There are new lands, new men, new thoughts. Let us demand our own works and laws and worship.

Undoubtedly we have no questions to ask which are unanswerable. We must trust the perfection of the creation so far, as to believe that whatever curiosity the order of things has awakened in our minds, the order of things can satisfy. Every man's condition is a solution in hieroglyphic to those inquiries he would put. He acts it as life, before he apprehends it as truth. In like manner, nature is already, in its forms and tendencies, describing its own design. Let us interrogate the great apparition, that shines so peacefully around us. Let us inquire, to what end is nature? . . .

Philosophically considered, the universe is composed of Nature and the Soul. Strictly speaking, therefore, all that is separate from us, all which Philosophy distinguishes as the NOT ME, that is, both nature and art, all other men and my own body, must be ranked under this name, NATURE. In enumerating the values of nature and casting up their sum, I shall use the word in both senses;—in its common and in its philosophical import. In inquiries so general as our present one, the inaccuracy is not material; no confusion of thought will occur. Nature, in the common sense, refers to essences unchanged by man; space, the air, the river, the leaf. Art is applied to the mixture of his will with the same things, as in a house, a canal, a statue, a picture. But his operations taken together are so insignificant, a little chipping, baking, patching, and washing, that in an impression so grand as that of the world on the human mind, they do not vary the result . . .

To speak truly, few adult persons can see nature. Most persons do not see the sun. At least they have a very superficial seeing. The sun illuminates only the eye of the man, but shines into the eye and the heart of the child. The lover of nature is he whose inward and outward senses are still truly adjusted to each other; who has retained the spirit of infancy even into the era of manhood. His intercourse with heaven and earth, becomes part of his daily food. In the presence of nature, a wild delight runs through the man, in spite of real sorrows.

Nature says,—he is my creature, and maugre all his impertinent griefs, he shall be glad with

me. Not the sun or the summer alone, but every hour and season yields its tribute of delight; for every hour and change corresponds to and authorizes a different state of the mind, from breathless noon to grimmest midnight. Nature is a setting that fits equally well a comic or a mourning piece. In good health, the air is a cordial of incredible virtue. Crossing a bare common, in snow puddles, at twilight, under a clouded sky, without having in my thoughts any occurrence of special good fortune, I have enjoyed a perfect exhilaration. I am glad to the brink of fear. In the woods too, a man casts off his years, as the snake his slough, and at what period soever of life, is always a child. In the woods, is perpetual youth. Within these plantations of God, a decorum and sanctity reign, a perennial festival is dressed, and the guest sees not how he should tire of them in a thousand years. In the woods, we return to reason and faith. There I feel that nothing can befall me in life,—no disgrace, no calamity, (leaving me my eyes,) which nature cannot repair. Standing on the bare ground,—my head bathed by the blithe air, and uplifted into infinite space,—all mean egotism vanishes. I become a transparent eye-ball; I am nothing; I see all; the currents of the Universal Being circulate through me; I am part or particle of God. The name of the nearest friend sounds then foreign and accidental: to be brothers, to be acquaintances,—master or servant, is then a trifle and a disturbance. I am the lover of uncontained and immortal beauty. In the wilderness, I find something more dear and connate than in streets or villages. In the tranquil landscape, and especially in the distant line of the horizon, man beholds somewhat as beautiful as his own nature.

The greatest delight which fields and woods minister, is the suggestion of an occult relation between man and the vegetable. I am not alone and unacknowledged. They nod to me, and I to them. The waving of the boughs in the storm, is new to me and old. It takes me by surprise, and yet is not unknown. Its effect is like that of a higher thought or a better emotion coming over me, when I deemed I was thinking justly or doing right.

Yet it is certain that the power to produce this delight, does not reside in nature, but in man, or in a harmony of both. It is necessary to use these pleasures with great temperance. For, nature is not always tricked in holiday attire, but the same scene which yesterday breathed perfume and glittered as for the frolic of the nymphs, is overspread with melancholy today. Nature always wears the colors of the spirit. To a man laboring under calamity, the heat of his own fire hath sadness in it. Then, there is a kind of contempt of the landscape felt by him who has just lost by death a dear friend. The sky is less grand as it shuts down over less worth in the population.

Language

Language is a third use which Nature subserves to man. Nature is the vehicle of thought, and in a single, double, and threefold degree.

1. Words are signs of natural facts.
2. Particular natural facts are symbols of particular spiritual facts.
3. Nature is the symbol of spirit.

1. Words are signs of natural facts. The use of natural history is to give us aid in supernatural history: the use of the outer creation, to give us language for the beings and changes of the inward creation. Every word which is used to express a moral or intellectual fact, if traced to its root, is found to be borrowed from some material appearance. Right means straight; wrong means twisted. Spirit primarily means wind; transgression, the crossing of a line; supercilious,

the raising of the eyebrow. We say the heart to express emotion, the head to denote thought; and thought and emotion are words borrowed from sensible things, and now appropriated to spiritual nature. Most of the process by which this transformation is made, is hidden from us in the remote time when language was framed; but the same tendency may be daily observed in children. Children and savages use only nouns or names of things, which they convert into verbs, and apply to analogous mental acts.

2. But this origin of all words that convey a spiritual import,—so conspicuous a fact in the history of language,—is our least debt to nature. It is not words only that are emblematic; it is things which are emblematic. Every natural fact is a symbol of some spiritual fact. Every appearance in nature corresponds to some state of the mind, and that state of the mind can only be described by presenting that natural appearance as its picture. An enraged man is a lion, a cunning man is a fox, a firm man is a rock, a learned man is a torch. A lamb is innocence; a snake is subtle spite; flowers express to us the delicate affections. Light and darkness are our familiar expression for knowledge and ignorance; and heat for love. Visible distance behind and before us, is respectively our image of memory and hope.

Who looks upon a river in a meditative hour, and is not reminded of the flux of all things? Throw a stone into the stream, and the circles that propagate themselves are the beautiful type of all influence. Man is conscious of a universal soul within or behind his individual life, wherein, as in a firmament, the natures of Justice, Truth, Love, Freedom, arise and shine. This universal soul, he calls Reason: it is not mine, or thine, or his, but we are its; we are its property and men. And the blue sky in which the private earth is buried, the sky with its eternal calm, and full of everlasting orbs, is the type of Reason. That which, intellectually considered, we call Reason, considered in relation to nature, we call Spirit. Spirit is the Creator. Spirit hath life in itself. And man in all ages and countries, embodies it in his language, as the FATHER . . .

This relation between the mind and matter is not fancied by some poet, but stands in the will of God, and so is free to be known by all men. It appears to men, or it does not appear. When in fortunate hours we ponder this miracle, the wise man doubts, if, at all other times, he is not blind and deaf;

——"Can such things be,
And overcome us like a summer's cloud,
Without our special wonder?"

for the universe becomes transparent, and the light of higher laws than its own, shines through it. It is the standing problem which has exercised the wonder and the study of every fine genius since the world began; from the era of the Egyptians and the Brahmins, to that of Pythagoras, of Plato, of Bacon, of Leibnitz, of Swedenborg. There sits the Sphinx at the road-side, and from age to age, as each prophet comes by, he tries his fortune at reading her riddle. There seems to be a necessity in spirit to manifest itself in material forms; and day and night, river and storm, beast and bird, acid and alkali, preexist in necessary Ideas in the mind of God, and are what they are by virtue of preceding affections, in the world of spirit. A Fact is the end or last issue of spirit. The visible creation is the terminus or the circumference of the invisible world. "Material objects," said a French philosopher, "are necessarily kinds of scoriae of the substantial thoughts of the Creator, which must always preserve an exact relation to their origin; in other words, visible nature must have a spiritual and moral side."

This doctrine is abstruse, and though the images of "garment," "scoriae," "mirror," &c., may

stimulate the fancy, we must summon the aid of subtler and more vital expositors to make it plain. "Every scripture is to be interpreted by the same spirit which gave it forth,"—is the fundamental law of criticism. A life in harmony with nature, the love of truth and of virtue, will purge the eyes to understand her text. By degrees we may come to know the primitive sense of the permanent objects of nature, so that the world shall be to us an open book, and every form significant of its hidden life and final cause.

A new interest surprises us, whilst, under the view now suggested, we contemplate the fearful extent and multitude of objects; since "every object rightly seen, unlocks a new faculty of the soul." That which was unconscious truth, becomes, when interpreted and defined in an object, a part of the domain of knowledge,—a new weapon in the magazine of power.

Nature, Wild and Tame

ASHER B. DURAND FORMULATES THE AMERICAN LANDSCAPE

After Thomas Cole, Asher Brown Durand was one of the leading figures in the establishment of a self-consciously American school of landscape painting. Durand was a successful and highly accomplished engraver. Inspired by Cole and encouraged by his friend Luman Reed, he turned to landscape painting, and by the middle of the 1840s he had begun the intense study of nature that would be the hallmark of his art and that of his peers in the so-called Hudson River school (see "Earl Shinn on Criticism," chapter 12). President of the National Academy of Design from 1845 to 1861, Durand was an ardent spokesman for the legitimacy and moral value of landscape painting. In part due to his ceaseless efforts—which included securing the support of wealthy New York patrons—the Hudson River school painters rose to prominence as the foremost pictorial celebrants of the American land.

With the art critic and journalist William J. Stillman, Durand's son John launched and edited The Crayon *in 1855. Beginning with the first issue, in January 1855, Asher Durand published a series of nine "Letters on Landscape Painting," addressed to a hypothetical student. These letters are the definitive formulation of Durand's precepts for modern landscape painting. Based in part on the English critic John Ruskin's doctrine of fidelity to nature, the ultimate and sole source of truth, they also express Durand's own idealism and belief in God in nature, a position that aligns him with Ralph Waldo Emerson. Durand's solemn missives also reveal his strategy for elevating landscape from the level of view painting to something far more serious, substantial, necessary, and even sacred.*

Asher B. Durand, "Letters on Landscape Painting," Crayon 1 *(January 3, 1855—June 6, 1855).*

LETTER I.

I am compelled to return an unfavorable answer to your application for admission into my studio as a pupil. Among the many instances in which I have found it necessary to return a refusal, your own case is most painful to me, on account of the earnest love of nature which you manifest, and the strong desire you have expressed to devote your whole time and energies to the study of Landscape Art. I hope the disappointment will not be regarded by you as discouraging, for I can readily imagine you may have overestimated the advantage of such lessons as you desire at my hands, and I take occasion to submit for your consideration, by way of en-

couragement, some remarks resulting from my own experience under circumstances very similar to your own . . .

You need not a period of pupilage in an artist's studio to learn to paint; books and the casual intercourse with artists, accessible to every respectable young student, will furnish you with all the essential mechanism of the art. I suppose that you possess the necessary knowledge of drawing, and can readily express with the lead pencil the forms and general character of real objects. Then, let me earnestly recommend to you one STUDIO which you may freely enter, and receive in liberal measure the most sure and safe instruction ever meted to any pupil, provided you possess a common share of that truthful perception, which God gives to every true and faithful artist—the STUDIO of Nature.

Yes! go first to Nature to learn to paint landscape, and when you shall have learnt to imitate her, you may then study the pictures of great artists with benefit. They will aid you in the acquirement of the knowledge requisite to apply to the best advantage the skill you possess—to select, combine and set off the varied beauty of nature by means of what, in artistic language, is called treatment, management, &c., &c. I would urge on any young student in landscape painting, the importance of painting direct from Nature as soon as he shall have acquired the first rudiments of Art. If he is imbued with the true spirit to appreciate and enjoy the contemplation of her loveliness, he will approach her with veneration, and find in the conscientious study of her beauties all the great first principles of Art. Let him scrupulously accept *whatever* she presents him, until he shall, in a degree, have become intimate with her infinity, and then he may approach her on more familiar terms, even venturing to choose and reject some portions of her unbounded wealth; but never let him profane her sacredness by a wilful departure from truth. It is for this reason that I would see you impressed, imbued to the full with *her* principles and practice, and after that develope the principles and practice of Art; in other words, the application of those phenomena most expressive of the requisite sentiment or feeling. For I maintain that all Art is unworthy and vicious which is at variance with Truth, and that only is worthy and elevated which impresses us with the same feelings and emotions that we experience in the presence of the Reality. True Art teaches the use of the embellishments which Nature herself furnishes, it never creates them. All the fascination of treatment in light, and dark, and color, are seen in Nature; they are the luxuries of her store-house, and must be used with intelligence and discrimination to be wholesome and invigorating. If abused and adulterated by the poisons of conventionalism, the result will be the corruption of veneration for, and faith in, the simple truths of Nature, which constitute the true Religion of Art, and the only safeguard against the inroads of heretical conventionalism. If you should ask me to define conventionalism, I should say that it is the substitution of an easily expressed falsehood for a difficult truth.

But why discuss this point—is it not a truism admitted by all? Far from it! Or if it be admitted as a principle, it is constantly violated by the artist in his practice, and this violation sanctioned by the "learned" critic and connoisseur. The fresh green of summer must be muddled with brown; the pure blue of the clear sky, and the palpitating azure of distant mountains, deadened with lifeless grey, while the grey unsheltered rocks must be warmed up and clothed with the lichens of their forest brethren—tricks of impasto, or transparancy without character—vacant breadth, and unmitigated darkness—fine qualities of color without local meaning, and many other perversions of truth are made objects of artistic study, to the death of all true feeling for Art,—and all this under the name of improvements on Nature! To obtain truthfulness is so much more difficult than to obtain the power of telling facile falsehoods, that one need

not wonder that some delusive substitute occupies the place which Nature should hold in the artist's mind.

I have offered to you these remarks and opinions as the result of experience. I do not desire that my humble productions shall be regarded as the evidence of their correctness. I am more certain as to their aim in accordance with these opinions than in their successful attainment of that aim; and I will only add that neither their faults nor their merits are chargeable to any instructions received in the studios of artists, though many an useful lesson has been taught me by intercourse with professional brethren—even often from the student and the tyro. But by far my most valuable study has been

"Under the open sky"—
and there would I direct you to

"Go forth and list
To Nature's teachings, while from all around
Earth and her waters, and the depths of air,
Comes a still voice"—

a voice that no student can disregard with impunity, nor heed without joy and gladness—broken, it is true, too often by repeated failure, and by the conviction that the most successful transcripts that Art is able to produce must appear but abortions in her presence, and only tolerable when withdrawn and examined in the seclusion of the painting room.

There are however, certain motives in Art which I am persuaded the young landscape painter may do well to consider with reference to directing his studies. These I will give you as opportunity offers, in some future letters.

LETTER II.

As a motive to meet with courage and perseverance every difficulty in the progress of your studies, and patiently to endure the frequent discouragements attending your failures and imperfect efforts, so long as your love for Nature is strong and earnest, keeping steadily in view the high mission of the Art you have chosen, I can promise you that the time will come when you will recall the period of these faithful struggles with a more vivid enjoyment than that which accompanies the old man's recollections of happy childhood. The humblest scenes of your successful labors will become hallowed ground to which, in memory at least, you will make many a joyous pilgrimage, and, like Rosseau, in the fullness of your emotions, kiss the very earth that bore the print of your oft-repeated footsteps.

There is yet another motive for referring you to the study of Nature early—its influence on the mind and heart. The external appearance of this our dwelling-place, apart from its wondrous structure and functions that minister to our well-being, is fraught with lessons of high and holy meaning, only surpassed by the light of Revelation. It is impossible to contemplate with right-minded, reverent feeling, its inexpressible beauty and grandeur, for ever assuming new forms of impressiveness under the varying phases of cloud and sunshine, time and season, without arriving at the conviction

—"That all which we behold
Is full of blessings"—

that the Great Designer of these glorious pictures has placed them before us as types of the Divine attributes, and we insensibly, as it were, in our daily contemplations,

> —"To the beautiful order of his works
> Learn to conform the order of our lives."

Thus regarding the objects of your study, the intellect and feelings become elevated and purified, and in proportion as you acquire executive skill, your productions will, unawares, be imbued with that undefinable quality recognized as sentiment or expression which distinguishes the true landscape from the mere sensual and *striking* picture.

Thus far I have deemed it well to abstain from much practical detail in the pursuit of our subject, preferring first to impress you with a sense of the elevated character of the Art, which a just estimate of its capacity and purposes discloses, and this course may still be extended in reference to the wide field for its exercise, which lies open before you. If it be true—and it appears to be demonstrated, so far as English scenery is concerned—that Constable was correct when he affirmed that there was yet room for a natural landscape painter, it is more especially true in reference to our own scenery; for although much has been done, and well done, by the gifted Cole and others, much more remains to do. Go not abroad then in search of material for the exercise of your pencil, while the virgin charms of our native land have claims on your deepest affections. Many are the flowers in our untrodden wilds that have blushed too long unseen, and their original freshness will reward your research with a higher and purer satisfaction, than appertains to the display of the most brilliant exotic. The "lone and tranquil" lakes embosomed in ancient forests, that abound in our wild districts, the unshorn mountains surrounding them with their richly-textured covering, the ocean prairies of the West, and many other forms of Nature yet spared from the pollutions of civilization, afford a guarantee for a reputation of originality that you may elsewhere long seek and find not.

I desire not to limit the universality of the Art, or require that the artist shall sacrifice aught to patriotism; but, untrammelled as he is, and free from academic or other restraints by virtue of his position, why should not the American landscape painter, in accordance with the principle of self-government, boldly originate a high and independent style, based on his native resources? ever cherishing an abiding faith that the time is not far remote when his beloved Art will stand out amid the scenery of his "own green forest land," wearing as fair a coronal as ever graced a brow "in that Old World beyond the deep."

LETTER III.

There can be no dissent from the maxim, that a knowledge of integral parts is essential for the construction of a whole—that the alphabet must be understood before learning to spell, and the meaning of words before being able to read—not to admit this would be absurd; yet many a young artist goes to work in the face of an equal absurdity—filling a canvas just as an idle boy might fill a sheet of paper with unmeaning scrawls, occasionally hitting the form of a letter, and, perhaps, even a word, so that the whole mass, at a little distance, may have the semblance of writing; and so, after he has wasted sufficient materials to have served, by well-directed study, to effect the attainment of the knowledge he lacks, he feels this deficiency, and goes back, or more correctly speaking, takes the first step forward, and begins with his letters. You have learned these letters, and how to spell, in the practice of drawing, and you have found out the meaning of many words, but there are yet many more, with phrases and whole sentences to learn

(and this, I myself, feel, in more than one sense, while writing to you), before you can write and entirely express your thoughts.

Proceed then, choosing the more simple foreground objects—a fragment of rock, or trunk of a tree; choose them when distinctly marked by strong light and shade, and thereby more readily comprehended; do not first attempt foliage or banks of mingled earth and grass; they are more difficult of imitation, which, as far as practicable, should be your purpose. Paint and repaint until you are *sure* the work *represents* the model—not that it merely resembles it. This purpose, that is, the study of foreground objects, is worthy whole years of labor; the process will improve your judgment, and develop your skill—and perception, thought, and ingenuity will be in constant exercise. Thus you will not merely have observed in the rock, the lines, angles, and texture, and in the tree trunk, the scoring or plainness of surface, which respectively characterizes them, but you will have acquired knowledge and skill applicable alike to every portion of the picture. In producing such an imitation, you will have learned to represent shape with solidity, projection, depression, and relief, nearness and distance, the cooperation of color with form, light and shade, and above all, you will have developed and strengthened your perception of the natural causes of all these results.

LETTER IV.

Every experienced artist knows that it is difficult to see nature truly; that for this end long practice is necessary. We see, yet perceive not, and it becomes necessary to cultivate our perception so as to comprehend the essence of the object seen . . .

But, suppose we look on a fine landscape simply as a thing of beauty—a source of innocent enjoyment in our leisure moments—a sensuous gratification with the least expenditure of thought or effort of the intellect, how much better is it than many a more expensive toy for which human skill and industry are tasked, and wealth continually lavished! How many of our men of fortune, whom nature and circumstance have well fitted for such enjoyment, surrender, as it were, their birthright, for a mess of pottage, by resorting to costly and needless luxuries, which consume, without satisfying—while Art invites to her feast of beauty, where indulgence never cloys, and entails no penalty of self-reproach!

To the rich merchant and capitalist, and to those whom even a competency has released from the great world-struggle, so far as to allow a little time to rest and reflect in, Landscape Art especially appeals—nor does it appeal in vain. There are some among "the innumerable caravan" that look to it as an oasis in the desert, and there are more who show signs of lively susceptibility to its refreshing influence—those who trace their first enjoyment of existence, in childhood and youth, with all the associations of their minority, to the country, to some pleasant landscape scenery; to such the instinct of nature thus briefly impressed, is seldom or never overcome. Witness the glad return of many an exile to the place of his nativity, and see the beautiful country-seat suddenly rising among the green trees that were young with himself, and almost regarded as playmates. He returns to end his days where they began, and loves to embellish the consecrated spot with filial tenderness, strewing flesh flowers on the grave of long-departed years. To him who preserves the susceptibility to this instinctive impulse, in spite of the discordant clamor and conflict of the crowded city, the true landscape becomes a thing of more than outward beauty, or piece of furniture.

It becomes companionable, holding silent converse with the feelings, playful or pensive—and, at times, touching a chord that vibrates to the inmost recesses of the heart, yet with no unhealthy excitement, but soothing and strengthening to his best faculties. Suppose such an one,

on his return home, after the completion of his daily task of drudgery—his dinner partaken, and himself disposed of in his favorite arm-chair, with one or more faithful landscapes before him, and making no greater effort than to look into the picture instead of on it, so as to perceive what it represents; in proportion as it is true and faithful, many a fair vision of forgotten days will animate the canvas, and lead him through the scene: pleasant reminiscences and grateful emotions will spring up at every step, and care and anxiety will retire far behind him. If he possess aught of imaginative tissue, and few such natures are without it, he becomes absorbed in the picture—a gentle breeze fans his forehead, and he hears a distant rumbling; they come not from the canvas, but through the open window casement. No matter, they fall purified on his sensorium, and *that* is far away in the haunts of his boyhood—and that soft wind is chasing the trout stream down the woody glen, beyond which gleams "the deep and silent lake," where the wild deer seeks a fatal refuge. He shifts the scene, and stretching fields and green meadows meet his eye—in such he followed the plough and tossed the new-mown hay; by the roadside stands the school-house, and merry children scatter from its door—such was the place where he first imbibed the knowledge that the world was large and round, while ambition whispered that the village grounds were too narrow for him,—and with the last rays of the setting sun, the picture fades away.

I need scarcely apologize for the seeming sentimentalism of this letter. In this day the sentiment of Art is so overrun by the *technique,* that it can scarcely be insisted on too strongly. In my next, I shall recur more minutely to the means, rather than the ends, of Art.

LETTER V.

I have already advised you to aim at direct imitation, as far as possible, in your studies of foreground objects. You will be most successful in the more simple and solid materials, such as rocks and tree trunks, and after these, earth banks and the coarser kinds of grass, with mingling roots and plants, the larger leaves of which can be expressed with even botanical truthfulness; and they should be so rendered, but when you attempt masses of foliage or running water, anything like an equal degree of imitation becomes impracticable.

It should be your endeavor to attain as minute portraiture as possible of these objects, for although it may be impossible to produce an absolute imitation of them, the determined effort to do so will lead you to a knowledge of their subtlest truths and characteristics, and thus knowing thoroughly that which you paint, you are able the more readily to give all the facts essential to their *representation.* So this excessively minute painting is valuable, not so much for itself as for the knowledge and facility it leads to.

There is then a marked distinction between *imitation* and *representation,* and if this distinction be at first difficult to understand, it will become more and more apparent as you advance. Although painting is an imitative Art, its highest attainment is representative, that is, by the production of such resemblance as shall satisfy the mind that the entire meaning of the scene represented is given. Now, if all objects in Nature could be equally well imitated, there would be no need of this distinction; but this is not the case . . .

Strictly speaking, beyond a few foreground objects, our Art is entirely representation, and that can be rendered satisfactory only by the utmost effort to produce imitation. When you shall have acquired some proficiency in foreground material, your next step should be the study of the influence of atmosphere—the power which defines and measures space—an intangible agent, visible, yet without that material substance which belongs to imitable objects, in fact, an absolute nothing, yet of mighty influence. It is that which above all other agencies, carries us

into the picture, instead of allowing us to be detained in front of it; not the door-keeper, but the grand usher and master of ceremonies, and conducting us through all the vestibules, chambers and secret recesses of the great mansion, explaining, on the way, the meaning and purposes of all that is visible, and satisfying us that all is in its proper place. This, therefore, is an important personage, and no pains should be spared to make his acquaintance.

[LETTER] VIII.

. . . The true province of Landscape Art is the representation of the work of God in the visible creation, independent of man, or not dependent on human action, further than as an accessory or an auxiliary. From this point of view let us briefly examine the conventional distinctions of Idealism and Realism, together with the action of the imagination in connection with them, and which seems to have given rise to these distinctions.

What then is Idealism? According to the interpretation commonly received, that picture is ideal whose component parts are representative of the utmost perfection of Nature, whether with respect to beauty or other considerations of fitness in the objects represented, according to their respective kinds, and also the most perfect arrangement or composition of these parts so as to form an equally perfect whole. The extreme of this ideal asserts that this required perfection is not to be found or rarely found in single examples of natural objects, nor in any existing combination of them. In order to compose the ideal picture, then, the artist must know what constitutes the perfection of every object employed, according to its kind, and its circumstances, so as to be able to gather from individuals the collective idea. This view of Idealism does not propose any deviation from the truth, but on the contrary, demands the most rigid adherence to the law of its highest development.

Realism, therefore, if any way distinguishable from Idealism, must consist in the acceptance of ordinary forms and combinations as found. If strictly confined to this, it is, indeed, an inferior grade of Art; but as no one contends that the representation of ordinary or commonplace nature is an ultimatum in Art, the term Realism signifies little else than a disciplinary stage of Idealism, according to the interpretation given, and is misapplied when used in opposition to it, for the ideal is, in fact, nothing more than the perfection of the real.

Every step of progress towards truthful representation of Nature will be so much gained of the knowledge indispensable to the attainment of the ideal, for all the generic elements of natural objects, by which one kind is distinguished from another, are the same in the imperfect as in the perfect specimen. The difference lies in the disposition of them; so when you shall have learned all that characterizes the oak as oak, you will be prepared to apply those characteristics according to the requirements of ideal beauty, to the production of the ideal oak. And this process continued through all forms and combinations, defines the creative power of Art, not in producing new things for its special purpose, but in supplying from Nature's general fullness, all particular deficiencies in whatsoever things she has furnished for its use. Thus far the meaning of Idealism is limited to the perfection of beauty with generic character and fitness in combinations. But the ideal of Landscape Art does not end here; it embraces, and with even higher meaning, the application of these perfections to the expression of a particular sentiment in the subject of the picture,—whether it be the representation of the repose and serenity of Nature in quiet and familiar scenes, or of her sterner majesty in the untrodden wilderness, as well as of her passional action in the whirlwind and storm—each has its own distinctive ideality. In this direction we come to the action of the imaginative faculty, which perfects the high Ideal.

In so far as we have arrived at any understanding of the term Idealism and Realism, there does not appear any definite line of distinction between them, or at best, these terms are inexpressive, if intended to describe separate departments of Art power; nor can I discern wherein the imaginative faculty exercises an influence independent of the perfect ideal of representative truth, but only in extending its meaning to the utmost limit, spiritualizing, as it were, the images of inanimate objects, and appealing through them to the inmost susceptibility of the mind and heart, thus becoming the highest attribute of the great Artist in developing the true ideal. Hence its legitimate action is not seen as creating an imaginary world, as some suppose; but in revealing the deep meaning of the real creation around and within us . . .

It is not my purpose, however, to discuss the nature of the imaginative faculty, nor the subtle abstractions of idealism. It is sufficient if we have arrived safely at the conclusion, that all the elements with which the imagination deals, and on which idealism is based, exist visibly in Nature, and are, therefore, not separate creations of Art, my chief object being to guard against the false notion that High Landscape Art disregards all restrictions imposed by the law of truthful representation of nature . . .

Let us . . . be thankful in the assurance that it is by reverent attention to the realized forms of Nature alone, that Art is enabled by its delegated power to reproduce some measure of the profound and elevated emotions which the contemplation of the visible works of God awaken. Could the picture do more by means of whatsoever Art-license or departure from the truth?

Imitation of Nature is indeed servile, and every way unworthy, when it discards the necessity of selection, and indiscriminately accepts all things as of equal value, not only bestowing the same care on the wild thistle of the field as on the rose and on the passion-flower, but without discerning the two-fold commendations of superior beauty and significance, as indicated in the perfume and in the symbolism which invest the latter with higher claims to a place in the Art-conservatory.

THE HUDSON RIVER SCHOOL IN PUBLIC

By the 1850s, landscape painting had emerged as prime vehicle for the expression of national identity, its practitioners well represented at the important New York exhibitions (see also "Too Many Landscapes," chapter 7). Putnam's Monthly *views this new school of new men with approval, contrasting the reverence for nature evident in Asher B. Durand's landscapes with the stilted artificiality of Thomas Cole's* Voyage of Life, *now hopelessly outmoded. The writer for the* Illustrated Magazine of Art *states unequivocally that only in landscape painting may American art win renown among nations, and only in landscape may our practical civilization find true expression. Placing Durand at the head of the American landscape school, the writer admires his truthfulness; even his trees, genuine "patriarchs" of the forest, are individual. Expressive of his pure and simple devotion to nature, Durand's paintings are models for a genuinely American school of art. In a similar vein,* Literary World *observes that landscapes constitute almost half the total number of works on display at the National Academy of Design. Among them, Durand is obviously the leader. In this show he exhibits his characteristic out-of-door studies, which the reviewer appreciates for their quiet, pastoral poetry. Durand also shows his ambitious allegory* Progress (1853), *which contrasts wilderness with civilization. Complementing Durand, the subjects chosen by the other artists (including Jasper Cropsey and Frederic E. Church) make up a roster*

of celebrated American sites, more than a match for the two European views included among Cropsey's offerings.

"The National Academy of Design," Putnam's Monthly 5 (May 1855).

On the walls of the Academy we have followed Cole through his progress, and seen Durand, year after year, working out his problem of originality, and Cropsey, Kensett, Church, and their brethren of the younger generation, growing up into notice and excellence. Each exhibition has shown an increase of numbers in the artistic ranks, and a higher attainment of technical ability than the previous one manifested . . .

. . . We do not forget Allston, Vanderlyn, Trumbull, and their cotemporaries; but in their day Art was an exotic transplanted here, and refused to maintain its existence under the circumstances in which it found itself. The last leaves which fell from it were Vanderlyn and Cole. They were products of the old system, that of nutriment and treatment rather than of positive knowledge. They had their triumphs, but they were rather those which consisted in creditably rivaling their masters, than in developing new and peculiar features of artistic wisdom. Their faces were like all their earlier confreres, turned backward, and they dreamed in the past—in the Art of Claude and Titian—rather than lived in earnest, looking forward to unexplored fields. They were not new men—not American, therefore—but from the influence of that unreal art there originated one of positive vitality. Its professors were Durand, Inman, Mount, Edmonds, Huntington and others, painters, to a greater or less extent, of things real, and of which they knew.

It may seem strange that we should draw such a dividing line between Durand and Cole, yet, such is the relation of their minds that the latter must be classed as a sentimentalist, and inclined both by feeling and study to the masters of the last phase of landscape; while the former in all respects conforms to the modern spirit, based on reality, and admitting no sentiment which is not entirely drawn from Nature. Cole was, it is true, in many cases forced into a partial recognition of the natural, but generally he seems to have regarded the forms of Nature only as characters, by means of which he impresses on us his story, and thus his pictures, though they may be poetical, are certainly not picturesque. For instance, in the "Youth," there is not an individual object in the picture which ever had its prototype in the natural world—not a tree, shrub or mountain form is there, which is not palpably a creation of the artist's imaginative brain. With Durand, on the contrary, there are no objects, with the exception occasionally of his cloud forms, which are not actual, real. This makes the distinction between the old school and the new—with that, things were types, and so long as they were understood it matters not how imperfectly they were expressed; with this, they are individualities, with the rights of the individual, and its influence in the general result.

With this new school we shall have to do at present, as far as it appears on the walls of the Academy's exhibition. Wherever our artists have given themselves to the admiration and following of European masters, we shall leave them to the kind of appreciation they have sought for, that which finds its enjoyment in merely technical qualities, without regard to the thought or extent of knowledge possessed by the artist. This is a species of Art which our people can never amply sympathize with, because it is an idle thing, aimless, and without root or permanence. The Art which they will have, and in which, therefore, they will be benefited, is that which arises from a genuine feeling for the things with which the people have sympathy. It hardly matters whether or no the materialism of the times is an error. So long as it is the spirit of the age, Art, to be in any way successful, must carry it out. Rhapsodies, dreams, and studio vagaries will

not satisfy a public sentiment accustomed to find in all other things some substantial, positive truth, something which the mind, grasping, holds ever after. If artists prefer to follow what they consider an ideal, and withdraw themselves from the appreciation of the men of their time, they may certainly do so . . . But if they seek encouragement, they must deal in wares the age has need of; and, to be immortalized, they must give their works vitality, that they may perpetuate their kind.

"American Art: The Need and Nature of Its History," Illustrated Magazine of Art 3 *(April 1854).*

The landscape that lies in beauty or grandeur, veiled in the illusive autumn-like haze of distance, may feed imagination, but cannot carry its distinctive meaning to the heart and reproduce there its own sentiment. The enchantment of distance must be dissolved by a nearer approach. It is so with AMERICAN ART, the outlines of which have already been given. We have looked upon it as an energy coming up out of conflict with the spirit of the people, the genius of a proud democracy, and indicating no uncertain future for itself. We wish now to mark its growth, and in it, feel its unfolding individuality . . .

. . . Portrait-painting is unduly prominent, and up to the present time has presented the only certain resource to young artists for subsistence . . .

Historical painting has been cultivated with considerable success, but with uncertain aim . . .

Landscape painting, the only department in which we can hope to form a school, has been cultivated with true devotion. Here we may gain a proud eminence among the nations, and here alone. The character of our civilisation is too earnest and practical to foster imaginative tastes: the nearness of our past denies to the artist the mellowness and deep perspective of distance. But "the hills rock-ribbed," the course of noble rivers, the repose of lakes, and a climate peculiarly our own, these things, as they appear in the Katskill and Addirondek, the Hudson, Lake George, and Schroon, and especially in our autumn loveliness, furnish rich materials for landscape composition.

Our prominent artists have not failed to notice them, and devote themselves to their study. Among those who have succeeded and gained for themselves a name in this department, no one stands so deservedly high as Asher B. Durand, the President of the National Academy of Design, as much on account of the purity and simplicity of his devotion to American landscape as his eminence and skill in his art. The individuality of his trees, true patriarchs of the woods, the charm of his autumn haze, and his quiet, philosophic contemplativeness, give to his works that place in painting which the "Elegy" of Gray, the "Excursion" of Wordsworth, and the "Thanatopsis" of Bryant, occupy in poetry. They are entirely American, and are destined, in our judgment, to become the models after which existing and future artists are to build up a distinctive school of American art in painting—a school whose fame is to be co-extensive with that of our industry. We have artists capable of this great work. They only wait the development of our civilisation to seize upon its different stages and spirit, and record them in colours and marble.

"The Fine Arts: The Exhibition of the Academy," Literary World, *April 30, 1853.*

There are "good years" for pictures as for other crops, and this is not one of them; but whatever the accidental circumstances may be, the unfailing successes of the President, Mr. Durand, are sufficient to illuminate the walls at every point. You cannot turn in any direction without alighting upon one of his quiet, natural, sensitive, out-of-door studies, where a genuine love of nature harmonizes every condition of the landscape. His pictures are such as Izaak Walton

would have loved to contemplate. There is the amiable poetry of feeling about them which characterizes that good man's "Angler" and sainted "Lives." Walton would have called for his song and ale in these noontide shades, would have delighted in the summer luxury of the cattle, as he sauntered down one of these smooth arcades, or cast his fly in the wimpling current; and he would have hurried home before that "coming storm," throwing a backward glance, as the waters darken in the foreground, at its fast speeding magnificence.

Durand's most elaborate painting is entitled "Progress" in the catalogue. Its aim is to contrast the ruggedness of primeval nature with the culture and forces of our present civilization. A party of Indians looks out from a rocky height, amidst thick forest trees, upon a composition of water and mountain scenery, the general features of which seem taken from the waters of the Hudson, bordered by the Catskills. A sweet sylvan expanse lies in the distance. On a promontory rises a city where a steamboat has just landed; the canal and the railway wind along the banks. The foreground is filled with the activities of rural life, wagoners and groups of cattle. How sweetly the sunlight reposes in the different portions of the picture, whether in the distant atmosphere, or the summer river, or the illuminated earth-bank, spotted by patches of shade.

In the same room hangs a large painting by Kensett, a stern, barren foreground of "the foodless rock," with soft hazy water and mountain scenery beyond. The rock predominates in the composition at the expense, we think, of some of this artist's finer qualities. Mr. Kensett exhibits only two other pictures, a small lake scene at the Franconia notch, and a "glimpse" of the Berkshire Bash Bish.

Church is in full force with Mount Ktadn, a New England sunset, with an orange fleckered sky, mountains in shade and water, and factory seat in the foreground, passing into the cool darkness. The last radiance of the sun still illuminates the horizon, broken by the mountains. Grand Manan Island, Bay of Fundy is another of Church's forcible skies and sunsets. You can scarcely look at the level rays across the water without winking. Church also gives us the Valley of the Madawasca, a companion to the Ktadn, and the Natural Bridge of Virginia, the colors of which we now for the first time appreciate.

Cropsey has a Niagara, the Second Beach at Newport, the Sybil's Temple at Tivoli, similar to the large one exhibited by him some few years since; Vermont Scenery, and a sketch of Melrose Abbey.

Of the other landscape painters, Inness exhibits several elaborate compositions in his manner, so strong a contrast to Durand's delicate open air sketches; Gignoux has a blue, warm sunny snow scene in broken rocky scenery, with a rich variety of sunlight and moisture; Richards has a Southern river scene of a dark steely quality in the shade and waters, with a massive gnarled tree on the bank dripping with moss; Casilear has but two pictures, but marked by his faithful qualities; one a sketch, the property of Mr. Kensett; Talbot, in his large open way, has painted Indian Hunting Grounds, an Eastern Caravan Encampment, a Coast Scene at Newport.

FACING NATURE: JASPER CROPSEY AND SANFORD GIFFORD

Originally trained as an architect, Jasper Cropsey had a short-lived practice in New York before turning to full-time landscape painting in the mid-1840s. Although he devoted himself to the celebration of the American landscape, he spent several years abroad, thus ignoring one of Asher B. Durand's cardinal principles. Nonetheless, he was a devoted student of nature. Published in The Crayon, *his essay on clouds combines*

meteorological precision with ecstatic romanticism. Cropsey's allusion to Ruskin offers clear proof of the latter's importance to Americans developing their own landscape aesthetic.

Sanford Gifford like Jasper Cropsey was associated with the second generation of Hudson River school painters. Although George W. Sheldon's article on Gifford dates from the last quarter of the nineteenth century, when an eclectic array of new styles jostled in the marketplace, this piece provides a detailed picture of characteristic mid-century methods. It is clear that, despite repeated visits to the site, and no matter how thick the portfolio with on-the-spot studies, the finished painting is an elaborate and laboriously fabricated studio production. Of particular interest is the information on Gifford's method of varnishing to achieve the veiled, luminous atmospheric effects for which he was known. Committed to the reverent study and imitation of nature, Gifford, well into the 1870s, remains loyal to the original tenets of The Crayon.

Jasper Cropsey, "Up among the Clouds," Crayon 2 *(August 8, 1855).*

Of all the gifts of the Creator, few are more beautiful, and less heeded, than the sky. Men go to and from their daily cares, but seem never to regard for a moment these alternate patches of blue and cloud that glisten from among the chimney-tops, and around the corners of our aspiring brick and stone mansions. The husband-man rising with the sun, will turn the sod from morn till night—cast his seed, and leave it with a beneficent Providence to water and bring it forward in its due time; and yet never look to that dome of treasure, the store-house from which shall descend the rains, the sunshine and shadow that shall mature his labors to an abundant harvest. So too—we all pursue our way, attentive to but the one object of our life, seeing not the flowers we crush beneath our tread, nor the beauty that encircles us like a halo from above. It is only to know which way the wind may blow—to say, "it is cloudy," "it is clear," or "it looks like rain," that we look up. Even the artist—a part of whose great mission it should be to give the delicate and evanescent beauty; that every hour in the day presents itself in the sky, and thus make man happier by the purity and beauty he breathes on his canvas—seldom seems to heed its lessons, or its truth . . .

Go to the far-off-looking hill-side, and there, in the cool shade of some wide-spreading tree—look up through the sturdy branches, scored and mossed by many a winter's storm, and summer's sun, now richly studded with verdure, and looking up through those trembling leaves in which the sun dances from one to the other, making them alternately gold and emerald in their joy—look through these leafy loop-holes into the blue sky and cloud above, and if there is music in your soul, you must feel a beauty, heavenly and indescribable, in the sky and cloud, thus gleaming from above, through the checkered, leafy, branch-ribbed bower.

But, these little joyous glimpses are not enough; they are novelties; look out on the wide-spread horizon, and study some of its phenomena and laws. Here we have, first of all, the canopy of blue; not opaque, hard, and flat, as many artists conceive it, and picture patrons accept it; but a luminous, palpitating air, in which the eye can penetrate infinitely deep, and yet find depth: nor is it always the same monotonous blue; it is constantly varied, being more deep, cool, warm or grey—moist or dry—passing by the most imperceptible gradations from the zenith to the horizon—clear and blue through the clouds after rain—soft and hazy when the air is filled with heat, dust, and gaseous exhalations—golden, rosy, or green when the twilight gathers over the landscape; thus ever presenting new phases for our admiration at each change of light or circumstance . . .

. . . If the cirrus is distinguished for its delicate fleecy, fibrous wave-ribbed character, the region of the cumulus is not less so for its grand masses of dreamy forms floating by each other, sometimes looking like magic palaces, rising higher and higher, and then topling over in deep valleys, to rise again in ridges like snowy mountains, with lights and shadows playing amid them, as though it were a spirit world of its own: again floating in compact masses up against the light, silvering edge after edge as each rounded form climbs above the other. In boyhood, we have often watched this dream-world, and peopled it with angels; in manhood, from the cares of life we have turned, and been refreshed by the glimpses of its "silver lining." . . .

While we are looking from our hill-side, we will stay yet a while to give a passing glance at the nimbus, the region of the rain-cloud, and the lowest of the sky regions. Of these clouds Ruskin remarks, "they differ not so much in their real nature from those of the central and uppermost regions, as in appearance, owing to their greater nearness." All those heavy, inky-looking skies of rainy days belong to this region. Although, in many respects, it is not beautiful, yet to it we are indebted for all those beautiful dreamy effects of the breaking up of mists and fogs, from over lakes and valleys, and creeping vapors that climb the mountain sides. It must have large claim upon our ideas of beauty, on account of its being the cloud in which the rainbow appears. And in a higher region of it, parted and drifting, spraylike, over the blue, with the sunbeams flickering through it, there is often presented a sky more pictorial than all others.

Add to this its influence upon the landscape, by its deep and gloomy parts obstructing the sun's rays, and burying in mystery the distant mountains, or sending its shadow fleeting fugitive-like over hill and valley; and again, in breaking disagreeable outlines of hills and mountains, by obscuring them in its curtain folds—by its drifting masses crowning their storm-riven heads, or hovering like winged spirits about their rock-ribbed sides, and moving in grandeur down their dark, pineclad ravines. It is perhaps in its grandest moods more impressive than all the other cloud regions—awakening the deepest emotions of gloom, dread, and fear; or sending thrilling sensations of joy and gladness through our being. Those of us who have watched the coming-up storm; or those who go down to the sea in ships for the first time, can remember their feelings when looking over the boundless waters toward the dark clouds of this storm-region as they were spreading over the sky, gathering and blackening; and when the fierce flashes of lightning parted in twain for a moment, their dark sides, followed by the solemn voice of thunder, how his thoughts have woke into more living inspiration of hope and praise.

If the cirrus and cumulus regions awaken soothing and poetical thoughts of serenest beauty, the rain region can certainly stir the heart as much, even though it appeal to the coarser elements of our nature.

It is this class of sky, owing to its nearness, and stronger grade of color, and the more powerful impressions it is capable of producing, that is susceptible of the highest and noblest results in Art. Owing to its nearness, it is generally of a warmer, brownish tint—often in the light portions of a brickish red, while in its dark and gloomy parts, as in the approach of rain or heavy wind, it has a heavy, inky, and black look; but to describe any particular color, is impossible, because it is susceptible of all the modifications of color arising from reflections, changes of form, dust and vapors from the earth, atmospheric distances and sunlight.

Its impressiveness and gloom have led artists to choose it in compositions, involving great and powerful emotions; but too often they have thought only of its blackness, omitting the beautiful handiwork of its form. Ruskin says: "We have multitudes of painters who can throw a light bit of straggling vapor across the sky, or leave it in delicate and tender passages of breaking light; but this is a very different thing from taking up each of those bits or passages, and giving

it structure and parts, and solidity." Because the people in their blissful ignorance should cry "bravo" to some such clever sweeps of the brush, there is no reason why an artist should do the same agreeable sky over and over again. But if with no other object than the glory of his art, and the honor due to himself as an intelligent mind, he should be led to strive for the noblest truth and beauty.

George W. Sheldon, "How One Landscape Painter Paints," Art Journal 3 *(1877).*

To one who knows Mr. Sandford R. Gifford well, his success as an artist seems natural enough. Like every other success in Art, it has come from insight and from perseverance. In his opinion— and the opinion is correct—an artist is simply a poet. Each works from the same principles, and each aims at the same results. The only difference between them lies in the materials they use. Both the painter and the poet strive to reproduce the impressions which they have received from beautiful things in Nature. If these impressions can be reproduced by words, it is the business of the poet to reproduce them. If they are subtle and elude the grasp of words, it is the business of the painter to reproduce them . . .

. . . Mr. Gifford's method is this: When he sees anything which vividly impresses him, and which he therefore wishes to reproduce, he makes a little sketch of it in pencil on a card about as large as an ordinary visiting-card. It takes him, say, half a minute to make this sketch; but there is the idea of the future picture fixed as firmly if not as fully as in the completed work itself. I have seen some of these simple card-sketches, and they do not seem to amount to much. They enable the artist, however, to keep clear in his memory the scenes that have impressed him, even though he should delay further work for months or for years. While travelling, he can in this way lay up a good stock of material for future use. The next step is to make a larger sketch, this time in oil, where what has already been done in black-and-white is repeated in colour. To this sketch, which is about twelve inches by eight, he devotes an hour or two. It serves the purpose of defining to him just what he wants to do, and of fixing it in enduring material. Sometimes the sketch is not successful, and is thrown aside to make room for another. It helps him, also, to decide what he does not want to do. He experiments with it; puts in or leaves out, according as he finds that he can increase or perfect his idea. When satisfactorily finished, it is a model in miniature of what he proposes to do.

He is now ready to paint the picture itself. All that he asks for is a favourable day on which to begin. To Mr. Gifford this first day is the great day. He waits for it; he prepares for it. He wishes to be in the best possible physical condition. He is careful about his food; he is careful to husband his resources. When the day comes, he begins work just after sunrise, and continues work until just before sunset. Ten, eleven, twelve consecutive hours, according to the season of the year, are occupied in the first great effort to put the scene on the canvas. He feels fresh and eager. His studio-door is locked. Nothing is allowed to interrupt him. His luncheon, taken in his studio, consists of a cup of coffee and a piece of bread. His inspiration is at fever-heat; every faculty is stretched to its utmost; his brush moves rapidly, almost carelessly. He does not stop to criticise his work. The "divine afflatus" is within him, and he does unquestioningly whatever it tells him to do, while his pigments are wet and in moveable condition. No day is ever long enough for his first day's work; and very often, at the end of it, the picture looks finished, even to the eye of an artist.

First of all, on this first day, he removes the glaring white of his canvas by staining it with a solution of turpentine and burnt sienna; the reason being that a surface of pure white causes the colours laid upon it to look at first more brilliant than when the canvas is entirely covered

with colours. You deceive yourself when you paint upon a white background. Then he takes a white-chalk crayon and makes a drawing of the picture he expects to paint. After that is done, he "sets" his palette, placing little piles of white, cadmium, vermilion, madder-lake, raw sienna, burnt sienna, caledonia brown, and permanent blue, one after another along the upper rim, in the order in which I have enumerated them. These are all the manufactured pigments that he uses; they consist of the fundamental red, yellow, and brown, with their lights and darks. Just below this row of pigments he puts another row, consisting of three or four tints of mixed white and cadmium, three or four tints of orange (obtained by mixing the former tints with red), and three or four tints of green (if foliage is to be painted). Along the lower rim of the palette he puts, one after another, several tints of blue. The palette is then ready. The workshop—the battle-ground, if we please—is in the centre, between these tints of blue and the tints of orange. Here are created all the thousand special tints which the spectator is soon to see in the picture.

The first thing that Mr. Gifford paints, when handling a landscape, is the horizon of the sky; and his reason for doing so is, that in landscape-painting the colour of the sky is the key-note of the picture—that is to say, it governs the impression, determining whether the impression shall be gay or grave, lively or severe; so much so, indeed, that landscape-painting may be called (what we have already said Mr. Gifford calls it) air-painting. Different conditions of the air produce different impressions upon the mind, making us feel sad, or glad, or awed, or what not. Hence the condition—that is, the colour—of the air is the one essential thing to be attended to in landscape-painting. If the painter misses that, he misses everything. Now, the colour of the sky at the horizon is the key-note of the colour of the air. Mr. Gifford, therefore, begins with the horizon.

When the long day is finished, and the picture is produced, the work of criticism, of correction, of completion, is in place. Mr. Gifford does this work slowly. He likes to keep his picture in his studio as long as possible. He believes in the Horatian maxim of the seven years' fixing of a poem. Sometimes he does not touch the canvas for months after his first criticisms have been executed. Then, suddenly, he sees something that will help it along. I remember hearing him say one day, in his studio: "I thought that picture was done half a dozen times. It certainly might have been called finished six months ago. I was working at it all day yesterday." . . .

Mr. Gifford varnishes the finished picture so many times with boiled oil, or some other semi-transparent or translucent substance, that a veil is made between the canvas and the spectator's eye—a veil which corresponds to the natural veil of the atmosphere. The farther off an object is in Nature, the denser is the veil through which we see it; so that the object itself is of secondary importance. The really important thing is the veil or medium through which we see it. And this veil is different at different times. One day we go out in the morning, and, looking up and down the street, take no note of the sight. We are not impressed. Another day there is a slight change in the density or the clarity of the atmosphere, and lo! what before was a commonplace view has become exquisitely beautiful. It was the change in the air that made the change in the object; and especially when finishing his picture does the artist bear in mind this fact.

Moreover, as the spectator looks through this veil of varnish, the light is reflected and refracted just as it is through the atmosphere—reflections and refractions which, though unseen, are nevertheless felt. The surface of the picture, therefore, ceases to be opaque; it becomes transparent, and we look through it upon and into the scene beyond. In a word, the process of the artist is the process of Nature . . .

Mr. Gifford's industry often leads him to make a dozen sketches of the same scene. The first

sketch, indeed, contains the essence, but day after day he visits the place, corrects the first sketch, qualifies it, establishes the relations of one part to another, and fixes the varied gradations of colour. His portfolios are heavy with studies of rocks, of trees, of fallen leaves, of streams, of ocean-waves. Some painters think that, if they reproduce such objects exactly, they lose some of the poetry of natural facts. Mr. Gifford does not think so. He believes in Nature, and is not ashamed laboriously to imitate her. An artist like Corot offends him by slovenliness. To him one of Corot's finished landscapes is scarcely more than a sketch. He gets from it nothing more than he would get from a drawing.

THE NATIONAL LANDSCAPE IN REPOSE: JOHN FREDERICK KENSETT

Like his friend and mentor Asher B. Durand, John Frederick Kensett formulated a landscape style that married sharp local specificity and meticulous description with an enveloping mood of tranquility and even sweetness, as Henry Tuckerman puts it in his fulsome appreciation of the painter. Tuckerman praises Kensett's ability to seize upon the most characteristic features of lake, beach, and mountain scenery and then to combine them with his own signature tact and delicacy. Kensett's quiet, atmospheric landscapes offered welcome respite from the troubled and often tumultuous times during which he practiced his vocation. Tuckerman suggests as much in noting how vividly Kensett's imagery recalls "our summer wanderings."

Henry T. Tuckerman, Book of the Artists: American Artist Life *(New York: G. P. Putnam, 1867).*

Kensett . . . Upon his return to his native land . . . commenced a series of careful studies of our mountain, lake, forest, and coast landscape; and in his delineation of rocks, trees, and water, attained a wide and permanent celebrity. Year after year he studiously explored and faithfully painted the mountains of New England and New York, the lakes and rivers of the Middle States, and the Eastern sea-coast, selecting with much judgment or combining with rare tact the most characteristic features and phases of each . . . His best pictures exhibit a rare purity of feeling, an accuracy and delicacy, and especially a harmonious treatment, perfectly adapted to the subject. Here it may be an elm-tree, full of grace and beauty, crowning a scene of rural peace, which steals, like nature's own balm, upon the heart of the spectator; there a "Reminiscence of Lake George" is wrought up to the highest degree of truth from the autumn mist to the lucent water and gracefully-looming mountains; now it is the dark umbrage, and now the shelving glen; here a ridge of stone and there a stormy mountain-cloud, or exquisite beach with greenly-curving and snowy-fringed billows—and all seem so instinct, both as to form and hue, tone and impression, with nature's truth, that they win and warm, calm or cheer, the heart of her votary, like the voice of one beloved, or the responsive glance of a kindred soul.

An able critic, in describing his "Lake George," has well said of this artist:—

"The most unaggressive and loved of the leaders of the American school of painting has at length produced a picture of size sufficient to call forth his best strength, and of importance enough in subject-matter, if successfully treated, to confirm his position as one of the three foremost men of our landscape art. Mr. Kensett has long been accepted as a most consummate master in the treatment of subjects full of repose and sweetness, and been honored by critics and painters for the simple and unpretending character of his works—works remarkable for tenderness and refinement of feeling, exquisite quality of color, and a free and individual method of painting certain facts of nature. Not great or extended in his range, not a colorist in the ab-

solute sense of the term, but with an unfailing feeling for harmony, and of a judicious and liberal mind, noticeable for taste, Mr. Kensett has painted some of the most exquisite pictures that illustrate our art . . . and if at times devoid of strength, in his best estate he fairly won for himself the honor of being called the lyrical poet of American landscape art."

The subdued tone of the autumnal atmosphere and foliage in this picture is tender and true; its effect is singularly harmonious; how exquisite the clouds, warm the atmosphere, and effective the large oak in the foreground; and, above all, what sublime repose! Kensett does not merely imitate, or emphasize, or reflect nature—he interprets her—which we take to be the legitimate and holy task of the scenic limner . . .

The variety and faithfulness of Kensett's studies of landscape may be learned at once by the sketches on the walls of his room. The traveller recognizes localities at a glance. One of the marked excellences of this artist is the truth and definite character of his outline; accordingly we behold a fragment of the Apennine range, an Alpine peak, and the more rounded swell of American mountains, in these artistic data for elaborate works. Careful observation is the source of Kensett's eminent success. He gives the form and superficial traits of land and water so exactly as to stamp on the most hasty sketch a local character indicative of similitude. His landscapes would charm even a man of science, so loyal to natural peculiarities are his touch and eye. Equally felicitous in the transfer of atmospheric effects to canvas, and with a genius for composition, scenery is illustrated by his fertile and well-disciplined pencil with rare correctness and beauty. Every material that goes to the formation of a landscape he appears to have carefully studied. We retrace, at ease, our summer wanderings, in his studio: there are the "Hanging-Rocks" which bound good Bishop Berkeley's old Rhode Island domain; here a bluff we beheld on the Upper Mississippi; and opposite, an angle in the gorge at Trenton, where we watched the amber flash of the cascade; how finely is reflected the morning and afternoon light of early autumn in America, in these two charming pictures; there is "Lake George" itself—the islands, the shore, the lucid water; how native is the hue of yon umbrageous notch; and what Flemish truth in the grain of that trap-rock; how rich the contrast between the glow of summer and the colorless snow on the summit of the Jungfrau; the trees in this more finished piece are daguerrotyped from a wood, with the fresh tint of the originals superadded.

There is one obstacle to impartiality in estimating Kensett, as an artist, to one who knows him well; and that is the personal confidence and sympathy he inspires. Of all our artists, he has the most thoroughly amiable disposition, is wholly superior to envy, and pursues his vocation in such a spirit of love and kindliness, that a critic must be made of very hard material who can find it in his heart to say a severe, inconsiderate, or careless word about John F. Kensett. Perhaps some of our readers will think all this is quite irrelevant to the present object, which is to define Kensett's position in art, wherewith personal qualities, it may be argued, have nothing to do. But we are of a contrary opinion. The disposition or moral nature of an artist directly and absolutely influence his works. We constantly talk of a "feeling for color"—of a picture exhibiting a fine or a true "feeling," and thus instinctively recognize a transfusion of the natural sentiment and a tone of mind into and through the mechanical execution, design, and spirit of a pictorial work. In landscape-painting especially, this result is obvious; Salvator's wild woods and savage romance, Canaletti's literal correctness, Claude's vague, but poetic sentiment, characterize their paintings. The calm sweetness of Kensett's best efforts, the conscientiousness with which he preserves local diversities—the evenness of manner, the patience in detail, the harmonious tone—all are traceable to the artist's feeling and innate disposition, as well as to his skill. If we desired to carry abroad genuine memorials of native scenery—to keep

alive its impression in a foreign land—we should select half-a-dozen of Kensett's landscapes. Other artists may have produced single pictures of more genius; may be in certain instances superior; but, on the whole, for average success, Kensett's pictures are—we do not say always the most brilliant, effective, or original—but often the most satisfactory. So thought Lord Ellesmere, after visiting nearly all our native studios, and so think those who have most carefully studied American scenery. It is rarely that, to use a common phrase, we can *locate* a landscape so confidently as Kensett's; the vein of rock, perhaps, identifies the scene as in New Jersey,—the kind of cedar or grass assures us that it was taken on the Hudson,—and the tint of water or form of mountains suggests Lake George. There was a time when we feared Kensett, with all his merits, would become a mannerist,—so peculiar and stereotyped were some traits; but he soon outgrew this, by enlarging his experience—studying nature at the English lakes, as well as along the Erie Railway, and in the Adirondacks, not less than by the sea-coast; his pictures of the latter illustrate what we have said of his local truth; for they define the diversities of the New England coast. We all feel that Newport scenery—even that of the sea—so apparently monotonous, differs from that of Beverly and its vicinage, but it would be hard to point out the individualities of the two; Kensett does it with his faithful and genial pencil. He is as assiduous as he is tasteful.

FITZ HENRY LANE, MARINE PAINTER EXTRAORDINAIRE

Working apart from the artistic community of New York, Fitz Henry Lane apprenticed in the lithography trade in Boston before settling in his native Gloucester, Massachusetts, where he spent the rest of his life painting luminous, hard-edged coastal and maritime views for local consumption. Although strictly local, Lane's work also referenced the conventions of Dutch and British marine painting, which he would have known through prints and by the example of his mentor, the Scottish marine painter Robert Salmon. Then Clarence Cook (see also "The American Pre-Raphaelites," chapter 7), art critic for a New York weekly, The Independent, *met Lane for the second time in 1854. His letter, published in* The Independent, *provides a firsthand account of Lane in his milieu. Lane paints first and foremost for those with intimate knowledge of ships and seafaring; indeed, Cook has reservations about Lane's earlier work, which he finds too literal. Now, however, the critic sees true feeling, power, and poetry in Lane's seascapes, praising one in particular for its glorious sunset radiance. Although Cook considers Lane more than ready to take to the national stage, the artist remained staunchly local, sending paintings to New York only on rare occasions.*

Clarence Cook, "Letters on Art.—No. IV," Independent, *September 7, 1854.*

There are only two stone buildings in this town of Gloucester: one is "the Bank," the other belongs to Mr. F. H. Lane, whose name ought to be known from Maine to Georgia as the best marine painter in the country . . .

Mr. Lane has put few pictures in his studio at present: for he is very industrious, and sends his canvases off as fast as they are filled. If you were to meet him in the street, you would hardly take him for an artist. A man apparently of forty years, walking with difficulty, supported by crutches, hard-handed, browned by the sun and exposure, with a nose indicating less the artist sensibility than the artist resolution, and an eye that shines clear as a hawk's, under over-hanging brows. This is the bodily portraiture of a man who is a master in his art. Conscious of his abil-

ity, conscious of the ability of others, studious, patient, eager to learn, relying on himself, and with all the modesty of reliance; a man, who in knowledge, feeling, and skill, has had no rival, certainly in America, and I doubt if more than two abroad.

With my recollections of four years ago, I was doubtful if I should find in Mr. Lane the poetical element that must be a constituent in the artist's mind. His early pictures had something in them too hard and practical to permit enthusiastic admiration; the water was salt, the ships sailed, the waves moved, but it was the sea before the Spirit of God moved upon the face of the deep.

His pictures early delighted sailors by their perfect truth. Lane knows the name and place of every rope on a vessel; he knows the construction, the anatomy, the expression—and to a seaman every thing that sails has expression and individuality—he knows how she will stand under this rig, before this wind; how she looks seen stern foremost, bows foremost, to windward, to leeward, in all changes and guises; and, master of his detail, he has earned his money thus far mostly by painting "portraits" of vessels for sailors and ship-owners. It is owing to this necessity, perhaps, that he has fallen into the fault of too great literalness of treatment, which I have mentioned as characterizing some of his earlier works; but with the rapid advance he has made in the past four years, there is no longer any fear that he is incapable of treating a subject with genuine imagination.

If Mr. Lane would on some fine morning turn the key of his studio door, and leave his pretty stone-cottage to take care of itself for a year or two, while he went to Europe to see what the great painters have done, Turner and Vernet, and what God has done far out in the awful ocean where he has never been, I believe, with his new experiences and the new inspiration with which this enlarged field of study would fill his open mind, he would come back a great master in marine painting . . .

He has indulged in no tricks and no vagaries; he has slighted nothing, despised nothing. If I appear to think less of his early pictures than they deserve, it is not because they are carefully even painfully studied, and because no detail has escaped his eye or brush; it is not that he has too much conscience; but simply because I missed in them the creative imagination of the artist. But it may well be a question whether at this day, when slight and untruthful work prevails, when artists will not paint with conscience, and the public does not strenuously demand it, conscience and love are not higher needs than imagination, and whether Mr. Lane's early pictures, the landmarks on his toilsome, earnest journey to his present place, have not a great value of their own. There is no one of them that I have seen, without some valuable passage, showing acute observation and careful, studious execution.

A sea-piece, "Off the coast of Maine, with Desert-Island in the distance," is the finest picture that Mr. Lane has yet painted. The time is sunset after a storm. The dun and purple clouds roll away to the south-west, the sun sinks in a glory of yellow light, flooding the sea with transparent splendor. Far away in the offing, hiding the sun, sails a brig fully rigged, a transfigured vision between the glories of the sky and sea. The clearness of execution and the poetical treatment of this portion of the picture are admirable. They are the work of a man who not only *knows* but has *felt* the sea. In the foreground of the composition is an old lumber-schooner, plowing her way in the face of the wind; the waves are rough but subsiding; dark-green swells of water, crowned with light and pierced with light. The truth and beauty of the water in this picture I do not believe have ever been excelled. I do not believe deeper, clearer water, or waves that swing with more real power, were ever translated in oil.

I urged Mr. Lane to send this picture to New-York for exhibition. It could not fail to make

an impression, and to call forth criticism. A finer picture of its class was never in the Academy, and it must be many years before another man can arise among us who can be a rival for so close a student and so learned an artist in his department.

Mr. Lane has painted landscapes and figures, but has done nothing worthy his efforts in this branch. The sea is his home; there he truly lives, and it is there, in that inexhaustible field, that his victories will be won.

AMERICAN LIFE

RALPH WALDO EMERSON ON NATIVE AND NATIONAL ART

Though seldom to achieve the luster and prestige of landscape painting, American genre painting occupied an important niche in the art world and the art market of the antebellum decades. The emergence of genre painting—the painting of daily life—paralleled the rise of Jacksonian democracy, which expanded suffrage beyond the propertied class to all free white men of legal age—a political body symbolized by the figure of the mythic if elusive "common man" that dominated political and social discourses during that era.

In the 1830s and '40s Ralph Waldo Emerson produced a series of addresses and essays that argued for new philosophy and new aesthetics based not on history, mechanical formulas, or rules but rather on dynamic engagement with nature, in the fullest sense of the word. In "The American Scholar," Emerson calls for intellectual independence from Europe and release from the burden of the past. For Emerson, only today's insight really matters. To this end, he opts for the low and the common in lieu of the sublime and beautiful. In his eyes, the humblest things yield up deeper and more spiritual truth than the grandest castle or the mightiest mountain. Continuing along similar lines, "The Poet" urges poets to address themselves to real life in the here and now. America needs a "genius" who can see that in these times, no matter how barbaric or materialistic, is the raw material for epic poems in a new vernacular. Although Emerson is speaking primarily of literature, his call for a democratic aesthetic meshes with the nationalistic spirit and common-man themes of genre painting as practiced during the same era by William Sidney Mount and his contemporaries.

Ralph Waldo Emerson, "The American Scholar" ["An Oration, Delivered before the Phi Beta Kappa Society, at Cambridge, August 31, 1837"] (Boston: James Munroe, 1837).

I read with joy some of the auspicious signs of the coming days, as they glimmer already through poetry and art, through philosophy and science, through church and state.

One of these signs is the fact, that the same movement which effected the elevation of what was called the lowest class in the state, assumed in literature a very marked and as benign an aspect. Instead of the sublime and beautiful; the near, the low, the common, was explored and poetized. That, which had been negligently trodden under foot by those who were harnessing and provisioning themselves for long journeys into far countries, is suddenly found to be richer than all foreign parts. The literature of the poor, the feelings of the child, the philosophy of the street, the meaning of household life, are the topics of the time. It is a great stride. It is a sign,— is it not? of new vigor, when the extremities are made active, when currents of warm life run into the hands and the feet. I ask not for the great, the remote, the romantic; what is doing in

Italy or Arabia; what is Greek art, or Provencal minstrelsy; I embrace the common, I explore and sit at the feet of the familiar, the low. Give me insight into to-day, and you may have the antique and future worlds. What would we really know the meaning of? The meal in the firkin; the milk in the pan; the ballad in the street; the news of the boat; the glance of the eye; the form and the gait of the body;—show me the ultimate reason of these matters; show me the sublime presence of the highest spiritual cause lurking, as always it does lurk, in these suburbs and extremities of nature; let me see every trifle bristling with the polarity that ranges it instantly on an eternal law; and the shop, the plough, and the leger, referred to the like cause by which light undulates and poets sing;—and the world lies no longer a dull miscellany and lumber-room, but has form and order; there is no trifle; there is no puzzle; but one design unites and animates the farthest pinnacle and the lowest trench.

Emerson, "The Poet," in Essays, 2d Series *(Boston: James Munroe, 1844).*

I look in vain for the poet whom I describe. We do not, with sufficient plainness, or sufficient profoundness, address ourselves to life, nor dare we chaunt our own times and social circumstance. If we filled the day with bravery, we should not shrink from celebrating it. Time and nature yield us many gifts, but not yet the timely man, the new religion, the reconciler, whom all things await. Dante's praise is, that he dared to write his autobiography in colossal cipher, or into universality. We have yet had no genius in America, with tyrannous eye, which knew the value of our incomparable materials, and saw, in the barbarism and materialism of the times, another carnival of the same gods whose picture he so much admires in Homer; then in the middle age; then in Calvinism. Banks and tariffs, the newspaper and caucus, methodism and unitarianism, are flat and dull to dull people, but rest on the same foundations of wonder as the town of Troy, and the temple of Delphos, and are as swiftly passing away. Our logrolling, our stumps and their politics, our fisheries, our Negroes, and Indians, our boasts, and our repudiations, the wrath of rogues, and the pusillanimity of honest men, the northern trade, the southern planting, the western clearing, Oregon, and Texas, are yet unsung. Yet America is a poem in our eyes; its ample geography dazzles the imagination, and it will not wait long for metres.

WILLIAM SIDNEY MOUNT AND
THE CELEBRATION OF NATIONAL CHARACTER

The early decades of the nineteenth century witnessed tremendous social and economic fluidity. Factories, wage labor (and a working class), and mechanized agriculture displaced older modes of self-sufficiency or subsistence, and growing transportation networks and commercial outlets distributed and sold goods on a large scale. With these changes came accelerated social mobility in both directions, up and down, as well as the formation of a commercial and professional middle class. The instability of both the economy and class position during the era created insecurity and anxiety. On the move, no longer confined to self-contained communities, Americans depended more and more on systems designed to facilitate foolproof social recognition, or typing, for sorting out who was who—and who was higher or lower—in the heterogeneous body politic.

In this dynamic social climate, William Sidney Mount emerged as the supreme

celebrant of American life and American character. Although New York City was his institutional base, William Sidney Mount spent much of his life living and painting on his native Long Island. Apprenticed to his brother Henry, a sign painter, Mount also studied briefly at the National Academy of Design. He launched his career as a painter of ordinary American life in 1830 with Rustic Dance after a Sleigh Ride, *which met with an enthusiastic reception. Mount from that time devoted himself to American country life in a succession of anecdotal, sometimes slyly satirical paintings in which a readable gallery of American types purported to represent the social and political body. Mount took many cues from the work of English predecessors such as Sir David Wilkie as well as seventeenth-century Dutch painters. So skillfully did he overlay those templates with American types and local landscapes that, although writers sometimes compared him to Wilkie, at the same time they praised what they saw as the authentically American character of his art.*

A comment in the New York Herald *on Mount's* Farmers Bargaining *typifies the nationalistic critical response that greeted the artist's down-home tableaux. W. Alfred Jones likewise fully represents mainstream critical opinion on the artist in figuring him as genuinely American and applauding his decision to stay home and preserve his "truly national" art from foreign adulteration. Jones casts Mount as an authentic albeit sophisticated American rustic who finds both happiness and subject matter in rural Stony Brook. It is noteworthy that Jones so readily equates the national with the local and the rural with the truly American; both suggest that the function of genre painting is to construct an idea or ideal of American life that passes for the real thing.*

"*National Academy,*" New York Herald, *May 17, 1836.*

155, Farmers bargaining, W. S. Mount, N.A.

Mount is exceedingly felicitous in catching the right expression. This is an image of pure Yankeeism, and full of wholesome humor. Both of the yeomen seem to be "reckoning," both whittling, both delaying. The horse, which is the object of their crafty equivocations, stands tied as "sleek as a whistle," waiting for a change of owners.

W. Alfred Jones, "A Sketch of the Life and Character of William Sidney Mount," American Whig Review *14 (August 1851).*

The paintings of W. S. Mount, one of the few American artists that deserve to be called painters, are of a strictly national character; the pride and boast, not only of his native Long Island, nor yet of the State of New-York solely, but of the whole country . . .

Doctors of Law and Divinity, Judges and Bishops, can be easily created by conventions and councils, but a true humorist is worth a county of such dignitaries . . .

Among those . . . who affect a liking for art in this walk, how few correctly appreciate it; placing the department of humorous description and comic satire below portrait and landscape, to say nothing of what passes under the style and title of history. In painting, however, as in literature, familiar history is in general far more valuable and directly interesting than the so-called heroic phases of art. Every thing depends on the artist and his mode of treatment of a subject. A great artist will make more of an ordinary scene than the inferior genius will be able to create out of the noblest materials . . .

The youngest of three brothers, artists, our painter, the son of a substantial Long Island

farmer, was . . . bred "a farmer's boy," as he himself expresses it, and which early education sufficiently explains the character of the subjects of his art—all rural scenes of a domestic character, or, as in most cases, of out-of-door scenes and occupations . . .

. . . Had Mount gone abroad at that time, he might very probably have learned new secrets of coloring; but as probably he would have been confused by the brilliancy of so much excellence, and, in his attempt to gain too much facility, have lost his distinctive local freshness, and untaught, natural beauties. A truly national painter might have been sacrificed to the varied accomplishments of a tasteful artist of the schools. Perhaps it was wisest for him to have remained at home . . .

Bargaining for a Horse, in the New-York Gallery, and which is to be one of the Art-Union engravings for next year, and *Nooning,* engraved by Alfred Jones, a capital engraving, appear to us his *chefs d'œuvre* in his out-of-door scenes. In the first picture, remark the diplomatic manner of the traffickers: how cool and indifferent; whittling; their attitudes, like their dress, easy and slouching. Nooning is nature itself, a perfect transcript from life: how close and sultry the mid-day heats; how lazily lolls the sleeping negro on the hay, whose ear the boy is tickling with a straw, which produces a slight smile. The white laborers are naturally disposed about with their farming implements. The landscape is unmistakably that of Long Island, bare and homely, yet with an air of thrift and comfort. In all of his productions, the details are carefully painted, but in some of them, separate faces or some special object form the most attractive features.

Power of Music and *Music is Contagious* are, like most of his works, of cabinet size and companion pieces. The titles tell the story, which is narrated with pictorial effect. They represent the love of music at different periods of life. The phrenological hobby of the artist is apparent in the musical bump of the negro, whose organ of tune in the second picture has been much developed.[3] The faces of the boys are full of sweetness. *California News* is a hit at the times. A group of listeners surround the reader of an "extra," containing the miraculous developments of gold discovery at the El Dorado; the scene, a village tavern bar-room, hung round, among other ornaments, with a handbill advertisement of a vessel up for the Mines. This is, altogether, a capital thing, full of telling effects: an historical painting, though of an humble order, in the genuine sense . . .

Mr. Mount is now living at Stony Brook, some three miles from Setauket, on the Sound side of Long Island, with his married sister. His studio is as rustic as possible, and nothing could be more appropriate. It is in the upper story or garret of an old-fashioned cottage, a comfortable homestead, with the light artistically let in from the roof . . .

The scenery about Stony Brook is not beautiful nor romantic, but has a certain rural charm that confirms local affection, when a more picturesque scene might fade out of the fancy. It has that ever-delicious repose of the country, that air of quiet and seclusion, so full of unobtrusive beauty to the citizen, tired of the turmoil of a town life . . . Here, in serenity, and in the enjoyment of social pleasures, practising a genial hospitality, with abundance of good-humor and native courtesy, combining much intelligence and true natural refinement, reside a pleasant society, of which the Mount family forms the centre of attraction. Pleasant excursions, and little parties at home or in the neighborhood, relieve the toils of the studio, the farm, the manufactory; and more real happiness is found than amid the splendid luxuries of the city.

[3] See "The Significance of Bumps on the Skull," this chapter.

The place of W. S. Mount, as an artist, may be considered as not easily assignable. He is an original painter, a follower of no school, an imitator of no master. But yet he may be classed generally with English painters, as partaking of certain of their qualities and as possessing similar attributes. Mount is not merely a comic painter, and by no means a caricaturist. At the same time, he is much above the most successful painter of still life. His forte properly is rustic picturesqueness, and heightened by true humorous descriptive power. He is something akin to Wilkie, with traits of the better part of Morland and a good deal of Gainsborough in him. Some of his cabinet pieces with a variety of figures deserve to be ranked in the same category with the admirable pictures of the Dutch and Flemish schools . . .

A comic artist without doubt, he is still essentially a rural painter. There is nothing of the town life in his pictures: all are imbued with a feeling of the country—its freshness, its foliage, its sweet airs and soul-calming secret recesses. His best works are, in a word, humorous pastorals, with sweetness and fine-tempered satire, (where there is any at all;) no bitterness, no moral obliquity or personal deformity impair their effect; they present a picture of country life, at once satisfactory for its truth and agreeable in its aspect and general features.

WILLIAM SIDNEY MOUNT'S THOUGHTS ON ART, LIFE, AND TRAVEL ABROAD

Even though Mount artfully contrived his subjects and his pictorial narrative style, he staked his claim to authenticity and true American values on the close and even obsessive study of nature, his ultimate authority. Scattered throughout his diary are exhortations and reminders never to forget this one true source. Several other themes recur in Mount's diaries and notes. In a seemingly democratic spirit, he seeks to paint "for the many." He worries about his secluded existence in the country and craves but fears the excitement of the town. He berates himself for failure to work harder and draws up lists of possible subjects. In his preoccupation with self-discipline and productivity, Mount is very much in line with the contemporary ethos of middle-class reform. His vacillation between country and city mirrors the widespread tensions that accompanied the emergence of industrial culture and the growing influence of the metropolis. Desiring to paint for the many and hit upon subjects with popular appeal, Mount acknowledges the power of the marketplace to determine value and win success for the artist in a democratic society.

Although critics and viewers (in addition to Mount himself) construed the Long Islander as a provincial artist of the soil, he was well informed on international art past and present, mainly through the medium of the abundantly produced and widely distributed prints, which for many American artists constituted an education. In his letter to Goupil, Vibert, and Company, Mount enumerates the many French painters who are "dear" to him—through engravings after their works. Goupil's offer to send him to Paris further indicates Mount's connection with an international cultural network. These connections extend to marketing as well: in the last paragraph, the artist anticipates the pleasure of seeing the engravings after his own paintings, just arrived from France. Writing to Charles Lanman, Mount elaborates the same themes, noting that two patrons in addition to Goupil have offered to send him to Europe. Mount, however, demurs; originality is possible here, even for "us Yankees," and, with plenty of orders, he is content to remain at home. Mount's comments also suggest his keen awareness of, and interest in, the market for his pictures.

William Sidney Mount, diaries, Long Island Museum of American Art, History and Carriages.

[Subjects, December 1844]

Two lovers walking out. Walking out after marriage one after the other—after the manner of Jude & Sam—The husband two months after marriage, with a bag of grain on his shoulder going to mill. A Whig after the Election. A Clergyman looking for a sermon at the bottom of his barrel. A Negro fiddling on the crossroads on Sunday. Kite broke loose. Claming & fishing. A Farmer feeding hogs—office holder. Croton Water.

[August 29, 1846]

I sometimes feel as if I should give all my time to pictures, make character, expression & color my only study. Paint scenes that come home to every body. That every one can understand. What I have endeavored to do, I believe I can do again, though some of my friends think I am falling off. I must put into practice my knowledge, and see if I have not one or two ideas left— For much preparation will not answer. I must go to work.

[July 1847]

A painter of pictures must lead almost a monastic life—For my part I am getting tired of it. This quiet country life. This loneliness hangs heavy upon me. Too heavy to stand a great while longer—In hours of relaxation we should associate with those who have a kindred spirit, or visit a gallery of choice pictures that will stimulate the mind—There does not appear anything noble and generous in the country. Just the pure atmosphere—The City should be the home of the artist, He can sally out in search of the picturesque when he pleases.

[October 19, 1847]

A painters studio should be every where, wherever he finds a scene for a picture in doors or out. In the black smiths shop—The shoe makers—The tailors—The church—The tavern— or hotel—The market—and into the dens of poverty & dissipation, high life & low life—In the full blaze of the sun in moon light and shadows. Then on the wave—the sea shore—in the cottage by fire light and at the theatre. See the sun rise & set. Go and search for materials— not wait for them to come to you. Attend—Fairs, shows, Campmeetings & horse racings, Treasur up something in your mind, or on paper, or Canvas, wherever you may hapen to be thrown—an artist should have the industry of a reporter. Not ashamed or afraid to plant his easel in the market place for figures, or background—or both. For painting is an honorable calling, and the artist will be respected let him sketch where he will. Time has now come that the artist should throw aside his cane & gloves and like the painters of old, go forth for subjects, with the industry of bees in a flower garden—sip the beauties of passing objects, and return.

[February 1854]

Paint pictures that will take with the public, in other words never paint for the few, but for the many—Some artists remain in the corner by not observing the above.

[Undated]

My best pictures are those which I painted out of doors—I must follow my gift—to paint figures out of doors, as well as in doors, with out regard to paint room. The longer an artist leaves na-

ture the more feeble he gets—he therefore should constantly imitate God—One true picture from nature is worth a dozen from the imagination.

William Sidney Mount to Goupil, Vibert, and Co., February 14, 1850, William Sidney Mount Papers, courtesy of The New-York Historical Society.

Messieurs Goupil Vibert and Co.

Your circular about the new school of art "of sending one American student or more" to Europe to study the fine arts at the expense of the International Art Union is a compliment that will not be lost upon my countrymen. I hope Gentlemen, that you will continue the management of the International Art Union. I have long had a desire to see France, her great painters are dear to me. The works of Le Sueur, Le Brun, Poussin, Claude, Guerin, Regnault, Perrin, Jourenet, Lairesse, David, and latterly the Vernets, Delaroche, Scheffer, Debuffe &c, all have given me instruction & pleasure principally through engravings of their works. France has been illuminated by the works of her gifted painters & sculptors. All nations are magnified more or less, as they encourage art.

I would go to Paris tomorrow, if my engagements would permit. I am sorry I cannot accept at present your very kind and liberal offer to spend a year in Paris. I feel very grateful for the compliment.

I am anxious to see the engravings from my pictures of "Just in Tune" and Boys Trapping. Say to Mr. Wm Schaus that I expect to visit the city the last of next month and will be happy to call and see him. The coloured engraving of "Music is Contagious" which Mr. Leon Vibert presented to me is very much admired.

I remain dear Sirs,
Yours most truly,
WM. S. MOUNT

William Sidney Mount to Charles Lanman, January 1, 1850, William Sidney Mount Papers, courtesy of The New-York Historical Society.

I have not time to think on the subject at present. I am too busy. However, as you request—I will mention with pleasure two or three of my latest pieces. "Turning the Leaf"—"Farmer whetting his scythe"—"The Well by the Wayside" and "Just in Time." The last represents a character tuning his violin—the size of life—on canvass 25 × 30. It is owned by George J. Price N.Y. City. It is to be published by Goupil, Vibert & Co and has gone to Paris to be engraved the size of the original by the celebrated Emile LaSelle. "Boys Trapping—Painted for Chas. A. Davis of N.Y. City in 1839 it is now in Paris under the magic hand of Leon Noel, and then both of the above paintings after serving the purposes of the engraver, are to be exhibited in the ensuing collection of painting at the Tuilleries. I have painted at intervals about fifty pictures besides portraits. I have frequently been paid more for my pictures than the price asked. I have often spent days, and weeks & months without painting—there is a time to think and a time to labour. I have always had a desire to do something before I went abroad. Originality is not confined to one place or country which makes it very consoling to us Yankees.

The late Luman Reed—of N.Y. desired me to visit Europe at his own expense. Jon Sturges Esq. N.Y. City—has made offers of friendship if I desired to visit Europe and lastly Messrs. Goupil Vibert & Co. have very kindly offered to furnish the funds if I would spend one year in Paris and paint them four pictures. I have plenty of orders and I am contented to remain a while longer in our own great country.

Have you seen the engraving from my picture "Music is Contagious"—companion to the "Power of Music"? If you will let Wm. Schaus know your address perhaps he will send you one, or both of the above engravings. Schaus was inquiring about you when I was in the city. Brother Shepard is in town I shall write to him or see him in about 10 days time & talk about Charles Lanman. Sister Ruth sends her best regards. You must come and see me next spring . . . Give my love all around the board.

THE SIGNIFICANCE OF BUMPS ON THE SKULL

The middle class in the industrializing United States became the locus of intersecting reform movements in the 1830s and later. Inspired in large part by evangelical zeal, middle-class men and women dedicated themselves to the mission of improving, ordering, and perfecting the shape of American society—morally, spiritually, and physically. Numbers of different groups formed to oppose slavery and combat crime, poverty, prostitution, and drunkenness—all viewed as threats to the republic and its institutions. The new pseudoscience of phrenology was enlisted in the cause. Developed and popularized by Orson Fowler, phrenology derived from eighteenth-century theories of physiognomy propounded by Johann Kaspar Lavater and others. Phrenology posited that inner character manifested itself in external signs, specifically, the contours of the skull, which corresponded with each region of the brain. Although the lofty goal of phrenology was salvation through moral and physical improvement, in practice it was often used to affirm racial difference and to justify scientifically the superiority of white Anglo-Saxons over African American, Native American, and immigrant groups. In this way, phrenology gave ballast to the practice of typing that enabled individuals to identify, sort, and rank others in an increasingly heterogeneous social body. Thus, in comparing the attributes of the European race with those of American Indians and the "African race," Fowler offers what purport to be irrefutable facts that demonstrate the hierarchical differences. By this system, class, gender, and racial differences are ordained by the irrefutable law and order of nature. Popular and authoritative, phrenology strongly influenced antebellum artists, who—the better to produce readable types—routinely incorporated its signs in genre and portrait painting as well as sculpture.

Orson S. Fowler, Fowler's Practical Phrenology *(New York: Fowler and Wells, 1840).*

VIII. *The truth of phrenology is mainly supported by an appeal to the demonstrative evidence of* PHYSICAL FACTS. In this place an allusion can be made to only a few of the innumerable facts that have already been observed in support of phrenological science. Throughout the whole animal kingdom, they abound; but, more especially, and in the most striking manner, are they found to be manifested in that most important and wonderful of the animal species—man.

The human head generally presents a large development of the frontal and coronal portions of the brain; and, according to phrenology, the former of these portions, is the seat of the *intellectual,* and the latter, of the *moral,* organs; but, in the brains of animals, these portions are almost entirely wanting, as their heads manifest scarcely any traces of these organs: and does not this perfectly correspond with the mental qualities of these different classes of beings? The European race (including their descendants in America) possess a much larger endowment of these organs, and also of their corresponding faculties, than any other portion of the human species. Hence, their intellectual and moral superiority over all other races of men. Franklin,

Locke, Bacon, Browne, Edwards, Webster, and Drs. Richard and James Rush, and indeed, all deep and profound reasoners, all original and powerful thinkers, without a solitary exception, possess really immense *causality* and *comparison*. Among all the heads examined and noticed by the author, he has never seen one with so very high, broad, and deep a forehead, or, in other words, in which the *reasoning organs* are developed in so extraordinary a manner, as in that of Daniel Webster; and where do we find his supcriour for displaying those faculties of the mind which are imparted by these organs? . . . Men of ordinary talent, possess a respectable endowment of these organs. The Hindoos, Chinese, American Indians, and the African race, still less, but much more than the lower order of animals. Idiots, scarcely any; and the lower order of animals, none, or next to none at all . . .

The monkey possesses immense philoprogenitiveness . . .

A great number of Indian heads and sculls, from many of the different American tribes, has fallen under the author's observation and inspection; and he has found, as a general feature common to them all, an extreme development of destructiveness, secretiveness, and cautiousness, together with a large endowment of individuality, eventuality, tune, conscientiousness, and veneration, and, sometimes, firmness; large approbativeness *or* self-esteem, and sometimes *both* large; moderate acquisitiveness, benevolence, causality, combativeness, amativeness, and constructiveness: and, in the female, extremely large adhesiveness and philoprogenitiveness; but in the male, philoprogenitiveness moderate. This combination of organs indicates just such a character as the Indians generally possess. Their extreme destructiveness would create a cruel, blood-thirsty, and revengeful disposition—a disposition common to the race—which, in connexion with their moderate or small benevolence, would make them turn a deaf ear to the cries of distress, and steel them to such acts of barbarity as they are wont to practise in torturing the hapless victims of their vengeance. Their extremely large destructiveness combined with their large secretiveness and cautiousness, and smaller combativeness, would cause them to employ "cunning and stratagem in warfare, in preference to open force;" would give them less courage than cruelty; cause them to be wary, extremely cautious in advancing upon an enemy, and to lurk in ambush; and, with high firmness, admirably fit them to endure privation and hardship, and even the most cruel tortures; and, at the same time, render them unconquerable: and if to these we add large approbativeness, we may expect them to glory in dark deeds of cruelty; in scalping the fallen foe, and in butchering helpless women and children.

Their large conscientiousness would make them grateful for favours, and, according to their ideas of justice, (which, in consequence of their small causality, would be contracted,) honest, upright, and faithful to their word; and these constitute the principal sum of their moral virtues; but when we add their high veneration and marvellousness, we find them credulous, religious, and superstitious. Their small amount of brain in the coronal region of the head, when compared with their immense development of the animal passions and selfish feelings, would bring them chiefly under the dominion of the animal nature of man, and render them little susceptible of becoming civilized, humanized, and educated: hence, the rugged soil which they present to the labours of the Christian missionary. Their very large individuality and locality, and full perceptive organs generally, with their large destructiveness, secretiveness, and cautiousness, would cause them to delight in the chase, and admirably qualify them to succeed in it; whilst their small causality, would render them incapable of producing many inventions and improvements, or of reasoning profoundly. Their small acquisitiveness would create in them but little desire for property; and this would result in a want of industry, and leave them, as we find them, in a state of comparative destitution as regards the comforts, and even the necessaries,

of life. The very large philoprogenitiveness of their females, admirably qualifies them to protect and cherish their offspring under the peculiarly disadvantageous circumstances in which they are placed; whilst the small endowment of this faculty in their males, would cause them to be comparatively indifferent to their children, and to throw the whole burden of taking care of them while young, upon the other sex. Their large tune, and very large destructiveness, would give them a passion for war-songs and war-dances; and these combined with their large eventuality, would cause them to adopt this method of perpetuating their warlike exploits . . .

. . . And thus it appears, that, in passing from the European race to the Indian, and from one tribe of Indians to another, we find, in every instance, a striking coincidence between the phrenological developments of brain, and the known traits of character.

The African race as found in America, furnish another instance of the striking correspondence between their known character and their phrenological developments. They possess, in general, either large, or very large, adhesiveness, philoprogenitiveness, hope, language, and approbativeness, *or* self-esteem, and sometimes *both*; large veneration, marvellousness, individuality, locality, and tune; with moderate causality, constructiveness, and mirthfulness. Combativeness, destructiveness, secretiveness, acquisitiveness, and, perhaps, conscientiousness, unlike these organs in the Indian head, vary in size, being sometimes very large, and in other instances, moderate or small. Their extremely large hope, would make them very cheerful, and little anxious about the future; and, with their large approbativeness and small acquisitiveness, extravagant, and predisposed to lead a life of ease and idleness. Their very large hope and language, with small secretiveness and mirthfulness, would give them hilarity and garrulity, without much pure wit.

Their large, or very large, tune, which inspires them with melody, with their smaller reasoning organs, which give them but few thoughts, and their large language, would furnish exactly such composition as we meet with in negro songs, doggrel rhymes glowing with vivacity and melody, and containing many words and repetitions with but few ideas. Their small reasoning organs would give them but little depth and strength of intellect, and a feeble judgment, with very little talent for contriving and planning. Their very large philoprogenitiveness, adhesiveness, and inhabitiveness, would make them extremely attached to their families and the families of their masters, and pre-eminently social.

Their excessively large approbativeness and self-esteem would create in them that fondness for dress and show, and that pride and vanity, for which they are so remarkable. Their large religious organs would produce those strong religious emotions, and that disposition to worship, for which they are distinguished, as well as those rare specimens of eminent piety sometimes found among them. Their *variable* selfish organs would cause those *extremes* of temper and character which they display, sometimes running into cunning, thievishness, and general viciousness and cruelty, and sometimes showing the opposite character. Their large marvellousness accounts for their belief in ghosts and supernatural events so often manifested among them; whilst their very large language, combined with their large perceptive organs generally, would create in them a desire to learn, and enable them to succeed well in many things.

WALT WHITMAN ON AMERICAN PAINTING

The poet Walt Whitman had an early career as a newspaper correspondent, during which he wrote on all manner of cultural and political topics. He had a particular interest in daguerreotypes (see "Responses to the Daguerreotype," chapter 5), and

he also discussed painting on occasion. In this short review of works exhibited by the American Art-Union, he gives readers a sense of his taste in painting as well as his penchant for colloquial expressions and a conversational tone in his prose. Whitman extols genre painter Richard Caton Woodville for his subdued tone, "free from that straining after effect." The rest of the review is an argument against obsessive detail and glaring execution.

Paumanok [Walt Whitman], "Letter from New York," National Era, October 31, 1850.

The exhibition of the Art Union is now open, with its new pictures—all spack and span, and shining, in their handsome frames. There is a pleasing piece here, painted in a very subdued manner, by Woodville, called "Old '76, and young '48." An old revolutionary veteran is seated at the tea-table, or has just pushed back his chair from it, listening to a young man, probably his grandson, returned, with his arm in a sling, from the Mexican war. On the opposite side are the young man's mother and father. Fain to linger at the door, are two or three old black servants of the family. The mother and the old '76er are beautifully done; the whole picture is good, and free from that straining after effect, whose attempt is too evident, (*that's* the fault,) which mars most of the pictures here.

"The Death of Bayard" is a large, showy piece, by a young man named Nahl. There is too little soul in the picture, whose subject demands that it should be specially full of that element. The plumes, the armor, the velvet tunic, and all the small fixings, are carefully and elaborately rendered. An upholsterer's or dry-goods man's wife might be in raptures with it, but the piece falls dead before the judgment which demands something consistent with the noble death of the pink of chivalry, surrounded by the most stirring of circumstances.

It is a distressing fault of our painters—and one sees it all over the walls at this exhibition—that they strain so hard to make every material thing so clean-lined and clear, lest a body may fail to understand what they mean. Nearly every picture seems to thrust itself from its frame, and "stand out," as they call it. This effect is openly sought after. It is fatal to the truth and life of art. Not protruding but retiring—not staring out of its frame, but retiring in—must be that picture which deserves a place among the things of genius. Nature never thrusts anything forward in this way—it will do for a melo-drama on the stage, but is no part of true greatness, either in life or in art.

I remember that sublime emanation, "The Dead Christ," by A. Scheffer, with the mourning women around. How utterly uneffective, according to the school of the startlers; and yet what awe crept over one, gazing on that yellowish pale face, with the death sweat moistening the lips—the corpse of a god it was; for there had worked the fingers of a truly great painter!

Too many of our young fellows, among those who ought to know better, are carried away with the false principle of working up the details of a picture to the minutest specification. This is the business of the modelist, not the artist. On a small bit of canvass you are not to give a model. Aim to produce that beautiful resemblance which will excite the motion that the real object might produce—the rest is the mere drippings, the shavings and sawdust. Keep them out of sight, unless you would mar the perfect work.

DAVID GILMOUR BLYTHE ON MODERN TIMES

While the majority of genre painters focused on the bright side of American life and glided over social inequities and ills, the Pittsburgh painter David Gilmour Blythe

confronted them head-on both in his paintings and in his poetry. An outsider to the polite East Coast urban establishment, Blythe critiqued modern American society in his images of loafers, drunkards, and disorderly crowds in and around Pittsburgh, a factory town riddled with social unrest and overhung by a pall of industrial smog. The eccentric and nonconformist painter also wrote furiously satirical poems, some in the form of letters to his friend, Hugh Gorley, and others for the private venting of his demons. In one poem, Blythe recognizes the power and dangerous potential of the media in the dawning age of mass communication. He sees the pulpit as platform for vain demagoguery and the courts as panderers to public opinion. In "Carrier's Address," Blythe issues a blanket indictment of corrupt society, caked with the filth of vileness, vice, hypocrisy, drunkenness, and deceit. He holds out no hope of reform; for this disaffected painter, American society is morally bankrupt, without possibility of redemption.

David Gilmore Blythe, letter to Hugh A. Gorley, Vermont, Ill., from East Liverpool, Ohio, 1857; in James Hadden, "Sketch of David G. Blythe: Reminiscences of a Queer Genius," No. 7, Uniontown [Pa.] News Standard, *April 16–May 28, 1896.*

Dear Friend H., I've just received your kind
Epistle. It puts me in mind
Of other days, when hope was lined
With velvet. But alas, how soon
Fate's "hurdy-gurdy" changes tune!
"I cry you mercy" in the matter
Of not answering your last letter,
Because, although I know you wrote it,
I'll take my oath I never got it.
You thought I'd left for parts unknown
Well, you were right, for I have grown
Almost gray and half-demented
In trying to find some place where I could
Get acquainted . . .
But everything now-a-days is "run
In the ground." Many a town begun
And nurtured by the gendering sun
Of illegitimacy has won,
Notwithstanding its bastard birth,
An envied place 'mong cities of the earth.
The press, that mighty, monster lever
Which shakes things like a western fever,
Of which truth and truth alone
Should be the fulcrum, scarcely one
Except, perhaps, your own, but's gone
Astray from it.
And yet the world looks on and cries
"What's the odds?"
An editor has as good a right as any
Body else to make an honest penny.

One-half our pulpits too are chuck
Full of vain, empty-headed truck
Ambitions only to have a stuck-
Up congregation to preach to, and
Ten thousand or so at their command.
Our courts with few exceptions,
Are fit subjects for like objections.
Public opinion first. Blackstone second.[4]
Justice now here's the way law is reckoned
Now-a-days. And then our juries,
Oh! if there are such things as Furies
Why don't they "pitch in?" Curious,
Just imagine twelve ignoramuses
With flat heads and red "wammuses"
Sitting in judgment on an intricate
Case of Law. Beautiful, isn't it?

David Gilmore Blythe, "Carrier's Address," Pennsylvania Democrat *1, January, 1851; in Hadden, "Sketch of David G. Blythe: Reminiscences of a Queer Genius,"* No. 2, Uniontown [Pa.] News Standard, *April 23, 1896.*

Time, with his great self-sharpening shears
Hath clipped our century of half its years
And trembling recollection turns
In vain to rummage o'er the urns
Of bygone years in search of one
She would recall and dwell upon.
Yes fifty years have passed away
And left us these shadowy
Gleams of memory, that play
Upon the rubbish of the past,
Like glimmering rays of moonshine cast
Upon the midnight wave. We trace
Towering above the vacant space
Like streaks from Satan's quenchless fires,
Ten thousand monumental spires
Built on ruins rich green sod
That, with the seeming hand of God,
Beckon us to heaven. Save this,
The past seems but a fathomless
Ocean, and each swelling wave
A kind of deep, dark yawning grave
Whose greedy vortex hath sucked in
A whole half century of sin

. . .

[4] "Blackstone" is a reference to Sir William Blackstone's *Commentaries on the Law of England* (1765–69), from the time of its first publication a standard reference on common law.

The past we never can recall,
And round the future is a wall
Impenetrable which must fall
Ere we can tell anything about it.
The present, ah! now comes the rub,
Would to God somebody would grub
Up by the roots what we have sub-
Stituted for moral honesty, take a tub,
Of soapsuds and a brush, and scrub
From our moral tablets, the vile counterfeit.
Oh! What a mixed-up black compound
Of vice and virtue may be found
In hideous festoons hung around
The present.
All wear the hypocrite's brazen crown,
From lordly nabobism down
To the meanest, "ornryest," lousiest clown
In Christendom.
The holy minister of God
May stand on consecrated sod
And smash down pulpit with his rod,
Yet who in the Dickens minds him.

LILLY MARTIN SPENCER: MAKING IT IN NEW YORK

The extraordinary career of genre painter Lilly Martin Spencer stands alone in the middle decades of the nineteenth century. An indefatigable worker, she painted for more than sixty years and, in her heyday, was virtually the only woman to achieve viability as a professional painter in the art capital of New York. Indeed, Spencer was the primary means of support for her family of eight children; her husband, Benjamin, a tailor and sometime artist, served as her occasional assistant. Life was never easy for her, as the following reviews and letters to her parents make clear. Circumstances dictated that she was always keenly attuned to the market for pictures. Her description of her principal patron, the American Art-Union, as "gorged even to throwing up with pictures" is memorable (see "The American Art-Union," chapter 3). From the moment she moved to New York from her native Ohio in 1849, she was forced to struggle for sales and recognition in an art world unaccustomed to the presence of a professional woman.

For example, just a decade before her arrival, one New York journal declared it would refrain from publishing a notice of any work of art painted by a woman. At times, Spencer might have wished that other periodicals followed such a policy. Even writers who saw some merit in her work, such as the reviewers in the New York Tribune *(1848) and* The Crayon, *below, frequently commented on her perceived "deficiencies" in drawing and perspective, which probably intensified her desire to seek further training, a leitmotif in her letters. Particularly poignant is her faithful attendance at drawing class in 1852 at a time when her child was gravely injured and a potential client was demanding*

her attention. The juggling required of working mothers is nowhere more apparent than in this letter. Despite the fact that she was living an unconventionally professional life, Spencer still felt it necessary to apologize to her mother for her inability to attend a convention on women's rights; her duties as breadwinner and mother prevented it. She also tried to shield her parents from particularly scurrilous reviews, such as the one in the New York Tribune *below. (Spencer makes a guess as to the identity of the source of the attack; her letter, read in conjunction with the entire review, points the finger at artist Thomas Hicks.) Amid the discouraging forces documented at length in her correspondence, it must have been a relief to receive the final letter from Elizabeth Ellet, a feminist historian endeavoring to help women artists find patronage.*

"Mrs. L. M. Spencer," New York Tribune, *December 5, 1848.*

MRS. L. M. SPENCER—This is the name of an American artist, a native we believe of Cincinnati who has recently arrived in this City, with several products of her pencil, betraying, with great faults of execution, natural powers of a high and unusual order. Her breadth of light and shade, force of expression and great power of foreshortening, contrast strangely with her crude and unmeaning chiaroscuro, her spotted and unequal coloring and her sometimes glaring defects of drawing. Some of her faces are of truly celestial beauty, and there is a freedom and vigor of design in many of her sketches really startling. One of her pictures, the Fisherman's Wife and Children on the Seashore, is comparatively free of faults and is absolutely a painting of immense power, touch and beauty. The watching mother, looking out to sea and shading her eyes with her hand, is as pure, sweet and joyous a piece of Nature as we remember to have seen transfixed on canvass. The Egeria has many glimpses of glorious outline and patches of delicious flesh-tinting, but the outline is overcharged, the attitude ungraceful and unnatural and the light and shade unartistically distributed. In a word, Mrs. Spencer has evidently a very strong and original genius, but is deficient in the fundamental elements of her art. Under a severe and rigid course of two years' study, in a competent school, she would in our opinion, produce paintings of great and unqualified excellence.

Lilly Martin Spencer to Angelique Martin, letters, Archives of American Art.

> *[March 29, 1850]*

When we came to New York I found myself so inferior to most of the artists here that I found that if I did not want to be entirely lost among them I would have to make the closest study of almost every part of my art and also paint some as well as I could to sell; I found it required twenty times the labor and time to accomplish anything that could stand by the works I had about me, for I found the people here—were almost all pretty good judges and very severe critics particularly if they had any idea of buying. And then after all I would have to sell it at an enormous sacrifice for as I have often heard you say Mother—everybody rushes to a big city thinking that they will get there the best prices, until they throng each other so that they actually get less good prices than they do at home. I do not actually get half as well paid for my works than I did west, and however have to do ten times better work . . .

I felt so provoked to find myself so far behind even painters that had no reputation whatever. I found myself particularly deficient in drawing drapery and even coloring, but I determined to try all I could to improve myself. I found I had to go to work and study everything I

had neglected to study when a girl—perspective and all. There is a dreadful competition here, however we both work hard, both economize, to the utmost! and by that means manage to get along happily and to make both ends meet, which is doing pretty well in New York.

[October 11, 1850]

As to what you heard, dear Mother, with regard to me in the Cincinnati paper—with regard to my improvement, it is true, for if ever anyone tried hard and perseveringly I do—but with regard to my being well patronized, it is very very! far from being true, I assure you dear Mother. I will try to show you dear Mother how far I have improved by sending you the picture which I have promised to send but it takes me so much longer to finish a picture than it used to for I am endeavoring by conscientious application to improve myself in every picture I do. But still I get very little more for them than I used to. The expenses of living in New York are enormous, so that it is only by continued exertions and strict economy in both of us, that we can live here at all. We have managed, by selling my finest pictures, rather (according to my opinion) at a sacrifice to have just what will get us our winter fuel and absolute necessaries for the winter which here is very severe and long, and I have as far as now no particular prospects either of portraits or orders for fancy pieces. There is a perfect swarm of painters here and very very good ones too, that can hardly get along. For my part, I cannot see how they get along at all, dearest Mother I assure you I tell you strictly the truth with regard to our affairs. We told that gentleman of the Times paper when he came, that when he went he should say we were doing very well, for we did not wish that the people in Cincinnati to think that I was not doing extra well, as I used to be rather discontented with them there. You know when a person wants to get along they must shake the nails in their pockets when they have no money; however I am doing very well considering this babel of a city in which we are, and the number of much better artists who are much longer established, and the immense deal of study I have to go through. I have contrived to sell all that I have done, because I let them go for nearly one third of what I ask for them, and because they are well painted and very good. Nothing dear Mother! would give me greater pleasure dear Mother than to be able to send you the sum you desire if it were all in my power to do so. The Art Union, which is my chief point, indeed almost my only one for the sale of my pictures, are gorged even to throwing up with pictures and good ones too . . .

With regard dear Mother to the subject of the convention of women, dear Mother I heard nothing but some slight notices in the paper that we take, and what you told me in your letter. My time dear Mother to enable me to succeed in my painting is so entirely engrossed by it, that I am not at all able to give my attention to anything else, all though whenever there is any thing to be seen in the paper I know about it, if I hear or see anything about it I will let you know, and you know, dear Mother, that I cannot leave my little babies nor my business to attend those meetings if they were even closer than they are, Worcester is too far for me, to dream of going to. You know dear Mother that that is your point of exertion and attention and study like my painting is mine, and you know dear Mother as you have told me many a time that if we wish to become great in any thing we must condense our powers to one point.

[March 6, 1852]

Since I commenced this letter to you this is the first time I have been able to sit down quietly to finish my letter to you . . . a portrait (quite a profitable one) came which I had to get at in the greatest haste, then Angelo was playing downstairs in the basement with Benjamin, and the girl and the baby Charley, when, in running about, he knocked his nose against the leg of the table,

and came running up to Ben and myself with his nose bleeding. Ben stopped the bleeding, cuddled him in his arms a little, and then he went down again to play, but in the evening complained that his mouth pained him. (It was a good deal swelled), but we did not pay much attention to it as we had both to hurry out on some urgent business. I rubbed it with some ointment and put him to bed and went out. When we came back we went to see if the children where sleeping. They were both asleep but Angelo was moaning in his sleep and his mouth was much swelled. The next day he was much worse and the poor dear little fellow suffered so much they he could not sleep or stand up but remained laying in his father's arms all day, and could not even bear him to move even to change him from one arm to the other. I had to go at the portrait, for my sitter came. The girl was washing and Ben had to hold little Charley on one knee and Angelo on the other, and so we went through that day. Poor little Angelo seemed so much worse—his whole face was swelled. At night I bathed his feet in mustard water to take the inflammation from his head, and I put a poultice to his face. This did him some good. He slept that night and was rather better but he became again worse towards the afternoon. Ben went for the first doctor he could; when the doctor looked at Angelo he said he did not like to undertake curing him as he was sick in too many ways and that we must send for a doctor better acquainted with children's diseases. You may guess how frightened I was. Ben then ran for another doctor—the one who generally attends us. He said he was very sick, and found what I had suspected was the truth—that he had broken his tooth which had caused a serious gathering in his face, and his system generally was sick. We had to watch, in turns, that night and the next and then the next again. At last, by dint of good nursing (Ben had to hold him constantly in his arms) and I had to keep constantly at my portrait, for besides *their* being very impatient to get it, I had reason to hope that I would get several more portraits from the same quarter, if I pleased them in that one, so I spared no pains to make it a splendid painting. In the meantime poor little Angelo got gradually better, but he no sooner began to get well (besides all this I have attended the drawing academy every other night to improve myself in drawing), than little Charley got extremely sick with his teeth—so sick as to threaten convulsions—the poor little fellow could not rest night or day. It really seemed as though there would be no end to the disturbance we had, but that with helping each other patiently we at last got through it all and the children got better, but just as this difficulty was getting over, we found we were going to have to move as the landlord of the house we lived in (and a most comfortable place it is, too), had sold the property, and the house was going to be torn down to build a store, so that the lady who rents the house from him, and from whom we rent our part of the house, had to look for another house, and to those who do not live in New York it is impossible to imagine the difficulties of house hunting. We had to hunt every day. Ben had to go constantly in order to miss no chance, and I had to go also whenever I could. The scarcity of houses this year is terrible and the rents enormous.

"The Fine Arts," New York Tribune, *March 30, 1854.*

There is one picture which is such an utter deformity in itself, and seems so much to involve the sense of moral evil, that it is our duty to condemn it strongly, and to condemn the Committee of Arrangements for giving it a place on the walls. We refer to No. 322, *Portrait of an Infant,* by L. M. Spencer. It is impossible to believe that nature ever produced so monstrous a little creature, with flesh hanging about it so in bunches as if loosened from its frame by beating, and with face and person so discolored and distorted. In some of the old pictures there are little fiends not unlike this portrait. It is not fit to be seen, and should have been excluded from the Exhibition.

I received your dear anxious letter, of the 11th, on the 19th, and hasten to answer, for I would not have you feel bad on account of that foolish piece in the Tribune. It is too coarse and transparently vindictive, to hurt me much—don't mind it dearest Mother. I don't, it is not the only foolish attack I have got in the papers, nor have I been without my pufs, but I care just as little about the one as the other. I do not depend on the pufs for my true and lasting reputation, nor do I fear the attacks from the same source, they are equally unlasting, and are apt to be pretty equally false and exaggerated. I depend entirely on my own truthful and persevering efforts to improve, and my own natural powers whatever they may be—on this raft of quiet and comfortable self resilience, I float completely amidst all these vain attempts from jealous shafts, to keep me down. Feeling conscious of my own merit, and knowing exactly the extent of my powers, these attacks can never put me down—and being also well aware of my defects, exaggerated praise cannot blind or exalt me—I depend upon my own good judgment, and the finger of Nature to guide and support me. It is likely dear Ma that you may hear perhaps worse attacks yet upon me, but don't mind them Dearest Mother. Why! Dear old Mother! Don't you remember that you used to tell me that it was the best sign in the world, to see jealous attacks begin, and this article has been dictated by malignity. (So it is reported at any rate) I had heard people talk of a very abusive article upon me in the Tribune, some of my friends saying that the author ought to be shot, others saying he ought to be Cow hided, and so on, but I had not even taken the trouble to read it, till I noticed so many going to see the little fiend, as it was called, and several asking me if I knew who had written that scurrilous article. I told them I did not know, nor did I care. –Well said, the one addressing me, if you want to know, see who's pictures are most praised in that article, it is he who dictated it. I had previously heard others say the same. Well! Who ever it is, I care not, he has only spit on his own nose. So you see my dear old Ma in what light I look upon all of this, you see I am not down in my spirits. I will send you a daguerreotype of the little fiend, taken from the picture itself, and you can judge for yourself. As to their saying in the article that the picture had an immoral tendency, I can not for the life of me, understand what they mean nor do I care to find out. So you see dear Ma that all their abuse falls on me like water on a ducks back. I have plenty of work now.

"Exhibition of the National Academy," Crayon 3 (May 1856).

Mrs. Spencer has a truly remarkable ability to paint, but unfortunately ruins all her pictures by some vulgarism or hopeless attempt at expression. She paints still life with unsurpassed delicacy and force, with exquisite color both in tint and quality, and above all, works with entire freedom from artistic conventionalism. Even as a specimen of flesh painting, we should be willing to place the face of the servant girl in No. 94 by the side of any American artist's work, but beyond that in praise we should not care to go. She draws poorly; witness the enormous disproportion of the heads in No. 86, and the disjointedness of all the figures in No. 94. The head of "The Young Wife" in the former picture is enough to ruin even a picture perfect in every other respect. Mrs. Spencer has no power over transitory expression, and the slightest remove from immobility of features ends in grimace. We are well satisfied, both from the pictures of this year and those of years past, that though she might be eminent as a painter of still life, her ambitious attempts at humorous painting will proclaim by their failure, that she mistakes her vein. The most pitiable of all people is some one who attempts to be funny and only succeeds in being ridiculous, for it is always a descent to bend from the sobriety and dignity of calm thoughtfulness, to mere humor and jesting, and *such* descents when unsuccessful become

supremely ridiculous in their result. The whimsical expressions in the faces of Mrs. Spencer's figures should be fleeting and spirited to be successful; but they are fixed and rigid, as though the laugh or momentary perplexity had been assumed, and kept on the face of the model she was painting from; and the feeling we have is not one of merriment at the incident, but of painful sympathy with the poor people whose faces have been, by some magic, fixed in the midst of a grin, unless indeed, as in the case of "The Young Husband" in No. 86, the distortion of feature amounts to destruction even of the semblance of expression. If Mrs. Spencer would paint noble pictures, she must leave out her attempts at humor.

But there is another and more radical difficulty in her realization of objective; she is earnest and grave, without any trace of frivolity or affectation, and without any token of spirit in her execution—all is patient and sincere, and as far as such things can express dignity, dignified. But the subjects she chooses are frivolous and whimsical, things to be laughed at for a moment, and then passed by, even if ever so successful; and in which, to attain the measure of success requisite, a corresponding spirit in, and rapidity of, execution is necessary, that the idea and its form of expression may be congruous. A labored jest is as bad in painting, as at the dinner table, and every token of thoughtfulness in a humorous picture interferes with its primary impression. It is therefore, that we judge that Mrs. Spencer will never succeed as a painter of humor, as well as because there is no indication in her works of *depth* of humor. The thoughtfulness with which she studies and realizes detail, is an unmistakable indication of her true course in choice of subject. Is there in her woman's soul no serene grave thought, no quiet happiness, no tearful aspiration, to the expression of which she may give her pencil? Being a woman, she should have some deeper, tenderer conceptions of humanity than her brother artists, something, at all events, better worth her painting, and our seeing, than grinning house-maids or perplexed young wives. We should hope for much from her, if she could see that it was her duty to be serious sometimes.

Lilly Martin Spencer to Angelique Martin and Gilles Martin, September 10, 1856, Archives of American Art.

Painting as a profession seems to be gone to the dogs. I had expected that after having so many of my pictures engraved that I should have had plenty to do, but it is not so. The publick taste runs so little that way, that private orders, or purchases, are not to be had for fancy prices—when once publishers have got what they want, there is no one to buy—and portraits, that used to be the mainstay of artists, photographing has almost entirely destroyed that branch, for they furnish two or three pictures for the lowest price, that an artist is obliged to ask for painting a portrait in the ordinary way.—in fact, it is machine work. Oh! It makes me sad to see how little pictures are cared for and how perfectly indifferent and ignorant the publick is with regard to the difference between a good or a bad picture. All they care about is the low price, in fact I will tell you how picture manufacturing is done here, and sold of by wholesalers at auction, and the publick are so ignorant that they do not know the difference between one of these manufactured daubs and a good original painting, and as all they care about is having something surrounded by a gilt frame, to put in this place or that place of their rooms, these kind of pictures do them as well and better than any other because they can get more of them for the same money. Now for the picture manufacturing business, there are large auctioneering establishments (and these establishments are increasing frightfully), where they pay miriad of german and french painters of no reputation, to copy popular engravings and pictures (of course you know what kind of pictures) upon canvasses 25 × 30 inches in size, for from three to four dollars, a piece. They then put a frame of from nine to ten dollars in value, about them. And then sell this pic-

ture, frame and all, for about 20 to 25 dollars, and still make smart profits, as they call it, on them. The middling classes supply themselves with pictures from this quarter entirely, and the very rich are beginning to think it vulgar and unfashionable to have their beautiful walls covered with pictures. So you may see by this that the glory, the poetry of art is entirely gone from here. I hope! It is not going out entirely. I do not know whether it is a passing cloud over the light of my prosperity, or whether it is the night, or the death rather, of the fine arts approaching. God only knows! I hope not, but this I do know that I am, and have not for seven or eight months sold a picture or had a single portrait to paint, notwithstanding my continuing painting picture after picture with the same ambition, to excel in each one. Oh! It feels sad to possess a talent as I know I do and to see it so totally uncared for and what vexes me more is that all the artists are the same way—a great many are leaving the profession but I really shall hate to leave that dear second nature!

Elizabeth F. Ellet to Lilly Martin Spencer, October 6, 1858[?], Archives of American Art.

I have long cherished the project of founding a Society of Lady Artists, and making it international, connected with the English. The first thing to be done is to excite an interest in the works of our lady artists among people of wealth and taste. For this purpose, I intend to give weekly receptions, beginning about the middle of Nov. inviting the very best people (free of expense) to come and see the paintings. I have engaged handsome parlors at 32 East Twentieth St. near Fourth Avenue for the purpose. I shall bear the expense myself—only asking the lady artists to send me some of their choice pictures for temporary exhibition. I shall write descriptive articles in the papers—and as the whole thing will be private, and have an air of privacy and fashion, I think I can set up quite a little excitement, and do the artists a deal of good. Now, I want you to let me have "The Gossips." And as many more of your charming paintings as you can. Send them to 32 E.20^{th} St. soon after Nov. 1^{st}. They will be taken care of in the intervals, and on Saturday evenings placed in the parlors. There will be no expense to you. When I get the public interest awake, I shall found the Society, and then solicit contributions from capitalists, to purchase a building for Lady Artists.

ARTISTS OF COLOR AND THE REPRESENTATION OF RACE

THE PUBLIC DISPLAY OF SLAVERY

One of the most remarkable episodes in the fight against slavery was the revolt of captured Africans aboard the slave ship Amistad *in 1839, followed by a celebrated legal proceeding in which the former U.S. president John Quincy Adams argued successfully for the freedom of the captives, who had ended up in the United States despite their attempt to sail the ship back to Africa. Cinque (Sengbeh Pieh), the leader of the revolt, became something of a hero to the abolitionist cause, and among the several images taken of him at the time was an oil portrait (1840) by Nathaniel Joselyn, a painter and engraver based in Connecticut, where the Africans had been jailed. When the portrait was submitted to the Philadelphia Artists Fund Society for exhibition, it was unexpectedly refused because of worries about the slavery controversy, or as artist John Neagle put it euphemistically, "the excitement of the times." This act prompted the following scathing notice, which boldly asserts that "a negro-hating nation" would never abide the display of an exemplary African figure in a public picture gallery.*

Clearly, proponents of slavery found any type of African American imagery problematic, none more so than abolitionist engravings designed to depict the cruelty and torture of forced bondage. In 1836 abolitionist and social reformer Gerrit Smith made light of the claim that such pictures incited slaves to revolt, reminding readers that southern bondsmen and women needed no visual reminders of their inhuman treatment. Such images would be more productively exhibited in the North, where they would, one hoped, incite outrage at the cruelty of the "Peculiar Institution."

"The 'Hanging Committee' of the 'Artists' Fund Society' Doing Homage to Slavery," Pennsylvania Freeman, *April 21, 1841.*

My Brother,—Robert Purvis, of this city, employed an artist of New Haven, Conn.,—Jocelyn, to paint a portrait of CINQUE, the chieftain of the Africans of the Amistad. The work was done, and the portrait has been in the city some weeks. The "Artists' Fund Society" have recently been fitting up their picture gallery for exhibition during the coming season. A member of that society requested of Mr. Purvis, the use of Cinques' portrait to hang in the gallery—not dreaming that any objection could be made to it as the painting had, by the first artists of the country, been pronounced to be of the first order. Mr. Purvis cheerfully consented, and sent the portrait to the "hanging committee," whose business it is to arrange and hang the pictures around the gallery. After keeping it some ten days, the committee returned the portrait with the following note:

"*Dear Sir,*—The hanging committee have instructed me, most respectfully, to return the portrait which you kindly offered for exhibition—it being contrary to usage to display works of that character, believing that under the excitement of the times, it might prove injurious both to the proprietors and the institution.

"At the same time, I am instructed to return the thanks of the society for your tender of the use of so excellent a work of art.

 Respectfully, &c.

 J. NEAGLE.

 April 14, 1841."

Why is that portrait denied a place in that gallery? Any objection to the *artist?* No. He has been recently elected an honorary member of the society; and, if I mistake not, this rejected portrait was the principle means of procuring him that honor—if honor it be. Any objection to the *execution?* No. The "hanging committee" themselves pronounce it as "excellent work of art." Those who are allowed to be judges in such matters rank it among the first portrait paintings of our country. Any objection to the *character* of Cinque? This could not be, for portraits of military heroes have been and are displayed in that gallery. He resisted those who would make him a slave by arms and blood. For doing this, did that committee exclude his portrait from their exhibition? Besides, he has been pronounced GUILTLESS in this deed by the highest tribunal of this country, and by the government of England. Was the portrait rejected because Cinque is a man in whom there is no interest? This could not be, for his name and his deeds have been heralded in every paper in this nation and in England—have stirred every heart and been the theme of every tongue. Though confined in a prison, he has been, the last eighteen months, an object of interest to the United States, to Spain, to England and to France. Cinque will continue to be an object of interest, and his name will be the watchword of freedom to Africa and her enslaved sons throughout the world.

Why then was the portrait rejected? *Why?* "*Contrary to usage to display works of that char-*

acter!" "The excitement of the times!" The plain English of it is, Cinque is a NEGRO. This is a Negro-*hating* and a negro-stealing nation. A slaveholding people.—The negro-*haters* of the north, and the negro-*stealers* of the south will not tolerate a portrait of a negro in a picture gallery. And such a negro! His dauntless look, as it appears on canvass, would make the goals of slaveholders quake. His portrait would be a standing anti-slavery lecture to slaveholders and their apologists. To have it in the gallery would lead to discussions about slavery and the "in-alienable" rights of man, and convert every set of visiters into an anti-slavery meeting. So "the hanging committee" bowed their necks to the yoke and bared their backs to the scourge, in-stalled *slavery* as doorkeeper to the gallery, carefully to exclude every thing that can speak of freedom and inalienable rights, and give offence to man-stealers!! Shame on them! Let the friends of humanity, of justice and right, remember them during the summer.

Had he looked into the future a little, J. Neagle would have sooner severed his hand from his body than have allowed it to sign his name to that note. Posterity will talk about him, when slavery is abolished, as it surely will be; and then all his fame, as an artist, will not save him from merited condemnation.

If Mr. Jocelyn is the man I think and hope he is, he will return his certificate of membership to the "Artist's Fund Society," counting it no honor to belong to a society that can perpetrate such meanings and outrage.

Thine.

H. C. WRIGHT.

Gerrit Smith, "Northern Spirit," Philanthropist 1 (February 26, 1836).

But the pictures! the pictures!! "You send pictures to the south"—is the charge that is now rung against us, since that of amalgamation has become stale and incredible. But the charge is quite as false and absurd, as that of our being a society of match-makers. If "abolitionists" make pic-tures illustrative of the horrors of slavery, they are not made for the south, but to wake up the dormant sensibilities of the north. Here such pictures instruct; and the bosom of the beholder alternately swells with indignation towards the tyrant, and melts with pity for his victim. But how unphilosophical to expect, that the temper of the poor slave would loose its balance, by his looking at pictures of the sufferers under the lash! He would stand unmoved at the tame copies of scenes, with which he had been sorely familiar. To bring up such pictures to strengthen his recollections of the mangling of his flesh by the driver's whip, and to give him a livelier sense of his sufferings, than he experienced in the sufferings themselves, is indeed, "to carry coals to New Castle." I would as soon think of calling a painter to sketch the agonies of the stake, that the martyr, who was enduring them, might draw from the picture a juster sense of his condition; or to supply the traveller to Niagara Falls with some pencillings of that wonder, to deepen his impressions, whilst standing before the mighty original. No—before the aboli-tionists will expend their money in scattering their pictures over the south, they will have be-come as bad reasoners, as are their accusers. But let them tax the painter's art to the utmost for effect—righteous and blessed effect—at the north. Let them hang round our parlors and kitchens and workshops with the most vivid and affecting appeals, which that art can produce, in behalf of bleeding and crushed humanity;—and let objects be multiplied without limit, to remind us, that there are and in our own country too, millions of our own brother men, who are robbed of their own bodies and minds and souls, and whose condition cries out for our . . . pity and prayers, with an energy, that it would seem even the sleep of death itself could hardly resist.

William Sidney Mount frequently depicted African Americans with what, for the times, was exceptional humanity and even sympathy. At the same time, he took pains to differentiate blacks from whites in such a way as to suggest their "natural" inferiority, as in Farmers Nooning, *where viewers such as W. Alfred Jones readily perceived the sleeping black man as lazy (see "William Sidney Mount and the Celebration of National Character," this chapter). In another part of the same article, Jones considers Mount's "Ethiopian portraits" the finest ever painted and goes on to praise their vivid and truthful characterizations of the black minstrel. A confirmed Democrat, Mount was opposed to the abolitionist cause. The Mount family had once been slaveowners, and the neighborhood was still home to a small population of free blacks, with whom Mount (as a musician and employer) apparently had friendly relations. His writings reveal his ambivalence. The two letters to William Schaus indicate that for Mount, as for many other white Americans, blacks were meant to play separate and often humorously entertaining roles. Nevertheless, Mount's nostalgic boyhood recollection of Hector portrays the old Negro as a master of the art and craft of spearfishing. Even though the black servant addresses the boy as "young Master," it is clear that the real master here—if only temporarily—is Hector himself.*

W. Alfred Jones, *"A Sketch of the Life and Character of William Sidney Mount,"* American Whig Review 14 *(August 1851).*

One field still remains open to him which he could worthily occupy—the Southern negro, plantation life, corn-shuckings, &c. He would find open-handed patrons among the cultivated and opulent planters. His heads of negroes, in Right and Left, and the Lucky Throw, are the finest Ethiopian portraits ever put upon canvas . . .

Within the last year Mr. Mount has been executing orders (of which Just in Time, Right and Left, and the Lucky Throw, are three already completed) for the enterprising French publishing and print-selling house of Goupil & Co., whose agent, Mr. Schaus, had the taste and judgment to select Mount, as the most national of our artists, to introduce to the French and European public. These pictures are tastefully lithographed in Paris by La Salle, a spirited hand. In this enterprise, he has ventured on the experiment of combining portrait and comic design. The heads are life-size, half-lengths; but, to our eye, what they gain as portraits, they lose as humorous pictures. The classic size for comic pieces has been *diminutive*. Yet they are truly excellent, and we must add a few words by way of description . . .

Right and Left is a negro fiddler calling out the figures of a dance at a ball, fully equal to the last-mentioned. The negro is a comely specimen of his race, and something of a village dandy, to boot.

The Lucky Throw—a negro who has won a goose at a raffle—inimitable for spirit, expression, details and *coloring*. Indeed, the coloring in these last three is much superior to that in his earlier works: a fine tone is prevalent, and there is no sign of carelessness or neglect.

William Sidney Mount to William Schaus, *letters, William Sidney Mount Papers, New-York Historical Society.*

[December 20, 1850]

The commission you gave me—a negro holding something funny in his hand I have almost completed. I wish you to see the work either here or in the city. Mrs. Seabury desired you to

dine with her on Wednesday next—procure a ticket to Lake road station you will arrive here one hour sooner. I shall expect to see you here Christmas if consistent with your engagements.

[September 9, 1852]

Your letter of Sept 1ˢᵗ I have received. I like the tone of it. The good feelings manifested. I am ready to negotiate with you if you will state the time when and where I can meet you. I will undertake those large heads for you—although I have been urged not to paint anymore such subjects. I had as leave paint the characters of some negros as to paint the characters of some *whites* as far as the morality is concerned. "A Negro is as good as a White man as long as he behaves himself."

William Sidney Mount to Charles Lanman, November 17, 1847, William Sidney Mount Papers, courtesy of The New-York Historical Society.

To those wishing exercise for their health the spearing of fish has the advantage over all others. I have derived great benefit from it.

An old Negro by the name of Hector gave me the first lesson in spearing flat-fish & eels.

Early one morning we were along shore according to appointment, it was calm, and the water was as clear as a mirror, every object perfectly distinct to the depth from one to twelve feet, now and then could be seen an eel darting through the sea weed, or a flat-fish shifting his place and throwing the sand over his body for saf[e]ty. "Steady there at the stern" said Hector, as he stood on the bow (with spear held ready) looking into the element with all the philosophy of a Crane, while I would watch his motions, and move the boat according to the direction of his spear. "slow now, we are coming on the ground," on sandy & gravelly bottoms are found the best fish—"look out for the eyes," observes Hector, as he hauls in a flat-fish, out of his bed of gravel, "he will grease the pan my boy" as the fish makes the water fly about in the boat. The old negro mutters to himself with a great deal of satisfaction "fine day—not a cloud—we will make old mistress laugh—now creep—in fishing you must learn to creep," as he kept hauling in the flat-fish, and eels, right and left, with his quick and unering hand. "Stop the boat," shouts Hector, "shove a little back, more to the left the sun bothers me, that will do—now young Master step this way. I will learn you to see and catch flat-fish—there," pointing with his spear—"don't you see those eyes, how they shine like diamonds." I looked for some time and finally assented that I did— "well now don't you see the form of the whole fish (a noble one) as he lies covered lightly in the sand.—"very good—now" says he, "I will strike it in the head, and away went his iron and the clear bottom was nothing but a cloud of moving sand, caused by the death struggle. The old negro gave a grunt and sang out "I am a little negro but oh! Lord." as he threw his whole weight upon his spear—"I must drown him first, he is a crooked mouth, by golly." The fish proved to be a large flounder and the way old Hector shouted was a caution to wind instruments.

FREDERICK DOUGLASS ON AFRICAN AMERICAN PORTRAITURE

Frederick Douglass, an escaped slave from Maryland who became one of the nineteenth century's most forceful voices against slavery and racial discrimination, advanced the cause of abolition through his autobiography (1845), innumerable speeches, and several fiery newspapers. One of the latter was the North Star, *which began publication in Rochester, New York, in 1847. In the course of a review of Wilson Armistead's book* A Tribute for the Negro, *which Douglass wrote for that newspaper's pages, he laments*

the quality of the engraved portraits included in the volume. This leads him to assert the impossibility of truthful portraiture of blacks by white artists (see also "Memorializing the War," chapter 7). Cataloguing the supposed racial characteristics of the African physiognomy, he turns the list on its head by creating a similarly exaggerated profile of the Caucasian face. He ends by advancing a prescient sentiment that more than a century later would find voice in the political slogan "Black is beautiful."

Frederick Douglass, "A Tribute for the Negro," North Star, April 7, 1849.

Before quitting the pictures, we shall venture one remark, which we have never heard expressed before and which will, perhaps, be set down to the account of our Negro vanity; and it may be, not unjustly so, but we have presented it for what it may be worth. It is this, Negroes can never have impartial portraits, at the hands of white artists. It seems to us next to impossible for white men to take likenesses of black men, without most grossly exaggerating their distinctive features. And the reason is obvious. Artists, like all other white persons, have adopted a theory respecting the distinctive features of Negro physiognomy. We have heard many white persons say, that "Negroes look all alike," and that they could not distinguish between the old and the young. They associate with the Negro face, high cheek bones, distended nostril, depressed nose, thick lips, and retreating foreheads. This theory impressed strongly upon the mind of an artist exercises a powerful influence over his pencil, and very naturally leads him to distort and exaggerate those peculiarities, even when they scarcely exist in the original. The temptation to make the likeness of the Negro, rather than of the man, is very strong; and often leads the artist, as well as the player "to overstep the modesty of nature." There is the greatest variety of form and feature among us, and there is seldom one face to be found, which has all the features, usually attributed to the Negro; and there are those, from which these marks of African descent (while their color remains unchanged,) have disappeared entirely. "I am black, but comely," is as true now, as it was in the days of Solomon. Perhaps, we should not be more impartial than our white brothers, should we attempt to picture them. We should be as likely to get their lips too thin, noses too sharp and pinched up, their cheeks too lantern-like, their hair too lank and lifeless, and their faces altogether too cadaverous. But we must let the picture go, and console ourselves as Thos. Witson once did, when he told us he should become handsome, if public opinion was changed. For our part, we like a large nose, whether it be flat or sharp, no matter which, so the metal is there. Every one to his taste, so he does not trample on human rights.

THE VERSES OF DAVE THE POTTER

Dave the Potter appears to have been born into slavery around 1800. He had a succession of masters in Edgefield, South Carolina, where the abundance of high-quality clay gave rise to a thriving ceramics industry. Dave became extremely adept at throwing large, stoneware storage vessels (some holding a remarkable 30 to 40 gallons) with wide, rolled mouths and two or more handles on the shoulders. His alkaline glazes gave his pots an earthy, slightly iridescent tone ranging from olive green to oatmeal to dark brown. Beyond this, some two dozen of his extant pots were distinguished by an unusual addition: an original poem incised with Dave's own hand into the unfired clay. Unlike most slaves, Dave could read and write, and his thoughtful, witty couplets demonstrate not only a literary sensibility but also knowledge of religion and the wider world beyond Edgefield. The selection given here contains all the poems in which Dave refers to him-

self or to the pot he has made. Although short and pithy, they constitute an almost miraculous survival of the voice of an enslaved man leaving his mark through material culture. Dave's latest surviving vessel is dated 1864. After emancipation, he was known as Dave Drake, having adopted the last name of a former master. He is thought to have still been living in 1870.

Dave the Potter, poems, *in Jill Beute Koverman, ed.,* I Made This Jar . . . The Life and Works of the Enslaved African-American Potter, Dave *(Columbia, S.C.: McKissick Museum, 1998).*

Put every bit all between
surely this jar will hold 14
−12 July 1834

Dave belongs to Mr. Miles
wher the oven bakes & the pot biles
−31 July 1840

I wonder where is all my relations
Friendship to all—and every nation
−16 August 1857

I made this jar for cash
though its called lucre trash
−22 August 1857

Making this jar: I had all thoughts
Lads & gentlemen: never out walks
−30 January 1858

I made this for our Sott
it will never − never − rott
−31 March 1858

This noble jar will hold 20
fill it with silver then you'll have plenty
−8 April 1858

A very large jar which has four handles
pack it full of fresh meat—then light candles
−12 April 1858

When you fill this jar with pork or beef
Scot will be there to get a peace
on the other side reads a dedication:

This jar is to Mr. Seglir
who keeps the bar in orangeburg

for Mr Edwards a gentle man
who formly kept Mr Thos bacons horses
—21 April, 1858

Good for lard or holding fresh meats
blest we were, when Peter saw the folded sheets
—3 May 1859

Made at Stoney Bluff
for making lard enuff
—13 May 1859

Great & noble jar
hold sheep goat and bear
—13 May 1859

A noble jar for pork or beef
then carry it a round to the indian chief
—9 November 1860

I – made this Jar all of cross
If you don't repent, you will be lost
—3 May 1862

J. P. BALL'S PANORAMA OF SLAVERY

In the 1850s several abolitionist panoramas toured the United States: multipaneled canvases unrolled to an accompanying narrative of the cruelty of slavery. They were often produced and managed by free blacks. For example, Henry "Box" Brown, a former slave who famously mailed himself to freedom in a shipping container, took his "Mirror of Slavery" on tour early in the decade. J. P. Ball, a Virginia-born African American daguerreotype operator in Cincinnati, produced an even more elaborate panorama with the help of painter Robert Duncanson (see "Robert Scott Duncanson and 'Passing,'" chapter 8). The "photo-panorama" was reportedly 600 yards long with fifty-three scenes depicting the lives of slaves, from African captivity to plantation work to attempted escape. Intermixed were scenes of important political and historical events. Like the majority of panormas, Ball's did not survive (see also "Life on the Mississippi in John Banvard's Panorama," chapter 6), but the abbreviated table of contents gives an idea of the presentation.

Ball's Splendid Mammoth Pictorial Tour of the United States. Comprising Views of the African Slave Trade; of Northern and Southern Cities; of Cotton and Sugar Plantations *(Cincinnati: Achilles Pugh, 1855).*

CONTENTS.

THE PANORAMA—Early career of its proprietor—Daguerrean Gallery,
AFRICAN VEGETATION—The Niger,

NATIVES OF AFRICA—Lion Hunt,

AFRICAN CHARACTER—Village Customs, Slave Trade,

DESTRUCTIVENESS OF THE TRADE—Inhumanity of the Traders,

SUFFERINGS ON BOARD OF SLAVERS—Small Pox between decks, Blindness on the "Rodeur."

EFFORTS TO DESTROY THE TRADE—Sierra Leone, Liberia,

CHARLESTON, S. C.—Anecdote of the Domestic Slave Trade, Laws regulating Colored persons, Sandhillers,

DISCOVERY OF THE MISSISSIPPI—De Soto, his death and burial, Other Explorers,

SETTLEMENT AND EARLY INHABITANTS OF NEW ORLEANS—Yellow Fever, Elements of prosperity, Amalgamation,

PUBLIC SQUARES—Buildings, Congo Dance, Hoodooh, Cemeteries,

BANKS ARCADE—Rotunda of the St. Louis, Slave Auction,

BAYOUS OF LOUISIANA—Swamps,

SUGAR REGION—History of Sugar culture and manufacture, Destructiveness to life, Mad. Beanjoie.

ESTATE OF ST. JAMES—Stock, Productions,

RUNAWAY SLAVES—Dismal Swamp, Negro Dogs, death of a Runaway,

CITY OF NATCHEZ—Natchez Indians, Gamblers,

SUGET'S PLANTATION—History of Cotton, Skill of Indians in weaving Cotton, Planting, Gathering,

MARTHA WASHINGTON—R. J. Ward, Memphis,

CAIRO—Burning of Spencer's Boat, First Steamboat voyage and the Earthquake of 1811,

ST. LOUIS—Missouri Compromise,

LOUISVILLE &c.:

CINCINNATI; its settlement and rapid advancement—Pro-Slavery Riots, C. Burnet's Monument, Colored People,

INDIAN CORN—Wheeling, Tobacco,

PITTSBURGH, &c.,

CHRISTIANA—Death of Gorsuch,

WYOMING VALLEY—Indian Tradition, Massacre of 1778, Fugitive Slave Act and "Bill Thomas,"

WASHINGTON CITY—Why the Virginia Militia were detained from the defence of Washington in 1814,

BOSTON—Her Schools, Love of Liberty, Simms and Burns,

NIAGARA FALLS—Rapids, Goat Island, Suspension Bridge, Whirlpool, Father Hennepin,

QUEENSTON AND UNDERGROUND R. R.—Death of a Fugitive, Murder of Conclin, Successful Conductor, Conclusion.

AN IMAGINARY PICTURE GALLERY

In 1859 a seven-part series, "Afric-American Picture Gallery," appeared in the initial volume of the Anglo-African Magazine, *the first black literary journal in the United States. The monthly was edited by Thomas Hamilton, a New Yorker who believed that*

African Americans must speak and write for themselves rather than allow white abolitionists, no matter how sympathetic, to plead their case. In an elaborate extended metaphor, the anonymous author of this series uses a fictitious art gallery—and its visitors—to address a variety of issues concerning slavery and the future of freed blacks. This "Afric-American Picture Gallery" features images that appear in no other American exhibition: portraits of exemplary blacks, historical paintings detailing the story of slavery, and genre paintings showing capable freed slaves farming and supporting themselves. In a particularly affecting passage, the boy who works in the gallery desires his own portrait to be added to the collection. The gallery also includes satirical images, such as a landscape view of George Washington's plantation, Mount Vernon, where the mythology of the first president is skewered in the light of the place's connection to slavery. Throughout, the author deftly uses the conventions of a critical art review to argue for greater truth in representation and to expose the contradictions at the heart of the racial policies that operated in the United States. The entire series comprises thirty pages of text; a portion is excerpted here.

"Ethiop," "Afric-American Picture Gallery," Anglo-African Magazine 1 (February–August 1859).

I always had a *penchant* for pictures. From a chit of a boy till now, my love for beautiful, or quaint old pictures has been unquenched.

If an ever abiding love for any branch of *Art* is indicative of a fitness to pursue it, then I should have been a painter. Even when so small as to be almost imperceptible, I used to climb up, by the aid of a stool, to my mother's mantle piece, take down the old family almanac and study its pictures with a greater relish than ever a fat alderman partook of a good dinner including a bountiful supply of the choicest wines. All this however, never made me a painter. Fate marked out a rougher, sterner destiny for me. But the habit of rambling in search of, and hunting up curious, old, or rare and beautiful pictures, is as strong as ever.

It was in one of these rambles, that I stumbled over the Afric-American Picture Gallery, which has since become one of my dearest retreats wherein to spend many an otherwise weary hour, with profit and pleasure.

The collection is quite numerous, having been sought from every quarter of the American continent, and some from abroad; and though as a *Gallery of Art,* if not highly meritorious, still from its wide range of subjects and the ingenuity with which many of them are presented, it must, to the lover and curious in such matters, afford much for amusement, and to the careful observer and the thinker much that is valuable and interesting.

In style and excellence these pictures vary according to the fancy or skill of the artist. Some are finely executed, while others are mere rough sketches. Some are in oil, some in water colors, and India Ink shadings, a few statues, statuettes, and a few Crayons and Pencilings possessing a high degree of merit; others are mere charcoal sketches and of little worth beyond the subjects they portray.

But without pursuing this general outline further, let the reader, with me enter into this almost unknown Gallery. Well, here we are, and looking about us.

The first thing noticeable, is the unstudied arrangement of these pictures. They seem rather to have been put up out of the way, many of them, than hung for any effect.

The walls are spacious, and contain ample room for more, and, in many instances, better paintings; and many niches yet vacant for busts and statues; and just here, let me make an humble petition in behalf of this our newly discovered Gallery.—It is that generous artists, will, at

their convenience, have the goodness to paint an occasional picture, or chisel a statue or bust, and we will be sure to assign it to its appropriate place. But let us take a survey, and speak only of what strikes us most forcibly in our present mood.

PICTURE NUMBER 1.—THE SLAVE SHIP.

This picture hangs near the entrance, on the south side of the Gallery, and in rather an unfavorable light.

The view is of course Jamestown harbor, Virginia, in 1609, and has all the wild surroundings of that portion of our country at that period; the artist having been faithful even to every shrub, crag and nook. Off in the mooring lays the *slave ship,* Dutch-modeled and ugly, even hideous to look upon, as a slave-ship ought to be. On the shore is a group of emaciated *Africans,* heavily manacled, the first slaves that ever trod the American continent; while in the fierce and angry waters of the bay, which seem to meet the black and dismal and storm-clad sky, is seen a small boat containing another lot of these human beings, just nearing the shore.

If the artist's general conception of this picture may be regarded a success, in its details, beyond all question, this is its crowning point. The small boat struck by, and contending with a huge breaker, is so near the shore that you can behold, and startle as you behold, the emaciated and death-like faces of the unfortunate victims, and the hideous countenances of their captors; and high and above all, perched upon the stern, with foot, tail and horns, and the chief insignias of his office, is his Satanic Majesty, gloating over the whole scene.

What is more truthful than that the devil is ever the firm friend and companion of the slave ship?

PICTURE NUMBER 2.—THE FIRST AND THE LAST COLORED EDITOR.

This small, but neat picture hangs on the north side of the gallery; and though simple in its details, is so well executed that it has much attracted me.

The Last Colored Editor, quite a young man, with a finely formed head and ample brow— thoughtful, earnest, resolute—sits in chair editorial, with the first number of the Freedom's Journal, the first journal ever edited by, and devoted to the cause of the colored man in America, held in one hand and outspread before him, while the other, as though expressive of his resolve, is firmly clenched.

Surrounding him are piles of all the journals edited by colored men from the commencement up till the present, among which the Freedom's Journal, Colored American, People's Press, North Star, and Frederick Douglas's paper are the more prominent. The First Editor is represented as a venerable old man, with whitened locks and placid face, leaning on a staff, and unperceived by the Last Editor, is looking intently over his shoulder on the outspread journal.

It is his own first editorial, and the first ever penned and published by a colored man in America. The scene is the linking together of our once scarcely hopeful past with the now bright present.

PICTURE NO. 3—THE FIRST MARTYR OF THE REVOLUTION.

This is a head of Attucks. It may not be generally known, and it may not be particularly desirable that the public should know, that the First Martyr of the American Revolution was a colored man; that the first bosom that was bared to the blast of war was black; the first blood that drenched the path-way which led up to American liberty, was from the veins of a colored man.

And yet such is the fact; and the artist has done a service in the execution of this head. It

hangs at the north east end of the Gallery, and is a fine likeness of a bold, vigorous man,—just such, as would be likely to head a revolution to throw off oppression. May the name of Attucks and the facts connected therewith never perish . . .

PICTURE VII.—TOUISSANT L'OVERTURE.

Pictures are teachings by example. From them we often derive our best lessons. A picture of a once beloved mother, an almost forgotten grandfather whose image perhaps we bear, or a long lost child, once the centre of our affections; such a picture occasionally taken down from its hiding-place, and looked at, calls up associations and emotions, and produces troops of thought that paint the memory afresh with hues the most beautiful, touching, beneficial and lasting. A picture of a great man with whose acts we are familiar, calls up the whole history of his times. Our minds thus become reimpressed with the events and we arrive at the philosophy of them.

A picture of Washington recalls to mind the American Revolution, and the early history of the Republic. A picture of Thomas Jefferson brings before the mind in all its scope and strength that inimitable document, the Declaration of Independence; and in addition, carries us forward to the times, when its broad and eternal principles, will be fully recognised by, and applied to the entire American people. I had these conclusions forced upon me by looking not upon either the picture of Washington or Jefferson in the gallery. Far from it; but by a most beautiful portrait of one of the greatest men the world ever saw—TOUISSANT L'OVERTURE.[5] This painting hangs in the south east corner of the Gallery in a favourable position and in good light as it ought; as it portrays the features of one of God's and Earth's noblemen long since retired.

Far be it from me to venture to a description of either the picture or the man. I have no pencil and no pen with which I can do it. Some future historian in other times, will yet write the name of Touissant L'Overture higher and in purer light than that of any man that has lived up to to-day. But the special point to which I wish to call attention, and upon which I may venture a remark, is the long and interesting train of historical facts in relation to Hayti, that gem of the sea, this portrait associates in the mind of the intelligent beholder. To say nothing of him who led the breathings of this people after liberty; the breaking in pieces the yoke that galled them their heroic struggles, the routing finally and utterly from the soil their oppressors; their almost superhuman efforts thereafter, to rise from the low state in which the degradation of slavery and chains had placed them and their final triumph over every obstacle; in fine the whole history from first to last of this Island and this people is so vividly brought before the mind, by merely this likeness of the inimitable Touissant L'Overture, that it is reimpressed with the extraordinary, *useful and touching lesson it teaches* . . .

PICTURE IX.—MOUNT VERNON.

Our artist must have taken time by the forelock in the execution of this picture; as MOUNT VERNON has become of late the great popular theme of the American people. Mount Vernon just now enters into everything. It has something to do with every spring of the machinery of American society; social, political, and religious. It is Mount Vernon in the pulpit, Mount Vernon on the rostrum, Mount Vernon from the Press, Mount Vernon from every lip.

[5] Pierre Dominique Toussaint L'Ouverture led a successful rebellion of Haitian slaves in 1797.

The boys in the streets busily cry out Mount Vernon; the fashionable young belle simpers Mount Vernon.

Mount Vernon exclaims the breast-laden patriot; Mount Vernon echoes the good old ladies, Mount Vernon is piped, Mount Vernon is harped; Mount Vernon is danced; Mount Vernon is sung. Even men walk by the aid of Mount Vernon canes, manufactured from some of its decaying relics. And what is Mount Vernon?

Mount Vernon as the readers must know is a spot of earth somewhere in Virginia, and once the Home of the Father of his Country. How careful ought we to be, then, in word or deed about Mount Vernon.

I must plead in excuse, therefore, that in the conception of this picture, the Artist has simply failed; if not in faithfulness to the original, certainly in gratifying the popular American feeling. The Picture hangs on the south side of the Gallery, and in excellent light.

It is of largest size, exhibiting the grounds, the mansion, out-house, slave huts and all; once planned, laid out, and erected with so much care by *Washington;* but now alas, all in a state of dilapidation and decay. Decay is written by the Artist's pencil more legibly than in letters, on everything.—On the house top, on the door sill is written decay. On the chimney, on the gables, on the eaves, is written decay. The consuming fingers of decay and delapidation mark each and every out house.—Every old slave hut, like so many spectres shadows forth decay.—Decay stands staring in the gate-ways, staring in the porches, staring in the cellars.—The very wind which bends the here and there scattering tree-tops, (land marks of the past) seem to creak through the many visible crevices of the Old Mansion and sigh decay, decay! decay!!

I never saw Mount Vernon; and as I gaze upon this Picture I ask myself is it true? Is this the home of the *Father of his Country?* Is it, that, every thing Washington possessed should so perish? Or, so perish the all, that we should have left to us, but his name; and yet with a tendency to forget names however great, I am at a loss to know how we shall preserve even the name of Washington many years longer.

But there is another feature in this Picture besides the stern solemn passing away, that I desire to direct attention to. The Artist has located, and I suppose correctly enough, on the banks, where sluggishly glides the Potomac's waters, the Tomb of Washington.

The first thing that here arrests the eye is the recently dug up coffin of Washington; just behind which stands the ghost of his faithful old slave and body servant; while in front, a living slave of to-day stands, with the *bones* of Washington gathered up in his arms, and labelled 'For Sale' 'Price $200,000; this negro included.' 'Money wanted.'—A number of other slaves, men, women, and children, are placed in a row along the bank just beyond, bearing about the neck of each the following inscription: *These negroes for sale. Money wanted.*

Proceeding from the Old Mansion to the *Tomb,* are two elderly, portly, aristocratic looking gentlemen, bearing unmistakable evidences of being the present proprietors of the Mount Vernon estate, and celebrated relatives of the great Virginian, and Father of his Country; and a noted son of Massachusetts. These gentlemen are followed towards the tomb by a few pious looking old ladies . . .

PICTURE NO. X.—A NEW PICTURE.

Our gallery Boy who barred its doors so firmly against intruders, has just entered the Gallery with his own likeness, and desires that it may be hung up; and, for more reasons than one he shall be gratified. The picture comes to us in mien pleasant, smiling, and as fresh as nature itself.

This boy *Thomas Onward* (I call him *Tom* for shortness,) though he has seen all of life—yea

more, is not an *Old Tom* by any means; nor an *Uncle Tom,* nor a *Saintly Tom,* nor even what is commonly deemed a good Tom; but a shrewd little rogue, a real live *Young Tom,* up to all conceivable mischief and equal to all emergencies. He is a perfect model of a little fellow in his way, and a fair representative of his class. Sound in limb, symmetrical in form and robust in health, jovial, frank, easy mannered and handsome—infinitely so compared with even the likeness I hold, one would scarcely conclude that this boy has come down to us through nearly three hundred years of hard trial.

And yet it is true. Such is his history. He was almost whipped into existence, whipped into childhood, whipped up to boyhood. He has been whipped up to manhood, whipped down to old age, whipped out of existence. He was toiled into life; he has been toiled through life; toiled out of life. He has been robbed of his toil, robbed of his body, robbed of all but his soul.

He has been hated for what he was, hated for what he was not, and hated for what he ought to have been. He has been dreaded because of his ignorance, and dreaded because of his knowledge, dreaded for his weakness, dreaded for his strength.

Noble, innocent boy! hadst thou been able to remember a tithe of the hard things done to thee; or hadst thou known a tithe of the hard things said of thee; or of the hard feelings entertained towards thee, it would be difficult to conjecture the result. But out of all these mountains of dust and ashes without one bit of sackcloth upon thee, hast thou come forth fresh, smiling and free. *Tom, Tom!!!* Who shall write a fitting apostrophe to thee and thy rising fortunes.

What sorry figures do the hard, grave, iron, half savage and half barbarous faces of Washington and Jefferson, of Clay, Webster and Calhoun, present beside the fine expressive likeness of this rising little fellow. The American Nation, if it can, may try its hardened hand yet a few centuries longer upon our live little Tom; but it will hardly mould him to their liking. Like gold ore he will lose but the alloy and become brighter and brighter in the oft passing through the furnace of their oppression . . .

PICTURES NOS. XIX AND XX. PREACHING AND AFTER PREACHING.

The first represents the interior of a church—a negro church.

Locality—sunny South. The particular spot, I conclude from its surroundings, is among the best of the good old plantations.

The church is filled to overflowing with devout worshippers, and is being discoursed to, affectionately, of course, by a double-fisted, burly, white-faced old Southern Preacher—a genuine Hard Shell.

The *artist* has caught him just in the nick of time.

The Preacher is just in the act of exhorting his sable hearers to obey their masters—their kind, good masters.

"He that knoweth his master's will and doeth it not shall be beaten with many stripes." These are his words. In catching the artist's conception, you feel them, you hear them—you put yourself in his audience, and then they are gracious words to you. They are unctious. On them your parson is feeling; he looks full of feeling; he looks unctious all over. Unction pours out of his mouth; it beams out of his eyes; it sticks out of his outspread fingers; it runs down his broad face in greater profusion than did the oil down the venerable beard of Aaron.

Just at this unctious point is our good man taken, and I heartily thank the artist for having done him such justice. A fairer exhibit of a Southern preacher is certainly nowhere else on canvass.

Nor has the artist lost any of his inspiration in the other details of his picture. The preacher's

sable hearers, with eyes dilated, mouths agape, nostrils distended and ears alert, are intently leaning forward, that they may lose no word of the good admonition, while here a moody brow, and there a skeptical face, or yonder a defiant look, combine to form an admirable back-ground.

The second of this pair of pictures, entitled *After Preaching*, represents the congregation standing about outside the church in groups around the faithful leaders, who, being men carefully selected by the white piety of the sunny South, are of course, all of the Uncle Tom school.

By another masterly stroke of the artist's conception, they are taken just at the point of the extreme of their extacies about the great and good sermon they have just heard, while the leaders are in earnest exhortation on submission and willing obedience to masters as the height of Christian duty.

In the back-ground may also be seen a few young, determined-looking faces, on which are expressed disbelief in, and detestation of, the whole affair. They are the same noticed in the back-ground of the former piece.

These young spirit-faces possess such a strong look of meaning that none need mistake it. A look so strong, so bold, so towering, that, like Monadnoc among the granite hills, it peers far above the scrawny frowns, and puny smiles, and jeers, and gibes, and sneers, and hates of the vulgar, the mean, the base; a look that will go up through all time, and, as light before the coming sun, so as surely will it be the forerunner of the great deliverance of long-'pressed humanity. The look and the meaning do actually exist, and the sooner the World knows it the better.

These faces, in contrast with the others of the congregation, give a most striking effect to the picture. They are the unruly, the skeptical, the worthless of the flock—the wicked ones, who would rather run the risk than be bound up in the religious love so feelingly and so faithfully proclaimed to them—the religious love of the land.

It is of this class comes our Nat Turners, who laid a scheme for redemption, and the *man* in Georgia who received nine hundred and ninety-nine lashes by way of gentle compulsion, and then would not so much as reveal one particle of the *plan* laid by and for the uprising of his oppressed brethren. It is of this class come the Margaret Garners, who rather than their babes even shall clank a chain, prefer to send them up to their God who gave them. It is of this class comes our Douglasses and our Browns, and a host of other spirits now cast upon the regions of the North, as a Southerner once expressed it, "to wailin the misery of their sins, and lament in the wretchedness of their misunderstood liberty."

These are good views, and may be studied with profit by any Southern Preacher, master or monster who will take the trouble to visit the Afric-American Picture Gallery . . .

It may not be forgotten by the reader, that I was last seen standing bolt-upright in the middle of the Afric-American Picture Gallery, surrounded by quite a number of the notables of our times, who had been attracted thither by the notoriety the Gallery has recently assumed . . .

An old lady, who had hitherto been a quiet spectator to the whole scene, now threw up her *spectacles* . . .

"Bless me," said she at length; "what is this? Colored folks farming!! Ah now, that is it. This puts the question in a clear light; and if you young folks could only throw up your metaphorical veils, you could see it."

No one ventured to interrupt, and she proceeded:

"Now here are colored folks farming for themselves; and don't their grain grow as well as if they were white; and don't it sell as well?"

"Is not this a change only of condition? Talk of changing nature!!!"

"But where is the boy, that I hear you say so much about," inquired the "old lady," evidently

puzzled.—"The Village?" said she. "Yes, yes; and here is its colored village blacksmith, shoeing his white neighbor's horse."—"What can't change our condition?"

"Fiddle-sticks and nonsense," exclaimed she again. "Talk of changing appearances!"

"And look here," cried she out again; "here is a colored man tending his own mill; and is not the flour as white as any other? and are not all the town, white and colored, running to procure it?"

"Welladay, welladay," said the "old lady," and shook her head disapprovingly.

Peering over the picture, she spied a splendid carriage, drawn by a span of spanking bays, driven by a boy, and containing the owner, a colored gentleman and his family, just entering the village.

"The Lord be praised," fairly screamed out the "old lady" this time; and she put up both hands, threw up her *specs,* and wheeled square round to the company, exclaiming: "and you would have them change the color of their faces, would you, before you would have them ride thus? This is your methaphysics, is it?" and "welladay, welladay," muttered she again.

A little further on, and she espied a large mansion, in process of erection by colored, and white mechanics conjointly.

"The Lord be praised," ejaculated she again. "Now if this is not, what I call truly practical. For it is truly a practical operation where color is no bar," said the old lady.—Away with your methaphorical, methaphysical nonsense, and give them plenty of the wherewith to do with, and they may wear their color without let or hindrance."

EASTMAN JOHNSON'S *NEGRO LIFE AT THE SOUTH*

One of the watershed events of the nineteenth-century American art world was the debut of Eastman Johnson's complex genre painting Negro Life at the South *(fig. 4) at the National Academy of Design in 1859 (see also "Eastman Johnson's Formula for Success," chapter 8). Enraptured critics reacted as if they had never previously been presented with an image of slavery, although the popular press had certainly featured such lithographs and engravings for many years. What was novel was that Johnson had elevated the subject to the format of an ambitious salon painting and had treated his composition with consummate academic skill, reflecting his European training in Düsseldorf, the Hague, and Paris. The artist had set his scene in an urban backlot behind his father's home in Washington, D.C., but for most viewers the painting became associated with the rural plantation, easily transferred in their minds to a neighboring southern state such as Virginia or the proverbial "Old Kentucky Home." In the reviews that follow, the critics grapple with this ambivalent imagery, invoking both the stereotypes of minstrelsy and the indignation of abolitionism, sometimes in the same sentence. The final two selections, written in 1867 when the painting was sold in New York before being sent to the Universal Exposition in Paris, revisit the painting with the historical distance made possible by the terrible war years and the eradication of slavery in the United States.*

"Fine Arts," Albion 37 *(May 7, 1859).*

The picture, which gather most frequently around it a group of admirers—careful not to commit themselves by expressed admiration—is undeniably Mr. E. Johnson's *Negro Life at the South,* no. 321. And a capital picture it is, presenting you a truthful and most artistic glance at the *dolce*

far niente of our coloured brethren. It is day-time, and any where else signs of work would be apparent; but what matter? The old house, in the yard of which "life" goes forward, is a rick-etty and dilapidated concern; but what matter? Uncle Ned plays the banjo, and old "Mormer" teaches one little darkie his steps, and another little darkie looks on with mute wonder at the musician, and a young couple make love in one corner, and a mother looking out of an upper window sets her infant on the sloping roof of the piazza so as to command a view, and help the others as it were to do nothing. The very animals, and the accessories of all kinds, are under the witchery of idlesse and insouciance. The only contrast is a bit of the adjoining house, trim and spruce, and a young lady emerging from the back-door thereof and peeping at the scene—and both, we think, might well have been omitted, the completeness being slightly marred by this superfluity. But it is, we say, a capital picture; excellently drawn, and finished to the requi-site point. Perhaps the groups are too much isolated; perhaps the old tumble-down fireplace is a hair's breadth too prominent; perhaps the young mulatto girl on your right sinks a little into the wall against which she leans; perhaps there is a distribution of pepper-and-salt in the colour-ing which does not accommodate itself to our eye. What of these little drawbacks? The success is great and decided. The artist is imbued with his subject. Negro life is before you. If you don't catch the point of it, and feel grateful to Mr. Johnson for setting it thus palpably forth—turn to some other part of the collection—you have no taste for *tableaux de genre.*

"The National Academy Exhibition," New-York Semi-Weekly Tribune, *May 24, 1859.*

It is a sort of "Uncle Tom's Cabin" of pictures, and gives rise, therefore, to quite as many painful as pleasant reflections.

But the most trivial accessories receive from him, so far as they need them, the same care-ful study and the same conscientious labor as the most important features of the picture; and the whole is seen through a medium as luminous as the all-pervading daylight . . . In the Life at the South there is a story within a story; first, that of slave-life, as telling as a chapter from "Slavery As It Is," or a stirring speech from the Anti-Slavery platform; the negro quarters teem-ing with life, human and animal; the old building, moss-covered, neglected, ruinous, and des-olate, contrasted with the well-built and carefully-kept dwelling just seen beyond it; the indo-lent servants enjoying to the full their only solace—music; the mistress, refined and elegant, just looking in upon what clearly, from the fact, is not a daily scene, with her maid behind her, better fed, better clothed, much more of a woman, much less of a slave in her outward life, than her fellow servants, all presenting a sad picture of Southern Slavery, when viewed from one stand-point. On the other side is the careless happiness of simple people, intent only upon the enjoyment of the present moment, forgetful, perhaps ignorant, of degradation, and thought-less of how soon may come the rupture of all those natural ties in which lie the only happiness that life can give them; the delighted mother and her dancing child; the old man, wrapped up in the sweet sounds of his own creation; the little boy, with his neglected plaything, entranced by the true negro love of melody; the children wondering at the sight of "Missis" in the negro-yard; the young lovers, their very attitudes instinct with the fine sentiment which belongs alone to no condition, but is common to every human creature; and even the little dog which lends his hilarious bark to the general fun."

"Fine Arts," Home Journal, *June 18, 1859.*

In No. 321—"Negro Life at the South," by Eastman Johnson—we have the most individual and original picture of the collection. Every one must recognize the zeal and conscientiousness which

prompted the study of every part of this work—the exceeding care with which each fact and circumstance has been wrought. Nothing has been neglected. Dilapidated humanity in ruinous surroundings. How in keeping with the scene is the effect of light chosen. No direct sunray to illumine the abode of squalor and degradation. The well-to-do neighboring house catches a gleam from the declining sun; but the wretched tenement looks danker, more mouldy and repulsive, from the almost twilight contrast, which the momentary gayety of the foreground group only augments. A more dramatic and original picture has never been exhibited on these walls, or one with a deeper moral.

"National Academy of Design," Crayon 6 *(June 1859).*

One of the best pictures in respect to Art and the most popular, because presenting familiar aspects of life, is E. Johnson's "Negro Life at the South." Here are several groups of negroes, who are assembled in the rear of a dilapidated house. We never saw a better rendering of American architectural ruins; the time-worn clapboards and disintegrated bricks, the broken window-sashes, the rotten beams of a dismantled shed, with just enough of a moss-covered roof left to make the sheltered space underneath a receptacle for all kinds of kitchen implements and a lounging-place for darkies; all these objects are perfectly painted, and in perfect harmony with the characters portrayed. Any one of the groups on this canvas forms a picture by itself. The melancholy banjo-player arrests our attention first, and he is so completely absorbed, it is but natural to look for the effect of his music upon the parties who surround him. Immediately in front we see a knotty-limbed wench and one or two dancing "pickaninnies," and behind these, near the player, a boy completely lost in wonder as he gazes at the musician; off to the right are noisy children, representing that element of a musical party that cannot be made to keep quiet under any circumstances; perhaps they hear the approach of "white folks," as two ladies step out from a garden door on the extreme right to enjoy "Poor Lucy Neal;" leaving these groups, the eye goes to the second story, and, glancing at a cat about to disappear through a broken sash, comes to a mulatto-woman in the adjoining window and her child, the latter seated upon the moss-covered shingles on top of the shed, perfectly alive with infantile glee. This is one of the best episodes of the picture. The only group that appears not to be directly under the influence of external music, but no doubt alive to a better music within, is that of a graceful mulatto-girl on the left, who is listening to the blandishments of a colored gallant, whose face we cannot see, because his back is very poetically and very properly turned upon all the rest of the world. The accessories are in harmony with the subject. A peculiar curly-haired dog in the foreground shows his ownership unmistakably, besides serving the artistic purpose of connecting the groups; and not the least poetical incident on the canvas is that by which we recognize the time of day to be the evening hour, namely, the attitude of a hen on the top of the old shed, who is in the act of springing into a tree where her lord and master has preceded her to select a roosting-place. Although a very humble subject, this picture is a very instructive one in relation to Art. It is conscientiously studied and painted, and full of ideas. Notwithstanding the general ugliness of the forms and objects, we recognize that its sentiment is one of beauty, for imitation and expression are vitalized by conveying to our mind the enjoyment of human beings in new and vivid aspects. We speak of this picture at length, because the Art by which the *beauty* of the subject is conveyed to our minds is of the most excellent description. The picture of "Negro Life at the South" ranks with Wilkie's "Blind Fiddler," and is of a kind of Art that will be always popular, so long as lowly life exists to excite and to reveal the play of human sympathy. But "Negro Life at the South" is not "high Art," for the reason that the most beautiful

thoughts and emotions capable of Art representation, are not embodied in the most beautiful forms, and in the noblest combinations.

"Fine Arts," New York Evening Post, *January 30, 1867.*

Few pictures have ever been painted in America that are so worthy of serious attention as the "Old Virginia Home," popularly known by the misnomer "Old Kentucky Home." . . .

The "Old Virginia Home" has its faults, but its author doubtless sees them better than we do. As he has learned to do better now it is useless to criticise his early work. Yet there are qualities in this picture that we would regret to miss in his later works. It is entirely consistent in the relation of its parts to each other. There is no elaboration with a view to giving prominence to particular details, and yet there is nothing lost in the general effects of masses . . .

But the picture is now interesting in another respect. Here we see the "good old times" before the "peculiar institution" was overturned, times that will never again return. The very details of the subject are prophetical. How fitly do the dilapidated and decaying negro quarters typify the approaching destruction of the "system" that they serve to illustrate! And, in the picture before us, we have an illustration also of the "rose-water" side of the institution. Here all is fun and freedom. We behold the very reality that the enthusiastic devotees of slavery have so often painted with high-sounding words. And yet this dilapidation, unheeded and unchecked, tells us that the end is near.

The prophecy has been fulfilled. No more does the tuneful banjo resound in that deserted yard; no more do babies dance or lovers woo; no more does the mistress enjoy the sport of the slave, but scowls through the darkened blind at the tramping "boys in blue." The banjo is silent; its master sleeps in the trench at Petersburg. The lover has borne the "banner of the free" through hard-fought battles, and now is master of the soil that gives him bread.

Time has made this picture historical. No other like it exists or can exist, for the time in which to paint it has passed.

"American Artists," Harper's Weekly 11 *(May 4, 1867).*

EASTMAN JOHNSON made himself famous among our artists by his picture of "The Old Kentucky Home;" and the talent which that work revealed has constantly sustained itself in the pictures which have followed it. The "Kentucky Home" was as unique among our pictures as "Uncle Tom's Cabin" among our stories. Here was the great tragedy of our national life, with countless passionate and poetic aspects, teeming with every kind of inspiring subject, and our moral pusillanimity was such that Literature and Art avoided it, and "society" made it impolite to allude to it. Even HAWTHORNE, the great romancer, gravely said that American life was monotonous, and afforded no fine contrasts of light and shadow such as imaginative literature required. Year after year the Academy walls were covered with "Portrait of a Lady," "Portrait of a Gentleman," "Haying," "The Chemunk Meadows at Twilight," "Cedric the Saxon and Gurth the Swineherd," "Mary," "Luther at Wittenberg," "The Sword of Bunker Hill," "Lady Jane Grey and Anne Boleyn and Mary Queen of Scots: A Reminiscence"—every time, every country, every event, every history, every tragedy and romance except our own. Mrs. STOWE broke the spell in literature. EASTMAN JOHNSON broke it in art. He and the war have shown us the throbbing life and passion and romance among ourselves. We do not mean that Mr. JOHNSON is a preacher, nor an antislavery lecturer, nor a man with a conscious "mission." But "The Old Kentucky Home," a scene of Slave State life, not of the whipping-post nor of the auction-block, but of a quiet interior, of the edge of a slip-shod household, of a pair of young negro lovers, not cari-

catured, but of a kind familiar to common experience, admitted the prescribed race to the common sympathies of humanity. The moral of the picture, instinctively felt, was a man's a man for a' that. The human romance of the picture was as pure as that of Romeo and Juliet. The spectator felt it. The better he saw the picture to be as a picture, the more deeply he felt this truth; and he asked, and every man of the thousand generous and thoughtful who saw it and admired it asked, In what country are such men and such women made brutes by the law and sold like swine? The imagination and insight which the picture showed in the artist, his shrewd observation, his reliance upon truth and the common aspect of life, are qualities which appear in each of his successive works. He has always something to say in all his pictures, and he says it with delightful directness and simplicity.

ARTISTS: ADVICE AND CAREERS

RUFUS PORTER'S RECIPE FOR MURAL PAINTING

Born in West Boxford, Massachusetts, in 1792, Rufus Porter was an itinerant artist who worked throughout New England and as far south as Virginia. He was also a soldier, a sailor, and an inventor who made an early use of the camera obscura and other labor-saving devices. He subsequently edited Scientific American *for several years during the 1840s. Porter developed techniques for "rapid-style" portrait and mural painting, and he is thought to have executed some 150 domestic murals during his travels, either small overmantels or landscapes covering entire rooms. Keen on sharing his "inventions," he published a practical art manual in 1825, which went through several subsequent editions. Although relatively few of this type of decoration survive from the early nineteenth century, Porter actively promoted them as an improvement over expensive, imported wallpaper, which he warned was prone to tearing, mildew, and infestations of vermin. His published mural formula is a clear, step-by-step guide for mixing colors, dividing the wall plane, and achieving effects of depth in rural scenes.*

Rufus Porter, A Select Collection of Valuable and Curious Arts, and Interesting Experiments *(Concord, N.H.: J. B. Moore, 1825).*

Dissolve half a pound of glue in a gallon of water, and with this sizing, mix whatever colours may be required for the work. Strike a line round the room, nearly breast high; this is called the horizon line; paint the walls from the top to within six inches of the horizon line, with sky blue, (composed of refined whiting and indigo, or a slip blue,) and at the same time, paint the space from the horizon line to the blue, with horizon red, (whiting, coloured a little with orange lead and yellow ochre,) and while the two colours are wet, incorporate them partially, with a brush. Rising clouds may be represented by striking the horizon red colour upon the blue, before it is dry, with a large brush. Change some sky about two shades with slip blue and paint your design for rivers, lakes or the ocean. Change some sky blue one shade with forest green, (slip blue and chrome yellow,) and paint the most distant mountains and highlands; shade them while wet, with blue, and heighten them with white; observing always to heighten the side that is towards the principal light of the room. The upper surface of the ocean must be painted as high as the horizon line, and the distant highlands must rise from ten to twenty inches above it.—Paint the highlands, islands, &c. of the second distance, which should ap-

pear from four to six miles distant, with mountain green, (two parts sky blue with one of forest green,) heighten them, while wet, with sulphur yellow (three parts whiting with one of chrome yellow,) and shade with blue-black, (slip blue and lamp black equal.) Paint the lands of the first distance, such as should appear within a mile or two, with forest green; heighten with chrome yellow and shade with black; occasionally incorporating red ochre, french green or whiting. The nearest part, or fore ground, however, should be painted very bold with yellow ochre, stone brown (red and yellow ochre and lamp black equal,) and black. Paint the shores and rocks of the first distance with stone brown; heighten with horizon red, shade with black. For those of the second distance, each colour must be mixed with sky blue.—The wood lands, hedges and trees of the second distance are formed by striking a small flat stiff brush endwise, (which operation is called bushing, and is applied to the heightening and shading all trees and shrubbery of any distance,) with mountain green deepened a little with slip blue; with which also the ground work for trees of the first distance is painted; and with this colour the water may be shaded a little under the capes and islands, thus representing the reflection of the land in the water. Trees of the first distances are heightened with sulphur yellow or french green; and shaded with blue-black. Every object must be painted larger or smaller, according to the distance at which it is represented; thus the proper height of trees in the second distance, is from one to two inches, and other objects in proportion. Those in the first distance from six to ten inches generally; but those in the fore ground, which are nearest, are frequently painted as large as the walls will admit. The colours also for distant objects, houses, ships, &c., must be varied, being mixed with more or less sky blue, according to the distance of the object. By these means the view will apparently recede from the eye, and will have a very striking effect.

THOMAS SEIR CUMMINGS ON MINIATURE PAINTING

Miniature paintings—small portraits executed in watercolor on ivory—were popular keepsakes (given as gifts, treasured as remembrances, even worn as adornment on bracelets and rings) throughout much of the eighteenth and early nineteenth centuries. On special occasions, patrons often commissioned as many as a dozen copies of a single portrait, for distribution to family members. Many preferred them to larger oil paintings because of their more modest and less ostentatious format. By the time of the Civil War, however, they had passed out of fashion, displaced by the photograph.

Thomas Seir Cummings was one of the best-known miniaturists during the second quarter of the nineteenth century. "General Cummings," as he came to be known because of his service in the New York State militia, was extremely active in professional art circles, especially in the National Academy of Design, of which he was a founding member and the longtime treasurer. His friendship with William Dunlap, forged during the early years of the Academy, resulted in the following treatise on the technical aspects of miniature painting, which Dunlap included in his history of American art. Cummings's later "memoirs," published a year after his death, provide valuable information on his early business partnership with Henry Inman. The text also makes it clear that Cummings chafed under the view that miniature painting was a "lesser" art than oil portraiture. Ironically, Cummings's death in 1894, at the age of ninety, occurred just as interest in miniature painting was rekindled, as part of the nostalgic movement known as the Colonial Revival.

T. S. Cummings, "Practical Directions for Miniature Painting," in William Dunlap, History of the Rise and Progress of the Arts of Design in the United States *(New York: George P. Scott, 1834).*

Miniature painting is governed by the same principles as any other branch of the art, and works in miniature should possess the same beauty of composition, correctness of drawing, breadth of light and shade, brilliancy, truth of colour, and firmness of touch, as works executed on a larger scale; and the artist who paints in miniature, should possess as much theoretic knowledge and the same enlarged views of his art, as if he painted in any other style.

It may be asked, what is the proper preparatory course of study for a miniature painter? We should unquestionably answer, the same as for any other branch of the art. It is in the mechanical part only that it differs.

Miniatures, as they are at present painted, are usually executed on ivory,* and in transparent (water) colours,† and according as the mode of application of the colours to the ivory partakes of the line, the dot or smooth surface, is the style,‡ technically termed hatch, stipple or wash. In the first named, the colour is laid on in lines, crossing each other in various directions, leaving spaces equal to the width of the line between each, and finally producing an evenly-lined surface. The second is similarly commenced, and when advanced to the state we have described in the line, is finished by dots placed in the interstices of the lines, until the whole has

*Ivory for miniature painters' use may be purchased at most of the ivory turners or fancy stores, sawed in thin sheets. It should be selected for the closeness of its grain, mellowness of colour, transparency and freeness from changeable streaks. It is then prepared for use, by first scraping out the marks of the saw, if any appear, and afterwards grinding it with finely pulverized pumice and water on a glass slab until all *polish* is removed; it is then washed with clean water, perfectly free from the pumice, and left to drain itself dry; when dry it is attached to white card paper, by dots of gum on the corners, and is then ready for use.

†Colours are now manufactured in cakes ready for use, only requiring to be diluted with more water, though some miniature painters regrind them. Those manufactured by Newman, of London, are generally considered the best, and I believe, if genuine, are fine enough for all purposes. Fineness of texture and permanency are the great requisites. It is however necessary that the student understand the qualities of the pigments made use of, both as to the tints they form when mixed with one another, and their transparency, or opacity; for on this must depend their fitness for different parts of the work, even when the same tint is procured. They may be classed under three heads, transparent, semi-transparent, and opaque, though it is by no means my intention to enumerate all the varieties of colour, those generally used will be sufficient.

Opaque colours.	Semi-transparent.	Transparent.
Constant white,	Burnt ter. de sienna,	Gall stone,
Flake white,	Indian yellow,	Brown pink,
Vermilion,	Ultramarine,	Lake,
Indian red,	Cobalt,	Carmine—burnt do.
Opaque.	*Transparent.*	
Yellow ochre,	Vandyke brown.	
Burnt umber,	Sepia,	
Lamp black.	Indigo,	
	Pr. blue,	
	Ivory black,	
	Burnt madder.	

To prepare a palette for a miniature painter it is only necessary to rub the colours, with the addition of water, on a glass, china or ivory palette, in spots agreeable to the requisition of the artist.

‡The style or manner of execution is decided by the taste of the artist, and is after all of little consequence. There is no manner in nature. That style which gives the best imitation of nature, and conceals most the means used to obtain it, must undoubtedly be considered the best.

the appearance of having been stippled from the commencement. The third is an even wash of colour, without partaking of either the line or dot, and when properly managed, should present a uniform flat tint. Artists vary much in their style of execution, and even in the degree of smoothness they bestow on their pictures, some preferring a *broad,* others a minute style; though the first is decidedly the most masterly. It must, however, be governed, in a great measure, by the size of your picture and your subject.

In the mode of obtaining the desired result, and in the colours to be used for producing it, there is also a great difference of opinion. This is unessential to the student.

The following process I have found to possess many advantages, and I believe as free from errors as any that has fallen under my experience.

Having your colours and ivory prepared, and your subject selected, your next step is to procure a correct outline. If it be a head from the life, (which will perhaps best illustrate my meaning,) you will carefully examine it in all its views; both as to attitude, and light and shadow; and having selected that position which in your judgment possesses most of the likeness and character of the individual, you will proceed to outline it.* Your outline carefully drawn on your ivory, you will next lay in the dark shadows with a light and warm neutral tint,† sharp, firm, and of the right shape. Having carefully placed these, both with regard to individual form and relative, bearing to each other, you may proceed with the lighter shadows or middle tints.‡ They should also be laid in very lightly, colder in colour than the shadow tone, but still definite in form, however light. These effects correctly obtained, and as much depth given as you think necessary for the proper rounding of your subject, you strengthen your dark shadows, altering their forms if necessary. All being justly situated, you then lay in the general colour of the complexion,§ and having produced the requisite depth, you will, with a sharp lancet,** scrape off the shining lights on the face, such as the high light on the forehead, nose, &c., and again compare with your original, particularly as to general effect; this proving correct, you proceed with each feature, giving its individual parts more attention, still keeping the whole effect in view, and the work broad; endeavouring to preserve the general effect in conjunction with the completion of the detail. Having gone over all the features, corrected their drawing and colour, you next examine if the drapery and hair of your sitter suit you; if so, copy them, if not, leave them for another and more happy arrangement of forms, and then complete them, at least as to general form. Your picture then is sufficiently advanced to put in your background.

It is commenced with a round-pointed pencil†† and faint colour, in broad lines, crossing

*It may be well if the student's hand be not firmly fixed in drawing, to make an outline on paper of the required size, and afterward transfer it, by placing the ivory over it. Its transparency will enable you to trace it very distinctly. There are many advantages in this method. You insure a clean outline on your ivory, the head of the proper size, and in the proper place in your picture, which will not always be the case if you outline directly upon the ivory.

†A good neutral tint may be made with Indian red and a little blue, which will form a reddish pearl colour.

‡Middle tints may be composed of the colour you use for your shadows, with the addition of a little more blue.

§In washing in the general colour of the face you will reverse the picture, commencing at the chin; by this means you will obtain the gradation of colour requisite for your head; the brush becoming exhausted, will naturally make the forehead the lightest part. This is of course presuming the head to be painted in the ordinary light used by painters.

**The lancet is a very useful instrument in the hands of a skillful practitioner in augmenting the high lights; it must, however, be sparingly used by the student, and should never be considered as an eraser.

††Pencils used for miniature painting are the sables. They should be elastic, and drawn to a firm point when wet; if they open, they are not fit for use. The size must be governed by the kind of work, or degree of finish you want them for. Generally young miniature painters are too fond of a sharp pointed pencil; it gives dryness and hardness to their work, and will in no way contribute to the finish they vainly hope to attain by such means.

each other at an acute angle, gradually increasing in fineness as you approach the completion; and then still further finish by stippling, constantly bearing in mind that its beauty is more dependent on preserving the masses even, and the grain open, than on the smallness of the dot, or line, which, however minute, will never produce effect, unless the general massing be attended to. Your back ground so far advanced, it is time to insert your drapery. If light, you proceed much the same as with the face; if dark, it is treated with opaque colours. The outline previously obtained, you with a full pencil float on a quantity of the colour* you wish to produce, always giving it body by the addition of white, and smoothness by laying the picture horizontally during the operation; this will allow the colour to become perfectly flat from its fluidity. When dry, it is ready to receive the lights and shadows, as indicated by your model. Your picture equally advanced to this stage, it becomes impossible to lay down rules for its further progress; it must depend altogether upon circumstances arising from the proper performance of the foregoing, as to what additions the picture may require. Generally you will find the flesh-colour deficient, and the shadows weak; these you strengthen and improve, in accordance with the original, adding such colour as in your judgment you think will render it more like the nature before you; and lastly, give brilliancy and transparency by the addition of gum† with your colours, in the dark parts, or wherever else you may deem transparency desirable.

Thomas S. Cummings, "Memoirs of a Miniature Painter," Monthly Illustrator 5 *(September 1895).*

The painter of portraits "in small" had perhaps less opportunity of being known through public exhibitions than an artist of any other class. This was not only by reason of the size of his work but on account of its seclusion. During all my practice the exchange of miniatures formed the lover's engagement-pledge, and far from being publicly exhibited they were worn against the heart to be drawn forth by means of their blue ribbon—emblem of constancy—and dwelt upon only by the lovers themselves.

As to the term, "miniature-painter," it is of little consequence it is true. "A rose by any other name—" etc., yet some doubt seems to exist as to whether the expression applies to the artist or to his productions. There is nothing especially original or confined to myself in the following from a published notice:

"Ah! here is another worthy—my friend Cummings, who, as he is the last whom I address by name, so is he the least,—that is in the size of his pictures. He is a small painter, this Mr. Cummings, whether we regard the dimensions of his earthly tabernacle or those of his paintings, but if we consider their merit alone, ah' then we shall indeed find him A No. 1."

Now it is a well known fact that some of the largest men in the profession were miniature-painters, but let that pass. The term is uncalled for. It is meaningless, as it does not even designate the division of art represented. Marines and landscapes are always executed below natural size, yet who would think of calling them miniatures? On the other hand, who would describe as a colossal or mammoth painter the man who portrayed in magnified form that little nimble jumper yclept the flea? To all this, however, we would not offer serious objection were the term

*The mode of mixing this opaque colour, is by grinding such colour as you desire for your use, and adding to it white, to produce the requisite opacity. Blue cloth may be obtained by mixing indigo, indian red, and white. Black cloth, by ivory black, indian red, and perhaps blue. The red is necessary to give the warmth observable in a cloth texture. In silks it is omitted, and blue substituted in greater quantities, according as the silk partakes of the blue tone. It is, however, impossible to make rules for the imitation of colour—the artist's eye is the best guide.

†Gum is used with the colours in finishing your picture. It is the ordinary gum arabic, dissolved in water.

not so often used in a derogatory sense. In criticism it has been frequent to see portraits in small bunched together by the quantity as "Nos. ——— Miniatures. Some good, some otherwise. The best, Nos. ——— are by —."

The so-called miniature is a portrait, and the painter a portrait-painter. It will scarcely be questioned that a work in small, to possess the same merit, must have the same gracefulness of composition, correctness of drawing, truthfulness to nature, and the same proper management of color, light and shade. If it be painted on ivory and in water-color, the artist has a far less acceptable ground than the prepared canvas, for the ivory must be brought to a granular surface before the color will adhere to it, as it does but slowly and limitedly at best. The pigments are precisely those used in oil, but being mixed with water they can only be brought to an approximate depth and richness by the use of gum or mucilage—not an agreeable working-medium. The number of hours of actual work are far greater than those required on the same kind of work in oil, more delicacy of touch is needed, more steadiness of hand; the eyes are far more tried, and in every way the work is doubly confining and exhausting to the system. To all this it may be added that the recompense is scarcely one-half, and the reputation attendant thereon not one quarter of that which is awarded to similar work in oil, be the size what it may.

About 1823, when I began to study under Henry Inman, almost all the artists painted both portraits in oil and miniatures in water-color, but for three years I confined my study to oil-portraiture. Then I copied a miniature on ivory in water-color,—a very sweet picture by Dickenson. Inman suggested that I try one from life, and when it was done he was very much pleased with it. On coming to the studio one morning he proposed that I should paint miniatures, as he was tired of it and had all the practice he wanted in oil. He framed a specimen and hung it on the wall beside mine. His price had been thirty dollars for a miniature, and he suggested that I should place mine at twenty-five and he would raise his to fifty. It was customary at that time with all the artists to have a specimen on the wall and a card of prices on the table. Some, it is true, had their works exhibited in windows on Broadway, but that was tabooed by genuine artists and at once relegated the adventurer to "the Buddingtonian school," so called from a man named Buddington who did the worst work in the city—and bad enough it was.

I did as Inman desired, and was very thankful for what I thought would be an opportunity of earning money. People called, examined, and invariably chose the fifty-dollar style, and I received no orders, although I painted the greater portion of the fifty-dollar pictures for Inman, and was paid by him. One day on entering he said, "I am determined to do no more d— miniature-painting. Take down my specimen and let yours remain at the fifty-dollar price."

This brought me employment at once. No one objected to the price, and then we formed a firm of Inman & Cummings, Portrait and Miniature Painters, the second only of its kind in the country. Inman received half the profits of the miniature-department, and the partnership continued until he moved to Philadelphia. Though I did not relinquish my oil-painting, and constantly did much of it for Inman, our arrangement made me a miniature-painter. Ingham, like Inman, gave up his miniature-work and sent it to me, on condition that I did not exhibit or present myself prominently before the public as a portrait-painter in oil. I might still paint in oil, but must not exhibit such work.

A FOLK ARTIST OVERCOMES A DISABILITY

For a largely self-taught artist such as Joseph Whiting Stock, constant itinerancy was a career requirement. His plain portraits (and later, his daguerreotypes) appealed to

a somewhat provincial clientele dispersed widely around Springfield, Massachusetts, and points south in Connecticut. Yet a childhood injury that left Stock unable to leave his bed would have seemed to preclude this kind of life. In the autobiographical intro-duction to his journal, Stock explains how he learned to paint while an invalid and how a doctor helped him to regain his independence in the world through the use of a modi-fied wheelchair, which could be lifted onto trains and carriages. The fire that severely burned Stock in 1839 and presented him with another setback is also a reminder of the dangers inherent in the artistic profession.

Journal of Joseph Whiting Stock, c. 1846, Connecticut Valley Historical Museum, Springfield, Massachusetts.

I was born in Springfield, Mass. Jan. 30th, 1815. My parents, were poor, married early, and have had a large family to support, but have ever maintained a respectable standing in society by their honest and industrious habits. My father has been employed in the U.S. Armory, ever since his removal to Springfield which occurred a short time previous to my birth.

My early years were spent like those of most boys of the same age, in attending the common schools, and play, and I recollect no event worth mentioning here previous to the accident which rendered me a cripple, and influenced my course through life.

On Sunday April 9th 1826, my brother Isaac, Philos B. Tyler, and myself were standing near the body of an ox-cart which leaned nearly upright against the barn very intently engaged in conversation, when suddenly, I percieved it falling, which instead of endeavoring to avoid, I attempted to push back and was crushed under it. The boys unaided lifted the cart and drew me from under it. I experienced no pain at the time and no other sensation than a heaviness and prickling numbness in my legs, which were powerless and led me to exclaim that they were broken.

My mother was soon called (father was gone to meeting) who carried me into the house where all the Medical Men in town were soon gathered and at once pronounced it to be an in-jury of the spine, caused by a laxation of the last dorsal from the first lumber vertebra which wholly destroyed all the nerves proceeding from the spinal chord below the injury, and conse-quently destroyed all action and sensation in the lower extremities, from the hip downwards. It was set three times within a week, but it was impossible to keep it in its proper place while the joint had time to reunite. For several weeks I suffered much pain from the injury and also from the confined and unchangeable position which the nature of the injury required during the process of nature for rejoining and strengthening the wounded part. My constitution was so much weakened and exhausted by these efforts and the profuse suppuration from ulcers which had formed on my hips as to induce symptoms of hectic [fever] and mortification and for many months my friends dispaired of my life. But the unceasing care and attention of my parents and physician (Dr. Loring) aided by a naturally robust constitution finally overcame the dis-ease and I was restored to comparatively good health.

I was confined almost constantly to my bed only while it was being newly made and changed my father held me in his arms or laid me on another bed. Many eminent surgeons visited me and examined my injury but gave no encouragement of a recovery and I became cheerful and contented in my situation, amusing myself in a variety of ways. Sometimes by reading, study-ing, sewing at other times by indulging my Yankee propensity for whittling and making toys for the children. My friends often consulted and inquired for some occupation by which I might gain a livelihood but my situation made me incapable of following pursuits by which most men gain a living.

My attention at length, was directed by a friend, (Dr. Loring, who I shall ever remember with grateful feelings inspired by his uniform kindness and attention during my sickness and confinement.) to the art of Painting which he thought I might easily attain and support myself by painting portraits.

This was in the fall of the year 1832, when I commenced. Mr. Franklin White, a young artist, pupil of Chester Harding, called upon me frequently and showed me his manner of preparing and laying the pallet and lent me some portraits to copy. I followed this course some months when I attempted my sister Eliza's portrait and made so good a likeness as to induce my friends to encourage me by their patronage. It was soon noised abroad and received many visits from citizens and some orders which were executed with various degrees of success like the productions of all beginners. My terms were very low and many were induced to patronize me from benevolent motives and as I gained more experience from observation, and the patronage thus bestowed upon me I soon acquired more skill and expertness in the use of the pencil and gave more perfect likeneses. I painted some portraits for people from the neighboring towns and frequently received invitations to make them a professional visit but my situation prevented. About this time (1834) Dr. Swan removed to S. and had occasion to call upon me to excute some anatomical illustrations. He became at once interested in trying to remedy the inconvenience resulting from the injury, and long confinement to the couch in nearly the same position. Several attempts had been made to construct something by which I might be enabled to sit up which had failed of accomplishing the desired effect and my friends had become discouraged from any further attempts, when Dr. S. submitted his plan. It met with but little favor at first and he had many difficulties to contend against in developing and maturing his plans for my relief. He however, by dint of perserverance succeeded in constructing a chair which answered all our expectations. I was soon enabled to sit up several hours in the day and could roll myself all over the same floor of the house.

My health improved and in the spring of 1836 I left my father's house for the first time at the invitation of several friends in North Wilbraham who wished their portraits painted and thought there might be many others who would be induced to patronize me after seeing theirs finished. Accordingly I took a room near the Academy and my success was such as to equal my most sanguine expectations and their kind and generous encouragement in this my first professional excursion has left indelible impresion on my mind that all the kindness and success which has invariably attended my labors in the other towns has failed to efface. I have visited W. several times since also Cabotville, Stafford, and some other towns which will be mentioned in their proper place.

I was very well patronized and was doing a very good business when all my plans were frustrated and my life endangered for a time.

On the evening of the 1st of Jan. 1839 I was preparing some mastic varnish and was in the act of turning it off while hot when it took fire from the light and communicated to my dress and I was soon involved in the flames. It was soon extinguished but hands, face and neck, were badly burned, so that at the time my physician thought me in considerable danger. I was recovering rapidly from the effects of the burns, which were nearly healed when on the 17 of Jan I was attacked with a fever which endangered my situation very much. As the fever yielded to the skillful treatment of my physician another and more formidable difficulty appeared. My right hip had never become perfectly sound since the formation of the ulcer during the sickness arising from the first injury of the spine, This had now become so large, and suppuration

so profuse, as to render my case dangerous. There was a spontaneous laxation of the hip-joint, the ligaments destroyed and the bones in a degree carious. My constitution had become much wasted by the fever and suppuration produced some tendency to hectic.

At this juncture, my friends becoming alarmed my physician (Dr. Swan) requested counsel. Accordingly Dr. Flint, was called who considered me in a very critical situation. He advised more active and stimulating medicines to sustain and increase my strength. This treatment was followed for a short time without much perceptible benefit, and it was finally resolved to remove the diseased bones. The head of the thigh-bone was sawed off and diseased parts of the other bones removed. The operation was performed by Dr. Flint.

After the removal of the bones, I began very slowly to recover. The cavity gradually filled up but it was a long time before it had healed perfectly sound as it now is.

My physicians said the opening and suppuration of the hip-joint would under most circumstances, prove fatal. In my case not only the head of the thigh-bone but also a portion of the other bones, was carious, exfoliated and came away: and yet under all these unpromising circumstances, I recovered Thanks to a Kind Providence and the skill of the attending physicians.

It was many months before I was enabled to resume the labors of my profesion and more than a year before I completely recovered. During this time I painted very little and remained at home excepting a short visit to Cabotville to finish some portraits begun before my illness.

THOMAS SULLY'S *HINTS TO YOUNG PAINTERS*

English-born Thomas Sully was brought to the United States by his actor parents while he was a boy. Around 1801 he began his career as a portraitist, working for several years in Virginia, New York, and Massachusetts before settling in Philadelphia. Sully became that city's primary painter of portraits for some five decades, executing more than two thousand works. His characteristic style was fluid and gentle, with a buttery texture to the paint and an emphasis on flattering likenesses, free of any imperfections. Sully was an inveterate diarist, writing down his own technical discoveries and keeping a record of the advice and "recipes" of his fellow painters. In 1851 he brought together these observations and musings into a manuscript titled Hints to Young Painters, *which was published after his death. In the passage given here, he offers a step-by-step guide to the execution of a portrait, paying particular attention to process and materials.*

Thomas Sully, Hints to Young Painters *(Philadelphia: J. M. Stoddard, 1873).*

When the person calls on you to make arrangements for the intended portrait, observe the general manner, etc., so that you may determine the attitude you had best adopt. The first sitting may be short, as pencil sketches on paper, of different views of the person, will be sufficient to determine the position of the portrait.

At the next sitting make a careful drawing of the person on a gray canvas (kept for that particular purpose). It should be of a middle tint, made of white, and black mixed with white: it must not shine. This study must be made in charcoal, with its proper effect of shadow relieved with white chalk, using for the middle tint the color of the canvas. The drapery, also—if the time will allow—should be put in. I find that two hours is long enough to detain the sitter. I

seldom exceed that time; and six sittings of two hours each is the time I require. When alone, begin the portrait from memory, fix the place on the canvas by means of the strips of measurement from the top of the canvas and the other marks of distances; if the person is tall or short, place the head accordingly. The drawing made from the person in charcoal and chalk will enable you to paint in the effect of the picture with burnt umber on a white ground (some prefer a colored ground). Paint freely, as if you were using watercolors, not too exact, but in a sketchy manner.

In this process I use a mixture of drying-oil and spirits of turpentine in equal portions, to moisten my brush as occasion requires. (In all painting I use only this mixture.) This preparation may take two days to dry. Sometimes I hasten this effect by placing my picture in the sun, sheltered from the dust, by the window, and in winter I expose the picture to the fire. I recommend the use of large brushes.

In the next sitting tints are to be used, and all inaccuracies corrected; while, of course, the likeness is to be made as close and characteristic as possible . . .

Having adjusted the shadows, a little vermilion and white may be scratched on the cheek and on the lips.

The drapery and background should now be painted. These may be executed from the sketch made from the life. If it is a large picture where more of the person is seen, the drapery must be painted from an exact study made from the person. The color of the background should be either darker or lighter than the head or drapery. In the former painting the hair must be painted, the color of which must be a matter of judgment, as hair is of so many different colors that no rule can be offered. Burnt umber is an excellent color for the purpose; and Vandyke brown, for dark shadows, is excellent, but it is a bad dryer, and I have reluctantly abandoned the use of it.

We come now to the sixth and last sitting. In painting this, the same palette of tints is used, with the addition of asphaltum and madder lake. These are glazing colors, and may be used to darken and improve the shadows of the flesh tints. The hair and drapery may be glazed with the mixture of asphaltum and madder lake. To the bottom of the burnt terra sienna add two tints, also to the blue tint and the vermilion. These tints may be employed here and there in improving the color.

The complexion is a part of the likeness. The tints which I have arranged are for a light complexion; I merely strengthen the tints, and add Indian red to the vermilion, for dark complexions.

The last operation of the painter is to varnish his picture.

Suffer the picture to dry for about four or five weeks. Should it remain without varnishing for years, it will not suffer for the want of it; it will only look dull, and some colors will not show their effect.

A hard varnish, such as copal, is not suitable for a portrait. Mastic varnish and gum-de-mar varnish are good. I prefer mastic varnish. If it requires to be more liquid, thin it with spirits of turpentine.

When preparing to varnish, first apply raw potato to the picture, which effectually cleans it from soil of all kinds. (This is the discovery of an American painter by the name of Rand, who also invented the compressible tubes).[6] The raw potato must be peeled and rubbed on the painting; by dividing the potato into thin slices, the picture may be covered with the juice. This juice

[6] John G. Rand invented the collapsible zinc paint tube in 1841.

must be washed off with pure water, and entirely dried with a piece of chamois leather. The picture is then prepared for the varnish.

I recommend a flat varnish-brush, made of hog's bristles. In applying the varnish, move the brush from corner to corner, by which it may be laid evenly. This will dry in two or three days; expose it for that purpose to the sun (see that the dust is not admitted); in the winter expose it to the fire for a day or two. In three or four days the varnish will become dry.

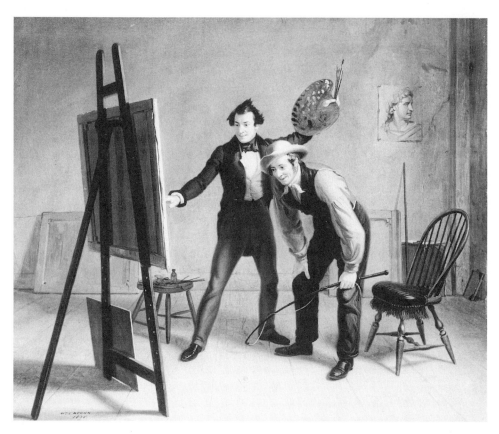

Fig. 5. William S. Mount, *The Painter's Triumph (Artist Showing His Own Work)*, 1838, oil on panel. Courtesy of the Pennsylvania Academy of the Fine Arts, Philadelphia, Bequest of Henry C. Carey (The Carey Collection).

5 ANTEBELLUM AMERICA

Public Art and Popular Art

THE U.S. GOVERNMENT AS PATRON: DECORATION OF THE CAPITOL

HORATIO GREENOUGH'S *GEORGE WASHINGTON*

In 1832 Congress commissioned Horatio Greenough to execute a greater than life-size marble statue of George Washington, to be placed in the Capitol rotunda (see also "James Fenimore Cooper Commissions a Statue," chapter 3). This was a major federal commission, equaled only by the four large canvases painted by John Trumbull for the same space. As such, it was the subject of intense scrutiny, both during its long genesis and after its completion in 1841. Greenough gave much thought to the depiction of Washington and eventually decided to forego modern dress and present the bare-chested president enthroned like a Greek god. The head would be taken from French sculptor Jean-Antoine Houdon's portrait of Washington (which had been done from life), but the body was inspired by Phidias's seated Olympian Zeus, as reconstructed by French savant Antoine-Chrysostome Quatremère de Quincy. In a series of letters reproduced here, Greenough tries out his iconographic ideas, explains his artistic conception, and defends his thoughts on sculptural attributes to Edward Livingston, the U.S. secretary of state; fellow artist Samuel F. B. Morse; and Lady Rosina Bulwer-Lytton, an English novelist. Already the issue of dress appears to preoccupy Greenough in these missives.

Once the work was delivered in Washington, problems arose immediately. Greenough found the angle of light in the rotunda unfavorable and asked that the statue be moved. Yet it was difficult to agree on a new location, and the sculptor rightly worried that an outdoor site would expose the delicate stone to destructive elements. His letter to Representative Robert C. Winthrop, of Massachusetts, rehearses his worries about the new site as well as airing his view that Congress had mismanaged its expenditures in the arts. The issue of whether Congress should authorize $1,000 ($4,000 less than Greenough requested) to move the statue occasioned a comical debate in the House that can only have been mortifying to him. Henry Wise, of Virginia, condemns the work as "plagiarism from the heathen mythology," criticizes the artist's Latin grammar, and suggests that Washington appears as if sitting in an outhouse. It was easy to lampoon Greenough's earnest figure (one senator called it "that thing in the east yard"), but the sculptor

also had his defenders. For example, Henry Reed, a professor at the University of Pennsylvania, and Alexander Everett, a diplomat and politician, penned supportive essays that discussed the monument in terms the artist would have applauded.

Horatio Greenough to Edward Livingston, July 8, 1832, National Archives.

The hope of being found worthy to execute a statue of Washington for one of the great cities of my country, has been my support through years of solitary study in a foreign land. I have looked forward to such an honour as the reward of a life of toil and sacrifice—I will not dissemble the confidence I have felt of the support of my countrymen at some future period, though I feared that there existed among them a diffidence of the national capacity in art; which could only be removed by persevering and successful demonstration—I accept this great opportunity with surprise at finding myself so early known and with joy that I am thought worthy of the task.

I propose to give the Statue together with its pedestal an elevation of about Twenty-five feet from the floor of the hall—I say *about,* for though I have fixed on Fifteen feet as the height of the statue itself, experiment alone will enable me to decide on that of the pedestal. This size, without encumbering the hall, will fill the eye at every part of the same and the features will be recognizable even from the door of the great entrance—To make the figure less, would be to risk the effect of the whole by producing a diminutive appearance. I agree with you that the square form will be the best for the pedestal and I am confident that the effect of this quadrangular body will be happier from its being enclosed by a circular wall—Had the cylindric form any advantages (and I know of none), I should think it worth while to sacrifice them rather than to repeat the form of the hall in its embellishments—Nature constantly sets us the example of varying shapes which are to be embraced together by the eye—I am much pleased that Houdon's bust was mentioned in the Resolution as my authority for the features of Washington—I have always used it from choice—I thank you for the liberty with which you permit me to understand the directions on this point and I believe I shall have occasion to profit by it.

The model of this statue will occupy at least a year—probably eighteen months. The bas reliefs will require at least three months in the clay—We will allow three months for drying the casts and transporting them to the quarries—The rough hewing and taking of the points will require ten months, the finishing will consume the residue of Four Years.

I have been able to avail myself of the experience of an artist who has executed a statue of dimensions similar to those I have mentioned and am willing to undertake this work for the sum of 20,000$ to be paid in annual instalments of 5000$ each—This is little, if at all more than Canova received for a statue of little more than the size of life—The transport of such masses of marble and plaister and the number of assistants necessary to maintain the proper degree of moisture in the clay & to waste the useless stone—render the increase of expence more than proportioned to the increase of size.

If you will permit me I would wish to transmit you from time to time drawings of my compositions for this work—It seems to me that a statue of Washington in that situation should not be a mere image of the man to gratify curiosity, nor a vain display of Academic art, but an embodying of his spirit—The accessories should be stamped with the character of our institutions—They cannot instruct perhaps, but they may impress and confirm. The Historic facts to be recorded on the pedestal are of a different character from the statue as regards the art and I think they should be so—Truth will be my first object in these. I mean by truth in this connection, not all that was, but nothing that was not. I shall adopt the dress of the time and secure as many portraits as are preserved.

Horatio Greenough to Samuel F. B. Morse, May 24, 1834, in New York American, *August 4, 1834.*

I am not displeased that my statue calls forth remarks; now is the time to hear and profit by them. I trust I shall be found open to conviction and desirous to learn; but I fear the making a statue of this kind, requires more attentive and instructed thought than most of our able men can spare from their occupations. I am pleased that the *artists* find my design significant. Your hint, or rather Mr. King's hint, about the constitution, is surely valuable; and if the object of the statue were to *instruct* people about Washington, it might have been anticipated by me. To put into his hand a scroll or a book would be easy; but as books are very like each other on the outside the meaning would be uncertain; and doubt in a statue is feebleness. We raise this monument because Washington's face and form are identified with the salvation of our continent. That sword, to which objections are made, cleared the ground where our political fabric was raised. I would remind our posterity that nothing but that, and that wielded for years with wisdom and strength, rescued our rights, and property, and lives from the most powerful as well as most *enlightened* nation of Europe. I look on the military career of Washington as being, though not perhaps *his* highest glory—*our* greatest obligation to him. I can conceive of his having died at the close of that struggle without any very bad consequences to our institutions. But a sword in the hand is an access[o]ry which adds little to the *contents* in any way; in art it is important. If people would consider the abstract nature of sculpture—its elements—its limits— they would cease to look to it for information on points which are better explained by other arts in other ways. They would as soon expect to hear Washington's dress described in a 4th of July oration as to see it sculptured in an *epic* statue. It is to the *man* and not to the gentleman that he would do honor. To embody in the work the abstract of a political creed, or the principles of a political party, might ensure protection for my work just now. But just now I can do without it.—I am pleased that you and your friends think my composition, in the main, significant. Those who imagine that I would dress Washington in a Roman costume misunderstand me. The time is past when civilized nations are distinguished by their dress.—If the United States ever had a national garb, I can conceive patriotic zeal interested in its preservation. But what distinguished the dress of Washington from that of Peter, Leopold, or Voltaire, or Burke? In many statues the dress of the time is most useful. In a statue of Howard, or Fulton, or Watt, or any other simple improver of the arts or institutions of society, I should think it very proper then to mark the date of his career, by exhibiting him in that circle of usages where he merely served. But the man who overthrew a tyranny, and founded a Republic, was a hero. When he sits down in marble immortality in the Hall of the Capitol, his dress should have reference to the future rather than the past; there should be about him nothing mean and trifling, or above all, ridiculous; which latter adjective, I hold to apply in its full extent, to the modern dress generally, and to that of Washington's time particularly. Three statues have been made of Washington: one by Houdon, representing the General, made with every advantage, and with an accuracy of detail that will ensure it, in its way, the first place among the representatives of the man: one by Canova representing a Roman in the act of thinking what he shall write: one by Chantry, representing him holding a scroll in one hand and a piece of his cloak in the other. I have heard these statues, in their time, examined and criticized by the country. I find nothing in the interest they excite to tempt me to follow either. I choose to make another experiment. If it fails, the next sculptor who attempts the subject will have another beacon in this difficult navigation: the rocks will not increase: the sooner light-houses are on them the safer. Only don't send us landsmen for pilots.

Horatio Greenough to Lady Rosina Wheeler Bulwer-Lytton, c. May 8, 1841, Library of Congress.

Being intended to fill a central position in the Capitol of the U.S. I have thought fit to address my Statue of Washington to a distant posterity and to make it rather a poetical abstract of his whole career than the embodying of any one deed or any one leading feature of his life—I have made him *seated* as *first magistrate* and he extends with his left hand the emblem of his military command toward the people as the sovereign—He points heavenward with his right hand. By this double gesture my wish was to convey the idea of an entire abnegation of Self and to make my hero as it were a *conductor* between God and Man—Though the Presidential chair is very like any other chair, I have thought it my duty to make that on which Washington is seated mean something with reference to the country—It is too large to be left dumb—I have represented the superior portion richly ornamented with acanthus and garlands of flowers while the body is solid and massive—by this I meant to hint at high cultivation as the proper *finish* for sound government and to say that man when well planted and well tilled must flower as well as grow—By the figure of Columbus who leans against the back of the chair on the left side I wished to connect our history with that of Europe—By that of the Indian chief on the right to shew what state our country was in when civilization first raised her standard there—The bas relief on the right side of the chair represents the Rising Sun which was the first crest of our national arms—under this will be written "Magnus ab integro saeclorum nascitur ordo—"[1] In that on the left side I have represented the Genii of North and South America under the forms of the infants Hercules and Iphiclus—the latter shrinking in dread while the former struggles successfully with the obstacles and dangers of an incipient political existence.

Horatio Greenough to Robert C. Winthrop, November 26, 1844, in Frances Boott Greenough, ed., Letters of Horatio Greenough *(Boston: Ticknor, 1887).*

I have just received a letter from a friend, speaking of a conversation with you respecting the statue of Washington, and he urges me to communicate with you about the transfer of that work to the eastern front of the Capitol,—precisely to the spot occupied by the Naval Monument.

I will endeavor to speak as briefly as I can. That statue was designed for the interior of a building, and not for the open air. Had I been ordered to make a statue for a square or other similar situation at the metropolis, I should have represented Washington on horseback, and in his usual dress, and have made my work purely a historical one. I have treated the subject poetically, and I confess I should feel pain at seeing it placed in direct and flagrant contrast with every-day life. Moreover, I modelled the figure without reference to an exposure to rain and frost; so there are many parts of the statue where water would collect and soon disintegrate and rot the stone, if it did not by freezing split off large fragments of the drapery, which, indeed, it would be almost sure to do.

If the statue must be uncovered, I beg leave to say that I by far prefer its actual site to any other in the public grounds. I think it would perish in the open air, but I prefer its perishing where it stands. On the site of the Naval Monument it would be seen to disadvantage from the walk below, and would show most unhappily from the stairs above; besides, that such a place seems to me ill adapted to a representation of Washington. It is a *subordinate* place.

[1] "The great sequence of ages is born anew" (Virgil, *Ecologue*, 4).

In order to show you, my dear sir, how far we are from consistency in relation to expenditures of this kind, I beg you to reflect on the amount expended by Government on colonnades,—mere displays of the pomp of straight shafts of stone. Compare these with the sums voted for art, and you will see how far we are from economy on the one side and true architectural beauty on the other. I do not wish to disparage the public buildings, but I have travelled much, and I know of no capital where larger amounts have been spent with less effect.

The Capitol, with all its faults, is imposing, and the Post-Office is beautiful. I wish to show only that we have learned to vote columns to the tune of hundreds of thousands, while statues seem to us useless luxuries.

Look, I pray you, at the Girard College! I could scarcely believe my eyes when I saw so stupendous a display of material and workmanship covering a few Quaker-looking square rooms. It was like seeing the Pitt diamond on an Indian squaw.

We must not, however, despair. When the literature of the country shall have cut the cord which stretches three thousand miles, when we shall have a theatre of our own, when, in a word, we shall be socially independent of Europe, I am not without a hope that pencils and chisels will be ready to echo in color and marble every noble cry of the American voice.

Debate from the House of Representatives, May 11, 1842, in Niles National Register 12 *(May 21, 1842).*

Mr. *Wise* wished to inquire of the committee who had charge of this statue, whether the pedestal was not, in strictness, a part of the statue?—and whether Mr. Greenough was not bound to complete it as such for the compensation already allowed him?

Mr. *Pendletan* said that the committee had nothing to do with that question. Their sole duty was as to the location of the statue.

Mr. *Wise* said that it was a necessary part of the statue, or it was not; and Mr. Greenough was bound to furnish it as such, or he was not. But Mr. W. had a further inquiry to put, viz: whether the statue itself had yet been formally and officially accepted by the government of the United States?

[Mr. *Pendletan* made the same response as before.]

Mr. W. said he thought that ought to have been a preliminary inquiry, before any thing further was done. Was it the wish of this government that an *image*, a personification such as that, should be erected in the rotundo of the capitol of the U. States, or that a statue of George Washington should be placed there? Mr. W. did not profess to be a man of any taste at all, let alone a man of exquisite taste and judgment in the fine arts; but, speaking as an American citizen, he must say that that was not the conception of George Washington which had any place in his mind.

He had been told, by those who had far higher claims to speak on subjects like this, that to look upon that piece of sculpture made the blood to thrill in one's veins. All Mr. W. could say was, that it never had had any such effect upon him: possibly because he never had looked long enough upon it at any one time. He must confess it had on him much the same effect as it had produced on a gentleman of Maryland, one of the olden time, a gentleman of the old school, who having heard so much said of this statue, mounted his horse and rode a long distance purposely to look at it: having hitched his horse before the capitol, he mounted the steps and entered the rotundo, where, after looking at the statue for a few seconds, turned from it, as he said the father of his country would do, who was the most modest of men. What was it but a plagiarism from the heathen mythology to represent a Christian hero? a Jupiter Tonans, or Jupiter Stator, in place of an American hero and sage? a naked statue of George Washington! of a man

whose skin had probably never been looked upon by any living. It might possibly suit modern Italian taste, but certainly it did not the American taste. Then there was that inscription on the back—"*simulacrum istud.*" A Latin inscription on Washington! Never had there so noble and so just an eulogium been pronounced upon the man as that now common in the mouth of every American: "First in war—first in peace—first in the hearts of his countrymen." That would have been the motto for American ears; and not a Latin inscription, and that bad Latin to boot: yes, bad Latin written in Italy!

Mr. *Wise* said he would vote to spend no more on this statue till he first knew whether it had been accepted by the government.

Mr. *Fillmore* said he presumed there was very little doubt of that.

After some criticisms on the use of the imperfect tense "*faciebat*" for "*fecit,*" Mr. *Wise* said he had submitted a transcript of the entire inscription to one of the most competent critics in this country, who replied that it would not bear examination.

There was scarce one of the specimens of sculpture or painting in the rotundo which had not been dubbed with some disgraceful epithet or been made the subject of some pungent criticism. The Indians, when looking at the representations of their fellow aborigines, had observed with much caustic shrewdness, that the first over the door of entrance, represented the old world coming to the new, and the new welcoming the old and giving it corn; but in the next was the representation of a treaty, in which the white man cheated the Indian! Then came Smith saved by Pocahontas from death; and in the very next panel was Boon murdering two Indians! "We give you corn, you cheat us of our lands: we save your life, you take ours." A pretty faithful history of our dealing with the native tribes! Then as to the painting of the Declaration of Independence, every body remembered John Randolph's nick name of "the shin-piece." And who could forget the bitter criticism of Burgess, on the representation of Boon, "that it very truly represented our dealing with the Indians, for we had not left them even a place to die upon. (The whole ground in that panel being occupied by the body of the Indian already despatched, so that when the other fell it must lie on the body of his countryman.) What would he have said of this statue of Washington?

A countryman, entering the rotundo by the library door, and seeing the back of the statue, would very naturally ask who is this? and looking at the inscription would say to himself *Simul Acrum.* Who is Simul Acrum? [A laugh.] But the next word [*istud*] would tell him. [Increased merriment.] It was offensive. Mr. W's objection to the statue was that it was not American—it was not Christian; it belonged to another age and country. Mr. W. made some remark here about the position of the one hand as if holding up the clouds, a position better suited to "the cloud-compelling Jove," and to the gracious surrender of his sword with the other, which some Irishman had mistaken for a harp. He also very *sharply* criticised the left shin, and seemed no better pleased with the naked feet and the sandals. When standing at right angles to the statue what was the idea it presented? Not that of one seated on a throne—that would not be tolerated here; some had thought it was a garden chair; but Mr. W. should say it was something else that he was sitting on—a throne belonging to an unmentionable temple.

Mr. W. said he knew all this was dangerous ground to take; he was no artist—on the contrary, in works of art he was a perfect ignoramus. [A voice: "never a truer word."] He spoke from the untutored taste of nature and of an American citizen, who had been taught from his cradle to venerate every thing, little or great, which pertained to the greatest man that ever lived. He preferred seeing Washington as Hudon had represented him in the statue in the capitol at Richmond, in a lapelled coat and military boots; with epaulets, and a sword by his side. Per-

sico, the sculptor, had told him this anecdote. When he had visited Richmond he had gone to see the statue. Now Persico, though an Italian, gesticulated with all the extravagance of a Frenchman; and as he stood looking at it in admiration of the beautiful head, expressed by gestures his abhorrence of the dress and figure, and his wish that the head could be cut off and preserved, while the rest was destroyed. A Virginia sentinel, who was always on guard in the space before the statue, seeing a foreigner making signs to show his wish to cut off Washington's head, very unceremoniously stepped up to him, saying: *"There's the door! begone."* So, in regard to this statue of Greenough's, if the head could be preserved, Mr. W. would vote to throw the body into the Potomac, to hide it from the eyes of all the world, lest the world should think that that was this people's conception of their nation's father.

Henry Reed, Arts of Design: An Address before the Art-Union of Philadelphia *(Philadelphia: King and Baird, 1849).*

I remember having seen Greenough's statue of Washington, as it is placed facing the Capital, for the first time in the early morn of a bright spring day. There was no trivial noise—no intrusive criticism to disturb the solemn impression it is fitted to give. The eye seemed to reject all sensations save what came from the unclouded sky and from the spotless marble—a harmony rather than a contrast, and the things of earth had no part in it. In that ideal portraiture the moral of the character—the history of the life in its marvellous integrity and with its perfect consummation, was visible—the one hand laying down, as if at his country's feet, the sheathed sword, and the other pointing to the sky. There was nothing between the finger of that uplifted arm and the highest heavens; and as the imagination of the spectator was thus carried upward, you could not but feel that no cloud of mortal passion had ever dimmed the glory of the character here idealized in marble, and that that soul had risen above the strife of self-will and the tumult of human frailties, into the serene atmosphere of duty and of Christian heroism. Thus is it that the sculptor's genius has its triumph; and casting away the self-hurtful temper of narrow and disputatious criticism, we may render thoughtful gratitude to the moral beauty and power of art.

Alexander H. Everett, "Greenough's Statue of Washington," in Henry T. Tuckerman, A Memorial of Horatio Greenough *(New York: G. P. Putnam, 1853).*

Greenough's great work has surpassed my expectations, high as they were. It is truly sublime. The statue is of colossal grandeur; about twice the size of life. The hero is represented in a sitting posture. A loose drapery covers the lower part of the figure, and is carried up over the right arm, which is extended, with the elbow bent, and the forefinger of the hand pointed upwards. The left arm is stretched out a little above the thigh; and the hand holds a Roman sword reversed. The design of the artist was, of course, to indicate the ascendency of the civic and humane over the military virtues, which distinguished the whole career of Washington, and which form the great glory of his character. It was not intended to bring before the eye the precise circumstance under which he resigned his commission as commander-in-chief. This would have required a standing posture and a modern military costume; and, without an accompanying group of members of Congress, would have been an incomplete work. The sword reversed, and the finger pointed upwards, indicate the moral sentiment, of which the resignation of his commission, as commander-in-chief, was the strongest evidence, without the details, which were inconsistent with the general plan. The face is that of Stuart's portraits modified so as to exhibit the highest point of manly vigor and maturity. Though not corresponding exactly with any of

the existing portraits, it is one of the aspects which the countenance of Washington must necessarily have worn in the course of his progress through life, and is obviously the proper one for the purpose. In expression, the countenance is admirably adjusted to the character of the subject and the intention of the work. It is stamped with dignity, and radiant with benevolence and moral beauty . . .

This magnificent product of genius does not seem to be appreciated at its full value in this metropolis of "the freest and most enlightened people on the globe." I have met with few persons here who have spoken of it in terms of strong or even moderate satisfaction. Every one has some fault to point out, that appears to withdraw his attention entirely from the grandeur and beauty of the whole, which, when they are pressed upon him, he is compelled to acknowledge. One is dissatisfied that the figure is colossal; another that the face is not an exact copy of Stuart's portrait; a third, that the posture is sitting and not standing; a fourth, that there is a want of repose in the general expression; a fifth, that one of the ankles is incorrectly modelled; and so of the rest. Most of these objections proceed, as I have heard them stated, from persons who would think themselves wronged if their sensibility to the grand and beautiful in nature and art were called in question. But how feeble must this quality be in one who can see nothing in so splendid a monument but some trifling real or imaginary fault! I should not blame any one for indicating and insisting on what he might consider as blemishes, if he were also to exhibit a proper feeling for the acknowledged merits of the work: but I almost lose patience when I hear a person, not without some pretensions to good taste, after a visit of an hour to the statue, making no other remark than that one of the ankles is incorrectly modelled; an error which, after a careful examination for the express purpose, I have been wholly unable to discover . . .

The objections above mentioned to the size, attitude, and costume of the statue, and to the character of the features, proceed upon the supposition, that it was the interest of the artist to make the nearest possible approach to the person and countenance of Washington, as represented in the most authentic portraits and statues; and in costume, to the dress that he actually wore. This supposition is obviously an erroneous one. These are matters which have their importance as points of historical information—especially in connexion with a character of so much interest. But the object of the artist, in a work of this kind, is much older than that of satisfying curiosity upon these particulars. It was, as it should have been, his purpose to call forth, in the highest possible degree, the sentiment of the moral sublime, which the contemplation of the character of Washington is fitted to excite. This purpose required such a representation of his person, for instance, as, consistently with truth to nature, would tend most strongly to produce this result. A servile adherence to the existing portraits is not essential to the accomplishment of such a purpose, and might even be directly opposed to it; as, for example, if these had been executed in the early youth or extreme old age of the subject. Still less would it be necessary to preserve the costume of the period, which is already out of fashion, and for every subject, except the satisfaction of antiquarian curiosity, entirely unsuitable for effect in sculpture. The colossal size—the antique costume—the more youthful air of the face— are circumstances which, without materially impairing the truth to nature, increase very much the moral impression, and, instead of furnishing grounds for objection, are positive merits of high importance.

The question between a sitting and a standing posture is substantially the same as whether the subject was to be presented under a civil or a military aspect. In the latter case, a standing

posture would undoubtedly have been preferable. But if the ascendency, given by Washington through his whole career to the virtues of the patriot citizen over the talents of the military chieftain, was the noblest trait in his character, and if it was the duty of the artist to exhibit him, on this occasion, under the circumstances in which he appeared, in real life, to the greatest advantage, then the civil aspect of the subject, and with it the sitting posture, like the other particulars that have been mentioned, instead of being a ground of objection, is a high positive merit . . .

It is rather unpleasant to be compelled, in commenting on this splendid effort of genius, to meet such objections as these, instead of joining in the general expression of mingled admiration and delight which it ought to elicit from the whole public. I make no pretensions to connoisseurship in the art of sculpture, and judge of the merit of the work merely by the impression which it makes upon my own mind; but I can say for myself, that after seeing the most celebrated specimens of ancient and modern sculpture to be found in Europe, including the Laocoon and the Apollo Belvidere, with the finest productions of Canova, Thorwaldsen, Sergell, and Chantry, I consider the Washington of Greenough as superior to any of them, and as the master-piece of the art. The hint seems to have been taken from the Olympian Jupiter of Phidias, who said himself that he had caught the inspiration under which he conceived the plan of that great glory of ancient sculpture, from a passage in the Iliad. In this way the noble work of Greenough connects itself, by the legitimate filiation of kindred genius, transmitting its magnetic impulses through the long lines of intervening centuries, with the poetry of Homer. The vast dimensions of the Jupiter of Phidias may have made it to the eye a more imposing and majestic monument; but if the voluntary submission of transcendent power to the moral law of duty be, as it certainly is, a more sublime spectacle than any positive exercise of the same power over inferior natures, then the subject of the American sculptor is more truly divine than that of his illustrious prototype in Greece. When Jupiter shakes Olympus with his nod, the imagination is affected by a grand display of energy, but the heart remains untouched. When Washington, with an empire in his grasp, resigns his sword to the President of Congress, admiration of his great intellectual power is mingled with the deepest emotions of delightful sympathy, and we involuntarily exclaim with one of the characters in a scene of much less importance, as depicted by an elegant female writer: "There spoke the true thing; now my own heart is satisfied."

LOBBYING FOR CAPITOL COMMISSIONS

Although John Trumbull, who painted the first four Capitol rotunda paintings, lobbied to be given the commission for the remaining four wall spaces, he was disappointed in his request. Samuel F. B. Morse also made an unsuccessful bid to Congress in an 1834 letter, below. (Morse was reportedly passed over because of antipathy from ex-president John Quincy Adams.)

Instead, after a few false starts and much politicking, the paintings were assigned to John Chapman, William Powell, John Vanderlyn, and Robert Weir. Congress directed that the artists choose subjects depicting "any important events, civil or military, connected with the discovery of the western continent, the discovery and settlement of the colonies which now compose the United States of America, the separation of those colonies from Great Britain, or with the history of the United States up to the time of the

adoption of the federal constitution." Powell received his order in 1847—later than the others—after the death of Henry Inman, who had originally been allocated one of the paintings. Before Powell had been selected, Asher B. Durand and twenty-three other artists and patrons lobbied Congress on behalf of Morse. Their petition rehearses Morse's qualifications, and in retrospect it can be seen as a last-ditch (and unsuccessful) effort to bring the inventor of the telegraph back to the world of the fine arts.

Passed over yet again by Congress, Morse writes to James Fenimore Cooper that he has lost all interest in painting. Ruefully conceding that his ideal of the profession has always been "too exalted," Morse despairs of the American cultural climate as well as (implicitly) the political culture that offers such meager support to native talent.

Emanuel Leutze did not receive a rotunda commission either, but he would ultimately paint a large fresco in the Capitol, in the west staircase of the House of Representatives: Westward the Course of Empire Takes Its Way *(1861–62) (see also "The American Spirit of Emanuel Leutze," chapter 6). The supportive remarks of Senator James Cooper of Pennsylvania indicate that Leutze had been seeking a Capitol commission for at least a decade before he executed the fresco. They also suggest that he, along with his fellow artist George Healy, had correctly gauged the nationalistic themes that would be necessary to be considered for government work. Sculptor Henry Kirke Brown, in his letter to Montgomery Meigs, the "Captain of Engineers in Charge" at the Capitol, similarly shows himself to be a master of thoughtful and persuasively nationalistic language, though his proposal for a sculptural program for the pediment on the Senate side of the building was not, in the end, viewed favorably by Meigs; he received no commission.*

Samuel F. B. Morse to Member of Congress, March 7, 1834, Samuel F. B. Morse Papers, Library of Congress.

I perceive that the Library Committee have before them the consideration of a resolution on the expediency of employing four artists to paint the remaining four pictures in the Rotunda of the Capitol. If Congress should pass a resolution in favor of the measure, I should esteem it a great honor to be selected as one of the artists.

I have devoted twenty years of my life, of which seven were passed in England, France, and Italy, studying with special reference to the execution of works of the kind proposed, and I must refer to my professional life and character in proof of my ability to do honor to the commission and to the country.

May I take the liberty to ask for myself your favorable recommendation to those in Congress who have the disposal of the commissions?

Petition on behalf of Samuel F. B. Morse to be commissioned to execute a painting in the Capitol rotunda, May 1846, in Charles Fairman, Art and Artists of the Capitol of the United States of America *(Washington, D.C.: U.S. Government Printing Office, 1927).*

To the Honorable the Senate of the United States.

The undersigned, the friends of Professor Samuel F. B. Morse, beg leave respectfully to represent:

That Professor Morse, whose early life for thirty years was devoted to the cultivation of the art of painting, studied for four years in the Royal Academy of London, then under the presidency of that distinguished painter, Benjamin West; but Mr. Morse was more especially, while in England, under the tuition, in historical painting, of the late Washington Allston, and was a

fellow pupil under the same master with Leslie, so well known as one of the first painters in England; when he returned to this country, and practiced painting with distinguished success.

In the year 1826, Professor Morse was the principal instrument, aided by other artists, in founding and establishing, at great personal sacrifices, The National Academy of Design, one of the most flourishing of the institutions of the city or State of New York. From its foundation, for nineteen years he was annually unanimously chosen to preside over the academy, and then declined a reelection, from causes which will be presently explained.

In 1829, he again visited Europe to perfect himself in historical painting, having in view to offer himself as a candidate for the commission to paint one of the great historical paintings to be placed in the rotunda of the Capitol, and pursued his studies for three years in Rome, Naples, Florence, Venice, and Paris; and with the common consent of the artists and connoisseurs of this country, it was conceded that this honor would unquestionably be conferred upon him, and for this purpose he had made all the requisite preparation for a painting to represent the germ of the republic. That the committee of Congress, then appointed, (contrary to the universal expectation of those best qualified to judge of the merits of the several candidates,) set aside the claims of Professor Morse, and as an evidence of the sense of injustice which was felt among the profession, we can state that the late eminent and excellent artist, Mr. Inman, wrote President Van Buren a letter, in which he offered to resign the panel which had been assigned to him, expressing the hope that Professor Morse might be appointed to supply his place—a generous offer, which the committee to whom this letter was referred did not think proper to accept. That as a further expression of the sense of the injustice done to Professor Morse, in rejecting his application to be employed as one of the painters, an association was voluntarily formed, of twenty-nine artists and amateurs of New York and Philadelphia, (among whom we note the names of three out of the four successful candidates for these pictures,) who subscribed a sum of money, and appointed a committee of their body to request Professor Morse to paint for them, in small, the picture he had intended to paint for the rotunda, had Congress seen fit to grant him the commission. Although the money was subscribed, the neglect to pay promptly the quarterly installments embarrassed Professor Morse in the progress of painting the picture, and after every effort to proceed, he was reluctantly compelled to abandon the enterprise. He consequently laid aside his pencil, determining to devote himself for a while to pursuits which would furnish him with the means of resuming his picture at a future day; to which determination the country is indebted for the successful establishment of his magnetic telegraph—an invention destined to associate his name in our country's annals with that of Franklin—an invention of which the country may justly be proud—the benefits of which are but beginning to be appreciated and understood.

The death of Mr. Inman now presents an opportunity of securing to the country a painting, which we have no doubt, will form one of the chief ornaments of the Capitol, and also of retrieving the error which refused the commission to an artist to whom the arts of design in our country are so much indebted for his self sacrificing devotion to their interests for so many years.

As the friends of Professor Morse, we beg leave to present to the due consideration of your honorable body his claims for executing the painting of the panel now vacated by the decease of Mr. Inman; claims which we are sure the great body of those whom he has benefited as an artist would sanction.

While Professor Morse will, very probably, (under the circumstances,) not request the commission by any personal solicitation for himself, we are assured that he will accept the commission, if offered to him by Congress.

Samuel F. B. Morse to James Fenimore Cooper, November 20, 1849, Yale Collection of American Literature, Beinecke Rare Book and Manuscript Library.

Alas! My dear sir, the very name of *pictures* produces as sadness of heart I cannot describe. Painting has been a smiling mistress to many, but she has been a cruel jilt to me. I did not abandon her, she abandoned me. I have taken scarcely any interest in painting for many years. Will you believe it? When last in Paris, in 1845, I did not go into the Louvre, nor did I visit a single picture gallery.

I sometimes indulge a vague dream that I may paint again. It is rather the memory of past pleasures, when hope was enticing me onward only to deceive me at last. Except some family portraits, valuable to me from their likenesses only, I could wish that every picture I ever painted was destroyed. I have no wish to be remembered as a painter, for I never was a painter. My ideal of that profession was, perhaps, too exalted—I may say is too exalted. I leave it to others more worthy to fill the niches of art.

Remarks of Senator James Cooper, **Congressional Globe 24** *(April 8, 1852).*

Mr. President, I hold in my hand an application from Mr. Leutze, the distinguished American artist, author of the painting representing 'Washington Crossing the Delaware,' exhibited for the last two or three weeks in the rotunda of the Capitol, and which, I presume, you and most of the Members of this body have seen and admired. The application of Mr. Leutze is addressed to Congress, and proposes to repeat, with such emendations as experience may suggest, the beautiful painting to which I have just referred, together with a fellow to it the subject of which is to be likewise drawn from that portion of American history which represents Washington rallying our retreating troops at the Battle of Monmouth.

I need not state, Mr. President, that subjects better calculated to inspire the genius of the artist, or awaken the patriotism of the American spectator, can hardly be selected. Of the truth of this there is evidence in the painting which the memorial proposes to repeat. Who that has looked upon that admirable picture, and contemplated that majestic form, and composed, yet inflexible, determination which beams from the countenance of the heroic chief, working his perilous way through the ice of the Delaware to reach the enemy and strike a decisive blow for freedom, then almost expiring, has not felt his patriotism stimulated, and the blood flowing in warmer and quicker currents through his veins? And who, in addition to this, has not experienced a just pride in learning that this fine stirring representation of one of the great acts of the drama of our Revolution, was the production of American talent? No one, I am sure, could contemplate this noble picture without experiencing the glow of both of these emotions of patriotism and pride. With the true tact of genius, the artist has seized the turning point in the great struggle for independence—the moment when hope was attending with despair, to present the leader of our armies, upon whom all hopes were concentrated and all eyes turned, in the attitude of striking a great and decisive blow, calculated, if successful, to revive the drooping courage and cheer the fainting hearts of his almost desponding countrymen. It was the critical moment, pregnant with the result of the impending contest, with the hopes of humanity, with the destiny, perhaps of the world. All these hung suspended on the events of the night, and the success of the morning which was to follow it. The event of the crossing of the Delaware was an event more justly memorable than the crossing of the Rubicon. The spirit of all this the artist has caught, and transferred to the canvas with a fidelity and truthfulness which must have struck every beholder . . .

Since the application of Mr. Leutze was placed in my hands, Mr. Healy, an artist of equal

eminence and merit, has expressed his wish to execute for Congress, from subjects connected with our Revolutionary history, two paintings—the subject of one to be 'Throwing Overboard of the Tea in Boston Harbor,' the other 'The Battle of Bunker Hill.'

In the first of these events was contained the germ of the American Revolution. The second will represent the first of the great battles in which our untried troops measured their strength with veterans of England. Both are subjects of deep and lasting interest, well calculated to draw out and develop the highest powers of the artist.

Mr. President, I pretend to no very refined judgment in matters of art; but if I were permitted to express an opinion on the subject, it would be to state that Healy's 'Webster Replying to Hayne in the Senate' and Leutze's 'Washington Crossing the Delaware' are amongst the finest modern historical paintings which I have anywhere seen. Of such artists the country may well entertain a just pride, and if her representatives would but echo her sentiments, they would receive encouragement.

Allow me, sir, one word more. It seems to me that it is the duty, as well as the privilege, of Congress to do something to encourage the development of native talent, in this most attractive and refining branch of art. We have evidence in the pictures of Leutze and Healy, exhibited in this city during the present session of Congress, to prove that American genius, in this branch of the fine arts, needs but scope and encouragement to give it a commanding and enviable reputation. But in this country public taste in this direction has not been sufficiently educated and developed. Congress should, in my judgment, take the initiative and lend its aid. Private fortunes possessed by men of refined taste and judicious liberality are still too rare amongst us to afford either constant or certain encouragement to the artist. There is one individual in this District to whom the friends of art are indebted of an intelligent dispensation of his ample means in collecting a gallery of pictures; and it is to be hoped his example will be followed elsewhere, and by others in similar circumstances. Let others, like him, thus dispose of their abundant means, and they will thereby acquire, as he has done, a just title to the gratitude of the artist and the friends of art wherever they are found.

In other countries the fine arts are objects of the patronage of the Government. They are encouraged, not only for their refining influences, but likewise with a view to the perfection of the useful arts. Schools of painting and design have done much to perfect various branches of manufactures, furnishing patterns for tapestry, brocades, laces, carpets and various kinds of damask and figured fabrics. Heretofore we have been obliged to resort to Europe for designs for all these kinds of articles which are produced by our artisans. But, by encouraging painting and the kindred art of design we would soon cease to be dependent upon Europe for our patterns.

Henry Kirke Brown to Montgomery Meigs, February 12, 1856, in Fairman, Art and Artists of the Capitol.

I have been most vexatiously delayed for the last three weeks in consequence of the failure of my photographer and the very bad weather we have had for printing and am at last compelled to send you very poor impressions of the work, though they may be sufficient to show you the general intention of my design and for you to judge of its capabilities.

You will see by it that my country is no myth in my eyes and that I have had recourse to no unfamiliar symbols to express my idea of it, but have sought the America of today surrounded with the material interests which stimulate her children to action. America occupies the central position in the group extending her blessing and protection alike to all, not merely to her own citizens, but to the poor and distressed foreigner who kneels at her feet on the left. On her right are the anvil, wheel and hammer representative of the mechanic arts. The first standing

figure to the left of America represents a citizen depositing his vote in the ballot box, a very distinguishing feature of our country and the symbol of equal rights. Next to him is the farmer cultivator of the soil, ingenuous and simple resting on his plow with the products of his labor at his feet. Next comes the fisherman seated upon his upturned boat mending his nets. Lastly upon that side is the brave and athletic hunter combating the wild animals. I have placed him upon the outskirt of civilization showing him to be hero of all border strife and hardship.

Upon the other extremity is the Indian trapper in whom I have desired to express that stillness and wariness peculiar to his race. Beside him are his dog, trap and the dead object of his pursuit. He stands for the interests of the fur trade.

Next to him I have introduced the miner, or gold seeker of California with his pick, shovel and pan. Next the American boy, frank and brave, with his little boat which he evidently intends to launch upon the first convenient sheet of water. He is the promise of commerce and navigation, the perpetual renewal of the hope of all. Next the old weather-beaten navigator and discoverer demonstrating with globe and maps the characteristics and resources of the countries he has found and exhibiting a specimen of mineral ore to the statesman, who stands attentively considering his propositions.

My feeling is that all art to become of any national importance or interest must grow out of the feelings and the habits of the people and that we have no need of the symbols or conventionalities of other nations to express ourselves. Our country has a rich and beautiful history to illustrate, full of manliness and grandeur and every American artist should endeavor to infuse into his works all the vitality and national policy in his power that when future generations shall look back upon his work they may see that he has expressed himself with truthfulness and honesty.

I have sought in the general composition of the work in question to produce a fullness and harmony of effect [which] should not be destroyed or rendered little by the massiveness of the building and have avoided all staring projections of arms or of other objects, but have sought the same serious simplicity which characterizes the sculpture itself. In this specific idea of America I have represented my country as showing favoritism to no class, she holds out no prizes to any, but distributes equal blessing to all trades and professions. Further than this the design will show for itself its merits and demerits you will discover. I would be judged by them.

I have sought the true dignity of my country and my art and if you find in what I offer that which is worthy a place in her Capitol I shall be happy with the hope of soon hearing from you.

THE LIBERTY CAP AS A SYMBOL OF SLAVERY

In 1855 sculptor Thomas Crawford was given the commission for the crowning figure on the Capitol dome, a 20-foot bronze Statue of Freedom *(1863). Crawford's original scheme for the figure included the liberty cap, a simple head covering worn by freed slaves in ancient Rome. Earlier, when Crawford was working on a pediment for the east façade of the Capitol, he had also tried to introduce the liberty cap but was overruled by Jefferson Davis, a slaveowner and future president of the Confederacy who was then secretary of war. Davis objected to any reference to liberty for slaves. In Crawford's letter to Montgomery Meigs, the administrator in charge of construction, he anticipates Davis's reaction and makes an argument for the cap on* Freedom *based on historical precedent and the universal recognition of the symbol. Davis, though, would*

have none of it. Although his letter to Meigs seems to defer to the artist, Crawford apparently understood it to be an order. He did away with the cap and substituted the helmet suggested by Davis.

Thomas Crawford to Montgomery Meigs, October 18, 1855, in Henry T. Tuckerman, **Book of the Artists** *(New York: G. P. Putnam and Son, 1867).*

It is quite possible that Mr. Jefferson Davis may, *as upon a former occasion,* object to the cap of Liberty and the fasces. I can only say in reply that the work is for the people, and they must be addressed in language they understand, and which has become unalterable for the masses.

The emblems I allude to can never be replaced by any invention of the artist; all that can be done is to add to them, as I have done, by placing the circlet of stars around the cap of liberty: it thus becomes more picturesque, and nothing of its generally understood signification is lost. I might, did time permit, enter upon a lengthy argument to show how sculpture is limited in the use of accessories, and that those only of the simplest and most intelligible character can be admitted, particularly in works destined for the instruction and gratification of the public. All arguments, however, must reduce themselves into the question: 'Will the people understand it?' I, therefore, hope the Secretary will allow the emblems to 'pass muster.'

I have said the statue represents 'armed Liberty.' She rests upon the shield of our country, the triumph of which is made apparent by the wreath held in the same hand which grasps the shield; in her right hand she holds the sheathed sword, to show the fight is over for the present, but ready for use whenever required. The stars upon her brow indicate her heavenly origin; her position upon the globe represents her protection of the *American* world—the justice of whose cause is made apparent by the emblems supporting it.

Jefferson Davis to Montgomery Meigs, January 15, 1856, in Tuckerman, **Book of the Artists.**

Sir:—The second photograph of the statue with which it is proposed to crown the dome of the Capitol impresses me most favorably. Its general grace and power, striking at first view, has grown on me as I studied its details.

As to the cap, I can only say, without intending to press the objection formerly made, that it seems to me that its history renders it inappropriate to a people who were born free, and would not be enslaved.

The language of art, like all living tongues, is subject to change; thus the bundle of rods, if no longer employed to suggest the functions of the Roman lictor, may lose the symbolic character derived therefrom, and be confined to the rough signification drawn from its other source, the fable teaching the instructive lesson that in union there is strength. But the liberty cap has an established origin in its use as the badge of the freed slave, and though it should have another emblematic meaning to-day, a recurrence to that origin may give to it in the future the same popular acceptation which it had in the past.

Why should not armed Liberty wear a helmet? Her conflict being over, her cause triumphant, as shown by the other emblems of the statue, the visor would be up, so as to permit, as in the photograph, the display of a circle of stars—expressive of endless existence and of heavenly birth.

With these remarks I leave the matter to the judgment of Mr. Crawford; and I need hardly say to you, who know my very high appreciation of him, that I certainly would not venture, on any question of art, to array my opinions against his.

In 1859 President James Buchanan appointed three artists—a sculptor, a portraitist, and a landscape painter—to constitute the United States Art Commission. Their charge was to advise Congress on the decoration of the Capitol building. In their report, the commissioners argued for a sweeping painting program for the rotunda and the chambers of the House and Senate, and they went beyond their mandate to comment upon what was, in their view, the sorry state of U.S. coinage. In the excerpts given here, the artists pluck the strings of nationalism, advocating an emphasis on local subjects, modern American portrait dress, and native artists (as opposed to European artists, whom they denigrate as belonging to "an effete and decayed race"). In a circling of the wagons for professional artists, they also come out against competitions, suggesting that established artists have earned the right to be given direct commissions based on the merits of their previous work. Worried about the cost of the recommendations, Congress did not endorse the report; the commission was subsequently abolished.

Henry K. Brown, James R. Lambdin, and John F. Kensett, Report of United States Art Commission, *February 22, 1860.*

The erection of a great national capitol seldom occurs but once in the life of a nation. The opportunity such an event affords is an important one for the expression of patriotic devotion, and the perpetuation, through the arts of painting and sculpture, of that which is high and noble and held in reverence by the people; and it becomes them, as patriots, to see to it that no taint of falsity is suffered to be transmitted to the future upon the escutcheon of our national honor in its artistic record. A theme so noble and worthy should interest the heart of the whole country, and whether patriot, statesman, or artist, one impulse should govern the whole in dedicating these buildings and grounds to the national honor.

It is presumed to be the wish of government not only to decorate their present buildings in the best possible manner, but to use the opportunity which the occasion affords to protect and develop national art. If there is to be any discrimination between native and foreign artists, the preference should be given to citizens. And our national history, in its application to the decoration of the public buildings, should take precedence of all other subjects.

If this assumption be correct, the money expended by government for the last five or six years for this purpose has been misapplied, with the exception of commissions like those awarded to Crawford and Rogers; for we find but little else which relates to our history, or in which the American mind will ever be interested. The arts afford a strong bond of national sympathy, and when they shall have fulfilled their mission here by giving expression to subjects of national interest, in which the several States shall have been represented, it will be a crowning triumph of our civilization.

Art, like nations, has its heroic history, its refined and manly history, its effeminate and sensuous history—the sure presage of national decay. Our art is just entering upon the first of these planes. Shall we allow it to be supplanted here in its young life by that of an effete and decayed race which in no way represents us? Our pride should revolt at the very idea. We should not forget so soon the homely manners and tastes of our ancestors, and the hardships they endured with undaunted hearts; but it should be our pride to welcome their venerated forms in these buildings and grounds, and surround them with the insignia of a nation's love and homage; and patriotic hearts should perform the noble work . . .

Are our portrait statues, in which the Greek or Roman costume has been substituted for that worn by the individuals represented, satisfactory? Do they not rather convey a feeling of shame for the paucity of invention on the part of the artist, and an acknowledgment that we have sought refuge in stuffs and draperies to conceal our want of power in the expression of character? We want nothing thrown in between us and the facts of our history to estrange us from it. We want to be brought near it, to realize it as an existence, not as a myth. True genius presents us no nightmares, no vagaries; but is clear-seeing, and by its subtleness of perception and power of expression renders truth palpable to duller senses.

We are shown in the Capitol a room in the style of the "Loggia of Raphael;" another in that of Pompeii; a third after the manner of the Baths of Titus; and even in the rooms where American subjects have been attempted, they are so foreign in treatment, so overlaid and subordinated by symbols and impertinent ornaments, that we hardly recognize them. Our chief delight in this survey is in a few nicely painted animals and American birds and plants, in some of the lower halls; and even here one familiar with foreign art sees constantly intermingled the misapplied symbols of a past mythology, but wanting in the exquisite execution and significance of the originals . . .

Few are aware how disturbing to thought the display of gaudy, inharmonious color can be made. Hence its adoption for military uses—as in showy uniforms, painted banners, bright plumes, and scarlet coats—for dramatic and scenic effects, and for all purposes where it is desired to address the senses instead of the intellect. This very quality renders it unsuited to the halls of deliberation, where calm thought and unimpassioned reason are supposed to preside. Great richness of effect may be obtained, and is, perhaps, only to be obtained, by a true sense of the subordination of inferior parts. It is believed that this criticism will hold true in regard to all efforts of the mind. It is always observable in nature, and underlies her universal laws. Color is subject to these laws as well as everything in nature. Bright colors are sparingly distributed throughout the natural world. The white, red, blue, and yellow blossoms of plants, shrubs, and trees are not over prominent even in their season of bloom; while the main masses are made up of cool greens, grays, drabs and browns intermingled, and are always harmonious and agreeable.

In regard to the four great stairways, it is not thought advisable to recommend their permanent decoration at this time, but merely to paint them in simple colors. None but pictures of the highest order should be admitted to places of such prominence. To acquire these, not only time, but the utmost care and deliberation are requisite. There can be no doubt of the ability of our artists to perform this work, but time should be given them for preparation, both in fresco and in oil. Heretofore they have been engaged, with few exceptions, on easel pictures, and it is impossible at once for them to adopt the style required in works of such magnitude . . .

It having been determined to fill the pediments of the eastern porticos with statues, and the statues for one of them having already been executed here in marble, under the direction of the former superintendent, it would be proper to recommend an appropriation for the remaining pediment at any time; but as the progress of the building does not render it important at present, it is deemed advisable to defer it to another year. In connexion with this subject, however, the commissioners feel constrained to add that had it not have been decided to fill these pediments with statues they would have recommended *alto-relievi* for that purpose. Statues must always convey an idea of detachment, as something superadded; while *alto-relievi* form a part of the building, and consequently admit of a treatment more in harmony with it. Various grades of relief are proper in the same work, adding thereby great richness and variety of effect . . .

In expenditures of money for works of art it is important as a wise measure of economy that productions of sufficient merit should be secured to render their future removal or obliteration unnecessary. It is true that governments as well as individuals must purchase their experience in these as in all other matters; but it would seem that the system heretofore pursued in this particular, from its inadequacy to meet the requirements of the age and its falsity as an expression of our artistic development, had been already indulged in with sufficient liberality. Nations have been proud of noble works of art, and even when their power and splendor in other respects have departed, art has stood forth to remind them of their former greatness. For us to flaunt in the borrowed and fragmentary arts of another country, is like the Indian who abandons his native wild dignity and forest dress, and struts through the streets of a city in a cast-off military uniform.

It is believed that the true method of procuring designs for statuary and paintings, as a general principle, is to invite liberal competition, with such regulations as shall secure to every artist an impartial and unbiassed adjudication of his work; but the well-known repugnance of artists of the first rank, who have achieved a national reputation, to compete with each other, would render this a doubtful policy to pursue with them. It is therefore deemed but respectful and proper to award to such artists commissions for works for which their talents and acquirements have fitted them. The commissioners are sustained in this position by the experience and practice of all nations in similar cases.

ART IN PUBLIC

HIRAM POWERS'S THE GREEK SLAVE

The reception of Hiram Powers's marble statue The Greek Slave *(1844) was a rare moment in the history of art, when unprecedented international success occurred at both the popular and elite levels. Not even the artist (who had a healthy sense of his own genius) could have predicted the wide popularity of this image of a modern Greek woman stripped for display in a Turkish slave market. Eventually Powers and his workmen executed six full-length versions, several reduced-scale copies, more than one hundred busts, and some table-top specialty items such as the slave's right foot. In addition, pirating entrepreneurs manufactured countless unauthorized reductions in parian, a porcelaneous material. In Boston, the Southworth and Hawes firm sold elaborate daguerreotypes of the statue, showing her from three different perspectives.*

The Greek Slave debuted in England, in 1845, where it was received with wild enthusiasm—notable for a work by an American artist. In 1847 another version was sent to the United States, where Powers's artist friend Miner K. Kellogg (see "Washington Allston's 'Secret Technique,'" chapter 2) conducted it on a two-year tour. The Greek Slave visited New York, Washington, D.C., Baltimore, Philadelphia, Boston, Cincinnati, Louisville, and New Orleans; in the final city there were actually two marble versions on display, one owned by Powers and the other a previous sale to a local collector. More than 100,000 people paid to view the statue, and receipts totaled nearly $25,000. In the Hiram Powers papers there is a scrapbook that includes two hundred pages of press notices of The Greek Slave *from this tour. Dozens of poems were published in her honor; Protestant ministers devoted sermons to her in various cities. There was also a second American tour of the* Slave, *and it became one of the highlights of the Great*

Exhibition in London (1851). All told, it is estimated that more people saw The Greek
Slave *than any other work of art in the nineteenth century.*

The following collection of texts related to The Greek Slave *is a tiny fraction of the
immense archive of responses to the work. All the press selections here date from the first
American tour. The praise was usually extravagant, but there were also the inevitable
complaints about the statue's nudity and questions about the appropriateness of women
viewing it in the company of men. The composition of the work is quite simple, yet every
detail of the body was obsessively described and analyzed: the arch of the toes, the con-
tour of the thigh, the flesh of the upper arm. The few additional iconographic elements
were similarly parsed: the embroidered cap and fringed clothing laid to one side, the
locket, the cross.* The Greek Slave *also provoked discussion of several social and politi-
cal questions of the day, from the propriety of corsets and tight lacing in women's dress,
to the conflict between Christianity and Islam, to the continuing tragedy of American
slavery.*

*Yet amid the waves of praise there were doubters. Several commented that the
statue was simply a beautiful maiden and no more—the elaborate moral tales and
emotional narratives were in no way suggested by the pared-down forms of the* Slave.
*Others said, in essence, that the emperor had no clothes. Minister Orville Dewey had
famously written that* The Greek Slave *was not* naked *("Brocade, cloth of gold, could
not be a more complete protection than the vesture of holiness in which she stands.");
the* Journal of Commerce *countered in 1847, "We doubt very much whether the spec-
tators generally perceive any such vesture. We certainly did not see it." In the end, the
reign of* The Greek Slave *was not long. Within a few decades, her version of ideal senti-
mentality had passed from fashion, dismissed in 1864, for example, by James J. Jarves
as "a feebly conceived, languid, romantic miss, under no delusion as the quality and
value of her fresh charms."*

Hiram Powers, letter explaining story of The Greek Slave, *in Henry T. Tuckerman,* Book of the Artists
(New York: G. P. Putnam and Son, 1867).

The Slave has been taken from one of the Greek islands by the Turks, in the time of the Greek
revolution; the history of which is familiar to all. Her father and mother, and perhaps all her
kindred, have been destroyed by her foes, and she alone preserved as a treasure too valuable
to be thrown away. She is now among barbarian strangers, under the pressure of a full recol-
lection of the calamitous events which have brought her to her present state; and she stands
exposed to the gaze of the people she abhors, and awaits her fate with intense anxiety, tem-
pered indeed by the support of her reliance upon the goodness of God. Gather all the afflic-
tions together, and add to them the fortitude and resignation of a Christian, and no room
will be left for shame. Such are the circumstances under which the Greek slave is supposed
to stand.

"Powers's Great Statue," New York Tribune, *August 1847, in scrapbook, Hiram Powers Papers, Archives
of American Art.*

We have seen the Greek Slave and were our admiration not justified by the deep enthusiasm
with which it has everywhere been received by the critics no less than by the uncritical, we should
scarcely venture to record it until it had been confirmed by repeated observation and study of
this statue, which we must believe to be the greatest work of modern sculpture. But with our

first impression thus only according with the mature opinions of the best judges, we do not hesitate to attempt some feeble expression of the delight, the joy, as if at a new revelation of the divine treasures of Beauty, the religious elevation of feeling which seem to flow from the marble like inspirations.

The figure is of full size and represents a woman perfectly nude. But in that nakedness she is unapproachable to any mean thought. The very atmosphere she breathes is to her drapery and protection. In her pure, unconscious naturalness, her inward chastity of soul and sweet, womanly dignity, she is more truly clad than a figure of lower character could be though ten times robed. Indeed, no one can feel that anything is wanting, and the longer you gaze the deeper is your sense that so noble an ideal of beauty and of Woman could only thus be seen.

The wrists are fastened together by a chain, and the right hand rests on a low pillar, which is covered with the drapery and cap apparently just said off. The right foot is a little raised, the person being supported on the hand and the left leg. The face is cast down and turned aside in grave, sad and unwilling submission to this necessity of her lot, but still she is not demeaned even in her own estimation. There is too profound and too firm an inner character for that. Though a slave she still retains all the tender heroism of a woman, and patiently confronts her fate. The face is lovely, and more than lovely, in keeping with the whole work. So much we know of it, that it is a face to study and admire more and more . . .

The first thing that impressed us in this statue was its originality. At the first sight you feel that here is a new work made directly from Nature. No other ancient or modern sculptor whose works you know of has produced its prototype. It is no copy of the antique and no piece of routine built after academic rules. It comes fresh from the hand of Genius, just as each true form of living beauty comes fresh from the hand of God. The artist has been in the counsels of Nature and caught the spirit of her works. The secret of his creative power lies in the reality thence imparted to this combination and refinement of many perfections. This reality is surprising; that is not marble but flesh and blood; that cheek must yield to the touch, and you instinctively watch for the heaving of the bosom.

But while the Slave is so admirable in its generals, in all particulars it is no less satisfactory. The perfection of its finish is not its least remarkable feature. Here too, the artist has not feared to learn or to follow the method of Nature. No most delicate skin is more delicate than the surface of his marble, while in the exquisite variety of its undulations and local qualities it rivals life.

"The Greek Slave, by Powers," New York Commercial Advertiser, *August 30, 1847.*

We have to say, then, that we are greatly disappointed by the statue. Not *qua* statue, as a legal friend of ours would say, but as *the* statue or representation indicated by the title. Call it merely the marble image of a perfectly formed woman, chaste as unconsciousness of wrong and the snowy purity of the marble can make it, and we join heartily in any praises it may call forth. But that very unconsciousness of wrong is the defect by which we are disappointed. The attitude does not convey the idea of shrinking with maiden timidity from the rude gaze of an observer; the expression of the features does not tell of a virgin's mortification and distress. To quote the apt and keen remark of a lady, which we overheard at the exhibition room, the maiden seems quite accustomed to standing undraped before company; and probably the fault may be ascribed to the very fact that the living model *was* quite accustomed to that situation.

Take away the chains and call the statue Eve, or a nymph entering the bath, and to our con-

ception it would be perfect. But if the introduction of the chains is necessary to convey the artist's idea, then in our judgment he has not wrought out his idea well.

"The Greek Slave," New York Courier and Enquirer, *August 31, 1847.*

None of the many descriptions which we had heard and read of this statue, gave us any idea of what we were to expect. All were but vague and unmeaning expressions of admiration from which we could gather nothing save that their object was a beautiful woman with her wrists chained. We wondered at this, but having seen the statue, we wonder no longer; its beauty is so pure, so lofty, so sacred, takes such a clinging hold upon the heart and so subdues the whole man, that time must pass before one could speak of its merits in detail without doing violence to the emotions awakened in him; and there are few, we think and hope, of the great number who have already seen this exquisite creation of the chisel who will not sympathise with us in this feeling. We cannot attempt, at present at least, to analyse the impressions which this lovely woman makes upon us, or to indicate in detail the many delicate beauties which go to make up the one great and almost oppressive beauty of her presence.

It is extremely interesting to watch the effect which the statue has upon all who come before it.—Its presence is a magic circle within whose precincts all are held spell-bound and almost speechless. The grey headed man, the youth, the matron and the maid, alike yield themselves to the magic of its power and for many minutes gaze upon it in silent and reverential admiration, and so pure an atmosphere breathes round it that the eye of man beams only with reverent delight, and the cheek of woman glows but with the fullness of emotion, Loud talking men are hushed into a silence at which they themselves wonder, those who come to speak learnedly and utter extacies of dillettanti-ism slink into corners where alone they may silently gaze in pleasing penance for their audacity, and groups of women hover together as if to seek protection from the power of their own sex's beauty.

Puritas, "Powers's Greek Slave," **New York Commercial Advertiser,** *in scrapbook (n.d.),* **Hiram Powers Papers,** *Archives of American Art.*

Attracted by the praises bestowed upon this beautiful work of the chisel, I stepped in to gratify my curiosity, and participate in the intellectual enjoyment promised by so admirable a specimen of the noble art of statuary. Of course I was aware that the figure appeared wholly unclothed by any drapery, and in simple nudity. On entering the chamber of exhibition I found it filled with a goodly company of ladies and gentlemen, conversing in whispers, and gazing in silent admiration upon the unveiled beauty before us.—Now, while I detest prudery, justly so called, I could not divest myself of the feeling of the indelicacy of youthful spectators of both sexes gazing simultaneously upon unveiled charms, which from childhood I had been taught to consider unsuited to exposure to the common eye. It seemed to me (to descend in my illustration) that if it would be deemed highly indelicate to introduce into an assemblage of young persons of both sexes a naked sleeping infant, although pure as the statue, it could not do otherwise than tend to injure the fine delicate feelings of a youthful maiden, to find herself, in company with a young man, in the presence of a naked female statue.

Now whether this feeling be defensible in the eye of an artist or not, I hope the ground of it will ever distinguish American females, and I believe I may say I do know that very many, who would like to see the statue, will not do so unless in female company alone. I do therefore hope the curator will make an arrangement by which a day may be set apart in each week, when a fe-

male may be in attendance and none but females be admitted. And moreover I am sure it will prove a beneficial step to the owner in a pecuniary point of view.

Orville Dewey, "*Powers' Statues,*" Union Magazine of Literature and Art 1 (October 1847).

The Greek Slave is clothed all over with sentiment; sheltered, protected by it from every profane eye. Brocade, cloth of gold, could not be a more complete protection than the vesture of holiness in which she stands. For what does she stand there? To be sold; to be sold to a Turkish harem! A perilous position to be chosen by an artist of high and virtuous intent! A perilous point for the artist, being a good man, to compass. What is it? The highest point in all art. To make the spiritual reign over the corporeal; to sink form in ideality; in this particular case, to make the appeal to the soul entirely control the appeal to sense; to make the exposure of this beautiful creature foil the base intent for which it is made; to create a loveliness such that it charms every eye, and yet that has no value for the slave-market, that has no more place there than if it were the loveliness of infancy; nay, that repels, chills, disarms the taste that would buy. And how complete is the success! I would fain assemble all the licentiousness in the world around this statue, to be instructed, rebuked, disarmed, converted to purity by it! There stands the Greek Girl in the slave-market, with a charm as winning as the eye ever beheld, and every sympathy of the beholder is enlisted for the preservation of her sanctity; every feeling of the beholder is ready to execrate and curse the wretch that could buy such a creature! There she stands, with a form less voluptuous than the Venus de' Medici, but if possible more beautiful to my eye; manacles clasp her wrists and a chain unites them; her head is turned aside a little; and then her face—I cannot describe it—I can only say that there is the finest imaginable union of intellectual beauty, touching sadness, and in the upper lip, the slightest possible curl, just enough to express mingled disdain and resignation. The thought of a fate seems to be in her face, and perhaps nothing could better bring to its climax the touching appeal of innocence and helplessness.

I will only add, that Mr. Powers' work seems to me to be characterized by a most remarkable simplicity and chasteness. Nature is his guide, to the very letter. No extravagance, no straining after effect, no exaggeration to make things more beautiful; all is calm, sweet, simple nature.

"*The Greek Slave,*" Christian Inquirer 1 (October 9, 1847).

After thousands of our countrymen from north, south, east, and west have thronged to see the statue, and gazed upon it with the purest, most elevating, and completely respecting delight, a question is raised as to the propriety of the exhibition; and that not by the religious papers, which are naturally the first to take alarm, but by others. So wide a departure from the common course of things, cannot but excite some surprise and suspicion. Crowds of ladies, and clergymen of all denominations; people from the least educated portions of the country, as well as those who have been abroad, would never have looked at the statue for hours without a misgiving, if there had not been about it something which redeemed and sanctified it, leaving an impression which was felt to be anything but deleterious. This, however, is a question which we leave to be debated by those who may entertain doubts on the subject. We will only observe that we are not of such as believe things which are proper abroad, may yet be improper at home; and while similar exhibitions form part of every day's highest improvement with the very best of our countrymen traveling in Europe, we shall ever regret that an attempt has been made to mar the pleasure which the many who cannot travel may receive from this first opportunity to behold a work of the highest art in sculpture.

For ourselves, we have something else to say about the result of viewing the Greek Slave. We are disposed to ask for some permanent moral effect from so exquisite a production. If it ministered to nothing higher than that passionate love of the beautiful which lives in every human heart, it would not be without value; but this we hold to be impossible. Whatever excites emotion—calls up memory—causes the heart to question itself—fills the eye with unbidden tears—makes for itself a shrine in the thoughts, and dwells there in spite of the turmoil of common life—must have a moral effect. This we believe to be the case with the statue; but we would ask some little examination of that effect. Does it evaporate in good but vain aspirations? Do we gaze on that noble brow, whose strength is yet feminine, and that cheek which we feel to be pallid with suffering, anxiety, shame, and fear—without learning respect for all misfortune, tender pity for all suffering, indignation against all wrong? Is the heart made better by the sadness of that sweet countenance? Do we feel, in sympathy with the trembling modesty of the whole figure, how precious a thing is modesty—how odious the brute force which dares to violate and agonize it? So godlike a creature subjected to irresponsible power, suggests lessons which it would take a volume to write out completely; but do we learn them?

A yet deeper moral is there, for Americans, in the leading idea of this statue. It is an impersonation of SLAVERY. This creature, exhibited for sale in the slave market, is a counterpart of thousands of living women. Every day does our own sister city of New Orleans witness similar exposures, with a similar purpose. Let no one keep down the natural promptings of his indignation by the notion of wooly heads and black skins. Let him rather read the advertisements of these sales, and see what qualities are insisted upon by the salesmen. Let him not shut his eyes and his heart to the fact, that many who meet this fate are the daughters of white men, daughters brought up in luxury, and taught to expect fortune. Let him not ignore the fact that white skins, fair hair, delicate beauty, often enhance the market value of his countrywomen thus exposed for sale; and if the idea of a coarse outside would render him callous to the moral wrong of such practices, let him correct his impressions as to the reality, by some inquiry into the damning truth. Let him go to the spot; witness the tears, the agony, the shame, the despair; let him count the suicides that are no uncommon result; let him follow the more patient into the degradation and misery that awaits them. Let him go still further, and see the victim, after youth and beauty are gone, torn again from luxury, placed again on the stand, to have her teeth examined, her muscles tested, her paces tried, in order to prove her remaining fitness for hard labor in the cotton field!

Does the soul sicken at the thought? Oh that it would sicken, until to cast out such abominations from among us would be the burning desire of every man and woman in the land! Would that the Greek Slave, as she passes through various portions of our country, might be endowed with power to teach, to arouse, to purify public opinion. None need fear to look upon the icy chill of her despair. No tragic passionateness derogates from the chaste and patient dignity of her aspect.

"The Greek Slave," Western Continent, *April 22, 1848.*

Reader, have you seen the Power's great master piece? If not, suffer us to entreat you to go at once and feast your eyes upon a statue of rare and delicate beauty. At first, it may be, you will feel disappointed, because you have heard so much said about it, but look at it for a time, and the beauty of the figure, the symmetry of the artist's chaste conception thus, embodied and externalized in white, pure marble, will gradually sink into your heart, and you will pronounce it one of the loveliest things your eyes have ever rested on.

So much has already been said in reference to this great piece of sculpture, that it seems almost superfluous in us to attempt to add another paragraph to the volumes which have been written, and yet we cannot refrain from contributing our mite of praise. To look at the figure aright, you must transport yourself in imagination to the bazaar of Constantinople, and fancy the satellites of despotic pleasure gathered to purchase rare beauty for their imperious masters. This lovely creature is placed before them, her delicate form laid bare to their brutal gaze. Her laced tunic is thrown over a post on which her right hand rests and lends her partial support. Her head is turned aside and slightly bent downwards, and her body is very near erect. The manacles upon those beautiful wrists complete the story of her situation, and appeal powerfully to our sympathies.

At first sight the face does not seem to belong to one in her situation. It is exquisitely beautiful, and appears too tranquil for a young female so heinously insulted. There is no strong emotion, no indignation, no consciousness of the depth of her degradation. Neither is there the dull stagnation, the cold lethargy of feeling that results from despair. Nor can we trace there anything like a bold effrontery and indifference to her great misfortune; she wears, on the contrary, an expression of genuine maidenly modesty and of real heartfelt grief. She seems to us to have lost all consciousness of her present condition, and to be thinking of something far away from the scene before her—perhaps of her old father, and the lover dearer than life, who lie unburied among the ashes of her far home, which she is destined, alas! never to see again. This deep, silent sorrow overpowers every other feeling, so that in its engrossing interest even the rude gaze of her brutal purchasers is forgotten. So completely is her mind absorbed by it, that she actually does not know that she stands denuded in the public market place and chaffered for like a beast of burden. Such, at least, appears to us to be the solution of what at first struck us painfully as a great incongruity.

THE PUBLIC DISPLAY OF THE NUDE

Early American attacks on the nude in art often dwelt on the "heathen," anti-Christian images depicted. However, the following passage condemning two Claude Marie Dubufe paintings, The Temptation *and* The Expulsion, *indicates that even biblical subjects were not insurance against moral censure. (Dubufe's paintings toured the eastern seaboard for several years in the early 1830s.) As with so many complaints against "immorality," the author here takes particular pleasure in describing the canvases that "heave with passions." Believing, perhaps, that such arguments are best made with exaggeration, the imaginative critic conjures a room with thousands of nude pictures viewed by a jostling crowd of men and women. This fantasy (not included here) also features, oddly enough, a full-length portrait of a naked Napoleon.*

"The Fine Arts," New-York Mirror, June 1, 1833.

"The two grand moral paintings, the Temptation of Adam and Eve, and the Expulsion from Paradise, painted by Dubufe. Lately exhibited in this city, to the universal admiration of twenty-five thousand persons. These paintings have been acknowledged the finest productions of the French school. Perfectly chaste and beautiful in conception, they unite the force and power of truth to that of poetic energy; and cannot fail to make a deep impression on the mind of every beholder."
—Vide advertisement

Since these two celebrated paintings are removed (we trust, forever) from our city, we can speak fully and freely on their character and tendency, without incurring even the trivial imputation of a desire to injure the pocket of their proprietor: other imputation we defy, as our sole motive is to subserve the cause of virtue.

A depreciated and debased tone of moral sentiment is in no way more surely indicated than in the objects with which its possessor chooses to be conversant. At least it is true, affirmatively, that one who habitually seeks scenes of indecency (whether gross in their coarseness, or luxurious in their elegance) either is wanting in moral perception, or sees through a depraved medium. Gross immorality, fortunately, can scarcely find any one so abandoned, so lost to shame, as openly to advocate its cause. But it is not very unusual to see the power of genius and the elegance of art unite to adorn a subject which, seen aright, would shock all the better portions of society: and thus it may often happen that the community needs a word of warning, or a sentence of rebuke, from some one who is willing to strip vice of its adornment, or to say that indecency, beautified though it be, is indecency still.

There is nothing abstract in this. The paintings of which we speak, in addition to their wantonness, are splendid in licentiousness, which aggravates the offence against public morals by attempting to make voluptuousness "lord of the ascendant" in the realm of fashion, and a welcome companion in the circles of taste: and *now*, forsooth! not to be indelicate, is fastidious; and to stop short of stripping the last, thin covering from the human form, "*puritanical!*" How is it that our citizens are thus enamoured of *primitive nakedness?* And in what school of glittering iniquity did they first learn to pronounce eulogium on the artist whose pencil could "round the swelling muscles," and cause the canvas to glow with the tints and heave with the passions of denuded flesh? Or is this propensity to admire what is abominable unlearned, innate, a deep-seated "leprosy of soul," now breaking forth in its might to keep pace with the *refinement of the age?*

GEORGE TEMPLETON STRONG VISITS THE NATIONAL ACADEMY

George Templeton Strong, a graduate of Columbia College in 1838, followed a legal career in New York City, although today he is much better known for the urbane, monumental diary he kept for four decades. Strong was interested in art, literature, and music, and his entries are a fascinating, opinionated look at the New York cultural scene. In the following two entries written in his early twenties, Strong reports on his visit to the annual exhibitions of the National Academy of Design. His observations about portrait and history painting are humorous, displaying a caustic sarcasm not usually seen from the antebellum elite.

George Templeton Strong, diary, New-York Historical Society.

[*May 26, 1841*]

Warm and showery. The Quakers are holding their yearly meeting, so we shall probably have a week of rain . . .

Went to the Academy of Design with Anthon. A great crowd. Certainly the public can't be accused of neglecting the arts when they throng to such a collection of ugly faces. Scarce anything there but portraits—and one or two are rather pretty ones. Generally they're terrible; there's quite a collection of infants and they all look like foetuses—one would think hydro-

cephalus epidemic. One of Huntington's (*Mercy's Dream*) is really about the best in the collection, and that's not saying much. Cole and Mount have pictures there but they're below par.

I'd go on hands and knees out to Harlem to see the original of one portrait there—it is a most exquisite thing—but, alas, I never saw an original yet half so good-looking as her likeness. The Daguerreotype is the only limner that doesn't flatter.

[April 28, 1842]

Went to the Academy of Design last night. It's a queer collection. It forms a distinct and well-defined species of monomania, the insane longing that ugly people have to publish their ugliness at these exhibitions. There are not more than three or four decent portraits in the whole concern, but two of them are beautiful enough to redeem the rest, if that be possible. Should like to enjoy the pleasure of seeing the originals, as Sam Weller did the original that Dodson & Fogg sent him. One or two pretty landscapes. One grand historical piece—don't know what it is—but it's either Judith and Holofernes, Richard the first and Berengaria, Don Juan and Haidee, Sir Otto von Franksaugen and Bertha von Lichenried, or Hagar and Ishmael, or Jael and Sisera, or Diana and Endymion, or Saul and the Witch of Endor, or a fancy family piece—Mr. and Mrs. Snooks, or something else. It's an extraordinary production. Then there's an attempt at an Ascension—all red draperies, light, and all quite uniform, except some dark indigo clouds—and one gamboge cherubim. Also the "Marriage of Pocahontas," very extraordinary; the bride's absolutely indecent, and the costumes of the civilized and the hides of the uncivilized are of a consistent, yellow-jaundiced, dirty orange color. Three great Sagamores roosting on a cross beam up in one corner have a grand effect; one's sympathies are so excited in thinking how they'll get down.

TOO MANY PORTRAITS?

Portraiture was the mainstay of American art before the nineteenth century, and even in the early 1800s dozens of portraits typically clogged the galleries of annual exhibitions of the National Academy of Design. The same was apparently true of American residences, as the early critic John Neal wrote in 1829: "Our head-makers are without number . . . You can hardly open the door of a best-room any where, without surprizing, or being surprized by, the picture of somebody, plastered to the wall and staring at you with both eyes and a bunch of flowers." By the middle decades of the century, however, some viewers had had enough. In these three reviews of National Academy exhibitions, critics take issue with the propriety of displaying portraits of average citizens in public and the tendency of portrait artists either to err on the side of literalism or to indulge in overly romantic costuming. In the final essay, the author suggests that painted portraiture might be elevated above photography through two seemingly contradictory approaches: either strip the image down to a head and a cool gray background, with no narrative superfluities, or give thoughtful consideration to the setting and objects surrounding the person as a means of revealing character and intellect.

"The Fine Arts," New York Herald, April 19, 1848.

The collection this year is as large as usual, but the first impression of the visitor is the unpleasant one of seeing so many portraits. Turn which way he may, common-place faces, painted in a

common-place manner, glare upon him, till he is sick of the sight. Old age, middle age, and youth, the decrepid, the homely, the passable, throng the walls; the smirking girl who has been told that she is beautiful, till she really believes it, looks out upon you with an air of impudence, which is intended for archness; old men who have been told that they have a venerable and dignified appearance, like "General Washington" or "Chief Justice Marshall," and believed it; young men, who have cherished the idea that they possess a most uncommon look of intellectual ability; old ladies who have supposed that they resembled the matrons of Sparta, or Rome, or the mothers of the heroes of the revolution, are all there, and though there are a few good portraits, which the student may study to advantage, yet this host of unwelcome faces peep out upon you from every corner, and call you to make oath to their glorious qualities whether you will or no; and, as if this were not enough, children in red, blue and yellow drapery, and in every possible and impossible attitude, turn up their round eyes upon you, and being the favorites of *their* parents, challenge your admiration also. What on earth can be the motive of people, who are themselves of no consequence to the public, to put their resemblances out for the public gaze, we never could imagine. Portraits of noted warriors, statesmen, literary men, &c, are interesting to the public, and there is a propriety in placing them in a public hall for exhibition, but in the other case it must arise from a miserable vanity on the part of the originals of the pictures, and of the artists who produce them.

"The Fine Arts," New-York Daily Tribune, *June 21, 1851.*

The multitude of Portraits is always the reproach of exhibitions of Painting. The objection, however lies not against the quantity but the quality. Titian, Tintoret, Rubens and Vandyck are names large enough to cover and to consecrate any number of good works of this kind. A portrait well managed is one of the finest of pictures. A portrait in which the suggestion of individual nature and character is adequately expressed is a picture of exhaustless interest. Portrait implies, however, a peculiar power and organization in the artist. Not the most masterly manipulation or the most striking likeness, whether of countenance or of costume, suffice to a fine portrait.

Portrait Painting is a branch of the highest art and not a department of Daguerreotype or of wax work. It is not the fixed permanence of a transient mood nor the *"pleasantest expression,"* nor the [illegible] wrinkles and bottle nose or the complexion creamy as a rose-leaf's texture. It is a representation of the general impression made by the subject upon the appreciating mind of the artist. Hence no artist can be a successful Portrait Painter who has not a fine instinct of character, nor can any spectator be a judge of a portrait, considered as a work of art, who has not the same delicacy of perception. The universal feeling of friends respecting any individual portrait illustrates this principle. Rarely is a husband satisfied with the picture of his wife, rarely a child with that of the parent. It is because they do not themselves know what is the essential character of the person they love, or because the artist has failed to perceive it. The portrait which satisfies universally is one of Daguerrean exactness of detail to the crumpled shirt-bosom and the single hairs. But that is the simple satisfaction of imitation like the reflection in a mirror or the plastic precision of wax-work. Such a portrait is not necessarily a work of art, and of course does not fall within the limits of genuine artistic criticism . . .

In portrait the person must show as he appears to the mind, not as he looks to the eye. We do not want Terpsichore asleep or reposing, nor do we insist upon Washington's bag-wig and knee buckles. And if this is true of Costume, as it undoubtedly is, how much truer is it of that which is costumed and which lends to dress what character it has. We do not care to see Benjamin Franklin in a Roman toga, nor our Mothers and Sisters draped as Grecian dames. There

are proprieties of treatment which suggest themselves to the same instinct which fits the Portrait Painter for his task. The perception of the due relation of costume to character is implied is genuine artistic genius. To hang the Druidical drapery of Norma upon the form of a lovely lady of New-York who under no circumstances would go into a wood alone at midnight to sing heathen hymns to the Moon, is quite as absurd as to rage against a statue of Washington because there are no brass buttons or lace cravat upon it.

"Exhibition of the National Academy," Crayon 3 *(May 1856).*

We regret the poor esteem in which portraiture seems to be held by our artists, even those of them who follow it professedly as their peculiar branch of art. There is painfully evident, a want of earnestness with regard to it, and a feeling that the only outlet a portrait painter can have for his *genius,* should he have any, is in painting aimless fancy pictures, in which, by certain licenses of departure from the simple truth of the subject, he may substitute attractiveness in color and "composition" in the picture, for sterling qualities of mind and severe perception of truth, in himself. A portrait is almost universally regarded as a kind of work which must be done from a disagreeable necessity to earn one's bread, and when it is successful in the great point of giving a likeness, it is pushed off with as little regard as may be for anything else. A background is brushed in of some color which will foil the flesh color effectually, smeared in, never so rudely and paintily, senselessly blended masses of greys and browns, relieving the head by violent and artificial contrasts—draperies are produced with the slightest possible trouble, and the thing is done—a sketch of a head with the remaining inches of the canvas covered "somehow this way"—not a work of art, only a kind of conventionalized phototype—just what the artists saw without taking more trouble to see further than a camera would, if it had nerves.

Now, if without a life's experience in painting portraits, we might venture on a few suggestions as to the true way of doing these things, we should say that there are two ways of treating a head, and making it thereby a work of art—the simpler, and to our mind, preferable one, where pure portraiture is demanded, is by giving the portrait a grey monotoned background, as aerial in quality as is possible, and thus relieving the head by space, simply as though we saw it against a dark, deep recess; the draperies simple, correct and severely realized, with no superfluous accessories, and above all, without any of the affection of "avoiding the air of a portrait." Why deny that of which the work itself, by its very existence, is a testimony? The subject sits himself or herself down to be studied and painted, and the business of the artist is to study the character of the face before him, and to render it on canvas with his utmost consciousness: feeling that it is his highest purpose to tell the deepest and most earnest, as well as noblest, story he can and recorded in the lines and colors he sees, and not to think how he shall give the impression that his subject was unconscious of his being the object of study . . .

But the other method in which we would admit that the artist may make his art enhance the value of his works over mere photography, is in so placing and surrounding his subject, that the situation and surroundings shall be significant of the character of the individual. Merely to place the person in a landscape or in a furnished parlor, and paint those accessories well, is only a more complete phase of phototype portraiture; but to place the subject in the midst of an objective which proclaims his sympathy, avocation, or his moral and intellectual qualities, is the work of a thoughtful and poetic mind. It may seem a severe requirement to bring all portrait painters to this standard—it may be impossible with most of them; but the standard is no less true, and to be insisted on as the essential condition of rank as a great portraitist, that one of these two methods shall be regarded.

Born in New York City in 1843, writer Henry James would later move to Europe and embrace continental culture, leaving him immune to the charms of much American painting (see "Damnable Ugly: Henry James on Homer," chapter 8). As a boy, however, he was smitten by the antebellum artistic spectacle that was readily accessible to him on Broadway, just blocks from his home on Washington Square. In this reminiscence, he recreates his wide-eyed reaction to the spit and polish of the Düsseldorf school, the dramatic forms of Emanuel Leutze's Washington Crossing the Delaware *(1850) under gaslight, the riches of Thomas J. Bryan's collection of 250 old master paintings, and the constant inspiration of a large Italian view by Thomas Cole that hung in his home.*

Henry James, A Small Boy and Others *(New York: Charles Scribner's Sons, 1913).*

Ineffable, unsurpassable those hours of initiation which the Broadway of the 'fifties had been, when all was said, so adequate to supply. If one wanted pictures there *were* pictures, as large, I seem to remember, as the side of a house, and of a bravery of colour and lustre of surface that I was never afterwards to see surpassed. We were shown without doubt, under our genial law here too, everything there was, and as I cast up the items I wonder, I confess, what ampler fare we could have dealt with. The Düsseldorf school commanded the market, and I think of its exhibition as firmly seated, going on from year to year—New York, judging now to such another tune, must have been a brave patron of that manufacture; I believe that scandal even was on occasion not evaded, rather was boldly invoked, though of what particular sacrifices to the pure plastic or undraped shocks to bourgeois prejudice the comfortable German genius of that period may have been capable history has kept no record. New accessions, at any rate, vividly new ones, in which the freshness and brightness of the paint, particularly lustrous in our copious light, enhanced from time to time the show, which I have the sense of our thus repeatedly and earnestly visiting and which comes back to me with some vagueness as installed in a disaffected church, where gothic excrescences and an ecclesiastical roof of a mild order helped the importance. No impression here, however, was half so momentous as that of the epoch-making masterpiece of Mr. Leutze, which showed us Washington crossing the Delaware in a wondrous flare of projected gaslight and with the effect of a revelation to my young sight of the capacity of accessories to "stand out." I live again in the thrill of that evening—which was the greater of course for my feeling it, in my parents' company, when I should otherwise have been in bed. We went down, after dinner, in the Fourteenth Street stage, quite as if going to the theatre; the scene of exhibition was near the Stuyvesant Institute (a circumstance stirring up somehow a swarm of associations, echoes probably of lectures discussed at home, yet at which my attendance had doubtless conveniently lapsed,) but Mr. Leutze's drama left behind any paler proscenium. We gaped responsive to every item, lost in the marvel of the wintry light, of the sharpness of the ice-blocks, of the sickness of the sick soldier, of the protrusion of the minor objects, that of the strands of the rope and the nails of the boots, that, I say, on the part of everything, of its determined purpose of standing out; but that, above all, of the profiled national hero's purpose, as might be said, of standing *up,* as much as possible, even indeed of doing it almost on one leg, in such difficulties, and successfully balancing. So memorable was that evening to remain for me that nothing could be more strange, in connection with it, than the illustration by the admired work, on its in after years again coming before me, of the cold cruelty with which time may turn and devour its children. The picture, more or less entombed in its relegation, was

lividly dead—and that was bad enough. But half the substance of one's youth seemed buried with it. There were other pictorial evenings, I may add, not all of which had the thrill. Deep the disappointment, on my own part, I remember, at Bryan's Gallery of Christian Art, to which also, as for great emotions, we had taken the omnibus after dinner. It cast a chill, this collection of worm-eaten diptychs and triptychs, of angular saints and seraphs, of black Madonnas and obscure Bambinos, of such marked and approved "primitives" as had never yet been shipped to our shores. Mr. Bryan's shipment was presently to fall, I believe, under grave suspicion, was to undergo in fact fatal exposure; but it appealed at the moment in apparent good faith, and I have not forgotten how, conscious that it was fresh from Europe—"fresh" was beautiful in the connection!—I felt that my yearning should all have gone out to it. With that inconsequence to handle I doubt whether I proclaimed that it bored me—any more than I have ever noted till now that it made me begin badly with Christian art. I like to think that the collection consisted without abatement of frauds and "fakes" and that if these had been honest things my perception wouldn't so have slumbered; yet the principle of interest had been somehow compromised, and I think I have never since stood before a real Primitive, a primitive of the primitives, without having first to shake off the grey mantle of that night. The main disconcertment had been its ugly twist to the name of Italy, already sweet to me for all its dimness—even could dimness have prevailed in my felt measure of the pictorial testimony of home, testimony that dropped for us from the ample canvas of Mr. Cole, "the American Turner," which covered half a side of our front parlour, and in which, though not an object represented in it began to stand out after the manner of Mr. Leutze, I could always lose myself as soon as look. It depicted Florence from one of the neighbouring hills—I have often since wondered which, the picture being long ago lost to our sight; Florence with her domes and towers and old walls, the old walls Mr. Cole had engaged for, but which I was ruefully to miss on coming to know and love the place in after years. Then it was I felt how long before my attachment had started on its course—that closer vision was no beginning, it only took up the tale; just as it comes to me again to-day, at the end of time, that the contemplative monk seated on a terrace in the foreground, a constant friend of my childhood, must have been of the convent of San Miniato, which gives me the site from which the painter wrought.

POPULAR ART, EDIFICATION, AND ENTERTAINMENT

RESPONSES TO THE DAGUERREOTYPE

For artists and laymen alike, the invention of the daguerreotype, the first widely disseminated photographic process, abruptly challenged the prevailing visual habits of mind and changed forever the nature of representation. Artist Samuel F. B. Morse happened to be traveling to Paris with his telegraph invention in the spring of 1839 when he made contact with Louis-Jacques-Mandé Daguerre and brought back news of the discovery to America. With instructions from Daguerre, he constructed his own apparatus and took the first photograph in the United States, a view of the Church of the Messiah, on Broadway in New York City. Morse did not see photography as a threat to painting, as he indicates in a speech to his fellow artists. He welcomes it as a labor-saving tool for painters that will improve their fidelity to nature, as well as the taste of their patrons.

Others immediately assumed that the appearance of the daguerreotype meant the death of the existing reproductive arts, as illustrated by a hyperbolic article in the Cor-

sair *(reprinted in several publications and said to be written by Nathaniel Parker Willis). The wide-eyed wonder that pervades this article, along with the similar diary entry by Philip Hone, provides a glimpse of the remarkable combination of euphoria and trepidation that greeted the first views of the almost impossibly detailed plates. It seemed too much to comprehend that these images could be produced, or "thrown off" by nature. Had they always been there? Were images from past eras still bouncing around invisibly in the present day? What would the future bring? Could rooms foil crimes by taking pictures of the thieves who entered them? Did sound work like light; could future artists simply say "tree" aloud and watch it appear on the plate?*

Not everyone troubled themselves with such questions. Some, like Walt Whitman, simply reveled in the opportunity to gaze at so many faces. Ever the lover of humanity, Whitman feasts on portraiture in his account of a visit to Plumbe's daguerreotype parlor in New York (see also "Walt Whitman on American Painting," chapter 4). It should be remembered that nineteenth-century Americans were simply not used to seeing so many faces, especially recognizable celebrities, in one place. T. S. Arthur comments on this new ubiquity of the portrait, writing that prior to the daguerreotype only wealthy people could ever dream of having their likeness taken. Arthur also recounts the humorous actions of sitters who were ignorant of the photographic process and fearful of its effect on their bodies. Finally, Albert Southworth, in an address recalling his early days as a daguerreotypist, speaks of a different type of body—the corpses he was asked to photograph as memento mori. *In unusually frank language, he describes dealing with squeamish relatives, overcoming rigor mortis, and expelling liquids from the departed before posing them.*

[Nathaniel Parker Willis], "The Pencil of Nature," Corsair 1 *(April 13, 1839).*

We know not how it is, but just as we are going to have something good in this world, up starts a mischief to mar it or to vilify it. There is not a real panacea, but has its rival. Engraving, set upon a firm basis, one would have thought might have been supreme. No such a thing—her illegitimate sister, Lithography, sets up her claim, and by means of cheap publications, calls in the masses, who naturally prefer the inferior article; and here commences the democracy of art. Print shops have increased out of number—print auctions are every where; so that, if all the world do not become judges of art, it cannot be for lack of means to make them acquainted with it.

There is no breathing space—all is one great movement. Where are we going? Who can tell? The phantasmagoria of inventions passes rapidly before us—are we to see them no more?—are they to be obliterated? Is the hand of man to be altogether stayed in his work?—the wit active—the fingers idle? Wonderful wonder of wonder!! Vanish aqua-tints and mezzotints—as chimneys that consume their own smoke, devour your-selves. Steel engravers, copper engravers, and etchers, drink up your aquafortis, and die! There is an end of your black art—"Othello's occupation's gone." The real black art of true magic arises and cries avaunt. All nature shall paint herself—fields, rivers, trees, houses, plains, mountains, cities, shall all paint themselves at a bidding, and at a few moment's notice. Towns will no longer have any representatives but selves. Invention says it. It has found out the one thing new under the sun; that, by virtue of the sun's patent, all nature, animate and inanimate, shall be henceforth its own painter, engraver, printer, and publisher. Here is a revolution in art . . . The Dagueroscope and the Photogenic revolutions are to keep you all down, ye painters, engravers, and, alas! the harmless race, the sketchers. All ye, before whose unsteady hands towers have toppled down upon the paper,

and the pagodas of the East have bowed, hide your heads in holes and corners, and wait there till you are called for. The "mountain in labor" will no more produce a mouse; it will produce itself, with all that is upon it. Ye artists of all denominations that have so vilified nature as her journeymen, see how she rises up against you, and takes the staff into her own hands . . .

What would you say to looking in a mirror and having the image fastened!! As one looks sometimes, it is really quite frightful to think of it; but such a thing is possible—nay, it is probable—no, it is certain. What will become of the poor thieves, when they shall see handed in as evidence against them their own portraits, taken by the room in which they stole, and in the very act of stealing! What wonderful discoveries is this wonderful discovery destined to discover! . . .

Mr. Babbage in his (miscalled ninth Bridgewater) Treatise announces the astounding fact, as a very sublime truth, that every word uttered from the creation of the world has registered itself, and is still speaking, and will speak for ever in vibration. In fact, there is a great album of Babel. But what too, if the great business of the sun be to act registar likewise, and to give out impressions of our looks, and pictures of our actions; and so, if with Bishop Berkeley's theory, there be no such thing as any thing, quoad matter, for aught we know to the contrary, other worlds of the system may be peopled and conducted with the images of persons and transactions thrown off from this and from each other; the whole universal nature being nothing more than phonetic and photogenic structures.

Philip Hone, diary entry, December 4, 1839, in Bayard Tuckerman, ed., The Diary of Philip Hone, 1828–1851 *(New York: Dodd, Mead, and Co., 1889).*

The manner of producing them constitutes one of the wonders of modern times, and, like other miracles, one may almost be excused for disbelieving it without seeing the very process by which it is created. It appears to me a confusion of the very elements of nature. It is nothing less than the palpable effect of light occasioning in a reproduction of sensible objects. The reflection of surrounding images created by a camera, obscured upon a plate of copper, plated with silver, and prepared with some chemical substances, is not only distinctly delineated, but left upon the plate so prepared, and there remains forever. Every object, however minute, is a perfect transcript of the thing itself; the hair of the human head, the gravel on the roadside, the texture of a silk curtain, or the shadow of the smaller leaf reflected upon the wall, are all imprinted as carefully as nature or art has created them in the objects transferred; and those things which are invisible to the naked eye are rendered apparent by the help of a magnifying glass. It appears to me not less wonderful that light should be made an active operating power in this manner, and that some such effect should be produced by sound; and who knows whether, in this age of invention and discoveries, we may not be called upon to marvel at the exhibition of a tree, a horse, or a ship produced by the human voice muttering over a metal plate, prepared in the same or some other manner, the words "tree," "horse," and "ship." How greatly ashamed of their ignorance the by-gone generations of mankind ought to be!

Samuel F. B. Morse, speech at the National Academy of Design annual dinner, April 24, 1840, in M. A. Root, The Camera and the Pencil: Or the Heliographic Art *(Philadelphia: J. B. Lippincott, 1864).*

Gentlemen:—I have been requested to give my opinion of the probable effects to be produced, by the discovery of Daguerre, on the Arts of Design. It is known to most of you, that, for many months, I have been engaged in experiments with the daguerreotype, more particularly for the purpose of forming an intelligent judgment on this point.

The daguerreotype is undoubtedly destined to produce a great *revolution* in art, and we, as artists, should be aware of it and rightly understand its influence. This influence, both on ourselves and the public generally, will, I think, be in the highest degree *favorable* to the character of art.

Its influence on the artist must be great. By a simple and easily portable apparatus, he can now furnish his studio with *fac-simile* sketches of nature, landscapes, buildings, groups of figures, &c., scenes selected in accordance with his own peculiarities of taste; but not, as heretofore, subjected to his imperfect, sketchy translations into crayon or Indian ink drawings, and occupying days, and even weeks, in their execution; but painted by Nature's self with a minuteness of detail, which the pencil of light in her hands alone can trace, and with a rapidity, too, which will enable him to enrich his collection with a superabundance of *materials* and not *copies;—they cannot be called copies of nature, but portions of nature herself.*

Must not such a collection modify, of necessity, the artist's productions? Think how perspective, and, as a consequence, proportion also, are illustrated by these results. How the problems of optics are, for the first time, confirmed and sealed by nature's own stamp! See, also, what lessons of light and shade are brought under the closest scrutiny of the artist!

To the architect it offers the means of collecting the finest remains of ancient, as well as the finest productions of modern architecture, with their proportions and details of ornament, executed in a space of time, and with an exactness, which it is impossible to compress in the ordinary modes of an architect's study.

I have but a moment to speak of the effect of the daguerreotype on the *public taste*. Can these lessons of *nature's art* (if I may be allowed the seeming paradox), read every day by thousands charmed with their beauty, fail of producing a juster estimate of the artist's studies and labors, with a better and sounder criticism of his works? Will not the artist, who has been educated in Nature's school of truth, now stand forth pre-eminent, while he, who has sought his models of style among fleeting fashions and corrupted tastes, will be left to merited neglect?

Walt Whitman, "Visit to Plumbe's Gallery," Brooklyn Daily Eagle, *July 2, 1846.*

Among the "lions" of the great American metropolis, New York City, is the Picture Gallery at the upper corner of Murray street and Broadway, commonly known as *Plumbe's Daguerreotype establishment.* Puffs, etc., out of the question, this is certainly a great establishment! You will see more *life* there—more variety, more human nature, more artistic beauty, (for what created thing can surpass that masterpiece of physical perfection, the human face?) than in any spot we know of. The crowds continually coming and going—the fashionable belle, the many distinguished men, the idler, the children—these alone are enough to occupy a curious train of attention. But they are not the first thing. To us, the *pictures* address themselves before all else.

What a spectacle! In whatever direction you turn your peering gaze, you see naught but human faces! There they stretch, from floor to ceiling—hundreds of them. Ah! what tales might those pictures tell if their mute lips had the power of speech! How romance then, would be infinitely outdone by *fact* . . .

Indeed, it is little else on all sides of you, than a great legion of human faces—human eyes gazing silently but fixedly upon you, and creating the impression of an immense Phantom concourse—speechless and motionless, but yet *realities.* You are indeed in a new world—a peopled world, though mute as the grave. We don't know how it is with others, but we could spend days in that collection, and find enough enjoyment in the thousand human histories, involved in those daguerreotypes.

There is always, to us, a strange fascination, in portraits. We love to dwell long upon them—to infer many things, from the text they preach—to pursue the current of thoughts running riot about them. It is singular what a peculiar influence is possessed by the *eye* of a well-painted miniature or portrait.—It has a sort of magnetism. We have miniatures in our possession, which we have often held, and gazed upon the eyes in them for the half-hour! An electric chain seems to vibrate, as it were, between our brain and him or her preserved there so well by the limner's cunning. Time, space, both are annihilated, and we identify the semblance with the reality.—And even more than that. For the strange fascination of looking at the eyes of a portrait, sometimes goes beyond what comes from the real orbs themselves.

Plumbe's beautiful and multifarious pictures all strike you, (whatever their various peculiarities) with their *naturalness,* and the *life-look* of the eye—that soul of the face! In all his vast collection, many of them thrown hap-hazard, we notice not one that has a dead eye. Of course this is a surpassing merit. Nor is it unworthy of notice, that the building is fitted up by him in many ranges of rooms, each with a daguerrian operator; and not merely as one single room, with one operator, like other places have. The greatest emulation is excited; and persons or parties having portraits taken, retain exclusive possession of one room, during the time.

T. S. Arthur, "American Characteristics," Godey's Lady's Book *38 (May 1849).*

If our children and children's children to the third and fourth generation are not in possession of portraits of their ancestors, it will be no fault of the Daguerreotypists of the present day; for, verily, they are limning faces at a rate that promises soon to make every man's house a Daguerrean Gallery. From little Bess, the baby, up to great great-grandpa', all must now have their likenesses; and even the sober Friend,[2] who heretofore rejected all the vanities of portrait-taking, is tempted to sit in the operator's chair, and quick as thought, his features are caught and fixed by a sunbeam. In our great cities, a Daguerreotypist is to be found in almost every square; and there is scarcely a county in any state that has not one or more of these industrious individuals busy at work in catching "the shadow" ere the "substance fade." A few years ago it was not every man who could afford a likeness of himself, his wife or his children; these were luxuries known to those only who had money to spare; now it is hard to find the man who has not gone through the "operator's" hands from once to half-a-dozen times, or who has not the shadowy faces of his wife and children done up in purple morocco and velvet, together or singly, among his household treasures. Truly the sunbeam art is a most wonderful one, and the public feel it is a great benefit!

If a painter's studio is a place in which to get glimpses of human nature, how much more so the Daguerreotypist's operating-room, where dozens come daily, and are finished off in a sitting of half a minute. Scenes ludicrous, amusing or pathetic, are constantly occurring. People come for their portraits who have never seen the operation, and who have not the most distant conception of how the thing is done. Some, in taking their places in the chair, get so nervous that they tremble like aspens; and others, in the vain attempt to keep their features composed, distort them so much that they are frightened at their own image when it is placed in their hands . . .

The different impressions made upon sitters is curious enough. The most common is the illusion that the instrument exercises a kind of magnetic attraction, and many good ladies ac-

[2] The Society of Friends, or Quakers.

tually feel their eyes "drawn" towards the lens while the operation is in progress! Others perceive an impression as if a draft of cold air were blowing on their faces, while a few are affected with a pricking sensation, while the perspiration starts from every pore. A sense of suffocation is a common feeling among persons of delicate nerves and lively fancies, who find it next to impossible to sit still; and on leaving the chair, they catch their breath and pant as if they had been in a vacuum. No wonder so many Daguerreotypes have a strange, surprised look, or an air as if the original was ill at case in his or her mind. Of course, these various impressions are all the result of an excited imagination and an *effort* to sit perfectly still and look composed. Forced case is actual constraint, and must appear so. In Daguerreotype portraits this is particularly apparent.

Among Friends, it is well known that there has existed a prejudice against having portraits taken. To some extent this is wearing off, and very many prominent members of this Society have, of late years, consented to sit for their likenesses, and in Daguerrean Galleries a goodly number of plain coats and caps may be seen among the specimens. But large numbers still hold out, and will not be tempted to enter a painter's studio or a Daguerreotypist's room.

Albert S. Southworth, "Comments at the National Photographic Association," Philadelphia Photographer *10 (September 1873).*

When I begun to take pictures, twenty or thirty years ago, I had to make pictures of the dead. We had to go out then more than we do now, and this is a matter that is not easy to manage; but if you work carefully over the various difficulties you will learn very soon how to take pictures of dead bodies, arranging them just as you please. When you have done that the way is clear, and your task easy. The way I did was just to have them dressed and laid on the sofa. Just lay them down as if they were in a sleep. That was my first effort. It was with a little boy, a dozen years old. It took a great while to get them to let me do it, still they did let me do it. I will say on this point, because it is a very important one, that you may do just as you please so far as the handling and bending of corpses is concerned. You can bend them till the joints are pliable, and make them assume a natural and easy position. If a person has died, and the friends are afraid that there will be a liquid ejected from the mouth, you can carefully turn them over just as though they were under the operation of an emetic. You can do that in less than one single minute, and every single thing will pass out, and you can wipe out the mouth and wash off the face, and handle them just as well as though they were well persons. Arrange them in this position (indicating), or bend them into this position. Then place your camera and take your picture just as they would look in life if standing up before you. You don't go down to the foot of the sofa and shoot up in this way (indicating). Go up to the side of the head and take the picture so that part of the picture that comes off from you will come off above the horizontal line. So it would be as if in a natural position, as if standing or sitting before you. There is another thing which will be useful to you in carrying out your operation, and that is a French plate mirror about four feet long and not very wide. This will suit some cameras, arranging the mirror so the reflection of the party will be thrown upon it in an easy, graceful, natural way, and then take your picture from the mirror. You can do it with the mirror without much trouble.

TASTE AND PRINT CULTURE

In the course of a review of William Dunlap's History of the Rise and Progress of the Art of Design *and Henry Tuckerman's* Artist Life, *the critic of the* Southern Quarterly

Review vehemently decries the lack of taste and penchant for cheapness in American print culture. The sins of "gaudy" lithographs, "fuzzy" mezzotints, and "worn out" steel plates are catalogued and bemoaned. Although the general sentiments regarding the wont of artistic knowledge in the United States are scarcely original, the attention to the character and cultural importance of prints and illustrated works is notable.

"The Fine Arts in America," Southern Quarterly Review 15 (July 1849).

The true difficulty in the way of our artistic advancement is the want of taste in our people. There is no lack of interest in the arts. Go where you will, unless the poverty of the people is of the most abject character, there will be found some indications of an uneducated fondness for them. Little plaster busts of Byron, Scott or Napoleon, bedeck the mantle-piece; portraits of some national worthies, pictures of battles, or rude scenes of love and household life adorn the walls. Yet these very indications of popular inclination betoken also the absence of correct taste. It is well known that gaudy lithographs and flaring daubs will attract more attention and find more purchasers than the finest engravings or the most exquisite paintings. In seeking the cause of this defective judgment in such matters we cannot attribute it to a natural imbecility, for the world generally will agree in the opinion that we are "a nation not slow and dull, but of a quick, ingenious, and piercing spirit, acute to invent, subtile and sinewy to discourse, not beneath the reach of any point that human capacity can soar to."

We must look then to extraneous causes. One of the chief of these is the rage for cheapness. While in England they build houses in a solid and durable manner, we run up a shell of brick so thin that it often falls before it is roofed in. Our rail-roads are laid in the most rapid and least expensive manner, while John Bull seems to fix his on the very foundations of the globe, without any regard to the cost. Our newspapers are printed on paper very cheap indeed, but which being half plaster breaks and frays at the first folding, while the English papers arrive here, after a voyage across the ocean, as fair and firm and tough as the hardy islanders themselves. England does every thing substantially, America cheaply and rapidly, so that while Mr. Bull is enjoying the work of his hands, Jonathan is repenting of and amending at his leisure what he has done in a hurry. The same principles guide the two nations in their dealings with the arts. In England commissions are given to the best qualified, or to him who is so considered; here they are put out to the lowest bidder. The painter, sculptor or engraver who will work for the lowest wages will get the most employment. Mediocrity is consequently encouraged, while merit starves. A fine picture, a perfect statue or a finished engraving is the result of long and patient toil, preceded by years of continued and earnest study, without which the most exalted genius can produce nothing but splendid failures. Now, a man must live by his labor, and if he who does things slowly and well receives the same pay as he who does them rapidly and ill it is easy to see who gets the most advantage from the public. That pictures, busts or engravings can be produced speedily by untutored hands no one doubts or denies, for we see them every day. But how "flat, stale and unprofitable" they are. Mezzotints in which the prominent characters are of such retiring modesty that their features and personal identity are lost in the fuzzy indistinctness of the back ground, or of such bold effrontery that they stare out in ghastly whiteness from an atmosphere of condensed and ominous blackness; line-engravings, the solemn formality of which makes them appear, on close inspection, like miniature maps of the city of Philadelphia, or plots, on a small scale, of public lands in the new States; measly stipples and vague lithographs make up our popular collections. In painting, too, cheapness is a great recommendation to the "sovereigns." Any person who is too lazy to do anything else can fit up a

room and get as many sitters as he wants at ten dollars a head, or fifteen for a kit-cat, and that too from people who ought not to be gulled with such stuff. Congress, it is true, pays pretty well for works of art, but exhibits very little judgment in their purchase, and the decorations of the Capitol are true representations of the taste of the nation, one or two good things among a whole rabble of trash. Persico's stupid and awkward nothings and Trumbull's formidable colonnades of legs obtrude themselves upon the view, and take the attention from the few meritorious works which Congress has collected at the seat of government.

Many of our illustrated works, so far from improving the public taste, do much to depress it. They go upon the principle we are condemning, of getting every thing at the lowest price, without regard to quality. They compete with one another in the number, not in the excellence of their illustrations. This stuff, too, is palmed upon the public with the most unblushing impudence. Old steel plates, which have been worn out in the service of English annuals, and of editions of the Book of Beauty, are bought up by American publishers, the numbers rubbed down, new titles affixed to them, and, with the lying superscription, "Engraved expressly for this Magazine," are given to the American people. Men calling themselves respectable publishers lend themselves to this imposition, and acquire the reputation of fostering American art while they are really depressing it, and, as far as lies in their power, starving it out . . .

How can we expect the arts to flourish among us while so niggardly a spirit prevails? How can a refined public taste be formed when the mass of the people never see a good engraving except by accident, and when the miserable apologies for pictures they receive are represented to be unrivalled prodigies of genius and skill?

DANIEL HUNTINGTON'S *MERCY'S DREAM*

A lion of the mid-nineteenth-century New York art world, Daniel Huntington served as president of the National Academy of Design for two decades (see "Internationalist Backlash," chapter 11) and was a prolific painter of portraits who, in addition, enjoyed pursuing landscape subjects. Early in his career he was also known for his history paintings and his religiously inspired "fancy pictures," the most famous of which was Mercy's Dream *(1841). This painting, which depicts a scene from* Pilgrim's Progress, *the widely popular devotional book by John Bunyan, became very well known in the United States through the three versions Huntington painted and at least four engravings—prints that were often framed and hung in middle-class parlors. In the following letter to the Philadelphia owner of* Mercy's Dream, *Henry Carey, Huntington lays out his views on the process of executing an engraving from a painting. Huntington was dissatisfied with the copy of the canvas by James McMurtrie that had been sent to the New York engraver, Alexander Ritchie. He also worried that another of his paintings owned by Carey,* Christiana and Her Family Passing through the Valley of the Shadow of Death *(1842–44), was unsuitable for engraving because of its delicate color.*

Godey's Magazine was just the type of periodical likely to reproduce such an engraving, and the impassioned, sentimental language of the following profile of Huntington typifies the tone of the pious art and literature consumed in the American domestic setting. The essay also serves as a defense of the conjoining of religion and art, arguing that the senses are a primary means of access to the soul, especially in a troubled modern era. Yet exactly the features of Mercy's Dream *that found favor in the article—its simplicity of composition, calm outlines, subdued color, easy legibility, and reverent*

earnestness—condemned it as "meretricious weakness" in the eyes of later generations,[3] *as Eugene Benson's dismissal written in 1870 makes clear.*

Daniel Huntington to Henry Carey, November 24, 1849, Historical Society of Pennsylvania Collection.

I have called on Ritchie the engraver as you requested. He finds it difficult to execute his print from the copy made by our friend McMurtrie. The genius of McMurtrie is of too *original— fiery* and *impulsive* a nature to succeed well in the shackles of a *copyist.*

My ideas in regard to an engraving from a picture are these.

1. That the painter of the picture should (when it is practicable) choose the engraver and overlook his plate often while in progress, so as to suggest improvements, etc.

2. That the plate should be engraved either from the *original*—or a copy made *by or under the eye of the painter* and endorsed by him. (Such are often made in the studios of artists commenced by pupils & finished by the master) or from a reduced (water color in light & dark) drawing made by some one whose *whole* business it is to make *elaborate* & *closely accurate* reductions from pictures for the use of Engravers.

This last method is the usual one in Europe. But there are *no such copyists* in this country. I would have as soon thought of employing Michel Angelo to copy a miniature of Miss Ann Hall as to have commissioned the erratic and impatient genius of McMurtrie to do *anything* requiring so *minute & slavish an imitation.* What can be done? It is evident that without some change in the proceeding we shall all be disgraced—the Art-Union, the Engraver, Mercy & myself.—

As to engraving Christiana I conscientiously think the Art-Union of Philad. had better not engrave it *at all*—the effect of *color* is so important in that picture that an engraver should be in trouble, and there are many other pictures very much better fitted for their purpose. I know you will excuse my speaking out plainly—for you are a lover of *facts & truths.* I will think about the matter of the plate now in progress and write you again. Ritchie is a good engraver—a very clever man indeed—but at present he is "stuck in the mud." If you can suggest anything pray do so.

"*Our Artists.—No. 1. Huntington,*" Godey's Magazine and Lady's Book 33 (August 1846).

It is to our sympathies rather than our observation that Huntington appeals. He is not merely a clever portrayer of fine-looking men and women; he represents states of minds, conditions of feeling, phases of character. The minute exactitude of the Flemish school and the dramatic effect of the French are equally distant from his province. The main idea, the chief aim of his pictures, to which fidelity of detail and artistical effect are subsidiary, is to express a sentiment, and this it is which at once attracts and pervades us as we gaze. He does not amuse, dazzle or simply please us; he teaches and inspires, by some lofty, sweet or pious feeling represented with unaffected grace and simplicity. Those who cannot seize at once upon this emotion, who do not find some passage of their life or tendency of their character or instinct of their nature thus brought palpably to view, who are not, as it were, mesmerized by and placed in relation with the subject, fail to recognize what is most characteristic of Huntington. Those who have an eye only for the picturesque, or whose notion of painting is confined to the graphic reflection of external nature, will find comparatively but little satisfaction in the fruits of such a pencil; but all who delight in the beauty of the inner world, who are aware of what is latent in existence, who are wont, like the patriarch, to go forth and muse at eventide—to whom love and faith are

[3] James Jackson Jarves, *The Art-Idea* (New York: Hurd and Houghton, 1864), 204.

necessary and real, will enter into the feeling and accept the suggestions which breathe from his canvas. He is not definite, scholastic, nor vivacious and brilliant, nor yet wild and terrible, but chaste and gentle, serene and elevated; and he is so, not through any strongly marked, but through a vague and contemplative manner . . .

By the spiritual cast of his mind and the daily conversation of his friends, as well as from the vivid impressions of childhood, ideas such as immortalize the creations of Overbeck and hallow the names of Raphael and Domenichino, became familiar and dear, and he felt himself destined for a religious painter. All that had preceded was admirably calculated to promote his success. His ability, at once felt and acknowledged in landscape, and the bold and characteristic style of his portraits were simply evidences that he possessed the requisite command both of figure and scenery, and now to these mechanical aptitudes were added the inspiration of Faith.

Two visits to Europe, where his time was chiefly passed in Rome, without making Huntington an imitator, have contributed to improve his taste, and afforded him many desirable facilities for advancing in the high and difficult range of art to which his native instincts spontaneously led. If his life is spared, we feel assured he is destined to add most worthily to the existent trophies of Christian art, for since Allston our country can boast of no painter whose gifts of execution and graces of character are so well adapted for this species of excellence . . .

If we were to select any one picture as illustrative of the genius of Huntington, it would be "The Dream of Mercy." It is in the collection of as judicious a patron of the arts as we have yet had among us, whose latter years, darkened as they would otherwise have been by illness and confinement, derived an interest and a beauty from his devotion to this high source of pleasure, which affords a noble example to all who have the soul to redeem trial or adorn prosperity. In this painting the sweetest fancies of the brave author of that immortal allegory, "Pilgrim's Progress," are admirably concentrated. The consoling rays that glorified his imprisonment so long ago, still quiver around the face of the blest sleeper and buoy up the wings of the angel that fills her dream. A kindred feeling broods over the work to that which charms us in Correggio's Magdalen. The idea expressed is, indeed, different. The gracefulness of Guido's "Michael triumphing over Satan" is observable in the winged messenger, but the expression of Mercy is heavenly. A violinist, under the influence of tender or aspiring emotion, will sometimes cause his instrument to vibrate with a thrilling accent, born not of the music he interprets, but rather the offspring of an individual feeling. Thus, in depicting "Mercy's Dream," has Huntington informed it with a sentiment of his own. If he was not thus inspired, we are totally deficient in metaphysical perception. When he had nearly finished this picture, a friend objected that he should rather have chosen his subject from Spenser than from Bunyan. The next day, the artist, by introducing a cross in the crown which the angel extends to Mercy, added a beautiful significance to the composition.

And this brings us to that mooted question which has been such a thorn in the side to conscientious but narrow minds—the true relation of Art to Religion. To deny any whatever is absurd, as long as men gather beneath a roof, however simple, to worship; and if we recognize in the arcades of the forest and the glory of the mountain either the tokens of divine benignity or the unconscious praise which the universe offers to her Creator, how much more significant are the intelligent trophies of genius which his love has consecrated when gathered to illustrate His truth! The recoil of the world's free spirits from the civic tyranny of Papacy, has blinded too many to what is essentially good and true in her customs. When we meet the idea dissevered from all incidental prejudice, the attempt to set forth what is most touching in the Christian faith, in melody that wraps the soul in a holy trance, or in forms and colors that bring

worthily before the eye examples that cheer or soften, or purify the weary and cold affections, does it not commend itself to reason? It is in vain for a few peculiar, though it may be superior minds, to legislate for humanity. We must look at our race objectively and not merely through our individual consciousness. They are destined to receive good, not according to any partial theories, but by the observance of universal laws, by reverently consulting the wants, capacities and principles that are traced in the very organization of man by the hand of Creative wisdom. Thus regarded, is it not obvious that through the senses we must reach the soul—that the abstract must be made real—that sensation is the channel of spirituality? Why runs there through the frame this delicate and complex web of nerves? Why do eye and ear take in impressions which stir the very fountains of emotion and gradually mould the character? Why are brain and heart filled and electrified by art? Is it not because she is the interpreter of life, the medium through which we are made conscious everlastingly of high and vast destinies? Argue and moralize as bigots may, they cannot impugn the design of God in creating a distinct and most influential faculty in our nature which has not merely a useful or temporary end— the sense of the beautiful. Ideality is as much a heaven-implanted element as conscientiousness. Nature's surpassing grandeur and loveliness hourly minister to it, and Art, in its broadest and highest sense, is its legitimate manifestation. When a human voice of marvelous depth and sweetness yields to thousands a pure and rich delight, or a human hand of ideal skill traces scenes of grace and sublimity, and bequeathes the features hallowed by love or glorified by fame,— then is the worthiest praise offered to God by the right and sacred exercise of those faculties which unite mortal to angelic existence. Far, then, be from every liberal mind and feeling heart the idea that genuine art can ever profane religion, that the symbol must necessarily shroud the fact, that in seizing on any intermediate links of the golden chain which binds us to eternity, as with our frailty and limited vision we are ever fain to do, any serious alienation is threatened to what is actual in faith or desirable in sentiment. As long as we have senses, they must be represented; and there is far less danger of our being enthralled to images or ideas of any kind than to interest, the basest and most subjugating as well as universal of idolatries.

In Huntington's manner there is something that revives to the imagination that noble band of artists who so gloriously illustrated religion in the palmy days of the church. His figures generally have the roundness which distinguishes several of the best Italian masters, and his tints are subdued and harmonized like many of the favorite pictures both of the Roman and Tuscan schools. Another incidental analogy may be found in the circumstance that in several of his pictures the same female physiognomy is discoverable. The eye is gratified without being perplexed, by a chaste tone and judicious combination of hues. His draperies do not take the place of, but only cover his forms. We recognize the bosom under the tunic and the arm within the sleeve. A striking merit in his compositions is their simplicity. Several of his happiest efforts consist of two or three figures of half-length life size—a species of painting admirably fitted to embellish the walls of our dwellings, where more ambitious specimens would be out of place. This singleness of purpose and absence of complexity in design, render his works at once intelligible, and on this account they convey a more decided, lasting and entire impression . . .

They breathe a spirit which, in this busy and eager country, amid the warfare of trade and politics, seems to us peculiarly desirable. When, from the anxious mart or the thronged arena, the American citizen retires to his home, the exciting battle-pieces of Salvator or the festive scenes of the Flemish limners, however admirable in themselves, bring not precisely the refreshment he needs and which art can so genially bestow. It is well for his eye to rest upon some aspect of humanity calmer and more exalted. It is needful that the privacy of his domestic retreat should

be hallowed by images of serene truth, indicative of repose and hope—not that "stick at nothing, Herodias-daughter kind of grace," but tranquil, contemplative subjects, "the brow all wisdom and the lips all love." The pleasurable and soothing contrasts thus afforded between life and art, the holy efficiency of the latter in cooling the fevered pulse and awakening the heart to better aims and a nobler faith, are finely illustrated by painters who, like the subject of this imperfect notice, seem to whisper from the glowing canvas—"to be spiritually-minded is life eternal." And these silent guests, with their beautiful teachings, their unobtrusive inspiration, their familiar grace, make the loneliest room a temple, and yield some of the choicest joys of society, without the chilliness of etiquette or the wearisome demands of vanity. Like Ophelia and Cordelia, they put us on a sweet track of musing; and if it be true, as has been said, that the strength of virtue is serenity of mind, the artists who work in this spirit are genuine priests of humanity and oracles of God.

Eugene Benson, "Pictures in the Private Galleries of New York," Putnam's Magazine 6 (October 1870).

An urbane author of a time that is past, who had the pleasing consciousness of addressing the "gentle reader," was fortunate in the temper he felt and touched. Accustomed to polite society, scrupulous about the amenities of life, he knew that he must be agreeable; and he was agreeable. To-day the "gentle reader" seems a fiction of our fathers' time, and the style of the writer who addresses him is suggestive of the ancient, and faded, and conventional. Yet if it were possible to revive his pleasing presence he should be here; and if, by chance, we could discover his local habitation, we would solicit the pleasure of his company in the private gallery of Mr. Marshall O. Roberts. We would not shock him with strange and late developments, but we would place him among some of the familiar pictures of his palmiest days; we would place him before Huntington of twenty years ago; and, instead of speaking, we should wish to listen to him. But the gentle reader, shade that he is, is likewise voiceless. However sure of his tenderness towards the famous pictures that were novelties in the art of his time, we should get no verbal sign from him. But we will even suppose him to be present; for no spirit less gentle than his should preside over us in a gallery crowded with pictures that were famous ten years ago, but which must suffer from the present fashion of understanding art. Our genial companion, whose face is peaceful and gladdening, and without a suggestion of the influence of railroads and newspapers, is suffused with pleasure before Huntington's picture of "Mercy's Dream." The pure intention of the artist and the sacredness of the familiar story, are united in a form of art consecrated by the reverence of ages—and it is enough for the gentle reader. This is a picture which is almost as popular, while it appeals to much the same feelings, as illustrations of the lives of Catholic Saints for devout Roman Catholics. It is a myth of the Puritan mind which in beauty and vividness does not decline before the historic splendor of the more prolific plastic imagination of the Catholic of the south of Europe. An ideal of Protestantism is here realized. How much the Evangelical public has been gratified by this picture! We will not breathe a word of criticism before this figure consecrated by the affection and veneration of a thousand homes. Away, profane and skeptical critic, nourished on modern novels, modern science, modern French art, and American journalism! You are before an ideal of a religious mind, albeit the ideal is in a conventional form. Mr. Huntington's art can be brought in question elsewhere, and when criticism is less likely to wound pious prejudices. And, after all, rob the angel in his picture of lustre, and "Mercy" of grace, lower the art of the painter, dispute his understanding of form, obey the instincts of a detractor, and be insensible to the unction of Mr. Huntington's picture, and your task would not be productive of good to any one. You might whisper that it

is most appropriate to a Sunday-school banner, but your very suggestion would be a vindication of the popular significance and spotless purpose of the painter's work.

GIFT BOOKS AND SENTIMENTAL CULTURE

Gift books were an important publishing phenomenon of the antebellum era, and they became an established part of the "parlor culture" that developed in middle-class American homes. Volumes such as The Token, The Jewel, *and* The Gift *were issued annually, replete with poems, stories, essays, and engravings. The latter were often humorous or sentimental prints after American genre paintings, in keeping with the themes of friendship and courtship that governed the publications. For the most popular paintings, publishers sometimes commissioned short stories to amplify the narrative of the image. Samuel Goodrich, a Connecticut-born children's book author, published* The Token *between 1827 and 1842. In his autobiography he reflects on the popularity of gift books and the significance of steel engraving in disseminating reproductions of fine art.*

One of the most popular gift book artists was William Sidney Mount (see "American Life," chapter 4). In fact, his Painter's Triumph (Artist Showing His Own Work) *(1838, fig. 5) had the distinction of having two different short stories written for it, one in* Godey's Lady's Book *and one in* The Gift, *both issued in 1840. The painting, depicting a dashing artist dramatically presenting his work to a presumably unsophisticated country bumpkin, was owned by Edward Carey, the Philadelphia publisher of* The Gift. *The passage from each story that relates most directly to Mount's composition is reproduced here. J. H. Ingraham's "The Young Artist" tells the tale of Henry Irvine, a young man who gets into trouble at school with his friend, Davy Dow, and who must leave his small town as a result, despite his love for Mary Odlin. Years later, Henry, now an artist, encounters Davy in his studio and tests his friend's identity by revealing a portrait of the cruel schoolteacher who beat them as boys. After a joyous reunion, Davy delivers an important message from Mary. Here, Mount's painting serves as a climactic scene in the narrative. In contrast, A. A. Hardwood's story treats it merely as an intermediary episode, designed to introduce the character of Raphael Sketchly, who will go on to paint the portraits of the protagonist, Herbert Shockley, as well as Farmer Dobbs, the unsophisticated figure in Mount's painting. Later in the story, the portraits become switched, to comic and, ultimately, happy effect.*

S. G. Goodrich, Recollections of a Lifetime *(New York: Miller, Orton and Co., 1856).*

The success of this species of publication, stimulated new enterprises of the kind, and a rage for them spread over Europe and America. The efforts of the first artists and the first writers were at length drawn into them, and for nearly twenty years every autumn produced an abundant harvest of Diadems, Bijous, Pearls, Gems, Amethysts, Opals, Amaranths, Bouquets, Hyacinths, Amulets, Talismans, Forget-me-nots, Remember-me's, &c. Under these seductive titles, they became messengers of love, tokens of friendship, signs and symbols of affection, and luxury and refinement; and thus they stole alike into the palace and the cottage, the library, the parlor, and the boudoir. The public taste grew by feeding on these luscious gifts, and soon craved even more gorgeous works of the kind, whence came Heath's Book of Beauty, Lady Blessington's Flowers of Loveliness, Bulwer's Pilgrims of the Rhine, Butler's Leaflets of Memory, Christmas among the Poets, and many others of similar design and execution. Many of the engravings of these works

cost five hundred dollars each, and many a piece of poetry, fifty dollars a page. In several of these works the generous public spent fifty thousand dollars a year!

At last the race of Annuals drew near the end of its career, yet not without having produced a certain revolution in the public taste. Their existence had sprung, at least in part, from steel-engraving, which had been discovered and introduced by our countryman, Jacob Perkins. This enabled the artist to produce works of more exquisite delicacy than had ever before been achieved; steel also gave the large number of impressions which the extensive sales of the Annuals demanded, and which could not have been obtained from copper. These charming works scattered the very gems of art far and wide, making the reading mass familiar with the finest specimens of engraving, and not only cultivating an appetite for this species of luxury, but in fact exalting the general standard of taste all over the civilized world.

And thus, though the Annuals, by name, have perished, they left a strong necessity in the public mind for books enriched by all the embellishments of art. Hence we have such works as the Women of the Bible, Women of the New Testament, the Republican Court, by Dr. Griswold, together with rich illustrated editions of Byron, Rogers, Thomson, Cowper, Campbell, and others, including our own poets—Bryant, Halleck, Sigourney, Longfellow, Reed, &c. Wood-engraving has, meanwhile, risen into a fine art, and lent its potent aid in making books one of the chief luxuries of society, from the nursery to the parlor.

J. H. Ingraham, "The Young Artist," Godey's Lady's Book 20 *(March 1840).*

Two hours afterwards, on returning to his room, which, as most artists are wont to do, he had left unlocked, he discovered, seated in his chair before the easel, and gazing with looks of surprise and gratification upon the sitter's portrait he had replaced there, no less a person than his former rustic visiter. He surveyed him a moment with a smile, and then approaching him, slapped him good humouredly on the back, and said:

"You seem to be fond of paintings, my good friend!"

"Noa, measter, not particularly," said Davy, quietly looking up from the canvass; "Ise ony waitin' here for the painter."

The voice and face of the speaker brought back to the artist his boyhood. He scanned his features with eager curiosity, as if he sought to trace there familiar lines. But the tan of the sun and the seasons, combined with a heavy beard, defeated his scrutiny. Davy, in his turn, stared at the painter, his face alternately lighting up with hope, and clouding with doubt, as at one moment he thought he detected a resemblance, which, the next instant, was replaced by an expression altogether strange to him. On the part of the young painter, conviction grew to certainty, that an old companion of boyhood stood before him: but, as if prompted by a sudden thought, which suggested a plan for the better confirmation of his suspicions, he removed the picture from the easel, and silently, with a half smile, replaced it by one covered by a cloth, which hitherto had stood against the wall, and then said:

"I was about to ask your name, my good friend; for your face reminds me most forcibly, of one I knew in my boyhood; but I choose to satisfy myself by means of my art. Look at this picture," he added, removing the cover; "if you recognize it, I think I shall not be at a loss to call you by name without asking it. Stand here before it!"

Davy took the position he pointed out, and had no sooner fastened his eyes upon the canvass, than they seemed to start from their sockets with mingled surprise and bodily fear. He stepped back, again advanced, and then bent his face closer to it as if scarcely believing his eyes for wonder; finally, he stooped down before it, with both hands, from one of which stuck out

the handle of his inseparable cart whip, resting on his thighs, and gazed upon it until a broad smile of amusing recognition, illumined his ruddy visage. Near him, with his pencil extended in one hand, and his palette elevated in the other, stood the painter, watching every expression in his face, and enjoying in triumph, the anticipated success of his art.

All at once, Davy drew back, and doubling his massy fist, said, while he shook it at the canvass, "If thee beest no' Dominie Spankie, thee beest the de'il!" Then turning and looking at the amused artist, he added, "There be but one could do that, and if thee beest not Measter Henry—"

"Then," interrupted Henry, smiling, "thou art not Davy Dow."

"Odds butters! Bessy's mine, Bessy's mine!" he cried, capering round the studio. "Give us thee hand, Measter Henry! Dod! it's thyself, after all, then! How thee hast shot up; and the tan has made thee brown as a hazle-nut; and what with that whisker on your upper lip, I'd barely know'd thee, but for the Dominie, here. I know'd nobody could ha' done him but you. Well, it's odd, the old chap's picture should ha' made you go off, at first, and then be the means o' making me find you again."

The two friends cordially shook hands, and Henry passed one of the pleasantest hours since his exile in reviving old associations with the communicative Davy. That Mary formed the burden of the numerous questions he put to his foster-brother, need not be told. At length, Davy began to feel in the capacious pockets of his frock as if suddenly recollecting that he had not delivered all his message. "Dang it, Measter Henry, what with talking 'bout the Dominie, and the gals, and the old women, I'd loike to a' forgot! Here's a bit of a letter and a round gold ring for ye!"

Henry seized them with eagerness, while a heightened colour betrayed the state of his heart. He kissed the silent token, and placed it on his finger, and then tore open the letter. It contained but a single word:

"*Come.*

"Mary."

"I obey!" he exclaimed.

A. A. Harwood, "The Painter's Study," The Gift (Philadelphia: E. L. Carey and A. Hart, 1840).

Herbert received, upon his arrival at the renowned city of Gotham, all those hospitable attentions which are usually paid to young gentlemen of good prospects, and several days were passed in the exercise of life's conventional hypocrisies; when, in his first solitary ramble, the modest sign of "R. Sketchly, artist," at once reminded him of his father's injunction, and bespoke his patronage by its simplicity. Finding the street door open, he followed the mute direction of a hand, carelessly yet spiritedly traced upon the entry wall, up a flight of stairs, to the painter's study. With all the veneration which an amateur feels towards an established artist, he approached the *sanctum* with a noiseless step. The door stood half-open and discovered the *tableau vivant,* which, thanks to the gifted pencil of Mount, and the skilful burine of Lawson, figures as a frontispiece to our tale. Herbert paused with the instinctive appreciation of a lover of art, for a picturesque accident. The light striking only through the upper portion of the north window of an *atelier* scantily furnished, but strewed, with a characteristic disregard to order, with unfinished pictures, portfolios, strained canvass, and in short all the paraphernalia of the *metier,* revealed the artist in front of his easel, brandishing his palette and pencils aloft in one hand, while with the other he pointed to a landscape which he was exhibiting to a hale farmer. The latter with his hands placed upon his knees was bending forward, with an expression of open-

mouthed wonder, which displayed the surviving upper and lower masticators of his unfurnished mandibles, gazing in rapt astonishment at a highly successful delineation of the scenery near his own quiet home on the Hudson. "See there," said Mr. Raphael Sketchly, overlooking entirely in his enthusiasm the presumable incapacity of his auditor to comprehend the technicalities and mysteries of art, "how nicely nature has herself composed the picture, how well it is balanced, what a noble breadth of effect! mind how warm and transparent I've kept that shadow! how that light sparkles upon the sail in the river! what a delicious pearly gray that mountain opposes to the evening sky! just observe, too, the variety of mellow tints upon that broken plaster on the gable of the house!"

"Nat'ral as life," said Dobbs; "but you might have made the gable a bit smarter, for we're a going to mend and whitewash it in the fall."

"Don't do it, I entreat you," exclaimed the horrified artist, "you'll ruin the effect!"

"Must though," insisted Dobbs; "our folks thinks it's a kinder shabby, and I guess we're rich enough to fix it."

HIGH AND LOW: TASTE IN PAINTING

In this passage from an unsigned essay, the author celebrates the untutored taste of the masses, even when they err in their enthusiasms (as in the popularity of Emanuel Leutze's Washington Crossing the Delaware; *see chapter 6). The argument is that the hearts of the many, rather than the minds of the few, should dictate success in American art. William S. Mount's "representative men" are held up as good examples of this principle.*

"American Art," New York Quarterly 1 *(June 1852).*

The accusation brought against the American people, of a want of taste, is not well grounded. It may be true that it is not highly cultivated, but it is the fault of those who have the guidance of public taste, if it be not improved and improving. It is true, also, that they know little of the rules and systems of art, and equally true that they have little feeling for nude statuary and illustrations of heathen mythologies; and we hope that this may continue; but to the thought of art they are as susceptible as any other civilized people. It is, indeed, always the case that the masses love more enthusiastically, though they talk far less wisely, than the higher classes, whose feeling is often deformed and dwarfed by fashion and pride, and who, though they should, and sometimes do, intensify it by cultivation, oftener chill and destroy it, or suffer it to be overgrown with evil weeds. The heart of the people is right, whatever their intellects may be. This is proved by the enthusiasm which practical works of art excite—as, for instance, the Washington of Leutze, which, though a third-rate picture, and so full of falsenesses and faults as to shock any one who really understood art, was received with unbounded favor by the multitude; nor would it have been otherwise than more loved by the meanest taste, had it been by Delaroche, instead of Leutze.

Mount's pictures are a thorough proof of this position. Taking his inspiration from the humble, he has been met by the approval of both high and low; and, from the first, his popularity has been as great as deserved. His art is earnest and vital, and will be loved when its contemporaneous affectations shall have been forgotten. In some respects like Wilkie, he has met with the same success, but he lacks the academic training and technical knowledge which Wilkie had; yet is he a man, it seems to us, of even greater originality and more complete self-reliance. His rendering of individual character is more subtle, and the expression of the figure at least equally good.

His men are not only exponents of his story, but they are "representative men," each typifying his section of the country as well as his class and nature. Wilkie was reared in the midst of works of art (and was ultimately ruined by them); the American, where art had hardly a foothold, and he was compelled to work out his own problems.

CURRIER & IVES: ART HAND IN HAND WITH BUSINESS

The Bavarian Alois Senefelder's invention of the lithographic process in 1798 made possible the mass production of images on an unprecedented scale, and by the middle of the century the American trade in popular prints as well as advertising and other commercial imagery was booming. Among the most successful publishers of such prints was the New York firm of Currier & Ives. Nathaniel Currier, a job printer, had gone into business for himself in 1835; bookkeeper James Merritt Ives became a partner in 1857. At their premises on Spruce Street, the firm produced and marketed art like any other commodity, the prints colored by young women on an assembly line and sold by subscription, door to door. In their lithographed letter (dating from the 1870s but applicable to the firm's antebellum practices), Currier & Ives offer their new catalogue of "Popular Cheap Prints," with subjects ranging from "Love Scenes, Kittens and Puppies" to "Comic" and "Memory Pieces." The letter notes with pride that pictures have "now become a necessity," which the firm is well equipped to supply. Sold in bulk for cash on the barrelhead, pictures are guaranteed to reap handsome profits. Never pausing to equivocate about the marriage of art and commerce, the letter exults in its moneymaking potential.

Currier & Ives, letter to salesmen, New York, 1870s, in Harry T. Peters, Currier & Ives: Printmakers to the American People *(Garden City: Doubleday, Doran and Co., 1942)*

New York 187—

Dear Sir,

Herewith we enclose our new Catalogue of Popular Cheap Prints containing nearly Eleven hundred subjects, from which you can make your own selection of kinds wanted, you will notice that the Catalogue comprises, Juvenile, Domestic, Love Scenes, Kittens and Puppies, Ladies Heads, Catholic Religious, Patriotic, Landscapes, Vessels, Comic, School Rewards and Drawing Studies, Flowers and Fruits, Motto Cards, Horses, Family Registers, Memory Pieces and Miscellaneous in great variety, and all elegant and salable Pictures.

Our experience of over Thirty years in the Trade enables us to select for Publication, subjects best adapted to suit the popular taste, and to meet the wants of all sections, and our Prints have become a staple article which are in great demand in every part of the country.

To Pedlars or Travelling Agents, these Prints offer great inducements, as they are easily handled and carried, do not require a large outlay of money to stock up with, and afford a handsomer profit than almost any other article they can deal in, while at the same time Pictures have now become a necessity, and the price at which they can be retailed is so low, that everybody can afford to buy them.

Our price for the prints named on the list is Sixty dollars per thousand, and to accommodate those who cannot conveniently purchase a thousand at a time, we sell them at the same rate by the hundred, Six dollars per hundred, if you wish us to send them by Mail, enclose Sixty cents per hundred extra, as we have to prepay postage.

Our terms are strictly *Cash with the Order* and on receipt of same we carefully envelope and promptly forward Prints the same day that the order is received. Money should be sent by *Post Office Order* if possible, if a Post Office Order cannot be procured, send in *Registered letter,* and Money so sent may be at our risk, but do not send Bank bills in a letter without registering it, be careful to sign letter plainly with name of writer, Town, County, and State; we are sometimes much troubled by receiving letters containing Money without signature, or date of place whence mailed. Address letters plainly to

> Currier & Ives,
>
> 123 & 125 Nassau St.
>
> New York

Remember that on receipt of Six dollars and Sixty cents by post Office Order, or in a registered letter, we send by mail post paid so that you will receive without further expense One hundred prints such as we retail at Twenty cents each.

OLIVER WENDELL HOLMES ON STEREOGRAPHS

Stereo photography was one of the vogues that swept the United States in the mid-nineteenth century. Stereo photographers mimic a human's binocular vision by taking pictures of a subject with two cameras set several inches apart. When viewed through a lensed apparatus, the pair of prints "merge" to simulate three dimensions. Elaborate "parlor sets" of stereo views from around the world became a standard component of middle-class domestic culture. Physician and author Oliver Wendell Holmes (see also "The Photograph and the Face" and "Photographs of Antietam," chapter 7) became fascinated by stereo photography and wrote about it on several occasions for the Atlantic Monthly. *Many of Holmes's observations seem very modern today. He begins by suggesting that the ability to see in three dimensions is cultural, not innate. He also recognizes that stereo photography upends conventional notions of the fixity of scale or the equation of form and matter. Holmes describes photography's indexical ability to catalogue detail and form a new kind of visual archive. He brings the relativity of time and space into play as well, engaging in a dreamy, armchair world tour and musing on his contemporary connection to the smudged handprints from the past that are visible in a view of an English cottage. In essence, Holmes creates his own type of "virtual reality," an alternate visual and philosophical existence not possible before the invention of photography.*

Oliver Wendell Holmes, "The Stereoscope and the Stereograph," Atlantic Monthly 3 *(June 1859).*

A stereoscope is an instrument which makes surfaces look solid. All pictures in which perspective and light and shade are properly managed, have more or less of the effect of solidity; but by this instrument that effect is so heightened as to produce an appearance of reality which cheats the senses with its seeming truth.

There is good reason to believe that the appreciation of solidity by the eye is purely a matter of education. The famous case of a young man who underwent the operation of couching for cataract, related by Cheselden, and a similar one reported in the Appendix to Müller's Physiology, go to prove that everything is seen only as a superficial extension, until the other senses have taught the eye to recognize *depth,* or the third dimension, which gives solidity, by converging outlines, distribution of light and shade, change of size, and of the texture of surfaces.

Cheselden's patient thought "all objects whatever touched his eyes, as what he felt did his skin." The patient whose case is reported by Müller could not tell the form of a cube held obliquely before his eye from that of a flat piece of pasteboard presenting the same outline. Each of these patients saw only with one eye,—the other being destroyed, in one case, and not restored to sight until long after the first, in the other case. In two months' time Cheselden's patient had learned to know solids; in fact, he argued so logically from light and shade and perspective that he felt of pictures, expecting to find reliefs and depressions, and was surprised to discover that they were flat surfaces. If these patients had suddenly recovered the sight of *both* eyes, they would probably have learned to recognize solids more easily and speedily.

We can commonly tell whether an object is solid, readily enough with one eye, but still better with two eyes, and sometimes *only* by using both. If we look at a square piece of ivory with one eye alone, we cannot tell whether it is a scale of veneer, or the side of a cube, or the base of a pyramid, or the end of a prism. But if we now open the other eye, we shall see one or more of its sides, if it have any, and then know it to be a solid, and what kind of a solid.

We see something with the second eye which we did not see with the first; in other words, the two eyes see different pictures of the same thing, for the obvious reason that they look from points two or three inches apart. By means of these two different views of an object, the mind, as it were, *feels round it* and gets an idea of its solidity. We clasp an object with our eyes, as with our arms, or with our hands, or with our thumb and finger, and then we know it to be something more than a surface. This, of course, is an illustration of the fact, rather than an explanation of its mechanism.

Though, as we have seen, the two eyes look on two different pictures, we perceive but one picture. The two have run together and become blended in a third, which shows us everything we see in each. But, in order that they should so run together, both the eye and the brain must be in a natural state. Push one eye a little inward with the forefinger, and the image is doubled, or at least confused. Only certain parts of the two retinæ work harmoniously together, and you have disturbed their natural relations. Again, take two or three glasses more than temperance permits, and you see double; the eyes are right enough, probably, but the brain is in trouble, and does not report their telegraphic messages correctly. These exceptions illustrate the everyday truth, that, when we are in right condition, our two eyes see two somewhat different pictures, which our perception combines to form one picture, representing objects in all their dimensions, and not merely as surfaces.

Now, if we can get two artificial pictures of any given object, one as we should see it with the right eye, the other as we should see it with the left eye, and then, looking at the right picture, and that only, with the right eye, and at the left picture, and that only, with the left eye, contrive some way of making these pictures run together as we have seen our two views of a natural object do, we shall get the sense of solidity that natural objects give us. The arrangement which effects it will be a *stereoscope,* according to our definition of that instrument . . .

How shall we make one picture out of two, the corresponding parts of which are separated by a distance of two or three inches?

We can do this in two ways. First, by *squinting* as we look at them. But this is tedious, painful, and to some impossible, or at least very difficult. We shall find it much easier to look through a couple of glasses that *squint for us.* If at the same time they *magnify* the two pictures, we gain just so much in the distinctness of the picture, which, if the figures on the slide are small, is a great advantage . . .

The first effect of looking at a good photograph through the stereoscope is a surprise such

as no painting ever produced. The mind feels its way into the very depths of the picture. The scraggy branches of a tree in the foreground run out at us as if they would scratch our eyes out. The elbow of a figure stands forth so as to make us almost uncomfortable. Then there is such a frightful amount of detail, that we have the same sense of infinite complexity which Nature gives us. A painter shows us masses; the stereoscopic figure spares us nothing,—all must be there, every stick, straw, scratch, as faithfully as the dome of St. Peter's, or the summit of Mont Blanc, or the ever-moving stillness of Niagara. The sun is no respecter of persons or of things.

This is one infinite charm of the photographic delineation. Theoretically, a perfect photograph is absolutely inexhaustible. In a picture you can find nothing which the artist has not seen before you; but in a perfect photograph there will be as many beauties lurking, unobserved, as there are flowers that blush unseen in forests and meadows. It is a mistake to suppose one knows a stereoscopic picture when he has studied it a hundred times by the aid of the best of our common instruments. Do we know all that there is in a landscape by looking out at it from our parlor-windows? In one of the glass stereoscopic views of Table Rock, two figures, so minute as to be mere objects of comparison with the surrounding vastness, may be seen standing side by side. Look at the two faces with a strong magnifier, and you could identify their owners, if you met them in a court of law.

Many persons suppose that they are looking on *miniatures* of the objects represented, when they see them in the stereoscope. They will be surprised to be told that they see most objects as large as they appear in Nature. A few simple experiments will show how what we see in ordinary vision is modified in our perceptions by what we think we see. We made a sham stereoscope, the other day, with no glasses, and an opening in the place where the pictures belong, about the size of one of the common stereoscopic pictures. Through this we got a very ample view of the town of Cambridge, including Mount Auburn and the Colleges, in a single field of vision. We do not recognize how minute distant objects really look to us, without something to bring the fact home to our conceptions. A man does not deceive us as to his real size when we see him at the distance of the length of Cambridge Bridge. But hold a common black pin before the eyes at the distance of distinct vision, and one-twentieth of its length, nearest the point, is enough to cover him so that he cannot be seen. The head of the same pin will cover one of the Cambridge horse-cars at the same distance, and conceal the tower of Mount Auburn, as seen from Boston . . .

Oh, infinite volumes of poems that I treasure in this small library of glass and pasteboard! I creep over the vast features of Rameses, on the face of his rock-hewn Nubian temple; I scale the huge mountain-crystal that calls itself the Pyramid of Cheops. I pace the length of the three Titanic stones of the wall of Baalbec,—mightiest masses of quarried rock that man has lifted into the air; and then I dive into some mass of foliage with my microscope, and trace the veinings of a leaf so delicately wrought in the painting not made with hands, that I can almost see its down and the green aphis that sucks its juices. I look into the eyes of the caged tiger, and on the scaly train of the crocodile, stretched on the sands of the river that has mirrored a hundred dynasties. I stroll through Rhenish vineyards, I sit under Roman arches, I walk the streets of once buried cities, I look into the chasms of Alpine glaciers, and on the rush of wasteful cataracts. I pass, in a moment, from the banks of the Charles to the ford of the Jordan, and leave my outward frame in the arm-chair at my table, while in spirit I am looking down upon Jerusalem from the Mount of Olives.

"Give me the full tide of life at Charing Cross," said Dr. Johnson. Here is Charing Cross, but without the full tide of life. A perpetual stream of figures leaves no definite shapes upon the picture. But on one side of this stereoscopic doublet a little London "gent" is leaning pensively

against a post; on the other side he is seen sitting at the foot of the next post;—what is the matter with the little "gent"?

The very things which an artist would leave out, or render imperfectly, the photograph takes infinite care with, and so makes its illusions perfect. What is the picture of a drum without the marks on its head where the beating of the sticks has darkened the parchment? In three pictures of the Ann Hathaway Cottage, before us,—the most perfect, perhaps, of all the paper stereographs we have seen,—the door at the farther end of the cottage is open, and we see the marks left by the rubbing of hands and shoulders as the good people came through the entry, or leaned against it, or felt for the latch. It is not impossible that scales from the epidermis of the trembling hand of Ann Hathaway's young suitor, Will Shakspeare, are still adherent about the old latch and door, and that they contribute to the stains we see in our picture . . .

What is to come of the stereoscope and the photograph we are almost afraid to guess, lest we should seem extravagant. But, premising that we are to give a *colored* stereoscopic mental view of their prospects, we will venture on a few glimpses at a conceivable, if not a possible future.

Form is henceforth divorced from matter. In fact, matter as a visible object is of no great use any longer, except as the mould on which form is shaped. Give us a few negatives of a thing worth seeing, taken from different points of view, and that is all we want of it. Pull it down or burn it up, if you please. We must, perhaps, sacrifice some luxury in the loss of color; but form and light and shade are the great things, and even color can be added, and perhaps by and by may be got direct from Nature.

There is only one Coliseum or Pantheon; but how many millions of potential negatives have they shed,—representatives of billions of pictures,—since they were erected! Matter in large masses must always be fixed and dear; form is cheap and transportable. We have got the fruit of creation now, and need not trouble ourselves with the core. Every conceivable object of Nature and Art will soon scale off its surface for us. Men will hunt all curious, beautiful, grand objects, as they hunt the cattle in South America, for their *skins,* and leave the carcasses as of little worth.

The consequence of this will soon be such an enormous collection of forms that they will have to be classified and arranged in vast libraries, as books are now. The time will come when a man who wishes to see any object, natural or artificial, will go to the Imperial, National, or City Stereographic Library and call for its skin or form, as he would for a book at any common library. We do now distinctly propose the creation of a comprehensive and systematic stereographic library, where all men can find the special forms they particularly desire to see as artists, or as scholars, or as mechanics, or in any other capacity. Already a workman has been travelling about the country with stereographic views of furniture, showing his employer's patterns in this way, and taking orders for them. This is a mere hint of what is coming before long.

THE AMERICAN MUSEUM

Straddling the borders of high culture and vulgar commercial spectacle, showman Phineas T. Barnum's popular American Museum on lower Broadway in New York offered entertainment and uplift to both sexes, all ages, and nearly every class (except African Americans) in a city where social tension and conflict were on the rise. Like Charles Willson Peale's museum, only much more so, the American Museum offered a wildly eclectic mix of exhibits and diversions calculated to appeal to every taste. Some, like the celebrated Fiji Mermaid, were frankly humbugs; others, notably the performances of plays by Shakespeare and approved modern writers, lent a reassuring

air of moral respectability to the whole operation. The 1850 guidebook, touting Barnum's genius as "truly American," makes much of the museum's respectability; there is no alcohol sold on the premises, and the "most fastidious" need not fear to take their families to the Lecture Room.

Although the museum's carnival atmosphere repelled the more cultivated, they too succumbed to its allure. In his diary, George Templeton Strong—lawyer and high-ranking member of the elite—records several visits to the American Museum, where the sensational "What-is-it" (William Henry Jackson, a mentally impaired African American man) strikes him as quintessential humbug. Nonetheless, Strong finds value in the interest and quality of the natural history displays (see also "George Templeton Strong Visits the National Academy," this chapter). The catastrophic fire that destroyed the museum on July 13, 1865, provides the New York Times *with the opportunity to offer an extensive catalogue of the lost holdings. A heterogeneous and impure mixture, Barnum's museum is a colossal cabinet of wonders both vulgar and refined.*

Barnum's American Museum, Illustrated *(New York, 1850).*

The genius of Barnum is truly American. He has not rested content, as many other men would have done, after the great efforts he has already made, and the handsome fortune he has already realized; on the contrary, he is the same active spirit as ever. His introduction to the New York public of the Chinese Lady and her attendants, is of too recent occurrence to require more than this brief allusion, and its comparisons as an indication of endeavor, with the proposal, he made to Jenny Lind, which that eminent *cantatrice* has accepted. In point of liberality, the terms of the "Swedish Nightengale's" engagement in America are far beyond any yet proffered her by European managers, and evince Mr. Barnum's determination to do all in his power, to secure the highest talent and attraction, and so not to be out done, in his character of a public caterer, by any man whatever . . . [4]

. . . As the attractions of the Museum are intended for the moral and the intelligent, in contradistinction to these who seek unwholesome excitement, no bar for the vending of intoxicating liquors is to be found upon the premises; but ample accommodation is offered to those persons who may desire the refreshing and healthful drinks of the season. As a further guarantee of the propriety which pervades the entire establishment, the amusements presented in the elegant Lecture Room (which we shall have to describe in full) are of that pure and domestic character, which cannot fail to improve the heart, while they enlarge the understanding. The most fastidious may take their families there, without the least apprehension of their being offended by word or deed; in short, so careful is the supervision exercised over the amusements, that hundreds of persons who are prevented visiting theatres, on account of the vulgarisms and immorality which are sometimes permitted therein, may visit Mr. Barnum's establishment without fear of offence on that point.

George Templeton Strong, Diary *[1860], edited by Allan Nevins and Milton Halsey Thomas (New York: Macmillan, 1952).*

March 2, FRIDAY. Stopped at Barnum's on my way downtown to see the much advertised non-

[4] The Swedish soprano's tour of the United States in 1850–51 was a huge sensation, thanks to P. T. Barnum's management and canny promotional campaign.

descript, the "What-is-it." Some say it's an advanced chimpanzee . . . But it seems to me clearly an idiotic negro dwarf, raised, perhaps, in Alabama or Virginia. The showman's story of its capture (with three other specimens that died) by a party in pursuit of the gorilla on the western coast of Africa is probably bosh . . . But his anatomical details are fearfully simian, and he's a great fact for Darwin.

March 3 . . . There are other animals in the establishment much more interesting; for example, a grand grizzly bear from California, a big sea lion, a very intelligent and attractive marbled or mottled seal (*phoca vitulina?*), a pair of sociable kangaroos, and (in the happy family cage) an armadillo, a curious spotted rodent said to be Australian, two fine owls, and so forth . . .

June 6. Summer begins to pronounce itself. Was industrious in Wall Street and stopped on my way uptown at Barnum's. That specimen of showmen has resumed his functions, and his ancient and seedy museum is instinct with new life. The old wax figures are propped and brushed up and some of the more conspicuously mangy of the stuffed monkeys and toucans have disappeared. There is a colossal fat boy on exhibition (a real prodigy of hideousness), in addition to the miraculous calculator and the "What-is-it?" I went to see the aquaria. Sundry splendid tropical things from the Gulf of Mexico have been introduced there.

"Disastrous Fire," New York Times, *July 14, 1865.*

The fire which yesterday destroyed BARNUM'S American Museum, while greatly injuring and materially impoverishing its enterprising and public-spirited proprietor, did a damage to this and the adjacent communities, which neither time nor money can replace. Granting the innumerable sensations with which the intelligent public were disgusted and the innocent public deluded, and the ever patent humbuggery with which the adroit manager coddled and cajoled a credulous people, the Museum still deserved an honorable place in the front rank of the rare and curious collections of the world . . .

Almost in the twinkling of an eye, the dirty, ill-shaped structure, filled with specimens so full of suggestion and of merit, passed from our gaze, and its like cannot soon be seen again. Considering that for many years the Museum has been a landmark of the city; has afforded us in childhood fullest vision of the wonderful and miraculous; has opened to us the secrets of the earth, and revealed to us the mysteries of the past; has preserved intact relics of days and ages long since gone, and carefully saved from the ravages of time and the gnawing tooth of decay the garments and utensils of men of note long since mouldered, and afforded men of learning and of science opportunities for investigation and research, which their limited means and cramped resources relentlessly refused them, we deem it but right to the public, but meager justice to the hard earned success of Mr. BARNUM, that we place on record a:

CATALOGUE OF THE CONTENTS

of the building when at noon of yesterday the fierce tooth of fire pierced and destroyed it. In the basement was an immense tank, used at times for the accommodation of whales or hippopotami, around which stood huge cages for the tenement of wild beasts . . .

Passing the stairs, broad and easy of ascent, the

SECOND FLOOR

was reached. Gazing placidly down upon the coming visitor, stood the largest elephant that the civilization of the nineteenth century has yet known . . .

Across the farther end of the room was a narrow platform . . . at one end of which was placed a large arm chair for the Nova Scotian Giantess Miss SWAN, an exceedingly tall and graceful specimen of longitude, whose movements in and about the place were such as would be noticeable in

an eight-foot pair of dividers. ZERUBBY, a beautiful Circassian girl, with a head of hair frizzled by nature as no barbarous iron could do it, generally stood at the side of the lengthy curiosity, and shared with her the admiration of the crowd . . . A steam-engine, working, made entirely of glass, was on exhibition . . . and deservedly attracted a great deal of attention. But of all the atrocities in the Museum, perhaps the waxen figures of our nineteenth century notables were the greatest. There was NAPOLEON, with a squint-eye; VICTORIA, with a wry neck; TOM THUMB and wife, with a baby; KENNEDY, the hotel burner, in his "own clothes;" JEFF. DAVIS, in petticoats; and the Siamese Twins, in unisonic, ligaturistic existence. On the other side of the room, in a glass case, were Christ and his Disciples, and a collection of moving figures representing a dying chief, with a ratling, wheezing breast, surrounded by a host of weeping, head-moving sympathizers . . .

Leading from the large hall of this floor, on the north side, was a long room, mainly devoted to

THE AQUARIA . . .

. . . There were at least forty large cases, neatly constructed of marble, iron and glass, in which fish from every ocean, river and lake were kept. These were not only interesting to the ordinary observer but to the curious in this specialty; and from the little stickleback's nest to the chameleon tints of the angel fish, we were never tired of studying the peculiarities and admiring the beauties of these wonderful creatures of the Omnipotent . . .

Ranged around the walls were several hundred poor pictures, but good portraits of eminent men of former generations. Entirely valueless as mere works of art, they possessed a merit peculiarly their own in the eyes of school teachers and historians. They were nearly all originals, and from the pencil of that eccentric but worthy man, REMBRANDT PEALE. They embraced portraits of Generals, Admirals, Governors, pirates, and other noted people, and were so concisely and conspicuously labeled that no causal glancer, though a fool, could mistake the one for the other . . . The "learned seal" *Ned,* occupied a conspicuous position on this floor . . . His performances on the hand-organ were, doubtless, painful to him, but to the flippant crowd they were amusing and pleasant . . . On the

THIRD FLOOR . . .

was the

FAMOUS PETRIFICATION,

representing a horse, about whose body wound a boa constrictor who was striking at the arm of the rider. The vital energy of the *pose* was remarkable, and the spirit of the group singularly effective . . . Around the walls were cases of butterflies, or various insects, of curious cuttings in wood and carvings in ivory, of Chinese balls and American whistles made of pigs tails, of puzzles for young people and curiosities for older ones, of spears and clubs from the islands of the sea, of sharks' teeth and whales' jaws, skeletons of snakes, of monkies and of reptiles, scraps of cloth from coats of Revolutionary heroes, shirts taken from the dead bodies of notable soldiers, continental currency and American paper money, buttons from the vest of a dying Wolfe, and the shirt pierced by the murdering bullet of a Ledgard. Relics of the Revolution which money cannot replace are gone forever. Valuable mementoes of Washington, Putnam, Greene, Marion, Andre, Cornwallis, Howe, Burr, Clinton, Jefferson, Adams, and other eminent men which should have been carefully stored in a fire-proof vault, yesterday smouldered in the heat which tried the fat of a Labrador whale, and stirred the snakes from the forests of South America.

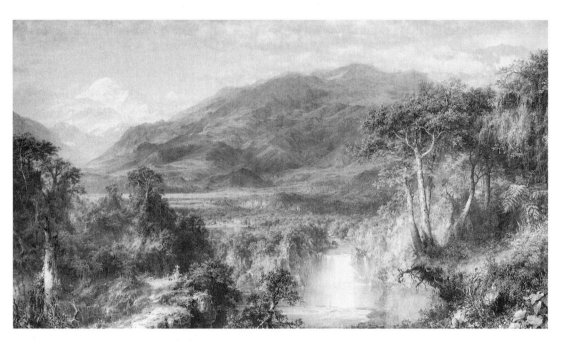

Fig. 6. Frederic Church, *Heart of the Andes,* 1859, oil on canvas. The Metropolitan Museum of Art, Bequest of Mrs. David Dows, 1909 (09.95). Image © The Metropolitan Museum of Art.

6 ANTEBELLUM AMERICA

Expanding Horizons

INTERNATIONAL TRAVEL AND EXCHANGE

DÜSSELDORF AND THE DÜSSELDORF GALLERY

In 1849 New York City received an artistic delegation from Germany in the form of fifty-six paintings from Düsseldorf, home of a prominent academy at mid-century. The works were the property of Johann Gottfried Böcker (or Boker), a wine merchant who had first come to the United States in the 1820s; as individual paintings were sold, he replaced them with new stock. Admission was 25 cents, and for almost a decade this collection functioned as a kind of municipal art gallery for the city. The Düsseldorf School was known for its meticulous attention to detail (its "snuff-box finish," in the words of the American Art-Union critic below), complex figural stagings, and somewhat heavy coloring. The local availability of Boker's paintings allowed them to become a touchstone for comparison to American art, which is the main thrust of the first essay below.

Back in Germany, the Düsseldorf Academy was a draw for several American figure painters, including Eastman Johnson, Richard Caton Woodville, Emanuel Leutze, and George Caleb Bingham. Landscape painters such as William Trost Richards, William S. Haseltine, James Hart, and Worthington Whittredge also flocked to the Academy. In the latter's autobiography, he discusses the influence of Boker's collection, the informal methods of his teacher, Andreas Achenbach, and the artistic coming of age of Albert Bierstadt.

"Gallery of the Düsseldorf Artists," Bulletin of the American Art-Union 2 *(June 1849).*

The great lesson which, in our opinion, is to be learned by American artists from the Düsseldorf Gallery, is the *indispensable necessity of long and laborious preparatory study*, before they can hope to fulfil, with complete success, the duties of their profession. That peculiarity of our people—the desire of immediate realization, is the besetting sin of this, as it is of other occupations. Beginners here despise a long drill of the eyes and the fingers, which elsewhere is thought to be absolutely essential: and when they should be learning the rudiments, they are painting "Last Judgments" and scenes from Shakspeare. If they go abroad to foreign schools, how much is their vanity mortified—how much are they oppressed and cast down by the fastidiousness of their masters and the severity of their discipline. We have seen letters from young Ameri-

cans, full almost of despair at the tasks demanded of them; and yet it is by this training only, that Kaulbach, and such as he, have been able to soar so high in the realm of Art. It is Knowledge alone which can sustain the continuous flight of Genius . . .

In the department of Form, alone, how much might be said of the great, the very great inattention of our painters, and how conspicuous is the knowledge of it in the collection before us! Everywhere abroad is this element recognized as the corner-stone of artistic education—in England, theoretically at least; on the Continent, in the teachings of the schools and the practice of the students. Nor does their discipline in this branch terminate with their pupilage. The great masters are continually exercising themselves in studies from the model . . .

In this connection it may be well to mention two faults which the Committee of the Art-Union have had frequent occasion to observe in works submitted to them for purchase, and from which these Düsseldorf pictures are generally free. One of them is the hasty and imperfect manner with which subjects appear to have been *thought out* before they are committed to canvas. In many cases, all the labor has been bestowed upon the execution, and none whatever upon the original conception. The crudest, the most incoherent, the most insipid ideas—subjects which are in no degree whatever suited to the pencil, are elaborated with a zeal and patience worthy of a better cause. Or else, as was to have been expected, artists have become dissatisfied with their first designs, and therefore changed them in the progress of the piece—thus cobbling together the new thoughts with the old, filling the picture with *pentimenti,* and producing, after all, a most inharmonious and unattractive result . . .

Another of these faults to which we desire to call attention, is the sketchy, incomplete manner with which paintings in this country are often executed. If the treatment by the Düsseldorf artists be too minute, by ours it is too general. Very frequently forms are only suggested, not represented. All that is aimed at, is an agreeable general effect. Details are everywhere avoided . . .

We trust that the preceding remarks will not be misunderstood by our readers. We have written them, knowing well that there are exceptions, bright and glorious exceptions, among American artists, to whom these censures cannot be applied. But it is no less true that there are many who deserve them, and to whom it is proper to speak with candor and distinctness. We have written them, also, in the full understanding and appreciation of several excellences which our painters possess in an unusual degree, considering the circumstances of their situation, and which they promise to carry still higher in future. In purity and splender of color, for instance, they have certainly made very great advancement. There are, without doubt, many works produced by them, and now on exhibition, which, in this respect, are decidedly superior to any in the Düsseldorf Gallery. We need only mention Mr. GRAY's *"Apple of Discord,"* beside which these German pictures would look quite pale and ashy. So, also, there is a freshness—a novelty of idea in many of the paintings of our countrymen, which is truly delightful. They work, of course, more immediately from nature, and less through other pictures. Their canvas smacks of fresh air, rather than of dingy galleries. They show more of their own minds and less of other men's, which gives a variety—an originality—a wider range of representation to their attempts.

Worthington Whittredge, The Autobiography of Worthington Whittredge, *ed. John I. H. Baur (New York: Arno Press, 1969).*

The "Düsseldorf School" was known at this time in America chiefly through an exhibition in New York of a large number of paintings painted by different German artists residing there. This exhibition belonged to a Mr. Boker who was the German Consul residing then in New

York. It was the first exhibition in America if not in the entire world, which was opened to show paintings at night . . .

But with all Mr. Boker's light on his pictures in Broadway, and the thousands of people who went to see them, and all the quarter-dollars he took in by his exhibition, it was but a little while before the works of the "Düsseldorf School" as it was called fell into considerable disrepute. Critics began to criticize many of the works most admired by the public, and with much good reason. Many of these works were in the hardest German style, colorless and with nothing to recommend them except their design. This was to be sure often a compensation for lack of color and the charm of handling but it was not enough and never will be enough to satisfy us in the realm of art.

I found the professors of the Academy in Düsseldorf among the most liberal-minded artists I ever met, extolling English, French, Belgian, Norwegian and Russian art. The Düsseldorf School, when I reached there, was made up from students of all countries; there were few French students and only a few Englishmen, but Norway, Sweden, Russia, Belgium and Holland were strong in their representation. The School therefore was not alone the teachings of a few professors in the Academy but of the whole mass collected at that once famous rendezvous, and America had Leutze there, the most talked-about artist of them all in 1850.

I am mentioned sometimes in the catalogues of exhibitions as the pupil of Andreas Achenbach. This would be true if I could say that he ever gave me a regular lesson or in fact any lessons at all. He hated, with a hatred amounting to disgust, to see artists imitating his pictures, and he had no sympathy whatever for the usual French atelier where numbers of students were doing nothing more than imitating the techniques of their masters. He used to say these ateliers were not making artists at all, that not one teacher in a hundred could place himself in the shoes of his pupil and help him on in his own way . . .

I purchased some pictures in Düsseldorf for friends in Cincinnati and purchased some from Achenbach, and this gave me free entry, sometimes, "on business". I had occupied the little room one week and had my large picture of "Sieben Gebirge" well under way, having commenced it elsewhere, when one morning my jolly master stepped in, cigar in mouth, and with a hearty "Wie gehts?" (How are you?). He glanced at the picture and said, "Sehr gut" (Very good), and immediately began to tell a story, and he kept on telling stories and making jokes until he was called to dinner—and that was all the instruction I got at that time and is a fair example of all his visits during the year that I was in his house. His talk sometimes took a serious turn, but this was generally at the "Mahlkasten" (Paint Box), a club in which all the artists of the town congregated every evening. I could have learned just as much about painting if I had never met him anywhere else but at this club during the whole year that I was with him . . .

Albert Bierstadt, who afterward sold his "Recollections Of The Rocky Mountains" for $30,000, came to Düsseldorf in 1852 and for a time worked in my studio which was in the same building with Leutze. While I did not give lessons, he called himself my pupil during the time that he was with me. He brought with him a few studies which he had made in America, in the hope that by showing them to us, he could induce us to intercede for him and persuade Achenbach to give him lessons. The studies had nothing in them to recommend Bierstadt as a painter. They were in fact absolutely bad and we felt compelled to tell him very decidedly that Achenbach never took pupils. He arrived in Düsseldorf with very little money, which fact he frankly told us, and when he was out of sight Leutze remarked, "Here is another waif to be taken care of," no pleasant announcement to either of us. But Bierstadt was not made to be a waif. He soon proved that he was not likely to be a charge upon anybody. He refused to drink beer or

wine, and if invited to dinner managed to get around all such invitations in a polite way, especially if they looked in the least as if they required dinners to be given in return. He had no money to spend in that way and preferred to be thought unsociable rather than impoverish himself by giving costly dinners. After working in my studio for a few months, copying some of my studies and a few others which he borrowed, he fitted up a paint box, stool and umbrella which he put with a few pieces of clothing into a large knapsack, and shouldering it one cold April morning, he started off to try his luck among the Westphalian peasants where he expected to work. He remained away without a word to us until late autumn when he returned loaded down with innumerable studies of all sorts, oaks, roadsides, meadows, glimpses of water, exteriors of Westphalian cottages, and one very remarkable study of sunlight on the steps of an old church which some years afterwards was turned into a picture that gave him more fame than anything he had ever painted. It was a remarkable summer's work for anybody to do, and for one who had had little or no instruction, it was simply marvellous. He set to work in my studio immediately on large canvases composing and putting together parts of studies he had made, and worked with an industry which left no daylight to go to waste.

THE LURE OF ITALY

In the decades before Paris and Munich became the primary destinations for American artistic study, most artists who traveled to Europe were seeking the golden sunshine of Italy, along with the rich classical legacies of such cities as Rome (see also "Women Sculptors in the Eternal City," chapter 11).

In 1829 Samuel Morse raised money to embark on a second trip to Europe with the aim of studying the masters of Renaissance and baroque painting. His time in Italy, however, engendered intense feelings of ambivalence about Catholic religious imagery. In a journal entry penned toward the end of his stay, Morse reflects on the dilemma this poses for his own art. After visiting the Milan cathedral, Morse observes that Catholic art is designed to delight the senses of worshippers rather than appeal to their understanding. He confesses to feelings of doubt about the legitimacy of his own art but expresses confidence in art's mission to educate, refine, and elevate its viewers. As for art in churches, it may well be useful but ultimately too dangerously seductive. For Morse, the challenge is how to awaken the reasoning faculties of his audience while ensuring that imagination slumbers undisturbed.

James De Veaux, a portrait painter based in Charleston, South Carolina, made two trips to Europe, and in the following excerpts of letters from his second visit he (in contrast to Morse) epitomizes the rapturous response to the Italian campagna and the mysterious interiors of Catholic churches. Italy was seen by some as a "dangerous" environment—not just for its spiritual threats but also for its Mediterranean climate, so different from North America's. De Veaux, in fact, died in Rome in 1844, and other American artists, such as landscape painter Thomas Hotchkiss, also met with early deaths in Italy. The passage from an unsigned essay in the New York Quarterly *warns of these dangers, and it passes severe judgment on American artists who seek to travel and live in Italy.*

When writer Nathaniel Hawthorne traveled to the peninsula, however, his reactions were considerably more upbeat. He took a great interest in American expatriate artists, and his visits to their studios in 1858 provided him with wonderful anecdotes, excerpted

below. Hawthorne's incisive critical language is filled with clear-eyed, cool assessments but also with sympathetic understanding and wit. His comments on Thomas Craw-ford's Washington monument, unfinished at his death and destined for Richmond, Virginia, are particularly interesting, as are his views on Hiram Powers's desire to depict Washington in the nude.

Samuel F. B. Morse, diary entry, July 31, 1831, Samuel F. B. Morse Papers, Library of Congress.

How admirably contrived is every part of this system to take captive the imagination. It is a religion of the imagination; all the arts of the imagination are pressed into its service; architecture, painting, sculpture, music, have lent all their charm to enchant the senses and impose on the understanding by substituting for the solemn truths of God's Word, which are addressed to the understanding, the fictions of poetry and the delusions of feeling. The theatre is a daughter of this prolific mother of abominations, and a child worthy of its dam. The lessons of morality are pretended to be taught by both, and much in the same way, by scenic effect and pantomime, and the fruits are much the same.

I am sometimes even constrained to doubt the lawfulness of my own art when I perceive its prostitution, were I not fully persuaded that the art itself, when used for its legitimate purposes, is one of the greatest correctors of grossness and promotors of refinement. I have been led, since I have been in Italy, to think much of the propriety of introducing pictures into churches in aid of devotion. I have certainly every inducement to decide in favor of the practice did I consult alone the seeming interest of art. That pictures may and do have the effect upon some rightly to raise the affections, I have no doubt, and, abstractly considered, the practice would not merely be harmless but useful; but, knowing that man is led astray by his imagination more than by any other of his other faculties, I consider it so dangerous to his best interests that I had rather sacrifice the interests of the arts, if there is any collision, than run the risk of endangering those compared with which all others are not for a moment to be considered.

James De Veaux, letters from Italy, 1841, in C. Edwards Lester, The Artists of America *(New York: Baker and Scribner, 1846).*

At Paris I remained six or seven weeks, sketching at the Louvre, and studying Italian. At the end of that time I flung myself into a French 'diligence,' gave the word 'go,' and during ten days and nights was continually *en route;* and here have I been in old Florence nearly a month, painting at the Gallery *the* six hours, drawing at night from the living model, and the rest of the time rambling about among the old churches, palaces, prisons, gardens, etc., etc. Oh! pack your trunk, and leave the sand-hills for a season—a walk along the Arno, or a peep at the frescoes in old Santa Croce, is worth the jaunt;—besides—fruit season is *in,* and always is, and how you would enjoy the juice of the grape! . . .

Models for pictures are the heaviest items of expense here,—since I have been engaged on my angels, I have had models enough for inspection to people a small village,—angels,—Italian angels! from three years up to thirty; women and children, male and female. I wish you could see me hauling up one little fellow with a belly-band and rope and tackle, and when I get him in the air and say 'fly, sir,' he curls all his limbs into a heap and falls to crying! . . .

Think of making a man forget his home, and desiring to nestle with strangers! But the people enter not into my calculations—the climate, the scenery and the arts make the chief of its charms. Oh! leave cob-webs and dust and politics and pines and scrub oaks, and all other dirty things, and come here and *breathe* in Italy,—quit the damp, dank, suffocating air of sand-hills,

and the leaden exhalations of those eternal swamps, and come stand at my side at sunrise or sunset, and let me hear you say, 'this is life,'—one day in the city of the Medici, is better than a thousand within the walls of Gotham,—it is better to be a doorkeeper in the palace of the Grand Duke, than dwell in the White House forever. Throw a few things into an old trunk—borrow a few dollars, and come and let me 'cicerone' you about—no description, written or pictured, can give more than a glimmer of the landscape, or the faintest idea of the climate, the atmosphere, the sunsets, olive groves, vineyards, chateaux, towers, mountains, all at one glance;—and each cloud that intervenes throws a huge shadow over some object and changes the whole character of the picture. From minute to minute thus there are constant changes, and the rapt spectator becomes 'drunk with beauty.' Oh! come and let me teach you to enjoy nature and art in their magnificence!

I am studying hard—but with what success you shall shortly judge. The subject I have chosen for my *debut* in history-painting is '*Christ administered to by the Angels.*' Painting it under the *eye* of the best works of *dead* masters, and having now and then the scrutinizing eyes of living judges to contend against, I have been floundering about in true whale fashion for several months. It has been a good study for me,—it has kept me always busily thinking and fretting, and they are apt to leave impressions firmly graven. Tell me what you think of it candidly for an original. Before my funds give out, I shall have one such, at least, for each of my good friends. There are American painters and sculptors here of all sorts. I find nothing in their society to please me, and so keep to myself. Strange that so much venom should exist among professors of a liberal art,—but the truth is, that envy and jealousy are our (painters') besetting sins, and the first thing I heard of here was a flare up at Rome amongst the American artists, and now they are all in Florence for the summer, so I keep housed. Except religious sects, I think *we* are the warmest and best haters, and the most malignant devils the sun ever deigned to shine upon. Except the French, I find artists the most disagreeable associates, so can't expect to make many friends among them, though I make some small sacrifices to avoid making them enemies. The few friends I have among them are exceptions to the general rule . . .

A run up to the top of one of the hundreds of villa-capped hills (that actually encircle this old walled city of eighty thousand inhabitants), at sunset, is a perfect view of Paradise before the fall. Oh! what chiaró scuro—the city at your feet, with towers and steeples *toned* by time, and fresh varnished by the rays of an Italian sun!—the Arno, one sheet of silver valley, stretching far and wide—the immense spreading of plains shadowed by a mountain cloud, and cut into by a broad sheet of sunlight! such things I have never seen, and will never tire of—each second brings a change and a new picture. In all this lavish sport of hot and cold, light and shade, the eye rests soothingly upon the old white-headed Apennines, that seem to be stretching their necks to get a look at the old Cathedral's huge comfortable looking knob, and so warm themselves in imagination . . .

The dim religious light that is so studiously prepared in these churches, adds of course to the well painted illusions, and one loves to sit in the solemn silence and gaze himself into a state of joyous entrancement that nothing earthly equals. Shall I become a Catholic? No,—I can have these sweet dreams and be a Protestant 'for a' that'—the heretics are not shut out from heaven—on earth at least.

"*American Art,*" New York Quarterly 1 (June 1852).

Our artists troop off to Europe to study *Art;* almost simultaneously with the discovery of artistic talent, they are hurried off by sanguine friends to study abroad. And then where do they go?

not to England, the nurse *par excellence* of intellectual greatness; whose spirit and institutions so nearly resemble ours; where humanity exists in its noblest forms, and with its most vital influences, but generally to Italy, amidst death and pestilence; to a land which dug the graves of its own arts, and now, beautiful in its decay, allures those of other nations to its poisonous embrace—to a miasma more fatal than that of its marshes. Italy has cursed her own children, will she bless America's? But says one, "method—the style of the old masters." Oh, fatal folly, will the style of Shakspeare make you a poet? Will the diction of Homer immortalize you? What were the words of Isaiah without the burning prophecy which gave them their fire? Method is but the vehicle of matured thought, and though you could make verses like Dante, or sweep your brush like Michael Angelo, still were it but babbling or daubing, unless their thought possessed you. Better, far better, were the feeble efforts of some untaught forest child struggling to impart the lessons which nature had taught him, than this systematized falsehood, and decorated degradation, which in the hands of modern artists, belies and abrogates the highest principles of art. Better the barbaric rudeness of the catacombs than such treachery to beauty and nature.

"But in Italy they have such great facilities for study and good models, and then it is such a delightful country, so dreamy and delicious." But what do all the facilities for study amount to when your study is wasted, except to pervert your tastes or degrade them: and you are not required to paint Italian subjects, then why Italian costumes! As regards the excellence of models, it cannot amount to much, for there are no Italian bred artists in America who can draw so good figures as Mount or Darley, who were never out of the country. But if American men and women were all deformed, we don't want them corrected by Italian models—let the deformity be at least of nature's own making. But "dreamy" "delicious"—ah! there's the secret! Now he who supposes that art is a dream, is no artist—art is toil, earnestness, humility, a vocation only to be followed with the utmost reverence for nature, and the most entire devotion of time and talents. No dreamer or sensualist can be an artist; they do but mock its spirit who are such, and yet many such there are: men of talent, once gifted with the spirit of beauty, and called in this nineteenth century to the exercise of the noblest calling man can follow,—who, gathering up their means, sell their birth-right for a life of ease, and turning their blinded eyes from the ineffable beauty which lies at their very feet, and calls to them from every roadside, go forth to a land of sensuality and vice, while nature, betrayed by the children she has gifted, tearful and heavy-hearted waits for another generation to be the interpreters of her lessons, the prophets of her mysteries,—waits and grieves that even yet her glory and beauty, so worthy the love and adoration of men, should sit in rags and neglect. How many artists are there in Europe now, who, claiming to be Americans, care for America only as a market for their works, forgetful of everything good and noble in their native land. There is more of beauty in every forest-nook in our broad land than a Turner could paint in years; in any village in the country than a Raphael might develop in a lifetime; and do they who are blind to it here, think they will find it in the widest wanderings? Has humanity become idiot, or the spirit of art perished, that we should turn backward in our tracks and ask for a dead past to teach us? And must we, chemist-like, shut out the sun and look for light in decayed bones?

Nathaniel Hawthorne, Italian Notebooks *(Columbus: Ohio State University Press, [1858] 1980).*

William Story looks thin and worn, already a little bald and a very little gray, but quite as vivid—in a graver way—as when I saw him last, a young man. He can yet, methinks, be scarcely thirty-seven. His perplexing variety of talents and accomplishments—a poet, a prose-writer, a lawyer,

a painter, a sculptor—seems now to be concentrating itself into this latter vocation; and I cannot see why he should not achieve something very good. He has a beautiful statue, already finished, of Goethe's Margaret pulling a flower to pieces to discover whether Faust loves her; a very type of virginity and simplicity. The statue of Cleopatra, now only fourteen days advanced in the clay, is as wide a step from the little maidenly Margaret as any artist could take; it is a grand subject, and he appears to be conceiving it with depth and power, and working it out with adequate skill. He certainly is sensible of something deeper in his art than merely to make beautiful nudities and baptize them by classic names. By the by, he told us several queer stories about American visitors to his studio; one of them, after long inspecting Cleopatra (into which he has put all possible characteristics of her time and nation and of her own individuality) asked "Have you baptized your statue yet?" as if the sculptor were waiting till his statue were finished before he chose the subject of it; as, indeed, I should think many sculptors do. Another remarked of a statue of Hero (who is seeking Leander by torchlight, and in momentary expectation of finding his drowned corpse,) "Is not the face a little sad?" . . .

This is a strange fascination that Rome exercises upon artists; there is clay elsewhere, and marble enough, and heads to model; and ideas may be made sensible objects at home as well as here. I think it is the peculiar mode of life, and its freedom from the enthralments of society, more than the artistic advantages which Rome offers; and then, no doubt, though the artists care little about one another's works, yet they keep one another warm by the presence of so many of them . . .

We went to the Piazza di Termini, near the baths of Diocletian, and found our way with some difficulty to Crawford's Studio. It occupies several great rooms, connected with the offices of the Villa Negroni, and all these rooms were full of plaster casts, and a few works in marble, principally portions of his huge Washington monument, which he left unfinished at his death. Close by the door at which we entered, stood a gigantic figure of Mason, in bag-wig, and the coat, waistcoat, breeches, and knee-and-shoe buckles of the last century—the enlargement of these unheroic matters to far more than heroic size having a very odd effect. There was a figure of Jefferson on the same scale; another of Henry; besides a horse's head, and other portions of the equestrian statue which is to cover the summit of the monument. In one of the rooms was a model of the monument itself, on a scale, I should think, of about an inch to a foot. It did not impress me as having grown out of any great and genuine idea in the artist's mind, but as being merely an ingenious contrivance enough. There were also casts of statues that seemed to be intended for some other monument, referring to Revolutionary times and personages; and with these were intermixed some ideal statues or groupes—a naked boy, playing marbles, very beautiful; a girl with flowers; the cast of his Orpheus, of which I long ago saw the marble statue; Adam and Eve; Flora; and several others, all with a good deal of merit, no doubt, but not a single one that justifies Crawford's reputation, or that satisfied me of his genius. They are but commonplaces in marble and plaster, such as we should not tolerate on a printed page. He seems to have been a respectable man, highly respectable, but no more; although those who knew him seem to have rated him much higher. Miss Lander tells me that he exclaimed, not very long before his death, that he had fifteen years of good work still in him; and he appears to have considered all his life and labour, heretofore, as only preparatory to the great things that he was to achieve hereafter. I should say, on the contrary, that he was a man who had done his best, and had done it early in life; for his Orpheus is quite as good as anything else we saw in his rooms.

People were at work, chiselling several of the plaster-casts in marble, a very interesting process, and what I should think a doubtful and hazardous one; but the artists say that there is no risk

of mischief, and that the model is sure to be accurately repeated in the marble. These people, who do what is considered the mechanical part of the business, are often themselves sculptors, and of higher reputation than those who employ them. It is rather sad to think that Crawford died before he could see his ideas in the marble, where they gleam with so pure and celestial a light, as compared with the plaster; there is almost as much difference as between flesh and spirit. The floor of one of the rooms was burthened with immense packages, containing parts of the Washington monument ready to be forwarded to its destination. When finished and set up, it will probably make a very splendid appearance, by its height, its mass, its skilful execution, and will produce a moral effect through its images of illustrious men, and the associations that connect it with our Revolutionary history; but I do not think it will owe much to the artist's force of thought or depth of feeling. It is certainly, in one sense, a very foolish and illogical piece of work—Washington mounted on an uneasy steed, on a very narrow space, aloft in the air, whence a single step of the horse, backward, forward, or on either side, must precipitate him; and several of his contemporaries standing beneath him, not looking up to wonder at his predicament, but each intent on manifesting his own personality to the world around. They have nothing to do with one another, nor with Washington, nor with any great purpose which all are to work out together . . .

A few days ago, my wife and I visited the studio of Mr. Mozier, an American, who seems to have a good deal of vogue as a sculptor. We found a figure of Pocahontas, which he has repeated several times; another which he calls the "Wept of Wish-ton-Wish"; a figure of a smiling girl playing with a cat and dog; and a school-boy mending a pen. These two last were the only ones that gave me any pleasure, or that really had any merit; for his cleverness and ingenuity appear in homely subjects, but are quite lost in attempts at a higher ideality. Nevertheless, he has a groupe of the Prodigal Son, possessing more merit than I should have expected from Mr. Mozier; the son reclining his head on his father's breast, with an expression of utter weariness, at length finding perfect rest, while the father bends his benign visage over him, and seems to receive him calmly into himself. This groupe (the plaster-cast standing beside it) is now taking shape out of an immense block of marble, and will be as indestructible as the Laocoon; an idea at once awful and ludicrous, when we consider that it is at best but a respectable production. Miss Lander tells me that Mr Mozier has stolen—adopted, we will rather say—the attitude and general idea of this groupe from one executed by a student of the French Academy, and to be seen there in plaister.

Mr. Mozier has now been seventeen years in Italy; and, after all this time, he is still intensely American in everything but the most external surface of his manners; scarcely Europeanized, or much modified, even in that. He is a native of Ohio, but had his early breeding in New York, and might—for any polish or refinement that I can discern in him—still be a country shop-keeper in the interior of New York or New England. How strange! For one expects to find the polish, the close grain, and white purity of marble, in the artist who works in that noble material; but, after all, he handles clay, and, judging from the specimens I have seen here, is apt to be clay, not of the finest, himself. Mr. Mozier is sensible, shrewd, keen, clever; an ingenious workman, no doubt, with tact enough, and not destitute of taste; very agreeable and lively in his conversation, talking as fast and as naturally as a brook runs, without the slightest affectation. His naturalness is, in fact, a rather striking characteristic, in view of his lack of culture, while yet his life has been concerned with idealities, and a beautiful art. What degree of taste he pretends to, he seems really to possess; nor did I hear a single idea from him that struck me as otherwise than sensible . . .

We have been, recently, to the studio of G. L. Brown, the American landscape painter, and were altogether surprised and delighted with his pictures. He is a very plain, homely, Yankee sort of a man, quite unpolished by his many years residence in Italy; he talks ungrammatically, and in Yankee idioms, walks with a strange, awkward gait, and stooping shoulders; is altogether unpicturesque, but wins one's confidence by his very lack of grace. It is not often that we see an artist so entirely free from affectation in his aspect and deportment. His pictures were views of Swiss and Italian scenery, and were most beautiful and true. One of them—a moonlight picture—was really magical, the moon shining so brightly that it seemed to throw a light even beyond the limits of the picture; and yet his sunrises, and sunsets, and his noontides too, were nowise inferior to this, although their excellence required somewhat longer study to be fully appreciated. I seemed to receive more pleasure from Brown's pictures than from any of the landscapes by old masters; and the fact serves to strengthen me in the belief that the most delicate, if not the highest charm of a picture is evanescent; and that we continue to admire pictures prescriptively and by tradition, after the qualities that first won them their fame have vanished. I suppose Claude was a greater landscape painter than Brown; but, for my own pleasure, I would prefer one of the latter artist's pictures; those of the former being quite changed from what he intended them to be, by the effect of time on his pigments. Mr. Brown showed us some drawings from Nature, done with incredible care and minuteness of detail, as studies for his pictures. We complimented him on his patience; but he said "Oh, it's not patience;—it's love!" In fact, it was a patient and most successful wooing of a beloved object, which at last rewarded him by yielding herself wholly . . .

I suppose there is a class-feeling among the artists who reside here, and they create a sort of atmosphere among themselves, which they do not find anywhere else, and which is comfortable for them to live in. Nevertheless, they are not generous or gracious critics of one another; and I hardly remember any full-breathed and whole-souled praise from sculptor to sculptor, or from painter to painter. They dread one another's ill-word, and scrupulously exchange little attentions for fear of giving offence; they pine, I suspect, at the sight of another's success, and would willingly keep a rich stranger from the door of any studio save their own. Their public is so much more limited than that of the literary men, that they have the better excuse for these petty jealousies . . .

At our visit to Powers's studio, on Tuesday, we saw a marble copy of the fisher-boy, holding a shell to his ear, and of the bust of Proserpina, and two or three other ideal busts; besides casts of most of the ideal statues and portrait-busts which he has executed. He talks very freely about his works, and is no exception to the rule that an artist is not apt to speak in a very laudatory style of a brother-artist. He showed us a bust of Mr. Sparks by Persico—a lifeless and thoughtless thing enough, to be sure—and compared it with a very good one of the same gentleman by himself; but his chiefest scorn was bestowed on a wretched and ridiculous image of Mr. King, of Alabama, by Clark Mills, of which he said he had been employed to make several copies for Southern gentlemen. The consciousness of power is plainly to be seen, and the assertion of it by no means withheld, in his simple and natural character; nor does it give one the idea of vanity on his part, to see and hear it. He appears to consider himself neglected by his country—by the Government of it, at least—and talks with indignation of the by-ways and political intrigue which, he thinks, win the rewards which ought to be bestowed exclusively on merit. An appropriation of twenty-five thousand dollars was made, some years ago, for a work of sculpture by him, to be placed in the Capitol; but the intermediate measures, necessary to render it

effective, have been delayed, while the above-mentioned Clark Mills—certainly the greatest bungler that ever botched a block of marble—has received an order for an equestrian statue of Washington. Not that Powers is made sour or bitter by these wrongs, as he considers them; he talks of them with the frankness of his disposition, when the topic comes in his way, and seems to be pleasant, kindly, and sunny when he has done with it. His long absence from our country has made him think worse of us than we deserve; and it is an effect of which I myself am sensible, in my shorter exile,—the most piercing shriek, the wildest yell, and all the ugly sounds of popular turmoil, inseparable from the life of a republic, being a million times more audible than the peaceful hum of prosperity and content, which is going on all the while. He talks of going home, but says that he has been talking of it every year since he first came to Italy; and between his pleasant life of congenial labor here, and his idea of moral deterioration in America, I think it doubtful whether he ever crosses the sea again. Like most twenty-year exiles, he has lost his native country without finding another; but then it is as well to recognize the truth, that an individual country is by no means essential to one's comfort.

Powers took us into the farthest room, I believe, of his very extensive studio, and showed us a statue of Washington that has much dignity and stateliness; he expressed, however, great contempt for the coat and breeches, and masonic emblems, in which he had been required to drape the figure. What the devil would the man do with Washington, the most decorous and respectable personage that ever went ceremoniously through the realities of life! Did anybody ever see Washington naked! It is inconceivable. He had no nakedness, but, I imagine, was born with his clothes on and his hair powdered, and made a stately bow on his first appearance in the world. His costume, at all events, was a part of his character, and must be dealt with by whatever sculptor undertakes to represent him. I wonder that so very sensible a man as Powers should not see the necessity of accepting drapery; and the very drapery of the day, if he will keep his art alive. It is his business to idealize the tailor's actual work. But he seems to be especially fond of nudity, none of his ideal statues—so far as I know them—having so much as a rag of clothes. His statue of California (lately finished, and as naked as Venus) seemed to me a very good work; not an actual woman, capable of exciting passion, but evidently a little out of the category of human nature. In one hand, she holds a divining rod, which luckily does the office of a fig-leaf. "She says to the emigrants," observed Powers, "here is the gold, if you choose to take it." But in her face, and in her eyes, very finely expressed, there is a look of latent mischief—rather grave than playful; yet somewhat impish, or spritelike—and in the other hand, behind her back, she holds a bunch of thorns. Powers calls her eyes Indian . . .

Soon [on a later date], Mr. Powers made his appearance, in his dressing gown and slippers, and sculptor's cap, smoking a cigar, which by the by was none of the best. He was very cordial and pleasant, as I have always found him, and began immediately to be communicative about his own works or on any other subject that came up. There were two casts of the Venus de Medici in the studio, which he said were valuable in a commercial point of view, being genuine casts from the mould taken from the statue. He then gave us a quite unexpected but most interesting lecture on the Venus, demonstrating it as he proceeded by reference to the points which he criticized. The figure, he seemed to allow, was admirable, though I rather think he hardly classes it so high as his own Greek Slave or Eve; but the face, he began with saying, was that of an idiot. Then, leaning on the pedestal of the cast, he continued—"It is rather a bold thing to say, isn't it, that the sculptor of the Venus de Medici did not know what he was about?" Truly, it appeared to me so; but Powers went on remorselessly, and showed, in the first place, that the eye was not

like any eye that Nature ever made; and, indeed, being examined closely, and abstracted from the rest of the face, it has a very queer look—less like a human eye than a half-worn button-hole . . .

After annihilating this poor visage, Powers showed us his two busts of Proserpine and Psyche, and continued his lecture by showing the truth to nature with which these are modelled. I freely acknowledge the fact; there is no sort of comparison to be made between the beauty, intelligence, feeling, and accuracy of representation, in these two faces, and in that of the Venus de Medici. A light—the light of a soul proper to each individual character—seems to shine from the interior of the marble and beam forth from the features, chiefly from their eyes. Still insisting upon the eye, and hitting the poor Venus another, and another, and still another blow on that unhappy feature, Mr. Powers, turned up, and turned inward, and turned outward, his own Titanic orb (the biggest by far that ever I saw in mortal head) and made us see and confess that there was nothing right in the Venus, and everything right in Psyche and Proserpine. To say the truth, their marble eyes have life, and, placing yourself in the proper position towards them, you can meet their glances, and feel theirs mingle with your own. Powers is a great man, and also a tender and delicate one, massive and rude of surface as he looks; and it is rather absurd to feel how he impresses his auditor, for the time being, with his own evident idea that nobody else is worthy to touch marble. Mr Bryant told me that Powers has had many difficulties and quarrels, on professional grounds, as I understood him, and with his brother-artists. No wonder! He has said enough, in my hearing, to put him at swords' points with sculptors of every epoch, and every degree, between the two inclusive extremes of Phidias and Clark Mills . . .

Before we went away, Powers took us into a room apart—apparently the secretest room he had—and showed us some tools and machinery, all of his own contrivance and invention. "You see, I am a bit of a Yankee," he observed. This machinery is chiefly to facilitate the process of modelling his works; for (except in portrait-busts) he makes no clay-model, as other sculptors do, but models directly in the plaster; so that instead of being crumbled, like clay, the original model remains a permanent possession. He has also invented a certain open file, which is of great use in finishing the surface of the marble; and likewise a machine for making these files, and for punching holes through iron; and he demonstrated its efficacy by punching a hole through an iron bar, with a force equivalent to ten thousand pounds, by the mere application of a part of his own weight. These inventions, he says, are his amusement; and the set of his nature towards sculpture must indeed have been strong, to counteract, in an American, such a capacity for the contrivance of steam-engines.

MANIFEST DESTINY

> *A rallying cry for U.S. territorial expansion, the idea of manifest destiny held that under a God-given mandate the mission and goal of the American people (i.e., Anglo- or Euro-Americans) was to move inexorably westward, bringing civilization, democracy, and freedom to the land from the Atlantic to the Pacific coast. The influential Democrat John L. O'Sullivan, founder and editor of the* United States Magazine and Democratic Review, *coined the term in 1845. It quickly came to serve as an all-purpose justification for the ever-increasing waves of settlement across the continent while providing an implicit or explicit program for American history painting and for the visual representation of life and landscape on the western frontier.*

In the articles below, O'Sullivan articulates the program, rationale, and inevitability of U.S. expansion. He sees the United States as a nation without limits, set on a mission toward greatness. The fulfillment of this mission will be the realization of America's fundamental organizing principles: universal freedom, equality, and individual rights. Blessed and chosen by God, Americans will set an example, spelling death to tyranny and spreading enlightened values wherever they go. It is the Americans' inevitable and inexorable "manifest destiny," in sum, to claim, occupy, and civilize the entire continent. Significantly, O'Sullivan excludes African Americans from his vision of future glory and fails even to acknowledge the existence of Native Americans.

John L. O'Sullivan, *"The Great Nation of Futurity,"* United States Magazine and Democratic Review 6 (November 1839).

The American people having derived their origin from many other nations, and the Declaration of National Independence being entirely based on the great principle of human equality, these facts demonstrate at once our disconnected position as regards any other nation; that we have, in reality, but little connection with the past history of any of them, and still less with all antiquity, its glories, or its crimes. On the contrary, our national birth was the beginning of a new history, the formation and progress of an untried political system, which separates us from the past and connects us with the future only; and so far as regards the entire development of the natural rights of man, in moral, political, and national life, we may confidently assume that our country is destined to be *the great nation* of futurity . . .

What friend of human liberty, civilization, and refinement, can cast his view over the past history of the monarchies and aristocracies of antiquity, and not deplore that they ever existed? What philanthropist can contemplate the oppressions, the cruelties, and injustice inflicted by them on the masses of mankind, and not turn with moral horror from the retrospect?

America is destined for better deeds. It is our unparalleled glory that we have no reminiscences of battle fields, but in defence of humanity, of the oppressed of all nations, of the rights of conscience, the rights of personal enfranchisement. Our annals describe no scenes of horrid carnage, where men were led on by hundreds of thousands to slay one another, dupes and victims to emperors, kings, nobles, demons in the human form called heroes. We have had patriots to defend our homes, our liberties, but no aspirants to crowns or thrones; nor have the American people ever suffered themselves to be led on by wicked ambition to depopulate the land, to spread desolation far and wide, that a human being might be placed on a seat of supremacy.

We have no interest in the scenes of antiquity, only as lessons of avoidance of nearly all their examples. The expansive future is our arena, and for our history. We are entering on its untrodden space, with the truths of God in our minds, beneficent objects in our hearts, and with a clear conscience unsullied by the past. We are the nation of human progress, and who will, what can, set limits to our onward march? Providence is with us, and no earthly power can. We point to the everlasting truth on the first page of our national declaration, and we proclaim to the millions of other lands, that "the gates of hell"—the powers of aristocracy and monarchy— "shall not prevail against it."

The far-reaching, the boundless future will be the era of American greatness. In its magnificent domain of space and time, the nation of many nations is destined to manifest to mankind the excellence of divine principles; to establish on earth the noblest temple ever dedicated to the worship of the Most High—the Sacred and the True. Its floor shall be a hemi-

sphere—its roof the firmament of the star-studded heavens, and its congregation an Union of many Republics, comprising hundreds of happy millions, calling, owning no man master, but governed by God's natural and moral law of equality, the law of brotherhood—of "peace and good will amongst men."

But although the mighty constituent truth upon which our social and political system is founded will assuredly work out the glorious destiny herein shadowed forth, yet there are many untoward circumstances to retard our progress, to procrastinate the entire fruition of the greatest good to the human race. There is a tendency to imitativeness, prevailing amongst our professional and literary men, subversive of originality of thought, and wholly unfavorable to progress. Being in early life devoted to the study of the laws, institutions, and antiquities of other nations, they are far behind the mind and movement of the age in which they live: so much so, that the spirit of improvement, as well as of enfranchisement, exists chiefly in the great masses—the agricultural and mechanical population . . .

. . . Already the brightest hopes of philanthropy, the most enlarged speculations of true philosophy, are inspired by the indications perceptible amongst the mechanical and agricultural population. There, with predominating influence, beats the vigorous national heart of America, propelling the onward march of the multitude, propagating and extending, through the present and the future, the powerful purpose of soul, which, in the seventeenth century, sought a refuge among savages, and reared in the wilderness the sacred altars of intellectual freedom. This was the seed that produced individual equality, and political liberty, as its natural fruit; and this is our true nationality. American patriotism is not of soil; we are not aborigines, nor of ancestry, for we are of all nations; but it is essentially personal enfranchisement, for "where liberty dwells," said Franklin, the sage of the Revolution, "there is my country." . . .

Yes, we are the nation of progress, of individual freedom, of universal enfranchisement. Equality of rights is the cynosure of our union of States, the grand exemplar of the correlative equality of individuals; and while truth sheds its effulgence, we cannot retrograde, without dissolving the one and subverting the other. We must onward to the fulfilment of our mission—to the entire development of the principle of our organization—freedom of conscience, freedom of person, freedom of trade and business pursuits, universality of freedom and equality. This is our high destiny, and in nature's eternal, inevitable decree of cause and effect we must accomplish it. All this will be our future history, to establish on earth the moral dignity and salvation of man—the immutable truth and beneficence of God. For this blessed mission to the nations of the world, which are shut out from the life-giving light of truth, has America been chosen; and her high example shall smite unto death the tyranny of kings, hierarchs, and oligarchs, and carry the glad tidings of peace and good will where myriads now endure an existence scarcely more enviable than that of beasts of the field. Who, then, can doubt that our country is destined to be *the great nation* of futurity?

John L. O'Sullivan, "Annexation," United States Magazine and Democratic Review 17 (July 1845).

It is time now for opposition to the Annexation of Texas to cease, all further agitation of the waters of bitterness and strife, at least in connexion with this question,—even though it may perhaps be required of us as a necessary condition of the freedom of our institutions, that we must live on for ever in a state of unpausing struggle and excitement upon some subject of party division or other . . .

Why, were other reasoning wanting, in favor of now elevating this question of the recep-

tion of Texas into the Union, out of the lower region of our past party dissensions, up to its proper level of a high and broad nationality, it surely is to be found, found abundantly, in the manner in which other nations have undertaken to intrude themselves into it, between us and the proper parties to the case, in a spirit of hostile interference against us, for the avowed object of thwarting our policy and hampering our power, limiting our greatness and checking the fulfilment of our manifest destiny to overspread the continent allotted by Providence for the free development of our yearly multiplying millions . . .

. . . Texas has been absorbed into the Union in the inevitable fulfilment of the general law which is rolling our population westward; the connexion of which with that ratio of growth in population which is destined within a hundred years to swell our numbers to the enormous population *of two hundred and fifty millions* (if not more), is too evident to leave us in doubt of the manifest design of Providence in regard to the occupation of this continent. It was disintegrated from Mexico in the natural course of events, by a process perfectly legitimate on its own part, blameless on ours; and in which all the censures due to wrong, perfidy and folly, rest on Mexico alone. And possessed as it was by a population which was in truth but a colonial detachment from our own, and which was still bound by myriad ties of the very heart-strings to its old relations, domestic and political, their incorporation into the Union was not only inevitable, but the most natural, right and proper thing in the world—and it is only astonishing that there should be any among ourselves to say it nay . . .

California will, probably, next fall away from the loose adhesion which, in such a country as Mexico, holds a remote province in a slight equivocal kind of dependence on the metropolis. Imbecile and distracted, Mexico never can exert any real governmental authority over such a country . . . The Anglo-Saxon foot is already on its borders. Already the advance guard of the irresistible army of Anglo-Saxon emigration has begun to pour down upon it, armed with the plough and the rifle, and marking its trail with schools and colleges, courts and representative halls, mills and meeting-houses. A population will soon be in actual occupation of California, over which it will be idle for Mexico to dream of dominion. They will necessarily become independent. All this without agency of our government, without responsibility of our people—in the natural flow of events, the spontaneous working of principles, and the adaptation of the tendencies and wants of the human race to the elemental circumstances in the midst of which they find themselves placed . . . Whether they will then attach themselves to our Union or not, is not to be predicted with any certainty. Unless the projected rail-road across the continent to the Pacific be carried into effect, perhaps they may not; though even in that case, the day is not distant when the Empires of the Atlantic and Pacific would again flow together into one, as soon as their inland border should approach each other. But that great work, colossal as appears the plan on its first suggestion, cannot remain long unbuilt. Its necessity for this very purpose of binding and holding together in its iron clasp our fast settling Pacific region with that of the Mississippi valley—the natural facility of the route—the ease with which any amount of labor for the construction can be drawn in from the overcrowded populations of Europe, to be paid in the lands made valuable by the progress of the work itself—and its immense utility to the commerce of the world with the whole eastern coast of Asia, alone almost sufficient for the support of such a road—these considerations give assurance that the day cannot be distant which shall witness the conveyance of the representatives from Oregon and California to Washington within less time than a few years ago was devoted to a similar journey by those from Ohio; while the magnetic telegraph will enable the editors of the "San Francisco Union," the "Asto-

ria Evening Post," or the "Nootka Morning News" to set up in type the first half of the President's Inaugural, before the echoes of the latter half shall have died away beneath the lofty porch of the Capitol, as spoken from his lips.

Away, then, with all idle French talk of *balances of power* on the American Continent . . . And whosoever may hold the balance, though they should cast into the opposite scale all the bayonets and cannon, not only of France and England, but of Europe entire, how would it kick the beam against the simple solid weight of the two hundred and fifty, or three hundred millions—and American millions—destined to gather beneath the flutter of the stripes and stars, in the fast hastening year of the Lord 1945!

MANUFACTURING HISTORY

AMERICAN HISTORY, PRO AND CON

The middle decades of the nineteenth century saw renewed discussion on the subject of the high art of history painting and its place in modern America. What historical moments were worthy of commemoration? Did America have enough history yet to warrant commemorating at all? Obviously there were undisputed heroes in the past, George Washington above all; there were pivotal events such as the embarkation or the landing of the Pilgrims, or, further back, the voyage of Christopher Columbus; painters more often seized upon those subjects than any other. But in tension with any glorification of the past was the vision of America on the frontier of the future, moving inexorably to its manifest destiny.

A major bone of contention among art critics and by extension artists in the midcentury decades was the viability of a national, American "school" of painters and sculptors. Clearly, landscape painting had some claim to that distinction, as did genre. Some writers, however, argued that only the high art of national history painting truly qualified. Others just as vigorously spurned such provincial thinking, contending that only the development of national spirit, not subject, would constitute a truly American school of art.

The journalist, critic, and painter Charles Lanman looks (with considerable prejudice) at both sides of the question in the Southern Literary Messenger. *He devotes the first half of his article to those who insist on national subjects to the exclusion of all else. It quickly becomes apparent that in Lanman's view such fervent nationalism has done little beyond launching vainglorious campaigns to Americanize orthography and replace the acanthus leaf of the Corinthian capital with ears of corn. The American artist, rather, should transcend patriotic clichés and national borders; the whole world is his for the plucking. One wonders if Lanman's clarion call for an American art of global scope and significance echoes the confident expansionist spirit of victory just achieved in the war with Mexico.*

Charles Lanman, "On the Requisites for the Formation of a National School of Historical Painting," Southern Literary Messenger 14 (December 1848).

There are some men among us who are such scrupulous and exclusive patriots, who are so jealously devoted to the aggrandizement and glorification of our own dear country, that they insist upon the necessity incumbent upon all our artists of painting nothing but national subjects; oth-

erwise, say they, the artists are false to the resources and reputation of the land that gave them birth, and do not deserve the name of *American*. If landscape is the artist's choice, let him paint nothing but American scenery, especially views of such places as have witnessed the triumphs of the American arms. If historical painting be the object of his devotion, let him illustrate only the great events of American History. There is a similar class among the literary men of our country, who are continually crying out for a "National Literature," as if a National literature would come any the sooner by their crying for it than by their writing for it, and meanwhile they are mostly authors of such mean abilities, that while they are crying it up, they are writing it down. From this principle, however, has originated a vast and vapid array of novels, tales, poems, &c., founded on the red men and the Revolution, which two branches comprehend almost all the available nationality we can boast of, always excepting those everlasting Pilgrim Fathers, who have so often, on canvass, been placed, have headed and handed, amid ice and snow and the dreariest cold of a New England winter, that it is a special Providence they have not been frozen to death long ago. Some wiseacres have proposed that all American books and newspapers should be printed in a peculiar letter, avoiding all forms of the *Roman* as being decidedly *English* . . . Another and a later set, still more rabid, have attempted to remodel the orthography of the whole language, and they print books and a newspaper in a character that looks as if their fount of type had been mixed up with portions taken from other founts of Greek, old Saxon, Russian, Coptic and Gibberish. This is a free country, and men are at liberty to make fools of themselves in any harmless way they like, especially if they pay the expenses themselves. Some architects have carried the principle of nationality into their branch of the fine arts, and have proposed a column whose capital shall be adorned with silk-tasseled ears of Indian corn, and strings of tomatoes, which, as the "American order," shall supersede, among the "Natives," the acanthus leaves and almonds of the graceful Corinthian and the chaste Ionic . . .

Now what is the foundation of all these propositions? Is it patriotism? If so we should at least give them a respectful consideration, for true patriotism is a noble virtue, although it has a name which is nearly worn threadbare. But it must be remembered that patriotism, like valor, generally lies dormant in the "piping times of peace," and is developed only at epochs of national danger or distress. *Then,* no people that have Anglo-Saxon blood in their veins, will be found to lack it. But gazing on patriotic pictures is by no means a sure way to arouse patriotic emotions. I have stood in the rotunda of the Capitol at Washington, looking at some of Col. Trumbull's shirt-sleeve heroes of the Revolution, and have seen a man come in, just fresh from the country, whose opinion of his native land was great in strict proposition with his ignorance of all others, and I have watched the effect produced upon him. His eyes shone when I explained the picture to him; he asked question after question, and finally, slapping his hand vehemently upon his thigh, he almost shouted—"Yes, them's the fellers that licked the British! Them's the fellers for me!" It excited in him, to an intense degree, the passion of *National vanity:* while in me, who love my native land, I believe, as well as any man, the only feeling was that, as a work of art, the picture was a poor concern, and unworthy of the Capitol of a nation as great as ours. *National vanity* is the root whence all these silly projects of "nationality" arise, and their advocates, who are chiefly to be noted for two things, clamor and pertinacity, will almost invariably be found to be men who have great ambition with small ability, who have discovered that National vanity is a strong and lusty beast of burden, which can carry great freight, and which they are determined to mount, in the vain hope that they may thus securely ride to the regions of renown . . .

Now the great object of Art is, not to pander to National vanity, but to encourage and develope in man the sense of the beautiful, the good and the true, and by fit representations of

them, to enchant him with their love. It is intended to appeal to the sympathies, the feelings, the principles, the belief, the hopes, the fears, the affections of man as man, and not as an American, or an Englishman, or a Frenchman . . .

. . . Let us look at the brief history of American art thus far, and see what the National principle has done for us. The great "National" pictures are in the Rotunda at Washington. Of these, Trumbull's are valuable only for their portraits. Chapman's Baptism of Pocahontas is a decided failure. Weir's and Vanderlyn's are the best of the seven, but strictly speaking they do not illustrate subjects of American history at all, if by "American" we are to understand, as we suppose, "belonging to these United States." For Weir's represents a company of Englishmen, on board an English ship, in a Dutch port, at a time when neither the vessel nor any of her famous passengers had ever seen or set foot in America. And Vanderlyn's is a Spanish and not an American picture, by the same rule; for all the persons represented are Spaniards, the scene is in an island that never belonged to us and probably never will, and the great discoverer himself never touched on any part of the coast of these United States. So the best pictures in the Rotunda are those that are *not* American. West was an American artist, and was the first to give America a name for the arts, yet what national subject did he ever illustrate? Allston raised his country's fame still higher, and has also won an European reputation as a historical painter. Yet he too was devoid of "patriotism." And among living historical painters of our country, some of whom have risen, and several bid fair to rise to eminence, what nationality has been displayed? To illustrate by a case in point, so as to ascertain what *is* the true value of this nationality in art, take the case of Powers. His statue of the Greek Slave has established his reputation in Europe, and placed an American on a par with the highest living sculptors; and his statue of the boy holding a shell to his ear has only increased his fame. Now would the glory to our nation have been any the greater if the Greek Slave, instead of a Greek, had been made a lovely young Choctaw squaw, or the boy with the shell had been modelled from a little responsibility among the Sacs and Foxes? And to fortify our position by but one case from among our literary men; what writer has done more to raise our character abroad than Prescott, a man acknowledged by all European critics to be second to no living historian, if he be not himself the first.[1] And yet he has written only Spanish, Mexican and Peruvian history—not one word of American.

But what are the contracted limits to which these men, of one idea, (and that one both little and false,) would confine the aspiring though youthful energies of American art? There are, first of all, the Red men—very interesting characters, no doubt, in Mr. Cooper's Novels, or Mr. Catlin's Indian gallery, of which the latter is worth infinitely more than the former, because it is "founded on fact." But it is hard to make much, in the way of art, of a "brave" who chooses to adorn himself, like a bantam cock, with feathers down to his heels. A tawny chief may be made to look very sentimental on canvass, indeed, if you imagine him arrived, towards the hour of a cloudy sunset, at the jumping-off place on the borders of the Pacific ocean and fancy him ready to take the leap. Something may be made out of a council-fire, and something out of a pipe of peace; though a tomahawk is decidedly too bloodthirsty to be artistical. But is the national artist to be bound up to an eternal round of Pottawotamies, Chickasaws, Black-feet and Flat-heads, braves, squaws, and papooses? Is he to be shut up forever in the forest, or the smoky and spacious wigwam? Oh no! say these patriotic curtailers of the Liberty of Art,—there are

[1] This reference is to distinguished American historian William Prescott, authority on the Spanish conquest and colonization of the New World. See "Emanuel Leutze's Clash of Civilizations," this chapter.

"Washington and his Generals." And are these to be done to death by American artists, as "Napoleon and his Marshals" have been served by the French? "But then," chimes in a nasal down-easter, "there are the Pilgrim fathers, let them paint them!" I would respectfully remind the nasal down-easter, that, in the first place, the Pilgrim fathers are not very picturesque objects, and, in the second place, that they have been very extensively "done" already; Weir made the most of them, and there they are in the Capitol, as gray as Norway rats and as cold as Quincy granite. No! FREEDOM is the motto of our country! The son of New England is at liberty to go forth to any corner of the world, however remote, trade and traffic there, and bring home the proceeds of his enterprise to enrich his native place, and enjoy himself on his gains. And may not the Yankee artist likewise go to any quarter of the world for the subject of his picture? Let him handle it well, let the fire of genius warm his fancy, and the patience of perseverance bring his design to a perfect work, and no matter whence the subject comes, he has brought fame to his country and to her school of painting, and let him enjoy it without interference. It would be a poor sort of liberty we have, and one not worth boasting of or painting pictures for its everlasting glorification, if the Yankee artist were not at least as free as the Yankee pedlar.

No! the field, spread out before the American Historical Painter is as wide as the domain of Art can make it. Religion lies first, and highest, and deepest. It is the source of the truest and most enduring inspiration, and has ever been the favorite subject of the greatest works of the pencil. And her sacred finger has already signed the youthful forehead of American Art with the sign of the Cross. For here were the noblest efforts of West displayed. Here Allston exerted his highest powers. Here our living Huntington has chosen his home, and his "Mercy's dream," and "Christiana passing through the valley of the shadow of death," will live and bring comfort and peace to the heart of many an humble believer,—yes, and be reckoned high in the school of American Historical painting too, when Colonel Trumbull's National picture of one hundred and twelve legs, in knee-breeches, shall have passed away, or sunk into the insignificance which many may think it enjoys already.

Besides the inexhaustible field of religion it must be remembered, that since our country has opened as it were an asylum for the oppressed of all countries, and reckons among her citizens natives of almost, if not quite all, the kingdoms and States in christendom, as American painters have a right to naturalize, in American art, all the nationalities of all the nations under heaven. The world is all before them where to choose. Only let them choose for themselves, and not suffer themselves to be dictated to by pragmatical ignoramuses, whose only qualifications for such an office are long tongues and strong lungs, and whose inkstands are never dry, for they are constantly putting in more water. But let them, when they have selected a subject, *love* the theme of their own choice, and work it out with patient, true affection, and they will be doing *their* duty to American Art.

There are then but two grand requisites for the formation of an American School of Historical Painting.

First: *That there shall be American painters.*

Second: *That these American painters shall paint well . . .*

. . . Liberty is theirs! Let them show their country and the world, that they know how to use it!

THE AMERICAN SPIRIT OF EMANUEL LEUTZE

A German American who spent the most productive years of his career in Düsseldorf, Emanuel Leutze earned fervent acclaim in the United States for his large-scale, dra-

matic paintings of epochal events in American and European history. Born near Würt-
temberg, Leutze was raised in Philadelphia and Fredericksburg, Virginia. He studied
at the Royal Academy of Fine Arts in Düsseldorf, while there offering friendship and
advice to numerous young Americans (see "Düsseldorf and the Düsseldorf Gallery,"
this chapter).

A fervent liberal, Leutze supported the German revolution of 1848. Henry Tucker-
man's account of the young artist highlights Leutze's freedom-loving politics and intrin-
sically American sympathies. Tuckerman describes Leutze's epiphany in the Swabian
Alps and his subsequent resolution to make "the progress of Freedom" his overarching
theme in a "grand series" of paintings charting its epochal course through history. In
Tuckerman's eyes, Leutze might be the spirit of manifest destiny incarnate: were he not
a painter, he would surely be found trekking energetically on some Rocky Mountain
expedition. Unquestionably, Tuckerman values the timely meaning of Leutze and his
work.

Henry Tuckerman, "Our Artists.—No. III. Leutze," Godey's Lady's Book 33 (October 1846).

The paintings of Leutze . . . instead of merely telling a story, have a moral significance—
conveying some great idea of chivalry, as in the Northmen—moral dignity, as in Columbus—
loyalty to truth or faith, as in Knox and Queen Mary. In each instance, it is not so much the
fidelity of the historical scene as the interest of the moral purpose which affects the spectator . . .

Three years since Leutze visited Munich . . . After his recent constant application, there was . . .
a need of tranquillity. He knew that the mind, like the earth, is enriched by lying fallow, and
determined to consecrate a few months to repose . . . Having finished "Columbus before the
Queen," Leutze took advantage of some casual excuse to withdraw himself awhile, and plunged
for refreshment into the beautiful scenery of the Suabian Alps—a region abounding in histor-
ical interest and full of remains of the architecture of the middle ages. For nearly half a year he
loitered about the foot of the Hohenstaufen, where stood the castle of that great race, alike ro-
mantic in its rise and fall, from Barbarossa to the ill-fated Conradin of Naples.[2] With the tone
of mind so clearly evinced in his pictures, we can easily imagine what food for contemplation
Leutze found amid these trophies of the past—memorials of the strife between church and state
that agitated civilized Europe for centuries. There are the picturesque relics of the free cities,
with their gray walls and frowning towers, in which a few hardy burghers bade defiance to their
aristocratic oppressors, and gave the first impulse to that love of liberty which realized itself,
after countless vicissitudes, in the institutions of that far western land so dear to the affections
of the pilgrim of art. The progress of Freedom thus represented itself in pictures to his mind,
forming a long cycle from the first dawning of free institutions in the middle ages to the
Reformation—through the revolution in England, the causes of emigration, including the dis-
covery and settlement of America; her early protests against oppression—to the war and dec-
laration of independence. Leutze has given us some noble illustrations of this grand series of
events, which thus arrayed themselves to his fancy . . . into a magnificent epic uttered in forms
and colors, and we earnestly hope that he will forge many other enduring and golden links of
the chain, and thus make the effective in human art symbolize the glorious in human destiny!

[2] These are the dukes of Swabia and members of the powerful German Hohenstaufen Dynasty; as Holy Roman
emperor, Frederick I ("Barbarossa") clashed with the pope, constrained the power of the German nobility, and con-
ferred independent rights on the principal cities.

Such an enterprise accords with the spirit of the age infinitely better than the constant and tame reproduction of obsolete ideas.

There is a spirit in the world born of earnest natures, which gives rise to what may be called the poetry of action. It aims to embody heroic dreams and prompts men to nourish great designs in secret, to leap from the crowd of passive lookers-on and become pioneers, discoverers and martyrs. It gives the primary impulse to reform, lends sublime patience to scientific research, cheers the vigil and nerves the arm of him who keeps watch or wages battle for humanity. It is the spirit of Adventure. The navigators of the age of Elizabeth and the religious innovators of a later day, knew its inspiration; and in all times the knight, the apostle, the crusader and the emigrant, have illustrated its power. All the momentous epochs of life and history are alive with its presence, and it glows alike in the wars of Spanish invasion, the protests of Luther, the voyages of Raleigh, the revolt of Masaniello, the experiment of Fulton, and in the heart of many a volunteer who is, at this moment, encamped beyond the Rio Grande. Leutze delights in representing Adventure. He ardently sympathizes with chivalric action and spirit-stirring events; not the abstractly beautiful or the simply true, but the heroic, the progressive, the individual and earnest phases of life warm his fancy and attract his pencil. His forte is the dramatic. Events awaken his interest far more than still-life, however charming, and the scenes he aspires to portray, instead of being calm reflections of nature, must be alive with some destiny, suggestive of a great epoch in human affairs, or palpitate with the concentrated life of one of those moments in an individual's career when the thoughts of years converge to a focus or shape themselves into victorious achievement. This sense of the adventurous and vivid sympathy with what is impressive in character and memorable in history, seems to us the marked characteristic of Leutze's genius. It is manifest in all his successful efforts, and distinguishes him from that large class of artists who are quite content with the mere beauty of a scene and the familiar in life. If Leutze were not a painter, he certainly would join some expedition to the Rocky Mountains, thrust himself into a fiery political controversy, or seek to wrest a new truth from the arcana of science. He is a living evidence of one of Emerson's aphorisms—"there is hope in extravagance, there is none in routine." We remember hearing a brother artist describe him in his studio at Rome, engaged for hours upon a picture, deftly shifting pallette, segar and maul-stick from hand to hand, as occasion required; absorbed, rapid, intent, and then suddenly breaking from his quiet task to vent his constrained spirits in a jovial song or a romp with his great dog, whose vociferous barking he thoroughly enjoyed; and often abandoning his quiet studies for some wild, elaborate frolic, as if a row was essential to his happiness. His very jokes partook of this bold heartiness of disposition. He scorned all ultra-refinement, and found his impulse to art not so much in delicate perception as in vivid sensation. There was ever a reaction from the meditative. His temperament is Teutonic—hardy, cordial and brave. Such men hold the conventional in little reverence, and their natures gush, like mountain streams, with wild freedom and unchastened enthusiasm. Leutze resembles Carlyle. There must be great affinity in their minds—both impress and win us through a kind of manly sincerity and courageous bearing. The paintings of the one, like the writings of the other, often violate good taste and offend us by exaggeration in details; but we readily forgive such defects, because of the earnest and adventurous spirit, the exhilarating strength of will, the genuine individuality they exhibit. Both, too, eloquently teach Hero-Worship, and enlist our sympathies in behalf of those who bravely endure or calmly dare for the sake of "an idea dearer than self." Leutze has given evidence that he can illustrate some of the highest tendencies of the age. We recognize in him a prophetic rather than a retrospective genius. If true to himself, he will convey higher and more effective

lessons than modern art has usually aspired to. We have painters enough who can ably depict the actual in external nature and the ideal of beauty in the abstract, but very few who have the energy and comprehensiveness to seize upon heroic attitudes and make clear to the senses, as well as to the soul, that "the angel of martyrdom is brother to the angel of victory." Leutze has a heart that beats in unison with the echoes of the mountains, that swells at the thought of great deeds and exalted suffering, and can appreciate the majestic loveliness that plays, like a divine halo, around those who have deemed freedom and truth dearer than life, and vindicated their faith by deeds. We hope to see more of the great events of our own history made the subject of his labors, for we are confident that no living painter is better fitted to enter into the spirit which makes glorious our country's annals, than Emmanuel Leutze.

EMANUEL LEUTZE'S CLASH OF CIVILIZATIONS

Emanuel Leutze's Storming of the Teocalli by Cortez and His Troops *(1848), which represents Spanish forces assailing the last Aztec stronghold, is part of the painter's ongoing project of representing key turning points in the epic story of progress toward freedom and democracy. Exhibited at the American Art Union, the work attracted the attention of a* Literary World *writer, who notes that a passage from William Prescott's* History of the Conquest of Mexico *(1843) furnished the subject of Leutze's picture. After describing the pictorial excitement in some detail, the critic states that Leutze has been "fortunate" in his source, since Prescott has dramatized the victory of civilization itself in this violent clash with savagery. Despite its brilliance, though, the picture does not satisfy: it lacks coherence, and its "moral power" is weakened by its insistence on an unrelieved accumulation of "horrors." Leutze has also cut corners on his research, taking certain details from ancient Central American architecture and simply applying them to his recreation of the Aztec temple. This measured and discerning critique suggests that at least some nineteenth-century viewers were well informed and not necessarily credulous in their understanding of history paintings. Given the date, it is likely too that this critic had the recent Mexican-American war in mind when commenting on the triumph of civilization in the war between the Spanish and the Aztecs.*

"The Paintings on Exhibition at the Art-Union," Literary World *(September 8, 1849)*.

We noticed last week the pictures already purchased by the Art-Union for the Annual Distribution . . .

Of these pictures, the most prominent is Leutze's "*Storming of the Mexican Teocalli by Cortez,*" which has been, during the last few weeks, one of the leading attractions of the gallery. It arrived but recently from Dusseldorf (where it was painted), by the way of Bremen, at which place it was exhibited for a few days previous to its shipment . . .

Leutze has produced a very powerful and effective picture.

The scene forms one of the most striking passages in Prescott's History of the Conquest of Mexico. It is the fierce battle between the Spaniards and the Aztecs on the steps and summit of the great *teocalli* of Huitzilopotchli. The picture represents the final struggle around and beneath the huge idol which crowns the pyramid. The last hour of the Aztecs has come, and they are meeting the determined, irresistible onslaught of Cortez and his soldiers with the reckless courage of despair. There is no retreat possible to either, and all the elements of a deadly struggle crowd

the moment. The standard of Castile has already been planted on the pyramid; the divinity, half shrouded in the smoke which rises from the altars on either side, almost totters on his throne; the priests, surrounded with their bloody sacrificial implements, implore his intercession in vain; the women and children who had taken refuge on the consecrated summit are wild with terror and helpless despair. With the combatants the fighting is hand to hand. The Spaniards press their way inch by inch up the steep, slippery steps—the Mexicans strive in vain to maintain their ground, and are forced to grapple with their foes in the mad effort to hurl them down the precipitous side of the *teocalli,* even at the risk of perishing themselves. Through all the noise of the battle rises the clatter of the great drum beaten with human bones by the Aztec priest at the altar, to drown the cries of terror and inspire the warriors to fresh exertion.

The artist has been fortunate in an historian who has given to this scene a significance apart from its dramatic interest.

It is a great historic consummation. It is not only the fierce fight between desperate foes, but the final struggle of the two races—the decisive death-grapple of the savage and the civilized man—the victory of the civilized over the savage, with all its immense results, which we have before us on the canvas. We may say, too, that the historian is fortunate in an artist who has been able to seize with so much vigor the main features of his description, and embody them in a work which stamps itself on the recollection with so much vividness and reality.

But, in spite of its brilliant and unquestionable artistic power, this picture hardly satisfies our expectation; hardly, we think, satisfies the artist's reputation. We make allowances for great difficulties in the way of executing a design where the resources at command in respect to space and grouping were so disproportionate to the necessities of the subject, and these go far towards excusing some of the faults of detail which have been urged against the picture. Taken as a whole, however, there is a want of unity and completeness in the work. The strength of the artist has been lavishly expended upon single figures and groups, and as much energy as he could command thrown into individual attitudes. But in this straining after separate effects there is a sacrifice of what should be the main object of the picture. The separate portions of the work become quite isolated and distinct. The upper groups, especially, seem to belong to a region entirely separated from that immediately below. The figures are unwarrantably diminutive and indistinct, and, compared with the others in their vicinity, positively Lilliputian. We are not aware of any artistic rule or of any necessity in the picture itself justifying this difference. A truer effect might have been gained by the introduction of some element of contrast to the unmixed savageness of the scene. Beyond a certain point in the delineation of the terrible, nothing is gained by the accumulation of horrors. The work seems to us to be weakened in its moral power by the over tension of all its forces in one direction.

The architecture of the upper masses of the *teocalli,* and of the conglomerated idol on the summit, is all taken from the drawings of similar structures in Central America. By what authority are they adapted to the Aztec *teocalli?* If we mistake not, there is no reason, apart from the fancy or perhaps the want of research of the artist, for the appropriation. If so, it is wrongly done.

In noticing these defects of Mr. Leutze's picture we have no disposition to judge him severely. We have the highest opinion of his abilities and the surest confidence in his success; but we trust that the reputation he is acquiring will not lead him to neglect the lesson,—the first that our artists should learn,—that in every true work there must be, besides genius in the conception, care in the execution; that Invention is useless without Industry.

Although Leutze painted the gigantic Washington Crossing the Delaware *as an inspiration to German revolutionaries, the work was an immense success in America. Exhibited in New York and in the rotunda of the United States Capitol in 1851 and 1852, the painting was in fact the second version of an original damaged in a studio fire. Regardless, many hailed it as the great American history painting, inspiring, patriotic, and noble. The fervent endorsement of the* Bulletin of the American Art-Union *suggests why the monumental work had such great popular appeal. The writer states that Leutze's painting has far greater power than any "tame" historical description because it literally* makes *history. When viewers henceforth think of that momentous event of the Revolutionary War, Leutze's picture is the one they will see in their mind's eye. Even though the artist has departed from strict fidelity to historical fact, what matters is the inspiring conception and execution of the whole, which comes to a climax in the resolute figure of Washington, the supreme American hero. For those who contend that the American school of painting must focus on American historical subjects, Leutze's painting is a triumphant vindication.*

"The Chronicle: Art and Artists of America," **Bulletin of the American Art-Union** *4 (November 1851).*

Leutze's Washington.—Before the present number of our Journal shall be published, the exhibition of this picture will have been opened, and the admiration it has already excited among the few who have seen it, confirmed and justified by the verdict of the people at large. It is the approbation of this class which the artist most ardently desires—the praise of the great body of citizens, uninstructed in the technicalities of the school, but fully able to sympathize with and appreciate the noble qualities of courage and patriotism which he has sought to embody in his work . . .

Mr. Leutze has no reason to fear that the decision of the great body of the people will be other than highly favorable. His picture has the simplicity and straightforwardness of an old chronicle . . . As for ourselves, we certainly never fully comprehended before the greatness of the achievement it commemorates. Nor have we ever seen a better proof than it affords of the superiority of painting over literature, in its power of presenting at one view, the multitude of contemporaneous circumstances, which make up a great historical event. How tame the descriptions in Marshall[3] and other writers appear beside this canvas, so full of life and motion! How much more powerful and lasting will be the impression made by even a brief inspection of it than by a careful reading of any treatise or history! It gives a body and substance to our ideas; and hereafter, when we think of Washington, in connection with the passage of the Delaware, the image in our minds will be complete and glowing, and not that vague and confused one, which is all we should have gained from books. Who can doubt in this view of the case, the momentous importance of providing a nation with great works of art, simply as a means of teaching its own history? District School libraries and oral instruction will do a great deal, but half an hour's sight of this painting will infuse into a boy's bosom a clearer notion of the great exploit, and a more intelligent and durable admiration of the men who performed it, than the study of books for years . . .

Our readers will recollect that in the winter of 1776, the American army, reduced in num-

[3] John Marshall was an early biographer of George Washington.

bers to about three thousand men, depressed by defeat and exhausted by fatigue, had retreated before their victorious opponents, and were posted upon the west side of the Delaware. The British, under General Howe, were stationed in New Jersey, about four thousand of them being distributed along the east side of the river, at Trenton, Bordentown, the White Horse, and Burlington, and the residue between the Delaware and the Hackensack. In the month of December, the continental army was reinforced, and Washington determined to recommence active operations. He had noticed the unprotected situation of the winter quarters of the British troops, and he contemplated the preservation of Philadelphia and the recovery of New Jersey, by sweeping, at one stroke, all the enemy's cantonments on the Delaware. General Greene's division, with whom was the Commander-in-Chief, were ordered to cross the river at McKonkey's ferry, nine miles above Trenton, to attack that post. General Irvine was directed to cross with his division at Trenton ferry, to secure the bridge below the town, and prevent the retreat of the enemy that way. General Cadwallader was to pass the river at Bristol ferry, and assault the post at Burlington. The night of Christmas was selected for the execution of this daring scheme. It proved to be so intensely cold, and so much ice was made in the river, that Generals Irvine and Cadwallader, with the latter of whom was the artillery, were unable to cross with their divisions. The Commander-in-Chief was more fortunate. He succeeded in crossing, with General Greene's command, although he was delayed in point of time. The result was the Battle of Trenton, at which one thousand of the enemy were taken prisoners, and a thousand stand of arms and six pieces of artillery captured. Of the American troops two privates were killed and two frozen to death, and one officer and three or four privates were wounded.

According to Dr. Bancroft, from whose biography of Washington we have taken most of the preceding details, the passage of the Delaware was made before four o'clock in the morning, at which hour perfect darkness must have prevailed. Mr. Leutze has very excusably departed from strict historic truth, by representing the movement as occurring at a later hour. Indeed, if he had not done thus, we should have had no picture at all, or but a very imperfect one.

The General's boat and the persons it contains are the principal objects in the painting. They fill nearly the entire foreground. In the left distance are the other boats indistinctly seen in the hazy morning light. On the right, a great way off, and covered with snow, rise the low desolate hills of the Jersey shore. In the centre of the distance, and arresting the attention next after the principal group, is the broad expanse of the frozen Delaware, along which the eye travels for miles and miles, seeking in vain for something warm and living. We have never seen in art a representation of nature so gloomy and austere as this immense barren vista, stretching northward as far as the eye can reach, and filled with innumerable cakes of floating ice. One may almost feel the biting wind sweeping over this frigid waste. The aerial perspective is so well managed here that the impression of vastness and desolation is wonderfully enhanced by it, and the difficulty of the passage told in unmistakable language. The boat is represented with its broadside to the spectator, and propelled by three or four oarsmen, while a sturdy fellow at the bows with a pole, is pushing away the huge lumps of ice which obstruct its path, and some of which are seen floating in the open, green water of the foreground. Standing near the bows of the boat, with his right foot raised upon a seat, is WASHINGTON, the central and most conspicuous object of the composition, and upon which the light is chiefly concentrated. His head, which is in profile, is relieved against the brightest part of the wintery morning sky. He wears a military cloak, which he restrains with his left hand against the action of the wind, while his right resting upon the knee that is raised, holds a small reconnoitring glass. He is dressed in full uniform,

and wears the silver-mounted, green-hilted sword, which, we believe, is still preserved. He looks earnestly forward towards the shore he is approaching, and there is in his features and attitude an expression of dauntless energy, and at the same time of calmness and resolution and self-reliance, which befits the man and the occasion. It corresponds with our ideal of Washington, and what higher praise than this can we award. It is forcible without being extravagant, or melo-dramatic, or contradicting our belief in the dignified gravity of his character. Seated beside him in front, and grasping the gunwale of the boat with his right hand, the rest of his body being enveloped in a blue military cloak, is Greene, who is also looking intently forward towards the point of debarkation. Immediately behind Washington stands Colonel Monroe (afterwards President), at that time a young man of nineteen, and the aid of General Greene. He is bearing the flag, the loose folds of which are blown out by the wind. In this duty he is assisted by a sturdy countryman in a light frock and fur cap, whose countenance seems to us one of the most successful portions of the picture. It was taken in part, we have been informed, from the features of Webster and Jefferson, and it seems to embody the great traits that characterized the old Continentals, and assured the success of their arms. It is the grandest exhibition of the American type of countenance we have ever seen . . .

As we have said before, we think the courage and patriotism that prompted the passage of the Delaware, and the circumstances that rendered it so difficult an achievement, could scarcely be more satisfactorily represented than they have been by Mr. Leutze in this painting. This striking and noble conception of the scene is the greatest merit of the work while in its technical qualities it is deserving of great admiration. In composition, form, and color, it is eminently satisfactory, and we regret we have not left for ourselves sufficient space to enlarge upon these particulars.

We cannot conclude our imperfect sketch without expressing an earnest hope that this work may not be permitted to remain permanently in a foreign country, or, at any rate, that a duplicate of it may be obtained to adorn the capitol at Washington. We have often had occasion in these pages to call the attention of the public to the importance of making the proposed enlargement of that building an occasion for the encouragement of High Art. The artists who should naturally direct public opinion on this point, and be most earnest in arousing attention to it, after a single meeting last winter, have entirely abandoned the subject. Is this because they have felt themselves unequal to the professional tasks which the proposed undertaking would have imposed upon them? We hope that Mr. Leutze's painting will stir up the people themselves to demand that for which the body of the artists seem too indolent to make any vigorous effort. If no other able and willing hands can be found to undertake the adornment of the Capitol, why not intrust it to Mr. Leutze alone? What more entirely reasonable and proper commission can be given than to place the entire decoration of the new halls under Mr. Leutze's control, and vote a generous appropriation for the purpose, just as the King of Prussia has been employing Cornelius to decorate the great Campo Santo at Berlin, and Kaulbach for the galleries of the new Museum? Why should second-rate powers so far excel our own great nation in rewarding Genius, and in appropriating its labors for public purposes? We feel we have almost a hopeless task before us, when we contrast the feeble encouragement of Art by the American Government with that which has adorned the modern history of foreign states, so inferior to our own in wealth and power. The difficulties to be overcome in changing this state of things, are so numerous and important, and the laborers in the cause so few and scattered, that it seems almost a mockery to use our poor pen in its advocacy, and we are tempted to throw it down in despair.

The Noble Savage/Vanishing Race

GEORGE CATLIN PORTRAYS THE NATIVE AMERICANS

The 1803 Louisiana Purchase, which opened up sprawling new territories for settlement and exploitation, had serious consequences for Native Americans, whose presence on desirable land now became a hindrance to the development promoted by economic interests. In 1830 President Andrew Jackson signed the Indian Removal Act into law, mandating the migration of southeastern tribes to reservations in Oklahoma. Some seventy thousand were forced to join this brutal exodus. Many white Americans feared (or hoped) that the steady march of civilization would doom the Native population to extinction. Such prospects galvanized efforts to document Native culture before it disappeared entirely.

George Catlin made that mission his life's work. A portrait painter, he joined General William Clark's expedition in St. Louis in 1830 and spent the next six years studying and visually documenting the customs of forty-eight tribes. During that time, Catlin painted several hundred portraits and scenes of everyday Native life. In 1844 he published a copiously detailed memoir—part travel narrative, part ethnography—divided into a series of richly anecdotal letters. In the first letter, below, Catlin extols the Native Americans' beauty and dignity, at the same time deploring the corruptions of civilization that spell doom to their simple way of life. He announces his lofty purpose to become their historian before it is too late. Despite his profound sympathy for the Natives' plight, Catlin sees no hope; the race is traveling into the sunset, soon to vanish forever.

In the next letter, Catlin carefully enumerates and describes, with ethnographic precision, every detail of the outfits worn by his Blackfoot sitters, including a strikingly clinical account of the manner in which scalp locks are prepared as ornaments. Catlin reveals his romantic yearnings, though, in his references to Greece, Rome, and medieval chivalry when describing the Native warriors' weapons, armor, and hunting prowess.

In letter 15 Catlin describes the process of portrait painting as a complete novelty to the ill-fated Mandans (see "Prince Max and Karl Bodmer among the Mandan," this chapter), who take him to be magically empowered. The story of Ma-to-he-hah's portrait illustrates the insidious process of corruption in the way that Anglo-American conventions of visual representation have begun to adulterate the Native sense of self. Finally, Catlin's letter 55 (as told to the French guide and fur trader Ba'tiste) is a morality tale demonstrating the tragic consequences of cultural encounter in the case of one young man (Wi-jun-jon, "The Pigeon's Egg Head"), whose journey to Washington transforms him into what his tribe comes to see as a dangerous threat.

George Catlin, Letters and Notes on the Manners, Customs, and Condition of the North American Indians, *vols. 1–2 (London: G. Catlin, 1841).*

Letter no. 1

I was born in Wyöming, in North America, some thirty or forty years since, of parents who entered that beautiful and famed valley soon after the close of the revolutionary war, and the disastrous event of the "Indian massacre."

The early part of my life was whiled away, apparently, somewhat in vain, with books reluctantly held in one hand, and a rifle or fishing-pole firmly and affectionately grasped in the other.

At the urgent request of my father, who was a practising lawyer, I was prevailed upon to abandon these favourite themes, and also my occasional dabblings with the brush, which had secured already a corner in my affections; and I commenced reading the law for a profession, under the direction of Reeve and Gould, of Connecticut. I attended the lectures of these learned judges for two years—was admitted to the bar—and practised the law, as a sort of *Nimrodical* lawyer, in my native land, for the term of two or three years; when I very deliberately sold my law library and all (save my rifle and fishing-tackle), and converting their proceeds into brushes and paint pots; I commenced the art of painting in Philadelphia, without teacher or adviser.

I there closely applied my hand to the labours of the art for several years; during which time my mind was continually reaching for some branch or enterprise of the art, on which to devote a whole life-time of enthusiasm; when a delegation of some ten or fifteen noble and dignified-looking Indians, from the wilds of the "Far West," suddenly arrived in the city, arrayed and equipped in all their classic beauty,—with shield and helmet,—with tunic and manteau,—tinted and tasselled off, exactly for the painter's palette!

In silent and stoic dignity, these lords of the forest strutted about the city for a few days, wrapped in their pictured robes, with their brows plumed with the quills of the war-eagle, attracting the gaze and admiration of all who beheld them. After this, they took their leave for Washington City, and I was left to reflect and regret, which I did long and deeply, until I came to the following deductions and conclusions.

Black and blue cloth and civilization are destined, not only to veil, but to obliterate the grace and beauty of Nature. Man, in the simplicity and loftiness of his nature, unrestrained and unfettered by the disguises of art, is surely the most beautiful model for the painter,—and the country from which he hails is unquestionably the best study or school of the arts in the world: such I am sure, from the models I have seen, is the wilderness of North America. And the history and customs of such a people, preserved by pictorial illustrations, are themes worthy the lifetime of one man, and nothing short of the loss of my life, shall prevent me from visiting their country, and of becoming their historian . . .

With these views firmly fixed—armed, equipped, and supplied, I started out in the year 1832, and penetrated the vast and pathless wilds which are familiarly denominated the great "Far West" of the North American Continent, with a light heart, inspired with an enthusiastic hope and reliance that I could meet and overcome all the hazards and privations of a life devoted to the production of a literal and graphic delineation of the living manners, customs, and character of an interesting race of people, who are rapidly passing away from the face of the earth—lending a hand to a dying nation, who have no historians or biographers of their own to pourtray with fidelity their native looks and history; thus snatching from a hasty oblivion what could be saved for the benefit of posterity, and perpetuating it, as a fair and just monument, to the memory of a truly lofty and noble race.

I have spent about eight years already in the pursuit above-named, having been for the most of that time immersed in the Indian country, mingling with red men, and identifying myself with them as much as possible, in their games and amusements; in order the better to familiarize myself with their superstitions and mysteries, which are the keys to Indian life and character . . .

I set out on my arduous and perilous undertaking with the determination of reaching, ultimately, every tribe of Indians on the Continent of North America, and of bringing home faith-

ful portraits of their principal personages, both men and women, from each tribe; views of their villages, games, &c. and full notes on their character and history. I designed, also, to procure their costumes, and a complete collection of their manufactures and weapons, and to perpetuate them in a *Gallery unique,* for the use and instruction of future ages . . .

The world know generally, that the Indians of North America are copper-coloured; that their eyes and their hair are black, &c.; that they are mostly uncivilized, and consequently unchristianized; that they are nevertheless human beings, with features, thoughts, reason, and sympathies like our own; but few yet know how they *live,* how they *dress,* how they *worship,* what are their actions, their customs, their religion, their amusements, &c. as they practise them in the uncivilized regions of their uninvaded country, which it is the main object of this work, clearly and distinctly to set forth . . .

The Indians of North America . . . were once a happy and flourishing people, enjoying all the comforts and luxuries of life which they knew of, and consequently cared for:—were sixteen millions in numbers, and sent that number of daily prayers to the Almighty, and thanks for his goodness and protection. Their country was entered by white men, but a few hundred years since; and thirty millions of these are now scuffling for the goods and luxuries of life, over the bones and ashes of twelve millions of red men; six millions of whom have fallen victims to the small-pox, and the remainder to the sword, the bayonet, and whiskey; all of which means of their death and destruction have been introduced and visited upon them by acquisitive white men; and by white men, also, whose forefathers were welcomed and embraced in the land where the poor Indian met and fed them with "ears of green corn and with pemican." Of the two millions remaining alive at this time, about 1,400,000, are already the miserable living victims and dupes of white man's cupidity, degraded, discouraged and lost in the bewildering maze that is produced by the use of whiskey and its concomitant vices; and the remaining number are yet unroused and unenticed from their wild haunts or their primitive modes, by the dread or love of white man and his allurements.

It has been with these, mostly, that I have spent my time, and of these, chiefly, and their customs, that the following Letters treat. Their habits (and their's alone) as we can see them transacted, are native, and such as I have wished to fix and preserve for future ages . . .

Some writers, I have been grieved to see, have written down the character of the North American Indian, as dark, relentless, cruel and murderous in the last degree; with scarce a quality to stamp their existence of a higher order than that of the brutes:—whilst others have given them a high rank, as I feel myself authorized to do, as honourable and highly-intellectual beings; and others, both friends and foes to the red men, have spoken of them as an "anomaly in nature!" . . .

From what I have seen of these people I feel authorized to say, that there is nothing very strange or unaccountable in their character; but that it is a simple one, and easy to be learned and understood, if the right means be taken to familiarize ourselves with it. Although it has its dark spots, yet there is much in it to be applauded, and much to recommend it to the admiration of the enlightened world. And I trust that the reader, who looks through these volumes with care, will be disposed to join me in the conclusion that the North American Indian in his native state, is an honest, hospitable, faithful, brave, warlike, cruel, revengeful, relentless,—yet honourable, contemplative and religious being . . .

The very use of the word savage, as it is applied in its general sense, I am inclined to believe is an abuse of the word, and the people to whom it is applied. The word, in its true definition, means no more than *wild,* or *wild man;* and a wild man may have been endowed by his Maker with all the humane and noble traits that inhabit the heart of a tame man. Our ignorance and

dread or fear of these people, therefore, have given a new definition to the adjective; and nearly the whole civilized world apply the word *savage,* as expressive of the most ferocious, cruel, and murderous character that can be described . . .

I have roamed about from time to time during seven or eight years, visiting and associating with, some three or four hundred thousand of these people, under an almost infinite variety of circumstances; and from the very many and decided voluntary acts of their hospitality and kindness, I feel bound to pronounce them, by nature, a kind and hospitable people. I have been welcomed generally in their country, and treated to the best that they could give me, without any charges made for my board; they have often escorted me through their enemies' country at some hazard to their own lives, and aided me in passing mountains and rivers with my awkward baggage; and under all of these circumstances of exposure, no Indian ever betrayed me, struck me a blow, or stole from me a shilling's worth of my property that I am aware of . . .

For the above reasons, the reader will be disposed to forgive me for dwelling so long and so strong on the justness of the claims of these people; and for my occasional expressions of sadness, when my heart bleeds for the fate that awaits the remainder of their unlucky race; which is long to be outlived by the rocks, by the beasts, and even birds and reptiles of the country they live in;—set upon by their fellow-man, whose cupidity, it is feared, will fix no bounds to the Indian's earthly calamity, short of the grave.

I cannot help but repeat, before I close this Letter, that the tribes of the red men of North America, as a nation of human beings, are on their wane; that (to use their own very beautiful figure) "they are fast travelling to the shades of their fathers, towards the setting sun;" and that the traveller who would see these people in their native simplicity and beauty, must needs be hastily on his way to the prairies and Rocky Mountains, or he will see them only as they are now seen on the frontiers, as a basket of *dead game,*—harassed, chased, bleeding and dead; with their plumage and colours despoiled; to be gazed amongst in vain for some system or moral, or for some scale by which to estimate their true native character, other than that which has too often recorded them but a dark and unintelligible mass of cruelty and barbarity.

Letter no. 5

In my former epistle I told you there were encamped about the Fort a host of wild, incongruous spirits—chiefs and sachems—warriors, braves, and women and children of different tribes—of Crows and Blackfeet—Ojibbeways—Assinneboins—and Crees or Knisteneaux. Amongst and in the midst of them am I, with my paint pots and canvass, snugly ensconced in one of the bastions of the Fort, which I occupy as a painting-room. My easel stands before me, and the cool breech of a twelve-pounder makes me a comfortable seat, whilst her muzzle is looking out at one of the port-holes. The operations of my brush are *mysteries* of the highest order to these red sons of the prairie, and my room the earliest and latest place of concentration of these wild and jealous spirits, who all meet here to be amused and pay me signal honours; but gaze upon each other, sending their sidelong looks of deep-rooted hatred and revenge around the group. However, whilst in the Fort, their weapons are placed within the arsenal, and naught but looks and thoughts can be breathed here; but death and grim destruction will visit back those looks upon each other, when these wild spirits again are loose and free to breathe and act upon the plains.

I have this day been painting a portrait of the head chief of the Blackfoot nation; he is a good-looking and dignified Indian, about fifty years of age, and superbly dressed; whilst sitting for his picture he has been surrounded by his own braves and warriors, and also gazed at by his

enemies, the Crows and the Knisteneaux, Assinneboins and Ojibbeways; a number of distinguished personages of each of which tribes, have laid all day around the sides of my room; reciting to each other the battles they have fought, and pointing to the scalp-locks, worn as proofs of their victories, and attached to the seams of their shirts and leggings. This is a curious scene to witness, when one sits in the midst of such inflammable and combustible materials, brought together, unarmed, for the first time in their lives; peaceably and calmly recounting over the deeds of their lives, and smoking their pipes upon it, when a few weeks or days will bring them on the plains again, where the war-cry will be raised, and their deadly bows will again be drawn on each other.

The name of this dignitary, of whom I have just spoken, is Stu-mick-o-sucks (the buffalo's back fat), *i.e.* the "hump" or "fleece," the most delicious part of the buffalo's flesh . . .

There is no tribe, perhaps, on the Continent, who dress more comfortably, and more gaudily, than the Blackfeet, unless it be the tribe of Crows. There is no great difference, however, in the costliness or elegance of their costumes; nor in the materials of which they are formed; though there is a distinctive mode in each tribe, of stitching or ornamenting with the porcupine quills, which constitute one of the principal ornaments to all their fine dresses; and which can be easily recognized, by any one a little familiar with their modes, as belonging to such or such a tribe. The dress, for instance of the chief whom I have just mentioned, and whose portrait I have just painted, consists of a shirt or tunic, made of two deer skins finely dressed, and so placed together with the necks of the skins downwards, and the skins of the hind legs stitched together, the seams running down on each arm, from the neck to the knuckles of the hand; this seam is covered with a band of two inches in width, of very beautiful embroidery of porcupine quills, and suspended from the under edge of this, from the shoulders to the hands, is a fringe of the locks of black hair, which he has taken from the heads of victims slain by his own hand in battle. The leggings are made also of the same material; and down the outer side of the leg, from the hip to the feet, extends also a similar band or belt of the same width; and wrought in the same manner, with porcupine quills, and fringed with scalp locks. These locks of hair are procured from scalps, and worn as trophies . . .

The scalp of which I spoke above, is procured by cutting out a piece of the skin of the head, the size of the palm of the hand or less, containing the very centre or crown of the head, the place where the hair radiates from a point, and exactly over what the phrenologists call self-esteem. This patch then is kept and dried with great care, as proof positive of the death of an enemy, and evidence of a man's claims as a warrior; and after having been formally "danced," as the saying is, (*i.e.* after it has been stuck up upon a pole or held up by an "old woman," and the warriors have danced around it for two or three weeks at intervals,) it is fastened to the handle of a lance, or the end of a war-club, or divided into a great many small locks and used to fringe and ornament the victor's dress. When these dresses are seen bearing such trophies, it is of course a difficult matter to purchase them of the Indian, for they often hold them above all price. I shall hereafter take occasion to speak of the scalp-dance; describing it in all its parts, and giving a long Letter, at the same time on scalps and scalping, an interesting and general custom amongst all the North American Indians.

In the chief's dress, which I am describing, there are his moccasins, made also of buckskin, and ornamented in a corresponding manner. And over all, his robe, made of the skin of a young buffalo bull, with the hair remaining on; and on the inner or flesh side, beautifully garnished with porcupine quills, and the battles of his life very ingeniously, though rudely, pourtrayed in pictorial representations. In his hand he holds a very beautiful pipe, the stem of which is four

or five feet long, and two inches wide, curiously wound with braids of the porcupine quills of various colours; and the bowl of the pipe ingeniously carved by himself from a piece of red steatite of an interesting character, and which they all tell me is procured somewhere between this place and the Falls of St. Anthony, on the head waters of the Mississippi . . .

So, then is this sachem (the buffalo's back fat) dressed; and in a very similar manner, and almost the same, is each of the others above named; and all are armed with bow and quiver, lance and shield. These north western tribes are all armed with the bow and lance, and protected with the shield or arrow fender, which is carried outside of the left arm, exactly as the Roman and Grecian shield was carried, and for the same purpose.

There is an appearance purely classic in the plight and equipment of these warriors and "knights of the lance." They are almost literally always on their horses' backs, and they wield these weapons with desperate effect upon the open plains; where they kill their game while at full speed, and contend in like manner in battles with their enemy. There is one prevailing custom in these respects, amongst all the tribes who inhabit the great plains or prairies of these western regions. These plains afford them an abundance of wild and fleet horses, which are easily procured; and on their backs at full speed, they can come alongside of any animal, which they easily destroy . . .

Such is the training of men and horses in this country, that this work of death and slaughter is simple and easy. The horse is trained to approach the animals on the *right* side, enabling its rider to throw his arrows to the left; it runs and approaches without the use of the halter, which is hanging loose upon its neck bringing the rider within three or four paces of the animal, when the arrow is thrown with great ease and certainty to the heart; and instances sometimes occur, where the arrow passes entirely through the animal's body.

An Indian, therefore, mounted on a fleet and well-trained horse, with his bow in his hand, and his quiver slung on his back, containing an hundred arrows, of which he can throw fifteen or twenty in a minute, is a formidable and dangerous enemy. Many of them also ride . . . with a shield or arrow-fender made of the skin of the buffalo's neck, which has been smoked, and hardened with glue extracted from the hoofs. These shields are arrow-proof, and will glance off a rifle shot with perfect effect by being turned obliquely, which they do with great skill.

This shield or arrow-fender is, in my opinion, made of similar materials, and used in the same way, and for the same purpose, as was the clypeus or small shield in the Roman and Grecian cavalry. They were made in those days as a means of defence on horseback only—made small and light, of bull's hides; sometimes single, sometimes double and tripled. Such was Hector's shield, and of most of the Homeric heroes of the Greek and Trojan wars. In those days also were darts or javelins and lances; the same were also used by the Ancient Britons; and such exactly are now in use amongst the Arabs and the North American Indians.

In this wise then, are all of these wild red knights of the prairie, armed and equipped,— and while nothing can possibly be more picturesque and thrilling than a troop or war-party of these fellows, galloping over these green and endless prairies; there can be no set of mounted men of equal numbers, so effective and so invincible in this country as they would be, could they be inspired with confidence of their own powers and their own superiority; yet this never can be done;—for the Indian, as far as the name of white man has travelled, and long before he has to try his strength with him, is trembling with fright and fear of his approach; he hears of white man's arts and artifice—his tricks and cunning, and his hundred instruments of death and destruction—he dreads his approach, shrinks from him with fear and trembling—his heart

sickens, and his pride and courage wither, at the thoughts of contending with an enemy, whom he thinks may war and destroy with weapons of *medicine* or mystery.

Letter no. 15

I have been continually at work with my brush, with fine and picturesque subjects before me; and from the strange, whimsical, and superstitious notions which they have of an art so novel and unaccountable to them, I have been initiated into many of their mysteries—have witnessed many very curious incidents, and preserved several anecdotes, some of which I must relate.

Perhaps nothing ever more completely astonished these people than the operations of my *brush*. The art of portrait-painting was a subject entirely new to them, and of course, unthought of; and my appearance here has commenced a new era in the arcana of *medicine* or mystery. Soon after arriving here, I commenced and finished the portraits of the two principal chiefs. This was done without having awakened the curiosity of the villagers, as they had heard nothing of what was going on, and even the chiefs themselves seemed to be ignorant of my designs, until the pictures were completed. No one else was admitted into my lodge during the operation; and when finished, it was exceedingly amusing to see them mutually recognizing each other's likeness, and assuring each other of the striking resemblance which they bore to the originals. Both of these pressed their hand over their mouths awhile in dead silence (a custom amongst most tribes, when anything surprises them very much); looking attentively upon the portraits and myself, and upon the palette and colours with which these unaccountable effects had been produced.

They then walked up to me in the most gentle manner, taking me in turn by the hand, with a firm grip; with head and eyes inclined downwards, and in a tone a little above a whisper—pronounced the words "te-ho-pe-nee Wash-ee!" and walked off.

Readers, at that moment I was christened with a new and a great name—one by which I am now familiarly hailed, and talked of in this village; and no doubt will be, as long as traditions last in this strange community . . .

Te-ho-pe-nee Wash-ee (or medicine white man) is the name I now go by, and it will prove to me, no doubt, of more value than gold, for I have been called upon and feasted by the doctors, who are all mystery-men; and it has been an easy and successful passport already to many strange and mysterious places; and has put me in possession of a vast deal of curious and interesting information, which I am sure I never should have otherwise learned . . .

I had trouble brewing also the other day . . . ; one of the "*medicines*" commenced howling and haranguing around my domicil, amongst the throng that was outside, proclaiming that all who were inside and being painted were fools and would soon die; and very materially affecting thereby my popularity. I however sent for him and called him in the next morning, when I was alone, having only the interpreter with me; telling him that I had had my eye upon him for several days, and had been so well pleased with his looks, that I had taken great pains to find out his history, which had been explained by all as one of a most extraordinary kind, and his character and standing in his tribe as worthy of my particular notice; and that I had several days since resolved that as soon as I had practiced my hand long enough upon the others, to get the stiffness out of it (after paddling my canoe so far as I had) and make it to work easily and successfully, I would begin on his portrait, which I was then prepared to commence on that day, and that I felt as if I could do him justice. He shook me by the hand, giving me the "Doctor's grip," and beckoned me to sit down, which I did, and we smoked a pipe together. After this was

over, he told me, that "he had no inimical feelings towards me, although he had been telling the chiefs that they were all fools, and all would die who had their portraits painted—that although he had set the old women and children all crying, and even made some of the young warriors tremble, yet he had no unfriendly feelings towards me, nor any fear or dread of my art." "I know you are a good man (said he), I know you will do no harm to any one, your medicine is great and you are a great 'medicine-man.' I would like to see myself very well—and so would all of the chiefs; but they have all been many days in this medicine-house, and they all know me well, and they have not asked me to come in and be *made alive* with paints—my friend, I am glad that my people have told you who I am—my heart is glad—I will go to my wigwam and eat, and in a little while I will come, and you may go to work;"—another pipe was lit and smoked, and he got up and went off. I prepared my canvass and palette, and whistled away the time until twelve o'clock, before he made his appearance; having used the whole of the fore-part of the day at his toilette, arranging his dress and ornamenting his body for his picture.

At that hour then, bedaubed and streaked with paints of various colours, with bear's grease and charcoal, with medicine-pipes in his hands and foxes tails attached to his heels, entered Mah-to-he-hah (the old bear), with a train of his own profession, who seated themselves around him; and also a number of boys, whom it was requested should remain with him, and whom I supposed it possible might have been pupils, whom he was instructing in the mysteries of *materia medica* and *hoca poca*. He took his position in the middle of the room, waving his eagle calumets in each hand, and singing his medicine-song which he sings over his dying patient, looking me full in the face until I completed his picture, which I painted at full length. His vanity has been completely gratified in the operation; he lies for hours together, day after day, in my room, in front of his picture, gazing intensely upon it; lights my pipe for me while I am painting—shakes hands with me a dozen times on each day, and talks of me, and enlarges upon my *medicine* virtues and my talents, wherever he goes; so that this new difficulty is now removed, and instead of preaching against me, he is one of my strongest and most enthusiastic friends and aids in the country.

Letter no. 55

Wi-jun-jon (the Pigeon's Egg Head) was a brave and a warrior of the Assinneboins—young—proud—handsome—valiant, and graceful. He had fought many a battle, and won many a laurel. The numerous scalps from his enemies' heads adorned his dress, and his claims were fair and just for the highest honours that his country could bestow upon him; for his father was chief of the nation . . .

Well, this young Assinneboin, the 'Pigeon's Egg Head,' was selected by Major Sanford, the Indian Agent, to represent his tribe in a delegation which visited Washington city under his charge in the winter of 1832. With this gentleman, the Assinneboin, together with representatives from several others of those North Western tribes, descended the Missouri river, several thousand miles, on their way to Washington . . .

I was in St. Louis at the time of their arrival, and painted their portraits while they rested in that place. *Wi-jun-jon* was the first, who reluctantly yielded to the solicitations of the Indian agent and myself, and appeared as sullen as death in my painting-room—with eyes fixed like those of a statue, upon me, though his pride had plumed and tinted him in all the freshness and brilliancy of an Indian's toilet. In his nature's uncowering pride he stood a perfect model; but superstition had hung a lingering curve upon his lip, and pride had stiffened it into contempt. He had been urged into a measure, against which his fears had pleaded; yet he stood un-

moved and unflinching amid the struggles of mysteries that were hovering about him, foreboding ills of every kind, and misfortunes that were to happen to him in consequence of this operation.

He was dressed in his native costume, which was classic and exceedingly beautiful . . . ; his leggings and shirt were of the mountain-goat skin, richly garnished with quills of the porcupine, and fringed with locks of scalps, taken from his enemies' heads. Over these floated his long hair in plaits, that fell nearly to the ground; his head was decked with the war-eagle's plumes—his robe was of the skin of the young buffalo bull, richly garnished and emblazoned with the battles of his life; his quiver and bow were slung, and his shield, of the skin of the bull's neck.

I painted him in this beautiful dress, and so also the others who were with him; and after I had done, Major Sanford went on to Washington with them, where they spent the winter.

Wi-jun-jon was the foremost on all occasions—the first to enter the levee—the first to shake the President's hand, and make his speech to him—the last to extend the hand to them, but the first to catch the smiles and admiration of the gentler sex. He travelled the giddy maze, and beheld amid the buzzing din of civil life, their tricks of art, their handiworks, and their finery; he visited their principal cities—he saw their forts, their ships, their great guns, steamboats, balloons, &c. &c.; and in the spring returned to St. Louis, where I joined him and his companions on their way back to their own country.

Through the politeness of Mr. Chouteau, of the American Fur Company, I was admitted (the only passenger except Major Sanford and his Indians) to a passage in their steamboat, on her first trip to the Yellow Stone; and when I had embarked, and the boat was about to depart, *Wi-jun-jon* made his appearance on deck, in a full suit of regimentals! He had in Washington exchanged his beautifully garnished and classic costume, for a full dress 'en militaire' . . . It was, perhaps, presented to him by the President. It was broadcloth, of the finest blue, trimmed with lace of gold; on his shoulders were mounted two immense epaulettes; his neck was strangled with a shining black stock, and his feet were pinioned in a pair of water-proof boots, with high heels, which made him 'step like a yoked hog.' . . .

On his hands he had drawn a pair of white kid gloves, and in them held, a blue umbrella in one, and a large fan in the other. In this fashion was poor Wi-jun-jon metamorphosed, on his return from Washington; and, in this plight was he strutting and whistling Yankee Doodle, about the deck of the steamer that was wending its way up the mighty Missouri, and taking him to his native land again; where he was soon to light his pipe, and cheer the wigwam fire-side, with tales of novelty and wonder . . .

After Wi-jun-jon had got home, and passed the usual salutations among his friends, he commenced the simple narration of scenes he had passed through, and of things he had beheld among the whites; which appeared to them so much like fiction, that it was impossible to believe them, and they set him down as an impostor. 'He has been, (they said,) among the whites, who are great liars, and all he has learned is to come home and tell lies.' He sank rapidly into disgrace in his tribe; his high claims to political eminence all vanished; he was reputed worthless—the greatest liar of his nation; the chiefs shunned him and passed him by as one of the tribe who was lost; yet the ears of the gossipping portion of the tribe were open, and the campfire circle and the wigwam fireside, gave silent audience to the whispered narratives of the 'travelled Indian.' . . .

Two days' revel of this kind, had drawn from his keg all its charms; and in the mellowness of his heart, all his finery had vanished, and all of its appendages, except his umbrella, to which

his heart's strongest affections still clung, and with it, and under it, in rude dress of buckskin, he was afterwards to be seen, in all sorts of weather, acting the fop and the beau as well as he could, with his limited means. In this plight, and in this dress, with his umbrella always in his hand, (as the only remaining evidence of his *quondam* greatness,) he began in his sober moments, to entertain and instruct his people, by honest and simple narratives of things and scenes he had beheld during his tour to the East; but which (unfortunately for him), were to them too marvellous and improbable to be believed. He told the gaping multitude, that were constantly gathering about him, of the distance he had travelled—of the astonishing number of houses he had seen—of the towns and cities, with all their wealth and splendour—of travelling on steamboats, in stages, and on railroads. He described our forts, and seventy-four gun ships, which he had visited—their big guns—our great bridges—our great council-house at Washington, and its doings—the curious and wonderful machines in the patent office, (which he pronounced the *greatest medicine place* he had seen); he described the great war parade, which he saw in the city of New York—the ascent of the balloon from Castle Garden—the numbers of the white people, the beauty of the white squaws; their red cheeks, and many thousands of other things, all of which were so much beyond their comprehension, that they 'could not be true' and 'he must be the very greatest liar in the whole world.'

But he was beginning to acquire a reputation of a different kind. He was denominated a *medicine-man,* and one too of the most extraordinary character; for they deemed him far above the ordinary sort of human beings, whose mind could *invent* and *conjure* up for their amusement, such an ingenious *fabrication* of novelty and wonder . . .

. . . In this way the poor fellow had lived, and been for three years past continually relating the scenes he had beheld, in his tour to the '*Far East;*' until his medicine became so alarmingly great, that they were unwilling he should live; they were disposed to kill him for a wizard. One of the young men of the tribe took the duty upon himself, and after much perplexity, hit upon the following plan, *to-wit:*—he had fully resolved, in conjunction with others who were in the conspiracy, that the medicine of Wi-jun-jon was too great for the ordinary mode, and that he was so great a liar that a rifle bullet would not kill him; while the young man was in this distressing dilemma, which lasted for some weeks, he had a dream one night, which solved all difficulties; and in consequence of which, he loitered about the store in the Fort, at the mouth of the Yellow Stone, until he could procure, *by stealth,* (according to the injunction of his dream,) the handle of an iron pot, which he supposed to possess the requisite virtue, and taking it into the woods, he there spent a whole day in straightening and filing it, to fit it into the barrel of his gun; after which, he made his appearance again in the Fort, with his gun under his robe, charged with the pot handle, and getting behind poor Wi-jun-jon, whilst he was talking with the Trader, placed the muzzle behind his head and blew out his brains!

PRINCE MAX AND KARL BODMER AMONG THE MANDAN

During nearly the same time span as George Catlin, the German scientist-naturalist Prince Maximilian of Wied and a young Swiss artist, Karl Bodmer, traveled up the Missouri River from 1832 to 1834 to study and record Native tribes of the northwest wilderness. Published in Europe from 1839 to 1843, Maximilian's travel narrative is notably less romantic in tone than Catlin's but equally rich in observation. In the passages below, Maximilian tells of Bodmer's ruse to appease an angry Mandan sitter and gives a detailed description of the elaborate costumes and rituals of the Mandan

Dog Dance and *Buffalo Dance*, along with a word portrait of the well-known and much admired chief Mato-Topé ("Four Bears"). Of particular interest is Maximilian's account of Mandan art forms: the men paint their bodies and faces according to whim or rule and decorate buffalo robes with schematic images of battles, animals, and the bestowal of gifts. With their decorative patterning of firearms, these robes bear witness to the contact with white men that would soon decimate the Mandan people: a small-pox epidemic in 1837 reduced their numbers to some two hundred. In prose and pictures, Maximilian and Bodmer "preserve" a particular tribe whose vanishing is soon to be all too real and sudden.

Maximilian, Prince of Wied, Travels in the Interior of North America *(London: Ackermann and Co., 1843).*

Even in the midst of winter, the Mandans wear nothing on the upper part of the body, under their buffalo robe. They paint their bodies of a reddish-brown colour, on some occasions with white clay; and frequently draw red or black figures on their arms. The face is, for the most part, painted all over with vermilion, or yellow, in which latter case the circumference of the eyes and the chin are red. There are, however, no set rules for painting, and it depends on the taste of the Indian dandy; yet, still, a general similarity is observed. The bands, in their dances, and also after battles, and when they have performed some exploit, follow the established rule. In ordinary festivals, and dances, and whenever they wish to look particularly fine, the young men paint themselves in every variety of way, and each endeavours to find out some new mode. Should he find another dandy painted just like himself, he immediately retires and makes a change in the pattern, which may happen three or four times during the festival. If they have performed an exploit, the entire face is painted jet black. Sometimes, though seldom, the Man-dans adorn the wrist and upper arm with polished steel bracelets, which they obtain from the merchants; often they wear many brass rings on their fingers, and are, on the whole, excessively fond of ornaments and finery. The chief article of their dress is the ample buffalo robe, called mahita, or mih-sha, which is often very elaborate and valuable. In dry weather these buffalo robes are worn with the hair inwards, and in rainy weather with the hairy side outwards. They are tanned on the fleshy side, and painted either white or reddish-brown, and ornamented with a transverse band of blue or white glass beads, and three large rosettes of the same beads, often of very tasteful patterns, at regular intervals. The centre is frequently red, surrounded with sky blue, embroidered with white figures, or sometimes the reverse. The transverse band is worked with variously dyed porcupine quills, and is then narrower. This, however, is now old-fashioned, and was worn before the coloured glass beads were obtained in such numbers from the Whites. Other robes are painted with a reddish-brown ground, and black figures, especially of animals; others have a white ground, with representations of their heroic deeds in black, or in gay colours, with the wounds they received, the loss of blood, the killed, the prisoners, the arms they have taken, the horses stolen (the number of which is indicated by the number of horse-shoes), in black, red, green, or yellow figures, executed in their yet rude style of painting. The nations on the Missouri are all in the habit of painting such robes; but the Pawnees, Mandans, Manitaries, and Crows, are the most skilful in this art. Another mode of painting their robes is, to repre-sent the number of valuable presents they have made. By these presents, which are often of great value, they acquire reputation and respect among their countrymen. On such robes we observed long red figures, with a black circle at the termination, placed close to each other in transverse rows; they represent whips, indicating the number of horses given, because the whip belonging to the horse is always bestowed with the animal. Red or dark blue transverse figures

indicate cloth or blankets given; parallel transverse stripes represent fire-arms, the outlines of which are pretty correctly drawn. The robe is frequently cut, at the bottom, into narrow strips, like fringe, and ornamented on the sides with tufts of human hair, and horse-hair dyed yellow and green, and with glass beads. Formerly the Indians painted these robes more carefully than they now do, and it was possible to obtain one for five musket balls and some powder; now they are far inferior, and eight or ten dollars is not unfrequently paid for them. A robe handsomely painted is equal in value to two not painted . . .

There was a heavy fall of snow during the night, and the morning of the 12th again presented the landscape clothed with its white covering. Mr. Bodmer had taken an excellent portrait of Machsi-Nika, the deaf and dumb Mandan, in his war dress. He came to our residence to-day with angry gestures, and evidently greatly enraged against us, so that I was afraid that this half-witted, uncivilized man would attack the artist. Mr. Kipp was requested to clear up the matter, and it appeared that his anger had been caused by a malignant insinuation of the perfidious old Garreau, who had pointed out to him that Bodmer had drawn him only in a mean dress, while all the other Indians were represented in their handsomest robes. This ill-natured insinuation completely exasperated the poor man, and we in vain endeavoured to pacify him, by assuring him that we intended to make him known to the world in a truly warlike costume. Mr. Bodmer then thought of an expedient: he quickly and secretly made a copy of his drawing, which he brought in, tore in half, and threw into the fire in the presence of the Indian. This had the desired effect, and he went away perfectly satisfied . . .

On the 7th of March, the band of the Meniss-Ochata (dog band), from Ruhptare, danced in the medicine lodge at Mih-Tutta-Hang-Kush. Mr. Bodmer went to see the dance, and met Mato-Topé, who, however, puffed up by his high dignity as a dog, would not notice him. Sih-Chida, who also belonged to this band, went into the lodge, where he discharged his gun. In the afternoon the band approached the fort, and we heard the sound of their war pipes at the gates. A crowd of spectators accompanied the seven or eight and twenty dogs, who were all dressed in their handsomest clothes. Some of them wore beautiful robes, or shirts of bighorn leather; others had shirts of red cloth; and some blue and red uniforms. Others, again, had the upper part of their body naked, with their martial deeds painted on the skin with reddish-brown colour. The four principal dogs wore an immense cap hanging down upon the shoulders, composed of raven's or magpie's feathers, finished at the tips with small white down feathers. In the middle of this mass of feathers, the outspread tail of a wild turkey, or of a war eagle, was fixed. These four principal dogs wore round their neck a long slip of red cloth, which hung down over the shoulders, and, reaching the calf of the leg, was tied in a knot in the middle of the back. These are the true dogs, who, when a piece of meat is thrown into the fire, are bound immediately to snatch it out and devour it raw . . . Two other men wore similar colossal caps of yellow owl's feathers, with dark transverse stripes, and the rest had on their heads a thick tuft of raven's, magpie's, or owl's feathers, which is the badge of the band. All of them had the long war pipe suspended from their necks. In their left hand they carried their weapons—a gun, bow and arrows, or war club; and in their right hand the schischikué peculiar to their band. It is a stick adorned with blue and white glass beads, with buffalo or other hoofs suspended to it, the point ornamented with an eagle's feather, and the handle with slips of leather embroidered with beads.

The warriors formed a circle round a large drum, which was beaten by five ill-dressed men, who were seated on the ground. Besides these, there were two men, each beating a small drum like a tambourine. The dogs accompanied the rapid and violent beat of the drum by the whistle of their war pipes, in short, monotonous notes, and then suddenly began to dance. They

dropped their robes on the ground, some dancing within the circle, with their bodies bent forward, and leaping up and down with both feet placed close together. The other Indians danced without any order, with their faces turned to the outer circle, generally crowded together; while the war pipe, drum, and schischikué made a frightful din . . .

The morning of the 9th of April being fine and serene, and the ice having almost entirely disappeared from the river, seven men were sent down to Picotte in Indian leather boats. The grass began to sprout, and some young plants appeared in the prairie, even a pulsatilla, with purple blossoms, apparently the same as the *P. vulgaris* of Europe; the Indians call this plant the red calf-flower. At noon the thermometer stood at 65°, with a north-east wind, and the river was free from ice. Towards evening, nine men of the band of the buffalo bulls came to the fort to perform their dance, discharging their guns immediately on entering. Only one of them wore the entire buffalo head . . . ; the others had pieces of the skin of the forehead, a couple of fillets of red cloth, their shields decorated with the same material, and an appendage of feathers, intended to represent the bull's tail, hanging down their backs. They likewise carried long, elegantly ornamented banners in their hands. After dancing for a short time before us, they demanded presents. Besides the strange figures of this dance, Mr. Bodmer painted the chief, Mato-Topé, at full length, in his grandest dress. The vanity which is characteristic of the Indians induced this chief to stand stock-still for several days, so that his portrait . . . succeeded admirably. He wore on this occasion a handsome new shirt of bighorn leather, the large feather cap, and, in his hand, a long lance with scalps and feathers. He has been so often mentioned in my narrative, that I must here subjoin a few words respecting this eminent man, for he was fully entitled to this appellation, being not only a distinguished warrior, but possessing many fine and noble traits of character. In war he had always maintained a distinguished reputation; and on one occasion, with great personal danger, he conducted to Fort Clarke a numerous deputation of the Assiniboins, who had come to Mih-Tutta-Hang-Kush to conclude peace, while his countrymen, disregarding the proposals, kept firing upon the deputies. Mato-Topé, after having in vain exerted himself to the utmost to prevent these hostilities, led his enemies, with slow steps, amidst the whistling balls and the arrows of his countrymen, while he endeavoured to find excuses for their culpable conduct. He had killed many enemies, among whom were five chiefs. Plate XXII gives a fac-simile of a representation of one of his exploits, painted by himself, of which he frequently gave me an account. He was, on that occasion, on foot, on a military expedition, with a few Mandans, when they encountered four Chayennes, their most virulent foes, on horseback. The chief of the latter, seeing that their enemies were on foot, and that the combat would thereby be unequal, dismounted, and the two parties attacked each other. The two chiefs fired, missed, threw away their guns, and seized their naked weapons; the Chayenne, a tall, powerful man, drew his knife, while Mato-Topé, who was lighter and more agile, took his battle-axe. The former attempted to stab Mato-Topé, who laid hold of the blade of the knife, by which he, indeed, wounded his hand, but wrested the weapon from his enemy, and stabbed him with it, on which the Chayennes took to flight. Mato-Topé's drawing of the scene in the above-named plate, shows the guns which they had discharged and thrown aside, the blood flowing from the wounded hand of the Mandan chief, the footsteps of the two warriors, and the wolf's tail at their heels—the Chayenne being distinguished by the fillet of otter skin on his forehead. The buffalo robe, . . . painted by Mato-Topé himself, and which I have fortunately brought to Europe, represents several exploits of this chief, and, among others, in the lower figure on the left hand, the above-mentioned adventure with the Chayenne chief.

*In the era of manifest destiny, artists in search of fresh and picturesque subject matter turned to the West and its native inhabitants. Arguing that only by embracing such intrinsically American subjects can young artists win the trophy of European respect, Henry Tuckerman holds out the example of Charles Deas. Inspired by a visit to George Catlin's Indian Gallery, Deas had ventured to western lands, where by studying Indian customs he compiled a rich and abundant archive of images. In his description of Deas's travels, Tuckerman emphasizes the colorful, "exotic" character of the Native subjects: gala dress, garish body paint, dances, dog feasts. Such subjects furnished Deas with material for paintings that are less edifying than entertaining, as their titles—*The Wounded Pawnee, Hunters on the Prairie—*suggest.*

[Henry Tuckerman], *"Our Artists.—No. V. Deas,"* Godey's **Magazine** and Lady's **Book** 33 *(December 1846).*

It was one of the earliest delights of Deas to note the mysteries of color, and trace the manner in which the brilliancy of one is heightened by the gravity of another . . . His views, however, from the first, were directed with enthusiasm towards a military life, and upon leaving school he went to live on the Hudson, and prepared himself to enter the Military Academy there situated . . . He was a zealous sportsman, and found his purest enjoyment when wandering equipped with gun, fishing-rod, and sketch-book . . .

With the tastes and habits we have described, it is not difficult to fancy the effect produced upon the mind of Deas by the sight of Catlin's Indian Gallery. Here was a result of art, not drawn merely from academic practice or the lonely vigils of a studio, but gathered amid the freedom of nature . . . To visit the scenes whence Catlin drew these unique specimens of art, to study the picturesque forms, costumes, attitudes, and grouping of Nature's own children; to share the grateful repast of the hunter, and taste the wild excitement of frontier life, in the very heart of the noblest scenery of the land, was a prospect calculated to stir the blood of one with a true sense of the beautiful, and a natural relish for woodcraft and sporting. A brother of the artist was attached to the fifth infantry, then stationed at Fort Crawford, and in the spring of 1840 he left New York for that distant port . . . Besides a happy meeting with his brother, he was cordially received here by his messmates. General Brooke was at that time commanding in the northwest, and through his influence and that of the gentlemen connected with the Fur companies, he was enabled to collect sketches of Indians, frontier scenery, and subjects of agreeable reminiscence and picturesque incident, enough to afford material for a life's painting . . . The new post of Fort Atkinson, fifty miles west of Crawford, was also visited. The picturesque appearance of the cabins and tents, the novel mode of life in the open air, the excellence of the grouse-shooting on the route, the success of which was enhanced by the perfect training of the pointers, rendered the trip delightful, and furnished some camp incidents for the sketch-book . . .

On another occasion, Deas left the hospitable walls of Fort Crawford to accompany an expedition into the interior of Iowa, and penetrated the country as far as the east branch of the Des Moines river. While absent, besides enjoying fine sport, he enriched his portfolio, and thus ended with renewed gratification his first summer in the West. Prairie du Chien, at this period, was almost a French village, and the lively manners of the inhabitants, their races and other out-of-door amusements, during the fine autumn weather, afforded new subjects of observation. The groups of half-breeds, Indians, and voyageurs, always to be found about the trading houses and fur depots, realized all that an artist needs in the way of frontier costume and man-

ners . . . The ensuing summer he made a tour to Fort Snelling and the upper Mississippi—painted a view of St. Anthony's Falls, and several of the fine-looking Sioux in the vicinity . . . Deas remained a week or two on a beautiful sloping prairie, dotted with the conical lodges of the race of Indians who make such regions their home. Here he saw some admirable specimens of the human form, and witnessed the celebrated ball-play in its perfection, each man appearing in a gala dress and painted from head to foot. There were also dog feasts, rice feasts, dances, songs, and recitations by the old men of their principal exploits in war. The occasion was the ratification of a treaty, and called out all the display of which the Indians were capable . . .

It will be seen from what has preceded, what extensive opportunities he has enjoyed in the sphere which he has chosen for the exercise of his talents. If it be true, as is maintained by many advocates, that Nature is the best guide, and that the poet and the painter are most successful who throw themselves heartily into her embrace, who are jealous of the encroachments of authority, and seek mainly to reproduce what they see and feel, independent of the dictation of schools and public opinion, we may justly look for some rich and peculiar results from the youthful experience of this artist. He is now established at St. Louis, and it is gratifying to add, from his own testimony, that he has there found all that a painter can desire in the patronage of friends and general sympathy and appreciation. Among the subjects which have recently occupied him are "Long Jake," designed to embody the character of the mountain hunter; the "Indian Guide," whose prototype was a venerable Shawnee who accompanied Major Wharton; "The Wounded Pawnee;" "The Voyageur," "The Trapper," two illustrations from the history of "Wenona," "A Group of Sioux," and "Hunters on the Prairie."

AMERICAN INDIANS AS PICTORIAL MATERIAL

The Crayon here urges American artists to discover the picturesque riches to be found in the subject of the American Indian. Like many others lamenting (and acquiescing to) the fact that the "red man" is quickly fading into extinction, the writer highlights the importance of the Native American as an actor and a subject in American history. Like Catlin, this critic admires the Indian in his original state of nature and urges painters to downplay bloodthirsty savagery in favor of native dignity and nobility. Offering suggestions for historical or genre scenes involving Indians, the writer recommends using them as particularly effective accessories in the landscape—a remark that illuminates Anglo-American desire to link noble savage and mythic wilderness in a compelling visual trope of national identity.

"The Indians in American Art," Crayon 3 (January 1856).

It seems to us that the Indian has not received justice in American art. The simple dignity of his ordinary carriage does not, perhaps, permit those picturesque accessories which are indulged in by mere picture-makers; but there are sublime passages in his history that deserve illustration at the hands of our historical painters. It should be held in dutiful remembrance that he is fast passing away from the face of the earth. Soon the last red man will have faded for ever from his native land, and those who come after us will trust to our scanty records for their knowledge of his habits and appearance . . . Already, he is oftener seen in our pictures, bedecked with European finery, than in the unadorned simplicity of his primitive condition . . .

We should rejoice to see the Indian figure more upon our canvas, and the costumed European less; for it cannot be hidden that it is the seductive blandishments of the white man's clothes

that allures the artist into the portraiture of his history. We have had some remarkable pictures of the red man already painted, but few of them of sufficient pretension to be considered by posterity as authority. A few years since, Chapman's marriage of Pocahontas, in the Rotunda at Washington,—the most ambitious attempt we now remember. Penn's treaty will of course always be regarded with reverence. West knew the Indians when comparatively untainted by the white man's vices. Some years ago, a young man by the name of Deas, sent to New York some excellent pictures of Western Indian life. They had the stamp of being truthful portraits. He has, in a few instances, engaged the attention of the sculptor, but altogether we think, his claims have been sadly neglected.

Setting aside all the Indian history of the West, how much there is that is romantic, peculiar, and picturesque in his struggles with civilization in our own section of country . . .

Picture the group of Aborigines, who, hiding in the forest, wonderingly watched the landing of the Pilgrims. What attitudes for the sculptor. One of them, perhaps, crawling along on his hands and knees in the snow, holding one hand over his eyes to hide the light, and the other by his side, clutching his bow, peering cautiously through a vista at the approaching strangers. Suppose an Indian hunter in this attitude, crawling along in sight of his prey, beckoning back with his hand behind him, his crouching dog, and holding with the other his gun. Here is an original action, unknown in antique sculpture—picturesque, composing agreeably, wholly American, full of lively incident, and telling its story perfectly.

The Indian, reposing at night by his campfire, or seen in the energy of his fiercest fight, skulking behind logs and trees, stealthily tracing his enemies' path in the leaves and bushes, grouped in council or roving in solitude—in all these positions, and in hundreds of others, is eminently picturesque and interesting. As an accessory in landscape, the Indian may be used with great effect. He is at home in every scene of primitive country. Picture them marching in "Indian file," winding silently along through the light and shade of some grand old primitive forest.

Western Life

GEORGE CALEB BINGHAM: WESTERN LIFE AND WESTERN POLITICS

Western expansion and settlement excited intense curiosity as well as anxiety in the East. Distant western lands were quite literally terra incognita *to easterners who passed their entire lives in established urban areas and—in an age long before the instantaneous transmission of information—had to rely on heavily mediated, often distorted or exaggerated accounts of life on the edge of civilization.*

George Caleb Bingham, often dubbed the "Missouri Artist," played a significant role in the visual mythologizing of the West as a rough, tough, yet democratic frontier. Born in Virginia but raised in Missouri, Bingham like George Catlin started out as a portrait painter, but in the middle of the 1840s, likely galvanized by exposure to the work of eastern genre painters, he began to craft his identity as a painter of Missouri life and customs. Almost at once, Bingham's work attracted attention. Through the patronage of the American Art-Union, he exhibited and sold his frontier paintings in New York; reproduced as engravings and lithographs, they circulated widely. Oscillating between representations of rough riverboatmen at the very fringes of civilization and images of organized political activity in prosperous settled communities, Bingham's work incorporated both extremes of the mythic American frontier.

Bingham's correspondence with the Whig politician James Sidney Rollins reveals

the extent to which art and politics overlapped in the painter's life. Like his friend, Bingham was a passionate Whig (and anti-Democrat) dedicated to Henry Clay's American System, which supported high tariffs, a national bank, and federal funding of internal improvements—rivers, railroads, canals—that would link all parts of the country in a vital economic network. Dealing with political banners and hard-fought elections, all three letters clearly indicate that Bingham's frontier was no backwater but a thriving, progressive regional center where national politics played out on the local stage.

George Caleb Bingham to James Sidney Rollins, letters, James S. Rollins Papers, 1546–1968, Western Historical Manuscript Collection, Columbia, Missouri.

[September 23, 1844]

With reference to the banner which you desire for your delegation to our convention, I can merely state, that I shall be happy to execute it, provided you allow me to paint it on linnen, the only material on which I can make an effective picture.

I am now just beginning one for Cooper, and one for Howard, each 7 by 8 feet—on one I shall give a full length portrait of Clay as the Statesman with his American System operating in the distance, on the other I shall represent him as the plain farmer of Ashland—each of them will also have appropriate designs on the reverse side, and will be so suspended, as to be eisily borne by four men walking in the order of the procession. The cost will be from fifty to sixty dollars each.

They will be substantial oil pictures and may be preserved as relics of the present political campaign. If your delegation would be pleased with a similar banner as "old Hal" is already fully appropriated, I would suggest for the design as peculiarly applicable to your county, old Daniel Boone himself engaged in one of his death struggles with an Indian, painted as large as life, it would make a picture that would take with the multitude, and also be in accordance with historical truth. It might be emblimatical also of the early state of the west, while on the other side I might paint a landscape with "peaceful fields and lowing herds" indicative of his present advancement in civilization.

[November 2, 1846]

If when you see me again you should not find me that pattern of purity which you have hitherto taken me to be, let the fact that I have been for the last four months full waist deep in Locofocoism[4] plead something in my behalf. An Angel could scarcely pass through what I have experienced without being contaminated. *God help poor human nature.* As soon as I get through with this affair, and its consequences, I intend to strip off my clothes and bury them, scour my body all over with sand and water, put on a clean suit, and keep out of the mire of politics *forever.* If you should be a candidate for the presidency however I may condescend to vote for you—or the next best Whig that may be presented.

[December 12, 1853]

My "County Canvass" will keep me, I think, fully employed until the Election is ready for distribution. *The gathering of the sovereigns* is much larger than I had counted upon. A new head

[4] A radical working-class and reformist wing of the Democratic Party, organized in 1835 and named for the new self-igniting lucifer, or "locofoco"—matches.

is continually popping up and demanding a place in the crowd, and as I am a thorough democrat, it gives me pleasure to accommodate them all. The consequence, of this impertinence on one side and indulgence on the other, is, that instead of the select company which my plan at first embraced, I have an audience that would be no discredit to the most populous precinct of Buncomb.[5]

I have located the assemblage in the vicinity of a mill, (Kit Bullards perhaps) The cider barrel being already appropriated in the Election, I have placed in lieu thereof, but in the back ground, a watermellon waggon over which a *darkie,* of course presides. This waggon and the group in and around, looming up in shadow, and relieved by the clear sky beyond, forms quite a conspicious feature in the composition, without detracting in the slightest degree from the interest inspired by the principal group in front.

In my orator I have endeavored to personify a wiry politician, grown gray in the pursuit of office and the service of party. His influence upon the crowd is quite manifest, but I have placed behind him a shrewd clear headed opponent, who is busy taking notes, and who will, when his turn comes, make sophisms fly like cobwebs before the housekeepers broom.

CRITICS ON BINGHAM, EAST AND WEST

Bingham had two primary publics and two sharply divided groups of critics, in Missouri and in New York. Comparison of comments from both venues illuminates sharply opposed views of western life and western people. Whereas Missouri writers express great pride in Bingham's "purely Western" spirit and extol his choice of characteristic regional subject matter, New York writers pan the vulgarity of his paintings, even going so far as to proclaim The Jolly Flatboatmen *(1846) a "death blow" to high art. In these strong differences one can sense the shaping power of preconception. Supposing the West to be wild and crude, New York critics respond to Bingham's work accordingly, the mere presence of such backwoods art in urban galleries an affront to their cultural authority. By the same token, in Missouri the very fact that the region has produced a genius of Bingham's stamp is a sign that high culture has moved west to marry with the distinctive regional character that the "Missouri Artist" celebrates on canvas.*

"The Missouri Artist," Weekly Missouri Statesman, January 9, 1852.

We called in a few days ago at the studio of our old friend George C. Bingham, of Columbia, Mo., and in looking over some of his latest productions, could not but feel more sensibly than ever how truly proud our State should be of this gifted disciple of Fine Arts. A good deal has been said lately about his "Election Day," which, naturally, first attracted our attention. It is not yet quite finished, but the vivid truthfulness that speaks from every part of the canvass, sufficiently stamps it already as one of the choice productions of a high order of genius. The most striking feature about the painting, perhaps, as is the fact that whoever looks at it seems to recognize at once some old acquaintance in the various groupings, and is disposed to fancy that the portrait was taken from the life. We saw most unmistakably an old Country Court Judge, of the interior, who may invariably be seen on "election day" perched upon the court house fence, discoursing with the learning and authority which are inseparable from high official po-

[5] Buncomb: empty, insincere, pandering political speech.

sition, upon the infallibility and super-excellence of the "Democratic" party. There he sits, in the identical place and attitude in Bingham's picture, so true a copy that we are sure, were the original to see it, he would feel insulted at the artist's presumptuous transfer of such an unapproachable greatness to vulgar canvass. Every character exhibits so perfectly some expression, attitude or occupation that is inseparable from such scenes, that we will not venture to particularize any, for fear of doing injustice to the rest. All who have ever seen a country election in Missouri are struck with the wonderful accumulation of incidents in so small a space, each one of which seems to be a perfect duplication from one of these momentous occasions in real life. We understand that a liberal offer has been made to Mr. Bingham for this painting, by a gentleman in New York, so that it is possible it will not remain here long after it is finished. We sincerely hope, however, that some public-spirited patron of the arts may be found in St. Louis, who will prevent the exquisite delineation of a purely Western scene from crossing the Mississippi. We could not object, of course, to its being taken abroad for the purpose of exhibition, but we cannot help protesting against its permanently leaving Missouri.

There are several other sketches from Western life which have upon them the distinctive marks of Bingham's excellence, and which all who can enjoy at all the rarest productions of genius should not lose the opportunity of seeing.

"Paintings," Daily Missouri Republican, *April 21, 1847.*

PAINTINGS—It is well worth while for any one who can appreciate the beautiful displays of art, to pay a visit to the room of Mr. WOOLL, on Fourth street, and look at two paintings there, by Mr. G. C. BINGHAM, better known by the soubriquet of the "*Missouri Artist.*" They are gems in the art of scenic painting. Mr. BINGHAM has struck out for himself an entire new field of historic painting, if we may so term it. He has taken our western rivers, our boats and boatmen, and the banks of the streams, for his subjects. The field is as interesting as it is novel. The western boatmen are a peculiar class in most of their habits, dress and manners. Among them, often in the same crew, may be found all the varieties of human character, from the amiable and intelligent to the stern and reckless man. In dress, habit, costume, association, mind, and every other particular, they are an anomaly. They constitute a large, interesting, and peculiar class, and in their labors they are surrounded by natural scenery, or accidental occurrences, which lend to their own peculiarities a yet deeper interest. Their employment, the dangers, fatigues and privations they endure—the river and its incidents and obstacles—its wild and beautiful scenery—its banks of rocks, or its snags, sawyers and sand bars, draw out, as it were, the *points* of these hardy, daring, and often reckless men.

Mr. BINGHAM seems to have studied their character very closely, with the eye and genius of an artist and the mind of a philosopher. He has seized the characteristic points, and gathered up their expressive features, and transferred them to his canvas with a truthfulness which strikes every observer. To look at any of his pictures, is but to place yourself on board of one of the many crafts which float upon our streams.

There is another peculiarity about Mr. BINGHAM'S paintings. He has not sought out those incidents or occasions which might be supposed to give the best opportunity for display, and a flashy, highly colored picture; but he has taken the simplest, most frequent and common occurrences on our rivers—such as every boatman will encounter in a season—such as would seem, even to the casual and careless observer, of very ordinary moment, but which are precisely those in which the full and undisguised character of the boatman is displayed . . .

In one of the paintings, to which we alluded at the beginning of this article, Mr. BINGHAM

gives a view of a steamboat, in the distance, aground on a sandbar. A portion of her cargo has been put upon a lighter or flatboat, to be conveyed to a point lower down the river. The moment seized upon by the artist is, when the lighter floats with the current, requiring neither the use of oar nor rudder, and the hands collect together around the freight, to rest from their severe toil. One is apparently giving a narration of his adventures at *Natchez under the hill,* or somewhere else, and the rest are listening—whilst a few others are seeking more congenial enjoyment in the jug, pipe, &c. The characters grouped together on the lighter, their dress, expression of countenance, positions, &c., are true to the life.

The other, and, in our estimation, the better picture, is a group on a *raft,* floating with the current. Two men are playing a game of cards, well known in the west as *three up.* The two players are seated astride of a bench—one has led the *ace,* and the other is extremely puzzled to know what to play upon it. As often occurs, he has two friends, on either side of him, each of whom are giving advice as to which card he ought to play. The expression of countenance given to each one in the group is perfectly life-like. Every one who has ever witnessed such a scene, will at once see on the canvas all the incidents and expressions of real life.

"The Fine Arts. The Art-Union Pictures," Literary World 2 *(October 23, 1847).*

No. 1. *Jolly Flat Boat Men,* and No. 91, *Raftsmen Playing Cards.*—G. C. Bingham. The first of these subjects has by some fatuity been selected by the committee, to be engraved for distribution to the members of the present year. The painting is not now on the walls, and as few probably of the subscribers have seen it, we are sorry to inform them that the opinion we formed of it last year, when it was exhibited at the rooms for a few days, was that it was a vulgar subject, vulgarly treated, that the drawing was faulty and the composition artificial,—altogether a most unworthy and unfortunate selection. Were it not somewhat redeemed by the engraving of Huntington's Sybil, we should feel great commiseration for the members, that to the possibility of drawing some of the bad pictures was added the certainty of getting a print of so low a character. Of Mr. Bingham's qualities as a painter, however, No. 91 and another subject yet unpurchased, are a sufficient example. In color they are disagreeable, a monotonous, dull, dirty pink pervades every part; and in texture there is the same monotony. Flesh, logs, and earthen jug have the same quality of substance, the same want of handling. We think this must be produced by going over the colors when wet with a "softener," in order to avoid hardness; but we would rather see the figures as hard as statues than see light, shade, color, and texture swept thus into a mass of soft confusion. In composition, Mr. B. should be aware that the regularity of the pyramid is only suitable to scenes of the utmost beauty and repose; that when motion and action are to be represented, where expression and picturesqueness are objects sought for, proportionate departures must be made from this formal symmetry. A little study of the compositions of any of the great men of old, would do much towards correcting the artist's faults in this respect.

"The Fine Arts," Literary World 1 *(April 3, 1847).*

The following resolution was moved by Mr. Wm. J. Hoppin, at the annual meeting:

"*Resolved,* That it is the duty of this Association to use its influence to elevate and purify public taste, and to extend among the people, the knowledge and admiration of the productions of High Art."

Mr. H., in support of his motion, offered some pertinent and eloquent remarks; and we regret that in accordance with the spirit of the resolution, and the comments of the gentleman

who offered them, the Committee did not select some other subject for engraving than the "Jolly Flat Boatman"—the very name of which gives a death blow to all one's preconceived notions of "High Art." The picture is tolerably well in its way; but it is by no means what a student in art would select as a standard of taste, and it contains no redeeming sentiment of patriotism. Nevertheless, it will please a portion of the subscribers, whose tastes are yet to be formed; and the engraving of the "Sybil," from one of Huntington's best pictures, by Casalier, will amply atone for all that the other may lack.

LIFE ON THE MISSISSIPPI IN JOHN BANVARD'S PANORAMA

Eastern audiences had the opportunity to travel the Mississippi themselves in the form of John Banvard's purportedly three-mile-long panoramic painting. Spooled and stretched between two massive, elaborately geared cylinders, Banvard's gigantic work displayed the changing scenery of the Mississippi from the mouth of the Missouri River all the way to New Orleans. Based on a year's solo sketching trip down the river in a skiff, the painting took Banvard four years to transfer to canvas in a huge building he rented in Louisville, Kentucky. In 1846 Banvard took his panorama to Boston, where it was a huge success, and from there it went on to still greater popularity in New York and London. Presented as a faithful picture of life along several thousand miles of river, the Mississippi panorama excited interest in western settlement and contributed to the construction of the region as a land of limitless resources and sublime beauty.

The writer in Howitt's Journal *claims that the artist was motivated not by the hope of gain but by sheer patriotic fervor. Banvard is a frontiersman of art, traveling alone with his rifle, killing his dinner, and sleeping under his flimsy skiff. The painting itself is manifest destiny in material, visual form, rolling inexorably on its course, encompassing both the savage past and the far-off but undoubtedly glorious future.*

"John Banvard's Great Picture: Life on the Mississippi," Howitt's Journal *2 (September 4, 1847).*

In the year 1840, a young man, hardly of age, took a small boat, and, furnished with drawing materials, descended the river Mississippi, resolved to gain for his country a great name in the kingdom of art. It had been said that America had no artists commensurate with the grandeur and extent of her scenery, and John Banvard, now in his little boat, sets sail down the Mississippi, to prove how unfounded was this assertion . . .

. . . The idea of gain, we are assured, never at that time entered his mind; he was actuated alone by a patriotic and honourable ambition of producing for America the largest painting in the world; one which would represent on canvas the whole extent of the scenery of the Missisippi—a gigantic idea, which seems truly kindred to the illimitable forests, and vast rivers of his native land. The first step towards this great undertaking, was to make the necessary drawing. "For this purpose," we are told, "he had to travel thousands of miles alone in an open skiff, crossing and recrossing the rapid stream, in many places above two miles in breadth, to select proper points of sight from which to take his sketch; his hands became hardened with constantly plying the oar, and his skin as tawny as an Indian's, from exposure to the rays of the sun and the vicissitudes of the weather. He would be weeks together, without speaking to a human being, having no other company than his rifle, which furnished him with his meat from the game of the woods or the fowls of the river. When the sun began to sink behind the lofty bluffs, and evening to approach, he would select some secluded sandy cove, overshadowed by the lofty

cotton wood, draw out his skiff from the water, and repair to the woods to hunt his supper. Having killed his game, he would return, dress, cook, and from some fallen log would eat it with his biscuit, with no other beverage than the wholesome water of the noble river that glided by him. Having finished his lonely meal, he would roll himself in his blanket, creep under his frail skiff, which he turned over to shield him from the night dews, and with his portfolio of drawings for his pillow, and the sand of the bar for his bed, would sleep soundly till the morning; when he would arise from his lowly couch, eat his breakfast before the rays of the rising sun had dispersed the humid mist from the surface of the river—then would he start fresh to his task again. In this way he spent above four hundred days, making the preparatory drawings. Several nights during the time, he was compelled to creep from under his skiff where he slept, and sit all night on a log, and breast the pelting storm, through fear that the banks of the river would cave upon him, and to escape the falling trees. During this time, he pulled his little skiff more than two thousand miles. In the latter part of the summer he reached New Orleans. The yellow fever was raging in the city, but, unmindful of that, he made his drawing of the place. The sun the while was so intensely hot, that his skin became so burnt, that it peeled off from the back of his hands, and from his face. His eyes became inflamed by such constant and extraordinary efforts, from which unhappy effects he has not recovered to this day. His drawings completed, he erected a building at Louisville, Kentucky, to transfer them to the canvas. His object in painting his picture in the West was to exhibit it to, and procure testimonials from, those who were best calculated to judge of its fidelity—the practical river-men; and he has procured the names of nearly all the principal captains and pilots navigating the Mississippi, freely testifying to the correctness of the scenery."

The following letter from an American gentleman, the bearer of government despatches to Oregon and California, addressed to his friend, General Morris, at New York, introduces the reader to the artist in his study, and will be read with interest.

St. Louis, April 13, 1846.

My Dear General,—Here I am, in this beautiful city of St. Louis, and thus far "on my winding way" to Oregon and California. In coming down the Ohio, our boat being of the larger class, and the river at a "low stage," we were detained several hours at Louisville, and I took advantage of the detention to pay a visit to an old school-mate of mine, one of the master spirits of the age. I mean Banvard, the artist, who is engaged in the herculean task of painting a panorama of the Mississippi river, upon more than *three miles of canvas!*—truthfully depicting a range of scenery of upwards of two thousand miles in extent. In company with a travelling acquaintance, an English gentleman, I called at the artist's studio, an immense wooden building, constructed expressly for the purpose, at the extreme outskirts of the city. After knocking several times, I at length succeeded in making myself heard, when the artist himself, in his working cap and blouse, pallet and pencil in hand, came to the door to admit us. He did not at first recognise me, but when I mentioned my name, he dropped both pallet and pencil, and clasped me in his arms, so delighted was he to see me, after a separation of sixteen years.

My fellow-traveller was quite astonished at this sudden manifestation, for I had not informed him of our previous intimacy, but had merely invited him to accompany me to see in progress this wonder of the world, that is to be, this leviathan panorama. Banvard immediately conducted us into the interior of the building. He said he had selected the site for his building, far removed from the noise and bustle of the town, that he might apply himself more closely and uninterruptedly to his labour, and be free from the intrusion of visitors. Within the studio, all seemed

chaos and confusion, but the life-like and natural appearance of a portion of his great picture was displayed on one of the walls in a yet unfinished state. Here and there were scattered about the floor piles of his original sketches, bales of canvas, and heaps of boxes. Paint boxes, brushes, jars and kegs, were strewed about without order or arrangement, while along one of the walls several large cases were piled, containing rolls of finished sections of the painting. On the opposite wall was spread a canvas, extending its whole length, upon which the artist was then at work. A portion of this canvas was wound upon an upright roller, or drum, standing at one end of the building, and as the artist completes his painting, he thus disposes of it. Not having the time to spare, I could not stay to have all the immense cylinders unrolled for our inspection, for we were sufficiently occupied in examining that portion on which the artist is now engaged, and which is nearly completed, being from the mouth of Red river to Grand Gulf. Any description of this gigantic undertaking that I should attempt in a letter, would convey but a faint idea of what it will be when completed. The remarkable truthfulness of the minutest objects upon the shores of the rivers, independent of the masterly style, and artistical execution of the work, will make it the most valuable historical painting in the world, and unequalled for magnitude and variety of interest, by any work that has ever been heard of since the art of painting was discovered. As a medium for the study of the geography of this portion of the country, it will be of inestimable value. The manners and customs of the aborigines and the settlers—the modes of cultivating and harvesting the peculiar crops—cotton, sugar, tobacco, etc.—the shipping of the produce in all the variety of novel and curious conveyances employed on these rivers for transportation— are here so vividly pourtrayed, that but a slight stretch of the imagination would bring the noise of the puffing steamboats from the river, and the songs of the negroes in the fields, in music to the ear, and one seems to inhale the very atmosphere before him. Such were the impressions produced by our slight and unfavourable view of a portion of this great picture, which Banvard expects to finish this summer. It will be exhibited in New York in the autumn—after which, it will be sent to London for the same purpose. The mode of exhibiting it is ingenious, and will require considerable machinery. It will be placed upon upright revolving cylinders, and the canvas will pass gradually before the spectator, thus affording the artist an opportunity of explaining the whole work. After examining many other beautiful specimens of the artist's skill, which adorn his studio, we dined together in the city. As our boat was now ready to start, I shook hands with Banvard, who parted from me with feelings as sad as they had been before joyful. His life has been one of curious interest, replete with stirring incidents, and I was greatly amused in listening to anecdotes of his adventures on these western rivers, where, for many years past, he has been a constant sojourner, indefatigably employed in preparing his great work.

SELIM WOODWORTH.

WILLIAM JEWETT'S LETTERS FROM CALIFORNIA

The Gold Rush of 1849 brought tens of thousands of easterners to northern California, among them William S. Jewett, a New York portrait painter. Jewett arrived at San Francisco Bay filled with hope for financial success in the inflated economy of the booming city. During the years he spent there, he speculated in real estate and tried his hand at mining, but his mainstay was painting portraits, for which he could command prices that far exceeded his receipts on the East Coast. In the two letters excerpted here, written a month after his arrival, Jewett marvels at the market for portraits and the spirit of boosterism that infuses the many schemes of the "Forty-Niners."

William Jewett, letters to family members, Bancroft Library, University of California, Berkeley.

[January 28, 1850]

In my last I told you I had shared the luck of nine out of six coming to this country, that I had been posoined sadly, well, after some three weeks of swelling, burning and *itching* (oh dear) and ending it off with some score of boils any where and evry where I am left better than I have been in health since I left my teens and I sing and whistle all the time and come ashore where I flounder through the mud in first rate stile—many of my old New York friends are here and they have all insisted so strongly upon my sitting up my easel right amongst all this crazy stuff that I have at last done so and am at work quite in earnest as it is impossible to get up to the mines if I should ever choose to go—I shall give my pencil the preference until all is safe and pleasant traveling and then shall look in upon the *diggers* and try and get enough for you all some trinkets . . . Society has great hopes of *me* here and think I am a lucky fall to them, gentlemen desire their portraits to send home to their families and I am likely to be full of work I paint very rapid take them on the wing and all are profesighing a fracture to my hand. I am hand in glove with the leading politicians of *the State* yet dont know which party they belong— the govenor [Peter H. Burnett] and Lt. gov. [John McDougal] have been written to requesting their portraits Col. [Jonathan D.] Stevenson has been today and ordered his—the Prefect of the City [Horace Hawes] has ordered his and some of the principal merchants—I am painting— and I am as jolly among them as a clam at high water, I charge from hundred and fifty to eight hundred dollars—shall paint two or three per week if they come fast enough I was paid for one last night—all in silver (no paper here) and what to do with the mass I could not tell it was the first time in my life that my money was ever a trouble to me—So I came home and got a large canvas bag I had used for common trapsticks went back and I shoveled it into it and lugged it home. One of the old masters it is said died of the fetique of carrying home a load of copper coin he got for one of his pictures I never believed it until now—I am in no alarm for my strength however—All expenses here are enourmous—rents the base of them all. I pay one hundred and twenty-five dollars per month for a little room not larger than the one I kep my coal in in N.Y. but I like these high prices if you are brisk enough in your business to keep pace with them a fortune can be made speedily—I don't expect to make a fortune yet I shall make all I can in a fair way.

[January 30, 1850]

I am not sick of my fellow men as some are who are disappointed here, those had better pluck the beam out of their own eyes perhaps—to see the peaceful state of things here where there are no laws nor ladies is admirable to the unprejeduced beholder of the scene—The great vices here are gambling and drinking—and wearing dirty shirts—here I heave a deep sigh for what shall I do? Pay six dollars a Doz. for washing my old ones! If any one will wash them to the halves I will thank them—I am determined to live as economical as possible. "And save my money and buy me a farm." I made fifty dollars today in painting one little head at one sitting—There are other artists here and doing comparably nothing some do not endeavor to paint at all, I somehow appear to be popular and don't know why either deservedly or undeservable most likely the latter. I dont know how long it may last—I will do all I can however in the mean time to deserve its continuance . . . There are some gents here who are determeined I shall paint a mammoth panorama of the rivers and diggings, they offer all the money and every possible convenience, it would be a most uncongenial task for my mind and I try to shuffel them off I

promised to see them to night but rather stay home and write to you—besides there has been some artists here on the same business and the ground is preoccupied which would so much impare the novelty to the publick that I think there would be no profit in the result, yet so great is their faith in the powers of my pencil that they say the bush would only be beaten for me to katch the game. But I declare I wont do it as long as I can make fifty dols. per day at portraits . . . but I am bound to see the diggings and sketch on my own accout and dig on the account of all my friends to get gold enough to make them all a present.

FREDERIC CHURCH'S SUBLIME LANDSCAPES

HEART OF THE ANDES

The most famous American landscape painting is undoubtedly Frederic Church's Heart of the Andes *(1859, fig. 6), a ten-foot-wide canvas depicting the equatorial regions of Ecuador. Church first traveled to South America in 1853, and he returned there four years later with artist Louis R. Mignot. These trips provided him with raw material (in the form of hundreds of vivid oil sketches) for a series of tropical landscapes that spanned three decades. Of these, the ambitious* Heart of the Andes *was understood to be the* summa *of the group and, indeed, of the region. As two lengthy pamphlets on the work—written by Louis Noble and Theodore Winthrop—explained, Church had captured and processed all the available scientific and visual evidence of the Andes. His canvas was an encyclopedic treatise covering botany, geology, meteorology, and in a higher sense, cosmology; the history of the very formation of Earth could be confidently read from the painting's forms by its explicators.*

This vast panorama is viewed from a disembodied, elevated position. One hovers, God-like and all-seeing, like a cosmic landlord surveying the territory—an impression heightened by the massive walnut frame designed by the artist to approximate a view through a large window. Church created Heart of the Andes *during a period of growing U.S. interest in the Southern Hemisphere, and many of the reviews of the painting discuss that region with a degree of possessiveness. Although its subject was not within the bounds of Church's own country,* Heart of the Andes *was received as a masterpiece of painting in the United States, a clarion statement of artistic emancipation from Europe, a sentiment forcefully advanced by a writer in the* New York Herald, *below. In this context, the reviews from London are notable. The* Saturday Review *recognizes Church's potential but declares that it will never be realized unless he studies in Europe. The London* Art Journal, *in contrast, gives Church perhaps the best review he ever received, declaring that he is the heir to James Turner and urging British landscapists to sail west for America.*

Church's marketing of Heart of the Andes *was unprecedented. It was unveiled on April 27, 1859, in Lyrique Hall in New York, to a crowd of some five hundred invited guests. It then moved to the Tenth Street Studio Building, where twelve thousand people paid 25 cents to view it surrounded by potted palms, gaslights, and reflectors. Many more thousands saw it on its two-year tour of North America and England. Clearly, Church planned for his new painting to be a sensation, and he was not disappointed. The depth of the press coverage was remarkable; reviews were far more than single-paragraph mentions, as the sample compiled here indicates. (In his autobiogra-*

phy, Worthington Whittredge remembered artists gathering in astonishment to read the newspaper coverage of Heart of the Andes *in the Café Greco in Rome.) Confronted with nearly 60 square feet of canvas, writers felt compelled to discuss composition, light, color, and the balance of detail and general effect far more extensively than was common. Musical metaphors appear several times as a means of explaining the way that individual "notes" and "chords" are assembled into a larger whole. When criticism was leveled at the work, as in the review in* The Century, *it was usually directed at the superabundance of detail—"nature's statistics" in the words of another reviewer. It was this quality that led to descriptions of disorientation and bewilderment before the canvas. In fact, the written accounts of* Heart of the Andes *are unusually experiential in tone, nowhere more so than in Mark Twain's (Samuel Clemens) captivating letter describing his brain "gasping and straining" when he viewed the picture in St. Louis.*

"Mr. Church's New Picture," New York Times, *April 28, 1859.*

The long and patient toil which Mr. CHURCH always bestows upon his paintings has ripened in this instance to a landscape which may fairly and fearlessly challenge comparison with the grandest imaginations in this kind. In baptizing his work the "Heart of the Andes" the artist has happily indicated the high poetic tenor of the composition. It is not like the "Niagara" a simply magnificent mirror of one scene and one moment in Nature, but like the noblest works of CLAUDE and TURNER, a grand pictorial poem, presenting the idealized truth of all the various features which go to the making up of the Alpine landscape of the tropics. You must look upon it long and often; study it minutely one day in its multitudinous details, and bearing them well in mind, recur to it again afresh to receive a new impression of its marvelous, much-embracing unity, before you can begin justly to appreciate what it is that the artist has attempted and achieved. The harmony of design which so subordinates all its opulence of gradations and perspectives as completely to exclude the panoramic in favor of the picturesque, is of so high a merit that the eye unfamiliar with landscape-painting of the first order will be as slow to apprehend its beauty, as the unpracticed ear is to take genuine delight in such musical wonders as those of LISZT and CHOPIN. What seems, at first, a chaos of chords or colors gradually rises upon the enchanted mind a rich and orderly creation, full of familiar objects, yet wholly new in its combinations and its significance.

"The Heart of the Andes," Century, *May 21, 1859.*

We are glad to learn that the new picture of Mr. CHURCH is a popular success. The strength of characterization in every part, making it instantly understood and enabling every form to tell the purity of the sky, the wonderful rendering of water in the stream and fall, the great variety of incident, the extent of perspective and real grandeur of spaces in the plain, all combine to delight the beholder. The greatness of the mountain and remoteness of its peak are not so distinctly felt. Perhaps the broken cloud forms, unconsciously, compared with other magnitudes and distances impair the effect of this gigantic pyramid. The very fault of the picture, an indulgence in detail hardly worthy of the dignity and majesty of the subject, will increase its popularity with the multitude, who delight in imitation and are willing to turn from the mountain, plain and skif, from the sleeping distance and the visible silence of the scene, to admire sunshine on a tree trunk, a broken bank, a bright bird or fern. The picture suffers somewhat in effect from the dullness of its surroundings. The color of the work itself not being sufficiently contrasted with that of its wooden frame, we carry the impression of black walnut into the can-

vas. The design is very grand—the forms, though perhaps somewhat too numerous, are well chosen and disposed, and in parts of the work its execution is fully equal to the design. Great power is manifest in all parts, but to regard a work in parts, as we are here compelled to do, is criticism, not compliment. This picture is greater in the parts than in the whole, while a supreme work has no parts, and refuses to be dissected or disorganized. Standing by itself, apart from the contemporary exhibition of the Academy, this challenges a strict comparison with the landscapes there, while it exhibits the greatest excellence in its own kind and on its own level, as a piece of masterly statement and representation, we think its appeal to our deepest sympathy with Nature is less direct and conclusive than that of less conspicuous pictures in the common gallery.

Mr. CHURCH is in danger from his facility of characterization and expression. He paints objects so well that he is tempted to make a picture by combination of objects. His delicate touch, his easy command of all detail, his clear and accurate perception of form, prevails in many cases over his ideal feeling. He introduces a multitude of particulars, interesting enough, and well presented, but they break the unity of his work, and seem to stand there for their own sake, and not to be subordinated to the spirit of the scene. In the best landscape we feel most perfect repose. In Nature, largely viewed, we are drawn neither to this or that point, but all points are lost in a harmony, whether of grandeur and solemnity, or cheerful splendor or pensive sweetness. It is for the sake of this sentiment—the soul for which objects furnish merely a body—that we paint the landscape, and its reproduction in effect is the last excellence of our Art . . .

Mr. CHURCH seems not to be so surrendered to an inspiration, but rather to revel in the delight of his eyes and in his power to reproduce what they receive. His foregrounds are not therefore thoroughly related to his distances, his detail becomes hardness in the nearest objects, the repose which he certainly reaches in parts of his work, as in the distance and middle distance on the left in his "Heart of the Andes," is not carried quite through the work. The effect of single forms is weakened by multiplication of forms. It is as though the artist, having much to say and ability to speak, should never know when to be silent. Only the deepest feeling can prompt to wise and sublime refraining, which is always the climax of eloquence . . .

There is a manifest break between his foreground and his distances. His nearest objects are not treated with a grandeur and generality worthy of the entire theme, but are hard in quality, too much broken by detail, and seem artificially introduced. Composition is betrayed in them, and throughout the work we feel that too many points have been brought into prominence, and we are not quite able to connect these parts into a majestic inevitable whole. The work commands great admiration, yet leaves a doubt—does not convince and master the mind. It appears what it is—the work of a young artist who has attempted more than he could thoroughly perform; who is working intellectually, and bravely coping with a gigantic enterprise from which diffidence might perhaps have withheld him if his awe and reverence before nature were at all equal to his perception.

A deep love for the spirit which is manifest in every scene teaches that the greatness of materials does not make the greatness of a work of art. Its excellence depends rather on the manner in which it is seen, and RUSKIN has well said that he who cannot make an ant-hill sublime will make a mountain ridiculous. This Mr. CHURCH has never done, and, with his vigor of statement, is in no danger of doing; but in his choice of subject, furnishing as it does the fairest field for his talent and facility of representation, he seems in danger of devoting himself to a sensuous or sensible effect, and forsaking the highest excellence. The truth of nature in North is worth as much as the truth of nature in South America (more indeed, if, as we believe, the sobriety

and moderation of our high latitudes are related to nobler attributes in man than the luxuriance and prodigality of the tropics), and the truth of nature is what we seek to give value to our Art. The blue sky in The Heart of the Andes is its best success in representation, and the same blue sky is over all. There is as much danger in landscape as in any other department of falling into melo-drama and exaggeration, and the safeguard against it is a habit of selecting modest or moderate materials, and elevating them by grandeur of conception, by the unity, depth and solemnity of our regard. So much of caution and criticism when, perhaps, the reader may think all should be thanks. The artist knows that he who does not criticise does not love or honor Art. Mr. CHURCH has painted a great picture—tried by any but the highest standard, a sufficient picture.

"Church's 'Heart of the Andes,'" Saturday Review *(London), September 10, 1859.*

It does not need a prophet to arise and point to the West in order to proclaim in what direction we may look for a young and vigorous school of art. Those who scan the horizon augur a great art future for America, and we regard with peculiar interest the harbingers of that new school which we anticipate . . .

A certain mastery of manipulation Mr. Church undoubtedly has, but whether he is in the highest sense a great artist we are not yet prepared to decide. The "Heart of the Andes" exhibits his versatility rather than increases his reputation. The local colour of American scenery is new to us; yet, arguing from what we know, the proofs would confirm us in the opinion that Mr. Church is not a great colourist. We know the exquisite tints of American shrubs and flowers transplanted from their natural soil, and then we ask why they should lose their brilliant luminous appearance and delicacy by being painted in the Tropics. The painting might have been expected to be startling in its vividness, yet, on the contrary, it is opaque—the texture reminding us of German painting on copper. It is summer, but there is no warmth—there is sun, but it is simply light, without heat. The mountains are leaden, like the clouds—the sky has no luminousness. There is no tender dying away of tint, without which Mr. Ruskin has said there is no good, no right colour. We much regret that Mr. Church has never been in Europe—has never seen the masterpieces of his art. Nor, for the present, is he likely to do so, for he is now devoting his ambitious energies to painting icebergs in Greenland. It is impossible, however, that so determined and adventurous a man should fail to achieve success, with youth, talent, and discipline in his favour. His fellow countrymen admire and applaud him because he "sticks at nothing." He should follow the bent of his own genius, without forgetting his real public—men with eyes and hearts trained in the study of the noblest works of art. To them he must look to win his highest praise—higher than the admiration of the untravelled American connoisseur. We look on Mr. Church as the probable founder of a school of landscape painting. Something grand and revolutionary in art should, one might expect, be originated by the influences of nature on a grand scale, moulding the minds of those who study the secrets of her beauty; yet this is not necessarily the result, if we may generalize from a particular instance, and speculate whether it is as true of a people as it is of an individual that the first flights of genius are rarely very original. There is an old way of trying wings to feel how high they may soar.

"The 'Heart of the Andes,'" Art Journal *(London) 11 (October 1859).*

We feel, ardently, that it behooves those amongst us whose opinions justly command most influence with respect to the advance of intellectual power and refinement, to congratulate our transatlantic brethren cordially—to waft to them, over the vast deep, fraternal greetings in cel-

ebration of another conquest they have achieved in those ideal realms, where the gain of one people is so happily the gain of all. Already for a long time honourably distinguished in that republic of art, which is only anxious *not* to define a geographical boundary, they may now, we believe beyond question, claim a most high, a central position, in the particular state or department of landscape painting. Niagara and the Andes have found an American pencil able to unfold the clear brightness of these glories to the untravelled ones, far as picture may be sent. America rejoices in a great landscape-painter; and it becomes us also, brothers in race, to hail the event with that tender animation with which we should ever accept some noble gift to the world at large. Yes; here is obviously one of those mental mirrors, of a rare brightness, which have literally the power to fix and transfer their reflections. In other terms, here is manifestly a gaze of extraordinary clearness and vigilance; a gifted hand, swift to follow it with graceful strength and lightness; a tender and capacious spirit, which unites harmoniously the minute and the vast, the delicate and the forcible, the defined and the mysterious, and can reduce multitude and diversity to simple order, under the sweet sovereignty of beauty. Here is a painter (it is delightful to see it) whose modest patience and cheerful industry no amount of labour can weary or deaden. In these days, too, it is specially pleasing to see that though, as we are told, ever from his youth ardently devoted to nature, he has evidently no disposition to disdain the time-honoured laws of Art, by virtue of which Art *is* Art, and alone can bring the spirit of infinite nature within the compass of our finite minds. At a time when so many of our own painters are sinking to anarchy, it should be as a pointed rebuke to us, to find the symmetries, the grace, the rhythm, the rhymes, as it were, that complete the composition of refined poetic Art, taught us anew in a land where nature is most untramelled, and freedom broadest. And this is the more remarkable, inasmuch as the painter has not yet visited Europe, and consequently, except through engravings, has little or no acquaintance with the works of the great masters. Such are some of the reflections and felicitations, which arise in the mind on first seeing Mr. Church's extraordinary picture, "The Heart of the Andes," a work which begets a mingled, two-fold admiration—delight and astonishment at the novel magnificence of the landscape itself, and at the power by which it has been represented . . .

From the sharpest articulations of these objects, which would in the reality be discernible, up to the most delicate mysteries of the airy mountain, all is rendered with the untraceable ceaseless gradations of nature; her multitudinousness and brightness are expressed without a moment's forgetfulness of her vastness, and complexity, and atmospheric modifications, and all is subjected by this mastermind to a grand and graceful unity and harmony. Specially welcome is the last result, in this our own but unsatisfactory period of landscape painting, in which a heavily-glaring, one-sided parade of the *letter* so commonly omits the *spirit*, a smattering of geological and botanical minutiae takes place of the old poetical or true Art-feeling for beauty; and disorder and insubordination—a predominance of littleness of every kind—are frequently prevalent, from disregard of principles and laws, cast aside by the crude ignorance, without distinction of good and bad, and nicknamed, all alike, by that much-abused word, conventionalism. Mr. Church's picture is the completest union we are acquainted with of literal minuteness with freedom, freshness, and a comprehensive, simplifying grasp of the higher spirit of the whole scene. The painter draws excellently; the minutest and most intricate details are touched off at once with a spirited grace, which contrasts remarkably with the heavy drudgery of our Pre-Raphaelites; and the same sense of beauty which gives free, wavy life to stems and leaves, models his mountains; so that, as in Nature, sublimity is built up of beauty. The fresh vigour of hue, unimpaired by the precision and minuteness, especially charmed us. The aerial perspec-

tive is wonderful—quite equal, we believe, to any ever painted; and of *clear-obscure* (to translate the foreign terms *literally,* for the sake of our particular meaning), this is surely one of the finest of instances. The *obscure* of the nearer mountain is the most picturesque and striking contrast possible to the *clear* of the foreground and remoter distance; and, moreover, highly judicious in a case where, had all been clear alike, the eye and the mind would have been oppressed with far too much. The picture combines more than any other we know, the minute and literal truth at which the Pre-Raphaelites aim imperfectly, with Turner's greatness and grace of conception. On this American more than on any other—but we wish particularly to say it without impugning his originality—does the mantle of our greatest painter appear to us to have fallen. Westward the sun of Art still seems rolling . . .

It has frequently occurred to us—and never more forcibly than when contemplating this very beautiful painting—that America offers a wide and grand field for our landscape artists. Why do not some of them take a trip thither? the voyage is not long, and the cost need not be great. If the Old World is not exhausted, it has become so familiar to us that we seem to know almost every spot of interest or picturesque beauty that it has to show; but the New World is, as yet, almost untrodden ground in Art, and we see in Mr. Church's work what it affords to those who know how to use such materials. Many of our painters travel south and east, and a few have occasionally gone north; we would now recommend them to try the western world.

"Wonderful Development of American Art—Uprising of Enthusiasm," New York Herald, *December 5, 1859.*

One of the most marked of our characteristics as a people is the readiness with which we give way to our impulses. Let anything strike our fancy, lay hold of our sympathy, or impress itself on our convictions, and we at once abandon ourselves to its influence. We do not wait for the verdict of others to be guided in our judgments. Unlike the European communities, which are led by the nose by pedants, we have the independence to decide for ourselves, and to decide promptly. The consequence is, that notwithstanding our comparative inexperience in art matters, we make fewer mistakes in the appreciation of works of genuine merit than we find committed by foreigners who have had larger opportunities of observation.

There has never been a period in the history of the arts in this country in which this national peculiarity has more strongly manifested itself than within the last few weeks. In this brief space of time we have witnessed a series of excitements which, springing from well-founded causes, must have the effect of giving an immense impulse and development to the creative genius of the country. They constitute, in fact, one of those historical eras which serve as a guide to the art student . . .

From the exhibition of Church's great picture, the "Heart of the Andes," may be dated the inauguration of this new art epoch. This extraordinary work may be said to embody all the peculiarities and excellences which, in painting as well as in sculpture, have given the stamp of originality to American art. The landscapes of our artists differ as much from the pictures of Turner, and of the modern English school generally, as they do from those of Salvator Rosa, Claude Lorraine, and Nicolas Poussin. With the breadth which constitutes one of the chief merits of such works they combine minuteness and elaboration of detail—qualities that are not to be found united to any extent in the productions of the masters that we have named. They have, too, this distinctive feature, that they represent an atmosphere totally different. In English scenery there is a mistiness, and in Italian scenery a haze, which only imperfectly reveal objects. The American sky, on the contrary, is pure, bright and transparent, and brings out everything clearly and sharply to the eye. The rays of the sun, penetrating through a vista of forest scenery, lose

none of their force through the intervention of the exhalations which, in European countries, modify their effects. For this reason American landscapes must always possess a character *sui generis*, part due to climatic influences and part to the independent spirit of our artists, who refuse to be bound by the conventionalities of other schools.

Samuel Clemens to Orion Clemens, March 18, 1860, in Mark Twain's Letters, *ed. Albert Bigelow Paine (New York: Harper and Bros., 1917).*

Pamela and I have just returned from a visit to the most wonderfully beautiful painting which this city has ever seen—Church's "Heart of the Andes"—which represents a lovely valley with its rich vegetation in all the bloom and glory of a tropical summer—dotted with birds and flowers of all colors and shades of color, and sunny slopes, and shady corners, and twilight groves, and cool cascades—all grandly set off with a majestic mountain in the background with its gleaming summit clothed in everlasting ice and snow! I have seen it several times, but it is always a new picture—*totally* new—you seem to see nothing the second time which you saw the first. We took the opera glass, and examined its beauties minutely, for the naked eye cannot discern the little wayside flowers, and soft shadows and patches of sunshine, and half-hidden bunches of grass and jets of water which form some of its most enchanting features. There is no slurring of perspective effect about it—the most distant—the minutest object in it has a marked and distinct *personality*—so that you may count the very leaves on the trees. When you first see the tame, ordinary-looking picture, your first impulse is to turn your back upon it, and say "Humbug"—but your third visit will find your brain *gasping* and straining with futile efforts to take all the wonder in—and appreciate it in its fulness—and understand how such a miracle could have been conceived and executed by human brain and human hands. You will never get tired of looking at the picture, but your reflections—your efforts to grasp an intelligible Something—you hardly know what—will grow so painful that you will have to go away from the thing, in order to obtain relief. You may find relief, but you cannot banish the picture—it remains with you still. It is in my mind now—and the smallest feature could not be removed without my detecting it. So much for the "Heart of the Andes."

AFTER ICEBERGS WITH A PAINTER

An indefatigable traveler, Frederic Church evidently hoped to bring the entire globe under the control of his brush. His geographic "conquests" included South America, Mexico, the Catskills, New England, Niagara Falls, Jamaica, Europe, the Holy Land, and the Arctic. This last subject was made possible through a trip north he made in the summer of 1859 with his friend the minister Louis Noble, and it resulted in one of his most spectacular canvases, The Icebergs *(1861). In these two excerpts from Noble's account of the voyage, he struggles to find analogies to describe the wonder of sailing so close to these mountains of ice, and he injects more than a little melodrama into the efforts of Church (referred to as "C——") to make accurate oil sketches in the open air.*

Louis L. Noble, After Icebergs with a Painter *(New York: D. Appleton, 1861).*

Icebergs! Icebergs!—The cry brought us upon deck at sunrise. There they were, two of them, a large one and a smaller: the latter pitched upon the dark and misty desert of the sea like an Arab's tent; and the larger like a domed mosque in marble of a greenish white. The vaporous atmosphere veiled its sharp outlines, and gave it a softened, dreamy and mysterious character.

Distant and dim, it was yet very grand and impressive. Enthroned on the deep in lonely majesty, the dread of mariners, and the wonder of the traveller, it was one of those imperial creations of nature that awaken powerful emotions, and illumine the imagination. Wonderful structure! Fashioned by those fingers that wrought the fluttering fabrics of the upper deep, and launched upon adamantine ways into Arctic seas, how beautiful, how strong and terrible! A glacier slipped into the ocean, and henceforth a wandering cape, a restless headland, a revolving island, to compromise the security of the world's broad highway. No chart, no sounding, no knowledge of latitude avails to fix thy whereabout, thou roving Ishmael of the sea. No look-out, and no friendly hail or authoritative warning can cope with thy secrecy or thy silence. Mist and darkness are thy work-day raiment. Though the watchman lay his ear to the water, he may not hear thy coming footsteps.

We gazed at the great ark of nature's building with steady, silent eyes. Motionless and solemn as a tomb, it seemed to look back over the waves as we sped forward into its grand presence. The captain changed the course of the steamer a few points so as to pass it as closely as possible. C—— was quietly making preparation to sketch it. The interest was momentarily increasing. We were on our way to hunt icebergs, and had unexpectedly come on with the game. We fancied it was growing colder, and felt delighted at the chilly air, as if it had been so much breath fresh from the living ice. To our regret, I may say, to our grief, the fog suddenly closed the view. No drop-curtain could have shut out the spectacle more quickly and more completely. The steamer was at once put on her true course, and the icebergs were left to pursue their solitary way along the misty Atlantic . . .

To the north and east, the ocean, dark and sparkling, was, by the magic action of the wind, entirely clear of fog; and there, about two miles distant, stood revealed the iceberg in all its cold and solitary glory. It was of a greenish white, and of the Greek-temple form, seeming to be over a hundred feet high. We gazed some minutes with silent delight on the splendid and impressive object, and then hastened down to the boat, and pulled away with all speed to reach it, if possible, before the fog should cover it again, and in time for C—— to paint it. The moderation of the oarsmen and the slowness of our progress were quite provoking. I watched the sun, the distant fog, the wind and waves, the increasing motion of the boat, and the seemingly retreating berg. A good half-hour's toil had carried us into broad waters, and yet, to all appearance, very little nearer. The wind was freshening from the south, the sea was rising, thin mists—a species of scout from the main body of fog lying off in the east—were scudding across our track. James Goss, our captain, threw out a hint of a little difficulty in getting back. But Yankee energy was indomitable: C—— quietly arranged his painting-apparatus; and I, wrapped in my cloak more snugly, crept out forward on the little deck,—a sort of look-out. To be honest, I began to wish ourselves on our way back, as the black, angry-looking swells chased us up, and flung the foam upon the bow and stern. All at once, huge squadrons of fog swept in, and swamped the whole of us, boat and berg, in their thin, white obscurity. For a moment we thought ourselves foiled again. But still the word was On! And on they pulled, the hard-handed fishermen, now flushed and moist with rowing. Again the ice was visible, but dimly, in his misty drapery. There was no time to be lost. Now, or not at all. And so C—— began. For half an hour, pausing occasionally for passing flocks of fog, he plied the brush with a rapidity not usual, and under disadvantages that would have mastered a less experienced hand.

We were getting close down upon the berg, and in fearfully rough water. In their curiosity to catch glimpses of the advancing sketch, the men pulled with little regularity, and trimmed the boat very badly. We were rolling frightfully to a landsman. C—— begged of them to keep

their seats, and hold the barge just there as near as possible. To amuse them, I passed an opera-glass around among them, with which they examined the iceberg and the coast. They turned out to be excellent good fellows, and entered into the spirit of the thing in a way that pleased us. I am sure they would have held on willingly till dark, if C—— had only said the word, so much interest did they feel in the attempt to paint the "island-of-ice." The hope was to linger about it until sunset, for its colors, lights and shadows. That, however, was suddenly extinguished. Heavy fog came on, and we retreated, not with the satisfaction of a conquest, nor with the disappointment of a defeat, but cheered with the hope of complete success, perhaps the next day, when C—— thought that we could return upon our game in a little steamer, and so secure it beyond the possibility of escape.

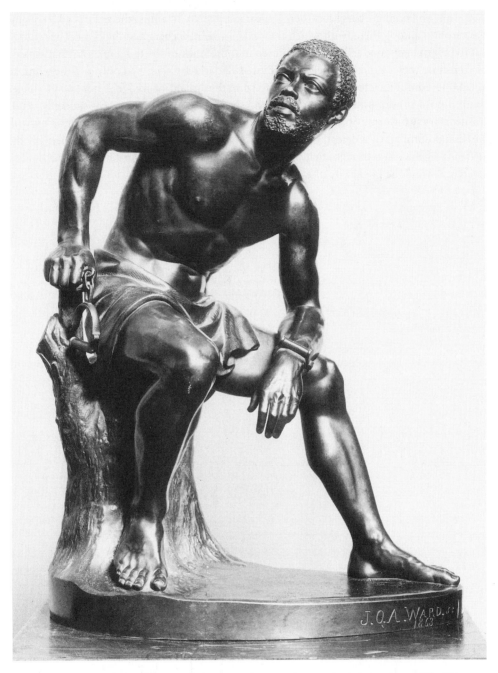

Fig. 7. John Quincy Adams Ward, *The Freedman*, 1863, bronze. The Detroit Institute of Arts, Gift of Mr. Ernest Kanzler. Photograph © 1996 The Detroit Institute of Arts.

7 THE 1860s

TAKING STOCK

THE PHOTOGRAPH AND THE FACE

By the 1860s, the photographic revolution had gone through several phases, from the stiff daguerreotype (see "Responses to the Daguerreotype," chapter 5), to the cheap tintype, to the finely detailed albumen print, available in innumerable multiples thanks to its wet collodion glass negative. Such changes prompted reflection about the new ubiquity of the human face and the evolving mores surrounding its exchange in domestic and public life (albums, advertisements, cartes de visite). Using his characteristic colorful and precise language, author Oliver Wendell Holmes marvels at the new way photography chronicles and preserves our visions and memories of loved ones (see also "Oliver Wendell Holmes on Stereographs," chapter 5, and "Photographs of Antietam," this chapter). On the other hand, popular columnist "Fanny Fern" (Sara Willis Parton) exhibits mock horror at the ease with which people's likenesses now fall before the eyes of strangers, and she looks back with nostalgia to a time of greater privacy and modesty. In the longer and more reflective "My Photograph," the author ("R.H.E") also invokes the quaint era of the cut-out silhouette and miniature portrait but with less of a feeling of regret or censure. Instead, the essay examines the modern act of sitting for a portrait, the nagging feeling of vanity that results, the widespread availability of photographs, and, interestingly, the future life of such images after they have passed from the hands of those for whom they were intended. The essay ends poignantly, by considering the relationship of death and photography—in the strange continuing presence of her dead child in a photograph and in the affecting daguerreotype keepsake of a Civil War soldier killed in battle.

Oliver Wendell Holmes, "Sun-Painting and Sun-Sculpture," Atlantic Monthly 8 *(July 1861).*

We are now flaying our friends and submitting to be flayed ourselves, every few years or months or days, by the aid of the trenchant sunbeam which performed the process for Marsyas.[1] All

[1] Marsyas is the mythical satyr skinned alive by Apollo.

the world has to submit to it,—kings and queens with the rest. The monuments of Art and the face of Nature herself are treated in the same way. We lift an impalpable scale from the surface of the Pyramids. We slip off from the dome of St. Peter's that other imponderable dome which fitted it so closely that it betrays every scratch on the original. We skim off a thin, dry cuticle from the rapids of Niagara, and lay it on our unmoistened paper without breaking a bubble or losing a speck of foam. We steal a landscape from its lawful owners, and defy the charge of dishonesty. We skin the flints by the wayside, and nobody accuses us of meanness.

These miracles are being worked all around us so easily and so cheaply that most people have ceased to think of them as marvels. There is a photographer established in every considerable village,—nay, one may not unfrequently see a photographic *ambulance* standing at the wayside upon some vacant lot where it can squat unchallenged in the midst of burdock and plantain and apple-Peru, or making a long halt in the middle of a common by special permission of the "Selectmen."

We must not forget the inestimable preciousness of the new Promethean gifts because they have become familiar. Think first of the privilege we all possess now of preserving the lineaments and looks of those dear to us.

"Blest be the art which can immortalize,"

said Cowper. But remember how few painted portraits really give their subjects. Recollect those wandering Thugs of Art whose murderous doings with the brush used frequently to involve whole families; who passed from one country tavern to another, eating and painting their way,— feeding a week upon the landlord, another week upon the landlady, and two or three days apiece upon the children; as the walls of those hospitable edifices too frequently testify even to the present day. Then see what faithful memorials of those whom we love and would remember are put into our hands by the new art, with the most trifling expenditure of time and money.

This new art is old enough already to have given us the portraits of infants who are now growing into adolescence. By-and-by it will show every aspect of life in the same individual, from the earliest week to the last year of senility. We are beginning to see what it will reveal. Children grow into beauty and out of it. The first line in the forehead, the first streak in the hair are chronicled without malice, but without extenuation. The footprints of thought, of passion, of purpose are all treasured in these fossilized shadows. Family-traits show themselves in early infancy, die out, and reappear. Flitting moods which have escaped one pencil of sunbeams are caught by another. Each new picture gives us a new aspect of our friend; we find he had not one face, but many.

It is hardly too much to say, that those whom we love no longer leave us in dying, as they did of old. They remain with us just as they appeared in life; they look down upon us from our walls; they lie upon our tables; they rest upon our bosoms; nay, if we will, we may wear their portraits, like signet-rings, upon our fingers. Our own eyes lose the images pictured on them. Parents sometimes forget the faces of their own children in a separation of a year or two. But the unfading artificial retina which has looked upon them retains their impress, and a fresh sunbeam lays this on the living nerve as if it were radiated from the breathing shape. How these shadows last, and how their originals fade away!

Fanny Fern [Sara Willis Parton], "Then and Now," New York Ledger, April 5, 1862.

There *was* a time when the presentation of one's "likeness" meant something. It was a sacred thing, exchanged only between lovers or married people, kept carefully from unsympathizing

eyes, gazed at in private as a treasure apart. But we have changed all that now. People like their faces to hang out at street doors, and in galleries, to lie on everybody's and anybody's table in albums, and to be hawked about promiscuously and vulgarly like a fashion print, or a specimen of sea-weed, or a stuck insect, for the gaze of the curious. Anybody *now* who acknowledges to any sentiment on the subject, or has an old-fashioned fastidiousness about being made as common as a street lamp-post, is gazed at with round-eyed wonder. I have actually heard women express *pleasure* at being paraded in these public show-cases. Fancy an *old-fashioned* lover endorsing such desecration of his Laura's sacred picture! Fancy him carrying round his *own* picture in his pocket, to be offered to Tom, Dick and Harry, like a business card or a concert ticket!

R.H.E., "My Photograph," Godey's Lady's Book and Magazine *74 (April 1867).*

One of the truest profiles I ever saw was cut fifty years ago, out of the back of an old letter, but it was by wit, not hit, for genius held the scissors. Itinerant artists once did a thriving business in this line, caricaturing simple souls without mercy. They were funny little miniatures, all wearing a homogeneous stamp, showily and shabbily put together with a broad margin of brass, and easily resolved into black and white elements by the pulling out of a brad or two. We laugh at the spiritless things, and our children despoil them, but our grandfathers and grandmothers paraded them with an innocent pride. What strides art has taken since then! Libelled nature has rebelled against these pen-and-ink impositions, and the elements themselves have come to the rescue. The making of fine portraits is not now peculiar to genius, nor their possession to the purses of the rich. The humblest chambermaid can to-day send to her lover as true a likeness as a duchess can have at her bidding. What if it be not so pretentious and flattering; what if it shall fade rather than mellow by time; it will be more true to nature and less to sentiment, and shall answer far better the present purpose of setting a homely face before a homely heart. Patrick will not look upon it with the eye of a dreamer or an artist, but of a lover. If Kathleen is honest, clean, and comely, he only asks that she look honest, clean, and comely in her picture. Photographs are the portraits of common life. Common life has little to do with ideality. Its faces give few hints to the artist, but nature helps cut out quickly their harsh and unsuggestive features.

How would one of those bygone dabblers with ink and scissors stare, could he be set down in a photographer's gallery of to-day! How his fingers would fairly tingle with shame for the sombre impositions which he had thrust upon our credulous ancestry! But we could not be over hard with him, for all present signs are of a still more progressive march in the daguerreotypal line. The artist, who now hands you a dozen cards, with a moderate bill and the calm assurance that the picture is not to be surpassed fifty years hence, would doubtless be glad to fib himself away from the imperfections of his work. Who thinks nowadays of sitting for a sleepy daguerreotype! Here and there this style of likeness is kept of a dead face, but more out of tenderness than justice to the memory of a friend. Already the more pretentious photograph is threatened by higher methods to come, and I know that my grandchildren will make mouths at my picture, which is now looked upon as a triumph of art.

Sitting for one's photograph is a shamefaced process. There is a sort of assumption in the act itself of the presentability of your earthly tabernacle. You would a little rather your best friends would not catch you about it. Your very desire to look at your best defeats your purpose. You find that you have practised attitudes and expression to no effect. "Not quite so sober," calls out the operator. As well might he enjoin composure upon a bashful school-girl. How can you

look otherwise than solemn at a nail, or a door-knob, or a blank patch of ceiling, with your head in a vice, your muscles twitching, and your eyes blinking from an overdose of sunshine? You are, moreover, borne down by the appalling uncertainties of the process; interloping of clouds, freaks of chemicals, mistakes in attitude, and the like. When you sit down to have a tooth extracted, you know that the first big pang will end the task; when you sit for your photograph, you feel that your success is evenly poised betwixt chance and persistency . . .

It is, after all, but a harmless subterfuge, this imposing upon the sight of those we love. I always have a feeling of shamefaced tenderness for the faded women, who exhibit to me the little paintings upon ivory, taken for their younger selves, but which never looked in the least like them. I do not feel wicked when I fib it and say, "You must have been very handsome once." The mental reservation, "if you looked like this," makes all right with conscience. I know that this bit of lying ivory will be more grateful to the pride of a coming generation than the truest likeness. I do not think there can be such a thing as a flattering photograph. You do not want to leave to your children the bare outlines of your mortal body; but rather the expression and spirit, which made your face to them more beautiful than any other face beside. It is not possible to invest it with any charms, which shall not seem real to a tender and grateful memory. What if it is toned down and softened, and made to look younger and more engaging than your own aging face? Nobody will be the wiser when you are out of sight; and those who love you, remembering some inspired moment when you looked just as lofty and noble to them, will come in time to think that you always looked so. Therefore, I take it as no disparagement to me or my picture when people say, "It is remarkably fine as a work of art;" "It is much better than So and So's, which does not flatter;" "I should know it was you, though," and twenty other things of the same sort. The artist and I understood each other. The photograph was not to be a correct likeness; but rather the embodiment of a sentiment, for the benefit of loving credulity. Looking forward into the uncertain years I see those to whom my memory as well as my picture is a lawful legacy, rating my body not with its real imperfections, but rather as shaped into comeliness by the soul's better thoughts and aspirations.

Where shall you hang your picture after it is done? Indeed, why shall you hang it at all? A fine oil painting asks for a good light in your best room; but more than modesty shrinks from a bold publication of your own likeness. It becomes a sort of vitalized thing to you, an emanation from your own being, and you rebel at making it a common gazing stock, as you shrink from the gregariousness of a common crowd. An excusable vanity spots the walls of our living rooms with the likenesses of our kinsfolk; but after all I question the propriety of the display. One's guests are regardless of their presence, and, we ourselves are apt to get tired of their expression of eternal benignity. Better bestow them upon some unused apartment, where they shall gain upon us by isolation, and be ready to surprise us into fresh recognitions of their worth and suggestiveness.

How narrow the circle, when reduced by true affinities, for which you really have your pictures taken! How lightly they pass out of the family, or rather the family passes away from them; how easily they are lost to association! Here and there painted faces, without story or tradition, but touched with the divine afflatus of genius, are gladly housed in high places. But a common portrait of a nameless and common face is seemingly a valueless thing. Not so to me—it has ever a pathetic interest for me. It becomes alive to me through sentiment. I weave a little history for it, and, after all, the stories of common life are the truest ones. The sitter for it never suspected that he had a common-place or stupid face. He looked upon it with delight when it was done, and passed it down to one of his own kind, whose affection covered it with a rare

and costly garnish. It was well hung and tended in its day and generation. When and how it got pushed out of keeping it is easy to conjecture. Prosperity and culture outgrew its style; death, marriage, and the varied circumstances of life marred association, tradition usurped certain knowledge, and interest faded out with relationship. Against such odds the tame picture of a tame face fell out by the way—just as yours and mine shall chance to fall out, if we make no investment for the pride of our descendants. Somehow it gives me a desolate feeling to think of having my faded picture trundled about some hundred years hence as worthless lumber, or being tolerated as a thing of habit, rather than affection, in some out-of-the-way corner. Perhaps saucy children will some day stick pins through my eyes, and scratch my cheeks, and nobody will be grieved or angered by it. Now my friends stand aside to catch them in good light and discuss their expression and force, as if they were freighted with messages of love to the remotest generation. After all, there is a fitness and naturalness in the rejection of your likeness, when it has ceased to be a link betwixt you and the memory of its owner. This precarious hold upon posterity is in the very nature of things a foregone necessity. This world is the sphere of your mortality, and you have no cause to complain if your own generation is faithful to you. You have at least the beautiful assurance that your children will be true to your semblance, as they were true to you by instinct. New marriage relations may banish your picture from parlor to garret, but a child's love shall be sure to find it out, and, brushing away the cobwebs, shall reinstate it in some loyal household. Why care then to outlive your day and pass, through outgrown gearing, into grotesque contiguities?

A baby's photograph, to all save doting parents and relations, is a stupid thing. An underyearling at best but crows and kicks its way into appreciation; agility and strength its chief attractions. Unfortunately these qualities are unpresentable by negatives, and plethora of flesh and a general aspect of milk-sappiness is all I could ever find in any baby's picture. Babyhood is practically a patience-trying, dreary condition. If it were not for the hope one has in the little darling, puling things, it would be intolerable. It is the exceedingly slow but sure dawning of intelligence which nurses a mother's patience, and warms her loving heart. The first look of recognition, the first word clumsily lisped are epochs of the primeval year, marking the child's redemption from a state of lower animalism into the rear rank of thinking humanity. One gets impatient for the fulfilment of augury or the crowning of desire, founded upon the hardly readable features of obese babyhood, and out of its inertness and heaviness is ever hunting for resemblances to those who have worthily wrought out their own lineaments of face and character. What value then in a picture which can portray to you only the utter stupidity of callow mortality, with no possible suggestiveness of what you hope or long for?

There is an unwelcome limner, however, who is able to forestall the future for you, and from nature's dim hints, one of the plastic and unformed features of infancy, give you a sharpened outline of what the face in mature life might have betokened. Death will give you a more worthy picture of your baby's face than any mortal artist can do. Sharpened by disease, its little rigid features shall stand out to you with a storied distinctness, so that you may read, as from an open page, your child's possible and probable character and bearing. You lose hold of its flesh and blood semblance in time; but the clear cut, marble face, invested with spirit and suggestiveness of fine capacities, by the stripping off of mortal vestments, stays with you with beautiful distinctness as long as you live.

I am sure that the triumph of a short-lived maternity was once found by me, as I looked upon the glorified features of my dead child. Through the many past years I bring that face back to me. I remember how my grief hushed in awe, when I beheld the blighted promise of high

nobility in his broad and beautiful brow, when I saw how much capacity for grace and dignity, all unknown to me, had been born into the little form. I had never been so proud of him before. Never so grandly had he folded his little hands, or carried his shoulders, or knit his lips together. There was no such character or meaning in his living attitudes; but death, as a heart offering, had composed him into a type of what time and culture would have made him had he lived into manhood. This picture, cut into my memory with agony, ennobles me, for it tells me that I was thought worthy to be intrusted with a child too rare for an earthly probation. I would not exchange it for the best work of mortal hands . . .

Once upon a time, waiting in the office of an army hospital, my eye caught a package lying upon a table amongst scores of others of the same sort. It was not worth much in dollars and cents; an old daguerreotype case, tied up with two or three soiled letters by a cord, the cord passing through a coarse finger-ring. It was simply inscribed with the name of a private, unknown soldier; not worth much, as I said, in solid currency, but of priceless value in some smitten household, and utterly redeemed to me by its beautiful suggestiveness. Whose picture was inside, how near its relationship to the dead owner, I know not. It was doubtless an ordinary face, more like that of the homely wife of a homely soldier, for the finger-ring betokened his humble origin. It was, however, fine enough to be kept with utter care by him, from whom it was going back sacred with the tragic history of his short-lived ownership.

A SUNNY VIEW OF AMERICAN PROGRESS IN ART

In contrast to the chorus of voices condemning this or that failure of American art during the 1860s, there were a few unabashed boosters among the critics. One of them penned this positive assessment of the progress of painting during the previous decade. The author lauds American landscapists in particular and ends with a roll call of artists in whom, it is suggested, readers may take pride. The Civil War is not directly mentioned here, but as the article appeared in the Continental Monthly *opposite a pro-Union poem, "Virginia," inspired by a painting by Jervis McEntee, the patriotic overtones of this support of the "native school" cannot be missed.*

"Visit to the National Academy of Design," Continental Monthly 3 *(June 1863).*

We remember many years ago passing directly from the gallery of Düsseldorf pictures, then recently opened in New York, to the hall of the National Academy. The contrast to a lover of his country was a painful one. The foreign school possessed ripeness of design, and accurate, if in many instances somewhat mannered and artificial execution. The native collection exhibited a poverty in conception, and a harshness and crudity in performance, sadly discouraging to one who would fain see the fine arts progress in equal measure with the more material elements of civilization. Since that time, however, year by year, the art of painting, at least, has steadily advanced, the light of genius has been granted to spring from our midst, our artists dwelling in foreign lands have returned to find a congenial atmosphere under their native skies, and, in so far as landscape is concerned, we have now no need to shun comparison with the best pictures produced abroad. Our school is an original one, for our artists have gone to the great teacher, Nature, who has shown them without stint the bright sun, luminous sky, pearly dawns, hazy middays, glowing sunsets, shimmering twilights, golden moons, rolling mists, fantastic clouds, wooded hills, snowcapped peaks, waving grain fields, primeval forests, tender spring foliage, gorgeous autumnal coloring, grand cataracts, leaping brooks, noble rivers, clear lakes,

bosky dells, lichen-covered crags, and varied seacoasts of this western continent. Here is no lack of diversity, here are studies in unity, both simple and complex, and here, too, even civilized man need not necessarily be unpicturesque; witness Launt Thompson's 'Trapper,' Rogers's bits of petrified history, or Eastman Johnson's vivid delineations of scenes familiar to us all. We have no reason to follow in any beaten, hackneyed track, but, within the needful restrictions of good sense, good taste, and the teachings of nature, may wander wherever the bent of our gifts may lead us. We may choose sensational subjects, striking contrasts, with Church, follow the exquisite traceries of shadow, of mountain top and fern-clad rock, with Bierstadt, learn the secrets of the innermost souls of the brute creation with Beard, revel in cool atmospheres and transparent waters with Kensett, paint in light with Gifford, in poetry with McEntee, or with Whittredge seek the tranquil regions of forest shade or quiet interior.

JAMES JACKSON JARVES'S *THE ART-IDEA*

James Jackson Jarves is an intellectual figure rife with contradiction. On the one hand he formed the greatest private collection of early Italian Renaissance painting in America; on the other he railed against "idolatrous" Catholicism and worried that it was infecting the dominant Protestant culture of the United States. One of the most important critics of American art at mid-century, he nevertheless passed much of his adult life outside the United States. These tensions are evident in The Art-Idea, *a somewhat philosophical book written during the worst years of the Civil War. Jarves's view of American achievement in the arts is bleak, and he finds the United States absolutely destitute of laudable antecedents in painting and sculpture, viable academies of art, and significant collections. In the passages included here, Jarves begins by lamenting the American tendency toward enthusiastic praise of commonplace "native" achievement; his own sharp commentary is offered as an implicit corrective. Looking to Europe, he asserts that modern French art, with its high standard of technique and its appeal to the people, offers the best model to Americans. He discusses several American artists, four of whom are featured here. For Jarves, Frederic Church and Albert Bierstadt represent the worst of the melodramatic, pandering landscape style of the 1850s, which he associates with a mob taste for "trash-literature" and panoramic painting. As an antidote, he advances the names of John La Farge and George Inness; his is one of the earliest appreciations of the more ruminative, tonal, and poetic qualities of their art. Jarves ends on an optimistic note, even suggesting that such tragedies as the New York Draft Riots of 1863 might become the raw material for an unflinching, modern school of American art.*

James Jackson Jarves, The Art-Idea *(New York: Hurd and Houghton, 1864).*

The ordinary productions of men who handle brush or chisel are spoken of in public prints as "works of consummate taste and ability," "perfect gems," proofs of "astonishing genius," and with similar puffery. These vague, swelling words would be received at their real value, did not so many of our people, just awakening to aesthetic sensations, have such a mistaken estimate of art. They view it as an undefined something above and apart from themselves and their daily lives, an Eleusinian mystery of a sacred priesthood, to be seen only through the veil of the imagination, not amenable to the laws of science or the results of experience, nor to be spoken of except in high-sounding phrases and wanton praise. Feeding artists on this diet is like cramming children with colored candies. Every true artist shrinks from it, and yearns for a remedy.

This will appear as soon as the public comprehend that it is as feasible to teach the young to draw, paint, and model, presupposing average intellectual faculties, as much else they are required to learn; and that the result would equal much that now passes for fine art. We can educate clever external artists as readily as clever artisans; a certain knack of hand, and development of taste and of the perceptive faculties being sufficient. When the public see this, they will cast aside their nonsense and mummery about art, and judge its mechanical qualities with the same intelligent freedom and decision that they do the manual arts with which they are acquainted. In fact, design and the science of color should be made an elementary branch of instruction in our system of common education, precisely as we are now training the ear to music, and the muscles to strength and suppleness. Genius is not essential to mere painting and modelling, certainly not to a knowledge of principles, and a respectable degree of skill or dexterity in their manifestation. These qualities can be acquired by study and application. Genius is the exception, talent the rule, of art and literature. It is as fatal an error to postpone the acquisition of knowledge, or the development of a faculty, from the want of genius, as to fancy that genius exists because we have a facility of doing certain things. Unless we conform our language to truth, we shall lose sight of the right distinction of words. An artisan who makes a good coat is more useful and respectable than a painter who makes bad pictures. Even a child would laugh at the absurdity of calling "dime-novels" or "Rollo story-books" works of astonishing genius, or of applying to them any of the hyperbolical expressions of admiration which are so lavishly showered by excited friendship or an indiscriminating press upon almost every effort of an American artist . . .

It is the French school that mainly determines the character of our growing art. In some respects New York is only an outgrowth of Paris. Every year witnesses a marked increase of the influence of the metropolis of France in matters of art, taste, and fashion, on the metropolitan city of America. So powerful, indeed, is its influence in Europe, that the hope of the English school now lies in the example and teaching of its rival. Exhibitions and sales of fine specimens of the French school have already vastly benefited us. Owing to the concentration of our most promising artists at New York, it has grown to be the representative city of America in art, and indeed for the present so overshadows all others that we should be justified in speaking of American painting, in its present stage, as the New York school, in the same light that the school of Paris represents the art of France. This predominance is more likely to increase than decrease, owing to growing professional facilities and the encouragement derived from a lavish patronage. It is particularly fortunate for the American school that it must compete at its own door with the French. The qualities of French art are those most needed here, in a technical point of view, while its motives and character generally are congenial to our tastes and ideas. The Dusseldorf was an accidental importation. That of Paris is drawn naturally to us by the growth of our own. Were the French school what it was under the Bourbons, or the Empire even, conventional, pseudo-classical, sensual, and sentimental, deeply impregnated with the vices of a debauched aristocracy and revolutionary fanaticism, we should have been less inclined towards it than to any other. But it crosses the Atlantic refined, regenerated, and expanded by the force of modern democratic and social ideas. The art of France is no longer one of the church or aristocracy. It is fast rooting itself in the hearts and heads of the people, with nature as its teacher. The primary tendency of what may be called the democratic art-instinct, as distinguished from that founded on the ideas of an aristocracy of blood, is to materialistic expression. This, in turn, gravitates toward the animal, sensational, and common, from a disposition to please the masses. In no democratic community, as yet, have they been elevated in æsthetic refinement and taste

to the standard of the aristocratic sentiment. That they may and will be, we devoutly believe. To this end, we cannot watch too closely the training of our youthful school . . . If our art relied solely on its own intuitive popular instincts for its development, its inclination would be too much toward the low and common, or purely external, as we see in those artists who are averse to studying foreign examples. Their proclivities naturally return towards their source, in the vast underlying materialism of the present stage of our civilization. France holds a check over democratic vulgarity which we lack. This exists in the standards of refinement, elegance, and finish, the perfection of styles and details as fine art, which an aristocracy accumulates as evidence of its intrinsic superiority of position and education. We have the reflected influence of this in the works and pupils of the French school. Without this living, refining element, destitute as we are of museums and galleries of classical and mediæval art, our progress would not merely be less rapid, but would be mainly in a direction not the most desirable . . .

The prophecy of a great colorist and a profound artist of deep religious feeling, of a tone inclining to spiritual melancholy, and of a rare and peculiar sensibility, intensified, perhaps, by influences outside of art, strictly speaking, is rapidly unfolding in La Farge. Of a wealthy New York family, La Farge goes to art with earnest devotion and an ambition for its highest walks, bringing to the American school depth of feeling, subtilty of perception, and a magnificent tone of coloring, united to a fervid imagination which bestows upon the humblest object a portion of his inmost life. These qualities are rare and remarkable anywhere, but particularly so in America. He evokes the essences of things, draws out their soul-life, endowing them with an almost superhuman consciousness. The solemn splendor and interpenetrative power of his free, unconventional manner, with its spiritual suggestiveness of hues, seize upon the imagination and bind it firmly to his art, through sentiments that act more directly upon the heart than the head. His forms are massed and hinted in an effective manner, instead of being sharply outlined and elaborated as is the art of the realists. But La Farge's, although devoid of much that the Pre-Raphaelites insist on as the exact, rigid truth of nature, as seen with microscopic eye, is truer to the consciousness of his topics in the whole. His landscapes are gems of imaginative suggestion and delicate, vital treatment, not pantheistic in sentiment, although the soul of nature breathes in them. They interpret nature to us as sentient, sensible, not sensuous, but spiritually beautiful,—the Christian idea of one God manifest in the universe, contrasted with the Pagan invention of gods many. He takes up the spirit of the landscape where Turner left off, and infuses it with a wonderful vital quality, making it a living thing akin to man, or uniting it and the spectator into one common sentiment of childhood to the Father, bestowing upon it human moods of inspirational fervor and intenseness, such as we have seen in no other American artist. This treatment is as remote from the Greek idea on the one hand, as it is from the ascetic, spiritual conception of the mediævalists on the other. It is a fresh truth given to landscape art, and, if perfected, destined to win for it a holy distinction, and endearment in human hearts.

A flower of his has no botanic talk or display of dry learning, but is burning with love, beauty, and sympathy, an earnest gift of the Creator, fragrant and flexible, bowed in tender sweetness and uplifted in stately pride, a flower whose seed comes from Eden, and which has not yet learned worldly ways and deformities. Out of the depth and completeness of his art-thought, by a few daring, luminous sweeps of his brush he creates the universal flower, the type of its highest possibilities of beauty and meaning, using color not as fact, but as moods of feeling and imagination, having the force of passion without its taint . . .

The thoroughly American branch of painting, based upon the facts and tastes of the coun-

try and people, is the landscape. It surpasses all others in popular favor, and may be said to have reached the dignity of a distinct school. Almost everybody whose ambition leads him to the brush essays landscape. To such an extent is literalness carried, that the majority of works are quite divested of human association. "No admittance" for the spirit of man is written all over them. Like the Ancient Mariner's "painted ship upon a painted ocean," they both pall and appall the senses. Their barrenness of thought and feeling become inexpressibly wearisome after the first shock of rude or bewildering surprise at overstrained atmospherical effects, monotonous in motive, however dramatically varied in execution. The highest aim of the greater number of the landscapists seemingly is intense gradations of skies and violent contrasts of positive color. The result is destructive of any suggestion of the variety and mystery of nature. We get coarse paintings, pitched on a wrong key of light or color, hastily got up for a market, and sold by scores, often all by one hand, at cheap auction-sales. The more common features of nature are so easily given on canvas as they appear to the undiscerning eye that the public is deluged with a sort of trash-literature of the brush, which ought to be consigned to oblivion so far as it attempts to pass itself off for true art.

Furthermore, we are undergoing a virulent epidemic of sunsets. Despite that one of our transcendental painters says there can be no great work without the three fundamental qualities of "rest, repose, and tranquillity," our bias is rather in the direction of exaggerated action and effects. In accordance with his scale of definition, he might have added three others much in vogue, namely, "bigness, greatness, largeness," culminating in what an artist wittily calls full-length landscapes. To be added to these foibles are slipshod work, repetition, impatient execution, and an undue self-estimate, arising from want of competitive comparison with better-instructed men. Numbers of pictures seem painted for no other purpose than to display the painter's autograph. We have noticed this even in portraits, the artist's name being more conspicuous than the sitter's features. Thus much for the weaknesses of our landscape art. Now for its strong points.

Church leads or misleads the way, according as the taste prefers the idealistic or realistic plane of art. Certain is it that Church has achieved a great popular success in his tropical scenery, icebergs, and Niagaras,—success which brings him orders for pictures as fast as he can produce them, at prices heretofore fabulous in his branch of art. Dr. Johnson says he who writes otherwise than for money is a fool. For "writes" read "paints," and we get a primary motive-power for any school of artists. Not that true artistic ambition does not here exist, but a sudden success, measured by pecuniary gain and sensational effect, is not the most wholesome stimulant for youthful art.

No one, hereafter, may be expected to excel Church in the brilliant qualities of his style. Who can rival his wonderful memory of details, vivid perception of color, quick, sparkling, though monotonous touch, and iridescent effects, dexterous manipulation, magical jugglery of tint and composition, picturesque arrangements of material facts, and general cleverness? With him color is an Arabian Nights' Entertainment, a pyrotechnic display, brilliantly enchanting on first view, but leaving no permanent satisfaction to the mind, as all things fail to do which delight more in astonishing than instructing. Church's pictures have no reserved power of suggestion, but expend their force in *coup-de-main* effects. Hence it is that spectators are so loud in their exclamations of delight. Felicitous and novel in composition, lively in details, experimentive, reflecting in his pictures many of the qualities of the American mind, notwithstanding a certain falseness of character, Church will long continue the favorite with a large class.

But a competitor for the popular favor in the same direction has appeared in Bierstadt. He has selected the Rocky Mountains and Western prairies for his artistic field . . . Bierstadt uses

the landscape also to illustrate Indian life. His figures are picturesquely grouped, prosaically true to actual life, giving additional interest to most observers, though rendering his great work, the Rocky Mountains, confused, and detracting from its principal features, beside making it liable to the artistic objection of two pictures in one, from different points of view. We form our estimate of him from this picture. It is to be welcomed, because it recalls one from the delusive enchantments of the Church style to a more strictly scientific expression of nature . . .

The prominent characteristics of the American landscape school are its realism, vigor, enterprise, and freshness. Partaking of the spirit of our people, it is dexterous, quick to seize upon new points, intellectual, and mechanical, viewing nature rarely in other than external and picturesque aspects, and little given to poetry or ideas. Aspiring to the natural only in motive, it looks as earnestly to the practical in result. If it be deceptive, it is so only as trade is, from ambition of success and fervor of competition. Partaking of the enterprise of commerce, it sends its sons to Brazil, to the Amazon, to the Andes, beyond the Rocky Mountains; it orders them in pursuit of icebergs off frozen Labrador; it pauses at no difficulties, distance, expense, or hardship in its search of the new and striking. The speculating blood infuses itself into art. Within proper limits, the zest of gain is healthful; but if pushed to excess, it will reduce art to the level of trade.

But landscape does not wholly go in this direction. Inness is a representative man of an altogether different aspect. He influences art strongly in its imaginative qualities and feeling; impersonating in his compositions his own mental conditions, at times with a poetical fervor and depth of thought that rises to the height of genius, and at others with a chaotic wildness and disregard of law or fact, though never without a disclosure of original power, that causes one to pause before deciding upon his final position. Wildly unequal and eccentric as he is, recklessly experimentive, indulging in sameness of ideas, often destroying good work by bad, lawless in manner, using pigments sometimes as though they were mortar and he a plasterer, still there is ever perceptible in his works imagination, feeling, and technical instinct of a high order, which need only the balancing power of experience and a steady will to raise their possessor to the rank of a master . . . At times his skies are tough, woolly, and opaque, from carelessness of brush in details, while infusing the whole with vital life and action. His trees sway; his leaves play in the breeze; his clouds lower and are rainladen; water sparkles and ripples in limpid, rhythmic joy; vegetation has the qualities of tender growth; the earth has a sense of maternity; mountains, hills, and meadows, sunlight and shadow, all gleam with conscious existence, so that, unlike the generality of our landscape art, his does not hint a picture so much as a living realization of the affluence of nature. Inness gives with equal facility the drowsy heat, hot shimmer, and languid quiet of a summer's noon, or the storm-weighed atmosphere, its dark masses of vapor, and the wild gathering of thunderclouds, with their solemn hush before the tempest breaks. He uses sunlight sparingly, but it glows on his canvas, and turns darkness into hope and joy. His is, however, a stormy nature, pantheistic in feeling with a naturalistic expression, brooding over the changeful scenes of earth, rejoicing in the gorgeous mysteries or wild mournfulness of glowering sunsets, or clouds radiant with rainbow-promise of final peace. There is nothing of terror or the grotesque in his imagination. It speaks rather of the mourner who faints and hopes. This overflow of sadness is almost epic in expression, and is heightened by his intense idealism of color . . .

The spirit of his landscapes alone is American. Their tone is not Venetian, nor wholly French, but partakes of that fervid warmth with which we love to invest the heart's creations. Gold and purple, intense greens, crimsons, hues that melt and harmonize into liquid warmth, vigor, dar-

ing, intensity, poetry, a passionate delectation in nature, as if he were born of her untutored, irrepressible emotions: such are his characteristics, varied with startling inequalities and wantonness of brush, making Inness the Byron of our landscapists . . .

The radical difference between the antagonistic styles of these masters will be felt at once. However much our admiration is captivated for a season by the dramatic spectacular touch of Church and his gem-like, flaming brilliancy of color, or the broader, less artificial, colder tinting of Bierstadt, the rich harmony of Inness and attendant depth of feeling, with his perfect rendering of the local idea of the City of the Cæsars, seize fast hold of the imagination, and put the spectator on his feet in the very heart of the scene. He becomes an integral part of the landscape. In the other paintings he is a mere looker-on, who, after the surprise of novelty is gone, coolly or impatiently criticises the view. The countryman that mistook the Rocky Mountains for a panorama, and after waiting awhile asked when *the thing was going to move*, was a more sagacious critic than he knew himself to be. All this quality of painting is more or less panoramic, from being so material in its artistic features as always to keep the spectator at a distance. He never can forget his point of view, and that he is looking at a painting. Nor is the painter himself ever out of mind. The evidences of scenic dexterity and signs of his labor-trail are too obvious for that; indeed, with too many the value attached to his work is in the ratio of their display. But the effect of high art is to sink the artist and spectator alike into the scene. It becomes the real, and, in that sense, true realistic art, because it realizes to the mind the essential truths of what it pictorially discloses to the eye. The spectator is no longer a looker-on, as in the other style, but an inhabitant of the landscape. His highest faculties are stimulated to action, using the external senses as servants, not masters. He enjoys it with the right of ownership by the divine seisin of kindred thought and desire, not as a stranger who for a fee is permitted to look at what he is by its very nature debarred from entering upon and possessing . . .

Now, American art, though in intellectual knowledge and technical ability so greatly behind it, has actually given hints of ideas, in Story's Sibyl and Ward's Freedman, that belong to and express thoughts of the living nineteenth century. Imperialism in France will not permit art to become the language of social and political hopes and aspirations. But there is no reason why the art of democratic America shall not. What lessons might not be taught out of the demoniac passions that give birth to New York riots, if their true origin, spirit, and intent were exhibited realistically or symbolically. What, also, of the wider view of the duties of humanity which is coming to the surface of men's consciences in the present struggle of the powers of light against the powers of darkness! But, setting aside lofty motives, we have better promise of a genuine, original school of color than any other nation. On looking at Allston, Babcock, Hunt, La Farge, Inness, and Vedder, it really seems as if the mantle of Venice had fallen upon America, and the far-off New World was about to revive the departed glories of the Old. Possessing the burning language of poets and prophets, we await their full prophetic utterance.

No nation can turn to a more heroic or grander record of sacrifice, suffering, and triumph. We are now passing through the transition period of unformed youth, with its raw impulses, weak compromises, and hasty decisions, into the fuller wisdom of ripe manhood, tried by an ordeal of the greatest civil war the earth has ever seen, and for the greatest ideas and largest liberty to the human race. Ours is the victory for all humanity. Out of this war for equality, exaltation, and unity of peoples, must spring up a school of art of corresponding nobleness. The people's Future is its field. A great work is before it. Little is done,—nothing, compared to what there is to do. But slight as is the showing of our art in a national sense, it still precedes the popular taste. Art awaits a valid public opinion to inspire it, and to be amenable to. The common

taste rests upon the level of materialistic landscape. It is just expanding into a liking for dead game and ordinary *genre* subjects. To it, the sublime, impassioned, or spiritual, is an unknown tongue. It has not even learned the true definition of art, much less comprehended its entire spirit and purpose. There is a crude liking of prettiness, mistaken for beauty, but no deep conviction of our æsthetic poverty, still less any such fixed faith in art as we have in science. Art itself has not grown into a faith. It aspires overmuch to dollars and praise. Although leading public taste, it stoops to it. Knowing the right, it hints at better things, but hesitates to do them. It wants backbone; has no lofty conception and belief in its own future. But, full of young blood, the dawn of its morning twilight tinges the horizon with far-off golden light.

HENRY T. TUCKERMAN'S *BOOK OF THE ARTISTS*

Henry Theodore Tuckerman, a prolific writer, published in the fields of poetry, biography, criticism, history, and travel literature. Born in Boston in 1813, Tuckerman came to New York City in 1845, having earlier made a formative trip to Italy. A friend of American artists and a collector of their work, he took a studio in the celebrated Tenth Street Building in Manhattan. Tuckerman wrote several sympathetic volumes of biographical appreciations of artists, notably his important Book of the Artists. *In the following passages from the introduction to that publication, he gives a wide-ranging account of the progress of American art at mid-century. Unlike his gloomier colleague, James Jackson Jarves, Tuckerman is largely upbeat, even if he finds private and institutional support of artists to be lacking (see also "The National Landscape in Repose: John Frederick Kensett," chapter 4).*

Henry T. Tuckerman, Book of the Artists *(New York: G. P. Putnam and Son, 1867).*

New York is nobly supplied with Hospitals and Libraries, but she lacks one Institution essential to a great civilized metropolis,—a permanent free Gallery of Art. There is no safe and eligible place of deposit and exhibition for pictures and statuary. The many valuable works that formed the City Gallery, and were once gathered in the Park, long mouldered in a cellar; among them were the masterpieces of Vanderlyn and Cole. A few years ago, an enterprising merchant offered to place a large collection of pictures, by the old masters, in any secure edifice, for the benefit of the public; but neither public munificence nor private enterprise would furnish the requisite shelter for these artistic exotics, and they now repose in the obscurity of lumber-rooms. Mr. J. J. Jarves brought a chronological selection of "old masters" from Italy, and sought a permanent home for them here in vain. Our native artists, toiling in their scattered *ateliers,* have no appropriate medium whereby their labors can be known to the public. It is not the custom here, as in Europe, for strangers to visit studios uninvited; accordingly, our artists, when they have a new picture to dispose of, send it to a fashionable print-shop, and pay an exorbitant commission in case of sale.

The surprise and delight exhibited by the thousands of all degrees, who visited the Picture Gallery of the Metropolitan Fair, has suggested to many, for the first time, and renewed in other minds more emphatically, the need, desirableness, and practicability of a permanent and free Gallery of Art in our cities. The third metropolis of the civilized world should not longer be without such a benign provision for and promoter of high civilization. Within the last few years the advance of public taste and the increased recognition of art in this country, have been among the most interesting phenomena of the times. A score of eminent and original landscape painters

have achieved the highest reputations; private collections of pictures have become a new social attraction; exhibitions of works of art have grown lucrative and popular; buildings expressly for studios have been erected; sales of pictures by auction have produced unprecedented sums of money; art-shops are a delectable feature of Broadway; artist-receptions are favorite reunions of the winter; and a splendid edifice has been completed devoted to the Academy, and owing its erection to public munificence,—while a School of Design is in successful operation at the Cooper Institute. Nor is this all; at Rome, Paris, Florence, and Dusseldorf, as well as at Chicago, Albany, Buffalo, Philadelphia, Boston, and New York, there are native *ateliers,* schools, or collections, the fame whereof has raised our national character and enhanced our intellectual resources as a people. These and many other facts indicate, too plainly to be mistaken, that the time has come to establish permanent and standard galleries of art, on the most liberal scale, in our large cities. Heretofore the absence of fire-proof buildings has prevented many Americans of wealth and taste from contributing to such institutions as include the Fine Arts in their objects. Not long since a fire occurred in Boston, whereby several invaluable historical portraits were destroyed, and the risk of such catastrophes deters prudential lovers of artistic treasures from indulging at once their public spirit and private taste, by presenting works of art to such institutions as already exist. No sooner did the New York Historical Society possess a fire-proof edifice than valuable donations began there to accumulate; the Nineveh marbles, the Egyptian museum, the Audubon collections, portraits, statues, and relics, were gratefully confided to this secure and eligible institution. It was soon found inadequate as to space, and the late President, with some of the more enterprising members, obtained a charter from the Legislature for a museum of art and antiquities, to be erected in the Central Park, and open to the public, as are similar institutions in Europe. As a nucleus for the statuary department, the casts from CRAWFORD'S Roman studio are most appropriate and valuable; they are already stored in the old Arsenal . . .

To these auspicious indications of art-study, progress and taste, many others could be added, suggestive of the growing interest of the American public in the subject, and the more intelligent enterprise exercised in its behalf. We may cite, for instance, the free education, in elementary art, afforded by the benevolent founder of the Cooper Institute, in New York. Under the scientific training of Dr. Rimmer, and the effective co-operation of many ladies of the city, poor women acquire skill in wood-engraving so as to obtain an honorable subsistence thereby; others have developed superior capacity in plastic art, and become accomplished in drawing and designing. The careful anatomical instruction of Dr. Rimmer initiates a thorough system of art-knowledge and practice. Yale College has recently been endowed with an Art-fund, which will lead to pictorial exhibitions, a permanent gallery, and professional instruction. In Hartford, Connecticut, is a permanent art-exhibition, at the Wadsworth Gallery; in Brooklyn, Long Island, an active and prosperous art-association,—and in Boston a tasteful and efficient art-club; while, by the recent action of Congress, each State of the Union has been invited to fill certain niches or spaces in the old House of Representatives, in the Capitol, at Washington, with two statues, one of each of its most distinguished men, civil and military . . .

Constant, indeed, though irregular, has been the increase of means, appliances, resources, and recognition, in native Art. From annual metropolitan, we have advanced to frequent exhibitions in every part of the land,—those held within a few years at Providence, R.I.; Albany, Buffalo, Troy, and Utica, N.Y.; Chicago, Ill.; Baltimore, Md.; Washington, D.C.; Portland, Me.; Charleston, S.C.; New Haven, Ct., and elsewhere, having brought together a surprising display of superior achievement in Art, the result of native talent or tasteful purchases of old and new foreign works. Let us rejoice, also, that American Art has, at last, been recognized as a fact abroad.

A permanent group surrounded the "Greek Slave" at the Manchester Exhibition; Crawford's equestrian statue of Washington was the admiration of Munich; Leutze's departure from Düsseldorf is regretted as the loss of a leading spirit of its famous school; Allston's pictures are among the most cherished in the noble collections in England; Story's "Cleopatra," and the landscapes of Church, Cropsey, and others, have won high critical encomiums in London.

At the late Fine Art Exhibitions in Antwerp and Brussels, several landscapes by American painters attracted much attention. The American Minister at Belgium, Mr. Sandford, writes that an artist of Brussels, of much merit and celebrity, declared the works of our artists there exhibited to be among the most characteristic of the kind ever brought to that city, and that admiring crowds were gathered around them at all hours. Hubbard's "Afternoon in Autumn" was especially regarded with appreciation, and Rogers's statuette groups, derived from incidents of the war, also attracted great attention. At the Antwerp exhibition, one of Kensett's landscapes occupied the post of honor, and a noted picture-dealer of that city has made a proposal to the artist to paint exclusively for that market, offering large prices as inducements for so doing . . .

Within a few years past, American artists, especially painters, have, in many instances, been remunerated for their labor far beyond its actual market value, if we take European prices as a standard. One cause of this is the sudden prosperity of an imperfectly educated class, who, with little discrimination, and as a matter of fashion, devote a portion of their newly acquired riches to the purchase of pictures; and as our artists have of late established a certain social prestige, friendly influences are not wanting to secure their liberal patronage. In fact, the entire relation of Art to the public has changed within the last ten years: its products are a more familiar commodity; studio-buildings, artist-receptions, auction sales of special productions, the influence of the press, constant exhibitions, and the popularity of certain foreign and native painters, to say nothing of the multiplication of copies, the brisk trade in "old masters," the increase of travel securing a vast interchange of artistic products—these and many other circumstances have greatly increased the mercantile and social importance of Art . . .

Another obvious characteristic of our artists, as a body, and viewed in comparison with those of Europe, is the inequality of their productions. Abroad we are accustomed to recognize a different manner, as it is termed, in the works of painters, according to the epoch, from Raphael to Wilkie. Two classes of pictures, two kinds or degrees of style, identify different periods of the artistic career; but in America the variations of ability of merit in the results of individual art are unparalleled. We can sometimes hardly realize that the same hand is responsible for the various works attributed thereto, so wide is the interval between crudity and finish, expression and indifference, between the best and worst pictures: so many are experimental in their work, so few regularly progressive. The imperfect training, the pressure of necessity, the hurry and bustle of life, the absence of a just and firm critical influence, and a carelessness which scorns painstaking as a habit, and is only temporarily corrected by the intervention of some happy moment of inspiration and high encouragement—are among the manifest causes of this remarkable inequality. Incomplete endowment, and "devotion to the immediate," explain these incongruities of artist-life and practice in America . . .

It is evident that Art in America, as a social and æsthetic element, has formidable obstacles wherewith to contend; the spirit of trade often degrades its legitimate claims; its thrifty, but ungifted votaries thereby achieve a temporary and factitious success, while its conscientious and aspiring devotees often pine in neglect. The lottery system, under different forms, and the "tricks of trade," still further materialize what should be an artistic standard; criticism, so called, ranging from indiscriminate abuse to fulsome partiality, rarely yields instructive lessons; fash-

ion, ignorance, the necessity of subsistence, the absence of settled principles of judgment in the public, and of intelligent method, scope, and aim in the artist, tend still further to lower and confuse the pursuit. But on the other hand, charity and patriotism, perseverance and progress, self-respect and earnestness, continually vindicate the character and claims of American artists. Among them are some noble men and refined associates, whose influence and example are singularly benign; the war for the Union had no more disinterested volunteers, and the *Pro Patria* inscribed on the pictures they contributed to the Sanitary Fair was the watchword of their conduct in that perilous time. Very true to their intuitions and special faculty, also, are many of our artists, working on in modest self-reliance, undeterred by vulgar abuse, cold indifference, or the temptation to compromise honest conviction and the higher claims of an intellectual profession . . .

Here, in America, as we have seen, Art long struggled against the tide of thrift, political excitement, and social ambition. The tranquillity, the individuality, the pure and patient self-reliance and unworldliness, which is its native atmosphere, have been and are alien to the tone and temper of our national life. But, on this very account, is the ministry of Art more needful and precious; and with all the critical depreciation which strict justice may demand, we find, in the record and the observation of artist-life in America, its association and its influence, a singular balm and blessing. Consider it, for instance, as manifest in our great commercial centre and metropolis.

Reader, did you ever spring into an omnibus at the head of Wall street, with a resolution to seek a more humanizing element of life than the hard struggle for pecuniary triumphs? Did you ever come out of a Fifth avenue palace, your eyes wearied by a glare of bright and varied colors, your mind oppressed with a nightmare of upholstery, and your conscience reproachful on account of an hour's idle gossip? Did you ever walk up Broadway, soon after meridian, and look into the stony, haggard, or frivolous countenances of the throng, listen to the shouts of omnibus-drivers, mark the gaudy silks of bankrupts' wives, and lose yourself the while in a retrospective dream of country-life, or a sojourn in an old deserted city of Europe? A reaction such as this is certain, at times, to occur in the mood of the dweller in the kaleidoscope of New York; and as it is usually induced by an interval of leisure, we deem it a kindly hint to suggest where an antidote may be found for the bane, and how the imagination may be lured, at once, into a new sphere, and the heart refreshed by a less artificial and turbid phase of this mundane existence. Go and see the artists. They are scattered all over the metropolis: sometimes to be found in a lofty attic, at others in a hotel; here over a shop, there in a back-parlor; now in the old Dispensary, and again in the new University; in Studio Building or Academy, isolated or in small groups, they live in their own fashion, not a few practising rigid and ingenious economies; others nightly in *élite* circles or at sumptuous dinners; some genially cradled in a domestic nest, and others philosophically forlorn in bacheloric solitude. But wherever found, there is a certain atmosphere of content, of independence, and of originality in their domiciles. I confess that the ease, the frankness, the sense of humor and of beauty I often discover in these artistic nooks, puts me quite out of conceit of prescriptive formalities. Our systematic and prosaic life ignores, indeed, scenes like these; but the true artist is essentially the same everywhere—a child of nature, to whom "a thing of beauty is a joy forever;" and, therefore, a visit to the New York studios cannot fail to be suggestive and pleasing, if we only go thither, not in a critical, but in a sympathetic mood . . .

Our people do not lack insight, observation, perseverance; many of our young artists have a vein of perception or feeling which they long to express, and at the outset, they do express

it—crudely, perhaps, but sincerely; it is probably unrecognized; they hear skilful execution praised, they find mechanical adepts glorified, and so they turn aside from their own inspiration to follow the multitude; they conform, and seek money, and forget the dreams of youth; what was and is *naïve* and original in them is overlaid and baffled.

And yet our atmosphere of Freedom, of material activity, of freshness and prosperity, should animate the manly artist. He has a vantage-ground here unknown in the Old World, and should work confidently therein for the reason given by Agassiz[2] in regard to science—*the absence of routine.* Academic trammels, prescriptive patronage, the deference excited by great exemplars, do not here subdue the artist's aspirations, or make him despair of himself, or bewilder his ideal of excellence. However little our people know about Art, they are eminently *teachable.* Point out what is admirable or expressive in a picture, and they will perceive, remember, and draw wisdom from it. Let the American artist rise above the national drawbacks, the love of gain and the conformity to public opinion—let him use wisely the resources around him, and *be true to himself,* and he can achieve miracles . . .

Art, like everything else here, is in a transition state. A few years ago, upon entering the dwelling of a prosperous citizen, even in some isolated district or minor town, who boasted the refinements of an educated ancestry, we found a full-length portrait by Copley, stiff, gorgeous, handsome, but official in costume and aspect; or a vigorous old head by Stuart, full of character and magnificent in color; or one of those sweet, dignified little pastel profiles of Sharpless, wherein the moral dignity of our Revolutionary statesmen seems gently incarnated; now, in addition to these quaint relics, a landscape by Doughty, Cole, Kensett, Church, Bierstadt, or Durand, a *genre* piece by Eastman Johnson, a bust by Crawford, Powers, or Palmer, or a group by Rogers, some specimen of the modern continental schools, with a good copy of Raphael, Domenichino, or Guido—indicate a larger sympathy and a more versatile taste. In the cities, this increase of works of art as household ornaments is remarkable; a European amateur lately purchased in the United States old pictures to the value of thirty thousand dollars, to re-transport across the Atlantic; while many gems are scattered through the sumptuous abodes of wealth and fashion throughout the land, and in each metropolis a rare picture or new piece of native statuary is constantly exhibited, discussed by the press, and admired by the people. European travel, the writings of Art-commentators, clubs, and academies, the charming or tragic biographies of artists, lectures, more discrimination in architecture, a love of collecting standard engravings, the reciprocal influence in society of artists and amateurs, and their friendly coöperation; these, and such as these, are among the striking means and evidences of progressive intelligence and sympathy among us in regard to Art—her trophies, principles, and votaries . . .

The stereoscope is a familiar drawing-room pastime; Art-unions and picture-raffles, the *éclat* of a new or the purchase of an old painting, Art-criticism, Art-clubs, Art-journals, are no longer novelties. But while a superficial observer might infer from these "signs of the times" an auspicious future for Art in America, and while they undoubtedly evince a tendency in the right direction—when we consider that, justly regarded, this great means of culture and sphere of genius is positively degraded by mediocrity—that it is sacred to Beauty, Truth, and high significance, moral and intellectual, and, therefore, absolutely demands accuracy, harmony, power, grace, purity, expression, and individuality, as normal attributes; and remember how much more these are the exceptions than the rule—to what a complacent level, to what an ex-

[2] Louis Agassiz was a Swiss scientist and Harvard professor who disputed Darwin's theory of natural selection.

clusive mechanical facility and economical spirit, the feeling for, and practice of Art is often re-
duced among us—these indications of a superficial recognition of its claims must be taken with
allowance. The instinctive aptitude, the normal love, exist in abundance; but only occasionally
are they intensified into lofty achievement or elevated into a legitimate standard of taste. The
caricatures in "Punch," the rude "counterfeit presentment" of a popular statesman, the wooden
filigree of an anomalous villa, the coarsely "illustrated" paper, delineating an event or a per-
sonage about which the town is occupied; bank-bill vignettes, Ethiopian minstrels, and "the
portrait of a gentleman," form the staple Art-language for the masses; and, in all this, there is
little to kindle aspiration, to refine the judgment, or to hint the infinite possibilities of Art. We
have abundance of assiduous painters, who exhaust a town in a month in delineations of its
leading citizens, fill their purses, and inherit a crop of newspaper puffs; but give no "local in-
habitation or name" to any idea, principle, sentiment, or even rule of Art; we have abundance
of croaking artists, who dally with the pencil and moan over their poverty and neglected ge-
nius; there is no lack of prodigies of juvenile talent, who never realize the prophecies that hailed
their first attempts; and in every city may be found stationary devotees of the palette, who, partly
from indolence, partly from egotism, and not a little from discouragement, have settled down
into a mannerism in which there is no vitality, and, therefore, no progress . . .

But it is not alone a lack of enlightened public sympathy and extensive accesable resources
for self-culture, against which the artist contends in America. The history of Government pa-
tronage, thus far, shows a lamentable ignorance and presumption in dealing with Art as a na-
tional interest; only to a limited degree have men acquainted with the subject had a potential
voice in assigning commissions or regulating decorative work; contracts have been secured in
this, as in other departments, through local and personal influence, irrespective of capacity; in
more than one instance the higgling spirit of bargain, instead of the generous recognition of
just claims, artistic and native, has been disgracefully exhibited; men in power, wholly unversed
in Art, have gratuitously pronounced the most superficial judgments, and acted upon them to
the detriment of the highest interests of the people and of native talent; no single harmonized
plan or principle has governed the adornment or extension of the Capitol, which, therefore,
inevitably presents a most incongruous combination of good and bad effects, commonplace
and superior ornaments—architectural, statuesque, and pictorial—brought together in a
desultory, casual manner; and the achievements of as many different minds, schools, and de-
grees of capacity, as there are separate items in the record. Our representatives have manifested
no perception of what is due either to Art or to her genuine votaries; the former has been treated
without a particle of feeling for its unities, its intrinsic significance, and its national claims; and
the latter, like so many pedlers, expected to compete with their wares and be favored accord-
ing to their politics, diplomatic tact, local origin, or some other quality or circumstance apart
from the only test and criterion applicable in the premises—ability to execute a noble, patri-
otic trust, and produce an indisputable artistic work.

SCULPTURE IN MID-CENTURY AMERICA

*Mid-century assessments of the state of American art usually focused on the medium
of painting. Here, in contrast, the topic is contemporary sculpture and its inability to
speak to the people. The blame is laid at the feet of antiquity and all those who worship
at its Greco-Roman altars. The author looks hopefully to the future, in search of a more
realistic style and subject matter that is relevant to Americans in the second half of the*

nineteenth century. In fact, these qualities would be delivered by the next generation of sculptors, who moved from chilly Italian marble gods to more immediate portrait statues executed in bronze. Although the dichotomy between classicism and realism was never as cleanly drawn as it is in this essay, trends were definitely favoring the latter over the former.

"Sculpture in the United States," Atlantic Monthly 22 *(November 1868).*

Is there a first-class portrait-statue in the United States? Our plastic artists are famous men abroad, as well as here; they rank as high in Florence and Rome as those of any nation,—we are prone to think a trifle higher,—but can we properly call them American sculptors, or their works American works? Ward's fine statue of the Indian Hunter belongs to us, and a few other meritorious statues; the quaint little people of John Rogers are ours, and the productions of Clark Mills and Vinnie Ream; but may we claim the Lybian Sibyl, the Greek Slave, the Zenobia? The subjects of these are strange to the people, and the workmanship is foreign. American artists dwelling in Europe are in some degree denationalized. While in Rome they must do much as the Romans do, and they cannot respond fully to our needs and sympathies at home. Our best sculptors, devoted to what we call classic art, and loving the flesh-pots of Italy, which take the tempting shape of beautiful marble and excellent workmen, join themselves at last to their idols abroad, and come to care little for popular appreciation in America. Those who emigrate, attaining wider fame, seriously influence those who remain. Few of these are interested in our national art. Being persuaded that their work will be judged by a foreign or classic standard, they almost inevitably render foreign themes, as well as imitate foreign style; and surrounded by casts of the antique, and nothing else, the beginner is led to believe that he must produce something equal to the Quoit-thrower of Myron or the Apollo Belvedere. The absurdity of the attempt is concealed from him; he forgets that he has no faith in Apollo or any heathen, and that his own gods are remarkably different from those of Greece. Few students are able to perceive the ages of school that lie hidden in the masterpieces of Greek art. Without thorough anatomical knowledge and without anything like a fair opportunity to study the nude figure in action, the sculptor here often attempts to reproduce a kind of art which could develop only in the most favorable climate and under the auspices of a poetic religion. It is clear that this is labor thrown away. Nothing valuable to the American people comes of it. The work has already been thoroughly done; the best Greek modelling of the human figure is certainly well enough . . .

The nude figure in its antique grandeur being impossible to us, it is still more absurd to try to revive the empty drapery, and labor upon the folds of the extinct toga and tunic, clothing even the busts of private individuals with the robes of Roman senators or Greek philosophers. Yet the copying of the antique, nude and draped, is one of the principal means of teaching adopted by the modern schools, if they may be called schools, of sculpture. Study from life in this country is so limited that it must be considered as comparatively useless.

Such being the course chosen by nearly all our plastic artists, time and money are expended without worthy result. Among the increasing number of modellers in and for America, the earnest students, believing in the present, and working directly from nature, are far too few to develop the popular taste. Good judgment in the formative art, which would seem to be easily acquired, is almost unknown. There is little to serve as a basis. Perhaps the work of Crawford at Richmond and Washington is quite as much admired as any in the country; and it is not to be doubted that he was an artist of great energy, some invention, and skilful hand; but his statues, both portrait and ideal, sometimes overstep the modesty of nature in excess of action or

execution, and lose the dignity which belongs to any proper subject of sculpture, and in some sense to the material employed. One is forced to the conclusion that such work is not all sculpture, but is alloyed with acting . . .

If modern sculpture, by patient following of the antique, could attain its marvellous perfection in the representation of the human figure, could the art by such means hold a rank in our culture equal with that which it held in Greece? If subjects worthy of such vast science and nice handiwork cannot be found, the acquirement of this branch of technical power is useless. By repetition of antique subjects, sculpture cannot re-establish its proper relation to the people. Statues of the gods cannot inform the American mind, except through its sympathy with the ancient Greeks and their mythology,—a remote and vague influence. The masses regard such marbles as workmanship or ornamentation, and art is more than that. Something must be done to carry the mind beyond externals. Zeus was a vital force to the Greek, he is only a shadow to the American . . .

Those who desire the encouragement of classic art sometimes assume that it is folly for the artist to try to maintain a direct relation to the general public, which cannot appreciate fine art, and that he should model or paint only for those whose culture and taste fit them to be connoisseurs. Here a direct issue may be stated; for the realists, who also claim the best culture, believe that it is vain to model or paint for anybody else but the people. They say that if art is but the language of the learned, or the toy of the rich, it may as well die utterly, having become a useless luxury. History sustains this position. No really great art has existed, which did not in some degree reflect the inner life of the people; and no art can help us in America, unless it is based upon the sympathy and criticism of the public . . .

Happily, our artists are not often forced to decide between the support of their wise and wealthy patrons and that of the masses; but where such a choice becomes necessary, there can be little hesitation in the minds of those who respect their calling. To model or paint for a person of wealth is comfortable, and to be conscious of the sympathy of a few choice souls is very pleasant; but to model or paint for a nation raises the artist to his true place of a great teacher . . .

Take any good specimen of modern classic or Roman plastic art, by an American artist, and set it quietly in the Park at New York or Boston, without any advertising, and it will encounter very little criticism, and excite but the most transitory admiration. Give the full history of the subject in the public prints, and a biographical sketch of the sculptor, and it would attract much more attention; yet the influence of the figure upon popular thought would be inappreciable, and would lessen year by year. This is not the case with the humblest modelling from life of the patient and literal kind. If the subject is a public man, the public is immediately a sympathetic and a correct critic. It is the same if the subject is taken from our common life. The little groups by John Rogers, simplest realism as they are, and next to the lowest orders of true art, carry more significance than all the classic sculpture in the country, and will possess historic value which we cannot overestimate. Though the classicists and the realists are almost equally helpless in the great ebb of formative art,—the former in lack of anything to say, and the latter in lack of ability to say anything,—their positions relative to the future are different and opposing,— the realists enjoying possibilities . . .

While everything pertaining to sculpture is in its present chaotic state, any attempt to indicate precisely its future course would be presumptuous; but allusion may be made to the most obvious means for its development. Among these its union with architecture is of the first importance. Interior ornamentation of buildings generally includes work only on a flat surface, in light and shade, with or without color, though the formative art might well be combined

with it; but the refinement of the exterior depends almost wholly upon raised forms. If ever the laws of fine art have been set utterly at defiance, it is in the so-called decoration of modern architecture. Gross forms, like nothing on earth or in heaven, mechanically multiplied in plaster or wood or iron or zinc, and, worse still, sometimes in clean stone, flaunt from sill to cornice throughout the cities of the United States,—cheap, showy, and senseless. With few exceptions of recent design, there is scarcely a building between the Lakes and the Gulf worth a second glance for the art employed upon it. Many public edifices, of course, deserve the builder's attention as examples of good construction or as reproduction of Old World styles, but of invention or significant decoration there is an utter dearth. Here the work of the sculptor is wanting, and that only. The meaningless forms should be abolished, and the finer thought of the practised artist woven in. He alone can fill the empty niches, and cover the vacant spaces with intelligible history; he can make the walls respond to the love of nature imprisoned and dying in crowded cities. When the sculptor gets fairly at work on the exterior of buildings he is in a certain sense the agent of the whole people, and may express his thought in the freest and boldest manner, unfettered by the patronage of individuals or cliques. He will not be forced to represent forgotten myths. The source whence the people draw their ideas of the true and beautiful will also furnish his themes. The realist sculptor and the architect of the so-called Gothic or unlimited school having joined hands, good work is at once possible. For such union some sacrifice is necessary, the architect being too often not a sculptor, and the sculptor not an architect; but the one must not hesitate to avow his want, and the other must not hold himself above supplying it. The plan is so far from being impracticable, that, wherever tried, it has been immediately successful; and of those who have given thought to the subject nearly all are convinced of its feasibility and necessity . . .

There is "genius" enough in America to furnish a school equal to the Greek; but of general culture in the science of art there is very little, and of artists carefully trained in the school of nature there are very few. Drawing from natural objects should be taught in the public schools, not only for the benefit of those who wish to become artists, but as an admirable exercise of the eye and hand, and likely to add greatly to future culture and enjoyment of life. The knowledge thus gained would soon change the character of plastic art in this country. Endowing the public with power to appreciate what is now obscure in the best art, and also to detect blunders in means and execution, it would soon do away with meaningless puffery, and obstinate fault-finding, substituting for these kind and careful criticism. Then the great power of artists like Greenough, Crawford, Story, and Powers would be utilized, and sculpture could no longer be called an anachronism in America.

LANDSCAPE AT A CROSSROADS:
NATURE SEEN THROUGH TELESCOPE AND MICROSCOPE

THE AMERICAN PRE-RAPHAELITES

On January 27, 1863, eight men met in the New York studio of artist Thomas Farrer to found the Association for the Advancement of Truth in Art, a radical group with the mission of reforming American Art and promoting the "Pre-Raphaelite" philosophy of English critic John Ruskin. Their primary tenet was the exacting study of the natural world, down to the humblest weed or blade of grass. The sharp-tongued journal they established, the New Path, *entered the polite New York art world much like a Molotov*

cocktail hurled into the galleries of the National Academy of Design. As one New Path *essayist wrote in 1864, "We exist for the purpose of stirring up strife; of breeding discontent; of pulling down unsound reputations; of making the public dissatisfied with the work of most of the artists, and, better still, of making the artists dissatisfied with themselves." Nothing like this had previously been heard in American art circles, and nothing like their work had been seen: minute, fanatically detailed, jarringly colored paintings that were proudly unbeholden to standard notions of subject, composition, facture, and tone.*

In the inaugural essay of the New Path, *critic Clarence Cook lays out the philosophical precepts of the new organization while summarily dismissing all the American art that preceded it. Then Farrer, an English émigré, answers the critics of the American Pre-Raphaelites, using language reminiscent of a zealous religious convert or missionary intent on "saving" American art. Farrer believes unwaveringly in "absolute facts"; the artist must aim for the utmost accuracy, always distinguishing between oak and elm, birch and beech. In the next essay on the "true" and "false" schools, the author lampoons the typical Hudson River school artist, described as spending only a few minutes before actual nature study and worrying more about vacation destinations than correct drawing. The conventional paintings that result from such trips are also skewered, as are the modish viewers who praise them.*

In the final essay, again by Cook but written four years after the Society was formed, the critic seems to have lost patience with his former colleagues. Cook's review concentrates on two Catskill landscapes by Charles Moore, a young Pre-Raphaelite artist who would go on to teach art history at Harvard College. Cook finds that however meritoriously accurate the paintings may be, they have no poetry, no capacity to elevate the viewer. The revolution, in Cook's view, is still unfinished.

[Clarence Cook,] *Introductory Manifesto,* **New Path** *1 (May 1863).*

The future of Art in America is not without hope if looked at from certain points of view. The artists are nearly all young men; they are not hampered by too many traditions, and they enjoy the almost inestimable advantage of having no past, no masters and no schools. Add, that they work for an unsophisticated, and, as far as Art is concerned, uneducated public, which, whatever else may stand in the way; will not be prevented by any prejudice or preconceived notions from accepting any really good work which may be set before it. These are solid advantages, hardly possessed in such a degree by any other society, and make a good foundation on which to build well and beautifully for the future. All the omens are favorable, and the voices of the gods speak very plainly; nothing is wanting but that the priests fulfill their office worthily.

If we examine the list of the contributors to this year's Exhibition of the Academy, we shall find it set thick with the names of the young. The old names one by one disappear, and this, not because they represent superannuated, or feeble, or dead men; but because the breath of the new dawn which has already risen on our country blows too freshly and keenly for any but the young in spirit, in hope and courage, to breathe. It would be wanting in grace to speak harshly of men, the memory of whose works is fast disappearing from the minds of the people as the works themselves are slowly leaving the walls of the Academy. They have done their work, and done it, no doubt, to the extent of their ability; our business is only to bid them "Farewell," while we turn to greet the young Americans who are to inaugurate the new day. It is no disgrace for the elders to have failed. Failure was foreordained. We cannot justly rebuke them be-

cause, after forty years' uninterrupted labor they have given us not a single work which we care to keep, for they have worked under influences hostile to study and to the culture of Art, with no spur from within, and no friendly or sympathizing audience without. Good work has never been produced under such influences.

But for the younger men there is no such plea. The next generation may perhaps see a better time, but this is good enough. The old time was an era of political subsidence and stagnation. Hardly had we outgrown our colonial dependence; new-hatched as we were, many unseemly pieces of the old shells and straws from the nest still stuck to our feathers; the mother-hen, who did not know that she had hatched a swan, but thought us like herself, mere "tame, villatic fowl"—has even yet hardly ceased her admonitory cries and cluckings at our efforts to swim for ourselves, and, indeed, this reproach was fairly brought against us, that our literature and our Art were only copies, and feeble copies at the best of European originals. But, within a few years, there has been a great change: a new tide has set in; our independence on Europe has begun to be something more than a name. In literature, in religion, in education, in society, in art—we are fast sweeping into the glad new year when America shall sound, the trumpet-call, and marshal—her children to do her work in her own free way.

The young men, therefore, have the field to themselves, and they enter upon it untrammeled. They have not to fight the old men—these have quietly given place to the rightful masters of the soil. They cannot complain that the time is dull, and the people thick witted and slow to learn. They ought to leap with the strength of youth into this unfenced acre and take full possession. It is theirs. Can they do it? Will they do it? . . .

These then are some of the advantages with which the new men take the field. There are others, but we will not dilate upon them now; we rather turn to see what the age has a right to demand at the hands of the artist in return for these advantages. And the first demand she makes is that they shall one and all immediately stop grumbling at the public, and try to find out just how far the neglect, indifference, and, seemingly, deliberate acceptance of poor work that they complain of is their own fault, and how much may be fairly charged to the stupidity and perverseness of the people: our word for it, they will find that there is no one to blame but themselves. Let them look upon their work, in the first place, as something more than a mere means of living. Let them try to get something out of it in the way of enjoyment, love of God's work, a desire to make others sharers in that enjoyment, something, at any rate, beside money. Or, if they will have money, let them try to give the buyers the full worth of their gold, something that shall gather its own interest of pleasure, teaching, culture year by year, as the gold he gets for the canvas or the marble will bear its percentage, and not, prove a bargain that having tickled a momentary fancy shall be flung into the garret and forgotten with the whim that prompted its purchase. And this new way of looking at their work, and with the majority of our men no doubt it would be a new way, will speedily bring forth fruit in far better pictures than have ever yet been painted in America; pictures that will give us a right to rejoice in the present and to look forward with hope to the future.

And, again, let these young men from whom we hope so much, turn their backs deliberately and without ceremony upon the rubbish of the past, and if they doubt their power to discriminate between the rubbish and the good work; let them turn their backs upon the past altogether . . .

A few individuals persuaded of these things have joined themselves together in a Society, for mutual strength, and for the better dissemination of these ideas. They propose to print from month to month a journal in which they can communicate with others who think with them, or may be led to do so. There is a need of a journal of this sort in which art can be treated with

more justice and a broader criticism than it has thus far received at the hands of our public prints. Most of the writing on art which we find in the newspapers is personal, either in what it praises or what it condemns, and is apt to be feebly apologetic if moved to speak with any directness as if artists were made of more fragile clay than other men, and were to be much more daintily handled. We hold to a different view, and believe that to be a good, not to say a great artist, a man needs such powers of brain and heart as are quite inconsistent with irritability or unwillingness to hear the words of frank and generous criticism. While we mean that in these pages what we believe to be the truth shall be spoken without fear and without favor, we also aim to criticize on far higher than personal grounds, and to apply the same tests to works of painting and sculpture that all men are agreed in applying to written works of imagination and fancy.

In conclusion; it may seem that we have given expression to very high and enthusiastic hopes, which are built on very slight grounds of actual performance. There is truth in the criticism, for we cannot point to the works of any one man in proof of the revolution which we predict. But our faith is built on signs which are none the less infallible because they are as yet rather felt than seen. We believe, in short, that at length some new principles in art, few but potent, have been discovered and accepted, and that these principles, taking hold of the younger men, and gradually improving their lives and shaping their work, will in time produce pictures, statues, and buildings worthy of the age and country in which we live.

Thomas Farrer, "A Few Questions Answered," New Path 1 (June 1863).

And, now, let me say a few words about this "work," and I speak on this point from personal experience, so it is not my opinion, my ideas, or my thoughts that I tell you, but, simply, the facts, the things which I know; for I am sorry to say, I too, wasted a great deal of time, working in the old way, before I knew any better. Oh, I wish I could express in words, and make you feel how much happier I have been since I have been working rightly, doing the truth, and what a glorious consciousness it is, after a summer of earnest effort, to know that however faulty your work may be, and whatever its shortcomings, yet, it is absolutely right, that you sought God's truth, and sat down and did it. The critics and Art public generally, used to coarse, bad work, and having had their natural right feeling for delicate drawing, fine colors, and beautiful forms deadened by an artificial and long continued admiration of false work, when they see artists doing their simplest duty and drawing leaves or trees in such a fanatical manner, that you can really tell, by looking at their pictures, whether it is an Oak, an Elm, or a Pine, and painting rocks with such "painful fidelity" that you can actually see the difference between Trap Granite and red Sandstone—"What!" say the discerning public, "are painters to become botanists and geologists! If this sort of thing comes into fashion what will become of the ideal!" The public, instead of opening their hearts and receiving these signs of vitality and life with joy and gladness, receive them with a howl of scorn and disdain, and the works in which the artist has been true to his calling, and made trees look like trees, and rocks like rocks, and moreover has had the awful audacity to paint the summer trees green, think of it! are characterized as finished with the "painful fidelity of the Pre-Raphaelites." "Its details are wrought out with agonizing fidelity." "The cold remorseless fidelity with which every detail—" &c., &c. These expressions are literal quotations from some of the best Art criticism that New York has yet produced. Poor, weak critics, how it must shake their delicate nerves to see honesty and truth! I feel anxious to know whether they are consistent men, whether truth and fidelity in their servants and housekeepers, can be so painful and agonizing; if so, I should advise them to die at once, and save themselves further pain; for truth and fidelity being on the increase in the world,

and all the nations and people, by God's providence, advancing in that direction, their milky minds and soft nerves will not survive it long.

"Painful fidelity" is a silly, absurd paradox, and I wish, now, to assert most positively, that painful labor in good works of Art, is an utter impossibility, and if the signs of careful, earnest drawing, and deep love for the Creator's work, in an artist, afflict you with any sense of agony or pain, look to yourself, for be sure it is you, who are wrong, not the artist or his picture. And if a young artist find that it is "agonizing" to him to draw nature as she is, and painful to be faithful, then most certainly he has mistaken his calling, and the sooner he gives it up and finds some more congenial employment, the better for himself and the world . . .

Suppose, for the sake of illustration, that the face of Nature should entirely change, that trees were to grow differently, rocks be formed in a new way, and all the facts be altered, the generations that follow us would have nothing but our landscapes to tell them what the world looked like in the nineteenth century; think you they would form a very bright idea of it from the works of Cole, Durand, Allston or Geo L. Brown? If a few Pre-Raphaelites had lived and painted before the flood, do you not think we should value their works very highly? Do you suppose for a moment, that we should fight about the "painfulness" of their fidelity, or, if they had painted the Saviour's life and acts think you we should quarrel with them and refuse to be instructed simply because they were carefully drawn and faithfully painted? I am inclined to think this would be our principal cause of admiration and belief. Time and future generations will ask of our Art and our Literature, "Is this the way the people of the nineteenth century worked, dressed and acted? Are these their passions, principles and feelings? Is this the Palisades, and the North River, and the Catskills in the year 1863? If not, they are valueless to us, however perfectly they may conform to rules of Art in texture, tone and central light; for Nature is absolutely right; it makes no difference to her whether Durand looks upon her, or W. T. Richards; an Elm leaf is still oval and pointed, and a Hickory leaf long and sharp, and summer's foliage still green, and shadows on tree stems still purple, and rocks still stratified, although Geo. L. Brown and Wust continue to insist upon it that they are not.

Another of the objections made against us is, that we draw every leaf on a tree that is three miles off, with all the careful precision with which we draw leaves right in the foreground. It is true that we draw every leaf, and yet there are no leaves—only masses of light, and shade, and color, produced by the leaves; and we insist on these masses being drawn with the same "painful fidelity" that every weed, leaf and stone in the foreground is, for these masses tell the specific characters of the tree or rock. An Elm tree, in the distance, takes a particular form, and produces a mass of light and shade that is entirely different from any other, and could not, by any possibility, be produced by an Oak, or a Chestnut, or a Pine; but some artists seem to think that any lumpy mass of light and dark will do for trees or rocks in the distance. How much better would it be for the persons who make such objections to tell the plain, simple truth, and say, we have never thought about the matter or looked carefully at a naturalistic picture, and therefore are not competent to give our opinion; for what they say amounts to nothing more nor less. A noble work it would be for us who talk so much about truth, and insist on the absolute facts of everything, and for Mr. Ruskin, who has devoted his whole life to ascertaining the positive facts in Nature and Art, to come forward to the support of a set of men, who were painting uncompromising falsehood, under the pretence of painting uncompromising truth. It is just as wrong for a man to paint leaves when he cannot see leaves, as for the old fogies to paint trees and weeds that are close to the spectator, with a few careless daubs of the brush, that mean nothing but imbecility, and look like nothing but the paint-pot.

It is the absolute facts of everything that we are fighting for, and not for smoothness, not for execution, but for truth and reality. It is also believed by some rather sensible people in other respects, that all we wish to do or to teach, is painting in a small manner, covering the canvas all over with little touches, consequently when they see a picture in an Exhibition, fiddled all over with little niggling spots of paint, and looking as smooth as a Japanned tea tray, (as seen in the works of several of the modern Germans,) they say, "Oh, there is a Pre-Raphaelite picture!" they never stop to think, (thinking on Art matters being at a decided discount,) or ask whether it is the facts of any given place, or whether it was all manufactured in the studio, it is all the same to them, it is little work, and therefore must be Pre-Raphaelite. Now little niggling work or great abundance of work, is *utterly valueless,* unless it expresses the absolute facts of the things represented. Fine delicate execution, is valuable, (not for itself at all,) but only because it enables an artist to tell more truth, and to paint a thing more completely, than coarse, clumsy execution; but a truth told in a coarse, clumsy manner, showing all the signs of paint, and human weakness, is infinitely more valuable to the world than inane nothingness, or absolute falsehood, painted with all the marvelous skill, and delicacy of touch, of a Mieris, or a Gerard Douw . . .

But Art is not dead yet, nor the artists entirely depraved and lost. There is some vitality and life in it yet. In spite of dash and boldness, creeds, conventions, and the trammels of misguided patrons, it overflows and finds expression in the intensely-earnest painting of the fields, trees, and weeds and the noble love of little things, found in the present reaction, rising in Europe, where the culture is largest, it rolls steadily onward, until it breaks on the American shores of the Atlantic, and spreads over the whole continent, and all the cities of the world feel the shock of the great truth that is sweeping over them, shaking the old conventional ideas and superstitions to their very foundations; dropping its beautiful seeds like daisies on a lawn, and soon you see them poking up their heads fresh and very green, and they grow apace and flourish, putting out their slender strong roots, and seizing on everything that is good and true. If ever a body of men stood on a foundation of granite, it is the Pre-Raphaelites, and if ever a cause was absolutely sure, it is their cause, for it is God's work they are doing, and the more the world advances in civilization and knowledge, the more they will appreciate and admire the work of these men. It is the Art of the future, the Art of progress, the Art of Science and of Religion;— as Ruskin so well expresses it, "This Art is the expression of man's love to God, and the other the expression of man's love for himself." All that is necessary is patient perseverance, strong faith and determination to do the *truth,* and be true at any and every sacrifice, conscious that all opposition must cease when faced by fact, and as time goes on and civilization advances, the men who would live *must* be with us, and those who will not sail in our boat, must sink to rise no more.

"The Work of the True and the False Schools," New Path 1 *(November 1863).*

It has been said by some of our readers, and with some truth, that our journal talks in a general way about the principles of true art but does not tell us the real, tangible difference between the opinions and works of the true and false schools. The purpose of this article is to state in plain terms the positive difference between the conventional and true artist . . .

Take as an illustration of the difference between the two schools, the way in which the artists of each use their time in this country. One goes out of town just as soon as it is warm enough to work. He does not spend much time searching for noble subjects, knowing that everything touched by God is beautiful and valuable to the world—but, believing every subject worthy,

he goes to work at once earnestly and lovingly, endeavoring faithfully to render every beautiful curve of line and every smallest shadow and tender gradation of light and color; and on this if it be a pencil drawing he may work not less than six weeks; if an oil study, about three months.

What is the other artist doing in the meantime? He stays in his studio until it becomes too warm to live in the city; then he thinks and wonders, and makes all sorts of inquiries as to the most suitable place. The very finest scenery in the country must be placed before him before he will deign to put brush to canvass. He starts about the middle of July, and this notice appears in the daily papers, under the head of "art items." "Mr. I. P. Mahlstock, has gone to the Catskills for a few days, after which he intends to pass through Vermont and enrich his portfolio by a few weeks' stay in the White Mountains. He expects to be back in his studio about the middle of September."

Arrived in Catskill, he stays one day in the village; walks about until he finds the finest views of the mountains, when he spends half an hour making a sketch; that is, he scribbles on a large sheet of tinted paper the mere outlines of the mountains and trees, and those not truly; then he goes to dinner, after which he takes another splendid view in about the same time and manner. In the evening he leaves for the Mountain House, feeling no regret at passing by all the noble things that surround him on every side, but thinking he has done all that the scenery deserves. In the mountains he stays about a week, covering large sheets of paper with mere lines and "notions for pictures," making several very broad oil sketches, putting down on his canvass not the colors of nature but those which he has learned in the studio to substitute for them, brown for green, grey for blue, and ochre for gold.

Having so done the Catskills it will be time for him to think of some other place, say Vermont, for about a week, and then he will spend three more at the White Mountains, where he will make what he calls his earnest oil studies, and at the end of six weeks he is home again—his portfolio enriched with numerous large sheets of coarse tinted paper, covered with scribbled outlines of subjects and several very broad oil sketches from which he will manufacture an endless number of pictures of every conceivable subject, size and price, for the next nine months. This is the practical difference in their manner of work.

We will now endeavor to express in words a few of the more salient differences between the *pictures* of the two men, and hope by this means to dissipate the erroneous idea so generally held that the new school men paint nothing but detail . . .

We have before us a pencil drawing by one of the true men, not more than six inches long and four wide. The amount of truth that is crowded on this small piece of paper might shame any of the old school men who yearly cover the walls of the Academy with canvasses, six or eight feet long. The drawing represents the interior of a pine wood. In the upper left hand corner in less than two inches of space are drawn the trunks of about ten forest trees, lichen covered and various in light and shade; all the distinctive characters of each at the distance of about two hundred feet from the spectator perfectly rendered. It is true, all the details of this scene are drawn, yet no leaves are to be seen and no distinct marking of the bark on the tree stems, though we feel all the unevenness of their surface. Between the trunks the limbs of each tree, covered with foliage, stand out dark against the sky. The foliage at this distance is nothing but a soft, confused mass of light and shade, and yet we could not lose the smallest of these little masses, for each one means a limb covered with its hundreds of thousands of beautifully formed leaves, sparkling in the sunlight. They bend gracefully to the ground or hold up their leaves to the sky according to the growth and character of the tree. We can no more allow an artist to draw these forms carelessly or falsely than to put meaningless touches in his foreground for leaf

or weed. This is only two inches of the drawing. No words can describe the myriad facts and marvellous delicacy and decision of hand and eye that has followed every little clover leaf with a loving care, and rendered the whole truth of every patch of lichen on the tree stems—in the foreground. Several broken limbs partially covered by grasses, and dead and fallen leaves lie in the nearest foreground, not the sixteenth of an inch in diameter, yet each one has its perfect gradation of light and shade. On the under side the most delicate little reflected lights prove that the leaves and grasses are drawn with marvellous accuracy. Then comes the shadow and then the highest light giving perfect roundness to it. This drawing was made entirely out of doors.

Now take a picture by an artist of the old school, painted in the studio. It is about three feet long by two wide. In the distance are some pale greyish blue mountains, not *pure* blue or purple as they would be in nature. On the left hand side a group of trees of raw sienna green stand up against the sky. On the right hand side are some smaller trees with cattle standing sleepily under them. A quiet stream runs through the centre of the picture and over it a little wooden bridge, and on the bridge some country folks in a wagon go riding to market. On the left side of the stream two men are fishing. Right in the foreground is a man in a little boat but what he is doing there we cannot tell for no oars are to be seen. On either bank great masses of yellowish brown are intended to represent the fullness of a foreground life, but we cannot find a distinct form of either grass or leaf. The lights and shadows are all blended into the "sweetest softness."

You cannot tell whether the sun is shining though the sky is quite clear, because there are none of the sharp shadows which sunlight would throw upon the large trees on the left. Although quite near to the spectator we fail to discover a single form bearing close resemblance to a leaf. True the canvas is covered with little touches of paint made with the sharp end of a camel's hair brush, but they look as much like the spots on a checker board as leaves on a tree. One side of a tree is dark and the other side light. This correspondence holds good throughout the picture. There is light in the upper part of every tree which gradually blends into dark shadow. Every line and edge is soft and uncertain, the picture having been scumbled over when finished, with a mixture of white permanent blue and naples yellow to give it atmosphere.

This is no fancy sketch but a description of an actual picture by one of our most popular men, and is a very good type of the mass of studio pictures that are so pleasing to the ignorant public. Everything is softly and superficially touched upon, but nothing thoroughly drawn or painted. The mind cannot rest with satisfaction upon any part of it for more than three minutes. And such are the pictures in front of which ladies and connoisseurs congregate, expressing their admiration in this wise, "What a lovely picture! O, Mrs. Smith, is'nt it sweet! Everything so soft and delicate! nothing positively defined! such a velvety texture to everything; so artistic and beautifully generalized." Whereupon Smith who has been to Italy, seen a great many pictures by the old masters and thoroughly enjoys generalization, central light and velvety textures, buys the picture for five hundred dollars, puts it in a prominent place in his drawing-room where it becomes the centre of attraction for a select circle of connoisseurs and artistic friends.

[Clarence Cook], "The National Academy of Design," New-York Daily Tribune, *July 3, 1867.*

In some respects, Mr. Charles Moore's pictures in this year's exhibition do not justify what we have said of his work in the past. We had made up our mind, almost, that he had an eye for color; certainly, his "Cattskills in Winter," of the last Artists' Fund Exhibition, was lovely in color; but neither of his pictures on these walls has any charm in this respect. It is not sufficient

to get the local color of the several parts of the landscape truly; these local colors must be harmonized into unity. This is a truism with which Mr. Moore is as well acquainted as we are; and yet he has failed to put it into practice in these pictures. The consequence is, that they have to conquer the spectator's interest and approval by the power of drawing they display, and the carefulness of observation they bear witness to; they do not charm him into their presence and hold him by their beauty; and when he has looked long, he is apt to turn away with the intellectual satisfaction that results from a clear scientific demonstration, rather than with the glow and elevation of spirit that it is the great privilege of art to produce. But unless a picture produces this effect, it falls short of its full office, and all the study and learning of the artist if they do not go for nothing, at least fail to give a pleasure answering to the expenditure of time and labor that they imply. Now, we withdraw nothing of what we have at any time said as to the absolute necessity—if we are ever to have an art worthy of the name—of study, and thought, and labor, on the part of the artists; but everybody will admit that poets are just as capable of this devotion as matter-of-fact people, and we may as well confess, without making too many wry faces about it, that what we are in sorest need of just now, is a poetical painter. Mr. Farrer, Mr. Moore, Mr. Newman, Mr. Henry Farrer, the Hills, Miss McDonald, Mr. Bulson, Miss Granberry—these are the names of the artists who compose the realist school. They are distinguished by the general excellence of their drawing, and by the delicacy and closeness of their observation, but they make no appeal to anything in the vulgar mind but the sense of wonder, and rouse that only feebly, while educated, thoughtful, sensitive people find nothing in their work to stir deep feeling, or to excite and elevate the mind. We must remember that there is no figure-painter among them all, and landscape must ever be insufficient to call forth or to satisfy what is deepest in us; yet they are not even landscape painters, all of them, though they aim to be, but, as any exhibition of their works would show, they have produced principally studies of fruit, flowers, birds—many of them very precious—but still incapable of making any profound impression on the public. Now, what gives the men of the old school so much weight with the public is the impression that their pictures make upon the imagination of the public; uneducated, half-taught people delight in what they believe to be beautiful color and agreeable composition, and thinking them such, they very reasonably delight in them. Let anybody be much in the habit of frequenting picture galleries, and listening to the remarks and criticisms that are made at his elbow—a very amusing, and perfectly proper, species of eaves dropping—and he will soon learn that it is the pictures, which, intellectually and scientifically, are the least worthy, that attract and hold the mass of the people; but we believe he would be very wrong to draw from this that the people like only what is bad. So far is this from being so, that every picture greatly and long admired by the public must have a certain absolute merit, and our business is to find out what that merit is, and ascertain if it is necessary that it should be tied up with all the defects and short-comings that make the picture offensive—if it be offensive—to educated and refined people. We once heard a gentleman, whose faith in realism is almost a fanaticism, and whose skill as an artist might well excuse his intolerance, exclaim, "By George, Sir! I tell you, Sir, those fellows (he meant the fellows of the Academy) know how to choose a subject, Sir!" Now, this most clever artist, a man of prodigious diligence, of unwearied study, and of a devotion to his Art almost unknown among us; a man who holds the Academy and all its doings in sovereign and hearty contempt, and whose knowledge and skill give weight to his criticism—this man sees, plainly enough, that there is another side to the matter of the public taste, and that there must be a root of reason, even in what seems at first blush quite unreasonable. To admit this, is it to recede from our high position; to give in to the arguments of the

crowd; to confess that the principles and the practice we have defended are mistaken! Far from it; it only declares that having laid a good foundation, we must now consider of the building to be raised on it, and that we must search out the principles of widest application and most universally accepted. The danger is, lest we should mistake what is, and can be, only foundation, for the building itself, and rest satisfied with what has been aimed at thus far, and thus far achieved. Because we admit that the realists need to take another and a higher step, and that they may get a hint of this step in the practice of the best among the men of the opposing school, this is not to admit for a moment that the steps they have thus far taken are to be regretted. Even if it shall prove, as it may, that no one among them is capable of taking that higher step, the work they have accomplished, the lesson they have taught, the principles they have established, are, none the less, a substantial good, and every man of them, the women included, is to be held in honor. If they cannot be poets themselves, they have prepared the way for poets, and as they are nearly all young, and some of them in their first youth, it would be simply presumption to take it for granted that they are not to turn out poetical painters. All we have ventured to assert is, that, thus far, they have not produced poetical pictures, nor come as near it as one or two of the men they oppose; and all we venture to predict is, that, unless they can produce poetical pictures, their skill, and dexterity, and science, nay, even their truth, will go for naught, and the world will never care for them.

ALBERT BIERSTADT'S GREAT PICTURE

Born in New Bedford and trained in Düsseldorf, Germany, Albert Bierstadt joined Frederick Lander's western survey expedition to the Rocky Mountains in 1858. En route, in conformity with the Düsseldorf method, he made numerous on-the-spot oil sketches of scenery, flora, fauna, and Native inhabitants, then used these field notes to compose his vast and intricately detailed Rocky Mountains, Lander's Peak, *first exhibited in 1863 in Manhattan's Tenth Street Studio. By publicizing and shrewdly marketing this first of his own "great Pictures," Bierstadt positioned himself in direct competition with Frederic Church, who had vaulted to notoriety with his own huge scenic canvases,* Niagara *(1857) and* Heart of the Andes *(1859).*

A description of The Rocky Mountains, *most likely written by the artist himself to promote the sale of the engraving by James Smillie, testifies to its authenticity by placing Bierstadt at the scene—even though the painting itself is a composite, worked up in the studio. The writer furnishes the particulars of the location and devotes considerable care to an ethnographically flavored description of the Shoshone village in the foreground. The affirmation of manifest destiny becomes clear in the final paragraph, which envisions a great city on the plain where the Natives once dwelt. In grandiose visual form,* The Rocky Mountains *thus claims the West for Euro-America.*

Given its platform of truth and sincerity in art, the New Path's *judgment of Bierstadt's* Rocky Mountains *is not surprising. Clarence Cook deplores the new culture of "puffery" and aggressive publicity that has arisen around the spectacular display of art, in particular the alluring, crowd-pleasing, and meretricious images of the West that are Bierstadt's speciality. Overinflated, Bierstadt's reputation and his art alike are symptomatic of the new commercial culture that arouses pernicious cravings for fame and money.*

"A. Bierstadt's Great Picture, The Rocky Mountains, *Engraved by James Smillie"* (New York: E. Bierstadt, *1863), printed testimonial, Library of Congress, Rare Books and Special Collections Division, Printed Ephemera Collection.*

This noble picture is the result of a visit to the "Far West," undertaken by the Artist in the summer of 1858, in company with the late General Lander's exploring expedition. The various studies of the country, and of the people of that region, necessary for the present work, were made by him at that time, and are in every instance from nature. This picture represents the scenery in the Wind River range of mountains, in Nebraska Territory, being a portion of that great chain known as the Rocky Mountains, which runs north and south through the western part of North America, parallel with the Pacific sea-board, and extends from the northernmost point of the British Possessions, through the Territory of the United States, Mexico, and Central America, down to the Isthmus of Darien.

The particular portion which the Artist has here depicted, lies at a distance of about seven hundred miles northeast of San Francisco, and portrays the western slope of the mountains. The streams which are seen leaping down their sides,—the waters of which form a lake in the basin of the valley,—are the head waters of the Rio Colorado, a river that empties into the Gulf of California more than a thousand miles from its source.

The principal peak of the group is Mt. Lander. Its summit is covered with perpetual snow, and immense glaciers are formed upon its sides. Traces of their movement are shown in the picture by the furrowed lines which sear the slopes of the mountains. A silvery mist hovers about their brows, and sunshine and shadow rest upon their breasts. The effect of light and shade in this picture is one of its chief attractions, and has been admirably managed by the Artist.

The Indian encampment in the foreground is known as the Shoshone Village, and the various implements of the chase, warfare, and domestic use, scattered about, are those in general employment by this tribe. It seems hardly necessary to enter into any elaborate description of this picture, and we shall therefore content ourselves by simply noting the main features in it which attract the attention of the beholder.

The wigwams are constructed of poles covered with skins of animals, and on many of them symbolical figures are painted or worked. Leaning against an open lodge is seen, strapped in the Indian fashion, to a board, a young pappoose wrapped in skins, and guarded by a faithful dog. Near by before a blazing wood fire several fish are cooking, an arrow or sharpened stick being thrust through them and stuck into the ground. The products of the chase, in the shape of an immense grizly bear, elk, antelopes, mountain sheep, ducks, and various birds are also pictured. The mode of shooting the marmot,—two of which little animals are seen sporting among the debris of fallen rocks, at the left of the picture,—is shown by the Indian lad kneeling, with drawn bow, before its burrow, watching for it to come forth. Beyond him is raised the amulet or charm, being the embroidered blanket of a war horse, over which the medicine man has uttered his incantations, which keeps evil spirits away from the tribe, and is supposed to guard the village from all attacks of a supernatural character. Among the plants and herbs which are introduced, are the dwarf sunflower, the wild sage, and the artemesia; and the trees, which stud the plain on the left, are the cottonwood, a species of tree which are found in great abundance throughout this part of the country, and belt the rivers with a zone of green. There are also a great variety of evergreens. The various groups of Indians scattered over the plain are all, more or less, engaged in some characteristic pursuit, and are attired in the dresses usually worn by them. The squaw standing in the open doorway of the principal tent, with her back towards

the spectators, is arrayed in a very costly and fashionable robe; and, as it trails upon the ground, it is evident that in this extravagance, the wearer is not a whit behind her white sisters.

This picture possesses a geographical and historical value, such as few works by modern artists have obtained. Nor will time destroy its worth, but rather add to it. It is not only a correct representation of a portion of our country of which we as yet know comparatively little; but it introduces into it the every-day life of that race which, before the advance of civilization, fades away like the mists of morning before the rays of the rising sun. Their customs and habits through it will be preserved when, perhaps, the scene which it depicts, will no longer echo to the ring of their war-cry, or mark their stealthy step following in the chase. Upon that very plain where now an Indian village stands, a city, populated by our descendants, may rise, and in its art-galleries this picture may eventually find a resting-place.

[Clarence Cook], "Notices of Recent Pictures: Bierstadt's 'Rocky Mountains,'" New Path 2 (April 1864).

Mr. Bierstadt's much talked-of picture of Rocky Mountain Scenery, after having been shown for one evening to a few invited guests, and, then, snatched away to Boston where it was the object during several weeks of an almost unprecedented *furore,* has at last been unveiled to the long expecting New York public. It is at present going through the ceremonies of exhibition and puffery preparatory to being engraved, which have now become settled by prescription, and with which all New Yorkers are thoroughly familiar; the upholsterer has done his work, the tin lorgnettes and the magnifying glass have been duly provided, the puff-disinterested has been written, printed on the sheet of letter-paper that etiquette prescribes, and distributed, and the gentleman-in-waiting stands ready, at all hours, to enter in his subscription-book the names of those who desire to add this combined result of Mr. Bierstadt's genius and Mr. Smillie's talent, to their plethoric portfolios.

We have no desire to satirize what, no doubt, has been found, by experience, to be the best way of managing the business of selling pictures. But, still, when we see this vast machinery of advertisement and puffery put in motion, and on an equally ponderous scale for all sorts of pictures, good, bad and indifferent, we cannot help contrasting the new way with the old, and wishing that we had a man strong enough to draw the world to him and make it seek him out, instead of there being need of all this apparatus to force the world to look at what it would often never seek of its own will . . . Our artists are unwilling to trust their works to the popular verdict. They have no faith in the judgments of the masses, but, they have a most unbounded faith in its gullibility. They have learned that by the assistance of well adjusted draperies, innumerable tin tubes, nicely printed critical-descriptive sheets of letter-paper—the public can be made to see no difference between "Final Harvests," "Rocky Mountains," "Niagras," and "Marie Antoinettes Leaving Judgment-halls." That is, they think they have learned it; but, we advise them, in a spirit of the strongest friendship, to trust less and less to the ignorance of the public, to put as little trust as possible in machinery, and to bend all their energies to painting good pictures that people must admire, whether they will or no.

In justice to Mr. Bierstadt, we must say, that we do not intend these remarks to apply to the exhibition of his pictures more than to any other . . . Our remarks are aimed at the system itself, which we think has reached the *rank* of an organized nuisance, and we call upon all artists who wish to elevate their profession above that of the showman, to help us abate it.

Without any puffery, and with only the advertisement in the public journals absolutely necessary to inform people where they could see the picture, this work of Mr. Bierstadt's would undoubtedly have attracted a good deal of attention. It professes to give a faithful report of the

scenery of a part of our country about which we know little or nothing. It transports us from the tamer scenery of our hills and meadows to a land of gigantic mountains, glacier fields, cascades and virgin forests. On entering this region, we leave behind us all that we know of civilization, and set foot on those enchanted plains where the Indian yet lives in pristine simplicity, hunting, fishing and worshipping in the narrow verge to which the cruel rigor of the whites has pushed him. So great a charm have mere grandeur of landscape, apart from all human associations, and the word "the West"—to the mass of our people, especially to the young, that this picture must inevitably have been run after and praised, even if, instead of being a reasonably good piece of work, as it is, it had been as bad as one of Cole's or Durand's masterpieces.

Mr. Bierstadt has shown a greater power of filling a large canvas with interesting matter than any man we have yet had. In this respect, he is very far superior to Mr. Church, who never knows what to do with his foreground, and, so, generally contrives not to have any. But, as far as the mere mechanical art of laying on color is concerned, Mr. Church is far more dexterous. He could not, perhaps, have made his mountains look as high as Bierstadt's, but, they would not have showed the marks of the brush so unpleasantly. It would have been all well enough, if the marks of the brush had, by dexterous handling, been made to stand for scarp and fissure, crag and cranny, but, as it is, we have only too little geology and too much bristle. Still, there is no doubt that we do get an impression of very high mountains from this picture, and, if the detail is far less satisfactory than might be wished, we will hope that study and labor will add this excellence in time to works of this artist yet to be painted . . .

But, when the best has been said, we must still regard this work as immature, and on too pretentious a scale. The ambition of our young artists is leading them to attempt impossibilities. They attack in holiday mood, what should only be approached as serious and weighty enterprises. What a giant like Turner only undertook after years of toil that seems to us almost superhuman, these young men paint with a want of preparation, of study, of experience, and an easy nonchalance, the result of which, if it satisfies them shows a shallowness very bad to contemplate, and if it should satisfy us would show that we have studied nature to very little purpose, and art to as little.

Twenty times the study that the artist has given to this picture,—study represented by actual sketches, built upon a previous ten years, at least, of absorbing toil given to various branches of his art, would not have justified him in attempting to fill so large a canvas in such a way that the poet, the naturalist and the geologist might have taken large pleasure from it. And, even if he knew all that Turner knew, he could have put upon a canvas one sixth as large, enough to have brought the world to his doors . . . We wish, heartily, that our young men would not be so greedy for money or as eager for notice as to make them exhibit the immature work of their hands with the facility which is getting to be so common; and we wish, moreover, that they would believe that the maturity of their power can be as well proved by a small work as by a large one.

The best part of this picture is the episode of Indian Life in the foreground. It is very interesting and very valuable. It is a subject not beyond the artist's powers, carefully and faithfully painted from actual sketches, or, directly from the objects themselves.

VARIATIONS ON A SCENE:
JOHN FREDERICK KENSETT, ALBERT BIERSTADT, AND THOMAS HILL

In the 1860s, John Frederick Kensett and Albert Bierstadt were polar opposites in both style and subject. Kensett, specializing in serene lake and coastal scenes, worked in a

tranquil luminist mode of space, light, and atmosphere—Bierstadt in a far more highly charged manner appropriate to the dramatic western scenery that soared and sprawled on his oversize canvases. Despite that, both celebrated landscapes that were quintessentially American, historically as well as topographically. Playing on those intertwined themes, Harper's Weekly *praises Kensett's* Lake George *(1864) and Bierstadt's* Rocky Mountains *(1863), stylistically so different yet so alike in their American sentiments. The critic's nationalistic paean ends with the thought that such pictures would be fitting adornments for the Capitol in Washington, D.C.*

A few years later, California's Overland Monthly *finds marked contrasts in the sublime Sierra landscapes of Bierstadt and Thomas Hill, who like Bierstadt made Yosemite Valley a special subject. This critic too sees Bierstadt's* Donner Lake from the Summit *(1873) as a historical landscape, one that plays off the tragedy of the ill-fated Donner party against the technological triumph of Collis Huntington's Central Pacific Railroad, which now passes through the mountains with impunity. In contrast, Hill's vigorous and scintillating* Royal Arches of the Yosemite *(c. 1870–73) is more down to earth and more typical of the Sierra on an ordinary day. Significantly, the figures in Hill's painting, identified as tourists, eloquently testify to the status of the western American landscape as symbol, spectacle, and commodity. In this review, indeed, the discursive construction of the far western landscape is in full swing. Rugged and sublime, this terrain represents the fulfillment of America's manifest destiny.*

"The New Pictures," Harper's Weekly **8 (March 26, 1864).**

The Sanitary Fair will have a picture-gallery in which there will be admirable works, and the National Academy will open its doors in April. Meanwhile there are pictures to be seen worthy of the most careful study . . .

Mr. KENSETT's "Lake George" is now upon exhibition at GOUPIL's. It was painted for a noted connoisseur, who understands that one of the chief duties of those who are able to buy pictures is to let others see them. It is a thoroughly characteristic work, representing upon a large scale a certain aspect of American climate and scenery which no painter so exquisitely renders. The view is down the lake toward Caldwell. The fore-ground is a wood, traversed by a small stream which falls in a lovely cascade upon its way to enter the lake; and the gleam of the lake, broken by the islands, dotted with sails, and walled by the mountains upon the other side, complete the picture. The firm and faithful treatment of the single tree-trunks in the foreground, the perfect quality of the rocks, the clear shadows and the sunny greenness of the forest aisle, are points of artistic excellence which will escape no one. But the exquisite gradation, the delicate airy perspective, the depth of the sky, the fidelity of the mountain forms, are not less remarkable. Yet above them all, and in them all, and through them all, are the spirit and splendor of Nature in the serene triumph of her summer repose. And it is Nature in her American costume. It is not Italy, nor the Orient, nor Switzerland, nor England, nor the Tropics; it is the clear-breathed, soft-skied America of every day and of common experience. It is pure landscape also. Nothing wins the mind from its brooding delight in the tranquil scene. Fancy follows the bounding deer which the eye does not see. It lingers around the invisible camps. It muses upon the dusky departing race. It remembers the gay Sabbath flotilla of ABERCROMBIE's army. It hears ETHAN ALLEN thundering in the name of the Continental Congress. Or, still receding, glides along the calm with the canoe of the Jesuit explorers. Thus it has the highest charm of landscape art, the undisturbed presentation of the scene leading on to all its historical and imaginative associations.

From this most thoughtful and masterly work the transition is not difficult to Bierstadt's "Rocky Mountains," which is no less thoroughly American. It is a scene upon the head waters of the Colorado at the foot of the great range of the Wind River Mountains, which fill the depth of the canvas, pouring the hills and streams from their skies and glaciers into the calm lake, upon whose broad green meadow, which forms the fore-ground of the picture, is an Indian camp. It is purely an American scene, and from the faithful and elaborate delineation of the Indian village, a form of life now rapidly disappearing from the earth, may be truly called a historic landscape. It is the curtained continent, with its sublime natural forms and its rude savage human life; nor do we recall any work in which the subject is so strikingly presented. It is an extremely interesting picture, stimulating the imagination and satisfying curiosity. And unlike Mr. Church's pictures of the equatorial mountain scenery of America, which from their volcanic and tropical character, however luxuriant, yet forbid hope and leave an impression of profound sadness and desolation, this work of Bierstadt's inspires the temperate cheerfulness and promise of the region it depicts, and the imagination contemplates it as the possible seat of supreme civilization.

It is a most interesting pendant to the "Lake George" of Mr. Kensett. And who now will undertake the Prairie and the Mississippi Valley with the same thoughtful skill; or the bayous of the Gulf and the Everglades? Are not these, also, the kind of picture which should adorn the Capitol?

"Two California Landscapes," Overland Monthly 10 *(March 1873).*

Visitors to the gallery of the San Francisco Art Association have lately had the opportunity to study two fine paintings of Sierra Nevada scenery, which are doubly interesting from their subjects and intrinsic merit, and from the fact that they illustrate two different methods in art. One of these paintings is Bierstadt's *Donner Lake from the Summit;* the other is Hill's *Royal Arches of the Yosemite.* Both are of exhibition size—that is, six by ten feet. Bierstadt's picture is generally admitted to be the most faithful and satisfactory California view he has yet executed . . . His point of view was several hundred feet above the line of the Central Pacific Railroad, where it crosses the summit of the Sierra, and upward of 7,000 feet above the sea, looking eastward over Donner Lake and down the descending valley of the Truckee to the distant Washoe mountains. This point was chosen at the instance of the gentleman for whom the picture was painted, because right here were overcome the greatest physical difficulties in the construction of the road, while the immediate vicinity was the scene of the most pathetic tragedy in the experience of our pioneer immigration, for it was on the shore of Donner Lake that the Donner party were caught in the winter snows, and suffered horrors worse than the death which overtook so many of them. The two associations of the spot are, therefore, sharply and suggestively antithetical: so much slowness and hardship in the early days, so much rapidity and ease now; great physical obstacles overcome by a triumph of well-directed science and mechanics. For these reasons, the picture is in some sense historical. The entire range of the landscape, from the summit to the Washoe mountains, is not less than fifty miles, and the descent from the foreground to the middle is over 2,000 feet. Besides the difficulty of representing so much descent, the artist had to deal with the rugged facts of cold gray granite cliffs, of ridges largely denuded of timber, and a body of water three miles long so far below him that its shore details are lost, while its usual color is dark and leaden. Mr. Bierstadt has contrived to make of such materials a work which is both grand and poetical. By taking early sunrise, when the vapors from lake and river are lifting, and the light filtered through them casts long shadows over the foreground, warms the face

of the rugged cliff to the right, and gives a greenish silver tint to the lake, he was enabled to soften the natural asperities of the scene without sacrificing essential truth. The mist-softened sun a few degrees above the sky-line of distant mountains is the key to the tone of the whole picture... At the right, rises a sheer precipice of granite, a thousand feet high, whose base broadens to the shore of the lake. Through a tunnel in this rocky battlement the cars pass; but the hard fact of the railroad is only hinted by a puff of smoke, and by an unobtrusive sketch of the line of snow-sheds. At the left hand is a splendid group of dark pines, which gives miles of distance to the landscape beyond... Above Donner Lake itself the vapors are rolling off in cumulous clouds, which are reflected in its bosom... It is painted with great refinement. The surface objects and inequalities are realized with photographic closeness. The rocky structure is massive and solid. The trees are Nature itself. There is evidence of the most intelligent and careful work all over.

Turning to Mr. Hill's canvas, we see in the immediate foreground a river-curve of still water, reflecting the tree-fringed banks in green tint on the right side, the massive cliffs in gray on the other. The river is edged with oaks and alders, and other deciduous growths, and describes a half-circle in the middle of the foreground. From its left bank projects a sand-spit, where driftwood has collected, and where a party of mounted tourists are debating the chances of fording. The reflections in the water are wonderfully illusive; to look at them is like looking down into another heaven from the edge of a wall. Just behind, rises the perpendicular granite cliff, whose surface-markings, where the rock has peeled off, suggest the name of "Royal Arches;" the further end of this cliff being the well known promontory of "Washington's Column." A narrow bit of level valley lies at the base of this column, grassy, belted with a few pines and oaks, and stretching to the river; and then, looking across a hazy chasm, we see the "Half Dome" frowning at an altitude of several thousand feet, thrown into distance by a sharp line of dark rock which comes down from the right, the forenoon light pouring in a full blaze between, warming up the face of the "Royal Arches," and illuminating the rocky summit of the North Dome beyond, where a few fleecy clouds are drifting off into the distance... It is painted with great breadth and boldness; the color is laid on thick, and the detail is all in the effect at the proper point of view... The cliffs are massy, solid and lofty, and their structural character is faithfully rendered. The opal, pink, and brown mottlings of color on the scarred face of the "Royal Arches," and the haze-softened ruggedness of the "Half Dome," are fine effects. A bit of scaling dark gray granite on the river's edge is wonderfully literal, and the uprooted oak on the sand-spit is equally so. The management of color and light, sustained in a high, bright key through the whole picture, and the almost stereoscopic prominence of cliff and tree, give the impression of openness and airy space. Mr. Hill is eminently an out-door painter; and if his work looks almost bald in its strength, compared with the beautiful refinement of Bierstadt's, it is no less true to nature, and probably expresses her more usual aspects in the upper Sierra... It is instructive to see two such works together; to be told so graphically how various nature is in her effects and impressions, and by what different methods in technical art she may be reproduced for our enjoyment.

TOO MANY LANDSCAPES

As early as 1833, periodicals such as the American Monthly Magazine *were questioning the preponderance of landscape paintings produced by American artists: "The study of landscape, though calculated to elevate the mind by the contemplation of the beauties of creation, is neither so sublime in itself, nor does it rank so high in the art as historical*

painting. Unfortunately, the former pervades in the studio of the American artist, and the latter is scarcely to be found." Two decades later, it was not so much the eighteenth-century valuation of landscape art as "lower" than history painting that concerned reviewers. Rather, they had simply grown weary of a kind of reverential nature worship that no longer accorded with the times and seemed merely descriptive. The new importance of academic training based on the study of the figure was also a factor. In the excerpts below—reviews of National Academy Annuals written in 1865 and 1868—the authors mock the ideals of the Hudson River school (which had not yet been named as such—see "Earl Shinn on Criticism," chapter 12). They also blame the public for an indiscriminate lionizing of popular landscape painters. Twice the metaphor of "upholstery" comes up, with landscape painting likened to so much fashionable "furniture" for the parlor, divorced from high art.

"The National Academy of Design," New York World, *May 16, 1865.*

Painting, especially in America, has so tended of late years toward a pantheistic worship of inanimate things, that we are anxiously on the watch for the coming man who shall "re-habilitate" human life.

An ingenious young gentleman in Boston observed the other day that "If he lived long enough and took pains with himself he hoped some day to be as good as a negro." And really it is hardly an exaggeration to say that rocks and stones, trees and waterfalls, have been presented to us for several years past by our artists and critics as the great moral exemplars of mankind. We have heard and seen so much about the "truth of trees," the "purity of pumpkin-vines," and the "serenity of stones," that the human in art has subsided into a secondary and insignificant position . . .

The noblest themes of human art, we venture to believe with the old Italian masters, are to be sought at these "inner fountains" still; and the predominance of the landscape in modern art we regard as a positive misfortune, one of the natural ill effects of which we are already suffering under in the development of what we may call the upholstery of painting. That a man of genius can suffuse a landscape seen by his eye with the "master-light" of his own spirit, and that the landscape thus informed and idealized may be so reproduced by him upon the canvas as to affect other minds with the emotion of the artist, is of course true. It is equally true that descriptive poetry may in like manner be made a vehicle of subtle human thought, of delicate and aromatic human feeling; but the highest range of descriptive poetry lies still far below the summits of epic, lyric, and dramatic art.

The present preference for landscape in art, while it is no doubt in a great measure a matter of mere fashion, has a more real root, perhaps, in the crowded and feverish character of modern life. The world of men is so much with us that the spirit, fagged and favored, delights to repose itself by lakes and rivers and piny mountains.

"National Academy of Design," Watson's Weekly Art Journal, *May 20, 1865.*

The most noticeable feature in all exhibitions of paintings of the present time, at least in this country, is the pre-eminence of the landscape element.

In all genuine art it is the heart that paints, and it paints what it believes and loves. But the faith and the love of our fathers was not ours. We therefore no longer delight to fill the gloom of the sanctuary with glowing embodiments of rapt saints treading under foot the dark, cloud-shrouded plain of nature. Nay, from this very nature we dispel the clouds and admit the sun-

rays, and see therein the living Deity. To our fathers this goodly eden, rich with the glories of mountain, meadow, stream and blossom, was, after all, something unclean, something damned, full of lurking places of the demoniac, fit only to be trodden under foot. They sought the spirit beyond the clouds. Ours is a new faith, a new love, hence a new art.

True art is necessarily religious. In changing the direction of its energy from the supernatural (using the word in its strict sense) to the natural, it does not divest itself of its religious character; it only broadens, and in the end, perhaps, deepens it. It follows, then, that the one grand prerequisite to good landscape painting is an intense religious love of nature.

This love of nature, in its development, shows itself at first as a reverential enthusiasm in the presence of her sublimer aspects. A more mature love adds to this a holy regard for her minuter forms and more insensible phases, and is filled with the feeling that

> "The meanest flower that blows can give
> Thoughts that do often lie too deep for tears."

There may then be two tendencies in landscape art, representing these two moods in the contemplation of nature—tendencies which are not at variance with each other, and which may, and indeed often should, co-operate.

But there is still another tendency. Nature is not stationary; nature is growth, development. And there are moments of hers when especially she seems to project the mind of the beholder beyond herself into a realm of infinite power and promise. Such moments as these the poet-artist, of imagination all compact, seizing, transfers to canvas.

"National Academy of Design," Watson's Weekly Art Journal, *June 10, 1865.*

It is with no slight sense of relief that we take our leave of the landscape element of the Exhibition. We gave it our first attention because it thrust itself most prominently upon the view by reason of the spread of canvas and the flash of color. The task has not always proved a labor of love. A few pictures have, indeed, afforded us genuine satisfaction, but the general effect has been feverish. Under the influence of the hothouse atmosphere these walls engender, we have at times been almost driven to doubt whether landscape-painting is not, at the best, a weak and unholy mimicry of the awful nature, or we have wondered whether earth, water, and cloud are not, after all, just so much earth, water, cloud. It is only when we have come again under the open sky and have soothed the inflamed sense with the contemplation of the stray bits of country our open squares afford, that we have regained a healthy state of mind.

In truth, work flowing from a self-forgetting love, is seldom to be seen in our exhibitions. We have much of picture-making, little, almost naught, of landscape art. And whose is the fault? It is yours, O Public. A devotee of fashion, you hear of certain names of successful makers, and you buy pictures of them to ornament your bran new parlors—pictures for which you care not in the least. Thus, under the name of artists, certain upholsterers are maintained in the exercise of their trade. You do not care for nature; a tree is to you not much more than so many cords of wood. You do not, therefore, ask of the picture you buy that it worthily suggests to you—that for which you have neither knowledge nor love. You purchase because landscape furniture is fashionable now-a-days, and the name of the maker who supplies you stands among the first. Ah, if you would only buy what you know and have a heart for—painted robe, or wine flask, or loin of beef, or horse, or dog, we should have these done well. Then indeed we should be relieved of this surfeit of parti-colored hills, and trees, and skies; and the genuine artist, addressing himself to the lovers of nature, would stand forth her interpreter and priest. Dear pub-

lic, will you not take a fancy to some other kind of furniture—a kind that does not dignify itself with the name of art?

"The National Academy," New York Evening Mail, *April 15, 1868.*

Church and Bierstadt and their fellow-artists have done all for American art that they will do. Their genius has been felt, and its influence, good or bad, is at work. What they may yet do will only multiply their pictures, and with them multiply their merits and their faults. As to whether they die to-day or to-morrow, American art, as a profession, has little interest. As men, indeed, they may not have passed the prime of life. As artists they have fully reached it, and they now move, upon a high plane, perhaps, but still upon a level. It is to younger men, younger in artistic reputation, we mean, to whom we must look for future development and progress; and it is the ambition, the taste, the tendency, of this still "young" class of artists that gives so much greater interest to this exhibition than that of last winter possessed.

When we compare the collection now at the Academy with European art, it is not a satisfactory one, whatever embryonic interest it may have. We have already asked the question— do American artists think? We asked it after a tour through Mr. Avery's[3] collection of French and German paintings. After a tour through the Academy yesterday, we have an unsatisfactory answer to make. We cannot answer "no"—we can simply say "they are beginning to think." In this, be it understood, we ignore the landscapes. We do not care at present to discuss the question, how much of what we call "thought" in art is required in landscape painting. That question approaches the metaphysical, and we shall always avoid it. When we call for more "thought" we do not care to have the landscapist pay the least attention. But in all that pertains to, and so particularly interests, human nature, as *genre*, historical, plain figure, and "heroic" painting, this exhibition, like all that have preceded it, is lamentably deficient. It is one of the most encouraging in this respect which we have had, if not, indeed, the best; but we have compared it with the efforts of European artists, and not with those of our own. There are a few very strong and very suggestive pictures. There are a few more which evince an effort to be so. There are several others which are very weak; and take them all together, the pictures of this class offer but a pitiable and unsatisfactory view of the branch of American art which they represent. This particular subject is one of so much interest that we shall give it our entire attention in another article.

CIVIL WAR

THE WAR AND THE ARTIST

No aspect of American culture and society was untouched by the Civil War (1861–65). The war bifurcates the nineteenth century. Its horrors quickly made the sunny optimism of the Jacksonian era seem quaint and naïve, just as its mass carnage and mechanistic methods of battle introduced the nation into the cold, troubled, modern world. The bloody toll of the conflict—nearly a million casualties—seemed unimaginable (more Americans died in the Civil War than in all the other wars fought by the United States, combined). What was the place of art in such an upheaval? For some it was a refuge.

[3] Samuel P. Avery was an early art dealer specializing in European painting.

"It has been a peculiar relief to turn aside from the harassing cares of the time, to be calmed and refreshed by the placid charm of Art," wrote a critic in Harper's New Monthly Magazine in June 1863. Yet such an attitude could scarcely be maintained in the face of the shocking photographs being sent back from the front, or even the milder reminders of the war such as Winslow Homer's illustrated Campaign Sketches or John Rogers's plaster group, "Wounded to the Rear"—One More Shot (both 1864). In the war's aftermath, critics would be able to discern its effect on all manner of painting and sculpture, but at the time artists and writers alike struggled with the question of how the nation's art might emerge from the dark days of the early 1860s.

As the first Union regiments were organized in 1861, the art press wondered if artists would be involved in battles, either as combatants or as recorders. Some artists did, in fact, enlist, including James Beard, James Wells Champney, Frederick S. Church, Sanford Gifford, and Jervis McEntee. In an excerpt below, the National Academy's vice president, Charles Cromwell Ingham, a portraitist filling in for the recently resigned president, Asher B. Durand, worries that the distractions of war will erode support for the nation's artists. The Crayon, reporting that artists are, in fact, going to the front, suggests a variety of subjects for their brushes. And in a much longer essay, Mrs. J. H. Layton fans the flames of nationalist sentiment and argues that art and patriotism be conjoined, especially in the sphere of genre painting.

Just a few years later, the ability of art to serve the cause of war would be called into question. The eccentric German American artist John Frankenstein published a 112-page poem "Written during the Third Year of the Great Rebellion, 1863–4." He actually criticizes a great variety of issues and actors in the American art world, but his lines on the Civil War are particularly dark. While the conflict rages, and with the fate of slaves still in question, he asserts that the fine arts should be put aside; their "universal language" is "understood by none at all."

Charles Cromwell Ingham, presidential address, National Academy of Design, May 8, 1861.

I cannot congratulate the Academy on the present state of the fine Arts. The great rebellion has startled society from it propriety, & war, & politics, now occupy every mind. No one thinks of the Arts, even among the Artists, patriotism has superceded painting, & many have laid by the palate, & pencil, to shoulder the musket. Union for the country, is the word on every lip, & the feeling in every heart. Let us not however, in our love of Country, forget our love of Art, nor forget that if union is good in the nation, it is also good among the Artists, & as unity in a nation is absolutely necessary to command the respect of mankind, so a united body of Artists, is equally necessary to obtain the respect of society.

"Postscript.—Artists Going to the Seat of War," Crayon 8 (May 1861).

One might vulgarly suppose that the artists would be the last class in the community to perform military service. When duty calls them, however, they can show the fire of patriotism and self-sacrifice as well as any other body of citizens. We can but hastily allude to those who have already shouldered the musket, and are now on their way to Washington. Capt. Shumway, of the favorite N.Y. Seventh Regiment, is first to be mentioned, under the banner of which most have assembled. We hear of painters—among them Gifford, J. M. Hart, Whitredge and Baker; engravers from the two Bank-note companies; and architects—Clinton, Congdon, and some whose names as yet only float on the sea of rumor.

A period of civil war is not usually a harvest time for artists. Carried away by the needs and impulses of the hour, with the anxieties and cares, the losses and bereavements which follow in its train, few people remain sufficiently withdrawn from the popular movement, to bestow much attention upon the peaceful works of artists. War is destructive; art is constructive.

It is impossible to walk the streets or to cross the rivers in our ferry boats, without witnessing scenes which would make most effective groups for the pencil. The parting of friends; the enlisting rendezvous; the return of the slain of Baltimore to their homes; the faces of eager recruits and earnest debaters. On the departure of the Seventh Regiment, we observed a very pleasing incident that would make a good picture. One of the soldiers, in the midst of that great parting scene, looked sad and lonely—no one seemed to know him, nor was he able to see any one he recognized; his brothers in arms, on either hand, were bidden an affectionate adieu by near friends, but no one spoke to the solitaire, when a kind-hearted lady who had been watching him, just as the regiment was ordered to move on, threw him her own handkerchief, with a ring attached. The surprised and grateful look of the soldier, as he waved it with a cheered heart but tears in his eyes, may well be imagined.

Mrs. J. H. Layton, "American Art," Knickerbocker 68 *(July 1861).*

Little or nothing is now being done in the studios; many of our artists have shouldered the musket and gone off to the wars: yet it needs no prophet's ken to foresee that American art will arise from out this political chaos rejuvenated and soar aloft on the expanded wing of the American eagle. This same old eagle, by the way, has had too long a rest, and it is high time he addressed himself to a *coup d'œil*[4] of the most glorious country the sun ever shone upon.

It is not often in the *mêlée*, in the strife, that art is perfected; it is rather after the turbulent spirit has subsided and the waves of commotion have sobbed themselves into placid rest, that we may expect to realize the beneficial effects of this wholesome electric shock upon national art.

We make bold to urge upon the public the necessity of American art. *'Il n'est pas une luxe— il est une necessaire:'*[5] the famous rejoinder of Hortense to the busy-body who affected to pronounce upon the superfluity of the *morceaux de vertu* of her boudoir. Apply it to national art. The love of art is the constant craving of the individual soul for those expressions of beauty, truth and goodness so replete in the handiwork of the Creator; a taste for something better than what is merely of the earth, earthy: a penchant for those glorious talismans which out-live time.

National art is but the wholesome food for the aggregate æsthetic want of individuals expressed as one grand whole; and never was there a time in the annals of our country when art held a more important position than it now does. As the visible record of the standing of a nation speaking a universal language which the whole world understands and which will be equally legible to posterity, it is the voucher for our political integrity, the symbol of our faith, the talisman of immortality distinguishing us from barbarians. Symbolic art is the escutcheon of a nation; historic art is its record; landscape and *genre*-painting are its topography and poetry. And is it not a noble work, this catering for the æsthetic food to satisfy the craving for immortality ineradicable in the hearts of men?

[4] *Coup d'œil:* glance.
[5] "It is not a luxury—it is a necessity."

Mutation is the stamp of all things earthly; yet we none of us care to be covered with the veil of oblivion. This eternal fighting against the transitoriness of time and change constitutes the zest of strife in our ideal lives: yet an 'Old Mortality' is as much needed within our city walls to remove the dust and smoke of Mammon from our national escutcheon as to scrape the moss and lichens from the tomb-stones of our ancestors in the quiet country church-yard. And is not the thought of a grand national art sufficiently glorious to incite us to struggle on through all present trials and discomfitures in order to finally compass so great a blessing?

Yet these are perilous times for our artist *confrères*. In hours like these, when even moneyed men feel poor, when nothing is ordered, nothing bought, there must necessarily be suffering in the studio; and the most we can do is to open our galleries for the exhibition of their works, our pages to speak a genial word of encouragement and hope, and our hearts to a liberal out-flow of fraternal sympathy—for art and literature go hand in hand. So we bid our *confrères* of the palette and chisel be of good courage and struggle on, as *we* are struggling. A good time *is* coming for us all as sure as the glorious 'Stars and Stripes' are to forever wave above the old Capitol. American Artists: Be National! Rest not satisfied with the rendition of the art of other nations, but depend upon your own identity for immortality. This is the duty you owe the past, the present and the future: it is the duty you owe yourselves and the goddess whom you worship. Frenchmen, Italians and Germans, we welcome you to our shore; but deem not that you have come hither to paint the 'decadence of Rome:' we have no models for you.

Dare to be National! Honestly evolve the spirit, the *genus loci* of the country in which you live. Be true to the indigenous poesy of the soil which cherishes you. Tell some story, record some sentiment which shall fix upon the page of immortality the date of your nativity. By na-tional art we mean the expression of national poesy: and whose fault is it that national art has been no more fostered? We grieve to say that it has been the fault of the American people that they have not *felt* more national. In our greedy pursuit of the 'almighty dollar,' we for a time forgot that we had a country; but it is so no longer. Next, it is the fault of those who have as-sumed to patronize the fine arts; who pay six thousand dollars for a Meissonnier, but who will not pay six thousand cents for an American *genre*-painting. But shall we *for gold* prostitute our nationality and become the mere servile copyists of the French and German schools, because they are *a la mode?* Have we no individuality—no nationality? A question it is scarcely *safe* to ask amid yon waving banners and beating drums, marshaling troops to the defence of The Union.

> Tramp! tramp! tramp!
> A thousand men or more:
> They come like the surging billows
> That beat on the rocky shore!
>
> 'Now hand me down the rapier
> Burgoyne gave up to Gates,
> When Albion said to the Union:
> 'Be independent States!'
>
> 'Go, fetch my rusty rifle,
> My moth-eaten coat of gray,
> And put up my palette and brushes,
> No more can I paint to-day.'

Abandoned the palette and brushes,
 The 'mahl-stick' rests on the floor,
As the artist onward rushes
 With a thousand men or more!

Tramp! tramp! tramp!
 A thousand men or more:
They go, like the surging billows,
 That ebb from the rocky shore.

But have we no National Art? Go to the Governor's Room, City Hall: see the revered shades of the 'Heroes of the Revolution,' our 'Statesmen' and 'Warriors;' are they not worthily limned? In the historical *genre* we rank first among the nations of the earth, young as we are in history. See the works of Trumbull, Vanderlyn, Weimar, the venerable Sully, yet living; the elder Jarvis; Catlin, Waldo and Jewett; Inman, Jarvis, Elliott, Huntington, Hicks, Morse, Gray, Mooney, Page, Kellogg and a host of others. And in sculpture, are we so far behind other nations that it can be said we have none? Is not the very presence of *Le Pere de la Patre* in our council-hall a sufficient answer?

The public has a penchant for the landscape *genre*. None need be told that Church is great—that he is national. Has he not given us his 'Niagara' and his 'Heart of the Andes,' and is he not treating us this summer with his refrigerating 'Iceberg?' How those dazzling mountains of ice freeze into the very soul, awing us with the mystic revelations of another sphere! And G. L. Brown, though he has loitered long in the Land of the Vine, comes to us at last with his heart in the right place, and gives us the 'Harbor and City of New York,' the 'Crown of New-England,' and 'Niagara by Moon-light.'

But it is not alone in the historical and landscape *genres* that we must search for the individuality of a nation.

We detect *à l'instant* a French, Italian or German *genre*-painting at a casual *coup d'œil*. Its nationality is insensibly enwrought among the very pigments, becoming inseparable from it. But where, save in the historical and landscape *genres,* can we detect American poesy? And why is this? Must we again ask: have we no nationality; no *manière d'être;*[6] no priceless individuality to evolve and enshrine? . . .

'At the Spinning-Wheel,' a cabinet gem by a celebrated French artist, a few years ago, brought many thousand francs. Are not *our* spinning-wheels as good models as the French? Are they not as eloquent in their latent poetry? Who will elicit it? There is now in the archives of the New-York State Agricultural Society, in Albany, a curious spinning-wheel, presented by Mrs. Eleanor Fry, upon which she spun twelve linen cambric handkerchiefs, equal in quality to those of European manufacture; and lawn of a fine quality, of which were made dresses. To us, this is a theme worthy of the artist's canvas or the poet's lyre. And must we go to the *past* for themes of poesy? . . .

Say you we have no fit subjects for *genre*-painting? Who is our Hübner, to seize the eloquent brush fraught with latent power, and depict the 'Relief of the Kansas Sufferers?' That memorable scene enacted at Atchinson, Kansas Territory, described by General Pomeroy, in his letter of thanks to Mr. Bryant, Chairman of the Committee of Relief; when a father and his three

[6] *Manière d'être:* way of being.

sons, after journeying thirty miles with their cart and oxen, arrived almost famished, and nearly destitute of clothing; and upon being warmed, and clothed, and seated at a plentiful table, they all wept, *because mother and sisters were starving at home!* Here is a subject rife with as much pathos as the 'Poor Weavers of Silesia,' which threatened a political revolution, and was banished Germany by a *coup d'état* . . .

Why should *genre*-painting not succeed with us? Have we not as venerable sires, as glorious types of manhood, as dignified matrons, as noble youth, as beautiful maidens, and as lovely infants as other nations? Then, why should there be a dearth of the *depeinture* of the poesy of American homes? Why go to Europe for models when we have them at our own threshold? Our forefathers made sacrifices in subduing and settling this goodly soil, and it is for their children to perpetuate their spirit by fostering American Art. Let the public set the example of patronizing *genre*-paintings of the American brush, and we will give them a national art to be proud of. We have artists of merit silently struggling in our midst to evolve great thoughts. AMERICANS! will you leave them and their families *to starve;* or worse than that, to *prostitute our nationality for bread?* ART-PATRONS! would you evince your patriotism? lay your gold on the shrine of your country by placing it in the hand of the struggling American artist. ARTISTS! yield not up the sacred heirloom committed to your charge for a mess of pottage; remember that your eloquent brushes are recording the history of a nation.

It is high time we came out boldly, and declared the INDEPENDENCE OF AMERICAN ART!

John Frankenstein, American Art: Its Awful Altitude *(Cincinnati, 1864).*

If great men are so wrong and are so weak,
When, where, for better things shall we then seek?
Or does the common herd in common sense,
Seem for less mind to find a recompense?
No matter: now occasion is at hand,
To try the People in supreme command,
And they have done well so far; therefore friend,
Drop palette, brushes, here a hand now lend—
To make and keep men's freedom pure and stable,
This cause needs all, all who are willing, able.
How many are there now this cause to flout—
Come! come! be at them! put them to the rout!
The President freed slaves by proclamation,
And that must be sustained by this great Nation.
Of the Supreme Court there need be no fear,
For if the People speak that court must hear.
Let all then go to work; now is the time;
To be indifferent to this cause is crime.
 In such a crisis where are Fine Arts, ah!
Seem they not then a great and wild *faux-pas?*
Till all get leisure, industry, desire,
To see the beauteous, exquisite attire,
The world we live in wears—until the soul
Can do without bread, shelter, clothing, coal,
Till then the Fine Arts are from life apart;

E'en if you're rich, they may still crush your heart!
A universal language you would call
That which is understood by none at all?
To feel that no one wants what you can make,
May sometimes e'en the stoutest spirit shake;
At times her influence so soothing, tender,
Nature refuses utterly to render.
Niagara I love, yet all its power
Could not illume for me the horrid hour.

A SOUTHERN VIEW OF THE ARTS DURING WAR

In the Civil War era there were many more artists in the North than in the South, and the view of the arts at the time tends to be dominated by the Union perspective. Still, writer Samuel Davis considers the place of the fine arts in the southern states in the following essay, even as he apologizes for doing so during the great conflict. Southern exceptionalism was prevalent at the time, and Davis takes pains to identify a particular attitude toward art in the "temple of our Southern nationality" (see also "Art in the South," chapter 8). He calls for a monument to the Virginian, George Washington, and hopes for an umbrella organization to foster art in the South. Strangely, he also writes about morality in art, praising by way of example Hiram Powers's The Greek Slave, *a statue many contemporary viewers saw as a sermon against slavery (see "Hiram Powers's* The Greek Slave," *chapter 5).*

Samuel D. Davis, "The Fine Arts at the South," Southern Literary Messenger *36 (November–December 1862).*

It may, perhaps, appear unseasonable, at this particular period of our history, to call attention to the subject here proposed. For, as the arts have been seen to flourish only in times of great social prosperity and quietude, when the mere satisfying of the physical wants no longer controls the application of thought and labor, and the mind has leisure to abandon the busy field of practical life, in order to devote some attention to its own peculiar interests, it might be supposed that the present disturbed and anxious condition of the public mind, would be ill adapted to encourage any pursuit of a purely intellectual character.

In view, however, of the immense value of the arts, as an agency of general civilization, we may be pardoned for giving them more prominence than they may seem to merit, at this early stage of our national career . . .

Unfortunately, we have not enjoyed a season of repose sufficiently long to permit the character of our people to mirror itself in a general sentiment respecting the arts. The natural temperament of the Southerner, however, seems to resemble that of the Roman, rather than the Greek. It may be described as strongly objective and emotional, and we see these traits exhibited in his high sense of honor and the readiness with which he realizes it, in resenting an injury, or indignity; and in those humane and generous sensibilities, which give practical existence to his well-known courtesy and hospitality. So much may be said of those in whom the Southern character has reached its fullest development.

But its æsthetical tendencies and capabilities have recently manifested themselves in a form which cannot fail to excite a profound interest in their future progress and results. Who has not been gratified at the exhibitions of poetical talent, which have lately appeared among us,

stimulated as it has been by the inspiration of the mighty events now in progress and expressed with all the fervor and energy of real intensified feeling? Whether in arousing the fiery spirit of heroism, or awakening with gentler touch the tenderest chords of human sympathy, we recognize in it the very essence of true poetry, the sincere and spontaneous utterances of nature itself. Indeed, it seems to be the inauguration of a new era of poetry, or rather a return to that simplicity, pathos, freshness and vigor which are blended with such irresistible effect in the compositions of the earlier Grecian poets, and particularly in those of Homer. Far removed from the cold artificiality of Northern taste, which sacrifices the living feeling in its effort after elaborate forms of expression, our poetry presents itself in a garb of the utmost delicacy and transparency, resembling rather the light and graceful drapery of an antique statue, than that superabundance of dress and ornament, which modern fashion has invented, to conceal and distort the perfect model of nature . . .

If we are to be a cultivated, and at the same time, a warlike people, then the arts become the most appropriate and efficient auxiliaries of science in accomplishing this twofold purpose. Nor need they want for inspiration. The present grand and striking manifestations of human power and feeling, have already furnished abundant themes, deserving the highest embellishments of poetic genius; for poetry, in its fullest sense, is "the music of man's whole manner of being," and its beautiful creations will have, for the future citizen of the republic, a far more intelligible significance, a far more direct and penetrating influence upon the feelings, than all the force that argument and eloquence can ever command. A monument to Washington, for example, will do more to perpetuate the remembrance of his virtues, and preserve the affection and veneration which they naturally inspire, than the most elaborate eulogies of the historian; and for the obvious reason, that nothing so deeply impresses the ordinary observer, as what addresses itself immediately to the senses . . .

But art may be prostituted from its noble calling, and become the minister of low and degrading passions. The artist has, therefore, a sacred trust, a vast responsibility, and well has he fulfilled his duty when, by the power of his genius, he subdues the impulse to sensuality, by proving the superior worth of chaste and spiritual beauty. Who can look upon that exquisite conception, the "Greek Slave," and forget that he sees only the beauty of innocence and purity in a situation most capable of exciting the deepest emotions of sympathy and love? . . .

But it was not our purpose to attempt a treatise on æsthetics. We set out with the intention of recommending the establishment, at the South, of an institution devoted to the encouragement of the arts, founded on a popular basis, but administered by individuals whose taste and judgment qualify them for such an office. Institutions, known in Europe by the name of Art-Unions, have been found to contribute more to enlarge the province of æsthetics and disseminate an improved and appreciative taste, than any other means that have yet been applied. Without intending to offer any original or fully developed plan, we think an institution combining the following general features, would probably answer the object to be attained.

Firstly, an association of individuals formed for the purpose of encouraging and supporting the arts, by pecuniary means to be derived from voluntary contribution, and employed in purchasing such artistic productions as have been approved and recommended by competent judges, such productions to be distributed among the members of the association, or retained collectively, as a common stock. The advantages of such a society are obvious. It encourages the aspiring artist, by assuring him that his success and reputation are not dependent upon the uncertain humour of the public, and invites him to enter upon his noble calling, by pointing him to those who are bound to recognize and reward his merits.

Secondly, the formation of societies of artists, within their respective departments, with a view to inspire that esprit du corps, which dignifies the common purpose, developes a reduplicated zeal and activity in its prosecution, and, in general, renders all combined exertion so infinitely superior to isolated individual effort. It was by mutual interchange of opinion and harmonious co-operation among philosophers, that the most splendid achievements of modern science have been made, nor will the same principle fail in its application to matters of taste.

Thirdly, stated public exhibitions of art-productions, in order to popularize the influences of taste, and stimulate the artist to his best exertions. The desire to excel in these public displays of taste and skill, affords the very best guarantee that he will not permit his art to become degraded in his hands, but will rather endeavor to present it in its noblest and most spiritual aspect. For the true artist instinctively shuns the vulgar, and aspires to the noble and the pure.

Fourthly, the award of premiums, to be paid from the treasury of the association, independently of the price of the article to be purchased, as a gratuitous tribute to the genius of the author . . .

It is not expected that the considerations suggested by our subject, will be viewed as at all practicable at the present time; but when we shall have succeeded, under the divine favor, in emancipating ourselves from the degraded and degrading despotism that is now seeking to force its chains upon us; when we shall have the proud consciousness that, through our own unaided efforts, we have rescued our liberties from the grasp of the usurper, and enshrined them in the inviolable and indestructible temple of our Southern nationality, then may our people, confident that the strength and valor which preserved them once, can preserve them through all time, commence the grand movement that shall carry them to the most conspicuous height of moral and intellectual dignity.

PHOTOGRAPHS OF ANTIETAM

It is estimated that more than one million Civil War photographs were taken during the four years of the conflict. No event since the invention of photography had played such a momentous role in American life, and as a result the war prompted the most extensive visual archive yet undertaken in the United States. Cameras and collodion wet plates were not sufficiently advanced to capture battlefield action, but photographers such as Timothy O'Sullivan and Alexander Gardner trained their lenses on the aftermath, the human detritus littering the fields of Gettysburg and Antietam. President Abraham Lincoln had himself viewed O'Sullivan's images of Gettysburg prior to writing his Gettysburg Address in November 1863.

In the following two accounts of the photographs of the dead of Antietam presented by Mathew Brady, one senses the struggle to deal with horrific visual information of a type never before seen. The reviewer of the New York Times *contrasts the experience of reading newspaper lists of the fallen and actually seeing their lifeless bodies. For the writer, the intensity of the visual experience ("a terrible distinctness") vies with the perverse seductiveness of the imagery ("a terrible fascination"). Oliver Wendell Holmes (see "Oliver Wendell Holmes on Stereographs," chapter 5, and "The Photograph and the Face," this chapter), who had himself visited Antietam four days after the battle, tries to imagine how these photographs will be looked at, how they will be "used" in later years. He clearly understands their power to teach, which he contrasts with the more conventional visual rhetoric of history paintings.*

"Brady's Photographs," New York Times, *October 20, 1862.*

The living that throng Broadway care little perhaps for the Dead at Antietam, but we fancy they would jostle less carelessly down the great thoroughfare, saunter less at their ease, were a few dripping bodies, fresh from the field, laid along the pavement. There would be a gathering up of skirts and a careful picking of way; conversation would be less lively, and the general air of pedestrians more subdued. As it is, the dead of the battle-field come up to us very rarely, even in dreams. We see the list in the morning paper at breakfast, but dismiss its recollection with the coffee. There is a confused mass of names, but they are all strangers; we forget the horrible significance that dwells amid the jumble of type. The roll we read is being called over in Eternity, and pale, trembling lips are answering to it. Shadowy fingers point from the page to a field where even imagination is loth to follow. Each of these little names that the printer struck off so lightly last night, whistling over his work, and that we speak with a clip of the tongue, represents a bleeding, mangled corpse. It is a thunderbolt that will crash into some brain—a dull, dead, remorseless weight that will fall upon some heart, straining it to breaking. There is nothing very terrible to us, however, in the list, though our sensations might be different if the newspaper carrier left the names on the battle-field and the bodies at our doors instead . . .

Mr. BRADY has done something to bring home to us the terrible reality and earnestness of war. If he has not brought bodies and laid them in our dooryards and along the streets, he has done something very like it. At the door of his gallery hangs a little placard, "The Dead of Antietam." Crowds of people are constantly going up the stairs; follow them, and you find them bending over photographic views of that fearful battle-field, taken immediately after the action. Of all objects of horror one would think the battle-field should stand preëminent, that it should bear away the palm of repulsiveness. But, on the contrary, there is a terrible fascination about it that draws one near these pictures, and makes him loth to leave them. You will see hushed, reverend groups standing around these weird copies of carnage, bending down to look in the pale faces of the dead, chained by the strange spell that dwells in dead men's eyes. It seems somewhat singular that the same sun that looked down on the faces of the slain, blistering them, blotting out from the bodies all semblance to humanity, and hastening corruption, should have thus caught their features upon canvas, and given them perpetuity for ever. But so it is.

These poor subjects could not give the sun sittings, and they are taken as they fell, their poor hands clutching the grass around them in spasms of Pain, or reaching out for a help which none gave. Union soldier and Confederate, side by side, here they lie, the red light of battle faded from their eyes but their lips set as when they met in the last fierce charge which loosed their souls and sent them grappling with each other and battling to the very gates of Heaven. The ground whereon they lie is torn by shot and shell, the grass is trampled down by the tread of hot, hurrying feet, and little rivulets that can scarcely be of water are trickling along the earth like tears over a mother's face. It is a bleak, barren plain and above it bends an ashen sullen sky; there is no friendly shade or shelter from the noonday sun or the midnight dews; coldly and unpityingly the stars will look down on them and darkness will come with night to shut them in . . .

These pictures have a terrible distinctness. By the aid of the magnifying-glass, the very features of the slain may be distinguished. We would scarce choose to be in the gallery, when one of the women bending over them should recognise a husband, a son, or a brother in the still, lifeless lines of bodies, that lie ready for the gaping trenches. For these trenches have a terror for a woman's heart, that goes far to outweigh all the others that hover over the battle-field.

Oliver Wendell Holmes, "Doings of the Sunbeam," Atlantic Monthly 12 (July 1863).

Let him who wishes to know what war is look at this series of illustrations. These wrecks of manhood thrown together in careless heaps or ranged in ghastly rows for burial were alive but yesterday. How dear to their little circles far away most of them!—how little cared for here by the tired party whose office it is to consign them to the earth! An officer may here and there be recognized; but for the rest—if enemies, they will be counted, and that is all. "80 Rebels are buried in this hole" was one of the epitaphs we read and recorded. Many people would not look through this series. Many, having seen it and dreamed of its horrors, would lock it up in some secret drawer, that it might not thrill or revolt those whose soul sickens at such sights. It was so nearly like visiting the battlefield to look over these views, that all the emotions excited by the actual sight of the stained and sordid scene, strewed with rags and wrecks, came back to us, and we buried them in the recesses of our cabinet as we would have buried the mutilated remains of the dead they too vividly represented. Yet war and battles should have truth for their delineator. It is well enough for some Baron Gros or Horace Vernet to please an imperial master with fanciful portraits of what they are supposed to be. The honest sunshine

"Is Nature's sternest painter, yet the best";

and that gives us, even without the crimson coloring which flows over the recent picture, some conception of what a repulsive, brutal, sickening, hideous thing it is, this dashing together of two frantic mobs to which we give the name of armies. The end to be attained justifies the means, we are willing to believe; but the sight of these pictures is a commentary on civilization such as a savage might well triumph to show its missionaries. Yet through such martyrdom must come our redemption. War is the surgery of crime. Bad as it is in itself, it always implies that something worse has gone before. Where is the American, worthy of his privileges, who does not now recognize the fact, if never until now, that the disease of our nation was organic, not functional, calling for the knife, and not for washes and anodynes?

SANITARY FAIRS

Artists who were not themselves combatants or war correspondents could nevertheless aid the cause of the Union by contributing to the exhibitions at Sanitary Fairs— fund-raising endeavors in support of the troops that took place in several northern cities. The largest and most celebrated of these benefits occurred in New York City in the spring of 1864. As the review makes clear, the exhibition was an opportunity not only to provide relief to the U.S. military but also to take stock of the American achievement in painting. This included the famous juxtaposition of Frederic Church's Heart of the Andes *(1859) and Albert Bierstadt's* Rocky Mountains, Lander's Peak *(1863).*

"Art Notes: The Art Gallery of the Sanitary Fair," New York Times, April 11, 1864.

The exhibition of works of art in the spacious galleries of the Sanitary Fair, in Fourteenth-street, is, beyond all comparison, the most extensive, the most choice and the most elegantly arranged that has ever been seen in New-York City. It comprises nearly four hundred oil paintings, including specimens of almost every American artist of note, together with a very large number of the works of distinguished foreign painters, some of which are of great excellence, and which are rarely or never seen away from the galleries of their princely owners. Objects of great pe-

cuniary value, they have been instructed to the dangerous keeping of the fair, with a sacrific-
ing liberality that deserves the warmest commendations of all lovers of art. The private galleries
of the wealthiest collectors of New-York and vicinity have been liberally drawn upon to enrich
this collection; and it now stands a superb monument of the art wealth of our metropolis, and
a school in which the student at a glance can trace the progress of art in his own country, and
compare it with the finest examples of the Old World.

The visitor will be agreeably surprised by the magnificence of this gallery. The recollection
of the best exhibitions in this City in past times will not enable him to preconceive the splen-
dors of this. All the pictures hang upon the walls of a single room, of vast dimensions, whose
shape is a simple parallelogram. At one glance the whole grand effect is received, and it im-
presses us with a splendor of effect, such as a visit to all the principal galleries of Europe have
failed to produce.

There is room to see the large pictures which hang upon its walls at a distance to which they
are entitled, and which has probably never before been accorded to them. In no other gallery
in this City could this important advantage be obtained. But the hanging authorities, partly
negativing these advantages, have placed the larger pictures so low that they must be seen through
the head of the multitudes that always intervene. But it is a great advance upon the intricate
labyrinth of closets and obscure passages of the rooms to which New-Yorkers have hitherto had
to traverse in seeing pictures . . .

But to the artists must be awarded the greatest meed of praise for liberality. It is no great
sacrifice for wealthy owners of pictures to loan them for a brief period for the benefit of the
suffering soldier; but when the toiling artists, many of whom have but a hard struggle for hum-
ble existence, contribute as free gifts, as they have done for this fair, sometimes several paint-
ings, which represent often many days exhaustive work, we must award them a degree of com-
mendation far above the ostentatious sacrifices of wealthy purchasers. They have been called
upon, and have liberally contributed their best works for the Boston, the Brooklyn and the New-
York and several other Sanitary Fairs. Their liberality is thus seen to be very conspicuous.

To this collection owners have loaned 153 paintings—the artists have given 207.

As the visitor advances down the gallery amid the splendid array he will detect many a gem
that has charmed his earlier days. Everywhere his eye will encounter objects worthy of his re-
gard, and he may spend weeks without exhausting the treasures of the superb collection. There
are many pictures here which have had prosperous careers of popular exhibition, and many
which have been famous in their day as gems of former annual exhibitions. Some once cele-
brated will now scarcely pass critical muster, and others hold their merited supremacy. Several
have world-wide reputations, and are valued at many thousand dollars. The whole collection
cannot be worth less than five or six hundred thousand dollars . . .

There are two pictures, hanging on opposite walls, facing each other, which have made consid-
erable noise in the American art world. We are thankful to have a chance to see them thus face to
face. They are the "Rocky Mountains," by BIERSTADT, and the "Heart of the Andes," by CHURCH.

The observer cannot fail to discern how closely they resemble each other in general effect as
well as in handling and color, and other details. Neither of them look so well here as when seen
by themselves and surrounded by all the appliances of the skillful picture-hanger. They are beau-
tiful pictures, and well deserve the stand they have taken as pioneers in the advancing stride of
American art. But they are now in company that painfully tries their merits. Perhaps they would
retain their reputation better if they had not intruded into the presence of so much splendid
art as everywhere surrounds them.

The famous painting by LEUTZE, of WASHINGTON crossing the Delaware, hangs at the end of the hall in a splendid position—WASHINGTON with the head and air of a dancing-master, stands upon the prow of the boat ready to teter ashore and dance a pirouet on the snow. It is not the patriot WASHINGTON of the American people. And as for the rest, in such a subject, who cares for the boat or the ice, how really they are painted, or how picturesque and how romantically they are arranged. They are well done—but the hero is a dreadful failure. It is a very fine specimen of the art of picture making as practiced in Germany.

DURAND, of whose works we see too little of late, is represented in this collection by several of his best works. They loom up grandly amidst the recent multitude of overstrained works, notwithstanding their modest and unpretending style, and they irresistibly assert their overwhelming excellence.

And COLE, too—how shall we thank those who have so kindly sent here these splendid works of this great master, so superb in their radiant skies of cerulean purity, and their wealth of resplendent tone and color.

So many of the better pictures of the American school are to be seen here that the collection is almost entitled to be called a historical gallery. It would have indeed been a rare chance for a review exhibition. Works by all the old and departed artists might have been obtained, and thus we should have had a chance to compare them with recent works. But, as it is, we have in the catalogue the names of BENJAMIN WEST, GILBERT STUART, COLE and others from the past, and a host of pictures by artists whose early works are so old, as, in the hurry of this new world, to be called historical.

HISTORY PAINTING AND THE WAR

It is incorrect to say that the Civil War produced no notable history painting. Evidence to the contrary is found in the works of James Beard, A. F. Bellows, Albert Bierstadt, Edwin Forbes, Sanford Gifford, Edward L. Henry, Winslow Homer, George C. Lambdin, and Henry Mosler, among others. Yet it is true that few Americans painted the kind of dramatic battle scenes that had glorified the military exploits of Napoleon and set the standard for such imagery earlier in the century. For many, the "glamour" of swordplay and cavalry charges evaporated in the face of a new kind of slaughter on an industrial scale. Yet critics refused to give up on history painting, as is the case with Clarence Cook, who, while acknowledging Eastman Johnson's contribution, laments the fact that "foreign artists" such as Constant Mayer have stepped in to fill the breach. After an introductory examination of the lack of figure painting in American art, the critic of Watson's Weekly Art Journal *also discusses Mayer's work, in this case* North and South—An Episode of the War *(1865), which depicts a Confederate combatant kneeling above a dying Union soldier. Writing just two months after the surrender of the South, the author uses the occasion of Mayer's painting to address Reconstruction politics, bias against non-American artists, and institutional racism at the National Academy of Design. Two years later, a writer in the* New York Herald *concludes that the heroic painting of the past is no longer possible in the modern, postbellum age.*

[Clarence Cook], "Painting and the War," Round Table 2 (July 23, 1864).

One of the most remarkable circumstances connected with the existing war is the very remote and trifling influence which it seems to have exerted upon American art. The illustrators of the

pictorial newspapers have been active, and the spirited groups of Rogers show that he has had an eye to the dramatic aspects of the great struggle; but the chief body of our artists have gone on painting landscapes and genre pieces and portraits, as if the old peace had never been interrupted. The few who have illustrated episodes of the war have selected those of a grotesque or humorous character, or occasionally those appealing to the sentimental or pathetic springs of the heart. We scarcely remember anything large in manner or dramatic in feeling from an American painter, with the exception of Eastman Johnson's cartoon, exhibited last winter. Pictures like Lang's "Return of the Sixty-ninth Regiment," of which, fortunately, few have been produced, are scarcely worthy of serious criticism. It is not now our purpose to inquire why Americans, of all others the most interested in the bloody drama daily enacting before their eyes, should neglect subjects so suggestive and effective, and which, from their knowledge of local scenery and national character and habits, they ought to be best able to illustrate. Such is, however, the fact, and it is therefore with less surprise than regret that we see foreign artists eager to undertake what we appear indifferent to. Pictures like Constant Mayer's "Consolation," which attracted so much admiration at the last Academy exhibition, or Hubner's "God save the Union," should have emanated from our own countrymen, and it is a lasting reproach that men foreign to the soil, and who cannot feel the deep interest that we do in the rebellion, should be the first to show what themes for illustration it affords.

"National Academy of Design," Watson's Weekly Art Journal 3 *(June 17, 1865).*

Man is undoubtedly the highest product of Nature. To paint him worthily must therefore require the highest order of genius. But why in this country, if our readers will pardon a brief preliminary inquiry, why have we displayed so little genius, and so little predilection for the portrayal of human character? Perhaps it is because the study of nature, rather than of man, is in harmony with the spirit of the age. Science, the dominant power of the day, leads forth the mind into the natural world; it familarizes it with the tree, the flower, the rock, the cloud; it finds sermons in stones. It is true, it deals too with man, but with men as a member of society, as a component part of vast organizations. It subordinates the individual to the race. Art, on the contrary, subjects the race to the individual; it brings forth the hero as typifying the virtues, the vices, the passions of mankind; it sums up and embodies the macrocosm in the microcosm. From this scientific spirit of the day arises the devotion of our countrymen to landscape painting. But science cannot be restricted to the so-called natural world. It is already invading with success the domain of psychology. When it shall have more fully explored this realm, then doubtless the desire and the genius for worthily depicting man in all his varied relations, in all his kingliness, will receive a wide extension. The basis of the art of the future is laid in the rapidly developing science of to-day.

But still another reason may be given, why we at the present day show so little genius for the portrayal of man—a reason, however, which, on closer inspection, will be found to resolve itself into that already given. At whatever epochs of the past, man has been rendered in a manner to appeal powerfully to the sympathies, some one form of religion has ruled supreme. Through the necessary anthropomorphism of the human mind, a genuine religion revolves about some ideal or ideals of humanity. Art gratifies the longings and aspirations that have these ideals for their object by embodying them to the sight. Thus was it under the classical polytheistic regime, thus was it in mediæval times. But now we live in a revolutionary era; we are passing from the old spirit of the middle ages to some new and more universal mood of mind that has not yet fully declared itself. Hence arises the mixed character of the art of the day. We are

all afloat. We wish to paint—we don't know what to paint, we have no certain ideals. Sometime we depict a Venus, sometimes a medieval saint. The treatment is equally varied, sometimes classical, sometimes romantic. No all-controlling religious spirit determines the choice and the handling. We paint what we will, not what we must.

Shall Art, then, lie still and wait! Is there nothing for it to do in the interregnum? Let it work on. If only to seek to do, not its own will, but the will of the Father, it may perform a noble part in the evolution of the new spirit. Every new phase of development is of slow growth. The highest art of to-day is that which, recognizing the on-coming power, subordinates itself to it, neither attempting to anticipate, nor willing to lag behind. Of such a character as this do we esteem that recent tendency, which has unfortunately called itself Pre-Raphaelite. There is in it the beginning of a new religious art, before the glories of which the splendor of the past shall dim.

Perhaps the one great feature of the new art, will be the emphatic recognition of a common brotherhood, extending beneath all differences of race or opinion . . .

[In] harmony there with is Mr. Constant Meyer's painting, entitled "North and South" . . .

Mr. Meyer bids us remember that the men of the South, though they have erred are yet our brothers, that all differences of opinion, of feeling, belong to the surface—the moment, that the great heart of humanity beats back of all. A trite lesson indeed—yet a lesson which neither the religion (the corporate religion, we mean) nor the art of the past has consistently taught . . .

Mr. Meyer's contribution is particularly appropriate at the present time, when reconciliation and reconstruction are the order of the day. We wish those scribblers for the press, who are doing everything in their power to stir up feelings of hate among the people, who are hounding on the Government to sully the grandeur of its triumph by base acts of revenge—men who for the most part did all they could to bring the South into an attitude of rebellion, and were the most ready to cringe to it in the days of its might—we wish, we say, that men such as these could be touched by the noble sentiment of this picture.

A work like this, so lofty in its purpose, so powerful in its treatment, ought to have received the most honorable place in the rooms of the Academy. But Mr. Meyer is not an Academician, so let him as much as possible be kept out of sight! Yet surely then the Academy should itself have put forth some picture indicative of its appreciation of the grand events of the times. Shall we think it had not the ability? Then let it give place to assistance from without. Shall we think that, wrapt up in its own petty interests, it had no leisure for a liberal sentiment? In truth, we shall not then think uncharitably. An association that to this day has the meanness to exclude negroes from their exhibitions, is not likely to be animated by any noble impulse, by any response to the spirit of the times.

But Mr. Meyer labors under another disadvantage. He is, we suppose from his name, a German. Our little artists (!) do not wish any interlopers. Let these Dutchmen remain at home! Why do they come here to put to shame our pretty pictures of fashionable ladies and well-dressed landscapes? Why do they assume to divert the public attention by painting pictures inspired by the grandeur of the times? Damn the times! Damn the Dutchmen? For our own part, we recognize no nationality in art. Upon this arena let men of every nation, of every hue, enter and strive together, not emulously like children, for personal advantage, but with the noble desire of manifesting to men God's truth and beauty.

"The National Academy of Design," New York Herald, *April 29, 1867.*

Aside from one or two historical portraits and a very few other exceptions, our artists do not here evince any direct powerful influence of the late war upon their minds. But time enough

has not yet elapsed, perhaps, to invest the realities of the war with the traditional hale which catches the eye of an artist. Moreover the equality which prevails in our democratic country is by no means favorable to the heroic style. The sublime and the heroic in art belong peculiarly to the aristocratic societies in the earlier periods of their formation. Truly religious art belongs almost exclusively to an age of unquestioning belief—an age that seems everywhere to have passed away. Modern civilization restricts the artist for the most part to the beautiful; this must be his ideal. History shows that the art of painting is most extensively practised in the age of mixed plutocracy and democracy. If this stage of national life is best fitted to foster non-religious art, as a thoughtful writer has argued, we may expect to witness in the United States, and particularly in rich and democratic New York, a rapid growth both of demand and supply in the picture market.

WINSLOW HOMER'S *PRISONERS FROM THE FRONT*

The notable exception to critics' laments of a lack of Civil War history painting was Winslow Homer's Prisoners from the Front *(1866). Homer had been sent as an illustrator in the employ of* Harper's Weekly *to cover the Union army in 1861, and he was also at the front in Virginia in 1862 and 1864. Though his published wood engravings were successful, the artist much preferred working independently of* Harper's, *and he exhibited his first two Civil War paintings at the National Academy of Design in 1863. Others followed, but it would be* Prisoners from the Front *that truly put Homer on the critical map. It depicts three captured Confederate soldiers facing off a lone Union officer, with a northern infantryman in the background. The officer is Major General Francis Barlow, with whom Homer had spent time behind the lines in camp. The painting became the "picture of the season" when it was unveiled at the Academy in 1866.*

There is a certain sameness to the reviews of Prisoners from the Front, *as if the guild of art critics had made a secret pact to elect this work the single, representative visual statement of the war. From the raw battle wounds and conflicted sentiments of the recent conflict, Homer seemed to have distilled a clarion visual statement, a modern American infusion of the timeworn genre of history painting. The key to the painting, according to most reviewers, was a precise, physiognomic reading of "type": the principal players—even the causes—of the war could be read from left to right, in the faces and postures of Homer's lineup of soldiers. Still, politics had a role equal to psychology in the interpretation of* Prisoners from the Front, *as is clear from the contrasting descriptions of the Southern soldiers in the following two reviews. The last selection, a letter from artist John F. Weir to his brother Julian, indicates that just a decade after its creation* Prisoners from the Front *had already become a benchmark in American painting (see also "J. Alden Weir Writes Home about Jean-Léon Gérôme," chapter 11).*

Sordello [Eugene Benson], "National Academy of Design," New York Evening Post, April 28, 1866.

For integrity of purpose and directness of statement it would be difficult to find any work to match Mr. Homer's episode of the war ("Prisoners from the Front,") placed in the west gallery. There is a force in the rendering of character, and a happy selection of representative and at the same time local types of men, in Mr. Homer's picture, which distinguish it as the most valuable and comprehensive art work that has been painted to express some of the most vital facts of our war.

It is easy enough to place one's hand on the defects of Mr. Homer's painting, but they are defects that do not affect the veracity of his work, and scarcely touch its artistic merit; for Mr. Homer's execution, which in any other subject would be obtrusive and coarse, is admirably adapted to render episodes of war where character and positive force are in the ascendant, and where we are neither introspective nor sentimental, nor much given to the delicacies of life.

If there was a desire to encourage art, to advance it independent of the ostentation of having a work by a poor painter with a great name, Mr. Homer's picture would certainly occupy a place in the Union League Club or in the Century Club. It is a genuine example of true historical art—the only kind of historical art which is trustworthy in its facts, free from flimsy rhetoric and barbaric splendor; sensible, vigorous, honest.

The more we consider Mr. Homer's very positive work the more suggestive it is. On one side the hard, firm-faced New England man, without bluster, and with the dignity of a life animated by principle, confronting the audacious, reckless, impudent young Virginian, capable of heroism, because capable of impulse, but incapable of endurance because too ardent to be patient; next to him the poor, bewildered old man, perhaps a spy, with his furtive look, and scarcely able to realize the new order of things about to sweep away the associations of his life; back of him, "the poor white," stupid, stolid, helpless, yielding to the magnetism of superior natures and incapable of resisting authority. Mr. Homer shows us the North and South confronting each other; and looking at *his* facts, it is very easy to know why the South gave way. The basis of its resistance was ignorance, typified in the "poor white;" its front was audacity and bluster, represented by the young Virginian;—two very poor things to confront the quiet, reserved, intelligent, slow, sure North, represented by the prosaic face and firm figure and unmoved look of the Union officer.

In our judgment Mr. Homer's picture shows the instinct of genius, for he seems to have selected his material without reflection; but reflection could not have secured a more adequate combination of facts, and they that think more must admit this natural superiority which enabled the painter to make his work at once comprehensive and effective . . .

So much for the *meaning* of Mr. Homer's work and its relation to our national life; as an example of painting it is simply and strongly painted, a little black in color, a little rude in execution, but vital, vigorous, and with no defect of manner which Mr. Homer may not conquer.

"Editor's Easy Chair," Harper's New Monthly Magazine 33 (June 1866).

"Prisoners from the Front," is to many the most thoroughly pleasing picture in the Exhibition. It is not large, but it is full of character and interest. A group of rebel prisoners confront a young Union General, who questions them. The central figure of the group is a young South Carolinian of gentle breeding and graceful aspect, whose fair hair flows backward in a heavy sweep, and who stands, in his rusty gray uniform, erect and defiant, without insolence, a truly chivalric and manly figure. Next him, on the right, is an old man, and beyond him the very antipodal figure of the youth in front—a "corn-cracker"—rough, uncouth, shambling, the type of those who have been true victims of the war and of the slavery that led to it. At the left of the young Carolinian is a Union soldier—one of the Yankees, whose face shows why the Yankees won, it is so cool and clear and steady. Opposite this group stands the officer with sheathed sword. His composed, lithe, and alert figure, and a certain grave and cheerful confidence of face, with an air of reserved and tranquil power, are contrasted with the subdued eagerness of the foremost prisoner. The men are both young; they both understand each other. They may be easily taken as types, and, without effort, final victory is read in the aspect of the blue-coated

soldier. It will not diminish the interest of the picture if the spectator should see in the young Union officer General Barlow.

John F. Weir to Julian Alden Weir, July 22, 1875, in Dorothy Weir Young, The Life and Letters of J. Alden Weir (New Haven: Yale University Press, 1960).

I think the *picturesque* merely, belonged to the last century rather than to this. Artists then sought material that *made a picture* rather than a theme that pictorial expression made vivid to the mind and the higher faculties. Winslow Homer's *Prisoners from the Front* was in the true sense a contribution to Art, for although the technical execution was immature perhaps, and crude, it was vigorously in keeping with the spirit of the occasion, and the whole characteristic of the struggle between the North and the South, with the typical qualities of the respective officers and men faithfully and astonishingly rendered. This indicates the *seeing eye*, to appreciate character and the respective values that compose it, so unerringly.

RACE

SOJOURNER TRUTH INSPIRES A SCULPTOR

Born into slavery in upstate New York, Sojourner Truth gained her freedom in 1827 and spent much of her subsequent life traveling as a public speaker and ardent abolitionist. She left a deep impression on Harriet Beecher Stowe, author of the incendiary abolitionist novel Uncle Tom's Cabin *(1852). Recalling Truth as a powerful, authentically African type, Stowe imagines her as a queenly prophetess in ancient times. As related to him by Stowe, Truth's tale in turn is the germ of the American sculptor William Wetmore Story's inspiration to create his lofty figure of the Libyan Sibyl, the renowned female seer of antiquity who foretold the day when the hidden truth would be revealed. Though the motives of both author and artist are above reproach, Stowe's language reveals a deeply embedded racial bias in her evocation of "African nature" as deep, dark, hidden, mysterious, and primal—in other words, standing in radical opposition to progressive and rational white civilization. Similar in its rhetoric, the review quoted by Stowe suggests that such assumptions were an unquestioned norm.*

Harriet Beecher Stowe, "Sojourner Truth, the Libyan Sibyl," Atlantic Monthly 11 (April 1863).

When I went into the room, a tall, spare form arose to meet me. She was evidently a full-blooded African, and though now aged and worn with many hardships, still gave the impression of a physical development which in early youth must have been as fine a specimen of the torrid zone as Cumberworth's celebrated statuette of the Negro Woman at the Fountain. Indeed, she so strongly reminded me of that figure, that, when I recall the events of her life, as she narrated them to me, I imagine her as a living, breathing impersonation of that work of art.

I do not recollect ever to have been conversant with any one who had more of that silent and subtle power which we call personal presence than this woman. In the modern Spiritualistic phraseology, she would be described as having a strong sphere.[7] Her tall form, as she rose

[7] Spiritualism was a popular, quasi-religious movement emerging in the late 1840s and premised on the possibility of communication with the spirits of the dead.

up before me, is still vivid to my mind. She was dressed in some stout, grayish stuff, neat and clean, though dusty from travel. On her head she wore a bright Madras handkerchief, arranged as a turban, after the manner of her race. She seemed perfectly self-possessed and at her ease,—in fact, there was almost an unconscious superiority, not unmixed with a solemn twinkle of humor, in the odd, composed manner in which she looked down on me. Her whole air had at times a gloomy sort of drollery which impressed one strangely . . .

It is with a sad feeling that one contemplates noble minds and bodies, nobly and grandly formed human beings, that have come to us cramped, scarred, maimed, out of the prison-house of bondage. One longs to know what such beings might have become, if suffered to unfold and expand under the kindly developing influences of education.

It is the theory of some writers, that to the African is reserved, in the later and palmier days of the earth, the full and harmonious development of the religious element in man. The African seems to seize on the tropical fervor and luxuriance of Scripture imagery as something native; he appears to feel himself to be of the same blood with those old burning, simple souls, the patriarchs, prophets, and seers, whose impassioned words seem only grafted as foreign plants on the cooler stock of the Occidental mind.

I cannot but think that Sojourner with the same culture might have spoken words as eloquent and undying as those of the African Saint Augustine or Tertullian. How grand and queenly a woman she might have been, with her wonderful physical vigor, her great heaving sea of emotion, her power of spiritual conception, her quick penetration, and her boundless energy! We might conceive an African type of woman so largely made and moulded, so much fuller in all the elements of life, physical and spiritual, that the dark hue of the skin should seem only to add an appropriate charm . . .

But though Sojourner Truth has passed away from among us as a wave of the sea, her memory still lives in one of the loftiest and most original works of modern art, the Libyan Sibyl, by Mr. Story, which attracted so much attention in the late World's Exhibition. Some years ago, when visiting Rome, I related Sojourner's history to Mr. Story at a breakfast at his house. Already had his mind begun to turn to Egypt in search of a type of art which should represent a larger and more vigorous development of nature than the cold elegance of Greek lines. His glorious Cleopatra was then in process of evolution, and his mind was working out the problem of her broadly developed nature, of all that slumbering weight and fulness of passion with which this statue seems charged, as a heavy thundercloud is charged with electricity.

The history of Sojourner Truth worked in his mind and led him into the deeper recesses of the African nature,—those unexplored depths of being and feeling, mighty and dark as the gigantic depths of tropical forests, mysterious as the hidden rivers and mines of that burning continent whose life-history is yet to be. A few days after, he told me that he had conceived the idea of a statue which he should call the Libyan Sibyl. Two years subsequently, I revisited Rome, and found the gorgeous Cleopatra finished, a thing to marvel at, as the creation of a new style of beauty, a new manner of art. Mr. Story requested me to come and repeat to him the history of Sojourner Truth, saying that the conception had never left him. I did so; and a day or two after, he showed me the clay model of the Libyan Sibyl. I have never seen the marble statue; but am told by those who have, that it was by far the most impressive work of art at the Exhibition.

A notice . . . from the London "Athenæum" must supply a description which I cannot give . . .

" . . . The *Sibilla Libica* has crossed her knees,—an action universally held amongst the ancients as indicative of reticence or secrecy, and of power to bind. A secret-keeping looking dame she is, in the full-bloom proportions of ripe womanhood, wherein choosing to place his figure

the sculptor has deftly gone between the disputed point whether these women were blooming and wise in youth, or deeply furrowed with age and burdened with the knowledge of centuries, as Virgil, Livy, and Gellius say. Good artistic example might be quoted on both sides. Her forward elbow is propped upon one knee; and to keep her secrets closer, for this Libyan woman is the closest of all the Sibyls, she rests her shut mouth upon one closed palm, as if holding the African mystery deep in the brooding brain that looks out through mournful, warning eyes, seen under the wide shade of the strange horned (ammonite) crest, that bears the mystery of the Tetragrammaton upon its upturned front.[8] Over her full bosom, mother of myriads as she was, hangs the same symbol. Her face has a Nubian cast, her hair wavy and plaited, as is meet."

JOHN QUINCY ADAMS WARD'S *FREEDMAN*

The Ohio-born sculptor J. Q. A. Ward studied with Henry Kirke Brown (see "Lobbying for Capitol Commissions," chapter 5) in Brooklyn, New York, for more than five years before going out on his own at age twenty-six in 1856. Two years later he executed a bust of the ardent abolitionist congressman Joshua Giddins (Ohio), and four years after that, perhaps as a response to President Abraham Lincoln's Emancipation Proclamation (September 22, 1862), he began modeling his Freedman *(1863, fig. 7) in plaster, which debuted at the National Academy of Design and was later translated into bronze and shown at the Paris Universal Exposition of 1867. Ward's statuette depicts a heroic, seminude male slave who has broken the manacles around his wrists; it became the first American depiction of an African American executed in bronze.*

As Ward's letter makes clear, he conceived of his Freedman *as a heroic figure who was the author of his own fate. And as the following reviews indicate, his work became a critical sensation at a charged political moment, a lightning bolt of illumination from a previously unknown artist. Writers praised its naturalism and clearly identifiable racial characteristics. The word "fact" comes up repeatedly in the reviews, although the ever contrary* New Path *magazine found even Ward's plain depiction to be overly aestheticized and lacking in antislavery persuasiveness.*

John Quincy Adams Ward to J. R. Lambdin, April 2, 1863, Archives of American Art.

I shall send tomorrow or next day a plaster model of a figure. Which we call the "Freedman" for want of a better name, but I intended it to express not one set free by any proclamation so much as by his own love of freedom and a conscious power to brake things—the struggle is not over with him. (As it never is in this life) Yet I have tried to express a degree of hope in his undertaking. It is only about two feet high sitting.

"Mr. Ward's Statue of the Fugitive Negro, at the Academy of Design," New York Times, *May 3, 1863.*

With the exception of a few monumental works, the American sculptors of our day have been gravitating toward decorative art. A large majority of works of this kind are the faces or figures of pretty girls and children, out of which all traces of soul have been elaborated away in a mere aim at prettiness and mechanical finish. These emasculations, in a spirit of weak sentimentality, are called, incessantly, "Hope," "Faith," or "Innocence," to suit the pleasure of the pur-

[8] The tetragrammaton is four Hebrew characters, transliterated as IAUE or Yahweh, the name of God.

chaser, and may be changed at his sweet will, so that one statue can be made to do service for a whole gallery of sentiments. So much multiplied has this class of work become, and so ostentatiously has it been thrust before the public, that they have almost come to think that nothing better is worthy of their notice. It is not a little refreshing, therefore, to find a man who can grapple successfully with the higher requisites of his noble art.

The genuine interest and admiration which Mr. J. Q. A. WARD's work attracts is a symptom of a healthy change.

Here is the simple figure of a semi-nude negro, sitting, it may be on the steps of the Capitol, a fugitive, resting his arms upon his knees, his head turned eagerly piercing into the distance for his ever vigilant enemy, his hand grasping his broken manacles with an energy that bodes no good to his pursuers. A simple story, simple and most plainly told. There is no departure from the negro type. It shows the black man as he runs to-day. It is no abstraction, or bit of metaphysics that needs to be labeled or explained. It is a fact, and not a fancy. He is all African. With a true and honest instinct, Mr. WARD has gone among the race, and from the best specimens, with wonderful patience and perseverance, has selected and combined, and from the race alone erected a noble figure—a form that might challenge the admiration of an ancient Greek. It is a mighty expression of stalwart manhood, who now, thanks to the courage and genius of the artist, stands forth for the first time to assert in the face of the world's prejudices, that, with the best of them, he has at least an equal physical conformation.

We have seen no work of modern American sculpture which equals this in artistic ability. It is genuinely original. It has been studied from nature, not as are most American statues, in the galleries of the old world. In its individual parts, there are no plagiarisms from the Apollo. In all the galleries of ancient art, no sculptured man sits in this posture, no one embodies the same or a similar sentiment. The great forms, as well as the minuter details, are felt with all a Greek's eye for an expressive and harmonious whole. In this statue there is no skin-deep work. His muscles swell to a definite purpose, and though they cover, they still account for the underlying mechanism . . .

The fidelity to the actual, we take to be the first and indispensable condition of real influence in a work of art. Without it we can have no hold on strong minds and strong hearts: we cannot even arrest the final judges, men of reality, earnest for fact as the weapon with which they must do the work of the world. Is this negro, then, a *bona fide* negro—the "genuine article?"

The final question will be, whether he makes a good and sufficient fight. When the difficulties are fairly shown, is there yet manhood enough in the figure to overmatch them? Here is the round head, the flattened face, the air, well felt through all his energy, of long oppression before superior force—here are all the elements of his tragedy; now, is there fire enough in him to convert them all to mere fuel for the flame of heroism? Is our Negro a load or a lift?

But the significance of this figure is not narrowed by its individuality, or confined to that. This joy of escape from bondage to self-reliance; this mind divided between evasion and resistance; this determined vigilance, the guard and price of freedom, is not merely or mainly an incident of the passing day. In its largest meaning, this is the story of every exodus, and so is a piece not only of our own time and history, but of all history and of universal time.

That the figure is well placed, and, as a mere figure, is very largely, as well as accurately conceived and modeled, no intelligent student will fail to see. As a spiritual presence, a spark and kindler of imagination, while we feel we, cannot, of course, measure or define, its power, it has no prettiness or pettiness—not enough of action or incident to interfere with the full effect of character or personal and impersonal force. It is, in every respect, an effort in the right direc-

tion; an example of true, not counterfeit ideality; a work that will not dwindle or vanish before our eyes.

If the reader would see Mr. Ward's statue, let him grope his way to a sequestered alcove of the Academy rooms, where, dimly lighted, crowded into a corner, so that he may only see one side, he will find a work which, for genuine artistic aim and thorough realization, no American statue has surpassed, thrust into obscurity by a committee of artists, who hang in the best places scores of pictures that scarce deserve to be called works of art. In the nobler ages of art the sculptor was conceded the front rank, but here he is made to stand aside, that vast canvasses, crowded with poor representations of beasts, may not be lost to the sight of shoddy purchasers.

"A Letter to a Subscriber," New Path 1 *(January 1864).*

Mr. Ward is by far the best sculptor in America, and there is no man calling himself American, at home or abroad, who could have made the figure of the negro which Mr. Ward contributed to the last Academy Exhibition, but Mr. Ward himself. As a blow levelled against slavery, however, it was most ineffectual. The most pro-slavery of plantation overseers could have taken only a pure satisfaction from the contemplation of such a "splendid nigger." With such a model on his mantel-piece how his imagination would have glowed over the fancy price to be obtained for such a display of bone and muscle. Only one thing in the statue would have roused his indignation. That any blacksmith could have been found stupid enough to make handcuffs that would fall to pieces of their own accord, would have been too much for his credulity or his equanimity. His admiration for the "likely fellow" would have been over-balanced by his contempt for the blacksmith—Yankee, of course. As for any moral impression, it could never have been produced by Mr. Ward's admirably scientific performance. It requires different work from any that we have been considering, to stir the hearts, convince the minds or rouse the consciences of men.

James Jackson Jarves, The Art-Idea *(New York: Hurd and Houghton, 1864).*

A naked slave has burst his shackles, and, with uplifted face, thanks God for freedom. It symbolizes the African race of America,—the birthday of a new people into the ranks of Christian civilization. We have seen nothing in our sculpture more soul-lifting, or more comprehensively eloquent. It tells in one word the whole sad tale of slavery and the bright story of emancipation. In spiritual significance and heroic design it partakes of the character of Blake's unique drawing of Death's Door, in his illustration of the Grave. The negro is true to his type, of naturalistic fidelity of limbs, in form and strength suggesting the colossal, and yet of an ideal beauty, made divine by the divinity of art. The expression of the features is as one of the "redeemed." It is the hint of a great work, which, put into heroic size, should become the companion of the Washington of our nation's Capitol, to commemorate the crowning virtue of democratic institutions in the final liberty of the slave.

Sordello [Eugene Benson], "J. Quincy Ward's 'Indian Hunter,'" Evening Post, *November 3, 1865.*

The talk of the instructed and judicious in matters of art for the past three years has pointed to Mr. Ward as our strongest man in sculpture. He has been serious, reserved, patient. He rarely exhibited his studies, but often enough to explain his reserve and impress us with works noble in purpose, accurate in style, and thorough in execution. Two years ago Mr. Ward gave us a small model for a statue of "A Freedman," a work well known and fully appreciated. That sim-

ple and we may say eloquent statue spoke powerfully for the manhood of the negro. Through it American art paid its noblest tribute to an oppressed race, and bore witness to the beauty and grandeur of a simple physical life animated with a moral purpose. Mr. Ward embodied a fact in bronze. He exposed a lusty negro with firm and expanding muscle looking up with a face that expressed hope, and questioned, while his broken shackles and half-exerted strength bore testimony to his emancipation and to his unconscious power. It was not tragic; it was not strikingly dramatic; it was a simple, physical man, expectant of a future and conscious of his rights. To us it seems impossible to conceive a more direct expression of a fact. This work was too genuine and too much in sympathy with a dominant cause not to have been well received, but many received it well because of its moral significance, and but few understood its artistic promise. The firm and accurate modeling of the figure and the plainness of the conception, or rather the simplicity of the pose, was cause of joy to every thoughtful lover of art, for here was the evidence of a genius that could impress without striking an attitude or exaggerating a line. In other words, here was the Greek's conception of art—repose and simplicity—applied to a modern fact; here was nothing involved, complicated, or theatrical.

ANNE WHITNEY'S *AFRICA*

Whereas John Quincy Adams Ward's Freedman *was met with a chorus of praise when it was shown at the National Academy of Design in 1863, Anne Whitney's* Ethiopia Shall Soon Stretch out Her Hands to God, *or* Africa *(1864), a reclining female figure, received a decidedly mixed reception when it appeared in the Academy's annual exhibition two years later. Ward's plaster statue was celebrated for its racial naturalism, but Whitney's marble work was condemned in extraordinarily explicit terms by the* New Path *and other journals for its absence of any recognizable African physiognomy. Whitney must have read these criticisms carefully, for later that same year she recut the facial features of her statue so they would "read" as African. Almost every critic felt that Whitney had overreached with* Africa, *but the* New York Leader *nevertheless commended her for her daring, bold effort. This writer, likely a woman if one can judge from her pen name, lauded Whitney for encapsulating an entire race at a moment of historical change.*

"National Academy of Design," New-York Daily Tribune, *May 20, 1865.*

This "Africa", is indeed a most presumptuous work, but it has some meaning. Still, it is a great mistake for any tyro, man or woman, to take so mighty a subject. Angelo himself, if he had lived in our day, and comprehended all that this subject means, would hardly have dared to summon such an imprisoned imagination from the marble block. His highest subject is petty beside it. And yet, a beginner, with unfledged powers, without true comprehension of the vastness of the theme, without the culture to feel the absolute necessity of imaginative treatment, and without the judgment to teach her that imagination in such a case, must necessarily include the characteristic forms of the personified race, offers us this feeble, half-formed figure as a fit representative of that Ethiopia that shall yet stretch out her hands to God! Of course, it is a disastrous failure. We do not know the man living in whose hands it would not have been, in conception, an equal failure, although there are men enough who would have perceived that such an immense mass of flesh must have a few bones in it somewhere to enable it to stand or even to lie. One good result of the rough training men get is, that they are ashamed to expose

their ignorance to other men—women are rasher and count on forgiveness, perhaps on toleration. But it will be good for them not to be allowed these immunities any longer.

The best view of this mighty woman is from the north doorway of the west gallery, looking through it at the back of her head and her shoulders. There is considerable rude strength on that side, and Miss Whitney shows by it that if she will take the trouble, and determine to learn to walk before she attempts tight-rope dancing, something may come of her yet. Seen, however, from the side, the statue is an amazing compound of poverty of conception and ignorance of the structure of the human body. The right arm is especially feeble, and the feet are only half formed. But the failure of the whole body is as nothing to the face, which is without either character, or force, or beauty. It is not in the least like the African type, which Miss Whitney has no more dared to accept than Mr. Story in his Libyan Sibyl, and it wants the sensuous beauty of which his statue has considerable. The attitude of Miss Whitney's figure seems to us to have but little expression. She is waking up, apparently, but her way of doing it is borrowed, not from nature, but from the stage.

If Miss Whitney is going to be a sculptor, she needs to learn the lesson of true simplicity, and to understand that imagination and convulsion are not synonymous. The sublime lies in a hair breadth, and if this "Africa" were as large as the mastodon it might still be small. However, we shall not leave the artist without rendering her our thanks for having refused to belittle her statue with a trace of finikin detail. If she could have introduced a few links of chain, or a bit of netting or a necklace, or a tassel or a shell, and had the thing neatly out by her workman, she would not indeed have secured our praise thereby, but she might have earned that of others no doubt better worth having.

"A Word about the Statues," New Path 2 *(June 1865).*

The Sculpture Gallery is unusually poor this year, and yet, in Miss Whitney's colossal "Africa," it contains a work which under any circumstances would command attention and respect. With the exception of Henry K. Brown's "Striking Indian," and, perhaps, Mr. Thompson's somewhat exaggerated bust of Bryant, it is the only work in the room that looks as if it had been done by a man. Compared with Mr. Kuntze's unfortunate "Columbia," it looks almost grand, but we presume the artist would prefer a different standard. The conception, or the intention, rather, is praiseworthy; the conception is neither true nor forcible, and the execution is so feeble and unskilful that we wonder the artist's friends ever allowed it to leave the studio. The intention was to represent "Africa" wakened to new life by the spirit of the age and the great movements of our time working her regeneration and the reception of her children to Christian brotherhood, stretching out her hands to God. The conception presents us neither with the race personified in a woman's face and figure, nor with the action that the motto describes. The face is not the negro face nor any variety of it, nor is the head the negro head. Miss Whitney has only half dared and between realism and idealism has made a woeful fall. She has shrunk from the thick lips, the flattened nose, the woolly hair, and in striving to suggest forms which a great artist would have accepted with a brave unconsciousness she has succeeded in making only a debased type of the Caucasian breed. The African nose is flat but it is a nose and is capable of expressing all that our noses can. Angelo would easily have made it sublime. Phidias would have made it the type of beauty. But Miss Whitney's Africa has no nose. It is still in the undeveloped stage of the infantile cartilage. So with her lips. They are not the African, nor do they suggest them. And the hair is simply a wig of frizzled hair, such as our ladies deform their beauties with.

Doubtless these comments will provoke a sneer, perhaps many sneers. But they are surely grounded in truth. Call a statue "Africa," and it is the first essential that the forms should suggest, at least, the African race. Nay, call it by that name or not if the artist meant "Africa" the statue should proclaim itself to every eye and mind. Certainly this figure is far from doing so, nor can any candid person give a reason for its name. Yet, crude as it is, feeble as it is, it is stronger and better than anything ever done by Palmer, or Powers, or Greenough, or Crawford, or Miss Hosmer. It needs only that the artist should search it through and through, find out for herself its defect, and holding fast to what she feels is good in it, press boldly on to better work.

"Esperance," "Academy of Design," Leader, *June 17, 1865.*

"Africa," a statue by Anne Whitney, is the first object attracting attention in the sculpture room. And yet this expression is insufficient, for this statue not only attracts attention—it rivets the astonished gaze. There is in the figure a bold magnificence, a wild abandonment, and at the same time a yearning aspiration in the expression of the face that both astonishes and excites a deeper sentiment of admiration.

And yet the faults of this remarkable work are almost commensurate with its fine qualities. In all mechanical details it is crude and incomplete, and, what is worse, like many of Rubens' figures, lacking that divine restraint which, when united to a true power of expression, produces the highest results of which art is capable, it positively offends by a voluptuousness amounting almost to coarseness, so that at first you scarcely know whether to praise or to blame it most until, as you gaze upon it, like spots upon a luminous body, its external blemishes pass away, and the only sentiment remaining in your heart is that you are gazing upon the great embodiment of a great idea.

Its defects are the faults in art that may be, and in this case that undoubtedly are the result of untrained power, and they are overpowered by the spiritual power lying beyond them.

For the artist has sought to express in her statue a nation's life, and she has nobly succeeded in a high attempt.

That quiescent, gigantic woman arousing herself from the dark sleep of an undeveloped past—that yearning soul gazing with dazzled eyes into the dim vista of an unknown future, not only suggests the idea of a nation struggling with oppression, but awakening to hope, it is that idea incarnated in stone.

Miss Whitney has seized the sentiment of the present day with regard to the future of a race hitherto oppressed, but of a race, under the fostering influences of freedom, about to enter a new career, and has given it life in art. Her statue is its living impersonation, and, with its rich, sensuous beauty, it grandly prophecies the oriental magnificence, the gorgeous luxuriance to which the tropical races, with their potent organizations, always tend, and in which they will inevitably seek their final expression should they ever succeed in becoming a power upon the earth.

With all its faults, therefore, this statue is a great one. It is a great effort in the right direction; not only an achievement in itself, but a promise of higher achievements in the future; and we welcome this artist's advent to her artistic career as the rising of a new star in the firmament of fame.

POSTWAR PAINTING AND RACE

African American subjects had been present in genre painting produced in the United States for some four decades (see "William Sidney Mount's Ambivalence on Race,"

chapter 4), but it was really not until the conclusion of the Civil War that critics began to address the phenomenon directly. In the wake of the war, the nation could hardly be anything but self-conscious on the issue of race, and this may explain the unusual number of paintings of African Americans produced in the early years of Reconstruction. In 1867 the annual exhibition of the National Academy of Design featured several such works: Thomas Waterman Wood's triptych: The Contraband, The Recruit, *and* The Veteran; *Thomas Satterwhite Noble's* Margaret Garner *and* The Contraband Still; *and Swiss artist Frank Buchser's* Volunteer's Return. *Before discussing these works at length, the critic of the* Evening Post *penned the reflections transcribed below.*

By 1867 Eastman Johnson's Negro Life at the South *(1859; see chapter 4) had become the measuring stick for depictions of African Americans, but that year Henry Tuckerman also gave some thought to the representation of Native Americans. In the short passage given below, he nominates Johnson for the job.*

"The Artists and the African," New York Evening Post, *May 2, 1867.*

The African seems just beginning to assume a prominent place in our art, as he has for some time in our politics; and it is a natural consequence of the late war that the characteristics of the negro race in America should become a subject of study for the artist as well as the political philosopher. Still our artists have been slow in turning the new subjects offered them to account; so that it has been a common remark that but few works of any value as illustrating the war have yet been produced, and only a small number of them relate to the part taken by negroes, and the phases of character developed in them by the circumstances amid which they have lately been thrown.

We, therefore, bid hearty welcome to such works as those of T. W. Wood and Frank Buchser, as well as to the vigorous though crude productions of Thomas Noble, all of whom contribute to the present exhibition meritorious pictures illustrating negro character. Mr. Wood and Mr. Buchser give us the genuine "contraband" in all his phases, but Mr. Noble prefers to illustrate the horrors of the defunct "institution," and portrays tragic and emotional subjects.

These pictures recall to mind the efforts made by Mr. Hazeltine, president of the Philadelphia Sketch Club, a few years ago, to get up a competitive exhibition of works of American artists, in which it was proposed to confer prizes for meritorious works. Among other premiums the sum of two thousand dollars was offered for the best work illustrating the war of the rebellion. As might have been supposed, the result, as far as getting works illustrative of the war was concerned, was a failure, though the premiums were given out, but to whom and for what works we are not at present informed. Mr. Hazeltine and his sketch club were ahead of the times, and realized that fact when they discovered that the artists had not yet found out that the war could give them fit subjects for the exercise of their talents.

Henry T. Tuckerman, **Book of the Artists** *(New York: G. P. Putnam and Son, 1867).*

In his delineation of the negro, Eastman Johnson has achieved a peculiar fame. One may find in his best pictures of this class a better insight into the normal character of that unfortunate race than ethnological discussion often yields. The affection, the humor, the patience and serenity which redeem from brutality and ferocity the civilized though subjugated African, are made to appear in the creations of this artist with singular authenticity . . .

And in view of the subject, we cannot but hope that Eastman Johnson will do for the aborigines what he has partially but effectually done for the negroes. In a few years the Indian traits

will grow vague; and never yet have they been adequately represented in art. Catlin's aboriginal portraits are indeed valuable and authentic; Ward's statue of the Indian Hunter, and Crawford's of the Indian in his conscious decadence, are beautiful memorials; but much remains to be done in pictorial art. A recent glance into the portfolio of Eastman Johnson convinced us that he would do peculiar justice to a comparatively unworked mine of native art. While at Great Portage, on the Upper Mississippi, a few years ago, he sketched the figures and faces of some of the Sioux—old men and women, young squaws and children: and we have never seen the savage melancholy, the resigned stoicism, or the weird age of the American Indian, so truly portrayed: a Roman profile here, a fierce sadness there, a grim, withered physiognomy, or a soft but subdued wild beauty, prove how the artist's eye had caught the individuality of the aboriginal face; and with the picturesque costume, scenic accessories, rites of *fête* and of sepulture, it is easy to imagine what an effective representative picture of the Red Man of America, with adequate facilities, this artist could execute.

ART AFTER CONFLICT

MEMORIALIZING THE WAR

Although it would take a decade or more for the most important Civil War monuments to be completed, public discussion of the need to memorialize the heroes of the conflict began soon after Lee's surrender at Appomattox. In the following excerpt from the Nation, *the author worries that decision making by committees will result in the selection of poor artists for memorial commissions. Local politics and personal favoritism, it is asserted, will preclude fair judgments, leading to the half-humorous suggestion that juries draw lots rather than deliberate on the entries. James Jackson Jarves, in an excerpt from his book* Art Thoughts, *places greater store in competitions. He shares the view that the United States is not quite ready to meet the demand for Civil War monuments, largely because its sculptors have not moved beyond the sentimentalism of such works as Hiram Powers's* Greek Slave *(1843; see chapter 5). For Jarves, competitions will have the Darwinian effect of forcing American sculptors to better themselves, lest all the commissions go to more talented Italian stonecarvers.*

Frederick Douglass, in contrast, is less interested in the actual monuments and more worried about the moral authority of those who construct them. In a letter printed in a New York newspaper, the former slave declines to serve on a committee for a monument to Abraham Lincoln funded by white people on behalf of African Americans. A more fitting memorial, he suggests, would be one financed and controlled by his own community (see also "Frederick Douglass on African American Portraiture," chapter 4).

"Something about Monuments," Nation 1 *(August 3, 1865).*

Let us assume that about one-half of the memorial buildings which it is now proposed to erect within the United States will be built during the next two or three years. It appears, then, that many American cities and villages, now somewhat bare of other ornament than wayside trees, will either be adorned by good buildings or disfigured by very bad ones, and that many cemeteries will either gain their first good monuments or be more than ever burdened by those which are poor and tame. For it is difficult to build a monument of negative merit. Such buildings, as they have no utilitarian character, must be truly beautiful, or they are ugly and hurtful; they

cannot be respectably because appropriately designed; like statues, they must be noble, or they are worthless. And there is a necessity, similar and almost as positive, of great artistic excellence in those buildings which unite a practical use with their monumental purpose.

It will be well, therefore, if those who intend to give money or time to build monuments will give a little thought on the subject as well. We Americans are not so sure of ourselves in artistic enterprises that we can afford to omit the common precaution of thinking about the work we mean to do. Good monuments are not so plenty anywhere in the world that habit has grown to be second nature, and that monuments in the future will somehow be good also. But, in both these cases, the converse is true. Of thousands of sepulchral and commemorative monuments built during the last three hundred years in Europe, statues, triumphal arches, columns, temples, towers, obelisks, scarce one in a thousand is good. Out of hundreds of architectural enterprises brought to some conclusion in America, scarce one in a hundred has been even reasonably successful. There is no undertaking for which most people in the United States are less ready than this of building the monuments which they earnestly desire to build—monuments to their townsmen, college-mates, or associates, who have fallen in the war—monuments to the more celebrated of our military heroes—monuments to the honored memory of our dead President.

Peculiar difficulties will surround and hinder these undertakings, because nearly all these proposed memorials will be built, if at all, by associations; few by private persons. When a gentleman of average intelligence wishes to erect a monument to his brother or friend, there is a reasonable chance that he will employ an architect or sculptor of reputation and professional ambition, even if not of the first artistic skill, and so get a memorial that neither artist nor employer need be ashamed of. But there is much less chance of this in the case of action by a community or association. If a city or society employ an artist, without experimenting with a "competition," they very seldom select the best or even one among the best of the artists within their reach; political influence, private friendship, personal popularity, accidental availability, or temporary popular favor, always interfere to govern the choice. If they resort to competition the result is not practically different; for, supposing the most absolutely fair and careful consideration by the judges of the submitted designs, and supposing the submission of a great number of good designs, what likelihood is there that the judges are fit to judge? How many committees of management, or boards of trustees, or building committees with power, contain each a majority of men who understand the complex and many-sided art of ornamental architecture? How many persons are there in the land, not professed architects or sculptors, who can select the best among twenty or ten designs, each design illustrated only by formal and technical drawings, or by these aided by a fancifully colored and shaded "perspective view" of a building which it is proposed to erect? It is not enough to have "good taste"—to have a correct natural feeling for beauty of form, or to be accustomed to drawings. No man is at all fit to pick out one design among many, unless he has some knowledge of what has been and of what can be done in actual marble, stone, and bronze. There is apt to be a gentleman on every committee who has travelled in Europe, and who gets great credit for knowledge and judgment, and great influence over his colleagues on that account. But that gentleman must give proof of a better than guidebook knowledge of what he has seen, and of a less confused memory than most travellers bring home, and of having bought photographs of the best buildings instead of those most beloved by *valets de place,* before he can be considered an authority by sensible stayers-at-home. It will often be better if the judges will decide by lot—as judges have been known to—among the designs laid before them. There will then be a reasonable chance that they accept the best design, which chance dwindles indefinitely when most committees of selection attempt to select.

It will be well, therefore, if the people will give some thought to this matter during the months that are to come, that they may learn to bring some wisdom of choice and some appreciation of beauty to their chosen task of grateful remembrance, and that the nation may give its best art and its most poetical feeling, as well as its material abundance, to honor its noble dead.

James Jackson Jarves, Art Thoughts *(New York: Hurd and Houghton, 1869).*

Everywhere, except in Italy, where linger some traditions and many examples of better days, sculpture falls behind painting. American sculpture is more ambitious in some respects than its sister art, aspires to a higher range of motives, and is feeling its way towards what may be called, if not original treatment, one more in accord with modern ideas than that of European sculpture in general. There is springing up a large and munificent demand for it in the shape of public monuments; it is coming into fashion as an adjunct to architecture; and there is a bounteous call for costly busts, portrait-statues, cheap copies of classical marbles and dear-at-any-price originals of Eves, Judiths, White Slaves, and other crude fancies of second-hand sentiment, or bad effigies in stone of imperfect nudity in the flesh. Unlike the Grecian, the American ideal sculpture has no perfected standard of beauty, but vibrates from one inferior model to another, with such original touches as the fancy of the sculptor supplies for its betterment. So far as the stimulus of buying is concerned, the American sculptor is the most fortunate of modern artists. If ample patronage can create a national school, we shall have one soon. But the demand having preceded knowledge and skill, we are obtaining our sculpture to the detriment of our taste. It forces an inept art on an unprepared public as its standard of good in this direction. Some benefit may come of its effigies by familiarizing the people with the idea of art in general, and in time begetting a desire for better work. But for the moment the tendency, as before shown, is to view it more in the prosaic light of the business instincts of the masses than in a strictly æsthetic sense . . .

But the greater number of our monuments have no unity of parts or purpose; are crude or commonplace in conception; either made up hastily for the market, or unadvisedly stolen or altered from preceding work, and calculated to reflect no honor on the dead or living. Soon there will be seen, in high places and in low, huge effigies, in bronze and stone, of volunteers on guard, at corners of columns, obelisks, and shafts of every conceivable degree of disproportion, misapplication, and inappropriate ornamentation, dedicated to the heroes of our late contest. Alas for them, or rather for us! For they are gone where the beautiful reigns paramount. We must remain a while longer where ugliness will, if we persist in paying an enormous bounty for it . . .

How are we to secure better? There are two means. One, by competition. The point with the public is to get good sculpture, at prices which remunerate the artist proportionately to the talent or genius displayed. Anything over is almsgiving, or else a premium awarded to ignorance and charlatanism; if less than the work merits, the public forces the true artist into competing with the false in misleading the people, that he may gain his daily bread. Some stand out manfully, and abide their day of rightful appreciation; but the many go over to the ranks of the empirics, and, as things go, win fortunes. I shall enlarge on this aspect of the question, further on. Now the point is how to compel the sculptor to do his best. As he puts his profession on a level of trade, the patron must meet him on the same ground. Give the work to him who will do it best at a given price. To this it may be objected, Who is to be the judge? Adopt the system, and the competition and the criticism that must ensue, will speedily instruct both the sculptor and his patron. The immediate effect doubtless would be to turn a large part of the commissions

now given by hazard or friendship to Americans into Italian hands, which, for one third the money at present so recklessly wasted, would return an equal amount of respectable mediocrity in marble and bronze, beside saving the nation from being made absolutely ridiculous in so much of its statuary . . .

If competition be freely invited, the fear of losing his position would spur the American sculptor to that amount of study which is absolutely necessary for him, if he would compete with the European in the quality of his work, not to speak of surpassing him,—which I believe he could, judging from the progress made in busts, and some ideal statues and compositions of persons not yet known to fame, were he to pay the same attention to his preliminary education that his rival does. With Americans, and English too, it is quite common, after learning to draw a few common objects in a common way, to open a studio, and advertise themselves as sculptors, sometimes obtaining great commissions before giving evidence of ability to draw the human figure correctly. Now something more is necessary to make a sculptor than to be able to pat clay into a seeming likeness of a man or woman, and then give the model to cheap workmen to be fashioned into marble, while the model-maker spends more time in studying the means to open the purses of patrons than to perfect himself in sculpture.

Frederick Douglass to W. J. Wilson, Anglo African, *September 3, 1865.*

My Dear Sir: In answer to your note requesting me to allow my name to stand as one of the officers of the "Educational Monument Association," I beg to state that I cannot allow my name as you request, nor can I, with my present views, favor the plan adopted by the Association. On many accounts I wish I could unite with you in this enterprise, and not the least among them is the pleasure I experience in finding myself cooperating with yourself, and other gentlemen connected with this Educational Monument Association, for the common elevation and improvement of our condition as a people. But I must be true to my conviction of fitness.

When I go for anything I like to go strong, and when I cannot go thus I had better not go at all. You cannot want a man among you who cannot bring his whole heart to the work. I can't do this, and hence will not fill the place, which, if filled at all, should be filled more worthily.

You will, my old friend, naturally inquire why I cannot do this? Here there is no difficulty but the time required to answer. There is much I could say, but I must be brief. First of all, then, I must say, this whole monument business, in its present shape, strikes me as an offence against good taste, and as calculated to place colored people in an undesirable and discreditable position before the country. Such, I say, is my present conviction. Do not consider me hostile to monuments nor to colleges; I am not to either. Things good in standing alone are not always good when *mixed.*

Now, a monument by the colored people, erected at the expense of the colored people, in honor of the memory of Abraham Lincoln, expressive of their gratitude and affection for their friend and great benefactor, however humble and inexpensive the marble, I could understand and appreciated, and the world would understand and appreciate the effort. A monument like this would express one of the holiest sentiments of the human heart. It would be, as all such offerings should be, free from all taint of self-love or self-interest on our part, as a class. It would be our own act and deed and would show to after-coming generations, in some degree, the sentiments awakened among the oppressed by the death of Mr. Lincoln. A monument of this kind, erected by the colored people—that is by the voluntary offerings of the colored people—is a very different thing from a monument built by money contributed by white men to enable colored people to build a monument. We should bury our own dead and build our own monu-

ments, and all monuments which we would build to the memory of our friends, if we would not invite continued contempt of the white race upon our heads. Now, whenever a movement shall be made for such a monument, I am with it, heart and soul, and will do my best to make it a success.

THE NATIONAL ACADEMY OF DESIGN: PRAISE AND CONDEMNATION

Though much in American cultural life remained tenuous and uncertain after the Civil War, the artists of the National Academy of Design were unusually optimistic. Against all odds, they had raised more than $225,000 to purchase a building site on Twenty-third Street in Manhattan and erect a stylistically radical Ruskinian-Gothic building (affectionately dubbed the "Doge's Palace") by architect P. B. Wight. At the opening ceremony, with Albert Bierstadt's Looking Down Yosemite Valley, California (1865) *hanging on the wall behind him, poet William Cullen Bryant marveled at how far the artistic profession had come since the days of the Academy's founding forty years earlier. Yet he also stopped to issue a warning to the artists: Do not be so spoiled by fame and social prestige as to forget the lofty purposes of the fine arts.*

Unfortunately, some critics believed that the entrenched Academicians had done just that. In the two essays that follow Bryant's address, one author argues that by their very nature academies promote mediocrity and fail to foster and recognize genius. The other concentrates on the National Academy's schools—located in the basement of the new building. As the critic accurately points out, these "classes" had long been neglected by the Academy; perhaps stung by such accusations, the Academy appointed Lemuel Wilmarth as instructor in the schools in 1869, the first regular faculty member to be employed. Wilmarth had had extensive European training in the 1860s, both in Munich and in Paris; he was the first American student of Jean-Léon Gérôme. In a later reminiscence, given as a speech to members of the Art Students League in 1897, Wilmarth describes the teaching spaces of the Academy, both before and after the construction of the Doge's Palace, making particular reference to the struggle to allow women to study from the nude model (see also "Lemuel Wilmarth on the Life Class," chapter 10).

Willam Cullen Bryant, address at the opening of the National Academy of Design, New York Evening Post, *April 28, 1865.*

I congratulate the Academy of the Arts of Design, and all the friends of art, on the event of this day. After forty years of wandering, the Academy has at length a fixed habitation. Ever since the year 1825, when the Drawing Association was formed, the germ, the embryo out of which arose in the following year, this Academy, with its present name and organization, the tribes of Art may be said to have dwelt in tents. The close of this nomadic stage in their history is marked by rearing this temple to Art—built after a pattern of medieval architecture, yet with an historical congruity to the purpose it will serve, since it was for the adornment of buildings not dissimilar in style that the art of modern painting put forth its early efforts, and advanced to that stage of perfection which gave us the great colorists of the Venetian school.

I congratulate you all, therefore, on the completion of a building not one stone of which, from the foundation to the roof, was laid, and not one beam or rafter framed into its place, for any other purpose than the glory of Art . . .

At present, I believe that only three out of the twenty-five artists who founded the Academy

are now living—Morse, its first president, to whom the cause of art in this country owes so large a debt; Durand, his successor, then an engraver, whose landscapes, full of sunshine and peace, are reflections of the kindly serenity of his own nature, and Cummings, the treasurer of this institution from the beginning, who has turned from the production of his beautiful miniatures to the task of teaching the art he practiced so long and well, and who has just laid before us a welcome gift—the history of the Academy for the forty years which now close. Late may arrive the hour which gathers these honored survivors to their former associates.

Meantime an important change has taken place in regard to the social position of those who made the fine arts their profession. Forty years since their occupation was not regarded as it is now. The majority of fashionable people, I believe, or if not the majority, very many of them, would almost as soon have thought of asking a hod-carrier to their entertainments as a painter. But now I find the artists courted and caressed by that very class. Eminent artists have become standing lions, the Artists' Receptions are thronged with what the newspapers call the beauty and fashion of the metropolis; the artists' studios are frequented by distinguished men and elegant women; the young artist has more invitations to mingle in society than is good for him to accept. It is pleasant to know that Art is thus honored, but I am not quite sure that the change is in every respect for the advantage of the artist, and I hope that none of my young friends of the brush or the chisel will allow themselves to be spoiled by it . . .

I have spoken hitherto of the past, comparing it with the present, but I cannot conclude without a word concerning the future. I am confident in the expectation that a day of great glory for Art in this country is at hand—a day of which we now behold the morning, coincident with the signal overthrow of a mighty and fearful conspiracy against our national existence, and with the near prospect of returning peace. The temperament of our people and the influence of our climate are, I think, highly favorable to the cultivation of the fine arts . . .

The works of our great painters have been seen with delighted surprise in the old world; the masterpieces of American sculpture have divided the praise of mankind with the productions of the most eminent statuaries of modern times. Let us hope that the opening of this edifice, consecrated to Art, will mark our entrance upon a new stage of progress, even higher and nobler than we have yet attained.

"National Academy of Design," Watson's Weekly Art Journal, *May 20, 1865.*

It has always been a matter of question among men of Art, whether Academies of Art, even when most favorably organized, and subject to the most impartial guidance, do not obstruct the development of Art, rather than promote it.

The best products of modern Art preceded the rise of Academies; Art deteriorated because, losing the religious spirit, it became the mere hand-maid of luxury. Academies seem to have sprung up over this decay—in part, they represent the vain effort of talent to attain, by the mechanism of association, the results of genius; in part, they are used as convenient and elegant mediums of exchange between the picture makers and their patrons.

The same reasons that afford a good motive to the establishment of Academies of Science, do not apply in the case of those of Art. Science demands co-operation—is the product of the contributions of many minds. Art, like poetry, is based upon individuality. But Academies of Art, when they honestly aim to be what their name implies, smother individuality, and cripple genius by subjecting it to the rule and square of some conventionalism, or other. Where, however, as is often the fact, they are not much more than advertising agencies, they tend to prostitute Art to the tastes of the rich vulgar.

Then, again, they often become the bulwark of men of mediocre talent, who, taking shelter behind them, impose upon the world with the sounding names of "member," "associate," &c., &c. Once safely ensconced here, with comparative impunity they wage petty warfare upon superior ability. Genius is the terror of academies; it unsettles them, threatens to overthrow and render contemptible their conventionalisms by the display of original power. Hence, they openly disparage or silently ignore it wherever it appears; only when it becomes too strong in public estimation to be treated with indignity do they allow it to penetrate their well-guarded precincts.

The writer, not himself one of the guild of artists, and having a very limited acquaintance therein speaks from a large part of the walls of the exhibition-rooms with cloying repetitions of fashionable ladies and gentlemen on landscapes of a given pattern . . .

But this whole matter of conferring academic honors is puerile. The abiding effect, once the sensation of the moment subsided, is the only proof of power. Leave rewards of merit, the gift of pompous stupidity, to boys. The genuine artist, the consecrated servant of the beautiful, will consult his own dignity and the sacredness of his calling, by declining to accept the honors of the academy, whether proffered early or late.

A good school of Art, where students may have every facility for carrying on their studies, under direction that shall foster—not repress—individuality, is something to be desired, something that we never have had. As for associations that, under the pretentious name of academy, have for their real object the exaltation of a certain set and for their influence upon art— its prostitution to merely ornamental uses—Heaven relieve and defend us from such arrant cheats!

"Our Leading Art School," **American Art Journal 7 (May 4, 1867).**

We think it is apparent to the meanest understanding that professes to know anything, even such as know only the word picture, that upon the corner of Fourth avenue and Twenty-third street, of this city, is an institution called "The Academy of Design." Why it is called the Academy of Design we are at a loss to comprehend, save only because it has continual designs on the public purse, and is conducted by designing men. The word Academy, as far as we know the signification of it, means a school, or place of tuition, and certainly the . . . close corporation of 23d street is none of this.

From time immemorial the Academy of Design has professed to keep an art school. This attempt is divided into two parts, the first being the Antique School, where the new pupil is supposed to be taught to draw from the model or statue, and receive elementary struction in art, and the second, the Life School, where he learns to draw the living figure, and advances to all the higher grades of art study. With the last we shall have little to do; it is the school of the advanced artist, and its shortcomings can be better overlooked than the first, which is the introduction of the student to his future profession, and badly managed, is calculated to crush out whatever talent or enthusiasm he may bring to his work.

At the Twenty-third street establishment, which holds up its head and clamors loudly for precedent beyond all the art schools of America, about fifty pupils are entered for study in the Antique School. These pupils are tied to certain rules and regulations, enacted by somebody, which say that they must come at a certain hour, and go at a certain hour, and do certain things, under strong and fearful penalties, of which expulsion is prominent. Like the handle of a jug, these precious regulations are all on one side, and not a word is said about rules that shall govern *any one* but the pupils. We were about to say masters, but recollecting in good time that no such individuals exist, we halted. Out of these fifty scholars, about fifteen or twenty put in a

daily appearance, posting themselves in solemn silence at their labor, and free to follow the bent of their own fancy, draw away for six mortal hours, at the end of which time, no matter at how critical a period of their work, they must drop crayons and go forth. During this six hours no teacher approaches them, no Huntington, Leutze or Durand drops in to give them golden encouragement in a few words of advice or instruction, and not even a salaried officer of the so-called Academy of Design deigns to honor them with his countenance and knowledge of art. We believe we are speaking strictly the truth when we say that through this entire winter the pupils of the Academy, such as have not thrown up their crayons in disgust and gone to other and more genial places, have labored on in dreary, half-warmed rooms, without a word of tuition, a symptom of a lecture, or any of the mental or physical comforts that should emanate from this rich institution to encourage the young and struggling artist in his career. And yet this is called an Art *School!*

If this shortcoming arose from the poverty of the institution we would be one of the first to take the hat and beg for its relief; but it does not. It arises from criminal selfishness and neglect. Upon the rolls of the Academy are scores of names, each of which should blush to display itself openly in print, knowing what we have here recorded. They should blush for their own sake, and for the sake of art, when an occasional hour of their time could do so much for its advancement. While they are clamoring to the national Legislature for protection from foreign talent, they are allowing native effort to die of very hunger. We have nothing to say of the salaried officers of the institution—they are fossils and nothing is expected of them; but for the Academicians we again declare that their neglect of the art school is personally and jointly a disgrace to them.

Lemuel Wilmarth, address given at the Art Students League, 1897, Archives of American Art.

I wish I could sketch for you in a few words an illustration of the educational opportunities offered to a student of art forty years ago, by this metropolis of the world.

Come with me and I'll try.

Down on 13th St. near Broadway. Mount to the upper floor of a (in those days) lofty building. Four stories not twenty-four! At the head of the upper stairs we notice a sign on the door "Council Room of the National Academy of Design." The top floor is stored, almost crammed, with plaster casts. Some of the smaller ones mounted on pedestals; the larger figures and groups on the floor in sections, one piece here, another piece there. We are in the antique school room of the Academy, opened three evenings a week during the winter months. Closed in day time the whole year around, for lack of day light. No instructor. No instruction what-so-ever. I mean in the art of drawing. But the Vice President of the Academy Thomas S. Cummings that genial old gentleman who sits there at the desk serenely reading, often breaks forth, to the great edification of the class in reading aloud some passage from a favorite poet, or some inspiring incident from the life of some eminent artist. What pleasanter way of awakening the drowsey student or of replenishing the fire of the enthusiast?

Order, heaven's first law, must be maintained in an art school, and the slightest expression of the superabundance of youthful spirit should be held in proper bounds by the reminder that the "profession of an Artist is preeminently the profession of an educated gentleman."

To an art student wishing to draw from plaster cast, this was absolutely the only opportunity offered by New York forty years ago.

But drawing from life? Was there no life class at that time?

Yes. I'll sketch that.

In the same loft, at the south end of the room, was a raised platform in front of which was

a curtain, a sort of miniature stage. Two nights a week during the months of January and February this was the holy of holies of the life class tabernacle. At a signal the curtain would be drawn and the ten or dozen life class students who had been waiting in decorous silence if not in awe, would begin their work. During rest time the curtain was closed. The coming and going of the model was shrouded in deep mystery. No instruction in this class, either, if we except the strict inculcation of the before mentioned heaven's first law.

At that date there was *one* professional female model in New York City, very inferior in figure—as to form, but quite superior in figure as to price. She was paid $2. an hour.

Let us now skip a decade and come to a period thirty years ago.

The Academy of Design has now a home of its own in a marble palace designed to echo Venetian Gothic.

Its collection of casts have been transferred, promoted I was going to say, from an attic to a basement. The improvement however is decided. More elbow room more ceiling space and *some* day light. The antique class was then opened all day. And women were admitted as well as men. A great step forward.

At that time the woman's art school of the Cooper Union had also been instituted.

In regard to facilities for the study of the nude model, there was as yet no improvement. The life class of the Academy was held only at night, two evenings a week during the months of January and February. Women of course were not admitted to the life class.

Such were the conditions thirty years ago.

In 1870 I was engaged by the Academy as instructor in its schools. Some of the older friends present will remember the struggle that then began for greater opportunities to study. To establish a day life class, to open the night life class five evenings a week and during the whole season from October to May. And, by far the most difficult of all, to establish a life class for *women*.

The student of to-day can scarcely realize the prejudice that had to be met and overcome before women were permitted to study from the nude model. But the vigorous protests that the opening of the women's life class called out from the older and more conservative artists and the unpleasant odium suffered by those who championed it, are still fresh in my memory.

SETTLING IN: ARTISTS IN THEIR STUDIOS

Not long after the end of the Civil War, the poet and editor Thomas Bailey Aldrich toured and explored the studios of New York. His report, written in lively prose expressly for a juvenile audience, offers a look at studio life in a city not long before torn by riots and political strife (see also "A Child's View of the Watercolor Show," chapter 12). Marveling that Richard Morris Hunt's Tenth Street Studio Building (designed and built in 1857) looks more like an arsenal than an artist's refuge, Aldrich describes the commodious interior and lists the tenants, a who's who of prominent midcentury names, including Frederic E. Church, Emanuel Leutze, and Worthington Whittredge. Aldrich's inventory of the furnishings and accessories in the studios of Leutze, Bierstadt, and Church is especially illuminating; each artist has surrounded himself with "trappings" associated with his trademark subject matter. In the dingy University Building on Washington Square, Aldrich finds painters, including Winslow Homer and William J. Hennessey, in less opulent circumstances. Scaling the stairs, Aldrich finds Homer's studio rough and almost bare, whereas Hennessey's is as cozy as some domestic parlor and adorned with potted plants, choice books, and a Whittredge landscape. With such

observations, Aldrich's studio tour conveys a vivid sense of social and artistic geography in postwar New York (also see "William Merritt Chase's Super-Studio" and "Elizabeth Bisland Roving the Studios," chapter 9).

Thomas Bailey Aldrich, "Among the Studios," Our Young Folks, *nos. 1, 3, and 4 (September 1865, July 1866, and September 1866).*

[*September 1865*]

On Tenth Street, between the Fifth and the Sixth Avenues, stands a large three-story building of red brick, with brown sandstone trimmings. The architecture is somewhat peculiar, but very non-committal. The deep-set windows, the four airy balconies, each in front of a dark, mysterious-looking door, and the aspect of eminent respectability about all the tasteful cornices and mouldings, would be apt to puzzle a stranger. Pedestrians sometimes pause on the sidewalk opposite, evidently wondering what the structure is used for, and then turn away, probably possessed with the idea that it is an Arsenal or a Half-Orphan Asylum.

If the passer would only glance at the crosspiece over the doorway, he would see thereon, in dusty gilt letters, the word—Studios.

The best side of the Studio Building, in every sense, is the inside. Let us take advantage of this fact. At your right hand, on entering, is the Janitor's office, and behind an oaken desk, near the window, sits that faithful warden himself,—a courteous *cicerone* to the true lovers of Art, but a most terrible enemy to all itinerant venders of pen-holders and shoe-blacking. He would stop the Father of his Country if he came there to sell things. Opposite the Janitor's is a similar room, which has been occupied by a series of eccentric physicians, each in turn having given up the business in despair, in consequence of the imperturbable good health of the artists. At the end of the hall or vestibule, which separates these apartments, is a large double door, leading into a spacious Exhibition-room, lighted from the roof, and admirably adapted to the purpose for which it is reserved. On each side of this gallery extends a narrow corridor, opening upon which are the studios.

Each floor is similarly arranged. Here and there, by accident or design, is a room lacking the peculiar light required for painting. These rooms are generally used as sleeping apartments by architects or literary men. The late Major Theodore Winthrop, who fell early in the war, bravely battling for his country at Big Bethel, tenanted one of these chambers. The Janitor will point it out to you in the eastern wing of the building. There it was he wrote "Cecil Dreeme" and "John Brent," long before we thought of him as anything more than a finished, quiet gentleman. But to be a gentleman is the necessary beginning of a hero. Since then, Winthrop's glorious death, and the publication of his charming books, have placed him in stronger colors before the world.

The wood-work throughout the building is of plain pine, oiled instead of painted, and has a rich, mellow effect in connection with the neutral tint of the walls. The staircases, of which there are two, are very wide, with heavy mahogany banisters. The number of mountains and rivers and ships and castles carried down those broad stairs in the course of a year, would astonish the reader if he could see them all at once.

On the ground floor are the studios of Whittredge, Bradford, Dana, Beard, Thompson, the sculptor, Le Clear, Guy, and Bierstadt. The second floor is appropriated by Church, McEntee, Leutze, Hays, Hart, and Gignoux. Mr. Tuckerman, the author, has a pleasant study and library on this floor. On the third story are Gifford, Hubbard, Suydam, Weir, Shattuck, Thorndike, Haseltine, De Haas, Brown, Casilear, and Martin. Here they are all together,—historical, figure,

portrait, landscape, marine, animal, fruit, and flower painters. It is not often that so many clever fellows are found living under one roof. A community composed exclusively of gifted men is unique,—a little colony of poets, for they *are* poets in their way, in the midst of all the turmoil and crime and harsh reality of the great city!

Many of the studios have bedchambers attached: so the artist can live here and "keep house" very cosily. Indeed, several of the younger unmarried immortals do; and it would amuse you much to see Master Painter boiling his coffee in a toy tea-kettle over the gas, or toasting his French roll at the grate, while the amiable cutlet on the gridiron is crying out to be eaten! In summer, a dish of berries or fruit is always added to this simple bill of fare. Nothing could be more delicious than these make-believe breakfasts, and no banquet-hall quite so charming as the studio, with its mellow twilight, its pictures and screens, and antique furniture . . .

The characteristics of an artist—his travels—the particular bent of his mind—are often very prettily indicated by the *souvenirs* and knick-knacks ornamenting his studio. In Mr. Leutze's, for instance, you will find rusty old helmets, shields, breastplates, coats of chain mail, ronçies,[9] arquebuses, and all those cumbrous mediæval trappings which he introduces with such fine effect in his pictures. When you look on one of Mr. Leutze's works, you may be sure that the costumes and all the details are historically correct . . .

In Mr. Bierstadt's room, also, you will see at a glance the direction of his studies and wanderings. It is a perfect museum of Indian curiosities,—deerskin leggings, wampum-belts, war-clubs, pipe-bowls, and scalping-knives. The latter articles look so cruel and savage that you don't feel like prolonging your visit, for fear the artist might get out of patience with you! These traps Mr. Bierstadt brought with him in his trunks from the Rocky Mountains; but in his brain and his portfolios he brought more precious things;—those wild ravines, and snowy sierras, which he has bequeathed to us on canvas.

Mr. Church's love of the Tropics is as plainly discernible in his studio as in his landscapes. Everywhere about the room we have sunny hints of the equator. Even the pot-plants at the casement threaten to turn into graceful date-palms and cocoanut-trees under the influence.

As to Mr. Bradford's studio, we candidly confess to having caught a severe cold from merely looking at his Icelandic relics,—Esquimaux harpoons, snow shoes, seal-skin dresses, and walrus-teeth. In his recent journey due north, Mr. Bradford, it seems to us, pocketed the best part of the Labradors, including several chilling but picturesque icebergs which are now on exhibition . . .

The Tenth Street Studio Building is a very busy and cheerful hive in winter. The artists are a hospitable race, and they have no end of visitors. Statesmen, generals, diplomates, divines, travellers, suspicious counts, merchants, authors and actors,—in short, all sorts of celebrities, real and silver-plated, visit the studios. In summer the place is as deserted as an unsuccessful oil-well. At the unfolding of the first leaf, the artists are off, like so many birds, for the green-wood;—some on the coast of Maine, some up among the Catskills, others in the Far West among the red men; all making sketches and studies. No spot escapes them. They follow Nature into her most secret and remote fastnesses—though they do not always succeed in capturing her!

[July 1866]

The University is one of those buildings that have lost their enthusiasm. It is dingy and despondent, and doesn't care. It lifts its machicolated turrets of whity-brown marble above the

[9] A type of sword.

tree-tops of Washington Parade-Ground with an air of forlorn indifference. Summer or winter, fog, snow, or sunshine,—they are all one to this dreary old pile. It *ought* to be a cheerful place, just as some morose people ought to be light-hearted, having everything to render them so. The edifice faces a beautiful park, full of fine old trees, and enlivened by one coffee-colored squirrel, who generously makes himself visible for nearly half an hour once every summer. As we write, his advent is anxiously expected, the fountain is singing a silvery prelude, and the blossoms are flaunting themselves under the very nose, if we may say it, of the University. But it refuses to be merry, looming up there stiff and repellent, with the soft spring gales fanning its weather-beaten turrets,—an architectural example of ingratitude.

Mr. Longfellow says that

> "All houses wherein men have lived and died
> Are haunted houses."

In one of those same turrets, many years ago, a young artist grew very weary of this life. Perhaps his melancholy spirit still pervades the dusty chambers, goes wearily up and down the badly-lighted staircases, as he used to do in the flesh. If so, that is what chills us as we pass through the long, uncarpeted halls leading to the little nookery tenanted by Mr. Winslow Homer.

The reader should understand that the University is not, like the Tenth Street Studio Building, monopolized by artists. The ground-floor is used for a variety of purposes. We have an ill-defined idea that there is a classical school located somewhere on the premises, for we have now and then met files of spectral little boys, with tattered Latin grammars under their arms, gliding stealthily out of the sombre doorway and disappearing in the sunshine. Several theological and scientific societies have their meetings here, and a literary club sometimes holds forth up stairs in a spacious lecture-room. Excepting the studios there is little to interest us, unless it be the locked apartment in which a whimsical *virtuoso* has stored a great quantity of curiosities, which he brought from Europe, years ago, and has since left to the mercy of the rats and moths. This mysterious room is turned to very good dramatic account by the late Theodore Winthrop, in his romance of "Cecil Dreeme."

It has taken us some time to reach Mr. Homer's *atelier,* for it is on the third or fourth floor. But the half-finished picture on his easel, the two or three crayon sketches on the walls, (military subjects,) and the splendid view from his one window, cause us to forget that last long flight of stairs.

The studio itself does not demand particular notice. It is remarkable for nothing but its contracted dimensions: it seems altogether too small for a man to have a large idea in. If Mr. Homer were to paint a big battle-piece, he would be in as awkward a predicament as was the amiable Dr. Primrose, when he had the portraits of all his family painted on one canvas. "The picture," says the good old Vicar of Wakefield, "instead of gratifying our vanity, as we hoped, leaned, in a mortifying manner, against the kitchen-wall, where the canvas was stretched and painted, much too large to be got through any of the doors."

[September 1866]

Near the end of a lonely hall in the third story are two doors facing each other. Each door has a small white porcelain slate attached to it, and under the slate the name of the occupant of the premises. With one of these rooms (Mr. Homer's) the reader is already acquainted. The other is the studio of Mr. Hennessy.

The two studios offer a strange contrast. Mr. Homer's workshop is as scantily furnished as

a shelter-tent. A crayon sketch of camp-life here and there on the rough walls, a soldier's overcoat dangling from a wooden peg, and suggesting a military execution, a rusty regulation musket in one corner, and a table with pipes and tobacco-pouch in the other,—these are the homely decorations of Mr. Homer's chamber. Mr. Hennessy's apartment, on the contrary, is rather exquisitely arranged, as the reader will observe on turning to the engraving which accompanies this article. The tinted walls are covered with choice paintings, engravings, and photographs. A landscape by Whittredge—showing a ledge of rocks near the sea-shore,—is one of the gems of Mr. Hennessy's snuggery . . .

We would like to linger half the day in this pleasant room, where Mr. Hennessy, like a skilful gardener, has turned every inch of his limited ground to good account. From the ivy-vine, which shoots up from the flower-pot on a bracket, and wreathes itself into a graceful drapery for the window, to the few rare volumes on the escritoire, you see something of that sense of refinement which is never wanting in this artist's pictures, however homely or commonplace the subject may be. So much for Mr. Hennessy's studio.

THE CONDITIONS OF ART IN AMERICA

The following unsigned essay is one of many written in the late 1860s with a goal of diagnosing the ills of cultural and moral life in the United States and prescribing a regimen for a more worthwhile future. The author begins by condemning the nineteenth century as a particularly undistinguished artistic era. What is lacking is "pure intellect"—the probing consciousness and higher body of knowledge that are the prerequisites of advanced critical faculties. In this writer's view, no one really "knows" anything—not artists, not critics, not connoisseurs. And the American system kills any desire to learn, driving potential geniuses away from the arts. Whereas the cultural arbiters of the antebellum era placed a premium on sentiment and morality, this author stresses art's practical and educational role in a period of universal male suffrage (including, notably, ex-slaves). The usual pieties surrounding democracy are dispensed with, perhaps because of postwar disillusionment. Art will flourish not because of any particular system of government unique to the United States but through intellectual training, the cultivation of thought, the "accessibility to ideas." There are moments of optimism in the essay, but overall the pervasive tone is coldly rational.

"The Conditions of Art in America," **North American Review 210 (January 1866).**

The American people do not well understand, nor much care for, the arts that have to do with visible beauty. To beauty itself they are not indifferent. Beauty as it exists in nature is probably of as much concern to the Americans as a nation, as to most other nations. But they do not readily respond to the appeals of beauty as seen in art. And for the theory and practice of art that deals with beauty they care very little . . .

If we admit that, on the whole, it is not a very great age of art in which we live; if we admit that all that is done and all that has indisputably been gained is principally useful as enabling us to judge of what more we can do; if we admit that all the actual achievement of the nineteenth century could be mentioned in one of these pages and described in this article,—we are still aware that the arts of visible beauty exert a great influence and possess a great power in England, France, and Germany, and that this influence and power are daily growing greater and gaining firmer seats. There is real and well-directed effort; there is intelligent adjustment of ef-

fort to material. There is just criticism. There is wide-spread and still spreading interest. There is sincere love for the arts of the past, and sincere wish to advance the arts of the future. And there is immediate hope for these arts of visible beauty in Europe,—a hope that can be long deferred only by national and international wickedness or folly.

But when we consider the position in America of those fine arts of which there is present question, we find all different. There is no body of art critics in the land whose opinions anybody will receive as of decisive importance. There is no class of true *connoisseurs* of these arts, few students or lovers of them, whose opinions it is worth anybody's while to ask. There is no large class of persons who care for these arts at all. There are, indeed, a few collectors of etchings and prints; there are a few *dillettanti* who frequent the studios of popular artists, and talk a learned language of art, in which familiar words have strange meanings. But these have generally no knowledge of the history or the principles of art, and little care for its meaning and spirit. There are those who throng the exhibitions and those who buy pictures and statues at prices relatively high. But neither a love nor a comprehension of art is to be attributed to these; and their indiscriminate admiration and reckless buying have done much harm to themselves, to the artists, and to the public . . .

Where the people disregard art, a certain amount of clever art is possible; caricature may flourish, though even this does not reach power without losing refinement; landscape, full of good natural feeling, but of dim and partial insight into nature, is possible; representation of facts of the day and book illustration, both of fair quality and of some interest, may exist. All these are likely to exist in a Christian country in the nineteenth century. But great art is the expression of great thoughts; and great thoughts find no adequate expression, find only a partial and incomplete existence, if the people are not accessible to them.

Two conditions are necessary for great achievements in any intellectual field,—the power in the few to produce, the demand among the many for production. And this is especially true of those fields where sentiment is joined with pure intellect, as much as it is in the fine arts generally. Now if a great artistic genius is born into the world in the midst of a people regardless of art, there must follow one of these results: either he will spend his God-given power in pandering to prince's or people's vanity; or, if of purer nature, he will be driven crazy for want of sympathy; or, if of stronger nature, he will be driven in upon himself and his finest impulses crushed; or he will be put at once to other work than his own,—engineering, mechanical occupation, struggles for money in mart or counting-house, some task to which the divine inspiration avails nothing. We of America have no knowledge how much great art-power we have wasted because of having failed to use it. We can never know. The greatest genius is clever at many things; our possible Titians and Leonardos have invented machinery, or made enormous fortunes in newly discovered ways of their own. Lesser genius is less generally efficient, but can do good service in many ways; our Angelicos, our Hogarths, our Rubenses, are at work all over the land,—hard at work, be sure,—employed, but not well, because not properly employed.

Whatever the born artists have done, it has surely not been their fitting work. No great work of art has been produced in America,—no work of art that, by any just kindness and honest liberality in the use of the word, we dare call great. Two or three works of art have been exhibited which it would be right to call good, meaning by that epithet well-meant, instructive, successful in a partial and bounded way. Of clever works of art, works that possess some unusual and pleasing technical qualities, or cleverly appealing to temporary popular feeling, the catalogue is not long. By far the largest number of pictures, drawings, and works of sculpture exhibited at any exhibition it is impossible to include in either of these three classes. Nearly all

our buildings, even those on which the most money and thought have been spent, are without even those salient qualities that would entitle them to be called clever designs. Our manufactured articles which are capable of being made beautiful are generally made ugly, whatever of cost or care is given to most of them going to purchase deformity; our glassware, for instance, plate, jewelry, bookbinding. The art of engraving, in all its branches, is so dependent upon the higher art of painting as to claim no special notice here . . .

The importance of art is great as a help to education, because it addresses and can influence some of the noblest faculties of the soul, not to be reached, or less easily to be reached, by other means. Once the principal means of educating the mass of the people, painting and sculpture retain the power to educate, and can be made to address the uninstructed or the highly cultivated. Now we in America cannot afford to throw away any means of educating ourselves and our fellow-countrymen, cannot afford to let escape us any means to that end within our reach. We have undertaken a task which we may well contemplate with grave anxiety, for its successful accomplishment will only be possible to a wise and virtuous and considerate nation, working in the fear of God and with His aid. We have undertaken to make of this disordered country, full of jarring interests, a homogeneous and organized and peaceful nation, and to bring this about through the dangerous instrumentality of universal equal suffrage. Had we not better educate our people? When some object to universal suffrage,—and there are thoughtful Americans who do so,—what is the only defence we can put in? This,—that the more the people are educated, the safer it becomes, and that it in itself tends to educate the people. Good; but let every means in our power be employed to educate the hearts, the feelings, the senses even, as well as the minds of men. Women will exercise some influence over our future. Can women be rightly educated without the influence of those arts that have to do with beauty? Not so. We need the fine arts, all the fine arts. A change cannot come too soon in our national mind on this subject . . .

There is abundant reason to believe that the fine arts have before them a splendid future in America,—a future of results, perhaps, in many respects, different from results elsewhere attained, but not different because inferior. It is not only because we long for this consummation that we also hope for it. We share the faith of our countrymen in the future of our country,— a future that includes all greatness that can be a nation's lot . . .

Out of the war, that unparalleled struggle that once seemed about to be the nation's last, must come every good thing that a nation needs, or the people will have falsified their hopes and failed to secure the due reward of their sufferings and labors. The future must be not only prosperous and peaceful, but truly great. The nation must be righteous as well as powerful, and enlightened as well as prosperous. The confidence of the people in their institutions, and their love of them, can only be justified by a new life for the nation, healthy and pure, by a government firm and liberal, a policy just and generous, a culture truly refined, an intellectual training at once broad and deep. There must then be no "contempt for the finer and higher arts, and for all that they teach and bestow." There must be such regard for them, and such cultivation of them, as will truly enlighten and help.

Into the mooted question, Are free institutions likely to produce good art and the love of it? it is not necessary to go far. The argument *a priori* is of about equal weight in either scale. The arts are found to be about as likely to prevail and grow great under one form of government as under another. It is easy to show that courts and hierarchies must be, from the nature of things, the most munificent patrons of art. It is as easy to show that the energetic people nursed in democracy must be, from the nature of things, the most earnest workers in art . . .

It seems, then, that there is nothing in forms of government alone to lead us to conclude, in any given case, that art will or will not flourish. The fate of the arts is in other things than these,— is in the freedom of thought, "accessibility to ideas," willingness to trust to ideas, gravity, chastity, patience of a people. Most foolish, then, and inconsequent is the reiterated assertion that republicanism will have an unhealthy influence upon the fine arts, and equally unwise the assertion that "free institutions secure the greatness of the fine arts." We have no cause to be doubtful of our power to make our lives beautiful with art. But we have work to do, and bad tendencies to escape or resist, if we would have it so.

Our national evil genius is mediocrity. And the form it takes with us is the undue respect we have for commonplace work. The criticism of the first stage, which we have said is passed, consisted entirely of praise for the commonplace. But there is still praise of the commonplace. The whole spirit of ordinary journalism, ordinary schooling, ordinary preaching, ordinary writing on science, philology, metaphysics, is simple mediocrity. But little profound learning exists in America. That is not the worst: shallow learning thinks itself profound, and tries to teach and decide. But little patient thought is in America. That could be borne: but crude speculations and hasty conclusions are supposed to be worth preserving and publishing, and old things are rediscovered with great triumph to the discoverer. In nothing is this mediocrity more marked or more injurious than in the fine arts.

DISSATISFACTION WITH ARTISTS

The art world was not immune to the general pessimism and dissatisfaction with American culture and society that followed the trauma of the Civil War. In these two articles, writers attack American artists for what they perceive as their thin skins, their hypocritical position regarding publicity and criticism, and their grasping, mercantile efforts to advance their careers. Seizing on a short letter to the editor from the Düsseldorf-trained still-life and genre painter George Hall, a critic from the Nation *acknowledges that American criticism has recently acquired a severe edge but asserts the right of anyone to register an opinion on publicly exhibited works of art. This author attacks a cardinal principle that American artists had advanced throughout the first half of the nineteenth century—that professional artists alone are competent to judge of their efforts. With characteristic acidity, Clarence Cook goes much further in indicting the men of the brush and chisel. Responding to an artists' petition to levy a tariff on foreign works of art, he sees it as one more example of unseemly pushing and greed. In fact, the American artistic community would reverse itself on the tariff issue; the next generation of artists, largely trained in Europe, would eventually lobby for "free art" and the eradication of the tariff (see "The Tariff Controversy," chapter 11).*

"*Minor Topics,*" Nation 2 *(March 22, 1866).*

We have received the following note from Mr. George H. Hall:

To the Editor of The Nation:

Your art critic, in noticing my fruit-pieces, says "his purple is shaded not with darker purple, but with grey." If he will hang a bunch of purple grapes against a grey wall, he will see, as I did, that its shadows are filled with grey reflections.

The American artist bears with patience a great deal of crude writing published by so-called

art critics, and I think it only fair that he should sometimes expose the ignorance of these oracular gentlemen.

Yours respectfully, Geo. H. Hall.

We at first thought of refusing it insertion as an act of kindness to Mr. Hall himself, because we fear the last paragraph will not raise his temper in public estimation, and it certainly cannot serve his pictures. One can accomplish no more by telling a critic he is an ignoramus than by telling an artist or an author that he is an ass. The process to be gone through in all these cases was well described some years ago, we believe, in "Household Words," in a controversy between two pot-house politicians: "'Prove it,' says I. 'Facts proves it,' says he. 'Prove *them*,' says I." Whatever authors and artists may think or expect, the public will never accept the theory that a critic is *prima facie* unworthy of attention because he is a critic and not a painter or a historian or a poet. It is now too late to get people to believe that nobody can form a correct opinion of works of art who is not capable of producing them. The fact unfortunately is, that it is the opinions of those who were neither poets nor artists which have built up all the great reputations that ever existed, and consigned all the daubers and rhymesters to obscurity or oblivion. And we must protest against the notion that the artist himself is the best judge whether his coloring is good or his drawing correct. If no one were allowed to differ with him on this point, of course every picture that is painted or that ever was painted would be a masterpiece. It is the critics after all—that is, in the vast majority of cases, men who can neither paint nor draw— who give an artist his fame or sentence him to damnation. We should like to know what artist has ever acknowledged that an unfavorable judgment passed on his picture by a fellowman, whether lay or professional, was well founded?

We think, for our part, that American artists display in the matter of criticism an absurd and, let us add, very raw sensitiveness. We deny that they "bear with patience a great deal of crude writing," or any other kind of writing, about their pictures, that is not laudatory. They find themselves now, for the first time, subjected to the ordeal of hostile, perhaps often over-censorious, comment—something to which the artists of other countries have been exposed for two centuries, but no more think of flying into a rage about than they do of blubbering. We do not know any better proof of immaturity and "greenness" than a tendency on the part of either author or artist to lose temper over the public expression of unfavorable opinions of his work, and anybody who finds this tendency still strong in him may feel satisfied that his education in his profession is still far from complete.

There is one thing that artists should bear in mind, and that is that pictures are not put on exhibition for sale simply, like fish or butter. They are to be seen and commented upon. People will differ in opinion about them. Some will think them masterpieces—others daubs; and some people will publish these opinions, and others simply retail them at the dinner-table or in the club. But no matter where or how they may be expressed, the artist has no right to complain, much less to lose his temper or feel personally aggrieved, unless his motives or his character are assailed. The mere fact of exhibition is a challenge to criticism. If a critic says that he thinks either color, or drawing, or expression, or thought is bad, why it is simply an invited expression of opinion; and there is nothing more certain—we mention it for Mr. Hall's consolation—than that no good painter was ever yet written down by one critic or two or three. In fact, any criticism, let it be ever so hostile, is of service to any artist who has any merit at all. It leads to discussion; it causes the public to examine his work more carefully; and, if it is good work, of course the more it is examined, the better it will appear; if it is bad work, the interest of art requires

that it be driven out of the field, and the artist be convinced of his own shortcomings as soon as possible. And we must remind Mr. Hall that if the artists have had to bear with a good deal of "crude writing," the critics and the public have had to bear with a monstrous deal of crude painting. People do see now and then historical pictures that are none the better for having had the subject strained through the artist's imagination; figure-pieces of all kinds that are simply bits of maudlin sentiment or affectation; fruit and flower pieces which, in spite of the artist's having taken the greatest pains with the coloring, are not well colored, after all, and are not so considered by the public, and will adorn the trunk-rooms of posterity. Of course, in saying all this, we neither express nor imply any judgment on Mr. Hall's work.

Clarence Cook, "The Cry from the Studios," Galaxy 3 *(February 15, 1867).*

The petition which the artists of the National Academy of Design have sent to Congress, praying that a heavy tax may be imposed on all foreign pictures imported into this country, has naturally enough excited a good deal of discussion among people interested in art and desirous of seeing the public share in that interest . . .

Perhaps, indeed, it may not have occurred to them that the public, as well as themselves, has a direct and personal interest in this matter. If we may say it without giving offence, which is hardly to be hoped, they seem to have looked at the subject in that purely mercenary aspect which is at present the fashion here in America. We shall be upheld by all those who have considered the matter when we write that there is as much speculation, as much strategy, and as much trickery employed to-day by certain artists in selling their pictures, as there is among certain Wall Street men in selling stocks; and this mercantile, trading spirit is rapidly becoming infectious, and threatens to retard the growth of a genuine art in this country, if not to kill it altogether. No one can have been long in a position to command an inside view of the world of what, for convenience sake, we call art, here in New York—the studio, the auctions, the galleries, the "private views," the Academy, the newspaper criticisms—without coming to the conclusion that, whatever may be said for the actual art, the knowledge of manœuvring, the business ability, the familiarity with artful dodges, the stone out of which this great seething pot of soup has been made, are deserving, from a worldly point of view, of the very warmest applause. We have many anecdotes to tell which would abundantly illustrate and justify the statement, but the facts are too patent to need either illustration or justification. If, however, any one should seriously doubt or deny, let him, if he can, secure the possession of an editorial chair in some journal whose circulation makes its praise worth having and its censure worth fearing pecuniarily, and he will not be long in learning that there are many artists who can be as persistent, as pushing, and as brazen in their efforts to secure his praises as the keeper of a Chatham Street clothing store could be in the pursuit of a customer. We are very far from saying that all our artists are of this sort; unpleasant as our experience has been, it does not prevent our seeing that these uneasy, vain, avaricious men are as yet the exception, not the rule; but they are, for all that, not men whose influence is to be despised. They are men of mark, men well known, and if they are not men of real merit, the public knows nothing of that; it is not to blame for being deceived by this clamor of puffery, this manifest outward success, this universal assenting voice of praise . . .

Now, our only practical concern with this state of things, apart from the personal annoyance and mortification of seeing charlatans and pretenders usurp the places of better men, lies in the fact, that cannot be denied and may as well be faced, that the influence of these men is making itself felt on the whole body of artists, and is rapidly making traders of them. The younger

ones, especially, who see men with comparatively little talent, and that merely mechanical, rise to place and wealth and influence with a rapidity proportioned to their lightness, are sorely tempted to envy their success, and to inquire how it has been accomplished . . .

We have no desire to be captious, if we can help it. We do not rashly conclude that this desire for money, country-houses, horses, and the rest, shows an innate or acquired depravity. On the contrary, we dare say that they are very good things, else we do not see why the world should be so bent on having them. But this we do say, and will maintain, that just so soon as an artist, or a body of artists, or a literary man, allows these things to come between him and his art, just so soon his art will deteriorate, and if he persists in dividing his thoughts between his art and the world, the world will finally devour him and his art, and make an end of both. This is not sentimental nor fanatical talk; it is plain common-sense, and is backed by all history and experience; and although we know very well, beforehand, that many who read it will laugh at it, we shall continue to believe it until something better than a laugh can be brought against it.

Now, it is greatly to be regretted that the habit of looking at art as a business, a speculation, a means of realizing money—aspects in which it never was regarded in any great era, nor by any true artist—should become the fashion here. But, unfortunately, the signs are plenty that it is getting to be the fashion, and both the artists and the public are suffering from the effects. There is no lack of talent among us; there are young men who, if they once could feel the stimulus of a cultivated public opinion, or of professional enthusiasm, to say nothing of the inspiration of the muse, urging them to study, to devotion, would produce sterling works, and make art mean something worthy of the world's serious regard. We could name a half-dozen such at least; we will name them;—but no, the public knows them well enough, and they, alas, know the public, and are content to give it all it asks for, because in return the public gives them all that they demand—gold for falsehood and flummery, dross for dross.

This latest movement of the artists, appealing to Congress to help them sell their pictures by giving them a monopoly in the market, is of a piece with the other developments of the spirit we complain of. But, more than this, it shows an indifference to the rights of the public, and to its pleasures, which seems to us very illiberal; these gentlemen consider only themselves, and forget, or else are indifferent to the fact, that, outside of their small circle, the matter in dispute may not be looked at with their eyes. They have come to be so in the habit of looking at their pictures from the shopkeeper's point of view, that they do not see any distinction between his goods and theirs, nor any reason why, if it be desirable that he should be protected by prohibitive duties, it should not also be desirable to protect them. The same way of looking at their work has led them to denounce criticism, for, "why," one of them asks, and in so many words, "shall the critic be allowed to say my picture is bad, and yet it shall be libel if the same man go into my father's grocery and publish that he sands his sugar and sells beans for coffee?" And because this reasoning has seemed good to the artists they have made a combined and strenuous, if not very successful, effort to send the critics to Coventry. In the matter of criticism they were easily answered, for it was plain that if they put their pictures in a public place and asked people to look at them, there could be no law either written or unwritten, forbidding the public to look and speak its mind. So, if the paternal grocer had sent his sanded sugar or his make-believe coffee to the fair, and entered into public competition with other grocers, it would have been perfectly proper for the committee to announce that he had sent inferior goods; his sending them there implies that he dares the risk of being found out and exposed. So much for criticism, where the artists, however anxious to have their productions treated like any other man-

ufacture, could not convince the public that they were justified in their demand. And, now that they have made a second attempt to reduce art to the same level with manufactures, and to have it subjected to the same laws that govern trade in pigs of iron and lead, or in bales of goods, we venture to prophesy that they will not succeed any better . . .

We will confess to something of impatience when we see how easily the men who, by the specific gravity of their genius, sink ever more and more to the bottom, men who never study, who are thoroughly satisfied with themselves, who disdain to be taught, fly for a remedy for their poverty, their ill-success, their failure to draw the regard of the public, not to study, not to devotion, not to persevering endeavor to excel, but to legislation and all external aids. We have, among our artists, earnest students, faithful workers, high-minded, aspiring men, and these men are content with their success, have indeed no reason to complain of neglect. Here we may without impropriety name names, and ask whether any one hears of Eastman Johnson, or Church, or Durand, or Huntington, or Kensett, or Farrer, or Guy, or J. G. Brown, or Charles Moore, complaining that they cannot sell their pictures because of Cadart and Pilgeram?[10] Do Quincy Ward and Henry K. Brown and William Story go about crying because nobody will buy their statues? Was there ever a really thorough, good piece of work made that could not easily be sold for a fair price? We know that there never was, and especially there is never such a thing seen in these days. But if poor work will not sell, we are glad of it. We only wish it were true, but it isn't, for there has been a mania lately for giving more for the poorest American work than can be got for the best foreign, and no good will come of the pecuniary success which has been gained for these works by illegitimate means.

WHAT DOES ART TEACH US?

A prolific author, Russell Sturgis was an architect as well as a critic associated with the Society for the Advancement of Truth in Art. In this preamble to an exhibition review, Sturgis looks to American art as a measure of American civilization after the Civil War. He makes the assertion, rare for his time, that the culture produces and bears responsibility for the image as much as, or even more so, than the artist. Yet he also finds a strange absence of meaning in American art of the 1860s, a lack he attributes to a wont of collective self-knowledge. Such an antipathy toward self-examination was perhaps understandable in the wake of the terrible American-on-American violence of the war. Later in the review he nevertheless devotes a lengthy passage (not included here) to Eastman Johnson's Pension Claim Agent *(1867), suggesting that this work, which confronts the wounds of battle and looks forward to healing, may offer a new direction in painting.*

Russell Sturgis Jr., "American Painters," Galaxy 4 (June 1867).

> Good pictures do not teach a nation: they are the signs of its having been taught. Good thoughts do not form a nation: it must be formed before it can think them.

In an essay upon any subject connected with the fine arts, the writer finds it almost essential to state without reserve what are his assumed grounds of judgment. In this paper, then, it is as-

[10] Alfred Cadart and F. J. Pilgeram were nineteenth-century European art dealers and print publishers.

sumed that the pictures of a nation, like the pictures of an individual painter, are the evidences of its civilization: they are as the mind and heart are that create them. Pictures which are simple and unaffected declare truly the nature of the man or the community that is behind them, whether it be childish or mature, gentle or vulgar. And even pictures which are affected speak truly of the nature they represent, in this respect—that it is capable of pretending to be what it is not. How far, indeed, the beautiful arts are also an aid to civilization, how potent they are as teachers, it is not now my purpose to inquire. But, in a general way, it is safe to believe that the appointed teachers of a man or of a nation are to be found nearer at hand than in a picture gallery. A good picture may generally be used for his own good by a good man, as nature may, as adversity may, or prosperity, or his own animal passions. Nevertheless, primarily, a picture is to be judged as an embodiment of good and bad qualities, and a picture gallery to be visited as a partial record of the national life for the time being. It is not my aim, however, to deduce any theory of our national character from the character of American art. It is rather because I think it usually more the community's fault than the man's, when a picture is bad, that I have put at the head of this paper those two sentences from Ruskin, and have expanded what seems to me their meaning into this preamble.

M. Henri Taine's theory of the fine arts, which he regards as a common and all-sufficient standard from which to judge them, is that the artist is the embodiment of his era. It is true in the sense that whatever his art does embody is of his era, and more or less truly representative of it. But the theory fails in this, that some eras are but imperfectly represented by their fine arts, and some hardly at all. This present decade, for instance, in the United States, is but poorly expressed by the pictures, taken together, which are produced here and now. The only thing the pictures of the day truly represent is a comparatively unformed national mind and character— a want of national individuality. And so long as our art shows that, it will not show much else. Very few of our pictures represent anything or are about anything. As yet, our faculties are not in order, nor do we, as a people, know what faculties we have or might have. Art is the result of a civilization in some respects, at least, more matured. It is no matter what excellent traits we may have as a people, how much flexibility and strength, how much of that savage energy that helps toward civilization; so long as we do not understand ourselves, or our needs, better than now, we shall have no good art. We are far behind the best culture of Europe in those refinements and in that training that make some good art sure, and great art possible.

IS RELIGIOUS ART STILL RELEVANT?

Among the critical certitudes of the antebellum era was the almost missionary importance of art in the service of religion (by which was usually meant Christianity). In the wake of the war, religious sentiment appeared less and less in writing about art, although few writers would openly dismiss it. An exception was a critic for the New York Times, *who, considering Edwin White's painting* St. Stephen's Vision, *in May 1867, questioned what a modern audience could gain from such works. His remarks provoked the response recorded below from "Paletta," a critic for the* American Art Journal. *In this impassioned defense of religion in art, the writer provides a moral diagnosis of the era, likening the attitude of the* Times *to certain contemporary social ills, including lack of respect for the elderly and an "independent, go-ahead, selfish feeling." Henry Tuckerman, characteristically more even-tempered, takes on the same issue in his* Book of the Artists, *also published in 1867. He argues against narrow doc-*

trinal reactions to religious art, replacing them with more universal concepts of spiritual beauty, nature, and the links between the senses and the mind.

A few years later, another religious controversy erupted, this time with a work by William Page. Dubbed "the most originally experimental of American portrait painters" by Tuckerman, Page was seen as a ruminative loner, despite that fact that he was an active participant in the organizational art life of New York. In any case, patience for Page's eccentric work evaporated in 1871, when he showed a decidedly uncanonical depiction of Christ at the Academy Annual. Critics lined up to condemn the work as "repulsive," "shocking," a "hideous deformity," "a positive sacrilege," and "a libel on the Christian Religion." At play seem to have been several issues, among them the propriety of the public display of religious art, the blurring of boundaries between portraiture and history painting, and the conflict between Page's personal expressionism and the general taste for realism. Of the two reviews included here, the first is characteristic of the negative responses while the second, by Susan Nichols Carter, shows unusual sympathy and understanding. Curiously, both dwell on "racial" questions related to the perceived Jewish nature of Page's head (an undercurrent of anti-Semitism also threads through this debate). Carter tries hard to explain why Page's painting should cause such widespread offense, and in the end she attributes it to the artist's Swedenborgianism, a somewhat mystical variety of Christianity unusually popular among American artists (see "George Inness and the Spiritual in Art," chapter 8).

"Paletta," "Art Matters," American Art Journal 7 (June 1, 1867).

Had this passage occurred in "Volney's Ruins," "The Age of Reason," or "Vestiges of Creation," one would not be surprised, but that such blasphemy—for by no other name can it be called—should be published in a respectable newspaper is almost beyond belief. Have we then arrived at the millenium and are we too good and holy to need Bible instruction in whatever form it may be presented? "People care nothing, now-a-days, about the martyrdom of St. Stephen"—the critic speaks with decision, but does he believe that the majority of his readers coincide with him? Heaven send otherwise. We are all wicked enough, but the worst of us still retain at least some veneration for holy things, and it will be a long time ere the infidel doctrine conveyed in this article can gain ground or influence. Yet writing such as this is doing evil day by day, and is, alas, becoming too popular with the masses. Americans are notorious for the little respect they pay to gray hairs, and this same independent, go-ahead, selfish feeling gains ground daily. The writer who can speak lightly or scoffingly of religious and family ties and duties is admired by the masses, and, if he clothe his baneful doctrines in amusing language is looked upon as a clever wit and applauded accordingly. But whither does this all tend? In what light does it present us to other nations, less "fast" in their ideas? What will they think when they see one of our leading newspapers assert that we read our Bibles with a "*certain* kind of religious interest?" Are we heathens and infidels that the whole Christian community should be thus branded? Or are we, after all, what the critic of the *Times* would make us out? Heaven grant, for the sake of our national honor, it may be otherwise!

As to the art view of the matter it is simply absurd. That an historical painter, which Mr. White eminently is, should confine himself entirely to painting pictures of the present day is a view that no one, having a thorough knowledge of art, will for one instant entertain . . .

As to religious pictures being devoid of interest, it is to be devoutly hoped that the day is far

distant when this will be true. Art is the teacher, the instructor of man, and the higher her teachings the greater the benefit she confers upon mankind; and surely art can never be better employed than when bringing all her powers to bear in presenting to us those grand and elevating truths which go to make up Holy Writ.

No newspaper criticism nor infidel writing can ever controvert this great truth—a truth which has lived as long as art has lived, and must exist to all eternity.

Henry T. Tuckerman, Book of the Artists *(New York: G. P. Putnam and Sons, 1867).*

And this brings us to that mooted question which has been such a thorn in the side to conscientious but narrow minds—the true relation of Art to Religion. To deny any whatever, is absurd, as long as men gather beneath a roof however simple, to worship; and if we recognize in the arcades of the forest and the glory of the mountain, either the tokens of divine benignity or the unconscious praise which the universe offers to her Creator, how much more significant are the intelligent trophies of genius which his love has consecrated, when gathered to illustrate his truth! The recoil of the world's free spirits from the civic tyranny of Papacy, has blinded too many to what is essentially good and true in her customs. When we meet the idea dissevered from all incidental prejudice, the attempt to set forth what is most touching in the Christian faith, in melody that wraps the soul in a holy trance, or in forms and colors that bring worthily before the eye examples that cheer or soften, or purify the weary and cold affections, does it not commend itself to reason? It is in vain for a few peculiar, though it may be superior minds, to legislate for humanity. We must look at our race objectively, and not merely through our individual consciousness. They are destined to receive good, not according to any partial theories, but by the observance of universal laws, by reverently consulting the wants, capacities, and principles that are traced in the very organization of man by the hand of Creative wisdom. Thus regarded, is it not obvious that through the senses we must reach the soul—that the abstract must be made real—that sensation is the channel of spirituality? Why runs there through the frame this delicate and complex web of nerves? Why do eye and ear take in impressions which stir the very fountains of emotion, and gradually mould the character? Why are brain and heart filled and electrified by Art? Is it not because she is the interpreter of life, the medium through which we are more conscious everlastingly of high and vast destinies? Argue and moralize as bigots may, they cannot impugn the design of God in creating a distinct and most influential faculty in our nature, which has not merely a useful or temporary end—the sense of the beautiful. Ideality is as much a heaven-implanted element as conscientiousness. Nature's surpassing grandeur and loveliness hourly minister to it, and Art, in its broadest and highest sense, is its legitimate manifestation. When a human voice of marvellous depth and sweetness yields to thousands a pure and rich delight, or a human hand of ideal skill traces scenes of grace and sublimity, and bequeathes the features hallowed by love or glorified by fame,—then is the worthiest praise offered to God by the right and sacred exercise of those faculties which unite mortal to angelic existence. Far, then, be from every liberal mind and feeling heart the idea that genuine art can ever profane religion, that the symbol must necessarily shroud the fact, that in seizing on any intermediate links of the golden chain which binds us to eternity, as with our frailty and limited vision we are ever fain to do, any serious alienation is threatened to what is actual in faith or desirable in sentiment. As long as we have senses, they must be represented; and there is far less danger of our being enthralled to images or ideas of any kind than to interest, the basest and most subjugating as well as universal of idolatries.

"The Fine Arts," New York Times, *April 23, 1871.*

Anything that comes from the hands of so eminent an artist as Mr. PAGE is worthy of more than passing notice. On one or two occasions Mr. PAGE has been accused, in striving after originality, of overstepping the bounds of artistic license. In the picture now on exhibition at the Academy of Design, his love of originality has certainly betrayed him into the production of what may almost be termed a monstrosity. Mr. PAGE, it is said, has been at work on this painting for over two years, and he has apparently mused over it so long that it has grown into a sort of Frankenstein beneath its creator's hands. It seems to us that the production of such a work, by such an artist, can only be accounted for by supposing him to have set out with the determination to discard all previously conceived ideas of the material form of our Savior, and to evolve one purely out of his "inner consciousness," which should be unlike all others. A very much greater artist than Mr. PAGE might well have failed in the attempt. We know how impossible it is for any mortal hand to portray a head of Christ, which shall in all things be satisfactory. The meekness, the purity, the devotion, the courage, the fervor, the dignity of Christ's character, cannot be put on canvas. But we may at least look for its two leading traits, meekness and purity. In Mr. PAGE's Christ we find neither of these. His idea of the "Lamb of God," as represented in the picture under consideration, is a sturdy young Jew, and that not of the pure but the mixed race, with a rather broad face, low forehead, remarkably prominent eyes, thick nose, and the lips of a Bacchanal. The contrast between the purplish red of the lips, and the reddish yellow of the beard, is alone sufficient to render the picture repulsive. Instead of the meek, the pure and lowly Jesus, the consoler and the comforter, we have here a stout young fellow who appears to have just risen from a good dinner, at which, judging from his flushed cheeks and glaring eyes, he has been indulging rather too freely. We have remarked that the face is not that of the pure Jewish type. The descendants of pure Jews, who are now only to be found in Jerusalem, are not distinguished by thick lips and noses. These are types of the mixed race. Why, therefore, Mr. PAGE should have thought it necessary to give his Christ these characteristics we are at a loss to understand. Perhaps it was because all other painters have avoided them, and Mr. PAGE was determined to be original. The picture is, to our thinking, positively repulsive; nor do we even accept the dictum we have heard concerning it that, "unsatisfactory as it may be, a great artist alone could have painted it." We believe that, did it not bear Mr. PAGE's signature, it would not attract a second thought from any one.

Susan Nichols Carter, "The Spring Exhibition at the Academy of Design," Appleton's Journal 5 (May 27, 1871).

The head, in the east room, marked 205, the property of Mr. Tilton, and painted by William Page, is without a name. But the verses on the frame of the picture, from the first chapter of John—"Again the next day after John stood, and two of his disciples; and looking upon Jesus as he walked, he saith, Behold the lamb of God!"—and the emblems of a lion, a lamb, and a crown, but still more the character of the head itself, leave no doubt as to its intention to represent Jesus Christ.

The figure is that of a young man of large and powerful frame, a very full forehead and head, and a fair, florid skin. What at first strikes the beholder is the soft mass of reddish, curling hair—the real Titian red—and the beard of a lighter hue, which falls as softly as threads of silk over his chest, its texture plainly showing that it never has been cut, and that its wearer is a "Nazarite." The nose is straight and rather broad, with firm, strong nostrils. Full and very red lips pout out through the tawny beard, and to any one who has an image in his own mind of a

suffering and risen Redeemer they suggest too powerfully the earthly side of his nature. Yet the suggestion is but superficial, and it is only a *touch* of earth; for the lower part of the face is small, the mouth neither large nor powerful and the fulness and redness of his lips are but the slight link through which the frailties of earth could be apprehended by the spirit which sits behind the wonderful eyes of the picture.

The eyes are really the key to the portrait. His vast head is turned partly down and round over his shoulder, his beard and hair-sweeping backward with the action, and the "Lion of Judah" is revealed through the great pale-gray eyes, which are set and formed like those of the king of beasts. The great black pupils also suggest the lion. But here the animal likeness ends, and the supernatural and typical character of the face commences. Occasionally, but very rarely, in women and young children, we see pale, blank eyes, into which the soul of the person ebbs and flows; and such, though in a wondrously higher degree, are the eyes of this Christ. The face is entirely serious and unconscious, and all the nature of the man seems held in abeyance, waiting the advent of the God. As you gaze into the eyes, capacities of expression are revealed to you—power, thought, and love, and also, what I have never seen in face or picture, the look of the supernatural. The human element seems to be possessed and spellbound by it, and it affects and enchains the beholder. It is this element, I think, which affects, excites, and repels so many, and which makes the picture seem so strange, so foreign, and so much a thing by itself among the others, that when the eye rests upon it, traversing the walls of the academy, one is startled and almost shocked, and, like a child scared by a ghost-story, tries to laugh, to criticise, and to condemn, and yet, as if fascinated, returns again and again to inquire and to wonder, and, in my own case at least, to finally accept the picture as a work of decided genius and originality.

The truth is, that this picture, like all other works of art, should be judged from the standpoint of the artist, and not from that of other people. We should consider what the artist has sought to convey, and then see whether or not he has carried out his idea successfully. Mr. Page is a Swedenborgian, with views of Christ differing essentially from those now current in the world. According to the Swedenborgian doctrine, the Jewish nation was not selected for the incarnation on account of its excellence, but rather because it was spiritually the worst of mankind. The Lord, in order to raise and redeem humanity, went down to its lowest depths, and was incarnated in a woman who, so far from being of immaculate conception, was subject to the strongest tendencies and temptations of her race, and transmitted those tendencies in their fullest measure to her offspring. The *human* nature of Christ, therefore, was at first peculiarly human, and combined in itself all the evil propensities which then afflicted humanity, and from which the race would have speedily perished if the divine Creator had not assumed humanity himself, in order to meet evil spirits on their own plane, and, by resisting and overcoming as a man the worst of temptations, put the devils to flight, and thus restored and preserved the freedom of the human mind, to whose very existence freedom is absolutely essential. From this point of view, then, Page's picture must be judged. His Christ is not the conventional Christ of the artists—all sweetness and loveliness, the man of sorrow and suffering—but rather the Christ still contending with the infirmities of his Jewish nature, and still ready to denounce the Pharisees and scourge the money-changers out of the Temple.

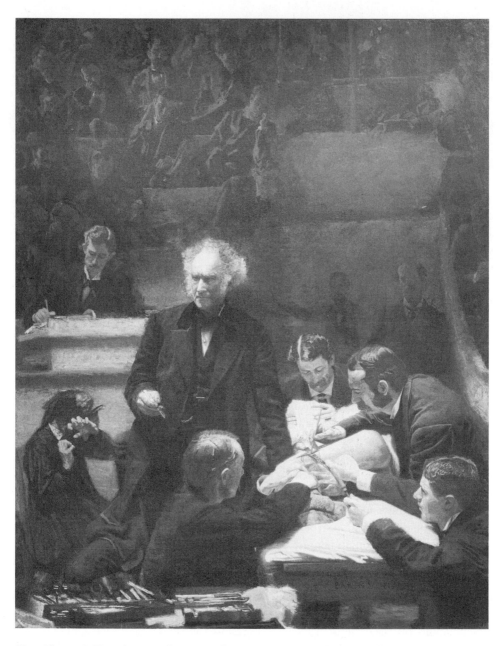

Fig. 8. Thomas Eakins, *The Gross Clinic*, 1875, oil on canvas. Courtesy of the Pennsylvania Academy of the Fine Arts, Philadelphia. Gift of the Alumni Association to Jefferson Medical College in 1878 and purchased by the Pennsylvania Academy of the Fine Arts and the Philadelphia Museum of Art in 2007 with the generous support of more than 3,400 donors to the Fund for Eakins' Masterpiece.

8 THE GILDED AGE

Life and Landscape at Home

NATIONALISM AND HOME SUBJECTS

EUGENE BENSON'S FRENCH GOSPEL FOR TRULY AMERICAN ART

The American Civil War exposed the fiction of any coherent national identity and cata-
lyzed an urgent need to fabricate or weave it anew once peace was concluded. From the
end of the war through the 1870s, accordingly, critics engaged in vigorous debate on the
present and future state of American art. During that time, the periodical press and
commercial galleries gave space to the latest in art from abroad, in particular modern
French painting in every genre. The concurrent migration of American students to art
academies in Munich and Paris, coupled with a mounting distaste for antebellum styles,
added critical pressure to the problem of identity for American art: Was it to take its
cues from abroad or develop in isolation? How might artists forge a truly American
style? What would the truly American artist paint? Was there an American school;
should there be one?

Eugene Benson, painter and critic, was one of the leading early voices in the call
for reform in American art. Benson wrote reviews for the New York Post *under the*
sobriquet "Sordello" and contributed important articles on modern art and society to
Putnam's, The Galaxy, *and other magazines (see also "Eugene Benson," chapter 12).*
Conversant with modern French literature and art, Benson wrote knowledgeably on
those subjects as well as their American counterparts.

In "Modern French Painting," Benson turns to the socialist-anarchist Pierre-Joseph
Proudhon as an example for American art and artists. Summarizing Proudhon's thought
as expressed in his book Du Principe de l'art et de sa destination sociale *(1865), Benson*
describes Proudhon's new ideal: art must be free, democratic, contemporary, and based
completely on ordinary life. This must, for Benson, become America's "gospel" of art as
well.

At the same time, American painters at all costs must eschew the false language of
"French wit." In his review of the 1865 National Academy of Design exhibition, Benson
urges artists rather to "stutter in a language of their own," however inelegant and tenta-
tive the result may seem at the outset.

Eugene Benson, "Modern French Painting," Atlantic Monthly Magazine 22 *(July 1868).*

No modern nation has a group of men comparable to the French painters of the last thirty years. In the art of painting, as understood by painters, they have no peers, save in the sixteenth and seventeenth centuries. Their science of art is French; their ideas are universal,—do not belong exclusively to the French mind. Today, French art is more local, less universal; therefore, not great. It has again fallen to the level of the average French mind. The average French mind— or genius—is exact like Gérôme, light like Chaplin, pagan and sensual like Cabanel, full of exaggeration like Doré, bold and prosaic like Vernet, whose popularity "is the accusation of a whole nation." But, back of all these traits, which are so characteristic of the French, there is a genuine love of out-of-door life; and the modern French landscape painters are the artistic correspondence of that love. That love is universal; therefore the French landscapists have a public outside of France. They are not localized. Great men are not local. They do not correspond with the average men of their nation; they correspond with the superior men of the world . . .

None of Delacroix's works have any value as studies of manners, or as realistic renderings of the subject. If you are in the habit of occupying your mind with details; if you follow the contemporary method in art,—in which the observation is everything, and the dream nothing,— in a word, if Balzac and Thackeray are your best types, you will not understand, much less appreciate, Delacroix . . .

The aggressive Proudhon, who opposes the whole spirit and fact of French art as being anti-democratic and anti-realistic, says: "Delacroix has a lining of Lord Byron, of Lamartine, of Victor Hugo, of George Sand; he is also the illustrator of Shakespeare and Goethe." And then he asks: "But what do I care for all these declaimers and weepers?"

No doubt these are appropriate and expressive words in the mouth of a democrat. No doubt the man occupied with the question of labor and emancipation has no respect for the romantic dreams, the spiritual and moral disorders of men and women whom excess of sensibility and passion for the ideal forbid to mix in the hurly-burly of life, but place before the spectacle of the human soul, in its body of flesh, enacting the perpetual drama of its desires and its debasements.

Proudhon's book is a running, aggressive, democratic commentary on art. It is the only book that I know which is a brave and sturdy effort to refute the artistic idea as it is understood by the artists; it aims to substitute a purely democratic idea of the painter's function. The only art that can hold a place in Proudhon's emancipated society is the modern landscapist's; or the art of the painter who flatly outrages the classic ideal and the studied form,—like Courbet.

If I should speak from Proudhon's book about French art in the nineteenth century, I should be perfectly well understood by every American; and the average reader would recognize good sense, and wonder why he ever admitted the metaphysical talk about "art" and "beauty" and "the ideal" to impose itself upon his mind and convict him of ignorance. I should be thought sensible and convincing with Proudhon's thought on my lips; but, let me hasten to add, I should be at once outside of the idea of art as it is understood by artists. I should be speaking from the very lapse of the artistic sense. I should be honoring common sense, which in Proudhon, as never before, does its iconoclastic work upon the beautiful world, cherished at the cost of the comfort of the people.

Proudhon's book is the gospel of modern art as it must be developed in America; that is, free from tradition, free from the voluptuous, based wholly on the common life of the democratic man, who develops his being on a free soil, and in the midst of a vast country.

"Sordello" [Eugene Benson], "National Academy of Design. Fortieth Annual Exhibition. Second Article," New York Evening Post, *May 12, 1865.*

Continuing our examination of the pictures in the new galleries, we remark the absence of works purely artistic. Our best executive talent seems to be exercised on pictures the motive of which is adequate, and characterizes the subject. It is here that we diverge from the art of France. French painters show the most exquisite and expressive characteristics of style in works that do not mean much, or are trivial; but though many of the rank and file of the profession of art have not much to tell, that little they tell so charmingly that we forget to ask more than they give. But our painters, when not utterly negative and conventional, aim to make us share something of their experience; and they paint in an awkward, immature manner. With the exception of such men as Gifford, Kensett, Inness, E. Johnson and Vedder, our painters do not illustrate art as a beautiful expression of nature. Our painters illustrate art as a means of expression not yet mastered, as a language not yet acquired; for they neither show elegance, grace, opulence, nor vitality of style. We sometimes get positive strength, as in the works of Winslow Homer; we sometimes find the careful and studious, as in Griswold's pictures; sometimes the brilliant, as in the portraits by George A. Baker; sometimes the graceful and delicate, as in M. O. Stone's heads; but these works are exceptions. The great majority of paintings on view at the new galleries are simply devoid of charm or distinction of style, and the motive of these paintings is not strong or great enough to characterize them. But seriousness and truth in *patois* ought to be more precious than folly and falsehood in the polished language of a French wit. Certainly we do not hanker after the graces, the seductions of French art. And if our sturdy reliance upon ourselves does not come from insensibility, we find cause to hope much of painters who would rather stutter in a language of their own that admits of a great development than impose upon themselves the letters of what is acquired and foreign.

HOME SUBJECTS AND PATRIOTIC PAINTING

In the Gilded Age, demands for the purging of foreign influence in American painting alternated with anxiety about the possibility of developing a genuinely American school. The author of "About an American School of Art" describes the current American art scene as "chaotic," the problem being that younger artists imitate art rather than nature. Only when they learn to see things for themselves will a great and authentic school of American art take root.

In "Home Subjects for American Art," the unnamed writer criticizes much of the work at the National Academy of Design exhibition as "imitation" but sees this as an unfortunate necessity for artists seeking patronage in a market flooded with foreign goods. Only a few intrepid artists, particularly Enoch Wood Perry, Eastman Johnson, and Winslow Homer, persist in painting home subjects. The author's endorsement of Perry, however, suggests the fundamental dilemma of home subjects: ostensibly authentic and local, they were also anachronistic and in that sense delusive. Representing American rural life, Perry's paintings are truthful and healthy. Yet they are ill adapted to the "Fifth Avenue parlors" decked out in the latest French fashion. Nonetheless, were there only a few more like Perry and his colleagues, an American school of art might truly take shape.

In his historical survey of American art, the critic S. G. W. Benjamin seeks to draw

attention to the rich trove of hitherto neglected yet richly picturesque subjects to be found in the modern metropolis. Benjamin argues, though, that it is not subject but rather "treatment" that demonstrates nationality in art. The truly patriotic artist, wholly in sympathy with his homeland, will produce an authentically native art regardless of the subject he or she happens to choose.

"About an American School of Art," Scribner's Magazine 10 (July 1875).

In America, art is chaotic. There is nothing that we can talk of yet as an American School of Art. Some of our best artists go abroad and remain there, because they can live cheaper there, and make more money. There is but a faint degree of cohesion and sympathy among those who remain at home. One is characterized as painting in the French style, another as painting in the English style, and still others as adherents and imitators of certain strong individualities among themselves. Wherever there is not a strong and broad sweep of influence in a certain direction, there are, naturally, a thousand eddies. Where a School is not in process of formation, every young artist and every feeble artist becomes easily colored and influenced by the strong men with whom they come in contact. It does not matter whether the strongmen are strong in a healthy way, or strong in an unhealthy way. They only need to be powerful to work a thousand mischiefs all around them. It needs only some Turner to rise among us with some Ruskin to glorify him, to give him a fearful following.

The danger to all our young artists, of course, is that of being fascinated by unique individualities, and thus led away from nature and themselves. To see things as the demigod sees them, to represent them by his methods, to be led by him, magnetized by him, fooled by him who has the misfortune to see things exquisitely wrong, and the power to represent them outrageously beautiful, is to be artistically ruined. What nature says to him, his admirers cannot hear, save through him. What he sees in nature, they can never know, save by his interpretation. There is no safety in following anybody, in any field of art. What God and nature say to the artist, that, precisely, he is to speak, and he ought to speak it in his own language. To choose another's words, to look at nature from another's window, is a sad confession of artistic incapacity and untruthfulness. Schools of art are no more built up around a man than a house is built up around a window. Turner could never produce a school, although he might injure one very materially—possibly benefit it, in some respects. Pre-Raphaelite theories can never produce a school, although they may contribute ideas to one. What our young artists need is absolute disenthrallment from the influence of strong individualities in art, and a determination to see things for themselves. They must yield themselves to the influences of their time and their home, look into the life and nature around them for themselves, and report exactly what they see in the language natural to their own individualities. They must be led away from their duty by no man's idiosyncrasies, no man's mannerisms, no man's theories.

It is only in this way that a great school of art can grow up in America. The broad culture that comes of tolerant and respectful study of all who labor in the realm of art, the discarding of partisanship, the renunciation of bondage to theories and methods—these must precede the formation of a school, if we are ever to have one which shall be worthy of the name. Nature, as she speaks in America to those who listen with their own ears, and report with their own ingenuities; life as it is embodied in our political, social, and religious institutions; life as it is lived upon our own soil, and in our own homes—these are the basis of an American school of art. Such a school must be a natural growth, or it will hold no principle of vitality, no law of development, no present or historic value.

Looking honestly and without prejudice at the exhibition in our Academy for evidences of American talent, it must be confessed that we did not discover any calculated to excite much enthusiasm. Most of the work was merely imitation; it was executed abroad under the influence of foreign teachers, and, in the majority of cases, the subjects were foreign as well as the methods.

Our artists are not to be blamed for seeking foreign instruction, or for the adoption of foreign methods and models, for they find it necessary to go abroad if they desire to be patronized at home; and if any one took note of the happy painter whose pictures in the Exhibition were inscribed with that delightful and cheery monosyllable "Sold" upon their frames, they will remember that they were mostly those having the greatest resemblance to foreign masters and which had the smallest tincture of Americanism in their composition. But there are a few of our artists who bravely persist in painting pictures illustrative of American subjects, and who resolutely refuse to imitate in their methods any of the fashionable foreign masters whose works are so much sought after by American collectors. The neglect that these artists suffer in consequence of their devotion to American subjects and ideals is not calculated to encourage others to follow their patriotic example. One of the most conspicuous of our American artists, who devotes himself wholly to subjects of a local character, and who does not permit his foreign studies to intrude upon his home production, is Mr. E. Wood Perry; he had five pictures in the Academy Exhibition which were all illustrative of American rural life; they all smelled of the soil and were full of healthy influences; but the homeliness of their subjects rendered them unattractive in spite of their truthfulness and their artistic excellence. A hearty-looking farmer's wife, or daughter, bearing an armful of green corn which she had just gathered in the field; a sturdy, young farmer sowing grain in the early Spring, and a dairymaid churning butter, while her beau gives a "helping hand," are very suggestive of the sweetness and pleasures of a rustic life, but they are not adapted to the surroundings of Fifth Avenue parlors where everything else reflects the latest caprices of French fashion. Where all the furniture looks as if it were of the latest importation, it is natural that the owner should want pictures to correspond with the chairs and tables, the chandeliers and the carpets. Eastman Johnson is another of our artists who confines himself to homely American subjects, although he has had the benefit of European studies. His two *genre* contributions to the Exhibition this year were thoroughly domestic, and the two portraits would be recognized anywhere as Americans. Mr. Winslow Homer is another of our native *genre* painters who resolutely confines himself to American subjects, and who, we trust, finds his account in doing so. These are not all, by any means, of our distinctively American painters, but they are the most prominent, and each keeps in his own distinct province. We wish that the success of these artists was such as to encourage many others to follow the course they have so courageously followed. If there were a few more like them they might form an American school of art, which would work in honorable rivalry with the English, the French, the Belgian, the German, the Spanish, and the Roman school. But we must be patient for a while. The American school of art at present gets its best encouragement from the illustrated journals, and exhibits its most encouraging developments in drawings on the block. The amusing manner in which our native artists work abroad was, at the time of the Exhibition, referred to in this paper, in connection with two large paintings by American pupils of Piloty in Munich. Both of these were studies of the same subject and were almost identically treated, and in both the incongruity was displayed of American artists painting in Europe Turkish subjects in Italian style. The only special attractiveness of these pictures was the "splurge" of color for which they happily afforded an opportunity, so as to divert the attention from their intrinsic empty

unreality. The strange mixture of nationalities which they embodied showed conclusively how antagonistic our system of art education is to anything like the cultivation of a national, or even an individual, school of art in the United States.

Samuel Greene Wheeler Benjamin, Art in America: A Critical and Historical Sketch *(New York: Harper, 1879).*

It is with additional pleasure that we note the works of some of our more recent native *genre* artists, because we see indicated in them a growing perception of the fact that abundant subjects may be found at our own doors to occupy the pencil of the ablest minds. It is not uncommon to hear young artists who have studied in the ateliers of Paris and Munich, and who have returned here to work, complaining that they find no sources of inspiration here, no subjects to paint at home. This dearth of subjects certainly would be a very grave obstacle to the ultimate development of a great American school of art, if it actually existed. But on examining the question, it seems to us that the difficulty lies not in the lack of subjects, but in the way the artist has learned to look at things, and the range of sympathies to which he has become accustomed by his foreign experiences.

The artist who is the man of his time and his country never yet lacked material for inspiration in the every-day life and every-day objects around him. Goethe has said that the truest poetry is that woven out of the suggestions gained from simple things. There has never yet been such a state of society or such an order of scenery that the artist who was in sympathy with it could not find some poetry, some color, some form or light or shade in it that would stir the finer elements of his genius, stimulate his fancy, and arouse his inventive powers. Some quality of beauty is there, concealed like the water in the rock; the magician comes whose rod can evoke the imprisoned element, and others then see what he had first seen.

As we stroll, for example, through the streets and squares of New York's metropolis, by its teeming wharves, and among its dilapidated avenues of trade, we are astounded to think that any one could ever look on this seething mass of humanity, these various types of man, and the various structures he has erected here, and find in them no inspiration for his brush or his pen. What if there are no feluccas or painted sails in our harbor; one has but to cross the river on the ferry-boat at sunrise or sunset to see wonderful picturesqueness and beauty in our sloops and schooners, our shipping thronging the piers, all smitten by the glory of the rosy light, or over-canopied by scowling gray masses of storm-driven scud.

Or if one saunters up our streets and gazes on the long vista of Broadway toward nightfall, as the lazy mist gradually broods over the roofs and delicately tones and softens the receding rows of buildings, he shall see effects almost as entrancing and poetic as those which charm the enthusiast who beholds the sun, a crimson disk, couching in a gray bank of smoke at the end of the boulevards of Paris, on an evening in October.

Is there nothing picturesque and artistic in the Italian fruit venders at the street corners, especially when after dark they light their smoking torches, that waver with ruddy glow over brilliant masses of oranges and apples?

There is yet another scene which we often encounter, especially early in the morning, at a time when perhaps most artists are yet wrapped in dreams. We refer to the groups of horses led through the streets to the horse-market. Untrimmed, unshorn, massively built, and marching in files by fours and fives with clanging tread, sometimes thirty or forty together, they present a stirring and powerful effect, which would thrill a Bonheur or a Schreyer. Why have none of our artists attempted to paint them? Have we none with the knowledge or the power to render the subject with the vigor it demands?

No, we lack not subjects for those who know how to see them; while nothing is more certain than the truth that a national art can only be founded and sustained by those who are wholly in sympathy with the influences of the land whose art they are aiding to establish. Those who are familiar with American art will easily recall a number of our artists, educated both at home and abroad, who have no difficulty in finding material around home, and at the same time take the lead among us in point of artistic strength.

While indicating, however, some of the many subjects which address one at every turn in our land, and render it unnecessary for artists to go abroad for a supply of fuel for their fancy, we would not, on the other hand, imply that an artist should, in order to be an exponent or leader of a native art, be confined exclusively to one class of subjects. Although it is one of the most remarkable and indisputable laws in literature and art that those who are identified with nature and human nature, as it appears in their native country, are at the same time most cosmopolitan, still it is, after all, not so much in the subjects as in the treatment that the individuality of a national art is best demonstrated. It is when the artist is so thoroughly imbued with the spirit of the institutions of his native land that it appears in his art, whatever be the subject—it is then that he is most national. We hear a great deal about the French school and the English school; but it is not because each school finds its subjects invariably at home that it possesses an individuality of its own, but because we see unconsciously reflected in it the influences of the land that gave it birth. For this reason, if an English and a French painter shall each take the same scene, and that a wholly foreign one, say an Oriental group, although the subject be a foreign subject and identical in each canvas, you can discern at once that one picture is English, the other French in treatment. Each artist has stamped upon his work the impression of the influences of the people to which he belongs.

Patriotism, a wholesome enthusiasm for one's own country, seems, then, in some occult way to lie at the basis of a native art, and native art founded on knowledge is therefore always the truest art; while the artist who is thus inspired will generally find material enough to call forth his æsthetic yearnings and arouse his creative faculties at his own door.

EASTMAN JOHNSON'S FORMULA FOR SUCCESS

By the late 1860s, Eastman Johnson had begun to mine the vein of rustic New England subjects that vaulted his popularity to new heights. Although he also explored themes of middle-class urban life in both portrait and genre paintings, Johnson won his most fervent accolades for the succession of complex and monumental scenes of rustic New England life that occupied him in the 1870s. The quintessential painter of the home subjects so desired by chauvinistic critics and viewers, Johnson worked in a conservative but cosmopolitan style that drew elements from (among others) seventeenth-century Dutch and contemporary French Barbizon art. Staking his claim to authenticity by living on quaint Nantucket Island and working from local models during summers in the 1870s, Johnson celebrated rustic simplicity, childhood innocence, pastoral tranquility, and communal ritual in his scenes of country life. Wholesome and accessible, his pictures told visual stories about what many wanted to believe was real *American life, far from the cities, railroads, factories, and social conflicts that were, increasingly, the true face of modernity.*

Johnson exhibited The Old Stage Coach *at the National Academy of Design to rave reviews in 1871. Dozens of newspaper and magazine articles heaped glowing praise on*

the picture and the painter, who seemed to have aimed unerringly at the viewing pub-lic's desire for escapist yet utterly believable all-American art. The Evening Post *review below encapsulates all of the elements that added up to the painting's immense appeal.*

"Eastman Johnson's Last Picture: The Old Stage Coach," Evening Post *(New York), March 10, 1871.*

The serious work of our most conscientious artists merits more than the brief mention of hap-hazard remark, or the complacent common-place of fulsome compliment. Works which have been happily conceived and judiciously treated—which have really presented difficulties that have been successfully surmounted—which are, in most respects, more than agreeable, are to be classed with pictures that ought to be popular. We are much mistaken if Mr. Eastman John-son's "Old Stage Coach" is not such a picture. It is one of his most genial productions, and in purpose and execution is perhaps more of an achievement than anything he has painted since his "Old Kentucky Home." He has not painted anything that presented greater difficulties, or which required more of his best artistic intelligence in the treatment of nature.

An old stage-coach without wheels, and abandoned in some village lot or lane, is a forlorn looking object, possibly pathetic to a musing mind, probably suggestive of merriment, of racy humor, to most men, but to boys it is a playhouse, a royal chariot, a dumb thing subject to the nimble and fervid imagination of the most adventurous. Johnson's old stage-coach is just such an actual, old, dilapidated but capable vehicle, and it is evident that it is quickened with the fleet life of glad boys and girls who are in little what its old stagers have been. Mimicry so trite pleases us precisely because it is so natural and sportive. All the world's a stage, the poet tells us, but to these boys and girls all the world's a stage-coach. Just here we are glad to see it as a spectacle. Mr. Johnson has painted a picture that ought to slide into our consciousness through the yesterdays of our boyhood. Does not as much glee, so much pure spirit, communicate it-self to our own jaded or inert being so that life springs anew, and we drink again from the pure sources of existence—childhood and summer in the country! If Johnson's old stage coach does not do so much for us it does little, indeed: it is but a painted show to be criticised, to be judged as mechanism, or anything that is without relation to our feelings. We think less of Mr. John-son's work as a *picture* simply because it means so much as *life* . . .

Mr. Johnson is on the same plane with many of the best modern novelists: he is natural, sometimes realistic, and always keeps close to the actual. The interest of his subject takes the precedence of its treatment. Later we dwell with satisfaction and sometimes with delight, upon the details of his art. In his last picture we must notice the variety of character and incident in his happily grouped figures, the admirable sunniness of the effect, the heartiness and earnest-ness with which each of his little personages enacts the character that seems to suit the match-less natural impulses of boys and girls left to themselves. The occasion for closer criticism will, of course, afford us the opportunity to notice the cleverly discriminated characters which Mr. Johnson has grouped together. The boy standing on the top of the coach, waving his hat, shout-ing his satisfied glee; the thin, nervous boy, who prances; the flexible mulatto girl; the rough boy who plays the vicious horse; the lazy one who rides with the driver himself, who cracks his whip and holds the ribbons like a master—is not all this of itself so much dramatic life suc-cessfully rendered by Mr. Eastman Johnson? And the broad, filmy sky, so light, so full of air; and the dull red of the old coach; the sunshine, the precious pictorial expedient of color in the ashes and embers of the fire in the foreground, with which the boys have amused themselves—all this is to us unhackneyed in incident and truly natural in color, and we extend to Mr. John-son our congratulations and take pleasure in expressing the satisfaction we have had in seeing

the noisy sport of a happy lot of boys and girls in an old Nantucket stage coach. The picture has been happily conceived and judiciously painted, and although necessarily less elaborate than his "Old Kentucky Home," it is not less expressive of the primary and ultimate artistic purpose of his work, which is to communicate the untroubled joy of childhood, to express the sportive movement, and the bland air and delightful sunshine of country life.

ART IN THE SOUTH

In the course of reviewing several artist biographies, the southern writer Margaret Preston bemoans the fact that the "rich and magnificent Southern country" has not been as historically supportive of artists as "stern, harsh unlovely New England" (see also "A Southern View of the Arts during War," chapter 7). Although she was actually born in Pennsylvania, there is a distinctly partisan tone to Preston's essay, with reference to the "unique character of its [the South's] chivalrous and storied past"—code words for apologists of the slave era (her husband was a Confederate officer). Still, she cannot account for this lack of patronage, admitting that even before the poverty of the Reconstruction period the wealthy South did not cultivate local artists. This might be changing, she suggests, giving the example of the Virginia-born sculptor Edward V. Valentine.

Margaret J. Preston, "Art," Southern Review 26 (July 1879).

It is a somewhat remarkable fact that our Southern States have never produced an artist of worldwide, or, indeed, of universally acknowledged national reputation, if we except Washington Allston. He owed to South Carolina his gentle birth and high breeding; but he never received from his native State, during his life-time, that recognition, encouragement and patronage which were due to his genius; nor, after his death, that memorial embalming which should have preserved and kept fresh his name and fame. We are not aware that any biography of him has ever been given by a Southern pen. It has been left to the loving appreciation of "cold New England" to do fitting honor to this noble Carolinian.

This sectionality of the art-spirit in our country is something unaccountable. One has but to run one's eye over a catalogue of American artists to discover that they have been drawn almost entirely from the Northern and Middle States; few, comparatively, come from the vast West, and fewer still from the South. That stern, harsh, unlovely New England, with its pale skies, its grudging soil, its granite rocks, its hard ways of living, and its severe Puritan traditions, should beget and foster the passion for, and the culture of, the beautiful, seems inconsistent with the natural order of things. That our rich and magnificent Southern country, with its Italian-like glow of summer sunshine, its soft temperatures, its luxuriance of forest and fruit and flower, the semi-tropical warmth and fervor of its blood, the unique character of its chivalrous and storied past, and the exemption, from its first occupation, of its better classes from the necessities of menial toil—that all these heightened and exceptional advantages should not have made it the very cradle of the arts in this Western world, has always been a fact for which we have been able to find no satisfactory explanation. The true art-spirit and art-perception are confined to no civilized race or country. Every nation of the Orient possesses them. Indian, Chinese and Japanese art objects are, at this moment, the craving and the despair of all Europe and America. And yet, even when the taste has here and there manifested itself among us, the possessors of it have had to go elsewhere for recognition, and encouragement, and reward.

In the present attitude of affairs, we are accustomed to make our poverty the apology—a

sufficient one, we almost think, when the ruin entailed by the civil war is considered—for all neglect of the fine arts, since they can only flourish where culture and wealth go hand in hand. But to convince us that this reason is not wholly satisfactory, we have only to go back seventy-five years—when the city of Charleston was one of the most important commercial cities of the United States, and South Carolinians were among the princeliest livers in the land; when Richmond was the abode of old colonial grace and elegance, and East Virginia planters were the dispensers of a superb and costly hospitality—to see that matters were not greatly different in those golden days. We read of one limited collection of paintings existing in Charleston; we know of no gallery in Richmond. Yet, at this very time, not a large city north of the Potomac but had its collection and its galleries, though of course they were limited.

We have names among us now of which we are proud. Valentine, of Virginia, is one of the foremost of American sculptors; Ezekiel is winning for himself a name in Rome; Porte Crayon has been heard of beyond his native mountains; Shepherd, Elder, and others, are gaining reputation. But were Mr. Valentine's studio to-day in Rome, or London, or Boston, or New York, is it too much to say that his hands would be filled with commissions. Is it beyond the truth to aver that his pathetic and exquisite *Andromache and Astyanax* would have been gracing, in *marble,* some princely saloon, instead of having to wait for orders in the moulder's clay? Is it putting it too strongly to declare that *replicas* of his inimitable *Knowledge is Power,* (exemplified by the sleeping negro-boy with his dropping book,) or his marvellous reproduction of the saucy, good-for-naught *Nation's Ward,* would be in every large gallery of representative modern art? The hand that moulded the recumbent figure of Leo, and gave us the busts of Maury and Stuart, would not be suffered, surely, to let its skill lie dormant for lack of commissions! If England, with her supercilious opinion, so often expressed, that "art is crude yet in America," can afford to praise this masterpiece of the Richmond sculptor, having no better or truer idea of it than photographs can give; if Roman critics have words of commendation for Ezekiel's *Christ* and his *Religious Liberty,* where is our pride in the genius of our sons, that we do not do vastly more than merely re-echo this applause?

MODES OF REALISM

WINSLOW HOMER, ALL-AMERICAN

"Realism" in the Gilded Age was a protean concept, usually involving some measure of fidelity to concrete fact and things seen, but beyond that subject to differing and even conflicting interpretations. With the postwar desire for home subjects and artistic reform came a resurgence of interest in homegrown varieties of realism distinct from—and even opposing—foreign trends. Of the painters identified with home subjects—including Eastman Johnson, Enoch Wood Perry, and Thomas Waterman Wood—Winslow Homer emerged as the standard bearer: the most realist, the most American, and the least compromising of them all, and his work the crux of the debate about what exactly was, or should be, the character of American realism. Working in a seemingly blunt, unembellished, literal manner and painting contemporary urban or rustic Americans, Homer in his matter-of-factness seemed to embody the very essence of national character. At the same time, his refusal of prettiness and repudiation of ingratiating sentiment—in addition to what many perceived as crudeness in drawing and color—sparked anxiety, doubt, and resistance.

At the National Academy of Design exhibition in 1870, Winslow Homer exhibited three major paintings of modern life: The White Mountains *(Bridle Path, White Mountains) (1868),* High Tide *(Eagle Head, Manchester, Massachusetts) (1870), and* Manners and Customs at the Seaside *(1870). Featuring independent young women at leisure in the open air, all three departed from earlier conventions dictating the representation of middle-class femininity as domestic and demure. Homer instead showed them riding solo in the mountains and sea bathing, insouciantly barelegged.*

Focusing mainly on The White Mountains *in his review, Eugene Benson (Homer's friend and astute critic) singles out its salient national and modern qualities. Indeed, Benson can hardly restrain himself from enumerating the American qualities that saturate every square inch of the picture, which is in turn the work of a real, natural American artist. Although far from beautiful, Homer's painting is admirable in its strength, vigor, and originality.*

The following year, Homer's Country School *(1871) won accolades for its authentically American mode of visual address. Describing its utterly "national" character, the* Evening Express *critic sums up the all-American appeal of the painting.*

Eugene Benson, "The Annual Exhibition of the Academy," *Putnam's Magazine 15 (June 1870).*

Mindful of the actual condition of American art, we shall solicit your attention to, and hope to give you a statement of, the works of the *live* men of the present year . . .

From these notable examples of portrait-art we turn to the figure-pictures of the exhibition. The best, the most natural and original figure or genre painting of the exhibition is by Mr. Winslow Homer . . . Mr. Homer is one of the few young men who appear to have a manly aim, and to be in directly personal relations with nature; other young painters seem feeble or affected or groping.

We are before Mr. Homer's best picture (No. 173), the girl on horseback, just at the top of Mount Washington. It is so real, so natural, so effective, so full of light and air; it is so individual; it is so simply, broadly, vigorously drawn and painted; the action of the horse is so good, the girl sits so well; she is so truly American, so delicate and sunny, that, of course, you surrender yourself to the pleasure of her breezy, health-giving ride; you look at her with gusto; you see she is a little warm, perhaps too warm, from her ride up the mountain; but then she, like us, lets herself be refreshed with all the coolness and light about her, with the rising vapors that make a white, a dazzling veil between her and the shining, glittering valleys, all hidden by mist, and, as it were, under a river of light. This is something of contemporary nature, something that will never become stale; this is the picture of a man who has the seeing eye—an eye which will never suffer him to make pictures that look like "sick wall-paper," the elaborate expression of mental imbecility and a mania for pre-Raphaelite art. Here is no faded, trite, flavorless figure, as if from English illustrated magazines; but an American girl out-of-doors, by an American artist with American characteristics—a picture by a man who goes direct to his object, sees its large and obvious relations, and works to express them, untroubled by the past and without thinking too curiously of the present. Mr. Homer is a positive, a real, a natural painter. His work is always good as far as it goes; and generally it falls below the standard of finish and detail which is within the reach of our most childish and mediocre painters, and which misleads many, and deceives painters with the thought that by going from particular to particular, of itself insures a fine result in art.

Our best *genre* painter said to us the other day, that many picture-buyers were too stupid to

appreciate Mr. Homer's girl on horseback; and we agreed with him. Mr. Homer may be called a downright painter of nature; as an artist, he has yet to reach the exquisite and beautiful; he is now in the good and true. He has invention, he is fresh and just in his observation, and he has but to attain the beautiful to become our master figure-painter. We have no figure-painter who can put a figure in action better than Mr. Homer; not one who sees the actuality of his subject better; not one who is closer to the objective fact of nature. Mr. Homer is represented by eight or nine pictures, including his sketches, each of which is remarkable for the truth of local color and the striking rendering of the effect of light. But the three girls on the beach in the large picture in the north gallery are not beautiful; their legs are not well drawn, nor are they fine or elegant in form.

The moment a painter selects a girl for a subject, the lovely, the beautiful is his object; happy if, like Greuze, he can delight his contemporaries, and go down to posterity as the master of an exquisite and immortal type of human sweetness and graciousness—master of a luminous and perfumed and soft and melting face expressive of purity and desire, like the girl-heads of Diderot's painter-friend.

Mr. Homer's three girls are awkward; not very interesting, but very natural; his "Manners and Customs on the Coast" in the east gallery is very real, bright, effective; but an objection may be made to the Siamese twins dressed like two coast-swells; and prudish eyes may question the modesty of the two girls in the foreground, who, of all bathers that we have ever seen on this side of the Atlantic, alone may be said to be prettily costumed for a little sea-sport.

"The Academy Exhibition," New York Evening Express, *April 18, 1872.*

"The Country School," by Winslow Homer, must be greeted as being one of the pictures in the exhibition which will be remembered. It can safely be welcomed as a picture thoroughly national, and one, moreover, which will fully vindicate its painter as holding a proud position in native art. A pretty maiden is teaching the young idea of a country village. The sunlight streams through the windows, and throws great flecks upon the ruddy faces, the shock heads, and the bare feet of the motly crew that are her pupils. The whole thing is a page taken out bodily from the book of nature. Each group and figure tells its own story in a homely and unmistakable manner that is altogether charming, and all this with no undue studying after effect, but with a simplicity and directness that are very delightful.—Mr. Homer has shown us here not alone a mastering of color, drawing, and light and shade, but a thorough acquaintance with our life as a people, and so deserves all the good that may be said of his work.

DAMNABLY UGLY: HENRY JAMES ON WINSLOW HOMER

Still at the threshold of his distinguished literary career, Henry James was a seasoned critic and cosmopolitan when he reviewed the New York exhibitions of 1875 (see also "Henry James Remembers a New York Childhood," chapter 5). A subtle thinker with a discriminating eye, James discerns many of the same qualities and eccentricities that struck Eugene Benson in his far more positive review of Homer five years earlier. Puzzled by Homer's rejection of "literary" painting, James construes the artist to be an unthinking camera capable only of reproducing what is directly before his eyes, without selecting or refining, let alone using his imagination. In both style and subject, Homer's paintings are simple, crude, and even ugly. Even so, James finds the work undeniably and perversely likeable, not least because of the painter's sheer audacity and undeniable

success in treating the homeliest subjects as if they were seductively paintable Mediter-
ranean ports of call. James also comments on Homer's ability to see things all at once
in a unifying "envelope" of light and air. It is interesting to compare James's remarks
on Eastman Johnson, included here. Manipulating and caressing objects with his brush,
Johnson is a "real painter," which means something quite different from the class of
"genuine painter" to which Homer is consigned.

Henry James, "On Some Pictures Lately Exhibited," Galaxy 20 *(July 1875).*

The standing quarrel between the painters and the *littérateurs* will probably never be healed. Writers will continue to criticise pictures from the literary point of view, and painters will continue to denounce their criticisms from the free-spoken atmosphere of the studio. Each party will, in a manner, to our sense, be in the right. If it is very proper that the critics should watch the painters, it is equally proper that the painters should watch the critics. We frankly confess it to be our own belief that even an indifferent picture is generally worth more than a good criticism; but we approve of criticism nevertheless. It may be very superficial, very incompetent, very brutal, very pretentious, very preposterous; it may cause an infinite amount of needless chagrin and gratuitous error; it may even blast careers and break hearts; but we are inclined to think that if it were suppressed at a stroke, the painters of our day would sadly miss it, decide that on the whole it had its merits, and at last draw up a petition to have it resuscitated. It makes them more patrons than it mars; it helps them to reach the public and the public to reach them. It talks a good deal of nonsense, but even its nonsense is a useful force. It keeps the question of art before the world, insists upon its importance, and makes it always in order. Many a picture has been bought, not because its purchaser either understood it or relished it—being incapable, let us say, of either of these subtle emotions—but because, for good or for ill, it had been made the subject of a certain amount of clever writing "in the papers." It may be said that not only does the painter have to live by his pictures, but in many cases the critic has to as well, and it is therefore in the latter gentleman's interest to foster the idea that pictures are indispensable things.

Of course what most painters urge is not that criticism is *per se* offensive, but that the criticism of the uninitiated, of those who mix things up, who judge sentimentally, fantastically, from the outside, by literary standards, is the impertinent and injurious thing. Painters, we think, complain of this so-called "literary" criticism more than any other artists—more than musicians, actors, or architects. There is probably more unmeaning verbiage, in the guise of criticism, poured forth upon music than upon all the other arts combined, and yet the melodious brotherhood take their injury, apparently, in a tolerably philosophic fashion. They seem to feel that it is about as broad as it is long, and that as they profit on the one side by the errors of the public, there is a rough reason in their losing, or even suffering, on the other . . . Meanwhile, as we are expected to exhibit a certain sensibility to the innumerable productions of our own period, it will not be amiss to excuse us for sometimes attempting to motive our impressions, as the French say, upon considerations not exclusively pictorial. Some of the most brilliant painters of our day, indeed, are themselves more literary than their most erratic critics; we have invented, side by side, the arts of picturesque writing and of erudite painting . . . The latest phase of the French school—that little group of Gallicised Spaniards of which Fortuny and Zamacois were the most brilliant ornaments—is founded upon a literary taste, upon a smattering of culture, upon a vague, light diffusion of the historic sense. We may say the same of the cleverest English painters of the day, several of whom are so exquisite—Mr. Burne Jones, Mr. Ros-

setti, Mr. Leighton. Mr. Burne Jones paints, we may almost say, with a pen; there is something extremely rare and interesting in his combination of two distinct lines of culture, each in such a high and special degree. These gentlemen's pictures always seem as if, to be complete, they needed to have a learned sonnet, of an explanatory sort, affixed to the frame; and if, in the absence of the sonnet, the critical observer ventures to improvise one, as effective as his learning will allow, and to be pleased or displeased according as the picture corresponds to it, there is a certain justification for his temerity . . .

We have uttered these few reflections rather because we had had them for some time in mind than because they are in especial harmony with our impressions of the exhibition just closing at the Academy of Design. We do not claim the distinction of needing them as a weapon either of defence or of offence. Few of the painters represented at the Academy did much in the way of winning from us an expenditure of fancy and ingenuity. The most striking pictures in the exhibition were perhaps those of Mr. Homer; and this artist certainly can rarely have had occasion to complain of being judged with too much subtlety. Before Mr. Homer's little barefoot urchins and little girls in calico sun-bonnets, straddling beneath a cloudless sky upon the national rail fence, the whole effort of the critic is instinctively to contract himself, to double himself up, as it were, so that he can creep into the problem and examine it humbly and patiently, if a trifle wonderingly. Mr. Homer's pictures, in other words, imply no explanatory sonnets; the artist turns his back squarely and frankly upon literature. In this he may be said to be typical of the general body of his fellow artists. There were the painters who, like Mr. Edgar Ward and Mr. Thayer, desire to be simply and nakedly pictorial, and very fairly succeed; and there were the others who, like Mr. H. P. Gray, with the "Birth of our Flag," and Mr. Eastman Johnson, with "Milton Dictating to his Daughters," desire to be complex, suggestive, literary, and very decidedly fail. There is one artist—a complex and suggestive one if there ever was—we mean Mr. John La Farge—whose pictures are always a challenge to the imagination and the culture of the critic. When Mr. La Farge gives himself a largely suggestive subject to handle, he is certain to let it carry him very far; and if there is an occasional disparity between the effort and the total achievement, one's sense of it is lost in those delicate minor intimations, that subtle, intellectual detail, in which the artist's genius is so abundant. In his contribution to the present exhibition, however, the disparity of which we speak is perhaps exceptionally marked. Mr. La Farge's "Cupid and Psyche" is a work of an even overwrought suggestiveness; but the fugitive, recondite element in the artist's fancy has, to our sense, been unduly reflected in the execution—in something tormented, as the French say, something which fails to explain itself, in the tone of the work, and, in places, in the drawing . . .

Mr. Gray's picture hung in the place of honor, and, as regards size, was the most considerable performance in the room. Though an ambitious picture, this struck us as a not especially felicitous one; it is a singular congregation of *pièces rapportées*. One has a curious sense of having seen the separate parts before, in some happier association. The eagle and the flag (which are rather awkwardly and heavily contrived) possess, indeed, the merit of originality; but the other things have each an irritating air of being a kind of distorted memory of something else. The young woman's body, her arms, her head, the landscape behind her, the sky, are very old friends; but somehow, on this occasion, they are not looking their best. It describes Mr. Gray's picture not unjustly, we think, to say it is a superficial *pastiche* of Titian. This is especially true of the management of color. The artist has contrived very cleverly to recall Titian's deep-hued azures, to a casual glance; but at the end of a moment you perceive that this sumptuous undertaking rests on a very slender expenditure. Mr. Eastman Johnson, whom we mentioned just

now in conjunction with Mr. Gray, is a painter who has constant merits, in which we may seek compensation for his occasional errors. His "Milton and his Daughters" is a very decided error, and yet it contains some very pretty painting. Like Mr. Gray, Mr. Johnson here seems to us to have attempted to paint an expensive picture cheaply. To speak of the work at all kindly, we must cancel the Milton altogether and talk only about the daughters. By thus defilializing these young ladies, and restoring them to their proper sphere as pretty Americans of the year 1875, one is enabled to perceive that their coloring is charming, and that though the sister with her back turned is rather flat, rather vaguely modelled, they form a very picturesque and richly-lighted group. One of Mr. Johnson's other pictures, a young countrywoman buying a paper of pins from an old peddler, is a success almost without drawbacks. Mr. Johnson has the merit of being a real painter—of loving, for itself, the slow, caressing process of rendering an object. Of all our artists, he has most coquetry of manipulation. We don't know that he is ever really wasteful or trivial, for he has extreme discretion of touch; but it occasionally seems as if he took undue pleasure in producing effects that suggest a sort of lithographic stippling. The head of the woman, pretty as it is, in the picture just mentioned, is a case in point; her dress, and the wall beyond it, are even more so. But the old hawker, with his battered beaver hat, his toothless jaws and stubbly chin, is charmingly painted. The painting of his small wares and of the stove near him, with the hot white bloom, as it were, upon the iron, has a Dutch humility of subject, but also an almost Dutch certainty of touch. For the same artist's lady in a black velvet dressing-gown, fastening in an earring, we did not greatly care, in spite of the desirable mahogany buffet against which she is leaning. Mr. Johnson will never be an elegant painter—or at least a painter of elegance. He is essentially homely.

Mr. Bridgeman's interior of an American circus in France was painted in that country, with a *brio* intensified possibly by national pride. It is an extremely clever little composition, and the most elaborate figure-piece in the exhibition. The group of the rider of the two horses abreast, with the young lady kicking out a robust leg from her aërial station on his thigh, holds together, moves together, with remarkable felicity. The diffused yellow daylight under the tent, falling on the scattered occupants of the benches beyond the ring, and upon the various accessories, is very cleverly rendered, though much of the painting is rather thin and flat. The picture dates, we observe, from 1870, when it appeared with success, we believe, in the Paris Salon. We hope that it does not sound harsh to express a regret that Mr. Bridgeman should not now be showing us a work subsequently composed, in which we should find all the performance of which this was the promise. Of Mr. Homer's three pictures we have spoken, but there would be a good deal more to say about them; not, we mean, because they are particularly important in themselves, but because they are peculiarly typical. A frank, absolute, sincere expression of any tendency is always interesting, even when the tendency is not elevated or the individual not distinguished. Mr. Homer goes in, as the phrase is, for perfect realism, and cares not a jot for such fantastic hairsplitting as the distinction between beauty and ugliness. He is a genuine painter; that is, to see, and to reproduce what he sees, is his only care; to think, to imagine, to select, to refine, to compose, to drop into any of the intellectual tricks with which other people sometimes try to eke out the dull pictorial vision—all this Mr. Homer triumphantly avoids. He not only has no imagination, but he contrives to elevate this rather blighting negative into a blooming and honorable positive. He is almost barbarously simple, and, to our eye, he is horribly ugly; but there is nevertheless something one likes about him. What is it? For ourselves, it is not his subjects. We frankly confess that we detest his subjects—his barren plank fences, his glaring, bald, blue skies, his big, dreary, vacant lots of meadows, his freckled, straight-haired Yankee

urchins, his flat-breasted maidens, suggestive of a dish of rural doughnuts and pie, his calico sun-bonnets, his flannel shirts, his cowhide boots. He has chosen the least pictorial features of the least pictorial range of scenery and civilization; he has resolutely treated them as if they *were* pictorial, as if they were every inch as good as Capri or Tangiers; and, to reward his audacity, he has incontestably succeeded. It makes one feel the value of consistency; it is a proof that if you will only be doggedly literal, though you may often be unpleasing, you will at least have a stamp of your own. Mr. Homer has the great merit, moreover, that he naturally sees everything at one with its envelope of light and air. He sees not in lines, but in masses, in gross, broad masses. Things come already modelled to his eye. If his masses were only sometimes a trifle more broken, and his brush a good deal richer—if it had a good many more secrets and mysteries and coquetries, he would be, with his vigorous way of looking and seeing, even if fancy in the matter remained the same dead blank, an almost distinguished painter. In its suggestion of this blankness of fancy the picture of the young farmer flirting with the pie-nurtured maiden in the wheat field is really an intellectual curiosity. The want of grace, of intellectual detail, of reflected light, could hardly go further; but the picture was its author's best contribution, and a very honest, and vivid, and manly piece of work. Our only complaint with it is that it is damnably ugly! We spoke just now of Mr. La Farge, and it occurs to us that the best definition of Mr. Homer to the initiated would be, that he is an elaborate contradiction of Mr. La Farge. In the Palace of Art there are many mansions!

WINSLOW HOMER'S WORKING METHODS

One of Winslow Homer's rare public statements, an interview with the Evening Post *art critic George William Sheldon, affords an illuminating insight into the artist's ideas. Indeed, one can see it as Homer's all-American manifesto. Homer scornfully dismisses fashionable French academic art, telling Sheldon that the works of the popular Adolphe-William Bouguereau amount to outright fakery, because they so flagrantly advertise the fact that they are studio products. Homer, by contrast, declares his invariable preference for paintings done in the open air. The open-air painter must blend and suffuse several different light effects—sky, sun, reflected light—into a unified whole. To do this in the studio is impossible: walls shut out the sky. Homer, who like nearly every one of his colleagues finished his open-air work in the studio, thus positions himself as a trustworthy, sincere American painter whose paintings tell the whole truth and nothing but. Ironically, in praising Homer's sketch of two pretty rustic girls as comparable to "anything Edouard Frère ever put his mark upon," Sheldon hits upon another French painter whom Homer in early days had vowed to surpass.*

The newly popular medium of watercolor became an important vehicle for Homer's ongoing experimentation with color as well as technique; in addition, watercolors were more readily saleable than many of the painter's oils. Homer began working in watercolor in earnest in the summer of 1873, during a visit to Gloucester, Massachusetts. During the 1870s he actively exhibited at the American Water Color Society, to which he was elected a member in 1876 (see "The American Taste for Watercolor," chapter 12).

In her comments on Homer's paintings at the 1877 watercolor show, Susan N. Carter finds particularly striking Homer's brilliantly calibrated color scales, obviously the result of deliberate calculation and so refined that Carter claims to have mistaken them at first

for new work from the "Roman world"—that is, from Mariano Fortuny and his peers. Carter's remarks offer insight into the subtle mind of the artist that lay behind his public construction as a naïve recorder of visual facts.

George William Sheldon, "Sketches and Studies," Art Journal (April 1880).

On Mr. Lawson Valentine's farm, near Cornwall-on-the-Hudson, just behind West Point, Mr. Winslow Homer made all the charming sketches of sheep and shepherdesses which brought him great praise at the American Water-Colour Society's exhibition of 1879; and almost everything that he has shown to the public as a result of his professional efforts has been drawn directly from Nature, and under the impression made by it upon his mind at the time when he committed it to paper or to canvas. No painter in this country, probably, has a profounder respect for such out-door work, a more lively apprehension of its value, or a sincerer and more serious aversion to manufactured and conventional studio-pictures. He paints what he has seen; he tells what he has felt; he records what he knows. Now, a painter who begins and finishes indoors a figure of a man, woman, or child, that is out-doors, misses a hundred little facts, the absence of which is sure to convict him of his offence against truth—a hundred little accidental effects of sunshine and shadow that can be reproduced only in the immediate presence of Nature. No matter how carefully drawn the figure may be, nor how admirably composed the composition may be, nor how exquisite the sentiment, nor how brilliant and harmonious the colour-scheme, the picture cannot be true unless it has been executed, in part, at least, under the all-embracing sky. One of the chief causes of the failure of some of our finest executants with the brush is their ignorance or neglect of this essential condition. It is so in Europe as well as in America; in Paris as well as in New York. Of Bouguereau, for instance, Mr. Homer says: "I wouldn't go across the street to see a Bouguereau. His pictures look false; he does not get the truth of that which he wishes to represent; his light is not out-door light; his works are waxy and artificial. They are extremely near being frauds." Yet, Mr. Homer is the last man in the world to be blind to what are really excellences in a painter like Bouguereau.

He believes, however, that the most complete pictures are not founded upon out-door studies. "The great compositions of the old masters," he says, "were almost all interiors. You can't control the thing out-doors." Yet he admits that it is possible, sometimes, to find a picture—a complete one—out-doors; to meet with a combination of facts so happy that a sketch of it would deserve to be called a picture—a rare case, of course, but not an impossible one. His 'Adirondack Camp-Fire' is almost an example in point. He painted it out-doors; but the large tree on the left, the line of which answers to the line of one of the poles of the tent, is not in the original scene. He found it elsewhere, built a fire in front of it, observed the effect, and transferred it to the canvas. With this exception, the composition is a general transcript of the surroundings of a fire lighted one night while he was camping in the Adirondacks. "I prefer every time," he says, "a picture composed and painted out-doors. The thing is done without your knowing it. Very much of the work now done in studios should be done in the open air. This making studies and then taking them home to use them is only half right. You get composition, but you lose freshness; you miss the subtle and, to the artist, the finer characteristics of the scene itself. I tell you it is impossible to paint an out-door figure in studio-light with any degree of certainty. Out-doors you have the sky overhead giving one light; then the reflected light from whatever reflects; then the direct light of the sun: so that, in the blending and suffusing of these several luminations, there is no such thing as a line to be seen anywhere. I can

tell in a second if an out-door picture with figures has been painted in a studio. When there is any sunlight in it, the shadows are not sharp enough; and, when it is an overcast day, the shadows are too positive. Yet you see these faults constantly in pictures in the exhibitions, and you know that they are bad. Nor can they be avoided when such work is done in-doors. By the nature of the case the light in a studio must be emphasised at some point or part of the figure; the very fact that there are walls around the painter which shut out the sky shows this. I couldn't even copy in a studio a picture made out-doors; I shouldn't know where the colours came from, nor how to reproduce them. I couldn't possibly do it. Yet an attempted copy might be more satisfactory to the public, because more like a made picture."

It is their lack of truth, their palpable falseness, that makes so many pictures displeasing, and so many artists lingering on the hither side of one's respect. Mr. Winslow Homer's words in this connection, brave, admirable, and stimulating as they are, constitute an excellent text for many of his comrades to wear in their phylacteries. There is wisdom in them and fortune too, if they be but read and inwardly digested. Go direct to Nature, and then tell what you see. Don't lie about her, don't misrepresent her, don't suppose that you can improve her. Your farthest industry and your most rapturous flights must end in failure and in loss, if they take you outside of her domain:

> "Summer's joys are spoiled by use,
> And the enjoying of the spring
> Fades as does its blossoming,"

when an artist comes home from the country, and sits down to manufacture pictures. "Beauty is truth, truth beauty." In some such fashion as this would Mr. Homer address an aspiring young pupil who came to him for advice. For one, the writer is disposed to admire the emphasis that he lays upon the matter of out-door painting; especially so in these days of imported Paris and Munich styles, when men's schools dispute the claims of Nature's school—when defty, dextrous, dashy, artificial effects are the rage in so many studios, and when the last thing most young artists think of is to sit meekly and long at the feet of Nature, that they may learn of her . . .

The sketch which we have photo-engraved for the *Art Journal* is as sweet and winning as anything Edouard Frère ever put his mark upon, while it has none of that weakness of touch which is sometimes to be regretted in the pictures of the great Frenchman. These *naïve,* fresh, wholesome farmers' lasses, walking on American soil, and in American costume, thinking their own thoughts, and pensive in the presence of the dawning possibilities of the most interesting days of girlhood—are they not a poem in charcoal? In truth they are themselves sufficient to justify an attempt at reproducing a series of American "sketches and studies," not merely because in some respects they are more valuable than many finished pictures—fuller in spiritual significance, ampler in suggestions of the true beauty of girlhood; but also because in the highest sense they are characteristic of the artist himself. In this and other sketches made during the last few weeks, Mr. Homer has done more, it seems to us, in revealing and bestowing the real wealth of his artistic possessions, than in scores of what would be called his "important" works.

S.N.C. [Susan N. Carter], "The Tenth New-York Water-Colour Exhibition," Art Journal 3 (1877).

The present Water-Colour Exhibition numbers nearly six hundred pictures. This is the tenth year since a few artists in New York started, with a small collection of their own, experiments in a material of which, until that time, the Americans knew little. Time, experience of the meth-

ods of using the paints, and study of the *aquarelles* of the French and the English schools, have improved these exhibitions from year to year, till this season is pronounced by the world of Art-lovers generally as the most successful the Water-Colour Society has seen . . .

At the head of these pictures, which are inspiriting to those who have watched our Art-progress, are the works of Mr. Winslow Homer, who has been a favourite for many years in his out-door scenes, his animated figures, and the vivacity of his dramatic situations. A sea picture of his, in oils, last year, of some boys in a boat scudding before a stiff breeze, may be remembered by our readers; but, with all his freedom of action, Mr. Homer has never in the past been an entirely successful colourist. His oil-paintings were murky, and even in his water-colours some cold or harsh tone destroyed the agreeable key of colour which else had been complete. But this year we wandered in the rooms of the Water-Colour Exhibition, and, as we went along, we observed the yellow-grey hue of the walls, which gave delicacy and lightness to the scene; we analysed the impression received from the pure and pale backgrounds of many of the works; but, even when we looked at pictures by Vibert and Villegas, somehow they seemed a little thin and lacking in gradation of colour as it appears in light and shade, and as seen in near or remote situations. But suddenly our eye was caught and held by studies of such remarkable force and precision of tones, and subtlety of hues, that we involuntarily exclaimed to ourselves that some new artist had dawned upon the French or the Roman world. The contrasts were so peculiar and so delicate, and the tints so full of texture, that for the first glance we had not the thought even to observe the form of the objects they composed. The perfectly free and precise handling, too, was in entire accord with the methods of the best of the foreign aquarellists, and was entirely distinct from any suspicion of "niggling," or of an inexperienced hand. But presently, in a picture which, by reference to the catalogue, we saw designated as 'Lemon,' by Winslow Homer, we recognized a typical American country-girl in a common calico "blouse" waist, a buff stuff skirt, and a Yankee face. She was half sitting, half hanging, on the edge of a stuffed ottoman, and was paring the skin from the lemon which she held between her fingers, and which her lips, drawn to a pucker, seemed to have tasted already in anticipation. The background of this painting was of a pale, lemon-coloured shade, and the girl's dress ranged all the way from the ruddy, yellowish hues of iron and of burnt siena to the purest cadmium, and the artist appeared to have delighted himself in exhausting his palette with every tint which he could afford to spread upon the skirts of the girl in defining the broad lights and shade upon her well-marked and nicely-accentuated figure. We speak from the artistic stand-point when we say that we scarcely know an example of a more vigorous treatment of the human form than Mr. Homer has delineated in this painting, with the simple folds and occasional stretching of this buff gown across the girl's knees and around her body. Such feeling of vitality has often occurred before in Mr. Homer's work, as, for instance, in his oil-painting, owned by a prominent New York amateur, called 'Snapping the Whip,' where a lot of urchins, just out of school, are striving to see which of them shall soonest break the circle which their joined hands still keep intact. But in this picture of 'Lemon' Mr. Homer has combined not alone expressive action of the human form, but he has accomplished in it a scale of refined colour and tone which even his warmest admirers could hardly have anticipated from his brush.

Walking through the north room, filled with paintings among the best of those in the exhibition, and admiring the pictures of Berne, Bellecour, Mrs. Stillman, and others, our eye was again caught and held by one called 'Book,' by Mr. Homer, representing a young woman lying easily, and in a natural pose, reading from an open volume, with a rich and agreeable palette of colour, composed of greens cool and warm, yellows of peculiar shades, composing textured

material positive and charming, and this combination was keyed and emphasised by deep, dark blues and iron-colour. This picture and the one above-described are but two of several paintings sent by Mr. Homer, all of which show, in our judgment, a marked advance.

WINSLOW HOMER'S SEA CHANGE

Winslow Homer's 1881 voyage to England dramatically transformed his art and laid the foundation for his subsequent induction into the canon of all-American masters. Abandoning the romping children and pretty farm girls of the 1870s, Homer began to paint the more serious and monumental subjects he studied at close hand in the remote north coast fishing village where he lived for nearly two years. Exhibited in Boston and New York even before his return, the new paintings took many critics and viewers by surprise and elicited new interest and respect.

Mariana Griswold Van Rensselaer's review of Homer's English work is the testimony of a convert; she notes that she once vehemently "hated" Homer's art, preferring prettier and more ingratiating pictures (see also "Mariana Griswold Van Rensselaer Meets Thomas Eakins," this chapter). Now, she has come to admire the power and boldness of his style. It is clear that Van Rensselaer appreciates the refinement and even the stylization of Homer's designs. Yet she insistently construes the artist as a naïf, whose primitive technique is the outpouring of authentic, unmediated feeling. Homer's all-American vitality, honesty, and strength, moreover, serve as an admonitory example to the younger generation of painters who have derived their "hackneyed practices" from the studios of Munich or Paris. Finally, like Henry James several years previous, Van Rensselaer struggles to understand how what is so ugly in Homer's art can also somehow be "austerely beautiful."

Mariana Griswold Van Rensselaer, "An American Artist in England," Century Illustrated Magazine 27 (November 1883).

Mr Winslow Homer holds, as to time, an intermediate place between our elder and our younger painters. He cannot be classed with those who won their position and gained their chief honors before the War of the Rebellion; nor is he identified with the later generation which has so rapidly grown in numbers and in influence since the appearance of a few clever Munich and Paris students on the Academy walls in 1877. And not only in time, but in the character of his work, he stands apart from both these well-known groups . . .

A noteworthy point about Mr. Homer's work, one that proves its inherent originality of mood and strength of utterance, is that it always makes itself felt, no matter amid what surroundings. Every passer-by marks it at once, and is apt to give it an unusually decided verdict in his mind, whether of approval or dispraise. No one can be blind to it in the first place or indifferent in the second, as one may be to the things by which it is encompassed on the average exhibition wall,—things probably more "pretty" or more "charming," possibly more polished, but in almost every case much weaker, more conventional, less original, and at the same time much less truthful. As an instance in point, I may refer to the way in which it affected my own childish eyes, in days when I dared to hold very few positive opinions in such matters. As a youthful visitor to our exhibitions and student of our illustrated papers, I remember to have hated Mr. Homer in quite vehement and peculiar fashion, acknowledging thereby his individuality and his force, and also his freedom from the neat little waxy prettinesses of idea and expression which

are so alien to true art, but always so delightful to childish minds, whether in bodies childish or adult.

Two or three years ago, Mr. Homer must have astonished, I think, many who, knowing his work so well, thought they had gauged his power and understood its preferences and its range; for he then exhibited a series of water-colors conceived in an entirely novel vein. No one could have guessed he might attempt such things. Yet the moment they were seen no one could doubt whose hand had been at work,—so strong were they, so entirely fresh and free and native. They were marine studies of no considerable size, done at Gloucester, Massachusetts. Never before had Mr. Homer made color his chief aim or his chief means of expression. In his paintings his scheme had usually been cold, neutral, unattractive. In his aquarelles he had often used very vivid color, but rather, apparently, for the purpose of meeting that most difficult of problems, the effect of full sunlight out-of-doors, than with an eye to the color in and for itself. And the result had usually been strength not unmixed with crudeness. But in these marine sketches color had been his chief concern, and there was much less of crudeness and more of beauty in the result. They were chiefly stormy sunset views—glowing, broadly indicated, strongly marked memoranda, done with deep reds and blacks. A sweep of red-barred black water, a stretch of black-barred red sky, and the great black sail of a fishing-boat set against them, with no detail and the fewest of rough brush strokes, gave us not only the intensified color scheme of nature but nature's movement, too,—the slow rise and fall of the billows, the motion of the boat, the heavy pulsation of the air. The hues were a palpable exaggeration of the hues of nature; but then all color that is homogeneous and good on canvas is and must be an exaggeration, either in the way of greater strength or of greater weakness. No one can paint nature just as she appears: and if one could, the result would not be clear and expressive art. As a Frenchman has well said, "Art is a state of compromises, of sacrifices,"—much omitted or altered for the sake of the clear showing and the emphasizing of a little. Most artists accomplish this end, as we know, by the weakening process—by taking, to start with, a lower, duller, less positive key than nature's, and by then still further modifying minor things in order that the chief may appear strong enough by contrast. To use the familiar phrase, they *tone things down*. But Mr. Homer had gone the other way to work in these little marines, and had toned things *up*. He had boldly omitted everything that could not serve his purpose,—which was to show the demoniac splendor of stormy sunset skies and waters,—and then, unsatisfied by the brilliant hues of nature, had keyed them to deeper force, made them doubly powerful, the reds stronger and the blacks blacker,—insisting upon and emphasizing a theme which another artist would have thought already too pronounced and too emphatic for artistic use. That he could do this and keep the balance of his work is a patent proof of his artistic power . . .

At the water-color exhibition of 1883, Mr. Homer again surprised us with drawings of a new kind and possessing novel claims to praise. They were pictures of English fisherwomen, set, as usual with him, in landscape surroundings of much importance, and were, I think, by far the finest works he had yet shown in any medium . . .

It is this most recent phase of Mr. Homer's work which is illustrated here,—both from his exhibited pictures and from the contents of his portfolio. "The Voice from the Cliffs" and the "Inside the Bar" were among the former, and seem to me not only, as I have said, the most complete and beautiful things he has yet produced, but among the most interesting American art has yet created. They are, to begin with, *pictures* in the truest sense, and not mere studies or sketches, like most of his earlier aquarelles. Then they are finer in color than anything except the sunset sketches just described, and finer than these in one way—as being more explicit and

comprehensive in their scheme . . . And in handling, these works were, I think, a great improvement on all that had gone before—more skillful, more refined, more delicate, while not less strong and individual. But the most interesting and valuable thing about them was their beauty of line. Linear beauty is a rare thing in modern art, scarcely ever aimed at even by a modern artist without a lapse into conventionality or would-be-classic lifelessness. And it is a quality which we might have thought the very last to which Mr. Homer could attain . . . The pose of the woman in "Inside the Bar" is fine in its rendering of strength, of motion, of rugged vitality. But it is very beautiful as well, even in the almost over-bold line of the apron twisted by the wind, which gives it accent, and greatly aids the impression of movement in air and figure. The grouping of "The Voice from the Cliffs" is still more remarkable. These outlines might almost be transferred to a relief in marble; and yet there is none of the stiffness, the immobility, with which plastically symmetrical effects are usually attended in painted work. They are statuesque figures, but they are living, moving, breathing beings, and not statues; and they are as characteristic, as simply natural and unconventional, as are the most awkward of Mr. Homer's Yankee children . . .

Nor is the linear beauty of these pictures confined to the figures only. The composition of the "Tynemouth"—with its waves and its drifting smoke-wreaths and the groups of figures in the foreground boat—is fine in every way; and in the "Inside the Bar," and other similar works, the lines of cloud and shore are arranged with consummate skill, framing, as it were, the figure, giving it additional importance, and bringing it into close artistic relation with the landscape . . .

But no analysis of these pictures, no pointing out of the elements upon which their power depends, can convey the impression that they make,—the way in which all elements work together to produce an effect of artistic strength, of artistic dignity and beauty, that fall nothing short of grandeur. They are serious works of "high art," in spite of their peasant subjects and their water-color medium. That is to say, they have an ideal tinge which lifts them above the cleverest transcripts of mere prosaic fact. And this idealism, this high artistic sentiment on the part of the artist, is of so strong, so fresh, so vital, so original a sort, that his pictures took the life and vigor out of almost everything else upon the wall. Many other things were as well done, some were better done as concerned their technique only; but not one seemed quite so well worth the doing. Mr. Homer does indeed, in these pictures, show something quite different from the fresh and individual but crude and unpoetic suggestiveness of his earlier aquarelles, something different from the prosaic realism of his war paintings and his negro interiors, something different also from the fervid, half infernal poetry of the Gloucester studies. The dignity of these landscapes and the statuesque impressiveness and sturdy vigor of these figures, translated by the strong sincerity of his brush, prove an originality of mood, a vigor of conception, and a sort of stern poetry of feeling to which he had never reached before . . .

. . . He was born too soon to be drawn into the current which some fifteen years ago set so strongly toward the *ateliers* of Europe. He has worked out his technical manners for himself. The results show something of crudeness, of rugged angularity,—are unscholarly, perhaps, but extremely original, and also forcible and clearly expressive of what he has to say. He has invented in some sort a language of his own. It is not polished, not deft and rapid and graceful. We could never care for it in itself and apart from the message it delivers, as we so often care for really beautiful artistic workmanship. But it is not hesitating, confused, inadequate. It is always sure of itself, and always reaches its end, as ignorant or immature work does not, though it may reach that end in a rather blunt and uncompromising fashion. In a word, it is not childish, uncertain technique; but it is, I think, a little primitive, a little *rustic*. It is the strong, char-

acteristic, personal, though unpolished, diction of a provincial poet. We do not resent the fact; we are tempted to feel, indeed, that upon this unconventional, unacademic accent of his brush depends something of the interest if not the value of his work. Perhaps it is *because* of his *naïveté*, his occasional *gaucheries,* his sturdy if angular independence, and not in spite of these things, that his handling seems so fresh, so unaffected, so peculiarly his own, so well adapted to the nature of the feeling it reveals . . . No artist has a more personal message to deliver than Mr. Homer, and none tells it more distinctly or in a more native way. And we can well afford to lose a little possible technical brilliancy or charm in the gain we register hereby. No man is less self-conscious, works less as though centuries of great painters were watching him from the pyramid of fine accomplishment. And his strong freshness of mood and manner is peculiarly precious in these days when most men *are* self-conscious,—these days of cosmopolitan experience and hackneyed practice . . .

And when a man feels so strongly, so freshly, sometimes so grandly and poetically, as Mr. Homer, and when he expresses himself so clearly, so distinctly, so impressively, we are foolish indeed if we resent the fact that he does not speak as smoothly, as beautifully, as gracefully as he might. Beauty—sensuous charm of motive and of treatment—is a factor in art, and a factor of much value; but it is not *all* of art. There is no denying the fact that Mr. Homer's work has sometimes been positively ugly. Even the beauty of his later efforts is beauty of form, of idea, of feeling, and of strong expression only—very rarely beauty of color, and never, whether in color, in form, in handling, or in sentiment, beauty of the suave and sensuous sort; and, needless to say, of so-called "decorative" beauty we find not the slightest trace. But always, whether it be austerely beautiful or frankly ugly, his work is vital *art*—not mere painting, not the record of mere artistic seeing, but the record of strong artistic *feeling* expressed in strong, frank, and decided ways. It is always artistic in sentiment if not artistically gracious in speech, always clear, always self-reliant, always genuine, and—to use again the word which comes inevitably to my pen—always *strong* to a remarkable degree. For the sake of these qualities—so important and to-day so very rare—we may a thousand times excuse all technical deficiencies we find; and the more gladly since, as I have said, they are gradually disappearing, year by year.

WINSLOW HOMER'S SAVAGE NATURE AND PRIMAL SCENES

Winslow Homer's vivid, fluidly rendered watercolors of angling and canoeing in the wilderness were highly successful and popular from the time he first exhibited them in 1889. His large oil Huntsman and Dogs *(1891), however, sounded a more somber note. Alfred Trumble's comments register an uneasy response to the painting, which portrays the world, and man's place in it, as unremittingly bleak, harsh, and cruel. In typing the young huntsman as a savage brute, Trumble betrays a class bias inflected, perhaps, by scientific theories "proving" that class and racial hierarchies are the natural result of evolution from the most primitive to the most advanced stages of human development.*

As Homer concentrated increasingly on elemental seascapes and scenes of masculine adventure in the wilderness, critics fashioned a corresponding image of the artist as rugged, solitary, all-American genius. So frequently did the same terms and even words of approbation recur that they coalesced into a discursive formation from which writers rarely deviated. Among others, William Howe Downes, art critic for the Boston Transcript *and one of Homer's most ardent admirers, was particularly active in formulating and perpetuating that construction of the artist. Downes, with his collaborator Frank*

Torrey Robinson, describes Homer as a recluse, battling with his art just as his hardy hunters and sailors battle with the elements (see also "William Howe Downes and Frank Torrey Robinson's 'Critical Conversations,'" chapter 12).

Embroidering on Downes, Frederick W. Morton admires the "Titanic" qualities of Homer's art and the vast power of his seas. Like others, Morton finds Homer's canvases ugly yet overpoweringly vital and figures the artist himself as a virile, modern Viking in perpetual confrontation with savage Nature. Insistently focusing on the all-American, the heroic and the manly, these critics resist cosmopolitanism and hint at a more pervasive anxiety about the integrity of American masculinity in a new urban world defined by corporate and consumer culture.

Alfred Trumble, "Notes for the New Year," Collector 3, no. 5 (January 1, 1892).

Mr. Winslow Homer's latest picture, "The Return from the Hunt," has been on exhibition in the galleries of Messrs. Reichard & Co. It is one of the least attractive pictures which the artist has painted—a bit of cold, uncompromising realism, which might have been created as an original for a Currier & Ives lithograph. Every tender quality of nature seems to be frozen out of it, as if it were painted on a bitter cold day in crystallized metallic colors on a chilled steel panel. The type of the huntsman, who carries the pelt of the deer over his shoulder, and its front and antlers in his hand, is low and brutal in the extreme. He is just the sort of scoundrel, this fellow, who hounds deer to death up in the Adirondacks for the couple of dollars the hide and horns bring in, and leaves the carcass to feed the carrion birds. The best thing in the picture is the true doggishness of the hounds. One doesn't expect hounds to have any instinct above slaughter. Throughout, however, the picture—albeit well composed and firmly drawn—is a cold and unsympathetic work, entirely unworthy of the artist, unless he had made it as the original for a newspaper illustration.

William Howe Downes and Frank Torrey Robinson, "Later American Masters," New England Magazine 14 (April 1896).

Conspicuous among the American artists who may be said literally to live for their art alone is that profound original genius, that guide to all great human epics of the untamed sea and the unexplored wilderness, Winslow Homer . . . Winslow Homer's foot-steps may be traced through many a league of solitary exploration. There is the character in his work which shows plainly that he is incapable of treading in the paths worn by others' feet. We see him in the depths of the North Woods, by the dashing stream where the fisherman lives alone in his squalid hut; we see him on the mountain side amidst the stumps of the dismal clearing, with the gray-bearded Adirondack guide for his comrade; we see him shooting the rapids in a canoe with the hardy woodsmen, the sturdy types of the American hunter and pioneer, brave, tough, and true,—types which we shall be glad to have preserved for future history. Now we stand with him where tremendous breakers dash against the rocky shore, and the black, whirling, angry clouds roll in an awful tumult in the tempestuous sky. Drenched with spray, we watch the stalwart fisher-girls in the raging surf, as they bend to their oars and urge their dory towards the struggling craft which has struck on yonder fatal ledge in the wild storm. Again, in more peaceful scenes, we are interested in the farmer's toil, so sympathetically and so shrewdly observed; in the farmer who, burdened with cornstalks, goes out to the dried-up pasture to feed his starving cattle, and in all those fellow-men of ours of whose lives, full of struggles, of want, of woe, and of heroism, we know so little. Indeed, Winslow Homer is the most original observer, and the most

truly and exclusively national painter ever reared in America. He knows the American sailor and woodsman as Burns knew the canny Scotchmen and as Millet knew the French peasantry. We will ask you to look with us, in fancy, at his now celebrated picture called "Eight Bells." The scene is laid on the quarter-deck of a Gloucester fishing schooner. Here are the captain and the mate of the tempest-tossed craft, trying to get a noon observation to ascertain their whereabouts. The men are clad in their oilskin suits and sou'westers—the armor of the modern sea-kings; and, with quadrant and sextant in hand, the calculations are being made under difficulties. What sturdy sailor-men! How bravely they will meet their fate, whatever it may be! What quiet and cool and modest natures, rough on the outside, but ready for any heroic enterprise! The wind whistles through the cordage, the seas sweep the decks, but we feel that the furious elements must obey the commands of these masterful souls, and that in the long run mind must conquer matter. Bravo, Homer! You make us realize that our lives ashore are tame and flat indeed in comparison with those of these latter-day Vikings of the New England breed.

Like Thoreau, Winslow Homer is a recluse, for the reason that art of the sort he lives for is incompatible with the amenities of society. He lives in a lonesome spot on the coast of Maine. His sole companions are natural and unsophisticated beings, outdoor folk, hunters, fishermen, sailors, farmers. No artificial refinements, no etiquette of the drawing-room, no afternoon tea chatter, no club gossip, for this hermit of the brush. God is King of all where he lives, and as His subject he faithfully portrays the infinite wonders of His realm. We are only too well aware that we have given our readers but a mere glimpse of this powerful and unique master, a mere hint of his greatness; but in him we may without extravagance lay claim to the possession of one of the few living painters of the world who can be called great artists.

Frederick W. Morton, "The Art of Winslow Homer," Brush and Pencil *(April 1902).*

Like the poet Whitman, between whom and himself there is a certain bond of sympathy and unity, Homer "accepts reality and dares not question it"; and again like Whitman, his art stands isolated, unique, alone.

There is something rugged, austere, even Titanic in almost everything Homer has done. The sensuous charm of mere placid beauty has never appealed to him as a motive. He is preeminently a painter of the sea, yet the unruffled water-mirrors, reflecting clouds and tinted sails, which gladdened the heart of a Clays, never impelled him to transcribe their prettiness. His sea is the watery waste as the expression of tremendous force, mystery, peril. He is the painter of landscapes, but his landscapes are redolent of the primeval forests of the New World, its bleak hills, its crags. They are not delightful, picturesque nooks and corners that suggest picnic parties and trysting-places. He is a painter of men and women, but his characters are not drawing-room loiterers or social favorites. They are pioneers, fishermen, seafaring folk, representatives of the humbler walks of life in a genuine democracy.

There is not in a single picture Homer ever painted the slightest trace of mere decorative beauty either in composition or coloring. On the contrary, his canvases are often frankly ugly, austere even to the disagreeable. His technique is strictly his own, and in no sense savors of the schools. Often his drawing is faulty and his flesh tints are at fault, yet when we have said this we must also say that everything he has painted is *vital* art. His art has been called the language of prose, but it is the prose that is more forceful than that which is tricked out with rhyme or measured into feet. It is not the record of a man who sees pleasantly and expresses what he sees artistically: it is the record of strong artistic feeling . . .

Homer's life, in a sense, is as isolated as his art. He has protested against conventions of every

sort, conventions in art, and conventions in society especially. Finally, perhaps as a further protest, he secluded himself in Scarboro, Maine, where he associates almost exclusively with the seafaring folk he loves to paint, and devotes himself with an earnestness and assiduity rarely seen among artists to his chosen work . . .

If one were asked to characterize by a single word Homer's more important works, that one word would doubtless be "virile." His "Maine Coast," for instance, is a masterpiece which carries conviction. The composition is simple, showing a mass of dark rocks in the foreground, and a rush of seething water as it recedes after having spent its force on the coast. The sea stretches beyond in white-crested mountains. It is a wild, squally day that the artist wishes to depict, and the spirit of the scene imperatively forces itself upon the beholder. The subject is comprehensive and lofty, and every technical requirement necessary to convey what the artist wishes to express is met. The simplicity of the drawing and the fidelity of the coloring to nature impart to the picture a truth and a power that make it impressive . . .

"The Lookout—'All's Well,'" now in the Museum of Fine Arts, Boston, is another of Homer's familiar canvases that displays the artist's unusual ability to take a homely scene, preserve all its rugged character, and at the same time invest it with poetic charm. The picture, as is evidenced by the accompanying illustration, is simplicity itself, merely a bronzed and weather-beaten mariner in sou 'wester and oilskins, on the deck of a liner, in the act of calling out the familiar words, "All's well." It is a mere incident in a sailor's life translated into poetic expression.

The man is not a mere individual. He is the type of a class. He represents the hardihood, the fidelity to purpose, the devotion to duty, of a numerous calling. Not one iota of the roughness of the mariner is extenuated. There is no conscious effort at idealization, and yet the man's face, grizzled and tanned to leather, is idealized. The composition is perfect. The ship's bell swinging in its metal fixtures, the star-studded sky, the wave breaking with foam crest, are all disposed with a master's skill. Inherent in the canvas is the suggestion of the vastness of the deep, and over it is cast an equally impressive sense of the loneliness of the hour . . .

And so with the famous "Eight Bells," "The Fog Warning," "A Summer Night," "Undertow," "Storm-Beaten," "One Boat Missing," "Cannon Rock," "Tynemouth," "The Ship's Boat," "The Life Brigade," and many another canvas in which Homer, with more force than elegance, and more truth than winsomeness, has told the story of the sea and those who court its dangers . . .

In all these canvases there is no trace of theatricality. No striving for effect, no manipulation of accessories to intensify impression by trickery. It is actually pure and simple, and the actuality is enough for the painter's purpose. It is the realism of stern fact—the awful hell of the seething waters, the mystery of a boundless deep, the might of blind force, the fears, the heroism, the despair, that attend this manifestation of power—all unadorned, uncheapened, direct, truthful, grand.

And so with Homer's bits of Maine coast, and his broad stretches of wild, flecked ocean. "The Gulf Stream," with its boat and fish in the foreground, is but another mute witness of the force of nature. His other bits of seascape, such as are herewith presented, while they lack the evidence of actual destruction, are no less eloquent of the waste of ocean—"dread, fathomless, alone." What Byron expressed in words that have challenged the world's admiration, Homer has expressed in paint with greater truth and greater suggestiveness. Even his sunniest, most placid seascapes convey an adequate impression of that boundless desert of water on whose azure brow time writes no wrinkles, whose ravages are all its own, whose surface, ever changing, has been the same since creation's dawn.

What boots it if some of Homer's colors are hard and crude, if his personages lack the tinsel of refinement, if occasionally he is guilty of a slip in drawing that makes him a mark for puerile caviling, if his skies lack softness of glow, and his seas the tempting placidity of repose? His seascapes are *the* seascapes of art. They are *virile* art. And the world will wait long before a greater than Homer arises.

THOMAS EAKINS IN EUROPE

Those who claim Thomas Eakins as an American "native hero" have sometimes been hard-pressed to account for his four-year period of study with Jean-Léon Gérôme at the Ecole des Beaux-Arts, where he was steeped in the purest French academic technique. In fact, this rigorous, cosmopolitan training marked his later art in many ways, but perhaps most important was the opportunity it provided the young student to reflect on his own artistic philosophy, to codify his relationship to artistic tradition and the natural world. In this, his intellectual confidant was his father Benjamin, and, in a series of letters home to Philadelphia, Eakins regularly announced his discoveries and worked out his worldview as an artist.

Certainly the most extraordinary of these communications is the "mud marks" letter of March 6, 1868, where Eakins breathlessly lays out his artistic credo through the extended metaphor of navigating a canoe in shallow waters. There is a passionate, Whitmanesque character to the prose, with words and metaphors running together in a heady stream of consciousness; one senses that he is so excited he can hardly get it all down on paper. Eakins asserts that the true artist is neither a copyist nor a creator but rather an observer, a selector, and a combiner. Nature provides the example and the "tools," and the artist adds knowledge, experience, and intuition. What Eakins aspires to is a condition in which Nature works through *him. Feeling and subject become intertwined, never separated, and this active connection replaces any reliance on formula or the art of the past. Eakins clearly believes that Nature has laws, and his reference to the British philosopher Herbert Spencer suggests a capacity for human progress that is one with Nature, divorced from the soulless, technological changes of the post–Civil War era.*

In subsequent letters Eakins gives updates on his progress, lectures his father on "finish," and allows that color is proving difficult to master. Notable is the letter from Madrid, where the "big painting" of the Spanish masters struck him like a bolt of lightning, and where he also expresses his hatred of Rubens with humorous hyperbole. For one so young, Eakins was remarkably opinionated but also remarkably confident, as illustrated by his claim to "paint heads good enough to make a living anywhere in America."

Thomas Eakins to Benjamin Eakins, letters, Pennsylvania Academy of the Fine Arts.

[March 6, 1868]

When earnest people argue together it will generally be found upon reflection that they are all arguing on the same side of the main question with some misunderstanding in a trifle, and so I look on the argument between you on the one side and the crowd on the other against you, for I cannot conceive that they should believe that an artist is a creator. I think Herbert Spencer will

set them right on painting. The big artist does not sit down monkey like & copy a coal scuttle or an ugly old woman like some Dutch painters have done nor a dungpile, but he keeps a sharp eye on Nature & steals her tools. He learns what she does with light the big tool & then color then form and appropriates them to his own use. Then he's got a canoe of his own smaller than Nature's but big enough for every purpose except to paint the midday sun which is not beautiful at all. It is plenty strong enough though to make midday sunlight or the setting sun if you know how to handle it. With this canoe he can sail parallel to Nature's sailing. He will soon be sailing only where he wants to selecting nice little coves & shady shores or storms to his own liking, but if ever he thinks he can sail another fashion from Nature or make a better shaped boat he'll capsize or stick in the mud & nobody will buy his pictures or sail with him in his old tub. If a big painter wants to draw a coal scuttle he can do it better than the man that has been doing nothing but coal scuttles all his life. That's sailing up Pig's run among mud & slops and back houses. The big painter sees the marks that Nature's big boat made in the mud & he understands them & profits by them. The lummix that never wondered why they were there rows his tub about instead of sailing it & where he chances to see one of Natures marks why he'll slap his tub into the mud to make his mark too but he'll miss most of them not knowing where to look for them. But if more light comes on to the concern that is the tide comes up the marks are all hidden & the big artist knows that nature would have sailed her boat a different way entirely & he sails his as near as he can to how nature would have sailed hers according to his experience & memory & sense. The stick in the mud shows some invention he has for still hunting these old marks a plomb line to scrape the shore and he flatters himself with his ability to tell a boat mark from a muskrat hole in the deepest water, and then he thinks he knows nature a great deal better than any one else. I have seen big log books kept of the distances made in different tacks by great artists without saying a word about tide or wind or anything else the length of a certain bone in the leg of a certain statue compared to the bone of the nose of a certain other one & a connection with some mystic number the whole which would more mystify the artists that made them than anyone else. Then the professors as they are called read Greek poetry for inspiration & talk classic & give out classic subjects & make a fellow draw antique not see how beautiful those simple hearted big men sailed but to observe their mud marks which are easier to see & measure than to understand. I love sunlight & children & beautiful women & men their heads & hands & most everything I see & some day I expect to paint them as I see them and even paint some that I remember or imagine make up from old memories of love & light & warmth &c &c. but if I went to Greece to live there twenty years I could not paint a Greek subject for my head would be full of classics the nasty besmeared wooden hard gloomy tragic figures of the great French school of the last few centuries & Ingres & the Greek letters I learned at the High School with old Haverstick & my mud marks of the antique statues.

Heavens what will a fellow ever do that runs his boat a mean old tub in the marks not of nature but of another man that run after nature centuries ago and who the fools & historians & critics will have run his boat in the marks of an Egyptian boat that was after a Chinese + (a + b + &c) × . . . Nature at last or maybe God like intelligence or atmospheric effect or sentiment of color lush or juice or juicy effect etc (see newspapers or Atlantic monthly magazine) No the big artists were the most timid of themselves & had the greatest confidence in Nature & when they made an unnatural thing they made it as Nature would made it had she made it & thus they are really closer to Nature than the coal scuttle men painters ever suspect. In a big picture you can see what o'clock it is afternoon or morning if its hot or cold winter or summer & what

kind of people are there & what they are doing & why they are doing it. The sentiments run beyond words. If a man makes a hot day he makes it like a hot day he once saw or is seeing if a sweet face a face he once saw or which he imagines from old memories or parts of memories & his knowledge & he combines & combines never creates but at the very first combination no man & less of all himself could ever disentangle the feelings that animated him just then & refer each one to its right place.

[October 29, 1868]

Your two last letters though intended to encourage me to keep hard working could not but dispirit me a little by showing me you were fearing perhaps that I was not in the right path or had stopped working or some such idea. I am working as hard as I can & have always the advice of a great painter who does all he can for his scholars & of boys friends who can paint the figure as well or better than any man in America. I have made progress & can equal the work of some of the big painters done when they had only been studying as long as I have, & as far as I have gone I see in their works that they have had the same troubles that I have had & the troubles are not few in painting. I have got to understanding much more than I did & though I see plenty of work ahead yet I am not altogether in the dark now but see it plain & sometimes how to catch hold of it. If I live & keep my good health I am certain now of one thing that is to paint what I can see before me better than the namby pamby fashion painters. Whether or not I will afterwards find poetical subjects & compositions like Raphael remains to be seen, but as Gerome says the trade part must be learned first. But with or without that I will paint well enough to earn a good living & become even rich. There is a common mistake made by those who do not know drawing, and that it that one should have the habit of finishing studies. This is a great mistake. You work at a thing, only to assure yourself of the principle you are working on & the moment you satisfy yourself you quit it for another. Gerome tells us every day that finish is nothing that head work is all & that if we stopped to finish our studies we could not learn to be painters in a hundred life times & he calls finish needle work & embroidery & ladies' work to deride us. His own studies are rough quick things mere notes & daubs, but his pictures are finished as far as any man's, therefore one will take his advice quicker than the work of a writer who knows nothing about painting such as Ruskin.

[June 24, 1869]

You asked me how I was getting on with my studies. I am getting on as fast as anyone I know of. There are often awful sticking points but at last by a steady strain you get another hitch on the thing and pass. When you first commence painting everything is in a muddle. Even the commonest colors seem to have the devil in them. You see a thing more yellow you put a yellow in it & it becomes only more gray when you tune it up.

As you get on you get some difficulties out of the way and what seems trying is that some of the things that gave you the greatest trouble were the easiest of all. As these difficulties decrease or are entirely put away then you have more time to look at the model & study, & your study becomes more regular & the works of other painters have an interest in showing you how they had the same troubles. I will push my study as far & fast as I can now I am sure if I can keep my health I will make better pictures than most of the exhibition. One terrible anxiety is off my mind. I will never have to give up painting, for even now I could paint heads good enough to make a living anywhere in America, I hope not to be a drag on you a great while longer.

[December 2, 1869]

I have seen big painting here. When I had looked at all the paintings by all the masters I had known I could not help saying to myself all the time, its very pretty but its not all yet. It ought to be better, but now I have seen what I always thought ought to have been done & what did not seem to me impossible. O what a satisfaction it gave me to see the good Spanish work so good so strong so reasonable so free from every affectation. It stands out like nature itself, & I am glad to see the Rubens things that is the best he ever painted & to have them alongside the Spanish work. I always hated his nasty vulgar work & now I have seen the best he ever did I can hate him too. His best picture he ever made stands by a Velasquez. His best quality that of light on flesh is knocked by Velasquez & that is Rubens only quality while it is but the beginning of Velaquez's.

Rubens is the nastiest most vulgar noisy painter that ever lived. His men are twisted to pieces. His modelling is always crooked & dropsical & no marking is ever in its right place or anything like what he sees in nature, his people never have bones, his color is dashy & flashy, his people must all be in the most violent action, must use the strength of Hercules if a little watch is to be wound up, the wind must be blowing great guns even in a chamber or dining room, everything must be making a noise & tumbling about, there must be monsters too for his men were not monstrous enough for him. His pictures always put me in mind of chamber pots & I would not be sorry if they were all burnt.

THOMAS EAKINS'S *THE GROSS CLINIC*

Within five years of returning from study in Europe, Thomas Eakins painted what is generally considered his masterpiece, The Gross Clinic *(1875, fig. 8), an over-life-size depiction of Samuel Gross, a professor at the Jefferson Medical College whose lectures the artist had attended in Philadelphia. A work of remarkable ambition,* The Gross Clinic *depicts the surgeon performing an operation on a patient's diseased thigh bone in a theater packed with medical students (here the artist includes his own self-portrait). The painting was shown twice in Philadelphia in 1876, at Haseltine's Galleries and in the U.S. Hospital Building of the Centennial Exposition—it had been rejected by the fair's Art Department (see "The Centennial Exhibition," chapter 10). But it was not until the work was given a prominent display in the annual exhibition of the Society of American Artists (see "Young Turks: The Formation of the Society of American Artists," chapter 10) in 1879 that it acquired a national reputation.*

At its debut in Philadelphia, the painting received an almost unqualified rave from critic William Clark, below. He praises the powerful drama of the composition and the magnificent portrait of Gross, and he defends the artist's dim tonalities, which he knows will be criticized by others. Clark ends by essentially calling The Gross Clinic *the greatest painting yet produced in America, a judgment many art historians would sustain today. Yet when the painting was shown three years later in New York, even those critics who acknowledged the strength of the picture's conception and the astonishing draftsmanship of the figures struggled with the bloody subject matter and the murky space of the canvas.*

There is great disagreement in these reviews about whether Eakins's chiaroscuro successfully knits together the various protagonists or plunges the composition into

*an unreadable puzzle. Some see a great deal of "thought" in the picture; others dismiss
it as a callow attempt to shock. Nearly all question the inclusion of the cringing female
relative of the patient, as well as the glistening blood on Gross's scalpel. At a time when
the philosophy of "art for art's sake" was in the air, some writers such as Clarence Cook
nevertheless faulted* The Gross Clinic *for teaching little, offering no lesson. Perhaps
recognizing that nothing like this had ever been produced by an American artist, the
critics search for comparisons in European painting: Rembrandt, David, Géricault,
Bonnat, Gérôme, and Regnault. But with a little more distance, a critic such as Wil-
liam Brownell, writing in 1880, can see that rather than searching for old master proto-
types one might celebrate* The Gross Clinic *for its contemporaneity, its modernity. He
accurately discerns Eakins's personal philosophy and expresses it in the present tense:
"Whatever is is beautiful."*

[William J. Clark Jr.], "The Fine Arts," Philadelphia Evening Telegraph, *April 28, 1876.*

The public of Philadelphia now have, for the first time, an opportunity to form something like
an accurate judgment with regard to the qualities of an artist who in many important particu-
lars is very far in advance of any of his American rivals. We know of no artist in this country
who can at all compare with Mr. Eakins as a draughtsman, or who has the same thorough mas-
tery of certain essential artistic principles. There are men who have a knack of choosing more
popular and more pleasing subjects, who have a finer feeling for the quality that can best be de-
scribed by the word picturesqueness, and who are more agreeable if not more correct in color.
For these reasons it is not difficult to understand that the pictures of men who cannot pretend
to rival Mr. Eakins as masters of technique should find more favor with the general American
public than his have been able to do. With regard to Mr. Eakins' color, however, there is this
to be said—and it is a point that must be considered by those who may be disposed to regard
his color as odd, not because it does not represent nature, but because it does not look like what
they have been accustomed to in other pictures—his aim in color, as in drawing, is to repre-
sent, as near as is possible with the pigments at command, the absolute facts of nature, and a
misrepresentation of facts for the purpose of pleasing the eyes of those who do not know what
nature looks like is something that his method does not contemplate. The genuineness of Mr.
Eakins' method is abundantly exemplified in the picture under consideration, and on a suffi-
ciently large scale for a just opinion with regard to it to be formed . . .

The picture being intended for a portrait of Dr. Gross, and not primarily as a representa-
tion of a clinic, the artist has taken a point of view sufficiently near to throw out of focus the
accessories, and to necessitate the concentration of all his force on the most prominent figure.
Dr. Gross is delineated as standing erect, one hand resting upon the bed, while with the other,
which holds the instrument with which he has been operating, and which is stained with blood,
he is making a slight gesture, as if to illustrate the words he is uttering. To say that this figure is
a most admirable portrait of the distinguished surgeon would do it scant justice; we know of
nothing in the line of portraiture that has ever been attempted in this city, or indeed in this
country, that in any way approaches it. The members of the clinical staff who are grouped around
the patient, the students and other lookers-on, are all portraits, and very striking ones, although
from the peculiar treatment adopted they do not command the eye of the spectator as does that
of the chief personage. The work, however, is something more than a collection of fine por-
traits: it is intensely dramatic, and is such a vivid representation of such a scene as must fre-
quently be witnessed in the amphitheatre of a medical school, as to be fairly open to the ob-

jection of being decidedly unpleasant to those who are not accustomed to such things. The only objection to the picture that can well be made on technical grounds is in the management of the figure of the patient. The idea of the artist has obviously been to obtrude this figure as little as possible, and in carrying but this idea he has foreshortened it to such an extent, and has so covered it up with the arms and hands of the assisting surgeons, that it is extremely difficult to make it out. It is a mistake to introduce a puzzle in a picture, and this figure is, at first glance, a decided puzzle.

Leaving out of consideration the subject, which will make this fine performance anything but pleasing to many people, the command of all the resources of a thoroughly trained artist, and the absolute knowledge of principles which lie at the base of all correct and profitable artistic practice, demand for it the cordial admiration of all lovers of art, and of all who desire to see the standard of American art raised far above its present level of respectable mediocrity. This portrait of Dr. Gross is a great work—we know of nothing greater that has ever been executed in America.

"The American Artists," New York Times, *March 8, 1879.*

He has terribly overshot the mark, for, although his method of painting is not disgusting in colors, as that of some foreign artists is, but rather wooden and academic, yet the story told is in itself so dreadful that the public may be well excused if it turn away in horror. The ugly, naked unreal thigh, the pincers and lancets, the spurting blood, and the blood on the hands of the Professor and his assistants are bad enough, but Mr. Eakins has introduced, quite unnecessarily, an additional element of horror in the shape of a woman, apparently the mother of the patient, who covers her face and by the motion of her hands expresses a scream of horror. Above and in the background, are the students in their seats in the surgical amphitheatre. The composition is rather confused. This violent and bloody scene shows that at the time it was painted, if not now, the artist had no conception of where to stop in art, of how to hint a horrible thing if it must be said, of what the limits are between the beauty of the nude and the indecency of the naked. Power it has, but very little art.

[Clarence Cook], "The Society of American Artists," New York Daily Tribune, *March 8 and 22, 1879.*

[March 8]

Larger and more important still is Mr. Eakin's "The Anatomist," one of the most powerful, horrible and yet fascinating pictures that has been painted anywhere in this century—a match, or more than a match, for David's "Death of Marat," or for Géricault's "Wreck of the Medusa." But the more one praises it, the more one must condemn its admission to a gallery where men and women of weak nerves must be compelled to look at it. For not to look is impossible.

[March 22]

The more we study Mr. Thomas Eakins's "Professor Gross," No. 7, the more our wonder grows that it was ever painted, in the first place, and that it was ever exhibited, in the second. As for the power with which it is painted, the intensity of its expression, and the skill of the drawing, we suppose no one will deny that these qualities exist. With these technical excellencies go as striking technical faults. There is no composition, properly so called; there is of course no color, for Mr. Eakins has always shown himself incapable of that, and the aerial perspective is wholly mistaken. The scene is in the lecture-room of a medical college. The Professor, announced as

a portrait, and said to be an excellent one, has paused in an operation, apparently one of great difficulty, and is making a remark to his class. The patient lies extended upon the table, but all that we are allowed to see of the body is a long and shapeless lump of flesh which we conclude to be a thigh because, after eliminating from the problem all the known members, there seems nothing but a thigh to which this thing can be supposed to bear any likeness. We make out that one of the Professor's assistants is holding a cloth saturated with chloroform over the patient's face, meanwhile two students hold open with flesh-hooks a longitudinal cut in the supposed thigh; another assistant pokes in the cut with some instrument or other, and the Professor himself, holding up a bloody lancet in bloody fingers, gives the finishing touch to the sickening scene. A mile or so away, at a high-raised desk , another impassive assistant records with a swift pen the Professor's remarks, and at about the same distance an aged woman, the wife or mother of the patient, holds up her arms and bends down her head in a feeble effort to shut out the horror of the scene. She is out of all proportion small compared with the other figures, and her size is only to be accounted for on the impossible theory that she is at a great distance from the dissecting table. This is the subject of a picture of heroic size that has occupied the time of an artist it has often been our pleasure warmly to praise, and that a society of young artists thinks it proper to hang in a room where ladies, young and old, young girls and boys and little children, are expected to be visitors. It is a picture that even strong men find it difficult to look at long, if they can look at it all; and as for people with nerves and stomachs, the scene is so real that they might as well go to a dissecting-room and have done with it.

It is impossible to conceive, for ourselves, we mean, what good can be accomplished for art or for anything else by painting or exhibiting such a picture as this. It was intended, we believe, for a medical college; but, surely, the amorphous member we have spoken of would create such doubts in the minds of neophytes, and such sarcasm in the minds of experts, as to make it a very troublesome wall ornament. As a scientific exposition, it is on this, as well as on other grounds, of no great value. The Professor's attitude and notion are apparently very unusual, and give an uncomfortable look of "posing" to the principal figure, which of course could never have been intended by the artist. Then, again, is it usual for the relatives of a patient who is undergoing a serious operation to be admitted to the room? And, whether it be or be not, is it not unnecessary to introduce a melodramatic element—wholly hostile to the right purpose of art—into the scene, to show us this old woman writhing her body and twisting her hands as the Professor details the doings of the scalpel in the house of life of someone dear to her? Thus we have a horrible story—horrible to the layman, at least—told in all its details for the mere sake of telling it and telling it to those who have no need of hearing it. No purpose is gained by this morbid exhibition, no lesson taught—the painter shows his skill and the spectator's gorge rises at it—that is all. It will be seen that we admit the artist's skill, and that skill would be more telling if he had known to confine himself to the main group. The recording scribe in the distance is well painted; no matter how slight the thing Mr. Eakins's people are doing, they always are doing it as effectually as if their painted bodies were real ones. And the old woman is well painted too; but neither the recording scribe nor the old woman has any right at all to be in the picture. They are only here for the sake of effect.

[Earl Shinn], "Fine Arts," Nation 28 (March 20, 1879).

Professor Eakins, so far as he is an artist, proceeds from the exact photographic realism of Gérôme, modified by the robust realism of Bonnat, who paints his figures so solid that you seem to see all around them. He, too, plays with languages. He has opinions on the various

readings of Dante, and makes pastime of mathematics. When he wishes to draw the ripple of a river for a boating subject, he protracts a set of waves on a paper in theoretical perspective, and lays out on each facet the shape of the reflected object which it would properly send off to the eye. Disguising the formality of this process by a sufficient quantity of variations, he paints from his diagram, secure that nobody will ever deny that his river is flat. His classes are coached through the difficulties of anatomy by an accumulation of illustrations not probably approached in any school in Europe. While a pro-sector lifts up a given muscle in the dead body upon the dissecting-table, a nude model is made to exhibit the same muscle in prominence by its being shocked from an electric battery. A third exhibition of the muscle is made on one of Auzoux's detachable manikins; a fourth upon Houdon's anatomical figure; a fifth upon the most suitable among the antique statues, of which he has painted some of the slenderer ones—like the Fighting Gladiator and Jason—into a map-work of red muscles and white tendons. Not much confusion can henceforth exist about that detail in the mind of the pupil thus made to see its ideal shape in the antique, its vital energy in the life model, and its reality in the dissection. With all this patience in laying up facts, it is to be seen whether the artist had the artistic faculty to apply them. He sends to the exhibition a kind of challenge to Rembrandt, a modern "Anatomy Lesson." The subject, however, is evidently living, from the chloroformed towel which conceals the head, and from the anguish of the old mother who covers her eyes in a corner; otherwise, it is simply a contemporary Dr. Tulp, explaining the secrets discovered by his scalpel to an audience of respectful pupils. The picture, ordered for Jefferson Medical College by a body of its alumni, and representing Dr. Gross in the familiar working attitude in which he had earned the reverence of his class, is no more amenable to questions of mere taste than Rembrandt's is. Rembrandt's has been removed from considerations of conventionality by the remoteness of its period and the interest of its art, and this may be held to be so removed by the remoteness of its destination in a college and the technical partiality of its future spectators. There can be no great harm in letting it be seen for a space, in an exhibition especially technical, as it passes on its way to the collegiate museum it is destined to remain in. The picture's scale is that of life, and at least twenty figures are included, the subordinate ones well subdued, though all connected with the central action by the most vivid expression of interest. The effect of the aged and quiet professor, in a sharp perpendicular light, as he demonstrates very calmly with a gesture of his reddened fingers, is intensely dramatic. Equally so is that of the horror-stricken mother, in decent and seedy dress of ceremony, overcome by a sudden horror which scatters ceremony to the winds. These two figures, telling by their contrast of professional habitude and unaccustomed terror, are relieved with great constructive skill from the accessory groups, massed together by ingenious combinations or devices of shadow. Few professors have got themselves painted in so interesting a presentment for posterity. A tendency to blackness in the flesh-shades is the principal artistic infelicity in this curious and learned work.

S. N. Carter, "Exhibition of the Society of American Artists," Art Journal 5 *(May 1879).*

Many of our readers will recall to mind Reynaud's painting of a decapitation in the gallery of the Luxemburg . . . The picture of the dissecting-room by Eakins has many of the same revolting features, and the surgery and the red dabblings were not offset, in the judgment of most visitors to the exhibition, by the great skill shown in the beautiful modeling of the hands, or even by the animated and eager interest depicted on the countenances of the young men who

surround the professor. There is a great deal of good composition in the massing of the lights and shadows in this picture which cannot fail to commend itself; but the least critical person must have found the colour of the background black and disagreeable; and to sensitive and instinctively artistic natures such a treatment as this one, of such a subject must be felt as a degradation of Art. In Rembrandt's famous picture, in Holland, of the doctors over a dead body, the reality of the corpse is so subordinated as to have scarcely more life than a statue, while nothing of the internal structure of the body brings its conditions vividly to the mind of the spectator; but this painting is considered to trench on the limits of the aesthetic, though it is ennobled by fine colour and by an admirable group of portraits.

William C. Brownell, "The Younger Painters of America," Scribner's Monthly 20 (May 1880).

Whatever objection a sensitive fastidiousness may find to the subject of his picture, exhibited here a year ago, entitled "An Operation in Practical Surgery," none could be made to the skill with which the scene was rendered. It was a canvas ten feet high, and being an upright and the focus being in the middle distance, it presented many difficulties of a practical nature to the painter; the figures in the foreground were a little more, and those in the background a little less, than life size, but so ably was the whole depicted that probably the reason why nine out of ten of those who were startled or shocked by it were thus affected, was its intense realism: the sense of actuality about it was more than impressive, it was oppressive. It was impossible to doubt that such an operation had in every one of its details taken place, that the faces were portraits, and that a photograph would have fallen far short of the intensity of reproduction which the picture possessed. What accuracy of drawing, what careful training in perspective and what skill in composition this implies, are obvious . . .

The play of emotions which is going on is strong and vivid. The chloroformed patient is surrounded by surgeons and students whose interest is strictly scientific, his mother who is in an agony of fear and grief, and the operator who holds a life in his hand and is yet lecturing as quietly as if the patient were a blackboard. Very little in American painting has been done to surpass the power of this drama. But if the essence of fine-art be poetic, an operation in practical surgery can hardly be said to be related to fine-art at all. Many persons thought this canvas, we remember, both horrible and disgusting; the truth is that it was simply unpoetic. The tragedy was as vivid as that of a battle-field, but it was, after all, a tragedy from which every element of ideality had been eliminated. The same thing is true, with obvious differences of degree, of most of Mr. Eakins's work. He is distinctly not enamored of beauty, unless it be considered, as very likely he would contend, that whatever is is beautiful.

MARIANA GRISWOLD VAN RENSSELAER MEETS THOMAS EAKINS

Mariana Griswold Van Rensselaer was one of Eakins's most sympathetic and incisive critics. She could see beyond what others described as his brutal and inartistic effects to find an admirable strength, a refreshing "actuality," and an unusually accomplished technique in such controversial paintings as The Gross Clinic *(1875) and* The Crucifixion *(1880). Van Rensselaer saw a rare pictorial intelligence in Eakins's work, and she often referred to his rich capacity for "expression" as setting him apart from more conventional artists. Yet nothing in his art prepared her for the man himself, whom she met at his father's home in Philadelphia in preparation for an essay (never published)*

that she planned to write for the American Art Review. *In this letter to her editor, the patrician Van Rensselaer registers her shock at finding a provincial young man whom she characterizes as boorish, ill-dressed, and incurious; ruthlessly, she also passes judgment on the furniture and décor of his home. Yet in struggling to find the right terms to describe the nonartistic man she believes she has met, she hits upon two that Eakins would have likely endorsed: inventor and mechanic. The artist revered scientists, and he had a deep respect for craft and handwork. That Van Rensselaer "read" him so accurately suggests that the man she actually encountered was less a naïve bumpkin and more a mature professional, adept at a calculated self-presentation.*

Mariana Griswold Van Rensselaer to Sylvester Koehler, June 12, 1881, Archives of American Art.

I went yesterday to Phil. but fear I can give you little idea in words—especially written ones—of the strong contrast between the real Mr. Eakins & the one I had pictured to myself. He was very polite & pleasant, & ready to do all he could to further our wishes. But he was not the clever man I had anticipated in any thing outside of his immediate work. He seems to understand his own aims & ideas & sort of work very well—as indeed, could hardly fail to be the case. But outside of that he is almost absurdly ignorant. He knew absolutely nothing about the black & white art of the country, had never heard of an American etcher except Ferris & in a vague way that there were some who do landscape work. Moreover, he did not know foreign artists, outside of Paris where he studied, even by name—had never heard of Leibl, for instance, or of Lenbach.

Still more curiously, he was, not only not a gentleman in the popular acceptance of a "swell", but not even a man of tolerably good appearance or breeding. His home & surroundings & family were decidedly of the *lower* middle class, I should say, & he himself a big ungainly young man, very untidy to say the least, in his dress—A man whom one would not be likely to ask to dinner, in spite of the respect one has for his work! I used to wonder why he did not put better clothes & furniture into his pictures, but now I wonder how he even managed to see anything so good! His want of a sense of beauty apparent in his pictures is still more so in his surroundings. His studio was a garret room without one single object upon which the eye might rest with pleasure—the sole ornaments some skeletons & some models of the frame & muscles which looked, of course, like the contents of a butchers shop! Things very necessary to him, of course, & also interesting, but which I had expected to see supplemented by others of a different kind. Of course all this is by the way, told merely to satisfy a little curiosity which I dare say you may have felt about the man. A more important fact is that the visit revealed absolutely nothing that I had not already seen. He says he destroyed his academic studies & since that time has never worked at all in black & white even for the purpose of making notes. He had not so much as a scrap of paper of any kind to show, & even in colors only half & dozen panels with rough studies for the "coach" picture. He has a slight sketch of that which had been done for a catalogue, by the way, that you might use & he said he should be glad to do some studies from life for our purpose tho' he was so unaccustomed to working in line that he did not know how he should succeed. He also had—& these were the *only* two things—a large copy in black & white that he had made from the "Prof. Gross" to have it photographed, but which had never been used in that manner. I think you might use it. It is awfully well done tho' of course I could not tell whether it would reproduce or not. He was so much in the dark about what we required—I regret to shock your sensibilities by saying that he had never seen a number of the Review!—that I got tired of suggesting . . .

The American public does not seem to appreciate him at his proper worth. He has about all

his pictures on hand in his rooms at present, so I was enabled to refresh my memory about them. I was most interested in his explanation of the way in which he studied for the coach picture & the principle on which he painted the horses as he did. It will make a good episode, & one which ought to be introduced in that article & for that reason I think there ought to be a sketch of the picture. As for large illustrations I fear you will have to come to the Prof. Gross, or rather I hope you will. I do not see why it is so much worse than other things that are passed without comment & enjoyed—such as battle scenes to say nothing of crucifixions. The blood was the only unpleasant part in the canvas to me, & that does not offend, of course, in the reproduction. When you see the drawing Mr. Eakins has I think you will not find it disagreeable & it is much the most important picture he has painted—one of the very most important, it seems to me, we have yet produced. The other pictures which you would have to choose between are only the "Rush" one which I do not care about, the "Coach," the two pictures of men rowing, the "Pathetic Song," the large woman in black at the piano, a few small studies & some water colors exceedingly nice, of course, but not important in subject. I should think he could do splendid sketches & studies for us if he only would and if you make out a list of just what you want I am sure he would be very glad to do all & everything. He is most modest and unassuming, like a big, enthusiastic schoolboy about his work. I do not believe he knows how good it is or how peculiar. I am sure you could get him to make some studies of men in action that would be novel as well as good—base ball players, for example—& also of animals in motion. Anatomy is his passion evidently & his only desire to paint human beings in motion. I believe that with proper encouragement he could do even better than he has done—that is if he had some one to order his pictures & some one to give him a little insight into the aesthetics of life & take him away from that "milieu" where he now finds himself. I hope I have not given you a very disagreeable account of him. He is interesting in his way, but it was such a different way to the one I had imagined that I could not get used to it & fancied myself all the time talking to someone else than the real Mr. Eakins! Of course his pictures are none the less good in my eyes—indeed, they seem more remarkable when I consider the source & place of their production! ... Do not understand me that he seemed at all unwilling to furnish whatever we wanted. On the contrary, he seems not to have much on hand just now & I doubt whether he is a prolific worker or works with an idea to making money or in an ambitious way of any sort. He seemed to me much more like an inventor working out curious and interesting problems for himself than like an average artist. His teaching occupies most of his time in the winter but now he will do whatever you want I am sure. I wonder how his photograph will look in your pages. He has a clever face in a way but a most extraordinary one. If you met him in the street you would say a clever but most eccentric looking mechanic!

EADWEARD MUYBRIDGE'S SERIAL PHOTOGRAPHS

The Anglo-American photographer Eadweard Muybridge pioneered the use of serial "stop-action" photography to capture the true outlines of bodies in motion. Famously, he worked with support from California railroad magnate Leland Stanford to prove that, for a split second, a galloping horse's four hooves are simultaneously off the ground. Thomas Eakins saw these photographs in the late 1870s, and he wrote with interest to Muybridge. Eakins embraced the camera as a tool for the artist, and Muybridge's visual research in movement and the body paralleled the painter's emphases in the studio and classroom. Although they would later develop a competitive relation-

ship, Eakins was undoubtedly involved in the effort to bring Muybridge to Philadelphia in 1884, when the University of Pennsylvania agreed to support the photographer's project. This work ultimately led to his massive publication, Animal Locomotion *(1887). Years before releasing that volume, however, Muybridge had been giving illustrated lectures on his findings. This transcript of one of those lecturers indicates the degree to which Muybridge integrated art and science in his presentations.*

Eadweard Muybridge, "The Attitudes of Animals in Motion," Journal of the Society of Arts *30 (June 23, 1882).*

The attempts to depict the attitudes of animals in motion probably originated with art itself, if, indeed, it was not the origin of art; and upon the walls of the ancient temples of Egypt we still find pictures of, perhaps, the very earliest attempts to illustrate animal motion. But artists of all ages seem to have followed peculiar grooves in this matter, and to have adopted uniform notions as to the movement of animals. How inaccurate these notions have been, I shall endeavour to demonstrate to you this evening. I will commence, however, by showing you the apparatus by which the photographs were made; you will then better understand the pictures themselves. Here is the apparatus, consisting of an ordinary camera, in front of which is a strong framework, enclosing a couple of panels, each with an opening in the centre, sliding, one up and one down. In connexion with it is an electro magnet, which, on completion of a circuit of electricity, causes a hammer to strike and release a catch which holds the shutters in position; the back shutter is then drawn upwards by a strong india-rubber spring, and the front shutter is simultaneously drawn downwards. Here is a photograph of three shutters in position, one showing the panels before exposure, one during exposure, and a third after exposure. The next picture shows the arrangement in front of the cameras. Here are a series of strong threads stretched across the track, each of which being pressed forward, causes two metal springs to touch, and thereby completes the electric circuit. These threads are arranged at a distance of 12 in. from each other, and as the horse passes along he thrusts the strings, one after the other, completes an electric circuit, which operates the shutter of the particular camera which he is passing at the moment.

Twenty-four cameras are arranged parallel with the direction of the animal. The next picture shows the entire photographic arrangements. The track is covered with india-rubber, to prevent dust flying from the horse's hoofs; and there are here five cameras arranged in a semicircle, the object of which I will explain presently. The result is this:—A horse, in his progress over the track, comes in contact with these threads successively, and is photographed in the position in which he happens to be when he strikes the thread; then he moves 12 inches, and of course assumes another position, and is so photographed, then another 12 inches, and so on; in this way we have several positions assumed by an animal during an entire stride. The time of exposure, I may say, is the 1/5000 of a second . . .

Here are photographs of a horse in the act of walking. A horse, while walking, is alternately supported on three feet and on two, and the two are alternately diagonals and laterals. Some very eminent authorities have asserted that a horse, while walking, has never more than two feet on the ground at the same time; but he has always two—that is the characteristic of the walk—and invariably three, four times during each stride, two hind legs and a fore leg, alternately with two fore legs and a hind leg. This horse, you observe, is standing on the right laterals. The most common fault of artists in representing the walk is to mistake the laterals for the diagonals: it arises, I am satisfied, from carelessness and lack of observation. Whenever a horse

or any other animal has two suspended feet between two supporting legs, those two suspended feet are laterals, never diagonals. You find them in pictures, engravings, and even in sculpture, quite as frequently represented one way as the other; but they are invariably laterals—that is, when they are suspended *between* two supporting legs. When supported on diagonals, suspended feet are outside the supporting legs. Here is a horse walking, photographed simultaneously from five different points of views, according to the arrangement of the cameras I referred to just now. Next, we have a photograph showing the regular series of positions taken by a horse while walking. Of course, in every thousandth part of an inch, a horse really gets into a different position, but these are all the positions of a stride which are worth illustrating . . .

Next we come to the trot, and as before, I first show you some examples of ancient and modern art. There is Marcus Aurelius on horseback, but that is not a real trot, because in a trot the motion of the diagonals is more synchronous than is here represented. The best example of a trot I have been able to discover of mediæval times is from a stained glass window in the Cathedral of Chartres. There are two from the Louvre, representing Louis XIV. and Louis XV.; none of them are quite correct, but none have such glaring faults as one by a very celebrated artist, Rosa Bonheur. She is, perhaps, one of the greatest artists of modern times; grand in colouring, splendid in drawing, a great observer of nature, but, unfortunately, she did not pay sufficiently strict attention to the positions of animals in motion. This is a very celebrated picture, and the horse is supposed to be trotting pretty fast. Now, one fore leg is extended backwards, really beyond the centre of gravity of the horse. It would be utterly impossible for him to bring it forward in time, at the rate he is going, to support his body, and he would be obliged to fall down—he could not help it.

Here are a series of photographs of a horse trotting at about ten miles an hour, showing all the various positions at the different periods of the stride. Now, to me it seems almost incomprehensible, but until these experiments were made, it was a question with some very experienced horse drivers whether a horse was entirely clear of the ground during a trot. Some imagined that he always had one foot on the ground, though I cannot see how it was possible for them to come to that conclusion. Even at a moderate rate, in trotting, the weight of the body is entirely unsupported by the feet, though they may drag along the ground at a certain portion of the stride, no matter how slow the pace . . .

Now, we come to the movements of mankind. This man is walking pretty fast, a seven foot stride. With regard to the walker, we all know that he lands on the heel; but in taking a run, if you ask any athlete in what manner he runs, I think he would tell you that he would not alight on the heel, that he would alight on the ball of the foot. They are generally very confident that in running they never come down on the heel. That is the opinion of the runner himself, I think, in nine times out of ten, and it was with very great difficulty, after this man had run, and had seen these pictures, that he could convince himself of the fact that in running he always came down in this manner. It is the same with the man as with all other animals, as far as I am aware, they always come down on the heel. Here is a photograph of a long jump of 16 feet, without any particular attempt to jump high. Here is one of a man clearing a hurdle four feet high. You would think that clearing a hurdle of that height, if it were possible for him to come down on his toes, and so break the force of the concussion by springing, that he would do so. But you see here where that man's toes are. He comes right down on the heel, and that is the only way in which he could come down. The man finds his springs in his knees when jumping; the horse finds them in his pasterns.

RACE AND REPRESENTATION

Robert Duncanson was the first major African American landscape painter, working as of 1842 in the mode of the Hudson River school in the Cincinnati area. After a trip to Italy in 1853, he incorporated idealized European scenes into his repertoire of American views. Of mixed-race parentage, Duncanson was light-skinned, a fact that undoubtedly helped him in the color-conscious United States. Yet it is unlikely that white America ever thought of him as anything other than "colored"; Frank Blackwell Mayer, a white artist visiting Cincinnati in 1851, made a particular note in his diary that Duncanson was "a negro." Understandably, Duncanson chafed at the idea of "passing" as white, and he is known to have given his support to abolitionism. In this angry letter written to a relative a year before his death, Duncanson professes a color-blind attitude in life and defends his white patronage (he implies that he has received little support from blacks) while also acknowledging his African American heritage and community.

R. S. Duncanson to Reuben Graham, June 29, 1871, transcript, Archives of American Art.

I heard today, not for the first time, of your abusive language toward me. Reuben I have lived to the age of fifty years, I have toiled hard, and have earned and gained a name and fame in my profession second to none in the United States, and now as God decrees on some Angel smiling in the Sun has sent me a friend. A wealthy citizen. I am assured of any amount. My declining years will glide smoothly along. He is of the race that you despise. I despise no being that God has made for he made all good, you have stated that I have all my life tried to pass for white. Shame on you! Shame!! Shame!! Shame!! Reuben. My heart has always been with the downtrodden race. There are colored persons in this city that I love and respect, true and dear to me. It does not follow that because I am colored that I am bound to kiss every colored or white man I meet. Hog's pick their company, and I have the same right. Reuben you and Mary have lived off your grandmother even Mr. Graham since his death, how have you and Mary paid her for her care and strict watchfulness over you. Shame!! Shame!! Shame!!! Reuben Need I point out the abuse that you have given to her who fed, clothed and succored you since infancy? I am here to watch you, and I will pass my arms between right and wrong mark what I say here in black and white I have no color on the brain all I have on the brain is paint. You seem to take a great deal on your puny shoulders. What have the colored people done for me? or what are they going to do to me? please answer? I care not for color: "Love is my principle, order is the basis, progress is the end." Reuben one step more in the course you have pursued and you fall. How often we see the total destruction of disobedient and God forsaken children. You have gone far enough in your abuse. I will write tonight to Mary. She too has lost that respect due me and I will wake you both up. MY conscience does not upbraid me a single nite. You can understand by what I have wrote that I mean business.

Born in Canada, Edward Mitchell Bannister came to Boston as a young man and began painting portraits. He moved to Providence, Rhode Island, in 1869 and became known as a landscape painter. One of his works, Under the Oaks, *won an award at*

the Philadelphia Centennial Exposition in 1876, which gave rise to the account of discrimination quoted below.

A decade later, Bannister had prospered to such an extent that he was selected for inclusion in Men of Mark, *a landmark collection of biographical sketches of prominent African Americans by William Simmons, a Baptist minister and educator who had escaped slavery as a child. Simmons details Bannister's accomplishments, explaining that discrimination both inspired and hindered the artist. Unlike Henry Ossawa Tanner, who was usually more circumspect about the difficulties that beset black artists, Bannister does not hesitate to name them.*

In the same year that the Simmons volume was published, George Alexander Bickles was accepted as the first African American student at the Art Students League (see chapter 10) in New York. The short account of this event indicates that, although some progress had been made since Bannister's humiliating experience of 1876, racial prejudice was still a hurdle for artists of color.

Edward Mitchell Bannister, quoted in George Whitaker, "Edward Mitchell Bannister," undated typescript, Archives of American Art.

I learned from the newspapers that '54' had received a first prize medal, so I hurried to the Committee Rooms to make sure the report was true. There was a great crowd there ahead of me. As I jostled among them many resented my presence, some actually commenting within my hearing in a most petulant manner what is that colored person in here for? Finally when I succeeded in reaching the desk where inquiries were made, I endeavored to gain the attention of the official in charge. He was very insolent. Without raising his eyes, he demanded in the most exasperating tone of voice, 'Well what do you want here any way? Speak lively.' 'I want to enquire concerning 54. Is it a prize winner?' 'What's that to you,' said he? In an instant my blood was up: the looks that passed between him and others in the room were unmistakable. I was not an artist to them, simply an inquisitive colored man; controlling myself, I said deliberately, 'I am interested in the report that *Under the Oaks* has received a prize; I painted the picture.' An explosion could not have made a more marked impression. Without hesitation he apologized, and soon everyone in the room was bowing and scraping to me.

William J. Simmons, "E. M. Bannister, Esq.," in Men of Mark: Eminent, Progressive and Rising *(Cleveland: Geo. M. Rewell, 1887).*

In the far off days of Greece and the story of Parrhasius, we seem almost to forget that within our neighborhood, and often within the circle of our own acquaintances, we have men who are equally ambitious to utilize their talents in such a manner as to bring glory and honor to the race . . .

Mr. Bannister was filled with some of this ambition; for this reason he undertook the study of art. What he has accomplished through his ambition to excel was through a desire to rebuke a slur which was passed upon the race by the New York *Herald* twenty years ago, in which it was said "that the Negro seems to have an appreciation of art, but is manifestly unable to produce it." This was said with reference to the number of colored people seen at the art exhibition; and this was the spur, the incentive, the goad that drove him to supreme effort in accomplishing such results as he has accomplished. In making himself felt and recognized as a first-class artist in a country noted for its prejudice against the Negro, and for its efforts in suppressing Negro talent, and, further, when expressed, for its efforts in many instances in keeping it from being recognized, he deserves unbounded credit.

Mr. Bannister says:

I have been sustained by an inborn love for art and accomplished all I have undertaken through the severest struggles which, while severe enough for white men, have been enhanced tenfold in my case. That I have succeeded in a measure, I can only point to the many encomiums passed upon my efforts by the leading white papers of the country.

Mr. Bannister was born in the town of Saint Andrews, New Brunswick, and was educated and grew up there. At the age of eighteen he went to Boston, Massachusetts, where he learned and worked at the photographic business for a number of years, using the only time at his disposal (nights) for the study of art, at the drawing school, at the Lowell Institute of that city. His study was, however, only elementary. That, however, is the only regular tuition, if it may be called such, that he has had, with the study of art anatomy, under Dr. Rimmer of Boston. The rest he has accomplished, as he says, "through God's help and the persistent effort on his part."

Mr. Bannister has received many notices from the very best sources in the United States, such as the *New York Herald, Tribune, Boston Globe, Traveler, Transcript,* and sketches have appeared in the Artist of the Nineteenth Century, American Artist, published by the Appletons of New York. He has received many medals and diplomas at important exhibitions, the most important of which he considers the first award medal from the Centennial Exhibition of 1876, where his picture was given a place of honor on the walls by a jury of European artists of eminence. He has exhibited some of his work in the Centennial Cotton Exposition held in New Orleans in 1884 and '85, to which reference has been made by the reporter of the *American Baptist,* in the issue of June 11, 1885, where it refers to his celebrated painting known as "A New England Pasture," valued at one thousand five hundred dollars.

Mr. Bannister says that to-day members of the race, which refused to receive him for instruction because of his color, would fill his room as pupils at the first sign of consent. He has endeavored to score a victory for his race in a humble way; what he has done seems to have proven to the writer of the work on "American Art," the possibility of an American artist making his own way without the aid of foreign study.

Nobody, however, appreciates the good to be derived from such study more than he; his opportunities for such have not come to him. So, with God's help, he will work within his lines and when through with it all, something left behind him may be accredited to his race, that will class him among the old masters for talent.

With such an ambition and with so laudable a purpose, may it not he hoped that he will be sustained in his aims and purposes for the race? We earnestly hope that the worthy persons among us will patronize such men as Bannister, Tanner and Stidum by purchasing their productions and placing them upon the walls of their homes, that their children may be inspired to undertake such a life, filled with such delicate and inspiring purposes as they have shown in silently and humbly working away from the multitude; not seeking applause, but in quiet studios, undertaking those things which require the very finest texture of mind and heart to show the æsthetical and the love of the beautiful in the race.

"Art Notes," Boston Daily Evening Transcript, *April 9, 1887.*

George Alexander Bickles, a young colored man from Long Island, was admitted last week into one of the art classes at the School of the Art Students' League, in New York city. He satisfied

the examining committee that he had the proper amount of skill in drawing and was able to pay his bills. Although no colored man had ever been a student in the school, or even applied for admission before, the committee promptly decided that he was as eligible as any one else. Mr. Bickles went into the antique class, which meets in the morning. There were about ninety young men and young women in it already, many of them from the South. An attempt was made at once to draw a sort of color line on the ambitious young negro draughtsman. No complaint was made to the managers, but during a recess the other day it was decided to hold a meeting, to sit, as it were, on Mr. Bickles's right to study antiquities. A [v]ote was taken on the question of remonstrating about his presence in the class, and the affronted party lost. There are still some murmurs of indignation, but nothing could be done after the vote in Bickles's favor, and he will probably be unmolested by the sticklers on the color line hereafter.

WINSLOW HOMER: PAINTING RACE

From the time of his travels with the Army of the Potomac, Winslow Homer studied, drew, and painted African American subjects. His earliest images verged on caricature, but nearly all that followed exhibited a monumentality and gravity of treatment that distinguished them from the conventionally condescending if not outright degrading representations appearing in magazines, newspapers, and exhibitions.

Homer's Visit from the Old Mistress *(1876) and* Sunday Morning in Virginia *(1877) at the National Academy of Design in 1880 prompted the* New York Times *to ponder American painters' failure—excepting Homer—to exploit the negro's picturesque potential. In this critic's view, the "negro" is so much raw, untapped local color, to be refashioned as picturesque spectacle. Appraising* Taking a Sunflower to the Teacher *(1875),* Appleton's *reviewer uses vocabulary reminiscent of the minstrel show to reify the inferiority and otherness of Homer's young model. Although the image does not strike one as overtly humorous,* Appleton's *declares it one of the "funniest" Homer has ever painted.*

The writer commenting on Homer's Cotton Pickers *(1876), by contrast, senses the "deep meaning" of the work and appreciates its simplicity and freshness. Responding to the solemnity of the two figures, the writer comprehends the unhappiness of one and the angry defiance of the other. But in referring to them as "slave women" rather than free blacks, and describing them as "specimens of the tawny race," this reviewer tacitly assigns Homer's figures to lowly status. Even Homer's tragic* Gulf Stream *(1899) strikes a facetious* Sun *critic as a shuddery melodrama rather than a somber reflection on the status of African Americans at the turn of the century.*

Little is known of Homer's own perspective on race relations in America or his true feelings about black people. The critical discourse, however, suggests that, whatever the artist's own sentiments, viewers tended to see his blacks as others, inherently inferior to white people, no matter how seemingly sympathetic the treatment.

"Artists and Their Work," New York Times, *April 9, 1880.*

THE NEGRO IN AMERICAN ART

That must be a morose critic who cannot find in three quarters of a thousand works of art some exceptions to the rule of commonplace which obtains in the exhibitions of the Academy. Two

or three pictures by Winslow Homer go far toward compensating for the ruck of indifferent and inane canvases that crowd every room. Mr. Homer shows his originality in nothing so much as in his manner of painting negroes. What a singular thing it is that, although the African race is thoroughly distributed through North America, east of the Mississippi, from Canada to Texas, the art of America should have in the main failed to make use of negroes as an element of the picturesque in painting and sculpture. This is not to say that sculptors and painters have not tried their 'prentice hands on the negro type; the attempt has been often made; but the results for the most part have been nerveless and inane. There is excuse for a German who paints a negro quite devoid of the African flavor, because negroes in Germany belong in the caravan of a circus, and are regarded very much as we might look on an Australian native. But to find the magazines of the United States over-run with pitiable caricatures of negroes, which do not contain the most evident characteristics of the race, is a surprising fact, and argues very ill for the powers of observation among our artists. Almost as poor as the negro of the draughtsmen for the monthlies are the usual attempts at painting the much-abused darky in oils. The painters who have had the wit and initiative to recognize capacities for the use of color in negro pictures may be counted on one hand. The political history of the last 50 years may have a good deal to do with this phenomenon, but at present there seems no reason why the various colors and types of negroes, especially at the South, should not afford to painters excellent suggestions toward art, if it be no higher art than genre painting.

Mr. Homer is one of the few artists who have the boldness and originality to make something out of the negro for artistic purposes. It need not be said that he has struck very deep into this vein or shows any signs of exhausting its capacity. On the contrary, he has merely ventured a little way, and if the results are remarkable, that cannot be fairly ascribed to the intrinsic richness of his out-turn, so much as to the apathy and ignorance of his brother artists. Several years ago, Mr. Homer had a large picture of negro women passing between rows of cotton-plants; recently, another somewhat like it was shown at a reception of the Union League. The pictures containing negresses here are of less extent of surface, but by no means less important; their smaller area offers better painting and more harmonious tones. The former two were open-air pictures; the present are interiors, and therefore lend themselves much more readily to successful treatment. No. 593, in the North-west Room, is the interior of a negro dwelling on a Sunday morning. An "Aunty" and a group of young people are reading the Bible. In the East Room is No. 327—"Visit from the Old Mistress"—another interior with negro women and children. There is nothing dramatic in the scene, unless the naturally awkward position of the former slaves may be supposed to indicate a sense of the change which has taken place in their condition since the war. The negresses are better figures than the mistress, since the latter shows uncertainty in the treatment of the face; she is neither glad, nor contemptuous, nor kindly, nor, indeed, much of anything beyond a presentable old lady of refined appearance. Is it unreasonable to ask that a painter of Mr. Homer's ability should have made a little more of this interesting situation between former mistress and former chattels?

"The Arts: The Water-Color Exhibition," Appleton's Journal 15 *(February 19, 1876).*

Winslow Homer has several pictures, some of which we have before described when they were in his studio. Mr. Homer has a very dry and excellent humor, aside from the technical qualities of his paintings, and at the "Water-Color Exhibition" is one of his happiest conceptions in this vein. He has a fine sense of the susceptibility of the colored race for artistic delineation, as

is shown in various tussles of a ragged masculine "Topsy" with cattle and with fowls.[1] Now his little urchin appears in a new character, that of a demure scholar at the day-school. Trudging along, with his black, woolly head bare of a hat, young Sambo appears in a little six-inch water-color, with his dusky face all drawn down to the importance of the occasion, for he bears on his arm and presses against his heart a flower for the teacher, in the shape of a great yellow sunflower, with its petals all expanded nearly as big as the little fellow's head, while its brown seeds that fill the centre glisten as does the child's moist countenance. We think this is one of the funniest pictures Mr. Homer ever painted, and, with its sub-flavor of wit, not too broad, and its half-concealed pathos as well, it is one of the happiest efforts of the artist, under a very modest form.

"Winslow Homer's 'Cotton Pickers,'" New York Evening Post, *March 30, 1877.*

Altogether the strongest and freshest piece of figure-painting that Mr. Winslow Homer has put his name to is his latest work, the "Cotton Pickers," which provoked the admiration of the artists at the latest reception of the Century Club, and will soon find good quarters and pleasant society in a private gallery in London. Two slave women, fully developed specimens of their tawny race, are in a Carolina field. One of them grasps with her left arm a large bushel-basket already almost full of cotton, and stoops slightly to pick some more. She is unhappy and disheartened. The other, having filled an immense gunny-bag and slung it across her shoulder, stands erect, defiant and full of hatred for her adversaries. Away in the distance the eye rest upon the blue green of a low mountain range; on the right are the borders of a forest, and on the left a single pine shoots high above the ripe, white harvest.

The story is one not only worth telling, but one that can be told better by the artist than by the historians. Its deep meaning stares you in the face, as it should do to be worth anything. The composition is simple, unpretentious, natural, and the technical execution is brilliant and complete. The scene was painted outdoors, and it looks outdoors. Like most good things, also, the picture is finely original and alluring, and when across the sea, will do honor to the land that made it.

"The Academy Exhibition," New York Sun, *December 27, 1906.*

To prove that the committee on moulding public judgments was acting according to its lights, we need but mention that Winslow Homer's "The Gulf Stream" has the spot of honor in the Vanderbilt gallery, though it is by no means the best picture in the room. But it is the most popular, and the Metropolitan Museum has consecrated that popularity by purchasing the canvas. It has a striking subject, strikingly executed. A fishing smack, dismasted, boom snapped close to the bow, rudderless and tossing in the trough of the sea, bears upon its deck a sprawling black man. He has encountered shipwreck in the Gulf Stream. Worse than that. Sharks are tumbling about him, some on their backs, their savage maws aching to crunch his toothsome African flesh. He is in the grasp of a nightmare horror. From the tail of his eye he witnesses the approach of a new born waterspout, whose advance guard of boiling foam is seen in the middle distance. A shadowy ship at the back is not perceived by the poor wretch. That would be too merciful on the part of the painter. The one touch of joy before us is in the leaps of some fly-

[1] Topsy is an unruly and clownish young slave girl character in Harriet Beecher Stowe's *Uncle Tom's Cabin* (1852).

ing fish. But of what avail are their volant tricks to the castaway? The perilous spout, the nagging sharks, the huge wallow of a wave that threatens in the foreground—these and the hopeless condition of the boat have deprived the negro of all volition, deprived the spectator of all hope. It would be an entirely pessimistic theme were it not for the absence of submarines, whirlpools and thunder skies. That ship will surely be of little use—sensible skippers always give waterspouts a wide berth.

The treatment is broad, flowing, virile. Mr. Homer is a veteran, but he can fence with any of the younger men in rugged force and graphic fidelity. Yet is his picture not a great one. It is only popular. It contains more shudders than the "Raft of the Medusa." It is too crowded, with naturalistic melodrama. In composition it is huddled. It is less fantastic than cruel, and the quality of the paint is neither pleasant nor translucent. Mr. Homer imagined that sea. He is happier when he sees it pounding upon a savage Down East coast.

HENRY OSSAWA TANNER

Born into a prominent African American family in Pittsburgh, Henry O. Tanner studied under Thomas Eakins at the Pennsylvania Academy of the Fine Arts in the early 1880s, where he was subject to racial harassment at the hands of fellow students, particularly Joseph Pennell. In his early career, Tanner explored black subjects in such dignified genre paintings as The Banjo Lesson *(1893) and* The Thankful Poor *(1894). W. S. Scarborough, writing in the* Southern Workman *in 1902, remembered, "When 'The Banjo Lesson' appeared many of the friends of the race sincerely hoped that a portrayer of Negro life by a Negro artist had arisen indeed. They hoped, too, that the treatment of race subjects by him would serve to counterbalance so much that has made the race only a laughing-stock subject for those artists who see nothing in it but the most extravagantly absurd and grotesque. But this was not to be."*

Instead, Tanner moved to Paris in 1891, where he would soon specialize in religious paintings, fueled by two trips he took to the Holy Land in 1897 and 1898–99. In 1899 Tanner was visited by Booker T. Washington, founding president of the Tuskegee Institute, who suggests in the following letter that photographic reproductions of the artist's work should serve as inspiration in African American homes across the United States. Despite the fact that Washington was a family friend, it is a bit odd that he should promote Tanner, since the former had famously written in his autobiography of the futility of African American youth studying French or aspiring to intellectual pursuits beyond manual labor. In an article written a year later, Helen Cole stresses Tanner's religious painting and the place he has won in Europe's art capital. Unlike Washington, she speaks only incidentally of race, but with decidedly biological and essentialist overtones.

Booker T. Washington, "To the Editor," Washington Colored American, *July 22, 1899.*

Our race owes much to the family of the Right Reverend Benjamin T. Tanner. It is very seldom that the children of a prominent man make for themselves such a unique and valuable place in life as is true of Bishop Tanner's children . . .

But I began this article with a view of writing especially about Henry O. Tanner, the eldest son of the family, who now resides in the city of Paris, and who has taken a high position here as an artist. Paris is today beyond question the headquarters of the world in art. Thousands of

artists come here from all parts of the world, and many of them toil for years without their names ever becoming known to the public.

Mrs. Washington and I have seen much of Mr. Tanner and his work since we have been in Paris. We have not only seen him and his work, but have had an opportunity of hearing the opinion of others regarding him. Mr. Tanner is still a young man, being now a little over forty years of age, yet in the art world, and out of it as well, his accomplishments are well known. Until we visited his studio in the Latin quarter, where most of the artists reside, we did not get a full insight into the life of this brilliant young American artist. He has achieved his success by hard study and persistent work. He permits nothing to turn him aside from his life's ambition. Mr. Tanner is determined that he shall not be known as merely a successful Negro artist, but that his work shall stand upon its merit alone. Here in France no one judges a man by his color. The color of the face neither helps nor hinders. "A man's a man for a' that and a' that."

There are two results for which almost every artist in Paris, and in the world for that matter, strives. One is that he may produce a painting that shall be of such high merit as to be purchased by the French Government and placed on exhibition in the Luxembourg Palace; the other is that the painting shall be so valued that on the death of the artist it may be given a place in the palace known as "The Louvre," which is the most remarkable palace in the world for its vast extent and for the magnificence of its architecture, and for the priceless art treasures it contains. The first object Mr. Tanner, though young as he is, and with all the obstacles he has had to overcome, has accomplished and has done it grandly.

A few evenings ago, when I remarked to some of my American friends that I was going to the Luxembourg Palace to look at a painting of a young American colored man, they looked at me in astonishment, and remarked that I must be mistaken. It hardly seemed possible to get it through their heads that a Negro had produced a painting that the highest critics of art would place in this palace; but when I finally convinced them of the truth of my statement, they, too, were on their way to the palace and were glad to claim Mr. Tanner as a fellow-countryman.

In this connection I would further remark that only two or three Americans have thus far been successful in getting their paintings in this Luxembourg Palace. The subject of Mr. Tanner's painting which hangs in the palace is "The Raising of Lazarus." I think he considers this so far, his masterpiece; but I feel sure that this is only a beginning of his great work. Other paintings of his which have attracted attention both in France and America are "Daniel in the Lion's Den," "The Annunciation," "The Jews' Wailing Place," "Flight into Egypt," and "The Still Hunt." . . .

There is another side to the efforts of Mr. Tanner, to which he may not thank me for alluding. In his early struggles to get upon his feet, I fear the race has not given him that practical and substantial support which it might have done. An earnest effort was made in Philadelphia and elsewhere some time ago to get our people to contribute sufficient money to purchase "The Bagpipe Lesson," an early work of the artist, but with little or no practical success. Quite a number of excellent orations and speeches were made upon the subject, but an artist can not live on fine oratory and speech making. This first work of Mr. Tanner's was finally, I believe, purchased by some Philadelphia white people. Few of the race are able individually to purchase Mr. Tanner's original paintings, but hundreds are able to secure the photographs of these productions. Will they do it? This is the practical test in a large measure of our gratitude to and admiration for Mr. Tanner. These photographs can be had for a small sum, and they should adorn the homes of thousands of our people in America. Mr. Tanner's address is 51 Boulevard St. Jacques, Paris, France. A man who has done the work which Mr. Tanner has done, and is

still doing, should be placed in a position where his mind will not be concerned about the matter of bread and butter. Will we help to do this or shall we leave it all to others to do?

Helen Cole, "Henry O. Tanner, Painter," **Brush and Pencil** *6 (June 1900).*

For a painter who occupies the position he does among his contemporaries, and whose success abroad has been so marked, Henry O. Tanner has had very little newspaper fame. Many a poor little artist (for those people are always "artists") whose work is not known outside his own city, and to a limited circle there, has received more enthusiastic notices than Tanner, at least from the American press. But the French journals, though they are not as a rule highly enthusiastic over foreign work, have said many charming things of him, and the French painters, who are denational in all that concerns art, admire him frankly and without reserve, not only for the technical excellence of his work, but for his genuine religious sentiment.

Most of his art education has been received in Paris. Aside from two or three years in the Philadelphia Academy of Fine Arts, he has studied here, and for the first part in the Julien school. It was in 1890 that he first came to Paris, so that he has been working at his profession not more than ten years in all, and since 1895 he has exhibited every year in the salon. Being a Julien pupil he naturally exhibited in the old salon, the Champs Élysées, but the fact of being a Julien pupil had nothing to do with his extraordinary success, and even after his first work, "The Sabot Maker," shown in that year, a distinguished career was predicted for him. That was before he had found his "voie" he entered upon in 1896 with his "Daniel in the Lion's Den." This aroused no end of comment. The effects of light were criticised; he was accused of weakly following Rembrandt, or of drawing from the fountain of Spanish art; but every one looked at his picture, and most people admired it unconditionally. The fact of its receiving a "mention" showed to what extent it was appreciated by the jury, who are not usually lavish of honors in the case of foreign artists.

The next year, in 1897, he showed the "Raising of Lazarus," which earned a medal of the third class only, but was honored in a more substantial way, being purchased by the French government for the Luxembourg Gallery. Ask any tourist who has been to the gallery if they have seen the "Raising of Lazarus," and they always recall it . . .

It was always the center of a group while it hung on the salon walls, and no one was surprised at its being bought by the government, unless it may have been Mr. Tanner himself. His modesty is so striking a characteristic of the man that even though he had worked on this picture nearly a year, and as he said, "put his very heart into it," his first emotion was rather surprise than anything else. The figure of Lazarus, recumbent, just awakening to life and with the glaze of death still in his eyes, is remarkably executed, and must have required the most careful and prolonged study. This occupies the foreground. In the middle, slightly to the right, is the Christ, with outstretched hands, looking down on the man in his grave-clothes with an expression of human pity and divine confidence. The Christ is motionless, but the figures about are full of movement and varied expression. The old man supporting the head of Lazarus is an interesting study, and makes one wonder where Mr. Tanner finds his models. They never have the look of regular studio models, it is certain. The open door shows the country beyond, and through it the crowd presses, eager to see the miracle the rumor of which has so quickly spread. The picture is most dignified, and yet most dramatic, in suggestion, and above all shows that it must have been created by a man of strong and simple faith. This is what is particularly noticeable in Mr. Tanner's work. He has not chosen Biblical scenes because they were "nice to paint," but because to him these events are the most vitally interesting of all human history . . .

Last year he showed "Nicodemus Coming to Christ," a moonlight scene, only the two figures, enveloped in a cold blue light, but the effect of night and remoteness and loneliness was exceedingly well rendered. This was studied "sur place," at least several studies for it were made while Mr. Tanner was in Palestine last year, and while it did not receive a medal, as some of his friends hoped, it was a conscientious and impressive work, and was much admired.

Many interesting studies were brought back both on Mr. Tanner's first and second visit to Palestine. One picture, the fruit of the first, impressed me strongly. It is called "The Jews' Wailing Place." A group of men and women is gathered about a wall, into which are built three stones taken from the temple of Solomon. They are all in attitudes of sorrow and despair, for it is here they come to wail over the dispersion of their race. The color scheme is charming. Trailing green things grow out of the wall, which has a warm, yellow tone, for it is bright sunlight, and the blue sky shows above, the deep intense blue of the South. The figures are strongly individualized, which, by the way, is always to be noticed in Tanner's groups. There is never any repeating of the model. They are living and breathing persons, and each one acts according to his character . . .

He paints for himself first, and for the public afterward. If they like it, *tant mieux.*[2] He is one of the hardest workers in the quarter, and has been very little known in student circles for the reason that with the roystering café habitues he has little sympathy. Now that he is so much sought, he is coming out of his shell a little more, and this year, for the first time, he will hold receptions twice a month in his studio in the Boulevard Saint Jacques. He has an ideal studio, quite out of the fashionable quarter and out of the American section of the Quartier Latin. His windows look across to the dome of the observatory and over the gardens. There is no rubbish lying effectively about, for this is a studio for work. It was built purposely for the occupant, and he is likely to keep it indefinitely. There are a few fine old pieces of furniture picked up at the Hotel Druot, for Mr. Tanner enjoys nothing more than a bargain in rugs or studio property, a few reproductions and photographs on the wall, but no half-finished pictures, no charcoal sketches, and no odds and ends. It is roomy and arranged in a way to quietly satisfy the eye, and is distinctly restful, and yet not a lounging or cigarette-smoking place. "Mr. Tanner does most of his work in the morning," said a friend, in speaking of him, "and he rises very early." "What does he do in the afternoons, then?" was asked. "Oh, he works."

The field which Tanner has chosen, or rather the line in painting which he felt strongly impelled to take, is one where he has little rivalry. Of the French school only Dagnan-Bouveret and Tissot are serious painters of biblical scenes, and Tissot works only for reproduction. In Germany Fritz von Uhde paints sacred subjects in a realistic way, but there is less directness and significance in his work than in Tanner's, though the sentiment is generally sincere. He idealizes a little, as is the German way. Aside from Dagnan-Bouveret, who Tanner acknowledges has influenced him to some extent, there is more true religious sentiment in Tanner's pictures than in any contemporary work. The French critics invariably characterize his work as *personelle,* which is the highest praise it could receive. To produce what is truly personal is to be great. Even Tolstoi, who is at variance with most of the modern ideas on the subject, insists constantly that art of any kind must be a personal expression, or it means nothing.

Certainly Tanner did not receive his inspiration in Paris, though it was here that he learned his technique, for even in the schools classic subjects are the favorite ones for composition. It

[2] *Tant mieux:* all the better.

came from within, and is perhaps an expression of the religious fervor of his race, for though he is no darker than the average Latin, it is a well-known fact that he has a certain proportion of negro blood. It must be rather a slight admixture, for he has delicately cut features, and from the thin, sensitive ears to the long, slender hands, he shows the artist in his physical make-up . . .

With the equipment he has and the place he has already won, there is no reason why Henry O. Tanner should not be one of the foremost painters of his time. He is young, and has only just felt his power, and though he can never speak with more feeling and sincerity than he has already, he may speak louder and more effectively. Certainly there are few enough in this generation capable of touching the chords he has touched, for few have the spiritual insight to paint these scenes realistically, and yet to express all that ought to be told.

LANDSCAPES: EAST AND WEST

The Old Northeast

ARMCHAIR TOURISM AND PICTURESQUE AMERICA

After the Civil War, vacations and leisure gradually attained the status of middle-class institutions, served by the burgeoning tourist industry. To antebellum attractions such as the White Mountains and the Catskills were added many more, from Mount Desert Island in Maine to the Valley of the Yosemite in California. Guidebooks, resorts, and other components of the tourist infrastructure proliferated accordingly. Picturesque America *was an exalted, exhaustive guidebook designed to tell readers not only what to see but, more important, how to see it. Launched in 1870 as a serial in* Appleton's Journal of Literature, Science, and Art, *it was subsequently issued as a subscription book in 1872–74. Lavishly illustrated with over nine hundred pictures by more than a dozen roving artists,* Picturesque America *offered a grand virtual tour of the continent. Although the ostensible aim of* Picturesque America *was to conduct readers on a comprehensive survey of American landscape experience, it embraced a nationalistic agenda as well. Representing the entire country,* Picturesque America *symbolically unified a nation recently torn asunder by war.*

In the chapter on the coast of Maine, Oliver Bell Bunce writes in a highly pictorial style as if painting a landscape with words. This is part of his strategy to instruct readers and tourists on the art of "selecting suitable points of view." It is vital that every would-be landscape tourist learn how to study the scene before his or her eyes with "appreciation and taste"; otherwise, Nature will never reveal her charms and never compose herself into the "picture" that ought to be every tourist's desire to see.

Oliver Bell Bunce, "On the Coast of Maine," in Picturesque America, or the Land We Live In, *vol. 1 (New York: D. Appleton and Co., c. 1872–74).*

The island of Mount Desert, on the coast of Maine, unites a striking group of picturesque features. It is surrounded by seas, crowned with mountains, and embosomed with lakes. Its shores are bold and rocky cliffs, upon which the breakers for countless centuries have wrought their ceaseless attrition. It affords the only instance along our Atlantic coast where mountains stand in close neighborhood to the sea; here in one picture are beetling cliffs with the roar of restless breakers, far stretches of bay dotted with green islands, placid mountain-lakes mirroring the

mountain-precipices that tower above them, rugged gorges clothed with primitive forests, and sheltered coves where the sea-waves ripple on the shelly beach. Upon the shores are masses of cyclopean rocks heaped one upon another in titanic disorder, and strange caverns of marvellous beauty; on the mountains are frightful precipices, wonderful prospects of far-extending sea, and mazes of land and water, and magnificent forests of fir and spruce. It is a union of all these supreme fascinations of scenery, such as Nature, munificent as she is, rarely affords . . .

The several points along the coast to which the visitor's attention is directed are the cliffs known as "The Ovens," which lie some six or seven miles up the bay; and "Schooner Head," "Great Head," and "Otter-Creek Cliffs," lying on the seaward shores of the island. It will fall more duly in order to proceed first to "The Ovens," which may be reached by boat or by a pleasant drive of seven or eight miles.

With a one-armed veteran for an escort, Mr. Fenn and the writer set forth for a scene where we were promised many charming characteristics for pen and pencil. It was necessary to time our visit to "The Ovens"—the nomenclature of Mount Desert is painfully out of harmony with the scenes it verbally libels—so as to reach the beach at low tide. The cliffs can be approached only by boat at high tide, and the picture at this juncture loses some of its pleasing features . . .

At one point on our drive to "The Ovens," the road, as it ascends a hill near Saulsbury Cove, commands a fine, distant view of the mountains, which Mr. Fenn rapidly sketched. Clouds of fog were drifting along their tops, now obscuring and now revealing them, and adding often a vagueness and mystery to their forms which lent them an additional charm.

The cliffs at "The Ovens" contrast happily with the rocks on the sea-front of the island in possessing a delicious quiet and repose. The waters ripple calmly at their feet, and only when winds are high do the waves chafe and fret at the rocks. Here the perpendicular pile of rock is crowned by growths of trees that ascend in exact line with the wall, casting their shadows on the beach below. Grass and flowers overhang the edge; at points in the wall of rock, tufts of grass and nodding harebells grow, forming pleasant pictures in contrast with the many-tinted rocks, in the crevices of which their roots have found nourishment. The whole effect of the scene here is one of delicious charm. The wide and sunny bay, the boats that glide softly and swiftly upon its surface, the peaceful shores, the cliff crowned with its green forest, make up a picture of great sweetness and beauty . . . The rocks are mainly of pink feldspar, but within the caves the sea has painted them in various tints of rare beauty, such as would delight the eye and tax the skill and patience of a painter to reproduce. The shores here, indeed, supply almost exhaustless material for the sketch-book of the artist . . .

From the quiet beauty of "The Ovens" to the turbulence of the seaward shore there is a notable change. Our next point visited was "Schooner Head," which lies four or five miles southward from East Eden, and looks out on the wide Atlantic . . . "Schooner Head" derives its principal interest from the "Spouting Horn," a wide chasm in the cliff, which extends down to the water and opens to the sea through a small archway below high-water mark. At low water the arch may be reached over the slippery, weed-covered rocks, and the chasm within ascended by means of uncertain footholds in the sides of the rocky wall . . . When the tide comes in, the breakers dash with great violence through the archway described, and hurl themselves with resounding thunder against the wall beyond, sending their spray far up the sides of the chasm. But, when a storm prevails, then the scene is one of extreme grandeur. The breakers hurl themselves with such wild fury through the cavernous opening against the walls of rock, that their spray is hurled a hundred feet above the opening at the top of the cliff, as if a vast geyser were

extemporized on the shore. The scene is inspiriting and terrible. Visitors to Mount Desert but half understand or appreciate its wonders if they do not visit the cliffs in a storm . . .

People in search of the picturesque should understand the importance of selecting suitable points of view. The beauty or impressiveness of a picture sometimes greatly depends on this. It is often a matter of search to discover the point from which an object has its best expression; and probably only those of intuitive artistic tastes are enabled to see all the beauties of a landscape, which others lose in ignorance of how to select the most advantageous standing-place. To the cold and indifferent, Nature has no charms; she reveals herself only to those who surrender their hearts to her influence, and who patiently study her aspects. The beauty of any object lies partly in the capacity of the spectator to see it, and partly in his ability to put himself where the form and color impress the senses most effectively. Not one man in ten discerns half the beauty of a tree or of a pile of rocks, and hence those who fail to discover in a landscape the charm others describe in it, should question their own power of appreciation rather than the accuracy of the delineation. The shores of Mount Desert must be studied with this appreciation and taste, if their beauties are to be understood. No indifferent half glance will suffice. Go to the edge of the cliffs and look down; go below, where they lift in tall escarpments above you; sit in the shadows of their massive presence; study the infinite variety of form, texture, and color, and learn to read all the different phases of sentiment their scarred fronts have to express. When all this is done, be assured you will discover that "sermons in stones" was not a mere fancy of the poet.

One of the characteristics of Mount Desert is the abundance of fog. In July and August especially it seriously interferes with the pleasure of the tourist. It often happens that, for several days in succession, mountain, headland, and sea, are wrapped in an impenetrable mist, and all the charms of the landscape obscured. But the fog has frequently a grace and charm of its own. There are days when it lies in impenetrable banks far out at sea, with occasional incursions upon the shore that are full of interest. At one hour the sun is shining, when all at once the mist may be discerned creeping in over the surface of the water, ascending in rapid drifts the sides of the mountains, enveloping one by one the islands of the bay, until the whole landscape is blotted from view. In another hour it is broken; the mountains pierce the shadowy veil, the islands reappear in the bay, and the landscape glows once more in the sunshine. It is a rare pleasure to sit on the rocky headlands, on the seaward side of the island, on a day when the fog and sun contend for supremacy, and watch the pictures that the fog makes and unmakes. Sometimes the fog skirts along the base of the islands in the bay, leaving a long, slender line of tree-tops painted against the blue ether, looking like forests hung in the sky. Then a vessel may be seen sailing through a fog-bank, now looking like a shadowy ghost floating through the mist, when suddenly its topsails flash in the light, like the white wings of a huge bird. In another moment the fog shifts, and the under edge of the mainsail may be traced in a line of silver, while all the rest of the vessel is in the deepest shadow. Now one sail glitters a brilliant white, and the fog envelops all the rest of the vessel. The pictures thus formed vary like a succession of dissolving views, and often produce the most striking and unique effects . . .

The interest of Mount Desert, as we have already said, is divided between its sea-cliffs and its mountain-views. It is customary for pedestrian parties to form at East Eden and walk to the mountain-top, and there remain overnight, in order to view the sunrise from this altitude . . .

The sunrise is a magnificent picture, but the prevalence of fogs is a continual cause of disappointment to people, who travel far and rise early often only to behold a sea of impenetrable mist. The prospect, however, whenever the fog permits it, is a splendid one at all hours, and

possesses a variety and character quite distinct from the views usually obtained from mountain-heights. Here there is not only a superb panorama of hills and vales, but a grand stretch of sea, and intricate net-works of bay and islands which make up a picture marvellously varied both in form and color.

POETRY IN PAINT: ART IN BOSTON

Landscape painting in the Gilded Age and after privileged poetic breadth and subjectivity instead of the topographic precision and seeming self-effacement of the Hudson River school. French Barbizon painting in particular was a rich mine of new ideas. Ardently collected and often exhibited in New York and especially Boston, the work of Théodore Rousseau, Camille Corot, Jean-François Millet, and others offered lyrical visions of the French countryside and its timeless peasants.

William Morris Hunt catalyzed Boston taste for the art of the Barbizon painters. After studying in Paris with Thomas Couture, Hunt moved to Barbizon and stayed there for two years to study with Millet. Upon his return to America, he sparked enthusiasm for Barbizon art among Boston Brahmin friends such as Quincy Adams Shaw, who eventually acquired sixty works by Millet alone. The prestige and popularity of the Barbizon school spurred many American artists—especially in Boston—to move in the same direction, adapting the earthy palette, atmospheric style, and romantic sensibility of the Barbizon painters to local conditions and creating intimate, richly toned pastoral scenes untouched by urbanization or social change.

"Three Boston Painters" sets forth the hallmarks of the Barbizon-inspired Boston style in the work of Hunt, George Fuller, and J. Appleton Brown. Boston painting is distinguished above all by its poetic and suggestive qualities, meaning that instead of literal, photographic imitation it conveys mood and the painter's own emotional response to the scene (see also "The Colonial Revival Landscape," chapter 10). Throughout the article, the writer invokes the names of Millet, Corot, and other Barbizon painters as the guiding stars of their Boston followers.

"Three Boston Painters," Atlantic Monthly 40 *(December 1877).*

Whatever differences exist between these three painters,—and they are many and great,—they have at least this in common: that there is in all their works an element of poetry, whether of incident, or of suggestion, or, more fundamentally important than either, that strictly pictorial kind of poetry which is the expression of the artist's intense appreciation of the beauty of form, of color, of the effects of light and shade, which he finds in his subject and which become the *motive* of his picture, the *reason why* he paints it, its inspiration.

A striking instance of this last kind of poetry is to be found in a small sketch, or study, though most certainly a picture, which was on the whole the most attractive feature of Mr. Hunt's exhibition. The subject is a very simple one. Two youths have come to bathe at evening in a secluded pool, shut in by a dense screen of foliage. One of them has waded out into the water until it has reached his armpits, bearing his companion upon his shoulders. The latter has raised himself to an erect position and stands with outstretched arms, preparing himself for the plunge which is evidently to follow. Both turn their backs to the spectator and their faces are invisible. The clear pearly white of the bathers' naked flesh, relieved against the dark green background, together with the beauty of the unclothed youthful figures, hesitating between action and re-

pose, motionless yet full of movement, constitutes the whole picture, one which has all its attractiveness, all its charm, all its poetry, within itself, and owes nothing to suggestions from without . . .

In another of Mr. Hunt's works there is also a group of bathers, but instead of being the principal feature they are the accessory to the landscape, which in this case, constitutes the picture. The hour is shortly after sunset. Near the horizon the cloudy sky is faintly streaked with red, while a ruddy glow, feebly contending with the prevailing gray, flushes the heavens and is repeated in the glassy surface of the stream. Less effective or less striking pictorially, less a picture in itself than the other, at least at the first glance, it has a charm of suggestiveness not felt and not needed in that, and may be taken as a good instance of another way in which a picture may be said to be poetical: namely, when it inspires in the sympathetic beholder poetic thoughts not arising directly from the artistic or poetical treatment of form, light and shade, and color. The theme, the motive, is evening; the moment when—

"fades the glimmering landscape on the sight,
And all the air a solemn stillness holds"—

a solemn stillness that seems, indeed, to be the prevailing sentiment of the picture; a stillness made only more marked by the fancied sound of shouts and laughter and of plashing water coming faintly from the distant group of bathers.

In yet another of Mr. Hunt's pictures may be found an instance of a third kind of poetical interest which may attach to a work of art, the poetry of incident.

The scene here represented is again sunset or early twilight, the after-glow of a November day. A russet rather than a rosy light still lingers in the sky, and a few faint crimson streaks mark the spot where the sun has just gone down behind the steep hill-side, which occupies the greater part of the canvas and at whose foot the spectator is supposed to be placed. Just beyond the crest of the hill we see, as we look up, an ox-cart, and two men at work gathering in corn-stalks from the pyramidal heaps in which they had been left to dry after the corn itself was harvested. A few *stooks,* only, are still standing, rising dark above the line of the hill-top against the evening sky, which, though warm in color, is suggestive of cold,—the harbinger of a frosty night. One of the men on the top of the load, already piled high, stoops to arrange in due order the bundles of stalks which the other lifts to him on the point of his fork. On the right, in a depression between the hills, a line of apple-trees closes the vista. The foreground, dimly seen in the gathering dusk, is a rough, plowed field, in which the lines of stubble, the half-effaced "hills" where once the corn stood in rows, with here and there a few scattered leaves and withered stalks, are felt rather than discerned.

Though this picture is by no means wanting in strictly pictorial poetry,—the purely artistic attractiveness which makes it a picture,—nor in the poetry of suggestiveness, these are both made subordinate to the poetry of incident, the story proper which the artist had chiefly in his mind to tell: that sad, pathetic story of the hard, laborious, joyless life of the small farmer in New England,—a life of which, for the most part, we have had, in painting at least, only caricatures, but which contains, when rightly seen, as many elements of poetry as that of the French peasants whom Millet has made immortal . . .

As for the poetry of suggestiveness in this picture, it is difficult to separate it from the poetry of the story, which is not told solely by the action of the men around the cart. Each portion of the picture takes up the tale in turn, or rather in concert; every inch of the canvas has

its part to play in the drama. And how well do these subordinate characters, as we may call them, play their parts! They speak the lines set down for them, and nothing more; not interpolating irrelevant matter to attract attention to themselves and to mar the unity of the play, as bad actors often do on the stage. The plowed field, with its half-effaced corn-hills, records the past labors of the husbandman and the successive stages of the growing crop; the sky says plainly that autumn has come and the long imprisonment of winter is near. It is no mere imitation of nature that we have before us. No photograph, no pre-Raphaelite rendering of sticks and stones, could give this impression, could have this suggestiveness. It is not a portrait of the field as it actually was, but as it appeared to the quick sense of the poet-painter.

But admirably, on the whole, as the story is told, effectively as every part of the picture is made to help in the telling, Mr. Hunt has not quite succeeded in giving it, in the genuine Yankee dialect, with a strong flavor of the soil about it, as Burns or Millet would have done had they been born in New England. Neither the men, nor the oxen, nor even the apple-trees, are of the pure Yankee type; and the whole picture has something of a foreign air. There is a want of that perfection of local coloring which we can never hope to see fully realized in the portraiture of the rural life of New England until some youth, "native here, and to the manner born," shall, as Millet did, quit the plow handle and the scythe for the palette and brush, and— profiting by the means of art education now beginning to be so abundantly offered—qualify himself to render a tardy justice to the race from which he sprang . . .

Whatever want of localization there may be in this episode of New England farm life, no fault of the sort can be found in the two large landscapes which plainly represent no other than New England woodland scenes . . .

Grand old trees spread abroad their gnarled and knotted branches darkly against the translucent, sun-illumined green of the foliage, their "immovable stems" fast anchored in the soil by the muscular grasp of their strong roots; while, impudently intruding on their venerable privacy, a group of upstarts of lesser growth here and there assert the New England character of the place, which is again marked by the low wall, long disused and half fallen, loosely built of large, unhewn, and lichen-covered stones. Subjects of this class ought to be especially dear to American landscape painters, as they have ever been to him who, of all American poets, has best described and most fully entered into the spirit of American scenery . . .

In spite of the bold and sketchy execution, the great masses of color, though laid on as with a trowel, are yet so carefully selected and skillfully placed that they have a harmony, a tenderness and delicacy so characteristic of sylvan scenery, and giving to the woods so much of their tranquillizing and consoling influence . . .

One of the great difficulties of the technical part of art is that its business is not to reproduce with literal fidelity the forms and colors of visible nature, but to convey to the beholder the artistic or poetical impression produced by these on the artist-painter. To distinguish what features of the scene before him produce the impression he feels is by no means easy; and having once found them it is equally difficult to keep them resolutely in view, shutting the eye to everything else . . .

This difficulty—which each of our three artists combats in his own way—Mr. Hunt seems to attack more boldly than the others, and by a method implying greater vigor and impetuosity of conception, or of impression, as well as of execution. Judging by his more recent productions, his present mode of working would seem to be to dash at once upon the canvas an abstract, as it were, of the actual appearance of things as they present themselves to his eye in the impassioned moment when his subject first captivates his imagination. The whole picture

is there from the first, but so broadly and expeditiously indicated as to be hardly intelligible except to the artist himself . . . We may regret that in some of Mr. Hunt's work the refining process has not been carried further; we may long to scrape away the great masses of what is too visibly paint and which almost prevent our seeing the picture,—as the shapeless lumps of clay hide the statue that is to be,—but it is impossible to avoid the conviction that, after all, the picture is there . . .

The pictures of Mr. George Fuller, exhibited at the gallery of Messrs. Doll and Richards during the past summer, have a certain quaint, old-fashioned air which is far from displeasing. There is nothing modern about them; none of the new French fashions so much decried by some and so eagerly and unintelligently run after by others. They awaken reminiscences of the works of the old masters, especially those of the Dutch school; and the relationship which they seem to claim with these must be traced, one would say, if at all, through English rather than French channels.

Very differently from Mr. Hunt, Mr. Fuller appears to approach the technical difficulties of his art with extreme caution, and to begin by enveloping his subject in a sort of misty obscurity, from which he gradually evolves (this seems to be his method of working) such parts of it as interest him and in which he seeks to interest us. One can imagine a picture growing gradually under his hands out of a mere flat mass of shadow: a head slowly assuming rotundity; the modeling, step by step, carried further; the illuminated portions receiving, touch by touch, a higher pitch of light and color; all done slowly, deliberately, tentatively, with many a backward step and fresh beginning, with constant reference to the ideal model,—the picture existing from the first in the painter's mind,—till, at last, the limit of art is reached, or the painter's hand tires and he is forced to confess that he can carry the process no further. But how successful it often is as far as it goes, and how little seems wanting!

The poetry of incident, in the few canvases in his exhibition which profess to tell a story, is of the most simple and tender kind. Its heroes and heroines are almost always children, for whom he seems to have as great a love as Edouard Frère, whom he at times resembles in treatment as well as in subject. One picture, especially, reminds one of Frère. It is a winter scene, in which a group of children are drawing a sled, loaded with their younger playmates, down a slight descent over the dry, crisp snow which covers the ground and which the wind whirls in a fine dust about their feet. This effect, so often noticeable in our coldest weather, is admirably rendered. No less successful is the winter sunset, seen through the slender trunks of young oak-trees that border the road and to whose branches cling the withered and ice-incrusted leaves. There is no tinge of the morbid melancholy so apt to be associated with winter by artists who attempt to *put* poetry into winter scenery instead of finding it there. The children are enjoying themselves heartily, and the beholder instinctively shares with them the healthy exhilaration of the keen and frosty air.

The greater part of the canvases in Mr. Fuller's collection were, however, studies of heads and portraits. Some of the studies had only partially emerged from their first nebulous state. Two heads of young women in this misty, vague, and shadowy condition are remarkable for the delicate and refined treatment of the hair, which in one is combed back from the forehead and falls in long loose tresses behind, resting on the shoulder, and in the other is gathered in a knot on the top of the head.

Stronger and deeper in tone and more positive in color are two nearly half-length studies of young girls, each with a wooded background. One of the girls has twined a wreath of leaves and wild flowers around her straw hat; the other has adorned in the same way her own dark hair.

This last study is a marvel of rich, ruddy, and golden color, of which it is no exaggeration to say that it is Rembrandtesque.

But the most satisfactory, upon the whole, of these studies of heads is that of a boy, whose light hair, rebellious to the brush, bristles over his forehead and short round face, and whose serious gray eyes, looking straight out from the canvas, have that dreamy, vacant gaze, susceptible of various interpretations, according to the mood of the beholder, which so often in portraits by the old masters—in those of Rembrandt especially—lends the charm of a certain mystery and unfathomableness to the expression . . .

The poetry in the pictures of Mr. J. Appleton Brown is in some respects quite different from that which characterizes the works of Messrs. Hunt and Fuller. In the poetry of incident, that is, of human incident, they are wholly wanting. No one of the thirty canvases in his recent exhibition professes in the least to tell a story in which any human being plays a part. The few figures introduced occupy very subordinate positions; trees, clouds, hill-sides, the wild waves, the running brooks,—these are his only subjects; it is of these only that he has a story to tell. Man and his works are almost wholly ignored: not a house, not even a distant spire, is allowed to intrude into the unaccompanied presence of nature; we have barely a glimpse, now and then, of a boat, a traveled road, or an artist's sketching umbrella left to itself on the edge of a wood . . .

Mr. Brown's landscapes are indeed thoroughly modern. There is little in them that recalls the old masters, and scarcely more to remind one of the so-called romantic school of landscape, developed in France simultaneously with the romantic school of literature, and whose leaders, Rousseau, Troyon, Dupré, Diaz, have until lately been regarded as the standards of excellence by those of our artists who have studied abroad. Mr. Brown's sympathies are with a later school of French landscape painters, whose best known names are, or were, Corot and Daubigny,—a school which, neglecting the strong effects in which their predecessors delighted, make the interest, the poetry of their pictures to consist in the reproduction of the physiognomy, the inherent character of each particular scene, and in harmonies of color rather than in oppositions of light and shade. They exult in the fresh greenness of meadows, the tender verdure of woods in spring, the thin foliage and tall, silvery stems of birches, the glassy surface of still water, the delicate grays and diffused light of a cloudy sky, the mists of early morning. They are in full sympathy with that very tender love of Nature which enters so largely into much of the poetry of to-day, and which tends more and more to centre about her simpler and less obtrusive aspects.

That Mr. Brown has indeed studied Corot might be suspected from the fondness which he shares with him for quiet river-side scenes, and especially for those where the stream is bordered by long lines of nearly leafless trees. Such resemblances as this, were there nothing more, would be evidence of mere plagiarism; but Mr. Brown should have credit for having sought deeper into the mysteries of Corot's art. It has been truly said that what most distinguished Corot above all his contemporaries was his thorough appreciation of *values*. It is here, rather than in his tall and slender trees, that Mr. Brown is really like him. It is this thorough mastery of values which gives its charm to the picture he calls November. The scene, evidently in New England, is an open pasture, sere and yellow: in the middle distance, toward the left, is a large oak-tree with russet-brown foliage; toward the right and farther off, a solitary figure, dark amid the faded grass; and farther still, a thin fringe of leafless trees. Quaker-like in the modesty and simplicity of its color, with no obvious striving for effect of any sort, the picture is yet thoroughly effective from its apparent and approximative truthfulness. Every object, having its proper pro-

portional value, keeps its place perfectly, and one can see exactly where it is, whether near or distant. As people stand in presence of the picture, it seems as though one might walk into it for miles . . .

Another point of resemblance which Mr. Brown has with Corot is that he is not in the least afraid, as occasion requires, of making his trees green. Curson's Woods and The Road to the Mill at Curson's, Newburyport, were the most striking instances of this. In both are dense masses of deep green foliage, with little or no sky visible; and how truly the impression of nature may confidently be left to any one to say who, during the late luxuriant summer, has walked or driven through the shaded lanes anywhere in Eastern Massachusetts . . .

There may be those who will miss in Mr. Brown's pictures as well as in Mr. Hunt's later work the evidences of long, laborious, and patient application, and will thence infer the absence of that love which gives an indefinable charm to the works of those who put their heart into what they do. It is perhaps difficult to associate the humility of a true love of nature with rapid execution and profuse production. We are apt to think that only by lingering long over one's work,—caressing it, as the French say, adding fearfully and tremblingly one loving touch after another,—the true lover of nature and of art is shown. But true love is manly as well as humble, can be bold on occasion, is content to do the best it can rather than to be forever "sighing like a furnace" for the unattainable, and so degenerating into sentimentality. Rapidity of execution is by no means incompatible with tenderness of feeling. Witness the cloud shadows in Mr. Brown's picture mentioned above. Though done with one sweep of the brush, it would be hard to conceive how any subsequent caressing or tinkering could add an iota to their tender and evanescent loveliness. Their charm was surely none the less felt by the artist because felt at once and expressed as soon as felt.

GEORGE INNESS AND THE SPIRITUAL IN ART

Like the Boston painters, George Inness was a highly individualistic offshoot of the Barbizon school by way of the Hudson River. Abandoning the structured classical landscape style of his early career, Inness in the 1860s adopted the informal composition, broad brushstroke, and earthy colors of the Barbizon painters. In the same decade, he found his lifelong inspiration in the teachings of the eighteenth-century mystic Emanuel Swedenborg, who believed that the only true reality lay in the spiritual realm (see also "Is Religious Art Still Relevant?" chapter 7). Wholeheartedly embracing Swedenborg, Inness in his later landscapes attempted to portray the correspondences between the material and the spiritual worlds. For him as for Swedenborg, the spiritual was the real; the material a veneer, a deception. In order to symbolize that spiritual reality on canvas, Inness dissolved his landscapes into veils of color and amorphous spaces. Painting from the imagination and not from nature, he strove to convey the subtle essence of the spiritual plane. Despite the mysticism that infused Inness's work, he insisted that he sought the spiritual on a firmly rational basis.

In an 1867 letter, Inness alludes to Swedenborg's formulation of correspondences between colors and spiritual or material states, and he proceeds to set down the system of correspondences that underlies his own use of color, methodically detailing the connotations of various saturations and values. Perfectly combined, the three primary colors will produce ideal harmony. Inness warns that only feeling and not science can

achieve this perfect state of balance. In Inness's cosmology, the search for God is rational whereas the love of humanity builds up the scientific. Like the perfect blend of colors, both may be harmoniously joined by "faith in the Lord." In a letter to his daughter Nellie on the eve of her marriage, Inness further explicates his Swedenborgian belief system, telling her that in this constantly changing world every natural fact is mere illusion; the real and only truth is to be found in God.

George Inness, "Colors and Their Correspondences," New Jerusalem Messenger 13 *(November 13, 1867).*

In reading Dr. Bayley's sermon on *The Ribband of Blue*, I have been impressed with the thought that if the word "Techeleth" signifies warm blue, as Dr. Bayley intimates when he says "God commanded the ribband of warm blue to be worn [by the children of Israel), &c," there has, probably from the want of a practical knowledge of colors, escaped his notice, a correspondence which, it seem to me, would make his argument much more perfect. Having given the study of color great attention during the larger portion of my life, I have been frequently impressed with numerous beautiful correspondences of the same, while reading the Word and the writings of Swedenborg, and the beauty of this one has struck me so forcibly that I have thought it my duty to put it on paper. It is generally known that there are three of what are called primitive colors, but it is not generally known that, of these three, one, namely, red, is positive, and apparently the parent of the two others, blue and yellow. Of these latter, blue presents an idea of what is spiritual and appears like something intangible. And yellow, presents an idea of something brilliant or external and can be shown to be an attenuation of red. The blue of the sky is produced by light over darkness, and white rubbed thinly over black has, when properly related to the other two colors, an appearance of blue that would astonish one who knew nothing of the art, and so even over red as in veins, particularly where the skin is delicate. The most intense transparent yellows are red in bulk, as gamboge, which is then hardly to be told from the lakes, but when spread out thinly or when mixed with white is bright yellow. But red is red and nothing else, be there little of it or much of it, it is always red, and no surrounding colors can do other than intensify it. Red corresponds to love. Blue corresponds to faith, and yellow corresponds to what is natural and external. In a work of art red in excess produces fineness, or what is artistically called hardness. Blue in excess produces coldness. Yellow in excess produces vulgarity, but the perfect combination of these three colors in their relative proportions produces harmony. This can only be done by what artists call *feeling*. Science may lay down rules but they cannot be of much service in any creative process. Blue when tinged with red loses its value as blue, without attaining any great degree of warmth, and becomes purplish, tending to the color which corresponds to royalty. Mingled with yellow it loses value as blue and becomes greenish, tending to the color of the natural, *par excellence*. But tinge blue with both and the greatest warmth is obtained without altering its value as blue at all, and not only so, but it will in this condition bear a greater amount of white, which corresponds to light and to wisdom, without loosing its value as pure blue, than even the purest blues that are known, as they always discover their parent red—tending to purple—when so mixed. But yellow is simply weakened by white without losing any value as yellow, and in this condition corresponds to science, which never discovers God. Faith which blue represents must be warmed by love to God and love to man. These are bound in one by love to the Lord, in whom is equally of heaven and earth. The blue ribband of Israel is then warmed with orange, the color of ripeness, the color of the most delicious fruits, the color of the pure,

celestial flame that warms while it illumines. Seeking for God, the rational is developed; loving humanity, the scientific is built up. Faith in the Lord joins them in harmonious union and is a "blessing to both."

George Inness to Nellie Hartley, February 13, 1877, in George Inness Jr., Life, Art, and Letters of George Inness *(New York: Century Co., 1917).*

Although I have neglected to write to you as soon as you might have expected me to, the answer to your question will probably take so much paper that I will leave other matters and commence with that.

I perceive from your question that you are beginning to think, in fact that your spiritual faculties are beginning to unfold, and that you are now experiencing your first temptation, which is to leave the ideas in which you have been educated because you fear that they may disturb you in the enjoyment of your natural desires.

Every individual man or woman born into this world is an offshoot of that Infinite Mind or Spirit which we call God. God creates in us sensation, and through it we are made conscious of the world we live in. A world which we eventually find to be a continual changing state, but a state which forms the basis of all our knowledges. This state is continually changing because our spirits individualized here, or born, created as distinct from the Infinite, gradually recede from natural surroundings into what each one eventually becomes, viz., the embodiment of his or her own love or desires. Now, as your own love or desire eventually becomes the center from which all your activities must flow, it behooves you to see that your love or what you desire is rational and not the effect of a mere natural impulse, which may be one thing to-day and another thing to-morrow, thus disturbing the orderly centralizing of your spirit to a state of happiness. Now, the center of all life is the Lord himself, the mystery of whose existence is the mystery of our own, and which will gradually unfold itself to us as we learn to subject our natural impulses to ideas of use and make them eventually our delight and the consequent center of our spirit life, which then becomes one with the Lord Himself. This unfolding of intelligence in us takes place in varying degrees to eternity, and is a great source of happiness or of unhappiness, as we are obedient or disobedient to the truth which we know; for this truth becomes in us the voice of conscience, which cannot be disobeyed with impunity. Now, what the spirit sees is not the truth, but only an appearance of truth. For instance, we say the sun rises and the sun sets, but this is not true except as an appearance, and so it is with every fact of the natural world. The truth is the Lord Himself, Who creates and controls all which is thereby made to appear to us. This truth reveals itself as from mind to mind, and is from the beginning one God, whose children we all are. God first reveals Himself to the innocent mind as command which it is impossible to disobey and live. Next to the intellect as truth that it may become rational or act in the order of use which is the preservation of innocence. Third to the will as good or as a power conjoining or making one the innocence of pure affection and the operation of the intellect creating in His children an eternally increasing state of happiness. Now, we fall from innocence when we indulge the senses and accept their evidence as truth to guide us to happiness. When the truth is that the gratification of the senses becomes more difficult and eventually impossible as the body becomes aged, and that those spirits who indulge them and are led by their allurements become dull, miserable, and wretched for the want of life—God. Consequently the truth is, thou shalt love the Lord. This is the command which innocence accepts as its guide and its savior, and it becomes its protection against the allurements of the senses.

Now, the Bible is the word of God or the truth of life in its intellectual form, and by obedi-

ence to its commands we become recipients of life itself as an inflowing principle of goodness uniting all our thoughts to innocent desires, thereby creating in us a love of the highest and most beautiful uses, which is to extend the Lord's love, which is harmony itself, throughout the world we live in. Thus we become spheres of what we are of innocence, truth, and goodness, seen by angels as spheres of the love and wisdom of God. If you would have this life, read the Word and obey the commandments. If you find yourself at fault, look to the Lord Jesus Christ, Who is the only example of this sphere of innocence, and Who is therefore within it and forms it. He will communicate to you the power to deny the allurements of sense or your outer self and attain to the love of duty which is the road to heaven or the happiness of the inner life. This life is the eternal future ever present to all who love the Lord more than self. That is a life within the commandments rather than a life outside of or without them.

That you may be obedient to the law of life, and thereby enter into the enjoyment of it, is the sincere wish of your affectionate father.

GEORGE INNESS AND THE LANDSCAPE OF THE MIND

By the 1880s, critics were acclaiming Inness as an inspired genius who had lifted land-scape painting to the highest plane of idealism. Writing as Henry Eckford, the art critic Charles de Kay attempts to probe the painter's mystical ideas while contextualizing him and his work in relation to movements past and present. Tracing Inness's progress from an analytical to a synthetic style, de Kay explains the reasoning behind the artist's Swedenborgian ideas, paying particular attention to the fusion of "religion, landscape, and human nature" in the artist's mind.

Elliott Daingerfield's reminiscence, published a year after Inness's death, offers a vivid glimpse of the artist's personality and working methods. Daingerfield was an ardent admirer and close friend of the older artist; his own landscapes, which blend Barbizon style with symbolist ideas, are close to Inness's in spirit. In his memoir, Dain-gerfield describes Inness's mercurial moods and excited conversational style and evokes the fierce, physical energy of the artist's painting technique, in which he attacks the canvas in a state of feverish excitement. For Daingerfield, Inness is the quintessence of the romantic genius, sensitive and intuitive, in the grips of exalted inspiration.

Henry Eckford [Charles de Kay], "George Inness," Century Magazine *24 (May 1882).*

Inness seems never to have had even so much of social ambition as to make him wish to knock at those doors in his city which are least ready to open to men neither rich nor well-accredited. Sufficient for him were his own family, his studio, and his private circle of friends. A steady workman at his profession, he would go to nature for impressions, simply, neither with boast nor with too much hope. Sometimes it is plain that he has labored hard at his sketches; hours and days pass while struggling at one scene. In such cases the work is minute, painstaking, almost painful. For his nature is most excitable, and can only be made to apply itself by the strongest exercise of will. But then the benefit of self-restraint shows unerringly in the sketch. On other occasions, he has been an impressionist in the fullest sense of the term. Overwhelmed by the beauty of a scene, the play of light and shade, the balance of clouds, distant hills and nearer masses of forest, he has dashed his paint on with hardly a line of pencil or charcoal to guide him, working in that rapt condition of mind during which the lapse of time is not felt, in which the mind seems to extend itself through the fingers to the tip of the brush, and the latter, as it

moves on the prepared surface, seems to obey the general laws of nature which fashioned the very landscape that is being counterfeited at the instant. These were moments of the painter's ecstasy, rare enough in comparison with cooler moods, but leaving their mark with equal unerringness. From sketches taken under such varying circumstances have arisen in the quiet of his studio the procession of landscapes issuing from his hand during the past thirty years. Grave landscapes and gay, landscapes noble and plain, expressive landscapes and those that told of indifferent moods. Some touch a height of magnificence that gives one cause to remember the great men of former days—Claude, Poussin, Rosa, Ruysdael, Constable, Turner. Others have the sturdy look of Rousseau. But Inness is not an imitator or follower of any of these: if he had one merit only, it would be originality. Genius more varied is not unknown and genius that has broader limits. But in his own lines as a landscapist and colorist he is like no one else. Consider his "Stone Pines at Monte Mario," and "Hickory Grove at Medfield, Mass.," his "Coming Storm," and "Light Triumphant."

It is only at a distance that the work of Inness seems to be unvaried. It is always landscape, and always one feels the individual manner which has not been allowed to degenerate into mannerism. But the moods in which the different pictures have been conceived are often varied, and then another key-note of color is struck. Sometimes that note is laid down on the canvas at the start; its complementary color is added; then follow the other colors and their shades of color, all with reference to the first. Again, it may seem better to reverse the order somewhat: the key color is washed over later. Inness has learned to subordinate his materials; they flow plastic under his brush or thumb. A disciple of the older school, he seldom uses the palette knife or brushes of extraordinary character, yet, if he thought better effects could be gained through them, he would not hesitate a moment to use them. This may seem trivial; it is only mentioned to show that, notwithstanding the intensity of certain of his convictions, which will presently be mentioned, he has no narrowness regarding the methods of his work or the tools employed. When the right mood is on he becomes dramatic, although always as a landscapist, and reaches closely to the borders of the sublime. There is a moorland piece which shows this trait well. Heavy bowlders encumber the moor; one almost hides a farmhouse, whose gray roof, were it not for the smoke at its chimney, might be taken for another mass of rock. A figure is detected in the open central space. The sky is magnificent with heavy, black rain-clouds, that reflect the ruggedness of the moor; in the center, and as a counterpart of the farm-house roof, is a brilliant white cloud that has caught the sunlight. There is a fine glowing effect in the heavens and in the distant moor that is aided by the smoke and the little curling white clouds above the heavier masses. This is not direct work from nature—it is pure dramatic imagination . . .

. . . Three epochs may be distinguished in his work, but their borders overlap, and it would be rash to affirm absolutely in every case to which of the three a picture belongs. With due deference, therefore, to the possibility of mistake, these three styles may be postulated: An ante-war style, consisting of painstaking, rather stiff, analytical work, similar to that of many of his comrades in the "Hudson River School," etc. Secondly, a war style, which we may consider the result of the agitation produced by the four years of tumult and national anguish, and which shows itself in fluidity of outlines, a breaking-up of the old rigidity, a new grasp of what is magnificent in landscape breadth, a throwing overboard of the pettiness of the former style. This may also be called the "Italian" style of Inness, not so much because he learned from the Italian masters,—his influences were rather French, Flemish, and Dutch,—but because he painted Italian scenes. Finally, a post-war style, in which he now works without loss of the

good in his previous efforts, but with complete control of his art. If big words are not out of place, the present may be called his synthetic style as opposed to the analytic of the days before the war . . .

. . . Now, Inness piques himself on the logic displayed in the management of his landscapes. His methods are the result of much observation of nature and the pictures of modern and ancient masters. Particulars are reasoned out with a rigidity of logic that sounds dry. His groping after truth has been as constant as it was earnest. Yet there is plenty of imagination and poetry in the scenes. Back of the landscapes, in whose confection rules founded on logic that can be expressed in the mathematical terms have been strictly followed, lies the whole world of immaterial spirits, of whom Swedenborg was the latest prophet. Not for Inness the wild extravagances of technique belonging to the later pictures of Turner. The so-called "Slave-ship" is a bugbear. He has a horror of the illogical presence of floating iron chains and of marine monsters unknown to the merely human eye—neither fish, flesh, nor good red herring . . . He regards as unmanly, if not positively ignorant, the fashion Turner had of placing the vanishing point—that point to which all the parallel lines seem to tend—to the left or the right of the picture, instead of near the center, thus disturbing its repose. But—paradox as it may seem—along with such dry and technical axioms, such *Philisterschaft*, in a true artist goes the fact that to Inness the whole cosmogony of inner spirits superintends the creation of the pictures. He is nothing if not an idealist.

He is, in fact, without being of a complicated nature, an artist with more than one side to his character. Alternately one might take him for a poet or a Philistine; an idealist or a hidebound realist; an impressionist or a pre-Raphaelite. Beginning under the influence of Durand, he saw the limitations of that good but restricted painter. From Thomas Cole he had the same repulsion that shows in his criticism of Turner. The pre-Raphaelite influences in their English shape were strong enough to make him try more than one study in that direction. But good sense—or, shall we say, the intuition of genius?—saved him from exhibiting much that smacked strongly of a movement wholesome as a preparation but misleading when taken literally. The impressionists also leave him cold, for has he not been, on many occasions, an impressionist? Some of his studies are faithful imitations of nature pursued for weeks at a time. Others, as we have said, are dashed in during the heat of imaginative creation.

Like some of the great Dutchmen, like their reverential followers Constable, Corot, Rousseau, landscape is to this artist the highest walk of art. It not only represents the nature that we see and the human feelings that move us when we look on nature, but something that includes both. It is an expression—feeble enough, to be sure, but still an expression—of the Godhead. In the mind of Inness, religion, landscape, and human nature mingle so thoroughly that there is no separating the several ideas. You may learn from him how the symbolization of the Divine Trinity is reflected in the mathematical relations of perspective and aërial distance. That such ideas are not mere whims with him is attested by various papers published in the magazines where he has given some of his thoughts. He not only believes what he says, but tries to carry out in his pictures this interrelation of art and religion . . . Inness is a modern to the last degree, and, thrown in upon himself by a scoffing world, tries to express his religious opinions under the veil of landscape. Perhaps even that is saying too much. Do his landscapes hint of religion? Does he try to express religion? We should say no. It is rather the methods by which he does them that are governed in his own mind by religious ideas. The result is fine, but, to the world, too far removed to be understood as religious in motive. Let us, then, rather say of his religion that he does not express, but hides it, in his art.

Elliott Daingerfield, "A Reminiscence of George Inness," **Monthly Illustrator 3 (March 1895).**

His moods were so well known to me that I could readily tell from his very knock at my door whether I was to be taken off across the hall to his studio, to view some great advance in his picture, or whether he was to drop into a chair in silence for a while, worn, tired, and with that depression of spirit which only the artistic nature can understand. At such a time, one word upon some abstract theme, no matter what, if really serious, would stir him into life and intense speech. It would not be argument, as between two; for, when Inness talked, the flame needed no draught. It blazed and flared until his own conclusions were reached, and then faded, even as the glow on some of his own forest trees seems to fade in the twilight time, until the deep silence left no room for speech. Nor were his arguments always carried to logical sequence: what mattered it? Does the storm forever sweep across the exact field you or I have chosen for its path? The rush and go of it were all there and the interest. If there were sympathy, which means understanding, in the listener's soul, these monologues of his yielded many great truths to him.

He came into my studio one day, with all the unrest and nervous eagerness which characterized him when thinking intensely; threw out several sentences about his picture, his purpose in it, etc., then with a sort of mad rush he said:

"What's it all about? What does it mean—this striving—this everlasting painting, painting, painting away one's life? What is Art? That's the question I've been asking myself, and I've answered it this way:" (I drew a writing pad to me, and jotted down his words; they are worth thinking about oftener than once.) "Art is the endeavor on the part of Mind (Mind being the creative faculty), to express, through the senses, ideas of the great principles of unity."

Perhaps no more characteristic sentence has ever been recorded of him. It satisfied him. He had made his conclusion and expressed it. He did not propose to supply us with brains to understand what the "principles of unity" may be. We might struggle as we pleased with that problem, as perhaps he had struggled with the other, although to a tyro the last seems exactly the same as the first. Art, Religion, and the Single Tax Theory were his chief themes, and, by a curiously interesting weaving, his logic could make all three one and the same thing.[3]

Oblivious to externals, both of persons and things, he often said and did much that evoked harsh criticism, but at heart, it may be truthfully said, he was as gentle as a child, even tender, and swiftly sympathetic. What a delight it was to watch him paint when in one of those impetuous moods which so often possessed him. The colors were almost never mixed;—he had his blue theories, black, umber, and in earlier days bitumen: he even had an orange-chrome phase. With a great mass of color he attacked the canvas, spreading it with incredible swiftness, marking in the great masses with a skill and method all his own, and impossible to imitate; here, there, all over the canvas, rub, rub, dig, scratch, until the very brushes seemed to rebel, spreading their bristles as fiercely as they did in the days of yore along the spine of their porcine possessor.

But stand here, fifteen feet away. What a marvelous change is there! A great rolling billowy cloud sweeping across the blue expanse, graded with such subtle skill over the undertone. Vast trees with sunlight flecking their trunks, meadows, ponds—mere suggestions, but beautiful; foregrounds filled with detail, where there had been no apparent effort to produce it, delicate

[3] The single-tax theory, propounded by reformer Henry George in *Progress and Poverty* (1879), was based on the idea that a tax on land values as the single source of government revenues would invigorate economic growth.

flowers scratched in with the thumb-nail or handle of the brush. One's imagination was so quickened that it supplied all the finish needed.

Inness used to say that his forms were at the tips of his fingers, just as the alphabet was at the end of the tongue. Surely it was true, and when he "struck a snag," as he called it, and he almost always did (I used to think sometimes, for the fun of the struggle that was to follow) 'twas in the *construction* of his picture, not in any mere matter of painting. He would find out where the "hitch" was and then go on . . .

No reminiscence of Inness would be complete without some mention of his great power as a colorist, for all his philosophy, all his many-sided nature, seemed to express itself in the fulness and beauty of color. We are not to make comparisons with the work of others—that were needless, Inness's color was his own. The early morning, with its silver, tender tones, offered him as great opportunity for the expression of what he called "fulness of color" as did the open glare of the noonday, or the fiery bursts of sunset. Mention has been made of his different color-moods, and one fairly held the breath to see him spread with unrelenting fury a broad scumble of orange-chrome over the most delicate, subtle, gray effect, in order to get more "fulness;" and still more strange was it to see, by a mysterious technical use of black or blue, the same tender silver morning unfold itself, but stronger, firmer, fuller in its tone quality. "One must use pure color," he would say: "the picture must be so constructed that the 'local' of every color can be secured, whether in the shadow or the light." Many of his canvases are criticised because of an over-greenness, or an intensity of the blues, but deeper study shows the man's principle, for which he strove with the whole force of his nature. A perfect balance of color quality everywhere in the picture. The mass of offending green will be found to balance perfectly with the mass of gray or blue of the sky. So that the whole canvas, viewed with that perceptive power without which there is no justice in either the criticism or the critic, becomes an harmonious balance, with all the intensity of his powerful palette. Inness maintained that the "middle tone" was the secret of all success in color—he strove for it until the end, and so great was his effort that the latest works are but waves of wonderful color, marvellous and mysterious—the very essence of the beauty of nature. When he chose to put aside his theories and produce a "tone study," following the habit of those masters who have glorified modern French art, he was as subtle as any of them, and far less labored; but it is in his very intensity that he has preserved his individuality, and if we are to understand him aright, we must study him from his own standpoint.

The New West

WILLIAM HENRY JACKSON: PHOTOGRAPHING THE WEST

Raised in Troy, New York, William H. Jackson taught himself to draw using J. G. Chapman's American Drawing Book. *He began his professional career as a photo retoucher and hand-colorist before becoming an independent "operator" during the Civil War. His autobiography,* Time Exposure, *includes interesting accounts of the photography trade during this period. However, Jackson's true contribution would be in photographing the West as a member of a series of U.S. government expeditions. Arriving in Omaha, Nebraska, in 1867, he set himself up as an all-purpose photographer; the first excerpt below describes this western business and, in particular, his cultivation of Native American subjects. Upon meeting Ferdinand Hayden, of the U.S. Geological Survey, Jackson agreed to join the expedition in 1870, along with the painters*

Sanford Gifford and Thomas Moran. The passages included here detail the trials and triumphs of this difficult job, such as his work at Mammoth Springs, along the Yellowstone. The last excerpt describes an accident that occurred on a subsequent trip with Hayden in 1873. Evident here are the prodigious amounts of patience required of field photograpers as well as the joy of securing the "perfect" view.

William Henry Jackson, Time Exposure *(New York: Cooper Square, 1970).*

Omaha was a fine location for business. The town was old, as age is reckoned beyond the Mississippi—the first house was built in 1853—and it had at the same time the enormous vitality of a boom town. Omaha was the marketplace for a prosperous farming country. The Union Pacific operations had brought in many workers and traders. By the time Jackson Brothers got under way Omaha was the unrivaled metropolis west of Chicago and north of St. Louis.

For the first year we stuck pretty closely to the usual work of studio photographers—straight portrait jobs; group pictures of lodges, church societies, and political clubs; and outdoor shots that gratified civic pride. There were many commissions to photograph shop fronts and, occasionally, interiors. Now and then, too, somebody would order pictures of his new house; or of his big barn, and along with it the livestock. We were kept busy.

Ed took care of the front office and did the canvassing. Ira Johnson, a boyhood friend, who had come west with my brother, handled the portrait jobs. I did the outdoor work, and my seventeen-year-old brother Fred (who had also come with Ed) was general studio assistant.

The business paid well enough, but it was hardly exciting. Every once in a while, however, I could increase the tempo by going off for three or four days as "missionary to the Indians." South of Omaha lived the Osages and Otoes; to the west, up the Platte, dwelt the Pawnees; north, along the Missouri, the Winnebagoes, and the tribe for whom the city had been named, the Omahas. They were all friendly—and there was money there, both for the red man and the photographer. Those Indians would pose for me by the hour for small gifts of cash, or just for tobacco or a knife or an old waistcoat. And I in turn was able to sell the pictures through local outlets and by way of dealers in the East. To handle this work I devised a traveling dark room, a frame box on a buggy chassis, completely fitted out with water tank, sink, developing pan, and other gear essential to a wet-plate photographer. Soon my one-horse studio (which at first scared the daylights out of all the livestock) ceased to be considered "bad medicine," and I was welcomed equally before the tepees of the Poncas and the earthen houses of the Pawnees . . .

On July 23, 1870, Dr. Hayden, on his way to Wyoming, called at my place of business in Omaha. He spent a long time studying my Union Pacific pictures and the Indian groups I had photographed near Omaha. Then, with a sigh, he remarked, "This is what I need. I wish I could offer you enough to make it worth your while to spend the summer with me."

"What *could* you offer?" I asked quickly.

Dr. Hayden smiled and shook his head.

"Only a summer of hard work—and the satisfaction I think you would find in contributing your art to science. Of course, all your expenses would be paid, but . . ."

At that moment my wife walked into the reception room. Our living quarters were on the floor above the gallery, and she often came in to lend a hand.

"Dr. Hayden has just been outlining his plans for Wyoming," I explained, after introducing him.

"And telling your husband how much I would like to take him with me, Mrs. Jackson," he added emphatically.

Mollie looked at Dr. Hayden for a moment, then at me. Then she laughed—and I knew that everything, so far as she was concerned, was arranged.

Two days later Dr. Hayden telegraphed me from Cheyenne to join him as soon as possible. Quickly I straightened out the affairs of my shop and left my wife in charge, for my brother Ed had withdrawn shortly before, to take over the management of his father-in-law's farm at Blair, Nebraska. She had the able assistance of my operator; but I doubt whether Susan B. Anthony herself was ever feminist enough to be willing to take over the management of a Nebraska photographic gallery.

On Sunday, July 31, we dined with my wife's relatives, the Campbells, and then I took the omnibus to the station. Next morning I was in Cheyenne . . .

My equipment, plus extras and refinements, was the same I had carried the previous summer: the double-barreled stereo, and the $6\frac{1}{2} \times 8\frac{1}{2}$ (also adaptable to stereoscopic work); the portable dark room, completely rebuilt and improved; a full stock of chemicals; and enough glass for 400 plates. The whole must have weighed not less than 300 pounds; but since I had one of the two ambulances at my disposal, neither weight nor bulk mattered much. I had also Hypo. A fat little mule with cropped ears, Hypo was almost as indispensable to me as his namesake, hyposulphite of soda, was to dark-room chemistry. Carrying my cameras, tripod, dark box, chemicals, water keg, and a day's supply of plates, all loaded in big, brightly painted rawhide containers called parfleches, Hypo was good for as many miles as my horse was, and together we covered an enormous amount of ground off the road from the wagon party.

It was those independent excursions, or, rather, the spirit beneath them, that made this expedition and all the ensuing ones under Dr. Hayden so engrossing and satisfying. Every day we had an informal conference around the campfire and then we would set about our work individually, or in groups of two or three. One little division might be assigned to calculate the flow volume of a stream; another would be given the task of sounding a lake; several other men might investigate the geology of the region or hunt fossils; Gifford, Elliot, and I would go off to record our respective impressions of a striking landmark, like Independence Rock or the Red Buttes. We all had work to do, and Dr. Hayden had the rare compound faculty that enabled him not only to select able assistants but to get all of them to pull together . . . Hayden knew that Congress would keep on with its annual appropriations exactly as long as the people were ready to foot the bill, and he was determined to make them keep on wanting to.

That was where I came in. *No photographs had as yet been published,* and Dr. Hayden was determined that the first ones should be good. A series of fine pictures would not only supplement his final report but tell the story to thousands who might never read it. Photo-engraving and ten-cent picture magazines were still unknown; but an astonishing number of people bought finished photographs to hang on their walls, or to view through stereoscopes . . .

I was peculiarly fortunate that first day. The subject matter close at hand was so rich and abundant that it was necessary to move my dark box only three or four times. My invariable practice was to keep it in the shade, then, after carefully focussing my camera, return to the box, sensitize a plate, hurry back to the camera while it was still moist, slip the plate into position, and make the exposure. Next step was to return to the dark box and immediately develop the plate. Then I would go through the entire process once more from a new position. Under average conditions a "round trip" might use up three-quarters of an hour. At Mammoth Springs,

however, there was so little shifting to do that I was able to cut the average time to less than fifteen minutes. Another thing that helped was the hot water at our finger tips. By washing the plates in water that issued from the springs at 160° Fahrenheit, we were able to cut the drying time more than half.

But soon the inevitable compensation occurred. After going up the Yellowstone as far as Baronet's Bridge, we proceeded to Tower Creek. At the point where that stream drops into the gorge the view is magnificent—but recording it on a glass plate from the bed beneath turned out to be my biggest photographic problem of the year. Clambering down, and even up, the steep sides of the canyon was not an insuperable task. Neither was moving the camera over the same precipitous route. But getting the heavy dark box within working distance was a stickler. In fact, in the absence of mechanical aid, it couldn't be done.

Since the mountain could not be brought to Mohammed, another method had to be worked out, and finally I solved the situation. After setting up and focussing my camera at the bottom of the gorge, I would prepare a plate, back the holder with wet blotting paper, then slip and slide and tumble down to my camera and make the exposure. After taking my picture, I had to climb to the top carrying the exposed plate wrapped up in a moist towel. With Dixon to help, cleaning and washing the plates, I succeeded in repeating the procedure four or five times. The end of the day found us exhausted but very proud; and we had reason to be pleased with ourselves, for not a single one of our plates had dried out before being developed . . .

Early in August all of us were together once more, on the high divide between East River and Rock Creek. And then catastrophe struck us. An evil mule named Gimlet slipped his pack and broke many of my exposed plates.

The Doctor himself was the first person to notice what had happened. Following directly behind my party, he found plates along the trail and galloped up to learn the cause. By that time Gimlet had scattered most of his load, and it was too late to do anything except right the pack and go back to pick up the pieces. Many plates were unbroken or but slightly nicked; many more, however, all 11 × 14's, were irreparably shattered.

I think I have never been so distressed in my life—my finest negatives lost before anyone had even seen a print. Nothing could be done to repair the damage, nothing. Dr. Hayden, who had started in to be severe, quickly realized that it was the fault of no single person; and, as always under trying circumstances, he dropped his customary nervous attitude and became the calmest man in the world. It was unfortunate, he agreed, but by no means disastrous—I could go back and retake the more important pictures. It really didn't matter at all, he assured me; there was plenty of time for all that, as well as for the other work ahead. And so I went back. What is more, Dr. Hayden was right. There *was* time enough for everything: the new negatives proved to be better than the old ones, and the delay brought me to the Mountain of the Holy Cross at the exact moment when every condition was close to perfection.

THOMAS MORAN AND THE WESTERN SUBLIME

The completion of the transcontinental railroad in 1869 marked the climax of American expansion: the entire continent, between the borders with Canada and Mexico, was under the dominion of the United States. Surveying expeditions set out to measure and map territories hitherto unexplored, among them the legendary Yellowstone and the Grand Canyon, sites of geological and natural phenomena so fabulous as to endow these places with an aura of myth. The English-born engraver and painter Thomas

Moran played a key role in translating those wonders into a pictorial language of grandeur, drama, and sublimity. Joining the geologist Ferdinand V. Hayden's govern-ment-sponsored survey of the Yellowstone in 1871, Moran worked in tandem with the expedition's photographer, William Henry Jackson, to produce dozens of watercolor sketches of the rugged, primeval landscape with its geysers and hot springs. Together, Moran's watercolors and Jackson's photographs were instrumental in persuading Congress to pass legislation making Yellowstone the first national park.

Schooled in the Ruskinian doctrine of truth to nature, Moran was simultaneously drawn to the romantic fervor and emotional color he admired in the art of James Mallord William Turner. In his own statement, Moran denies that he is in any sense a topographer; he tends, rather, "toward idealization." Unlike Frederic Church, cele-brated for the precision of description in his panoramic views of exotic scenery, Moran seeks to blend observation with expression, description with feeling. In this aim, he aligns himself with a newer sensibility that exalts poetry and subjectivity over prosaic fidelity to surface appearances.

Critics almost invariably stood in awe before the immensity and energy of Moran's huge paintings, which seemed in their very size to embody the vastness of the West. A Scribner's *critic takes Ferdinand Hayden's word for it that, despite the outlandish colors tinting the bluffs and pinnacles, the forms in* Grand Canyon of the Yellowstone *(1872) are true to nature even while expressing Moran's poetical instinct. The* Scribner's *writer reviewing* The Chasm of the Colorado *(1873) more eloquently suggests the emo-tional charge of Moran's vision. For this critic, Moran's landscape is profoundly dis-turbing and alienating, fraught with tumultuous emotion and forbiddingly weird. In this response one can discern the sublime in action, visiting on the unwitting spectator an "oppressive wildness that weighs down the senses."*

Thomas Moran, as quoted in George William Sheldon, American Painters *(New York: D. Appleton, 1878).*

Turner is a great artist, but he is not understood, because both painters and the public look upon his pictures as transcriptions of Nature. He certainly did not so regard them. All that he asked of a scene was simply how good a medium it was for making a picture; he cared nothing for the scene itself. Literally speaking, his landscapes are false; but they contain his impressions of Nature, and so many natural characteristics as were necessary adequately to convey that im-pression to others . . . His aim is parallel with the greatest poets who deal not with literalism or naturalism, and whose excellence cannot be tested by such a standard. He tries to combine the most beautiful natural forms and the most beautiful natural colors, irrespective of the partic-ular place he is presenting. He generalizes Nature always; and so intense was his admiration for color that everything else was subservient to that. He would falsify the color of any object in his picture in order to produce what he considered to be an harmonious whole. In other words, he sacrificed the literal truth of the parts to the higher truth of the whole. And he was right. Art is not Nature; an aggregation of ten thousand facts may add nothing to a picture, but be rather the destruction of it. The literal truth counts for nothing; it is within the grasp of any one who has had an ordinary art-education. The mere restatement of an external scene is never a work of art, is never a picture. What a picture is, I cannot define any more than I can define poetry. We know a poem when we read it, and we know a picture when we see it; but the latter is even less capable of definition than the former . . .

I place no value upon literal transcripts from Nature. My general scope is not realistic; all

my tendencies are toward idealization. Of course, all art must come through Nature: I do not mean to depreciate Nature or naturalism; but I believe that a place, as a place, has no value in itself for the artist only so far as it furnishes the material from which to construct a picture. Topography in art is valueless. The motive or incentive of my 'Grand Cañon of the Yellowstone' was the gorgeous display of color that impressed itself upon me. Probably no scenery in the world presents such a combination. The forms are extremely wonderful and pictorial, and, while I desired to tell truly of Nature, I did not wish to realize the scene literally, but to preserve and to convey its true impression. Every form introduced into the picture is within view from a given point, but the relations of the separate parts to one another are not always preserved. For instance, the precipitous rocks on the right were really at my back when I stood at that point, yet in their present position they are strictly true to pictorial Nature; and so correct is the whole representation that every member of the expedition with which I was connected declared, when he saw the painting, that he knew the exact spot which had been reproduced. My aim was to bring before the public the character of that region. The rocks in the foreground are so carefully drawn that a geologist could determine their precise nature. I treated them so in order to serve my purpose. In another work, 'The Mountain of the Holy Cross,' the foreground is intensely realistic also: its granite rocks are realized to the farthest point that I could carry them; and the idealization of the scene consists in the combination and arrangement of the various objects in it. At the same time, the combination is based upon the characteristics of the place. My purpose was to convey a true impression of the region; and as for the elaborated rocks, I elaborated them out of pure love for rocks. I have studied rocks carefully, and I like to represent them.

"Thomas Moran's 'Grand Cañon of the Yellowstone,'" Scribner's Magazine 4 (June 1872).

Mr. Thomas Moran's picture of the Yellowstone Cañon is the most remarkable work of art which has been exhibited in this country for a long time . . .

In the great size of his picture (about twelve feet by seven), the startling character of the geologic forms, the brilliant colors he has had to deal with, and in the manifold planes of distance presented by the view, all needing clear definition yet gradation, and all threatening to claim special and undue attention while requiring to be subordinated and harmonized to the whole—the artist has had a task of no common magnitude. A patent obstacle to the unity of the work, also, is the independent and, so to speak, rival significance and importance of the splendid mass of rock-work at the right, and the cañon proper with its waterfall. It is a favorite theory with some art critics that too great grandeur of subject in landscape painting may be as fatal to success as tameness or insignificance of theme, crushing and bewildering the artist by its splendor or variety, and calling unwelcome attention from its own wealth and immensity to his poverty and littleness of description. In the present work the artist has had not merely one but two such subjects to deal with—the superb cliffs with their exceptional coloring, and the equally superb waterfall, one of the most striking cataracts on this our continent of magnificent objects and colossal proportions. By his masterly arrangement, his ingenious combination and subordination of details, and his boldness yet harmony in coloring, he has blended the two to an impressive and artistic whole, and gone far to demonstrate his own theory, that any, the most imposing of Nature's works is legitimate matter for judicious delineation.

The perfect success which Mr. Moran has achieved in this wonderful painting is due to a happy and, we believe, unique combination of gifts and acquirements. It is evident that the painter of this picture possesses in a high degree the poetic instinct, as well as entire familiar-

ity with nature. He not only understands the methods of art but the processes and work of nature, so far as the faithful interpreter of natural scenery must know them. In all the rush of enthusiasm and glow of artistic power, he seems never to forget the faithful manipulation by which absolute truth is caught and fixed in the splendor of picturesque art. It is noble to paint a glorious and inspiring poem; it is satisfying to render nature with firm mastery of technical detail. In "The Grand Cañon of the Yellowstone" Mr. Moran has done both. He has produced a painting which has, we suppose, but a single rival in American landscape art; in certain elements of greatness it will be acknowledged to excel even this, and it is not likely soon to be surpassed by the work of any hand save, perhaps, that of Thomas Moran himself.

"'The Chasm of the Colorado,'" Scribner's Magazine 8 (July 1874).

The subject of Mr. Thomas Moran's latest large picture is Titanic. It represents a broken and deeply furrowed mass of rock, leading by devious angles from the main cañon of the Colorado River, near the line which separates Arizona from Utah. Standing before the painting, the first impression is of chaos, confusion. In the immediate foreground is a broken, rocky platform, dark with umber and iron. This is boldly cleft asunder by the cavernous dash of a crevasse which runs diagonally down the view. Beyond this is a yawning abyss,—a North American *malboge*—from up which crawls a shuddering mass of blue-white vapor. Tumultuous precipices skirt the further edge of this pit, and, lifting its castellated peaks into the sunlight, a cluster of basaltic rocks rises beyond these dark, forbidding shapes. Still receding from the middle distance, other angular but darker peaks are piled against the tortured sky. To the right, melting into the distance, the Colorado foams like a snowy thread down a wide cañon, into whose sloping sides the sunlight pours in golden showers. Further to the right the horizon appears where the sky is cut by the dim edge of the elevated plateau, or *mesa*, that leads the eye gratefully away from all this confusion to the tender vacuity of the melting perspective.

These are the points into which the vast mass of form and color slowly resolves itself. Over these moves a shower, the rent clouds pouring their weight of water down in black torrents at the left, while the sun brightens the blue sky at the right, glorifies the mimic castles in the middle distance, and mirrors itself in the shallow pools left in the foreground rocks by the passing rain. There is no sign of life anywhere—no human interest; not even a bird flecks the sky, nor so much as a lizard crawls on the pitiless rocks. Here and there a few stunted clumps of olive-green sagebrush or rugged mesquit bushes appear to enhance the forlornness of this utter solitude. It is awful. The spectator longs for rest, repose and comfort. On the castle-like group of rocks in the middle distance, the sunshine falls in splendor, gilding its rich tones with warmth and beauty. The long vista of the distant table-land suggests a sunny place of refuge from all this chaos and tumult. But for the rest, there is only an oppressive wildness that weighs down the senses. You perceive that this terror has invaded the sky. Even the clouds do not float; they smite the iron peaks below with thunderous hand; they tear themselves over the sharp edges of the heaven-defying summits, and so pour out their burdens in showers of down-flying javelins.

In spite of the sunlight here and there, and the blue sky beyond the tumult of the showers, the sensitive spectator will be dismayed. This seems to be a glimpse of another planet; the weary and troubled eye longs to find repose in some sweet pastoral landscape, which, beside this enormous grandeur, would dwindle into absurd pettiness. Down in the awful chasms that gape before you are rumbling the swift currents of unseen streams. From their black waves arise these pale blue mists that creep and creep up the rocky walls, half hiding the crags, and stretching

out their ghostly hands to lay hold on the iron ribs of the monstrous forms. All is terrible, fantastic and weird. And though the marvelous faithfulness of detail attests the photographic accuracy of the picture, one must be smitten with a sudden incredulity as to the actual existence of the scene; it may have been the grotesque glimpse of a dream!

FREDERIC REMINGTON'S WILD WEST

Although Frederic Remington spent the better part of his life in the East, his audience accepted his illustrations, paintings, sculpture, and tales of life in the Wild West as unimpeachable fact. Having studied art for a year at Yale University, Remington traveled to observe and record western life and soon after launched his extraordinarily successful illustration career in New York. His seemingly documentary images of the West as a primitive world of savage conflict between cowboys and Indians made a powerful appeal to white, middle-class men who feared the emasculating effects of overcivilized urban life. Fashioning a self-image to match his art, Remington became a popular symbol of everything authentically manly and American.

In his retrospective assessment of Remington's career, the art critic Charles de Kay recognizes the artist's role in "preserving" vanishing American scenes and types—thus situating Remington in the tradition of earlier recorders of Native American life such as George Catlin. Writing of Remington's characteristic subjects, William A. Coffin praises the vitality that enhances their status as truthful records of western life. These images, he claims, have shaped both preconceptions and perceptions of the West: Easterners going there would expect to see all things "exactly as Mr. Remington has drawn them." Finally, Remington himself, speaking of "big art," articulates his aesthetic and expressive ideas, showing a canny awareness of his audience and trumpeting the need to flee civilization and immerse oneself in elemental nature. Ironically, Remington made these remarks ten years after historian Frederic Jackson Turner officially announced the "closing" of the frontier that had played such a key role in the construction of national identity in the nineteenth century.

Charles De Kay, "A Painter of the West: Frederic Remington and His Work," Harper's Weekly Magazine, *January 8, 1910.*

It would be hard to say whether his paintings or his sculptures were the more popular, whether the scenes of combat between Indians and soldiers, the episodes in the life of cowboys and trappers, mine-prospectors, and frontiersmen, depicted by his busy brush were more to the taste of the public or the vivid groups which he modelled for bronze, wherein he brought to play an unrivalled knowledge of the horse and indeed enjoyed the expression of that knowledge to the top of his bent. In both mediums he had the advantage of a long and intimate acquaintance with frontier life, at a time when specialized communities of adventurers and Indians still existed in certain parts of the country, and in both he has left a record of the particular way in which that life impressed itself upon him . . .

Essentially an illustrator at first, Remington rapidly developed into one of the leading artists of Indian genre, but he was not content, as many of his forerunners had to be, with one or two hasty trips to the West to accumulate sketches on which to base many years of work in the studio. By his time communications had become so well established that an annual visit to his artistic hunting-ground was possible; and he availed himself of the advantage very often . . .

Remington's talent for telling a dramatic incident of frontier life is shown in such a picture as that of cowboys at a water-hole besieged by Indians, who are riding round and round at a distance, watching for a chance to snipe the man who exposes head or shoulder above the low mound in which the coveted water lies, or that showing a prospecting party, lying inside a ring of their horses, keeping off a raiding party of painted braves.

Like these is "Missing," a column of Plains Indians marching by twos. A chief in buckskins mounted on a lean pony leads as prisoner a hatless and coatless trooper on foot. The chief's lariat is round the captive's neck. With their chins in the air, their sharply curved noses suggesting wolves, their foreheads rendered still more retreating by their feather or fur head-coverings, the Indians ride along as conscious conquerors while the white man steps out proudly as if he meant to emulate the red man in the firmness with which he proposes to meet his death. This is perhaps as well composed, as characteristic, and as striking a picture as Remington ever painted. The march is across the parched plain, made still drier by the dusty branches of the sagebrush. Purple hills touched with snow peep behind the slope of yellowish distant plain. The conditions of Indian warfare are better told by this peaceful cavalcade than by the liveliest scrimmage. It is true, however, that the public has been more impressed by those groups in painting and sculpture which deal with hand-to-hand combats.

Realistic to the point of ruthlessness, these pictures of the defence by the Indian of his ancient home are also real in that they reproduce the sharp outlines of things in a clear dry climate that brings out colors very vividly and makes it hard to judge distance accurately. There is a metallic hardness to be observed in some of Remington's paintings, a clean-cut definiteness due in part to the atmospheric quality of the West, which is apt to lack those infinitely tender transparent veils of moisture found in Europe and some parts of the American seaboard . . .

Remington has rendered a service to his country by preserving scenes, types, and subjects in forms of art which are passing away, some of which have gone already. The painted brave on his war-pony, the cowboy on his bronco, the prospector on his mule, have run their course as such, dismounted from their steeds, and turned into mere commonplace men. Their kind is as dead as Don Quixote . . .

A great deal of Remington's early work was published by Harper & Brothers. His popularity was quick in arriving, and it did not fail him to the last. People have a healthy, normal, and well-grounded love of a story; they like to see deeds of daring; they are not squeamish about bloodshed and death; they reward in princely fashion those who know how to please them. Remington was one of them, shared their likings and dislikes, and through that sympathy and comradery was able to give them what they enjoy. Since the days of Fenimore Cooper the red man has looked romantic to the eyes of the people who live far enough removed from possible reprisals. Remington has shown the courage of the Indian and the daring and tenacity of purpose of the white. Rarely has he painted the negro, probably because the negro, owing to his former servitude, is not liked, notwithstanding his many attractive qualities. Another and more artistic reason may be the fact that the negro in white man's clothes is not picturesque. Indian and negro lose in dignity and in beauty when encased in the "foolish tubes" which form the raiment of men to-day, and they lose far more than white men, because their skins are naturally warmer in color and more beautiful than ours. As a last bit of injustice to alien races we ask them to hide their fine color and handsome muscles in the hideous apparel of "civilization." Fortunately for Remington, the red man used to go on the warpath nearly naked, leaving the precious products of our sweatshops in camp, or he wore buckskin coats trimmed with feathers or fur, decked perhaps with embroidery of colored quills, things that look right in the

open air and broad sunlight, however out of place they sometimes seem within the four walls of a house.

William A. Coffin, "American Illustration of Today," Scribner's Magazine 11, no. 3 (March 1892).

The cavalryman, the Indian, the scout, the miner, and the ranchman have furnished Frederic Remington with subjects that he illustrates with much vigor of line and striking effect. His drawing of horses in motion is spirited, and even if it is exaggerated sometimes, there is always a general look of truth and life and dash. In his pictures of life on the plains, and of Indian fighting, he has almost created a new field in illustration, so fresh and novel are his characterizations; and the hot, sandy plains, with soldiers marching doggedly under the burning sun, the vast prairies with the cow-boys in lonely watch over their herds, the frontier towns with their motley population of whites and half-breeds, are realized as they have never been before. It is a fact that admits of no question that Eastern people have formed their conceptions of what the Far-Western life is like, more from what they have seen in Mr. Remington's pictures than from any other source, and if they went to the West or to Mexico they would expect to see men and places looking exactly as Mr. Remington has drawn them. Those who *have* been there are authority for saying that they would not be disappointed.

Edwin Wildman, "Frederic Remington, the Man," Outing 41 (March 1903).

Lethargy and idleness, by some unaccountable fiction, have become associated with fleshy men. Remington is big—"tremendous," as he might put it; but he is a bundle of nervous energy that gives him the liveliness of a boy of ten . . .

In one of our talks last summer we fell afoul the *pros* and *cons* of the real mission of the artist.

"Big art is a process of elimination," he said; "cut down and out—do your hardest work outside the picture, and let your audience take away something to think about—to imagine. The big heroic, for instance (mentioning a great life-sized bronze group shown at the Pan-American Exposition), belongs to the Eden Musée[4]—it's all there, too gross—big creatures, life-sized—yet lifeless—awful! What you want to do is to just create the thought—materialize the spirit of a thing, and the small bronze—or the impressionist's picture—does that: then your audience discovers the thing you held back, and that's skill."

"But your audience?" I interrupted.

"Boys—boys between twelve and seventy—can't draw a woman—never tried but one, and washed her out of the picture. Horses, men—men of the Big West—country without a horse is no country for me—can't enthuse over the Philippines—no horse."

At sunset his favorite diversion was to paddle out upon the river and watch the changing tints of the sky and water.

"Seems as if I must paint them—seems as if they'd never be so beautiful again"—he said one perfect August evening, resting in his canoe on the crimson calm of the sun's afterglow reflected on the surface of the water. "But people won't stand for my painting sunsets," he added, exploding with a laugh that shook the boat. "Got me pigeon-holed in their minds, you see; want horses, cowboys, out West things—won't believe me if I paint anything else." . . .

"Come along," he said to a friend watching the view from my veranda. "This is no place to enjoy such a picture. You want to get away from everything civilized to catch the spirit of this

[4] The Eden Musée was a popular New York Wax museum, based on Madame Tussaud's in London.

thing—away from the house and people's gabble. White man spoils nature by trying to improve on it. The march of the derby hat round the world is answerable for more crimes against art than a hundred wars."

CULTURAL INTERSECTIONS: NATIVE ART AND THE WHITE IMPERIAL GAZE

After the Civil War, the U.S. project to control and subjugate the Native population gained fresh momentum as high-stakes enterprises, notably the building of the vast new railroad network, demanded that there be free and clear access to all lands that lay along projected routes. However fierce, Native resistance ultimately crumbled under the aggressive superior force of the U.S. Army. There remained the question of how, or whether, to "civilize" Native Americans, which generally meant the erasure of Native culture and traditions and the adoption of Euro-American dress, customs, and life-styles. Army officer Richard Henry Pratt was important in that "civilizing" process. Having transported captured warriors from Indian Territory (now Oklahoma) to Fort Marion in St. Augustine, Florida, in 1875, Pratt seized the opportunity to launch his radical program to refashion Natives in the mold of white men. When Esther Baker Steele visited the prison in 1877, she won the confidence of a Cheyenne chief, Manimic, who translated the pictographic letter sent by his wife from Indian Territory. In her report, Steele praises Pratt's efforts, which have so utterly transformed the erstwhile savages into docile conformists. Her description of the letter, however, shows respect and admiration for the eloquence and symbolic power of its pictorial language.

While the Indian was being "civilized" out of all recognition, the newly professionalized scholarly discipline of anthropology undertook a concomitantly intense and sustained study of Native religion, tradition, and art forms, which now came to be seen as remnants of a remote, primitive past that might yield up clues to human origins and evolution. The centralization and systematization of this knowledge became the primary objective of the Smithsonian Institution's Bureau of Ethnology, which from 1879 published encyclopedic annual reports on Native cultures, including picture writing, which was the subject of the 1888–89 installment excerpted below. Of particular note is the contribution of the anthropologist Frank Hamilton Cushing, who as field collector for the Bureau encountered the Zuni in 1879 and so successfully cultivated their trust that he lived among them for several years, during which he witnessed and even participated in secret ceremonials. Rather than manifesting the distant, superior tone of the scientific tourist, Cushing's account of Zuni sand painting is that of an insider who values the mythic character and sacred function of the art. At the same time, Cushing presents his evidence in a methodical and analytical fashion entirely consistent with the classificatory impulse of the dominant culture.

Esther Baker Steele, "The Indian Prisoners at Fort Marion," National Teachers' Monthly *(August 1877).*

It may not be generally known that at Fort Marion, St. Augustine, Florida, are about sixty-five representatives of the Cheyenne, Kiowa, Comanche and Arapahoe tribes, who, having been selected as among the worst specimens of the wild, cruel Indians of the far west, have, through the influence of judicious discipline and Christian kindness, become industrious, and tractable, creditably advanced in military training, able to read and to write, and, in some instances, unmistakable Christian converts. Only two years ago they came to Florida as prisoners convicted

of the grossest outrages and murders. They entered St. Augustine clad only in their blankets, their bodies still covered with hideous war-paint, and their eyes glittering with hate. Chained hand and foot, like so many wild beasts, and expecting immediate execution, their fear and fury could find vent only in savage yells. At the depot they refused to be moved, and were loaded by main force in wagons to be conveyed to the fort.

Last February and March, I had the pleasure of often visiting Fort Marion, and its Indian inmates. What did I find? A military company neatly dressed in United States uniform, with hair cut and brushed, nails cleaned, manners respectful and faces more or less intelligent . . .

What had wrought this wondrous change? It is not too much to say that it is almost entirely due to the untiring devotion of Captain R. H. Pratt, who was sent east in command of them and who has sole charge at the fort, having from time to time dismissed the guards, at first so necessary, supplying their places with the best behaved among his prisoners, until now they furnish their own sentinels, corporals and sergeants with only the one "White Chief" whom they love and reverence at their head. He has been aided by a few noble Christian women who have volunteered their services as teachers two or three hours daily. Lieutenant Pratt is an earnest Christian gentleman, who believes the American Indian to be a human being, quite as capable of civilization, and presenting quite as desirable a field for missionary labor as the far off denizens of Borrioboola-Gha.

What if, instead of the dreaded war-whoop, and news of fearful massacre, and the sudden cutting down of the flower of our army, and the continual trembling of women and children on our frontiers, and a great war-debt to be wrung from lank pockets in hard times, the next generation might be witnesses of peaceful reservations for every tribe, of Indian schools and churches where the memory of scalps and war-paint is forever wiped out, of Indian regiments thoroughly trained and worthy of trust as guardians of the peace among the western wilds, of a war-debt replaced by an educational or civilization fund, and an end forever to the treacherous spilling of our bravest American blood? . . .

The Creeks, the Cherokees and the Choctaws have proved that the civilization experiment is not a failure. Why not give the same opportunity to the Comanches, the Kiowas, even the bloody Sioux? . . .

It is my good fortune to possess an original letter sent in June, 1876, to Minimic, a Cheyenne Chief at Fort Marion, by his squaw in Indian Territory. It affords an admirable specimen of Indian picture-writing of which so few examples are extant. The address is at the right, and includes (1) Minimic or Eagle Head, (2) Howling Wolf his son, and (3) Making-Medicine. The symbol for the last named is a wigwam with sticks placed horizontally at the apex, the cabalistic sign by which a "medicine-man's" hut is distinguished. Minimic is informed that his son (5), Buffalo Head, desires to come to him, but is held back by his mother (4) Shooting Buffalo. The olive branch in his hand conveys assurance of his love. Minimic's daughter (6) Flying Dove and her young child Arrow, join in the greeting; also his daughter (7) Big Turtle, the belle of the tribe, an Indian beauty with "hair seventeen hands long" as the proud father informed us in his pantomimic way. Curly-Head (8) wife of Howling Wolf, has a young child, Little Turtle, named after his handsome aunt.

Running Water (9) is the daughter of Minimic by another squaw Shield (12) whom he afterward repudiated, or in his own expressive words, "threw away." With a shade of disgust on his usually placid face, the old chief pointed to the picture of her grave and ejaculated "That squaw no good; *too much talk!*" Shield's daughter, White Feather, (13) is buried by her side, and the frequent tracks about their grave show that Running Water—whose attitude also betokens

grief—goes often there to weep, though the single track which leads to the spot shows that she goes alone. Making Medicine's two wives (10, 11) with his children go together to mourn at the grave of his dead child, exhibiting a state of harmony between his squaws which must be very gratifying to the feelings of an absent husband. Thus it will be seen that this letter conveys intelligence of three births, two of them males, as the faces are painted red; gives the names of the little ones; reports the ability to walk of Making-Medicine's oldest child, as her little tracks accompany the others to her sister's grave; announces three deaths and the honors paid to the memory of the lost ones; gives assurance of the good health of the remaining parties represented; mentions particularly Buffalo-Head's desire to greet his father, and every face being turned in that direction, expresses a general desire on the part of the writers to see the distant prisoners.

Garrick Mallery, "Picture Writing of the American Indians," Tenth Annual Report of the Bureau of Ethnology to the Secretary of the Smithsonian Institution 1888–'89 *(Washington, D.C.: U.S. Government Printing Office, 1893).*

Picture-writing is a mode of expressing thoughts or noting facts by marks which at first were confined to the portrayal of natural or artificial objects. It is one distinctive form of thought-writing without reference to sound, gesture language being the other and probably earlier form. Whether remaining purely ideographic, or having become conventional, picture-writing is the direct and durable expression of ideas of which gesture language gives the transient expression . . .

The importance of the study of picture-writing depends partly upon the result of its examination as a phase in the evolution of human culture. As the invention of alphabetic writing is admitted to be the great step marking the change from barbarism to civilization, the history of its earlier development must be valuable . . .

When a system of ideographic gesture signs prevailed and at the same time any form of artistic representation, however rude, existed, it would be expected that the delineations of the former would appear in the latter. It was but one more and an easy step to fasten upon bark, skins, or rocks the evanescent air pictures that still in pigments or carvings preserve their ideography or conventionalism in their original outlines . . .

It is not probable that much valuable information will ever be obtained from ancient rock carvings or paintings, but they are important as indications of the grades of culture reached by their authors, and of the subjects which interested those authors . . .

The more modern specimens of picture-writing displayed on skins, bark, and pottery are far more readily interpreted than those on rocks, and have already afforded information and verification as to points of tribal history, religion, customs, and other ethnologic details . . .

American pictographs are not to be regarded as mere curiosities. In some localities they represent the only intellectual remains of the ancient inhabitants. Wherever found, they bear significantly upon the evolution of the human mind.

Distrust concerning the actual significance of the ancient American petroglyphs may be dispelled by considering the practical use of similar devices by historic and living Indians for purposes as important to them as those of alphabetic writing, these serving to a surprising extent the same ends . . . The old devices are substantially the same as the modern, though improved and established in the course of evolution. The ideography and symbolism displayed in these devices present suggestive studies in psychology more interesting than the mere information or text contained in the pictures. It must also be observed that when Indians now make pictographs it is with intention and care—seldom for mere amusement. Even when the labor is

undertaken merely to supply the trade demand for painted robes or engraved pipes or bark records, it is a serious manufacture, though sometimes only imitative and not intrinsically significant. In all other known instances in which pictures are made without such specific intent . . . they are purely ornamental; but in such cases they are often elaborate and artistic, not idle scrawls . . .

Sand paintings by the Navajo Indians . . . were made upon the surface of the earth by means of sand, ashes, and powdered vegetable and mineral matter of various colors. They were highly elaborate, and were fashioned with care and ceremony immediately preceding the observance of specific rites, at the close of which they were obliterated with great nicety . . .

Mr. Frank Hamilton Cushing, of the Bureau of Ethnology, kindly contributes the following remarks with special reference to the Zuñi:

A study of characteristic features in these so-called sand pictures of the Navajos would seem to indicate a Pueblo origin of the art, this notwithstanding the fact that it is to-day more highly developed or at least more extensively practiced amongst the Navajos than now, or perhaps ever, amongst the Pueblos. When, during my first sojourn with the Zuñi, I found this art practice in vogue among the tribal priest magicians and members of cult societies, I named it dry or powder-painting. I could see at a glance that this custom of powder painting had resulted from the effort to transfer from a vertical, smooth, and stable surface, which could be painted on, to a horizontal and unstable surface, unsuited to like treatment, such symbolic and sacramental pictographs as are painted on the walls of the kivas, temporarily, as appurtenances to the dramaturgle ceremonials of the cult societies, and as supposed aids to the magical incantations and formulæ of all the monthly, semiannual, and quadrennial observances and fasts of the tribal priests; sometimes, also, in the curative or "Betterment" ceremonials of these priests. It is noteworthy that, with the exception of the invariable "Earth terrace," "Pathway of (earth) life," and a few other conventional symbols of mortal or earthly things (nearly always made of scattered prayer meal), powder painting is resorted to amongst the Zuñi only in ceremonials pertaining to *all* the regions or inclusive of the *lower* region. In such cases paintings typical of the North, West, South, and East are made on the four corresponding walls of the kiva, whilst the lower region is represented by appropriately powder or paint colored sand on the floor, and the upper region either by paintings on the walls near the ceiling or on stretched skins suspended from the latter. Thus the origin of the practice of floor powder painting may be seen to have resulted from the effort to represent with more dramatic appropriateness or exactness the lower as well as the other sacramental regions, and to have been incident to the growth from the quaternary of the sextenary or septenary system of world division so characteristic of Pueblo culture. Hence it is that I attribute the art of powder or sand painting to the Pueblos, and believe that it was introduced both by imitation and by the adoption of Pueblo men amongst the Navajos. Its greater prevalence amongst them to-day is simply due to the fact that having, as a rule, no suitable vertical or wall surfaces for pictorial treatment, all their larger ceremonial paintings have to the made on the ground, and can only or best be made, of course, by this means alone.

It is proper to add, as having a not inconsiderable bearing on the absence generally of screen or skin painting among the Navajos, that, with the Pueblos at least, these pictures are—must be—only temporary; for they are supposed to be spiritually shadowed, so to say, or breathed upon by the gods or god animals they represent, during the appealing incantations or calls of the rites; hence the paint substance of which they are composed is in a way incarnate, and at

the end of the ceremonial must be killed and disposed of as dead if evil, eaten as medicine if good.

Further light is thrown on this practice of the Zuñi in making use of these suppositively vivified paintings by their kindred practice of painting not only fetiches of stone, etc., and sometimes of larger idols; then of washing the paint off for use as above described, but also of *powder painting in relief;* that is, of modelling effigies in sand, sometimes huge in size, of hero or animal gods, sacramental mountains, etc., powder painting them in common with the rest of the pictures, and afterwards removing the paint for medicinal or further ceremonial use.

Fig. 9. William Merritt Chase, *In the Studio,* 1880, oil on canvas. Brooklyn Museum, Gift of Mrs. Carl H. De Silver in memory of her husband.

9 THE GILDED AGE

Art Worlds and Art Markets

ART ON THE MARKET

FRENCH ART IN NEW YORK

*Competition, both internal and external, intensified in the post–Civil War art market.
Younger painters vied with each other and with the generation that had come of age in
the antebellum decades. Young and old soon found themselves in an unsettling contest
with the new wave of foreign art, brought to New York and Boston by enterprising
dealers who catered to the tastes and buying habits of wealthy capitalists: manufactur-
ers and entrepreneurs.*

*After the Civil War, French painting in particular enjoyed heightened visibility in
American cities, nowhere more so than in New York. The Parisian firm Goupil, Vibert
& Co. had been operating in New York since the late 1840s. Its successor, Michel Knoed-
ler, continued to deal in European pictures and sell high-quality reproductions of them
as well. Knoedler's and other galleries were critical in the internationalization of the
American art scene in the Gilded Age and by extension invigorated efforts by American
artists to retain their own share of the market.*

As the Putnam's *reporter below notes, Knoedler's specialty was the importation of
French pictures. This writer also contends that Goupil, and then Knoedler, had awak-
ened more excitement and curiosity about art than the National Academy had over the
entire course of its life as an institution. The description of the gallery's interior at its
new premises on Fifth Avenue and Twenty-Second Street conveys the deluxe atmos-
phere in which visitors could consume the latest and most fashionable examples of
modern French painting.*

"Fine Arts," **Putnam's Magazine** *n.s. 3 (May 1869).*

Few of our city readers are unacquainted with the pleasant picture shop on the corner of Broad-
way and Ninth St., where, ten years ago, Mr. KNOEDLER established himself as the American
representative of the great house of Goupil & Co.; but probably only a few remember when
this branch of the business was first opened, in 1847, on the corner of Broadway and Reade St.
Here, in modest quarters that bespoke our moderate though growing interest in art, the firm

made our citizens acquainted with the works of many of the great men who have made modern art illustrious in France and Germany. Finding their business rapidly outgrowing the capacity of their establishment, in 1852 they removed to No. 368 Broadway, and there opened a more spacious and convenient gallery, where works of art could be displayed to better advantage. It was the first picture gallery worthy of the name ever established in this country, and did more to familiarize our people with art and awaken intelligent art-ideas, and genuine art-sentiment, than our so-called National Academy has done during the whole period of its existence. Some of the greatest examples of modern French, German and English art were in succession exhibited there; and the beaux and belles of the period grew rapturous over Horace Vernet's "Joseph and his Brethren," Ary Scheffer's "Temptation of Christ," and "Dante and Beatrice," and the long list of works of other masters which we lack space even to name. But New York was still moving up town, and ten years ago Mr. Knoedler made another removal and established his quarters on the well known corner . . . From that time till his recent, and we trust last, removal, that gallery has been open almost every day, with only two or three exceptions free the whole time to the public, and constantly supplied with the choicest examples of modern European art . . . Mr. Knoedler made the importation of French pictures a specialty, and his collection was always more extensive and various than that of any other American dealer.

The lease of these pleasant premises expired this spring; and early in March Mr. Knoedler opened his new picture shop and gallery on the corner of Fifth Avenue and Twenty-second St . . . The east and north sides of the lower story are nearly all of plate glass; and at the angle is a large window where paintings, engravings, bronzes, carvings, and other works of art form a constant source of attraction and pleasure to the thousands who daily pass along the avenue. The interior presents a beautiful appearance, with its tasteful and elegant decorations and magnificent array of pictures, statuettes, carvings, bronzes, and other works of art. At the further end of the main room is an elegant staircase, leading up a short half story to a platform from which the picture gallery is entered. This is a beautiful apartment, with decorations tastefully designed, and executed with admirable skill. The uncarpeted floor is of hard wood, in alternate dark and light stripes. The walls are colored red, forming an agreeable background for the pictures. Light is admitted to the gallery from a large skylight, so contrived as to diffuse the light evenly upon the walls. If public picture galleries were equally well constructed, in this respect, we should hear fewer complaints of hanging committees. It would be almost impossible for the most un-amiable hanger to find a bad light in Mr. Knoedler's gallery . . .

. . . For the present, Mr. Knoedler may safely consider himself firmly planted, and we have no doubt the art-loving citizens of New York will for many years to come reckon his pleasant establishment among their favorite places of resort.

BUY AMERICAN

In his assessment of the progress of art in New York, author George Parsons Lathrop (son-in-law of Nathaniel Hawthorne) devotes considerable space to what now seemed an endemic problem: the preference for trendy French painting over what was perceived as less prestigious American work. Lathrop calls for patrons and collectors to dedicate themselves to the patriotic duty of buying American art on its own merits. Noting that American art schools are now on a par with those abroad, Lathrop recommends that students complete their education here, allowing only a selected few to travel abroad,

mainly to soak up tradition. In art matters, moreover, ordinary business standards should not apply. Only adherence to higher and more generous principles (in essence, exempting cultural production from the laws of the market) will enable American art to flourish and perhaps one day to stand supreme in the world.

George Parsons Lathrop, "The Progress of Art in New York," Harper's New Monthly Magazine 86 (April 1893).

There are two cardinal points which we ought sharply to impress upon ourselves . . . One is, that patrons and collectors should apply themselves earnestly to the pleasant and creditable duty of buying and ordering American works on their merits, in preference to foreign works. A single anecdote will exemplify fairly the state of artificial selection now too prevalent. An American purchaser asked the advice of a distinguished French painter who was visiting New York as to what picture he should buy in a certain dealer's gallery. The Frenchman strongly recommended a picture by an American artist, the price of which was $300. But the name of the American artist was (we will say) Toodles. "Oh," said the patron of art, "I don't want to hang in my house a picture by a man named Toodles. Why not get that Lerolle over there? It's about the same size."

"But," said the French artist, "it is not so good as Toodles's, and the price is $1500."

"Never mind," replied the American magnate. "When I show the picture to my friends, I want to be able to say it's a Lerolle—not a Toodles." And forthwith he bought the Lerolle, at $1500, against his foreign adviser's advice.

A curious commentary on this typical incident is the fact that, quite lately, an agent has been in this country trying to gather a large collection of American pictures for exhibition at Munich next year, and a similar attempt is being made by Spaniards in Madrid to bring to their capital a number of representative modern American paintings. These agents from abroad do not care whether the artist's name is Toodles or Yuba Bill. Europeans already appreciate American works of art better than our own people do.

The second point is, that we should no longer regard art education in New York as merely elementary. We have to-day every facility for instructing and moulding the young artist, and not only completely grounding him in all the elements of his art, but also carrying him far along the road toward the highest accomplishment. Our painter instructors are men thoroughly trained and equipped, who, besides their knowledge of foreign tradition and practice, have strong individuality, and their work shows great original merit. All that they have acquired they are willing and able to impart to others. They are, moreover, imbued with distinctly American temperament and ideas; and the competent pupil who goes forth from their hands is already an artist, who needs only time, experience, and perhaps travel to shape and perfect his growth . . . The Empire City is already an art centre, very much alive, and will continue to grow greater and more active. What is most needed now is a recognition of this fact, and a vivid sense on the part of business men and connoisseurs that the best and most far-sighted thing they can do, for themselves as well as for art, is to patronize American artists lavishly and sincerely, patriotically, yet with discrimination, and with an independent taste for what is good and genuine that should not lean upon foreign fashion. Instead of sending young artists abroad to receive their education, we ought to see that it is now quite possible to nearly complete their education here. Then we should assist a few of the selected to go to Europe on "travelling scholarships," simply to mature, to broaden their views, to stimulate the creative faculty by visiting and sojourning and working in the art capitals of different countries for a while . . . Fine art must be treated finely in every way, if we would have it flourish at its best.

Commercial necessity, of course, cannot be ignored in its affairs; but where business comes into contact with it the ordinary business standard should give way to a higher principle of cordial generosity, which is as essential to the well-being of national art as dew is to the flower. It is to be hoped, and reasonably to be expected, that when the new Fine Arts Society gets fully under way it will bring about a more direct, appreciative relation on the part of the stimulators, or buyers, toward artists, with ennobling rewards to the latter and to the community. Then perhaps we shall be saved from any further humiliation of seeing American painters forced, as even the best frequently are, into auction sales—a ruinous expedient, to which European professionals of similar standing are never driven. We need very much a stronger infusion of that spirit of sympathy which goes to make what we call an "atmosphere." Then, too, the elements of excessive haste and impatience, which disfigure our civilization, are drawbacks upon the achievement of ripe and enduring results in this domain of ideal reality. Artists in all branches are constantly "rushed" by their impetuous, restless employers or patrons, and are expected to deliver their work on the same methodical plan that a rolling-mill turns out iron or the merchant ships an invoice of cotton. We can crowd artists, no doubt, and extract from them a specified amount of labor and material in this way; but we lose a great deal by preventing them from putting into their fabric those enriching elements of time, thought, and deliberation without which the greatest and best things cannot come into existence. Even for our churches, including most Catholic temples also (which it might be supposed would especially insist upon the highest excellence in picture, statue, relief, or in glass-work and carving), it seems to be considered more important to get a particular piece of artistic creation into place by a date fixed, than to secure something which will outlast all dates and days, or at least continue to be a credit and glory while it exists. I trust that before long Americans will perceive that this is a false economy of time, as the beating down of prices for the best work is also false economy of money in matters of art. Gold can buy nearly every *appearance* of sumptuous art, but it cannot buy the perfect *reality,* unless it be given unstintedly, and be accompanied with a freely offered *bonne main* of patience, ideal interest, and entire sympathy. This may seem, to the wholly commercial mind, foolish. Nevertheless, it is the truth, and might as well—in fact, has got to be acknowledged and acted upon before we can reach the true goal. The principle once accepted by a considerable number of people, we shall find that the United States can lead the world in fine art, and that New York—without injury to other cities, and with no necessity for mutual envies—may, by living up to its opportunity, become the chief capital in our republic of the beautiful.

ART AS COMMODITY

In spite of the ebb and flow of the American economy, the trade in art—or certain forms of art—flourished in the Gilded Age, with some celebrated works, such as those of Jean-Léon Gérôme, selling for many thousands of dollars. With few exceptions American pictures sold for much less, but in the eyes of many the art world as a whole was in danger of fatal corruption by the entrepreneurial buying, selling, and speculation in pictures that prevailed in the marketplace. Such exchanges reduced paintings and other art objects to the status of any other commodity. In the press, writers fiercely condemned the degradation of art, and the depraved taste of the public, while acknowledging that artists did somehow have to make a living. The influx of French art also provoked pa-

otic backlash and chauvinistic rhetoric calling for purification of the American school. The artists themselves, meanwhile, fretted constantly about their own prospects in the modern marketplace, where conditions necessitated an entrepreneurial approach to the making and selling of art.

Writing in the wake of the Philadelphia Centennial, the editor of the North American Review *lays the blame for the decline of taste and quality in American art on the vast new fortunes reaped by the Civil War. Ruled by "gaudy taste," America is a land of flashy, superficial values, a place in which works of art are mere "articles of commerce." Trying to compete with the best French masters, Americans have become shallow imitators in the service of perverted taste.*

A decade later, another author targeted the art dealers who fed this market. Sheridan Ford, born in Michigan, came to New York City as a young man to seek employment as an art critic. He became a London correspondent for the New York Herald *and the* New York World, *and later his fortunes became famously entangled with another expatriate, James McNeill Whistler—the two battled in international courts over editorial control of the collection of Whistler letters,* The Gentle Art of Making Enemies *(see "James McNeill Whistler's Platform," chapter 11). Before that conflict, however, and soon after arriving in London, Ford published* Art: A Commodity *when he was just twenty-one years old. His book was an indictment of what he perceived to be the falsity of the New York art market and the taste it inspired. In this excerpt from a chapter titled "The Middleman," Ford looks at American picture dealers and finds them wanting.*

The Editor [Allen Thorndike Rice], "The Progress of Painting in America," North American Review 124 (May 1877).

We now come to what we may venture to term the second period of American art. In this period we include the present epoch. The war came. Vast fortunes were accumulated. Men who but yesterday had swept the streets rose to wealth and ease. Houses were bought and built in countless numbers. Pictures were needed to hang the walls of newly acquired mansions. The rooms must be furnished, the walls must be decorated, the paintings must be found. The demand came and the supply must be created,—a forced supply created by an unnatural want. It was with these new men not a question of quality, but of quantity. Their tastes were not cultivated, and everything was purchased in profusion. Paintings were turned out by the yard, good, bad, and indifferent, no matter what; but æsthetics had little to do in the selection. Fanned by the incessant excitement of war, the fever spread rapidly over the land, and bred that gaudy taste which has all but ingrained itself in American nature. Everything was splendid above and rotten below. It was the same in all property, in all corporations, in all classes, in all industries. The inflation spread over every corner of the country. We now see the reaction at every turn. In real estate, in railroads, in factories, in every walk and employment of life, do we find the terrible reaction from this unnatural state of things.

This inflation took its rise in those days of cumulative wealth when fortunes became so vast that the value of money paled before the desires of those who were poor men yesterday and millionnaires to-day. Those were the days when one of our first painters, finishing in his studio a painting to order, was offered by some son of fortune three times the amount contracted for. Works of art became articles of commerce. The Wall Street of painting might be found in

the rooms of the auctioneer. Galleries were purchased and soon disposed of at large profits. The same individual would purchase and sell again and again, prices and values being out of all proportion, and not a few of the best paintings giving way to the poorest. Young painters, only just started on a course of training, were summoned to supply the increasing demand. They painted and sold at figures which had never before been realized by the ablest of our artists. Yet the fault lay not with these young aspirants. It lay with the public. Had these young artists been encouraged to paint the scenes which at that time were being enacted, or had just passed away,—the scenes on the battle-fields which must ever touch the hearts of all Americans,— the first effect which the sight and recollection of such heroism and suffering would have inspired must have stamped the soul of all true men with that surpassing grandeur, the grandeur of national courage. It is indeed impossible to account for the small demand which the war created for scenes and episodes from the great struggle which for years was foremost in the minds of the people. The galleries and auction-rooms teemed with scenes of every age and clime, but few were the artists who were moved to translate to canvas the fury and medley of the battle-field, the cries of the wounded, the horrors of the dying, and all the picturesque and touching scenes and scenery which the eye of the soldier must have hailed with emotion. One young sculptor alone, John Rogers, made his fame and his fortune by the many appealing attitudes in which he has shown us the soldier's life. But the minds of his brother artists, the painters, seem at that time to have lost their sensitiveness. This may be accounted for by lack of public encouragement, or by the more charitable supposition that artists and the public were willing that the recollections of our civil war should drop into oblivion.

If this be so, it is well that painters should have led the way in this patriotic feeling, and done nothing to commemorate a struggle which all are now willing to forget. The time may come when men's minds will be less agitated by the events of the late war, and when subjects connected with it will be viewed only as translations of common humanity, without the idea of conflict. Whatever the cause which may have prompted this artistic reticence, the public at that period had no craving for home subjects, and were as averse to native scenes as to the waving of the bloody shirt. Painters were urged to turn out bad imitations and superficial reproductions of foreign and especially of French schools. Purchasers longed to see their walls hung with subjects which would recall to them the Reignaults, the Meissoniers and Geromes, of Transatlantic fame. The cavalier, the Turk, the Mameluke, and the grisette were all enticing subjects for this purpose. A dash of green here, a dash of red or blue there, gave sufficient satisfaction to an untrained eye. Dealers purchased in Europe, and still continue to purchase, a few paintings by prominent masters, to surround them here in their galleries with inferior productions by inferior artists, which upon their native soil would bring hardly the value of the canvas. These in superficial coloring approached the great masters around which they clustered, and not a few were similar in choice of subject. Unable to detect the wide difference of quality, the ordinary collector was induced to possess himself of these valueless pieces at comparatively great prices, and it was not long before the failures of Paris were thrown by cargoes upon the American market. It was partly thus by the large and increasing sale of inferior imitations of the best French masters that our young artists were forced into a track which must inevitably divest them of every vestige of originality unless the taste of the public should undergo a salutary change. A finished shoe, with pink heel and silver buckle, became more attractive to the general eye than all the soul and sensibility which might speak from a fine landscape or a fine face. Taste, instead of being formed, became perverted, the conception of the artist was sacrificed to his execution, and those who failed to purchase in France had recourse

to native artists, who must needs follow the mandate of the purchaser. This bade him paint things instead of thoughts, buttons instead of heads. It is painful to realize this melancholy truth at most of the auction-sales which take place to-day. A neatly painted row of buttons on the edge of a gaudily painted mediæval coat will bring larger prices than productions of far greater merit which breathe that repose which of late has become so obnoxious to Americans. This love of decorative, foreign, and past scenes in many cases urges our artists to become guilty of anachronisms which cannot be avoided. Before we can paint knights-errant, with sword and belt and armor of bygone days, we must first possess a British Museum or a Musée de Cluny. We shall then no longer be forced to contemplate some unfortunate knight of the fifteenth century confined to the Tower of London, and arrayed in the picturesque apparel of his age, with a pair of Wellington boots to mar it. It is partly to avoid these anachronisms that our young painters are forced to seek abroad the material to fill their canvas, and pander to the public taste. It is this very habit of foreign study, as generally practised by our artists, that stamps their work with lack of character and native strength. We walk through the galleries of our exhibitions, and recognize the orthodox methods of Munich or Paris, yet we cannot blame the painter, who follows only in the current of the market, which calls yearly for such immense supplies from the schools of Europe. Unhappily most of those who sought abroad the training which might lead them to acquire the style of foreign masters were only absent long enough to catch their faults of coloring, and failed to give to the study of the figure those years which alone can make the skilled draughtsman.

Sheridan Ford, Art: A Commodity *(New York: Rogers and Sherwood, 1888).*

The rise of the picture trade in the United States dates practically from the civil war. Its growth from small beginnings has been phenomenal. Superficial students of its development assert that the business is overdone,—a statement counter to all the facts. The truth is that this country, from its latitude, size, and conditions, has only fairly entered upon its larger and permanent picture-buying era. All the conditions are making for an increase in the volume of trade, and what has been accomplished but points to the larger prosperity that is to follow. One cannot name a house that has not made money. Even as things are conducted at present the profit margins are enormous.

The American dealer occupies a peculiar place. His position as importer coupled to the vast wealth controlled in this country by careless buyers gives him a prestige that he does not have abroad. There he can furnish collectors little that they cannot get without him, for there it is possible for collectors to deal directly with a greater number of current artists, to attend personally a greater number of noted sales and exhibitions, and there informed buyers outnumber the uninformed. The value of a picture is comparative,—based partly upon a true standard and partly upon a false one. There is a striking similarity between the tricks of the picture market and the stock jobbing methods of Wall Street. Picture dealers work up an artificial demand for the productions of those artists they control and pocket the profits. They "bear" prices on pictures a rival dealer is overstocked with and when they in turn control the supply at once proceed to "bull" them. By misrepresentation and a nimble juggling of facts they unload worthless canvases upon confiding "lambs" after the fashion set by Wall Street with watered stocks. The average picture collector is deficient in the knowledge of a picture's market value, and ofttimes doubtful even as to what is best for him to buy. It is natural, therefore, that at the outset he should cast about with some hesitation, commit innumerable blunders and pay dearly for his inexperience. So much does individual trust and personal magnetism enter into the busi-

ness that a salesman who has secured the confidence of a customer has but himself to blame should he forfeit it . . .

Dealers everywhere understand how largely personal trust enters into their operations and yet, strange to say, in the business of buying and selling pictures the code of ethics or *morale* is less high than that which obtains in the grocery or boot and shoe trades. In these lines the high class stores proceed upon the theory that it pays best to handle the best goods only and at a fixed price. There is not a picture shop to-day in New York City that shapes its tortuous course upon this simple, honest, and common sense plan. There is not a shop where the proprietor will not handle with cheerful complacency the cheapest trash if the handling puts money in his pocket. The inquiring mind can easily test the truth of this by a visit to any or all of their establishments. Side by side will be found *chef-d'oeuvres* from the hand of a master and unsightly daubs by misguided slaves of the brush,—impotent to advance the cause of art in any way save one, that of quitting her domain forever . . .

The fetich side of the picture business has been overdone. Some newspaper writers with an eye for sensational effect are fond of reporting phenomenal prices paid for single paintings by millionaires with souls more attuned to coupon clipping than art. It is small wonder that the uninformed public should gather erroneous impressions from the stories, and come to think that the only pictures worthy the name are the few famous ones in the galleries of the rich; as though a picture's worth could be measured by its money cost or a man's taste by the size of his bank account. In Paris I was once authorized by a compatriot to call upon M. Secretan and offer seventy thousand dollars for Millet's "Angelus,"—which by the way was courteously declined. The Croesus jokingly confessed to me one evening at the *Lion d'Or*, that so far as he was personally concerned he knew no more about art than a South Sea Islander and cared less. His wife wanted him to secure the "Angelus" for the sake of the notoriety its possession would ensure.

ARTISTS BROKER THEIR WORK

After the opening of the Tenth Street Studio Building in 1858, artists there and in studios elsewhere in New York began to organize gala open-house receptions in order to show new work to existing patrons and potential buyers. These were popular events, abundantly covered in the newspapers and attended by prominent tastemakers, collectors, and socialites. The heyday of studio receptions was the 1860s; in the 1870s, the rise of private galleries and the emergence of other exhibition venues provided by art clubs and other organizations took their place. Nonetheless, many artists continued to hold them into the 1880s, William Merritt Chase in particular gaining a reputation for the glamorous affairs he staged in his opulent studio in the Tenth Street building.

The author of "Art and Artists" makes the advantage of the studio reception very clear: it gives the artist mastery and shows the work to its best advantage, avoiding the risk of an unfriendly committee that might hang a painting in an obscure corner at the National Academy. The writer worries that the Academy exhibitions may suffer as a result of the receptions but concludes that the institution stands ultimately to benefit by their galvanizing competition. By contrast, a reporter covering the 1881 reception at the Sherwood Studio Building strikes a blasé attitude, asserting that the general feeling after going through the studios is one of "hopelessness" at the dearth of good pictures.

S.S.C., "Art and Artists," Galaxy 5 *(May 1868).*

Since the pleasant studio receptions were commenced, about two years ago, the exhibitions of the National Academy of Design have lost much of the interest and importance they once possessed. Many circumstances have contributed to this result. The artists found that by throwing open their studios once a week, or once a month, they could display their pictures to much greater advantage than by sending them to the Academy, where an unfriendly or unappreciative committee might hang them out of sight, or in bad company, or even reject them altogether. In his own studio the artist is master of the situation. He hangs his picture in the light best suited to bring out its full effect, and surrounds it with harmonious accessories. In addition to all this, he stands by to interpret the mysteries of his work, so that none may incur the mortification of mistaking a sunset for a morning effect—especially if they have the courage to ask questions, or he the tact to read a puzzled look, and preserve his visitor from committing a blunder. We are not surprised, therefore, to learn that several of our most eminent artists send no pictures this year to the Academy, and that others, who do send, have taken less pains than usual to prepare for the exhibition; but, while we are not surprised at this state of affairs, we cannot say that we like it. A good Academy exhibition, in which the best works of our best men are collected, has many advantages over a studio exhibition. It enables one to judge more readily, and, beyond a doubt, more correctly, of the progress of art and of the relative value of pictures. The *coup d'œil* in a well-arranged gallery makes an impression which cannot be gained in a studio, where a single picture is displayed. If the Academy exhibitions could be seriously affected by the studio receptions, we should be sorry they were ever commenced; but of this there is very little danger. The hanging committees will probably exercise a greater amount of care in arranging pictures, when they find that eminent artists decline sending their works to the Academy . . .

But, we feel justified in saying that if one-half the good pictures we have seen in the studios be accepted by the committee, the exhibition will be fully equal to the best of former years, and will in many respects surpass them. Art culture and art sentiment in New York have received a surprising impetus within the last two years—partly from the studio receptions, and still more from the greater familiarity of our citizens with foreign art, through travel and the importation of the works of the greatest men of France and Germany. Our own artists have felt the influence of this culture. It has given them new courage and higher ambition, and its effects cannot but be salutary and permanent.

"An Artist Reception: . . . Are Receptions Advisable?" New York Times, *February 25, 1881.*

Following precedents well established nowadays, the majority of artists that are housed in the ugly staring brick building which dominates the disheveled corner of the City at Fifth-avenue and Fifty-seventh-street opened yesterday their studios to friends and acquaintance. All sorts of painters have taken rooms here. They range from a juvenile water-colorist in the heyday of success, like Mr. Robert Blum, to a painter of Titianesque solidities, like Mr. William Page, who is a veteran even for an Academician, and long ago declined from his meridian. Between these extremes are such artists as Carroll Beckwith, who made his mark a few years ago, and adds to his prestige as a painter of likenesses the rank of a popular teacher in the school of the League; Tojetti, a little-known Italian; Shurtleff, the painter of charming water-colors, who is always to be seen at the Academy exhibitions with carefully prepared, but not always successful, oils; Wyant, one of the graybeards of the Academy, who has shown the falsity of the adage that you

cannot teach an old dog new tricks, for his landscapes have only of recent years been invested with that peculiar sentiment which constitutes their chief value; Anderson, yet to make his way; Symington, able to paint in water-colors a very charming woman; Edgar A. Ward, an industrious and clever member of the artistic army that invades the most picturesque haunts of picturesque Brittany, and who brings over to America capital scenes from the peasant life of France, painted with that knowing air of Paris which the more thoughtful stay-at-home artist may justly envy; Calvin Ray Smith, one of the many young painters who swear by and rave over Velasquez, but who, in spite of all the copies of his portraits they may take, do not seize the inimitable "go" of his methods; Cropsey, who belongs fairly and squarely to the "Hudson River School" of landscapists that dates from the epoch of the Englishman, Thomas Cole. The reception was a repetition of those that have gone before, with some slight differences, such as a scarcity of sketches and finished work in many of the rooms, the presence of bric-à-brac disposed with some regard for effect, and the good light and airiness of the apartments. Although a lamentable affair outside, the interior of the building seems to meet very well the requirements of the artists. The latter stood their ground in the usual manner, welcoming the inevitable floods of appreciative women that inundated the corridors and trying to look as if they did not wish the day well over. It cannot be said that any very striking work was to be seen . . .

The general feeling of the visitor after going through many studios is one of hopelessness; among so much that is indifferent or, frankly, bad, why so few good pictures? Are these painters ever going to do anything sturdy and noble, one asks one's self? Which of them all is going to be a winner in the long run? Very likely it is we who demand too much of the painters; under the glare of light thrown upon their simplest work by the press it may be that what is best in them hides itself or evaporates, and, what is worse, namely, tendencies to noisy, cheaply effective work, frivolous pictures, and clap-trap are put forward in its stead. Unless we are greatly mistaken, it would be better if artists did not ask the critics to receptions of this kind, but kept them even more private than heretofore. They only gain the very questionable good of a slight increase in notoriety, while in other ways their loss may be serious. Some artists, and by no means always poor workmen, are very disillusioning to see in sketches; the critic is liable to form his conclusions upon a half-finished picture, and when it comes to be exhibited, he may, be he ever so conscientious, retain the unfavorable opinion he has imbibed at his first visit. That this is sometimes entirely unjust to the artist need not be said. There are poor painters whose drawings and sketches are full of brightness and skill; there are masterly artists whose first beginnings on a picture are cold and repellant. Decidedly, artists ought to think twice before they hold receptions of this kind in their own studios.

AMERICAN ARTISTS: STARVING OR SELLING OUT

In an ideal world, the American artist would live on an elevated plane far from the market and its dirty doings. In the real world, there was no choice but to enter the fray. These two New York Times *articles from 1882 exhibit the confusion and mixed messages that this impasse engendered. On the one hand, as "Commerce in Art" argues, an unspoken ethos, or etiquette, constrains the artist from advertising, even though the dealer may do so as a matter of course. Though conceding that commerce in art is unavoidable, the writer deplores the dilemma of the American painter, waiting in vain for the "voluntary customer." The author of "Rewards of Painters" observes that in the current market the pictures that sell are either moderately priced sketches for*

the amateur collector or flashy canvases for millionaires. The present tendency is for the latter to eclipse the former, with negative consequences. The artist with the right Munich or Paris credentials, able to command high prices, develops a taste for luxury. To maintain his comfortable lifestyle, he becomes a meretricious "society artist" who has won the world but lost his soul.

"Commerce in Art," New York Times, *February 26, 1882.*

American artists, with some show of reason, complain of the lack of proper means of communication betwixt the artist and the buyer of art works. So far as the pictures of foreign artists are concerned there is no lack of show-rooms, galleries, or depots of works of art. The picture-dealers spread their wares amid attractive and alluring surroundings and in the most public manner. The dealers have no more scruple (why should they?) about advertising what they have to sell than the upholsters or the fire-proof safe manufacturers. But the dealers deal chiefly in imported pictures. Why they do not sell or offer to sell more American pictures it is not necessary here to inquire. It is sufficient to know that, with a single exception, the New-York picture-dealers are chiefly stocked with the works of foreign artists. Or, if there is a fair share of American work hanging on their walls, it is the product of American artists residing abroad and consigned to American dealers for sale. Perhaps we may safely assume that foreign pictures sell best in the American market. It is certain that the sales that attract the most attention are almost wholly made up of imported works.

When we consider the disadvantage under which the resident American painter labors in his competition with his European brother in art we can readily see how hopeless is his outlook for the future. The etiquette of art is almost as severe as that of the doctors of medicine. An art-dealer may advertise in the most flamboyant fashion. An artist must not advertise at all. A dealer may send out his circulars and alluring invitations with the freedom of a corn-doctor or a dealer in easy slippers. No artist of any sensibility, desirous of keeping his professional caste, would so much as print his card in the newspapers. A picture-dealer may close out his superfluous stock in trade by auction without inviting criticism or remark. An artist who holds a vendue is regarded askance by his brethren of the brush, unless he has the wit to disguise his sale with a pleasing fiction relating to his proposed departure to a foreign land, which compels him to dispose of his accumulated canvases, studies, and studio effects. The dealer may "drum up" customers. The painter cannot hawk his own pictures or invite competition with his fellow-laborers in the fields of art.

And as the bulk of the wares exposed for sale by the dealers is of foreign origin, it may be easily seen why the market is flooded with imported work while the home artist ruefully contemplates a gradual accumulation in his own studio, unbought and almost unseen. The art-dealer may force his pictures upon the market precisely as the dealer in woolen goods may force his goods when the waning of Winter warns him that his shelves must be cleared for more seasonable fabrics. This may be said to be true of all countries, but its effects are more noticeable and disastrous in our own, where we have a young art to be nurtured, where there is great wealth to be employed in picture-buying, and where we have the art of centuries for a competitor brought home to our doors. So, while the dealer, who draws from the rich storehouses of Europe, clamorously compels public attention, the native artist waits for the voluntary customer who must seek out that which he wants. Pride and professional etiquette keep the artist at home; they too often keep him poor . . .

. . . We must confess that a solution of the problem that presses upon us is not easy. We are

now looking at the subject in its very lowest aspect. There must be commerce in art. The painter cannot work lovingly and engrossingly over his picture, finish it, and leave it to some baser agency for profitable disposal. Somehow he must be brought in contact with those who buy pictures. The annual exhibitions are too few and too circumscribed in their limits. Even these limits may be monopolized by others who are not unselfish and who have the opportunity. Meantime, the voice of the auctioneer is loud in the land, and the native artist vainly struggles for recognition.

"Rewards of Painters," New York Times, *October 1, 1882.*

The pictures that sell nowadays seem to be dividing themselves, to speak broadly, into two main camps. They must be either small sketches rather than earnestly wrought paintings, quickly dashed water-colors and the like, for which small prices are asked, or else they must be big, showy canvases with a taking subject and a rousing price, which may confer cheaply a dear honor on the buyer. The multitude of amateurs who have to be very careful of their dollars pick up the former; the scattered millionaires and now and then a museum or a junta of benevolent amateurs buy the latter. The great successes of the Etching Club and Water-color Society are due to the spread of a love for the fine arts among persons of moderate means. The continued well-being of the National Academy must be due mainly to patronage by the rich. Between the two camps there is room for every price and every pocket. The matter is difficult to adjust in one's mind; the field is hard to overlook. But there is reason to believe that along with an increase of the great fortunes goes a decrease or a stagnation of the little, and that in the sales of paintings, perhaps more clearly than in other ways, one may follow this peculiar social divergence. Paintings have always had a vogue and a tendency to rise to extraordinary prices in times of luxury. Their portableness goes for much in the problem of their standing in the eyes of the well-to-do. They are speculative investments in one way; but the man who does not buy merely for a rise is pretty sure to get a good deal of solid satisfaction out of them. If he cannot understand or enjoy their beauties, he can bask in the envy of those who do, and he can appreciate his own reputation for wealth and a patronage of the arts. As mere investments they are surprisingly profitable when the buyer is a connoisseur. It is said that in Holland, where land and houses became enormously dear, the very peasants got to investing their earnings in oil-paintings, as purely commercial articles which the mania for works of art and the consequent speculation were pretty sure to make highly profitable. Under such circumstances it is easy to see what a field there was in Holland for all the arts of deception in the way of counterfeiting styles and signatures. Germany is said to be more prolific of counterfeit pictures now than Holland.

It is hardly possible that in the United States there could ever exist such a state of affairs. But it may not be amiss to consider what the effect of a continuance of high prices will be, particularly on the artists themselves. Every one has heard artists grumble at want of recognition, absence of purchasers, difficulty of making a living. And it is true that the great majority of married artists find it hard to follow their ideals at all and keep the wolf from the door. But the modern wolf is not the ancient. The modern artist wants everything and everything is dear. A family adds an unknown quantity to his expenses. It is not true that the unmarried artist of good abilities is badly off. On the contrary, and especially if he have talents, the encouragement is far too much for his own good. Taught at the smart schools of Paris, Munich, Antwerp, he commands a price for a picture that has taken him a week to paint which keeps him well lodged, well fed, well clothed for two months. He has to resort to buying bric-à-brac and getting an

expensive studio; but these are really his "properties" and aid in bringing him customers and raising his prices. He travels in Europe, gets lazy, fastidious, luxurious—and some fine day discovers that he has lost his touch and no longer has original ideas. As his expenses now keep level with his income, he has to resort to the smaller, less ideal measures of his profession. He becomes a society artist, and wins money largely through the sheep-like quality of the people of the world, who follow wherever the social bell-wether moves. He is a famous artist, who gets famous prices, but the young and unspoiled members of his profession think of him with contempt. And yet it does not appear that it was all his fault. Over-encouragement has ruined him. Now, unless the American artist of today is wiser than most men, the great rise in the rewards he obtains in Europe and the United States will surely do him more harm than good. It will stimulate him for the time being. But how can he escape the reaction of money and fame too easily won?

ART WORLD DIARIES: JERVIS MCENTEE AND J. CARROLL BECKWITH

Although they represent two separate generations of artists, there are many similarities between Jervis McEntee and J. Carroll Beckwith, the two most prolific American artist-diarists of the nineteenth century. Both were friendly with the greatest artists of their day, although their own work was not usually considered to rise to the same level of excellence. Perhaps because of these financial and critical disappointments, they each threw themselves into administrative work, serving on innumerable committees for clubs and, especially, the National Academy of Design.

McEntee was a New York landscape painter associated with the group of artists who came to be known as the Hudson River school. In his early career, he was particularly close to Frederic Church, although the latter's success was often difficult for the constantly struggling McEntee to swallow; later friends included Eastman Johnson, Sanford Gifford, and Worthington Whittredge—all of whom he met regularly at his Tenth Street Studio Building lodgings. His specialties were autumnal and winter scenes, often subdued in color and wistful in mood. Although not known as a genre painter, at times he experimented with incorporating figures into his landscapes, in the hope of improving his sales. McEntee kept a diary from 1872 to 1891, and it is an extremely valuable window onto the daily pleasures and travails of a working artist: finding a promising subject, painting his wife Gertrude, socializing with artist colleagues, attending to club and National Academy business, and (a seemingly constant concern) haggling over a sale.

Just as McEntee was a fixture at the Tenth Street Studio Building, Beckwith was known as the "doyen" of the Sherwood Building, an uptown apartment/studio residence popular among the artists who returned from foreign training in the 1880s. His diaries, which cover forty-five years, are filled not only with happy accounts of parties (such as the famous one he gave featuring Spanish dancer La Carmencita) in that building but also with the anguish that came from potential patrons who took little interest in his work. Beckwith's years of study in Paris marked him as a member of a younger, more cosmopolitan generation of artists. Unlike McEntee, who was active during a time when New York City art schools were not greatly developed, Beckwith also taught for many years at the Art Students League (his antagonistic views on women art students are evident here). Other topics that emerge in the excerpts below are the

excitement of moving into the Sherwood Building; the death of his model, Ivy Hughes, and the subsequent scandal; his inability to marry his fiancée, Bertha; and the difficulty of painting posthumous portraits from photographs. His nightly diary entries were usually quite brief, but they still offer insight into an interesting career pursued under difficult market conditions.

Jervis McEntee, diaries, Archives of American Art.

[July 14, 1872]

I am forty-four years old today, nearer I hope to some of the objects at which I have aimed in life and yet how far from much that one could desire. Sometimes I doubt if an artistic temperament is compatible with the happiest and serenest life, for while the satisfactions are often great how many inexpressible longings there are which will not shape themselves.

[November 16, 1872]

Mr. Hoe came in yesterday morning and I made a trade with him giving him my picture of Venice and agreeing to paint him one like Mr. Chickering's picture for the picture of Kaatskill woods I sold him last spring and two hundred dollars. I do not furnish frames for either. I consider this a good trade for I exchange a picture I have had some time and not a saleable subject for a picture which seemed to be very popular when it was first painted.

[November 28, 1872]

I have determined to sell my pictures at reduced prices and those that are not so popular at considerably less. Having determined upon this I feel relieved and can do it now easily. Someone sent me a copy of the London Times with a short but favorable notice of my October Snow now in the Dudley Gallery. I wrote Mr. Chickering to come and see his picture. He does not expect to be in New York this winter and asked if I would object to sending the picture to him by express and give him the privelege of returning it at his expense if he chose. I have written to him declining to do so. My first impulse was to do it but on reflecting I see many objections to it. Tuesday night I painted a sketch of Gertrude at the carved cabinet by gaslight which is pretty good. I would like to practise figures and am thinking of doing something at it. I think if I could arrange to do so next summer it would add greatly to my happiness and open up a new and attractive field to me. I feel that I could succeed in it after a while and shall consider it seriously.

[December 22, 1872]

Friday evening a meeting of the Century was called to pay our tribute of respect to the memory of Kensett . . .

A few of the Artists present hearing that the Committee on Art for the Vienna Exposition had resigned their duties into the hands of the National Academy chiefly on account of some newspaper attacks emanating from that officious nuisance Perry, united in a protest and expressing entire confidence in the Committee and urging them to carry out the objects of the committee. It was signed by Huntington, Eastman Johnson, Gifford, Whittredge, Beard, and myself and subsequently by Hubbard and Hicks. It is outrageous that this wasp of a Perry rises up to breed trouble in any undertaking connected with art.

[January 17, 1873]

I walked up to see Eastman Johnson today and while there he told me that a Mr. Hurlbert would call on me and that he had advised him to buy a picture. When I got home after doing several errands strangely enough I met him at my door. He delivered Johnson's card and I showed him all my pictures. He seemed very friendly and at last did what they all do went away promising to call again after telling me he had bought pictures of Gifford, Johnson, Hayes, Hart and others. Couldn't decide among all my pictures without considering. These things every day occurring show me how I fail to address in my pictures the great mass of picture buyers. I can't get used to it and feel every time the wound afresh.

[January 27, 1873]

Smith seemed rather struck with the picture I am painting Sea from Shore Cape Ann, and remarked that one of these days he would have to get something of mine. I told him to wait until I was dead, perhaps my pictures would be worth more. Gifford dined with us. Kruseman Van Elten called on me. He said he was going to have a sale and leave the country and go back to Holland as he could not make a living here. He regrets it as he likes America and would like to stay. I think that gradually every Artist will leave who can get away.

[February 1, 1873]

On Thursday I sent a note to each artist in the building inviting him to come and see, for his free and frank criticism, my last picture, (not entirely completed) "Sea from Shore." Nearly every one came between 11 and 12 and it proved a pleasant occasion. I gave them each a good cigar and tried to make them feel that I should like their comments which I think they gave freely.

[February 18, 1873]

Mr. Hurlbert came in today with his wife, two other ladies and Mr. Hawk. After some discussion he took my brook scene near Scribner's, for $400. Church came in and kindly, but rather persistently, I thought, recommended him to take this when I hoped he would like my "October in the Kaatskills." I confess I was disappointed and felt rather that I had lost a thousand dollars than made four hundred. I fail to impress these business men, ignorant of art. Church always comes in for the lion's share. I wish I were not restive under this neglect. I can't get used to it knowing as I well do that among cultivated and thoughtful people I am the peer of any of the painters. Church is very friendly to me but sometimes I think he does not really feel my pictures, and that he wouldn't like me so well if I had his popularity. I may do him injustice. An unsuccessful man has at least this advantage—he doesn't excite envy.

[May 11, 1873]

I went up to see Mr. Huntington on Saturday to urge him to stand for President of the Academy but he positively refused and I came away very much discouraged about Academy affairs. He, Page, Casilear, Guy had an informal meeting at the Academy and nominated Ward for President and me for vice-president but I shall never consent to stand being conscious of my unfitness, and while I esteem it a mark of confidence that some of my most valued artist friends like Whittredge and Johnson urge me to run I have positively decided I will not. I think the Academy will be wrecked for there is no espirit du corps . . .

Eastman and I talked of the Academy affairs and finally as we could hit upon no plan both concluded the only thing to do was to go to the meeting on Wednesday and let affairs take their course. I anticipate nothing but confusion, no one to take hold of the sinking ship and that our Academy that ought to be our pride and glory will go down on account of the apathy of some and the unwise measures which have been forced upon it by others.

[May 21, 1873]

A reputation in England is valuable while here it is worth nothing. Our people having no deep seated love of Art are fickle and take up and abandon their favorites in mere caprice. We who are living and working today are the pioneers and I hope and believe that those who come after us, who are strong and original men will have a better time. Mr. Blackburn told Vaux and Stoddard also that he considered me the best and most original landscape painter in America, but my pictures accumulate on my hands and there seems no one to buy them. It is well to look about now under these disheartening conditions to see if possible where the difficulty lies. In the first place I think the American artists as a rule ask too much for their pictures. I think my pride and my ambition to have my works esteemed among the best have often prevented my selling when I might have done so by taking smaller prices. I have resolved to ask less for my pictures and in future I hope I may be wise enough not to refuse any reasonable offer. One hardly knows what to do. There is the feeling of not wishing to depreciate one's works, but I can't afford to lay too much stress upon this and I hope I have resolved to swallow my pride.

[May 22, 1873]

Just as I was in the midst of writing a not very cheerful letter to my father there was a knock at my door and Mr. Francis Weeks came in. After talking some time he spoke of my picture on the easel and liked it very much. Then he asked me if I had the little picture of Scribner's Mill which I showed him. He asked my price for each and here I had an opportunity to put in practice my resolve of yesterday. I named $300 and $500 respectively but told him he could have them at $200 and $400 he paying for frames. He said that was perfectly satisfactory and told me that if Avery did not take the larger one he would; so I sold my picture and lifted myself at once out of the state of distraction in which I have been for some time past.

[December 27, 1873]

I have been thinking a great deal lately about figure painting and would practice it if I could decide upon the best way of proceeding. I should like very much to be able to paint figures and see no reason why I could not. Today I made a sketch of a head of a young girl from a pencil sketch I made, a recollection of a face I saw in the choir of the Methodist church. If I could get models, which is the part I dread, I am sure I could work with great pleasure.

[December 29, 1873]

This morning I commenced a little figure subject of a young girl taking an Autumn walk and stopping at a little foot bridge to watch the leaves floating in the water, using Gertrude for a model for the figure and drapery. We were very much amused by my invention for a railing for the bridge for her to lean on which I constructed from a quilting frame one end resting on the table and the other on a foot stool which answered capitally. I have succeeded in drawing a very graceful figure and painted on it all day with reasonable success. I am extremely interested and

find the days all too short. If I can only get into the way of doing figures what a new source of interest will be opened to me, and I am sure I can do them after proper practice.

[January 5, 1874]

I received a letter from Moore today very coolly informing me that as he had not sold the picture he got of me nearly a year ago he would not be able to send me any money. I sat down at once and wrote him that if he did not pay me for the three pictures I sent him last or the old account he must return the last pictures to me, that I was done selling him my pictures at small prices and waiting for my pay until he sold them and that I never contemplated giving him any such advantages as he seemed to expect as a matter of course. I am disgusted with him and what he gets from me hereafter he will have to pay me the cash for.

[February 3, 1874]

Avery called on me. He said if I had anything I wanted to sell he would like to have it at his place. I told him I had plenty to sell but that he preferred to invest his money in foreign pictures, which seemed to hit him pretty hard. He is a most unsatisfactory man for me to meet. I wish one dealer could arise that a candid man could talk with in an open candid way. I always feel like a criminal and a poor sort of fellow after talking with Avery. He never lets you see that he takes the least interest.

[March 24, 1874]

Another thing which I have always insisted on is that artists should always stand up for the dignity of their profession and not quietly listen to the conceited utterances of ignorant people who presume to set themselves up as authorities the moment they buy a few pictures. I have met with instances of this kind which were too offensive to be borne and have incurred the charge of being a churlish fellow because I would not quietly listen to it.

[April 7, 1874]

Varnishing day at the Academy. I went up there about 11 o'clock. Naturally my first anxiety ordinarily would be for my own pictures but I confess I was most anxious at this critical stage of the Academy to see what the character of the exhibition was. I was glad to find it much above the average, in fact a most interesting exhibition. My "Cape Ann" is in the large room in a good place. My "Wood Path" on the line in the West Room. My "Deans River" over another picture in the same room and looking very poorly. My "Solitaire" on which I most depended over another picture in the North Room. I feel that I have had a decided snub at the hands of the hanging committee David Johnson, Brandt, and Irving who took good care to have all their pictures on the line. It has made me feel a little depressed but I try to be philosophical. Poor Weir was most shamefully treated and was utterly cast down. His picture is hung over another in a dark corner and as he is an Academician and had sent only this picture I regard it as a downright insult.

[November 26, 1874]

Thanksgiving Day—When I reflect as I do oftener than once a year upon the many sources of happiness from which I am allowed to draw daily it seems weak and spiritless ever to give way to depression and discouragement. Still I do it in spite of my efforts to avoid it. I think one cause of discouragement is a certain impetuosity in my work. I try to do too much at once

rather than do what I can profitably in a day and then leave my work for the next day. After I have painted as far as I can with profit I ought to leave my picture and forget it until the next day, but I go on trying to finish and I get a certain hardness and then thinking of my work troubles me.

[April 4, 1875]

Sent my Academy contribution "Dark Days" to the club. It attracted considerable notice and I had many compliments regarding it from the artists. I have not sold a picture in a long time and no one comes here. I begin to be troubled occasionally as I see the end of my money but try to keep up courage in the hope that some one will come along when I least expect it. I saw in talking with Armstrong last evening that he thought I sold a great many pictures. I think that is the general impression. Have had a model four days this week to paint a figure in the woods . . . John Weir spent an hour with us, and told us about his brother Julian who is studying art in Paris. We both lamented that in our younger days we could not have had his advantages.

[May 27, 1875]

Moore came in and I let him have my little "Fisher Girl" to sell on commission. He to frame it at an expense of about $20. but I am not to pay for the frame unless I wish to. He is to sell the picture for $300. netting me $250. above frame and commission. I have repainted the "Wilderness" for him which he bought at auction for $200. He is to send me the Gazette des Beaux Arts and the Portfolio for a year for what I did. Mr. Van Valkenburgh called to see me a day or two ago and said he wanted to bring a Mr. Haines here. They had been here, but I was out. I think Mr. Van Valkenburgh would buy my picture if he knew enough but he is timid and wants some one to assure him.

[July 26, 1875]

Am reading Grimm's life of Michael Angelo in which I am much interested. Have a better idea of Italian politics of his time than I ever had before. Beyond reading I am doing nothing and I have my usual summer discontent, a longing to be doing something in my art. I think I would like to be sketching from nature, and still my summer sketches never help me much and going to work now might take the edge off my enthusiasm in the fall. This lying fallow I am convinced is not waste time. I am delighted to find that the great Michael Angelo often spent long seasons in apparent neglect of his art but who shall say what he was preparing in his mind. No man can accomplish great things without getting far enough from his work occasionally to see what he has done. If I had my way now I would take some excursions if I could find a companion and hunt up some pleasant region to sketch in the Autumn.

[November 2, 1875]

Election day. Voted the regular Republican ticket in spite of the blandishments of Reform Democrats. I prefer the party whose record has been good in trying times to the men who were faithless during the war. I am not ready to trust them yet.

[January 24, 1876]

Attended the Council meeting. The irrepressible Perry presented his scheme for a great paying school at the Academy signed by a whole lot of Academicians, as though we had never thought of this and utterly ignoring the fact that it is impossible under the law which frees us from tax-

ation. I cannot adequately express my disgust at this irrepressible and mischievous meddler. He has sown discord in the Academy and will be a nuisance there as long as he lives.

[February 1, 1876]

Have done no work today. Time frittered away . . . Nailed a lot of canvases on stretchers. Had a talk with a model on her mode of life. Advised her to go to housework . . . Spent the evening at Eastman Johnson's. We went up into his studio to see some little sketches of the arrangement of his sugar picture. A. T. Stewart has twice spoken to him about it and told him he would come up and look at his designs when he was ready for him.

[September 30, 1876]

This from the Tribune—Senor Escosura, the distinguished Spanish artist, walking through one of the New York picture galleries the other day, paused before one of Mr. Jervis McEntee's beautiful canvases and said, "I don't know this artist; I never saw any of his work before; but I know no one in Europe who could do better."

I confess the accompanying extract from the Tribune of today came to me as a great solace in the midst of my worries and anxieties. I am very glad to have the spontaneous endorsement of artists, and I am thankful I have had it many times. My pictures at the Centennial exhibition have had a number of very favorable notices and are always classed as among the best there. I only wish it would induce our picture buyers to think more of my work, and I think it will in time. My salvation is in going on and improving in my pictures and it is the fear that I may not be able to do this that often causes me anxiety. There is great danger that a man in need of money will be induced to work for popular favor and so prevent him from following out his own ideas. An artist above all men should be free from money troubles and I think constantly of how I can order my life so as to be independent in this respect.

[October 19, 1876]

Eastman came in to see me and in the afternoon he and I walked up to Reichard's new art gallery in 5th Avenue and had a little talk with him about American pictures and gave some reasons why we thought it worth while for someone to deal in the best American art. He seems a prudent pleasant man, but I do not think would be able to do much. We are more and more impressed with the fact that we shall ultimately have to get some dealers to interest themselves in our work or we shall sink out of sight.

J. Carroll Beckwith, diaries, National Academy of Design.

[February 18, 1880]

I reproach myself as an agregious ass whenever I consent to go to the Tile Club. I am so glad they never made me member . . . I went up to the new building. My new studio there will be infinitely more habitable than this & indeed it should be when I pay 200$ more.

[April 19, 1880]

I cannot say the afternoon was very enjoyable as it will be doubtless the last in this old studio. It was a farewell to my old den and a sensation comes over me that with this move my dear old bohemian life ends. I become as it were a member of society. What will the future disclose. I hope of all things I may improve in my art.

[February 16, 1881]

D__n their old reception. I have been in hot water all the evening over this detestable idea of having a reception. An art reception of all the things. I hate it & to throw my studio open to a mob. Ugh!!!

[February 17, 1881]

This horrible reception has put me in such a rage today that I am almost ill. nothing could be more antagonistic to my feelings of delicacy. And I was trapped onto the committee. A meeting took place this morning here in my room. All were here . . . It has made me quite miserable.

[February 24, 1881]

What crowds of swell people! My studio has been jammed & if I do say it myself the place looked very well. However, it is over & I am not sorry . . . The house has been crowded with the best people of N.Y. I am sure it has done my reputation more good than an academy exhibition. The artists in the building are all in fine feather tonight. I am almost dead with fatigue.

[January 18, 1883]

All the money that goes out and nothing that comes in but my school fees. It's horrible. I verily believe that I have scarcely made any progress in my work during these past four years. I am alarmed how badly I paint.

[March 3, 1883]

I suppose between two or three thousand people have been in my studio today. The weather was fine and at 2 o clock there commenced a party of revelers, Coffin, Van and others have but just left my room and bottles all empty. But not a human being has asked me the price of a thing or shown the least suspicion of a desire to purchase my work.

[February 27, 1884]

This beautiful Miss Hughes is certainly a fine model and a woman of great charm. She posed for me all day and lunched with me in our little den with greatest enjoyment. Tonight I took Ned to see her. So one woman fills up a day.

[March 9, 1884]

I have indeed had a restful day. Mais quel experience! I[vy] came before I was up and we lunched here together & remained in the studio until eight when we went to dinner. If ever I have had a reward of merit it has been today. By jove it pays to be good in this world . . . How honorably have I treated Ivy Hughes and how nobly she repaid me today by her glorious acknowledgement. If ever I had a right to be conceited I have it now.

[March 17, 1884]

Poor child is very ill indeed. I stopped there all night keeping watch.

[March 24, 1884]

This morning I came down here found patient bad and in view of the fact that the Dr. may be needed in the night I shall remain and we will take turns by the invalid . . . She is very ill. The morphine I abominate but she suffers so it is necessary to give it.

[March 26, 1884]

I have never seen such suffering . . . We are wearing out and I neglect everything.

[March 31, 1884]

Poor Ivy has had another operation . . . The odor of chloroform still clings to her.

[April 3, 1884]

I wonder if her sufferings will not come to their end soon and improvement commence. This second time I have been down today. The rest of the time I stopped home devoting myself as usual to letter writing, but things in a business way are about at their end now and once Miss Hughes is well I shall be able to go to work steadily. How fortunate that she fell in my hands when I happened to have some money. I have not the courage to add up my March expenses.

[April 19, 1884]

Poor Ivy Hughes is no more. She died soon after half past six tonight . . . Poor child, alone with strangers in a foreign land. I was glad she had not her mind. How earnestly we have all fought against death these past weeks.

[April 22, 1884]

Tonight I have a call from a nasty little World reporter with a doubly nasty story of malpractice. How disgusting.

[May 3, 1884]

I have been particularly depressed today. The thought that perhaps that nasty World would publish some scandal in which I was dragged simply through my kind heartedness has hung over me.

[March 3, 1886]

I came home and spent the afternoon getting my studio in order for this old reception which comes off tomorrow. How I dread it! They never brought me any money and that is what I need now.

[March 4, 1886]

This villainous day is at an end fortunately, and what alone consoles me for all the trouble, several men have sold, tho' I have not, some had a nibble. I feel heart sick some times at the almost hopeless way in which the thing goes on, and 171,000 dollars was paid last night at the Morgan sale. Thousands of people have flocked here today and my place has been jammed with people mais à quoi bon? Reputation, yes, I have that, for what ever it may be worth. Darling Bertha was here today and she is a great boon but I can not have her unless my profession will pay me something.

[February 17, 1890]

We went to Koster and Bial's and heard an awful performance closed by Carmencita!!!! Such a Spanish dancer I never saw before. We are going to try and have her up here in my studio.

[February 27, 1890]

What a delicious surprise it was to Bee. Poor little innocent . . . Carmen came at 12, a dozen men whom I had spoken to came in. I had a guitarist & mandolinist. She danced superbly

until near 3 o'clock when Sargent took her home. I have never had a more novel fête than tonight.

[February 28, 1890]

My place was a wreck this morning. The floor, of which I am usually so proud, was in a frightful condition from the flashes for photographs and the cigar ashes. A smell of stale champagne made the place uninhabitable.

[April 1, 1890]

Mrs. Gardner of Boston had heard so much of Carmencita that she sent to Sargent to engage her to dance. Chase consented to use his studio so a few of us were invited for tonight at 11. It was a stiffish company and it did not go well.

[April 20, 1890]

All day I have been on the Jury of the S.A.A. its 12th Exhibition. It is always hard work and a turn in a crowd of new radicals on it was harder than ever. The Monet gang back from Europe wanting everything pale lilac & yellow. I do not object but I want all movements in art fairly considered.

[February 15, 1892]

Van Boskerck lured a couple of picture dealers up into my studio but they confessed with polite regret that my works were unsalable.

[March 10, 1892]

By Jove here I have done a large three quarter and a bust portrait both for 1,000$ while Eastman Johnson charged 2000$ for doing but the ¾! But I was glad to do it.

[March 11, 1892]

I had an early start and got through at the League and lunch at the Players in time to be at the Academy by 1:30. The Jury was at work when I arrived. I am distinctly the one champion of the impressionists, and stirred up a good deal of comment. I realize that I am too independent and yet when the chairman (J.G. Brown) wished to retire he called on my to occupy the chair.

[May 20, 1892]

A most unheard of event. *A man came in my studio this afternoon and bought a picture* for 275$. This is only the third time in ten years this happened I think.

[May 23, 1892]

It poured torrents and I worked in my studio from the photograph on the portrait I am doing for Van Dyke in the Sage Library at New Brunswick N.J. Usually I have had more portraits to do from the photograph, not this winter. This is the first one. With a model I can get through them fairly well provided that sufficient time has elapsed for the people to have hit an uncertain idea how the person looked.

[December 12, 1892]

I had my model for the nude in the afternoon and put in some solid work. I can scarcely tell why I do these things save for the sincere pleasure I take in it for really no one wants them.

I went with Brush to his studio a strange dirty room the parlor of a cheap flat in 48th St. his wife I met on the stairs like a bedraggled tenement house nurse with her three children. He is doing a picture which has divine fire in it from his dirty wife and babies. Strange how it is but he is indeed an artist.

[March 9, 1896]

All day I have worked hard on this Parrish portrait. Mrs. P was here this morning and posed for the hand and I had Minnie in the dress all the afternoon. She is such a valuable model. Made me drop Mrs. P's shoulders a full inch which gives an air to the portrait it did not possess before and in many other ways helps me by her valuable suggestions.

[April 26, 1896]

How much more useful cooking schools would be than art schools for women.

[January 23, 1897]

I lectured this evening before the students of the Academy. Talked for an hour which quite surprised me as I did not know I could keep it up so long. The room was crowded and what satisfied me the most was that they were mostly men.

STUDIO LIFE AND ART SOCIETY

NEW MEN AND WOMEN IN NEW YORK

Art life in post–Civil War New York became increasingly competitive as younger painters and sculptors returned from study in Munich or Paris. Already a cultural capital of long standing, New York in the Gilded Age became an ever more dynamic hub of cultural production and home to a growing population of artists, many of them fresh from study abroad and all of them struggling to gain a foothold, pay the rent, and advance their careers. Well-established older artists were still active and highly visible; there was no clean break between the generations. Yet writers sensed that modern metropolitan culture was reshaping art life into distinctively contemporary forms; they sensed as well that art life in New York had its own peculiar character, quite unlike that of Paris or other European capitals. The growth of the artist population coincided with an expansion of opportunities in the fields of illustration, design, and other applied arts, leading many into the commercial realm temporarily or for the long term. In addition to providing employment for artists, the expansion of the popular illustrated periodical press became an important vehicle for disseminating news, information, and myths about them.

Representative of that new focus on artists in the mass media, William Bishop's exploration of artist life in 1880 focuses on the "young men of the new movement," the graduates of Paris and Munich. Having become the "most prominent element" in the city, Bishop finds that they are transforming the image and nature of modern art life. He is encouraged that the American type of art student manifests a practical attitude that needs no Bohemian flourishes in the European fashion. At the same time, he is

drawn to the studios of beginners, where a "veritable vie de Bohème*," prevails in dingy attics, thus reinforcing a romantic myth. Bishop also surveys the new commercial landscape that gives artists opportunities in illustration, advertisement, and shadier modes of money making. The author's matter-of-fact account of women artists, present in growing numbers, is particularly noteworthy. While Bishop observes that women tend to maintain a more domestic atmosphere in their studios, his language otherwise suggests that women artists have earned at least some measure of parity with men.*

William H. Bishop, "Young Artists' Life in New York," Scribner's Monthly Magazine 19 *(January 1880).*

The association of the sexes on terms of perfect equality gives American art-student life one of its distinctive aspects; it is gentle and courteous, perhaps even tame according to some ways of thinking, but free, at any rate, from the wild and brutal excesses too well authenticated of famous foreign *ateliers* . . .

Though there is no more delicate and charming sentiment than that which is the offspring of American life at its best, a strong practical vein is manifest in the American type of art-student. He has no traditions—no long hair and cloaks to adopt, and he has never been encouraged to feel that it is the business of any government or princely patron to take care of him. He is not, perhaps, quite enough given to seeking out romantic and original experiences, though this is a trait not to be over encouraged. He has not discovered, for instance, the picturesque capabilities of New York, which has a glow of color and an irregularity of outline with which neither London nor Paris can compare; for New York has made more of the arrangements for purely modern life than any other city in the world. Brow-beaten as the student naturally is by the traditional American reverence for foreign parts, perhaps it would not be fair to expect the discovery from this source. It is rather from the returned proficients, who have seen and know, that it is to be looked for.

These new-comers, mustering now in large force and strengthened by constant arrivals, must be counted the most prominent element in the artist life of the city. It is not only in the schools, where they occupy the professorships and control the coming generation, but in all the movements, formal and informal, without. The older men of the Academy are no longer an active social factor of artist life. Ten years ago a long tableful of them, with Page at the head, was still dining at an Italian restaurant in Third avenue, whither they resorted for the speech and cheap wine that gave them reminiscences of their days of travel in diligences across complicated frontiers . . .

A similar tableful of artists dines together to-day, but it is made up entirely of the young men of the new movement. They are graduates of Paris and Munich, and are the main supporters of the new "American Art Association." They have lived long enough in Europe to see something of its common-place side, and are content to discuss it chiefly from the point of view of its comparative practical advantages. They are not led by sentimental considerations to a French or German place, but choose a comfortable American restaurant. Their talk, when it is not jocose, is of a practical character by preference. They discuss technical points, the manner of this and that artist, new methods of laying paint with a palette knife instead of brush, and the disproportion in this country of the artist's expenses to his returns. The newest arrival complains that he finds $400 and $600 the ruling rates for studios, while he could have had the best in Munich for less than $200. On the whole, they are a superior group of fellows as they sit around their long table, with good heads, capable of thought on a higher order of matters

as well. Some current circumstance, one of the conflicting newspaper articles on their recent doings, turns the talk with a pleasant animation to theory and original speculation. Their position as pioneers in a new period of art development, and the prospective results, are touched upon. The American subject, the simple, the nude, the historical in art, such a one's new propositions in perspective, all come in for a share of attention with the coffee and cigars . . .

It is agreeable to note how reconciled the returned art students are on the whole, with a considerable touch of surprise, to what they find in this country . . . They make charming places of their studios in Tenth street or the Christian Association building, bestowing in them their tapestries and carved chests, which have an added preciousness in their new situation . . .

Scattered irregularly throughout the town are the studios of the beginners,—and of many who began long enough ago, heaven knows,—a great obscure body, full of aspiration, recognized failures and whimsical vicissitudes of fortune, between the student class and that of established reputation. Penetrating through the yard of an ordinary house in Fourth street, one encounters Michael Angelo's "Moses," and finds sculptors upstairs in an out-building. Others occupy a loft over a frame-maker's. Three others are in a cheap flat with a work-room in common. Another uses the parlor of the flat occupied by his indulgent family, in an uptown street, and keeps his mother and a small servant-maid posing while the household matters wait.

For the most part, however, the studios are on Broadway. Few of the older business buildings of the great thoroughfare from Houston street up but would yield to the search some obscure door in the upper regions bearing the title Artist. They are often the dingy quarters, with splintered, acid-stained floors, abandoned by photographers. There are rarely side windows, and the sole view is of the sky. The studio of the poorer class is sleeping room, and generally more or less kitchen as well. Disregard of conventional forms sometimes reaches the point of actual squalor. Here in one costing fifteen dollars a month, three persons are sleeping, two on a lounge—which also serves as a coal box—and one on a shelf conveniently placed at night on trestles. Coffee is drunk from a tomato can. A chop or steak is cooked by lowering it down with a wire through the top of an ordinary cylinder stove. The collection of dust-covered clothing, old boots and shoes, withered ferns, half dry sketches, plaster busts, groceries, books, and oil-cans, presided over by a battered lay figure in a Roman toga and slouch hat, would do little violence to the ideal of symmetry in a rag and bottle shop. It is a veritable *vie de Bohème* that goes on. Such a fellow is said to have reduced to a nicety the art of renovating a linen front with Chinese white instead of sending it to the laundry. Landlords are regarded in an odious light, and if possible locked out. One, who would be put off no longer, was paid his rent in busts of Evangeline, which even the amiable Longfellow had repudiated. Pictures are made a medium of exchange with the butcher and the tailor. If fortune be propitious the bohemian luxuriates at boarding-houses and restaurants, whose walls he becomingly adorns. At other times he takes but a single meal or only mush and milk . . .

The range of expedients for subsistence during the time the great projects which are to bring fame and fortune are matured is widely varied. Illustration takes the first place. It is more easy of access than formerly, when drawing on wood must be done in a formal way and was a kind of trade in itself. On the other hand the standard of performance has greatly advanced, and those who are able to meet the enlightened taste of the time are already on the high road to everything desirable. By a kind of anomaly it is the testimony of publishers that more wretched comic cuts are sent in by the distressed class than anything else. The weekly story papers are one resource. There are those again who debase excellent talents, on the pitiful plea that some

other will if they do not, to the service of the licentious flash journals. In another line, "real oil portraits" have been offered in the Bowery for $10. The crayon portrait was long a standing resource for keeping struggling artists alive, but the market is said to be much broken of late. An enterprising fellow carries on his campaign by making tours in the country, lettering rocks and fences with patent medicine advertisements. Another, "the black-eye artist," has developed a novel industry, especially lucrative about election times, in giving an innocent and normal appearance to faces damaged in rough-and-tumble encounters.

To the "shanghai," however, must be assigned the place of honor among the makeshifts of an impecunious, common-place, and not very conscientious class of artists. The "shanghai" is the glaring daub required by some frame-makers for cheap auctions. They are turned out at so much by the day's labor, or at from $12 to $24 a dozen, by the piece. All the skies are painted at once, then all the foregrounds. Sometimes the patterns are stenciled. The dealer attaches the semblance of some well-known name, of which there are several, and without initials. The sonorous auctioneer cries aloud: "This work of art is an original of Kenstett, gentlemen, and now can I believe my ears that I am offered but a hundred dollars for it?" . . .

It ought to be rather better known that there is no other city where the woman student can pursue advanced studies in art with so few embarrassments as in New York. She certainly cannot in the very different social customs prevailing at Paris and Munich, or in the murky gloom of the Slade and South Kensington schools of London, where four or five hours of daylight in the winter is the maximum allowance. Here, too, studio life for women has come to be a somewhat recognized mode of existence. It is understood now by the landlord, the butcher, the baker, and the milkman. There are usually two inmates, for protection and companionship; but the erection of a suitable studio building for women artists would be a genuine and amiable field for philanthropy. It should have ample household conveniences, for nobody is less bohemian in her own feelings than the woman artist. She has nothing in common with the disorder of her masculine *confrère*. She keeps house, it is true, in a small compass; but she maintains that the only difference between her domestic economy and that of the world at large is that she washes her dishes after dark. Everything is neat and compact as in the cabin of a ship. I have no idea that the one my lodging gives me an opportunity of observing at a distance, decorating Egyptian vases in a dim interior, and sometimes coming to the window to water a box of geraniums, would like to be thought of as a Hilda.[1] Her residence is in one of the most formal and decorous of the up-town buildings suitable for the purpose; and it is fire-proof shutters on a court she throws open in the morning, instead of coming to feed circling white doves from a battlemented tower.

A peculiar line of characters appear in the studios of the lady artist. She is apt to be more infested by bores, from the book-agent to the idle visitor, than a man, because they are less afraid of her. The expressman and the emissaries who bring provisions have more or less of a patronizing air.

ARTISTS AND MODELS

Unlike Paris and other European art centers, New York (and American cities in general) suffered a dearth of artists' models, a situation that became more acute with

[1] Hilda was a young painter in Nathaniel Hawthorne's novel *The Marble Faun* (1860); see "Women Artists, Woman's Sphere," chapter 11.

the growth of the artist population in the 1870s. For women, modeling in the nude, often associated with prostitution, was a risky business. But Charlotte Adams's report on models in New York reveals that many other kinds of modeling jobs were available, and how the artistic trends of the time created demand for particular types. Giving models rare credit for their essential role in the creation of artworks, Adams goes on to offer a wealth of information on the kinds of models available, their fees, and their specialties (see also "The Art Workers' Club for Women," chapter 11). It is strikingly clear in Adams's account that models are commodities, valued for their ability to represent a type. As with other commodities, supply may exceed demand: the urchin market is now "overstocked with small-boy models." Although Adams gives valuable insight into artists' working methods and interactions with models, she has little to say on the hardship and exploitation to which these workers were often subjected.

Charlotte Adams, "Artists' Models in New York," Century Magazine 25 *(February 1883).*

With the rapid growth of New York as an art-center, the demand for, and supply of, living models have increased proportionately . . . Realism, to which American art inclines, demands careful study of the model. As the artistic colony in New York became a recognized factor of the population, professional models followed as a natural consequence. It is little more than ten years since models were something of a rarity even at the Academy of Design. Some three or four were regularly engaged for the various classes and were paid at the rate of a dollar and a half an hour. With the appointment of the present director of the model department, a new order of things was instituted. By means of advertising and by exploring the by-ways of the great city, a number of models were brought together, untrained and inexperienced, but still suited to the purpose. The fee was temporarily reduced to seventy-five cents an hour, and competition rose high between the trained models and the inexperienced. Since that time, the supply of models has been constantly increasing, and to-day is fairly equal to the demand. They lack the experience and training of the foreign model, and it is rare to find one of either sex who has any of the grace or *chic* which makes of the Paris model a natural artist. They are also destitute of that dramatic instinct without which it is impossible to throw life or spirit into a pose. Few persons, outside of the charmed circle of art, realize the absolute power exercised by the conditions of the model over the brush of the artist. A stupid, awkward, or restless model will stultify the execution of a clever or charming idea. When a New York artist stands in need of a model, he has only to send to the Academy of Design or the Art-Students' League, on the books of which professional models are registered. The Academy has a list of some thirty models who pose for the nude figure as well as in costume. There are others who pose only for the draped figure. The average fee is fifty cents an hour. This is increased or lessened according to circumstances, such as special contract with the artist or class, or the varying demand for the model. Among these professional models are a few who have been trained to their occupation from childhood. These are chiefly foreign or of foreign parentage. One family, in particular, of mixed German and Italian blood, furnishes models of various ages and both sexes. This family serves as a stand-by through all the vicissitudes of the model-market, and as models are constantly increasing in numbers, it is fair to suppose that, with this nucleus, before many years have passed, trained and skilled models will be as easily procured in New York as in Paris.

The models of New York may properly be classed as a part of the floating population . . . Most of them, especially the female models, pose under fictitious names. They come no one

knows whence and vanish when necessity no longer demands that they shall eke out a livelihood in this precarious fashion . . . It often happens that a pretty face looks down from the wall in a New York spring exhibition, of which only this is known—that its owner, passing under an assumed name, applied at the studios for employment, and, after earning the money she needed, carried her beauty and her reticence back into the obscurity they came from, leaving the artist who had perpetuated the one and respected the other to speculate upon her identity, and perhaps at some later day to meet her in an entirely different sphere of life. A rounded arm or throat, a tapering hand, a head of curling golden hair, have temporarily fed and clothed many a young woman . . . Many of the professional female models have become such because they found they could earn a better living by posing than by working in shops, book-binderies, factories, in domestic service, or at the needle. I know of a French model who supports herself and a relative comfortably by posing. She formerly gave lessons in languages, and barely managed to exist. Another model, who is noted for her stately presence and superb physique, is greatly in demand, and commands three dollars a day. But the average fee of a model is fifty cents an hour when the engagement is made by the hour, or two dollars a day when the engagement is made for the day. For a morning or afternoon session, whether of two or three hours, the model receives only one dollar, unless there is a special agreement to pay more.

Foreign models occasionally come to New York on speculation, having exalted ideas on the subject of the gold to be picked up in the streets of the New World. There is a colony of Italian models in Crosby street, of the conventional type. They came from Paris to New York with magnificent ideas concerning the model-market. They began by asking a dollar and a half an hour, but finally condescended to accept twenty-five cents for the very few occasions upon which their services were required. American artists have rather outgrown the conventional Roman subject, so much in favor some years ago. With the increase of realistic tendencies and broad, rugged treatment, the Italian model has been relegated to the region of artistic "prettiness," so heartily disliked by the younger school of American art. These Italian models haunt the studios in groups . . . But, alas for them! Their day is over. Paris and Munich have driven out Rome. The neat old dame who sits in the portrait class of the League, with smooth white hair, good, patient face, and every-day dress of dark green and brown, is nearer the heart of the American art-student of the period than the insipid prettiness of the Roman *contadina*. Old women and old men are rather in demand as models in New York, now that strong and realistic types are preferred to ideal ones . . .

A few artists in New York have their models acting also as domestics or studio-retainers. This is a foreign custom imported by artists who have received their schooling abroad. Under these circumstances, a sort of comradeship arises between the artist and his faithful model, which has its pathetic as well as its grotesque side, since the remuneration of the model is apt to depend upon the successes or failures of the artist. There is a colony of young artists in New York which possesses a retainer known to the world as "Sammy"—a youth of muscular type with blonde mustache and hair and a fresh complexion. His face and figure fit him for all spheres of model life. One day, he poses as a stalwart fisherman, in a pea-jacket, a disreputable hat, and high sea-boots. Another week, in a dress-suit borrowed for the occasion, he figures as a ball-room gallant with one arm encircling the waist of a bald-pated lay-figure, arrayed in silken robes, likewise borrowed, into whose glass eyes he gazes with an expression of the deepest tenderness. He has even appeared as a bold horseman seated astride a wooden chair, which was placed on a table, tightly clutching two pieces of clothes-line for reins, with his body inclined at the an-

gle necessary to imply a furious galloping on the part of his fiery steed, and his coat-tails spread out and fastened to the wall behind to illustrate the action of the wind. In addition to his accomplishments as a model, this young man does everything an artist's henchman can be expected to do, in the line of general usefulness. There is another model much in favor, particularly among illustrators, on account of his gentlemanly appearance. His well-shaped head, black mustache and clean shirt front, can be adapted to almost any artistic exigency. When not engaged in posing, he finds employment as a porter, for his excellent education and musical accomplishments are of small service to him in the competitive bread-struggle of New York. Not long since, he entered the matrimonial state, espousing a widow with a pretty little daughter, seven or eight years old. The child entered the model field under the auspices of her stepfather. Being a picturesque child, with long, chestnut hair, she soon became a favorite model for illustrations designed for juvenile magazines.

These child-models are much sought after by artists. Those on the lists of the schools do not always meet the wants of the painter. Advertisements for pretty little children to serve as models are often seen in the morning papers, and are doubtless viewed by the unenlightened and ignorant as the device of some hideous ogre, some Croquemitaine of the metropolis, seeking what he may devour in the shape of tender nurslings. The initiated person, familiar with the *coulisses* of New York art, sees at a glance that the advertisement is only the last resort of some unhappy artist. The introduction of Christmas cards has greatly increased the demand for child-models. Then the "high art" picture books for children, imitated or reproduced from London publications, have set the fashion of mediæval or "Queen Anne" types in the illustration of native juvenile books and magazines . . .

Yet the fact remains that models are still an artistic luxury in New York. Few young artists can afford to employ models for any length of time for pictures that are painted on speculation and must take their chances in the crowded art-market of New York. Many a young painter is forced to content himself with the suggestions given him by a few sittings, and relies on his imagination and his inventive faculty to help him out. Then comes in the question of costume. A model may be everything, personally, that is desirable, and yet not possess the costume required by the artist. A female model with a tasteful wardrobe can find numerous engagements and command her own prices. Few artists in New York possess any costumes at all, and still fewer own modern female dresses, or have other than the usual masculine crudity of idea as to how they should be worn. Consequently they are entirely at the mercy of their models, and helpless in such matters to a degree that would astonish a Paris artist . . .

Sometimes an obliging female relative will lend an artist a handsome gown for his Exhibition picture, with many cautions as to paint from palette and brush. Sometimes, he repairs to the theatrical costumer and hires a vile concoction of gaudy colors and cheap material at a ruinous rate. Sometimes his model makes a gown to fit herself of some common, inexpensive fabric, say, for instance, blue silesia. By that mysterious and convenient agency known as *chic* it will appear on the walls of the Exhibition as the richest of blue satin. The artist buys half a yard of blue satin and studies the effects of the folds, then applies the same combinations of light and shade to the silesia gown on his model. The properties and methods of the studio are not unlike those of the stage: magnificent results are produced from humble materials . . .

Many artists prefer picking up their models in a chance way, believing that the types so secured will be more original and realistic than those whose poses have been reduced to method by Academic practice. One artist whose name is associated with the reproduction on canvas of

the small street Arab of New York, gathers up his models from their native element of mud, thereby preserving all their delightful *gamin* characteristics. When he first undertook his researches, it was with difficulty that he was able to make the audacious bootblack and the dauntless newsboy enter his studio. Fear and horror seized them upon the very stair, and they struggled for escape. But a few of the boldest of the tribe having undergone the operation of having their "picters took," the report of the wonders and beauties, not to say the commercial advantages, of the studio spread abroad, and the market became overstocked with small-boy models . . . By far the best models, from the point of view of originality, are those captured by chance. A model—a tramp—picked up in the street not long ago, fainted after a few moments of posing. He had seemed overjoyed at the prospect of earning fifty cents. He revived, insisted upon completing his task, received something over the fee promised from a suspicion on the part of the artist that his feebleness was the result of hunger, and went his way. Such episodes as this often occur among the experiences of a searcher after models. When an athletic model is required, the painter sometimes applies to circus-performers, heavy-weight men, boxers, and pugilists. They frequently appear on canvas as gladiators, Greek wrestlers, and Roman senators.

The New York streets offer a variety of picturesque types, which for artistic value are not surpassed by those found in any European city. The deficiency in color and conventional picturesqueness is atoned for by the strong realism and robust distinctiveness of character to be found in the surging humanity of this many-sided American city. The artistic exponent of American life lies in the reproduction of the very types that pass under the studio windows, in their daily round of work or pleasure. The great masters of foreign art, whether ancient or modern, have always found their models close to their own door-stones and hearth-fires. The same must be true of American painters before we can claim for ourselves a nationality in art, remembering the while that the familiar is not necessarily the vulgar . . .

It does not come within the scope of this article to enter upon the question of study from the nude model which has given rise to so much argument during the last few years. In the life-classes of the New York art-schools the discipline is most rigid. The monitor of the class is the only person who holds communication with the model, and in the case of a female model a mask is sometimes worn over the face. New York possesses an abundance of crude material in the way of models, and it is fair to suppose that a few years more will see the establishment of a complete and perfected system of accomplished and trained models, of those realistic types most valued by American artists.

WILLIAM MERRITT CHASE'S SUPER-STUDIO

After his student years in Munich, William Merritt Chase spent several months in Venice, where he sketched and painted the street life while amassing a trove of antique furniture, textiles, and bibelots. Returning to New York in 1878, he moved into the Tenth Street Studio Building. Originally dominated by landscape painters of the Hudson River school, the building in the 1870s gradually opened up to younger artists returning from abroad. Chase was of that vanguard, and his studio—the largest and grandest in the whole building, and stuffed with his treasures—almost immediately became a place of legend and glamour (fig. 9). Here, Chase successfully projected the image of affluence, cosmopolitan sophistication, and taste that made up the signature style of the modern, progressive American artist.

John Moran devoted a complete installment of his series of articles on studio life

in New York to Chase's studio. Noting that Chase's studio incorporates the "trophies" of his travels, Moran admires the way the artist has so tastefully arranged and harmonized his vast conglomeration. By such sleight of hand, Chase has conjured up a heady "aesthetic atmosphere." Moran catalogues the fascinating and exotic contents of the studio with evident relish, dwelling sensuously on color, shape, and texture. He notes that the collection's owner shudders to think of its cost—but more important, in any case, is the artistic value that Chase's refined taste has bestowed on dried devil-fish and Greek bronze alike.

A New York Times reporter describes how Chase used that aesthetic atmosphere to excite interest and desire. The occasion is one of the regular reception days (which began in 1858 and continued, intermittently, through the early eighties) at the Tenth Street Studio, when prominent art patrons flock to see the latest work. Chase's studio is one of the star attractions. The art atmosphere, however, is so seductive that it effectively upstages the work the artist wants to sell: the many "lady visitors" spend most of their time talking to Chase's parrot, petting his spaniel, and flocking around the debonair host himself.

John Moran, "Studio-Life in New York," Art Journal 5 (1879).

How many of those who profess, not to say feel, enthusiastic admiration for the pictures hung on the walls of their friends' houses or in the various Fine Art exhibitions which from time to time they visit—nay, how many of those who actually purchase and possess pictures, know anything of the places where they are fashioned and whence they issue, of the manner of men who paint them, or of the Art atmosphere of which they are, so to speak, the visible crystallisation? . . .

The movements of the Art world, during the past two or three years, have brought into prominent notice that section of artists popularly and often loosely described as "the impressionists." For this reason, as well as on account of its absolute claim on admiring notice, the reader is first introduced into the studio of Mr. W. M. Chase . . . Mr. Chase's studies were pursued in Europe, chiefly in Munich under Piloty, but he has travelled extensively elsewhere, and his studio bears manifold tokens of travel in the spoils and trophies which it contains. One is struck on entering by the restful sense of harmony in colour, by the deep and mellow tone, by the apparently fortuitous arrangement of line, drapery, and grouping, which never suggests an awkwardness. You cannot tell, you do not want to tell, how the effect has been arrived at. It is there and that is enough. It is a matter of intuition rather than of reason . . . After a time one's eye wanders about, now lighting on this object, now on that, till the wonder is excited how constituents so multifarious and seemingly incongruous can make up such a delightful *ensemble.* The room is large and lofty, the north wall being almost entirely taken up by the indispensable window, the lower half of which is obscured by curtains and hangings. Forming part of this is an old stained window of about the year 1600, taken from a church in Northern Germany, and there procured by Mr. Chase. A half-open shutter at one side serves as a panel on which are two broadly painted sketches, which might be taken to represent youth and age; above is perched the stuffed effigy of "a lordly raven of the saintly days of yore;" while below hang an old bronze lantern, the exact counterpart of that in Ribera's famous picture of Diogenes, another (more properly spelled "lanthorn," since the original semiopaque panes of horn serve in the place of glass), and a third, of brass, such as was carried in the old Venetian gondolas.

A number of Japanese umbrellas are variously disposed here, and underneath stands a table littered with old books (of which more anon), quaint jars, Egyptian pots, paint-brushes, strange

little wood-carvings of saints, Virgins, and crucifixes, and many other articles too varied to specify. Close by is a Nuremberg chair, with legs sloping like those of a settle, and a back solidly carved in the grotesque semblance of a human face. On it rests the fac-simile of a Puritan high-crowned hat, with enormous buckle, and one or two Italian court-swords—it may be a genuine Andrea Ferrara among them. The opposite side of the room is hung with a rich but subdued rug, and a superb specimen of Venetian tapestry, old and rarely beautiful in tone, a quality which is not often found, even where the linear composition and design are good. It represents a horse and a griffin, as nearly as one can make out, struggling in a forest. Over these draperies are placed a number of pictures and studies picked up in various places, but chiefly Venetian, with antique frames that bear the impress and mellow tone of many years. One of these surrounds a bronze medallion portrait, unquestionably of the time of Bellini; another an anonymous composition of sheep, which has quality of a high order; a third a crucifixion by Piazzetta, master of Tiepolo, the last of the strong Venetian painters; while others contain the head of a Fury, and various specimens of old painting. Here, too, hang arms, casques, and the various musical and offensive paraphernalia of warfare—guns, both Eastern and Venetian, swords, pistols, bugles, East Indian drums and tom-toms; a straight knife, with a leathern sheath and a rude wooden handle, on which is the date 1839, of the sort borne by the German farmers in the Bauern-Krieg, and many other curious articles. Under these, on the ground, stands a carved chest of the Renaissance period, such as was used in the hallways of Venetian palaces as a seat. Doubtless, could it speak, it could tell strange tales; it has heard many a page whisper soft speeches in the ears of pretty, black-eyed tirewomen, men-at-arms telling of their doughty deeds, or assassins plotting some secret crime. Now it is put to other uses, and has come into strange fellowship. It supports a Turkish coffee-pot of fine bronze, an Italian jar of exquisite green glaze, a gourd surrounded with wicker-work, and formerly used for carrying water, a white, pewter-mounted Renaissance jug of lovely shape and tone, with another and a candlestick of delicate blue, an old Nuremberg pot, duelling-pistols, a German-silver lamp, and a host of other objects. On the floor beside it lies a unique collection of women's footgear—dainty little slippers of green and blue velvet, with gold and silver embroideries, that have graced the feet of some sultana or favourite of the harem, choice Italian slippers, and rude shoes made from strips of rawhide, such as the Lapland women wear. The east end of the room is that where the easels stand, draped with old church velvets of about 1600, crimson and green in local colour, and spotted here and there with the wax that fell on them from the consecrated tapers which the acolytes bore. A palette, brushes, paint-tubes, oil-bottles, &c., are of course in keeping, and portraits and pictures in various stages may be uncovered to curious eyes. One lately seen may be alluded to. It is that of a very charming lady, with golden hair, dressed entirely in black, and standing in a natural and unconventional attitude against a background of figured silk, the prevailing tone of which is faint pink. The effect is beautiful and novel. On one side hangs the old, weather-beaten yellow sail of a Venetian fishing-boat, with its reefing-cords attached, and on the other some specimens of hand-made brocades, such as were worn by ladies in the rococo period, standing out stiff over enormous hoops . . . Here, too, are portfolios containing a most valuable and possibly unequalled collection, embracing some three or four hundred photographs of works by the old masters. There are studies and sketches by the artist and his friends; there is an old iron church-stand for candles, with legs like a tripod, a brass door-knocker representing a griffin, a Persian incense-lamp, a pile of quaint old books, and so on *ad infinitum*. Over the door by which we enter, and which fronts the end

of the studio just described, is the head of a polar bear, grinning down on three white-and-pink stuffed cockatoos perched on a screen—the frigid zone and the torrid in juxtaposition. To the left of this door stands a high cabinet, surmounted by a bronze bust of Voltaire, and having old Venetian lamps pendent on either side. One panel is covered with brocade, while over the other droops a scarlet Spanish donkey-blanket. It holds Japanese bronzes of curious design—a dried devil-fish, that looks almost like bronze, a veritable antique bust of marble, some delicate little ivory miniatures, various articles of pottery, Italian, Egyptian, and Japanese, an iron lamp, such as was used in the Thirty Years' War, with tweezers to pull up the wick attached, and a multitude of miscellaneous *bric-à-brac.* To the left of this cabinet is a door. Over it is an Italian coat-of-arms in the form of a shield, with lions rampant and quarterings, which the writer's utter ignorance of heraldry forbids him to descant upon, and beside it an old German clock ticks sonorously. This door brings one mysteriously to a small flight of stairs leading to a small gallery, which contains a sofa and an organ. It is a perfect little bower, and from it the entire studio can be overlooked, and a most exquisite effect caught. A solemn, almost religious feeling comes over one when, with church draperies and church lamps and burning incense around him, he sits in the subdued light below, and hears the organ sounding from above, now in a nocturne of Chopin, now in a sonata of Beethoven, now in a portion of a mass by Mendelssohn. In this gallery are hung a few choice water-colours by Villegas, Domingo, and others, and its recesses can disgorge multifarious treasures—things new and old . . . It would take days to explore the contents of this studio, and even then one would only be entering on a knowledge of the variety, value, and interest, of its contents . . . Japanese hand-wrought robes lie side by side with Venetian brocades and Spanish velvets. A Japanese ivory idol sits complacently alongside of a carved wooden saint, while a Greek bronze of Apollo stands proudly by. "From many times and lands" have come contributions to enrich a collection the cost of which the owner fears to think of; but everything has an artistic value, from the stained leather back of an old missal to the subtly delicate tracery of a bronze censer.

"Artists Receiving," New York Times, *March 5, 1882.*

It was "reception day" at the Studio Building, No. 51 West Tenth-street, yesterday, and the artists of the building threw open their studios to the inspection of numerous patrons. Over 1,000 invitations were issued, and for four hours in the afternoon there was such a crush of visitors that it was almost impossible to move about the building. Carriages lined both sides of the street, and crowds kept coming and going during the entire time given to the agreeable duty of receiving. The artists spent the time shaking hands with their callers, and in answering inquiries as to the newest works on their easels. Ladies constituted the majority of the visitors, and went into raptures over the curios in many of the studios, examining the easels and the draperies, bric-à-brac, and tapestries with great interest. Studios on the three floors were opened to the public, and the works of the artists were exhibited with attractive surroundings . . .

The double studio of Mr. Chase appeared to be the great centre of attraction to the lady visitors. It is on the ground floor, and the most elaborately furnished of any in the building. The walls are hung with all sorts of curious tapestries and bric-à-brac, and every nook and corner is crowded with some odd-looking treasure which arrests attention. The easels, with half-finished canvases, were but a small part of the attractions of the place, and the ladies spent hours in talking to the artist's birds and petting his spaniel, which lay stretched out lazily upon a couch of brilliant upholstery. The artist, with a little polo cap on his head, was kept busy entertaining

his many friends. Two colored valets in gorgeous costumes directed the curious observers hither and thither through the place with quaint courtesy.

ELIZABETH BISLAND ROVING THE STUDIOS

Elizabeth Bisland's tour of the New York studios in 1889 reveals a striking variety. In addition to the Tenth Street Studio Building, Bisland visits the Sherwood, the Holbein, the Fourth Avenue Studio Building, and the Benedick, among others. In passing, she remarks on studio social life, which ranges from St.-Gaudens's sybaritic Roman banquet to the middle-class domesticity of Carroll Beckwith and his wife. Bisland observes that, for some artists, studio décor also furnishes the props used in the tenant's paintings. This is the case in particular with the older John George Brown, successful painter of street urchins; his studio is full of such things as worn-out shoes and "battered little caps." Each studio Bisland visits clearly bears the stamp of its owner's individuality and stock in trade.

Elizabeth Bisland, "The Studios of New York," Cosmopolitan 7 *(May 1889).*

The tendency within the last decade has been to congregate in the great flat-buildings whose apartments are arranged with studios, conveniently lighted, and with domestic attachments that permit the artist's family to live next to his *atelier*. More recently many have preferred to take houses in the country, which permitted of larger and better lighted studios, arranged after their own designs, and where they believe themselves freer and further removed from jarring influences. The studio buildings still remain populous, however, perhaps the most famous of them being the Sherwood, on Fifty-seventh Street, built by John Sherwood, who was in his time a noted patron of the arts, and solicitous of the comfort and well-being of the painters. In this building most of the well-known artists have at some time found a home, and many have inhabited it for long terms of years. They never take root; they are likely at any given moment, after a good sale, to fold their tents—which are deposited in some storage warehouse—and steal away for a long sunny winter in an Egyptian *dahabeah*, to be heard of doing a little amateur guitar playing on a moonlit Venetian canal, or sketching muleteers in Spain. When the money from the sale is all spent, their names reappear on the door of some one of the apartments, and to the old artistic litter is added a new collection of picturesque odds and ends, redolent of Cordova leather or adorned with sphinxes, as the case may be—while canvases are stretched and primed for a great picture, the result of the months of wandering . . .

After the Sherwood, the best known of the studio buildings is on Tenth Street, where queer little labyrinthine corridors offer admission, through very small doors, to phenomenally lofty rooms lighted from above, and in which the voice echoes hollowly, as in a vacant barn . . .

St. Gaudens the sculptor has his *atelier*, somewhat gaunt in aspect—a few casts of heads and limbs and a still sparser furnishing of copies from the antique, making up its furnishing. The tools of his trade are about him; but Oriental hangings and Florentine daggers are no aid to the inspiration he needs for the stern type of "The Puritan," or the great sea-soldier which stands in Union Square, and in which all passers-by not only salute Farragut, the best type of modern American, but the best type of American monumental art as well. The sculptor's studio has far more the look of a workshop than the painter's, through the very nature of his materials . . . St. Gaudens, a New Englander, educated at the Cooper Institute, and thoroughly American in ex-

pression, is a tremendous worker, and his studio is a workshop in that sense as well as others, his time being always pledged for three or four years in advance. But once in a while he permits himself relaxations, one of which, a year ago, took the form of a Pompeiian supper, the big studio being decorated and hung with red, and the feasting artists disposed around the table on couches, clothed in Roman dress, and developing unexpected qualities of dignity and beauty brought out by filleted hair and classic draperies . . .

The Holbein studios, on Fifty-fifth Street, shelter Warren Eaton in a small, comfortable apartment, George Inness, declared by Benjamin Constant the greatest landscape painter of the nineteenth century, and others, not so famous, but well known. Inness occupies two large rooms, fitted much like two plain, dignified drawing-rooms, with conventional wall paper, carpets, and curtains, a few chairs, and no suggestion of the tools of his trade . . .

Near the Holbein is the Studio Building, and here among many others are the studios of William Lippincott and Bruce Crane, the latter occupying a little sun-flooded room, where he completes the studies he has made during the summer. He is still very young, and of strange, pallid, Spanish type. He began in the old American landscape school, which meant going to the Adirondacks to paint autumn foliage, but long ago found his brush was meant for better things, and has made his impression chiefly through pictures of the Long Island coast about Far Rockaway, and gray stretches of Jersey marsh done almost entirely in two colors, so low are they in tone. Beside these, which have a certain inimitable charm of quiet gravity, he has made several bold and successful experiments somewhat in the manner of Corot. A fishing-net canopies one corner of his room. There are a few stuffed sea-birds swung from the ceiling on wires, and a sparing and discreet use of the conventional studio decorations, while he is one of the very few of the artists who find pleasure in the companionship of a pet—a great, gray African parrot lightening his hours of toil with the charms of her conversation.

In the Sherwood lives Edwin Blashfield, a slender, erect blond, whose face is familiar in literary circles, through the merit of the brilliant magazine work done in conjunction with his wife. He is a New Yorker and a pupil of Bonnât, and his sixteen years of study abroad—principally in Paris—show in the delicate brilliancy of his style, in his accurate knowledge of antiquities, in a certain assured confidence in his touch, and in his appreciation of the value of architectural suggestions in his backgrounds. His studio is also his home, and includes a small suite of apartments, all of them adorned with the fruit of his many wanderings, in the shape of some peculiarly rich and splendid armor, antique jars and vases, and strange relics of Cleopatra's land . . .

Carroll Beckwith and wife find their home here, most of their life being passed in his pretty studio, where he knocks off work occasionally to lie on a divan under a low canopy, and strum his mandolin. The two are very familiar figures in society, and an air of much joviality pervades his workshop. He has been the teacher of several of the younger artists, and is peculiarly helpful and encouraging to the beginners in his profession. He also is from the West, and has many of the qualities to be found in the modern Spanish school, whose founder was Fortuny. Sawyer's studio in the same building is one of the handsomest in New York, being hung with magnificent Gothic tapestries, lined with valuable paintings—some of them old masters and others of the modern French school—furnished with black, deep-carved oak, and every spare niche and cranny crowded with antiques in bronze, marble, and pottery. It is of unexampled neatness, giving the impression of a handsome, well-arranged apartment where work is done incidentally, rather than of a workshop. Mr. Sawyer is the son of a wealthy New Hampshire man, and a nephew of the governor of that name. His father was opposed to his choice of profession, and

an agreement was entered into by which the son was allowed to study for three years, with the understanding that if he had not done something in that time to justify his choice, he would abandon it. A picture in the *Salon,* at the end of that period, vindicated his decision, and has been followed by a successful career . . .

Among the women artists, the best known are Rosina Emmet Sherwood, Rhoda Holmes Nicholls, and Dora Wheeler; but there is a numerous colony of them, mostly young, ambitious, and hard-working, either just back from study on the other side, or heroically economizing with a view to going there. Mrs. Sherwood is a pupil of Chase, and of Julien's Academy in Paris. She occupies her own parlor as a studio, a nice old-fashioned looking room divided by columns, and with an odd mingling of the usual drawing-room appointments with canvases, sitters' stand, easels, and paint-boxes. A pretty, tottering, silver-headed baby is an important and ubiquitous part of her studio furniture. Rhoda Holmes Nicholls also has substituted one in hers for the monkey which used to bear her company—finding a baby pleasanter and not much more mischievous. She used to occupy a great room at the Sherwood, heaped about with a confusion of stuffs and artistic lumber, and with a small space in the center cleared away, where she worked with tremendous industry and energy, producing medal pictures or teaching the young idea how to paint, in classes of respectful and admiring women. Within the year she has transferred the baby and the *Lares* to Twentieth Street, but has retained most of her methods of life and work . . .

In Fifty-second Street are some studios, so new that the unpainted wood still speaks to the senses of the forest, deeply yellow to the eye, and reverberant to the tread. Here, among others, live Miss Throop and George de Forest Brush; the first, alone in a big room adorned with relics of her life in Paris, and busily teaching, writing, and painting, with a view to return for more study. Higher up lives Brush, in a monkish cell, bare and narrow, and looking very much as if the artist had dropped in casually for a call, and was painting with another person's brush to while away the time of waiting for his host. Brush is a Southerner, born in Tennessee, and educated under the eye of Gérôme, whose superb methods he has absorbed without ever attempting to intrench upon his master's domain. He found at once in his own country his foreordained subjects. That gaunt, melancholy, pigeon-toed savage, standing alone in snow, "Mourning Her Brave," made his instant success, and since then he has created many noble additions to American art.

Dewing is another monk, who paints in a cell in the Fourth Avenue Studio Building, and whose only bit of bric-a-brac is a maraschino jug, hung there on a nail by Chase, after a frugal luncheon, while sitting for his portrait, as his decorative soul was vexed by the contemplation of bare walls. Dewing owns a more elaborate abiding-place, but it is mostly for show; and when he wishes to work he immures himself in this little, bare room, from which emerge his beautiful, cool, chaste dreams of women. He is a reformed Bostonian, a pupil of Boulanger and Lefevre, and a stalwart young David of ruddy countenance . . .

Robert Blum occupies a lofty, north-lighted room in the Benedick, on Washington Square, into whose windows come the sounds of rustling trees and distant, melodious thunder of church organs and singing choirs. The studio has reminiscences of Venice in its decorations, hints of Holland, and suggestions of Japan. Flowers grow on the windowsill, and a row of pegs is hung with bull-fighters' costumes, queer spangled muslin frocks of the Empire period, and prim lace caps that once framed fresh little Dutch faces. From Cincinnati, Blum got his art education for the most part in New York and Philadelphia, beginning by engraving bank-notes in his native

city. The rest of his teaching has been given him by himself during travels in Spain and Holland, and life in Venice . . .

Thomas Moran the etcher, and Mary Nimmo, his wife, work side by side down in their studio on Twenty-second Street. Big tables near the light, on which are laid the plates while the artists are at work, are an important feature of their furnishings; but there are easels, too, for before either of them was an etcher they were painters. There is not much attempt at decorative fittings here, the only adornments being Indian weapons, wampum belts, and other bits of savage finery, which were picked up by the artist when he was a member of a government surveying party and made the sketches for his great picture of "The Mountain of the Holy Cross." He lived among the Indians for many months, and from an artistic point of view has a high opinion of their value.

THE TILE CLUB: PLAY AS WORK

The Tile Club, active from 1877 to 1887, was one among several largely social artists' organizations formed in New York during the Gilded Age. Such clubs, which heightened the visibility of artist members through publicity, special events, or the exhibition and sale of work, were instrumental in building networks and new communities for mutual benefit and the well-being of the art world as a whole. Limited to twelve, membership of the Tile Club included Winslow Homer (briefly), R. Swain Gifford, Edwin Austen Abbey, and J. Alden Weir. Consistent with the group's fraternal culture, each member had a nickname: Homer was the "Obtuse Bard," Gifford the "Griffin," Abbey "Chestnut," and Weir "Cadmium." The decorative craze of the Aesthetic movement (see chapter 13) catalyzed the club's nominal aim, which was to meet monthly at one another's studios to paint decorative tiles. As important as the tiles was the jovial camaraderie of such gatherings, which extended as well to excursions in the country and other pleasures.

Member William Mackay Laffan describes the typical Tile Club blend of work and play in his 1879 article. His light tone belies that fact that the artists were keenly interested in mastering the novel medium, which demanded considerable trial and error. At the same time, the gathering described by Laffan fosters a mood of cozy male fellowship, complete with corncob pipes, cheese and crackers, various kinds of liquor, anecdotes, jokes, and impromptu music making.

William Mackay Laffan, "The Tile Club at Work," Scribner's Monthly Magazine 17 (January 1879).

This was early in the autumn of 1877, when studios were being dusted out and men were going around and smoking fraternal pipes with one another and comparing notes about the results of the summer work out-of-doors. There was more or less preliminary talk on the subject, and it was finally agreed that meetings should be held in one another's studios, every Wednesday evening, and that those participating should possess each in turn the results of one evening's work. It was determined, in an informal sort of fashion, to adopt the title of the "Tile Club," and to maintain it as a body without officers, limited in the number of its members to twelve, and to dispense altogether with entrance fees or dues of any description.

It was understood that the tiles for each evening were to be supplied by the person to whom when done they would accrue; and the same person was permitted to supply some other things,

but under rigorous restrictions. Cheese and certain familiar species of crackers were admissible. Sardines were not prohibited. Clay or corn-cob pipes and tobacco, and stone bottles of cider, and a variety of German ink not unknown to commerce completed the list. Upon one occasion, when a rash member ventured to produce hard-boiled eggs and sandwiches, he was visited with a reprimand—after they had all been eaten—that he will remember to the last day of his life.

The tiles that it was decided to use were those of Spanish make, of a cream-white color, glazed upon one side and in size eight inches square. Designs drawn upon them in mineral colors are subsequently "fired" in an oven and permanently glazed in. This process changes some colors entirely and it greatly improves the design by the brilliancy it imparts to the color and the manner in which it softens the outlines.

The first meeting of the Tile Club was called and was attended by two persons, whose feelings may be imagined. They painted two tiles, but as there is no record of those objects of art their authors are supposed to have relieved themselves by throwing them at each other . . .

Subsequently there appeared and handed in their allegiance the "Obtuse Bard" (whose birthplace was rendered obscure by a bad habit he had of promiscuously begging his bread, for purposes of erasure), the "O'Donoghue," the "Bone," the "Owl," "Polyphemus" (so called from his somewhat obscure resemblance to a gentleman of antiquity who is mentioned in connection with the crude experiments of the oculist, Ulysses), "Cadmium," and the "Marine" and the "Griffin." A certain enthusiasm declared itself, the attendance became regular and the club settled down into a solid, hard-working and self-respecting body . . .

It was not at any time prescribed what manner of tiles should be produced. Each member of the club proceeded just as his fancy dictated, and it was very seldom that any one did anything that was premeditated or studied in its character. To this fact may probably with justice be ascribed a certain freshness and simplicity of design, and an original and speculative quality, which gave to the products of each evening's labor a charm which was none the less distinctive and real for being more apparent to its individual authors than to any one else. Keenly alive to a sense of modesty as the writer undoubtedly is, yet should it be far from his purpose to say aught that even the most jealous or designing reader could construe into a reflection upon the tiles of the Tile Club, or their artistic quality. What it is sought to convey is merely that this artistic quality is so difficult of definition or accurate description that it had best be left to a discriminating and judicious public to discover and to admire . . .

The members of the Tile Club are nothing if not loyal to that worthy institution, and it is unusual to find one missing of a Wednesday evening, no matter if it hails, rains or snows. A cheery, jolly fire burns brightly under the tiled chimney-piece, and everything looks ruddy and warm and comfortable. The beneficiary of the evening has arranged a long table in the middle of the room. He has composed it with great skill from some small tables and a series of large drawing boards superposed. On it he arranges the tiles, the small palettes, the "turps" (*vulg.* for *spt. terebinthiæ*) the boxes of brushes, pencils, rags and color-tubes, and places his "student lamps." There are plenty of chairs of various patterns; there is a big Japanese screen; there are numerous pictures finished and unfinished, and frames for them old and new; there are countless odds and ends from the workshops of the "moon-eyed lepers"[2] and their more civilized

[2] Derogatory name for the Chinese.

neighbors, the Japs; and there is no end of the interesting litter and confusion necessary in every well-regulated studio.

At about eight o'clock the "Owl" drops in and, having taken off his ulster, assumes decent dimensions. "Polyphemus" and the "Bone" follow in a few minutes, and then the "Grasshopper" stalks up the stairs and emerging from his outer casing, extends his antennæ. Every one is in his place by half-past eight, cleaning off his tile with "turps" and a rag, or sketching in his design with a lead-pencil or a bit of lithographic crayon. Some get an idea or a drawing out of an old sketch-book, but the majority evolve their subjects out of their inner consciousnesses. Sometimes drawing after drawing is made and as quickly obliterated before one is hit upon that is thought good enough to be allowed to live. Occasionally it happens that an unhappy tiler ends up his work when all the rest are done by declaring that he "has nothing in his head"; and cleaning off his tile, he takes it home to execute it under more felicitous conditions. Of course it will be understood that this revelation is confidential.

Nearly all the tiles are done in monochrome, "Victoria blue" being the color chiefly affected. It is extremely difficult to use colors at night; in fact, no satisfactory work can be done with them by lamp-light. Some tilers do not sketch in the design at all, but go to work experimentally on the tile at once, gradually evolving something coherent and partially rational out of some probationary and capricious "dabbling." This, too, must be regarded as confidential; and while in this mood, at the risk of being considered reckless, it may be admitted that some frightfully bad tiles are known to ensue. These the beneficiary tries to receive with as good a grace as possible; being aided thereto by the author, who explains his motive, and cloaks the utter depravity of design and execution in choice terms of art, such as one reads in the newspapers when some eminent enthusiast is dwelling upon the vague transcendentalism of something "attributed to Corot."

Of course all the work began with the notion that it was expedient to "do something decorative"; but it would be very difficult to determine from a survey of it, or from a knowledge of the general spirit and behavior of the tilers, how far this idea was kept in view. It could not be said that any theory or theories of decorative art were worked out, or discovered, or even sought. There were discussions of these that were simply superb . . . There were frequent occasions when delightful rows occurred. Then the other tilers would fill their pipes,—for these things always occurred after the tiles were done,—and sit about and possess themselves with the sweetest satisfaction; occasionally giving the fire a friendly poke, by throwing in a lively suggestion, if there were any suspicion that either or both of the combatants were showing signs of flagging. Fortified with cheese, crackers, etc., these disputations progressed with great spirit, and were only interrupted when the master of ceremonies tapped the back of his violin with his bow and announced a quartette, a solo or a ballad from the "Barytone."

ARTISTS IN THEIR SUMMER HAVENS

Married to the peripatetic painter James Wells Champney, Elizabeth ("Lizzie") Champney too became an inveterate traveler (see also "A Child's View of the Watercolor Show" and "James Wells Champney on Pastels," chapter 12). At a pace that suits the subject, her rambling essay on American artists' summer haunts gives the reader a tourist's-eye view of the picturesque hideaways and quaint dwellings that sheltered the artist in search of refuge from the pace of metropolitan life.

Lizzie [Elizabeth] W. Champney, "The Summer Haunts of American Artists," Century Magazine
30 (October 1885).

Every summer the Europe-bound steamers go out freighted with tourists; and, in proportion to their numbers, our artists are more fully represented in the general exodus than any other class. They have strapped their sketch-boxes for out-of-the-way nooks in Surrey and Kent; for the Scottish Highlands and Lakes; for Normandy and Brittany, the Rhine and the Black Forest; for Grez and Barbizon; for the Tyrol or the Pyrenees, or the fiords and mountains of Scandinavia. Yet those who stay at home are more numerous than those who seek foreign scenes and exhibitions, and include, naturally, names of assured reputation,—men who have already profited by the educational advantages of Europe, and for whom castles, cathedrals, and wooden-shoed peasants have lost a little of the novelty and romance which appealed to their earlier years, and upon whom has dawned a growing appreciation of the artistic resources of their own country . . .

. . . The demand made by the public and the critics that the work of American artists should be American in subject at least, is largely conceded; and the varied scenes of our mountains and coasts, and our more pronounced and picturesque human types, are everywhere studied with avidity. One can now scarcely make a summer excursion in any picturesque locality without encountering the white umbrellas and light portable easels of the nomad artist. A few favorite sketching-grounds, typical artist-camps and summer studios, it is our purpose to describe.

The Hudson has long been considered the property of the older men . . . In these later days other less imposing names and buildings have bordered each side of the river with a picket-line of studios. Some are mere gypsy booths, or bivouacs in barns and venerable canal-boats which have outlived their days of commercial usefulness and now luxuriantly devote their declining years to Art; and over in the Catskills we have artistic campers and trampers whose entire summer's outfit might be fastened in a pair of shawl-straps. So varied is the environment with which artists love to surround themselves that one is tempted to ask for a new definition of the word studio. We have borrowed it from the Italian, where it means study or school. The French *atelier,* workshop, on account of its newness smacks a little of affectation, but it pretends to less and would serve our purpose better. Especially is it appropriate to the painter's summer shed. In the city he often yields to the temptation of a *show* studio, a museum of rare bric-à-brac and artful effects of interior decoration; in the country he surrounds himself rather with the necessary conditions of *work,* and with some these conditions are very simple, embracing little more than Nature and isolation. Barns have always been favorite workshops for artists. The airy loft, with its one great window and undivided space, would seem to furnish favorable light and elbow-room. But inasmuch as hay is dusty, an abandoned barn is a still greater treasure . . .

Rhode Island abounds in colonial buildings, and at Conanicut Mr. Sword of Philadelphia has leased the town hall, which he has fitted up as a most interesting atelier. In the same old town Walter Satterlee has established a summer studio.

Across the bay from Narragansett Pier is Newport, too fashionable a resort to be dear to men of the usual type of artistic temperament. "A man cannot serve two masters," and an artist, be he never so genial, cannot give himself to polo, lawn-tennis, garden-parties, and society, and be worthy of his calling. Newport, however, claims Mr. John La Farge and Mr. William T. Richards, whose new residence is at Conanicut; and Mr. Samuel Colman has dared to build a beautiful studio and home in the very center of the summer Vanity Fair.

Continuing our tour around the New England coast, we arrive at Nonquitt, near New Bedford,—a beach most appropriately named, for its waters seem to possess the magical return-compelling property of the Fountain of Trevi. Neighbors both in winter and summer, and friends all the year round, are Messrs. Swain Gifford and William Sartain. Mr. Gifford has painted here for twenty years. Eight years ago he established a summer home here . . . It is an old joke that both Mr. Sartain and Mr. Gifford paint Moors; but while Mr. Sartain's have been Saracens of Tangier, sheiks with Koran or nargileh, Mr. Gifford's are the lowlands that stretch about Nonquitt to the sea. Salt marshes, sand dunes, and low, flat reaches appeal to him strongly through their windy desolateness . . .

Sailing across Buzzard's Bay and skirting the shores of the Vineyard, we reach Nantucket, one of the rare spots which preserve the flavor and atmosphere of the olden time. The island—with its types of old men and women that are fading out elsewhere, even in other remote nooks of Massachusetts, its queer houses and windmills, its antique furniture and costume—has long been the artistic "property" of Mr. Eastman Johnson. The man and the place have a natural sympathy for each other. He is a chronicler of a phase of our national life which is fast passing away, and which cannot be made up with old fashion-plates and the lay figure of the studio. He lives in a fascinating "house of seven gables," filled with curiosities brought to Nantucket by seafaring men,—keepsake pitchers inscribed with amatory poetry, and made in England a century ago as gifts for sailors' sweethearts, and many another treasure in willow-ware or other china. Mr. Johnson's studio is stored with antique furniture, spinning-wheels, and costumes. A row of battered hats suggest the antiquated squires, Quakers, and gentlemen of the olden time that have made their bow to us in his pictures . . .

We have given but a hasty survey, noticing only a few of the outposts. Other home fields are worthily occupied, while more are still undeveloped. The South allures, and the North is full of stimulus. Everywhere the whole wide new land invites her artist sons, not in summer alone, but throughout every season of the changing year, to tell her story to the world.

VARNISHING DAY

Tonalist landscape painter Charles Warren Eaton is typical of the many young artists who struggled to begin their careers in New York City during the late nineteenth century. Born in Albany, he came to Manhattan in 1879 and studied at the National Academy of Design and the Art Students League. His lack of resources forced him to work full-time in a dry goods establishment, leaving only his evenings for painting. The resulting inability to work in natural light was, in his opinion, a serious handicap. Nevertheless, Eaton's first great success came in 1882, when several of his paintings were accepted for exhibition at the National Academy. In a letter to his friend Leonard Ochtman, a landscape painter then living in Albany, Eaton breathlessly recounts his initial experience of Varnishing Day, when artists had their first opportunity to view the placement of their works in the exhibition (his inattention to punctuation and spelling is probably a sign of his great excitement). Eaton jokes about the fact that his paintings were "skied"—hung very near the ceiling. Still, to have four paintings accepted was a coup.

A few years earlier, the New York Times *published an essay examining "that fetich of artists, the line," suggesting ways to reduce the hurt feelings stemming from skied*

pictures by contriving to hang more of them at eye level, "on the line." It is a rare, inside look at one of the rituals of the competitive art world. Another means of understanding this issue is through the set of guidelines established by the Society of American Artists to regulate the selection and hanging of works for their annual exhibition. These rules, passed in 1883 and amended several times in later years, are extremely detailed and complex. They stress merit above all else and can be seen as insurance against the "insider" methods of the National Academy, against which the Society rebelled (see also "Young Turks: The Formation of the Society of American Artists," chapter 10).

Charles Warren Eaton to Leonard Ochtman, October 21, 1882, Bruce Museum, Greenwich, Connecticut.

You have probably received my card telling you that our pictures were hung which I mailed as soon as I knew about it. I got away from the store yesterday afternoon and went to the Academy to learn our fate. Well! I got there and found that I was not the only one there in fact there was several ahead of me when I got to the foot of the Grand Staircase which was closed by a great gate to keep out intruders outside of the gate was a table at which sat an old lady with a long list in her hand. (she reminded of the recording angel or some other angel though she was not very angelic in appearance) which she looked at every time to find the name given her. which if she found, the owner thereof was allowed to go up stairs, if not he must go the other way.

My turn came at last and when I gave her my name I realized how disapointed I would be if she could not find it there. but she found it and I was allowed to go in . . . There was men (artists of course) around painting the floors and others painting the pictures and chairs and step-ladders lying about every where men smoking. Women with aprons on and varnish pots and brushes in their hands and a scene of confusion everywhere so you can imagine that it was rather difficult to see the pictures so I must reserve my opinion in regard to the exhibition until I have seen it under more favorable circumstances as it was I was rather disapointed. Well, I looked around for our pictures for I was still in ignorance of how many of mine they had hung so I commenced my search. and went first in the east room but found nothing then into the north room where I found my "Grey Autumn" beautifully hung on the top line and on the other side of the room your sheep Pasture (I call it that not knowing the name as the catalogues are not out yet) in an equally aristocratic position and I can assure you that they looked down disdainfully on those below them. having exhausted that room I went to the northwest room but found nothing there. next in turn came the West room where I found my "Spring Twilight" in not a bad position for although it was on the top line it was next to the door and not very high. as I had sent two more I still kept up the search and in the same room found my "November" still on the top line. Well! thinks I. if they hung that *thing* they surely wouldn't leave out "Hester Prynne" which I thought my best one so sure enough I found it in the south room and fairly hung so I was satisfied. having exhausted my stock I looked around to see who I could see and found out a number of artists by the pictures they were working on among others were Quartley, Turner, Blashfield, the two Morans, de Luce, etc. Thus ended my first experience on Varnishing day.

"Pictures Hanged, Not Hung," New York Times, *January 1, 1880.*

Perhaps artists hurry over the task assumed by the Hanging Committee because such service is disagreeable and ungrateful, but certainly it seems to the outer barbarian that those intrusted

by the Academy and the Society of American Artists with the arrangement of the pictures show little adaptive faculty. It would not be easy to overestimate the worry and vexations which assail men of any marked degree of sensitiveness when the question of how and where the pictures of their friends and acquaintances shall be hung demands an imperative answer. Artists are usually sensitive to an alarming degree, and, like literary men, not infrequently irascible. Consider, then, the position of, we will say, the three men who have to dispose of 500 pictures at one of the exhibitions of the Academy. How difficult must it not be to avoid partiality, how impossible to escape censure! The fair-minded members of the committee would like to have nothing but one strip of wall to deal with, and that so narrow that every picture would be on the line. For no matter what the picture, it must go on the line. It does not follow that an artist is pleased to see his picture skied, although it may have been designed expressly for a long view. The paint may have been put on with a trowel, and the lights and darks calculated for effect at a great distance, and yet, strange to say, the artist wants that picture "on the line." Why? Because the line has an honorary significance. People think a picture that is high up is despised, because pictures that are despised are, or at least ought to be, put as far off as possible, that their defects may not offend unnecessarily. An artist may, therefore, know that his picture will really look better skied, and yet refuse to permit it to be skied. He reasons that those who know will make the necessary allowances, while those who do not will be imposed upon by the fact that it has a place of honor. Such is the tyranny exercised nowadays by that fetich of artists, the line.

Since it is the line which is in fault, there are two ways to dispose of the line. One is to abolish the line. Attempts at this have been made, but in a very desultory way. One year saw the Academy full of pictures in groups, the members of each of which belonged to the same artist. While one or two of the canvases of each were on the line, the others were disposed above, and the feeling that these latter were in any way disparaged could hardly exist. The move was good, and only unfortunate in, not being repeated. If it did not abolish the line, it neutralized its deadly effect, for, of course, a choice was made in each man's work, and the picture that looked better high up was hung accordingly. The other way is to extend the line until it embraces almost all of the commendable or remarkable pictures. Why this has not been done before is indeed strange. Apparently, the Hanging Committees at the Academy have been waiting until some one adds another gallery or two to the building before obtaining such a result. Yet an extension of line can be obtained by very simple means, namely, by an extension of the ordinary method used in picture shops where choice paintings are disposed on easels. Why should not the centre of the large gallery of the Academy be fitted with a light framework, easily placed in position and quickly removable! Nearly as many pictures could be hung on it as the walls themselves contain. The framework need not be so high as to break the entire *coup d' oeil* of the gallery, and might be reserved for smaller pictures that want a close inspection.

There is still a third course to pursue which would consist in a combination of the above. The tyranny of the line might be broken by resolutely foregoing the present architectural system of hanging pictures. At present the Hanging Committee selects a large wall and puts a large picture in its centre. Two smaller pictures are then hung on either side for symmetry, and the still smaller grouped about them. This is supposed to please the eye as it takes in the whole side of a gallery. But while the general aspect is consulted the rights of the individual pictures are lost. The tendency is to hang by size, not by color or adaptability to light, subject or technical treatment. A big, ugly, sprawling picture (what exhibition here or abroad does not contain such?) gets a high seat in the synagogue from its mere brute elements of length and height. A smaller

picture, tenfold more valuable, waits long for its chance, and easily may have to bring up in an out-of-the-way corner where it cannot be seen. The watchword for Hanging Committees, then, should be the paradox: Break the line and extend it!

"Selection of Pictures for Exhibition," Catalogue of the Seventh Annual Exhibition of the Society of American Artists *(New York, 1883).*

RULE I.

Each picture offered for exhibition must pass a preliminary examination by the Board of nine Jurors, and receive a vote from each. A suitable concealment of the artist's signature shall have been previously made by the person in charge of the Exhibition, to continue till after the final verdict of the Jurors, pending which they shall not criticize or discuss the merits of the picture.

RULE II.

The degree of excellence of a picture shall be expressed by the use of a numerical series of ratings— ninety being the highest—decreasing by tens.

Each Juror shall indicate his opinion of such picture's merit by a vote which shall be expressed by the integor of the numerical class in which he places it, and these numbers being added together the sum will give the rank in the series to which their united judgment assigns it.

RULE III.

The numerical rating each picture receives shall be at once clearly marked upon the back, and they shall be placed in rows against the wall in the order of their series.

RULE IV.

All pictures, except those receiving on the first vote no mark whatever, shall be received the day following the completion of the first examination, a majority of the Jury deciding which pictures shall be subject to a second vote.

RULE V.

A two-thirds majority vote of the Jury shall decide with which number in the series rejection outright begins. (At the Exhibition of 1882 all picture below the rank of thirty were thus rejected.)

RULE VI.

HANGING. The Hanging Committee shall receive the accepted pictures, and hang them according to the rank in which they have been placed—liberty, however, being given them to facilitate proper arrangement upon the walls by a departure from the exact rating of a picture to an extent, either higher or lower, not exceeding the number five. They are at liberty also to hang a picture above its rated place, provided such change work no detriment to its effect. They shall, while the hanging is in progress, pursue their work without interference, unless such is asked by themselves.

RULE VII.

Should it be impossible to hang *all* the pictures, only those marked the lowest shall remain unhung, the full Jury to decide by a majority vote as to their rejection, the same latitude of choice being allowed as in Rule VI., and a line of pictures may be in such event placed upon the floor or on screens, should the full Jury so decide by a majority vote.

RULE VIII.

The numerical rank of each picture shall be distinctly marked on the *outside* of it previous to the final revision, which shall be made by the entire Jury after the Gallery is hung, a majority

of whom shall decide whether in any case a new vote is needed, in which case corresponding instructions shall be given to the Hanging Committee.

RULE IX.

No picture once hung can be withdrawn by the artist before the close of the Exhibition.

RULE X.

The Jury shall decide by a majority vote each year the number of pictures any one exhibitor may contribute, or the amount of space he may occupy.

Fig. 10. Robert Swain Gifford, *An Old Orchard near the Sea, Massachusetts,* 1877, oil on canvas. Smith College Museum of Art, Northampton, Massachusetts.

10 THE GILDED AGE

Education, Institutions, and Exhibitions

EDUCATION

A CAUTIONARY ESSAY ON ART INSTRUCTION

Art education was a growth industry in the United States during the late nineteenth century, as the figures in the following article by the critic and publisher Sylvester Koehler indicate (see also "Sylvester Koehler Reflects on a Decade of American Art," chapter 12). The periodical literature devoted to the many American schools of art was generally celebratory and positive, so it is interesting to read Koehler's warning that the United States might in fact be educating too many artists and filling them with false hopes for their commercial success. His essay stems in part from an elitist concern with eroding standards and hierarchies, yet it also is informed by extensive research he conducted (not included in this excerpt) on the market for art in the United States.

S. R. Koehler, "Art Education and Art Patronage in the United States," Penn Monthly *13 (May 1882).*

Some years ago, William Morris Hunt, the artist to whom we owe the mural paintings in the Capitol at Albany, was invited to lecture at Yale College. In reply to the invitation, he wrote a long letter, declining the honor, which he finally deemed it best to suppress, substituting therefor a short and formal note. The letter was, however, preserved, and Dr. Henry C. Angell gave it to the public in his "Records of W. M. Hunt," which appeared originally in the *Atlantic Monthly,* and were afterwards published in book form. From this letter the following extracts are taken:—

"One capable artist, with his assistants, employed as formerly, would produce more good workers than all the schools in the country, and with this difference: that works would be produced, instead of theories and advice and teachers. If good art is produced, take advantage of the fact, instead of inveigling hundreds into an occupation where not one in a thousand can make a living, unless he resort to talking, toadying, or speculation . . . It seems to me high time that something should be done to encourage producers. The country is being overrun with art-teachers and lecturers, because we don't want doers, but talkers. When we really want art, there will be a call for artists

to paint, and producers will be respected, employed and encouraged. The world seems to want machines to manufacture artists, poets, statesmen and philosophers; but when these exist, neither their work nor their opinion is wanted. One is invited cordially to join the gang, and produce what he is not to produce—works . . . If Michael Angelo and Titian were living to-day, they would not be called upon to paint. They would be listened to by the wise, and told that the Greek only could produce art. Were they even to lecture from Maine to Georgia, artists would not necessarily rise up in their wake."

William Morris Hunt is responsible for many queer things, painted as well as spoken, but nothing will be found in all the writing on art that has of late years afflicted the country, showing a better appreciation of the present artistic situation in the United States, and going more thoroughly to the very root of the question which it is the purpose of these papers to discuss, than the extracts just quoted. They contain the pithiest statement yet made of the strangely anomalous and dangerous condition into which art and artists have been forced in our country,— a statement which is all the more weighty, as coming from one who was himself an artist. It may be suggested, however, that it is simply the outcome of a mind embittered and diseased by unsatisfied ambition. But it needs only to be amplified, to convince all thoughtful persons that this is not so. To undertake this amplification will be my first and principal task.

We have heard a good deal, lately, of the great artistic development within these United States, and certainly the interest we have shown in matters of art has increased most marvellously. But it seems about time to stop in our career, and to examine what the development has led to. So far as I can see, the result may be summed up briefly thus:—An increase of schools, of artistic societies of all sorts, and of exhibitions; and an enrichment of technical methods, which latter, however, is due mainly to influences from beyond the sea. "Only this and nothing more."

"The world seems to want machines to manufacture artists, poets, statesmen and philosophers; but when these exist, neither their work nor their opinion is wanted. One is invited cordially to join the gang and produce what he is not to produce—works." That is what Hunt said, and Hunt was right. It suits the present state of affairs among us, exactly.

As evidence, I submit the following facts:

From a statement which I have lately made up, I find that there are at least thirty special schools in the United States in which "art" is taught. One-half of these schools are devoted to the training of artists proper and teachers of art, and the number of pupils attending them amounts to over 2,400. The other half comprises the schools for designers, skilled artisans, etc., and the attendance in them is between 3,000 and 4,000. With this second division of the army of learners, however, we are not concerned. If the schools which these artisans attend make them, indeed, more skilled, and do not corrupt them into unskilled artists, we will vote them a blessing. Our business lies more immediately with the 2,400, the great majority of whom are women.

Vasari, in the introduction to the third part of his "Lives," exults over the fact that, owing to then modern improvements, it was possible for an artist in his day to produce six pictures in one year, whereas formerly it took six years to produce one picture. We can beat that, as everyone knows quite well from the auction sales of some of our artists, who turn out seventy-five to one hundred pictures yearly with the greatest ease, even if we must admit that these pictures are not great frescoes or altar-pieces. But in spite of this fruitfulness of our painters, we will accept the modest sixteenth century estimate, and will call six works per annum the producing capacity of each artist. Now, if we place the course of study in our schools at four years, which will give us an average of 600 pupils in each class, we shall have a yearly accession of 600 to the

ranks of our artists, with a producing capacity of 3,600 works per annum. Furthermore, if, for argument's sake, we assume that there were no artists in the country when these young men and women began to study (which is manifestly untrue), and if we vouchsafe to each of them a life of only thirty years after they have left school (which is little enough, as artists are notoriously long-lived), we shall have, in thirty years from the time the first of the 2,400 entered school, 18,000 artists, with a producing capacity of 108,000 works per annum! And this upon the presumption that the number of pupils remains stationary, while one of the great arguments for our development is drawn from the fact that the attendance increases from year to year. I know well enough, of course, that not all of these students will reach the aim with which they entered upon their career. But we can discount the figures given to our heart's content, we can kill off as many of these unfortunates as we please, we may even say that fully one-half will never be producers, and still the number left will be simply appalling.

I argue, then, that we are producing altogether too many artists . . .

Art is "an occupation," said William M. Hunt, "where not one in a thousand can make a living, unless he resort to talking, toadying, or speculation." That is precisely the meaning of my friend's paradox.

In the face of these facts it behooves us, for the sake of humanity, as well as for the sake of art, to pause, and give serious consideration to our present system of art education and art patronage.

"If good art is produced," said Mr. Hunt, "take advantage of the fact, instead of inveigling hundreds into an occupation where not one in a thousand can make a living." In other words: "Do not induce more and more young men and women to apply themselves to art, so long as you have not work enough to do even for the good artists already among you."

Webster defines the verb *inveigle* as follows: "To persuade to something evil by deceptive arts or flattery; to entice; to seduce; to wheedle." It is a hard word to use in the light of this definition; yet I fear that Mr. Hunt was justified in using it.

But, before I proceed, I must beg of my readers most earnestly that they will not misunderstand what follows, as I hope that they have not misunderstood what went before. Whatever I may say against our prevailing system of art education does not stamp me an enemy of art schools on general principles. As we are now situated, art schools are a necessity, and the question is only as to their quality. Furthermore, I wish it to be distinctly understood that I am the last man likely to say anything against drawing in our public schools, from the primary classes up to the highest institutions embraced in our system, so long as it gives itself for what it really is and must be: that training of eye and hand, and that imparting of a knowledge of form which every one ought to have. Such teaching of drawing, however, is not "art education." As well might we call writing and grammar "poetical education."

Having thus defined my position, I can now endeavor to answer the question which will naturally arise in the reader's mind: How do we "inveigle" young people into the occupation of which Mr. Hunt has drawn such a doleful picture?

The answer is simple enough. By lowering the standard of art education; by easing the way of the student beyond all warrant; and by holding out rewards which, while they may serve to heighten the self-esteem of the pupil, are utterly worthless, either intellectually or materially.

It is not to be gainsaid that most of our art-schools are of a very elementary character. That, however, is not a crime, so long as they are acknowledged to be elementary, and are thorough as far they go. Speaking of the school of drawing and painting at the Museum of Fine Arts in Boston, Professor Ware, its late secretary, says: "The school is distinctly elementary, and as such

is not to be compared with such institutions as the Art Students' League in New York, the organization of which is specially adapted to students in a considerable state of advancement." No danger can arise from an institution whose limitations are so clearly understood, and so openly expressed. Nor is anything to be feared from a school like that of the Pennsylvania Academy of the Fine Arts. The admirable results it has shown are amply explained by the great importance attached in it to the study of anatomy, and by the last paragraph of its circular, which states that "the Academy does not undertake to furnish detailed instruction, but rather facilities for study, supplemented by the occasional criticism of the teachers." Plainly, this is not "a machine to manufacture artists." The danger arises from those schools which, by high-sounding titles and flattering prospectuses, hold out the vain hope of leading their pupils to the very pinnacles of art, and then, perhaps, cap the climax by sending those whom they have misled forth into the world with a certificate or diploma. I shall not endeavor to analyze the motives which animate these institutions. Whatever the motive, the result is the same. Take, for instance, the institution which bears the noble title of "The Massachusetts Normal Art School." No objection could be urged against it, if it were simply called, as it ought to be, a "Seminary for Teachers of Elementary and Industrial Drawing." But when we see the crude still-lives, and the weakly heads which are a regularly recurring feature of its exhibitions, and when in their presence we recollect that one of the certificates of this school entitles the holder to teach in *art* schools, our hearts sink within us . . .

A still greater evil, however, than the low grade of our schools is the undeniable tendency towards the multiplication of these incompetent institutions. Every city, every village almost, wants to have its "art school," when it ought to be satisfied with an ordinary drawing class. If we desire "to do something" for art, we straightway open a new art school, or, in the words of Hunt, we cordially invite a new lot of young people to join the great gang of those who are asked to produce works which they had better not produce, because nobody wants them. And to fill our classes and swell the list of pupils, we make the terms as easy and the course of study as pleasant as possible, and we give prizes and medals and honorable mentions, and possibly certificates or diplomas. And with these and a completed course of instruction, but nevertheless with a totally inadequate education, these students are sent forth into the world to begin the battle of life . . .

And once more the question recurs: What are these young men and women to do? If they were wise enough to laugh at the world's indifference, and energetic enough to do downright hard work, they would throw away their brushes and modelling-sticks and begin a new career,—difficult enough, no doubt, but not as difficult, at least, as that in which, to quote my text again, "not one in a thousand can make a living without talking" and sundry other unpleasant operations. Few, however, take this course; some because—looking upon themselves as slighted geniuses, Raphaels and Michel Angelos in disguise,—they will not; the great majority, probably, because they cannot. And so there is nothing left for them but to turn round and *teach;* that is to say, to inveigle others into the ranks of Mr. Hunt's hopeless gang,—a calling which their certificate of proficiency, mayhap, expressly authorizes them to exercise. Our cities abound with so-called artists who undertake to teach what they do not themselves know, and whose lives must often be embittered, if by nothing else, by the knowledge of their own incompetence. And as each incompetent teaches several others, everyone of whom is in turn compelled to do the same thing, it is quite evident that the curse must spread in ever-widening circles.

That this sad result is the outcome of well-meant effort, of charity, of enthusiasm, cannot be doubted. We are admired by all the world for the large sums we expend upon benevolent

and educational institutions, and French writers especially are astounded at the art schools cropping up all over the country, and all of them, with one exception, the result of private effort and munificence. Some people have even gone so far as to envy us these possessions, and to deplore that, besides the *Ecole des Beaux-Arts* and one or two provincial institutions, there are no art schools in France. Would to heaven that we had one great, thorough, yet broad, national school of art, with a Louvre and a Luxembourg alongside of it, the one to teach us the lessons of the past, the other to cheer and honor the workers of to-day!

Looking all these facts squarely into the face, I have come to the conclusion—at which some of my readers may possibly be shocked—that what we need at the present moment is the *discouragement* rather than the *encouragement* of art study.

I repeat, distinctly and deliberately, *discouragement. Discouragement,* that is to say, (by raising the standard and tightening the discipline of our art schools,) to those who would take up art from necessity or indolence only, as an easy and genteel occupation, and who, having no calling, can have no hope; but the best of *encouragement* to those who are willing to work faithfully and resolutely, and who come clothed in the garb of "love, fear, obedience and perseverance." We need not fear that by following such a course we shall incur the danger of stifling some genius. Genius cannot be stifled, and will work its way up in spite of all obstacles.

Boston

WILLIAM MORRIS HUNT'S *TALKS ON ART*

Although in later life he was based in Boston, painter William Morris Hunt spent more than a decade studying in France, where he was particularly marked by the teaching of Thomas Couture and the influence of Jean-François Millet. In painting, Couture believed the most important concept to master was value—*not the all-important line stressed by other French academics. Hunt came to feel that getting the values right— balancing the system of lights and darks that structures the entire range of tones of a painting—allowed for a more accurate translation of what the artist sees than an obsessive focus on contour, surface, or detail. His color was often subdued and applied in patches; his compositions were simple in design, consisting of a few broad slabs of paint fitted together loosely. When he drew, it was usually with friable charcoal, allowing for rich and varied effects of light, with banked shadows rather than crisp edges. These qualities he found epitomized in the works of Jean-Baptiste-Camille Corot and his hero, Millet. He also propagated his philosophy in his teaching of an informal class of women in Boston's Mercantile Building. The following conversational remarks, collected and arranged for publication by his student and assistant, Helen Knowlton, give an idea of his studio musings (see also "Poetry in Paint: Art in Boston," chapter 8).*

William Morris Hunt, Talks on Art *(Boston: H. O. Houghton, 1878).*

Drawing?

"Yes, or *trying.*"

All anybody can do is to *try!* Nobody ever does anything! They only try!

Nature is economical. She puts her lights and darks only where she needs them. Don't try to be more skillful than she is!

Why draw *more* than you see? We must sacrifice in drawing as in everything else.

You thought it needed *more* work. It needs *less.* You don't get mystery because you are too

conscientious! When a bird flies through the air you see no *feathers!* Your eye would require more than one focus: one for the bird, another for the feathers. You are to draw *not reality, but the appearance of reality!*

You put in so many lights and darks that your work is mystery overdone:—a negation of fact.

You see a beautiful sunset, and a barn comes into your picture. Will you grasp the whole at once in a grand sweep of broad sky and a broad mass of dark building, or will you stop to draw in all the shingles on the barn, perhaps even the nails on each shingle; possibly the shaded side of each nail? Your fine sunset is all gone while you are doing this . . .

Give up the idea of "color" for awhile! Consider masses—values, only. Some engravings of Titian's pictures almost represent his color. At first sacrifice the beauty of your drawing to getting values.

Make on a flat paper, the map of the thing. Then look for tangibility. See what makes the *picture!* The picture is what can not be described in any other way than by painting. Literature cannot take the place of art.

All notes in music are not high. There must be low tones as well. Put in only such details as will help the masses. Don't have your work *all trills!*

How are things visible? Can you see an egg against a white background? Not by drawing a line around it can you make it evident!

The vitality of flesh is *felt.* You cannot *see* the outline of that arm. It exists by the help of what lies next to it. The dark blue apron and the bit of blue waist help to make it visible.

Lay on your color like the Florentine Mosaics which are made of flat pieces joined. Keep the masses flat, simple, and undisturbed, and spend your care on skillfully joining the edges . . .

Let me give you a few simple rules for learning to draw:—

First, see of what shape the *whole* thing is!

Next, put in the line that marks the movement of the whole. Don't have more than one movement in a figure! You cannot patch parts together.

Simple lines! Then, simple values!

Establish *the fact of the whole.* Is it square, oblong, cube, or what is it? Keep in mind to look at the map of the thing! Put in all that is of greatest importance at first. It will never be the same again.

Keep things in their right places.

When values are so nearly alike that it is difficult to distinguish them, make them alike, and thus learn to simplify your masses . . .

You want to learn *how to paint!* Well, we won't mind now about the color. To arrive at color you must first learn *how to paint;* and it isn't done by patching. Learn a simple manner of proceeding. Attack things in a broad, simple way; and, when done, you will find certain faults of color which you can correct—*in another picture.* I must combat your eye for color; which is first-rate, by the way; and teach you the simple, broad manner of painting. Then your natural feeling for color will tell later. Take, for instance, burnt sienna, white, and cobalt. (Brown, white, and red would do it.) Lay the color on frankly and fully. Join the edges carefully. Don't work in the centre of things. Make flat masses of the right value and put your care into the edges. Unite them carefully. Give up the idea of getting color by niggling! Produce it in a broad, simple way; and remember that you can't copy that exactly, and the sooner you give up the idea, the better.

The passage from one tint to another is all in one tone. You've spent fifteen minutes in putting a great many tints into that face. Now spend one moment in looking at it simply and tak-

ing out nearly all that you have put in! Expand planes, instead of diminishing them! Do away with as many half-tints as you can. Expand the lights, look for the limits, and keep the gradations! Scrutiny makes you eat the whole light out of your work.

"I was trying to keep the reflected lights."

Reflected lights! You never saw a good picture with reflected lights! They'll come of themselves in the shadows. And don't think so much of the high light on the nose! Don't believe that a face is going to be relieved by it! Look at this Greuze! I hang it up there because it is so broadly done; but it is full of dandyism, is false in many particulars, and lights are put in where light could not possibly fall. There's the same trouble in my sketch there, near it. Look at that cheek! It comes out like a sausage. I did it, I am willing to confess, and I hate it! . . .

I do not see you walk away from your work enough! You can learn more in four minutes in that way than you could in an hour at your easel.

To *finish,* stop *fooling* over your work! Don't blister it all over with *facts! Facts are not poetry!* And stop this eternal going back to correct! I remember to have heard a distinguished statesman read aloud a French letter; and instead of reading on, to the best of his ability, he went back, correcting himself, and snubbing the words he had mispronounced; and the consequence is, that I've forgotten the substance of the letter, and only remember his blunders and corrections . . .

You must get over the idea, that the only firm thing is a fine line. Firmness is consistency, solidity—something thicker than a line. Why, an infant's cheek may be firm! A firm man doesn't go in a line. He is firm throughout. Firmness is in thickness, as much as in outline. A hard outline on the edge looks thin and weak rather than firm. A hoop is not a firm thing . . .

Transparent work in drawing doesn't amount to anything. Get a good solid tone! That crisscross of lines doesn't mean anything, unless it is a snow-storm! If you want black, make it black. If you want white, make it white. Don't be afraid of getting it black if black is what you want! You'll never get anything as long as you live if you don't take a broad piece of charcoal, or a big brush, and make a good solid tone—where there is one. Instead of one white light in your sketch, you have fifty . . .

I am always hoping to be able to paint a portrait in one day. There's my sketch—my impression of the boy as he came for the first time into the studio. With a few lines I represented my idea of his figure, manner. *My* impression, I say. Not yours: not the impression of anybody else. No one else would have sketched him in *just* that way.

Now don't think that when I say I want to paint him in one day that I count it only one day's work! For weeks I have considered it, have prepared different grounds—four certainly; have experimented on similar grounds to know which will be the best. I've thought of it day and night. Awaking at three o'clock in the morning with the thought of whether I can get him vigorous enough against a certain background. So I keep this picture in mind until I feel that I can strike the right color here, there; I can make this dark enough, that light enough. Then, when the time comes, I must be ready to paint; and I tell you it's no joke to paint a portrait! I wonder that I am not more timid when I begin! I feel almost certain that I can do it. It seems very simple. I don't think of the time that is sure to come, when I almost despair; when the whole thing seems hopeless. Into the painting of every picture that is worth anything, there comes, sometime, this period of despair! . . .

By being always careful you will gradually lose all freedom of movement, and come eventually to use only the tips of your fingers. A cat don't catch a mouse with her claws alone. She strikes out from her shoulders, after making a bound from her hind feet.

You must necessarily spoil a good deal of paper. Therefore, I beg of you, spoil it cheerfully. You will learn freedom of movement in so doing. If a child were as pedantic and fussy in his endeavors to pronounce as we are in trying to exactly determine certain little forms and colors, he would never learn to speak.

You might as well expect to learn to shoot by firing off one grain of powder at a time. No! Fire off the whole charge, right or wrong! The direction may be faulty at first, but the bullet will take effect somewhere, visibly; and if in the wrong place, *vary your aim, but not the power* . . .

Do! Do! Do! Let it go, and do another! You can't finish a thing farther than you can go. The moment you put your hand upon the canvas that part of it is finished. You never learned so much as when you painted that figure in two colors, and when you under-painted that head for me, and knew that you had only one day in which to cover the entire canvas.

It is *at last* that you'll finish! Corot doesn't finish; and he's over eighty years of age. If you all "finished," the book would be shut up . . .

Look at that drawing done by one of the last year class! Materially I can't compete with that. Among my drawings you can't find one so simply done as that. In it I recognize everything which I ever told her. I'd defy anybody to make such a drawing as that! It has all the needed elements except concentration. In it there's material enough to do better things than I ever did. I can represent a subject more closely than that; but I can't do anything so unconsciously as that is done.

Six out of twelve who are studying do a better thing than they who teach. At the same time, teaching helps the teacher. I come in here and put into words the very thing that I've been trying to do in my own room. I'll be there, niggling and fooling; come in and see you doing the same thing; go back and correct myself through you. I do a thing four times as easy since I've been teaching . . .

For years, Millet painted beautiful things, and nobody looked at them. They fascinated me, and I would go to Barbison and spend all the money I could get in buying his pictures. I brought them to Boston, "What is that horrid thing?" "Oh, it's a sketch by a friend of mine." Now he is the greatest painter in Europe . . .

I told you to paint the light on that cheek, with a single stroke of the brush. In your work I see two or three, as if you had niggled and patted in an undecided way.

"I put it on with one stroke, but it was a little too dark!"

No matter; take that for your key-note and go on! Your picture would simply have been a little lower in tone, but what of that? You spread your fingers over the keys of a piano and strike a chord. If too high or too low, you need not try again, but play on in that key. So in painting. Remembering that it is easier to transpose in painting than in music . . .

I believe that the best paintings of landscape are made from memory. Of course you must study nature carefully for certain details, but for the *picture*, paint it in-doors, from memory. I never saw Millet out with an umbrella. When before nature you are so much occupied with representing what you see, that you can't study combination and composition. You can't make a *picture!* . . .

We are all cursed by the nonsense of our early teachers. I took lessons, like the rest of you, with a pointed lead pencil and a measure; and to-day I feel the restraint which that way of beginning imposed upon me—so strong is the impression made by early lessons. We have all been taught by people who never did anything, never loved anything in the way of art. How can such people teach?

Do *fascinating* things! Not smart ones! Nobody ever tucks a *smart* sketch under his arm and

runs home with it. Paint your own impressions. Tom and Dick won't like the result; but, by and by, along comes Harry, who says, "By Jove! I've seen that very thing in nature!"

Do as I *say!* Not as I *do!* I come in here and tell you these things not only to help *you*, but to strengthen *myself* for my *own* work . . .

Drawing that ginger-jar? Well, how do you get on?

"I can't get it round enough."

Not round enough? You've made it *too round!* You have tried so hard for the quality of round-ness that you have sacrificed everything else. You have forgotten to keep the brilliancy, the color, and the appearance of porcelain. You should have tried to make it look sonorous, hard. Not like a plum-pudding, or any other kind of a pudding.

Take the *whole* thing, and look for its character! You say it is round; but is it round like a bil-liard-ball? No, it has *flat* planes. Look at the flat, angular shape of its "high light!" See how its shadows are great flat planes! If you go on working thoughtlessly, without thinking seriously how that jar really appears, you'll make it rounder and rounder every day.

Things declare themselves *flat.* Bad drawings look like grapes. Every little round represented. *Do the character first!* You'll get it in the first four lines, if you get it at all. The character! the *character!* the CHARACTER! That's the beauty! the *beauty!* the BEAUTY!

Keep this in mind! that it is the definite, individual character of an object which makes beauty. The effect of light is what makes things beautiful. Light never stops to find beauty! Half of the beautiful pictures in the world are painted from people who are not beautiful . . .

Our idea of "finish" is that everything should be *smooth!* Our arms should be carved upon pumice-stone; field—sand-paper; and crest—a *file rampant!*

A bird is finished when he can fly!

Ruskin calls finish "an added truth." I wish him joy and a long life! He confounds it with death and the judgment-day!

Finish is *leaving off anywhere on the outside, after having filled the interior!* Stopping before you or others are tired out! Before you are a corpse, or before you have killed your work! I mean that this is the receipt for us poor weak ones. Michael Angelo, and the diamond, seem *finished* without difficulty, because the *substance is finished!*

Stop with some breath in your body! Even with your work *ahead of you!* Not as though you had hauled it along to die of starvation on the mile-stone *beyond the last!*

Most work is *deliberately murdered,* in the hope that it may never speak of its author's *incapacity.*

THE MASSACHUSETTS DRAWING ACT OF 1870

One of the most sweeping developments in art education occurred in 1870, when the Commonwealth of Massachusetts instituted mandatory drawing instruction in public schools, elevating it alongside the other required subjects: spelling, reading, writing, grammar, geography, arithmetic, U.S. history, and good behavior. Massachusetts towns with populations exceeding 10,000 were also ordered to provide free instruction in in-dustrial or mechanical drawing to any citizen over fifteen years of age (legislators tried unsuccessfully to amend it to towns with populations exceeding 5,000 in 1875). In George Lathrop's article in Harper's, *he describes the curriculum as it was instituted. Walter Smith, a graduate of England's famed South Kensington design school (a model for in-dustrial training in the United States), was hired to oversee the new program in Boston.*

In his report written after a decade of statewide instruction, he lays out ten "proposi-tions" that guided his implementation of the legislation.

George Lathrop, "The Study of Art in Boston," Harper's Magazine *58 (May 1879).*

Let us look into one or two of the Boston schools, and see how this branch of knowledge, at once useful and flowery, is followed out by the children. Like all proverbial blessings, that of education in art here falls upon the rich and the poor alike. In the Eliot School, for example, where the pupils are contributed from a poorer quarter of the city, we find them tracing the same lines, copying the same designs, pictures, or models, furnished in the Brimmer School, where a class of more fortunately circumstanced children do their studying; and, best of all, we find them exercising the same sort of knowledge and imagination in making original decorative or architectural designs . . .

In the primary schools he learns the "alphabet and nomenclature of form;" he begins with lines and the simplest geometric forms, drawing them first upon a slate—so that even the slight additional difficulty of producing the same effect on paper may be avoided—and afterward in his book. These make a basis for varied outline exercises, with which he becomes perfectly familiar, all of them having something of beauty to stimulate him, and cultivating his intelligence as well as his eye and hand. In this way he is equipped with a vocabulary, which he can use with entire facility when he comes to more difficult forms of artistic expression . . .

Besides calling invention into play thus early, the primary course teaches drawing from oral description, without the pupil's seeing the design he is to reproduce; and another very good point in it is the drawing, *from memory,* designs which have been taught previously. Every one will perceive how much this discipline must strengthen the memory, and in that way act favorably upon other studies, though this and the learning to define and draw plane geometric figures are merely incidental advantages. The main thing is that, here at the start, the children learn simple principles of drawing which they can never forget, and from them they can go on developing technical power with great ease. This power will serve them well at every turn in life, whether they are to be machinists, carpenters, workers in stone or iron, gold, silver, or tin, pattern-drawers, engineers, artists, architects, teachers, lecturers, inventors, agriculturists, naturalists, antiquarians, journalists, or art critics. In fact, it has been said by an educator that "a boy or girl who can draw has acquired *one* qualification for *nine-tenths* of the occupations into which all labor is divided." . . .

Next in order are the high schools, and here the element of shading is brought in. Simple groups composed of a jar, a cube, a ball, and so on, are drawn and shaded from the actual object, giving a chance for study of smooth surfaces with nicely graduated light and shade upon them. After this, various reliefs are used as models; for instance, a plaster cast of a couple of quinces on a twig, with their leaves—which gives opportunity for dealing with shadows of greater inequality—or a cast of some of the Alhambra ornamentation. Moreover, the range of original design becomes wider and at the same time more special: instead of a mere re-arrangement of conventionalized flower and foliage forms, the pupils are required to invent their design and apply it to some particular decorative purpose, such as wall-papers, tiles, plates, cups, and lace . . .

The technical facility with the pencil of boys and girls who emerge from this course at the ages of sixteen or nineteen is as unconscious as the ability to write, and henceforth they can go about drawing landscapes, animals, human figures, or machines and patterns for themselves, constantly progressing farther on the path in which they have been so well started. To be sure,

the human figures which they draw will at first be poor affairs, because in that noblest and most difficult function of art they have had no practice. (Promising grammar-school pupils were at one time allowed to draw from life at the Lowell Institute, and probably similar facilities will in time be generally provided.) But the *processes* have been mastered, and after that the proficiency attained in any thing like figure-drawing will depend upon time, industry, individual talent, and opportunity for studying from the life.

Walter Smith, Report on Drawing; Addressed to the School Committee *(Boston: Rockwell and Churchill, 1880).*

The following propositions define the positions taken on this question of Industrial Drawing in the public schools:—

1. All children who can be taught to read, write, and cipher, can be taught to draw.
2. Drawing, by the law of Massachusetts, is required to be taught to every child as an element of general education, like reading, writing, and arithmetic.
3. As an elementary subject, it should be taught by the regular teachers, and not by special instructors.
4. The true function of Drawing in general education is to develop accuracy of perception and to exercise the imagination, thereby tending to produce a love of order and to nourish originality.
5. Educationally, Drawing should be regarded as a means for the study of other subjects, such as geography, history, mechanics, design. In general education it is to be considered as an implement, not an ornament.
6. The practice of Drawing is necessary to the possession of taste and skill in industry, and is therefore the common element of education for creating an enjoyment of the beautiful, and for a profitable, practical life.
7. In the Primary, Grammar, and High Schools, Drawing is elementary and general; in the normal and evening schools, advanced and special,—for teaching purposes in the first, and for skilled industry in the second.
8. Good industrial art includes the scientific as well as the artistic element; science securing the necessity of true and permanent workmanship, art contributing the quality of attractiveness and beauty. The study of practical art by Drawing should therefore comprehend the exactness of science by the use of instruments, as in geometrical drawing and designing, and the acquisition of knowledge of the beautiful, and manual skill in expression, by freehand drawing of historical masterpieces of art and choice natural forms.
9. From this study so undertaken, we may expect a more systematic knowledge of the physical world, in history and at the present time; for through the sensitiveness to appreciation by the eye, and power of expression by the hand, of its phenomena, may come a knowledge of Nature's laws, a love of the fit and the beautiful, and that ability to combine these in our own works, which alone produces the highest form of art,—originality.
10. Drawing may now take its legal place in the public schools as an element of, and, not as before, a specialty in, education, at as little cost as any other equally useful branch of instruction, with the prospect that at a future time as many persons will be able to draw well as can read or write well, and as large a proportion be able to design well as to produce a good English composition.

Chicago

Founded in 1866 as the Chicago Academy of Design, the Art Institute of Chicago had by 1882 developed into the dual museum/school that has characterized its organization ever since. In the late nineteenth century, it was the most important art school in the Midwest, larger than any other such institution in the United States. The Columbian Exposition of 1893 greatly impacted the Art Institute, leaving it with a new building and reinforcing a curriculum based in part on the Beaux-Arts ensembles of the fair. Sculpture was an important part of the exposition, and Chicago became known as a city friendly to the medium, thanks especially to the ministrations of local sculptor Lorado Taft. In the following short profile of the Art Institute, a new initiative is described in which students learn to carve directly in marble rather than working in clay and leaving the stonework to assistants. It serves as a good example of the institution's interest in bridging the divide between technical artisan and "fine" artist.

"*Marble Carving at the Art Institute, Chicago,*" Monumental News 10 (August 1898).

There is much food for contemplation in the remarkable record of the art schools of the Art Institute Chicago. With a roster of some 1800 students for last year and with prospects of overreaching the 2000 mark for the coming season, this institution outranks the other art schools of the country in point of numbers, and in other respects, it unquestionably stands in the top rank of art education. The constant cry of the management is for more class room, which was in part supplied by additions last winter, but more room is needed and every effort is being made to supply the need in one way or another . . .

It may be stated that the governing idea in this school is to create out of its students sculptors equal to at once becoming competent assistants to professional sculptors or to undertake work on their own account.

Before a student can realize whether he can become a sculptor, he must know whether he can model or draw. A young man once asked Gerome whether he thought he had any talent for painting. Gerome replied by asking him whether he could draw and paint. The young man said no. Then said Gerome, "you go and study for ten years then come to me and I will tell you." Excellent advice.

In the course of instruction the Art Institute first teaches the human figure, its composition, its bones and muscles, their relation to each other. Then follows their proportion—first construction then proportion.

Then follows surface modelling, how the surface flows over the bones and muscles. It is this covering or surface modelling that largely marks the individuality of the artist, offering him an opportunity to place his own interpretation on the finish.

The human figure gives such a schooling that after a student has acquired the ability to interpret the human figure correctly, it becomes an easy matter to model any other natural form.

After the faculties are trained to convey correct outlines and detail of form to ensure a perfect model, composition is next taken up. This carries with it the idea of telling a story in the design or expressing one in a sculptural sense. But the material must be considered, whether it be stone or bronze.

Coming to the marble carving section of art instruction which has recently been established in the Chicago Art Institute, and for the efficiency of which much credit is due the instructor

Mr. Charles J. Mulligan, sc., a great deal of interest is manifested, and great things are expected of it in the training of American sculptors.

Prominent European sculptors cut their own commissions in marble, and hence preserve the feeling of the work and the individuality of the sculptor in the finished marble. It is therefore essential that a sculptor should have the ability to cut his own model in the final medium.

The general practice in our country at present is, that when a work is to be executed in marble, a sculptor trained in the practice of marble cutting has to be employed to reproduce the designer's model. The result largely is that the personality of the original artist is supplanted by that of the marble carver. Mr. D. C. French, highly endorsing the new branch of work of the Art Institute, has suggested that by using the American marble it would lead the pupils to be less flamboyant in their efforts. Italian marble invites to the introduction of fine detail and tempts students to overlook dignity. Mr. French has had a large experience in carving in American marble in his early days.

This is the first year of such work in this institution and it has taken a very strong hold. Beside the artistic side of the question there is the practical one. After a student has gone through his regular course and is able to copy a figure correctly, he usually starts out as ready for work, although he is very far from possessing a practical knowledge of art. The Art Institute, in this additional work, therefore proposes to so equip its students, that all things being equal, they shall be thoroughly competent to assist professional sculptors, and so be able to earn a living when they issue from its doors.

To this end besides sculpturing in marble, students are instructed in plaster casting, enlarging and reducing sculptors models. When efficient knowledge is acquired with any natural talent a student should be well equipped for his profession.

It is gratifying to add that this class is already attracting the attention of aspiring marble cutters, who are wage earners in the day-time, a number have joined, and the evening classes will be largely extended the coming year.

New York

LABOR AND ART ON THE LOWER EAST SIDE

In the late nineteenth century, Central Park—and to a lesser extent the Metropolitan Museum of Art situated within it—became a staging ground for class hostilities. Many argued that, despite the rhetoric of community education and improvement, the uptown cultural institutions were inaccessible and unwelcoming to the poor who lived in lower Manhattan. In this article, Abram Bernheim, an activist in the settlement house and tenement reform movements, describes a series of three educational art exhibitions that took place between 1892 and 1895 in rented rooms in poor New York City neighborhoods. Almost 200,000 people visited these summer shows, a remarkable attendance. In an unusually frank passage, Bernheim describes the suspicion with which his plan was initially met by labor leaders, an indication of the degree to which cultural matters were implicated with social tensions.

A. C. Bernheim, *"Results of Picture-Exhibitions in Lower New York,"* Forum 19 *(July 1895).*

When it was first proposed to give a free art exhibition to the people of the East Side, there were many who doubted the wisdom of the undertaking, and questions were raised that could be answered only by actual experience. Are the people of the East Side of New York interested in

art? Will they attend the exhibition in large numbers, and will they make their visits so frequent as to be benefited by them? Will they "resent the display of the possessions of the rich"?—as has been urged by many. And, finally, why should there be a free art exhibition down-town, on the East Side, in addition to the exhibition daily at the Museum of Art in Central Park?

There have been three art exhibitions on the East Side, and the success attending them is the best answer to these questions . . .

It has been the successful endeavor of those interested in these exhibitions to procure, so far as possible, representative works of the best schools and classes of art. In the first exhibition there were sixty-six oil paintings, some water-colors, and about twenty sketches in black and white. The artists whose paintings were exhibited included well-known names—American, German, French, and English. There were paintings by Daniel Huntington, William M. Chase, Albert Bierstadt, Cazin, Daubigny, Corot, Gérôme, Lefebvre, and Josef Israels; among the water-colorists represented were Winslow Homer, W. Hamilton Gibson, and Frederick Crowninshield; among the black-and-whites were characteristic examples of Thulstrup, Joseph Pennell, Howard Pyle, W. A. Rogers and George Wharton Edwards. At the second exhibition there were one hundred and seven paintings in oil, a few pieces of sculpture, and pictures in black and white; and the artists were Franz Von Defregger, Cazin, J. Carroll Beckwith, Constant Mayer, Wm. M. Chase, Gérôme, Detaille, Frederick Remington, August Frederick, Wm. A. Coffin, Ludwig Knaus, and others. At the recent exhibition there were in all one hundred and twenty-three paintings, and they included the works of such well-known artists as Inness, Grützner, Knaus, J. P. Hasenclever, Ridgway Knight, Gérôme, Madrazo, J. W. Champney, Gabriel Max, Fromentin, Claude Monet, Sir Joshua Reynolds, A. H. Wyant, Detaille, Schreyer, G. H. Boughton and Neuville. The mention of these names shows that the effort to secure a collection representative of the best and highest in art, rather than to make a mere display of large numbers, has been entirely successful.

At these exhibitions it has been the custom to ask the visitors to vote for what they deem the best painting, and at all times the choice of the majority has been found to be consistent with good taste in art, the preference being marked, however, for paintings in which a story may be read, rather than for mere landscapes. Impressionism has found few admirers. One of the visitors wittily remarked, apropos of a decidedly impressionistic work of art, "Why, that isn't a painting; that's paint." In connection with this, the third exhibition, a series of lectures on art has also been provided.

There was reason for grave doubt as to the attitude of the labor-leaders and their followers toward an art exhibition on the East Side. Foremost among them in devotion to labor's cause is unquestionably Mr. Edward King, whose coöperation was sought and obtained for the first exhibition. In describing the attitude of the East Side at the beginning of the exhibition, Mr. King said, in a subsequent report to the University Settlement Society, that there were many among his friends who thought the exhibition "a cleverly disguised trick on the part of the eminent Mugwumps[1] in the University Settlement Society to get a grip on the district in the ante-election months." Others there were who ascribed the exhibition "to the seekers after notoriety, whose real sympathy with the poor could be gauged by their traditional view of the 'slums' as a place where curious specimens of human depravity were to be found, each in its appro-

[1] Mugwumps were political reformers who switched from the Republican to the Democratic Party in the 1880s.

priate cell, ready for inspection by the university social pathologist." And finally, Mr. King wrote in his report that a prominent Socialist, representative of his class, "bluntly refused his coöperation, and advised his friends to have nothing to do with us. 'The robbed and the robbers cannot sincerely fraternize,' he said, 'especially when the robber comes asking the robbed to accept as a favor a few crumbs from the feast which is the creation of the latter . . . The labor movement is a class movement, and nothing should be done to weaken the class spirit.'" The East Side labor papers criticised the exhibition from these various standpoints. But the sincerity and good faith of the promoters of the exhibition justified again the fundamental purpose of the University Settlement Society, whose object is "to bring men and women of education into closer relations with the laboring classes in this city, for their mutual benefit." Through a better understanding between the honest and industrious laboring classes and their unselfish, public-spirited fellow-citizens, which can be best obtained through such settlements, much can be done to solve the great economic problems of the age. In a not unimportant way, the East-Side Art Exhibition has been helpful to such a better understanding. Mr. King, who is one of the truest champions of labor, says:—"The result was that the most bitter and radical of the Socialists became our firmest friends, and worked incessantly as 'runners,' guiding droves of people to the exhibition, evening after evening—and the right kind of people, too—by the 'laws of natural selection.' Night after night, their leaders might have been heard explaining, in glowing terms, the special merit of this masterpiece and that particular school of painting, to groups of earnest listeners."

The popularity and success of these exhibitions have been demonstrated beyond a possible doubt.

LEMUEL WILMARTH ON THE LIFE CLASS

Although his own art was mildly conservative, reflecting the influence of the French genre painter Edouard Frère, Lemuel Wilmarth was open to more progressive ideas as a teacher. Widely seen as rescuing the schools of the National Academy of Design from a moribund state in 1870, he remained loyal to that institution, even though he also helped establish the rival Art Students League when the Academy temporarily suspended its classes in 1875 (see "The National Academy of Design: Praise and Condemnation," chapter 7). Wilmarth was a firm believer in study from the nude model, and he struggled against conservative forces opposed to introducing a women's life class at the Academy. In this interview, he relays valuable information on the way in which a typical life class was set up and managed. He also airs views on instruction that differ from those of his Philadelphia colleague (and fellow pupil of Jean-Léon Gérôme), Thomas Eakins (see "The School of the Pennsylvania Academy of the Fine Arts," this chapter). Unlike Eakins, Wilmarth was less eager to allow students to leave charcoal behind and move quickly to oil paint and the brush.

"*Talks with Artists*," Art Amateur 16 *(January 1887).*

"Sixty is the largest number of students that can satisfactorily study from one model," said Mr. L. E. Wilmarth, the instructor of the life class in the Academy of Design. "In an ordinary room not more than thirty can be accommodated, and that, in my opinion, is a large enough class.

"These are usually placed in three rows. The first row should be not less than twelve feet

from the model. A full-length figure can't be drawn at less distance. These should sit in a circle on low chairs. We generally saw the legs off to suit ourselves. The portfolios then rest on the backs of other chairs. Sometimes the students sit astride their chairs and rest the portfolios on the backs. This will do well enough for the boys.

"The second now sit on chairs of ordinary height and rest their portfolios on the chair-backs of the first row. The third row stand and work at easels. And I have known even a fourth row in an emergency, work, standing on chairs wherever they could get a view between easels.

"The lighting of the room is, of course, most important. For day work there should be a large, high side-light. North light is, of course, preferable on account of its steadiness. The bottom of the light should not be less than six feet from the floor. For night work there should be a powerful burner that will throw a concentrated light on the model. This should be hung about six feet away from and two feet above the head of the model. The heat of such a light is intense, and it must not interfere with the comfort of the model.

"For the students there must be another set of lights arranged around the circle and placed as low down as the easels will permit—say seven feet from the floor. These lights must be so shielded that they will reflect down on the class. Not a ray should strike the model, as you can understand it would have all the confusing results of a cross light."

"Which do you advise, study by gas or daylight?"

"A beginner finds it easier to study at night. The light is more powerful and the shadows stronger and better defined. But the results of study by daylight are better. There is necessity for closer, finer observation in the diffused light of day and the results are more subtle. Of course in drawing with color daylight is preferable, as it is hard to distinguish colors at night. For that reason night work is usually confined to black and white."

"Would you advise beginners whether by day or night to use black and white?"

"Yes, and to keep using black and white. In the Paris ateliers a student works years in crayon and charcoal before he touches color. But we can't do that here."

"Why?"

"In the first place we are too impatient a people, too insistent on results. In the second place our students begin too late in life to afford long preparation for a career. In Paris a boy will begin his artistic studies at fourteen. This gives him years for preparatory work. Here, rarely or never a student begins to draw seriously at sixteen. Most often he is over twenty.

"But to continue. The properties of a life class are few but they are very important. The first thing necessary is a revolving stand—like that of a sculptor, but lower and larger—that can be moved from one part of the room to another. This should be about eighteen inches high, in any case so that the model may be easily seen from every part of the room. In many of the foreign schools the floor is inclined downward toward the model, who stands on the throne, as it is called, and this is an admirable arrangement.

"There should also be some means of attaching a rope to the ceiling to keep the model in poses—of lifting, for example. For the same reason there should be a posing pole. In holding out the arm in this fashion it is impossible to retain the pose for any time. But it becomes easy with a posing pole. The pole can be marked where it passes through the hand and the next time the exact pose can be resumed with ease. There should also be wedges for the heel when the foot rests on the toe, and various sized boxes for raising the foot in other positions. This is not an imposing array of properties, but they are essential."

"Of course in respect to difficulties there must be gradations of pose. How would you advise a class of novices to select the pose?"

"An upright pose is the easiest, and, of course, one without muscular action. In fact all the world over violent action is avoided. In the first place the pose should be arranged to afford a number of interesting views, and these are necessarily limited. The best plan is to take suggestions from the antique, and I will mention the Antinous as a favorite and suitable pose. What are known as academic poses are all derived from the Greek sculptures. These experience has demonstrated to be the most suitable. They not only offer the best number of views, but they are easily resumed, and the student is not inspired to try and get action, when there are so many other difficulties to be mastered first."

"How long should a pose be kept?"

"A week. This, in Paris, gives to the day classes thirty hours' work. A séance there is five hours long—from seven to twelve, or from half-past seven to half-past twelve according to the season. Our hours are not so severe. The men's classes at the Academy of Design work twenty hours, and the women work fifteen hours, or three hours for five days in the week."

"How would you divide the time of the séance?"

"Here, again, our methods are milder. In Paris the model usually poses one hour and rests fifteen minutes, and I have known them to pose two hours without coming down from the throne. There the models are trained and prefer that distribution of time. Here a trained model will pose for three-quarters of an hour and rest one quarter. But the usual pose with the usual model is twenty minutes long with five minutes' rest. As the model grows more accustomed he prefers to lengthen the time of posing and reposing."

"What should be the temperature of the room?"

"That, too, should rest with the model. Some models require a very warm room, others prefer a lower temperature. The first are usually beginners. Eighty degrees is as high as students can ever stand. As models grow more experienced they like cooler rooms, and I have known old models not to want the room warmer than that desired by other people."

"Of course a certain etiquette is observed?"

"Every class should have a monitor. It is the monitor's place to pose the model, and at each séance to see that the same pose is resumed. During the séance a model is very apt to fall out of pose. When this is observed by a student he should address himself to the monitor. In fact all remarks concerning the model should be made to the monitor. You can imagine how confusing it would be to the model to have the different members of the class calling out warnings and reproof. If the model is a novice the class should be very lenient and allow him or her to rest often; in assuring the comfort of the model the class assures at the same time its own."

BREAKING AWAY: THE ART STUDENTS LEAGUE

For a younger generation of students in the 1870s, the National Academy of Design was insufficiently equipped or disposed to satisfy their needs or to adjust to new circumstances in a rapidly changing art world. When financial difficulties in the spring of 1875 threatened to jeopardize the Academy's teaching mission, concerned students met with their instructor, Lemuel Wilmarth, and conceived the plan for their own organization, dedicated to the support and formal training of professional artists. Modeled on Parisian art schools, where the basis of instruction was the life class, the Art Students League flourished (albeit with a few early stumbles), becoming a serious and viable alternative to the National Academy. The faculty consisted of leading younger cosmopolitans, including Kenyon Cox, Thomas Wilmer Dewing, Walter

Shirlaw, Julian Alden Weir, and the magnetic William Merritt Chase. With the Society of American Artists, which focused on expanding and liberalizing exhibition practices, the Art Students League played an important role in modernizing the New York art world and its institutions.

The 1875 manifesto outlines the democratically inclusive goals and mission of the new organization. The progressive spirit of the Art Students League also finds full expression in the 1883 presidential address by William St. John Harper. Harper lays particular stress on the League's efforts to meet the needs of women by scheduling additional life classes at more convenient times and giving them "an equal voice" in government and management. Harper goes on to discuss other innovations: a costume class, a series of informal lectures by prominent artists, and exhibits of photographs and studies. Most notable of all, perhaps, is the principle of student governance, which guarantees freedom of action and the opportunity for unrestricted engagement with the best of modern art.

Edward Prescott, chairman of the Board of Control, July 1875, Archives of the Art Students League of New York.

The attention of Art Students is called to the following:

The students of the National Academy of Design, remaining in New York, have formed, with Professor Wilmarth's coöperàtion, an Association called the ART STUDENTS' LEAGUE,[2] having for its objects the attainment of a higher development in Art studies; the encouragement of a spirit of unselfishness and true friendship among its members; the imparting of valuable information pertaining to Art as acquired by any of the members (such knowledge to be made the general property of the Society); the accumulation of works and books of Art, and such properties and material as will best advance the interests of the members; mutual help in study, and sympathy and practical assistance (if need be) in time of sickness and trouble.

As is well known in Art circles, the Council of the Academy of Design, at its last regular meeting, decided not to reopen the Department of Schools till some time in December; the question of employing a Professor was also decided negatively. Such being the fact, it is probable that the Life-school will not be organized till toward the close of the season. It is scarcely necessary to add that this determination of the Council causes great disappointment to those students who reside in New York, or who intend returning another season for purposes of study; for though the pressure of public opinion may cause some modification of this plan, it is probable that it will be adhered to to a greater or less extent.

To meet the want thus occasioned, the League will form and sustain classes for study from the nude and draped model, of composition, perspective, etc. The President of the Society, Professor L. E. Wilmarth, will take charge of these classes and conduct them on the principle of the Parisian ateliers. He has most kindly consented to do this gratuitously, till the Society becomes strong enough to compensate him for his services, or till the experiment has been fully tried. The number of names already enrolled makes the success of the Society almost certain, and enthusiasm and hearty coöperation is met with on all sides.

The League will commence active operations on the Fifteenth of September next, and classes will then be formed. Rooms have been taken on the corner of Fifth Avenue and Sixteenth Street (over Weber's Piano Rooms).

[2] The apostrophe was initially used in the name Art Students' League, but after the mid-1930s its use was discontinued.

It is intended to place the advantages of this Society within the reach of all who are thoroughly earnest in their work, both ladies and gentlemen; the question of dues will therefore be managed as economically as is possible under the circumstances.

All Art Students whose characters are approved of, are eligible for membership, and as it is considered desirable to strengthan the Society as much as possible at present, all persons receiving this circular are cordially invited to correspond with the Secretary of the Society, with the view of becoming members.

William St. John Harper, "President's Annual Address," April 17, 1883, Archives of the Art Students League of New York.

Fellow Students:—

You meet to-night for the seventh time in the history of the League, to receive from the officers to whom you have confided the business management, and artistic direction of your school, an account of how they have administered their trust.

The present season has been in many ways, the most trying that the League has known; and the manner in which difficulties, that in the early days of your society might have endangered its existence, have been met and overcome; gives proof of the strength of your organization and of the ability of your students to carry on the work they have undertaken. Financially your affairs are in a most satisfactory condition . . .

But for the wise economy and fore-thought of your managers in years past in putting aside a sum each season, to form a fund sufficient to meet just such a crisis, and to guarantee the fulfillment of such obligations; your school would not have opened this year. No individuals can be expected to assume such responsibilities on your account. I believe however that under existing conditions your surplus is sufficient for any probable emergency that may arise for some years.

Your quarters are ample for your present needs and the money expended on improvements may be considered as so much added to your reserve fund.

I would therefore advise, that all the income from your bonds from this time forward be expended, as I recommended last year, in Photographs, Studies, drawings, reproductions, and the like, and in art publications, that will have an immediate educational value . . .

We have been enabled this year to set aside a reading room especially for the members of the League. A special committee, aided by the generosity of members have endeavored to furnish this room, for the use of the society. It may be wise in the future to devote a fair proportion of the money received from the annual membership fees to improving this room, to subscribing for all the principal art Journals, and to covering the walls with the best reproductions obtainable, and also with borrowed pictures and studies of unquestioned art value . . .

The report of the school committee shows a decided increase in the attendance in all classes. Our enlarged space justifying the extension of the privileges of the school. The total attendance has been 410 an increase of 96.

The improvement in the day life classes both in point of numbers, and in the character of the work done is especially to be noted.

The large attendance has given rise to apprehensions among some of our friends that the standard of the school was being lowered, and the quality of the work done was not up to that of former years. I am *sure* that this is not the case. I am sure that better work is being done, and that the general average is higher than it has ever been before: and the students who take good rank in the League classes need have no fear of the position that they will hold in foreign ateliers . . .

The increased attendance in the afternoon life classes justified the arranging of a second session, extending the time of study to six o'clock.

The opening of a second life class for the lady students was no more than an act of justice to them. The gentlemen having had the benefit of two life classes since the League began, the ladies were certainly entitled to the same privileges when the attendance warranted it.

This arrangement should be continued whether it pays or not, as it has always been the policy of the school to give as great advantages as possible, to professional students, by making the Antique and Portrait classes, which are supposed to be more generally attended by non-members and amateurs pay a profit that will equalize any deficiency in the life classes . . .

Your lady students have been quick to recognize the importance to them, of a school which gives facilities for thorough, and serious study such as can be had in no other art school anywhere; advantages that they have never had before: a school that gives a solid groundwork for excellence in trades and occupations in which they can compete upon equal terms, and which opens to those who have the talent the possibilities of a profession, in which they are peculiarly qualified to excel; the highest honors of which are easily within their grasp.

From the organization of this society they have had in its government and management an equal voice; for its success and prosperity they have labored faithfully and well; and nobly have contributed their full share of the work. The future of this school has for them an importance that they fully realize. The rights and interests that they have acquired in the property and management of this association they mean to protect and to maintain . . .

The evening Costume Class under the careful management of the committee having it in charge, has been as successful as could have been expected. The large profit, due in a measure to the loan of costumes and properties will justify the committee in setting aside a sum for the purchase of draperies, furniture, and other accessories which will always be available for the afternoon sketch class and which will add to the interest of the costume class next year if it is continued. In which case I would advise that a much higher standard of admission be insisted upon, and also a limit in numbers. I think it should also be started in October.

But few additions have been made to the library. I think that a system of loaning books on art might be inaugurated, by which the number of volumes would be greatly extended during the school season.

This committee should also have a liberal proportion of the income from our surplus to be expended in the best art periodicals. There is nothing that will make our reading room more attractive than to have the current numbers of the leading art journals constantly on file.

The sketch class committee should have also a sum to expend in reproductions of the sketches of the best masters. This will be the most practical instruction that the students of this class can have.

The composition class has been largely attended and the character of the work contributed I think improved.

The small exhibits of photographs and studies collected by the committee have added much to the value of the class.

The opportunity which we have had at various times during the season to listen to some of our more prominent artists in a series of informal art talks, has been a valuable inovation; considering all the rubbish that is published under the head of art literature it is perhaps well that students should occasionally have the opportunity to listen to those who are competent to speak on the subject. On the principle that the man who can produce a work of art is best qualified to talk about it . . .

It has been well for your school that you have had instructors in your various classes who are so thoroughly in sympathy with students. Whose training and education under the greatest masters of Europe and knowledge of the best that has been done in art have so well qualified them to direct your studies.

The advice and guidance of men who are in such hearty accord with the progressive art movements of the day, can not be over estimated! You have been fortunate in working under men who though their work may hold high rank in the exhibitions both at home and abroad still come among you as students among students.

In a school like this, controlled by the pupils which started as a protest, and rebellion, against incompetence and ignorance crowned with academic honors; you are fortunate in enjoying that liberty of action which will enable you to deal with the best tendencies of modern art untrammeled by any outside dictation whatsoever.

Your society may now be said to have passed through its first stage, and your school may be considered fairly established . . .

Although you started unknown and without prestige your school has won favorable recognition throughout the country.

It offers advantages to serious students that no other school in the Union can give, and your corps of instructors is stronger than that of any other art academy in the United States. You have taken the lead and you mean to keep it.

The establishment of this school was the result of a demand for higher art education than any existing institution in New York could give. The students who founded the League felt this need and they set themselves to fill the want. They worked with an enthusiasm, an energy and determination, that knew no such word as fail.

They have labored patiently, and faithfully; with a singleness of purpose, that is beyond all praise.

Their task is done. The school is established. It only remains for you to maintain it.

Its future belongs to you.

Philadelphia

THE SCHOOL OF THE PENNSYLVANIA ACADEMY OF THE FINE ARTS

Although it was founded in 1805 (see "Quaker City Arts Organizations, c. 1810," chapter 2), it would be decades before the Pennsylvania Academy of the Fine Arts established a regular program of instruction in proper facilities. With the construction of a landmark building designed by Frank Furness, the golden age of this important school began. In his memoirs, engraver John Sartain, a key figure in the Philadelphia art community at the time, recounts its beginnings, under the direction of the Alsatian-born Christian Schussele.

Schussele took on Thomas Eakins as his assistant in 1876. After Schussele's death in 1879, the younger artist assumed direction of the school and greatly transformed its curriculum. Eakins sought a holistic view of the human body, one that seized the underlying structure of the figure and made its system of weight and skeletal support manifest. Thus, drawing was deemphasized, instruction in anatomy was intensified, and life classes in painting and modeling dominated the course of study. Eakins went about his teaching with an almost missionary zeal, and he endeavored to instill in his students the same ardent, mystical belief in the beauty of the human figure that he felt

himself. The profile of Eakins and his school by W. C. Brownell captures this sense of mission.

But the artist's pronounced views on artistic instruction led those who disagreed with him to characterize his directorship of the schools of the Pennsylvania Academy as tyrannical and myopic. Certainly he was uncompromising in his pedagogic opinions—in no area more so than in his advocacy of study from the nude. Eakins hated what he saw as the prudery and misplaced modesty of his critics, and it often seems that he went out of his way to goad them. A cache of recently recovered studio photographs showing the naked Eakins interacting with unclothed females indicates the degree to which he pushed the limits of propriety. Such practices, as well as the widely reported incident of the artist removing a loincloth from a male model in a mixed class of men and women, resulted in his dismissal in 1886. In these two letters, written over a two-day period to the chairman of the committee on instruction of the Academy, Eakins defends himself and his methods.

While admitting to "unconventional" behavior, Eakins justifies it by claiming the "professional privileges" of an artist and teacher, making frequent analogies to the training and work of physicians, a group he particularly admires. In his discussion of female students, he demonstrates a rare understanding of the impediments society puts before women artists, yet he also admits to the view that they will never do "great painting." Eakins is clearly offended and aggrieved at being judged by laymen, but while asserting his professional status above "the rabble," he nevertheless employs a coarse vocabulary that cannot have helped his cause. Certainly he could do little to explain the incident of his disrobing while alone with a student, Amelia Van Buren, an admission that is shocking, then and now.

John Sartain, The Reminiscences of a Very Old Man, 1808–1897 *(New York: D. Appleton, 1899).*

In 1868, I had hoped to meet in Paris my friend Christian Schussele, a French artist, pupil of Paul Delaroche, who had settled in Philadelphia, and won the high esteem of his fellow artists and of his adopted fellow citizens. Overwork had broken down his health, and he was now seeking a restoration of vigour in his native air. On my arrival, I found that Schussele and his wife had gone to Strasburg, so I followed them there, and was pained to see that my friend's paralytic affliction had grown much worse. The time could not be far distant when he would be unable to paint, but he would not be incapacitated for teaching, and I conceived a plan for establishing a proper art school at the Pennsylvania Academy, with Christian Schussele as professor.

There had never yet been in the Academy an organized school with regular paid instructors. Its collection of casts from the antique, destroyed in the fire, had not been replaced until some twelve or thirteen years after, when the affairs of the institution awakened into a state of livelier interest. The artists began to contribute freely to the annual spring exhibitions, and the public attended in paying numbers, especially in the evening, the galleries being well lighted. A number of casts were then procured from London and Paris, and a well-lighted room for study and their display was provided under the north picture gallery. Here students of art drew from the casts, and when sufficiently advanced were admitted into the life-class, a class carried on at their own expense, the Academy merely lending them the use of the room under the southeast gallery. I was always a contributing member of this life-class, and one of its committee.

Now seemed the opportunity for organizing the schools upon the proper basis. After maturing the entire plan in my mind, I suggested it to Schussele. He was pleased with the idea, and

we arranged together the terms that would be acceptable, and many of the details. Upon my return to Philadelphia, the committee of instruction and the board in turn concurred most heartily in the scheme, and thus in 1870 began the art schools of the Pennsylvania Academy of the Fine Arts.

About this time the institution began to feel cramped for space, and as the adjacent property could not be obtained, it seemed advisable to look around for another site. This action was precipitated by an offer of one hundred and forty thousand dollars for its ground to build a theatre. The transfer was to take place without delay, so the Academy stored its pictures and found temporary quarters for its schools. A lot one hundred feet front by two hundred and sixty feet deep was secured on Broad Street, at the corner of Cherry, and plans were invited. The designs submitted, however, while pretty enough in exterior effect, were within altogether unsuited to the uses required, notwithstanding full printed instructions as to what was needed. So all were rejected, the one thousand dollars offered in prizes were divided among the three best, and the drawings returned to the owners.

My long practical experience in the working of the institution having made me better acquainted than any one else with its needs, I was then asked to prepare plans for the distribution of the class-rooms and galleries on both floors, irrespective of course of the architectural forms, which were the province of the architects selected, Messrs. Furness and Hewitt. Thus commissioned I entered on the task with all my heart, and was enthusiastic to the degree that I felt as if the design and my individuality were merged into one. I could have breathed the prayer of Socrates: "O my beloved Pan, and all other gods, grant me to be beautiful within!"

The corner stone was laid December 7, 1872, at the northeast angle of one of the courses, over a cavity containing a collection that cannot fail to be interesting to explorers of the remote future. It was hoped that the building might be erected for a quarter of a million dollars, but it cost double that, including the price of the ground, ninety-five thousand dollars. It was completed, ready for occupancy, by the spring of 1876, so that its first exhibition opened simultaneously with the Centennial International Exhibition in Fairmount Park. The schools were installed in their new, well-lighted quarters under Professor Schussele's direction, and all the branches of the institution soon settled again into their usual order in their new home.

W. C. Brownell, "The Art Schools of Philadelphia," Scribner's Monthly 18 (September 1879).

The schools of the Pennsylvania Academy of the Fine Arts are conducted upon a much more elaborate scale than those of the National Academy of Design . . .

Models, male and female, are provided in abundance, and none of them are employed for more than a week or two every season. Dissections are arranged for to the heart's content of the students,—so any one unacquainted with their æsthetic usefulness would fancy. Modeling is cared for as well as painting and drawing. The collection of casts from the antique is larger than any in New York. One large room is entirely occupied by casts of the Parthenon and a few other marbles ranking next to these. The walls of another are nearly covered with Braun autotypes from the pictures of the old masters. The Academy's large collection of engravings and small but useful library are accessible to the students. There are two professors of drawing and painting and a lecturer on artistic anatomy . . .

Admission to the life classes is granted upon presentation of a satisfactory drawing from a cast of the entire figure. All the drawings are submitted to the committee of instruction, who, with Professor Schussele, examine and pass upon them at the regular bi-monthly meetings. In this room,—to take one class as an example of all,—some twenty young men, considerably

younger than the average at the National Academy schools, range themselves every morning and evening in a semicircle around a living and nude model. Almost without exception they use the brush—which would excite wonder and possibly reprehension from the pupils of the National Academy . . .

Professor Schussele, who is conservative, prefers a long apprenticeship in drawing with the point or stump.[3] He insists on a long preliminary study of the antique. Mr. Eakins, who is radical, prefers that the pupil should paint at once, and he thinks a long study of the antique detrimental. There is no conflict; for the instruction is nothing if not elastic, it appeals to the pupil's reason with candor, and avoids anything like rigid direction. But, as is natural with ambitious students, most of these take Mr. Eakins's advice. That advice is almost revolutionary, of course. Mr. Eakins's master, Gérôme, insists on preliminary drawing; and insistence on it is so universal that it was natural to ask an explanation.

"Don't you think a student should know how to draw before beginning to color?"

"I think he should learn to draw with color," was Mr. Eakins's reply. And then in answer to the stock objections he continued: "The brush is a more powerful and rapid tool than the point or stump. Very often, practically, before the student has had time to get his broadest masses of light and shade with either of these, he has forgotten what he is after. Charcoal would do better, but it is clumsy and rubs too easily for students' work. Still the main thing that the brush secures is the instant grasp of the grand construction of a figure. There are no lines in nature, as was found out long before Fortuny exhibited his detestation of them; there are only form and color. The least important, the most changeable, the most difficult thing to catch about a figure is the outline. The student drawing the outline of that model with a point is confused and lost if the model moves a hair's-breadth; already the whole outline has been changed, and you notice how often he has had to rub out and correct; meantime he will get discouraged and disgusted long before he has made any sort of portrait of the man. Moreover, the outline is not the man; the grand construction is. Once that is got, the details follow naturally. And as the tendency of the point or stump is, I think, to reverse this order, I prefer the brush. I don't at all share the old fear that the beauties of color will intoxicate the pupil, and cause him to neglect the form. I have never known anything of that kind to happen unless a student fancied he had mastered drawing before he began to paint. Certainly it is not likely to happen here. The first things to attend to in painting the model are the movement and the general color. The figure must balance, appear solid and of the right weight. The movement once understood, every detail of the action will be an integral part of the main continuous action; and every detail of color auxiliary to the main system of light and shade. The student should learn to block up his figure rapidly, and then give to any part of it the highest finish without injuring its unity. To these ends, I haven't the slightest hesitation in calling the brush and an immediate use of it, the best possible means."

"All this quite leaves the antique out of consideration, does it not?"

Mr. Eakins did not say "the antique be hanged," because though he is a radical he is also contained and dispassionate; but he managed to convey such an impression. "I don't like a long study of casts," he said, "even of the sculptors of the best Greek period. At best, they are only imitations, and an imitation of imitations cannot have so much life as an imitation of nature itself. The Greeks did not study the antique: the 'Theseus' and 'Illyssus,' and the draped figures in the Parthenon pediment were modeled from life, undoubtedly. And nature is just as varied

[3] A stump is a drawing tool made of leather or paper used to rub and soften lines made with charcoal.

and just as beautiful in our day as she was in the time of Phidias. You doubt if any such men as that Myron statue in the hall exist now, even if they ever existed? Well, they must have existed once or Myron would never have made that, you may be sure. And they do now. Did you ever notice, by the way, those circus tumblers and jumpers—I don't mean the Hercules? They are almost absolutely beautiful, many of them. And our business is distinctly to do something for ourselves, not to copy Phidias. Practically, copying Phidias endlessly dulls and deadens a student's impulse and observation. He gets to fancying that all nature is run in the Greek mold; that he must arrange his model in certain classic attitudes, and paint its individuality out of it; he becomes prejudiced, and his work rigid and formal. The beginner can at the very outset get more from the living model in a given time than from study of the antique in twice that period. That at least has been my own experience; and all my observation confirms it."

Here then are two things which distinguish the Philadelphia from the New York schools—immediate drawing with the brush and no prolonged study of the antique. Another is modeling, of which there is none at all done at either the Cooper Union or the National Academy, and which is not practiced at the League in direct connection with painting. When Mr. Eakins finds any of his pupils, men or women, painting flat, losing sight of the solidity, weight and roundness of the figure, he sends them across the hall to the modeling-room for a few weeks ...

What chiefly distinguishes the Philadelphia school, however, is its dissections for advanced pupils. Every winter, something more than a fourth part of the students spend more or less time in the dissecting-room, under Mr. Eakins's supervision, and twice a week all the pupils listen to the lectures of Dr. Keen upon artistic anatomy. The matter is pushed so far as to be pursued in studies outside the schools. In the instruction given by the schools, perhaps not more than one-tenth of the pupil's time is accorded to the work of dissection. Every winter or early spring, Mr. Eakins takes a large class to a suburban bone-boiling establishment, where they dissect horses in the slaughter-house, and in summer they continue the work with studies of the living animal (modeling and painting and studying his movement), which they make at Mr. Fairman Rogers's farm ...

"Don't you find this sort of thing repulsive? At least, do not some of the pupils dislike it at first?" Mr. Eakins is asked.

"I don't know of any one who doesn't dislike it," is the reply. "Every fall, for my own part, I feel great reluctance to begin it. It is dirty enough work at the best, as you can see. Yes, we had one student who abstained a year ago, but this year, finding his fellows were getting along faster than himself, he changed his mind and is now dissecting diligently."

"But you find it interesting, nevertheless?"

"Intensely," says one of the students, with ardor.

"And don't you find your interest becoming scientific in its nature, that you are interested in dissection as an end in itself, that curiosity leads you beyond the point at which the æsthetic usefulness of the work ceases? I don't see how you can help it."

"No," replies Mr. Eakins, smiling, "we turn out no physicians and surgeons. About the philosophy of æsthetics, to be sure, we do not greatly concern ourselves, but we are considerably concerned about learning how to paint. For anatomy, as such, we care nothing whatever. To draw the human figure it is necessary to know as much as possible about it, about its structure and its movements, its bones and muscles, how they are made, and how they act. You don't suppose we pay much attention to the viscera, or study the functions of the spleen, I trust."

"But the atmosphere of the place, the hideousness of the objects! I can't fancy anything more utterly—utterly—inartistic."

"Well, that's true enough. We should hardly defend it as a quickener of the æsthetic spirit, though there is a sense in which a study of the human organism is just that. If beauty resides in fitness to any extent, what can be more beautiful than this skeleton, or the perfection with which means and ends are reciprocally adapted to each other? But no one dissects to quicken his eye for, or his delight in, beauty. He dissects simply to increase his knowledge of how beautiful objects are put together to the end that he may be able to imitate them. Even to refine upon natural beauty—to idealize—one must understand what it is that he is idealizing; otherwise his idealization—I don't like the word, by the way—becomes distortion, and distortion is ugliness. This whole matter of dissection is not art at all, any more than grammar is poetry. It is work, and hard work, disagreeable work. No one, however, needs to be told that enthusiasm for one's end operates to lessen the disagreeableness of his patient working toward attainment of it. In itself I have no doubt the pupils consider it less pleasant than copying the frieze of the Parthenon. But they are learning the niceties of animal construction, providing against mistakes in drawing animals, and they are, I assure you, as enthusiastic over their 'hideous' work as any decorator of china at South Kensington could be over hers. As for their artistic impulse, such work does not affect it in any way whatever. If they have any when they come here they do not lose it by learning how to exercise it; if not, of course, they will no more get it here than anywhere else."

Insensibly the visitor begins to be impressed by the extreme sense of this, and his surroundings to take on a different look. The "subject" comes to be but an organism of bones and muscles. The casts of arms depending from a swinging bar become interesting for what they show; the muscles being painted red, the tendons blue, and the bones white, one is enabled to see at a glance their reciprocal relations. One "places" all the paraphernalia of the room; begins to appreciate first how much less liable the young men and women who study here are to draw impossible legs, arms, trunks, than they were before; come to feel that, after all, it is the province of an art school to provide knowledge and training, and not inspiration; and finally to perceive how wide of the mark it is to suppose that familiarity with such scenes as this of necessity dulls one's sensitiveness . . .

The dissections for the lectures are all done by the class of advanced students,—numbering some six or eight, perhaps, under the direction of Dr. Keen and of Mr. Eakins. Every day during the dissections, the life classes are admitted to the dissecting room to study the parts already lectured upon and to make drawings of them for reference and guidance. There are some thirty lectures in the course, which, one may judge from the following details, is tolerably thorough: after an introductory lecture upon the relations of anatomy to art, and methods of studying artistic anatomy, some eight lectures are devoted to the skeleton and twelve to the muscles, chiefly, of course, the superficial muscles; the face naturally occupies a good deal of attention and dissections of the human head are accompanied by dissections of horses', cats', dogs', and sheeps' heads to show comparisons and variations. Electricity is used to show the action of individual muscles, and four lectures are given to the individual features of the face, with analyses of their forms and their exaggerations in caricature. Two lectures relate to the skin and its appendages, the hair and beard, and a careful study is made of the wrinkles of the skin, especially those of the face. Finally, four lectures are devoted to the subjects of "postural expression," the proportions of the body, and the influence of sex upon physical development.

It quite takes one's breath away, does it not? Exhaustive is a faint word by which to characterize such a course of instruction. Must a painter know all this, one asks himself in a kind of awe-struck bewilderment. On the one hand, it may be inquired if it is possible for even a painter

to know too much; and on the other one may be reminded how dangerous a thing a little learning is. After all, systems of teaching, prescriptions what should be taught and how what is taught should be taught are very far from being simple matters to determine . . .

It is idle for critics of the Philadelphia methods to suppose that they are pursued with an enthusiasm that is blind to objections. "Of course, one can waste time over anatomy and dissection," Mr. Eakins said to me. "I did myself, when I began to study; I not only learned much that was unnecessary, but much that it took me some time—time that I greatly begrudged—to unlearn; for a time, my attention to anatomy hampered me." Nothing can be needed to show more clearly how fully this whole matter has been considered at the Philadelphia schools.

Thomas Eakins to Edward Horner Coates, letters, Pennsylvania Academy of the Fine Arts.

[September 11, 1886]

The careful consideration I have always had from you of my written matter, induces me to lay before you some opinions, in which if you do not agree with me, for there are all shades and degrees of even the same opinions, I yet trust I will at least make you understand me; for I have been fearfully traduced and I think even by you sometimes misunderstood: nothing is to be more feared I find than hasty judgment on real facts distorted and purposely deprived of circumstance.

If for instance, I should be in a railroad accident, and escaping myself unhurt, should on looking around me, perceive a lady bleeding most dangerously from the lower extremity; then and there I should try to find the artery and compress it, perhaps tie it if any bystander had the stomach to aid me: and for this I might well receive both her gratitude and that of her folks.

Now if years after, some evil disposed person would run busily about and whisper that I was a filthy person, that I had lifted up a lady's clothes in a public place, that on account of it, there was a great scandal at the time (when there was none), that I was near being killed, I should have upon me at once more than I might ever hope to fully contradict, except to a very few friends, and of my few friends, some would sympathize with me, but would wish I wouldn't do unconventional things, and some would tell me that it is always bad to have dealings with strange women anyhow, and others with much worldly wisdom that no motives can ever be understood by the public except lechery and money-making, and as there was no money in the affair I should not have meddled, as if my chief care should be the applause of the vulgar.

Again, a man could easily be accused of lewdness, and his actions be truthfully described in fearful terms; yet if the explanation were once listened to that he was an obstetric physician practising his calling he might rest blameless.

The long study of the man, and his skill have given him the right to do whenever necessary unconventional things; and the more civilized the community, the more its members differentiated, the more are such rights respected and understood. So the figure painter may be accorded privileges not allowed to the rabble, and must be if his work is to be worthy.

Although professional privileges are more tardily accorded to women than to men, and with reason, yet there is a decided advance making with respect to the education of women especially in America.

And if women are to be taught at all I think they should have good teaching.

I once knew a lady physician of some renown and large practice, whom I admired and greatly respected. She got a little troublesome sore on her master finger but did not recognize it as a venereal chancre, and delivering and examining many patients, she introduced the syphilis into

a great many families who never deserved it, and died herself after great suffering from the effects of her ignorance.

But within the last few years the young women medical students attend the same clinics as the men. The most dreadful diseases are shown them, described, and operated on, much to the safety of those families who are afterwards to employ these students become physicians.

And while students, these young women spy into each others' piddle with a microscope and do a hundred other unconventional things, from which the novelty now being worn off, even mild derision can hardly be excited against them.

I do not believe that great painting or sculpture or surgery will ever be done by women, yet good enough work is continually done by them to be well worth their doing, and as the population increases, and marriages are later and fewer, and the risks of losing fortunes greater; so increases the number of women who are or may be compelled at some time to support themselves, and figure painting is not now so dishonorable to them.

Miss Elizabeth Gardner who studied the nude at Paris (with young men) while I was a student there, paints the figure now almost exactly like Bouguereau, and her pictures sell so well that she must be rapidly accumulating a fortune, and I could name many other women both painters and sculptors who are honorably supporting themselves; and even if marriage should be contemplated by them, they are at least in a position from their education to decline ineligible offers.

But no woman could ever hope to paint like Miss Gardner or Miss Clementina Tompkins and live at all times the conventional life.

She must assume professional privileges. She must be the guardian of her own virtue. She must take on the right to examine naked men and women. Forsaking prudery, she locks her studio door whenever she wishes, and refuses admittance on the plea that she has a model. And without these privileges, she could not hope in any way to compete with men nor with the intelligent of her own sex, and a certificate of prudery would not in this age help sell a figure piece by a young lady.

Under the chairmanship of Mr. Rogers, the aim of the Academy schools was to give the advantages of the best instruction possible to men and women who were to become professional painters and sculptors. The result hoped for was the possible development of talent which would repay in honor by great work, the careful thought expended in the direction of the methods of study.

I need not perhaps tell you how earnestly I seconded his efforts.

I most carefully watched the progress of every intelligent student, and supplemented school work whenever possible by the advantages of my private studio.

Being the only artist in the city habitually using the nude model, I have often had my best students with me while making my pictures, and have freely advised or aided them in the making of their own, and I believe much of the success of the figure work by graduates of the school has come from supplementary work on my part.

And right here I shall tell you that I never gave these special advantages to any student man or woman, who did not show in my judgment the best talent in the class, or who did not intend to be strictly professional.

I see no impropriety in looking at the most beautiful of Nature's works, the naked figure. If there is impropriety, then just where does such impropriety begin? Is it wrong to look at a picture of a naked figure or at a statue? English ladies of the last generation thought so & avoided

the statue galleries, but do so no longer. Or is it a question of sex? Should men make only the statues of men to be looked at by men, while the statues of women should be made by women to be looked at by women only? Should the he-painters draw the horses and bulls, and the she-painters like Rosa Bonheur the mares and the cows?

Must the poor old male body in the dissecting room be mutilated before Miss Prudery can dabble in his guts? Such indignities anger me. Can not any one see into what contemptible inconsistencies such follies all lead? and how dangerous they are?

Take the case of poor Godley who by his actions and words during years admitted of no impropriety in the exposure of the living male form even to female eyes, yet was sent around by Frank Stephens to quarrel with me in the dissecting room matter, saying with words put into his mouth that he must draw the line somewhere. So he drew his line of propriety between the living and the dead body, and getting with the young women on the foolish side of the foolish line, they discussed obscenity.

Such inconsistencies brought to the attention of a thinker interested in art education should arouse some very serious thoughts.

If the exposure of the naked body for study purposes is improper, life classes should be shut up, but I maintain that art is refining rather, and I should have very little respect for any figure painter or sculptor man or woman who would be unwilling to undress himself if useful; yet by his presence in a life class would encourage a model to do it, holding it either a sin or degradation.

The class room with the distant model forms but a part of the education of a master painter or sculptor.

I believe I have the courage of my convictions. I am not heedless. My life has been full of care and thought, and governed by good moral principles, and it is very wicked and unjust to misfit my doings to motives which a very little consideration would show did not govern them.

[September 12, 1886]

Having given you in fragments some account of Miss Van Buren's studies with me I am moved to write it fully. She is a lady of perhaps thirty years or more, and from Detroit She came to the Academy some years ago to study figure painting by which art she hoped to support herself, her parents I believe being dead. I early recognized her as a very capable person. She had a temperament sensitive to color and form, was grave, earnest, thoughtful and industrious. She soon surpassed her fellows, and I marked her as one I ought to help in every way. Once in the dissecting room she asked me the explanation of a movement of the pelvis in relation to the axis of movement of the whole body, so I told her to come around with me to my own studio where I was shortly going. There stripping myself, I gave her the explanation as I could not have done by words only. There was not the slightest embarrassment or cause for embarrassment on her part or on mine. When next year she arrived at the Philadelphia school, I was using a nude man, and I had her come around and model alongside of me that I might give her more particular advantages of which she profited for some weeks. I also directed her choice of classes at the Academy and method of study.

Our social relations were what would be natural anywhere between kindly decent people.

She staid to lunch two or three times when it stormed for her health was not good, and I think she came to tea once and spent the evening with us.

She was taken sick that spring and went early to the sea-shore. She asked my advice about

the summer work, and I told her if she gained strength enough to want to work, then to make color studies of outdoor effects, and to model in wax with her companion from one anothers' bodies, and said that I would correct their work in the fall of they would bring it to me: which she intended to do.

When back in the fall, improved somewhat in health, she told me that although they had taken my advice about modelling, they had done but very very little. I supposed it was on this account they did not bring it to me for correction.

If it had been advanced enough to gain by criticism I do not believe she would have hesitated to undress herself before me any more than before her family physician; but as it was I never saw her undressed, and she never saw me undressed but the once, because no other occasion arose to require it.

The lady has been quite an invalid at home. After the Academy trouble, she wrote us a letter, (but without mentioning the trouble, although she had most abundant means to hear of it through my enemies), thanking me again for the interest and kindness I had always shown her.

Except yourself, I do not think Miss Cald. knew or cared for any Academy Director. She paid her money and took what the school provided.

I have spread out this history at length as it is the one to which I had always supposed before your denial that your question referred, as to whether I thought it right to undress before a person who did not want to see me.

The lady would hardly like to ask to see me, yet she was glad to do so. I think indeed she might have been embarrassed, if I had picked up a man on the street and endeavored to persuade him to undress before the lady for a quarter, while with me and Mrs. Eakins there was no danger of misunderstanding, or misapprehension of any kind.

Now if the Academy Directors wished to enquire into my private or professional affairs in order to act upon what seems to me did not concern them, I think they should have at least investigated them, and if any thing suspicious appeared to them, they should have told me just what it was, and have asked of me the explanation. The whole conspiracy against me was so secret that I could only guess at my accusers and of what they might have accused me, nor would any one enlighten me. The subsequent action of the Directors was to my mind cowardly cruel and dishonorable.

THE PENNSYLVANIA MUSEUM AND SCHOOL OF INDUSTRIAL ART

In contrast to the fine-art curriculum of the Pennsylvania Academy of the Fine Arts, another major Philadelphia art school, the Pennsylvania Museum and School of Industrial Art, trained weavers, designers, carvers, and metal and glass artisans. The institution was one of the largest American embodiments of the English "South Kensington" movement in technical artistic education; among its later alumni was the modernist painter Charles Sheeler. (Although the school enrolled both men and women, there was also a single-sex technical school in the city: the Philadelphia School of Design for Women.) The following article on the School of Industrial Art outlines its scope, methods, and philosophy. The author mentions the school's principal, Leslie Miller, who would be the subject of an important portrait by Thomas Eakins in 1901. Years after his dismissal from the Pennsylvania Academy, Eakins developed an interest in the School of Industrial Art; he donated several of his perspective studies for use as teaching examples for the students.

Ernest Knaufft, "Our Art Schools. Philadelphia.—II: The Pennsylvania Museum and School of Industrial Art," Art Amateur 24 (January 1891).

The Pennsylvania Museum and School of Industrial Art, in Philadelphia, is not an imposing building at first sight, as No. 1336 differs in no marked degree from its neighbors in Spring Garden Street. But after a thorough examination of the interior, and the system of instruction worked so admirably therein, one leaves it with astonishment that an enterprise so complex and well ordered could be successfully undertaken in such cramped quarters. The building is, however, entirely inadequate to even those departments at present working; indeed, the chemical branch, connected with the Textile Dyeing courses of this school, is crowded out and accommodated at Nos. 1346 and 1348 in the same street, a few doors from the main building.

The rooms of No. 1336 are of the ordinary dimensions of those in dwelling houses; these are allotted to classes for wood-carving, modeling, metal work, free-hand drawing and designing for stained glass, for wall-papers and other manufactures. Upstairs there is a large lecture-room, and, in an annex to the main building, a number of workshops with looms and other machinery connected with the process of weaving. It is typical of the institution to find that while perhaps a few hundred dollars have been spent on casts for the drawing class-rooms, many thousands have been expended in machinery for weaving. This divergence from the usual curriculum of art schools explains the dominant idea that controls the whole institution. The main object of its varied tuition is also incidentally revealed in the list of former students published with the circular of the school, wherein you find only about five per cent designated as "artists," for the majority are described as designers, decorators, "draughtsmen for mills or shops," overseers, superintendents and so on. This proves that the Industrial School is not only intended for artisans, but that its mission to provide technical instruction to be of practical value to the student directly he has graduated attracts chiefly the class to whom it appeals.

There is, it may be safely said, no other art school in the United States, and possibly no other in the world, where a student can acquire in so short a time that technical knowledge which makes his labor of higher market value, or attain it in greater degree, than at this one. For example, suppose a boy with a taste for art is an apprentice in a carpet factory, receiving seven dollars a week, and that his parents, anxious to better his prospects, are willing to pay for his education nine months at a school that will send him out equipped to earn the highest salary in his particular industry, they send him here, and in less than a year the authorities can fit him to earn twelve to fifteen dollars weekly.

In the course of a conversation with Professor Miller, the struggle of a poor young man with artistic talent was discussed, how such a one frequently earns barely enough to pay the rent of a studio, and "has to sustain existence in a garret," while, as the professor remarked, "the man who designed the pattern for the cloth of his trousers lives in a marble front and has his butler and carriage." But while picture painting is often treated scurvily by fortune, there are at present few positions affording better remuneration than that of a designer for manufactures. To this end, the museum school endeavors to qualify its young American students that they may be equipped to supersede the Scotch, German or French designers, who taking advantage of the unpractical training of our home talent, come over here to draw large salaries. A graduate of this school may feel assured that, if industrious and energetic, he is in no danger of being pushed to the wall in the struggle for existence that rages vigorously in our large cities, and it may be safely said that the students of few art schools dare venture a similar belief in the marketable value of the education they have received.

The history of the school is full of interest; to the sociologist it is particularly so as an illustration of the permanent effect of what at the time, appeared to be a transitory movement . . .

The lesson of the founding of this school is a case in point; for we are told that "the Pennsylvania Museum and College of Industrial Art owes its origin to the increased interest in art and art education awakened by the Centennial Exhibition of 1876." It was founded in February of that year, as an institution "to be similar in its general features to the South Kensington Museum of London." A fund of fifty thousand dollars was subscribed, with the help of which purchases were made from the Exhibition. Beside these acquisitions valuable gifts were made to the institution by individual exhibitors—for instance, the major part of the collection of the produce and manufactures of British India was presented to the museum by the British Government. The treasures of the museum are now on view at the Memorial Hall, but besides the founding of this collection, a school was established with a view to teaching the technical side of art production, and from that has grown the institution as we now find it, having its own annual exhibition (since 1888), where examples of art manufactures are shown.

In 1882, The Philadelphia Association of Textile Manufactures was founded. Aware of the part played by technical schools in foreign countries, in enhancing the market value of their native produce, the association turned its attention to American art education. Hearing of this, the trustees of the Industrial School placed class-rooms at the disposal of the association; and a night class for weaving and textile design was organized in 1883. At the next meeting of the association some thirty thousand dollars were raised to help this institution, twenty-five per cent of which was handed to the school to maintain its curriculum. The following season further funds were raised through the efforts of William Platt Pepper, President of the Museum and Industrial School, for an additional school building, which was completed in time for the school year, 1884–85. In 1885 a day class was inaugurated, the most improved machinery obtained, and arrangements were made for a course of instruction extending over a definite period. It is now a three years course, the subjects taught being designing, painting, weaving, and the cleansing and finishing of raw material. While it is true that the education in drawing and painting proper is weak in comparison with those schools training painters and sculptors only, yet the student is made to realize by practical experiment that drawing is the necessary foundation for an art education.

As the "official" Circular of the Committee of Instruction, 1890–91, says, "In several important aspects the superiority of the school over any of its European rivals is acknowledged. The advantages it offers are of two kinds: First, the association of technical education with artistic culture is more direct and complete here than in any European school whose mission is so distinctly technical; secondly, that in European schools the time is too much given to weaving, and the instruction is too apt to be general rather than individual. In such there is no direct connection between the work executed and the student's own design; whereas in the Pennsylvania school the individual student has an opportunity to work his own designs into the fabric, every step in the process of production, from the first sketch to the finished product, being his own work. The advantages of this method are not only apparent to any intelligent observer, but testimony to its sufficiency has been furnished by some of its pupils, who have attended the best European schools before coming here and who cheerfully own to the superiority of the Pennsylvania school."

A certificate of study is issued to students who pass satisfactorily an examination held at stated times during the year in connection with the regular course. This course embraces drawing and painting in water colors, lettering, geometry and perspective, modelling and casting, the use of

color and historic ornamentation and industrial drawing, together with lectures upon anatomy. After gaining this certificate pupils may complete a course in decorative painting and applied design, decorative sculpture, textile decoration, or chemistry, each of which covers two years; or they may take a course of a single year in either of these subjects. The student then receives a diploma. A course for teachers is also included in the curriculum.

San Francisco

A DEAF ART STUDENT IN SAN FRANCISCO

Born in San Francisco in 1851, Theophilus d'Estrella was orphaned at age five and educated at the Berkeley School for the Deaf, where he later taught. A painter and photographer, d'Estrella studied with Virgil Williams at the San Francisco School of Design. Williams had been a pupil of Daniel Huntington in New York and spent some seven years in Italy before traveling briefly to California in 1862; he settled there permanently in 1871 and continued to treat Italian subjects, as well as California scenes. D'Estrella's notes on his teacher's studio instruction were published a year after Williams's death in 1886. They are particularly important for the light they shed on the struggles of a deaf artist, and they also provide some flavor of the California artistic community, where success was measured against the paintings of local and visiting artists such as Thomas Hill and Albert Bierstadt.

Theophilus d'Estrella, *"Virgil Williams' Art Notes to a Deaf-Mute Pupil,"* Overland Monthly and Out West Magazine 9 *(March 1887).*

In 1879 I became a student at the School of Design on Pine Street, but not without difficulty, as Mr. Williams then opposed my admission, on the ground of my deafness. He seemed to have entertained a prejudice against deaf-mutes, as may be judged from his remark in after years, when our relations as teacher and pupil had softened into a genuine friendship: "You know there are very few mutes who have your education and intelligence. It is a pleasure to teach you. You comprehend everything so readily and appreciate so highly everything I do for you. But I am afraid that there are few like you."

He maintained that it was impossible to teach a deafmute; but when I, through the help of Messrs. Bradford, Perry, and Wilkinson, at last succeeded in having the doors of the school opened to me, Mr. Williams did not persist in any small-minded and piqued way of clinging to a prejudice, but at once took me in tow, though my condition necessarily entailed on him extra work very irritating to a man of his temper.

Our only communication was through paper and pen, as he could never master the hand alphabet. After I had been about half a year at the school, the idea occurred to me of saving scraps of paper on which he wrote and copying them into a note-book; and in that way the accumulated material, in the course of four years, covered more than one hundred pages of a good sized ledger. The bulk of the material touched upon matter connected with school routine, of but little interest to the general reader, though expressed in language that belongs to a man of scholarly attainments, and brilliant imagination, and perfect acquaintance with the subject.

He had a way of tapping me on the shoulder, on passing my easel, which gave me an instantaneous clue to his mood at the moment. From some of his taps I at once knew that he was behind the chair, rubbing his nose as he invariably did when irritated, and shaking his other hand in a tremulous way, as if calling, "Pencil! pencil! pencil!" and, as I fumbled in the pocket

for paper and pencil, I knew that a storm was pending. From his other taps I could instantly apprehend what was afterwards realized on the paper. He would then be kind, tender, and encouraging, and considerate of my misfortune. At such times he would sit by my side and have a chat with me.

He wrote with extreme ease, and never hesitated for a word. He never misspelt, though he often left a sentence incomplete in his impetuosity, impatient at the slow scribbling of the pencil. Sheet after sheet flies from the pencil; criticism runs into anecdote, and a dissertation on anatomy comes as easily as a description of a sunset on the beloved Naples; he scolds—which he oftenest does—and praises and encourages and cautions by turns; is witty one moment and instructive the next, but never flatters; is honest in his opinions even to harshness, liberal in his acknowledgment of merit, and frank in admitting his errors and defects. I once said to him that I had just seen his pictures at Woodward's Gardens, whereupon he replied. "If I were rich, I would buy back the whole lot and burn it."

He was far from being narrow-minded, dogmatic, and contemptuous of others' opinions: he once a little impatiently said to me, "You have placed yourself in the hands of Mr. Virgil Williams, and thus far you have profited by his disinterested assistance and advice, but when you come across a friend who knows more than he does, accept the advice that he may offer."

Of his character, of his capacity as an artist, a thinker, a conversationalist, and a teacher; of his moods, failings, and worthy traits, the notes, which he wrote impromptu, without attempt at pedantry and without knowledge of their being preserved, will, like epistolary correspondence, give a fair impression, and some of them I herewith quote with little or no comment:

"It [a sketch of mine] is awfully careless. Do not try after Hill. Try after Jerome, Bonnat, or any great French masters. Tom Hill has a great deal of knowledge and can afford to neglect details, and there is always so much evidence of knowledge in his work that the most careless sketch of his passes for good. You have his carelessness without his knowledge." . . .

I, once complained to him of what I thought a very harsh criticism of my work, whereupon he wrote:

"You may be sure that I am actuated only by a sincere desire for your improvement. I am severe sometimes on purpose to check a growing satisfaction with your own work—that is, in your own mind. There can exist in the road of a young artist no obstacle so great as what the late General Colton styled 'the big-head,' meaning, of course, excessive conceit; but I should be more severe with you sometimes if I could talk with you than I am now, as being obliged to write what I wish to say moderates my expressions considerably. In any case I want you to take what I shall say as friendly and meant to do you good. That you shall feel greatly discouraged sometimes is to be expected. No one with an artistic temperament but experiences periods of great dejection and corresponding elation. We must take the bitter with the sweet. If the ecstasy of drunkenness were not followed by reaction and pain, the whole world would be continually and gloriously drunk." . . .

Admirers of Ruskin may not agree with this:

"That book [Ruskin on Painting] is very pleasant reading for young ladies, but you will get no practical benefit from it. The author is a charming descriptive writer, but a conceited and prejudiced old ass—he is in art what Carlyle was in literature—both of them captious, arrogant, prejudiced, egotistical, and clever men . . . The first is not much esteemed by artists now, and the latter is fast finding his level. I think there are much better men in their respective lines— think Motley better as a historian than Carlyle, and I know that Hamerton is a thousand times the superior of Ruskin in the knowledge and demonstration of art."

"Read Hamerton's Thoughts on Art, Jarvis's lectures on Grecian Art, Art in the Netherlands, &c. The first you can make a *vade mecum* ('come with me') with safety. It is not liable to mislead like Ruskin."

"Phrenology is an ass."

"Avoid encircling your sketches with lines or fancy borders—it smacks of boarding school misses' work, and is not artistic." . . .

"Now in drawing landscape, neither Mr. Hill nor Bierstadt draw correctly. They get the character only. I have sat down many a time beside Bierstadt, and his drawing was not half as correct as mine, but he had a better *tout ensemble* than I. I once went out of Rome with Bierstadt and Sanford R. Gifford. We sat down and made a study of an old shepherd's hut built on a brick ruin, of thatched straw with little shelters around for sheep. We all made careful studies, taking some six hours. When they were done, it was curious to see how three men had represented the same scene. Bierstadt's was very true but he had the mountains in distance, which I however made all cool-gray of purple and red tones. Gifford made his whole study of a kind of a Naples yellow tone, that was his peculiarity. I still think my sketch was the best of the three. Unfortunately, I loaned it to—, who wanted to paint a picture from it, and I never saw it again." . . .

"The difference between an artist and any other cultivated person is not that they have not the same ideas, but that the artist is able to express his and the other person cannot. It is by knowledge gained by constant practice and study, that power is attained. There will always be difficulty, no matter how much you know—no matter how much dexterity of handling you possess."

"The only thing do is to think nobly and to work earnestly to express noble ideas.

"In saying that, I do not mean that you should be always trying to hunt up great ideas and moral precepts. This is what I mean by looking at things nobly. Take an old beggar, broken down—squalid—unclean. In his artistic look dirt goes for nothing. It even helps your picture by being in accordance or harmony with it. I might write you a volume on this, but I think you will discover it all for yourself." . . .

"Burnt sienna is a most valuable color. George Inness used to call it the Jesus Christ of colors." . . .

"I am going on a sketching-trip to Los Angeles next week. I hope to find some little corners among the Mexican inhabitants, such as the corner of a garden with an orange-tree, and a white shadowed wall with an old woman, or still better a young girl—warm and southern in her style, with color and richness. I hate the cold barren pictures of the north. I think I shall find something that will remind me of Italy."

After that visit to Los Angeles he was much more cheerful and hopeful . . .

"I am sure," he wrote, "that in your life at the Institution there must be some episodes that you alone could understand and express. You are not as other men are, and you must see things differently. There must be something peculiar, interesting, and touching that all would recognize as pertaining to the deaf and dumb, and if you can hit upon something that is pathetic, and yet unites beauty with affliction, you are sure to make a success of it. Look at Bonnet's 'La Communion.' See how simple its conception is, and how commonplace its idea, and yet it sold for $40,000. You may draw a blind girl at play on the piano, and carefully note the action of the hands as they make low and plaintive music, but the fondness of the blind for music is proverbial. Try and do something for the deaf-mutes."

This was the last time but one I met him, and the news of his death came, and a good friend and a valuable teacher was gone.

YOUNG TURKS: THE FORMATION OF THE SOCIETY OF AMERICAN ARTISTS

The discontent among younger, progressive, and foreign-trained artists with the established National Academy of Design had been growing during the 1870s, fueled by a series of conservative Academy juries and the temporary closing of the Academy schools in 1875. In 1877 an uncharacteristically liberal committee installed an annual exhibition that featured several younger artists such as Frank Duveneck and William Merritt Chase, thereby slighting the older men who were accustomed to favorable treatment "on the line" (see also "The Munich School," chapter 11). The hanging committee's actions (and its refusal to rehang the galleries after protests by Academy officers) prompted immediate backlash; the Academy members passed a measure protecting their right to privileged hanging in the annual exhibition, and they decided not to elect any new Academicians that year (they only selected one associate member, or ANA: John Dolph, an unthreatening painter of puppies and kittens). There was also discontent in the Academy ranks about the growing number of women artists in the younger generation; one Academician was quoted as saying that "he didn't mean to have the bread taken out of his mouth by women."[4]

Thus, in early summer, 1877, a small group formed what would become known as the Society of American Artists (SAA). Wyatt Eaton and Helena De Kay Gilder were among the organizers. The paragraph from Eaton's letter to Gilder, below, gives a sense of their frustration (and of his problematic spelling). Their first exhibition opened on March 6, 1878, and it included 124 works—in contrast, the National Academy show that year featured more than six times as many objects. A few weeks after varnishing day, George Sheldon wrote a sympathetic essay in Harper's *explaining the SAA's dissatisfaction with the Academy and likening their move to the independent spirit of the French impressionists (though little in the exhibition of 1878 betrayed the influence of impressionism). Clarence Cook, who had railed against the Academy for more than a decade, went further, declaring, "This exhibition means revolution."*

In subsequent years, it became an annual rite of criticism for comparisons to be made between the two organizations once their spring exhibitions opened. Not all were predisposed toward the newcomers. In 1880 the Appleton's *critic deemed the SAA works too extreme: unfinished, painty, and lacking in beauty. That same year Marianna Griswold Van Rensselaer praised them for almost these same qualities. Despite calls for reconciliation, some observers, such as a critic for the* New York Times, *found the competition to be bracing, invigorating debate and increasing interest in art. Nevertheless, in 1906, twenty-five years after the* Times *extolled this new competition in the art world, the Society of American Artists ceased to exist, merging with the Academy.*

Wyatt Eaton to Richard and Helena De Kay Gilder, June 21, 1877, New York Public Library.

I feel more than ever the necesity of a new art organization or movement.

I see the Academy as a great obsticle to art culture, growth & education. It must be completely turned over (which I do not believe possible) or it must die. The interests of artists &

[4] C.C. [Clarence Cook], "Academy Criticism," *New-York Daily Tribune,* June 6, 1877.

students are common—accepting this—no other evidence is necessary to prove the deformity and dwarf like chariter of the Academy. I feel deeply thankful for the prospect we now have of something better. I hope for something more than mearly an Exhibition of our own works. (although this necessarily must be the commencement) I shall do all that is possible this summer by letters—& this Autumn will give myself unresearvedly to the work. We can depend only upon men who have recently been to Europe who have breathed the larger artistic spirit, & have tasted the many advantages for the study of art abroad.

[G. W. Sheldon], "A New Departure in American Art," Harper's New Monthly Magazine 56 *(April 1878).*

Were you to talk with almost any member of the American Art Association, now holding its first annual exhibition in the Kurtz Gallery in New York city (I have talked with several of them), he would tell you that the principal reason why the Association was formed is that the National Academy of Design seemed unwilling to aid the progress of art in this country. He would say that the Academy is concerned too much with the comfort and the prejudices of Academicians; that it does not serve art energetically or disinterestedly; that it appears to be jealous of young artists who are or have been studying in Europe; that it does not represent the truest and freshest impulses in art; that, in a word, it is a mutual admiration and sustentation society, sluggish, easily satisfied, and wholly out of sympathy and patience with the rising children of light. Were you to ask him what the American Art Association proposes to accomplish, what aims it desires to realize, he might show you a copy of the simple resolutions passed at the time of organization, October 29, 1877:

> "*Resolved,* That an Association be formed by those present, with the object of advancing the interests of art in America, the same to be entitled 'The American Art Association.'
>
> "*Resolved,* That the Association hold annual and special exhibitions of paintings, sculpture, and other works of art, and that the first exhibition be held in the city of New York during the coming winter."

This is all that the society has yet written out with reference to its purposes. But it must be confessed that the phrase "advancing the interests of art in America" tells a comprehensive story.

The members of the Association are now fifteen in number, the following being their names, in the order of their election: Walter Shirlaw, president; Augustus St. Gaudens, vice-president; Wyatt Eaton, secretary; Helena De Kay Gilder; Olin S. Warner; R. Swain Gifford; Frederick Dielman; Louis C. Tiffany, treasurer; Francis Lathrop; Homer Martin; Samuel Colman; Julian A. Weir; John La Farge; Thomas Moran; and William Sartain. Three of them are members of the National Academy also, and two of them Associates of the same institution, where they still retain their places. One-third of the space in the Kurtz Gallery has been allotted to American artists now studying in Paris, one-half to American artists at home—no preference in the hanging of pictures being given to the artists in the Association—and the remaining space to American artists in Munich, Rome, Florence, and other European cities, and also to promising young foreign artists. The members of the Association have, I believe without exception, been trained in the most celebrated art schools of the Old World.

It is by no means surprising that dissatisfaction should have been manifested toward the National Academy of Design . . .

The Paris Salon, to be sure, is much more liberally managed. All former exhibitors have votes in the selection of a council and a hanging committee. Nevertheless, some clever artists, no-

tably the so-called "Impressionist School," open annually an independent exhibition. It is not at all strange, then, that there should be in New York city a company of artists who want more elbowroom than the National Academy gives them, who are not inclined to be at the mercy of the Academy until the time shall come—if it is to come—for them to be elected Academicians, and who, even if elected to-morrow, would be outvoted and practically powerless to help themselves or their friends. More than this, the members of the American Art Association and a good many other artists received last summer from the National Academy the snub direct. That institution, in view of what to it seemed to have been a partiality on the part of its last hanging committee for a few of our younger painters who had been or were studying in Europe, passed a law to the effect that hereafter in every annual exhibition eight feet of line should be reserved for the works of each Academician—eight feet at least, and as many more as a hanging committee should see fit to allow. The law, indeed, was very wisely repealed soon afterward, but its animus could not be forgotten by those to whom it was odious. To them it was the incarnation of the spirit of persecution. The reign of justice, they thought, was over. The Academy intended to take care of itself in the annual exhibition, letting outsiders eat of the crumbs that fell from the Academicians' table. The pride of the outsiders was touched. Their strength they knew, because the public had admired their pictures, and the press had praised them. Why not have a show of our own? they asked. Six or eight of them met together and organized the American Art Association. In conjunction with the American artists in Paris, they appointed a committee of judges in that city, who should accept or reject every painting or piece of sculpture there offered to the exhibition in this city. Artists, therefore, who lived abroad ran no risks in sending their works to New York, these works being accepted by the Association before they left Paris. Such artists, too, were further encouraged to contribute examples of their skill, because the exhibition was conducted by men of like artistic tastes and purposes with themselves. Their pictures would be received with sympathy, and placed where they could make themselves felt. At the same time the Association announced that it considered itself, and that it wished the public to consider it, in no sense a rival to the Academy. It recognized the fact that both institutions, each in its own way, worshipped the same supreme goddess. It had seceded, not in the spirit of bitterness or of commercial competition, but in the spirit of freedom and of independence.

In order to give breadth to the exhibition, it resolved to invite contributions from some of the Academicians, as well as from other artists at home and abroad. And with a view still further to increase the range of the display, it decided to exhibit studies and sketches as well as finished pictures. Studies, being made directly from their subjects, and (in the case of landscapes) in the open air, have their own peculiar charm of freshness and brightness. They differ from completed works as conversation differs from written discourse. Simple, vigorous, original, sparkling, they are often singularly interesting and forcible, revealing, too, in many instances, the genius of an artist whose insufficient technical skill does not permit him, in an elaborately conceived and wrought composition, to show himself to advantage. The same is true in a great measure of sketches also; so that a public exhibition which consists of good pictures, studies, and sketches is a field of varied beauty and of abounding pleasure. Besides, the schools of Munich and of Paris have long found favor in New York; and the productions of young men who, like many of the exhibitors, have been trained in those schools, possess at least this interest, namely, that they can be intelligently and curiously and, if we please, uncomplimentarily contrasted with the familiar works of the masters under whose instruction they came to light.

The members of the Association insist, however, that, in spite of their foreign training, they

are truly American in spirit and in work. They went from home simply to educate themselves, to develop their minds under more stimulating conditions than otherwise would have been possible. Their object was not to ingraft foreign art upon American art. They wished only to nurture their faculties, to cultivate their tastes, to widen their vision, to increase their knowledge of technique. Paris, for instance, offers peculiar advantages. Its schools of art employ competent teachers, and use approved methods. Its greatest painters in their private ateliers gather pupils and help them systematically, diligently, generously. Its atmosphere has the aroma and the oxygen of art.

C.C. [Clarence Cook], "A New Art Departure," New York Daily Tribune, March 9, 1878.

This exhibition means revolution. Here, in this modest room, Art in America, with half a tear in her eye for auld lang syne, but without flinching, flings a good-bye to her milk-and-water days, shuts the nursery door behind her, and with youth's bright glow in her cheek, with knapsack on back and staff in hand, sets off in earnest to climb the heights. Here at last is painting, for painting's sake; study, for youth's delight in study; an earnest [———?] of the day when our artists shall be bred at home as well as born at home, and the seal of a foreign school, the approval of a foreign master shall no longer be necessary to give an American a position among his own countrymen. Ten years with such a start as this, and we shall send to the next exposition (at St. Petersburg) something better than sewing-machines and patent cow-milkers; we shall send pictures and statues that will not be shamed by being set along side the work of France and England. American artists will find at home that "atmosphere" which for many years they have run abroad to seek, and which, to our great loss, too many of them have found there. The Wests and Leslies, the Stuart-Newtons, and Boughtons and Whistlers of the future will be content to breathe their native air, and wear home-grown laurels; nor shall we have the shame of disputing with foreigners over our right to call, our fellow-countryman, a man who for the sake of foreign employment denies his American birth and mispronounces his own name.

To the general public, wearying in these days of the tameness and insipidity of collections of American pictures, the very look of the present exhibition must, I think, be exhilarating. It is a recommendation that the collection is such a manageable one; the pictures are not too many, and their merit is so evenly balanced one can look long and contentedly in many directions. The hanging seems to be remarkably well done. An innovation in the management is the absence from the catalogue of the names of the hanging committee, but if I wish to know these names it is only for the pleasure of thanking those gentlemen to whom the so placing every picture as to bring out its good points, and give it the best possible chance to be seen, would appear to have been not so much a duty as a labor of love.

"The Spring Exhibitions," Appleton's Journal 8 (May 1880).

The annual spring exhibitions of pictures are occasions when we may properly take note of the progress or the variations that mark the course of our national art. In using the term "national art," we are well aware that art in this country is generally declared to be utterly without national character; but, whether this is true or not, the question momentarily before us relates to those indications of movement and those manifestations of taste that pertain to our American group of painters, and consequently the subject has sufficient national significance to justify the use of the term.

The exhibitions of the National Academy of Design and of the Society of American Artists are peculiarly indicative of current artistic tendencies, the latter embodying the latest and the

most revolutionary ideas in art, and the first displaying the conservative principles of established methods, with such modifications as current theories have produced. The old and the new school for the most part occupy hostile camps, and yet they manifestly need each other. All reactionary movements go too far, just as all conservatism is too tenacious. The artists of the new society are inspired by some very just ideas. They have a great contempt for mere prettiness, for emasculated art in all its forms, for sentimentalism and feebleness, for mere smoothness and polish, and they paint with great directness, simplicity, and vigor. But they have carried their contempt for sentimentalism so far as to exclude sentiment, and in their delight in rude strength have forgotten that the real purpose of art is the illustration of beauty. "Among the best gifts bestowed upon us is the sense of beauty, and first among the servants of beauty is art," declares a recent writer on art; and he adds, "The picture that does not fan into a glow our sense of beauty, whether as connected with charm or glory, *has no sufficient reason for existence.*" The italics here are our own. How many of the paintings produced by the artists of the new school will stand this test? No doubt this question can also be asked of the pictures in the Academy Exhibition, but at least we see recognition there of the prime necessity of beauty, and occasionally a painting may be said to have attained it. But our younger men seem to deny the principle. They produce works that are sometimes interesting in technique, but they do not conceive things or paint things that even touch our sense of beauty, let alone "fan it into a glow." In truth, they appear to conceive things and paint things that shall purposely deny the principle of beauty in art, that shall be servants of ugliness rather than servants of the elements that charm and delight. But these gentlemen will find their ground permanently untenable. Mutual admiration may hold them together for a time, but Mutual Admiration Societies are tolerably sure to ultimately degenerate into societies of mutual disgust. Artists can not flourish except by their hold on human sympathies and susceptibilities, by their power to move the public heart. Judged by this test, we do not see that the new school has made any advance over last year. They still persist in disdaining finish, imagining that brush-marks are acceptable instead of textures. Their flesh rarely looks like flesh, but commonly like fresh layers from the palette. They are fond of painting turbulent skies, but it is whirls of paint and not sweep of clouds that they give us. Their canvases, however, are always vigorous, and are valuable as giving unqualifiedly the artist's own impressions, rather than artificial and studied pretense. Their work, in its extreme forms, can never stand, but as a protest against opposite extremes of smoothness and lifeless imitation it will do some good, and force freshening ideas into conventional methods—advancing art just as pre-Raphaelitism advanced it, but, like pre-Raphaelitism, failing as a distinct method.

M. G. Van Rensselaer, "Spring Exhibitions and Picture-Sales in New York," American Architect and Building News 7 *(May 1880).*

In view of this year's exhibitions it does not seem incorrect or premature to speak of an elder and a younger school in American art. A few years ago we began to hear of "new men" from Munich and Paris, who, however, diverse among themselves, united in differing by aim and method from all those whom the nation had been long accustomed to regard as its interpreters in art. Three years since these new men formed into a society which was organized as a protest against the methods of government of the National Academy. Its exhibitions, however, have been an equally decided protest against the methods of work of the National Academicians and their followers. And it attracted to itself, furthermore, as members or exhibitors, such men as Mr. Hunt and Mr. LaFarge, who had till then seemed abnormal in their development, and had never been associated in the public mind with the mass of their contemporaries.

When I say that the two associations now mark two contrasted schools, I do not, of course, use the word in its fullest and strongest significance. The elder school of American art has not, indeed, been a school in any sense of the word save that which may denote a large number of men working on similar lines, and producing results similar in artistic grade. Taken as a whole, it can assuredly not be thought a school to which future students will ever turn for example or for teaching, however instructive may be the work of one or two among its members. As for the newer school, it is, of course, in its infancy, a school potential, or, as some may think, of future certainly, but still in process of development. It is these two facts which just now make this younger band of workers so interesting to watch—the fact of its rapid growth, its daily, hourly expansion, and the fact that it is at actual daggers drawn with the typical men of our elder generation. He who went to this third exhibition of the Society of American Artists and forgot these things—did not know what names were absolutely new, what men were showing maiden efforts and trying prentice hands, who did not see the great advance others had made since their first appearance a year or two ago, who did not appreciate how they are all striking in the very teeth of our traditions, striving to win the public ear without sounding a single note such as it loves and listens for,—may indeed have got much pleasure from the pictures, but can have gained little knowledge as to the recent progress or the future prospects of our art . . .

Let us briefly note the qualities which marked the antithesis between these walls and those of the Academy.

The terms most appropriate in the latter place are those most inappropriate here. Commonplace, mediocre, dull, are the last words we think of, while their exact opposites are constantly on our lips. These pictures are in almost every case unconventional, novel, individual, tentative, erratic—perhaps in one or two cases crude or ambiguous, and somewhat morbid in one or two more. Affected, I have heard them called not seldom, but without justice, as I think. There is, it seems to me, a note of sincerity in even the queerest products, and among the artists represented we find no copying of each other, which is one of the commonest results when affectation takes hold upon a company of men, work they on whatever line they may. With the non-existence of the commonplace, we must also note the absence here of anecdotal subjects. There were not half a dozen pictures in the room which needed a title, not half a dozen which existed for other than a reason which to the artist had been a simply artistic one. And in so working, an artist moves in the right direction, whether that reason quite justifies itself to the spectator in any given case or not. With the absence of anecdotal, literary interest, and the presence of purely pictorial efforts, we found, as we might have expected, an increasing love for and mastery of the pure technics of the art. This, indeed, is the main fact which resumed and presupposed the minor ones already noted. He who understands and values good painting, *per se,* will not care for inferior things, but will either devote himself to the simple exercise of his skill,—and when good, is not this often enough?—or will pass by its means to those higher things which can *never*—long as we have ignored the fact—exist satisfactorily together with neglect of those means. There are critics to-day who are not content to see our younger men making themselves good painters, who are not content to see our art freeing itself from the ruts of the commonplace, the bathos of sentimentality, and the ludicrous technical inefficiency, which have made it a byword; who are not content to wait for the possible development of highest beauty, and deepest imagination from a sound, undergrowth of technical knowledge and manual accomplishment. Should we not appeal to them to wait more patiently for these things, bidding them look back if they would judge the worth of what we do to-day, not only ahead to some rare ideal? Should we not say "wait till our painters master the language of art, and till

our public understands and values it"? Let us not match our new men only against the heirs of technically trained generations in the Italy, the Spain, the Holland of the past, or the France and Belgium of the present, but let us remember their parentage and the traditions they were born among, and credit them with their vast advance as well as with their evident shortcomings. It is a captious and, moreover, a harmful critic who, thinking of them thus, can deal savagely with this year's best pictures.

"Wholesome Rivalry," New York Times, *March 20, 1881.*

Much well-meant regret is wasted on the somewhat defiant attitude which the National Academy and the Society of American Artists assume toward each other. How much better, it is the common remark to say, if they would join hands and consolidate into one body, which would then be truly national? But would it be better? The hard feeling between the two camps expresses itself merely in an occasional growl from an Academician to the effect that the young men are grasping and unjust, attempting to prejudice the public against those who are their seniors, if not their superiors, in the profession. It exhibits itself in the extreme reluctance shown by the Academy to open even its associate doors to young painters of proved merit. On the other hand, from the society camp come now and then complaints that their existence is ignored except when some picture of theirs may lend interest to an Academy exhibition. Between the Academy growl and the society growl the common friends of both sides find very little to choose, and, since the exhibitions are meant for the public, may well be pardoned for caring more for the general effect of the tension between the two parties than a discovery of the quantity and quality of justice to be allotted to the one or the other. The question is whether good results or bad arise from the situation, and these, not only to the public, but to the artists as well. Indeed, the one thing means the other; for the artist and his public are, or should be, so closely connected that what is good for one is good for the other. Has the competition of the Society of American Artists done harm or the reverse?

The two exhibitions open during the coming week ought to give the answer distinctly enough. But if they should not, the events of the last three years stand in their stead. Never before has so much interest been shown in paintings of all schools, and especially in modern American work. There may have been seasons during and after the war when larger prices were paid, but none when there was so much intelligent criticism by the press and general public, when artists held so honorable a position, when their rights were conceded them more fully, when sincerer work was surer to be appreciated and shallow surer to be condemned. The variety and contradictoriness of the verdicts of the press are not half so bad a sign as people think; they show that there is no cut and dried system of criticism, which forcibly clips all art to one shape. Many wounds are struck, many bruises result, but out of the conflict of words the artist extracts philosophy, and sometimes a useful hint; neither the writing critics nor the talking critics can teach him anything of the methods of his profession, but in the long run they will teach him something of the needs and desires of his fellow-men, provided he be sufficiently humble to pay attention and sufficiently wise to apply the harsh cure.

Without the two poles formed by the Academy and the society there would be much less discussion. Nothing is more stupefying to professional men than the stiffness which invades an organization which has served its purpose in drawing them together at a former stage, when the discipline of union was a prime need . . .

Now, then, the cure for this is competition. At that magic word the old organization bestirs itself. All is not blue pills or brandy and soda in this world; here comes a band of hungry young

fellows who propose to share in the good things and set up a standard of their own. The old armor is taken from the wall and brightened up, the old hacks are led out and made to show their best paces. Drowsy old gentlemen, who have been getting rusty for want of excitement, develop surprising vigor, and may prove more than a match for their young antagonists. And yet there are wise men who go about shaking their heads over the inevitable conflict and descanting upon the evils of rivalry. For grown men rivalry is wholesome.

THE NEED FOR AMERICAN MUSEUMS

The year 1870 marked the founding of two of the most important art museums in the United States, the Metropolitan Museum of Art, New York, and the Museum of Fine Arts, Boston. Other public museums, such as the Art Institute of Chicago, followed in 1879, as did smaller private collections, such as the Smith College Museum of Art, Northampton, Massachusetts, in the same year. In the next two essays, written on the cusp of America's "museum moment," James Jackson Jarves and George Comfort advocate the creation of art museums, although their arguments and rationales differ somewhat. The elitist critic Jarves (see "James Jackson Jarves's The Art-Idea," *chapter 7) focuses mainly on high art and the class of wealthy philanthropists who can purchase it. He argues that great public collections will encourage connoisseurship, but that in order for that to happen wealthy men must be convinced that art offers something that science does not: "Pictures and statues are human souls reflecting themselves in ours as by an enchantment of our senses." Jarves holds out the most hope for Boston, a more cultured city than New York, in his view (see "Poetry in Paint: Art in Boston," chapter 8).*

Comfort, a professor of aesthetics and European languages, is more democratic in spirit, and he credits American artists with greater accomplishment and potential than the captious Jarves. Comfort also has more to say about the physical makeup of the museum, and in a discussion (not included here) of the encyclopedic nature of the best repositories he argues for the display of photography, engraving, furniture, and other decorative arts. The effects he predicts from the establishment of museums are similarly more wide-ranging than Jarves's: better home design, improved parks, more educated artists, and a non-elite class of picture lovers who take an interest in art, even if they cannot afford to own it.

J. Jackson Jarves, *"Museums of Art,"* Galaxy 10 (July 1870).

Were my readers to interpret the leading heading to this article strictly in the present tense, concluding that there do exist at this moment institutions worthy of this appellation, they would be led astray. My object is to set them right both as to the present and future, for reasons which will appear as we proceed. As yet, America has put forward no claim, in a national sense, to museums, or even a school of art. Nevertheless, from time to time some æsthetic seeds have been sown by the wayside, which have sprung up into scattered plants that will repay systematic culture . . .

As it has occurred in England, so in America artists and amateurs must precede institutions of art, by force of their organic laws. Therefore, if we had no other positive indications of the former besides the public recognition of the uses and merits of museums, this fact alone would indicate the growing existence of those classes to whom the masses must necessarily turn for

æsthetic entertainment and instruction. In fact, America has now several artists of a certain eminence in their respective spheres, mostly of a realistic tendency, aiming at original motives and treatment, besides a lesser number who aspire to embody ideas in preference to merely portraying facts; or else who attempt to incarnate in material forms their own sentiments and thoughts. Feeling, however, is the exception, not the rule, of American art. There are considerable fancy and a certain rude adroitness of composition, as in its literature, aiming at the particular and special rather than the broad and general. We are yet too young in art to have inspired it with those profound emotions and convictions which distinguish its highest flights in the Old World, or to have acquired other than a superficial knowledge of its history, methods, and purposes. Our great art lies latent in that future, the full character of which no one yet foresees. When and how it may be born time only will disclose. Now, I desire simply to take cognizance of the actual facts of to-day, as the seedlings of the projected institutions which are to guide us in our attempt to realize in art something commensurate to our political and commercial position in the world at large . . .

Indeed, until we possess ample resources of instruction and incitements to ambition of the character of the great institutions of art in Europe, it is hopeless to expect the development of a complete national school. Our population is not yet an art-loving people, and without a deep-seated passion for the beautiful in the popular mind there can be no great development of art.

Having said thus much about what we have not, a few words in regard to what we have in hand in our youthful æsthetic constitution may afford some encouragement to the workers in the good cause. As the songs of birds proclaim the coming spring, so does the increasing number of young artists of actual promise announce that the budding season of our national art is nigh at hand. But we must do as much for them as we do for the birds—provide the nests in which their offspring may be sheltered and reared until strong of wing themselves. The best ambition and talents are of small avail without means to train them to effective technical handicraft or a matured exercise of their highest powers. We have abundant talent, and are not without some evidence of genius in this direction. But both are now more fettered or crippled by want of opportunity for serious study and intelligent criticism than of pecuniary encouragement. The public also, although inclined to a liberal expenditure for art, are not sufficiently educated to decide on the quality of purchases to discriminate between honest art and its showy substitute; and they cannot be until they secure for themselves at home the necessary means of comparing what they buy with works of acknowledged merit in great galleries. When this is accomplished, the unfledged amateurs who now flood America with worthless copies of old masters, or garish, ill-designed originals, because they are "so cheap," will cease to be of authority as judges of art, to the detriment of the taste of the nation. The young artists also, instead of becoming content to repose on a few easily-won laurels, repeating themselves without advancing, will be put on their mettle to rival real masters, old and new, besides being fired by that sympathy with genius which is sure to show itself whenever there is any æsthetic bottom in common . . .

We must look also at our standing as regards amateurs and scholars, to see if we as a people are equally ripe for these institutions; for their immediate organization and support will depend more on the students and connoisseurs of art than on the artists themselves or the general public. In America, where every initiative in education must be taken by individuals, it is absolutely certain that no steps to advance any branch of learning ever will be undertaken until there are to be found a sufficient number of persons of wealth and æsthetic culture willing to assume for the public the duty which it really owes to itself to do at once and thoroughly.

Have we at this juncture enough of such disinterested individuals, of sufficient property and the right sort of training?

Unlike the founding of scientific institutions, experience proves that wealth and culture must be united in the same person to effect this desired end. Rich men contribute liberally to support a college, institute of technology, or museum of natural history, on the general principle of their usefulness, or for religious seminaries, without comprehending specifically anything of their studies or doctrines . . .

It is curious and instructive to retrace the geological history of the earth, by suites of fossils and minerals, out of primitive chaos through infinite ages down to our own, and, by means of the contents of long files of glass jars and mounted skeletons, man's own development from the first organic germ to his present imperfect being; but this study is limited to mere changes of matter, while that of art offers an exact chart of the progress of mind itself as it rules and shapes matter to its own volitions, or in obedience to those elementary forces which anticipate and create all material things. The one is the servant, the other the master. To very many, the forms of the lower creation, especially as seen preserved in alcohol, are repulsive apart from their value to science. Neither is comparative anatomy, in the shape of wired skeletons, very agreeable to the common eye. But a museum of painting and sculpture entertains and instructs every mind in some degree or other. Pictures and statues are human souls reflecting themselves in ours as by an enchantment of our senses. They mingle pleasure with teaching by assuming those guises which are most seductive to the outward man, while depositing or awakening within us ideas and emotions that fructify into spiritual happiness. Art is the exquisitely-flavored fruit of the tree of life, which only to taste confers immortality. Descending from the higher to the minor arts of a museum, we find no less to gratify the eye and much to interest on account of their relation to the industrial welfare of the country. Yet such is the hardness of our hearts, the blindness of our vision, toward the highest, purest, and most complete of the sources of our intellectual progress and enjoyment as a people, that, while many museums and schools of natural science have been founded and amply endowed, those of art exist only in name or in the minds of a few amateurs who, perceiving their importance in the progress of civilization, have just begun to obtain a public hearing to plead for their establishment.

Providence, however, matures its best gifts slowest, keeping the richest treasure in hidden store until man is ready to give it welcome. So it is happening with art in America. The period of its advent approaching, we detect a simultaneous stir in various quarters in the brains of artists and amateurs widely apart, moved by a common impulse to accomplish a common end. Wealthy connoisseurs, who have hitherto collected for their own gratification, are now proffering their stores of art and knowledge as free gifts to the public, solicitous to enjoy while living some of that patriotic satisfaction which must ensue to every one on hearing "Well done, thou good and faithful servant of the Lord," from the voices of millions of fellow men.

Mr. Corcoran of Washington was the first amateur to erect a beautiful building, endow it with a fund, and make it over to the national Capital for purposes of art, in charge of an intelligent board of trustees, whose duty it is to fill it and open it to the public. Mr. Peabody did the same for Baltimore not long before he passed away. In both instances the edifices have anticipated their contents, the value and usefulness of which will depend on the good judgment and æsthetic training of those to whom is confided the office of securing objects of art. Generous gifts have already been proffered. But with them begins the delicate task of discriminating between what is of real value for the ends in view, and works that would discredit museums and mislead students. Here comes in the need of competent experts, not merely in painting and

sculpture, but in bronzes, metals, precious and common, glass, ceramic ware, majolica, porcelains, lacquer, enamels of all kinds, gems, medals, coins, engravings, tapestry, designs and drawings, carved and inlaid furniture, miniatures, missals, ivories—in fine, every branch of ancient and modern industry in which ornament plays the conspicuous part. No connoisseur can master the whole field of great and little arts. Nevertheless, each should be represented as completely as possible in a cosmopolitan museum . . .

Although Washington, Baltimore, New York, New Haven, and even Chicago, may be said to have preceded Boston in their undertakings for the advancement of art, either having secured valuable collections, erected buildings, or organized museums in embryo, while Boston had nothing to show except the feeble collection of antique casts, copies, and modern pictures belonging to its Athenæum—no merchant prince having come forward to imitate the example of Mr. Corcoran at Washington, Lenox and Stewart at New York, or Mr. Street at New Haven—yet she proves to be behind none of her sisters in her convictions and intentions. Indeed, she carries away the palm of practical sagacity in quietly maturing a plan, which, if executed with similar intelligence and persistence to what is shown in her other departments of liberal education, will give her the real lead in æsthetic as in other branches of intellectual culture. Without notifying the public or exciting any discussion in the newspapers, a plan of artistic training on the basis of collections and schools like the South Kensington has been put into shape by a few competent amateurs, who bid fair to do all the more for Boston because they possess both the culture and means requisite to carry it on to a successful issue, before handing over its destinies to the people themselves as an established public institution . . .

As more books are read in Boston than in any other city by the masses, on account of the facility with which they are furnished by the city authorities, so her population may be the first to reap a harvest of æsthetic culture, owing to the simple plan of placing in the public schools casts and photographs of choice objects. If occasional verbal instruction likewise be given in the history and constitution of art by competent lecturers, it will prove a cogent refiner of manners, and secure to the public the rightful development of many a useful talent now wholly lost from want of an opportunity to declare itself. As this grateful task of making a practical beginning of instructing the pupils of the city in æsthetic knowledge has fallen into the proper hands, we may hope shortly to witness such beneficial results as will prompt to its rapid extension and enlargement of scope.

Although, as I declared in the beginning of this article, we cannot speak of art museums as matters of fact in America, yet it is evident their day is nigh at hand. The public wish them; earnest men are laboring to found them; and there is an adequate number of artists and amateurs to meet the immediate requirements of their organization.

George F. Comfort, Art Museums in America *(Boston: H. O. Houghton and Co., 1870).*

In the great intellectual awakening, which has followed our late national convulsion, the public attention has been turned in a marked degree to certain deficiencies in our educational system. Especially has the lack been felt of those institutions for the promotion of æsthetic culture, which are found in every nation and almost in every city in Europe. That this feeling is a deep conviction, and not a superficial, evanescent flush of sentiment, is shown by the tangible form which it has assumed in some of our largest cities. Movements for establishing extensive museums of the fine-arts were inaugurated in the cities of New York and Boston at almost the same time. These two movements, though begun under very different circumstances, still look to the same ultimate end. Without doubt other cities will soon follow the example of Boston and New York . . .

But here in America, after two hundred and fifty years of national growth we have scarcely begun to cultivate the formative arts, upon a scale at all commensurate with the immediate wants of the country, and with the culture of the present age.

Still in no country in the world is there more native genius for art than in America . . .

An edifice which is to contain public galleries of art, should be located away from the noisy and dusty thoroughfares of a great city; it should be placed where no other buildings will ever be erected in its immediate vicinity, which, by their shadows and reflections of light may make the rooms unserviceable as galleries of art; it should be placed where there will be opportunity for such indefinite expansion as may be required by the wants of the future; and it should be within easy access of the great mass of the population of the city. All of these conditions can be met with only in the public parks. In the chief park of every city, a plot should be left, upon which museum buildings of both science and art may be placed. This plot should be near the edge of the park, and in the vicinity of other institutions for the higher education, as schools of art and of practical science, colleges, universities, and public libraries,—all of which should be located within a convenient distance of each other. In this respect the city of Berlin has a great advantage over any other city in the world, and by this means the efficiency of all its institutions is greatly increased.

By their own example, the museum buildings should be promoters of one of the chief arts which their contents illustrate. They should be landmarks in the history of architecture in America. So great is now the *solidarité,* the coherence and intercourse between nations, that any new excellence which may be developed in one land is soon known, and is likely to be reproduced in other lands. We might therefore with as much propriety speak of American chemistry, astronomy, medicine, or music, as of American architecture. The museum buildings should, therefore, be landmarks,—not of American architecture, but of architecture in America, and they should mark a progress in the history of architecture in the world. And in its interior arrangement, a museum building should be planned with special reference to the purpose which the edifice is to serve . . .

A museum of art in a large and wealthy city should illustrate the history of the origin, the rise, the growth, the culminating glory, and the periods of decline and decadence of all the formative arts, both pure and applied, as they have appeared in all lands and in all ages of the world. True art is cosmopolitan. It knows no country; it knows no age. Homer sang, not for the Greeks alone, but for all nations and for all time. Beethoven is the musician, not of the Germans alone, but of all cultivated nations. And Raphael painted, not for the Italians alone, but for all, of whatever land or age, whose hearts are open to sympathy with the beautiful in art. An ideal museum must thus be cosmopolitan in its character; and it must present the whole stream of art-history in all nations and ages, as represented in the three great arts, of architecture, sculpture, and painting, in the minor arts, and in the many applications of art to industry, by the adornment of every material production which comes from the hand of man.

A work of art thus studied historically has other charms, besides its own intrinsic merits, as of beauty of composition, color, form, execution, or expression. It serves as a link in the great æsthetic development of the human race, and thus aids us to see the unity of the history of art, from the building of the first pyramids down to the present time. The history of art thus studied becomes an integral part of the history of civilization. And a collateral, but a by no means unimportant advantage to be derived from the study of art historically, is the interest which it awakens and the light that it throws upon the great events and the prominent characters in universal history; upon the customs, costumes, and daily life of different peoples and in different

ages; and upon the moral, religious, intellectual, industrial, and political progress of the human race . . .

Great museums of art should look to the future also, as well as to the past; and every great museum building should have a wing capable of indefinite extension, for the reception of such works as may be produced in the future by American artists especially, which shall merit a position beside the works of the old masters . . .

The cost of such a museum would not be greater than it is to build, equip, and sustain a single man-of-war, or twenty miles of an ordinary railroad (and we have nearly forty thousand miles of railway in America); it would not be greater than that of many of the cathedrals which are now being built; nor would it be one fourth of what we are now expending upon our parks. But the organization of such a museum will necessarily be a slow work; it will require at least a generation for its completion; and thus the burden for any single year or term of years will not be unduly severe . . .

Many important results will be accomplished by these museums. A purer taste will be cultivated throughout the entire community, and art in all its branches will be stimulated into a healthier and more vigorous life; chaste and tasteful ornamentation will replace the glaring colors, gaudy decorations, and bad designs that so often disfigure the furniture and the walls of our dwellings; paintings that offend a cultivated taste will disappear from the walls of our parlors; our streets will be filled with a purer architecture, and our parks with statuary of nobler motive and better execution. It will become fashionable also to visit the museums, as it now is to drive in the park, and to become acquainted with every important new work of art that is received; under the influence of this fashion, a certain portion of the vast sums of money, which are now spent upon luxurious living, expensive furniture, costly clothing, and fast horses, will be devoted to adorning the walls of our own houses with works of high art. That large part of the population, which must be forever prevented from purchasing works of art for their own homes, the poor, will have free access to galleries which no private citizen, whatever his wealth, would ever be able to gather together. And who can tell in how many young minds the germs of genius will be thus developed, which will give a glory to our country and to humanity, but which otherwise would remain dormant and thus be lost to the world!

GEORGE INNESS ON ART ORGANIZATIONS

Although he was a member of both the National Academy of Design and the Society of American Artists, George Inness takes aim at both organizations in this interview, and he tosses in the new Metropolitan Museum of Art for good measure. Inness evinces a suspicion of any type of elaborate art organization—an unusual view in an era of consolidation and professionalization of all aspects of American life. He finds exclusionary groups to be anti-American, and he ends with his own prescription for a future of art as "the expression of social sympathies."

George Inness, "Strong Talk on Art," New York Evening Post, June 3, 1879.

"The National Academy is criticised some, Mr. Inness."

"Yes, you can scarcely pick up a newspaper whose art-articles are not strictures, more or less severe, not only upon it, but also upon the other art associations of the city—the Metropolitan Museum and the Society of American Artists, for example. The history of these institutions has been in consequence a conflict rather than a development."

"And the reason of this is—?"

"Because they are founded upon ideas that prevail in countries whose social conditions and forms of government are different from ours. The spirit of the American people is antagonistic to the exclusive assumption of rights by any self-constituted body."

"How, then, shall artists associate most favorably for their own commercial good and for the growth of their own distinctive ideas?"

"That is the question; for I think it but sensible to assume that a national art can arise only out of the development of individual artistic tastes, modified by the effect of association."

"You are not satisfied with the National Academy?"

"No. It was founded by artists who were essentially English in their culture, and was naturally modelled by them upon the Royal Academy of London; in fact was, as far as could be, that institution over again. The hope was, no doubt, that it would prove as lasting. But one element in our national purpose appears to have been overlooked. The ambition of the Academy through its forty members to represent the national art instincts of the country was soon to find a check in the democratic spirit instilled in us from our birth. This spirit has led to an increase to nearly one hundred members with as many associates. With this increase of members there has been a corresponding increase of discordant elements and less directness of aim." . . .

"On what principles should art associations be organized?"

"The first thing to be understood in the investigation of the difficulties in the way of art associations with us is the true relation which the art instinct bears to the human one of universal freedom. The desire to give freedom to each individual of the race is not a conception of the lowest type of mind, but, on the contrary, of the highest. Now, art professes to perform a service between the lowest and the highest type of mind. Consequently the moment its instincts are made subservient to democratic control they begin to degrade, and art's distinctive purpose in the elevation of the race is lost. No culture, no wealth, no righteousness, whose possessor does not consider himself as but a factor in this divine operation of freeing the race can ever promote to the least extent the development of an art which shall represent the national aim of our people." . . .

"How, then, shall art associations be formed so as properly to do their business?"

"In its very nature art is restrictive and exclusive. A mind of thorough artistic instincts can do its best only where its surroundings are sympathetic with itself. All outside issues, and all influences that do not cherish art tend to dissipate such instincts. How then shall associations be formed to further the requisite purposes? I answer by the organization of small societies in each of which all the members have one general aim tending to the development of some distinct artistic sympathy. Assuming to represent nothing but themselves, these societies should never be so large that the smallest business capacity would not be sufficient to qualify its officers, thus making the clear evidence of artistic instinct and sympathy with the peculiar sentiment of each society the main qualification for membership. Twenty members should suffice for each society; certainly there should not be more than thirty. About these societies there naturally would spring up constituencies which would enable each one, that had sufficient vitality, to hold a reasonably good exhibition, upon which would depend its continued existence. By such an arrangement each exhibition would become a matter of especial interest to a certain class of minds who could purchase any picture toward which they might feel inclined with a confidence that they were obtaining something representative of an idea; something which would secure a more and more perfect expression with the increase of time, instead of, in a year or so, going 'out of fashion.'" . . .

"The ideal future of art then, is——?"

"In the past art has presented only ideas of truth. In the future it must be the expression of social sympathies—the deepest social sympathies, those which Christianity has awakened in the heart of civilization. Art, as a whole, would then taken a course representative of the culture of the day. Each art sentiment would have its own philosophy, growing with its growth, and criticism would eventually become established upon distinct ideas that would be more or less clearly represented at the several exhibitions. The works of each body would be judged from its own point of view, and the spicy insolence of self-constituted critics would no longer be considered a necessity. The confusion produced by viewing large unclassified exhibitions would be another evil done away with. As our art societies increased large exhibitions might be organized at certain periods representing the state, and these might eventually increase to a great national exhibition, all being classified by each society's being represented separately, the hanging being attended to by delegates from each society, but the general exhibition not being controlled by artists, farther, at least, than that their suffrages might be demanded for the election or appointment of commissioners. This of course must be a thing of the future, but in a city so large as New York funds which may now be used only in heaping up confusion might be used to form the nucleus of a general exhibition in which order, harmony and satisfaction might be made to rule, and the distinctive use of art as an element of social, and consequently national harmony, become a self-evident truth."

"What is the position of the Society of American Artists?"

"So far the society has been chiefly a clique. Like most new organizations it possibly embraces discordant elements yet to be sifted out. It must harmonize and crystallize itself. Whether or not, out of its present elements, it can make an ideal society like that which I have described remains to be seen. No such society can exist that is not composed of members of a reasonable degree of efficiency. All must be at least fair producers, otherwise the stronger will naturally desire to associate themselves with those who will in some reasonable degree keep pace. But the National Academy of Design assumes to bestow upon its members an honor and right to consideration above other artists by force of the toy magical letters 'N.A.' This in itself forms an attraction to superficial minds who have as much time to spend outside of their art as in it."

THE PHILADELPHIA CENTENNIAL AND THE COLONIAL REVIVAL

E. L. HENRY DREAMS OF THE PAST

As the nation approached its hundredth anniversary, still smarting from the soulless mechanism of the war years, artists and writers began to revisit the colonial and early national periods—locating heroes and heroines, scrubbing them clean of faults, and giving them an amber patina of patriotic reverence. One of the most zealous of such cultural workers was Edward Lamson Henry, a New York–based painter of meticulously reconstructed genre scenes. His images attained a certain popularity through the hand-colored reproductions he manufactured; Henry also collected antiques and labored to preserve landmark eighteenth-century American buildings.

These interests all came together in a commission Henry received from Samuel Chew, the owner of Cliveden, a mid-eighteenth-century mansion in Germantown, outside Philadelphia. Chew asked Henry to paint a reconstructed historical event: the reception accorded the visiting war hero, the Marquis de Lafayette, in the hall

of Cliveden in 1825. The artist and his patron engaged in careful research, securing appropriate costumes and interviewing elderly residents who were present. Henry's letter to Chew demonstrates his modern use of photography to document such minutiae visually. But it also ends with a descent into a dreamscape of Henry's imagining, a kind of "Antiqueland" where the artist's historical fantasies could be momentarily lived out.

Edward Lamson Henry to Samuel Chew III, November 1, 1873, Historical Society of Pennsylvania.

Hoping to be able to go over to Phila next week. I write you to have those portraits or miniatures photographed. A little carte d'visite head of each will do, and will not take any time to copy or cost much and be just as easy to copy into the painting as the real miniature would be. If you have them copied now I can bring them back, however they can be sent by Mail.

I am going on with the picture steadily. have all the cornices freizes & columns finished. it is tedious work but it repays for the labor. Now as I am to go on with the principal figures I hope to obtain all the likenesses and information this time for I shall not leave off till it is finished when I shall send on a photograph for your approval. I have dresses or at least can obtain them of the period. I only need an old coat of the time swallowtail or Frock it is all the same for I wish merely to get the effect of the narrow high collar sloping effect which I cannot do from a Modern one. This is all. I dreamed the other Evening of ransacking through your old garret with you amongst old chests in old presses and like all dreams the imagination ran riot and I was bewildered with the most rare old costumes, old china, Silver, quaint singular specimens of Furniture, till they seemed Endless, and my wonder was why you never spoke of it as having such treasures up there before and such a disappointment to find it a Dream. Perhaps though, there may be a reality and I was for a time clairvoyant.

THE CENTENNIAL EXHIBITION

The Philadelphia Centennial Exhibition of 1876 marked the first time the United States had hosted a major world's fair. It was seen as a cultural and industrial "coming of age" for the nation, and American visitors hoped for evidence that the discord of the Civil War and Reconstruction were behind them. An article in the Galaxy, *excerpted below, congratulates American art on its advances and looks forward to the exhibition as a stimulus for the patronage of American art. But the fair was also retrospective in outlook. As an antidote to recent strife, Centennial organizers highlighted early American history, looking back nostalgically to a "simpler" time. Thus, the showpiece of the fair was Gilbert Stuart's "Lansdowne" portrait of George Washington, which came as part of the British display but was transferred to the American section at the urging of John Sartain, the engraver in charge of the fine arts section. Nearly one thousand works of American painting and sculpture were on view, the largest retrospective exhibition of the art of the United States yet organized. A separate, landmark exhibition of photography was also featured. The critic Earl Shinn devoted a lengthy series of articles to the full display, two of which considered the American contribution (see also "Earl Shinn on Criticism," chapter 12). The colonial portraits seem to have come as a welcome surprise to him, and he repeatedly contrasts them favorably with what he perceives as the more disappointing generations of artists who followed: Washington Allston, John Vanderlyn, and Daniel Huntington. He is also dismissive of the bombastic landscape painting of his era, and even the popular Eastman Johnson comes in for censure. Of*

*the postcolonial artists, only the younger generation of progressive painters—
exemplified by John La Farge—finds favor with Shinn.*

Philip Quilibet, "Art and the Centenary," Galaxy 19 *(May 1875).*

The World's Fair managers have at length made known the terms on which they will admit "works of a high order of merit" to their fine building in Fairmount Park; and now comes the question what show our painters and sculptors can make on this the first general muster for inspection ever attempted by American art. Happily, if they disappoint old-world guests at all, they will disappoint by gratifying, because many Europeans who praise Yankee ingenuity in general, and the special Yankee genius for mechanism, expect of us comparatively little high culture in art; and as they rarely look to American sculptors for classicality, or to American painters for taste, so they ascribe to the nation as a whole a crude sense of the beautiful. Pirouette, twirling on tiptoe through the States, sees enough savagery, even in her brief and busy tour, to write home to her Alcide that these generous Americans are *barbares* in all decorative art; while Captain Cockney, by the aid of his eyeglass, discerns our public statues to be *monstrous.* The dancer and dandy, too, are nearly right. Surely the young American woman's drawings, high uphung on all the walls of ten thousand happy homes, are apt to be hideous whenever they are not ludicrous, while her samplers in worsted of distorted cats, enigmatic fruits, and landscapes whose streams flow uphill, might turn a man cross-eyed for life. During generations the favorite farm-house ornament, I remember, was the print of a mourner in the blackest of gowns and coal-scuttle bonnets, bending over the whitest of tombstones, shaded by the greenest of willows; and the average tavern parlor was bedecked with a sad monochrome, made up of drab waterfalls, drab angels, and drab beasts of the sort conceivable only in heraldic zoölogy. By a special stroke of inspiration, the trunk of the weeping willow I have known to be done in hair—the hair of the deceased; and with a like touch of art, I think I remember once seeing a small silver or silver-washed coffin-plate glued or screwed upon the blank space in the picture commonly left for an inscription. But who has not noted the change of the past twenty years in household decorations? Pretty chromos are driving from all the walls the home-made daubs in oil that once disfigured them—a great mission for chromos, after all; photography and kindred arts displace the melancholy mezzotints erewhile in vogue; and thus these repeating or reproducing industries have so far refined the coarse popular taste that the future is bright for painters and sculptors . . .

The Centennial Fair, in showing the progress of American art, ought to make a better market for it too. After all, what is the "Universal Ex-po-si-ti-on" but a big show-case for a man's handiwork or goods? The end is trade, and the fair ought to bring custom as well as fame. The rich *virtuoso* buys a little for variety as well as much for other reasons—buys a Swedish or a Turkish picture because it is Swedish or Turkish, though he may like Spanish and German work better. American pictures—pictures painted in America by Americans—probably have not had a just representation in foreign collections, even as specimens of national art . . .

But while the Centennial Fair should show foreign visitors that American studios on this side of the ocean furnish as worthy specimens of national art as American studios on the other side, it is chiefly our countrymen who will thereby become better acquainted with the products of American easels. Americans who are rich enough to beautify their homes with fine works of art, are rich enough to travel and to collect their treasures for this purpose from the shops of Europe. They find American ateliers set up from London to Naples, and are good patrons of their transplanted countrymen. They also discover that they can get good water-colors of great va-

riety in England; in France, charming genre pictures and an infinity of household decoration—beautiful Sèvres, and what not; graceful alabasters in Florence; bronzes for the park in the Munich foundries, whence hitherto have come nearly all such ornaments, even when designed by Americans; and then in Rome, where the world's sculptors congregate, their fancy flies to marble statuary. On the other hand, Europeans rarely buy pictures here, which makes the exchange unequal—a great part of the money spent by Americans on objects of art flows out to foreign pockets, while of foreign money for American art there dribbles back a very slender rill.

Edward Strahan [Earl Shinn], "The International Exhibition.—VII," Nation 23 (July 6 and August 3, 1876).

[July 6, 1876]

The American art-display, with all its shortcomings, is by far the best illustration that has ever been made of this country's talent in its completeness, the range being from Boston to San Francisco, in geographical source, and, in time, from Smybert's day to our own. An art we once had, and have now pretty well lost, historical painting, is almost completely absent; Trumbull's creditable groups remain in the Capitol, and there is little or nothing of their kind in the Exhibition. But the history of our painting back to the time when it was homogeneous with that of England is represented in portraiture, and the successes that have become legendary are revived to the sight among fresher and more heavy-looking works. John Smybert's bust-portrait of Bishop Berkeley, which must have been executed about 1730, is not bad; it has much more life and blood in it than the prim waxwork likeness of West made in his American 'prentice epoch; it is a lively, speaking head, relieved with vigor against the background, and only inferior in interest to the family symposion of Berkeley and seven other persons which is so carefully preserved at New Haven as Smybert's masterpiece. The loans of works by Copley, Allston, West, Wertmuller, Vanderlyn, Neagle, Dunlap, Peale, and Sully recall, to our shame, the day when we had a whole race of portraitists perfectly capable of discriminating and portraying dignity of character: our late war gave perhaps as good a chance for this sort of effigy-making as that of Independence, but it found the proper interpreters conspicuously absent. The dowagers, the flimsy fashionables, and the truculent brigadiers which our Bakers and Huntingtons are constantly sending forth from their studios, are styleless and characterless in comparison with the heroes and heroines of most of that Revolutionary group of delineators. True, Stuart was not much more of a draughtsman than was Reynolds; West could not hit a likeness, Peale could not color, Trumbull could not group, Sully could not give solidity, and, if we go back to Smybert, the piteous rheumatic hand he has given to the worthy Bishop of Cloyne would, if a fact, require a medicament stronger than Berkeley's favorite tar-water to mend it. But the worst of these painters was able to distinguish the fact that his age had a peculiar social tone, a certain massive self-confidence and staying-power, and to get it expressed on his canvas. Our own portraiture, spoiled by the photograph, usually expresses but the grimace of the hour . . .

Washington Allston's "Rosalie" and "Spalatro" show him respectively as a graceful painter of sentiment and a nervous sufferer from the spell of Anne Radcliffe; in both pictures his gift of colour is evident, but the design is too far from nature in both cases to teach us much; we see the scrupulous, intensely-careful, fastidious, hectic seeker; the solid repose of attainment is wanting. Stuart Newton's portrait of Irving is an interesting document. The exhibition of Copley comprises three of his works—his valuable portrait of John Adams, and the expressive and laboriously enriched ones of Mr. and Mrs. Thomas Boylston. There are characteristic game-

subjects by Audubon, a good deal blackened by time and a false method of color. A whole side of a room is tapestried with Catlin's sanguineous heroes, making us think of Charles Baudelaire's perfunctory frenzy of delight at the sight of the same artist's portraits of "Petit Loup" and "Graisse du dos de buffle" when exhibited at Paris. "The color has something mysterious which pleases me more than I can tell. Red, the color of Blood, the color of Life, so abounds in the sombre museum that it is an intoxication!" Furness, the early-lost and acutely-missed portraitist, is shown in a selection of his works which deepens the regret at his premature removal; each likeness is a tender and penetrating bit of scalpel-work, analyzing form and character to the last limit, yet so lovingly that not the incisiveness, but the flexibility, of the touch is felt. Here, too, saddest of monuments of hope deceived, is Vanderlyn's "Ariadne," which sixty years ago was thought to include all possible beauties of what was called in that day the "female shape." While his careful model-work—not much more impressive nowadays than the wax Cleopatra—was hidden, and perhaps sanctimoniously veiled, in the gallery of a millionaire, the painter was begging a shilling to get to his home to die.

Besides the painters who are dead, there are the painters whose art is dead, or whose phases of work are changed, leaving them to watch at a resurrection of their own past activities. Not only Morse is shown as a portraitist, but Huntington, who culminated in the "Mercy's Dream" and the "Christian Martyrs"—paintings seemingly of some twilight remoteness of time, when Cole made allegorical landscapes and Greenough made allegorical Washingtons—exhibits recent work, such as "Sowing the Word"—a sort of modern rendering of Da Vinci's "Modesty and Vanity." The sweet Guido-grace of the "Christian Martyrs" ought to have earned it the privilege of extraction from the private collection where it reposes—the same gallery that contains the "Ariadne" of poor Vanderlyn. It would then be seen how completely a respectable painter may lose the promise of his youth by success, and become a painter of opaque and pomaded portraiture.

[August 3, 1876]

The want of accent and anxious gentility of most of the modern American pictures causes us to linger with considerable tenderness among their predecessors, the Colonial or early Revolutionary canvases. Here at least is the distinction of a past school of thought. Benjamin West, besides his rather melancholy masterpieces in the English Department, is represented, more relishingly, by a portrait of his American period, before the age of twenty-five; it is that of Stephen Carmick, "a signer of the Non-Importation Act," smug, hard as an icicle, sitting across a chair as if on horseback, the beady eyes turned self-consciously contrariwise to the direction of the head, and an air of false amiability worthy of Lawrence Sterne. The manipulation, timid and cold, is confined to registering the social proprieties of 1765. C. W. Peale is seen in two of his better works, where the unction of the subject has enticed him away from his usual dried formality; his General Cropper, a bluff yeoman warrior, and the sweet, young, rustic-looking Mrs. Cropper, give one a more human idea of the man of many ingenuities than would be looked for. His son Rembrandt's likeness of Washington, and Wertmüller's Washington, are here, too, for comparison with the superb monumental portrait by Stuart. Vanderlyn's "General John Armstrong," dark and faded as if seen through a veil gives us the participant of the losses at Brandywine and Germantown in his blacker mood; the same artist's "Ariadne" recalls in brighter guise the fame of the artist who was medalled by Napoleon. Dunlap's portrait of Thomas Eddy, black, strong, Brougham-like, and full of character, represented as studying the report on Hudson River exploration and canal navigation, is the work of a feeble portraitist battling with an op-

portunity beyond his strength. Morse's "Lafayette," with his eyebrows of perpetual amazement, who starts back in dismay from the busts of Washington and Franklin, is another of the curiosities of Room 44 in the Annex. A simpler portrait by Morse, the old woman in a mob-cap, who straightens herself up as if to deliver a repartee, is more intelligible in expression, but errs with the same Opie-like smeared touches. Stuart's smaller portraits—as the old, shrewd-looking gentleman who reads the "*Pennsylvania Gazette,* No. 170," and the ornamental and well-preserved "Mrs. Nathaniel Coffin"—are almost always masterpieces; besides the character, the tender modelling, with little dwellings of the brush and lateral sweeps of color, is a lesson for painters; nine or ten specimens of this sensitive hand may be reckoned up, and they form a festival for the student. Stuart Newton, the nephew, represents, with W. S. Mount, the anecdote-painting of the next generation—the former by his "King's Poem," with the young literary king fastidiously showing his verses to a fat sycophant, and the latter by his "Corn-husking." Newton is shown, too, by his successful and precious cabinet portrait of Washington Irving. From these dead anecdotists and jesters we come down with a little fatigue to those who support the same roles at present.

Mr. Eastman Johnson's jocular "Old Stage-Coach" forms a central object immediately opposite the entrance to the principal American room, where the unlucky silhouette of its dismantled carriage-body, cut black against the distance like an exaggerated Chinese puzzle, forms a greeting the reverse of conciliatory; the obstinate difficulty which this artist finds in inventing a pleasing composition is almost unprecedented. The "Corn-husking Scene" (recently criticised in these columns) is more felicitously composed, with a vista and point of sight and a harmony of arrangement; but the "Kentucky Home," with negroes irregularly studded upon a dark, close relief, is positively repellent, doing injustice to its own qualities of patience and pathos; "Milton and his Daughters" is a faded conventionalism, altogether too high-heeled and courtly to touch the heart; in a single figure the artist succeeds better. The lady "Catching a Bee" in a garden flower is the best work we remember of the author, and, though hung nearly out of sight, attracts and compels notice by its play of soft glittering sunshine and delicate type of feminine beauty. Mr. Johnson, however, is not the one to stand within a doorway to challenge visitors as the champion of American *genre.* The trouble with him is, not that he imitates any foreign school, not that he offends by any kind of pretence, but only that he is washy and that it is easy to forget him.

Of Mr. La Farge, there is to be said that it is a crying injustice and an undeserved cruelty for him to occupy his faculties with so many flower-studies, but that the extraction of the great "Saint Paul" from his studio for the adornment of the Exhibition was a magnanimous act, to be warmly appreciated. Mr. La Farge's flowers are better than other people's flowers—their groupings of color are, more than any one else's, like the groupings of a pack of gorgeous odalisques by Diaz, and they make the most harmonious ornaments imaginable; but a flower-study is for such an artist little more than a piece of graceful ballet posturing, and does not reward a very long attention, even when it appeals to human sympathy in the form of a votive wreath with a Greek inscription. The "Saint Paul" which Mr. La Farge exhibits is a large figure, intended in all honesty for a church, and, as well as the "Virgin" and "Saint John" which remain behind in the studio, to be considered as a legitimate specimen of monumental painting, mural decoration, and religious appeal, suitable less for gallery use than for ecclesiastical pomp. It is decidedly noble in conception; the moral purity, intellectual simplicity, transparent self-abnegation, are very perfect. We are not sure that so religious a picture has been yet produced by any countryman of ours. The color is of a certain deep sweet dignity and repose that goes well with

the theme; as a matter of composition, it appears to us that the sudden brightening of the curtain behind the figure at a definite spot around the extended hand done so as to relieve it unnaturally with white and force an unwilling attention to the gesture, is an expedient rather of theatrical than of religious art; and the hesitating halo which throbs around the head is more dingy than subdued. A halo, one would say, should either be frankly and blankly displayed, as a symbol, or entirely omitted, if realism is the effect sought; none of the half-way trials at making traditional treatment look like natural accident deceive anybody—least of all, Mr. Holman Hunt's ingenious adjustment of the head of a naturalistic Christ in the circle of a naturalistic window. Mr. La Farge's "Saint Peter," as he stands in his utter provincial rudeness, his outlines floating, confused, and blotted against the simple drapery of an Eastern tent, planted well on both feet, dealing out the committed message with both hands, and retaining a great deal of the child behind the wrinkles and grizzliness of old age, is a memorable figure, rich in the most touching and inmost attributes of religious art. Mr. La Farge likewise sends his life-size portrait of a boy sitting beside a large hound; it is a study of character and color, the tone of the flesh being conspicuously well carried off by a system of harmonious surroundings.

Paintings so individual as these are what we have best to show, among a crowd of works usually betraying with the utmost pride of subserviency the influence of a particular foreign master or school. After contemplating the Bierstadts, which positively boast of their resemblance to Lessing and Achenbach, and the Thomas Hills, which are pale reminiscences of pale Kuwasseg, and the Thomas Morans, which are violent lunges at Calame and Turner alternately, it is like coming to a reality again to find the landscapes of Mr. H. Herzog, now naturalized in this country, and painting American scenery in such a Teutonic tone that we expect to hear the traditional jödel and detect the traditional chamois among the hills. Mr. Herzog gives us a Yo-Semite scene, between Sentinel Rock and Union Point; it is painted with a brush of such experienced ease and certainty of effect that most of the American landscape looks experimental or straining beside it. As we watch Herzog's evening shadow creeping up the terrible precipice, we seem to see it move voluntarily like a climber, attaining every moment more giddy ledges and more treacherous fissures, among whose increasing difficulties the eye is pained to be led. The illusion is there because the artist had a definite theme, that of the afternoon shadow, and to this purpose broadened out his execution. We experience a sensation rather uncomfortable than otherwise before the large neighbors which the American gallery accumulates in each other's presence—the "Donner Lake" of Mr. Thomas Hill, the "Holy Cross Mountain" of Mr. Thomas Moran, and the "Settlement of California" of Mr. Bierstadt; as among the family of giants in a museum, we cannot but feel that an admiration is expected of us which can only be felt by falsifying our point of view, and that for objects to have panoramic proportions is of less consequence than for them to be pleasing.

THE COLONIAL REVIVAL LANDSCAPE

Images from the Colonial Revival movement are usually architectural or figural: reconstructed scenes of rustic interiors and simply clad cottagers. However, the retrospective sentiments of the 1870s also manifested themselves in landscape. In particular, Robert Swain Gifford established a reputation as a moody painter of the barren, rugged shore of his native Massachusetts. His canvases are simplified in composition, with clotted, brooding skies and brushwork that is broad, dense, and layered. Critics responded to the air of sober melancholy in such images, seeing the wizened trees, spiky stubble, and

bleak atmosphere as a laudable, virile expression of the hardscrabble New England existence that had come to be associated with this terrain. Susan Nichols Carter, an artist who served as head of the Women's Art School of the Cooper Union, but who is better known today as a critic (see also "Is Religious Art Still Relevant?" chapter 7, and "Thomas Eakins's The Gross Clinic," *chapter 8), invokes these romantic associations in her review of Gifford's* An Old Orchard near the Sea, Massachusetts *(1877, fig. 10), which was included in the first exhibition of the Society of American Artists. Imagining that her feet "crunch the coarse grass beneath," near the "open, moaning sea," she gives herself up to the "meat of thought" of Gifford's painting.*

S. N. Carter, "First Exhibition of the American Art Association," Art Journal *4 (April 1878).*

The canvas is quite a large one—three or four feet long and rather narrow. A grey sky, light and full of sparkle, overarches a long, narrow blue line of distant sea, whose white rollers, as they come in upon some points of headland, mark its boundary to the land. By a gentle rise, the low shore slopes up into a grassy dry meadow, and on the right hand is a straggling group of old apple-trees. A few gnarly red apples cling to the topmost twigs; but the trees are so neglected, so old, and so moss-grown, that they can never again bear good fruit, even if they have formerly produced it. A number of angular, straggling branches have been broken from the tree in windy weather, or they have been killed by blight, and hang halfway down against the trees. We can all of us, who are used to New England, recall such places as this is, and know the feeling and the look of the grass that yet grows up, and keeps partially green, out of dry earth that the sun bakes into a hard crust. Under the shade of the apple-trees some people have wandered, as we often in such spots see gypsies or tramps, or farm-hands taking their noonday dinner and their nap. A two-wheeled cart has been dropped here, with its shafts dragging against the ground. This picture is a poem in paint, full of the meat of thought, and palpable to the senses, till we smell the dry, warm air, and crunch the coarse grass beneath our tread; and the objects in the picture cluster about themselves a vast crowd of unseen associations of the near farm, the open, moaning sea, and through the pleasant summer weather blows a whiff from the winter days which scarred these trees so, and blew up the white sand to trench upon the fertile fields. Mr. Gifford's beautiful, rich colour and his firm use of his brush have long been admired; but in this fresh story-picture it is not till after we have appreciated the thoughts it awakens that we notice how rich and how fine are the browns, the purples, the blues, and the grey tones, so completely is the manner lost in the matter of this fine work.

Fig. 11. Cecilia Beaux, *Sita and Sarita,* c. 1921, oil on canvas. Corcoran Gallery of Art, Washington, D.C., Museum Purchase, William A. Clark Fund. Photograph © Corcoran Gallery of Art.

11 COSMOPOLITAN DIALOGUES

INTERNATIONALISM

THE TARIFF CONTROVERSY

For much of the nineteenth century, a tariff (import tax) on foreign art existed in the United States. At times, American artists were in favor of such regulation. For example, in 1856, when the healthy federal budget meant that the tariff was no longer required for revenue, the National Academy of Design nevertheless petitioned Congress to impose a duty on certain categories of foreign art. By 1880, however, the situation had changed. The formation of public and private collections of European art meant that there was a new generation of wealthy individuals opposed to the tariff. The return of artists from extended periods of study abroad also created a pro-European constituency. Antitariff activism surged in 1883, when Congress tripled the duty on works of art to 30 percent of their value. In response, the National Free Art League was founded by artists to argue that art was not a consumable luxury but rather a permanent cultural asset.

One of the most insistent tariff opponents was the critic James Jackson Jarves (see "James Jackson Jarves's The Art Idea," *chapter 7). In the excerpts from his essay below, Jarves ridicules the notion that American artistic development will be fostered by closing the borders to foreign art. Taking another tack, the American artists resident in Paris sent a petition to Congress in which they pointed out that there might be retaliatory measures imposed by the French government, resulting in the withdrawal of state-sponsored instruction to American students. Among the signatories were John S. Sargent, Daniel R. Knight, Elizabeth Gardner, and Charles S. Pearce. The voluble J. Carroll Beckwith (see "Art World Diaries: Jervis McEntee and J. Carroll Beckwith," chapter 9), who had himself studied in Paris, argues in his letter that free art would create a kind of Darwinian proving ground on which collectors' tastes and artists' skills would be refined and improved. Using a bit of indirect logic, he also ties the importation of European art to the livelihoods of carpet and furniture manufacturers. (Late in life, Beckwith would reverse his views on this subject, arguing that the protective tariff was needed to make up for American collectors' reluctance to buy American art.) In the end, the tariff was reduced in 1891 but not eliminated.*

James Jackson Jarves, "Free Trade in Art Works," New York Times, September 20, 1880.

We are an enterprising people, aspiring to be the foremost in civilization. Among the fundamental essentials of a high standard of civilization a general knowledge and appreciation of art, with the ability to create its highest forms, are second to none in importance. All the great nations, past or present, excel ours in this respect. We have very much to learn from their experience and productions, and not less to enjoy, by the free introduction into our country of those ideas, put into æsthetic and artistic shape, which are the objective results of the long cultivated genius of foreign races in this direction. It is vastly in our own interest to obtain these objects as cheaply as possible, as models and lessons to our own artists professionally, and to help form specific standards of excellence in all branches of art, to improve the public taste, and gradually incite a general commercial demand for productions of the highest quality, which must be supplied by the efforts of a national school, formed and trained by the example of, and a practical acquaintance with, whatever is best of all other schools of all peoples of all times. It is as futile to expect a great original school of art, sufficient to respond to the requirements of our modern cosmopolitan civilization, to grow up among a people which try to isolate themselves selfishly from all others, by building up artificial barriers to a free exchange of the superior products of the art-mind, as it would be any great scientific or literary advance, by studiously keeping from American scholars and writers all books not written by our own authors, or discoveries and inventions not made by them.

The Congressional action as regards art, either with the specious plea of fostering native talent or of mere revenue, is one of crass ignorance and monstrous conceit, aggravated by the efforts of interested individuals to twist it to their particular benefit. Practically, as regards artists and public, we dig as deep a pit as we can, open only to the light from the zenith and shutting out all horizons beneath, thus secluding them from seeing or being seen by the rest of the world, and tell them to grow wise, great, rich, and happy out of the depths of their own inner consciousness and self-assurance, without heeding what the great outer world has done or discovered before them. "Go it blind" is the virtual maxim of Congress for encouraging American art, while forcing it to pay a very heavy tax for letting in on it any side light of superior knowledge and practice.

Petition of American artists in Paris, New York World, April 13, 1883.

The petition of the undersigned humbly showeth that we artists and art students, citizens of the United States of America, now in Paris, look with apprehension to the effect that is likely to be produced in consequence of the duty imposed upon works of art by the act of March 3, 1883; for, being cordially united in the effort to create a school of art which shall be characteristically American, we cannot but see, in the prohibitive duty imposed, a new and dangerous obstacle to the realization of our desires . . .

A large proportion of students who are to-day receiving gratuitous instruction in the Government School of Fine Arts in Paris are citizens of the United States.

The privilege of copying the works of old masters in the public museums of France has been fully extended to us.

Our pictures have been liberally admitted to the yearly exhibitions.

They have occupied places of honor there and have been awarded prizes with a liberal hand.

Last, but most significant of all, as indicating the existing animus of French artists to our citizens, many French masters occupying the first rank among the artists of the world give private and gratuitous instruction in their studies to all Americans desiring to study under them.

We believe that the presentation of these facts will determine the abrogation of a clause directed with unconscious ingratitude against the very persons to whom American art owes an incalculable debt.

But if the acknowledgment of this debt be not in itself sufficient to secure the abolition of the duty in question, we beg to submit to the honorable Senate and House of Representatives in Congress assembled the extreme probability that discriminations directed against French artists may be met by a withdrawal on their part of the advantages we have hitherto enjoyed. The press has already suggested that the Ecole des Beaux Arts and Public Exhibitions be closed to citizens of the United States; and we see ourselves on the eve of being excluded from privileges open to all the rest of the civilized world because we alone have responded to the liberality shown by taxing the hand that extends it.

J. Carroll Beckwith, Letter to the Editor, Critic *7 (December 19, 1885).*

If 'competition is the life of trade,' it is far more the secret of intellectual and technical progress. The principal argument I find used by the very few of my *confrères* favoring the present tariff, is the harm that would result from the influx of cheap and bad pictures that would be consequent upon a removal of the duty. Granting, for the sake of argument, that this deluge of paint would wash over our shores, there is yet the consoling thought that the number of good works which would as surely come to us would, in their beneficial results, counterbalance the evil effects of the bad. As a rule the more pictures people have, the more they want. Collectors begin with cheap and bad works, whose faults they soon recognize upon association; and their taste is cultivated thereby to the appreciation of better paintings. This is the history of almost all of our finest private collections. The ability to discriminate between good and bad art only comes after long association and practice of judgment among all classes of work. After all, our artists should not certainly fear the rivalry of 'trash.' . . .

Now the practical value of a high art standard to the commercial community is obvious. The manufacture of carpets, wallpapers, silver and all metal wares, pottery, furniture, figured stuffs, oil-cloths, and many other articles included in the manufacturing interests of our country, are intimately related to and largely dependent upon our art. Our struggling, self-supported local art-schools daily graduate pupils who are employed as designers, draughtsmen and modellers in our vast factories, where their brains and education keep many hundreds of hands employed; and this establishes a direct relation of the art of our country with its capital and labor. Who are the instructors of these students? Our artists. And how shall the artist progress if he is deprived of the example of schools in advance of his own? It is by daily contemplation of the works of men who are his superiors, as well as by studying to avoid the errors of those less clever, that he is enabled to improve himself and thereby his pupils. Among the many arguments that can be raised against this very harmful tariff, I cite only this one, which bears very strongly upon the education and industrial prosperity of our country.

INTERNATIONALIST BACKLASH

Some artists aligned with the "native school"—an earlier generation largely trained before the Civil War—worried about the postwar vogue for European art, and this anxiety was manifested in several ways. One annual event at the National Academy of Design's exhibition banquets was the reading of obituaries of members who had died during the previous year. In 1877 this tradition included the memorial of John Beaufain Irving, a

conservative genre painter who had studied in Düsseldorf under Emanuel Leutze during the 1850s. President Daniel Huntington (see "Daniel Huntington's Mercy's Dream," *chapter 5), who had also spent time in Europe, used the occasion to issue a partisan call to combat the influence (and increasing market share) of foreign art. The military imagery of his address is a good indication of the threat the native school saw in the internationalism of the Gilded Age.*

In an interview given later in the century, the outspoken painter J. G. Brown laments the obsession with technique of the French school and its followers and urges artists to take up American subjects (see also "John George Brown, the Public's Favorite," chapter 12). The interviewer underscores these points by contrasting the homely Brown, with his crust of bread and unadorned studio, with the luxury-loving younger artists imbued with French manners.

Daniel Huntington, presidential address, National Academy of Design, May 9, 1877.

[John Beaufain Irving] was one of those who did not hesitate to enter the lists for the contest with foreign Art, selecting his subjects in fields where the most eminent European Artists have won their laurels. This courage we cannot but admire and regret the fate which cut him off in the heat of the fight and while the shouts of his adherents were ringing in his ears. This battle must be maintained. There will be no truce. Let us be true to ourselves. Foreign Art will continue to pour in its forces and we shall triumph, not by imitating or decrying it but by surpassing it.

Ishmael, "Through the New York Studios," Illustrated American 6 (May 16, 1891).

JOHN G. BROWN, painter.

A plain name, and a plain but earnest man, with no nonsense about him. A type of the good old-fashioned artist we read of in English novels; fond of his craft, fond of his pipe, fond of work, fond of good-fellowship.

Well on in years, but hearty. Turned sixty, by the calendar, he says, yet not too old to dream young dreams, to think young thoughts, or to look forward with all the eagerness of twenty to the time when he may realize his cherished plan—quit studios and studio ways for the free life of a rover, wandering where he will, painting where he chooses, and resting where caprice may drift him.

Of medium height, gray-haired and bearded, quick and particularly warm of speech, impetuous, simple and unassuming, both in dress and manner.

Such was the John G. Brown who glanced at me through his spectacles and bade me welcome to his "diggings" on the top floor of the Tenth Street Studio Building, where, for some thirty years or more, he has worked on, not unsuccessfully or ill.

It does one good to have a chat with men like this, who care nothing for the gilding and pretence of art, who are content to make their modest way unpuffed and unsung, to bear the hardship and the toil of their career with patience and rejoice in their reward when it comes, with modesty. Be their art high or low, there is a great deal to be learnt from the John G. Browns, believe me. Lessons in courage, in cheerfulness, in endurance . . .

I wish that some of the young men who give themselves such airs in their luxurious studios could have heard with what enthusiasm the veteran mapped out the gypsy life for which he hungered. It might have made them blush for their Delmonico dinners, their dilettantism, and their big tailor's bills.

When he had paused for a few minutes, to drink a cup of coffee and devour a slice of bread, Mr. Brown went back to his easel and pegged away again at the picture, talking as he painted, in a brisk, vigorous way, of himself and his artistic adventures.

"I am an Englishman by birth," said he. "North country. But it's so long since I came over that I have grown thoroughly American at heart; or had, till we grew so confoundedly European. Naturalized? Oh, yes. I left the old country—let me see, when was it?—yes, in '53. I was just two and twenty when I landed in New York, and before I had been here a week I had made up my mind that this was the place for a working-man to live in . . ."

There was not much in the room to distract the eye from the easel at which Mr. Brown stood painting. A square room, hung with faded brown and purple curtains, furnished with well-worn cabinets and odds and ends, old chairs, old stools, and benches; a platform in the centre of one wall, lighted by such light as could creep in through the panes of a wide and dusty window; old palettes, pendent in one corner near a big portfolio of sketches; a table, littered over with innumerable tubes and brushes. Wherever they could possibly be piled or stacked together, scores and then more scores of studies. On two easels, standing side by side near the half-open door. I like a painter who will leave his door half open, two pictures, one in oil and one in water-color, of the same subject—a little, cross-legged vagrant, seated, playing silent serenades on a dumb broom with which he imitates a mandolin.

The face, the pose, the spirit of the lad are true as life. And if you mark them, you will get the key to the success of the painter. Technically, I doubt whether either of the two works (I prefer the water-color, myself) would have contented such men as Pelez or Bastien-Lepage, who have handled the same class of subject; but there is no question that the art they reflect is popular and pleasing. This may not be the highest kind of praise, but it is something, and, indeed, much.

Besides, as Mr. Brown holds, perhaps we think too much—or, let us say, too exclusively—of technique, and not enough of other things, like charm and character.

"Technique?" says Mr. Brown. "Technique is well enough in its way. But give me character! I hate this everlasting talk about mere skill, mere technical dexterity. Those Frenchmen seem to dream of nothing else. I'm sick of hearing of them. Our artists go abroad, and they come back full of—technique. Why don't they try and give us something else? Why don't they try to paint pictures like Americans, instead of aping all those Gallic tricks, and seeing their own life through French glasses? Painting? Why, any one can paint, with practice. What we want is to learn how to see.

"I can't bear French art," he went on, with growing heat. "They never paint a woman in Paris but they make her a *demi-mondaine.* They put their souls into the effort to paint an ear or an eyebrow, to show the touch of the brush in an effective way or what not, and they care nothing what becomes of the likeness, the character. And because they have seen the Frenchmen do it, the Americans who go to Paris must do likewise; and when they come home and want to paint their native fields they see only flat landscape; and when they have to paint trees they reproduce the everlasting French apple-trees, and call it art.

"Bah! I'm weary of it. As if America had not a picturesqueness of its own, and Americans a character of their own, although they don't wear wooden shoes. Well! well! In fifty years or so, I dare say, we shall change all that."

It struck me Mr. Brown was rather sweeping; but he was not the first New Yorker I had heard abuse French art.

"As to the subjects, you are, doubtless, right," I ventured. "The best and finest of all themes lies close at hand—in New York Bay."

"Good for you!" said Mr. Brown. "I've said so, time and time again. I've made enemies by saying things like that. They're true, though. The Bay is every bit as fine as Venice. But they don't paint it, or, if they do, they keep the thought of Venice in their heads all the while, and lose the character they ought to study."

THE RETURN FROM EUROPE

American artists who had devoted years of their lives to study in Europe often experienced a "reverse culture shock" when they found themselves in the United States again. American institutions and patronage did not follow European models, awareness and esteem of the artistic profession seemed less developed, and things simply looked different out of doors—in both city and country. Worthington Whittredge, after a decade in Europe, returned in 1859 to find an American landscape that seemed overwhelmingly unkempt (see also "Düsseldorf and the Düsseldorf Gallery," chapter 6). It would take him a good deal of study before he refound his aesthetic footing in the New World. A generation later, the critic Mariana Griswold Van Rensselaer describes a similar dilemma among returnees from Europe, whose "corporeal eye" now resided in New York but whose "mental eye" remained in Paris, resulting in "un-American" pictures. She cites the young Dwight Tryon as one of the few to have solved this problem. Will Low (see also "Will Low Remembers Barbizon," this chapter; and "American Art Poised for a New Century," chapter 14), who ended his student period in 1877 and moved to Manhattan, remembers the difficulties as more of a professional conundrum: how might these cosmopolitan bohemians manage to make a living without giving up their hard-won artistic principles?

Worthington Whittredge, The Autobiography of Worthington Whittredge, *ed. John I. H. Baur (New York: Arno Press, 1969).*

It was impossible for me to shut out from my eyes the works of the great landscape painters which I had so recently seen in Europe, while I knew well enough that if I was to succeed I must produce something new and which might claim to be inspired by my home surroundings. I was in despair. Sure, however, that if I turned to nature I should find a friend, I seized my sketch box and went to the first available outdoor place I could find. I hid myself for months in the recesses of the Catskills. But how different was the scene before me from anything I had been looking at for many years! The forest was a mass of decaying logs and tangled brush wood, no peasants to pick up every vestige of fallen sticks to burn in their miserable huts, no well-ordered forests, nothing but the primitive woods with their solemn silence reigning everywhere. I think I can say that I was not the first or by any means the only painter of our country who has returned after a long visit abroad and not encountered the same difficulties in tackling home subjects.

Will H. Low, A Chronicle of Friendships, 1873–1900 *(New York: Charles Scribner's Sons, 1908).*

This time saw the return of a number of young painters from their studies abroad; argonauts hearing what they fondly conceived to be the golden fleece, ravished from the old art of Europe, to find that it was esteemed to be only dross by the self-sufficient inhabitants of our Island.

One of the newly returned, cynical in his humour, said about this time: "Yes, we return from

Europe, undecided whether we'll go back to Paris for the rest of our life, or stay here and build a studio big enough for our work; and then, after a little, we're blamed glad to make drawings for some magazine at thirty dollars per drawing."

This paints rather accurately the state of mind—and the finances—of the "younger men," as the press and the Academy dubbed these home-comers; a title by which they were complaisantly known during all the twenty-seven years of the duration of the Society of American Artists, which they founded.

Fortunately, they had all, more or less, as a birthright, the resourceful spirit of their country, and where they found their compatriots reluctant to encourage the form of art which their training perhaps best fitted them to do, they have modified their production, not so much in the research of popularity as in obedience to the common law of demand and supply. Under these conditions, most of the men of that time have earned their living, some of them have achieved a wide-spread reputation as artists, and a few of them have produced works that reflect glory upon their native land.

M. G. Van Rensselaer, "Pictures of the Season in New York," American Architect and Building News 20 *(August 21, 1886).*

The tendency of many of our younger men to give themselves up largely to reminiscences of foreign lands, even when working here at home, has never shown itself so strongly—for very obvious reasons—in their landscapes as in their work with the figure. And this year we seem to see a distinct advance toward entire independence. American subjects are more numerous than ever, and in many cases are interpreted with a sympathetic truth which a few years ago was the rarest of qualities. I mean that a few years ago, even when a landscape was American in name it was too often French or Dutch in aspect—that while the artist's corporeal eye had been resting upon some local scene, his mental eye had been remembering foreign scenes and the manner of their interpretation by foreign brushes. Doubtless he was quite unconscious of the fact, and desired nothing so much as to be absolutely true to the special task he had set himself. But habits of eye and hand are stubborn things; and we have much reason to be thankful that so many of our young graduates of European schools have now succeeded in learning how to make American landscape themes "artistic" on canvas and yet not make them un-American. A singularly attractive example of this power is to be found in the work of Mr. Tryon. When his name first appeared in our catalogues it was associated with pictures that were excellent in many ways, but, I think, distinctly transatlantic in flavor. They always had the precious quality we call sentiment, but this sentiment apparently did not find itself quite at home amid our local materials. But year after year he has devoted himself to the study of American landscape under many aspects, and to-day has grown into a painter than whom it would be hard to imagine one more wholly in sympathy with this subjects. His technical ability has steadily improved as well, and he has wholly worked out of a certain undue softness and lack of vitality and variety in texture which once characterized his results, without losing the tenderness and individuality of color which they always possessed. To say that he has sentiment means, of course, that his work is poetical as compared with that which aims merely at giving the bare outer truths of nature . . .

Certainly our bare, square, little rural homes are not so attractive to the eye as the cottages of the old world; but nevertheless they are *here,* and if one essays to paint the land he must paint them, too, or confess to artistic cowardice. And, after all, they are by no means unpaintable, if a man has not an ordinary eye but the eye of a true artist.

American critics wrote a great deal about late nineteenth-century European art, but the reverse was not often true. Friedrich Pecht, a German engraver and critic, nevertheless demonstrated an unusual interest in American art, almost certainly prompted by the large number of students who flocked to his city of Munich from the United States. In his review of the American paintings shown in the International Exhibition held in Munich in 1883, Pecht is complimentary, but he regrets that there are not more "subjects taken from the nature or people of the great trans-atlantic republic." (In the portion of his review devoted to individual paintings, not included here, he finds some exceptions to this generalization, which clearly delight him: works by Eastman Johnson, J. G. Brown, and Thomas Eakins.) Pecht also gets in a dig against the American tariff on foreign art (see "The Tariff Controversy," this chapter), but his view is generally positive; he predicts that a full-fledged "American school" will flourish by the turn of the century.

"A German Critic on American Art," Art Amateur *11 (September 1884).*

I now come to American art—that is so far as we can talk of an American art, and not merely of American painters who have studied in Munich, Paris, Rome, and belong to the schools of those places. That these American artists could send in contributions so respectable in numbers and quality, is, however, a fact deserving, at all events, of attention, and nothing is more certain than that they will shortly form a very considerable competition to ourselves. That this is not the case yet, is owing only to the circumstance that these American pictures acquaint one with everything under the sun excepting American life itself, the peculiarities of which would, naturally, interest one most. Out of a couple of hundreds of canvases collected in these rooms, scarcely a dozen treat subjects taken from the nature or people of the great trans-atlantic republic. Therein this art radically differs from that of all other nations, a fact the more striking as popular life and especially nature in the United States manifestly offer an immense mass of the finest material. Just think of the life of the pioneers in the West; of the gold-diggers, miners, trappers; of the collisions with the Indians, Mexicans, Chinese, negroes; of the maritime life of this most restless of nations! While the fiction-writers, from Cooper down to Bret Harte, have already worked this rich material in all directions, and excellently well, it still remains to the painters an untouched treasure, and an American Knaus or Defregger would be sure of immortality.

All this strikes one at first very unpleasantly, and, added to the technique imitated from all possible European schools and tendencies, with scarcely ever a spark of originality, gives one the impression that all these pictures have no definite character at all, unless it be the effort not only to copy all European crazes, but to improve on them by the super-addition of trans-atlantic extravagance. Yet this is only apparently so. A closer examination soon shows far more points of departure toward the reproduction of national life, even toward a distinctively American art, than one would think on a first inspection. There is, indeed, as little promise of individual forms and expressions as North America has a language of its own, but plenty of healthy, if not very thoroughly trained or restrained, talent. So I venture to prophesy that in twenty years from now there will be quite as much of a national American art as there is already of an American literature. Not, however, if they are irrational enough to strive to shut out by prohibitory tariffs the works of art of other nations, while these foreign works of art alone can educate the taste of

native artists, and, still more, that of the American public, which stands in far greater need of training, if it is to exercise a beneficent influence on the artists, instead of a hurtful one, as it does now. If national art production could be gradually substituted almost wholly for foreign production in Germany, a country so fond of all that is foreign, without protective tariffs, simply because our artists learned to reproduce our own nature and history, our own views and modes of feeling, in forms that were noble and attractive if not always classically perfect, the same result must be achieved a great deal more easily in America with the help of the strong national spirit of the Americans. And when people still have much to learn, it seems rather absurd to slam the door in the schoolmaster's face.

That the Americans are still in this case there can be no doubt; the great fault of most of their pictures, produced in their own country, is that the artists undertook to fly before they had learned to walk. Moreover, they seem very quickly to unlearn over there what they had learned on this side of the ocean, because they are not under the control of a public taste formed by great art collections, as is the case in France or Germany. The consequence is that it is just the more talented American artists who are to be found lingering in Munich, Paris, or Rome, however unwholesome such an existence is, when long continued.

AMERICANS ABROAD

By 1889 dozens of younger American painters and sculptors were more or less permanently settled abroad. In his extended review of the American Fine Art section at the Paris Exposition, the journalist Theodore Child—working in Paris as agent for Harper's New Monthly Magazine—*marvels at the progress made by American painters since their lusterless showing at the last Parisian world's fair, in 1878. Child attributes this dramatic improvement to study and residence abroad. Indeed, comparison of the expatriates' work with that of artists living in America is with few exceptions "disastrous." As Child's descriptions reveal, the expatriates' work is for all practical purposes interchangeable with that of their European models. Like the latter, the Americans produce large, showy canvases representing open-air nudes, earthy French or Dutch peasants, and garish Orientalist spectacles. For Child it matters little whether or not such paintings are identifiably American; his interest (ironically) lies in their "individuality."*

Theodore Child, *"American Artists at the Paris Exhibition,"* Harper's New Monthly Magazine 79 (September 1889).

At the Universal Exhibition of 1878 the United States Fine Art section was an uninviting and justly deserted spot. The most important pictures were generally thought to be Mr. F. A. Bridgman's "Funeral of a Mummy," and Mr. W. P. W. Dana's marine entitled "Solitude," while a few pictures by Messrs. Lafarge, Vedder, Walter Shirlaw, J. G. Brown, and Dielman were with difficulty discovered to be worthy of remark by French critics.

Since 1878 American artists have made for themselves a large and glorious place in Europe. Year after year their works have attracted more and more attention at the Paris Salon, while at the same time high honors have been awarded to American painters who have contributed to the various exhibitions held in other European capitals.

At the Paris Universal Exhibition of 1889 there is no exaggeration in saying that the American Fine Art section was one of the strongest and most interesting of all the foreign departments . . . The important fact to be noted is that in 1889 America boasts an élite of artists whose

names are cited in company with the most illustrious, and that men like Whistler, E. A. Abbey, W. T. Dannat, and John S. Sargent can hold their own brilliantly in a palace of art where the exhibitors, besides the great Frenchmen, are masters of the eminence of Munkacsy, Adolf Menzel, Herkomer, Orchardson, Madrazo, Boldini, and Alfred Stephens.

The task of the critic charged with writing about the American artists in 1889 is therefore entirely agreeable; the variety of temperaments represented and the diversity of the pictures are equally remarkable; and while the general standard of excellence is high, the quality of the best pictures in the exhibition is of the very finest . . . What we seek for above all things, and rejoice to find, is artistic individuality . . .

Mr. Alexander Harrison first made his mark at the Paris Salon of 1882, with a charming picture called "Châteaux en Espagne," . . . and in the Salon of 1886 with "En Arcadie." . . .

Mr. Harrison's "En Arcadie," in spite of its title, contains nothing fanciful or imported from dream-land; it is entirely from nature. The modern French school of painting of the past fifteen years is based on two principles, namely, the observation of values and the integrity of the subject. The idea that has been professed, perhaps to excess, is that to make a picture we do not need dramatic or sentimental stories, neither the pear-shaped tears of Greuze nor the stupendous adventures of Sennacherib. The theory is that truth suffices, or, in other words, all that can be demanded of an artist is sincere observation, logical execution, and emancipation from academic influence, or, as others might say, individuality and self-respect. "En Arcadie" contains the result of the application of this theory to nude figures in the open air. Beside a stream, beyond which is a flowery meadow and an enclosing curtain of trees, is a carpet of velvety grass and flowers, studded with gnarled willows and silvery birches, through whose branches the afternoon sun strikes and forms a golden mosaic on the sward. In this landscape some nude women are reposing after their bath, sitting or reclining in the grass, while one in the foreground stands, and with uplifted arms grasps the branch above her head, and remains in languid pose, talking to one who sits on her left—dryads that are entirely human, and even modern, for the artist has made no effort to conceal his method of realizing his Arcadian vision: he has simply painted modern women nude in the open air, and reproduced, with the sincerity of contemporary analysis, the aspect of flesh that habitually wears clothes as it appears in the unusual conditions of nudity. In painting both the landscape and the figures Mr. Harrison has sought to attain truth to nature; not the mere textual image and reproduction, but truth in tone and relative values. The sun is not seen in the picture itself, but it pervades the whole in the light green of the grass, in the shadows which are only attenuated light, on the bodies of the women, which are enveloped in the caresses of varied and conflicting reflected lights. The landscape of "En Arcadie" is perfection; it is impossible to conceive a more absolute and delicate illusion of sunny woodland . . .

Mr. George Hitchcock revealed himself, a late-comer in art, at the Salon in 1887, when his "Tulip-growing in Holland" at once made him almost famous. In the background of the picture is a curtain of trees, and nestling under the trees a house, and in front of the house tulips, band after band, parallel and regular, rose, white, yellow, and red; and in the midst of this natural carpet of flowers stands the lady of the house, in Dutch costume, hesitating, scissors in hand, which tulip she shall cut. This lovely vision of floral color figured in the Universal Exhibition, together with "The Annunciation" (Salon of 1888), and a new picture of Dutch figures in pale and pearly landscape, called "Maternity." This last is charming in aspect and most delicate in tone; the landscape is exquisite; the figures alone betray the inevitable weakness of op-

simathy, and that, too, all the more so as they are conspicuous in the foreground.[1] Nevertheless, you feel that this picture is the work of a singularly artistic temperament. The same impression is given by "The Annunciation," reproduced in the accompanying engraving. This picture is a harmony in green and silver. In the foreground is a plot of tall-growing lilies in the full glory of their rich white bloom; a dark hedge of lilac bushes, broken here and there by willows, separates the lily garden from an expanse of bright green Dutch landscape that fades away with infinite delicacy of gradations toward the distant horizon of pearly sky. Against the background formed by the hedge stands the Virgin, personified by a plain Dutch maid, draped in simple vestments of lilac-gray tone and a short cloak reaching to the waist, and wearing the white muslin coiffure of Holland, with streamers that hang over the shoulders. In the idea of the painter, Mary has just received the divine message, and with downcast eyes replies to the angel invisible to profane eyes, "Behold the handmaid of the Lord; be it unto me according to thy word."

Mr. Hitchcock's "Annunciation" is distinguished and refined in composition and treatment; the color scheme of greens and grays with exquisite opaline transitions is charming; the invention of the picture implies intelligent selection, and the exercise of that rare quality which we call taste. To my mind "The Annunciation" is a beautiful work, one of the most refined and original pictures in the American section, and incontestably the vision of a man of delicate and artistic nature.

Mr. J. Gari Melchers, whose name first appears in the Salon catalogue in 1882, did not make his mark until the Salon of 1886, when he exhibited "Le Prêche," reproduced in the accompanying engraving. At the Salon of 1888 his "Dutch Pilots," with their placid faces, sitting round an inn table, talking about the sea, smoking, and carving models of boats, was one of the notable pictures of the year. At the Universal Exhibition Mr. Melchers was represented by both these works, and by a very large new picture representing the celebration of communion in a Dutch church, and containing some twenty life-size and remarkably ugly figures. Although Mr. Melchers works by preference in Holland, and although he has hitherto painted none but Dutch subjects, he is a pupil of Boulanger and Lefebvre, and thoroughly French in the modernity and quality of his vision. He paints figures round and solid, with a tendency toward the complete illusion of materiality. In all that concerns realistic work we cannot mention a French artist who is superior to him, for Mr. Melchers is marvellously skilful: in "Le Prêche" and in the large "Communion" picture there are figures and *morceaux* which are simply the last word of realism in painting. At the same time Mr. Melchers's pictures are rich in local color; the attitudes and gestures of the figures are full of character, studied with *esprit,* drawn faultlessly, and painted with simplicity and strength; the composition is not commonplace; the relative values are keenly observed; the figures admirably enveloped in air; in fact there is no technical detail, no matter of special knowledge, no material point, in which Mr. Melchers can be found even hesitating, much less positively at fault. His three pictures exhibited at the Champ de Mars are thoroughly remarkable works, and amongst the younger painters of the day, not only in America, but in Europe, Mr. Melchers has won for himself a very enviable and distinguished position. His work is new and quite personal; he has both the courage and the strength to be himself. Doubtless these pews full of Dutch women and girls in their quaint head-dresses interest many people. The sturdy pilots, too, and the plain-looking, cheesy-faced people gathered round the communion table in a bare and gray-walled Dutch church, will find admirers who will be struck by

[1] Opsimathy: study or learning delayed until later in life.

the sentiment of the subject, by the illusion of life, and by the rendering of commonplace features and ordinary characteristics that the first-comers can appreciate. But is the admiration of such as these sufficient for the artist's ambition? Is the theory of the integrity of the subject so incontestable as some maintain it to be? Are we not beginning to have enough likenesses of ugly people of advanced age and humble station since fashion directed the painters into the path of peasant portraiture, and since experience has shown them that it is far easier to paint the wrinkled parchment face of a stupid old hag than to reproduce the grace, the elegance, and refinement of a beautiful woman? Mr. Melchers appears to have skill and talent enough to attempt the noblest and most ambitious enterprises. He has already shown himself to be a draughtsman and a painter; the future will show whether this brilliant young man has the supreme gifts of taste and of beautiful invention that will make him an artist and a creator. Of the three pictures which he exhibits at the Universal Exhibition the most interesting is "Le Prêche," which has certain qualities of delicacy and refinement that make it charming to the eye. In his last and most ambitious picture, "The Communion," which is positively and frankly ugly, Mr. Melchers seems to tend rather toward following in the footsteps of Courbet, whose vision of nature is that of an impersonal observer, very searching, but without lyrism or charm— of Courbet, who above all things studied the volume of bodies, their thickness rather than their silhouette against the layers of transparent air, and the diversity rather than the lightness and daintiness of the effect . . .

Mr. Ridgway . . . Knight does not paint the life of country people with the austerity of Millet, who shows us the human being imbruted and deformed by his perpetual struggle against the earth and the elements; nor, on the other hand, has he yielded too much to the urban and cloying sentimentalism by means of which Jules Breton steals the hearts of the country cousins. Mr. Knight has an innate tendency to see the smiling and amiable aspect of nature; he exercises the artist's right to pick and choose and select. His vision of rural life is that of a healthy, happy man, unperverted by pessimism or dilettanteism or any other excess of mental refinement, and consequently he finds in the fields of Seine-et-Oise peasant girls far more goodly to look upon than the rough-hewn and heavy creatures whom the author of the "Angelus" has painted digging and delving, toiling and moiling, resigned and joyless. If there is any latent coquetry in a model, any elegance of line beneath the rough vesture, Mr. Knight's eye will detect it, and his brush will render it with the exaltation of idealism: in other words, Mr. Knight selects what is beautiful and pretty in the peasant, and avoids all that is hideous and unsightly . . .

Mr. Edwin Lord Weeks began to exhibit at the Salon in 1878, and continued with subjects from Tangier and Morocco until 1884, when he sent a souvenir of Indian travel, a "Hindoo Sanctuary at Bombay." In 1885 he exhibited at the Salon the large picture reproduced in our engraving, "Le Dernier Voyage," a souvenir of the Ganges. At the Salon of 1886 Mr. Weeks exhibited "The Return of the Mogul Emperor from the Grand Mosque of Dehli"; in 1887, some Bombay Bayaderes; in 1888, a "Rajah of Jodhpore." At the Universal Exhibition Mr. Weeks was represented by his "Dernier Voyage," his "Rajah of Jodhpore," a "Hindoo Marriage Procession" passing through the quaint streets of Ahmedabad, and some minor works. Mr. Weeks is gifted with great facility; his skill and sureness of eye and of hand in dealing with vast scenes are remarkable. No one has treated with greater effect and with such unhesitating directness the grand architectural backgrounds of India, with their pluri-color richness and splendor of detail. An excellent example of Mr. Weeks's skill in *mise en scène* is the large picture reproduced in our engraving. Two Hindoo fakirs are going on a pilgrimage to the holy town of Benares. One of them being at the point of death, his comrade is making haste to take him

across the sacred Ganges, so that he may breathe his last on its bank. Such is the scene depicted, with, in the background, a vision of holy India—temples, pagodas, funeral pyres, fakirs, and men of all kinds sheltering themselves from the blazing sun under umbrellas that look like gigantic white mushrooms; and, in the foreground, the broad Ganges, with its flotsam of pious corpses escorted by carrion-crows. This picture shows Mr. Weeks's dramatic and scenic qualities, and his careful observation of Oriental air and color. In the "Hindoo Marriage" and the "Rajah of Jodhpore" we admire Mr. Weeks's faculty of composing and setting on foot a great scene comprising landscape, architecture, animals, and countless figures, with all their diverse costumes, attitudes, and multifarious accessories. And this faculty, it may be added, is not common in these days of a "realism" which is too often content to limit its efforts to painting "studies." . . .

Mr. F. D. Millet was represented in the United States section by "A Handmaiden" and "A difficult Duet"; but, for reasons which do not concern us, his best picture, "The Piping Times of Peace," was exhibited in the English department. Of late years Mr. Millet has acquired a distinguished position in England . . . His work . . . is thoroughly English; it has the English qualities of sentiment and of careful and dainty technique, and that peculiarly English observation which is devoted to seizing the expressive movements of the human physiognomy, and conveying with the utmost intensity the anecdotic effect of the subject. Mr. Millet does not revel in painting considered as being by itself one of the fine arts; his intention is almost as much literary as it is artistic; an episode of life, an anecdote, a state of soul rendered manifest in a pleasing manner and in the midst of curious and amusing accessories, studied with the minuteness and neatness of touch of the later old Dutch masters—such is Mr. Millet's conception of his art.

The works above mentioned are those which made the reputation and success of the United States section, or, in other words, the cream of the Exhibition . . .

In the United States section a broad distinction was made between the American artists resident in Europe and those resident in America, and the works of each were hung in separate rooms, as if to challenge comparison. It must be said that the comparison was disastrous to the American artists resident in America, or classed as such.

ART EDUCATION

Germany

THE MUNICH SCHOOL

In the late 1870s the American art world discovered Munich. Artists from the United States had been studying at the Royal Academy in Munich since at least 1869, when Frank Duveneck arrived there, and more than four hundred American men (the Academy did not accept women) are known to have taken classes there. The aesthetic impact of the Munich manner struck full force when a series of exhibitions featured a critical mass of dramatic paintings by Munich students: Duveneck's one-man show at the Boston Art Club in 1875, an unusually liberal annual exhibition at the National Academy of Design in 1877, and the first exhibition of the Society of American Artists in 1878 (see "Sylvester Koehler Reflects on a Decade of American Art," chapter 12). Critics marveled at the bold technique of such Munich-trained artists as Walter Shirlaw and John White

Alexander: thick paint laid on alla prima *in flat, squared strokes, a reduced palette dominated by strong light and extremes of black and white, and a deliberate lack of finish that contrasted greatly with the predominant Parisian manner. Munich teachers such as Wilhelm Diez and Karl von Piloty taught their students to seek inspiration in the humble subjects and rich chiaroscuro of the Dutch old masters; thus, portrait heads, still life, and peasant studies predominated.*

The following reviews are typical of the responses to the Munich paintings that arrived on the American scene. Raymond Westbrook extols the merits of William Merritt Chase's large figural work Ready for the Ride *(1877) as well as the flesh painting of some of his colleagues. William Brownell greets Duveneck's* Turkish Page *(1876) as a revelation in technique and champions a controversial set of dark watercolors exhibited by J. Frank Currier. In contrast, Clarence Cook criticizes "the modern German hatred of color," and Edward Strahan (Earl Shinn) wonders if the Munich phenomenon might not be all flash and little substance, theatrical and designed to please an ignorant public.*

[Clarence Cook,] "Fine Arts," New-York Daily Tribune, *April 29, 1875.*

Munich . . . is a new quarter comparatively from which to look for influences upon American art. We confess we are not much pleased with what these artists have found there . . . So far as color is concerned all these . . . pictures might as well be frankly painted in black and white, and would lose no jot of their value as pictures by being engraved or photographed . . . The modern German hatred of color, and incapacity for either perceiving it or enjoying it, has so far infected us that we may excite some surprise by insisting on the essential unpictorialness of these Munich inspired pictures, and by the expression of our regret that after having shaken off so much of Düsseldorf as we have, we should still continue to be Germanized after this fashion. 'Tis out of the frying-pan and into the fire. However, we must take what is given us, and try to find out what there is good in it, and to be thankful for it. There is indeed much that is good in these pictures, and there is at least the appearance of earnestness, and evidence enough that there has been careful training of some sort and much loyal study. Color will never come, but other things may, and no doubt great things may be accomplished in light and shade. Nor is the least of the merits of these artists that their work is serious in its intention, and shows no sympathy with the 'millinery school,' nor with the 'goody anecdote school.'

Raymond Westbrook, "Open Letter from New York," Atlantic Monthly *41 (June 1878).*

Chase, the most mature and finished of the exhibitors, is of the Germans, sending his pictures from Munich, but he is even more of the Flemings and the old masters. Permeated with the essence of the great galleries in which he has lingered, he seems frankly to have abandoned any attempt at an originality which could detract from the incomparable grand manner of the past. So perfectly does he give a sense of Rembrandt, Hals, Velasquez, Raphael Mengs, that it is difficult to see in what respect he falls short of renewing their dark, rich, full, and vivid portraiture. His work needs no provincial audience for its appreciation, but can take its chances in the markets of the world. The peculiarity is the intense concentration of interest on the points of principal importance. In Preparing for the Ride, a full-length life-sized lady in a black riding-habit and a steeple-crowned hat, drawing on her gloves, the head and hands alone beam out of a rich, olive-tinted gloom. The figure is defined by a pale diffusion of light, which forms but a slight connection between these isolated points. From a distance you see in the large canvas only two

white spots. The head, cut off by a spreading lace ruff, seems to float, cherub-like, in space, or, rather, to rest upon a salver. The pale face, of a milk-like complexion, with thin blonde hair fringed above it, to which the large accessories give a sort of preciousness, has once been beautiful, but there is now in it the melancholy of an unmistakable fading . . .

Another powerful head, of a soldier in a battered steel helmet, is, by an opposite process, flat and dark against a ground almost white. The Apprentice is a graphic study of an unterrified young scion of the working classes, with the dirt grimed into the wrinkled skin of his wrists, who has been sent after a pot of beer. It has the reality of an actual person standing in the frame. In color it is an epitome of Munich . . .

Of other Munich work the character heads by Dannat and Gross are typical, and interesting for their method. They obtain a great brilliancy by being forced out of an almost black ground. Shadows fall under the nose and upon one side of the face almost as strong as on a plaster cast from an upper light in the evening. The flesh is roughly and solidly painted, the colors as far as possible being laid in patches side by side and left untroubled, or, at most, one slightly merged in the other by a dexterous sweep of the brush, for in oil scarcely less than in watercolor do uncertainty and experiments destroy freshness and the highest attainable results. The practice is carried to the extreme of caricature by Currier, whose Bohemian Beggar's complexion, painted in crude stripes, appears to have been flayed.

Edward Strahan [Earl Shinn], "The National Academy of Design," Art Amateur 1 *(July 1879).*

Half our young American artists go to Paris, to be educated in the ateliers of Bonnat, Gérôme, or Carolus Duran; the other half go to Munich, to receive the instructions of Piloty and Lindenschmidt. Our picture exhibitions have of late years been tilting matches for these contestants.

The Bavarian students make a more showy and popular effect. Whether this is because they happen to be stronger men than those educating in France, or whether the Munich system is a system which possesses some easy royal road to apparent excellence, is a question. However it may be, in the recent displays of the National Academy and American Artists' Society the clever superficial canvases of Duveneck, Chase, and Shirlaw proved more attractive than the patient, uninspired, tentative studies of Eakins, Bridgman, Eaton, Weir, Low, Ward, Sartain, and their parlez-vous compeers. On a discriminating view, however, the first impression of superiority suffered a modification . . .

The Teutonic art-schools are fond of sending to international exhibitions rows of model studies in costume and character, in the kind exemplified by the "Burgomaster" and the "Head." A living model of some sturdy, Düreresque type, is chosen, and clothed in furs, or in Dürer's favorite flapped bonnet. Whole classes of pupils execute the studies; and so decorative is the cap with its flaps, so amused is the attention with the fur, and the feathers, and the tossed hair, and the ivy-bush beard, and the wrinkles and warts, that you forget to see whether the effect is good as a piece of construction, whether the zygomatic[2] arches are in place, and the dome of the forehead recedes at its two sides in just perspective. The objection to be made to this "Head" and this "Burgomaster" is that the picturesqueness of the types has beguiled the artists into paying attention to the wrong qualities; they have not tried to represent the exact degree of yielding firmness of human flesh, but have given us faces like skilfully carved wooden ones that have been tinted.

[2] Zygomatic: referring to the cheekbone.

In fact, the fallacy of these decorative Bavarians is, that they represent not the vital secret of life, but represent its theatrical representation. Mr. Chase in his fard and ceruse[3] and superficiality, and the last-mentioned pair in their blockishness, are alike concerned with the superfices of life, rather than with its blood and bones and marrow and soul. And our specimens just named are quite complete enough, though they only show the sucking wolf prettily trying its milk teeth, for a true estimate. We are glad our Americans have gone no further, and we can see the tendencies of the teaching just as well as in the flashy street pageants of Makart, bathed in coppery lights that can only come from the theatre and never from nature, or the tin-foil and Dutch-metal brilliancies of Piloty, or the fifth-act tableaux of Gabriel Max.

Two or three more Munich efforts were contributed, and deserve mention. Duveneck showed a portrait of a handsome young American, weighted with the black cloak and felt of a Franz Hals portrait. The difference between this and a real Hals is, that if you expose the latter to dissolvents for twenty-four hours the blackness comes off, revealing nice drawing, draperies, folds, and details; whereas in the pasticcio similarly treated *all* comes off, and you get the bare canvas; still the sketch as a sketch was very graceful.

William C. Brownell, "The Younger Painters of America," Scribner's Monthly 20 (May 1880).

One of the most distinctive things that strike one in looking at the works of nearly all of the new men—at least of nearly all with whom this paper has to do—is, perhaps, the strength of their technique. That was the noticeable thing about their work in the Academy Exhibition of 1877 . . .

Few people who saw it can have forgotten Mr. Duveneck's "Turkish Page," to take a noteworthy instance; it was a good-sized canvas exhibiting a skeleton-like boy sitting on a leopard skin, a red plush fabric covering his extended legs from his ankles to his waist, a red fez on his head, a brass basin containing fruit, at which a macaw is pecking, in his lap, and at his left hand a copper dish and pitcher; the wall behind him, against which he leans, being hung with striped tapestry. In pure technique this was certainly one of the best pictures we have ever had exhibited here by an American. What painters call quality, it had in surprising manner; the fez was clearly wool, the basin brass, the pitcher copper, and the bird's plumage as feathery as one might see in nature; the flesh was only less admirably rendered. And in the higher branch of technique, pictorial arrangement, it was quite as good, the whole being a complete entity, in philosophical phrase, the apparently incongruous materials mentioned reciprocally interdependent and auxiliary, and the entire effect single. No one needs to be told what high technical excellence these two things imply, and though his "Turkish Page" is a conspicuous example of them, they are evident in everything Mr. Duveneck has shown here; in his portraits, and even in his "Coming Man," of which the elements were so few as almost to make the picture simply a study . . .

But it is unnecessary to multiply instances; it should be patent to any one who has examined the work of the "new men" with any care and attention that they have made it their first business to get command of their tools—to the end that, having command of them, they may play with them artistically; that their conception of painting is wholly different from that of accurately imitating natural forms; that drawing is with them only one of the elements of the painter's equipment; and that the years they have spent in Europe have been productive of some-

[3] "Fard and ceruse" refers to white paint, especially when applied to the face.

thing beyond a catch-penny ability to imitate the "tricks of the trade" practiced by certain char-latan instructors of ingenious youth—such as Gérôme and Piloty. The "tricks" of those painters, so far as technique goes, are hard to imitate.

However, technique goes for very little in a large reckoning. The slight interest that many of us have in so great a master of it as Gérôme, for example, is witness of that. And, indeed, ex-cellence of technique—which after all is chiefly a matter of diligent training—is not more char-acteristic of the new men than what may be called, for want of a more definite term, the gen-uine impulse to paint, which most of them certainly have. This is at bottom the test one applies to a painter, or indeed to an artist of any sort, of course . . .

Speaking broadly, therefore, whereas it used to be the main effort of American painters to imitate nature, it is the main effort of the new men to express feeling. Hitherto, admiration of American paintings has found expression in such statements as, "How true!" "How life-like!" "How marvelously Mr. Bristol has succeeded in rendering those blue Berkshire hills!" "How happily Mr. Heade has caught the hues of that humming-bird, and Mr. Eastman Johnson the attitude of that old man, and Mr. Brown the expression of that urchin, and Mr. William Hart the gorgeous brilliance of golden October!" and so on. To many people, it never occurred to question the fact as to whether nature had been thus happily imitated; the distinction between a photograph and a picture has only recently become hackneyed with us; few American con-noisseurs even paused to reflect that nothing could be less like nature than terra-cotta cows and decalcomanie[4] foliage, and theatric but metallic cloud "effects," and shiny banks of moss, of which and other similar elements a good deal of American painting has been and is composed. But aside from accepting thus unquestioningly the circumstance of "life-likeness," most people never thought of asking of a painting that it be "alive" instead of only "life-like." And yet, of course, this is the one thing needful to demand of a picture. And this characterizes the work of the new men almost without exception. Almost without exception, nature is to them a mate-rial rather than a model; they lean toward feeling rather than toward logic; toward beauty, or at least artistic impressiveness, rather than toward literalness; toward illusion rather than to-ward representation . . .

Mr. Chase sends a portrait, of which the eyes are barely modeled and not painted at all, to the Exhibition of his Society; Mr. Weir, along with a large and ambitious canvas, the rapid and hasty study for one of its heads; Mr. Ryder a number of pictures justly to be denominated freaks in respect of their serene and conscious disregard of the conventions of painting; Mr. Duveneck is represented by a canvas which is a mere sketch, and defiantly leaves off when its principal effect is secured. And it is clear, moreover, that in many instances this is wisely done; for to their technique, and their individuality, and their sense for what is pictorially interest-ing, many of the painters have not yet the ability to add either the largeness or the distinction that belong to an impressive style. For the present, at least, if Mr. Ryder, for example, should attempt more than he does, it is odds that it would be disastrous, to a degree. His pictures are marked by an almost contempt for form: they assume an attitude of almost hostility to the observer bent on "making them out;" they seem to take it for granted that a picture is a sim-ple rather than a complex thing, and to assert directly that a suggestive hint is as good as a complete expression. But if he should suddenly realize their short-comings in these respects and attempt to correct them out of hand, we should fear for their poetic feeling, their engag-

[4] Decalcomania: the transfer of designs to china or glass.

ing color, and their softness and tenderness; even to lose their fragmentariness would, one feels, be risky . . .

Mr. Currier's pictures are another instance of what can be done in art without poetry—even with the negation of poetry. The watercolors he sent here in the winter of 1878–79 made a sensation. They became the subject of endless discussion and may almost be said to have divided "art circles" into two hostile parties. It was contended on the one hand that they were wonderful examples of the way in which an impressionist, nobly careless of details and bent only on the representation of the spirit of nature rather than of her botanical forms, can succeed in the truest fidelity. On the other it was argued that nothing could be made out of them, that they were mere daubs, and that the only landscape which could in the faintest way resemble them was that of which one caught glimpses from the window of an express train. The ayes "had it" very clearly, in our view. Mr. Currier's "impressions" were masterly in technical qualities and very real at a proper distance. The fatal trouble with them was that they were horribly ugly. That is the difficulty with all of Mr. Currier's work; it is the difficulty with his genius. Painters such as he, who emulate the vigor and vividness of Franz Hals, forget that vigor and vividness are not the only nor the sufficient elements of a picture, and were never yet so deemed by any master even of the Dutch school. An exquisite and almost caressing art there is in the most intensely real Velasquez or in the most superficially ugly Franz Hals. Mr. Duveneck and Mr. Chase are in another category, though we suspect they are to be ranked as warm admirers of Mr. Currier. Mr. Duveneck atones for his absence of poetry not only by his power, and Mr. Chase by his extraordinary facility and swiftness, so to speak, but both by their sense of character of what is pictorially impressive, by their feeling in a word for picturesqueness. Nothing could be more picturesque than the Spanish-like portrait Mr. Duveneck sent to the Academy last year, and at the same time it was powerfully and subtly painted; and nothing more so than Mr. Chase's best work. His canvases have a life, an *élan,* a movement and an artistic interest in the highest degree noteworthy; we do not remember one of them which relies on beauty. They attract, stimulate, provoke a real enthusiasm at times for their straightforward directness, their singleness of aim, their absolute avoidance of all sentimentality,—but they have not charm. Mr. Shirlaw inclines more to things poetic; we remember a very charming picture of a sleeping girl; his "Gooseherd" was a by no means prosaic expression of jollity; and in portraiture he loses nothing of the sweetness and grace of an attractive subject. In the main, however, it is to be said that his strongest leaning is toward pure picturesqueness, and that in a measure he compromises a natural bent in essaying sentiment, however well he may handle it . . .

To recall our conclusions in regard to these, taking them in the mass, and somewhat loosely. They have acquired a strong, if not too flexible or comprehensive, technique; they have a genuine impulse, a natural bent toward painting; and, though as yet they lack *style,* and seem a little more content to lack it than is quite deferential, and have not noticeable feeling for poetry, they atone for this, to a degree, not only by the qualities just mentioned but by a lively feeling for character and a quick sense for picturesqueness—for what is pictorially impressive.

France

WILL LOW REMEMBERS BARBIZON

A native of Albany, New York, Will Hicok Low began work in New York City as an illustrator in the early 1870s (see also "The Return from Europe," this chapter; and

"American Art Poised for a New Century," chapter 14). But from 1873 to 1877 he studied in Paris under Carolus-Duran (Charles-Auguste-Emile Durand) and Jean-Léon Gérôme. In his autobiography he remembered this time fondly, especially the summers he spent in the Barbizon area, about 30 miles southeast of Paris. Famous as the inspiration for landscapist Théodore Rousseau, the forest of Fontainebleau, near the village of Barbizon, attracted an international crowd of artists anxious to follow Rousseau's tracks and study the fields made famous by the canvases of Jean-François Millet. In these excerpts, Low describes the joys and benefits of plein-air painting, group critique, and artistic socializing at the famous Hotel Siron.

Will H. Low, A Chronicle of Friendships, 1873–1900 *(New York: Charles Scribner's Sons, 1908).*

The previous year, a few months after my arrival in France, I had gone to a little village near the border of the forest of Fontainebleau, intending to spend the summer vacation. I had heard of Barbizon as the resort of many American students and, in my early resolve to see all that I could of the people of France and to avoid my compatriots, I had determined to find a place for myself . . .

On a beautiful morning, consulting Denincourt's map, I made my way through the forest, and by noon was seated at the hospitable board of the Hotel Siron in Barbizon, shamelessly glad to be able express myself freely in my native tongue, and from that time forth for many years Barbizon was to be the spot where I felt myself the most at home . . .

This was the first year that saw the influx of Hungarian, German, and Swedish painters at Barbizon, and the table d'hôte was polyglot and noisy. Siron's hotel was built around a court, a rambling structure giving evidence of gradual growth and added construction as necessity had arisen. The dining-room looked on the village street and was panelled with wood, on which all my and the preceding generation had painted rather indifferent sketches. Long tables ran around three sides of this room, a piano which was inured to hard usage was in one corner, and a fireplace in the other. For the modest sum of five francs a day augmented occasionally by "estrats," as the mysterious spelling of our host had it, we were furnished with very good food and lodging. As the hotel proper had limited accommodation the lodgers overflowed to various peasant houses, as well as to an annex which contained studios as well as bedrooms which Siron had caused to be built across the street . . .

Ridgway Knight and Henry Bacon, then and still domiciled in France, were there; Peppercorn and Johnson, since well known in England, Wyatt Eaton, Stevenson, myself, and a few others, made up the English-speaking contingent. The early morning saw us all astir, and a generous bowl of coffee and a bit of bread under the arbour at the back of the hotel having been disposed of, we separated to our work. Those who went far into the forest took a lunch with them, the others, working on the plain or in the peasants' houses in the village, met again at noon. But it was about sunset that one by one we entered the courtyard, shifted our loads of painting materials from our shoulders to the ground, and placed our freshly painted studies against the wall of the house. Then would come an hour of mutual criticism of our work, as seated at little round tables, conveniently placed, we absorbed various "estrats" in the guise of vermouth, or strolled from one canvas to the other. Many a helpful work came at these times, criticisms and suggestions as various as the nationalities represented; and the cheerful witticism was by no means debarred . . .

In the early morning, through the village street, with the incense of the wood fires rising straight in the clear, and the no less aromatic though more prosaic perfume of the soup of

Jacques Bonhomme permeating the air, we were astir. Sometimes we would issue from the village to the plain, the matin sun sharply defining the crest of the furrows, or, at another season, gilding the refined gold of the swaying wheat. Ah! that plain, what lessons of form it has taught its earnest students among the painters who have worked over its surface like so many patient husbandmen. For Millet who, as I have described, did not scruple to draw upon his store of knowledge to construct a human figure, has testified—by many careful drawings that are almost like the measured work of a topographical engineer—that memory is powerless to depict the subtle accidents of form, the delicate gradations of its surface. Like a loved countenance on which life has written its history, so might the story of many generations be read in the various shaped and vari-coloured fields, and the interlacing paths that ran hither and yon, defining plots of ground for which the energies of a family had toiled early and late. To the casual passer-by the plain may be featureless and devoid of interest, but it has sufficed for noble masterpieces of Millet and Rousseau, and none have ever studied it sincerely without finding it, under the overarching sky, a fitting scene for the twelve acts of the drama of the sylvan year . . .

The stillness of the morning, the spicy odours of the trees, welcomed the matinal painter, and a brisk walk never so long as to induce fatigue, for there were abundant *motifs* near at hand, brought him to his work. The folding easel was soon in place, the canvas placed upon it, the clear and pure colours, squeezed from their tubes, duly arranged upon the palette, and work began. Often, if the painting ground was some distance from the inn, a lunch would be carried, and a second canvas for an afternoon effect would be ready, when, after the lunch disposed of and sundry cigarettes burned on the altar of the arts, the industrious painter resumed his task. Canvases of large dimensions, too large to be carried to and fro, would be firmly fixed to upright stakes driven in the ground and, with the absorbent back of the canvas protected from the weather by oil cloth, would be left out of doors for weeks until the painting was completed.

No other protection was necessary; the painted surface of the canvas was practically impervious to rain, and the chance faggot gatherers, the forest guards, or even errant children passing that way had, one and all, too hearty respect for the arts to inflict the slightest damage on a painting in progress, thus left at their mercy. Many a picture in the museums to-day, protected by frame and glass, and the temperature of the gallery where it hangs carefully regulated, was thus born gipsy-like in the woods, where the shafts of sunlight by day and the stars by night watched curiously the progress of its growth . . .

The quitting hour was a fitting crown to a day well spent. When the shadows grew long, when the sunlight in the distance, which had effectually baffled your brush for a tantalizing period, had finally faded, the time to buckle up your traps, strap your knapsack to your back, and turn your face homeward had come. In the midsummer the golden light in the tree-tops sent you on your way through the cool shadow below as though your head were a halo, and it was yet day when, emerging from the forest, the pointed iron of the alpenstock to which the artist affixes his sketching-umbrella rang on the stone pavement of Siron's courtyard, and vermouth and friendly criticism awaited you. Later in the autumn, the evening settled chill, you stretched yourself a little stiffly as you ceased your work, glad at the prospect of the brisk walk. By the time your various paraphernalia of the artist were strapped together it was dusk, and, holding your newly painted canvas gingerly from your person, your footsteps echoed loudly as you gained the highway through the woods. You walked in a Gothic cathedral, the columnar trunks and the interfoliation of the branches standing dark against the crimson and golden stain of the windows of the sky. It was glorious, though sometimes a trifle weird, as far off in the dis-

tance you might hear the roaring of a wild boar or the booming of the deer; and a sense of solitude rose from the rhythmic beat of your feet. The lights would be lit in the inn on your arrival, the painters, growing fewer in number as the season advanced, would be gathered in the high room, panelled with sketches, where we dined; where the table, already set, awaited, and a fire crackeled on the hearth in the corner. Here, by the light of a candle held close to your sketch, your work received the approbation or frank disapproval of your friends, each on his arrival running the gauntlet of criticism, and there ensued a discussion on art in general, accompanied by becoming personalities, until it was interrupted by the entrance of Siron, bearing high a huge and smoking soup-tureen, and crying, "*à table, Messieurs, à table.*" We dearly loved the general discussion of art in those days, when we frankly talked "shop" on all occasions—and some of us have not outgrown the habit. On rainy days, or as the mood seized us, we worked in our studios or in the houses of the peasants. In these last, one was very close to the people, in more senses than one, but I have always been grateful for the experience. It gave me an insight which comparatively few of our compatriots have had, of the underlying force of the French nation; of the typical self-respect, accepting, not the superiority of one social station above another, but the simple difference between his own position and that of others; with the belief that each offers certain and perhaps equal advantages, which is a strong characteristic of the peasant.

J. ALDEN WEIR WRITES HOME ABOUT JEAN-LÉON GÉRÔME

Julian Alden Weir came from an artistic family; he studied with his father, Robert (who taught at West Point), and received advice from his older half-brother, John (who directed the Yale School of Fine Arts for more than four decades). However, unlike either of his relatives, Weir spent an intense period of four years studying in Paris, much of it in the studio of Jean-Léon Gérôme at the Ecole des Beaux-Arts (see also "American Artists Confront Impressionism," chapter 13). He was also greatly affected by the genre painter Jules Bastien-Lepage. In the following letter to his father, Weir appears to hang on every word of his master, Gérôme, rejoicing in even an off-hand compliment. To his mother he gives an account of a studio brawl, a somewhat regular occurrence in the Parisian ateliers. Finally, in two letters to his half-brother, Weir explains and defends the French academic system, cognizant of how this might improve John's pedagogic program at Yale.

J. Alden Weir, correspondence, in Dorothy Weir Young, The Life and Letters of J. Alden Weir *(New Haven: Yale University Press, 1960).*

[To Robert Weir, March 30, 1874]

I must now tell you some real good news as regards encouragement. Last week I painted from a cast of Masaccio. Gérôme did not come until Saturday. I had put the last touches on it before he got there and looked forward to pleasing him with that and a portrait of Mrs. Bass, which I had brought to show him. He walked around criticizing the drawings, and when he came to mine he said nothing at all about the drawing, but gave me a most savage talking to about the value of color and got up as if mad and went in to the small antique room; when he came back I had the portrait of Mrs. B. on an easel for him to see, but being a nouveau had to wait until he had seen some drawings of an old student. He turned suddenly from looking at his drawings to my portrait, then turned about and asked who did it. I answered in a rather sheepish

manner, expecting to be blown up much worse than before, but he said "Ce n'est pas mal du tout, du tout!"[5] Then put on his coat and went out. When he closed the door I received all kinds of congratulations from the old students, who said that he seldom ever praised one any more than this. He has also told me to paint from the life model this week, so that I now feel like taking hold with a new vigor.

[To Susan Martha Weir, May 19, 1874]

This week there are between seventy and eighty men working in the atelier, so we are well packed in and no room to spare in order that all can work from the model; about the middle were some of the old students who are of considerable reputation, one of them was insulted and slapped his opponent's face, which led to a desperate fight. They knocked over about a dozen or more easels, men were all covered with paint, and in a few seconds the whole atelier was in a terrible state. A Frenchman who sat beside me said that there would be a general fight; so I, as many of the rest, put my study aside, moved the chairs and easels back, and kept myself in as one of the reserve. For over an hour there was the clamor of all those voices and no chance of work; the model had got down to avoid it. It ended in a challenge to fight a duel, which we all did our best to prevent and I think it will blow over; but I have never seen such an infuriated crowd, for the friends of the two men came to the rescue. They fight with anything, a chair, easel; but most generally kicking is their greatest hold, and unless [under] great excitement they are a cowardly set. This is but one of the frequent brawls that has occurred here.

[To John F. Weir, March 21, 1875]

You ask about the manner of study at the Beaux-Arts École; each student that enters goes to the antique until he draws a tolerably fair figure and then directly to the life (not the d——n insane ideas of Jacquesson keeping a person for several years at the plasters) and when one draws tolerably well from the life (which of course is to be judged by the prof.) then he goes to painting, by only doing a part, a head, an arm, a torso, etc. and what is a great merit of the strength of the French art is that the student has his palette and color and studies to paint what he sees, without any receipt or Mother Goose's remedy or, in other words, to represent what he sees honestly with solid painting. The students who paint the whole figure generally spend two days in drawing it in. As regards to a student leaving, he ought never to leave until he has arrived at a state where his work does not improve. There are men in Gérôme's who have been there for thirteen years, but this might be said to be too long. The models they have are selected by the students from those who show themselves every Monday, mostly men and rarely children as they can't pose well. Generally once a month we have a female. In the drawing they use the stump,[6] shading just enough to express the darks and half tints and always they make them take in the whole of the paper, the head within a quarter of an inch of the top and the same of the bottom if standing. They find where the middle would come and then how many heads high the model is, looking for the grand lines. Perspective, anatomy, history of art are each twice a week, but the most necessary and the greatest advantage of the École is that we have the life model four hours a day to paint from and then in Yvon's school the seventy best have from four till six every afternoon. If you could get someone to leave some money or endow a chair for a model four hours each day,

[5] "That's not bad, not bad at all."

[6] A stump is a drawing tool made of leather or paper used to rub and soften lines made with charcoal.

it would advance your school more rapidly than in any other way, for there they can study color and drawing, not as Rembrandt, Rubens nor Gérôme, but as nature inspires them. In Gérôme's atelier he comes around twice a week, Wednesdays and Saturdays; in Cabanel's he comes but once a week, and in Pils' he only visits his atelier occasionally. Pils they say is the strongest in color, Cabanel next and Gérôme the last. Gérôme is very severe with the drawing and in representing the model as near as possible, which I think is the school for a student. He is liberal and says nothing to the manner; what he wants is to have the student's study serious (which I must confess I have not yet learnt, comparatively speaking). In using the stump he will not let the beginner put in anything but the principle darks and not until he has advanced will he let him put in the demi-tint. With regard to the new student in color, give him no theories, he has nature before him, let him represent it. After he draws the model in with charcoal he sets it by pouring milk on and then when dry rubs over it a general tone of the flesh and the background in the right value with it; they have draperies of different tones to change occasionally. Make the student paint the background as it is and not à la mode. In Gérôme's there are about seventy students. The model is on a raised platform or throne . . . The light comes in a large window so you see the painting and drawing from the life are both in the same room. If there are not enough stools or places in front, the draughtsman takes an easel but not unless.

[To John F. Weir, July 5, 1875]

I have your letter before me which I have been waiting for time to answer as it ought to be. You make use of a remark which I find very common amongst our American artists and which was breathed in my ear by the high and mighty Page. However, yours was in a more "cocasse"[7] way suggesting that if in studying abroad one loses his originality he might as well study at home . . . When I first went to Gérôme all that I looked for was for trying to produce a good effect of color and, as we in our ignorance say, "use the model," but by degrees Gérôme led me on, until I found out that there was a human being before me which I was to represent as well as possible . . . Now, old fellow, in the copying of a locomotive it does not suffice to copy the outside forms, the thing won't go, all the machinery must be studied, the forms, the joints and screws. One must know where to put the bowels of the machine, then after all this is done a person can know where to put the red, white and blue stripes. So it is with art, you must know where every bone is and the attachments of muscles and for this reason, Gérôme says, schools are necessary. In school he says: "There is your model. Represent it as close as possible and before you touch your canvas know what you are going to do." In this way one will make intellectual progress and when one returns to his own room, let him use what he has learned and do as he thinks. So you see, John, one cannot lose his originality unless one is a very weak mortal and then it would be the best thing for him. Originality means mannerism. Delacroix and Delaroche have both said at the end of their careers that the greatest painters are those who paint with "naiveté." This undoubtedly is the way to study and, John, old fellow, you will see that in a school such as this every man will do his best to represent the nature only as he sees it. So next year I will study more earnestly and I hope more intellectually. I feel that if I had known what I do now two years ago, I would have made a decided improvement by this time, but as that is impossible I am going to do my best to remain three years longer at the least. Your criticism on my studies was just: they are not carried far enough. It is not because I am afraid to spoil what

[7] Cocasse: comical.

I have done or that I am satisfied with my work, it is ignorance which disgusts me, so that to-wards the end of the sittings I am fagged out.

ELIZABETH BOOTT STUDIES WITH THOMAS COUTURE

In 1876 the privileged Bostonian Elizabeth Boott (later Duveneck) studied with the academic painter Thomas Couture outside Paris. During that time, she sent detailed letters back to fellow women students in the Boston atelier of William Morris Hunt, with whom Boott had previously studied as well. Although her course with Couture took place outside the structure of the Parisian academies, Boott's narrative provides an informative record of the young woman art student's activities as well as a full picture of the methods demonstrated by the master. Most striking is the intensity of Boott's almost single-minded dedication to her task, spurred on by her own high hopes and expectations as well as the standards that prevail in this community of artistic striving.

Elizabeth Boott Duveneck to multiple friends in Boston, June 14–September 8, 1876, The Elizabeth Boott Duveneck Papers, Cincinnati Museum Center.

Letter No. 1

Paris—June 14th, 1876 . . .

Dear friends—This is the first of a series of letters I hope to write to you from time to time this summer, to keep you informed of my life hereabouts and give you a few statistics of the teaching which I hope will be so profitable to me. If it is satisfactory who knows but we may all meet here some day and work together as we did before in Boston town?

But Oh how different it all is! I believe I am in a different planet, and well used to Europe as I always think I am, it is a constant surprise and pleasure to come. I shall send these letters al-ways first to our well beloved fellow worker Miss Ellis, who will show them or read them to as many of you as care to hear them, and will then keep them for me as they will be the only notes I shall possess of the techniques of Couture's instruction. To proceed at once to business, we left Paris this morning on an exploring expedition to Villiers-le-Bel. We reached the station in half an hour by the Chemin de fer du Nord. There an omnibus awaited passengers and we drove along a dusty and uninviting road for about 20 minutes more. The little town seemed to con-tain some good houses, and we had glimpses of trees and fields which were picturesque. The gate of Couture's garden was opened to us by his daughter a nice looking girl of about 16. You may imagine my excitement when we were told that the great man was in, and when I caught sight of him sitting at an open window with a cigar. He is just as he has been represented, only that in the flesh he is even queerer and more grotesque, but with most cordial manners and a pleasant original way of expressing himself which stamps him at once as a remarkable man. He smokes constantly, is far from neat in his appearance, and wears a long flannel dressing gown down to his heels and wooden sabots. I presented my letters from Mr. Crowninshield and Mr. Hunt[*] about whom he spoke with frank interest and regard . . . He said also that he was glad to see any-one recommended by Miss Norcross for whom he seems to have a most affectionate friendship and says that she made him teach her in spite of himself and that he was very glad of it.

[*]He said "Ah vous êtes élève de Hunt. Ce brave Hunt comment va-t-il?"

Presently, Mme. Couture appeared. She is much younger than her husband and a very pleasant friendly simple woman whom I took a great fancy to at once. They showed us the garden which is quite like an American wood, quite wild and uncared for but most picturesque. Mons. Couture says that he thinks the "Bon Dieu" does things better than man can, and he does not approve of pruning and gravel walks.

Letter No. 2

Villiers-le-Bel

June 26th, 1876

Dear friends—My last and first told you of our coming to Villiers-le-Bel and making arrangements for our summer. In this I will tell you how we are settled . . . and give you an account of my first lesson with Mr. Couture . . .

The day after our arrival, I went to Couture, taking with me a few water color sketches, and my "January" snow picture. He expressed himself pleased and said I was "bien organisée pour la peinture" which gave me great pleasure as you may imagine. I was to go the next day for my first lesson and you may imagine my state of trepidation during those 24 hours. He gave me a picture of his to copy, a head of a Roman girl which he painted for Miss Norcross. The first sketch was made in a *frotté* of brown, brun rouge and bitumen, and the finished sketch painted from that. He sat down to his own work by my side. He has formed a good many partly finished pictures lately which he is going to retouch and have a sale in the Autumn I believe. This one was a gen d'arme on a horse who is rearing in an admirable action. He told me to proceed as if he were not there, that the "Médecin doit connaître bien son malade, pour savoir le guérir"[8]— Meanwhile he smoked most of the time, or whistled or puffed each time he touched the brush to the canvas in the most comical manner. He is the most unconscious being that I ever saw, and one feels that he is a good example when he preaches unconsciousness in art, and modesty and faithfulness in rendering Nature, when one sees with what precision and care he works. One would think at first that he was a beginner, so slowly and painfully does he seem to work, till one sees that each stroke tells, that he knows just what he is going to do, and that a good result is reached sooner than by trying various ways of reaching the goal which one does not reach perhaps after all. My first day of work was a great failure. He said that he had observed me out of the corner of his eye, and that I worked too quickly, "trop à la Diable"—that I did not know at all how to attain my end, and that I must work more slowly and carefully, weighing every stroke, looking hardly at all at my work and always at the model. This Mr. Hunt always told me too, and I have always felt that it was one of my great faults. But I am going to work this summer as I have never worked before, and indeed I think I see things differently. The pictures in the Louvre never impressed me so much before, and I went there over and over again to admire and study them . . .

So I went home the first day, with a scolding and feeling rather down hearted. The next day I did the same head again, making the outline carefully with charcoal, on white raw canvas, and outlining the masses as we have learned to do, and shading lightly but never rubbing with the stump or finger. When this was done, Mr. C. took a pair of bellows and blew off the charcoal dust and then showed me how to make the outline with *Brun Rouge* and *Bitumen* moistened with the usual oil and turpentine. When the outline of the face was done with the greatest care

[8] "A doctor must understand his patient well to know how to cure him."

he put in the masses of the hair and dress, and scrubbed over the background lightly with a brush almost dry. By that time the lines in the face had "taken" and he could pass over them with a wet brush to put in the shadows. Using a long, thin bristle brush this can be done [illegible] well, laying on the color smoothly without rubbing. I did most of it under his eye and this was the end of the first lesson. Three hours were consumed in doing it so you see we work carefully! He says quickness of hand is to be guarded against, when not guided by the thought of course. If one thinks enough about it, one ought to be able to paint with one's elbow!

2 Lesson). The next day I took him a memory sketch of the head, and water color (sepia) with which he expressed himself pleased and asked me to give it to him!

So my spirits rose immensely tho perhaps he was only in a jovial mood and more easily pleased. In this lesson I was to prepare the preparation of the day before with a scrub of bitumen and cobalt, passing lightly over the shadows half tints and background. When all this was done, the outline was as distinct as the water color that we have always used. Then my palette was set—*White, Naples yellow,* (greenish [illegible] color) *Vermilion* (yellowish never the purple shade) *Brun Rouge, Cobalt, Yellow Ochre, Bitumen, Black.*

He put in first the high lights on the shirt, white with a little yellow ochre—the highest lights in the flesh put in with one stroke of a large brush and left. *White, Naples Yellow, Brun Rouge,* and a little *vermilion.* Then the half tints made of *Naples Yellow, Brun Rouge, Cobalt,* put on in the same way, not touching or hardly touching the lights. Then the shadows, *Brun Rouge, Cobalt, Bitumen,* and a little *Yellow Ochre.* The deepest shadows, *Brun Rouge* and *Bitumen,* or *Bitumen* and *Cobalt.* No other colors but these. When the thing is mapped out in [illegible] in this way, with a long slender bristle brush, he unites the edges very lightly and the thing is all but done. He uses a great deal of color so that the colors can be united without leaving any bare spaces. Above all, he says, do not mix colors, keep their brilliancy by mingling them as slightly as possible. Your tones when mixed on the palette should have the appearance of a tangle of silk of different colors, producing a harmonious whole, and yet each keeping its own individual quality and color. June 29th

I have had two more lessons and the last for the present. I am now to work alone for a time from models, following out Mr. C's teachings. Flowers too he recommended strongly as studies for pure color.

3 Lesson) I made an outline of another head of Mr. C's—a workman whom he painted also for Miss Norcross. When the drawing was done, he made the "Frottis" for me in Brun Rouge and Bitumen as before. It is a pleasure to see him work . . .

4th lesson . . . For the last two or three days, I painted in a large, handsome room, downstairs in his house looking on the garden. He came in occasionally to look at my work, talk art and smoke his cigar. His summer suit is quite sumptuous for him—a whole white linen suit with a scarlet sash and the usual panama wide awake. When I had finished my work, he came in and said, "C'est bien"—Now you shall work alone for a while and show me your things every now and then and come back for more lessons later." He seemed satisfied with what I had done, which gives me new ardor for my work . . .

 Letter No. 3

Villier-le-Bel
July 30th, 1876

No. 2. Mr L [Ernest Longfellow] and I go to work generally from models till 12, then a short rest, then work again for three or four hours either from models or landscape or still life and

flowers. In the evening we generally walk, as it is the coolest time and go to bed early to begin afresh the following day. A great deal of work can be accomplished in this way by steady earnest application and nothing to distract one's mind. Everything around us tends to make us work with a will—Everyone that one sees is more or less of an artist, nothing is ever talked about but paints and brushes and canvases when the higher artistic topics have been exhausted. The country is most beautiful especially now with the ripening grain and the wheat sheafs already stacked in places. We shall soon have scenes that Millet would have loved of gleaners in the field and carts heaped high with the golden corn. The people are picturesque but far from handsome. One sees occasionally a pretty face but one is surprised at it.

Letter No. 4

Villier-le-Bel

Sept 8th, 1876

Lesson 4th— . . . We all arrived early and took our places around the easel which as usual was close to the model. The man was made to play the bagpipe to give the action and the pose, then he kept it faithfully as only a trained model can. He tells us that he has been a model 20 years, has traveled everywhere, including Russia. But how many of his stories are to be credited is doubtful after his statement to me that he is only 28 years old (he looks 40) and the more startling one that he has 14 children and that they are all twins! Couture looked even more minute near his first canvas, but we all felt that physical size was nothing as he took up the chalk and sketched the figure over life size starting below the knees. With a few lines he gave the action of the figure, the foreshortening of the head, the easy sitting posture of a real Italian. Then he outlined it as usual. We all wondered how he could see what he was about for there was another picture underneath, not even scrubbed over, but as by miracle, the whites of the old picture came in the right place for this one, and to this end there was a shadow on the shirt collar of the most beautiful tint formed by a bit of sky in the underpainting . . .

Lesson 6th and last—In the morning he painted the shirt. In seeing him finish a picture in this way it is most useful to us how he makes all the first painting serve his purpose . . . I hope very much that this picture will reach America some day and that you will all see it. It is not entirely finished yet, but we saw the principal parts painted and have an affection for it which makes it trebly interesting. It is worthy of the old masters . . . Couture says "be simple, be true, be humble before Nature, see truth in beauty and not the truth in ugliness" and if there ever was a man who practiced in his art what he preaches so well, it is this queer ugly little man with an artistic soul six times too large for his awkward stout little body!

. . . The day after the lessons were over, Annie Dixwell came out to see us much to my joy. It is trying that she should not have been here all summer, but I hope that another year may bring her and many others of the Class. She will tell you the latest news of Villiers and Couture for I took her there to see him and the pictures and she was delighted with both . . .

Paris—Sept. 19th—We left Villiers regretfully on the 16th and shall remain here for a week before going to Italy. Let me not forget to say that my address there is simply *Florence, Italy* . . . This morning Annie Dixwell and I proceeded to the Louvre laden with our easels, canvases and boxes. We toiled up to the highest pinnacle of the palace to get my permit to copy and at last were safely seated in the long gallery before two Vandykes, admiring yet despairing before the difficulties they presented. I bought a piece of oil cloth as a [illegible] and a beautiful painting apron, clean if you will believe it, blue and white striped gingham which reaches to my feet! We shall paint there in the morning and do the sights and the various frivolities of dressmaking etc. in the af-

ternoon. I shall never make an artist I foresee, for I am much too fond of clothes, and when I see a fascinating bonnet with the last Parisian cachet upon it, the Vandyke goes out of my head entirely! I did forget everything before the "Decadence" at the Luxembourg the other day. It is a magnificent picture and I feel after my studies of this summer that I can understand it and appreciate it infinitely better than before. I must not close without sending my thanks to such of you as have written to me lately. If I had more time I would write willingly to you all.

KENYON COX STRUGGLES IN PARIS

Unlike Julian Alden Weir (see "J. Alden Weir Writes Home about Jean-Léon Gérôme," this chapter), Kenyon Cox did not have any other artists in his immediate family, and during his five years of study in Paris he constantly needed to justify his time abroad to his parents, who were highly cultured and educated but lacking in knowledge about the contemporary art world (see also "Kenyon Cox's Lonely Campaign for the Nude," this chapter). Cox seems always to have encountered difficulties in Paris: money woes, dissatisfaction with his teachers (principally Charles-Auguste-Emile Durand, or Carolus-Duran), and bad luck at the Ecole des Beaux-Arts. In this selection of letters to his parents, Cox documents his moves from one teacher to another, patiently explains the inner workings of the Parisian atelier system, and finally, voices his hopes for an eventual career as a painter in the United States.

Kenyon Cox, correspondence, Avery Architectural and Fine Arts Library, Columbia University.

[To Helen Finney Cox, December 18, 1877]

I paid for a year at Duran's for this reason. By the month, I found that it would cost 30 francs. By the year (of 10 months) 120 francs. In other words it would cost $2\frac{1}{2}$ times as much by the month as by the year. There are intermediate rates for quarter and half years, but as I was sure that I wanted a year's study at any rate, I thought it best to take it the cheapest way. Far from regretting it, I find that I like my choice better every day. For though I do not entirely like Duran's methods or notions, yet I see that there is much to be learned there, and that his ideas are less distasteful to me than those of most other professors here, and also that he is less strict in forcing them down his pupils' throats than are most of the teachers. I learned that Boldini kept no atelier, and although I might possibly perhaps induce him to take a pupil, yet I should not have that regular study of the model which I think more necessary than even the best teaching. Duran is a portrait painter, and as such, probably of the first rank in France . . .

Personally he is rather a snob. He wears tight pantaloons and little pointed boots, has a head of hair and wears a beard and a moustache, elaborately curly, and is very fond of waving and gesturing with a diamond-ringed hand. His favorite watchwords are "plus simple!" and "un demi tinte générale!" which he constantly spouts in a rotund manner. At the Beaux-Arts there are 3 ateliers. Cabanel's, Jerome's, and another. The principal advantage of them is that they are free, but they are full and there was no chance for me there. There is also an evening class between 4 and 6 to which admission is gained by passing a concours.[9] There will be a competition in March into which I shall certainly enter.

[9] Concours: competition.

After oatmeal (which some of the Americans here have induced the restaurant to cook every morning for first breakfast), Dr. Thorden and I visited an ethnographic museum now open in the Palais de l'Industrie. I had never been there before and was much interested. The fullest department is the Peruvian. You know I have been much interested in the ancient Peruvians for a good while. Here I found several Peruvian costumes such as were worn before the Spanish conquest. There was a warrior and hunter and girl and other figures with wonderfully artistic "fixins." I should like immensely to get studies of them but don't know whether it would be possible. The exhibition is open only twice a week to the general public, and only for this month, during which I shall be very busy with the concours at the Beaux-Arts. I registered Friday, and the preliminary examinations begin tomorrow. These are in history, anatomy, perspective, and drawing from an ornament. For these each candidate gets a certain number of points, the highest being 20 on each subject. According to the number of points he makes he gets a good or a bad chance to draw from the life, which is the final competition, and on this drawing alone does his admission or rejection [depend]. I expect to do pretty badly on history and anatomy and moderately well on perspective and ornament. On the final drawing I rather expect to get in but not to draw a very high number. There are fellows now in the class who draw much worse than I, but there are also strong men who have worked in the schools here for years and draw stunningly.

[To Jacob Dolson Cox, February 20, 1878]

The concours of which I wrote to Mother begins tomorrow at 8 o'clock. There will be two hours a day for three days for the drawing of an ornament from the plaster. After that an hour or two for history, anatomy, and perspective each. For the final life drawing there is a week with two hours each day, making 12 hours.

Last evening I was at a dinner given by the school to Duran. It cost us twelve francs apiece, and I could hardly afford it, but there was no decent way of avoiding it. It seemed to me that Duran showed the want of delicacy in his actions that I find in all his work. He was neither a dignified professor among students nor a man on friendly equality with others, but had a sort of condescending familiarity that I did not like. At table he proposed a toast something to the effect that he hoped his principles as carried out by his students might create a great movement in art. I thought this would have been a graceful thing for someone else to say, but certainly it did not seem the thing from him.

[To Jacob Dolson Cox, March 24, 1878]

I intend taking some steps soon for becoming a pupil of Cabanel in the Beaux-Arts as soon as my time is up at Duran's. Cabanel's is the strongest atelier in Paris, and Duran's is one of the weakest, and the being among a set of strong men is even more important than having a fine master because you see them at work and understand their processes and get the spirit of them. M. Jules Bastien-Lepage, the painter of the portrait I so much admired, is a pupil of Cabanel's and is only 26 years old. As it is much easier to get into the Beaux-Arts in the spring than in the fall, I shall take some of the best drawings I can make to M. Cabanel and try to get a card from him admitting me to his class. It is necessary to draw a longer or shorter time from the antique before being admitted to the life, and I may do some of that this spring (if I get in), working principally in the afternoon, and contriving to be about once a week in the morning

to receive his criticisms. This I hope will also gain me some qualities which I lack and which prevented my succeeding in the concours for the evening class at the Beaux-Arts, although I am confident that in proportion and understanding of form and character my drawing was better than many that got in. Its principal fault was a spottiness in the light and shade, the details spoiling the masses. It is my old tendency, which was here aggravated by my being unable to see my drawing from a distance and so being unable to judge of its mass. However, in detail, such as the hands and feet, and in the general character of the man, I saw few drawings I liked better than mine.

[To Helen Finney Cox, June 21, 1878]

You speak in your last letter of plans for years to come, and I will tell you what more and more my strong desire is, though I do not see at all how it can be accomplished. I wish then to spend four or five winters in Paris at hard close study. I am not, as you seem to think, an artist yet, but only a student, and not a strong one. I may be talented, but I have not half the knowledge of fellows who are still students and not artists. But I believe that four or five years of good work will prepare me to strike out for myself. Meantime of course, I must work for myself also, painting and trying to sell, but then I shall be finally ready to cut loose from schools. And then I want to go to Japan. The wish grows stronger rather than diminishes with time. I believe that I have enough sympathy with the art and the people to do what somebody surely ought to do before the country becomes altogether civilized, paint its customs and costumes, etc., etc. In the summers of the years I want to spend in Europe I shall hope to see a good deal of it, coming back here to work in the winter. But where the money is to come from troubles me a good deal. I feel that I am making rapid progress here, but I feel much less satisfaction in my work than when I came and doubt more and more my ability to make my living very soon. I believe myself to have considerable talent. I do not doubt of at least moderate success in the long run, but for the next few years I am more and more in doubt. An artist seems to have little chance until he has made some sort of a reputation, and I see little show for that for some time.

[To Helen Finney Cox, November 9, 1878]

Since I wrote, events have followed each other with great rapidity, and I have been waiting until I should be thoroughly settled before writing. I heard on the first day after I arrived that there was to be a clean sweep of the ateliers at the Beaux-Arts. In Cabanel's the crisis came on Monday. The new list was read and I was not on it, nor were scarcely any Americans. Two remained over. One of them is a clever and strong fellow and well deserved his place, and is also too poor to go elsewhere. I don't grudge him his fortune. The other is about the least artistic fellow I know and cannot draw at all. In Gérôme's atelier there was a concours, but the decisions seem to have been still more absurd. Some of very best students have been retained, but many good workers, clever and artistic fellows, have been turned out, and some most abject duffers have good places. This is not only my judgment, but, as far as I know, the universal judgment among the students, whether interested or not.

Of the Frenchmen who have been turned out or left in I can say little, but among the Americans the decisions have been monstrously unjust. In many cases the only ground of decision seems to have been that those who had been longest are to stay, and the newcomers are to leave. This is especially hard on many of us who were admitted at the end of the last term and paid our fees without getting more than a week or two of work for our money. In some cases there has not been an hour's work in the atelier, yet it is impossible to get the money back for we are

still technically members of the school and only sent down to the antique, and as the money is given, not to the school or the professor, but to the students to be spent etc.

For us who are turned out there are two recourses—to work from the antique or to go to another atelier. The antique department in the Academy is so cold and uncomfortable a place that it is impossible to work to advantage, and sometimes is even dangerous to the health. It is also miserably arranged and badly lighted.

Besides most of us feel that we are too far advanced to take the same profit from drawing casts as from life work. It is certainly profitable, but when one has got far enough along to make a tolerable drawing from life, it becomes necessary for him to have nature to keep alive his interest and make his work advantageous. There are, I think, none of us will decide to linger out a melancholy existence in the antique in the hope of sometime getting upstairs again, and that the other ateliers will reap an abundant harvest of nuovos.

I and several others have decided to go to Julian's. This atelier is conducted on rather a different plan to most of the ateliers here. In the others the professor generally gives his services and the students pay to one of their number, whom they elect, a certain sum monthly, from which sums he pays for the room, lights, models, etc. Julian, on the contrary, charges so much per month or year for admittance to his atelier and furnishes room, models, professors, and everything and calculates to make his own profit beside. The cost is about the same as at the other ateliers (smaller than at some), and his is in some ways more convenient than any other. He also gives prizes to the rate of a hundred fifty francs each month, but on that I by no means reckon. It will be a cost that I had not reckoned on, and after my expenses in Italy will pare me rather closely. The Beaux-Arts business has been a complete surprise to everyone, and was not all to be calculated on.

[To Jacob Dolson Cox, March 19, 1880]

The school has been closed for a month in consequence of a row when the students insulted Lehmann. I think Lehmann had acted very meanly, and I rather sympathize with the students. At the same time it was at least foolish of them to make the trouble they did. When I found the school was to be closed I did not know what to do. I thought of going to the country, of taking a tour, and of coming home at once. I hadn't money enough for the tour and I couldn't get anyone to go to the country with me, so I decided to go to Julian's atelier for a month. I should perhaps have written for some extra money and started for home were it not for my desire to see the Salon first. It will be my last chance for a long while to see good painting, and I want to carry as good an impression as I can home with me. Besides this closure of the school there was the concours of the atelier and Dyer's sudden departure for America on getting discouraging news about his love affair, to occupy me.

In the concours d'atelier I got a fair place (no. 11) which will, however, be of no use to me now. I had counted myself on getting no. 6 or 7, and a good many of my friends, French, Spanish, and American, have told me that they thought I should have been among the first three or four. So I was somewhat disappointed, but it makes no difference now.

I have also, naturally, been thinking more and more seriously of my prospects when I get home. I have addressed questions to everyone I could think of as to prices of living, chances of remuneration, etc., in New York, and I have come to these conclusions: 1st, that apart from studio rent, which is high, living in New York will cost about the same as here; 2nd, that the chances are very good for my getting paying work to do within a few months at most after I settle in New York. Robinson writes in his last letter, "I saw Drake of *Scribner's*. He has heard about you

and I sounded your praise somewhat. You could no doubt do a great deal of work for them if you wish to." Then I think there can be no doubt from my present point in painting that I have only to paint some pictures of moderate importance, or some portrait life-size and of a striking sitter, to start quite a reputation in New York. This I must do *before* I go to New York, so as to take my stand at once as an *homme arrivé*.[10] Here I am a student and want to stay so as long as I can. It is very pleasant, but I must make up my mind when I get home to "cast my humble slough" and firmly if modestly assume the position of an artist whose work is worth the doing and who holds himself on a level with the rest of the world. But to do this I must do some more important work than I have yet done and thus calculate to do during the summer and autumn, so as to carry it with me to New York in the winter. What I then ask you to do for me is to pay for a year's rent of atelier and the necessary fittings, which of course I will make as simple as possible, to fit me out in clothing and give me a start until I can get work. For myself, I promise to neglect no opportunity to make friends or to get work. I think I ought to be supporting myself entirely before the year is out.

MAY ALCOTT NIERIKER'S TIPS FOR STUDY IN PARIS

The youngest sister of the famed author Louisa May Alcott, May Alcott Nieriker studied in Boston with William Morris Hunt and William Rimmer before her elder sibling's success enabled her to study abroad, in London, Paris, and Rome. In her slim but lively advice book, she shares insider's knowledge and offers numerous tips for budget-minded young women for whom this publication was intended. In her chapter on Paris, Nieriker offers strategies for furnishing a small apartment attractively, discusses the ateliers of teachers most (or least) accommodating to women, and deplores the problems faced by women who seek to study the nude in an irreproachably respectable setting.

May Alcott Nieriker, Studying Art Abroad, and How to Do It Cheaply *(Boston: Roberts Brothers, 1879).*

Arrived in the metropolis and turning toward what is often called the painters' quarter of the *rive droite* or north side of the Seine (that circuit lying between the *gare du Nord* and *gare St. Lazare,* the Opera House and Montmartre), finds almost every block on Boulevard Clichy, Rochechonart, and the intervening streets entirely given up to studios; for not only do some of the leading masters, like Bonnat, Gérôme, and Müller, meet their classes in that locality, but also have their private residences there.

All Paris, however, is apt to strike a new-comer as being but one vast studio, particularly if seeing it for the first time of a morning, either in summer or winter, between seven and eight o'clock, when students, bearing paint-box and *toile,* swarm in all directions, hurrying to their *cours;* or still more when artistic excitement reaches its height, during the days appointed for sending work to be examined by the jury of the Salon. Then pictures literally darken the air, borne on men's shoulders and backs, packed in immense vans, or under an arm of the painter himself, all going to the same destination,—the Palais de l'Industrie on the Champs Elysées.

L'École des Beaux Arts, beside Monsieur Jackson and other masters, attracts many to the Latin Quartier for forming another little art world, so a stranger decides each *arrondissement*

[10] *Homme arrivé:* a man come into his own.

offers some advantages, and it is not a question of so much importance as in limitless London, where one selects an abode.

But to a party or painter, counting expense and crossing the Atlantic for several years of study in Paris, to hire and furnish an apartment is undoubtedly much cheaper than any hotel or pension can be. For living, until one learns the real French manner of doing it, is quite as high as in America, and a visitor is sadly disappointed if cheapness is expected to be found in anything beyond gloves and Turkey carpets.

To furnish even a small apartment prettily takes time and trouble, as every woman knows, but if one chooses to spend a few hundred francs at Hotel Druot (the great auction-rooms of Paris), a fine collection of useful and ornamental *meubles* may be bought for surprisingly little money, not perhaps quite new, but if carefully selected, suitable to adorn an American studio when no longer needed in France. And as household articles after a year's use, together with bric-à-brac which belongs in the category of "artist's tools of trade," can pass the customs free, the question of heavy duties in transporting such has not to be considered . . .

I have known ladies coming to Paris for only a short time, wishing to accomplish much shopping or sight-seeing with economy, be very comfortable by taking a room at the "Grande Hotel du Louvre," where by aid of a spirit-lamp a delicious cup of coffee is provided in the morning, lunch taken at a restaurant, in any part of the city where their wanderings may have led them, returning only at night for the substantial *table d'hôte* of the hotel.

Still another way, which has been followed by many students with success, is to hire a furnished room in some small hotel, such as one finds in Rue de Douai, for instance, at a franc per day, make one's breakfast of a roll and cup of coffee, taken at a *crèmerie*, buying lunch *en route* for the studio, and at six o'clock going to the nearest Duval establishment for a dinner, costing from one franc, fifty centimes, upward.

This, amounting in all to about four francs per day, a lady affirmed, judging from her own experience, was by far the cheapest and simplest arrangement possible for one intent on studying art in Paris.

For though it may have a somewhat homeless sound in description, yet the French live so entirely in the theatres, cafés, and on the boulevards, that a stranger looks in vain for anything corresponding to an English or American home, the comfort and beauty of which, like the word itself, seeming quite unknown in the frivolous capital.

Then, too, supposing our artist wants to study from early until late, and has perhaps sufficient strength and eyesight for the evening *séance* at the chosen *cours,* the hours are so fully occupied, there is no time for homesick repinings, so I will try to aid in the accomplishment of her plans, if possible, by mentioning some classes for instruction that have come under my notice.

Firstly, then, is the well lighted and ventilated studio of Monsieur Krug, No. 11 Boulevard Clichy, devoted to female students in all branches of art, and where the much-discussed question of the propriety of women's studying from the nude is settled in a delicate and proper manner by the gentlemanly director. Here one has the great advantage of severe and discriminating criticism, two mornings in each week, from Monsieur Carl Müller, the painter of the well-known "Conciergerie during the Reign of Terror," hanging in the Luxembourg, and the recipient of every honor France has to bestow on a man of genius. Monsieur Cott and the sculptor, Carrier-Belleuse, also visit the class to inspect the afternoon and evening drawings. Monsieur Krug's prices are moderate, being one hundred francs per month, for the two daily and one evening *séance,* with no extra charge for the excellent models provided, or for towels, soap, etc., as is often the custom.

This is, on some accounts, for an American lady, new to painting and Paris, the best *atelier* she could choose, for many are overcrowded, badly managed, expensive, or affording only objectionable companionship. Still the pupils or admirers of each leading painter sing his praises loud and long, and those who receive ladies are Messieurs Chaplin, Barrais, Duran, Cabanel, Jackson, Luminais, Bougereau, Robert Fleurry, and Lefebre.

Then there is Jullien's upper and lower school, in Passage Panorama, where a student receives criticism from the first leading authorities, and is surrounded by splendidly strong work on the easels of the many faithful French, who for years have crowded the dirty, close rooms, though I believe the lower school, as it is called, or male class, no longer opens its doors to women, for the price, being but one half that of the upper school, attracted too many. Also with better models, and a higher standard of work, it was yet found to be an impossibility that women should paint from the living nude models of both sexes, side by side with Frenchmen.

This is a sad conclusion to arrive at, when one remembers the brave efforts made by a band of American ladies some years ago, who supported one another with such dignity and modesty, in a steadfast purpose under this ordeal, that even Parisians, to whom such a type of womanly character was unknown and almost incomprehensible, were forced into respect and admiration of the simple earnestness and purity which proved a sufficient protection from even their evil tongues; M. Jullien himself confessing that if all ladies exercised the beneficial influence of a certain Madonna-faced Miss N. among them, anything would be possible.

Something beside courage was needed for such a triumph; and young women of no other nationality could have accomplished it, though, it must be acknowledged, a like clique will not easily be met with again.

So, let those who commonly represent the indiscreet, husband-hunting, title-seeking butterfly as the typical American girl abroad, at least do her the justice to put this fact on record, to her credit.

It only needs, however, the co-operation of a sufficient number of earnest female students to form a club, hire a studio, choose a critic, and engage models, to secure the same advantages now enjoyed only by men, at the same exceedingly low rates. This plan was seriously talked of not long ago, and only failed of being put into execution from the want of one member with time and energy enough to take upon herself the responsibility of making a beginning.

But it is the right thing to be done, and the only way open at present to successfully rectify the injustice of prices charged by Parisian masters for art instruction to women. Though, strange to say, these same masters, outside of their own studios, are generous of their time and will seldom refuse criticism to a class of ladies entirely free of charge.

This, however, may not be from wholly disinterested motives, as pupils are constantly proving by their ability and success, that time has not been wasted on them, and the honors received can only give added luster to the master's name and make his troop of followers the larger.

American women, particularly, are beginning to lead in this direction, so there should be no pains spared to remove all obstacles in the most direct path to a thorough education for them, by bringing the best in every branch within their (too often) limited means.

STUDENT LIFE AT THE ECOLE DES BEAUX-ARTS

Richard Whiteing was an English journalist who served as the Paris correspondent for several American publications. In this article, he provides information on the system of education at the Ecole des Beaux-Arts, as well as a lively account of the customary

initiation rite for new students, or "nouveaux." The latter was almost always a subject of amused letters home from American art students.

Richard Whiteing, "The American Student at the Beaux-Arts," Century Magazine 23 (December 1881).

Gustave Doré has complained of the French academical system that it forces all minds through one mind, first taking out of the students the peculiar talent, the germ of individualism, as a weed to be cast away. The academical system certainly takes a good deal of the nonsense out of a young student, whatever else it puts in; and it is always interesting to observe the student's surprise during the earlier stages of this process. He generally brings with him to the school a larger stock of feeling than of drawing, and he thinks he can make pictures with the first, but he is quickly undeceived. In time, he gives up the rebellious struggle and he meekly accepts academical direction . . .

Admission to the Beaux-Arts is usually obtained by application to a professor for leave to become an "aspirant" member of his class, or man taken on trial. Most of the Americans go to Gérôme. Students are beginning to avoid Cabanel, once the very prince of draughtsmen, but now grown lazy with age and success. Gérôme has a kindly manner, but an interview with him is rather impressive. He is one of the kings of art, and though kings at a distance may not appear very formidable to republican eyes, the presence has always its disturbing effect . . .

The fagging at the Beaux-Arts is the most novel of all new experiences for the transatlantic man. When he first hears of it he will probably ask for explanations from one of his set, and he must be easily satisfied if they are at all re-assuring. They are the less likely to be so, as he will get no sympathy in resistance, even from the old hands. "You have to be a slave to the fellows," he will be told, "to fetch and carry for them, wash the brushes, run errands, and stand any amount of chaff about your ugliness, if you have any—if not, about your good looks."

"I wont."

"Why?"

"Because I am an American."

"Humph! Who asked you to come here? When you are at Rome—you know the proverb."

"I mean to fight for it."

"No, you wont do that."

"Why, do you mean to say. I'm afr——"

"Most decidedly I do—afraid of being turned out of the school."

"Then I shall appeal to the professors."

"Sneak!"

"What about passive resistance—a Quaker shake of the head, without a blow or another word?"

"They'll put you out of the *atelier.*"

"I'll come in again."

"They'll daub you with paint till you are like Sitting Bull, or truss you up—arms and legs together—worse than any sitting frog, and hoist you upon a shelf. And you'll howl to come down, I can tell you; it hurts. No, old fellow, it wont do. There are, no doubt, a hundred ways of being fagged, but there is only one good one at the Beaux-Arts—to bear it with a grin. They soon call off the pack when there is no sport."

The freshman will finally come to the same conclusion, and will go down to the *atelier* as secure against any outbreak of temper as good resolutions can make him. In this frame of mind he will seek out the *massier,* a supervisor, a student elected by the others to manage all their common affairs. This is generally a big fellow, bearish in look and manner, his head covered

with a tangle of long hair, and his glance the perfection of surly insolence as he surveys you from head to foot.

"*Nouveau*" (freshman), he says, contemptuously,—he never once calls you by your name,— "you know our customs. Have you brought the money for your footing?"

The freshman is prepared for this, and he hands him thirty francs as his contribution to the cost of the "plant" in the *atelier,* and twenty more for refreshments—the last with the easy grace with which a man empties his pockets for the benefit of a Sicilian brigand who has friends in the neighboring bushes.

"Now, *Nouveau,*" he says, "we had better go out and fetch the things; some wine, cigars,— I smoke a two-*sous* weed myself; you can get some at one *sou* for the rest,—anything that's nice."

Very likely the freshman will not be prepared for this.

"What! take your orders for my treat! That's rather rough."

And who will blame him if he gets red in the face?

"*Nouveau,*" says the *massier,* complacently, "is the treat for us or for you? *Oh, ces braves Yankees! Mille tonnerres!*"[11]

"Bravo, young Barnum. Don't you go."

"*Vive l' Indépendance des États Unis!*"[12] cry half a dozen *faux frères,* whose faces are hid in the forest of easels. The true one, of whom he first sought counsel, and who, in spite of his affectation of being nonchalantly out of it, has all this time been watching his countryman from a distant corner of the studio, simply shakes his head and frowns. The *nouveau* understands him at once, smiles sweetly on the *massier,* and goes out for the things.

In half an hour he comes back, heavy laden. There is everything eatable and uneatable, including in the last category cheap French cheese. His entry is heralded with a great shout, which is the signal for the suspension of work in the *atelier.*

They drink his health, the health of George Washington, and the health of Mrs. Clarkson— the heroine of one of Dumas's plays, and about the only other person, with the exception of Mr. Barnum, of whose name they have ever heard in connection with the United States.

"He is a good *nouveau,*" says one, without looking at the unhappy giver of the feast; "at least, I should judge so by his sardines."

"I don't like his nose," says another, with the same absolutely impersonal air. "There's crime in it; he might go wrong at any moment."

"And to think he was once a savage."

"Hush! They carry knives in their boots."

"Now, *Nouveau,*" says the *massier,* as the feast is in its last stage of sour apples, and the pupils are going back to their easels, "you must sing a song."

"You would not understand it."

"*Nouveau,* we understand everything here; go on."

"I will see you hanged first. I am tired of this foolery; the play's played out."

This in English—probably because he means it so much.

"What does he say?" shriek a dozen men at once. "We don't speak Iroquois."

"He says he will do it with the greatest pleasure in life," says that good angel in the corner, coming forward and looking the freshman steadily in the face.

[11] "Oh, these brave Yankees! A thousand thunderclaps!"
[12] "Long live the independence of the United States!"

"Do it properly, *Nouveau*," shouts the *massier*. "Get up on the model stand."

He gets up.

"Oh, he's singing with his coat on" says somebody. "That's pretty cool."

He takes off his coat.

"If you will only turn your back on us, *Nouveau*," says another, "that will be perfect. I'm a believer in the evil eye."

In this way the freshman sings the first three stanzas of "Johnny comes Marching Home."

"Very good, *Nouveau*," says the *massier*. "Now go and fetch some black soap to clean the brushes, and that will do for to-day."

In less than a month from that time, the *nouveau* is helping to serve another *nouveau* in the same way.

A MIDWESTERNER IN THE CITY OF LIGHT

John Douglas Patrick was born to Scottish immigrants in Pennsylvania, but he grew up on the family farm in Lenexa, Kansas. At age seventeen he enrolled in the Saint Louis School of Fine Arts, where he studied for three years. Thus, unlike many American students, he had not experienced art education in any of the larger eastern cities before he left for Paris in 1885. This does not seem to have held him back, as demonstrated by his enthusiastic letters home. Unlike Kenyon Cox, for example, Patrick seems to have felt confident and optimistic about his prospects: he excelled at the Académie Julian; his teacher, Jules-Joseph Lefebvre, called him one of the best students he had ever seen, and he had several Salon acceptances, including Jerry, *a "portrait" of a family mule back in Kansas. Patrick's Parisian triumph was* Brutality *(1888), a massively powerful painting (almost 12 × 10 ft.) depicting a cartman beating a rearing horse, a work that later caused a sensation at the Munich and Paris universal expositions. Patrick therefore had reason, in the last letter below, to declare, "I aim to be among our first American artists someday not far off." But this was not to be. The death of his father forced him to take on family responsibilities, and he spent much of the rest of his long career teaching in Kansas City.*

John Douglas Patrick, letters to his family, private collection.

[November 15, 1885]

My tuition fare is $40.00 for term of six months full time. This school (Academie Julian) is considered one of the best if not the best drawing academies in the world. We have for instructors Bolanger, Lefebvre, Bouguereau. Lefebvre congratulated me on my very first drawing and wished to know where I had studied. We have Bolanger one month and Lefebvre the next and so on. Bolanger chose my study with three others as the best made in class during last week. We make compositions once every week illustrating some historical subject. The sketches are all arranged together and criticized by the professor. Out of about 50 or 60 he generally selects 15 or less some times 18 and numbers them according to their worth or merits. Those who get numbers on their sketches have first choice of places drawing from model. This is a big thing here since there's so many students. I got several numbers on my compositions. There are many old students here some have been going of three, five, seven, and ten years so it makes it rather hard for one to show up amongst them. Last Sunday 112 students made sketches (illustrating a bib-

lical subject, Joseph returns to Jacob his father with his two sons, whom receive blessings) for places during the concour[13] week. I got the 63rd place. The whole number will be divided into 4 rooms so that gives me a very good place. Concour week we have no instructor and the best study made during that week will get a prize of 100 francs.

[February 8, 1886]

In the last "Concour at Julians" in painting I came out 2nd, it caused considerable "talk" at the Academie. The profs hung on the studies for some time before they could decide which should be "first" but they finally decided in favor of a frenchman and old student. I have left the Julian school. I am now studying in three classes a day, Morot, Gleize, and Merson, all big painters. Before I left Julians I went to see one of my profs, M. Lefebvre, who talked considerable on subject wished to know why I had left his school. Because it is too full I told him. This he admitted, and that one could not also get the place he desired to work. He then told me that he would not advise me to do anything that I might do as I thought. And if I left the school and if within 4 or 5 months I got dissatisfied to come back and if I thought I could make more progress I may study with him in his studio.

[April 4, 1886]

My picture has been admitted to the "Salon" and better than that I got 3 for a number which gives me a place on the first line or just above it. I painted it in about three days at the Academie. Getting a number is a big thing for it is only the best work that gets it, so a great deal of the pictures are skied at the "Salon". Pictures from every place from all over the world (you might say) to the number of 7,057 were sent; only 1,800 were admitted; about one fourth of these get numbers and are hung in fair lights.

[November 14, 1886]

A few weeks back Lefebvre the great artist requested me to come up to his studio and bring some of the work which I did during the summer. I went to the great artist's home to be sure in short we might say he lives in splendor. A number of carriages stood before his home which had brought big artists to visit him. His atelier of course is on the last story and about five stories high. The stair-way you may understand was not brief. In short it was long and interesting. The walls were bedecked with fine photographs, reproductions of high art, and many original drawings by himself and other famous artists; this path to an art student is like one embellished on either side with laughing flowers; his atelier on entering we found him near the door in his every day attire and unassuming manner; his atelier is quite spacious and looking to the left we saw a number of artists sitting under a balcony quite cozy-like engaged in conversation. The room is lined with tapestries old and fine in design. Many canvases are lying around shows the guest at once this is the work shop of a successful artist.

Lefebvre took my sketches set them all out on the platform call the artists attention and told them "This American has made some of the best drawings ever done in the Academy; I would not want any better; and some day he will do something big!" He then sat down to look at my sketches, told me the bad and good parts; two he much liked and one he said was valuable and should be taking care of; he then raised to his feet and said my work would be valuable in ten

[13] Concours: competition.

years. I then unrolled old "Jerry" (you remember the study) he seemed to enjoy it much and all the others, he liked the way it was drawn, and painted said it was very good indeed, finished by saying "good! Patrick good!" I then rolled up my sketches. He then went to the door with me talked some time and told me to take good care of myself. He had inquired of Gutherz and he told him I had been sick. He then bid me a polite "bon jour" so here again begins that interesting stairway!

[August 14, 1887]

I am now making studies for a large picture which was much liked by one, if not the greatest animal artists of the present day Fremiet, pro. frem-ya. Besides the sketch or the subject has been much appreciated by all whom have seen it. It is a large, finest sort of a work horse being severely abused by a brute of a driver, from a sketch made on the streets in Paris. The horse will be painted fully life size and will rear back till sitting on hind legs and one front limb firmly set on the ground and body swinging to the right with head raised up in air with nostrils expanded from strokes on the head, with bit drawn through the mouth by the enraged driver who has one hand drawn back to strike the "Submissive Worker." As a subject it is original; I believe nothing of this kind has ever been painted or sculpted. It is (as I am going to treat it large and simple) filled with dramatic force. If I succeed with this picture I shall command the attention if not the admiration of thousands, and return home with much name and a better price on my work. I intend having it in the next "Salon" shall do all to succeed; I feel that this or next year is my most important one. I aim to be among our first American artists someday not far off.

THE NUDE

KENYON COX'S LONELY CAMPAIGN FOR THE NUDE

After studying in France for quite a few years, Kenyon Cox returned to live in New York City in 1883 (see also "Kenyon Cox Struggles in Paris," this chapter). Permanently marked by his training abroad, he began exhibiting "academies," or large-scale nude studies, which stirred considerable controversy in the American art world. He even found the need to defend his motives (and his models) to his mother, as is clear in the two letters that follow. Some years later he did so at great length, and to a larger audience, in his essay on the nude for Scribner's, *writing that "unless some artists occupied themselves almost entirely with the nude, the standard of construction and draughtsmanship would soon be lowered for all."*

Yet few critics appreciated Cox's nude paintings. They failed to find a rationale for such a pure, unabashed study without a trace of allegory. Reviews of his works could be brutal, and they often focused on his models, who were perceived as "earthy" and "heavy." About his Sleep (1893), *a critic in the* Magazine of Art *wrote, "It shows a Bacchante of a gross body who has dropped down on the ground in the sodden sleep after a debauch. She ought to have a gin bottle in her clasped hand." With notices like these, Cox must have been delighted with Mariana Griswold Van Rensselaer's positive discussion of his work in the nude, below. Alone among the critics, she recognizes his women as healthy flesh and blood, not the wan, classicized specters painted by Cox's colleagues.*

[*April 4, 1885*]

I am sorry you feel as you do about the nude. It is just such feeling that makes great art almost hopeless in this country. I insist that there is nothing immodest whatever about the nude when treated from a high artistic point of view, and that it is impossible for it to be as suggestive and lascivious as a figure partially draped and knowingly uncovered. The nude is pure. It is the *undressed* that is impure. If any person not corrupt sees anything immodest in my picture it is because I have failed.

[*December 1886*]

It seems as if no one would ever understand that an artist's models are tools like his palette and his easel, equally indispensable to his work and of as little importance in his work and his life. You go to one extreme in imagining that the models must have something of the inspiration of the artist to give him the expressions and the poses that he desires, and to the other in speaking of them as "dissolute women." They are simply hard-working, little-paid women who earn an honest living by one of the most fatiguing trades in the world, and those that I know I believe to be thoroughly virtuous, but they have no more to do with the feeling of the artist than so many paintbrushes. What there may be of elevation of type, beauty of expression, or grace of pose in my drawings is absolutely and altogether my invention. The model is there to aid me in carrying out my conception, and to assure me that the bones and muscles in my figures are not wrongly placed—that is all. They are seldom very good looking and some of the most useful are positively plain. That they are pretty honest the terrible fatigue they undergo for two or three dollars a day should show pretty well. Even were they beautiful, their nudity would be far less seductive than an evening dress. I would be as likely to make love to my lay figure [artist's mannequin] as one of them. I haven't the time. Do you suppose painting and drawing such easy things and so little absorbing that one can think of anything else while carrying them on? If the world could see the real thing, the absolute absorption in work and the agony of creation, the common ideas on artists and their models would disappear. When I am working at anything serious and difficult, I haven't a word to throw at a dog, and would absolutely forget that the model was human if it were not that her fatigue and inability to hold still any longer reminds me that she is not a plaster cast. I know Mr. Watrous, and do not believe the story you heard is true. Certainly I should have been as likely as anyone to have heard of it. Some artists have married models in N.Y. (not *nude* models, however), but because some men have made fools of themselves does it follow that others will? I believe many of the models to be perfectly honest and virtuous girls, but they are not ladies by birth or education. I have thought you knew me well enough to know that if I ever marry it will be [to] a woman not inferior to my own friends in all that constitutes ladyhood.

But enough of all this. I believe in art and in its nobility and I believe that the nude human figure is the highest vehicle for the expression of high artistic thoughts. If the world does not know enough of art to understand this, I must suffer its misconstruction.

M. G. Van Rensselaer, "Pictures of the Season in New York," American Architect and Building News 20 (August 21, 1886).

Among the figure-paintings proper the most striking are certainly those signed by Mr. Kenyon Cox. One, called "Evening," shows the life-size nude figure of a nymph who is stretching her-

self to sleep in the midst of a wooded landscape under a sunset sky. I suppose nymph is the accepted term in such a case though it hardly seems very representative here, in such different fashion from this are the average nymphs of current art conceived. For this is no bloodless abstraction, no classicizing nonentity, but a very handsome, very healthy, very superb specimen of femininity—one who would be characterized by the simple term woman better than by any other. To say this is in itself high praise, and it is higher still to add that although it is a strongly sensuous impression we first receive from the figure, it is not at all a sensual impression. If she is not an abstract nobody, neither is she simply an undressed model. There is very good color, it seems to me, in the flesh and the general scheme is strong and rich. The design of the landscape—with its broad, open foreground stretch and heavily-massed foliage in the background has a very desirable accent of dignity as well as charm, and the whole impression the picture gives speaks more of nobility, less of triviality or commonplace than is often the case in similar works. The drawing of the figure itself is in general very graceful and vigorous, though there is a lack of grace in the pose of the right arm which supports the reclining figure. With regard to correctness of drawing, I shall not venture to speak—for I have learned by long experience that this is a matter where, unless incorrectness is of a very patent sort or correctness proves itself beyond all question and all cavil, it is far safer and far juster for a layman to refrain from judgment. The artist who had his model before him, is much more likely to have reproduced correctly than we to imagine correctly: and in almost every case there is too much divergence in the verdicts of criticizing brother-artists for even their words to be taken as gospel.

Kenyon Cox, "The Nude in Art," Scribner's Magazine 12 *(December 1892).*

Ever since art existed artists have been in the habit of assigning a very high rank, if not the highest rank, to the sculptors and painters of the nude, and almost ever since the sculpture and painting of the nude existed the public has failed to understand it . . .

What I am to try to do here is to give as clear an account as I am able of what these reasons are which have induced some artists, in all ages, to devote themselves to the study of the nude, and have caused almost all artists to praise and applaud them for any success in that study.

The first of these reasons is that the study of the nude is the necessary foundation for all good representation of the human figure. It is not nearly so well known as it should be that the practice is almost universal among sculptors, and among the more serious painters of the figure, of first modelling or drawing the figure entirely naked and putting the drapery upon it afterward. In sculpture this is done even when the figure is finally to be in modern costume. In painting it is often dispensed with in modern genre subjects, but is common in proportion as the drapery is more simplified and shows more of the natural lines of the figure, and in proportion, also, as the painter cares for form and structure more than for color and effect. When a master of form does *not* make this preliminary drawing, as is often necessarily the case in portraiture, for instance, he dispenses with it only in virtue of the knowledge gained from long and profound study of the naked figure, which enables him to see and seize upon the slightest indication in the outer clothing of the natural form underneath. Good drawing and solid construction have always decayed with the decay of the study of the nude, and it is as well to understand clearly that if that study should ever be abolished, from any sense of fancied impropriety, all art but pure decoration and pure landscape would be abolished with it.

This, however, may be considered as a reason for the use of the nude model in preliminary study, but not as a reason for the depiction of the naked figure as a subject of completed art.

To this one may answer that, unless some artists occupied themselves almost entirely with the nude, the standard of construction and draughtsmanship would soon be lowered for all. The serious students of the nude figure have, in all ages, been those who have set and preserved the standard of form for the rest of the profession, and it is only when the painting and modelling of the nude figure have been recognized and encouraged as one of the highest forms of art, that tolerable drawing of even the draped figure has been practised and understood.

There is, however, a much stronger reason why artists have devoted themselves to the nude. Ideas, if they are to be expressed in graphic or plastic art, must be incarnated, and the human figure is the one great medium of expression for abstract ideas in the arts. That the figure should be nude if it is to express great and simple ideas, seems also natural. As Adam and Eve "were naked and were not ashamed," so the gods and heroes of all peoples have been the glorified natural man—clothes were an impertinence to Jupiter or Apollo. If one figures a human incarnation of some great idea, Force or Love or Glory or Beauty, it seems natural that the artificial trappings of civilization should be discarded, and one does not see what costume could have to do with Michael Angelo's Night and Morning. Truth is always "naked," and the Golden Age had no need of clothes.

ANTHONY COMSTOCK VS. KNOEDLER & CO.

Anthony Comstock is famous for his zealous crusades against what he termed immoral images, texts, and behavior. Comstock's organization, the New York Society for the Suppression of Vice, had an enormously high profile in the late nineteenth century as its leader attempted (often successfully) to arrest one "offender" after another. However, Comstock's legal pursuit of the distinguished art gallery Knoedler & Co. was a public relations disaster for his group. The Society for the Suppression of Vice had previously won court cases when they went after venders selling photographs of paintings depicting nudes, but when Comstock burst into the gallery with police officers and indicted Roland Knoedler and his clerk, George Pfeiffer, for the same "crime," the art world fought back, as indicated by the resolution of the Society of American Artists, below (see also "Young Turks: The Formation of the Society of American Artists," chapter 10). The Society artists argue that Comstock is "incompetent" to make any judgment about art; they also defend the study of the nude and note that some of the photographs seized were of paintings by the most distinguished French artists, works that had been shown in the Salon.

In a pamphlet quickly issued by Comstock, he asserts that morality trumps any notion of artistic privilege and taste. He calls the French paintings lewd and obscene, although without defining either term. Turning the "guild" argument on its head, he argues that artists have no right to impose their profession's standards on the public at large and that they are not qualified to pronounce on moral questions. Comstock makes it clear that he sees this issue in terms of class: cultured, wealthy patrons could look on the nude with impunity, but when it was exposed to "the rabble," problems developed. This point may have been made to ensure that the elite of New York society did not turn against him. He also found the medium of photography to be suspect; it was considered to be a step closer to "reality" than other types of prints and thus encouraging of prurient behavior. Most writers in the press failed to accept these arguments, and Comstock was generally ridiculed. In the end, two of the thirty-seven images

seized by Comstock were judged obscene by the courts, but the outcry over the arrest of Knoedler overshadowed this small victory.

Resolution, adopted by the Society of American Artists, November 15, 1887.

Whereas, We learn that the officers and agents of the Society for the Suppression of Vice, of this city, are interfering with the sale of photographic reproductions of the works of some of the foremost living painters on the ground that the said works are bad in their influence on public morals; and,

Whereas, We believe that the study of the nude is necessary to the existence of any serious art whatever, and that the proper representation of the nude in art is not only innocent, but is refining and ennobling in its influence; and,

Whereas, We believe the popularization of such works of art by photography to be of the greatest educational benefit to the community;

Resolved, That we protest against this action of the Society for the Prevention of Vice as the work of incompetent persons, calculated to bring into bad repute one of the highest forms of art, and denounce such action as subversive to the best interests both of art and of morality;

Resolved, That it is the sentiment of this meeting that the cause of art education in the United States and of higher education in general demands that measures be taken to restrain the agents of the said society from exceeding the limits of the field in which its work properly belongs.

Wm. M. Chase, president	William Sartain
H. Bolton Jones, vice-president	Francis C. Jones
Wm. A Coffin, secretary	Herbert Denman
Irving R. Wiles, treasurer	W. M. J. Rice
Augustus St. Gaudens	Walter Shirlaw
Eastman Johnson	Carleton Wiggins
J. Alden Weir	T. W. Dewing
Kenyon Cox	Frank Fowler
E. H. Blashfield	Wyatt Eaton
D. W. Tryon	William S. Allen
Will H. Low	John LaFarge
H. Siddons Mowbray	Chas. Melville Dewey
Albert P. Ryder	Olin L. Warner
Carroll Beckwith	R. W. Van Boskerck
Bruce Crane	Francis Lathrop

Anthony Comstock, Morals versus Art *(New York: J. S. Ogilvie, 1887).*

MORALITY OR OBSCENITY, WHICH?

Pure morals are of first importance. They are protected by law; while art, if unclean, is not.

The morals of the youth of this country are endangered by obscenity and indecency in the shape of photographs of lewd French art—a foreign foe. Ignorance of the real scope and purport of the laws against obscenity, and the real tests to be applied in the enforcement of these

laws, are two of the strongest points in favor of this enemy of our youth. A mistaken idea also prevails, that a painting or engraving, though exerting an obscene and demoralizing influence, is exempt from the provisions of law because it is called "a work of art." It is attempted to defend the indiscriminate sale of these French photographs on the plea that they "are works of art," or that "art is in danger."

In the guise of art, this foe to moral purity comes in its most insidious, fascinating and seductive form.

Obscenity may be produced by the pen of the ready writer in prose; it may come upon the flowery wing of poetry; or, as in this instance, by the gilded touch of the brush of the man of genius in art. Prose, poetry and art all have been employed to charm and entrance the human mind and to picture beautiful and seductive things. They have each of them also been prostituted to the reproduction of the most base, obscene and lewd ideas. There is no conflict, however, between either, of prose, poetry or art, and morals or law, until some person prostitutes some one of them to reproduce the impure conceptions of the individual mind . . .

Strychnine is a deadly poison. Its effect when administered sugar-coated is the same as when administered otherwise. When the genius of art reproduces obscene, lewd and lascivious ideas, the deadly effect upon the morals of the young is just as perceptible as when the same ideas are represented by gross expressions in prose or poetry. Indeed, the fascination of beautiful surroundings is added to the evil subject, as an apology for it. Why should this corrupting agency be protected or defended in art any more than in prose or poetry?

Art is not above morals. *Morals stand first.* Law ranks next as the defender of public morals. Art only comes in conflict with law when its tendency is obscene, lewd or indecent.

ART FOR ART'S SAKE.

The closer art keeps to pure morality the higher is its grade. Artistic beauty and immorality are divergent lines. To appeal to the animal in man does not inspire the soul of man with ecstacies of the beautiful. Every canvas which bears a mixture of oil and colors upon it is not a work of art. The word "art" is used as an apology for many a daub . . .

NUDE IN ART.

The nude in art is not necessarily obscene, lewd or indecent. The nude in art is, however, capable of, and often is employed to convey most lewd, lascivious and demoralizing ideas.

The artist conceives and makes a beautiful figure of a nude woman. From a standpoint of execution it is as perfect as he can make it. It is free also from any unchaste posture or expression. He has produced this to win fame for himself, and as a profitable venture from a business standpoint. He exhibits or sells it to make money.

Another person has a beautiful daughter. He says, "I have something more chaste, perfect and beautiful in form than that figure on the artist's canvas. If he can exhibit a beautiful figure of a nude girl for money, why may not I exhibit nature itself, which outshines his imitation, and thus make money too?" Would this be allowed? Would the father be permitted to even photograph his nude child and sell those photographs upon the public street? What would be the effect of such pictures upon young men? If nature cannot expose herself; if a photograph from life may not be allowed; why, then, should a photograph of an artist's attempt at reproduction of the nude figure of this girl be allowed a cheap and indiscriminate sale upon the public thoroughfare?

In the artist's picture the figure is chaste in expression and posture, and surrounded with a beauty and harmony of blended colors and attractions which practically clothes it.

These accompaniments certainly demand attention, and divert the mind of the observer from the nude figure, so that in contemplating the work as it left the artist's hands, one scarcely is aware that a nude figure is thus exposed. This figure thus exhibited to cultured minds in an art gallery, where it legitimately belongs, is a very different thing from what it appears to be to the common mind upon the public street in the shape of a photograph.

In what we are now saying and about to say, we desire it distinctly understood, that we speak of the world as it *is*, not as it *ought to be*. Constituted as society is, with hundreds and thousands in the community who cannot even appreciate the nude in art at its best, photographs of the nude are a curse to many. They appeal to passion, and create impure imaginations. To young men, cursed as thousands of the present day are, with secret vices, these photographs leave impressions upon their imaginations which are a continual menace to them. They fan the flame of secret desires. Again, with so many unclean minds as there are to-day (the natural harvest of seed sowing of corrupt publications and pictures in the past), these photographs are appropriated to lewd purposes, and but pave the way, and create a demand for that which is worse.

It is said the exposing to public view of the nude figures of women is "an educator of the public mind." It may educate the public mind as to the forms of beautiful women, but it creates an appetite for the immoral; its tendency is downward; and it is in many cases a blight to the morals of the young and inexperienced. As proof of this, note the throngs about windows where nude or partly nude figures are exposed.

This does not contradict the fact already stated that the "nude in art" is not necessarily of itself obscene, lewd or indecent, but may be chaste, sweet and free from lewd posture or expression in the original painting. But it does raise the question of the expediency of parading photographs of nude figures of beautiful women and girls before the eyes of young men and boys. It does not say that nude art has not its proper place. But we do in all sincerity appeal to the public, that the proper place is not before the eyes of the uncultured and inexperienced.

There is another view that demands fair consideration. Nude in art unclothes beautiful woman. To thus expose her in public is to rob her of that modesty which is her most beautiful mantle. It degrades her sex. It is food for impure imaginations, and provokes comment among the evil minded. In the sanctity of home the human form is only derobed in the privacy of a dressing-room, and then not for the gaze of others. Why this intrusion into the precincts of seclusion? By what right does a few selfish men enter that privacy and denude woman for the inspection of others or seek to put these representations of nudity upon the open market for all classes to gaze upon?

The painting, with its sweet harmony of blended colors and tints, is one thing to the cultured mind; but the cold reality of black and white in the photograph, where the nude figure is placed prominently before the eyes of the uncultured, is, in character and effect a very different thing . . .

While conceding that in the original painting the nude may be chaste and pure, yet when torn from its proper sphere its character and effect are changed, and it is capable of ministering to the lowest imaginings of uncultured minds.

Let the nude be kept in its proper place, and out of reach of the rabble, or those whose minds are already tainted or diseased with licentiousness, and its power for evil will be far less. The fault may be in the minds of the weak ones, but we must take the world as it is, not as we wish

it might be. Many a youth inherits tendencies to lust and intemperance, and such ought not to be exposed to temptation . . .

EXPERT TESTIMONY.

It is claimed by artists and liberals, that experts should be permitted to testify before a jury, and give their opinions as to whether a picture or book is obscene or indecent. Do ladies and gentlemen of ordinary intelligence require an artist to inform them whether a book or picture contains lewd and indecent suggestions or not? Must a physician be called in to tell whether a disease that has prostrated a person is liable to make him sick or not? The effect of the disease is felt by the one who is suffering, and he needs no one to tell him that it is an uncomfortable and unpleasant feeling. No more does a person require to be told when a book or picture is conveying obscene, lewd and indecent impressions, or whether the tendency of such impressions is to corrupt the morals of the young and inexperienced.

AUGUSTUS SAINT-GAUDENS RESIGNS

Yet another controversy surrounding the nude erupted in May 1890, when it became known that Augustus Saint-Gaudens was employing nude models in his coed class in clay modeling at the Art Students League (see "Breaking Away: The Art Students League," chapter 10). Of the group of seven students (three men, four women), one woman was reported to have complained, and as a result the League's Board of Control ordered Saint-Gaudens to cease the practice. The disagreement became a national story, played out in newspapers from coast to coast for several weeks. It emerged that the League's coed modeling class had been using nude models for more than two years without a problem, and the practice had also been in effect at the school of the Metropolitan Museum of Art. Unusually, some of Saint-Gaudens's colleagues publicly criticized him in the press. J. Carroll Beckwith, for example, who always made himself available to interviewers and was known as unfriendly to women art students, sarcastically mocked Saint-Gaudens as a "high and exalted being" who did not understand human nature and the social relations between men and women (see also "Art World Diaries: Jervis McEntee and J. Carroll Beckwith," chapter 9). Saint-Gaudens's students, in turn, published an angry letter in the sculptor's defense. Kenyon Cox, ever the champion of the nude, also spoke in favor of the class. One Philadelphia newspaper correctly pointed out that any class of female students was already "mixed" if its instructor happened to be a man. In the end, the controversy was an unusually public exposure of a fissure within the art world; it resulted in the resignation of Saint-Gaudens and the disbanding of the modeling class.

"*At Odds over Models,*" New York Tribune, *May 9, 1890.*

The use of nude models in the mixed class of Augustus St. Gaudens at the Art Students' League, No. 143 East Twenty-third-st., is still agitating the members of the Board of Control of that institution. Whether the Board will finally decide to allow the sculptor to continue the innovation which he introduced until the end of the term, now but two weeks distant, is at present uncertain, as the board is said to be about evenly divided upon that subject.

As stated in The Tribune yesterday, Mr. St. Gaudens, after using the models in his mixed class of young men and women for several weeks, separated the sexes into two classes by di-

rection of the officers of the Board of Control about ten days ago. At the monthly meeting of the League on Tuesday evening, however, the question came up for official consideration. After an extended debate, the League, by a vote of 32 to 17, declared itself opposed to the use of nude models in mixed classes in the future in the school. However, in answer to the request of Mr. St. Gaudens and the majority of his pupils, it decided to favor the innovation for the remainder of this term. At the close of the meeting the vice-president of the Board of Control, who is also a member of the League, sent word to Director Horace Draper to disregard the latter recommendation of the League . . .

Whether Mr. St. Gaudens will finally secure this permission rests with the Board of Control. Several of the members are violently opposed to the continuation of the practice even for the short time now intervening before the close of the term, and are determined to prevent it if possible. Miss Ketchum, vice-president and corresponding secretary of the Board, Miss Kellogg and Miss Lent, held a meeting at No. 44 West Ninth-st. yesterday morning, to protest against any possible action of the Board in favor of granting Mr. St. Gaudens's wish and carrying out the recommendation of the League. They prepared an unsigned statement expressive of their opposition, which probably will be presented at the meeting of the Board of Control this evening.

The majority of the corps of instructors seem to be opposed to the use of nude models of men and women before the mixed classes of the League which now numbers more than 800 pupils. Among the instructors who have advised its discontinuance is J. Carroll Beckwith. When seen yesterday in regard to the discussion, Mr. Beckwith said that he had first heard of it about ten days ago. "I wrote a letter to the Board of Control," he added, "advising them to discontinue the use of the nude models in Mr. St. Gaudens's class, as it would be disadvantageous to the school; that I had the interest of the school at heart, and realized what unfavorable comment it would cause abroad. My letter was afterward signed by W. M. Chase and presented to the Board.

"I wish to say now that I am greatly opposed to the use of nude models before young men and women at the same time. It is not at all necessary. They should be separated. In fact, I would go further than that and say that the male and female students should be separated by brick walls. I spent five years in Paris as a student and have since then been in that capital a number of times, but I have never known a school, myself, where Mr. St. Gaudens's practice was in vogue. I have been told, however, that Julien tried it for a time with a very small class. Those who favor it are usually high and exalted beings believing themselves superior to all human weaknesses. Art, however, is like many other things, and artists are usually human beings . . ."

W. M. Chase also supports the view of the vice-president in reference to the use of the models. "I think," he said yesterday, "that better results will follow when the sexes are separated, not only while using nude models, but at all times. I have found that to be the case in my own teaching." The patrons of the League, Mr. Chase thought, would not favor the practice introduced by Professor St. Gaudens, and he believed that it would be discontinued.

Kenyon Cox, however, did not look upon the question as so serious. At the meeting on Tuesday evening he favored the continuance of the use of the model in Mr. St. Gaudens's class. It was, he thought, a bad plan to interrupt the work of the class now, when the term was so nearly ended. He had understood that the whole class favored it, as the members wished to have the influence of the pupils who were especially clever. "But," he added, "I have known schools where good results came from such mixed classes. The tendency of the times is toward similar treatment of men and women. Artists look upon nude figures in the same way that you might look upon an undraped horse."

Professor St. Gaudens, who was also seen by The Tribune reporter, declined to make any statement.

ARCH-EXPATRIATES

JAMES MCNEILL WHISTLER, EXPATRIATE EXTRAORDINAIRE

Expatriate culture in the late nineteenth century was the latest utterance in the long-standing debate on nativism versus cosmopolitanism. The attraction of Europe had much to do with aversion to America, perceived as new, raw, crude, materialistic, and provincial. Offering generous support for the arts, Europe was old, cultured, refined, and worldly. For James McNeill Whistler—perhaps the most notorious expatriate of all—it also offered Bohemian freedom, sensuous pleasure, and a cornucopia of aesthetic riches that would never run dry.

Born in Lowell, Massachusetts, Whistler lived in St. Petersburg, Russia, as a boy. After an abortive stint at West Point, he plunged into la vie de Bohème *before moving to London in 1859. At first affiliated with the earthy realism of Gustav Courbet, Whistler later embraced the doctrine of "art for art's sake," becoming one of its leading apologists. Both as artist and tastemaker, he made a dynamic and indelible impact on American artists coming of age in the 1870s and after.*

Using newspapers and the periodical press to keep himself in the limelight, Whistler assiduously cultivated the acerbic wit and theatrical style that were guaranteed to excite comment. An intensely public personality, he so successfully concealed his private self— and his hard-working dedication to his art—that some came to think of him as a shallow, manipulative poseur. Many others, however, fell under his spell. A mythic figure and subject of innumerable anecdotes, Whistler spawned a lively culture of gossip in which much inaccurate information and many dubious stories were enshrined as truth.

The magazine feature "Whistler, Painter and Comedian" exemplifies the typically colorful style of journalism dedicated to the artist's eccentricities and mannerisms. The author says almost nothing about Whistler's work but rather paints a picture of an irresponsible, fun-loving, egotistical, trivial, and yet highly entertaining dabbler.

"Whistler, Painter and Comedian," McClure's Magazine *7 (September 1896).*

I first knew Mr. James McNeill Whistler many years ago in Venice, when he was quite unknown to fame. He had lodgings at the top of an old palace in the uttermost parts of the town, and many days he would breakfast, lunch, and dine off nothing more nutritious than a plateful of polenta or macaroni. He was just as witty, and gave himself just the same outrageous but inoffensive airs, as afterwards in the days of his prosperity. He used to go about and do marvellous etchings for which he could find no market, or else only starvation prices. When he was absolutely obliged to, he would sell them for what he could get; but he never lost the fullest confidence in his own powers, and, whenever he could, he preferred to keep them in the expectation—nay, the certainty—of being able to sell them some day at a high figure . . .

Those who know Mr. Whistler now can scarcely imagine him anything but the cheeriest and most sanguine of mortals. It seems as if no calamity could ruffle him, and as if there were no room in his delightful character for such a thing as vexation. But, like many light-hearted people,

when he does let himself run down, he runs down farther than a prosaic person would do. I am told that at one time he and his model fully made up their minds to commit suicide together by jumping into one of the canals of Venice. They set the house in order, and started out on their dismal errand, but happening to meet a friend on the way, they forgot all about it . . .

Mr. Whistler's laugh is one of the most characteristic things about him. It is a weird, mocking, almost fiendish laugh, unique of its kind. Mr. Irving got hold of part of it when he appeared as Mephistopheles in Faust, and Mr. Whistler's disciples caricature it, as they do most of his peculiarities as well as his art. But the original is inimitable.

Much of his table-talk would be pointless in print, as it owes its chief charm to his voice and manner and gestures. His great delight is to startle people, and he will often say things simply because they are unexpected. An admirer once said to him, "Mr. Whistler, there are only two great painters, yourself and Velasquez." Whereupon he slowly winked his left eye and asked, "Why drag in Velasquez?" A lady, raving about Thames scenery to him, said, "The whole trip was like a series of your superb etchings." "Ye-es," he replied; "nature is creeping up." There are certain phrases which he is always using, such as "Don't you know?" and "What?" at the end of a sentence. His favorite adjective is "amazing," and he applies it to all manner of people and things in a really amazing manner. He is fully alive to the importance of a drawl in giving point to an anecdote. He used constantly to say to a man with a dreadful stutter, "You know what makes you so amazing is that stammer of yours. If it weren't too late, I should try to grow one like it myself. If I could stutter as you do, I should get off some astounding things."

It is impossible to be in Mr. Whistler's society long without hearing him talk of "getting off" amazing or astounding things, by which he means epigrams. He will spare no pains to get off a good one, and will lead up to it with the most painstaking ingenuity, so that it may at last be jerked out in a natural way. His best-known *mot*—when Oscar Wilde said to him, "I wish I had said that, Jimmy;" and he said, "Oscar, you will;"—was the result of days of preparation, and was carefully treasured up until the right moment came to "get it off." . . .

Mr. Whistler's house at Chelsea was very pretty and artistic as far as it went, but, either through laziness or impecuniosity, he only furnished one room besides the bedroom during the first year or two of his stay. Everywhere you encountered great packing-cases full of pretty things, and saw preparations for papering and carpeting, but somehow or other nothing ever got any forwarder. What was done was perfect in its way. The white wainscotting, the rich draperies, the rare Oriental china, the pictures and their frames, the old silver—all had a charm and a history of their own.

All through the summer Mr. Whistler holds a kind of reception every Sunday afternoon in the garden at the back of his house. You meet all sorts and conditions of people there—men of light and leading in the world of art and literature; tenth-rate daubers who adulate him, and whom he takes pleasure in constantly snubbing; eccentric people who have taken his fancy; theatrical people—in fact, the sort of menagerie that could but rarely congregate at the same time anywhere else. He is the life and soul of the party, strolling about with a little child's straw hat on the back of his head, and a bit of ribbon in place of a necktie, and chattering away unceasingly wherever he can get the largest audience. He has a habit, when he is talking to any one, of gazing searchingly into his eyes, and literally buttonholing him; that is, holding him firmly by the buttonhole so that he cannot escape. His face is a remarkable one. It is covered with countless wrinkles, but is clear of complexion, and evidently very well groomed. He wears a well-curled gray mustache and slight imperial. His eyebrows are unusually bushy, and his glisten-

ing brown eyes peer out from underneath them like snakes in the grass. His hair is the most "amazing" part of his get-up. It is all arranged in separate curls, most artistically put together. They are all dyed black, with the exception of one, which remains quite white, and on grand occasions is tied up with a small ribbon.

When he goes out in London, he always gets himself up very elaborately, in a way that is sure to arouse attention. He wears a very long black overcoat, rather like that of one of the little men in the "Noah's Ark," and a French top hat with the brim standing straight out. In his hand he carries a kind of wand of bamboo about four feet long and very thin. His gloves and boots are very carefully selected, and of irreproachable fit. When he walks about the streets of London, he generally has a crowd of small boys in pursuit, and nearly everybody turns around to look at him with a smile as he passes. However, he very rarely walks, but usually goes everywhere in a hansom, except just in the very fashionable quarters.

ART ON TRIAL: JAMES MCNEILL WHISTLER VS. JOHN RUSKIN

Whistler's exhibition of portraits and nocturnes at the progressive Grosvenor Gallery in 1877 incited the scorn and wrath of leading critic John Ruskin. In the July edition of his newspaper, Fors Clavigera, *Ruskin published an inflammatory paragraph (quoted in full below) accusing Whistler of "cockney impudence" for "flinging a pot of paint* (Nocturne in Black and Gold: The Falling Rocket, *1875) in the public's face," the crowning outrage being Whistler's asking price, 200 guineas. Whistler sued Ruskin for 1,000 pounds in damages, and the trial took place on November 25 and 26, 1878, with witnesses on both sides drawn from the London art world.*

There is no completely accurate transcript of the trial, but the Daily Telegraph *account preserves a sense of the dialogue and tone of the exchanges. As the following transcripts show, the trial was well attended and often hilarious. The issues at stake, though, were serious. Paramount was that of artistic authority: what are the artist's rights, or the critic's? Is the artist obliged to imitate nature in order to produce work easily accessible to the public? Equally important, how much work must an artist devote to a painting in order to justify the asking price? Who decides when the work is finished, or if it is beautiful, or if it is art at all? What, in essence, defines quality: labor or genius?*

The trial was a disaster for Whistler, who was awarded one farthing (a quarter of a penny) in damages and billed for half the court costs, which, along with other debts, drove him into bankruptcy. His moral and aesthetic victory, however, was significant. Despite the farcical nature of the proceedings, he had used the witness box as bully pulpit to make a forcible case for his aesthetic platform.

"Whistler v. Ruskin," Daily Telegraph, *November 26 and 27, 1878.*

November 26, 1878

This is an action for libel. The plaintiff alleged in his statement of claim that the alleged libel was falsely and maliciously published, and that it had much damaged his reputation as an artist. He claimed £1,000 damages. The defendant pleaded that the publication was privileged, inasmuch as it was confined to a fair and bonâ-fide criticism upon paintings which had been exhibited to the public view.

Mr. Serjeant Parry and Mr. Petheram appeared for the plaintiff; and the Attorney-General and Mr. Bowen represented the defendant.

Mr. Serjeant Parry, in opening the case on behalf of the plaintiff, said that Mr. Whistler had followed the profession of an artist for many years, both in this and other countries. Mr. Ruskin, as would be probably known to the gentlemen of the jury, held perhaps the highest position in Europe and America as an art-critic, and some of his works were, he might say, destined to immortality. He was, in fact, a gentleman of the highest reputation, and it was, therefore, surprising that he had acted towards another in such a manner as to induce that other to bring an action against him for libel. Mr. Whistler, in 1877, exhibited several pictures at the Grosvenor Gallery, which was opened, he understood, by Sir Coutts Lindsay for the purpose of exhibiting many pictures which were unable to obtain a place at the Royal Academy. Mr. Whistler had also exhibited at the Dudley Gallery, and had been always an unwearied worker in his profession. Instead, therefore, of being treated by Mr. Ruskin with contempt and ridicule, he should have been held in great admiration by that gentleman, who, without doubt, was a sincere worker in his own profession. In the July number of "Fors Clavigera" there appeared passages in which Mr. Ruskin criticized what he called the modern school, and then followed the paragraph of which Mr. Whistler now complained, and which was: "For Mr. Whistler's own sake, no less than for the protection of the purchaser, Sir Coutts Lindsay ought not to have admitted works into the Gallery in which the ill-educated conceit of the artist so nearly approached the aspect of wilful imposture. I have seen and heard much of cockney impudence before now, but never heard of a coxcomb asking 200 guineas for flinging a pot of paint in the public's face." That passage, no doubt, had been read by thousands, and so it had gone forth to the world that Mr. Whistler was an ill-educated man, an impostor, a cockney pretender, and an impudent coxcomb. That was a very powerful condemnation, and Mr. Whistler's reputation had undoubtedly suffered from it. Some of the paintings had been collected for view; but he would ask that not only an isolated one should be held up in Court for purposes of ridicule, but that a large number of them, which were at the Westminster Palace Hotel, might be seen by the judge and jury, and that an opportunity might be so given for a full, fair, and proper criticism to be passed upon them. When they had heard the whole of the case he believed they would be of opinion that Mr. Ruskin had done Mr. Whistler an injustice, and that a verdict should be given in favour of his client.

Mr. James Abbott McNeill Whistler, the plaintiff, was then examined by Mr. Petheram, and said: . . . I exhibited eight of my pictures in the Grosvenor Gallery in the winter exhibition of 1877, at the invitation of Sir Coutts Lindsay. They were: 1, "Nocturne in black and gold;" 2, "Nocturne in blue and silver;" one "nocturne in blue and gold; an "arrangement in black (Irving as Philip II.);" a "harmony in amber and black," an "arrangement in brown," and a "portrait of Mr. Carlyle." The latter was from sittings given by Mr. Carlyle, and has been engraved. The artist's proofs were in bulk subscribed for previously. The portrait was "an arrangement in green and gold." I sold one of the nocturnes to Sir Percy Wyndham for 200 guineas. Since Mr. Ruskin's criticism has appeared I have not sold one at anything like the price. The only picture which I exhibited unsold at the Grosvenor Gallery was the "nocturne in black and gold."

Will you tell us the meaning of that word "nocturne" as applied to your pictures?—By using the word nocturne I wished to divest the picture from any outside anecdotical interest. The picture throughout is for me a problem which I attempt to solve, and I make use of any means, any incident and object in nature which will bring about such a symmetrical result if possible.

What do you mean by arrangement?—I mean an arrangement of line and form and colour.

Amongst my pictures are some night pieces, and I have chosen the word "nocturne" because it generalises the lot of them.

Cross-examined by the Attorney-General, the plaintiff said: Some of my pictures have been rejected by the Academy Committee.

Artists always give good value for their money, don't they?—I am glad that it is so well established.

You have been told that your pictures exhibit some eccentricities?—Yes; often. I do not expect that my pictures will not be criticised unless they are altogether overlooked.

Why did you arrange Mr. Irving in Black?

Baron Huddleston: Mr. Irving was not the arrangement. (Laughter.)

Plaintiff: I thought it was appropriate.

The Attorney-General: No doubt. We often see Mr. Irving in black. How long would you take to knock off one of your nocturnes?—I beg your pardon.

I was using an expression which was rather more applicable to my own profession. (Laughter.) How long do you take to knock off one of your pictures?—Oh, I knock off one possibly in a couple of days. (Laughter.)

And that was the labour for which you asked 200 guineas?—No; it was for the knowledge gained through a lifetime. (Applause.)

Baron Huddleston said that if this manifestation of feeling were repeated he would have to clear the court.

Cross-examination resumed: You know that many critics entirely disagree with your views as to these pictures?—It would be beyond me to agree with the critics. (Laughter.)

You don't approve of criticism?—I should not disapprove in any way of technical criticism by a man whose life is passed in the practice of the science which he criticises; but for the opinion of a man whose life is not so passed I would have as little opinion as you would have if he expressed an opinion on law.

You expect to be criticised?—Yes, certainly; and I do not expect to be affected by it until it comes to be a case of this kind.

Do you allow your pictures to mellow?—I do not understand.

Do you put your pictures upon a garden wall?—Oh, I understand now. I should be sorry to see them mellowed, but I do put them upon the garden wall in the open air, in order that the pictures may dry while I am painting.

(A painting of Battersea Bridge, in blue and silver, was then produced in court, representing the river by moonlight.)

Do you say that this is a correct representation of Battersea Bridge?—I did not intend it to be a correct portrait of the bridge, but only a painting of a moonlight scene.

What is that mark on the right of the picture, like a cascade—is it a firework?—Yes.

What is that peculiar dark mark on the frame?—That is all a part of my scheme. It balances the picture. The frame and the picture together are a work of art. (A picture of Battersea from near the bridge was then produced in blue and silver.) I completed the mass of the picture in one day.

In re-examination by Mr. Serjeant Parry, the plaintiff said: I conscientiously form my idea, and then work it out. My pictures are published for the purpose of a livelihood. My manual labour in painting is rapid. I would not be able to produce the quality I did unless I went on hammering away.

The Court then adjourned for lunch, and, during the interval, the jury visited the Probate Court, to view the pictures which had been collected at the Westminster Palace Hotel and brought over to Westminster Hall.

After the Court had reassembled, a picture in black and gold, representing fireworks at Cremorne, was produced.

The Attorney-General: What is the peculiar beauty of that picture?—It is impossible for me to explain to you the beauty of the picture, any more than for a musician to explain to you the beauty of harmony in a particular piece of music if you had no ear for music. I have known unbiased people express the opinion that it represents fireworks in a night scene. I offer the picture, which I have conscientiously painted, as being worth 200 guineas. I would not complain of any person who might simply take a different view. I did live in Cheyne-walk, Chelsea; but I now reside in the White House in Tite-street.

Mr. Wm. Michael Rossetti, examined by Mr. Serjeant Parry, said he had been connected with art since 1850, and had known the plaintiff since 1862. He also knew Mr. Ruskin. He was an art critic. The blue and silver painting of Battersea from the river was a very beautiful artistic representation of a bright but pale moonlight. The painting of Battersea Bridge represented a general diffused moonlight with a firework in the form of a cascade. The painting of Cremorne represented the indefiniteness of night broken by the light of fireworks. He had seen the portrait of Mr. Carlyle which was exhibited in the Grosvenor Gallery. That was a very fine portrait, but painted with a certain amount of peculiarity. It was a very good likeness, to the best of his judgment. His opinion of the plaintiff's works in the Gallery in 1877 was that they were very fine works with one or two exceptions. He considered the plaintiff was a sincere and good artist.

In cross-examination by the Attorney-General, the witness said that his criticism of the pictures in the Grosvenor Gallery was published in the periodical, the "Academy." Mr. Ruskin often praised artists for their works very much, and was the Slade Professor of Art at the University of Oxford. He would not call the painting of Cremorne a gem or an exquisite work of art. It was unlike most other paintings. He had not seen "The Grasshopper" at the Gaiety. The picture was a work of art because it represented what was intended, and was finished with considerable artistic skill.

The Attorney-General: Is 200 guineas a stiffish price?

Witness: I think it is the full value of the picture.

Mr. Albert Moore, an artist and art critic, who had earned his livelihood for fifteen years by painting and had studied at Rome, said he considered the paintings by the plaintiff were real works of art. The marvelous manner in which the plaintiff had painted the atmosphere in the picture of Battersea Bridge and the peculiarity of the scene at Cremorne were, to his mind, wonderful. The pictures were beautiful works of art. A price of 200 guineas was not too high a price for one of the paintings any more than such a sum would be too high for one of the learned counsel to earn without working for days and days. The money was paid for the skill of the artist, and not always for the amount of labour expended.

In cross-examination, the witness said he could not say that the pictures in question were exquisite works of art, but they were good.

Mr. W. G. Wills, dramatic author, who pursued art as a means of livelihood, said, to his mind, the plaintiff's pictures evinced a poetic fancy and a trained knowledge of art. He greatly admired the plaintiff's pictures.

This concluded the plaintiff's case.

November 27, 1878

The action by Mr. Whistler against Mr. Ruskin for libel was resumed to-day. The defendant pleaded that the words complained of were a fair and bonâ-fide criticism upon pictures which the plaintiff had exposed to public view.

Mr. Serjeant Parry and Mr. Petheram appeared for the plaintiff; the Attorney-General and Mr. Bowen for the defendant.

The Attorney-General, in resuming his address on behalf of the defendant, said he hoped to convince the jury, before his case closed, that Mr. Ruskin's criticism upon the plaintiff's picture was perfectly fair and bonâ-fide and that however severe it might be, there was nothing which could reasonably be complained of. Yesterday he was asking the jury to accompany him in imagination to the Grosvenor Gallery, where the plaintiff's pictures were exhibited. They went there, and having had an artistic chop served in a plate of ancient pattern, and some claret in a Venetian glass, they were attracted by Mr. Whistler's productions. They would, of course, have some difficulty in getting near them, for there was an intense admiration of his pictures among those votaries of art who principally frequented the Grosvenor Gallery. They would find "nocturnes," "arrangements," and "symphonies" surrounded by groups of artistic ladies—beautiful ladies who endeavoured to disguise their attractions in medieval millinery, but did not succeed in consequence of sheer force of nature—(laughter)—and he dared say they would hear these ladies admiring these pictures and commenting upon them. For instance, a lady, gazing on the moonlight scene representing Battersea Bridge, would turn round and say to another, "How beautiful; it is a nocturne. Do you know what a nocturne means?" "No; but it is an exquisite idea. How I should like to see Mr. Whistler, to know what it means!" Well, he did not know, after having received the explanation which Mr. Whistler gave the Court yesterday, the young lady would be any the wiser . . . Let them examine the nocturne in blue and silver said to represent Battersea Bridge. What was that structure in the middle? Was it a telescope or a fire-escape? Or perhaps it was the tubular bridge sent from the Menai Straits to span the Thames. Was it like Battersea Bridge? What were the figures on the top of the bridge? and, if they were horses and carts, how in the name of fortune were they to get off? (Laughter.) . . . It was the opinion of Mr. Ruskin that care and conscientious labour in a picture were matters to be appreciated, and that an artist ought not to present a picture to the public until he had, as far as he was able, brought it to a state of perfection, and that also was the opinion of artists whom he was obliged, he might almost say, to drag before the jury. Those artists would say that whatever Mr. Whistler had done in the past—and there was no doubt he had produced some most beautiful etchings and pictures—these were not works to be proud of, not works deserving admission into any art gallery in the country . . . It was said that the term "ill-educated conceit" ought never to have been applied to Mr. Whistler, who had devoted the whole of his life to educating himself in art; but Mr. Ruskin's views as to his success did not accord with those of Mr. Whistler. Who ever heard of a lawyer bringing an action because it was said that he was not a good lawyer? The libel complained of said also, "I never expected to hear a coxcomb ask 200 guineas for flinging a pot of paint in the public's face." It must be remembered that this term was applied to him as an artist, and not as a man. What was a coxcomb? He had looked the word up, and found that it came from the old idea of the licensed jester, who wore a cap and bells with a cock's comb on it, who went about making jests for the amusement of his master and family. If that were the true definition, then Mr. Whistler should not complain because his pictures had afforded a most amusing jest. He did not know when

so much amusement had been afforded to the British public as by Mr. Whistler's pictures. If Mr. Whistler's reputation as an artist was to be founded upon these pictures he was a pretender to an accomplishment he did not possess, and was worthy of the name of coxcomb. He had now finished . . .

The following evidence was then called on behalf of the defendant:

Mr. Edward Burn Jones, examined by Mr. Bowen: I am a painter, and have devoted about twenty years to the study. I have painted various works, including the "Days of Creation" and "Venus's Mirror," both of which were exhibited at the Grosvenor Gallery in 1877. I have also exhibited "Deferentia," "Fides," "St. George," and "Sybil." I have one work, "Merlin and Vivian," now being exhibited in Paris. In my opinion complete finish ought to be the object of all artists. A picture ought not to fall short of what has been for ages considered complete finish. I have seen the pictures of Mr. Whistler. The nocturne, in blue and silver, I consider a work of art, but it is an incomplete one. It is an admirable beginning, and is only a sketch.

Does it show the finish of a complete work of art?—Not in any sense whatever. The picture representing a night scene on Battersea Bridge is good in colour, but bewildering in form; and it has no composition and detail. A day or a day and a half seems a reasonable time within which to paint it. It shows no finish—it is simply a sketch. The nocturne in black and gold has not the merit of the other two pictures, and it would be impossible to call it a serious work of art. I have never seen any picture of night which has been successful, and Mr. Whistler's picture is only one of the thousand failures which artists have made in their efforts to paint night. The picture is not worth 200 guineas, considering how much more careful work is done for much less sum.

Mr. Bowen here proposed to ask the witness to look at a picture by Titians, in order to show what finish was.

Mr. Serjeant Parry objected.

Mr. Baron Huddleston: You will have to prove that it is a Titians.

Mr. Bowen: I shall be able to do that. (Laughter.)

Mr. Baron Huddleston: That can only be by repute. I do not want to raise a laugh, but there is a well-known case of "an undoubted" Titians being purchased with a view to enabling students and others to find out how to produce his wonderful colours. With that object the picture was rubbed down, and they found a red surface, beneath which they thought was the secret, but on continuing the rubbing down they discovered a full length portrait of George III. in uniform. (Laughter.)

Mr. Serjeant Parry said his objection to the production of a work of Titians was this. Mr. Whistler had never placed himself in the same position as that great artist, and therefore it was unfair to institute any comparison between them. However, he would not press the objection.

The witness was then asked to look at the picture, and he said: It is a portrait of Doge Andrea Gritti, and I believe it is a real Titian. It shows finish. It is a very perfect sample of the highest finish of ancient art. The flesh is perfect, the modeling of the face is round and good. That is an arrangement in flesh and blood. The colour is in perfect tone, and the drawing sufficiently fine. In Mr. Whistler's pictures I see marks of great labour and artistic skill, and I think he had great powers at first, which he has not since justified. He has evaded the difficulties of his art, because the difficulty of an artist increases every day of his professional life.

Cross-examined: What is the value of this picture of Titians?—That is a mere accident of the sale room.

Is it worth 1,000 guineas?—It would be worth many thousands to me, but it may have been

sold for 40 guineas. I have seen a Titians in the possession of Lord Elcho, for which he gave £20 only.

Mr. Serjeant Parry: He was very lucky.

Cross-examination continued: Mr. Whistler has an unrivalled sense of atmosphere in painting. I have exhibited two unfinished sketches at the Grosvenor Gallery, which I admit is not a very desirable thing to do. I think Mr. Whistler's colour in moonlight pictures is extremely good. The pictures alluded to in this case I look upon as incomplete.

Mr. Serjeant Parry: You would not, however, look upon a man as a wilful imposter who exhibited such pictures?

Mr. Bowen: I object to that question.

Mr. Serjeant Parry: I will not press it.

Mr. Frith: . . . I attend here on a subpoena against my will. I am much pained to have to give my evidence.

Cross-examined: I think Mr. Whistler has very great powers, but I do not see them displayed in these "things." In our profession men of equal merit differ as to the character of a picture. One may blame while another praises a work. I have not exhibited at the Grosvenor Gallery. I have read Mr. Ruskin's works.

Mr. Serjeant Parry: Is Turner an idol of Mr. Ruskin's?—Yes, and I think he should be an idol of everybody.

Mr. Serjeant Parry: Do you know one of Turner's works at Marlborough House called the Snowstorm?—Yes, I do.

Are you aware that it has been described by a critic as a mass of soapsuds and whitewash?—I am not.

Would you call it a mass of soapsuds and whitewash? I think it is very likely I should. (Laughter.) When I say Turner should be the idol of everybody I refer to his earlier works, and not to his later ones, which are as insane as the people who admire them. (Renewed laughter.)

Mr. Baron Huddleston: Somebody described one of Turner's pictures as "lobster salad." (Laughter.)

Mr. Frith: I have myself heard Turner speak of his own pictures as salad and mustard. (Renewed Laughter.)

Mr. Serjeant Parry: Without the lobster.

Mr. Tom Taylor: I am an art critic of long standing. I edited the Life of Reynolds and Haydon. I have always studied art. I have seen these pictures of Mr. Whistler when they were exhibited at the Dudley and the Grosvenor Galleries. The "nocturne" in black and gold I do not think a serious work of art. (The witness here read the criticism he had written in the *Times,* to every word of which, he said, he still adhered.) All Mr. Whistler's work is unfinished. It is sketchy. He, no doubt, possesses high artistic qualities, and he has got appreciation of qualities of tone, but he is not complete, and all his works are in the nature of sketching. I have expressed, and still adhere to the opinion, that these pictures only come "one step nearer pictures than a delicately tinted wall paper."

This was the case for the defence . . .

The jury retired at 2.40, and were locked up until 4.15, when they returned into court to ask the learned judge some questions as to the import of the words "wilful imposture." They again retired, and at 4.30 came into court to deliver their verdict.

The foreman of the jury, upon being asked whether they were all agreed, replied in the affirmative, and said they found a verdict for the plaintiff with one farthing damages.

Baron Huddleston, on the application of Mr. Petheram, entered judgment for the plaintiff.

Mr. Bowen asked that the costs, which were within the discretion of his lordship, should not follow the event, considering the nature of the action and the small amount of damages which had been awarded by the jury.

Mr. Petheram asked that costs should be given for the plaintiff.

Baron Huddleston, remarking that he had fully explained to the jury how that damages should have been found if they had considered that a substantial injury had been done to the plaintiff, entered judgment for the plaintiff without costs.

JAMES MCNEILL WHISTLER'S PLATFORM

Whistler's 1885 lecture, given on the evening of February 20 at Prince's Hall, London, was a high-society attraction, scheduled late so that the audience could enjoy a leisurely dinner before setting out to hear him. Goaded by rival Oscar Wilde, whose public lectures (in Whistler's view) represented a cheap, trivial corruption of aestheticism, Whistler resolved to deliver a formal presentation of his own views (see "Oscar Wilde's American Tour," chapter 13). Published in 1888, the lecture reached a wide audience and remains a theoretical cornerstone of modernism and even abstraction in its insistence on the artist's right to transcend nature.

In The Gentle Art of Making Enemies, *his compilation of letters and attacks on critics, Whistler included "The Red Rag," originally published in* The World, *May 22, 1878. Like the "Ten O'Clock" lecture, this is a manifesto in its own right, a declaration of independence from the obligation either to tell a story or to explain the meaning of his pictures and their musical titles.*

Whistler's refusal to subordinate himself before nature extended to his patrons as well. Insisting that the artist should be an untrammeled free agent, he demanded deference and absolute compliance from those who commissioned his work. Nowhere were those terms contested more bitterly than in the contretemps that erupted around Whistler's redecoration of the dining room in shipping magnate Frederic R. Leyland's London mansion. Retained to make minor changes in the color scheme, Whistler instead radically transformed it into an extravaganza of peacock blue and gold. In their interchange, Leyland indignantly refuses to meet Whistler's terms for payment, pointing out that the artist never told him of the elaborate plans for the room. In response, Whistler bitterly points out that Leyland paid (and shortchanged) him in ordinary tradesman's pounds rather than prestigious guineas. Yet, in the end, writes Whistler, the patron is incidental and expendable: only the work matters.

Finally, Whistler's letter to Theodore Watts-Dunton is a proclamation of the artist's right to exhibit his pictures at any place and time regardless of the owner's views. His work, he announces, belongs to the "whole world."

Mr. Whistler's Ten O'Clock (*London: Chatto & Windus, 1888*).

Nature contains the elements, in colour and form, of all pictures, as the keyboard contains the notes of all music.

But the artist is born to pick, and choose, and group with science, these elements, that the result may be beautiful—as the musician gathers his notes, and forms his chords, until he bring forth from chaos glorious harmony.

To say to the painter, that Nature is to be taken as she is, is to say to the player, that he may sit on the piano.

That Nature is always right, is an assertion, artistically, as untrue, as it is one whose truth is universally taken for granted. Nature is very rarely right, to such an extent even, that it might almost be said that Nature is usually wrong: that is to say, the condition of things that shall bring about the perfection of harmony worthy a picture is rare, and not common at all.

This would seem, to even most intelligent, a doctrine almost blasphemous. So incorporated with our education has the supposed aphorism become, that its belief is held to be part of our moral being, and the words themselves have, in our ear, the ring of religion. Still, seldom does Nature succeed in producing a picture.

The sun blares, the wind blows from the east, the sky is bereft of cloud, and without, all is of iron. The windows of the Crystal Palace are seen from all points of London. The holiday maker rejoices in the glorious day, and the painter turns aside to shut his eyes.

How little this is understood, and how dutifully the casual in Nature is accepted as sublime, may be gathered from the unlimited admiration daily produced by a very foolish sunset.

The dignity of the snow-capped mountain is lost in distinctness, but the joy of the tourist is to recognise the traveller on the top. The desire to see, for the sake of seeing, is, with the mass, alone the one to be gratified, hence the delight in detail.

And when the evening mist clothes the riverside with poetry, as with a veil, and the poor buildings lose themselves in the dim sky, and the tall chimneys become campanili, and the warehouses are palaces in the night, and the whole city hangs in the heavens, and fairy-land is before us—then the wayfarer hastens home; the working man and the cultured one, the wise man and the one of pleasure, cease to understand, as they have ceased to see, and Nature, who, for once, has sung in tune, sings her exquisite song to the artist alone, her son and her master— her son in that he loves her, her master in that he knows her.

To him her secrets are unfolded, to him her lessons have become gradually clear. He looks at her flower, not with the enlarging lens, that he may gather facts for the botanist, but with the light of the one who sees in her choice selection of brilliant tones and delicate tints, suggestions of future harmonies.

He does not confine himself to purposeless copying, without thought, each blade of grass, as commended by the inconsequent, but, in the long curve of the narrow leaf, corrected by the straight tall stem, he learns how grace is wedded to dignity, how strength enhances sweetness, that elegance shall be the result.

In the citron wing of the pale butterfly, with its dainty spots of orange, he sees before him the stately halls of fair gold, with their slender saffron pillars, and is taught how the delicate drawing high upon the walls shall be traced in tender tones of orpiment, and repeated by the base in notes of graver hue.

In all that is dainty and lovable he finds hints for his own combinations, and *thus* is Nature ever his resource and always at his service, and to him is naught refused.

Through his brain, as through the last alembic, is distilled the refined essence of that thought which began with the Gods, and which they left him to carry out.

Set apart by them to complete their works, he produces that wondrous thing called the masterpiece, which surpasses in perfection all that they have contrived in what is called Nature; and the Gods stand by and marvel, and perceive how far away more beautiful is the Venus of Melos than was their own Eve.

James McNeill Whistler, "The Red Rag," in The Gentle Art of Making Enemies *(London: William Heinemann, 1890).*

Why should not I call my works "symphonies," "arrangements," "harmonies," and "nocturnes"? I know that many good people think my nomenclature funny and myself "eccentric." Yes, "eccentric" is the adjective they find for me.

The vast majority of English folk cannot and will not consider a picture as a picture, apart from any story which it may be supposed to tell.

My picture of a "Harmony in Grey and Gold" is an illustration of my meaning—a snow scene with a single black figure and a lighted tavern. I care nothing for the past, present, or future of the black figure, placed there because the black was wanted at that spot. All that I know is that my combination of grey and gold is the basis of the picture. Now this is precisely what my friends cannot grasp.

They say, "Why not call it 'Trotty Veck', and sell it for a round harmony of golden guineas?"— naively acknowledging that, without baptism, there is no . . . market!

But even commercially this stocking of your shop with the goods of another would be indecent—custom alone has made it dignified. Not even the popularity of Dickens should be invoked to lend an adventitious aid to art of another kind from his. I should hold it a vulgar and meretricious trick to excite people about Trotty Veck when, if they really could care for pictorial art at all, they would know that the picture should have its own merit, and not depend upon dramatic, or legendary, or local interest.

As music is the poetry of sound, so is painting the poetry of sight, and the subject-matter has nothing to do with harmony of sound or of colour . . .

Art should be independent of all clap-trap—should stand alone, and appeal to the artistic sense of eye or ear, without confounding this with emotions entirely foreign to it, as devotion, pity, love, patriotism, and the like. All these have no kind of concern with it and that is why I insist on calling my works "arrangements" and "harmonies."

Take the picture of my mother, exhibited at the Royal Academy as an "Arrangement in Grey and Black." Now that is what it is. To me it is interesting as a picture of my mother; but what can or ought the public to care about the identity of the portrait?

The imitator is a poor kind of creature. If the man who paints only the tree, or flower, or other surface he sees before him were an artist, the king of artists would be the photographer. It is for the artist to do something beyond this: in portrait painting to put on canvas something more than the face the model wears for that one day; to paint the man, in short, as well as his features; in arrangement of colours to treat a flower as his key, not as his model.

Frederic R. Leyland and James McNeill Whistler, correspondence, Courtesy of Glasgow University Library, Department of Special Collections.

>*[Leyland to Whistler, October 21, 1876]*

Dear Whistler,

I have just received your telegram; but I think it will be more satisfactory now that the work is finished if we settle the amount you are entitled to charge.

I can only repeat what I told you the other day that I cannot consent to the amount you spoke of—£2,000—and I do not think you should have involved me in such a large expenditure without previously telling me of it. The peacocks you have put on the back of the shutters

may possibly be worth (as pictures) the £1,200 you charge for them but that position is clearly a most inappropriate one for such an expensive piece of decoration; and you actually were not justified in placing them there without any order from me. I certainly do not require them and I can only suggest that you take them away and let new shutters be put up in their place.

As to the decorations to the ceiling and the flowers on the old leather, as well as the other work about the house; it seems to me the only way of arriving at a fair charge is to take the time occupied at your average rate of earnings as an artist.

I am sorry there should be such an unpleasant correspondence between us; but I do think you are to blame for not letting me know before developing into an elaborate scheme of decoration what was intended to be a very slight affair and the work of comparatively a few days.

Yours truly
F. R. Leyland

[Whistler to Leyland, Draft no. 6, October 31, 1876, 2 Lindsey Houses, Chelsea]

Dear Leyland—I have enfin received your cheque—for 600 pounds—I perceive [words deleted] shorn of my shillings I perceive!—another fifty pounds off—Well I suppose that will do—upon the principal that anything will do—

Bon Dieu! What does it matter!—

The work just created *alone remains* the fact—and that it happened in the house of this one or that one is merely the anecdote—so that in some future dull Vassari you also may go down to posterity, like the man who paid Corregio in pennies!—

Ever yours
J. McN. Whistler

James McNeill Whistler to Theodore Watts-Dunton, February 2, 1878, The British Library.

My dear Watts—This is my position.—It is far from my wish to rob Leyland of any real right—whatever may be my opinion of his conduct—The portraits of himself and Mrs Leyland I have witheld because of certain remarks in one of his letters impugning their artistic value, and whereas I do not acknowledge that a picture once bought merely belongs to the man who pays the money, but that it is the property of the whole world, I consider that I have a right to exhibit such picture that its character may be guaranteed by brother artists—therefore it was my intention to show, in a public exposition these two paintings this spring—and thereupon restore them to their chance purchaser—

With reference to the portrait of Miss Florence Leyland I have to say that it is incomplete simply because the young lady has not sufficiently sat for it—and as she is not likely to sit for it again, I must do what I can to make it as worthy of me and of herself as possible—When this is all accomplished, Leyland shall have it—for my "stock in trade" is my reputation, and it is not represented by Leyland's money.

JAMES MCNEILL WHISTLER AND THE CRITICS

Despite Whistler's belligerent and belittling attacks on his critics, the artist was keenly affected by the public reception of his work. From early on, he collected clippings of critical reviews, many of which were more positive and sympathetic than the painter ever acknowledged in print. The selection below is representative. In his appreciative comments on Whistler's first one-man show, in the Flemish Gallery, Pall Mall, London,

Henry Blackburn belies Whistler's undying contention that critics persistently and often malevolently misinterpreted his work. The New York Times *and the* Nation *both suggest that Whistler's exhibition-as-entertainment formula is a guarantee of popular success—the* Nation, *moreover, noting that however slight the individual pictures may be, each plays an important supporting role in Whistler's nicely wrought, color-coordinated ensemble. In observing that none of the works bears the slightest trace of effort, the reporter highlights another of the artist's carefully cultivated pretenses.*

Published shortly after the Whistler-Ruskin trial, William Crary Brownell's extended commentary on Whistler was the most substantial piece on the artist yet to appear in an American periodical. Brownell, still in the early stages of his career as an art and cultural critic, offers an astute and judicious assessment of Whistler's art, noting that to Whistler nature is in a sense irrelevant, since the artist cares only about distilling from nature what Brownell calls "beautiful picturesqueness." Critical of Whistler's curious failure to produce anything truly great, Brownell nonetheless praises him as a true artist.

Elizabeth Robins Pennell, with her husband Joseph, was a friend and devoted admirer of Whistler. Her review of Whistler's triumphal exhibition at the Goupil Gallery dates from the period of Whistler's ascendancy into the upper reaches of the modern pantheon. Pennell here canonizes the artist as both pioneer modernist and established master, enjoying the last laugh at the expense of his critics. Significantly, she claims Whistler for America, citing his indelibly American identity and his supremacy as a great American decorator.

Henry Blackburn, "'A Symphony' in Pall Mall," Pictorial World **(June 13, 1874).**

Mr. Whistler's works—for the exhibition consists of paintings, sketches, and etchings, entirely by this artist—are exhibited in a congenial home. The visitor is struck, on entering the gallery, with a curious sense of harmony and fitness pervading it, and is more interested, perhaps, in the general effect than in any one work. The gallery and its contents are altogether in harmony— a "symphony in colour," carried out in every detail, even in the colour of the matted floor, the blue pots and flowering plants, the delicate tints of the walls, and, above all, in the juxtaposition of the pictures. When in America, I remember that Mr. Whistler's name was a household word in art circles, but Mr. Whistler's works seemed a household puzzle. "We are proud of our countryman, but we do not understand him," was a remark I heard more than once on the other side of the Atlantic; and it was curious to note the greatness of admiration and the smallness of result artistically. In America there are still only ten men who can draw in line, and of that little band there is not one who approaches Whistler, either in feeling or execution.

It will be interesting to see what amount of attention the present exhibition will attract in London, comprising as it does work of rare, if eccentric genius. There are seven full-length portraits, of which those of Mr. Leyland, of the artist's mother, and of Thomas Carlyle, are the most striking. The two latter are seated figures, nearly life-size. A line of etchings is ranged round the room; there are also some drawings in chalk, and numerous studies in colour, which, in the absence of a catalogue, we are unable to mention in detail.

But we should like to give the reader—as we may do in a future number—an idea of the effect and arrangement, in a sketch of the little gallery, with its graceful lines and delicate tints. If anyone wishes to realize what is meant by true feeling for colour and harmony—born of the Japanese—let him sit down here some morning, within a few yards of, but in secure shelter

from, the glare of the guardsman's scarlet tunic in the bay window of the club opposite, just out of hearing of Christie's hammer, and just out of sight of the conglomeration of a thousand pictures at the Royal Academy. A "symphony" is usually defined as "a harmony of sounds agreeable to the ear;" here, at 48, Pall-Mall, is a harmony of colour agreeable to the eye.

"Varied British Topics," New York Times, *March 17, 1883.*

"An arrangement in white and yellow" is the latest freak of Mr. Whistler. It is clever, if somewhat affected and impertinent. A room at the Fine Art Society is decorated in white and yellow, (the attendants are dressed in a livery of white and yellow,) and upon the walls are hung a collection of Mr. Whistler's latest etchings, many of which are admirable specimens of the etcher's art, and a few are "mere scratchings." On the private view day the room was crowded to suffocation, and royalty was present. Mr. Whistler presented many of the ladies with white and yellow butterflies. I have been to the gallery several times since, always to find ladies and gentlemen exploding with laughter over the artist's catalogue to his works in which he has published the imaginary criticisms of certain art writers upon this new series of etchings. Mr. Whistler's satire is bright and telling and sufficiently human to excite mirth as well as admiration. The eccentric American evidently enjoys the opposition he meets with, and it is absurd to question his merit. Some of his etchings are as good as his pastels, and one cannot help thinking that he flings in a few bad ones to stimulate the ire of his critical foes. His "arrangement in white and yellow" is very popular, and his catalogue is "selling like wild-fire."

"Notes: Whistler's Criticism in the Art of Painting," Nation 38 *(June 26, 1884).*

—One of the most entertaining features of the London picture season is the regular exhibition of the works of Mr. J. McNeill Whistler, with its strange mixture of wisdom and folly. This year it is called "A Harmony in Flesh-Color and Gray," and consists of the familiar "Notes," "Harmonies," and "Nocturnes," about seventy in number. It is held in a small room in Bond Street, hung with flesh-colored serge, carpeted with gray, and presided over by an elegant attendant in evening dress of the same colors. The pictures themselves are the same as usual—Piccadilly in a fog, bits of sea views, mist always predominating; reclining maidens whose anatomy can be discerned only by the eye of faith; sketches on Dutch and Venetian canals which occasionally raise a doubt whether they have not been inadvertently hung upside down. Half-a-dozen of the seventy are charming, violating none of the laws by which other painters consider themselves bound, and possessing in addition the touch and color peculiar to Mr. Whistler. Before the others, the unenlightened outsider can only stand in the attitude of the man to whom a mystery is shown. Every one will admit, however, that they all come up to the artist's own standard in suggesting no effort, and in not "reeking of the sweat of the brow." With one enormous exception, the largest picture in the exhibition does not measure much more than eighteen inches by a foot, and a good many valuable hints may be got from the manner in which they are framed. The frames are flat wood, without mounts, with one or two plain bevels running round, and they are colored with metal leaf or metallic paints to harmonize with the picture. The favorite tint is Dutch gilt—a kind of buff silver—and after that various tones of copper. A particularly pleasing effect is produced by a delicate little sketch of an old shop in Chelsea, in which there is a good deal of pink, with the paper left white in the background and foreground, and a broad, flat frame of buff silver. Mr. Whistler's harmonies of color are, perhaps, rather more audacious than usual—violet and amber, red and pink, pink and opal—and his cherished "accidents of alliteration," "variations in violet," "a bravura in brown," equally amusing.

William Crary Brownell, "Whistler in Painting and Etching," Scribner's Monthly Magazine *18 (August 1879).*

The qualities of few painters are so distinct, and indeed one is tempted to say aggressive. Every one will perceive in his slightest etching an effectiveness, an impressiveness, a force which may or may not justly be called eccentric, but which it is impossible not to recognize as original. More than almost any other contemporary painter that occurs to one, he seems to have been impressed by something, to have been harder hit than most. Less than any other, perhaps, is he concerned about the environment of an effect. His impression is manifestly always distinct, single and pictorial. It is so far from sophistication that it seems almost unreflective. It is indeed absolutely spontaneous, but it has the air of spontaneity unrevised by any after-thought, as so much of even what is justly to be called spontaneous does not. It is with aspect always and never with meaning that Mr. Whistler is concerned. Nothing can be less exact than to speak of his work as affected. It would be difficult to find a better example of a pure painter, a painter to whom art is so distinct a thing in itself, and so unrelated to anything else. His attitude toward it is as simple as that of the Renaissance painters, and indeed it is method and expression that chiefly distinguish him from these. It is not rare to find a painter who admires this attitude and endeavors his utmost to assume it, whose pictures somehow look like a protest against the encroachment of literature upon the domain of painting, and a vindication of the unliterary character of pictorial art. But nothing could be further from Mr. Whistler than protests or vindications. Nothing can be more foreign to his art than set purposes; the song of a bird is not more absolutely unconscious. Anything like philosophy, anything like introspection, it does not touch; there is far less of the nineteenth century about it than of the sixteenth. And it naturally follows from this that with those subtleties of dialectics such as Couture delighted in—whether art is superior to nature, for example—he does not concern himself at all . . . His unconsciousness is so pure, and sophistication is so opposite to his genius, that he is somehow relieved of the necessity of imagining that he is reproducing a scene. There is nothing perilous for him in the immediate attempt to convey an impression, without referring the observer to any analogue in nature for the grounds of it. This is because—and of how many painters can the same thing be said?—this is because Whistler is not so much enamored of his material as possessed by his ideal. . . . It is his ideal always with which his work is interpenetrated; it is his ideal that interests one in his expression, and not at all his success in rendering either the superficies or the essence of natural objects. He allowed nothing to stand in the way of this. Considerations hostile to this, the neglect of which has earned him his reputation for extravagance and fantasticality, he never in the least heeds . . .

And the nature of his ideal is singularly pure and high. It is this which, after all, finally measures an artist—the character of his ideal, his attitude toward absolute beauty, his conception of what is best in the visible world and the world that is to be divined. What impresses Mr. Whistler most in nature, that is, in the material out of which every artist is to create his picture, is what one may call beautiful picturesqueness. What his imagination creates out of this material at any rate shows an intimate union of both character and poetry that it is rare to find. One of these two elements generally preponderates in the work of most painters. The painter inclines insensibly either toward power or toward charm, or, at least, betrays an endeavor to avoid either what is vapid or what is ugly . . . But in the work of Mr. Whistler it would be difficult to discover a specific leaning in either direction. At first thought, and seeing that his work is never without the presence of character as a distinct force, one is tempted to say of it that it is strong, or, at least, picturesque rather than beautiful . . . At the same time, its character is not character simply, but always character that has a distinct charm. And this is the ideal attitude for a

painter to take; to Mr. Whistler's essential attitude, at all events, it is impossible to object. No better illustration of this could be found than "The White Girl" . . . , though, indeed, there is not an etching of Mr. Whistler's that does not more or less pointedly illustrate it. "The White Girl" is certainly a lovely picture, but its loveliness has a marked individuality. Nothing could be more delightful than the simplicity and delicacy of line and hue of this figure, nothing more graceful than her attitude, or more subtly charming than the broad harmonies worked out by the dark hair and the lily, the white drapery, and the soft fur upon which she stands. On the other hand, no one can fail to note the sense of character which pervades its loveliness, and to observe how its individuality is quite as strong as its beauty is charming. Indeed, one feels that it is an idealized portrait, quite as much as that it is ideal at all . . .

The "Arrangement in Black and Gray" . . . emphasizes what has just been said. It is a portrait of the painter's mother, and very similar in idea and treatment to that of Mr. Carlyle, exhibited in the first Grosvenor Gallery Exhibition. The title is felicitous, and directs attention to the pictorial purpose of the portrait, which is however evident enough perhaps. How far this is removed from the portraiture one commonly meets with it is not difficult to appreciate . . . Mr. Whistler, in the portrait of his mother,—as in that of Mr. Carlyle—does not seem to have had a "sitter" at all. The portraits are pictures; the pictorial quality is as prominent as the portraiture, and there is an exact equipoise between the two. In a grave dignity not without sensibility, a quiet and almost severe grace that is full of character, it is difficult to conceive of a more charming union of portraiture and picturesqueness. It should task all Mr. Ruskin's logical dexterity to believe the painter of a work so dignified and yet so poetic, capable of flinging a pot of paint in the public's face out of pure coxcombry; and yet it seems a very simple matter to see the same mind and hand in this work that are visible in the Nocturnes and Symphonies— the same delight in aspect, the same singleness of impression, the same heedlessness of environment and machinery, the same union of chaste poetry and strong character.

These qualities explain Mr. Whistler's undisputed excellence as an etcher. An etcher is logically an impressionist,—that is to say, as much of an impressionist as it is safe to call Mr. Whistler,—since an etching is essentially a memorandum. This is not true, of course, in a cast-iron way, but generally and largely it is true, as it is of a water-color or of anything that is chiefly dependent upon black and white values. And yet the qualities which an etching possesses besides its quality of artistic memoranda—its tone, its beauty of line and variety of light and shade, its pictorial qualities generally,—are what give it value after its distinctive quality as etching has been secured. And it is for the infallible union of these pictorial qualities with the essential quality of etching that Mr. Whistler's etchings are conspicuously admirable among the most admirable etchings, modern or old; in other words, they are always pictorial and always a memorandum of the subject . . . One can always discern in a plate of his the fitness of his subject for the especial treatment it has received,—the reason, for example, of his etching rather than painting those Thames objects which are visible from his Chelsea windows. He seems never to hesitate about the proper material expression for any of his widely various conceptions; and so when he etches, his plates have first of all the distinctive quality of etching—its quality of artistic memoranda; but they have also the pictorial qualities of his genius as prominently as his portraits or his landscapes . . .

If there is one rule, however, which is without exceptions, it is that one has always the defects of one's qualities. Mr. Whistler certainly has the limitations which the traits heretofore enumerated suggest. His manner and method are not commonplace; his artistic spirit is not unlike the true pagan spirit—not unlike the spirit of antique art before the Middle Age extin-

guished it, and of early modern art, after the monks had done with it; and his ideal is an ideal which includes both poetry and picturesqueness. But a painter of whom one's first thought is that he is not commonplace, is almost sure to seem at least tinctured with evident protestantism against conventionality; no one can utterly get rid of his environment, and be quick with the inspiration of other times and conditions; and the more comprehensive one's ideal, the greater danger there is that his art will not touch the highest point in any one direction. Mr. Whistler does sometimes seem to shun commonplace with violence . . .

And no one—certainly no one so sensitive and impressionable as Mr. Whistler—can utterly free himself from the influences around him, from feeling them keenly, and from resenting them indignantly, if they displease him. One may believe that the "Nocturne in Black and Gold" is more *outré* than it would have been if a protest against the conventionalities of Mr. Burne-Jones and the other advocates of "finish" had not insensibly influenced the painter's brush. And it is reasonable that his surroundings should affect him, not only in this way, but in a less positive, less obvious, and less traceable way. A painter living in Chelsea cannot get away from London and the nineteenth century entirely; and if his spirit be essentially opposed to the spirit of London and the age of steam, even to its happier manifestations, it will inevitably result that, in some way or other, his work will be limited . . . Spite of the infinite variety of its manifestations, the artistic spirit is everywhere, and at all times, essentially the same, it is true; but how its manifestations are warped and trammeled in some conditions, because of the inability of the artist either to neglect his surroundings or adapt himself to their stream of tendency! Mr. Whistler, admirable as his artistic spirit is, does somehow suggest these reflections. Their applicability to him may be slight; such questions are subtle, surely; but it is to be suspected that they have some real applicability to him; that the absence of any great work, any work of unmistakably large importance by him, is due to his inability to be either a child of his century or a pure pagan—to the circumstance that he is, in familiar language, more or less of a round peg in a square hole . . .

. . . But how delightful it is to reflect, that though he is not something other than he is—something which, with his traits, he could never become—nevertheless he is precisely what he is: perhaps the most typical *painter* and the most absolute artist of the time. That positive as is his delight in color, and great as is his success with it, . . . admirable as is his sense of form, as all his etchings show, skillful as is his composition, it is after none of these things, nor the sum of them, that he especially seeks, but after something of which they are merely the phenomena and attributes, something for which we have no other word than the Ideal.

N.N. [Elizabeth R. Pennell], "Mr. Whistler's Triumph," Nation 54 (April 14, 1892).

At the present moment all the world is rushing to see the exhibition of Mr. Whistler's paintings . . .

To those who look only for eccentricity from Mr. Whistler the show must be a disappointment. There are none of the yellow canopies and yellow walls, none of the fluttering butterflies and original schemes of decoration which his name suggests. The pictures, many in old and tarnished frames, hang on Messrs. Boussod & Valadon's red walls as at other times do those of the ordinary exhibitor, and the visitor looks at them from the upholstered sofa of commonplace commerce. The one old Whistler touch is in the catalogue, in which he has collected, as of yore, choice criticisms by men of note who ridiculed him once but to turn the laugh now against themselves. The device lacks novelty, but just after his triumph in France it is natural, and appropriate too, that he should have his jest again at the expense of the blundering English

critics who mistook the master for a mountebank. Ruskin's teachings are already obsolete, save in the provinces; Whistler's power has grown with the years.

But to those who delight in the artistic qualities of his work, in its beauty of color and form, its truth to the most subtle effects of nature, its perfect impressionism in the best sense of the word, the exhibition is almost inexhaustible in its interest. It is probably the most representative he has ever given . . . the importance of this new exhibition is less in any special contributions to it than in the estimate which, as a whole, it gives of Mr. Whistler's true rank as an artist and of his influence over the younger generation of painters. There is nothing more striking about the collection than what seems, as one first goes through the gallery, its intensely modern character. With the Champ de Mars in one's mind, with the latest efforts of the New English Art Club fresh in one's memory, even not forgetting Monet's forty impressions of a haystack, Mr. Whistler's work might be thought the very latest outcome of the most modern movement in art. The fact is, that Mr. Whistler was a quarter of a century or more in advance of his contemporaries: 1855 is the date on one canvas, the greater number belong to the sixties. He was an Impressionist almost before the name impressionism in art had been heard. The world wondered when Monet a year ago showed those forty haystacks under forty atmospheric conditions, is wondering now at his almost as many treatments of a poplar tree to be seen at Durand-Ruel's. But what are most of Mr. Whistler's Nocturnes but impressions of the river as he watched it from his Chelsea window, looking over to the plumbago works and the church spire and up to old Battersea Bridge? . . .

. . . I have heard it argued that it was because he was so determined to force the public to see just those qualities which he considers most essential in art, that in his Nocturnes he has so often sacrificed all others to them. It seems unlikely to me that Mr. Whistler ever had the public— Carlyle's majority—sufficiently at heart to consider them at all. But had he been charitably inclined . . . he could not have done better than to exhibit, as he is doing now, those of his earlier canvases which are strongest in color and most filled with detail. At these no one can look and continue to believe that it was to conceal his weakness of drawing and indifference to color that he recorded in paint his impressions of twilight and night when form is vague and indistinct and color subdued. Pictures like the "Little White Girl," with the exquisitely worked out geraniums against the muslin gown; the "Gold Screen," with the girl in sumptuous Japanese robes, Japanese fans at her feet; "The Lange Leizen—of the Six Marks," an arrangement of beautiful rich Japanese drapery and china; "The Music-Room," with the old-fashioned furniture and dress and the elaborate design on the window curtains reflected in the mirror; "The Balcony"— pictures like these are distinguished by a masterly rendering of detail which few of the old Dutchmen could rival, much less surpass, a beauty of color which the Venetians might have envied. And it is because he can, when he chooses, paint like this, that Mr. Whistler is qualified to create his Nocturnes, his Symphonies, his Arrangements . . . It was the apparent simplicity of his methods, the supposed ease with which the work was done, that so disturbed and puzzled the critics—the fear that he was making a jest of them that led them to lose their tempers and seek to overwhelm him with the storm of their abuse through which he has steered his course so gayly. But the last twenty or thirty years have proved that what seemed child's play to the uninitiated was the most difficult problem to the student, a problem to be solved only by genius. And perhaps the most curious as well as interesting fact in connection with the Goupil Gallery exhibitions is the way papers and critics whose sayings are quoted in the catalogue have, with a few exceptions, veered around and consented to recognize something besides the jester in Mr. Whistler. For his next catalogue he will not have so many choice quotations . . .

It should not be forgotten in America that Mr. Whistler is an American of Americans; it may therefore be appropriately asked, What has America done for him? It has treated him with—if possible—even more ignorance and coldness than England; this, of course, coming from the desire of the Anglomaniac to out-English the English. It is true that the "White Girl" is, or was, in the Metropolitan Museum; it is also true that the portrait of his mother went travelling around America, only to be bought in the end for the gallery which has the best chance of assuring immortality to the artists represented within its walls.[14] There is in Boston, I believe, at the present moment a public building in process of decoration by Americans. Has Mr. Whistler, the greatest decorator America has ever produced, been asked to give distinction and importance to what otherwise may be only a striking failure? If he has not—and I am almost sure this is the case—it is at least not too late for Americans at once to endeavor to obtain from him one, if no more, of the few examples of his work still in his possession, which, however, before long may be distributed among galleries everywhere except in his native land.

JOHN SINGER SARGENT, MAN OF THE WORLD

One of the most successful and famous portrait painters of the late nineteenth century, John Singer Sargent from one point of view was only nominally American, if that. Born in Florence to expatriate American parents, he studied in the atelier of the progressive Carolus-Duran in Paris, and from the moment he entered the public realm his brilliant, dashing, unconventional style attracted attention. With his early success in Paris neutralized by his controversial 1884 portrait Madame X, *Sargent rehabilitated his career in England and went on to paint the rich and famous on both sides of the Atlantic. His identity and affiliations proved slippery in his own time and in ours; he is claimed as an American painter and as an English painter alike.*

The colorful letter written by Sargent's distant cousin Ralph Curtis gives a firsthand report on the scandal and mockery that swirled around the portrait, which represented notorious professional beauty Virginie Amélie Gautreau wearing thick makeup and a form-fitting black velvet gown with a plunging neckline and slipped shoulder strap. Having seriously miscalculated the reception of his ambitious painting, Sargent is deeply disappointed and hurt, but, as Curtis notes, the artist proudly refuses to compromise and withdraw from public view what he believes to be his masterpiece.

Henry James's thoughtful article on Sargent raises many of the issues that would continue to haunt Sargent criticism. James launches into the key question at the outset, asking if Sargent is in fact an American painter at all. In the very next breath, he aligns Sargent with the new, Parisian-centered cosmopolitanism. The author's evident uneasiness in the face of Sargent's effortless facility finds expression later in critics' tendency to see his work as a brilliant but superficial conjuring act—or as a penetrating analysis of the secret self.

Although it includes one glaring inaccuracy—Sargent's marriage—Evan Mills's character sketch describes the artist in more discerning terms as a type of the modern cosmopolitan man, one who is at home everywhere and nowhere and who as a conse-

[14] The Musée du Luxembourg in Paris had acquired Whistler's *Arrangement in Gray and Black: Portrait of the Painter's Mother* (1871) in 1891.

quence remains "unattached to anything." Because of this detachment, Sargent's art lacks human sympathy and kindness. Considerably more emphatic is the opinion of the painter and historian Samuel Isham, who views Sargent as an absolute materialist and objective naturalist who pitilessly exposes the ugly truths his sitters attempt in vain to hide.

Ralph Curtis to Daniel and Ariana Curtis, May 1884, in Evan Charteris, John Sargent *(New York: Charles Scribner's Sons, 1927).*

My Dear People,

Your paper will be ordered this a.m. Yesterday the birthday or funeral of the painter Scamps (John Sargent). Most exquis. weather. Walked up Champs E[lysées] chestnuts in full flower and dense mob of "tout Paris" in pretty clothes, gesticulating and laughing, slowly going into the Ark of Art. In 15 mins. I saw no end of acquaintances and strangers, and heard everyone say "où est le portrait Gautreau?" "Oh allez voir ça"—John covered with dust stopped with his trunks at the club the night before and took me on to his house where we dined. He was very nervous about what he feared, but his fears were far exceeded by the facts of yesterday. There was a grande tapage [uproar] before it all day. In a few minutes I found him dodging behind doors to avoid friends who looked grave. By the corridors he took me to see it. I was disappointed in the colour. She looks decomposed. All the women jeer. Ah voilà "la belle!" "Oh quelle horreur!" etc . . . All the a.m. it was one series of bons mots, mauvaises plaisanteries and fierce discussions. John, poor boy, was navré [heartbroken]. We got out a big déjeuner at Ledoyens of a dozen painters and ladies and I took him there. In the p.m. the tide turned as I kept saying it would. It was discovered to be the knowing thing to say "étrangement épatant [strangely striking]!" . . . Mde. Gautreau and mère came to his studio "bathed in tears." I stayed them off but the mother returned and caught him and made a fearful scene saying "Ma fille est perdue—tout Paris se moque d'elle. Mon genre sera forcé de se battre. Elle mourira de chagrin" etc. [My daughter is lost—all Paris is making fun of her. My people will be forced to fight. She will die of shame]. John replied it was against all laws to retire a picture. He had painted her exactly as she was dressed, that nothing could be said of the canvas worse than had been said in print of her appearance dans le monde etc. etc. Defending his cause made him feel much better. Still we talked it all over till 1 o'clock here last night and I fear he has never had such a blow. He says he wants to get out of Paris for a time. He goes to Eng. In 3 weeks.

Henry James, "John S. Sargent," Harper's New Monthly Magazine *75 (October 1887).*

I was on the point of beginning this sketch of the work of an artist to whom distinction has come very early in life by saying, in regard to the degree to which the subject of it enjoys the attention of the public, that no American painter has hitherto won himself such recognition from the expert; but I find myself pausing at the start as on the edge of a possible solecism. Is Mr. Sargent in very fact an American painter? The proper answer to such a question is doubtless that we shall be well advised to claim him, and the reason of this is simply that we have an excellent opportunity. Born in Europe, he has spent his life in Europe, but none the less the burden of proof would rest with those who should undertake to show that he is a European. Moreover, he has even on the face of it this great symptom of an American origin, that in the line of his art he might easily be mistaken for a Frenchman. It sounds like a paradox, but it is a very simple truth, that when to-day we look for "American art" we find it mainly in Paris. When we find it out of Paris, we at least find a great deal of Paris in it . . .

From the time of his first successes at the Salon he was hailed, I believe, as a recruit of high value to the camp of the Impressionists, and to-day he is for many people most conveniently pigeon-holed under that head. It is not necessary to protest against the classification if this addition always be made to it, that Mr. Sargent's impressions happen to be interesting . . .

His work has been almost exclusively in portraiture, and it has been his fortune to paint more women than men . . . The most brilliant of all Mr. Sargent's production is the portrait of a young lady, the magnificent picture which he exhibited in 1881; and if it has mainly been his fortune since to commemorate the fair faces of women, there is no ground for surprise at this sort of success on the part of one who had given so signal a proof of his having the secret of the particular aspect that the contemporary lady (of any period) likes to wear in the eyes of posterity. Painted when he was but four-and-twenty years of age, the picture by which Mr. Sargent was represented at the Salon of 1881 is a performance which may well have made any critic of imagination rather anxious about his future. In common with the superb group of the children of Mr. Edward Boit, exhibited two years later, it offers the slightly "uncanny" spectacle of a talent which on the very threshold of its career has nothing more to learn. It is not simply precocity in the guise of maturity—a phenomenon we very often meet, which deceives as only for an hour; it is the freshness of youth combined with the artistic experience, really felt and assimilated, of generations . . .

The picture has this sign of productions of the first order, that its style clearly would save it, if everything else should change—our measure of its value of resemblance, its expression of character, the fashion of dress, the particular associations it evokes. It is not only a portrait, but a picture, and it arouses even in the profane spectator something of the painter's sense, the joy of engaging also, by sympathy, in the solution of the artistic problem. There are works of which it is sometimes said that they are painters' pictures (this description is apt to be intended invidiously), and the production of which I speak has the good fortune at once to belong to this class, and to give the "plain man" the kind of pleasure that the plain man looks for.

The young lady, dressed in black satin, stands upright, with her right hand bent back, resting on her waist, while the other, with the arm somewhat extended, offers to view a single white flower. The dress, stretched at the hips over a sort of hoop, and ornamented in front, where it opens on a velvet petticoat, with large satin bows, has an old-fashioned air, as if it had been worn by some demure princess who might have sat for Velasquez. The hair, of which the arrangement is odd and charming, is disposed in two or three large curls fastened at one side over the temple with a comb. Behind the figure is the vague faded sheen, exquisite in tone, of a silk curtain, light, undefined, and losing itself at the bottom. The face is young, candid, peculiar, and delightful. Out of these few elements the artist has constructed a picture which it is impossible to forget, of which the most striking characteristic is its simplicity, and yet which overflows with perfection. Painted with extraordinary breadth and freedom, so that surface and texture are interpreted by the lightest hand, it glows with life, character, and distinction, and strikes us as the most complete—with one exception perhaps—of the author's productions. I know not why this representation of a young girl in black, engaged in the casual gesture of holding up a flower, should make so ineffaceable an impression, and tempt one to become almost lyrical in its praise; but I well remember that, encountering the picture unexpectedly in New York a year or two after it had been exhibited in Paris, it seemed to me to have acquired an extraordinary general value, to stand for more artistic truth than it would be easy to declare, to be a masterpiece of color as well as of composition, to possess much in common with a Velasquez of the first order, and to have translated the appearance of things into the language of painting with equal facility and brilliancy . . .

Two years before he exhibited the young lady in black, in 1879, Mr. Sargent had spent several months in Spain, and here, even more than he had already been, the great Velasquez became the god of his idolatry . . . It is evident that Mr. Sargent fell on his knees, and that in this attitude he passed a considerable part of his sojourn in Spain . . . We can fancy that . . . Mr. Sargent . . . invokes him as a patron saint. This is not, in my intention, tantamount to saying that the large canvas representing the contortions of a dancer in the lamp-lit room of a *posada,* which he exhibited on his return from Spain, strikes me as having come into the world under the same star as those great compositions of Velasquez which at Madrid alternate with his royal portraits. This singular work, which has found a somewhat incongruous home in Boston, has the stamp of an extraordinary energy and facility—of an actual scene, with its accidents and peculiarities caught, as distinguished from a composition where arrangement and invention have played their part. It looks like life, but it looks also, to my view, rather like a perversion of life, and has the quality of an enormous "note" or memorandum, rather than of a representation. A woman in a very voluminous white silk dress and black mantilla is pirouetting in the middle of a dusky room, to the accompaniment of her own castanets, and that of a row of men and women who sit in straw chairs against the white-washed wall, and thrum upon guitar and tambourine, or lift other castanets into the air. She appears almost colossal, and the twisted and inflated folds of her long dress increase her volume. She simpers, in profile, with a long chin, while she slants back at a dangerous angle, and the lamp-light (it proceeds from below, as if she were on a big platform) makes a strange play in her large face. In the background the straight line of black-clad, black-hatted, white-shirted musicians projects shadows against the wall, on which placards, guitars, and dirty finger-marks display themselves. The merit of this production is that the air of reality is given in it with remarkable breadth and boldness; its defect it is difficult to express, save by saying that it makes the spectator vaguely uneasy and even unhappy—an accident the more to be regretted as a lithe, inspired female figure, given up to the emotion of the dance, is not intrinsically a displeasing object. "El Jaleo" sins, in my opinion, in the direction of ugliness, and, independently of the fact that the heroine is circling round incommoded by her petticoats, has a want of serenity.

This is not the defect of the charming, dusky, white-robed person who, in the Tangerine subject exhibited at the Salon of 1880 (the fruit of an excursion to the African coast at the time of the artist's visit to Spain), stands on a rug, under a great white Moorish arch, and from out of the shadows of the large drapery, raised pentwise by her hands, which covers her head, looks down, with painted eyes and brows showing above a bandaged mouth, at the fumes of a beautiful censer or chafing-dish placed on the carpet. I know not who this stately Mohammedan may be, nor in what mysterious domestic or religious rite she may be engaged; but in her muffled contemplation and her pearl-colored robes, under her plastered arcade, which shines in the Eastern light, she is beautiful and memorable. The picture is exquisite, a radiant effect of white upon white, of similar but discriminated tones.

In dividing the honor that Mr. Sargent has won by his finest work between the portrait of the young lady of 1881 and the group of four young girls which was painted in 1882, and exhibited, with the success it deserved, the following year, I must be careful to give the latter picture not too small a share. The artist has done nothing more felicitous and interesting than this view of a rich, dim, rather generalized French interior (the perspective of a hall with a shining floor, where screens and tall Japanese vases shimmer and loom), which encloses the life and seems to form the happy play-world of a family of charming children. The treatment is eminently unconventional, and there is none of the usual symmetrical balancing of the figures in

the foreground. The place is regarded as a whole; it is a scene, a comprehensive impression; yet none the less do the little figures in their white pinafores (when was the pinafore ever painted with that power and made so poetic?) detach themselves, and live with a personal life. Two of the sisters stand hand in hand at the back, in the delightful, the almost equal, company of a pair of immensely tall emblazoned jars, which overtop them, and seem also to partake of the life of the picture; the splendid porcelain and the aprons of the children shine together, and a mirror in the brown depth behind them catches the light. Another little girl presents herself, with abundant tresses and slim legs, her hands behind her, quite to the left; and the youngest, nearest to the spectator, sits on the floor and plays with her doll. The naturalness of the composition, the loveliness of the complete effect, the light, free security of the execution, the sense it gives us as of assimilated secrets and instinct and knowledge playing together—all this makes the picture as astonishing a work on the part of a young man of twenty-six as the portrait of 1881 was astonishing on the part of a young man of twenty-four.

It is these remarkable encounters that justify us in writing almost prematurely of a career which is not yet half unfolded. Mr. Sargent is sometimes accused of a want of "finish," but if finish means the last word of expressiveness of touch, "The Hall with the Four Children," as we may call it, may stand as a permanent reference on this point. If the picture of the Spanish dancer illustrates, as it seems to me to do, the latent dangers of the Impressionist practice, so this finer performance shows what victories it may achieve. And in relation to the latter I must repeat what I said about the young lady with the flower, that this is the sort of work which, when produced in youth, leads the attentive spectator to ask unanswerable questions. He finds himself murmuring, "Ay, but what is left?" and even wondering whether it is an advantage to an artist to obtain early in life such possession of his means that the struggle with them, the discipline of *tâtonnement,* ceases to exist for him. May not this breed an irresponsibility of cleverness, a wantonness, an irreverence—what is vulgarly termed a "larkiness"—on the part of the youthful genius who has, as it were, all his fortune in his pocket? Such are the possibly superfluous broodings of those who are critical, even in their warmest admirations, and who sometimes suspect that it may be better for an artist to have a certain part of his property invested in unsolved difficulties. When this is not the case, the question with regard to his future simplifies itself somewhat portentously. "What will he do with it?" we ask, meaning by the pronoun the sharp, completely forged weapon. It becomes more purely a question of responsibility, and we hold him altogether to a higher account. This is the case with Mr. Sargent; he knows so much about the art of painting that he perhaps does not fear emergencies quite enough, and that having knowledge to spare, he may be tempted to play with it and waste it. Various, curious, as we have called him, he occasionally tries experiments which seem to arise from the mere high spirits of his brush, and runs risks little courted by the votaries of the literal, who never expose their necks to escape from the common. For the literal and the common he has the smallest taste; when he renders an object into the language of painting, his translation is a generous paraphrase . . .

What shall I say of the remarkable canvas which, on the occasion of the Salon of 1884, brought the critics about our artist's ears, the already celebrated portrait of "Madame G."? It is an experiment of a highly original kind, and the painter has had in the case, in regard to what Mr. Ruskin would call the "rightness" of his attempt, the courage of his opinion. A beauty of beauties, according to Parisian fame, the lady stands upright beside a table on which her right arm rests, with her body almost fronting the spectator, and her face in complete profile. She wears an entirely sleeveless dress of black satin, against which her admirable left arm detaches itself;

the line of her harmonious profile has a sharpness which Mr. Sargent does not always seek, and the crescent of Diana, an ornament in diamonds, rests on her exquisite head. This work had not the good fortune to please the public at large, and I believe it even excited a kind of unreasoned scandal—an idea sufficiently amusing in the light of some of the manifestations of the plastic effort to which, each year, the Salon stands sponsor. The picture will always remain interesting to those who follow the artist's career and note its different stages, even though they may not clearly see the light by which some portions of it are painted. It is a work to take or to leave, as the phrase is, and one in regard to which the question of liking or disliking comes promptly to be settled. It is full of audacity of experiment and science of execution; it has singular beauty of line, and certainly in the body and arms we feel the pulse of life as strongly as the brush can give it.

Two of Mr. Sargent's recent productions have been portraits of American ladies whom it must have been a delight to paint; I allude to those of Lady Playfair and Mrs. Henry White, both of which were seen in the Royal Academy of 1885, and the former subsequently in Boston, where it abides. These things possess, largely, the quality which makes Mr. Sargent so happy as a painter of women—a quality which can best be expressed by a reference to what it is not, to the curiously literal, prosaic, Philistine treatment to which, in the commonplace work that looks down at us from the walls of almost all exhibitions, delicate feminine elements have evidently so often been sacrificed . . . In the Royal Academy of 1886 Mr. Sargent was represented by three important canvases, all of which reminded the spectator of how much the brilliant effect he produces in an English exhibition arises from a certain appearance that he has of looking down from a height—a height of cleverness, a kind of giddiness of facility—at the artistic problems of the given case. Sometimes there is even a slight impertinence in it; that, doubtless, was the impression of many of the people who passed, staring, with an ejaculation, before the triumphant group of the three Misses V . . . Works of this character are a genuine service; after the short-lived gibes of the profane have subsided, they are found to have cleared the air. They remind people that the faculty of taking a fresh, direct, independent, unborrowed impression is not altogether lost.

In this very rapid review I have accompanied Mr. Sargent to a very recent date. If I have said that observers encumbered with a nervous temperament may at any moment have been anxious about his future, I have it on my conscience to add that the day has not yet come for a complete extinction of this anxiety. Mr. Sargent is so young, in spite of the place allotted to him in these pages, so often a record of long careers and uncontested triumphs, that, in spite also of the admirable works he has already produced, his future is the most valuable thing he has to show. We may still ask ourselves what he will do with it, while we indulge the hope that he will see fit to give successors to the two pictures which I have spoken of emphatically as his best. There is no greater work of art than a great portrait—a truth to be constantly taken to heart by a painter holding in his hands the weapon that Mr. Sargent wields. The gift that he possesses he possesses completely—the immediate perception of the end and of the means. Putting aside the question of the subject (and to a great portrait a common sitter will doubtless not always conduce), the highest result is achieved when to this element of quick perception a certain faculty of lingering reflection is added. I use this name for want of a better, and I mean the quality in the light of which the artist sees deep into his subject, undergoes it, absorbs it, discovers in it new things that were not on the surface, becomes patient with it, and almost reverent, and, in short, elevates and humanizes the technical problem.

Evan Mills, "A Personal Sketch of Mr. Sargent," World's Work 7 *(November 1903).*

Mr. John S. Sargent is a typical example of the modern cosmopolitan man, the man whose habits of thought and life make him at home everywhere, and whose training has been such as to preclude the least touch of chauvinism. Such a man has become possible only during the last fifty years, and then only in the case of an occasional American. For the man born and bred in Europe of European parents must of necessity be influenced by national feelings that can not but make impossible any true detached cosmopolitanism. In the case of an American born and bred abroad, the only feelings that can possibly arise are those that come of cold selection; he is unattached to anything, and though living among and with the different European peoples, he never becomes one with them in sentiment or local bias. It would be impossible for one of the European States to produce such a man as has come from the happy combination of American birth and wholly European training.

Mr. Sargent, although born of American parents and warmly claimed as an American in this country, has none of the traits that one would ordinarily look for as indicative of his nationality. He has spent in all only about a year in this country, having come here for the first time when about twenty years old. Born in Florence, first taught to speak in German, educated in Italy, France and Germany having studied art in Italy, France and Spain, and having married and settled permanently in England, he is thoroughly cosmopolitan. Judging from his speech, manner, gait, and the countless little tricks peculiar to each country, Mr. Sargent appears to be a well-bred Englishman. He is phlegmatic, and anything but brilliant in conversation, lacking totally the verve and quickness of adaptability that make the typical American interested and interesting anywhere and in any company. Bashful and retiring, he has no presence, and cannot collect his thoughts when suddenly called upon. Physically, also, he would pass for an Englishman, being thick in the shoulders, tall, florid in complexion, and bearing the marks about his eyes of full living . . .

Perhaps the thing that strikes most people in his work is what one may call the touch of malice. This was extremely prominent in his student days, when he was in the habit of drawing animals that were the greatest possible likeness of the people he saw about him in the cafés and the theatres. Though this feeling is still to be noticed in his work, it should not be thought to be the result of ill-will or of personal feeling, for, from the minute that a person has assumed the pose, Sargent loses all interest in him as a person, and becomes wrapped up in the possibilities that he presents for artistic presentation.

This faculty of absolute detachment is perhaps the most marked trait of Sargent, the man. A tremendous worker, having on his recent trip painted more portraits than he spent weeks in this country, and having also in the same time placed and given the final touches to his decorations in the Boston Library, he lives and thinks only for his art, not caring overmuch for reading, and not being at all interested in society. In fact, his whole attitude is that of the curious and deeply interested observer of external appearances. Highly intellectual, neither his work nor his manner give much evidence of sympathy, kindliness or heartiness. This was noticeable in his youth, when he was thought to be rather romantic, for even then when a great reader his favorites were Shelley and Baudelaire, both of whom are more remarkable for their technical qualities than for any great definite human sympathy. This detached intellectuality he carries even into his recreation, for when tired to exhaustion by a day's work he seeks rest in playing Chopin or Beethoven by the hour.

Mr. Sargent is perhaps the most notable instance in our day of the man whose latent possi-

bilities have been steadily fostered in the way that was ultimately to bring him to success. Born of rich and cultivated gentlefolk, and given a sympathetic and cosmopolitan education, he has never known worry in the way that so many painters have known it, and he has had nothing to stand in the way of his development. Backed by fortune, culture and luck, by hard and devoted work toward a single end, he has had the good or the bad fortune, as one may look at it, to have no personality and no history aside and distinct from that of his paintings.

Samuel Isham, The History of American Painting *(New York: MacMillan Co., 1905)*.

We wonder whether he cared at all for the people he painted, either for their past or future, or for anything except the moment that they stood before him twiddling their watch-chains or spreading their fans. Of that moment, though, we have the absolute record, and a terrible one it is sometimes, for the artist, without illusions himself, is pitiless for those of his sitters. If a lady thinks to renew by artifice the freshness of her youth, she appears not with the roses and lilies of nature on her face, but with rouge and pearl powder manifest and unmistakable; if the statesman bends his brow and puffs up his chest, he is displayed not as a thunderbolt of debate, but as a pompous ass. An adoring family wails that instead of their young goddess they have been given a picture of a Gibson girl, and magnates of all sorts hear with bewilderment the inferences as to their personal characters which an enthusiastic public draws from their counterfeit presentments . . .

And in these pictures, even the most terrible of them, there is not a grain of malice. The features are painted as dispassionately as the necktie or the boots. Nothing is caricatured or exaggerated, but the people are alive and demand our judgment as real people. Nor is that judgment usually hostile; on the contrary most of the portraits awaken in us conflicting, but on the whole favorable, emotions, and there are many beautiful women and high-bred men whom it is a pleasure to have met . . . even in the soft outlines of childhood there is yet the discrimination of personal character, the minute details that make the individual different from all the rest of the world.

This display of character is the intellectual quality in Sargent's work to which all of his technical statements are subordinated. When an artist has mastered the meaning of a face, he may try to paint it dispassionately and exactly, but the inner meaning will be more vivid to the ordinary man in the picture than in the flesh, and no one, not even the greatest masters of the past, has read ordinary, everyday character as minutely and completely as Sargent. He is not profound. He does not touch on the eternal mysteries or try to lay bare the soul. He is incurious as to whether his sitters have souls or what will be their future state; but as to this present commonplace world of business and pleasure he is full of the most minute and valuable information. He tells whether they are pompous or cordial or shy, if they have or have not a sense of humor, whether they are nervous or stolid, sensible or eccentric, kindly or malicious. He diagnoses their health, shows their degree of education, displays the style of their establishment, and suggests approximately their annual expenditure.

On these and on a thousand other points he is rarely at fault, and some of the deductions drawn from his portraits by utter strangers are amazing in accuracy. His portraits of public men are historical documents as illuminative as the most elaborate memoirs, and it is not too much to say that the political situation in Europe would be clearer to us to-day if he had painted the Czar . . .

This penetrative analysis of character is not confined to those whose characters are important or distinguished. It is lavished on all alike and even on inanimate things, the silks and velvets, the furniture and bric-à-brac are all eloquent. A gleam of gold in the shadow has the dusty

tone that proclaims that it is old gilding even though its form is indistinguishable . . . The personality of a room, of a place, is given absolutely and unexpectedly . . .

Sargent's work has its limitations, but they are largely set by its qualities. If a transcript of life is to be made vivid, with all its changing effects struck instantly upon the canvas, there can be no brooding and musing and dreaming. The surface of the paint is smooth and flowing, the color is brilliant and pure, but neither have that absolute and subtle perfection that comes when an artist holds a canvas by him, looks at it long and often, searching it, adding a touch here and a glaze there with loving care until all fuses into unity . . .

With a certain temperament it is quite permissible to dislike his work, as it is permissible to dislike the work of Rubens; but with all limitations and reserves made, he has talents manifest and unmistakable that give him securely his position as the first portrait painter since Reynolds and Gainsborough.

NEW WOMEN IN ART

WOMEN SCULPTORS IN THE ETERNAL CITY

In the first half of the nineteenth century a small number of American women had built successful or not-so-successful careers in art (see "Lilly Martin Spencer: Making It in New York," chapter 4), but in the Gilded Age burgeoning numbers entered the field. The number of women attending art schools (including the recently established Cooper Union School of Design for Women in New York and the Philadelphia School of Design for Women) and academies swelled dramatically. New opportunities in the fast-growing fields of illustration, design, and advertising art offered alternatives to the more traditional practice of easel painting or (for the persistent few) sculpture. By the turn of the century, the proportion of women in all branches of the American art profession stood at nearly 45 percent. Yet higher numbers were no guarantee of greater visibility or success. Largely excluded from male social networks, women artists struggled to organize their own communities and fashion professional identities. Those who succeeded did so against the odds and through considerable personal sacrifice. Lack of representation and publicity spelled obscurity for many more.

Against such odds, a flourishing colony of women sculptors congregated around the charismatic American actress Charlotte Cushman, including the Americans Harriet Hosmer, Emma Stebbins, Anne Whitney, Vinnie Ream Hoxie, and Edmonia Lewis. Attracted to Rome because of its rich classical heritage and the availability of skilled stonecutters, the women also found there a degree of freedom impossible to realize in America. In particular, Hosmer broke the mold of decorous Victorian femininity; her mannish dress and tomboy manner shocked conventional American visitors. Hosmer and her colleagues enjoyed considerable success in a medium hitherto considered a strictly masculine preserve. Specializing in ideal, historical, or allegorical figures, as well as portraiture, they enjoyed steady patronage, received important commissions for public statuary and monuments, and gained international reputations; all were well represented at the 1876 Centennial in Philadelphia.

As abundantly documented in Henry James's William Wetmore Story and His Friends, *male sculptors and their colleagues in Rome found the circle of what James dubs the "white, marmorean flock" threatening and even repulsive. Undaunted by*

withering male condescension, Hosmer in her Atlantic Monthly *article rebuts wide-spread, damaging rumors that (because of the purportedly inherent limitations of her sex) her work is not original. Reminding the reader that all sculptors, male and female, rely on the skills of assistants to carry their works to full realization, Hosmer staunchly vindicates her standing as a creative artist. Finally, "H.W." (Henry Wreford) attempts a measured assessment of work by several "lady-artists" in Rome, praising Hosmer's cleverness and finding Lewis a sympathetic figure while patronizingly reducing her to the level of crude stereotype.*

Henry James, William Wetmore Story and His Friends, *vol. 1 (Boston: Houghton, Mifflin, 1903).*

W. W. Story to J. R. Lowell.

ROME, *February 11th,* 1853.

If one could get rid of the ghosts of old times would it on the whole be an advantage?

... "Apropos of which you are creating at this time a furore at 28 Corso ... among the emancipated females who dwell there in heavenly unity; namely, the Cushman, Grace Greenwood, H., S., and Co ... And for fear I should forget them, let me tell you of them. They live all together under the superintendence of W., who calls them Charlotte, Hatty, and so on, and who dances attendance upon them everywhere, even to the great subscription ball the other evening. Hatty takes a high hand here with Rome, and would have the Romans know that a Yankee girl can do anything she pleases, walk alone, ride her horse alone, and laugh at their rules. The police interfered and countermanded the riding alone on account of the row it made in the streets, and I believe *that* is over, but I cannot affirm. The Cushman sings savage ballads in a hoarse, manny voice, and requests people recitatively to forget her not. I'm sure I shall not. Page is painting her picture ...

... For Dr Hosmer I did what I could, but he did not like to be done for. I got Miss Hosmer a place in Gibson's studio, but W. took the credit of it. Miss Hosmer is also, to say the word, very wilful, and too independent by half, and is mixed up with a set whom I do not like, and I can therefore do very little for her. She is doing very well and shows a capital spirit, and I have no doubt will succeed. But it is one thing to copy and another to create. She may or may not have inventive powers as an artist, but if she have will not she be the first woman?" ...

... Story's "Hatty" is of course Miss Harriet Hosmer, the most eminent member of that strange sisterhood of American "lady sculptors" who at one time settled upon the seven hills in a white, marmorean flock. The odd phenomenon of their practically simultaneous appearance would no doubt have its interest in any study of the birth and growth of taste in the simmering society that produced them; their rise, their prosperity, their subsidence, are, in presence of some of the widely scattered monuments of their reign, things likely to lead us into bypaths queer and crooked, to make us bump against facts that would seem only to wait, quite in a flutter, to live again as anecdotes. But our ramifications might at such a rate easily become too many. One of the sisterhood, if I am not mistaken, was a negress, whose colour, picturesquely contrasting with that of her plastic material, was the pleading agent of her fame; another was a "gifted" child (speaking by the civil register as well as by nature) who shook saucy curls in the lobbies of the Capitol and extorted from susceptible senators commissions for national monuments.[15] The world was good-natured to them—dropped them even good-naturedly, and it is not in our fond perspec-

[15] Edmonia Lewis, who was African American and Chippewa, and Vinnie Ream Hoxie.

tive that they must show for aught else than artless. Miss Hosmer had talent (it would be to be remembered that her master, John Gibson, dedicated her to renown, were it not that John Gibson's own renown has also by this time turned so to the ghostly), and she was, above all, a character, strong, fresh and interesting, destined, whatever statues she made, to make friends that were better still even than these at their best.

Harriet Hosmer, "The Process of Sculpture," **Atlantic Monthly** *14 (December 1864).*

I have heard so much, lately, about artists who do not do their own work, that I feel disposed to raise the veil upon the mysteries of the studio, and enable those who are interested in the subject to form a just conception of the amount of assistance to which a sculptor is fairly entitled, as well as to correct the false, but very general impression, that the artist, beginning with the crude block, and guided by his imagination only, hews out his statue with his own hands.

So far from this being the case, the first labor of the sculptor is upon a small clay model, in which he carefully studies the composition of his statue, the proportions, and the general arrangement of the drapery, without regard to very careful finish of parts. This being accomplished, and the small model cast in plaster, he employs some one to enlarge his work to any size which he may require; and this is done by scale, and with almost as much precision as the full-size and perfectly finished model is afterwards copied in marble.

The first step in this process is to form a skeleton of iron, the size and strength of the iron rods corresponding to the size of the figure to be modelled; and here, not only strong hands and arms are requisite, but the blacksmith with his forge, many of the irons requiring to be heated and bent upon the anvil to the desired angle. This solid framework being prepared, and the various irons of which it is composed firmly wired and welded together, the next thing is to hang thereon a series of crosses, often several hundred in number, formed by two bits of wood, two or three inches in length, fastened together by wire, one end of which is attached to the framework. All this is necessary for the support of the clay, which would otherwise fall by its own weight. (I speak here of Roman clay,—the clay obtained in many parts of England and America being more properly potter's clay, and consequently more tenacious.) The clay is then pressed firmly around and upon the irons and crosses with strong hands and a wooden mallet, until, from a clumsy and shapeless mass, it acquires some resemblance to the human form. When the clay is properly prepared, and the work advanced as far as the artist desires, his own work is resumed, and he then laboriously studies every part, corrects his ideal by comparison with living models, copies his drapery from actual drapery arranged upon the lay-figure, and gives to his statue the last refinement of beauty . . .

The clay model having at last been rendered as perfect as possible, the sculptor's work upon the statue is virtually ended; for it is then cast in plaster and given into the hands of the marble-workers, by whom, almost entirely, it is completed, the sculptor merely directing and correcting the work as it proceeds. This disclosure, I am aware, will shock the many, who often ingeniously discover traces of the sculptor's hand where they do not exist. It is true, that, in some cases, the finishing touches are introduced by the artist himself; but I suspect that few who have accomplished and competent workmen give much of their time to the mallet or the chisel, preferring to occupy themselves with some new creation, or considering that these implements may be more advantageously wielded by those who devote themselves exclusively to their use. It is also true, that, although the process of transferring the statue from plaster to marble is reduced to a science so perfect that to err is almost impossible, yet much depends upon the workmen to whom this operation is intrusted. Still, their position in the studio is a subordinate one.

They translate the original thought of the sculptor, written in clay, into the language of marble. The translator may do his work well or ill,—he may appreciate and preserve the delicacy of sentiment and grace which were stamped upon the clay, or he may render the artist's meaning coarsely and unintelligibly. Then it is that the sculptor himself must reproduce his ideal in the marble, and breathe into it that vitality which, many contend, only the artist can inspire. But, whether skilful or not, the relation of these workmen to the artist is precisely the same as that of the mere linguist to the author who, in another tongue, has given to the world some striking fancy or original thought.

But the question when the clay is "properly prepared" forms the debatable ground, and has already furnished a convenient basis for the charge that it is never "properly prepared" for women-artists until it is ready for the caster. I affirm, from personal knowledge, that this charge is utterly without foundation,—and as it would be affectation in me to ignore what has been so freely circulating upon this subject in print, I take this opportunity of stating that I have never yet allowed a statue to leave my studio, upon the clay model of which I had not worked during a period of from four to eight months,—and further, that I should choose to refer all those desirous of ascertaining the truth to Mr. Nucci, who "prepares" my clay for me, rather than to my brother-sculptor, in the *Via Margutta,* who originated the report that I was an impostor. So far, however, as my designs are concerned, I believe even he has not, as yet, found occasion to accuse me of drawing upon other brains than my own.

We women-artists have no objection to its being known that we employ assistants; we merely object to its being supposed that it is a system peculiar to *ourselves.* When Thorwaldsen was called upon to execute his twelve statues of the Apostles, he designed and furnished the small models, and gave them into the hands of his pupils and assistants, by whom, almost exclusively, they were copied in their present colossal dimensions. The great master rarely put his own hand to the clay; yet we never hear them spoken of except as "Thorwaldsen's statues." When Vogelberg accepted the commission to model his colossal equestrian statue of Gustavus Adolphus, physical infirmity prevented the artist from even mounting the scaffolding; but he made the small model, and directed the several workmen employed upon the full-size statue in clay, and we never heard it intimated that Vogelberg was not the sculptor of that great work. Even Crawford, than whom none ever possessed a more rapid or facile hand, could never have accomplished half the immense amount of work which pressed upon him in his later years, had he not had more than one pair of hands to aid him in giving outward form to the images in his fertile brain . . .

I do not wish it to be supposed that Thorwaldsen's general practice was such as I have described in the particular case referred to: probably no artist ever studied or worked more carefully upon the clay model than he. What I have stated was only with the view of showing to what extent he felt himself justified in employing assistance. I am quite persuaded, however, that, had Thorwaldsen and Vogelberg been women, and employed one-half the amount of assistance they did in the cases mentioned, we should long since have heard the great merit of their works attributed to the skill of their workmen . . .

It will thus be seen how large a portion of the manual labor which is supposed to devolve entirely upon the artist is, and has always been, really performed by other hands than his own. I do not state this fact in a whisper, as if it were a great disclosure which involved the honor of the artist; it is no secret, and there is no reason why it should be so. The disclosure, it is true, will be received by all who regard sculpture as simply a mechanical art with a feeling of disap-

pointment. They will brand the artist who cannot lay claim to the entire manipulation of his statue, whether in clay or marble, as an impostor,—nor will they resign the idea that the truly conscientious sculptor will carve every ornament upon his sandals and polish every button upon his drapery. But those who look upon sculpture as an intellectual art, requiring the exercise of taste, imagination, and delicate feeling, will never identify the artist who conceives, composes, and completes the design with the workman who simply relieves him from great physical labor, however delicate some portion of that labor may be. It should be a recognized fact, that the sculptor is as fairly entitled to avail himself of mechanical aid in the execution of his work as the architect to call into requisition the services of the stone-mason in the erection of his edifice, or the poet to employ the printer to give his thoughts to the world. Probably the sturdy mason never thinks much about proportion, nor the type-setter much about harmony; but the master-minds which inspire the strong arm and cunning finger with motion think about and study both. It is high time that some distinction should be made between the labor of the hand and the labor of the brain. It is high time, in short, that the public should understand in what the sculptor's work properly consists, and thus render less pernicious the representations of those who, either from thoughtlessness or malice, dwelling upon the fact that assistance has been employed in certain cases, without defining the limits of that assistance, imply the guilt of imposture in the artists, and deprive them, and more particularly women-artists, of the credit to which, by talent or conscientious labor, they are justly entitled.

H.W. [Henry Wreford], "Lady-Artists in Rome," Art Journal *(March 1866).*

Of the lady-artists in Rome, less is known than should be. One or two, indeed, of distinguished talents have made themselves a name, and Miss Hosmer is supposed by the world to represent a sex whose genius is eminently adapted to sculptural or pictorial Art. Yet we have a fair constellation here of twelve stars of greater or lesser magnitude, who shed their soft and humanising influence on a profession which has done so much for the refinement and civilisation of man . . . Amidst difficulties common to the artist, peculiar to the woman, they struggle on from year to year, decorating whatever they touch, and creating forms of grace and beauty which are destined to refine and embellish many a home. Their history is as varied as their talents. Some of stronger mental fibre have come to Rome impelled by love of enterprise as well as by love of Art. Some of a gentler mould are scarcely known beyond the precincts of the rooms where from day to day they watch the growth of the delicate creations of their imagination. Some too, on whom fortune has frowned, are now devoting the tastes which they had formed and delighted in as an elegant *passatempe,* to the support of their independence; and one, a mere girl, has left her Indian wigwam to show in this great nursery of Art that God, who is no respecter of persons, has not set *His* mark, at least, on the coloured race . . .

Of Miss Hosmer, an American lady, it is unnecessary to say much, so well known is this clever artist to the British as well as to the American public. She arrived in Rome about twelve or thirteen years since, and studied for some time under the great master Gibson, of whom she was a favourite pupil. One of the first, if not the first, of her sex who adopted the profession of sculptor in the Eternal City, Miss Hosmer excited not a little curiosity, and later as much admiration, by the elegance of her designs, and the cleverness of her execution. Her 'Puck' on a mushroom, which has been often repeated, was one of her earliest successes. 'Zenobia' added much to her reputation; but to our mind none of her works has greater or so much merit as her 'Sleeping Faun.' The ease of position, the perfect *abandon* of the figure are wonderfully given,

and we are half disposed to step lightly lest we may disturb the slumber so graphically described. At present Miss Hosmer is modelling, as a companion to it, the 'Waking Faun.' A youngster of the same family is seated on the ground by his side, and, taking advantage of the somnolency of his parent, has managed to bind him; but the Faun suddenly awakes, breaks his bonds, and seizes the young delinquent by the hair . . .

From the same country as Miss Hosmer, is Miss Edmonia Lewis, a coloured lady, whose sex, extreme youth, and colour invite our warmest sympathies. Born of an Indian mother, and a Negro father, she passed the first twelve years of her life in the wilds, fishing, hunting, swimming, and making moccasins. Her love of sculpture was first shown on her seeing a statue of Franklin. "I will make something like that," she said to a benevolent gentleman who engaged an artistic friend in New York to permit her to visit his studio. Then she had some clay given her, and the model of an infant's foot, which she imitated so well as to merit praise and encouragement. "I often longed to return to the wilds," she said, "but my love of sculpture forbade it;" and here she is alone, a simple girl of twenty-three years of age, struggling against the prejudice entertained towards her race, and competing with the finished masters of the Art. As she has been here only two months, she has not much to show. A bust of Colonel Shaw, who commanded the first coloured regiment ever formed, is a meritorious work, and has been ordered by the family of the brave colonel who died fighting for his country. Another bust, of Mr. Dionysius Lewis, of New York, is nearly completed as a commission. The first ideal work of our young artist is a freed woman falling on her knees, and with clasped hands and uplifted eyes thanking God for the blessings of liberty. She has not forgotten her people, and this early dedication of her genius to their cause is honourable to her feelings. Two other groups, the design of which are taken from Longfellow's Minehaha, are nearly modelled. They represent first Hiawatha coming to the wigwam of his love, and laying down a deer at her feet, in token of an offer of marriage, and secondly, Hiawatha leading away his chosen bride: "So hand in hand they went." . . .

Miss Stebbings is another of our fair cousins from across the Atlantic. She first visited Rome eight years ago without any intention of pursuing Art as a profession, but the *genius loci* overpowered her, and now she is one of her most graceful lady artists . . .

. . . The notices which we have communicated are far from doing justice to these gifted ladies; indeed, all that we pretend to do is to invite attention to their works, and the winter idler in Rome will find ample compensation for the time and labour he may spend in visiting the studios of the lady-artists.

A FEMINIST LOOKS AT HARRIET HOSMER

Lydia Maria Child offers a highly positive and supportive view of Harriet Hosmer in a letter originally written to the editor of the Boston Daily Advertiser. *A prolific author, fervent abolitionist, and feminist, Child sees Hosmer's purported eccentricity and transgressive behavior as positive and necessary for the work the young artist wishes to carry out. Child writes with exhilaration of Hosmer's refusal to let her feet be trapped in the "little Chinese shoes" society imposes on women, with such crippling effects. Hosmer, by contrast, walks with vigor and determination. Strong as any man in body and mind, she also has true genius, that supreme attribute so jealously sequestered and denied to women. Asserting the rightness of Hosmer's claim to work and succeed on nominally masculine turf, Child sees in her a model of what a free woman can achieve.*

L. Maria Child, "Miss Harriet Hosmer," Living Age 56 (March 13, 1858).

The energy, vivaciousness, and directness of this young lady's character attracted attention even in childhood. Society, as it is called, that is, the mass of humans, who are never alive in real earnest, but congratulate themselves, and each other, upon being mere stereotyped formulas of gentility or propriety, looked doubtingly upon her, and said, "She is so peculiar!" "She is so *eccentric!*" Occasionally I heard such remarks, and being thankful to God whenever a woman dares to be individual, I also observed her. I was curious to ascertain what was the nature of the peculiarities that made women suspect Achilles was among them, betraying his disguise by unskilful use of his skirts; and I soon became convinced that the imputed eccentricity was merely the natural expression of a soul very much alive, and earnest in its work . . .

. . . Here, was a woman, who, at the very outset of her life, refused to have her feet cramped by the little Chinese shoes, which society places on us all, and then misnames our feeble tottering, feminine grace. If she walked forward with vigorous freedom, and kept her balance in slippery places, she would do much toward putting those crippling little shoes out of fashion. Therefore, I fervently bade her God speed. But, feeling that the cause of womankind had so much at stake in her progress, I confess that I observed her anxiously.

The art she had chosen, peculiarly required masculine strength of mind and muscle. Was such strength *in* her? I saw that she *began* wisely. She did not try her 'prentice hand on pretty cameos for breast-pins, or upon ivory heads for parasols and canes. Evidently, sculpture was with her a passion of the soul, an earnest study, not a mere accomplishment, destined to be the transient wonder of drawing-rooms. She made herself thoroughly acquainted with anatomy, not merely by the aid of books, and the instructions of her father, but by her own presence in dissection-rooms. She took solid blocks of marble to her little studio in the garden, and alone there in the early morning hours, her strong young arms chiselled out those forms of beauty, which her clairvoyant soul saw hidden in the shapeless mass.

She tried her hand on a bust of the first Napoleon, intended as a present for her father. This proved that she could work well in marble, and copy likenesses correctly. Her next production was a bust of Hesper, the Evening Star; in which poetical conception of the subject was added to mechanical skill. Soon after the completion of it, she went to Rome, to pursue her studies with the celebrated and venerable English sculptor, Mr. Gibson. From that land of marbles, she sent us Medusa and Daphne, Ænone and Puck. These were beautifully wrought, and gave indications of a poetic mind. They proved an uncommon degree of *talent;* of *that* there could be no doubt. But did they establish Miss Hosmer's claim to *genius?* In my own mind, this query remained unanswered. I rejoiced that a woman had achieved so much in the most manly of the Arts . . .

When I heard that she was modelling a statue of Beatrice Cenci, in her last slumber on earth, before the tidings of approaching execution was brought to her miserable cell, I felt that the subject was admirably chosen, but difficult to execute. I hastened to look at the statue, as soon as it arrived in Boston. The query in my soul was answered. At the first glance, I felt the presence of genius; and the more I examined, the more strongly was this first impression confirmed. The beauty of the workmanship, the exquisite finish of details, the skilful arrangement of drapery, to preserve the lines of beauty everywhere continuous, were subordinate attractions. The *expression* of the statue at once rivetted my attention. The whole figure was so soundly *asleep,* even to its fingers' ends; yet obviously it was not healthy, natural repose. It was the sleep of a body worn out by the wretchedness of the soul. On that innocent face, suffering had left its traces. The arm, that had been tossing in the grief-tempest, had fallen heavily, too weary to

change itself into a more easy posture. Those large eyes, now so closely veiled by their swollen lids, had evidently wept, till the fountain of tears was dry. That lovely mouth was still the open portal of a sigh, which the mastery of sleep had left no time to close.

Critics may prove their superiority of culture by finding defects in this admirable work, or in imagining that they find them. But I think genuine lovers of the beautiful will henceforth never doubt that Miss Hosmer has a genius for sculpture. I rejoice that such a gem has been added to the Arts. Especially do I rejoice that such a poetical conception of the subject came from a woman's soul, and that such finished workmanship was done by a woman's hand.

WOMEN ARTISTS, WOMAN'S SPHERE

From the middle to the end of the nineteenth century, critics, novelists, and social commentators tended to reproduce the dominant model of gender difference in their writings on art and artists. In that model, men were active, rational, adventurous, intellectually vigorous, creative, and innovative; they had free agency in the world of commerce, politics, and ideas. Women were passive, domestic, nurturing, and emotional; incapable of genius or true creativity, lacking free agency, they were adept at imitation. These discourses shaped the ways critics appreciated and assessed the work of male and female artists; they found a place too in fiction.

Nathaniel Hawthorne's character Hilda the Dove in The Marble Faun *is the embodiment of the female artist as copyist supreme. Her only ambition to reflect (dimly) the glory of the old masters, this young American is content to paint in their shadow. The columnist Fuller-Walker, reviewing the National Academy exhibition in 1880, notes a hefty number of women in the annual show (at least sixty-nine out of four hundred) but proceeds to typecast their work and rank it categorically and implicitly as mediocre. At the turn of the century the terms remain fixed, E. A. Randall's essay suggesting that the discourses of difference remained deeply entrenched, perhaps even more so, as women in greater and greater numbers threatened the boundaries so carefully drawn to exclude them from the world of action.*

Nathaniel Hawthorne, The Marble Faun: or, The Romance of Monte Beni *(Boston: Ticknor and Fields, 1860).*

Hilda, in her native land, had early shown what was pronounced by connoisseurs a decided genius for the pictorial art. Even in her school-days, (still not so very distant,) she had produced sketches that were seized upon by men of taste, and hoarded as among the choicest treasures of their portfolios; scenes delicately imagined, lacking, perhaps, the reality which comes only from a close acquaintance with life, but so softly touched with feeling and fancy, that you seemed to be looking at humanity with angel's eyes. With years and experience, she might be expected to attain a darker and more forcible touch, which would impart to her designs the relief they needed. Had Hilda remained in her own country, it is not improbable that she might have produced original works, worthy to hang in that gallery of native art, which, we hope, is destined to extend its rich length through many future centuries. An orphan, however, without near relatives, and possessed of a little property, she had found it within her possibilities to come to Italy; that central clime, whither the eyes and the heart of every artist turn, as if pictures could not be made to glow in any other atmosphere—as if statues could not assume grace and expression, save in that land of whitest marble . . .

We know not whether the result of her Italian studies, so far as it could yet be seen, will be accepted as a good or desirable one. Certain it is, that, since her arrival in the pictorial land, Hilda seemed to have entirely lost the impulse of original design, which brought her thither. No doubt, the girl's early dreams had been, of sending forms and hues of beauty into the visible world out of her own mind; of compelling scenes of poetry and history to live before men's eyes, through conceptions and by methods individual to herself. But, more and more, as she grew familiar with the miracles of art that enrich so many galleries in Rome, Hilda had ceased to consider herself as an original artist. No wonder that this change should have befallen her. She was endowed with a deep and sensitive faculty of appreciation; she had the gift of discerning and worshipping excellence, in a most unusual measure. No other person, it is probable, recognized so adequately, and enjoyed with such deep delight, the pictorial wonders that were here displayed. She saw—no, not saw, but felt—through and through a picture; she bestowed upon it all the warmth and richness of a woman's sympathy; not by any intellectual effort, but by this strength of heart, and this guiding light of sympathy, she went straight to the central point, in which the Master had conceived his work. Thus, she viewed it, as it were, with his own eyes, and hence her comprehension of any picture that interested her was perfect . . .

It has probably happened in many other instances, as it did in Hilda's case, that she ceased to aim at original achievement in consequence of the very gifts, which so exquisitely fitted her to profit by familiarity with the works of the mighty Old Masters. Reverencing these wonderful men so deeply, she was too grateful for all they bestowed upon her—too loyal—too humble, in their awful presence—to think of enrolling herself in their society. Beholding the miracles of beauty which they had achieved, the world seemed already rich enough in original designs, and nothing now was so desirable as to diffuse those self-same beauties more widely among mankind. All the youthful hopes and ambitions, the fanciful ideas which she had brought from home, of great pictures to be conceived in her feminine mind, were flung aside, and, so far as those most intimate with her could discern, relinquished without a sigh. All that she would henceforth attempt—and that, most reverently, not to say, religiously—was to catch and reflect some of the glory which had been shed upon canvas from the immortal pencils of old.

So Hilda became a copyist. In the Pinacotheca of the Vatican, in the galleries of the Pamfili-Doria palace, the Borghese, the Corsini, the Sciarra, her easel was set up before many a famous picture of Guido, Domenichino, Raphael, and the devout painters of earlier schools than these. Other artists, and visitors from foreign lands, beheld her slender, girlish figure in front of some world-known work, absorbed, unconscious of everything around her, seeming to live only in what she sought to do. They smiled, no doubt, at the audacity which led her to dream of copying those mighty achievements. But, if they paused to look over her shoulder, and had sensibility enough to understand what was before their eyes, they soon felt inclined to believe that the spirits of the Old Masters were hovering over Hilda, and guiding her delicate white-hand. In truth, from whatever realm of bliss and many-coloured beauty those spirits might descend, it would have been no unworthy errand, to help so gentle and pure a worshipper of their genius in giving the last divine touch to her repetitions of their works.

Her copies were indeed marvellous. Accuracy was not the phrase for them; a Chinese copy is accurate. Hilda's had that evanescent and ethereal life—that flitting fragrance, as it were, of the originals—which it is as difficult to catch and retain as it would be for a sculptor to get the very movement and varying colour of a living man into his marble bust. Only by watching the

efforts of the most skilful copyists—men who spend a lifetime, as some of them do, in multiplying copies of a single picture—and observing how invariably they leave out just the indefinable charm that involves the last, inestimable value—can we understand the difficulties of the task which they undertake.

It was not Hilda's general practice to attempt reproducing the whole of a great picture, but to select some high, noble, and delicate portion of it, in which the spirit and essence of the picture culminated—the Virgin's celestial sorrow, for example, or a hovering Angel, imbued with immortal light, or a Saint, with the glow of Heaven in his dying face;—and these would be rendered with her whole soul. If a picture had darkened into an indistinct shadow, through time and neglect, or had been injured by cleaning, or retouched by some profane hand, she seemed to possess the faculty of seeing it in its pristine glory. The copy would come from her hands with what the beholder felt must be the light which the Old Master had left upon the original in bestowing his final and most ethereal touch. In some instances, even, (at least, so those believed, who best appreciated Hilda's power and sensibility,) she had been enabled to execute what the great Master had conceived in his imagination, but had not so perfectly succeeded in putting upon canvas;—a result surely not impossible when such depth of sympathy, as she possessed, was assisted by the delicate skill and accuracy of her slender hand. In such cases, the girl was but a finer instrument, a more exquisitely effective piece of mechanism, by the help of which the spirit of some great departed Painter now first achieved his ideal, centuries after his own earthly hand, that other tool, had turned to dust . . .

It strikes us that there is something far higher and nobler in all this—in her thus sacrificing herself to the devout recognition of the highest excellence in art—than there would have been in cultivating her not inconsiderable share of talent for the production of works from her own ideas. She might have set up for herself, and won no ignoble name; she might have helped to fill the already crowded and cumbered world with pictures, not destitute of merit, but falling short, if by ever so little, of the best that has been done; she might thus have gratified some tastes that were incapable of appreciating Raphael. But this could be done only by lowering the standard of art to the comprehension of the spectator. She chose the better, and loftier, and more unselfish part, laying her individual hopes, her fame, her prospects of enduring remembrance, at the feet of those great departed ones, whom she so loved and venerated. And therefore the world was the richer for this feeble girl . . . Hilda's faculty of genuine admiration is one of the rarest to be found in human nature; and let us try to recompense her in kind by adducing her generous self-surrender, and her brave, humble magnanimity in choosing to be the handmaid of those old magicians, instead of a minor enchantress within a circle of her own.

The handmaid of Raphael, whom she loved with a virgin's love! Would it have been worth Hilda's while to relinquish this office, for the sake of giving the world a picture or two which it would call original; pretty fancies of snow and moonlight; the counterpart, in picture, of so many feminine achievements in literature!

Fuller-Walker, "Women Artists," American Art Journal 33, no. 3 (May 15, 1880).

Doré, the artist, says he has been too lazy to marry, and we fear that it may truthfully be said of many American women who aspire to be artists, that they are too lazy to paint. While there are several good pictures by women in the present exhibition of the National Academy, most of them are commonplace, if not really bad, and few are worth an extended notice. This year about fifty ladies are represented by seventy-five pictures, six of these contributing three each, and sixteen two each. As might be expected, flowers, fruit and still life occupy most of their at-

tention, although there is a laudable endeavor to paint portraits. There are a thousand things women might paint well, if only they shall make an intelligent and earnest attempt. Who should paint children better than a mother? Why may not all the domestic animals, birds and fowls, be painted by women? Shall we never have in America a Rosa or Juliette Bonheur?[16] And why may not women paint landscapes as well as men? Thus far the woman artist of America appears to be timid; she fears to attempt a noble work, and is content with an amateur expression of a very simple subject.

E. A. Randall, "The Artistic Impulse in Man and Woman," Arena 24 *(October 1900).*

Art in which music, painting, poetry, sculpture—all of its manifestations—appear is but an effect springing from a single cause or impulse. All are but results radiating from an eternal center.

The history of art is closely associated with the fact of sex. Art has masculine emotions, representing the katabolic,[17] militant spirit of man. Historical paintings and epic poems contain this motive. The connection between art and love, which reveals itself even in the song of a bird, continues to subsist in human art. The theme of all lyrics is love. The artistic impulse is but the biologic fact that the katabolic male seeks the anabolic female. It is the affinity of *Romeo* and *Juliet*—of prosaic Jack and Jill. The pictures of those artists that appeal to us are amatory instincts developed.

Since woman is by nature or cultivation passive, she possesses to a less degree than man the creative art. In regard to the inability of woman to create there seems to be no difference of opinion. Leaving the interpretative arts out of the question, one must confess that the artistic impulse in man is more spontaneous, more widespread and pronounced, than in woman. Freedom of expression has been more restricted among women; hence, freedom of impression has taken its place.

Human beings tend to reproduce. The creative impulse, the desire to express inner thought, is the characteristic of both sexes; but the power of repression has been cultivated in the female and the ability for expression in the male. Woman, because she has been denied free productive expression, has confined her creative skill to the restricted level of personal service; whereas in man the sexual instinct overflows in all channels. Early in the development of species, Nature established two sexes in separate organisms; and these differentiations were to the advantage not alone of the individual, but of the artistic and intellectual impulse. Among birds, esthetic taste is earliest displayed by the male. Song, which may be considered their intellectual activity, is the monopoly of the male. The male bird constructs the larger part of the nest in which the young are to be reared.

If we go back to early times we may be sure that the rough drawings of men and animals and other objects found on primitive implements and rocks were the work of man. Primitive woman, however, in the maternal desire to serve her young, began the first of arts or crafts. While the male savage was a fighter, expressing masculine energy or katabolic force, the female worked out the personal, conserving force of feminine energy; but, after this artistic impulse passed beyond the rudiments, we find it in the hands of the men. Among the Indians of Canada,

[16] One of the most celebrated woman painters of the day, Rosa Bonheur specialized in animal themes. Her sister Juliette was also an animal painter of note.

[17] "Katabolic" is a reference to catalysis, the destructive metabolic function whereby complex molecules are broken down into simpler forms. Anabolic processes are the opposite; they synthesize complex molecules from simpler ones.

tattooing is done by women, who introduce charcoal under the skin. The making of pottery is also largely in the hands of Indian women; but when we come to the higher stages of culture the supremacy of man is unquestioned. Galton found, in investigating over nine hundred individuals, that the sexes were nearly equal in minor artistic taste. Even in the matter of cooking, as a rule, it becomes a man's business when it reaches an art. This again is due to man's reaching-out process and woman's restricted impulses.

Schopenhauer describes woman as the "unesthetic sex," but if this is so it is due to her sexual coldness and to lesser opportunities than are afforded men. On the other hand, we find in woman a lively appreciation and inventive faculty where mere prettiness and not strength is concerned. The manufacture of wall-paper and silk hangings is almost entirely in female hands. House decoration, too, is an art reserved for women. There can be no doubt that women are superior to men in epistolary style. This may be largely due to their finding life and movement in little things. The adornment of the person is nowadays almost exclusively a feminine art; Renan calls it an "exquisite art." In still another attainment women hold undisputed sway. In the art of conversation woman has been a queen from the time of the Greeks down to Madame de Staël and the present. Conversation is woman's eloquence.

So far as music is a matter of the emotions, woman is much more sensitive to it than man: she absorbs it . . .

On the other hand, her sexual nature, restrained by every law, has acted as a stimulus upon the free agent, man; and we see this most forcibly in the art of music. While a man that has learned to play upon an instrument rarely ceases to delight in it, the intense love of woman for music often ceases with age. This may be due to the emotional rather than the esthetic impulse. The mattoid, or crank, whose whole life is devoted to the pursuit of some eccentric whim, is seldom a woman. Among geniuses—so-called congenital forms of mental abnormality—there are more men than women. Idiocy is of the same general tendency. Woman is more in harmony with Nature than is man . . .

In imitative art, women succeed much better than men. If we look back to the history of the stage we see more famous actresses than actors. This emotional explosiveness is largely due to this same repression of sex and social compunction that puts women by their very natures in the position of actors . . .

. . . In sculpture the great names are mostly those of men. There have been a few women, however, whose names deserve mention; Harriet Hosmer, for instance, has made the marble live with a man's force and skill.

There are few women whose names would occur to one in making out a list of the great artists of the world. Women have lacked the masculine emotions necessary for the production of great paintings. Rosa Bonheur is perhaps the only woman who was man's equal upon canvas. China painting and decorative art in general are the specialty of woman, who excels in the minor, personal artistic impulses, and in this way gives vent to her restricted life. Even the idea of maternity—the Madonna and Child—has found expression at the hands of men.

Woman has inherited from endless generations this anabolic tendency. Social conditions have caused it, and still tend to foster it. This has hampered her in giving the creative impulse room to spread in all channels, as man has been enabled to do. Galton presents interesting data upon the artistic faculty. Prefacing his remarks with the statement that the artistic impulse is inherited, he divides his data into classes: the first for music alone, the second for drawing, and the fourth for minor artistic impulses. It is, however, hard to reach definite results, for psychology

is yet in its infancy. The male and female come together through sexual attraction, and the chances of artistic life are increased through this association. A large part of the joy that men and women find in each other's society is rooted in this sexual difference and variability. If woman has been restricted in her creative ability, she has caused human development to proceed in the male line by influencing man with her concealed, suppressed energy.

MARY CASSATT, MODERN WOMAN

Philadelphia-born Mary Cassatt spent most of her adult years as an expatriate in France. Living a respectable, bourgeois life with her family, Cassatt nonetheless made bold departures from convention. Embracing modern life and a modern style, she exhibited with the impressionists and became an intimate if occasionally embattled friend of the acerbic Edgar Degas. Although her claim to fame in the late nineteenth century was based on her appealing pictures of women and children, this innocuous subject matter cloaked a feminist agenda. Planning her monumental and epochal mural, Modern Woman, *for the Women's Building at the World's Columbian Exposition in Chicago (1893), Cassatt explains her idea in a letter to Bertha Palmer, who led the fair's Board of Lady Managers. Noting that her young women in an orchard are "plucking the fruits of knowledge or science," Cassatt stresses the modernity of that theme and the others she has conceived for the mural. Most important, she self-consciously celebrates female autonomy:* her modern women have no need of men and may indeed be better off without them.*

Well represented in American exhibitions, Cassatt established herself as a leading painter whose association with the French impressionists lent a boldly modern edge to her work. As an independent, successful professional, Cassatt was the living embodiment of the aspirations symbolized in her Modern Woman *mural. Nonetheless, critics routinely and conventionally took gender into account when they discussed her work. In his review, the painter-critic William Walton clearly respects Cassatt, commenting on the vigor and individuality of her approach. He admires her ability to paint living, vibrant flesh, praises her vivid palette, and commends her avoidance of mere prettiness in favor of character. Yet in discussing Cassatt's representations of mothers and babies, Walton waxes poetic, describing them as modern Madonnas and extolling their sentiment and charm. He even goes so far as to suggest that there is something obsessive (though not quite pathological) in Cassatt's fascination with the "mystery" of babyhood. Arthur Hoeber's remarks reinforce the implicit drift of Walton's comments: mothers and babies are the supremely natural subjects for a woman's brush.*

Mary Cassatt to Bertha Palmer, October 11, 1892, Bertha Honoré Palmer Correspondence Collection, Ryerson and Burnham Archives, The Art Institute of Chicago. © The Art Institute of Chicago, used with permission.

Your letter of Sept. 27th only arrived this morning, so unfortunately this will not reach you by the 18th as you desired. Notwithstanding that my letter will be too late for the ladies of the committee, I should like very much to give you some account of the manner I have tried to carry out my idea of the decoration.

Mr. Avery sent me an article from one of the New York papers this summer, in which the writer, referring to the order given to me, said my subject was to be "The Modern Woman as

glorified by Worth"![18] That would hardly describe my idea, of course I have tried to express the modern woman in the fashions of our day and have tried to represent those fashions as accurately & as much in detail as possible. I took for the subject of the central & largest composition Young women plucking the fruits of knowledge or science &—that enabled me to place my figures out of doors & allowed of brilliancy of color. I have tried to make the general effect as bright, as gay, as amusing as possible. The occassion is one of rejoicing, a great national fête. I reserved all the seriousness for the execution, for the drawing & painting. My ideal would have been one of those admirable old tapestries brilliant yet soft. My figures are rather under life size although they seem as large as life. I could not imagine women in modern dress eight or nine feet high. An American friend asked me in rather a huffy tone the other day "Then this is woman apart from her relations to man?" I told him it was. Men I have no doubt, are painted in all their vigour on the walls of the other buildings; to us the sweetness of childhood, the charm of womanhood, if I have not conveyed some sense of that charm, in one word if I have not been absolutely feminine, then I have failed. My central canvass I hope to finish in a few days, I shall have some photographs taken & sent to you. I will still have place on the side panels for two compositions, one, which I shall begin immediately is, young girls pursuing fame. This seems to me very modern & besides will give me an opportunity for some figures in clinging draperies. The other panel will represent the Arts, Music (nothing of St. Cecilia) Dancing & all treated in the most modern way.[19] The whole is surrounded by a border, wide below, narrower above, bands of color, the lower cut with circles containing naked babies tossing fruit, &&c. I think, my dear Mrs. Palmer, that if you were here & I could take you out to my studio & show you what I have done that you would be pleased indeed without too much vanity I may say I am almost sure you would.

When the work reaches Chicago, when it is dragged up 48 feet & you will have to stretch your neck to get sight of it all, whether you will like it then, is another question. Stillman, in a recent article, declares his belief that in the evolution of the race painting is no longer needed, the architects evidently are of that opinion. Painting was never intended to be put out of sight. This idea however has not troubled me too much, for I have passed a most enjoyable summer of hard work. If painting is no longer needed, it seems a pity that some of us are born into the world with such a passion for line and color. Better painters than I am have been put out of sight, Baudry spent years on *his* decorations. The only time we saw them was when they were exhibited in the Beaux-Arts, then they were buried in the ceiling of the Grand Opera.—After this grumbling I must get back to my work knowing that the sooner we get to Chicago the better.

You will be pleased, believe me, my dear Mrs. Palmer

William Walton, "Miss Mary Cassatt," Scribner's Magazine 19 (March 1896).

The number of picture exhibitions in New York City, in the winter season of 1894–95, was very considerable, but, as among other institutions, those only of these displays make durable impressions which are endowed with strongly marked characteristics, and there are only a limited number that are worthy of permanent record. One of these in this case was undoubtedly that of a certain number of the works of Miss Cassatt, in which the strong individuality of the

[18] Charles Frederick Worth was a high-fashion couturier based in Paris who catered to an international clientele.
[19] Saint Cecilia was an early Christian martyr and the patron saint of music.

artist seemed to move and live, as it were, behind the mask of her works, and the spectator was impressed by a new personality with which he was brought almost into contact. The technical problems of their art, which have so great an importance in the eyes of the painters, interest only in slight degree, as everybody knows, the larger body of laymen, and it is the characteristics of the painter himself, as he makes them manifest, that lend their value in the eyes of the public to these technical processes. Miss Cassatt's works, oils, pastels, and dry points, seemed to have so much a style of their own as to at once attract attention—even among those more conventional or more timid who preferred milder methods of painting pictures. So many things are required in the successful practice of this art, that the translation of impalpable qualities by tangible and material applications assumes all sorts of interests to different appreciations, and this little exhibition, somewhat peculiar in this respect, while appealing most strongly to the visitor with a certain amount of information, was yet interesting to everyone. The subjects were mostly simple studies of women, or of women and children, frequently of the same sitters; a certain superficial family resemblance characterizing the very important group of pastels and paintings executed within the last five years, and a similar bond uniting the very different series of dry points printed in colors, somewhat better known to the ordinary New York picture-seer. Of still different methods were the earlier pictures in oils, some of them painted as far back as twenty years ago. One of the most important and one of the best known of these early works was the portrait of Mrs. Cassatt, all in white, glasses on nose, reading the *Figaro* with a surprising naturalness of attention. Another, of about the same date, was the beautiful color study of a lady with a fan, vaguely contemplating nothing with her very dark blue eyes, and which, in its harmony of luminous and warm mellow yellows and grays and browns, suggested in a general way the painting of Alfred Stevens before his decline began, and was different in color scheme from anything else in the collection. The figure is represented at half length, seated in an upholstered easy-chair, the back of the lady's head and the top of her chair reflected in the bottom of the large mirror behind her.

Of these early pictures, however, the most surprising when viewed from the stand-point of the latest works, is the earliest here shown, the Spanish balcony scene painted in Seville in 1873. It is not so much the careful academical rendering as the fine, old-fashioned, deliberately intelligent getting-up of the incident with which we used to be so familiar, that makes this work contrast so strongly with the direct modern way of presenting the subject. The man behind emerges from the dusky background in an effective fashion, the shawl of the pretty lady at the left is in dark red, and that of the heroine much lighter and yellowish, and ornamented with a flower pattern that is about the only thing in the whole picture that connects it with the painter's recent canvases. In the theatre scene, "In the Box," painted five years later, we seem to see the influence of Manet in the much freer and simpler rendering; a lady in profile, in black, seated in a box in the foreground and seen at half-length, looks through an opera-glass. Beyond her, in the distance, can be followed the long curving sweep of the stalls, brilliantly dark red and pale yellow in the warm artificial illumination, and spotted with vivid little black and white figures.

From these urban and somewhat conventional themes, Miss Cassatt seems to have turned in later years to the consideration of the simplest domestic and rural subjects, mothers with babies, or without their babies, seated on the grass, or on garden benches. Many of these are midsummer scenes, set in the greenest of landscapes. In all of them may be felt that directness and vigor of presentation which has caused this lady to be claimed by the impressionists; but hers is scarcely impressionistic painting as generally understood, vague as is that term. In all of them may be felt a certain sentiment, or charm, or poetry—something much more than mere good

painting. The feeling of nature, of summer air and space, of the charm of green apple orchards, or parks, and, very frequently, the mystery of mother love and the pulchritude of the Baby. But seldom indeed has that inefficient but most valuable of potentates been more carefully studied and faithfully rendered, in many of his various moods, and in his relations with the mother that bore him or the nurse that tends him. In this little exhibition alone might be seen a dozen variations on that old, old group of the Madonna—posing only as "Mother and Child," or "The Young Mother," or "Nurse and Child," with a fine affectation of being only painter's studies, with that aversion to the appearance of being sentimental so characteristic of the works of the artist of the day. In one painting only, the "Maternal Solicitude," has the painter ventured to give the real title of her work—the wonderful, infinite motherly yearning over the queer little unresponsive, responsive being of which she knows so little. The mystery, real and fictitious, of these small, naked infants counts for even more in the obsession of the painter than the thorny technical problem of presenting their bodies—and she seems to render it even more truly. That later prophet, Nordau, in his character as general scold, could never say of her infants as he does of those of Miss Kate Greenaway, that they are the disordered products of an unfortunately diverted love of children . . .

In her rendering of the adults that hover round these infants, or occasionally occupy themselves without them, there is the same search for character and truthfulness, with even less regard for that mere prettiness of expression that was once thought so requisite in similar subjects. The old doctrine of "Beauty" has been superseded among the moderns by a haunting fear of falling into the pretty-pretty. Miss Cassatt is probably too conscious of her strength to be much troubled by this dread, but the unregenerate spectator will sometimes wish for a little more pandering to his prejudices in this matter. To adopt his point of view for the moment, we may say that there was a fine sentimental picture among these, in which the blonde sitter who appears so frequently is represented on a bench under the trees, and looking at a pink or a geranium which she holds somewhat stiffly before her. Her physical beauty in this instance is even less than usual; of that youthful charm and grace, which were formerly considered indispensable under these circumstances, there is scarcely a trace. The probabilities are, however, that by avoiding the conventional and the pretty the painter has evolved a better and more artistic situation—the suggestion perhaps of the upspringing of all these tender, youthful, feminine longings and aspirations, and half-formed ideas in some soul more worthy of our interest than the usual one. A sort of variation on Hegel's theory of the beautiful—"the presence of the idea in limited phenomenon." This replacing of the pretty by something better is also very noticeable in "The Caress," suggesting the old renderings of the mystic marriage of Saint Catherine, and, like them, apparently meaning much more than it says. The baby's head is quite dignified and noble, and quite baby-like; and the settling of his fat, little shapeless body, creased by the mother's fingers in the mother's lap is excellently given. The thoughtfulness behind the good painting gives all these pictures their human interest . . .

Miss Cassatt's selections and compromises, among the various methods of flesh-painting known, constitute one of the most interesting features of her work. She cannot reconcile herself to the painting of a beautiful, smooth, hard substance like tinted ivory, and she is not satisfied with the coarsely hatched structure of many of her contemporaries, which at least suggests the depth of the fleshly integument, if not the finish. By wise and vigorous painting, with the full strength of her palette and a careful observance of the local variations, she secures the intrinsic quality of her fleshly tones—so that you can well imagine that her rendering would feel under your fingers much as the naked body does in life—and she is much aided in securing this

desirable effect by a free use of that hard outline which the impressionists so generally disregard. In her etchings, also, this skilful use of the outline is of the greatest service in securing this truthfulness—an almost flat rendering of a baby's torso is made at once to seem both pulpy and solid by the strong folds of the lower part of his body when seated on his mother's arm, or the creases and dimples which her fingers make in his sides. In her painting, to supplement this rendering of the structure, she contrives, by a certain care in blending and finishing, to invest it with more of that smooth and pleasant outer surface than do generally the practitioners of the newer schools; but her main care is, evidently, to make sure of the pulpy and kneadable quality rather than of that pinkness and whiteness and exquisite smooth coolness which make a baby's or a young girl's cheek such a delight to the touch. There is much to be said on both sides of this question—the delight of the eye is to be considered by the artist, and it may be doubted whether such flesh as sailors and laborers wear, and many painters paint, would ever have led civilized man to the invention of caresses and kisses. Something more than usual of this care for the outer finish may be seen in the beautiful pastel study of the child with the orange. This little maid's countenance, her round, white forehead, are so truly and beautifully rendered as to furnish a permanent joy—even her little nose is gently fleshly and compressible, instead of being hard and osseous in structure . . .

Among the paintings shown in this exhibition was a large one, representing a section of a boating party, the back of the rower in the foreground, nearly life-size, being clothed in flat, very dark blue, pure color, and his sash of a paler blue, much like the flat water beyond. At the top of the picture was a strip of landscape of about the same value as the water; the corner of sail shown was distinctly greenish in hue, and the boat was painted in green and white, amidst all of which the baby in the stern-sheets was of a species of shrimp pink. As a contrast to this cheerful navigation there was a little marine very like a Manet, a flat, grayish-yellowish expanse of sea spotted with three or four little black boats. Miss Cassatt's large painting for the decoration of the north tympanum of the Woman's Building at Chicago, two years ago, will be remembered by many visitors notwithstanding the very inconvenient height at which it was placed. In this she had worked in the methods exemplified in the later pictures shown in the New York exhibition, and her theme was not dissimilar—carefully selected but not idealized figures of women and children gathering fruit in a long, green orchard. It may also be remembered that some of the Western "Lady Managers" thought this conception of "Modern Woman"—her theme—somewhat inaccurate.

To the first exhibition of the impressionists in Paris, in 1878, Miss Cassatt was an important contributor, and her works have appeared in the Salons both before and since that date and in this country—as in the galleries of the Society of American Artists and at the Loan Exhibition of Portraits of Women in New York, November, 1894—but in general she seems to have attained to that desirable condition, coveted of artists, of being able to dispense with the annual-exhibitions. An art so learned, so well-inspired as hers, which so well combines the letter and the spirit, and knows how to present the prettiest and most popular of themes in a large and comprehensive way, preserving all the tenderness and avoiding all of the little and the commonplace, is sufficiently rare even in this age of over-production, and any knowledge of it is to be accounted as gain.

Arthur Hoeber, "The Century's American Artist Series: Mary Cassatt," Century Magazine 57 *(March 1899).*

Of the colony of American painters who for a decade or two past have made Paris their home, few have been more interesting, and none more serious, than Miss Cassatt. From her canvas

"Dans la loge," sent to the exhibition of the Society of American Artists some years ago, to her more recent contributions to the Durand-Ruel galleries in New York winter before last, this artist has gone through various stages of experiment and study that have all been entertaining, and have all, in the end, conduced to her advancement in art.

The influence of the impressionists has been scarcely less apparent than that of the art of Japan. Time was when Miss Cassatt gave strong evidence of her predilection for the curious group of Frenchmen who, sacrificing line and form, composition and harmony of arrangement, even beauty itself, concerned themselves solely with problems of light, air, and the effort to produce scintillating color. Then came her leaning toward those Oriental workers in the land of chrysanthemums, and Miss Cassatt produced many delicately conceived etchings, drawings, and paintings, betraying her affiliations with a wonderfully decorative race. Through all the efforts, however, there were seriousness, intelligent searching, and always individuality.

It would seem, however, that Miss Cassatt has found her true bent in her recent pictures of children and in the delineation of happy maternity. Here she has caught with great fidelity the beauty of child life and the dignity of motherhood, fitting subjects for the artist's brush, ennobling material for intellectual investigation. These she has portrayed with delicacy, refinement, and sentiment. Her technic appeals equally to the layman and the artist, and her color has all the tenderness and charm that accompanies so engaging a motif.

CECILIA BEAUX: BECOMING THE GREATEST WOMAN PAINTER

One of the most successful and respected portrait painters of the late nineteenth century, Cecilia Beaux was seen by many as the exception that proved the rule that male artists were by their very nature superior to women in the same line of work. Ferociously driven, Beaux, who trained at the Pennsylvania Academy of the Fine Arts and then in Paris, was a superb technician whose portraits vibrate with life (fig. 11). Recipient of many honors and awards, she was the first woman appointed as a full-time instructor at the Pennsylvania Academy.

Probably the only woman portrait painter to rival John Singer Sargent, Beaux was often compared with him in critical reviews. The Evening Sun *piece below well represents the subtle play of language that acknowledged Beaux's worth while affirming Sargent's supremacy. In his appraisal of Beaux's art, sculptor Lorado Taft is more generous, noting that the painter's individualistic style is technically admirable ("as the cleverest of our men"). In comparing Beaux to the "colored painter" Henry Ossawa Tanner, however, Taft suggests that despite her greatness Beaux—implicitly a second-class citizen—will never quite belong in the pantheon of white males. Taft's approval of Beaux's womanliness is also significant. Beaux's carefully calculated femininity was a strategy for acceptance and success at a time when it was widely believed that higher education and professional aspirations would unsex a woman, transforming her into a threatening, androgynous figure. As Taft's remarks about her distinction and refinement suggest, she also occupies an elevated rank in the social hierarchy designed to exclude those deemed alien and impure. Beaux's interview with the* Boston Herald, *though, hints at the extent to which she embraced the masculine norm, even to the extent of opposing women's suffrage. Most women still belong in the home, she indicates; only the truly exceptional (herself implicitly included) can surmount the biological and social obstacles that litter the path to greatness.*

"Miss Cecilia Beaux and Mr. W. M. Chase," Evening Sun *(New York), March 6, 1903.*

Miss Cecilia Beaux has frequently been spoken of as the ablest woman painter in America; but surely this is a poor compliment. Painting, like music, has long been regarded as one of the polite feminine accomplishments, a pastime to be taken up at school and dropped on the day of marriage; but this strange custom need not blind us when women enter into serious competition with men or give themselves up in earnest to the practice of their art. Miss Beaux's work challenges comparison with the best of its kind, and in sheer ability there are not many women and very few men, who could rival her exhibition at Messrs. Durand-Ruel's. Comparing it with another exhibition of portraits, Mr. Chase's at the Knoedler gallery, we find it nothing short in knowledge, facility, and mastery of material; in a word, Miss Beaux's method is so far from tentative or apologetic, that the usual allowances, if ever pertinent, may confidently be dismissed in her case.

Having cleared the ground thus far, we may go a step further and ask what would remain were the method, the executive part, discounted? What is it that makes these portraits so much better than the ordinary sort? They would strike attention at any exhibition; but have they anything that sticks in the memory, anything that tempts one back to gloat over after the first impression is worn off? There are portraits here that have been seen before, and we see them again with the same admiration for the knowledge they show, the breadth and assurance, the downright ability of the work. Of the individual charm that some women bring to work more or less imitative we find no trace; what we do find is a very rare degree of accomplishment. These portraits would command attention beside almost any of their kind, except a Sargent. Next a Sargent the best of them would doubtless suffer; we should miss the perfect grasp of things the infallible logic that makes a good portrait by Mr. Sargent so indisputable whether you want to like it or not. We should then begin to find lapses in Miss Beaux's work where everything hung together with absolute precision in her rival's; passages almost but not quite true to the intention; approximate values, almost but not quite, realized; forms almost, but not quite clearly, compassed.

If the comparison seems unnecessary the fault is, with Miss Beaux's portraits. Apart from their rare ability they have little to hold us; and it is because there is so little else that the temptation to linger over them is so slight. They discover nothing new when we meet them again; what they have to give is given away at once, at the first encounter.

Lorado Taft, "Work of Cecilia Beaux," Chicago Record, *December 21, 1899.*

With the close of the autumn exhibition we lose probably forever a picture which I would much desire to see retained upon the walls of the Art institute. It occupied the place of honor and shared with Mr. Wendt's extraordinary display the highest praise expended upon the collection. This beautiful painting, called "The Dreamer," shows a young woman of true American length of face, who leans slightly toward us over the arms of a chair. Her hands are lifted and pressed together against the chair back and support her head. She looks straight out at us—or on beyond. The countenance is refined and pure; the white dress simple and unornamented. No picture in our galleries could better illustrate the perfection of modern technique . . .

This superb painting is rendered the more notable by the fact that it bears a woman's signature. In doing such excellent work Miss Cecelia Beaux has not only distinguished herself, but has accomplished a great thing for her sex . . .

. . . Until this day the world has not seen a truly great woman painter; and in sculpture the record is still more disappointing. When you assure a pupil that there is no reason why woman

should not achieve the highest success in the walks of art, it is depressing to be obliged to add, "but she never has." Then, too, it has been unfortunate that these women who have won some meed of distinction in art have often been most manlike in characteristics. Rosa Bonheur's trousers were not her only masculine attributes; her portrait is scarcely distinguishable from that of "Père" Corot, while Harriet Hosmer still prides herself on having been a veritable tomboy and never having gotten over it. The gentle natures have as a rule been more or less meek followers of stronger guides. Elizabeth Gardner's paintings are feminine Bouguereaus, Harry Thompson's women pupils paint exactly like their teacher—gray foreground, gas-pipe trees and all. And so on, until very recently the exceptions to this discouraging rule have been few indeed.

The Philadelphia woman has emancipated her sex, as it were. She has not only made a record, but like Mr. Tanner, the colored painter, has shown the potentialities of her kind. Every woman artist should rejoice that her own artistic horizon has been thus enlarged. Henceforth they need fear no sotto voces, no mental reservations, in the godspeeds of the masters. Henceforth there are no limitations; all things are possible!

Miss Beaux has not only painted strong and beautiful works, as admirable technically as the cleverest of our men can offer, but she has evolved a style all her own. There is no trace of imitation in it, no mannerism, no copying of Bouguereau's waxy surfaces, nor of Courtois' thinness, naught of Dagnan-Bouveret's "tightness," nor of Lasar's famous "soup" atmosphere, though all of these eminent men contributed to Miss Beaux's art education, as had several Philadelphia painters before them. From each she took and assimilated what she required. Out of all these influences, but notably upon her own strong personality, she built up her artistic character . . .

The writer had the privilege of a visit to Miss Beaux's studio last winter and was relieved to find that the gifted artist was in no sense mannish; on the contrary, she gives the impression of a most womanly woman. She meets one cordially but with dignity and grace. She has the air of distinction and of cultivation, which is easier inherited than acquired—one does not put it on like a garment. She is strikingly handsome; tall, with hair turning gray, but the face young and finely chiseled. The modest yet interested way in which she showed her works, some of them of international fame, made the call most entertaining.

"Cecilia Beaux, Artist, Her Home, Work, and Ideals," Boston Herald, *September 23, 1910.*

As you draw near to Green Alley you are met with a series of surprises. The winding strip of road which leads from East Gloucester to the point becomes narrower and narrower, till finally a white-painted sign heralds "Dangerous passing. Automobiles Not Allowed." As the visitor was being driven into a bit of woodland the driver suddenly pulled up his horses by a tiny white picketed gate.

"Here's the place," he announced, and cramped his wheel for one to alight . . .

Following the winding path for a few yards, you stumble across a miniature bridge across a still more miniature brook. In striking contrast to the cool green of the tangled thicket are the white marbles ornamenting the bridge. Another twist of the narrow path brings you out of the enchanted forest to the palace . . .

Once inside the airy living room, with its dark panelled fireplace and white walls, the visitor waited while the maid started to announce her coming to the artist. In the mean time a door opened very vigorously from the garden and Miss Beaux entered the room.

She had been gardening, she explained, and chanced to be dressed in her painting clothes.

A large untrimmed straw hat, sitting low on her head, framed her face as completely as a nun's cowl. She wore a short woollen skirt and a soft gray collarless blouse, fastened at the throat with a quaintly enamelled pin. Over this was a mauve colored silk jacket, cut after the fashion of a Japanese kimono. Her only ornament was a long silver chain of very fine mesh, which twice circled her throat and hung to her waist.

"What should you like to talk about?" she began graciously, yet somewhat fearfully.

The American woman was suggested.

"What are her chances as an artist?"

"Every chance that there is," exclaimed Miss Beaux, enthusiastically.

"She has real talent, nothing stands in her way. The few obstacles that confronted her in this country have now been removed.

"A woman now has every opportunity that a man has," she continued. "She is admitted to any art school where she may apply, at least to every art school here that I know of.

"It isn't as it used to be. You know the pioneer students who went to Paris suffered all sorts of embarrassment in the mixed classes, much that they were conscious of, and a lot of misunderstanding that they did not even know existed.

"There is no reason why a woman cannot become as great an artist as a man. That is, as far as her ability goes.

"The fact is, that more men succeed in art than women. Why is this so? I do not know." Perhaps some day it may be proved to the contrary. Strength is the stumbling block to many women. They are sometimes unable to stand the hard work of it, day in and day out. They become tired and cannot re-energize themselves. They have not the vitality—the power to attack the thing anew after a brief rest. Vitality is a strange thing, you know, and very often exists in the frailest body . . .

"Perhaps you can put it this way. A man who does a man's work is a normal human being. A woman who does a man's work is a kind of superwoman. She must be two selves, one who supplies energy for her part of the world's work, the other the woman who fulfils the obligations custom has laid upon her.

"Am I a believer in woman's suffrage?" Miss Beaux leaned back upon her divan and laughed long and merrily. The question evidently did not impress her as a serious one. She looked reproachfully at her interviewer. Evidently she had been called upon to give an opinion upon the question many, many times.

"No, I am not, most emphatically."

"Is woman's place in the home?"

Miss Beaux smiled. Then, more seriously, "Yes, I am a very firm believer in all that kind of thing. Not that I believe for a moment that doing a man's work unsexes a woman. It does not. It is a question of whether she can satisfy the demands which her art makes upon her. Has she the vitality to give?

"I'm not sure that the normal woman does not spend too much energy upon housekeeping. I keep house, and it's really easy, much more easy than many people think," and again Miss Beaux laughed. "I don't find it hard. Perhaps because I have been fortunate in having very good servants and try to give my mind to it only at certain times. Any woman who works must have to shut out domestic matters absolutely, when they have once been considered. I do a great deal of work in my garden. I will show it to you before you go. My phlox was beautiful this summer. Just now I am afraid that its beauty is waning. Yes, you see I do many of the things that I warn other people against doing."

Frank discussions of the life choices available to women artists were rare in the nine-teenth century. Louise Howland King Cox takes on the subject in the following essay, which appeared in the short-lived periodical The Limner. *Cox advises her female readers to delay marriage until after they have received a rigorous education, equal to the training afforded men. Though recognizing the differences in gender expectations of men (professional and public) and women (domestic and family), she nonetheless argues that all artists suffer from distractions from their studio work. Under such cir-cumstances, she argues, both men and women should reduce their artistic production but retain the level of quality. Do less, but do it well. At the end, she criticizes women who would forego marriage for their careers, suggesting that in doing so they give up too much.*

Much of Cox's advice stems from her own experience. After falling in love with her teacher, Kenyon Cox, at the Art Students League, she engaged in a lengthy courtship while perfecting her skills, not marrying until 1892 at the age of twenty-seven. Her insistence on exacting study in the antique and life schools accords with her husband's method of teaching. After marriage, the Coxes raised three children, and although both made compromises that took them away from their studios, Louise ended up painting much less than Kenyon, eventually moving away from "ideal," allegorical work to specialize in the "female-appropriate" genre of children's portraits.

Louise Cox, "Should Woman Artists Marry," Limner *1 (May 1895).*

There has been and always will be, I suppose, much discussion of whether woman artists should marry. I say woman artists advisably; to my mind, a woman art student is just like any other art student and has to go through the long mechanical drill of study, day after day. Naturally, if she is married, the demands of family or social duties, render this routine application difficult except under very advantageous circumstances. Why should a woman, any more than a man, marry before completing her technical education, if she wishes seriously to pursue a profes-sion? It is the accepted thing that men shall not marry during their student days.

The trouble, however, in many cases, is not that women marry before finishing their tech-nical training, but that their training is faulty particularly with regard to the preliminary steps. Women, probably from their earlier development, acquire a certain facility in execution; more mind should be devoted to acquiring control of the tools for future workmanship, easily and rapidly than men—A very delusive facility as it is often acquired without the careful and elab-orate study of drawing and form, and, when removed from the direct influence of school or master they leave no foundation for self sustained effort.

This, to my mind is the question: Not should woman artists marry, but why should women try to be artists with a less serious education than men?

Woman writers marry, woman musicians marry; Why should artists be a class by themselves. The woman painters who marry and go to pieces would probably do that any way. Only since most women do marry, marriage is made a convenient scape-goat.

There used to be some absurd theory about men who painted being spoiled by marriage. If there ever was any ground for it was the same as with women—they married before they were ready for harassing responsibilities and when the mind should be as devoted to acquiring con-trol and tools for future workmanship.

Now I do not mean to maintain that all men can draw, or that all men are well grounded in their professions or that all women are not; but I do find among woman much less inclination for the serious routine grind of antique and life classes, more seeking for special masters and special artistic influences.

Much is said of the conflicting duties of women after marriage, but it should be remembered that men, too, have many distractions and still greater responsibilities. Painting serious pictures often occupies the least part of their time. Teaching, illustrating, bread-winning in every way, time and thought given to the management of clubs, societies, etc. form a part of nearly every prominent man's work. I do not contend that a woman has no distractions—she has and they are of a fearfully diverse nature too—only, cannot she concentrate her forces and produce better work, though less in quantity, from her finer development as a natural woman? Quantity counts for absolutely nothing in the making of a great painter—Look at Mr. Dewings exquisite single figures! Can acres of less well considered canvasses obscure their loveliness, their undeniable stamp of artistic superiority.

I should never honor a woman who would give up a marriage—not marriage in general, as but a marriage in particular for one exclusively devoted to art. I doubt her existence—but if she does exist, she shirks half her duties and loses more than half the happiness of life and is but a poor creature. Art after all is life and I will never yield to the pessimistic theory that the fuller development of one must kill the other in women any more than in men.

THE ART WORKERS' CLUB FOR WOMEN

The late-nineteenth century was an era of professionalization, labor organization, and "clubbing"—all three of which are invoked in the following notice of a newly founded group, the Art Workers' Club for Women. Notable are the progressive use of the term art worker *and the unusual inclusion of models as members on equal footing with artists. The Club sought to erase the stigma associated with models as well as dignify their contribution to the creation of works of art (see also "Artists and Models," chapter 9). Within five years, it had more than 350 members.*

"The Art Workers' Club for Women," New York Times, *February 11, 1899.*

A club bearing the above name has been recently organized by several energetic women artists of New York. The number of women engaged in art is very large and constantly increasing. A body of workers of such proportions has common interests which can be furthered by organization. Attempts at organization have been made before, as, for instance, the one of a year or two ago to interest women artists and students in the erection of a large building especially designed for their occupancy. This club will correspond to many which exist for men.

The club has adopted a constitution and by-laws. One of its most interesting features is the position accorded to models. Article II of the constitution announces the objects of the society as follows:

"In order to create beauty the artist must study beauty. People generally do not understand that in order to study the highest beauty, which is the human figure, the model is a necessity, and serves art as does the artist: thus the artist is responsible for the model. By the co-operation of the artist and the model, both art workers, the highest results for art are obtained. Only the artist reaps the benefit of this mutual co-operation for art's sake. The model does not share in the reward that

is her due, either as an aid to the highest results of art or as a woman. We, therefore in the spirit of fraternity, establish this club, the objects of which are:

"1st. To set the professions of artist and model in a right light before each other and in the eyes of the world;

"2d. To help the members of the club when in trouble;

"3d. Our own improvement and amusement;

"4th. To protect both artists and models from any, who, in either profession, would bring discredit on it."

The conception of the relations of artist and model herein expressed is well worth attention. There has always been and still is a gross and common superstition about the artist's model, which has reacted upon both artist and model. The position of the latter is often an unenviable one. Social prejudices have practically resulted in her ostracization. It needs but some such recognition as the above to give the model her true position, to place her on an equal social footing. The artist is the model's debtor. One is as necessary to art as the other; they are complementary as actor and playwright are.

ADVICE FOR WOMEN PHOTOGRAPHERS

Frances Benjamin Johnston, a photographer based in Washington, D.C., was a pioneer in the visual documentation of African American higher education, taking a series of photographs at the Hampton and Tuskegee Institutes. She also documented historic American architecture and ran a thriving business in society portraiture. Given this background, Johnston stresses the practical in her essay written for women contemplating a career in photography. It is as much a business guide as a primer on setting up an artistic studio. In the excerpts below, Johnston discusses the proper means of interacting with clients and ensuring profitability in the business, the demand for studio portraiture free of artificiality, the need for a pleasing and comfortable studio décor, and the necessity of general artistic training as a foundation for more specific technical knowledge. Elsewhere in the essay (not included here), she outlines the cost and type of needed equipment, darkroom requirements such as separate plumbing and tinted windows, and the pros and cons of professional apprenticeships. Johnston describes a kind of ideal artist/businesswoman who is utterly independent and commands the respect of her clients and peers thanks to her tact and confidence. One senses something of a self-portrait in the essay, as well as the author's desire to enable more women to enter the realm of the professional.

Frances Benjamin Johnston, "What a Woman Can Do with a Camera," Ladies' Home Journal 14 *(September 1897).*

In order to solve successfully the problem of making a business profitable, the woman who either must or will earn her own living needs to discover a field of work for which there is a good demand, in which there is not too great competition, and which her individual tastes render in some way congenial.

There are many young women who have had a thorough art-training, whose talents do not lift their work above mediocrity, and so it is made profitless; others who, as amateurs, have dabbled a little in photography, and who would like to turn an agreeable pastime into more seri-

ous effort; while still another class might find this line of work pleasant and lucrative, where employment in the more restricted fields of typewriting, stenography, clerking, bookkeeping, etc., would prove wearing and uncongenial to them.

PHOTOGRAPHY FOR WOMEN

Photography as a profession should appeal particularly to women, and in it there are great opportunities for a good-paying business—but only under very well-defined conditions. The prime requisites—as summed up in my mind after long experience and thought—are these: The woman who makes photography profitable must have, as to personal qualities, good common sense, unlimited patience to carry her through endless failures, equally unlimited tact, good taste, a quick eye, a talent for detail, and a genius for hard work. In addition, she needs training, experience, some capital, and a field to exploit. This may seem, at first glance, an appalling list, but it is incomplete rather than exaggerated; although to an energetic, ambitious woman with even ordinary opportunities, success is always possible, and hard, intelligent and conscientious work seldom fails to develop small beginnings into large results.

THE BEST FIELD FOR A BEGINNER

The range of paying work in photography is wide, and most of it quite within the reach of a bright, resourceful woman. Regular professional portraiture is lucrative if it is made artistic and distinctive, but it involves training, considerable capital, an establishment with several employees, and a good deal of clever advertising. Under these circumstances the most successful way would be to gravitate into studio portraiture after a few years of careful apprenticeship and experience in other lines.

As a rule the beginner will find her best opportunity, and her chances of success greatly multiplied if she is able to originate and exploit some special field of work. In this direction there are many openings, such as interior and architectural work, the copying of paintings, "at home" portraits, outdoor pictures of babies, children, dogs and horses, and of country houses, photography for newspapers and magazines and commercial work. Developing and printing for amateurs, and the making of enlargements, transparencies and lantern-slides have also been made profitable by a goodly number of women in some of the larger cities . . .

WHEN DISTINCTION AND ORIGINALITY ARE AIMED AT

To those ambitious to do studio portraiture I should say, study art first and photography afterward, if you aim at distinction and originality. Not that a comprehensive technical training is unnecessary, for, on the contrary, a photographer needs to understand his tools as thoroughly as a painter does the handling of his colors and brushes. Technical excellence, however, should not be the criterion where picturesque effect is concerned. In truth, to my mind, the first precept of artistic photography is, "Learn early the immense difference between the photograph that is merely a photograph, and that which is also a picture."

Any person of average intelligence can produce photographs by the thousand, but to give art value to the fixed image of the *camera-obscura* requires imagination, discriminating taste, and, in fact, all that is implied by a true appreciation of the beautiful. For this reason it is wrong to regard photography as purely mechanical. Mechanical it is, up to a certain point, but beyond that there is great scope for individual and artistic expression. In portraiture, especially, there are so many possibilities for picturesque effects—involving composition, light and shade, the study of pose, and arrangement of drapery—that one should go for inspiration to such mas-

ters as Rembrandt, Van Dyck, Sir Joshua Reynolds, Romney and Gainsborough, rather than to the compilers of chemical formulæ. In fine, learn everywhere and of everybody; study carefully the work of other photographers, whether good, bad or indifferent; be sure to always regard your own productions with a severely critical eye—never an over-indulgent one; guard against this, and, above all, never permit yourself to grow into a state of such superior knowledge that you cannot glean something from the humblest beginner . . .

ARRANGEMENT AND MANAGEMENT OF A PORTRAIT STUDIO

Photographic portraiture should prove as charming and congenial a field for artistic effort as a woman could desire; and that it is lucrative is well demonstrated by many women who are successfully established in the business. To properly conduct a photographic studio, experience, training and capital are required. Nothing more, however, than is necessary to enter other professions, with the added advantage that, from the start, photography is usually made to pay something.

The ideal studio is, of course, the one built or remodeled to suit the exact needs of the photographer. But, in most instances, the woman entering professional photography will be obliged to content herself with what she can find ready to her use.

My studio room is eighteen by thirty-two feet, with a single slant skylight of ribbed glass, on an angle of about sixty-five degrees, and twelve by sixteen feet in size. Ribbed glass gives the soft, diffused light so desirable for effective portraiture, but needs to be further screened with transparent white curtains over the entire skylight, and, on occasion, patches of semi-translucent curtains to tone down the intense high-lights. Inside the white curtains are opaque shades on rollers, which overlap and serve to shut out the light whenever necessary.

I have tried to make my skylight room as artistic, as cheerful and as inviting as would be the studio of an artist. Most people consider dentistry and having their pictures taken as being equally unpleasant and painful, and shrink from the one quite as much as they do from the other. I do not know if dentistry can be robbed of its terrors, but I am sure that the imaginary sufferings of those who visit the photographer can be to a great extent mitigated—in fact, can be wholly dispelled by making the studio of the photographic artist inviting and attractive. This is a very great factor in making portraiture photography a success. I fully understand and appreciate the fact that every photographic studio cannot be metamorphosed into an artist's den. This, of course, is impossible, and in many instances it would not prove a profitable undertaking. Again, it might not be suitable to so transform a photographic establishment, and besides, it might prove to be the very opposite of convenient. However, the point that I wish to give emphasis to is that a woman of good taste will exercise it in order to avoid the bare ugliness and painful vulgarity of the ordinary "gallery," and make it her careful study to render her surroundings as attractive and beautiful as possible. I must not be misunderstood as saying that the galleries of all photographic artists are ugly and vulgar in appearance, for I only want to say that with a little additional effort the usual photographic establishment can be made much more attractive and inviting to the public, also much more in harmony with art. I think that what I have said makes entirely plain the value I set upon making the studio inviting . . .

SITTERS BEFORE THE CAMERA

As to the actual work under a skylight, only a few general hints may be given, as here each must "work out her own salvation." Do not attempt to pose people, or to strain your sitters into uncomfortable or awkward positions, in order to obtain picturesque effects. Watch them, and help

them into poses that are natural and graceful. Study their individuality, striving to keep the likeness, and yet endeavoring to show them at their best. Avoid emphasizing the peculiarities of a face either by lighting or pose; look for curves rather than angles or straight lines, and try to make the interest in the picture centre upon what is most effective in your sitter. The one rule of lighting is never to have more than a single source of light. Many portraits, otherwise good, are rendered very inartistic by being lighted from several different directions.

Another consideration of the first importance is not to permit portrait negatives to be over-retouched. It is not too much to say that this is the worst fault of the average professionals. Their work strikes the level of inanity because they consider it necessary to sandpaper all the character and individuality out of the faces of their sitters. In regard to the finished work I would strongly advise the use of only the best and most permanent printing processes. "Mounts" should be quiet and effective, while correct taste, simplicity and a sense of the eternal fitness of things should be displayed in the matter of letter-heads, announcement cards and all other forms of advertising. The importance of this often-overlooked detail must be obvious to every one.

THE BUSINESS SIDE OF PHOTOGRAPHY

Good work should command good prices, and the wise woman will place a paying value upon her best efforts. It is a mistaken business policy to try and build up trade by doing something badly cheaper than somebody else. As to your personal attitude, be businesslike in all your methods; cultivate tact, an affable manner, and an unfailing courtesy. It costs nothing but a little self-control and determination to be patient and good-natured under most circumstances. A pleasant, obliging and businesslike bearing will often prove the most important part of a clever woman's capital.

By the judicious and proper exercise of that quality known as tact, a woman can, without difficulty (in fact, she can readily), manage to please and conciliate the great majority of her customers—even the most exacting ones. She may do this, too, without being very greatly imposed upon—without being imposed upon at all. Tact, I would emphasize, is a great factor in successfully conducting a photographic studio; it is, I suppose, a virtue to be cultivated by every one who has dealings with the public, and who is brought into contact with people in whatever business or calling she may be engaged.

Fig. 12. William M. Harnett, *The Old Violin,* 1886, oil on canvas. National Gallery of Art, Gift of Mr. and Mrs. Richard Mellon Scaife in honor of Paul Mellon. Image courtesy of the Board of Trustees, National Gallery of Art, Washington, D.C.

12 NEW MEDIA, NEW TASTEMAKERS, NEW MASSES

CRITICAL VOICES

EUGENE BENSON

At a time of almost bewildering transition in American cultural life, the progressive critic Eugene Benson occupied a judicious middle ground. Loyal to "native" subject matter (see "Winslow Homer's Prisoners from the Front," *chapter 7), he nevertheless believed firmly in the expressive, more personal modern art coming to the fore in Europe in the late 1860s. The occasion of a visit to the collection of John Taylor Johnston, the railroad magnate who served as the first president of the Metropolitan Museum of Art, offers Benson an opportunity to state his credo and back it up with examples. He begins by stressing the capacity of art to teach the viewer about contemporary social mores: art instructs not so much through great national themes as through the direct experience of "forms and colors." A committed humanist, Benson is fascinated by the personal— the taste and style that yield insight into the mind and beliefs of the individual painter or collector. He argues in favor of secular modernity, but with a nod to an earlier, less judgmental sense of beauty—leading him to the memorable inclusion of Phidias and Darwin in the same sentence. In the comparison of French to American landscapists (Corot and Dupré vs. Church and Cole), Benson displays his sensual, experiential method of responding to works of art. He looks for the ways that "sentiment" and "feeling" act on the psyche of the viewer and finds himself best pleased with the French examples. Characteristically, Benson understands what the works of Church and Cole meant to earlier generations but questions their relevance to the present one.*

Eugene Benson, "Pictures in the Private Galleries of New York," Putnam's Magazine 6 *(July 1870).*

A private picture-gallery means something more than the munificent disposition and refined taste of its owner: it is significant of many things of general interest. It may even be expressive, to a certain degree, of the range and scope of our social life, of our intercourse with nature, of our understanding of much that is related to our affections. An adequate account of pictures in modern galleries would be a comment on the ideas, the tastes, the sentiments, the manners and customs, of the men and women of our epoch.

For example, we are in Mr. John Taylor Johnston's gallery, which, in the number, interest, and value of the paintings that it holds, is second to no gallery in New York; and, with one or two pictures more, it could be made superior to any. It is wholly modern. Instead of representing a few simple ideas, like a gallery of ancient art—instead of presenting to us symbols and types—instead of giving us the religious and exalted,—it shows us forms and colors that express the particular tastes of individual men, which we enjoy because we are curious—because we are interested in more things than men of the pagan or of the pagan-Christian epoch.

But it may be said that all art is a representation of the particular tastes of individual men; so we must make this distinction: while the particular tastes of the old painters were more or less limited to madonnas, saints, and goddesses, the particular tastes of our modern painters carry them over every form of contemporary life. The old painters depended upon the natural, permanent, and typical; the modern painter relies upon the occasional, the customary, and the characteristic, and he is under the rule of propriety. The modern painter is secular in his aims, and the ancient was religious; and while he was religious he was not necessarily ascetic, but bore as free and uncorrupting witness to the loveliness of material beauty in the figure of a boy, girl, or woman, as, to-day, a pious girl does when she paints a wreath of flowers. But we make a distinction between the beauty of a flower and the beauty of a woman. We look upon the undressed loveliness of the first without reproach; but the undraped form of a girl is generally excluded from our art-galleries. Not only is our philosophy at fault, but our sentiment of the beautiful is feebler than our notion of propriety; and the suggestions which come from minds not free from mediæval prejudices—against what is called the flesh—are attributed to beauty itself, which is irreproachable.

When we get our Phidias and our Titian to work with our Darwin and our Huxley, we shall understand that God's unimpeachable manifestation is not less in the natural than in the spiritual, and that it is as blasphemous to impute evil or corruption to the beautiful, as to accuse God of wickedness . . .

Look upon that fine specimen of Corot—a wood-scene—recently added to Mr. Johnston's fine collection. If Corot's art is still a secret to you, look at this picture until you are permeated by the sentiment of nature which it expresses, and understand the delightful, easy (although, in fact, we suppose it to be the result of very great labor), natural style which it exhibits. Every thing is cool and dark, but not cold and black, in this picture. The daylight hardly gets into the woods, but you see it is outside in the spots of light that are seen through the trees at the horizon. And how fine is the rendering of light! how transparent and cool the shadows! how light and leafy the masses of foliage, at once airy and penetrable! It is a French wood—that is, a damp, dark place, with elegant and thin trees, not grand and solemn like our American woods. These tall, reed-like trunks, these scattered branches, this freedom from undergrowth, is unlike the tangled and profuse and varied vegetation of our forests; but it is nature, and it is nature as painted by a gentle and *naïf* man. The painters of our woods could be taught something by this specimen of Corot. The quality of the color, the absence of dryness and paintiness in the touch—a touch remarkably light and fleeting and suggestive—is worthy of attention. The scattered lights tell as light, and the gray, dim green of the woods is finely rendered. No style is better adapted to the subject; it is close to it. How far is the false and the artificial from Corot's pallet! But this wood-scene is a melancholy picture; it is a picture that would be good for the eye of a tired man, and make a soothing solitude for his reverie. We can imagine a positive man taking infinite pleasure out of Corot's art, precisely because it is so uncertain and harmonious, and so tender in its meaning; for do we not ask another to give us what we lack ourselves? But perhaps your sympathies

are not in the direction of such art-expression. Perhaps you like *éclat*—the dazzle and force of effect of full daylight. Such suggestions of dampness and melancholy as Corot's wood-road make you shiver, and you ask to feel warmth, to see color and sunlight in a landscape.

In Mr. Johnston's gallery, Jules Dupres will give you what you want. This little canvas, not much larger than the printed page you have under your eyes, is a remarkable piece of effect; it is bright, vigorous, and rich in color, and free and full in style. It is open to the charge of being *forcé* or artificial in color, but it is vivid, and it is capable of giving a sensation. However, while you enjoy so much effect, while you marvel at the very solid painting of the lights and the very transparent and thin painting of the shadows, you must let me remark, that the tree is not beautiful in form, and that bitumen may be said to play too great a *rôle* in the picture. And yet this little picture is one of the most instructive in its method of painting—so instructive that we believe it could teach many of our landscape-painters just in what respect their method is monotonous and feeble. It is the work of a master. Why is it that both of these specimens of French landscape-art are more interesting and charming than any American landscape in Mr. Johnston's gallery? It is because, in their style and sentiment, or method and feeling, they are superior to manner and feeling in the examples of our American painters. And we say this in front of the finest picture ever painted by Mr. Church.

The "Niagara"—the first Niagara painted by Mr. Church—is the only adequate representative of American landscape-art in Mr. Johnston's gallery. The drawing of the water, the rendering of the movement and character of the current, is finer than any thing we have ever seen of the kind in landscape-art. This "Niagara" is a remarkable study; it is a great part of the fact of nature, but its interest is closer to science than to art. It appeals to the intelligence, and it is the work of a good, cold understanding. We respect the talent of the artist, we admire the picture, but both are without charm; and, as art, the picture has very little that we care for. But in these bits of French landscape, so *unpretentious,* so strictly within the means of art-expression, so charming in suggestion, so natural, we have something that expresses a *love* of nature. They are full of sentiment, and indicate an artistic aim. We do not wish to detract in the least from what is justly due to Mr. Church as an artist. He has very pronounced merits next to very great defects. He is the only landscape-painter living who has any thing cosmical in aim and idea. But the very comprehensiveness of his aim, creditable as it is to his ambition, is hurtful to minor charms and precious truths in landscape painting. Mr. Church's "Niagara" justly holds a place of honor in Mr. Johnston's gallery, for it fairly represents some of the most striking, some of the most studied characteristics of American landscape-art. But, for the poetry and beauty of American landscape-art, we must look to Mr. S. R. Gifford; and yet the little specimen of Gifford in Mr. Johnston's gallery is a minor, if not an inferior, example of his talent. While Church is at his highest level in the "Niagara," all the other landscapists of our school are merely represented here by characteristic pictures.

The series of landscapes known as Cole's "Voyage of Life" are not to be considered as landscapes; they are good allegories and poor landscapes. They represent Cole's ideas in a graphic but conventional manner. Were they less conventional they would be less intelligible; and we require an allegory to be perfectly manifest and expressive. Cole's pictures of the "Voyage of Life" must always have a charm for Sunday-school teachers; they must always be striking and admirable to people who write and read tracts. They are not very close to nature, but they are expressive of a common and universal conception of life. But there is no mighty invention in them—invention such as makes a part of the glory of Milton; there is no intense reality, no clutch upon fact, as in Dante. And what are symbol and allegory in the hands of any but ex-

quisite or powerful masters? Consider Cole's "Voyage of Life," and be wise. Symbol and allegory are means only for the great ones, as the epical is an aim only for the greatest man.

EARL SHINN ON CRITICISM

Because of the controversial nature of their profession, critics sometimes felt it necessary to define, and defend, their literary art. Earl Shinn's attempt, written in 1875, is one of the clearest such essays. The Quaker-born Shinn rebelled against his religious upbringing and trained as a painter at the Pennsylvania Academy of the Fine Arts and the Ecole des Beaux-Arts, but he later devoted himself to art journalism. His ideal critic is a generous writer, with a universal and flexible mind used to point out merit rather than find fault (see "Thomas Eakins's The Gross Clinic," chapter 8). While employing vague terms such as "truth" and "excellence," which had clouded debates about artistic success in early decades, he also states a belief in "fixed principles," going so far as to call art criticism a "science." There is, however, one older term that he dispenses with categorically: taste. In the antebellum era and before, "taste" was a concept that had moral overtones, and it was a key ingredient to an artist's success. But Shinn dismisses taste as capricious, illogical, and conventional. In an era of "art for art's sake," the notion of taste has become too associated with bourgeois sentiment and limitation.

The second short excerpt from Shinn's review of the National Academy annual exhibition of 1879 makes familiar distinctions between the older "native" school and the new generation of artists trained in Europe. It is included here for what appears to be the first use of the term "Hudson River school," an appellation that arose long after the heyday of this important group of landscape painters.

E.S., *"Criticism and Art Critics,"* New York Evening Post, *April 30, 1875.*

We are inclined to believe that there is more reliance to be placed on the popular taste and judgment than in the opinions of most critics who write on art, or rather who write down art. Artists do not object to a fair and liberal expression of thought, and can make allowances for the difference of opinion and taste: but when it takes the form of severe and unjust criticism they feel aggrieved. Whether opinion is to be dignified by the appellation of criticism, with all the force and meaning of that word, or whether opinion indicates only the peculiar taste and view of the writer, depends upon what significance is given to criticism. Without disparagement to any of our writers on art, who deem themselves competent to exercise the prerogative of critic, and for the purpose of obtaining a fair judgment in behalf of the artists' works, it seems proper to inquire what is understood by art criticism. How does it differ from the exercise of taste, and how shall it be used? The first two questions will form the subject of inquiry in this letter.

Criticism, we take it, means true and impartial judgment, and is supposed to be based upon a positive knowledge of the principles which enter into and form part of the thing or subject criticised. This we assume to be a logical definition of criticism. It is the exponent of truth, and may properly be termed a science. As applied to the arts of design its requisites are an intimate acquaintance with academic rules and the uses and effects of color. This rudimentary knowledge requires years of patient and persevering study, and is within the reach of most persons who will devote to its acquisition sufficient time: but a knowledge of rudiments only, important as they are, will not make a great artist or a good critic. We are then to look for higher art elements, both for practice and criticism. They are a due appreciation of intelligent and ap-

propriate expression, poetic sentiment and cultured taste; and just in proportion as these prevail (other conditions being equal) will the artist and critic excel.

In the exercise of true criticism there is nothing evasive or undetermined; and whether a work of art is viewed as a whole or in part, objectively or subjectively, every merit and defect can be determined on fixed principles; if this be not so of what avail is criticism: Excellence might as well be called a mere knack, a fortuitous and inexplicable aptitude, dependent upon accident for success, and upon caprice for judgment.

It does not follow that the critic should be a practical artist, yet he should know every elementary principle which enters into art, and so much of the practice as to be able to determine the truth of certain effects and the means by which they are produced. So far the artist and critic can go together. There is, however, a diverging point, where the critic must act independently. It is well known that artists have their peculiar styles or manner of treatment differing in many respects from each other, following different schools, with different habits of thought and feeling, with a preference for certain effects, colors and handling: indeed no two artists, no matter how skilled they may be, will treat the same subject in the same way. This difference of manner or style does not interfere with the progress of the artist in arriving at satisfactory results: he may excel in his own peculiar manner as much as the other: his productions will have the stamp of genius, and genius has no monopoly of taste or style. Were it not so, there would be little or no progress, and one artist would be merely the imitator of another; but that very genius which has directed the channels of his thought to his peculiar style and manner of execution has interfered to a certain degree (although artists may not allow it) with a critical analysis of productions and effects different from his own. He certainly has a choice, and that is in his own favor. Idiosyncrasies of thought and peculiarities of manner characterize schools as well as individuals; hence arise the distinctive manners of the Venetian, Florentine, Dutch, Flemish and pre-Raphaelite as well as the Dusseldorf, modern French and other schools; so that the connoisseur and accomplished critic can at once determine the school that any work of art belongs to and, understanding the individual peculiarities of the artist, can recognise and give full value to his motive and to his work.

It is in the individual treatment that the genius of the artist lies, and it is the province of the critic to discover and appreciate it, not by comparison, for genius will not brook such an ordeal; nor by finding out faults, for no genius is without them; but by giving a proper estimate to everything meritorious in his work. If there is no merit, criticism is unnecessary and worthless.

Fault-finding, narrow and exclusive prepossessions, do not belong to a true critic or connoisseur. He must have universality and flexibility of mind, capable of recognising and respecting everything that possesses merit, even under peculiar conditions that seem to hide or disguise it. A single thought conveyed with appropriate art expression is worthy of acceptance and favorable criticism, although it may be in juxtaposition with a glaring inconsistency.

The lowest order of judgment which can properly come under the head of criticism—and it is by no means easy of attainment—is to determine defects and merits in drawing and in the rules of composition and color. This is judging art in its material aspect, yet so difficult is it to do that not one artist out of ten is master of the situation; and yet we find "critics" who will go through a gallery of paintings in an hour, and, with the utmost degree of assurance, pronounce judgment upon every object of art under their observation. There are some gentlemen of the quill who write very cleverly, so far as the use of words and construction of sentences are concerned, and who have at their command a choice vocabulary of art terms ready to apply as occasion presents; but who are totally incompetent either to comprehend the motive of the artist

or the execution of his work, and do not hesitate to "slash" at his picture right and left, with a bold flourish of their weapons, regardless of truth, modesty or propriety. Whether either the public or the artists are benefited thereby is extremely doubtful.

We do not mean to include in our category of pseudo-critics some of our best writers on art, who do not pretend to be accomplished critics, but whose cultivated tastes are beneficial in pointing out many beautiful objects and features of art which otherwise might not obtain due consideration, and whose opinions are received with great pleasure, interest and profit by the public and by the artists.

It is a common belief that persons possessing ordinary taste are good judges of art and good critics. Nothing is more erroneous. Although taste is an element of criticism, it is not much more than a perception of the beautiful and of its opposite and intermediate qualities. It is despotic, arbitrary and conventional, and does not possess the means of determining any forms or principles of art upon scientific or logical grounds. It is therefore capricious and untrustworthy; yet when highly cultivated it approaches criticism.

Edward Strahan [Earl Shinn], "The National Academy of Design," Art Amateur 1 (June 1879).

The present is the fifty-fourth exhibition of the National Academy of Design. In viewing the various works offered for inspection, it is striking how quickly the new tendencies and the old tendencies, the fogy pictures and the innovating pictures, the Hudson River school and the impression school, separate themselves out and assort their families. Never were the old men with their deeds more completely sent to the wall by the new men and their creeds. The ideas sprouting in the minds of those who have been seeking a fuller education in Paris or Munich, are seen lending their fuller color to the walls that in old years were so dull and conventional, and there are here and there instances of old-fashioned performers who have made a rapid and provisional change in their style, trying, as they say, to see nature more in the way of Corot or Rousseau. None present themselves, by the way, as trying "to see nature" in the way of Titian, or Valasquez, or Veronese.

An Academician, a lively and agreeable talker, who did himself the most flagrant injustice by his remark, said: "I am just like an old hen-goose I saw last summer, tied by the leg, and professing to . . . take care of a large flock of little chickens; the chicks were exploring for flies towards every part of the known world, and the old goose was pulling her leg off trying to follow after. So I am trying to get to the best view of nature, but there is the old string to my leg."

MARIANA GRISWOLD VAN RENSSELAER
ASSESSES THE PROGRESS OF AMERICAN ART

Mariana Griswold Van Rensselaer is one of the great figures in late nineteenth-century American criticism. Born into a wealthy, established New York family, she nevertheless became a widowed mother at age thirty-three and found it necessary to write for a living. Her output was prodigious, touching upon art, architecture, landscape, gardening, poetry, fiction, translation (she had been educated in Europe), contemporary life, and politics. To all of these she brought a keen, analytical intelligence and a profound knowledge of Western civilization. Had she not been forced to write for money, one nevertheless suspects she might have examined these subjects in much the same way, if for no other reason than to satisfy her highly developed powers of observation and evaluation. She was known for being fair and rational in her criticism, and her sym-

pathy for the challenges facing the creative intellect made her a favorite among artists. Although Van Rensselaer's writings certainly did much to educate the American public, she cannot be described as a populist. Indeed, the "voice" of her prose often reads like thoughtful salon conversation, addressed to a like-minded group of cultural initiates. The references are sometimes obscure, and the qualities she found successful in art and architecture are often hinted at only vaguely. Perhaps her greatest success as a writer was in making readers feel as though they belonged in this rarefied circle, participants in a revealing colloquy.

In this characteristic (a favorite word of Van Rensselaer's) essay of 1881, she distills from a season of disparate art viewing the larger, general trends in American art, preferring to provide commentary of a more sweeping scope. Van Rensselaer applauds the acquisition of European technique by the "new men," but she does not celebrate Continental manners in the abstract. Rather, she looks for the ability to make use of academic training to discover truths about contemporary American life, what she memorably calls "work racy with the flavor of the soil." She was constantly seeking the "national" in the art and architecture she reviewed, and she often found it in the works of Thomas Eakins, Eastman Johnson, or Augustus Saint-Gaudens (see "Mariana Griswold Van Rensselaer meets Thomas Eakins," chapter 8; and "The Farragut Monument," chapter 14). Yet she was far from a "nativist" in her criticism. As she advocated for American subject matter she pushed just as strongly for an elevated imaginative achievement that transcended cultural boundaries.

M. G. Van Rensselaer, "The New York Art Season," Atlantic Monthly 48 (August 1881).

In attempting a brief review of what the past season has produced in the way of pictorial art, it will be well, I think, not to content ourselves with a mere enumeration of individual objects of interest. We may profitably pass, by their means, to some estimate of the present condition of our art as a whole, and especially of the promise it gives as to its development in the near future. Only those who vividly remember American art as it was twenty years ago will quite understand the satisfaction we feel in looking back over the creditable showing of the past season; only such will appreciate the intense pleasure we draw from its evidence that the day is approaching when we shall have an art not only accomplished, but national,—not only schooled in the best contemporary methods, but devoted to the expression of our own local life and our own individual impressions. It would be idle, of course, to say that any such art yet exists in a comprehensive way. But we may fairly claim, I think, that we can already see its beginnings and foresee its wide development . . .

The so-called "new men," and the elder workers who are identified with them in aim and practice, have done far more for us than merely to paint their own pictures. They have established good methods of teaching, and have inculcated, by word and deed, better general views of art; and these views and methods have already impregnated our most conservative institutions. The worst work on our exhibition walls now rarely comes from the hand of a beginner, but is most often due to some older Academician, or to one of his contemporaries. It is a hopeful sign of the times, indeed, that many quite new and unknown names come yearly to swell the ranks of our best workmen, and to help carry off the highest honors. The generation that is just entering upon its life's work seems, in a word, to be starting along the right road, uninfluenced, to any dangerous extent, by the example of men whose names have long been held in honor, but whose practices could not now be followed without contempt for what we have

found to be better methods. Recognizing this fact the critic is no longer driven to constant fault-finding.

What, now, are the good qualities to be especially looked for in judging the present of our art and in calculating its future? Fifteen years ago our artists as a body—with a few notable exceptions, whom I need surely not stop to mention here—were not animated by individual and characteristic thoughts or feelings. Nor were they, on the other hand, masters of an accomplished technique,—of that precious artistic speech which can make the tritest or most casual thought, the most hackneyed or prosaic object, a painted joy forever. If we wished to improve upon our past, this technical ability was the first thing to be acquired as a necessary basis for all other excellence. Beginning, then, with the beginning, our younger artists have gone abroad in crowds to seek for manual training; that being a thing to be best learned by precept and example, not to be easily evolved from one's own soul, no matter how much artistic material might surround one, and no matter how truly one might be inspired thereby. We have now got far on the way toward technical accomplishment, I think; we may now boast of a large and rapidly growing body of young men whose work would in any country stand on a level with that of the ablest, of all but the most inspired, of modern brushes. We have been a little slow to recognize this fact, however; a little afraid to believe our eyes when they bore witness that young Americans, with quite unknown names and origins, were painting things as good as we could get from Europe, were conceiving of their art in the most thorough-going and artistic way, and were displaying, moreover, a commendable degree of diversity among themselves. At first we said, "They have caught a foreign trick from foreign masters. They have painted well, perhaps, in pupilage; but when left to themselves they will do the sort of work our men have always done, or they will run into extreme eccentricity and artistic aberration." They have amply proved, however, that they will do none of these things. The men who five or six years ago came home from foreign cities to be greeted with such prophecies now paint better than at that time. Each year—note the successive exhibitions of the Society of American Artists—they show less of mere eccentricity, fewer mere *tours de force,* more of balance, of discretion, and of high artistic effort. From extremely clever pupils they are growing to be masters in their art. They paint as enthusiastically, as steadily; they are as devoted to their art, and as entirely determined to pursue it irrespective of popular cavil, as when fresh from the inspiring atmosphere of Paris or of Munich. We are forced at last to confess that they can and do paint well,—still using the word in its narrower technical but most important sense. Convinced of this, however, we cannot rest satisfied a moment with so great a gain, so immense a promise for the future. We instantly demand that they shall do work racy with the flavor of the soil,—work such as no man has ever done before, and that will therefore be "original." This for records of external life. When they attempt imaginative work we insist that they shall at once show a power to rival that developed at the supremest moment of the noblest schools. These are all demands which must be realized, of course, before we can have a truly national art,—an art that shall be our own by any stronger title than the mere fact of its production on this side of the water. Art is long, however, and its steps are many and gradual, and must be properly sequent. It is only those who have no confidence in their own power to discern good work, though as yet unheralded by fame, in their own ability to perceive signs and promises as well as complete and wide results, who despair of the fact that our artists will soon see our own local materials in a pictorial manner, and think our own characteristic thoughts in an artistic way. It is for proofs that they have already begun, indeed, to do so,—for evidence that we have already men among us who are not only good painters, but American artists,—that we should most keenly look, in our current

criticising. While praising, therefore, good painter's work of every sort, no matter how unoriginal, it is for work in which local life and local ideas are most distinctly visible that our highest commendation should be reserved.

SYLVESTER KOEHLER REFLECTS ON A DECADE OF AMERICAN ART

One of the most thoughtful and hardworking critics writing on behalf of American art was Sylvester Koehler, a German émigré who came to Boston in 1868, worked for the Prang lithographic firm, founded the short-lived but important American Art Review, *and generally promoted the graphic arts in the United States as a curator and publisher. Koehler's book* American Art *appeared in 1886, and it included a long essay that examined recent art history, beginning in 1877. In it, Koehler shows himself as much a historian as a critic in his writing, grounding his discussion of art in the institutional dynamics that supported it. Koehler discusses technique and patronage, but he also connects the making of art to the larger issues of internationalism, capitalism, humanism, and the difficulties of living in a modern age. Clearly "art for art's sake" was an insufficient explanatory slogan for a critic of Koehler's intellect and awareness (see also "A Cautionary Essay on Art Instruction," chapter 10).*

S. R. Koehler, American Art *(New York: Cassell, 1886).*

The decade from the year 1877 to the present, closely as we are connected with it, and although its beginning is so near that it seems as if it were but of yesterday, lies before us with the distinctness of an historical period in the development of American art. It may be questionable, indeed, whether those who come after us will judge it as we do, but whatever the final verdict will be, the fact must remain that it was a period of awakening, of high hope, and of honest endeavor. It brought us a marvellous change in the character of our architecture; it saw arise and rapidly grow a school of wood engraving based upon entirely new principles; it introduced us to etching as a means of artistic expression hitherto almost unknown among us; it even exerted an influence upon sculpture,—although in a less degree, in so far as the bulk of production is concerned, than upon the other arts,—leading it away from a cold and lifeless classicism, acquired at several removes from its source, to a more vital and more picturesque treatment, and finally, but certainly not least, it revolutionized the technical processes of painting in a manner which gave to the canvases of American artists an outward attractiveness and a splendor never before seen in them.

It is said occasionally that the movement in American art noticeable in the period under consideration, is due to the influence exercised by the World's Fair,—good, plain, and sensible English for the more modern and shoddy "Universal Exposition"!—held at Philadelphia in 1876 to commemorate the independence of the United States, and the co-incidence of time seems to favor the supposition. That this is not so, that, on the contrary, the World's Fair was a result rather than a cause, I have repeatedly insisted upon, and it is well to again emphasize the fact here. Artists are not made in a day, and those who startled us at the exhibition of the National Academy of Design in 1877 and at succeeding exhibitions, had gone to Europe to pursue their studies long years ago, and some of them had quietly exhibited previously, and even at the Centennial Fair itself. Nor does the interest in decorative or industrial art date from that event. The State of Massachusetts passed its law placing drawing among the branches of learning required to be taught in the public schools in 1870, and the seal of the Museum of Fine Arts at Boston

shows that this institution was founded in the same year. It cannot be denied, of course, that the Centennial Fair in its turn acted as an impetus to the movement which called it forth, but it must be said, also, that its influence was harmful rather than helpful to art proper. For it directed attention mainly to decorative art, and thus rivetted still tighter the fetters which, in accordance with modern tendencies, hold art captive as the slave of private luxury. Still worse, however, was the effect produced by the attempt to show that art is commercially valuable, since such a sordid view of it must necessarily tend to obscure its true aim . . .

Strictly speaking the modern movement in American art goes back much farther than the year 1877. Its first apostle, or at all events one of its earliest representatives of sufficient personal force to attract followers, was William Morris Hunt, who returned to his native land, after several years of study with Couture and Millet, as early as 1855. The fact, however, that Mr. Hunt lived in Boston, restricted his influence, and gave to his following a provincial character. After all, New York is the metropolis of the country, and no movement can be successful that has not made itself felt there. Nevertheless, Hunt's influence was not quite inactive in New York, although it was communicated only indirectly, as for instance through Mr. La Farge, who was elected an Academician in 1869, while Hunt himself never had any connection with the Academy. It was through such agencies that the allegiance of American art students to Düsseldorf and to Italy was gradually overcome, and the tide of seekers of artistic knowledge was turned, with yearly accumulating force, towards Paris. Munich,—itself influenced by France and by Belgium (which again was only France by a round-about route),—also attracted a large number of American students, and it would be interesting to know precisely how they got there. Perhaps some one will write for us some day a history of the American colony in Munich, and a most fascinating chapter it certainly will be. Judging from appearances, accident had something to do with it. Mr. Shirlaw, one of the most eminent of our "Munich men," went to Europe in 1870, with the intention of going to Paris, but finding that city closed by the siege, he made his way to Munich, to stay there only temporarily as he believed, but in reality never to quit it until he returned to America in 1877. Mr. Charles H. Miller, and no doubt others,—Mr. David Neal, for instance, who went there in 1862, to become a fixture,—had indeed been in Munich before him, but the main representatives of the group generally known as "the Munich men" came to the Bavarian capital either simultaneously with, or somewhat later than, Mr. Shirlaw:—Mr. Frank Duveneck in 1870; Mr. Wm. M. Chase in 1872; Mr. Francis Dengler, the talented sculptor, unfortunately cut off before he could realize the promise he had given, in the same year; Mr. J. H. Twachtman in 1875. Some of these men were of German extraction, and the others had lived in the West, where German influences are powerful. Quite likely this had something to do with the preference given by them to Munich over Paris.

The names of Messrs. Miller, Shirlaw, Duveneck, and Chase will forever be prominently associated with the National Academy exhibition of 1877. As before noted, many of the European-American students had already exhibited in their own country in previous years, but their isolated efforts had been ignored, except by a few close observers, more especially as most of them had been skied or hung in corners, according to the amiable custom of hanging committees, who seem to think that the best way to strengthen newcomers is by placing obstacles in their way. The Academy hanging committee for the year 1877, however, consisting of Messrs. Thomas Le Clear (a home-bred artist, since deceased), Charles H. Miller, and A. Wordsworth Thompson (a graduate of the ateliers of Paris, whither he went in 1861), thought otherwise. They concluded to give the young men "a show," and it must be confessed that they had splendid material to work with. Mr. Shirlaw had sent his "Sheep-Shearing in the Bavarian Highlands," Mr.

Duveneck his "Turkish Page" and a portrait, Mr. Chase, less well represented than the others, his "Broken Jug" and "Unexpected Intrusion." In the heated discussion which followed the opening of the exhibition, it was charged that the committee had been swayed by its own Munich proclivities. That this was a mistake is evident from the analysis of the committee as given above. Its members were merely fair-minded men and good judges, quick to detect merit, and ready to acknowledge it wherever they saw it, whether in an apprentice or an Academician, and hence they placed those works first which to them seemed most worthy. Nor were only the Munich men represented in the exhibition. Mr. Edgar M. Ward's "Washing Place, Brittany," was on the line; from Mr. J. Alden Weir, then still in Paris, no less than five contributions had been accepted; Mr. Wyatt Eaton was represented by his "Harvesters at Rest," and of other names found on the catalogue and now sufficiently familiar to the public, may be specified J. Carroll Beckwith, F. S. Church, (entirely home-bred), F. Dielman (he, however, another Munich man), R. Swain Gifford (only two years ago returned from his second eastern trip), Thomas Hovenden, H. Bolton Jones, Alfred Kappes (likewise home-bred), D. Ridgway Knight, W. H. Lippincott, Geo. W. Maynard, Arthur Quartley (his "Close of a Stormy Day" on the line), and Louis C. Tiffany. And the older men of firmly established reputation had also not been slighted, as was clearly shown by the way in which Mr. Inness was honored. But the fact remained that these audacious youngsters, these *nouveaux venus,* had been hung on the line, and that some of the Academicians had been given second places,—some had been hung rather high,—one had even strayed over a door! And the worst of it was that the public, or at least that part of it which takes a special interest in art, and whose good opinion is best worth having, applauded! The consequence was a storm in the councils of the Academy. But that is a part of the secret history of the institution, of which outsiders are supposed to know nothing, and it is well, therefore, to let it rest.

Had the friends of progress within the Academy been able to muster a majority at the time, or had the young men, who were beginning to flock back from Europe, been less hot-headed, the split in the ranks of the American artists which ensued might no doubt have been avoided. But the Academicians passed a law,—since, I believe, rescinded,—that every one of their body should have eight feet upon the line at every exhibition, and the young men, fearing, justly enough, that they could expect nothing at the hands of the National Academy, established the Society of American Artists. Its first exhibition, held at the Kurtz Gallery (where the galleries of the American Art Association now are) in 1878, was another triumph for the new generation, or the reformers and almost revolutionists, as they were now coming to be looked upon. The membership list of the new society was not made up of the new comers only. It embraced from the start a number of men who had held close relations to the Academy, but who, owing to their modern tendencies, cut rather a strange figure, more or less, among their associates. Of this number were John La Farge, George Inness, R. Swain Gifford, Thomas Moran, Samuel Colman, and several others, and the list of contributors to this first exhibition showed a still broader fellowship. It included William Morris Hunt and John S. Sargent, George Fuller and F. A. Bridgman. To give an idea of the wealth of this exhibition, it would be necessary to insert the catalogue. As we are specially interested here in the productions of the leaders of the new movement, I shall recall only the "Good Morning" . . . of Mr. Shirlaw, the first president of the Society of American Artists, Mr. Chase's well-known "Ready for the Ride," remarkable, technically, for its careful finish, and Mr. Duveneck's "Coming Man," one of those realistic, vigorously brushed-in sketches which gave rise to the oft-repeated sneering at "Munich slap-dash." Mr. J. Frank Currier, that ultra of the ultras, was also represented,—his first appearance, probably, at an American exhibition.

At the National Academy exhibition of 1877, the Munich-Americans had specially attracted attention, although by the predominating importance of their work rather than by their numbers. The Society's exhibition of 1878 was more varied in its representation of different schools, but still the disciples of Munich played a prominent part in it. It was reserved for the exhibition held in Philadelphia in 1880, jointly by the Philadelphia Society of Artists and the Pennsylvania Academy of Fine Arts, to bring out the French-American students in force. As a whole the exhibition was rather one-sided. Home art and the art of the older generations was very inadequately represented, and the Munich men had nearly all of them staid away. But it was precisely this fact which gave to the exhibition its unique character. To many people, possibly it might truthfully be said to most, it was a revelation. Not a few of the artists represented had, indeed, like their Munich brethren, exhibited in America before, and some of them, like Mr. Bridgman, had long ago attained to fame, but no effort had thus far been made to mass their work, and it was this policy that gave to the exhibition its effectiveness. Mr. Bridgman was represented by no less than four important pictures, Mr. Blashfield by the same number, Mr. Charles Sprague Pearce by five, Mr. W. L. Picknell by his "Road to Concarneau" and "Edge of the Swamp" . . . and so on.

The question naturally presents itself:—What was there in these exhibitions that aroused the enthusiasm and kindled the hopes of those more deeply interested in art? And in what did they differ from those that had preceded them? . . .

It was a more thorough, more conscientious and more intelligent training; a facility acquired through years of patient labor, often superimposed upon an amount of previous practice which in former years would in itself have been thought sufficient to make an artist; a better appreciation of and finer feeling for color; a more alert power of observation, and consequently a more trenchant rendering of life, which separated the old from the new, and all this was accompanied by a greater independence, by a less patent reliance upon recipes and accepted formulæ, by the boldness of initiative, which gave to the works of the leaders among the rising generation a clearly defined personality, a flavor of individualism hardly to be expected, and therefore all the more joyously welcomed, among a lot of young painters fresh from school, and presumably still under the influence of their masters. Surely ground enough for the hope and the enthusiasm which their appearance inspired.

The movement in the United States . . . presented an aspect from the very beginning, quite different from that of the European movements. I have already pointed out that the impulse was due to outside causes. We saw others doing better, and were stung to emulation. We did not fashion our own tools, and learn how to use them by our own intellectual efforts. We borrowed the tools from others, and had them teach us how to handle them. And to this inherent defect, there was added another,—the lack of unity. True, modern methods are almost wholly based upon French precept, but the art students of America did not come under their influence until after they had been, not only diversified by individual, but even modified by national idiosyncracies. Hunt worked first under Couture and then under Millet, and totally different as these artists were, he was yet under the influence of both throughout nearly the whole of his life. And the "new men" were from the very beginning divided into two camps,—those of Munich and those of Paris. In one thing, however, they were of accord, and it was this, that the technical side of art, the *métier*, was their principal care. If they differed somewhat in the roads which they took to reach their goal, they certainly agreed that this goal was above all else to be *good painters*. And, curiously enough, the Munich men, those who had been under the influence of German "idealism," seemed to be most determined in this apparently materialistic view of

art, and occasionally mistook technical *légerdemain* for the highest aim of skill, and brutality for force.

It is the all but universal custom to see in this lack of originality of technique a defect in American art. It is more than doubtful, however, whether this view is correct. Although we aspire to be a nation, we are yet without a national name,—unless we should be willing to call ourselves "United Staters,"—and we present a mixture into which enter ingredients brought together from every quarter of the world. Our pride, therefore, must be in a greater, broader humanity than is possible among the better defined nationalities of the old world, which are really only tribal organizations on a larger scale. But the world's progress is towards universal brotherhood, and we are its most advanced exponents, however limited and hampered we may be by the old Adam still clinging to us, and the new sins evolved out of new conditions. Is it not natural that this state of things should show itself in our art? The distinctively German art of the beginning of the century was pedantic, over-intellectual and therefore unpicturesque, and limited in its range. English pre-Raphaelitism has many of the same characteristics, plus a morbid fancy and a forced sensualism, and minus the higher (however unpainter-like) idealism of the Germans. French art, on the contrary, as I have before stated, is thoroughly human and natural (except in some of its vagaries), and therefore a fit instrument for the expression of cosmopolitan thought. Hence it is quite easily understood why our artists should seek in it their model. It may be true, indeed, that it is not the form which is the main principle in art, not the method,—that it is the essence, the subject, the thing, or rather the idea, represented. But to be able to embody the idea, to set forth the subject, we need the technique, and its importance cannot be overlooked. And the more varied, the more universal are the ideas to be represented, the more pliable must be the method. It is well, therefore, that we should use that form which is least hampered by limitations, least prejudiced, most objective, best suited to express whatever may move us, without inherent incapacities of any kind. This universal, pliable, easily adjustable method once thoroughly mastered, we are ready for the greatest and most original tasks, provided there is something in us that really does move us and calls for expression. But here the artist, as an individual, is powerless, and he will strive in vain, so long as those with whom his lot is cast, for and with whom he must work, do not sustain and inspire him. For, granting even that he may be his own self-sufficient source of inspiration, all his efforts will nevertheless be useless if he is not understood, if he does not awaken an echo in those whom he addresses, if what he himself feels and tries to express does not struggle for expression also in the less fortunately endowed beings by whom he is surrounded.

The artists, therefore, instead of being blamed, are to be praised for their faithful endeavors to increase their technical skill, and if they are to be accused at all of one-sidedness in this respect, and of a lack of ideality, of "great efforts" in their works, it is only in so far as they are themselves part of the public. Many of them showed that, while they valued execution at its full worth, they were ready, nay, desirous, to try their skill upon more than studies, or decorative "bits," or pictures painted merely with a view to catching the eyes of the multitude and selling. But here, alas, their countrymen failed them! Nearly every young artist who came home from Europe either sent on before or brought along with him (or her), one or more large canvases upon which he had lavished all his skill and thought, and which, in many cases, had brought him honors and a name abroad. In their own land, however, they brought them nothing. The public was not responsive to their ambitious efforts, and most of them remain unsold to this day. Not even the Museums,—sorry substitutes at best for the places which used to supply the stage for art in the past, and merely last refuges for contemporaneous art when public patron-

age is wanting,—would buy them, for most of them had no funds, and their directors, with few exceptions, no heart for American art. And if, perchance, a public institution made earnest efforts to bring before the people the more ambitious productions of its students abroad, these efforts also met with no appreciation . . .

It is not strange, under such circumstances, that many of the younger artists should soon have assumed a position towards the public which savored of contempt, and in many cases actually expressed contempt. The motto "Art for Art's sake" was emphasized more and more, its meaning was perverted to "painting for painting's sake," and it was openly said that the artists did not paint for the public, but only for themselves. It is easy to understand how such a position came to be assumed, for neglect and injustice drive men to extremes. But technique for technique's sake, and as a last aim, is fatal. True art, like love, must have an object outside of itself. Without that love is impossible, unless it be self-love, which is unnatural and debasing. But while some of the artists were thus driven to one extreme, there were those also who were driven to the other. Some, indeed, abandoned the struggle, and quietly settled down to painting "pot-boilers,"—"saleable canvases of small dimensions," as the exhibition circulars expressed it. Others, in the struggle for existence and public favor, strove after all sorts of oddities and developed all kinds of mannerisms, and these were successful, if not financially, at least in attracting attention. For oddity and mannerism are easily comprehended, and, being "out of the common," seem *distingués,* while Nature is much too multiform and much too reticent and chaste to yield herself easily. The consequence was the gradual disappearance from our exhibitions of the more ambitious efforts which had given brilliancy to the beginning of the new period, and it was especially painful to notice that, as a rule, the artists who had returned home suffered more severely in this respect than those who remained abroad. And then came the disastrous seventh exhibition of the Society of American Artists, held at the National Academy of Design in 1884. Remembering the hopes that had been built on this society, its fiasco,—due apparently to a narrowness born out of the irritation above alluded to, and very different from the breadth of spirit which marked its first manifestations,—was most disheartening . . .

It is true, most certainly, that the impression usually made by American exhibitions is chaotic. A surfeit of paltry subjects which seem to justify the well-known sneer,—not first, however, provoked by American productions,—of the "anec-dotage" of art; a wild following of all the latest European vagaries; a restless change from Munich low tone to Chinese painting without shadows; a lack, apparently, of all technical as well as moral conviction,—excepting, perhaps, the conviction that we must make money. Here and there a bit of brilliantly bold handling, or of glowing or harmonious color which gives to the canvas showing it a purely decorative value,— in other cases a palpable imitation of age, which justifies the application to such productions of the title of "second-hand furniture dealer's art," as it goes well together with either genuine or spurious antiques, and might serve for the furnishing to order of bran-new ancestral halls. Of "great subjects" nothing, of obvious sentiment little,—an art, evidently, than which nothing else is possible, so long as our highest ideal is a "society," so-called, whose main reliance is stock-jobbing and stock-watering, and within whose *blasés* circles all serious discussion and all deep thought are forbidden. Does not the spirit of this "society" dominate us in all else? Do we not treat all subjects in the feelingless manner engendered by it,—the labor question, for instance, from the cold-blooded point of view of the political economist, who traffics in human blood and muscle, and stomachs and hearts, as he does in iron or cotton,—according to the laws of demand and supply, without the least regard to human sentiment and love? And why, if we

look upon human beings merely as ware, or as instruments for the creation of wealth to be enjoyed by a few, should we look upon art differently? To a society with such ideals art can be at the best only a servant of luxury. Quite as often it is an object of pride, of ostentation, or of "investment."

I have said before, and I say again, that the artists are not to blame for such a state of things, if it be deplorable, except in so far as they are themselves part of the public. There are those among them, no doubt, who are willing slaves of luxury, whose own views do not rise above those of ordinary "society," and who, therefore, are incapable of higher aspirations. But if they should all be of that kind, the fault would still lie with the public. We are unjust to the artists. If we would remember that the art of a time expresses its conditions, and that we, the public, are at least quite as answerable for these conditions as the artists, we would be more reasonable . . .

But is it really true that all our art is hollow, that there is nothing in it worth saving from a conflagration for the sake of posterity, and that, on this evidence, we must quite condemn ourselves? I do not think it is. Although it must be admitted that we are oppressed by an ever-growing idle class without any other aim but self-indulgence,—not to be confounded with those who, having ceased to strive after riches, devote their energies to intellectual pursuits,—and by a "society" whose reliance is stock-jobbing and stock-watering, and whose sole hope is the senseless piling of money upon money, we must recognize also that there is still to be found among us legitimate enterprise and respect for honest labor. And, although we are, no doubt, all of us tainted to a certain degree by the prevailing egotism, there is yet left among us love, truth, and the sense of justice, and the desire to make life pleasant without rude disregard of the rights and the comforts of others. We are not wholly bad, therefore, and hence our art also cannot be wholly bad.

Modern art, however, is difficult to understand. It is much more subtle than all that has gone before it, and therefore requires a keener analysis and a deeper sympathy for its appreciation. The shapes it assumes are manifold, Protean,—in accordance with the countless manifestations of modern life, its almost oppressive knowledge, its varying aims. There is an obviousness of motive in old art which is due to firmness of belief. We too have convictions, but they are convictions tempered by doubt,—doubt, noble and venerable, for it is the outcome of long and painful experience, of deep and anxious thought. And it is but natural that it should show itself in our art. Again, it must be borne in mind that we stand, if not at the end of a line of development, at least far from its point of beginning. But the beginnings are always more intensely interesting, and the first developments, after a movement has once got fairly under weigh, are more easily traced than the finer differences of the later stages. The development of technical processes, the rise of realism and its struggle with so-called idealism, impart a dramatic interest to the history of the art of the past. There is life upon the scene, we see the progress of the action, the plot unfolds itself rapidly before us . . .

Our art is of a more lyric character, and for the blare of trumpets and the clanging of bells we have the low sounds of stringed instruments. And is there any one willing to maintain that the lute or the violin is less impassioned, less deep in feeling, less subtle in shading, than the trumpet? But while this is certainly true in general, it yet cannot be said of us that we are incapable of rising to the height of epic deed or dramatic passion when occasion demands. We have shown it in life when we poured out our hearts' blood without stint on the battlefield for what we conceived to be right and true, and who knows but the time will come when these deeds shall be embalmed in song or fixed upon canvas?

*Based in Boston, Frank Torrey Robinson and William Howe Downes were self-taught
art critics who wrote for a variety of periodicals and labored on behalf of several late
nineteenth-century art institutions. Beginning in April 1894, the two writers launched
a series in the* Art Interchange *called "Critical Conversations by Howe and Torrey." It
ran for several years, and in the course of their monthly installments they discussed
more than fifty American painters, from acknowledged "stars," such as Winslow Homer
and James McNeill Whistler, to more obscure figures, such as the costume painter Ignaz
Marcel Gaugengigl and a specialist in African American genre scenes, Alfred Kappes.
The articles were presented as impromptu chats between the two men, and the result
was some of the most engaging and revealing criticism of the era. In the course of the
series, Childe Hassam is described as "a sort of Watteau of the Boulevards," John Sar-
gent's* El Jaleo *(1882) is called "a pictorial freak," and Eastman Johnson's* Funding Bill
(1881) is compared to Rembrandt's Syndics. *They debate the questions of John La Farge's
spirituality, they dismiss the work of Thomas Eakins and J. G. Brown, and in a comical
set piece Torrey effuses over Albert Pinkham Ryder while Howe tries to interrupt with-
out managing to get in a single word. It is both a serious appreciation of Ryder's poeti-
cism and a send-up of the contemporary tendency to exaggerate the moody depths of
his work (see "Beyond the Threshold: Visionaries and Dreamers," chapter 13). In the
first installment, given here, they cover George Inness (one of our greatest masters),
William Merritt Chase (an eye, not a brain), and Robert Blum ("his pastels are good
enough to eat").*

[William Howe Downes and Frank Torrey Robinson,] *"Some Living American Painters: Critical
Conversations by Howe and Torrey,"* Art Interchange 32 *(April 1894).*

It was one of those rare summer nights—a night when anything seemed possible, even paint-
ing a good picture or writing a readable book. Two men were sitting out on the veranda, smok-
ing their pipes, watching the stars and, as usual, talking and dreaming of art.

"Do you know," said one, "that it is the general opinion that we have no painters worth men-
tioning in this country?"

"Yes, I know it," said the other; "and I have never been more firmly convinced than at this mo-
ment that that is an error. We have in the United States about one eminent painter to each ten
million inhabitants, and that is a large proportion—quite enough for the kind of inhabitants."

"Have we any *great* American painters?"

"Well, the word is a ticklish one to apply to living men; but I will venture to say that we have;
yes, we can go even as far as that. We have Winslow Homer, George Inness——"

"Any more?"

"Yes; John La Farge."

"And Abbott Thayer."

"That makes four. Do you think of any others?"

"Well, there are Whistler and Sargent, if you call them American painters. They are officially
Americans, at any rate, since their paintings are passed through the Custom House free."

"Moreover, the English and French people appear to class them as Americans. I am sure we
should have no objections."

"None at all. Then there is Thomas Hovenden, a very interesting artist; there is Marcus Waterman, and I could add more names still."

"I suppose there are at least forty or fifty, possibly as many as sixty, living American painters who are really worth talking about."

"I doubt it. Will you make out a list?"

It was done and it led to many discussions. It was in this wise that the veranda chat grew insensibly into a sort of continued-story debate on American art . . .

GEORGE INNESS.

TORREY: "Now, here is a painter! Mere catch-words and smart phrases will not measure Inness's power; he is too well known and too well-appreciated to be hidden behind well constructed sentences; to speak as wisely, truly, and clearly about his works as one would wish to do, one should stand upon his level. But, since there is no critic who appreciates his work better than I do, let me, without apologies or preliminaries, which are not needed, tell you what I think of this earnest man, what there is in his art which appeals to me, bringing this one qualification of sympathy to the attempt to estimate his achievements. There are no successive phases in Inness's art; from first to last he has always seen and painted large; he has never toyed with nature; born enthusiastic, he has lived enthusiastic; art to him is yours and mine and any man's. Talk of one of his pictures and you talk of them all. Though the subject may not at once please every eye, the manner of interpretation cannot displease. I think that cultured America awoke in the Spring of 1884 to the fact that one of the unclassified stars of the art firmament had assumed the proportions of a planet, or, as Hugo would say, 'an Incendiary Giant.'"

HOWE: "I see that Inness's name excites you, and I do not wonder. Go on."

TORREY: "You will remember that it was at that time that a grand exhibition of his pictures was held in the American Art Galleries. It was like an irresistible attack—a bursting forth of the prodigious luminary. Here we felt all the magic of his chiaroscuro, the magnificent torrent of his color. Here were not only scenes and localities, but, with them, all the marks of the long years that had made them—the history of their existence to the moment. Here was the countenance of nature in many moods. It was no metrical, cadenced flow of poetical thought; it was unmeasured, unstinted, overflowing, like a deluge that knew no barriers. It was the fruitful tree bearing fruit; it was a creator creating. So stood forth Inness, representing nature. His gentlest Summer skies, free from clouds, might in the twinkling of an eye be angry with the instant glare of the lightning-bolt; his trees swaying in the soft breeze might soon be bowed to the very earth by the fury of the cyclone's blast. The cricket chirrups, the cows low, the cataract roars, and, not far away, American civilization dares for the first time to enter art with a railroad train."

HOWE: "Very true, but Turner had used the railroad as an art motive many years before, in his 'Rain, Steam and Speed,' in the National Gallery, you know."

TORREY: "Then comes twilight, and the moonrise. Then comes the amber morning's fleet Aurora, and the tender tints of the new day with all its vigor and hope. From right to left, from foreground to vanishing-point, above, beneath, all about, is the exultant life, the cheer of light, the eternal play going on, the everlasting movement, the teeming earth's respiration—the heavens declaring the glory of God, and the firmament showing his handiwork."

HOWE: "You almost persuade me that Inness is one of the immortals."

TORREY: "He was criticised years ago for his haste and carelessness, his eccentricity and reckless experimenting, and for using paint like plaster. Poor, deluded critics, who, while ap-

plauding this and condemning that, failed to see that the forenoon was but a part of the glorious day."

HOWE: "Which one of Inness's pictures is his best? Of course this is a hard question to answer with respect to the works of such an artist."

TORREY: "On no one picture can we place the laurel. There are certain canvases in which he seems almost to touch the infinite. The 'Nine o'Clock,' shown at the Chicago Exhibition, is a pure inspiration, in which he lays bare the soul of reposing, slumbering nature. In it he has espoused the hour with passion, with voice and instrument attuned, with sensuous breath; he must have lingered long under the flood of the moonbeams, and, at the stroke of the bell, left the enchanted scene sleeping like the odor between the petals of the rose. What a fairy offspring! It is worthy to be called the birth of the halo. Something of the same inspiring force is evident in almost every work. A picture by Inness is never boisterous, but often it is like a full orchestra. He may be said to give the symphony of nature. It is not the imitation, but the beautiful memory of things. It is not 'How like nature!' but 'I did not know that nature was so beautiful.' His 'Threatening Storm,' with its warning note, the far-off muttering color of the cloud-bank, the pallor of the foliage which stands so silent, sentinel-like, awaiting the command of the approaching storm-demon with submissive mien, the terrible logic of the hurrying messenger which sets the leaf and root a-thinking and men a-tremble—all this appeals to me. And then there is 'The Sunburst,' and 'The Sundown,' and the silver and iron-gray of 'The Lowery Day,' and the architectural 'Winter Morning;' to tell the truth, the strongest Inness is the one that you last saw. Such works fill me up. 'I live in art, which is the region of equals.'"

HOWE: "There were some magnificent things in the Summer Exhibition of 1893; that whole gallery-full of Inness's pictures made a tremendous impression."

TORREY: "Yes. As a brave man said to us while we were looking at the luscious green wood scene, the leafy dell, 'There is a clutch from nature.' It was more of a painting than a picture, yet there were pictures in it. The range of Inness's work as exemplified in that exhibition was something extraordinary, embracing as it did twenty-five years of activity; and one was just as likely to admire the 'Valley of the Olive Trees,' painted in 1867, as 'After a Spring Shower,' painted in 1893. I was much struck then with the ardor, the passion of the artist at more than three score years and ten. What are years to a man who lives in and by his art? The 'Wood Gatherers,' and the glowing and audacious 'Sunset on the Passaic,' of 1891, the rich and splendidly colored October landscape, 'Near the Village,' of 1892, and the 'Niagara,' dated 1893, possessed all the sap and vigor of an undying youthfulness. Who bid the unresting aged seer assume such power, and give to art those lofty flights of color and immortal beauty? The same Creator who gives us all our allotted tasks to perform, and who puts into the minds of men the desire to do them well."

HOWE: "Inness has always been himself; some of his pictures remind you of Dupré, others of Corot, but no one can say that there is the least trace of imitation in them. Great minds run in the same channel. One of the most interesting examples of Inness's art that I know of is a landscape painted at least twenty years ago in Perugia, Italy. It had a wayside fountain in the foreground, with some figures of peasants and a pair of priests. In the distance was a large white building on the top of a hill; I took it to be monastery. At the left was a deep gorge, shadowy and mysterious. The sun was just emerging from behind bluish-black storm-clouds, against which was a section of a rainbow, and the first warm rays of sunlight struck upon the old monastery and the hill-top and the trees—poplars and willows—on the slopes of the hill. The light was exquisitely felt, and, as I recall it, was as ethereal and tender as in the best Corots you ever saw."

TORREY: "The life of light animates everything in his works. He walks through the earth and

everywhere he finds the Garden of Eden. Wherever he plants his easel he becomes an interpreter, forging out the hidden meaning of things. The hammer-strokes of the iron-worker at his anvil fall unerringly and shape the white-hot metal; the tong-clenched mass grows longer, stretches, writhes, stubbornly ponders between the blows, and, slowly yielding to the master hand, awakens into a new form, and becomes the expression of the smith's thought of beauty. So Inness works, with nature for his raw material, and couples with that raw material his higher force, the designing energy which made the blacksmith and the iron." . . .

WILLIAM M. CHASE.

HOWE: "Chase comes as near to being a virtuoso of the first water as any painter of American birth. He has a painter's eyes. His way of seeing things is essentially graphic. His manners have all been painter-like."

TORREY: "His manners?"

HOWE: "Yes, his manners: he has had several within my recollection. I consider that Chase has been worth a good deal to us in this country, because, in spite of all the glib talk we have heard about 'technique' (which means one thing to one man and another thing to another), we have always been more in need of good craftsmen than of theorists. In a country where every other spinster is an amateur artist what in heaven's name do we want of any more painter-philosophers? We are forever talking about art, but how many of us produce anything that will live? Chase has one prime faculty; he knows how to look at the outside of things, and is properly willing to leave metaphysics to the metaphysician. He is not a thinker, but he is a seer."

TORREY: "He is, you mean, not so much a thinker as he is a seer probably?"

HOWE: "I mean to use the word thinker in the canting sense, or, if you will, he does not spell brains with a capital B, and sticks to his trade. His wisdom consists of the intuitions that belong especially to the painter."

TORREY: "His wisdom, you say?"

HOWE: "Well, yes, for his eyes, at least, are wise, and that is a great point, for a painter. It seems to me that Chase has been influenced in turn by the work of every great painter whose pictures have the quality of color and brilliancy, because color and brilliancy are the things in art and nature that most appeal to him. Although he was born in Indiana, he seems to be the æsthetic offspring of Veronese, Velasquez, Rubens, Hals, Vollon and Fortuny."

TORREY: "Distinguished lineage, indeed!"

HOWE: "There is an immense fund of gaiety, ease and spontaneity in all of Chase's pictures. He has all sorts of caprices, and many moods, but never seems to be sad. His butterfly nature absorbs artistic sweets wherever it flies, and dullness is a sin foreign to his character."

TORREY: "It is rather severe to compare him to a butterfly, I think. It conveys the idea of too much lightness. Why not call him the busy bee—that is more serious?"

HOWE: "Very well. He has more range than depth, that you will admit. And in spite of the masters who have specially impressed him he is modern, that is to say, restless, volatile, and a little self-conscious. It would not be true to say that his painting is heartless, but it is true that sentiment has a very small share in it."

TORREY: "What a difference there is between sentiment and emotion."

HOWE: "There is not a shade of either in Chase's work, at all events. I fancy that he knows it as well as any one, and you never catch him posing for what he is not. He has shown a strong disposition to experiment, but he has never been affected."

TORREY: "Nor coquettish."

HOWE: "His portrait of Whistler is a lampoon, and I do not like painted jokes. Then there is the hugely clever portrait of the little dancing girl, 'Alice;' it is horribly modern, flippant, bumptious. It is amusing to-day, but how will it be to-morrow, next year, next century? Perpetual motion is an unlikely thing to put into a portrait. It will be extremely tiresome to live with, I should say."

TORREY: "I agree with you entirely."

HOWE: "Now, with respect to Chase's landscapes, the larger ones do not offer evidence to my mind of a real and deep-seated love for this kind of work. They are deficient in what I may, for want of a better term, call landscape sentiment."

TORREY: "Perhaps he ought not to try to cover too much space. In the literary sense his pamphlet would be better than his book. Decamps never needed to paint large canvases, and he never did."

HOWE: "Chase's park pictures are very near perfect of their kind. They are an epitome of nature dressed up in her best Sunday clothes, clean, spick-and-span, and, as it were; ready for company. Nothing could be more sparkling in light and color. It takes a painter to make us see the full beauty of a bit of gravel walk, closely clipped turf, and a painted bench with a gleam of water, a few boughs, and a glimpse of blue sky. Chase may not appear to select with great care, but he does; and the proof of it is that none of his things are stupid or commonplace. With so much versatility he retains the saving grace of a clear, logical, pure style, which permits no tricks. It is better to say a little and say it well than to deliver one's matter, be it ever so high in import, in a slovenly style. Chase executes, he does not interpret. There is plenty of room for such robust prose as his in the wide country of art; he may be limited, but what he does is well done, and that suffices."

ROBERT BLUM.

HOWE: "Of course you are familiar with Blum's work? It is above all personal, dainty and full of style, with a sharp, deft, quick, accented touch, nervous, sensitive and delicate. He is a sort of Yankee Fortuny, fond of lustre and brightness, keen and unexpected notes of gem-like depth and radiance, flashing spots of intensely pure and strong color, applied with a pencil that has some of the knowingness and lightness of that of Degas."

TORREY: "You make him out to be a master in color and handling. Phew! Fortuny and Degas in the same breath!"

HOWE: "I do not think that Blum's virtuosity has been quite appreciated. Why, he has amazing style. The way he puts in a small figure, say, in a street scene, whether it is in Venice, Amsterdam, Tokio or New York, has an unspeakable swing, an aplomb which really gives you a sensation like the most extraordinary feat of a juggler in magical brushwork."

TORREY: "There is champagne in his work, and it effervesces with a joyous frolic of mounting bubbles. But this keen faculty of suggesting the effect of a moment does not succeed in touching and arousing us. It is amusing, and even fascinating, for the time being, but it will leave no great impression, it will find no echo in the heart of future generations."

HOWE: "Oh, as to that, I think if a man does a thing very well, and without imitating any one, it is all we can decently ask of him. It is only the imaginative artists who create anything new; the others are craftsmen, painters; but, as old Bonvin once said, 'Show me a man's work and I will tell you whether he can paint or not.' Now, I could show you a score of Blum's little pictures, any one of which would make you shout at sight, 'He is a painter!'"

TORREY: "Yes, a painter of surfaces that come at you, and that you do not care to resist. His

subjects are well chosen. He is not fond of the stencilled trysting-place, but a bouquet of women arouses his valor; his palette is in arms: the warrior of the pigments seeks such encounters. A Parisienne on the wing is good game for his brush."

HOWE: "Blum understands the charm of the whimsical and the impromptu; he did not need to voyage to far Japan to grasp the Japanese idea of pictorial art, for he knew it by instinct. His pastels are good enough to eat. He is also a free and snappy etcher of the Whistler type. In each medium he exhibits the same rare qualities of dash mingled with reserve, of fine suggestiveness, and a crisp and pungent style."

THE LITTLE MEDIA

In the years leading up to the Civil War, the triumph of American art was judged to be the grand, panoramic "machines" of landscapists Frederic Church and Albert Bierstadt, who covered yards of canvas with a filigree of insistent detail that almost defied belief. In postwar years, however, this type of painting began to be seen as naïve and bombastic. A reaction against the scale and finish of much antebellum art resulted in a new enthusiasm for smaller, more intimate works. A series of movements and revivals swept the galleries and exhibition halls, and critics began to talk of a "fever" for the "little media." Primarily this meant watercolor, etching, and pastel, but wood engraving and miniature painting on ivory also had their proponents (and their special clubs and societies). Artists were often involved in two or more of these enterprises, and the taste for one medium could lead to curiosity about another; groups of etchings, for example, were regularly featured at the early exhibitions of the American Society of Painters in Water Colors, and once the New York Etching Club was founded its annuals shared space with the watercolorists. An aesthetic of sketchiness was common to many of these groups, and a premium was placed on personal, "autographic" expression. Here, the influence of James McNeill Whistler was crucial (see chapter 11). The excited comments of artists and critics make it clear that the little media energized the American artistic community, but perhaps no less important were the increased opportunities for sales and the cultivation of new patrons who had been formerly disinclined (or unable) to purchase expensive oil paintings.

Watercolor

THE AMERICAN TASTE FOR WATERCOLOR

American artists had occasionally practiced watercolor before the Civil War, and a small group had even founded the short-lived "New York Water Color Society" in 1850 (members included Jasper Cropsey and J. W. Hill). But the flourishing of the American watercolor movement dates to December 1866, when ten artists met for the inaugural meeting of the American Society of Painters in Water Colors, later known as the American Watercolor Society. Samuel Colman became the first president; in subsequent decades he was succeeded by William Hart, James Smillie, Thomas W. Wood, and J. G. Brown. Early exhibitions favored small landscapes—often dozens of works by a single artist; later shows featured more figural compositions and the ubiquitous floral still life. Scale increased, with some painters specializing in large, elaborately finished

"carpet" sheets. By the late 1870s, the exhibitions had also grown considerably, both in the number of works and the artists represented. In 1882, for example, 1,550 water-colors were submitted, some 850 were accepted, and 650 were ultimately hung in the crowded galleries. The lower prices (often $50 or less) meant that many consumers could afford watercolors. Hundreds of artists—quite a few of them women, amateurs, and illustrators—annually exhibited their works on paper, making for a much more inclusive event than the exhibitions of their sibling societies. Yet established artists also took advantage of the informality of the medium and the venue; beginning in the 1870s, Winslow Homer was one such painter, putting as much effort into his watercolors as his larger oil works (see "Winslow Homer's Working Methods," chapter 8).

At the beginning of the watercolor movement, artists felt they had an uphill battle to cultivate interest in this medium among American picture buyers. The excerpt below, from a review of an early watercolor exhibition, explains the American "prejudice." Yet just a decade later, the tide seemed to have turned. In a short explanation of the new popularity of the watercolor medium, Richard W. Gilder begins with an obvious economic argument (watercolors are inexpensive). More novel, however, is the assertion that an inherent puritanism in American society predisposes viewers against the rich effects of oil painting and in favor of the simpler, more humble watercolor.

Stillman S. Connant, "The Exhibition of Water Colors," Galaxy 3 (January 1867).

The fact is undeniable that Americans entertain a prejudice against water colors. While some of the greatest of English artists have achieved their noblest triumphs in water color, the art has been totally neglected in this country; partly because it was popularly regarded as a kind of "lady's art," and partly because it is more easy to obtain a commonplace proficiency in oils. An unskilful dauber in oils can produce pictures which take better with the general public than anything he could do in water colors, which require greater delicacy and precision, and more accurate knowledge of nature and of methods to make them acceptable. Water-colorists have, therefore, received but little encouragement in this country. Even the best efforts of our men in this branch of art have been treated with mortifying and unjust neglect. I have now in mind an artist of high promise, whose exquisitely finished water-color paintings, which would have commanded fame and money in England, are here scarcely known outside of the circle of his personal friends. One of his finest works was exhibited two years in succession without finding a purchaser, and the artist was at length glad to get rid of it for the paltry sum of twenty-five dollars! It was a work that had cost days of conscientious labor, wisely directed by feeling, thought and knowledge. The artist had put his whole heart into it, and hoped at least for recognition and encouragement. But it was passed over by the public at the grand reception, and ignored by the critics of the press. And why? Not because it was not a beautiful picture, not because it was not composed with art and painted with exquisite skill, but because it was done in water color. Thoughtless people glanced at the number in their catalogue, saw it was "only a water color," and passed on without deigning to give it a moment's serious attention. It attracted far less notice, in fact, than did a series of crazy pencil drawings by a common draughtsman.

[Richard W. Gilder,] "The Art Season of 1878–9," Scribner's Monthly 18 (June 1879).

First to open, and the exhibition most heartily welcomed by the public and the press, was the Water-Color Exhibition, with its multitude of small pictures at low prices,—just the thing to tempt small investors. But there are more artistic grounds for this society's financial success.

Water-colors lend themselves better to the artistic qualities of our painters than oils, and the public understand and like them better. There is a quality among the Americans of the eastern and middle states that is called, for want of a better term, Puritanism, and although this characterization does not really fit the case, it will be sufficiently understood. This Puritanism, then, makes us a little obtuse to, and a good deal afraid of, anything that looks mellow, languid, or luxurious; so that when a painter does exhibit signs of a strong feeling for color, we are apt to fight shy of him. Water-colors are crisp, clear, and, unless in the best hands, crude; but even crudeness is not so terrible to us as richness of color. It is like our fear and contempt for what is called "Frenchiness" of manners, and like that may be termed a provincialism—healthy, it may be, but still a provincialism. The narrower limits and greater simplicity of water-color drawing predispose Americans to excellence in this branch, just as the wider range and greater complexity of oil-painting cause many of those who venture into that field to produce compositions rank or turgid in color.

A CHILD'S VIEW OF THE WATERCOLOR SHOW

Elizabeth W. Champney, a graduate of Vassar College in 1869, aspired to a career in literature and was a prolific travel writer and children's author. Her Three Vassar Girls series of ten novels, in which a group of undergraduate friends travel the world, was particularly well known. Upon her marriage to painter James Wells Champney, she added the art world to her range of subjects, occasionally writing on such topics as the summer art "colonies" on the island of Nantucket and elsewhere (see "Artists in Their Summer Havens," chapter 9). Her John Angelo at the Water Color Exhibition, treating the exhibitions of the American Watercolor Society of 1882 and 1883, is a unique literary genre, combining children's fiction and exhibition review, all delivered alongside an insider's view of studio buildings, models, and, most important, the debates surrounding the medium of watercolor. She evidently made the most of her contacts in the art world, for more than sixty exhibitors supplied her with drawings of their works as illustrations for her tale. Her protagonists, John Angelo and Teddy Landseer, are introduced as "studio children, born amongst easels and palettes, lay-figures and model stands, and reared on high art along with their oatmeal and milk." These young initiates enthusiastically ponder such issues as breadth versus finish, body color versus transparency, and native versus foreign subjects.

Lizzie [Elizabeth] W. Champney, **John Angelo at the Water Color Exhibition** *(Boston: D. Lothrop, 1883).*

Altogether the two boys lived in an atmosphere as peculiar as did the Children of the Abbey. The studio building itself, with its great windows, its stone staircases and resounding halls, cool even in summer, was not unlike an abbey; and the pleasant, shady square on which it looked, might have passed for the cloister gardens. They were as out of place as a colony of pigeons in a penitentiary; and yet they made themselves as much at home, and adapted themselves to their circumstances as well as the birds would have done. They had both of them the true art feeling, and had decided that they would be artists when they grew up. They had heard people say that painting was a beggarly profession, but they did not care for that, they both had a supreme scorn for riches, and had shrewdly observed that artists had "more fun than other fellers." Artists, therefore, and life-comrades they would be. It only remained for each to choose his peculiar style, for, as Teddy Landseer remarked to John Angelo:

"Pictures are different. Some like to paint landscapes, and some like to paint waterscapes; and some artists paint dogs and horses and folks and other animals; and some paint flowers and things."

"Yes," replied John Angelo. "And they paint 'em different. You set three artists to painting the same landscape, and they wouldn't look the same. One fellow's would be as green as a spinach-pot, and another would work it in all gray, and, like as not, the last one would get it brownish. I suppose they see things different."

"I don't see how they *can* see things different, if they look at the same things," remarked Teddy.

"I do," replied John; "we see what we like best, you know. Let's you and I take a run by Mr. Draper's studio door, and then tell each other what we saw."

"All right, go ahead.—What did you see?"

"There was somebody posing in the loveliest satin dress; it looked just like moonlight on a lily."

"I didn't see her dress," said Teddy Landseer; "but she was a mighty pretty young lady. She had lovely red hair and the jolliest eyes; she looked straight at me and smiled. I wish I could smile like that."

"That so? I didn't notice. But all right—didn't I tell you artists see different? Now if you will get your father's season ticket to the Water Color Exhibition we'll go over, and you'll see they paint different."

As the two boys stood in the entrance hall of the Academy of Design before the beautifully decorated grand staircase, our rough-and-ready Teddy involuntarily took off his cap.

"My!" said he under breath, "aren't those Japanese vases stunning?"

"And the palms! It must look like the forests of the Amazons. Teddy Landseer, just look at that door with the things over it—plaques, and fans, and lacquer-trays, and gold brocade, and pampas-grass, and no end of traps!"

"The prettiest thing of all is that big soap-bubble," said Teddy. "I wonder what keeps it from bursting."

"That isn't a soap-bubble, it's a bowl of iridescent glass!" cried John with a laugh. "It is rather jolly. Let's walk around the corridor."

"Hold on here, John Angelo, hold on," exclaimed Teddy excitedly, pausing before a street scene on a rainy night, by Mr. Lungren. "Here's a picture, now! Isn't that a regular soaker of a rain? I guess that old chap's mad he forgot his umbrella. Just see how blurry the gas-lights look through the sleet, and how the rubber overcoats shine! Wouldn't it be fun to splash around there with our rubber boots on?"

John Angelo peered at the picture, then turned to his friend with a disgusted expression. "See here, Teddy," he said, "I'm ashamed of you; that isn't any kind of a picture. What sort of drawing is that? Do you call that a horse? Why, it's only a blot. Your little sister could make a better horse than that."

"I don't care, it's nice and sloppy," grumbled Teddy Landseer, yet somewhat quenched; "besides, I've heard my father say that pictures are not made to be smelled of. If you stand far enough off that horse looks all right."

"You're a regular impressionist!" sneered John Angelo.

"I ain't either," retorted Teddy Landseer hotly. "What is an impressionist?"

"It's a fellow who slings his palette at his canvas, and then sits down and moans over it till he imagines it's a picture," replied John Angelo hotly. "Honest-true, father and two other artists sat down before an 'impression' and tried their level best to make it out. One of the gentlemen

thought it was a study of a sheepskin hung up in a tan-yard; the other said it was a waterfall tumbling over rocks; and father thought it was meant for a terrier dog and two cats. They got the catalogue, and found it was a *Study of a Beech Tree.*"

"I don't care," said Teddy; "I heard a lady say that a picture you could understand wasn't good for anything. There *must* be mystery in it. What kind of pictures do *you* like?"

"I like to have things look real," answered the dreamy-eyed, Vandyke-collared John Angelo. "Look at Mr. Woods' *Reporter.* That's a real live man. You *couldn't* take him for a beech tree. See him a-interviewing! Look at his eyes—sly as a fox, and his pencil is just scooting over that paper. He's got reams enough for a whole newspaper now."

Without being able definitely to express it, the boys had discovered the grand division in the art of today, and recognized that artists were either impressionists—those who see broadly a sudden effect, in a momentary glimpse through a closing door get a picture full of force but without finish or detail; and realists—the men of careful elaboration, who count nothing too trivial to be conscientiously finished. Of course the perfect artist would be the man great enough to catch and hold the quality and effect of the first sketch, while also efficiently skilful and painstaking to give every part of the picture its rightful finish.

Yes, they had come at the outset upon a "difference in seeing things." They found also that there were differences in *feeling*—that there were the idealists and the prose painters. Some artists invested commonest subjects with poetry, as Mr. Wyant and Mr. Gifford in their tender meadows and desolate moors, which might so easily have been only stretches of tiresome land. There were the brothers Smillie, too, who could not paint an old pine or a hemlock without making it look like a hero, and telling you by means of its gaunt, twisted arms how many fierce storms it had wrestled with and conquered . . .

"Here's another of the kind I like," said Teddy, "*The Witch's Daughter,* and the owl sitting on the moon. I like Mr. Church, I do! I say, John Angelo, what do they call a man who paints fairy-stories like that: things that couldn't be, you know?"

"I heard a lady say in father's studio the other night, that Mr. Church was the greatest imaginative painter of the day. There is another artist, Mr. Vedder, who paints queer things too, which you'd like. I don't see any of his here, though."

"What makes that picture look so funny?" asked Teddy. "This is a water-color exhibition, but that picture looks like an oil painting."

John Angelo screwed up his eye, looked through his hand after the manner of his elders, then shook his head. "Let's ask the Professor."

"There are two methods of working in water color," explained the Professor. "One is called transparent, or pure water color; the other opaque, or body color."

"Then artists paint different as well as see and feel different," said Teddy despondently.

"Certainly," replied the Professor; "transparent water color is considered the more legitimate. In it the white of the paper serves instead of a white pigment, and all the washes are transparent. The effect is entirely different when Chinese white is used, and the method, which the French call *guache,* of piling on color as in oil, is employed. Mr. Church's paintings are good examples of body color; Mr. Freer's clear and brilliant heads, of pure water color."

"I like that petticoat," said John Angelo, looking critically at a picture of Mr. Freer's, to which the Professor had called his attention.

"Yes," replied the latter; "it is painted with the knife."

"With the knife?"

"If you look carefully you will see that the quilted effect is rendered by scratching the paper

with a knife-blade. Mr. Turner's fine *Dordrecht Milkmaid* is another good example of body color."

"Isn't she splendid, and don't her milk-cans shine? I wish she sold us our milk—how good and clean she looks!" said John.

"She is *solid,* and real," said Teddy; "I suppose that is the reason the artist painted her in that heavy kind of painting."

"Mr. Blum's pictures," continued the Professor, "you will find, on the other hand, to be pure water colors."

"Oh, I know his pictures, they are the romantic ones," said Teddy; "I like 'em. Here's one, *Carriages of Venice.* I just like gondolas. The water's good, but I wish he had finished the house more."

"He's one of your impressionists," retorted John Angelo. "He didn't see any more of the house the first time he looked."

"Then why didn't he look again?"

"I don't know."

"Maybe it wouldn't have been so pretty. I don't think artists need to paint everything *just* as they see it, like a photographic machine. When I paint I mean to choose, and not put in every old ash-barrel that happens to be in the way. I don't like it."

"Ugly things are nice, sometimes," declared John. "They are strong and bold, and you can be sure whether they are painted well, because you see them every day." . . .

JOHN ANGELO stared hard at her, and it was no wonder; for a queerer little bundle of humanity rarely entered the studio-building. She was literally a bundle; for though hardly more than three feet high, she wore so many dresses and suits, one over the other, that she resembled a ball balanced on two pegs, surmounted by an elfish head in three different caps, and a bonnet.

"Are you a Model Child?" John Angelo asked. Experience had taught him that most queer figures haunting the halls were models.

The bundle nodded composedly.

"What you doing out here in the hall then?"

"Waiting for him;" replied the Model Child, pointing to the closed door of one of the studios.

"Then you come in here with me and Teddy Landseer. He's got *'back directly'* on his door. That means he's gone over to Brooklyn to cash a check, or up to Harlem to see his girl, or maybe to Jersey to make a sketch."

"Come along, girl," added Teddy Landseer, popping up from behind an easel; "we've got this studio all to ourselves this morning. We both are too sick to go to school, just sick enough to have some fun, you know. Besides you might take cold out there in the hall, you're so thinly dressed."

The Model Child entered, and calmly divested herself of a poke bonnet, a Tam o' Shanter, a scarlet Persian fez, and a Normandy lace cap. "I've got a pink sun-bonnet in my pocket," she said as John Angelo drew a prolonged whistle. "Mother didn't know which picture he might want to paint on, and so I wore all my dresses. This top one is my Mother Hubbard, and next comes a Kate Greenaway, and then a blue peasant suit, and under that my very best white Swiss and pink sash—it's sort of rimpled, but that don't show in a picture—and then my Dolly Varden chintz; next is a little spangled gauze fairy dress, and then my night-gown for the little girl looking for Santa Claus, and a black dress for the orphanless child, and then the very most last is a gypsy boy's suit," and here she smiled complacently, as though if there were a model in the city that understood her business it was she.

"Like to pose?" queried John Angelo.

"*Hate* it!"

"I should think it would be fun," meditated Teddy Landseer, "to get acquainted with all the different artists and see their studios."

"And you might learn a lot," suggested John Angelo, "watching them at their work."

"Can't," snapped the Model Child. "They are so various."

"So what?"

"They do it so different. One of my artists takes a great wash bowl of water and paddles and paddles, and swashes and splashes it over everything. He gets his studio soaking wet. I used to have bronctheria and diphtheretis when I first posed for him. I did, so. Now I wear my water-rubber-proof inside my gown when I go there."

John Angelo and Teddy Landseer, being artists' sons, knew enough of studio ways not to be surprised at this recital. "Well, what of it?" Teddy inquired coolly. "If the picture is good, I don't care if it is done in a laundry."

"Mr. Dielman don't paint laundry," calmly proceeded the Model. "He's careful, nice."

"You're right," assented John Angelo; "Mr. Dielman isn't afraid to finish, and his work isn't the least bit finnicky either. I've found out a difference between finish and finick. Ted, do you remember his 'Old Time Favorites,' the lady by the gate with the sunflowers on each side of her? She looked like a sunflower herself, so straight and stately with that old-fashioned hat shading her eyes. When I paint, I'm going to paint like that."

"You don't know how you're going to paint," replied Teddy Landseer philosophically. "You can't tell how you'll see things by that time. Maybe the lady'll stand by the gate all right, but you'll be seeing a sunset, and you'll get her and the sunflowers and everything else all lost in the color and the haze and the glow, and where'll be your finish then? But, old fellow, I do like some sorts of finish myself. There's those bird and flower pictures of Miss Bridges. I believe Miss Bridges used to be a bird before she was a lady. Her drawing is as fine as if it was done with a humming-bird's quill. When I look at her pictures it seems to me that no painting which is not just as delicate can be the right thing; but all the same, when I stood yesterday, 'way across the gallery and saw Miss Eleanor Greatorex' trumpet-creepers—great dashing spots of color that burn and flaunt just as the gaudy flowers themselves do out in the sunshine—why, I had to give in that things may be different and yet each be good. They *have* to paint 'various,' O Model Child!" . . .

"Aren't the decorations gorgeous?" Teddy murmured admiringly as they mounted the staircase.

"Yes; Beckwith knows how to do a good thing," replied John Angelo. "That great Japanese umbrella looks as if it was painted in water color too, and seems really to belong here, for a wonder."

"Now what I like about artists," announced Teddy Landseer, "is that they travel and see all sorts of nice places. They are explorers, you know, and they bring you back a kind of thing the writing-travellers can't capture. Just look around the walls of this Academy!" cried Teddy warming up, "you can make the tour of the world without leaving the building. What jolly fun to strap on one's sketch-box and do it really!" . . .

"But, Ted Landseer, did you ever see anything so horrid as those things by Mr. Currier? *Are* those trees, or *are* they old brooms stuck in the mud?"

Ted fired up at this. "They may look queer at this distance, but come away to this side of the gallery, squint up your eyes, and they look mighty real. Mr. Currier knows what he's about."

"They look about as slangy as you talk," retorted John Angelo after a long pause, during which he duly "squinted up his eyes."

"How can pictures be slangy?"

"I s'pose they can be coarse."

"John Angelo, that doesn't pretend to be a picture in your sense of the word—it's an *impression,* and I tell you it's *strong.*"

"So is a knock-down blow; but I don't like it."

"And I do. That's it; you can't argue about such things as Mr. Currier's pictures. Either you like 'em or you don't. Mr. Chase is an impressionist too. What do you think of his *Lady in Black*?"

"I like her dress, but she hasn't any face," returned John Angelo promptly.

"Nevertheless I dare you to forget either her or Mr. Currier's picture. They make an impression, I tell you, and Mr. Chase would tell you, that if you looked at the whole figure you wouldn't notice the face much, but that you would carry away a very strong impression that the lady was dressed in black."

"But see here, I don't care what she's dressed in! In that case, what does the picture amount to? I'd rather see a pretty lady's face than the handsomest dress that ever was made! Talking about faces, did you ever see anything lovelier than Mr. Freer's *Annie Laurie* or Mr. Beckwith's peasant girl with the spotted handkerchief tied around her head? And only look at Mr. Winslow Homer's fisher girls—you never could remember what they had on, and you couldn't forget their faces if you tried. That's the kind of impression I want made on me" . . .

"The exhibition," remarked the Professor, "is not, and should not, be confined to one clique or school, it should represent every aim and every method; the brilliant pure washes of the Spanish-Italian school, the loading of gray paper with Chinese white after the Dutch manner; Literalists and Idealists, Realists, Impressionists, and even Affectationists, should all have a place here, as they have. To my mind every artist ought to be allowed to pursue any method by which he best can bring about a pleasurable result, be that result a suggestive sketch affording scope to the imagination, or an exquisitely finished picture ministering complete satisfaction to the critical faculty."

"The Professor is a gentleman," remarked John Angelo as they turned away. "*That* sounds like 'Peace on earth, good will toward men.' I am tired of seeing so many pictures at once. Let's go home and talk them over with the Model Child and come again in the afternoon.

The studio door was open and they could see the child posed upon the model stand, reaching out a spoon after imaginary jam. She heard the boys in the corridor and her arm dropped wearily.

"You are tired," said the compassionate artist. "Take this stick of candy and go rest."

She threw off her poke bonnet and donned her Normandy cap as though the complete change of head gear were a comfort, and ran out to the boys.

They reported to her the Professor's confirmation of her verdict that artists were "various," and that it was well for the world of picture-lovers at large that they were.

"They do paint *so* different," assented the Model Child, "and they *act* various, too, while they are painting. Some of 'em walk backward and forward, to see how their pictures will look from the other end of the room. One of my artists makes faces all the time, lots funnier than he paints; a good many of 'em never say a word, but just smoke till it's no wonder they don't get the colors right. Some whistle, and one—the one I like best—sings songs from the operas. I've seen 'em run their hands through their hair as if they were trying to pull themselves up taller, and scowl awful and talk to theirselves; and some again talk to me, and tell me nice stories. I know

some one I like to pose for, because he paints such funny fairy-story pictures, and he helps me make paper dolls and panoramas" . . .

"Ted!" exclaimed John Angelo, "I have been thinking about another exhibition of pictures I went to see at an auction store the other day. They were European paintings—an awfully cheap lot. They looked like the pictures you see on cretonne[1]—just about the same color effect—such screaming blues and greens and furious reds. You could see the artists painted them on purpose for the American public, and that they had an idea that the American public had no brains nor taste. And yet they were going at the fanciest prices. The money paid for one hideous thing by a Spanish artist with a big name, would have bought a half-dozen of the little gems at the water color exhibition."

"So much the better for the right kind of picture-buyers!" cried Ted gleefully. "The ugly high-priced foreign pictures can only be bought by a few rich swells, you see, while people who are just comfortably off can afford to buy the really nice work of our own American artists instead of the photographs and engravings which used to be the best they could have. Isn't that just as it ought to be? Why, John Angelo, father says even the authors and the artists themselves are buying paintings this year! And if I were a painter I would rather have a picture of mine bought by some one who knows a good thing when he sees it, and who hasn't money enough to buy everything, so that he will cherish it, and look at it, and enjoy it, and prize the possession of it, and make a treasure of it, than by the wealthiest millionaire that ever lived if he didn't really care for the picture any more than for his wall-paper. I often think how an artist who can see both the beauty and the art in a very fine picture must wish he could buy it."

"I heard a lady say," remarked John Angelo, "that 'art decoration' was going out; that plush plaques with bunches of artificial flowers hung on them, ginger jars and drain-pipe, cattails and storks were no longer thought to be precious things. And the other lady she was talking with said: 'Good! I am really quite encouraged if people are already becoming educated beyond playthings so that a few really fine pictures, with severe simplicity in furnishings, will be "all the rage" before long.' She said she was just sick of the word bric-a-brac."

"And I say hurrah too!" cried Teddy. "For when all the gim-cracks are out of fashion in the parlor they will be moved up-stairs to the attic and nursery; and then won't the young ones have fun playing curiosity-shop, and auction, with all the gorgeous old things!"

John Angelo laughed: "I suppose it don't matter if the young ones' tastes are vitiated! nobody seems to think about that in children's playthings! However, the King is dead! Long live the King! Long live water-colors, at prices every-day folks can pay!"

Pastel

THE SOCIETY OF AMERICAN PAINTERS IN PASTEL

In North America, the medium of pastel had been employed throughout the eighteenth century as a less expensive and more delicate means of taking a portrait. The pastellist utilizes "crayons," sticks of pure, powdered pigment held together with gum, oil, or another type of binder. Artists wield them somewhat like chalks, depositing color easily on canvas or paper with light strokes, rubbing the soft pigment into the support if further blending is desired. The medium was officially "revived" in the United States in 1882, with the founding of the Society of American Painters in Pastel, with Robert Blum serving as its

[1] Cretonne: a strong, white fabric, traditionally woven of hemp and linen.

president. Other early members were J. Carroll Beckwith, Edwin Blashfield, and William M. Chase; American expatriates Mary Cassatt and James McNeill Whistler were also influential proponents of the medium. The Society organized only four exhibitions (1884, 1888, 1889, and 1890), and its membership ranks were small. Still, its influence was felt long after the organization disbanded, for pastel painting only gained in popularity, particularly among amateurs, in the last decade of the nineteenth century. As with the medium of etching, pastel had an eloquent champion in the person of critic Mariana Griswold Van Rensselaer, whose delighted review of the inaugural exhibition of the Society of American Painters in Pastel, and especially the work of Blum, is excerpted below.

M. G. Van Rensselaer, "American Painters in Pastel," Century Magazine *29 (December 1884).*

The time is not long past when, if the average educated American spoke of pictures, he meant oil paintings alone; if of prints, steel engravings only. Art—true art, "high art"—was confined for him to these two methods; and he would not have understood that certain so-called minor branches, of whose existence he was dimly conscious, might properly be ranked beside them. He would not have understood that each of these, however limited its scope, has yet an individual importance of its own, an aim, a character, and an outcome quite peculiar to itself.

But in all art there are two great factors: the mind that speaks, and the medium—the materials—through which it speaks. And in pictorial art the various mediums are extremely potent, each limiting with decision the effects that may be wrought in it, and so prescribing with authority those which should be sought. No painter, however great his mastery of oils, can do everything by their sole aid. To secure certain effects, he must perforce seek other help, and find it in some one of those humbler branches which until lately were ignored or despised by us. And so it is with engraving: etching, mezzotinting, and wood-engraving have each a province far beyond the power of steel and burin to embrace.

Great as has been our advance in oil painting within recent years, I think our most notable evidence of progress lies in the fact that these minor branches are no longer either unfamiliar or despised; that we have turned with eagerness to many methods of interpretation our fathers did not touch . . .

We are not overconfident, then, in feeling that our recently acquired impulse toward variety in medium is genuine, and not factitious; is a vital effort, and not a mere imported fashion, a mere expression of impatience with the beaten track, a mere search for novelty and change. I think we failed to appreciate these arts in other days partly because they were comparatively unfamiliar to our eyes, but chiefly because we felt no desire for the expressional facilities they offer. Absolutely unknown they were not, but their germs lay dormant till we awoke to a wider wish for self-expression. As soon as we really wanted to say many things through art, its language became of interest to our eyes, and we scanned its various dialects to find the one best suited to the moment's need. Great ideas, intense feelings, artistic messages of a deep and potent sort, I confess, we do not often speak as yet. But most of what we *do* say is appropriate to the form of speech selected. And this is the important because the fundamental fact. It proves that our instinct is not inartistic, and warrants the drawing of much prophetic comfort from the future.

For these reasons we cannot but rejoice that still another medium has recently found favor with our younger workmen. The first annual exhibition of the "Society of Painters in Pastel" was held in New York in the month of March, and its catalogue showed some sixty entries.

Scarcely one of these lacked interest, and as a whole they proved that their painters had understood the nature of the method—not only its technical management, but its expressional possibilities—and had striven to conform themselves thereto . . .

It is a question among artists, I believe, whether pastel should be called a process of drawing or of painting. "Painting" usually implies the use of some liquid medium; but pastels are simply cylinders of dry color which are handled much after the manner of the charcoal stick, the substance worked upon being commonly rough paper, to the "tooth" or burr of which the color-particles adhere. And yet it does not seem quite right to speak of drawings in pastel, partly because of their color and partly because of the way in which their effects are wrought. "Drawing," though it must often be used with less precision, really implies work with the *point.* One draws with the pencil or the etcher's needle, and the effects one seeks are effects of *line,* not mass. But with pastels one seeks effects of mass, not line. Either the color is completely blended with the stump or fingers, as was often the case in former days, or, if one uses the harder crayons most in favor now and their strokes remain distinct, these are comparable rather to the brushmarks of a painter than to the true lines of a draughtsman. The point too is used in pastels upon occasion, but subordinately—never conspicuously in the most artistic work. If, then, we must have a strict definition, we may call the process a sort of *dry painting.*

Since the color is not incorporated with the ground, but simply adheres to its surface, it will be seen that pastel work is of necessity somewhat fragile, yet not so fragile as is commonly supposed. Fixative may be used upon it, though with some danger to the color. And even without this, if it is covered with a glass and hung where no damp can reach it, there need be no cause for fear. Thus protected, a pastel should have, indeed, a surer chance of immortality than a work in oils, for it has no such troublous elements within itself. Its apparently vaporous tones are quite unchangeable, whereas we all know how Time the Destroyer finds a mighty ally in the slow transformation of pigments mixed with oil and varnish.

No color method is so useful to outdoor workers as is this. Since dry tints cannot readily be mixed, the pastel painter gets his ready-made from the hand of the color-man in an almost endless variety. They are light and portable, and always ready for instant, rapid use, without the necessity of any pause for dryings. And an added advantage (in which water-colors at least cannot claim to share) lies in the ease with which corrections may be made. A mistake can be effaced by friction, or, as the color is opaque, a superimposed tint retains its purity, and quite obliterates all that may lie beneath . . .

This first collection of our "Society of Painters in Pastel" was but modestly heralded and was opened in an unfamiliar gallery; yet it attracted much attention, and undoubtedly went far to explain to intelligent eyes the peculiar characteristics of the process. Let us now briefly review its contents and see what those characteristics are.

At a first hasty glance the pictures looked very like an assemblage of works in oil, so analogous were they in their varieties of size, of subject matter, and of color-scheme. But upon deeper examination this resemblance did not prove to be of a fundamental sort. As soon as we studied the process we began to see which were its most valuable because most *characteristic* results. We began to feel that, whatever his theme, the wise pastel-painter will choose from the mingled qualities of nature those which are most in sympathy with his material, from her multitudinous effects those which it best can render; and we began to learn that these are not quite identical with the qualities and the effects most consonant to the more familiar brush. We missed some charms which that brush can give, but we gained by others that it cannot imitate . . .

Looking now at the collective work of each artist, it seemed to me as though Mr. Blum de-

served the honor of first place, not so much because his pictures were very diverse and very clever, as because he showed in some of them a deeper intention, a more original mental impulse, than any of his fellows. We had had so much of mere clever workmanship in recent years; we had had so much of themes selected for their technical opportunities only; we had had so much of decorative frivolity, of shallow effectiveness, of picturesque futility; so many studio interiors with carefully careless accessories; so many models that were palpably nothing else; so much of the seductive froth and foam of manual dexterity, and so little keenness of artistic insight or spontaneity of artistic feeling, that we were thankful indeed for the fresh and genuine impulse that had prompted some of Mr. Blum's pastels—and doubly thankful, since superficial work might so easily have satisfied himself, and all but satisfied his friends, when he was trying a new process, extremely fascinating on its merely technical side.

His three chief pictures were groups of working-girls—actual transcripts from the local life about us, and from a side of that life which offers rich opportunities which have hitherto been neglected. They were no less truthful than novel, and were truthful in the best fashion—with a veracity touched by artistic idealization, but not transformed by it out of true verisimilitude. The artist had worked as an artist should,—realistically, but judiciously, I might almost say *judicially,*—keeping to the facts of nature, but carefully choosing from among them those which would best insure artistic felicity in his result. One of these pictures showed a group of young laundresses at work; another, a room full of busy seamstresses; and the third, called "The Sisters," two girls sewing by a window. All were unconventional and apparently unstudied in arrangement, rapid, frank, and nervous in handling, and charming though subdued in color. All had a gray scheme and a rather light tonality, cleverly vivified in the two first-named by touches of brilliant yet harmonizing color; and in all three the light shone strongly from the pictured windows toward the spectator's eye. Such a device often savors of affectation, or of a desire to secure effectiveness at the expense of simplicity and repose. But here it was so well managed that it seemed as natural and unforced as any more conventional expedient. It was merely an evidence of that artistic *choice* to which I have referred—a choice which is praiseworthy or blamable, not according as it is conventional or eccentric, but according as the result confirms or does not confirm its rightness. Another evidence of apt selection lay in the character of the figures themselves—in the grace and charm that had been given without taking them outside the bounds of faithful portraiture. All our working-girls are not ugly, coarse, or vulgar. Far from it, as the first street or shop will prove. And we owe Mr. Blum a debt for the clear yet discreet way in which he marked the fact—for his protest against the oft-supposed necessity of painting ugliness whenever we turn from "imaginative" work to the transcribing of our every-day contemporary life. The spirited facial expressiveness which he always manages to give his figures, even when they are most conventional in conception, was another merit in these pictures, and was further illustrated in a piquant little "Study in Red and Gray," which showed a saucy face smiling over the back of a chair . . .

These were not all the good works on the wall, for, as I have said, scarcely one of the sixty failed to interest or please to some degree. But a mere *catalogue raisonné* would be of little value here. It is more important that I should turn once more to the testimony given by the exhibition as a whole with regard to the specialties and the limitations of the process.

It showed us that pastel is a very flexible medium, in so far as execution is concerned. In some specimens the handling was extremely refined, sensitive, and subtile; in others it was very dexterous, spirited, and crisp; in others strong and self-assured, or as broad and fluent as it well could be without falling into absolute manual license. We saw that delicacy with pastel need

not mean feebleness; that accuracy need not mean hardness; that breadth need not mean diffuseness, or swiftness insufficiency. We saw, in a word, that technical individuality had here as wide a field as when the brush is used. And yet we could not ignore a difference in the technical results of the two arts. We could not fail to see that the delicacy, accuracy, breadth, or freedom of the pastel painter's work differs a little from the same quality when it is realized in oil.

We saw, again, that pastel color can range from the beauty of vaporous vagueness to the beauty of sparkling emphasis, or of incisive force, or of vivid brilliancy. But still just here in color there was one thing wanting, that one thing which is the peculiar glory, the distinctive specialty of work in oils—depth. Pastel color, bright and powerful though it may be, lacks profundity, liquidity, translucent glow, simply because these qualities are inherent in the oil medium and in the peculiar sort of transparence that comes to pigments mixed therewith. Water-color is transparent, but it too has little depth; while fresco and distemper in truth have none. And to these last pastel is somewhat akin in the quality of its tones. That dry, powdery, efflorescent nature which, rightly used, is its chief title to honor, giving a bloom, an airiness, a tenderness, a decorative grace that oil can hardly rival, marks out, on the other hand, the limitations of its power.

The general result of a color-scheme is the *tone* of a picture; and where color cannot be deep in the truest sense of the word, neither, of course, can tone. The tone of a pastel may vary from the palest to the darkest, an absolute black being as well within its reach as the most evanescent of hues. But *deep-toned* a pastel can never be—not deep-toned as Rembrandt, for example, would have understood the term . . .

It is not the best way to praise pastels to say, as I have heard it said by some of these young painters, "They can do anything that oil can do." *Almost* anything they can, in truth, though some things not so perfectly as oil. But if this were all, there would be no reason, save occasional convenience, why an artist should essay their use. It is because they can do certain things that oil can *not* do so well that they have a real claim on his attention. The most pertinent way to praise them is to state this fact; and the most admirable way to use them is to prove it in one's work. The pastel painter can do such lovely things with these docile crayons, can do things so unique in their artistic value, that he need not grudge the brush its own successes. He can do such lovely things—can fix such unsubstantial moods of nature, can seize such evanescent, shy effects, can imitate such inimitable textures, can elaborate such bewitching, rare tonalities, and such aerial or such audacious schemes of color—that he need surely not essay a *tour de force* and try for the deep translucency, the dignified severity, or the passionate force of oil.

If there are certain dangers attending the use of this medium,—if its supple facility may easily lead a painter to be superficial, puerile, or vapid, if its coloristic charm may tempt him to be content with mere decorative effectiveness instead of true pictorial beauty,—it has certain safeguards within itself which almost forbid his sinning in the opposite direction. If he tries very hard, he may do crude and "showy" work; but his crudeness and vulgarity will not be so offensive as though he had been working with the brush. And, though he try his very worst, he can hardly arrive at positive glare or harshness or brutality of effect.

JAMES WELLS CHAMPNEY ON PASTELS

Boston-born James W. Champney was a master of several media. After serving in the Union army during the Civil War, he worked in wood engraving before traveling to Paris and Antwerp for study. He was subsequently employed as an illustrator before

securing a position as the first instructor of art at Smith College in 1877. He was married to art critic Elizabeth Champney (see "A Child's View of the Watercolor Show," this chapter). Later in his career, Champney took up photography with enthusiasm, as well as pastel painting. In this interview in Art Amateur, *a periodical designed for nonprofessional artists, Champney discusses the technical challenges and rewards of the pastel medium. It was through such articles (including an earlier series on pastel painting that ran in the* Art Amateur *in the early 1880s) that professional artistic developments were transmitted to a lay audience.*

"Painting in Pastel: A Talk with Mr. J. Wells Champney," Art Amateur 33 (October 1895).

It is but a few years since pastels were taken up seriously in America as a means for the production of finished work. There was, as there had been previously with regard to water-color, a general notion of its insecurity, its lack of permanence. A drawing in pastels was—so writers on art affirmed—merely a little colored dust slightly attached to canvas or paper, and ready to come away with the first shock. It was, moreover, liable to injury by damp and mildew. But the many allurements of the medium led painters now and again to try it, and it was found that properly protected, it was, instead of being the most fugitive, in reality the most permanent of all media. The colors do not darken nor change tone as oil colors do. If executed on a properly prepared ground, and preserved under glass, like a water-color, they will be safe from the housemaid's feather duster, and no ordinary moving about will disturb the pigments. As to damp, if a house is so full of moisture as to affect a framed and glazed pastel drawing, it is far too damp to live in. Pastels have come down to us from the last century which have never been framed, and which have stood a hundred years' rough usage quite as well as ordinary crayon or chalk drawings would have done.

Among the American pastellists Mr. Champney is the most prominent and has done most to demonstrate the great range of the art. We have noticed with pleasure the special exhibitions in which he has shown numerous exact and charming copies of historical portraits; and he has shown many original portraits, landscapes, and other subjects of the highest merit. He is enthusiastic on the subject of his art and very willing to talk about it; but as many intending practitioners, readers of The Art Amateur, cannot attend his lectures, public or private, he consented to be interviewed for their benefit . . .

"I use," said he, "two kinds of grounds. One is a fine, prepared canvas, which I am obliged to import from France, as the dealers here do not keep it. The other is a prepared mill-board, also of French manufacture, but it may be got of our dealers. It is called 'papier anti-ponce,' which, I presume, means that it is *not* prepared with pumice-stone. It has an extremely fine and sharp grain, which makes even a rather hard crayon work soft and velvety. Still, I advise the use of soft crayons only; one should not feel the crayon under his finger any more than so much oil paint. This 'tooth' holds the powdered crayon with great tenacity, especially if it be rubbed in just the slightest degree in the world. If I could not get the canvas, which has certain advantages, owing to its elasticity, I would use no other surface than this 'papier anti-ponce' to work upon. It has the further advantage, I should say, over ordinary boards that it may be cut to any required size and shape. I usually commence my work on a sheet much larger than the size of my frame. I am thus enabled to develop my picture as I please. If I find as I go along that it would be well to include more of the sitter's dress or of the surroundings, I can do so, and I can also cut down the background, if it seems to be too much for the figure. When the work is done I take a sharp pen-knife and cut the paper to the size and shape that I judge best.

"As for the pastels themselves, I use every tint and hue that I can get. One of the greatest charms of the art is its directness; and when I find an uncommon tone in nature, I am happy if I can also find it in my color box. For this reason I always have many more pastels ready than I expect to use. I usually blend my colors a little with the finger, but not for the sake of producing compound tints, but only for delicate modelling and texture, and also a little for greater assurance of permanence. Your color box should hold all the colors, tones, and tints that you are likely to need."

Here Mr. Champney was asked what he would recommend in the way of a sketching-box not too cumbersome to carry in the hand. "In the first place," he answered, "I do not recommend pastels for landscape studies unless one is comfortably situated at home or in his farm lodgings and can study the view out the window. In such circumstances pastels are admirable for quick, positive, but no less exact studies of color relations and of passing effects of light, fleeting atmospheric conditions, sunsets, and twilights. No other medium can compare with pastels for such work; and in the conditions described, you should, of course, have everything ready, and not stint yourself as to the number of crayons that you use . . .

"To return to the portrait: I am aware that pastels lose something of their freshness of hue and delicacy of texture when rubbed in, and when I have a suitable subject I often work in the most direct manner, allowing every touch to stay. But the modelling of a young girl's cheek and the exquisite gradations of its color are not, it seems to me, to be got in that way. It is necessary to blend the touches a very little with the tip of the finger. A clean rag should be always at hand, and the finger should be cleaned after every touch . . .

"I need not dwell on the incomparable advantages of the medium. Its natural morbidezza[2] has been imitated in oils of late years by some of the so-called impressionist painters. It is not suitable for minute work, and it constrains a man to broad handling. It is the art of all arts for the colorist; and the ease, rapidity, and certainty with which one can work in it, without being obliged to wait for colors to dry, or needing to risk hazardous combinations of pigments, should recommend it to every sincere student."

Etching

THE "FIRST" AMERICAN ETCHING

Unlike the late nineteenth-century vogues for watercolor and pastel, the etching revival promoted a graphic medium of multiples—ensuring a much wider distribution among American patrons. Nevertheless, most of the writing on etching is decidedly elitist, constantly harping on its subtler, more "artistic" qualities in comparison to what were seen as the stiffer and cruder print media of engraving and lithography. As with watercolor, there had been isolated American experimentation with the etching process in the early and mid-nineteenth century (William Dunlap, Edwin Forbes, and George Loring Brown, among others), but stepped-up interest in the medium among British and French artists prompted a concerted campaign of promotion in the United States in the late 1870s and early 1880s (both the New York Etching Club and the Philadelphia Society of Etchers held their first exhibitions in 1882). New York dealers helped by importing the finest examples of recent European etchings, but even more crucial to this effort was the German-born author and curator Sylvester Rosa Koehler, whose short-lived American

[2] Morbidezza: delicacy, softness.

Art Review (1879–81) was perhaps the most sophisticated and comprehensive art organ of its time (see "Sylvester Koehler Reflects on a Decade of American Art," this chapter). Koehler bound actual prints by such "painter-etchers" as Henry Farrer, Mary Nimmo Moran, and Stephen Parrish into the pages of his journal, and his many essays stressed the spontaneous sketchiness, quavering line, and delicate tonal "color" characteristic of the medium. Koehler also brought examples of etching before the public in a series of exhibitions he organized at the Museum of Fine Arts, Boston.

It is rare that historians can locate the exact beginning of a movement in art, but in the case of the American etching revival, that date is May 2, 1877, when the New York Etching Club was organized in the studio of James Smillie, at 334 Fourth Avenue. The shared effort described below resulted in a small print, 2⅜ by 3½ inches, depicting several palm trees in a desert landscape.

J. R. W. Hitchcock, "Note in Connection with the Frontispiece," in Etching in America **(New York: White, Stokes, and Allen, 1886).**

Three of the organizers of the club shared in the preparation of the first etching of the New York Etching Club. The "ground" was laid by Mr. James D. Smillie, Mr. R. Swain Gifford drew the design, and Dr. Leroy Milton Yale "manned the press" and took off the first impression. This was on an evening in the winter of 1877–78, when some twenty artists, more than half unacquainted with the process, met in an up-town studio to organize an etching club and to gain some practical knowledge. In the preface to the first illustrated catalogue issued by the club, Mr. James D. Smillie has described the etching of the frontispiece-plate as follows: "Those twenty interested artists formed an impatient circle, and hurried through the forms of an organization, anxious for the commencement of the real work of the evening. Copper plates were displayed; grounds were laid (that is, delicate coatings of resinous wax were spread upon the plates); etchings were made (that is, designs were scratched with fine points, or needles, through such grounds upon the copper); trays of mordant bubbled (that is, the acid corroded the metal exposed by the scratched lines, the surface elsewhere being protected from such action by the wax ground), to the discomfort of noses, the eager wearers of which were crowding and craning to see the work in progress. This process being completed, in cleansing the wax grounds and varnish from the plates the fumes of turpentine succeeded those of acid. Then an elegant brother, who had dined out early in the evening, laid aside his broadcloth, rolled up the spotless linen of his sleeves, and became for the time an enthusiastic printer. The smear of thick, pasty ink was deftly rubbed into the lines just corroded, and as deftly cleansed from the polished surface; the damped sheet of thin, silky Japan paper was spread upon the gently warmed plate; the heavy steel roller of the printing press, with its triple facing of thick, soft blanket, was slowly rolled over it, and in another moment, finding scant room in the pressing crowd, the first-born of the New York Etching Club was being tenderly passed from hand to hand."

TWO VIEWS ON ETCHING

Perhaps the most eloquent proponent of etching was the critic Mariana Griswold Van Rensselaer, who in a lengthy article touted its special qualities and discussed all of the principal American etchers. In the excerpts below, she stresses the freedom of the medium—its tendency to encourage improvisation and rapid effects. She values the vis-

ible "hand" of the artist and the warmth that comes from personal expression, and she goes so far as to exhort American etchers to be even less timid in their experimentations.

Not every critic was ready to jump with similar enthusiasm onto the etching band-wagon. The same qualities Van Rensselaer found admirable were dangerous in the eyes of more traditional critics. The following review questions whether the "fad" might be encouraging idiosyncratic and eccentric work. Its author implies that the younger artists are no longer content to be a member of a "school" but instead are searching for an individual gimmick, or signature style. Between the lines, one senses a moral condemnation of such personal indulgence.

Mariana Griswold Van Rensselaer, "American Etchers," Century Magazine 25 (February 1883).

Why, in the first place, is etching held to be a much more "artistic" process than any other manner of engraving? Why does it attract the hand of original, creative artists who leave other processes to their special students? Simply because it is infinitely *freer* than any other multiplying process, being, indeed, freer than any other *point* process whatsoever, as the etching ground offers even less resistance to an artist's touch than paper to the pen or pencil. It is the only graphic process by which an artist can *improvise*—can put his own thoughts—directly, and with such ease that his most fleeting vision can be fixed and the least idiosyncrasy of his handling be preserved—upon a plate from which many duplicates may be printed. And, of course, it is this characteristic which makes etching so seductive to the artist, and which makes its results so interesting to the amateur.

Another charm of etched work—one which is less easy to explain in words, however, and which cannot be fully understood from the wood-cut reproductions here put before the reader—lies in the fact that the lines obtained by it differ vastly *in kind* from those obtained by any other engraver's process. Its blacks are deeper and richer and more velvety than those possible to any other linear process (whether a multiplying process or not), and its lights by contrast higher and more brilliant. Thus a wider range for the translation of color is at command. Moreover, an etched line, of whatever degree of strength or delicacy, has a peculiar quality of its own. An engraved line, cut slowly and painfully into the metal, will not only be stiffer, more mechanical, less autographic, than a line cut swiftly and easily into yielding wax, but when printed, from its even, monotonous structure, will always look cold and hard. But the action of acid is *not* even and mechanical. A bitten line is full of slight irregularities, ragged and minutely uneven; and when printed it will have far more of life and vivacity and accent. A lover of etching finds in the contemplation of a single strong, well-bitten line a pleasure akin to that found by the amateur of painting in the contemplation of a single strong, well-laid brush-stroke—a pleasure which has no equivalent if we study an engraved line in isolation. There is nothing at all in linear work (whether engraved or merely drawn) that compares with an etching for freedom, strength, and personal expression; and there is nothing like it in monochromatic work for warmth, variety, tenderness, and beauty of color.

A word must, however, be said as to the limitations of the art—limitations which its lovers will hardly acknowledge to be drawbacks. As it is a strictly linear process it cannot cope with processes where tints and masses are employed in the rendering of full and perfect tone. Almost perfect tonality can, it is true, be accomplished with the needle and its various aids, but only with much labor and a sacrifice of frank, linear expressiveness. Of the degree to which excellence has been attained in this respect, by modern "reproductive" etchers especially, I shall

say a brief word later on. Here I will only note that the greatest original etchers are usually content to give tone and gradation in a partial, arbitrary, and strictly interpretative way, since by so doing they retain rapidity of handling and—the prime excellence of the art—strong linear expression. In a word, they think more of form and color and freedom than of complete tonality.

When we begin to examine etched work in particular examples, we shall prize most highly those prints in which its characteristic qualities are most perfectly exhibited, its limitations most loyally respected,—since, as Mr. Hamerton well says, an art is at its best when most thoroughly *itself*. Those etchings which are the freest and most personal in handling and the richest in color, and in which the line is most strongly and expressively employed, will be the finest. Of course, as in all other arts so with this one, there is something more than technical skill to be considered: there is the idea which it expresses or the sentiment which it interprets. But as etching is not an imitative art, even to the comparative degree in which some arts may be so esteemed, as it is the most boldly and frankly interpretative of all graphic modes,—original, valuable ideas must have existed where really fine workmanship is seen. The etcher's translation into expressive linear language of something which has shown no similar lines in nature, presupposes a power of clear analysis. And in so interpretative an art, where very many facts in every theme must be omitted, their effect dispensed with altogether or merely suggested to the observer's memory, the converse power of synthesis is implied as well. An etcher who speaks strongly must speak concisely, significantly, rapidly, and, if I may so express it, typically or symbolically. Therefore he must be possessed by a clear idea of the things he wants to say, looking to it that they are not so many as to confuse or so alien as to confound his peculiar form of speech. And so it is that when we see in an etching really strong and individual workmanship, it vouches for intellectual qualities as well—it presupposes, by its very existence, clear, individual ideas or characteristic sentiments in the etcher, with the presence of the high artistic powers to which I have just referred,—the powers of analysis, condensation, and interpretation . . .

And these facts imply that perhaps the chief thing to be prized in an etcher's work is *economy of labor*. As the art is essentially a free and rapid one, and as it is difficult and (so far as the action of the acid is concerned) always more or less uncertain, one's effects should be produced with as much simplicity as possible. An elaborate, patiently worked-up plate is never as delightful as one executed with more freedom, with less expenditure of time and effort,—provided, of course, that the desired effect has been secured. Work done with few lines and vital ones, its meaning suggested by subtle "short-hand" methods, which leave the white paper to play an important part in the general result, appeals to most lovers of the art with especial force and charm. I should repeat, perhaps, that I am speaking now of original etchings only—of "painter etchings" as distinguished from reproductive work . . .

One of the chief temptations which assail an artist in our day is the temptation to make a show of boldness and rapidity and synthesis if the real things are not at his command,—to work in a rough and careless or pretentious way, which, to untrained eyes, may pass for the freedom and vigor and breadth of a master hand. And as etching is an art where freedom is especially prized, and where, from the strictly interpretative nature of the method, the public may find it difficult to distinguish between an almost arbitrary yet truthful and brilliant interpretation of nature like one of Mr. Haden's, and a "free" but meaningless scribble on the copper,—it was to be feared that our young etchers might fall into sins of a careless or pretentious sort. But such has not been the case. When they do sin it is usually in the way of too much timidity, too little personality and force of handling, too much useless elaboration, too little abstraction and

condensation and insistance upon the vital structure of their subject. They have not always conquered the possibilities of their art in the way of breadth and strength and originality; but they have not often travestied these best things. As a school they have begun conscientiously and soberly, and are therefore more likely to work their way to complete mastery than if they had begun in careless over-confidence or willful posturing.

Another fact which has struck me most favorably is that as a rule our men show a very just instinct in the choice of their material. There is no kind of material, scarcely an "effect" of any sort, which may not be attempted with success in etching,—which has not been successfully interpreted by the great men of one day or of another. But it is nevertheless true, with this art as with all others, that certain things are by nature best adapted to its use. From the description of the process it will be felt that it must work most easily and surely upon things which can be expressed by few and powerful lines and simple tonic schemes. Form and color are its strongholds; strength and directness its great virtues; and, as Charles Blanc says, "It is attracted most by everything that is irregular, *bizarre*, incomplete, unexpected, disordered, or in ruin." And with these requirements our etchers seem to be in unison.

There is still a third tendency to be discovered in our work which cannot be too highly praised. Our best men—with the exception of Mr. Whistler and a few who have been inspired by him and Venice—have learned their art at home and have chosen local themes for its display. While our art is still so young and so rapidly developing, it cannot be too often said that all hope for its future as a characteristic national school must lie in the willingness of our men to interpret the life which gave them birth, and to which—in spite of foreign residence and training—their spirits must be most akin. Nor need the American etcher, by the way, be the man to complain that nature so decrees. Admirable material for his art lies ready to his hand,—especially in our great harbors and in our coast lands, with their long reaches of sand and rock, their changeful skies, their rugged, wind-torn growths of stem and foliage, their quaint forms of hull and sail, their tangled lines of mast and cordage, and the picturesqueness of their weather-beaten little towns, with the irregular shapes and strong outlines proper to wooden structures no longer in the ugly pride of newness. It is fortunate indeed that our men see the value of these things—fortunate for themselves as well as for the national repute, since every worker does his best when most at home with his subject-matter, and since, moreover, there is no such spur to originality of expression—that chief of charms in etching—as freshness of material. We cannot be the parrots of any other man if we are saying something that none has said before . . .

And thus I come at last to say a brief word about reproductive etching. It is a quite distinct branch of the art, though, as always, we may find many good works occupying a middle ground between two logical extremes. As so very widely practiced by modern engravers it was unknown in earlier days. Etching was long used as an auxiliary in other kinds of engraving, but has only lately grown to its full proportions as an independent reproductive craft, its development being due to the decline of the great art of line-engraving, and to that newly born taste which demands color and tone and the preservation of a painter's technical method in a black-and-white reproduction of any sort. These things can all be secured to a quite wonderful degree in etching, but only at a sacrifice of some qualities we prize most highly in original work. The engraver-etcher's methods are very delicate, very subtile, very artistic, but almost always very slow and, of necessity, very complicated. So he lacks not only the individuality but the spontaneity and the swiftness of the artist, who is called—to mark him off from these engravers with the needle—the *painter-etcher.*

"The Etching Club Exhibition," Nation *38 (February 28, 1884).*

The collection of etchings on exhibition at the Academy in conjunction with that of the Water-Color Society, while to a certain extent marked by the same tendency to rest content with superficial success which we noted in the water colors, has the advantage of showing the work and its results in the nude simplicity of line, the faint advantage to be gained by artistic printing not carrying much weight. And the quality of the work is generally better than that of the associated exhibition; there are a few sterling works which quite justify, as achievement, the *furore* for the etching point and acid which seems to have taken the place, to a certain extent, of chalk and paper among our painters. But is not, on the whole, etching claiming in our day an importance which is out of all relation to its capability, and threatening to belittle and cheapen all line engraving to an extent dangerous to the general interest of artists? How many of the etchings now published here or in England merit, *as art,* the honor of reproduction? How many of the etchings here exhibited are worth keeping in a collection of works excellent in their kind, or have any more artistic value than a pen-and-ink sketch?

The passion for etching is an outgrowth of that morbid tendency to exalt individuality above all other qualities of art which is the vice (so it seems to us) of the painting of our time, and which is, after all, only a sort of apology for the lack of the great qualities of art which were the aim of the "old masters," who are practically the only great masters the world has seen. In the great schools of art, properly so called, we recognize more or less the individuality of the individual painter, but only in a remarkable and incisive degree that of the school . . .

Nowadays what is, in most painters, the end of labor, is to show their hand. What Giotto drew an O for, we paint pictures for. A man has scarcely learned the elements of his art as an amateur or student but he begins to study out some eccentricity, some peculiarity of style or manner which shall make his work distinctly to be recognized, among that of his contemporaries. It is a trifling with art—exaggeration of the personal, instead of self-effacement and sinking all in the ideal of excellence of the true schools of art. A great painter will in some way stamp his name on his work, though we find that the great schools were so closely bound together that we continually have to take from one of their masters, as a result of research, the honor hitherto given him and give it to another. Nowadays the only similitudes are simulations: the counterfeiter takes the place of the pupil, and this is made all the more easy because these sought-out characteristics of individuality or originality are invariably superficial and imitable by a superficial workman. Art all the world over (less in Germany, perhaps, than elsewhere) shows honest endeavor for true excellence in the nobler qualities of art more and more giving way to eccentricities, and the *cachet* of personality sinking down to *chic,* which is simply the settling down on the lowest level (dead level, too) of this morbid originality. Only when we have a standard of art which shall make affectations of originality in art as absurd as we know them in conduct, shall we be able to eradicate the vice of eccentricity, which is simply the vanity of art.

And this is the tendency on which etching rests its new-born enthusiasms. At its best etching can never compare with the work of properly trained line engravers in the expression of the highest qualities of art. Imagine the Madonna di San Sisto in etching! It is in the picturesque qualities that it shows its best points, but even there line engraving includes it, and that point alone in which it seems to be supreme is in the autographic quality—that which in its exaggeration is the vice of modern painting. There is no question of the fascination of etching and etchings, but is it on the whole a gain either that we should have etchings instead of engravings of the greatest even of modern works, not autographic; or that the rank and file of

painters and designers should fire at us their volleys of reduplications of work which is only tolerable as study of incomplete and struggling aspiration? When art runs into fads we need have no doubt that it is the vogue and not art that is in question. If we are not ready to say that we are sorry to see so many etchings in this exhibition, we can frankly say that we are sorry to see so many that have no evidence of sincere study or other aim than to give permanence to a study which at best ought to be merely tentative.

WOMEN ETCHERS: MARY NIMMO MORAN

The small scale of the "little media" meant that they were often associated with the feminine, and this is particularly true of etching. The number of important American etchers who were women far exceeds the percentage of recognized female painters, for example. Among artists of any gender, Mary Nimmo Moran stands as one of the most important American printmakers of the nineteenth century. Not as prominent as her husband, the painter Thomas Moran (see "The New West," chapter 8), Mary Moran produced a strikingly original body of work in the 1880s. She characteristically used a rich brown, rather than black ink, and her preference for a heavily inked plate resulted in unusual tonal effects. Her favorite subject was the marshy landscape of eastern Long Island, but she also produced remarkable New York cityscapes, featuring the then-developing Upper West Side. In the following appreciation written shortly after her death in 1899, Morris Everett begins with a consideration of the larger group of women etchers before moving on to Moran. As was often the norm during this period, he "reads" Moran and her work in contradictory gendered terms. She is singled out for consideration as a woman, yet her triumph is seen to be her erasure of any traits that might be construed as feminine.

Morris T. Everett, "The Etchings of Mrs. Mary Nimmo Moran," Brush and Pencil *8 (April 1901).*

When announcement was made in the fall of 1887 of an exhibition of the work of the women etchers of America, to be held at the Museum of Fine Arts in Boston, the surprise even of people well versed in art voiced itself in terms bordering closely on ridicule. The 4th of November came, and the public found, instead of a meager collection of "scratches on copper," a magnificent display of three hundred and eighty-eight plates, many of them of the highest order as regards both conception and execution. It was the first distinctive exhibition of the kind ever given. The etchings were discovered to be the work not of amateurs but of experts. Many of them were striking in their originality, and betrayed a force and skill of execution that compared favorably with the best efforts of men who had won fame with the needle.

Miss Gabrielle D. Clements, Miss Mary Cummings Brown, Mrs. Edith Loring Peirce Getchell, Mrs. Eliza Greatorex, Mrs. Anna Lee Merritt, Miss Margaret M. Taylor, and sixteen other talented women contributed to the exhibition. Among these was Mrs. Mary Nimmo Moran, who took rank both in number and quality of plates as the acknowledged leader of this select coterie—a position she held to the time of her death among women etchers. She exhibited fifty-four plates, diverse in character and theme, and her art was the subject of the most enthusiastic comment.

Mrs. Moran was not the pioneer woman etcher in America. Miss Cole, a sister of Thomas Cole, the artist, had etched a number of plates as early as the year 1844, and Mrs. Greatorex had etched her famous plate, "The Old Bloomingdale Tavern," in 1869. Mrs. Moran's first plate,

"Bridge over the Delaware," was not etched until 1879. When once her work had been begun, however, her position as an etcher was assured.

Her etching had an originality about it that gave evidence of a genius for that class of art production. It had a virile strength that set it in a class by itself. Her plates, as has frequently been said, would never reveal her sex, since they disproved the popular idea that the productions of a woman naturally betray feminine characteristics.

Her work was direct, emphatic, and bold to a point even that would not be attempted by male workers in the same line of art. Her own innate force of character, her broad, skillful treatment of her subjects and her wise avoidance of affectation and incongruities resulted in the production of plates that had about them no suggestion of a woman's hand.

As a result, the public for a long time was misled into believing that M. Nimmo, the name Mrs. Moran signed to her plates, was the name of a man. Indeed, when the members of the New York Etching Club were invited to send examples of their work to the newly formed Society of Painter-Etchers of London, England, of which that prince of English etchers, Seymour Haden, was the leading spirit, she, with a number of others of the New York club, was elected a member, receiving a diploma signed by Queen Victoria herself. As her etchings were simply signed M. Nimmo—her maiden name—she was supposed to be a man, and for years she received communications from the London society addressed to her as such . . .

The value of Mrs. Moran's etchings is doubtless largely due to the independent way in which the fledgling devotee of the needle went to work. Denied guidance and assistance during her period of experimenting, and too ambitious and of too strong a character to be a mere copyist, she set out on the broad, free lines that subsequently made her famous. As a painter she had become a good draughtsman, and at the very outset of her career as an etcher she went direct to nature. It may be said here by way of parenthesis that of the long list of original etchings produced by Mrs. Moran, every one, without exception, was drawn on the plate direct from the subject . . .

As Mrs. Schuyler Van Rensselaer long since pointed out, Mrs. Moran found her true artistic voice only when she took up the etching-needle. She discovered in it a means of expression suited to her intense personality. She recognized the aptitude she had for this peculiar form of work. From the outset she became a systematic, industrious, and unassuming student, and by choice she became an exponent of rural scenes.

She had a quick sense of the beautiful and the picturesque, and no dearth of artistic conceptions. Her favorite method of work was to take her copper-plate and etch her chosen subject, practically to the last stroke, in some secluded corner or under a sheltering tree, having the inspiration of the scenes she was depicting ever before her; and the plates herewith reproduced are sufficient witness that her method was well chosen.

Speaking of Mrs. Moran, S. R. Koehler, than whom American etchers never had a warmer friend or a more enthusiastic advocate, said some years ago: "In etching, Mrs. Moran finds a language that accords entirely with her ideas and modes of expression. She treats her subjects with poetical disdain of detail, but with a firm grasp of the leading truths that give force and character to her work. While her etchings do not display the smoothness that comes from great mechanical dexterity, her touch is essentially that of the true etcher—nervous, vigorous, and rapid, and bitten in with a thorough appreciation of the relations of the needle and acid, preferring robustness of line to extreme delicacy. The influence of her husband's example is plainly visible in all she does, even in the restlessness that pervades most of her plates. But with this peculiarity are also coupled the other admirable qualities of Mr. Moran's work—the vivid sug-

gestion of color, and the feeling of life and air, as of a sunshiny but windy day when cloud-shadows are scattered all over the landscape and break up its unity."

OTTO BACHER ON WHISTLER IN VENICE

Born of German parentage in Cleveland, Ohio, Otto Bacher occupied an important place in that city's art community in the mid-1870s. By 1878 he was convinced that he needed to leave for Europe, and after a fund-raising sale of his works, he embarked for Germany, where he enrolled in the Munich Royal Academy (see "The Munich School," chapter 11). In 1880, after a period of study with Frank Duveneck in Polling, Germany, Bacher and several other American artists traveled to Venice, where their teacher was spending the summer. There they formed a "colony" in rented rooms in the Casa Jankovitz. James McNeill Whistler, in Venice recuperating from his disastrous court battle with critic John Ruskin (see "Art on Trial: James McNeill Whistler vs. John Ruskin," chapter 11), attached himself to his younger compatriots, moving into their quarters and generally playing the part of the eccentric, gifted elder. Years later, Bacher wrote a delightful memoir of those months. A talented etcher, Bacher became a valued assistant to Whistler, who was attempting a revolutionary series of prints of the picturesque city. In these excerpts from his book, Bacher conveys the delicacy and complexity of Whistler's peculiar methods, from the careful preparation of the plate to the pulling of the print.

Otto H. Bacher, With Whistler in Venice *(New York: Century Co., 1909).*

There was a simple artisan in Venice whose work upon copper was most beautiful. He could hammer out and grind down a plate to just the thinness which Whistler desired. When not at work on his plates, he devoted his time to pots, kettles, and the usual things to be found in a Venetian copper shop. He was well trained, delivered his own goods, was reasonable in his prices—hence all of our plates were made by him. In grounding these plates, Whistler always used the old-fashioned ground composed of white wax, bitumen pitch, and resin. He heated the plate with an ordinary alcohol flame, holding the copper in a small hand-vice brought with him from England. The silk-covered dabber that spreads the ground over the plate was fascinatingly managed by Whistler, who seemed to love every phase of etching. When he came to smoking the plate, he preferred the old wax taper made for that purpose. He did not like to use the large torchlight wick and coal-oil lamp which I had, although it was surer and better. Later I generally grounded his plates because he learned to like my wax better than his own. It was the ground that bears Rembrandt's name, and is composed of thirty grains of white wax, fifteen grains of gum mastic and fifteen grains of asphaltum or amber. The mastic and asphaltum were pounded separately in a mortar; the wax was melted in an earthen pot, and the other ingredients were added little by little, the operator stirring all the time.

These grounded plates he would put between the leaves of a book to prevent them from being scratched, and leave them in the bottom of the boat. If he did much walking he took but a single plate wrapped in paper to preserve the etching ground surface, putting it in his pocket with one or two etching-needles that were always punched into a cork to secure their very fine, sharp points; and they were very sharp—every one of them. These etching-needles were ordinary dentist's tools that he had procured before coming to Venice. If a point was not as sharp as he desired, he whetted it on a small oilstone which he always carried with him—point for-

ward, pushing forward and backward the length of the small stone until it was of a desired sharpness. The sharpening of an etching-needle is quite a knack. He could keep a point for a long time. Occasionally he took only a clean copperplate, expecting to do a dry-point.

His gondolier, Cavaldoro, a very handsome type of man, was hired by Whistler by the month, and came to know with his Italian intuition just where Whistler most desired to go. If he did not ride, he would follow his master, carrying the paraphernalia under his arm. All of Whistler's etchings of Venice were drawn right from the subject, and all the figures in these etchings were drawn from life, although some of them did not pose in the same spot in nature as they are represented as posing in the etchings; these figures were always done from life and out of doors, and often near his house. Groups of bead-stringers and lace-makers could be found almost every day in any of the "calles" of Venice. Whistler often worked from these groups of women as they worked daily at their vocation.

I have known him to begin an etching as early as seven o'clock in the morning, and continue until nine, then put that plate aside, and take up another until twelve—noon—get a bite of lunch, and commence on a third, sometimes an etching or perhaps a pastel—then take a fourth—his final subject for the day, and continue upon it until dusk, the subjects being wholly different. Whistler always had a half dozen under way, more or less complete . . .

In etching he would get the essential lines, holding the copperplate in one hand, generally the left, and with the other "he spun web-like lines of exquisite beauty—fascinating to see in the begining as in the end." Where it required accuracy he was minute. He used the needle with the ease of the draughtsman with a pen. He grouped his lines in an easy, playful way that was fascinating: they would often group themselves as tones, a difficult thing to get in an etching. He used the line and dot in all its phases with ease and certainty. Sometimes the lines formed a dark shadow of a passage through a house with figures in the darkness so beautifully drawn that they looked far away from the spectator. These shadows which so beautifully defined darkness were made only by many lines carefully welded together and made vague as the shadow became faint in the distance or was contrasted with some light object.

He made his etched lines feel like air against solids; that is the impression some of his rich doorways of Venice gave me. He was the first to show me how to etch a deep, variegated door with a deeper figure somewhere in that darkness, all contrasted against something in the near opening that was much darker and which made the doorway effective. If he etched a doorway, he played with the lines and allowed them to jumble themselves into beautiful forms and contrasts, but was always very careful of the general direction they should run as a whole. In the partial darkness he could put in a hazy figure, the values being adjusted by the biting. He worked for hours on figures, and at times became quite excited over some success attained after much painstaking labor.

"Look at this figure!" he excitedly yelled to me one day on the Riva. "See how well he stands!" . . .

When he bit a plate he put it on the corner of a kitchen table with his retouching varnish, etching-needle, feathers and bottle of nitric acid at hand ready for instant use. Taking a feather he would place it at the mouth of the bottle of nitric acid, tipping the bottle and allowing the acid to run down the feather and drop upon the plate. He moved the bottle and feather always in the same position around the edge until the plate was covered. He would use the feather continuously to swash the acid backward and forward upon the plate, keeping all parts equally well covered, now and then blowing upon some place where an air bubble had formed. If he desired to make any change on some particular spot, he would blow away the acid, make the desired change, and re-cover with the feather. When the plate was properly bitten in this par-

ticular state, he would pull it to the edge of the table and drain the acid into the bottle again by placing the feather at the edge, holding it there until every drop had disappeared. Whistler never banked his plate, and he could bite it to the very edge without spilling a drop of the fluid. This method in the use of the acid was peculiar to Whistler; the skill which he displayed was astonishing.

When the plate was dry and clear, he looked sharply over it with a magnifying-glass for accidental scratches that would expose the surface of the plate in any future work upon it. He was most careful in detecting these as well as small bits of false biting or pits, which, on rare occasions, despite all his care, he found on the surface of the plate . . .

The most interesting part of his etching was the printing. If he wanted a proof from a plate in a certain state, his method of work was a revelation in the art, particularly the care with which he used the "dabber." When squashing the ink into the shallow lines and moving the hot plate over the surface of the plate-heater, he surely but gently forced in the ink from every side, rough-wiping neatly with muslin. When the plate was sufficiently chilled for manipulating, he used that remarkable hand of his to wipe the ink away in the daintiest manner imaginable. His hand would glide over the smudgy copper surface in light, quick strokes—*pit-pat-pat*—that fairly cut away the stiff ink that stuck fast in the palm. Buttoned close around his neck he wore a blouse that had seen service before. There was one large smudge on the right side that had layer upon layer of dry ink. In the same *pit-pat* regularity he wiped the ink from his hand on the same old smudge until the plate was ready for the press.

One of the many charms of his etchings is the delicacy of "biting." In some of his plates the lines are bitten so shallow that only with the greatest care and knowledge is it possible to retain the ink in them.

The method of printing his own plates was as much a part of his art as was the needle or the acid. From these delicate plates he could "pull" a proof so rich and full that it would surprise most etchers to see how much ink he got from those tiny, weblike scratches, some of them so faint that they could barely be seen when the polished surface was held to the light. These plates would baffle an ordinary printer, who would probably cast them aside as unprintable and worthless . . .

While in Venice, Whistler printed many of his etchings on old Venetian paper which took the ink remarkably well because of its matured, glue sizing. In order to procure this particular kind, he wandered among the old, musty, secondhand book-shops, buying all the old books that had a few blank pages which he cut out for his printing . . .

Whistler used the paper which he acquired at this time for pulling rare proofs. It had the rich mellow color of age with rare old watermarks delicately impressed upon its surface. Some sheets had been written upon in Italian script. Anything which had been left on by age, particularly if it were written, did not hinder him in its use, but added more to its charm.

Wood Engraving

The first wood engraving was done in the United States as early as the 1790s, but the heyday of the medium was the mid-nineteenth century, when it became the primary means of reproducing drawings and paintings. Using a transverse-cut wood block (the end grain provides a harder surface and thus a greater capacity for detail), the wood engraver would employ a dozen or more specialized "gravers." These tools enabled the artist to cut away the wood in areas that would read as "white" in the final print. The remaining, flat portions of the block would be inked and printed as black. The block

could be set alongside letterpress type, so that a complete page with its illustration would result from a single press run. In the late nineteenth century, wood engraving became quite sophisticated, more of an independent art than a journalist expedient. The Society of American Wood-Engravers was founded to promote this "new school." Members such as Timothy Cole and Gustav Kruell typically spent many months on a single print, primarily reproductions of paintings, or "translations" as some preferred to call them. The detail, luminosity, and tonal delicacy of these works led many to think of them as much more than mere copy work. In the following selection, this high/low debate is the main issue, with John La Farge, Worthington Whittredge, and George Inness weighing in on the subject. A century after it was introduced in the United States, wood engraving went into decline, with the development of the halftone process to reproduce photographic images in the 1890s.

"The Old Cabinet," Scribner's Monthly 16 (June 1878).

A letter from Mr. John La Farge, dated March 15th, and printed in the newspapers a day or two later, urged the admission of wood-engravings to the American division of the fine-art department, at the Paris Exhibition. Mr. La Farge declared that we have attained to a very high standard for the present day in the art of engraving on wood, and on this ground we could compete favorably with European nations, most of which are decidedly our inferiors. A like superiority, he stated, we cannot with certainty maintain in any other department of art, and he thought that all sincere lovers of art in America, would regret our throwing away this opportunity of deserved success and honor. The "World," the "Times," and the "Nation" heartily and intelligently indorsed Mr. La Farge's view, but the discussion came too late; the wood-engravings were not admitted to the walls of the art department, and engravings would not have gone to Paris at all (except those sent by publishers for their own shelves, where they will be lost to the general public), if, at the last moment, the commissioners had not consented to let Mr. Maitland Armstrong, the artist in charge, hang a few hastily gathered proofs somewhere among the beds, tables, candlesticks, and nutmeg-graters of the American department.

An exception to the general indorsement of Mr. La Farge's letter occurred in the case of the "Evening Post," which held that, "wood-engravers, properly speaking, are not artists, nor do artists, as a rule, recognize them as such.—The engraver is little if not an imitator and a plodder;—his business is to copy, not to create; to interpret, not to meddle with the text." Some may "try hard to be something more than mere copyists, and the occasional slight successes which they achieve in this direction have for us a mournful and tender interest. Their trade has clipped the wings of their spirits, and when they would soar, they can only flutter. They want to create, but they are held back. The artist, however, is distinctively a creator; and, in a fine-art exhibition, his absence cannot be compensated for by the presence of the engraver, who, so far from filling the chair of the former, is scarcely large enough to rattle about in it."

On points like these,—to say nothing of some much smaller points,—a controversy arose between the "World" and the "Post," which it is not necessary to follow. Mr. La Farge came himself to the defense. Whatever the "Post" says of wood-engravers not being necessarily artists, "is true," said he, "of painters and of sculptors likewise. Not all wood-engravers are artists, nor are all painters; but, when a man of artistic mind and training is an engraver, he does not cease to be an artist, not even if he should never engrave any original work of his own. This is an elementary rule of the grammar of art.—To translate faithfully the work of another artist into a different art, requires a high degree of many of the qualities that are rarest in art, and that are

identically the same as those through which the artist who paints or carves copies and imitates nature.—If he is an artist (and he must be an artist in soul to be a good engraver), he need not be 'a plodder and an imitator' any more than the artist in other departments, on whom we bestow this very reproach if he be not lifted beyond mere technical mechanism." Mr. La Farge also denied that engravers were not esteemed as artists by the brotherhood of painters and sculptors.

Mr. Whittredge followed on the same side in a generous letter, correct in its statements as regards America, in whose National Academy, engravers admitted as engravers, take equal rank with their artist fellows . . .

Said Mr. Whittredge, "Nothing, I think, would surprise American artists more than to learn that an engraver was not an artist."

The elder Inness joined in the controversy, thinking that the case had been "too strongly put" for the engraver. "In one sense, indeed," he said, "all workmen are artists—a wood-chopper is an artist, a carpenter, and a tailor; but, that the same artistic power is required in producing an engraving as in producing an oil-painting, I deny." Mr. Inness gave three excellent reasons to prove that "the best oil-painters are artists, in a higher sense than are the best engravers." But Mr. Inness was not consistent; though he rated the engraver with the wood-chopper he still discussed his position relative to that of the painter in oils. But, if an engraver is an artist in the same sense as is a wood-chopper, Mr. Inness, of course, wastes his time and degrades his own profession as a painter, in talking about the engraver's position relative to that of a painter in oil. But Mr. Inness knows very well that a wood-chopper is not an artist in any pertinent sense whatever; and therefore, we say, his argument is inconsistent. The fact is, and Mr. Inness acknowledges this fact in his comparison of engraving with oil-painting, that engraving is essentially artistic, just as painting is essentially artistic; of course, meaning by engraving, not the immature form of the art, and, of course, meaning by painting, something different from the work of the North American Indians. It is perfectly legitimate for Mr. Inness to discuss the difference between painting and engraving, and to exalt the former above the latter; just as it would be perfectly legitimate for a figure-painter to discuss the difference between figure-painting and landscape painting, and to exalt the former above the latter. Mr. Inness says that "a man naturally will not confine himself to engraving if he can paint equally well." Very true; but it would be surprising to the present writer if a painter would confine himself to landscape, when he could paint the figure equally well . . .

The denial of the term "artist" to an engraver is especially astonishing to those who have any knowledge of the methods of engraving on wood, although it might be thought that the *results* would be enough for the eye of any critic, particularly of any artist. In his second letter, from which we have already quoted, Mr. La Farge explains that "the art of engraving has mechanisms of its own, many of them invented for the occasion, which require as much capacity in artistic technique as painting or sculpture." He speaks of Mr. Marsh's well-known engravings of butterflies, which were only mapped out on the wood, the artist really drawing with his graver the insect which lay before him. In these engravings, any one who looks carefully "will recognize all sorts of artistic devices, often invented by himself on the spur of the moment, just as a painter does who is studying from nature; all done to reproduce the brilliant or sober color of these insects, their furry or metallic bodies, or the fairy dust which covers their wings.—This remarkable transcript of some of the most delicate beauties of nature is as much his own as the skies of Turner or the flesh-painting of Titian."

In the February number of SCRIBNER there is an engraving of St. Gaudens's panel of adoring angels, in St. Thomas's Church, New York. The lovers of art are indebted for this exquisite

reproduction of one of the most important pieces of sculpture yet made in this country, to a young wood-chopper by the name of Cole. In the reproduction of this beautiful bass-relief, Mr. Cole was not assisted by any draughtsman. The group was photographed upon the wood, and cut by the engraver with a large photograph before him. But the engraver could never have given so accurate, so valuable a copy, if he had not, also, seen and been inspired by the original in its place in the church; if he had not done his work in the same spirit in which St. Gaudens had done his.

Before us, as we write, lies a wood-engraving of a Madonna and child. The art of the master by whom the original was made is apparent here, but no less apparent is the art of the master who has given in firm and sensitive lines this rich, and broad, and luminous reproduction. And yet we are told that the man who draws thus with his graver as few other living artists can draw with pen, pencil, etching-needle, or brush,—we are told that William James Linton is scarcely large enough to rattle about in the chair of an "artist"; that, as an engraver, he is capable of imitating or expressing beauty in the same sense as is the wood-chopper, the carpenter, and the tailor.

POPULAR ART AND ITS CRITIQUE

THE *NATION* VS. PRANG & CO.

By the 1860s technical improvement and innovation in lithography facilitated the mass production of chromolithographs after paintings, so faithful to their models as to erase the difference between the real and the copy almost altogether (see "Currier & Ives: Art Hand in Hand with Business," chapter 5). Rendered by skilled artists and technicians and often months in the making, chromos were manufactured for a broadly middle-class market. The leading publisher of chromolithographs was Boston's Louis Prang, who from 1860 to the turn of the century sold millions of prints, ranging from mimetic copies of Albert Bierstadt's Yosemite landscapes to dining room still lifes and Christmas cards. In itself, the mass reproduction and circulation of images was by that time no novelty, but the chromo's pretensions to refinement mounted a challenge to cultural authority, spurring arbiters of taste to mount a vigorous defense. Even though the realms of officially sanctioned fine art and popular or commercial art overlapped and blended more often than not, critics often cordoned off one from the other as they staked out their own cultural turf.

Edwin Godkin, founder and editor of the Nation, *was one of the most ferocious critics of the chromo and of mass culture more generally. Godkin's 1867 attack, below, takes aim at Arthur Fitzwilliam Tait's* Group of Chickens, *an immensely popular, sentimental barnyard scene published by Prang. For Godkin, this picture and its ilk can never be more than "mere merchandise," because they are deceptive—imitating oil paintings—and mechanical. No "mechanical contrivance," he maintains, can ever match the hand of a "skillful painter." Three years later, Godkin renewed his attack on the chromolithographic imitation of oil painting, which in his view typifies "everything in bad art that is most disgusting." Such prints are a "sham" and a transparently commercial "swindle" calculated to "delude" the uneducated, "those who do not know," such as children or servants. Cheap, false, mechanical, and commercial, the chromo occupies a lowly position in the cultural hierarchy that Godwin strives to keep intact.*

Like other elites, Godkin believed that true culture was the result of education, discipline, and discrimination. In "Chromo-Civilization," he applies the figure of the chromo—cheap, mechanical, fraudulent—to modern American culture—or pseudo-culture—as a whole. Culture, he contends, is nothing more than a veneer compounded of a "smattering of knowledge" and a taste for "'art,'" diffused through the community by "newspapers and other cheap periodicals." In America today, a nouveau-riche "society of ignoramuses" preen themselves on their cultural sophistication and worship their own "trumpery prophets" with "barbaric fervor." Rather than true civilization, such a state of affairs verges on "mental and moral chaos." Godkin implicitly endorses the notion that culture in a mindless, materialistic society is the domain of the privileged few, whose duty is to protect and sustain it.

Prang, in contrast, presented his mission as bringing art to the millions. In "Our Aim and Name," published in his house organ, Prang's Chromo, he not only connects his enterprise with the improvement of democracy but also defends the level of taste of his prints, refusing to concede defeat in the high/low battle. Prang's Chromo was an effective marketing tool, giving advice on framing chromolithographs, explaining the technical process of the medium, and reprinting letters of praise that the company had solicited. James Parton's communication is one of these letters; Parton goes so far as to suggest that private collectors, who purchase and hang unique works of art in their own homes, are selfish in their motivation to guard an artistic treasure for their own delectation.

Prang was similarly unafraid of going after the cultural arbiters of his day. He enjoyed reprinting attacks on chromos (along with Godkin, Clarence Cook was a frequent critic), for they provided him with an excuse to defend his business. In the final selection, he goes after a critic from the Philadelphia Evening Bulletin who has questioned the artistic value of the famous chromo after Eastman Johnson's Barefoot Boy. After a few paragraphs designed to refute the critique of Johnson, Prang explains his views on reproduction versus creation. He also discusses one of the most controversial practices of his firm: a textured treatment of the paper to mimic the surface of a painting on canvas.

[Edwin Godkin,] "Fine Arts: Color Printing from Wood and from Stone," Nation, January 10, 1867.

Chromo-lithography, or lithochromy, to take from the French a less awkward word, is a recent invention, or rather a recently tried application of Sennefelder's fortunate discovery. It has not been made so widely useful in the industrial arts—except in one notable way, of which thereafter—as printing from wood-blocks. But it has been very rapidly developed into a pseudo fine art, and copies made by it from pictures, copies pretending, themselves, to be pictures, are in every print-shop and bookstore window . . .

Chromo-lithography has been introduced into this country, and many small pictures have been produced, and have sold well within the past three or four years. We have received from L. Prang & Co., of Boston, a copy of their chromo "Chickens," from a picture by Mr. Tait. This house has a recently established agency in New York, and does probably a much larger business in this line than any other American establishment. Hundreds, and in some cases thousands, of their chromos, at two dollars, three dollars, and five dollars a copy for "prints," have been sold in all parts of the United States. They are as common in Chicago as in Boston. None of these that we have seen are quite equal to the best of European make; it is impossible to train

good workmen and build up an establishment of sufficient resources in a day, but the improvement in the work of the Boston workmen is obviously rapid. It is of the value of the best of these as works of art, and of their probable influence in educating the people, that we propose to speak very briefly, and we instance six that lie beside us, viz.: "Going to the Bath," after Bouguereau (called "The Baby" in the advertisements); "The Sisters," artist unknown to us; "The Linnet" and "The Bulfinch," after water-color drawings by W. Cruikshank; "The Chickens," after A. T. Tait; and a study of ferns, etc., after a water-color drawing by Miss——. We have had no opportunity of comparing these with their originals; it is probable that they are as faithfully copied as it was found possible to do the work with the requisite speed. One thing only, quite unnecessary and quite inexcusable, throws discredit on the whole matter and makes the pictures merely merchandise; some of the pictures are made to look like oil-paintings on canvas, by printing them all over with indented lines to imitate the effect of the threads of the canvas, and by giving them a varnished surface. The main question, however, is this: Are these pictures good as pictures; good to have and to look at; good in their influence on people who do not have much original art within their reach; good as teaching people to feel and understand nature? So far as these six are concerned, the answer is easy: in none of them is there any brilliancy or purity or noticeable softness of color; in none of them is there any true or delicate "gradion" of color; in none of them is there any accurate, subtle, delicate drawing. Although it is hard to say what will or can influence any person to begin to observe nature or wisely enjoy art, this much is evident, that the more one loves nature and the more he knows what art is and can do, the less he will enjoy these chromos. And, on the other hand, as Ruskin has truly said that "if you are fond of the large finished prints from Raphael, Corregio, etc., it is wholly impossible that you can make any progress in knowledge of real art till you have sold them all or burnt them," in like manner one who enjoys these chromos and wants to study art to purpose, may begin when he has put them well out of his sight.

But will not the art become so much improved that such pictures will be good? Probably not. Good color, that is, delicately gradated color, is not to be produced by the printing-press. A black and white engraving or wood cut or lithograph is a true reproduction of the forms and of the light and shade of a picture, if it is only truthfully made. But a colored reproduction must be perfect or it is nothing. What the brush of a skilful painter does at every touch in graduating, softening, and blending tints, leading one color into another, breaking one color over another, until there cannot be found two grains of color the size of a pin's head that shall be really the same; this is beyond the reach of any mechanical contrivance. And, when a skilful operator, master of every device of his art, doing everything with supreme care and cunning from the first transfer to the stone to the printing of the last tint, shall have produced the best approach to handwork that the machine is capable of, at what cost per copy will he supply the trade with such prints? That, however, is a small matter. At whatever price, they would be nearly valueless as art, or as things of beauty and of truthful suggestion of nature.

[Edwin Godkin,] "Fine Arts: Autotypes and Oleographs," Nation, *November 10, 1870.*

For Albert Dürer, from what were hard circumstances with him, put his main strength into his engravings; and no great art can lose less than his and be more exactly represented by photography. In such a way, photographs from his famous engravings are fair examples of a noble form of cheap art, which we could hope to see common—as common as the nature of good things will allow. His most personal creations live with a life not outside of natural, untrained

appreciation, however rich in increasing interest they are as subjects of observation and study. Take, for instances, the "Melencolia" and the "Knight and Death."

It is not merely that such things give the only easy sight of famous and costly originals, that they offer us cheaply to-day what a few years ago was hard to seek, but that they are preservatives against the duration of meanness and vulgarism. Their superiority to the objects of our usual liking; a certain necessary difficulty in their appreciation; the happy fact that they must always be somewhat foreign, and that we must always put aside some prejudice when we wish to see them truly—in other words, that they never can be patronized—gives us, through them, a chance of avoiding the debasing use of art as a mirror for self-admiration. If the foreign god can only seat himself humbly alongside of the domestic idol, some fine day surely the latter will come to grief.

The same impartial publishers advertise also the "Oleograph." This "oleograph" differs from its brother and our old friend the "chromo," in some cases, through a certain lithographic flimsiness, characterizing, perhaps, its easy Italian manufacture as compared with the heavier Teutonic pretensions to honesty of the "chromo;" in other cases, the oil-paint impression rivals in thickness the oil-paint of hand-painted pictures, and, of course, imitates that look of paint quite well. The specimens published are copies of very poor Italian work, and of old paintings famous for extreme finish and inimitable drawing. They are "confidently recommended" by the publishers as "admirable studies for young artists"—a recommendation which seems to us all the more unfortunate that we were just about to ask why it is that the chromo-lithographic imitation of oil-painting is a type of everything in bad art that is most disgusting to the artist and to the cultivated. It is not because of any cheap democracy of the "chromo;" a certainly more democratic art, to which no aristocratic art objects, is the wood-cut. It is not because of the disagreeable appearance of a smooth, oily impression on paper, since, as a recorder of facts, the chromo-lithograph is well used in publications of art and archæology, where it copies tapestry, enamels, metal-work, etc., with success. Even for the poor drawing and bad coloring of the chromo all allowance would be made, were there no easier and surer means of obtaining records of fine originals. At bottom of this disgust we shall find the sensation of sham, of a swindle which disappoints even while it deceives—the uneasiness which one feels in the presence of pinchbeck jewelry. And this last comparison might explain why persons of doubtful taste have taken a fancy to the chromo, and have made much of it in print. Perhaps it may be well to notice how the absurdity of the chromo-picture lies in this, that it uses oil-painting to imitate oil-painting, being therefore nothing but an inferior and more mechanical method of applying oil-paint to a given surface. Now, oil-painting has its laws of method, the result of long experience, and some of its worst stages correspond pretty well with the methods of chromo-lithography. Hence the fatal success with which a poor painting is duplicated by the "chromo." And hence, besides his moral disgust, the aversion of the painter to the chromo-picture. He must often fear that his painting may possibly look like it, and his soul protests within him.

It is then quite open for any one to see why the chromo-copy cannot imitate a good painting. That it deludes those who do not know, or that, as Mr. Parton says, it gives him all that he can enjoy of an original, is a misfortune to be remedied by cultivation, but assuredly is no particular plea in its behalf. As much might be said in favor of hand-organ music. Unfortunately, also, the "chromo," being mechanical in the process of its printing alone, depends for all its art qualities upon the superior art of its workmen. They do its drawing and choose its colors. So

long as its workmen are not first-rate, the one great thing which it could give us, accurate and sympathetic copy of the drawing and composition of good or great work, we are as yet debarred from. This it is not yet the interest of the publisher to give us, both because he must have cheap work, and because he must not interrupt the course of trade. Let us remember that the chromo-manufacturer is not called upon by his profession of making as much money as he can to elevate the taste of the public, and to give us a better article than we ask for. What his interest is has been well shown by Mr. Parton, who, with Mrs. Stowe, has done much for the literature of the subject, viz.: there was a worse thing which this is replacing—the manufacture of cheap, oil-painting by the wholesale, painted in a way not dissimilar to the chromos, but very much more dingy and disagreeable in color.

The foregoing considerations, perhaps too grave, will not interfere with our purchase of "chromos." We shall, most of us who know better, even our artist-friends, doubtless, buy them for our children, our servants, or for some of our acquaintance. To quote the artist in Mrs. Oliphant's last novel: "There's my brother, who doesn't know the difference. I shall buy him some of those vile chromos."

[Edwin Godkin,] "Chromo-Civilization," Nation, *September 24, 1874.*

The newspapers and other cheap periodicals, and the lyceum lectures and small colleges, have diffused through the community a kind of smattering of all sorts of knowledge, a taste for reading and for "art"—that is, a desire to see and own pictures—which, taken together, pass with a large body of slenderly-equipped persons as "culture," and give them an unprecedented self-confidence in dealing with all the problems of life, and raise them in their own minds to a plane on which they see nothing higher, greater, or better than themselves. Now, culture, in the only correct and safe sense of the term, is the result of a process of discipline, both mental and moral. It is not a thing that can be picked up, or that can be got by doing what one pleases. It cannot be acquired by desultory reading, for instance, or travelling in Europe. It comes of the protracted exercise of the faculties for given ends, under restraints of some kind, whether imposed by one's self or other people. In fact, it might not improperly be called the art of doing easily what you don't like to do. It is the breaking in of the powers to the service of the will; and a man who has got it is not simply a person who knows a good deal, for he may know very little, but a man who has obtained an accurate estimate of his own capacity, and of that of his fellows and predecessors, who is aware of the nature and extent of his relations to the world about him, and who is at the same time capable of using his powers to the best advantage. In short, the man of culture is the man who has formed his ideals through labor and self-denial. To be real, therefore, culture ought to affect a man's whole character, and not merely store his memory with facts. Let us add, too, that it may be got in various ways, through home influence as well as through schools or colleges; through living in a highly organized society, making imperious demands on one's time and faculties, as well as through the restraints of a severe course of study. A good deal of it was obtained from the old Calvinistic theology, against which, in the days of its predominance, the most bumptious youth hit his head at an early period of his career, and was reduced to thoughtfulness and self-examination, and forced to walk in ways that were not always to his liking.

If all this be true, the mischievous effects of the pseudo-culture of which we have spoken above may be readily estimated. A society of ignoramuses who know they are ignoramuses, might lead a tolerably happy and useful existence, but a society of ignoramuses each of whom thinks he is a Solon, would be an approach to Bedlam let loose, and something analogous to

this may really be seen to-day in some parts of this country. A large body of persons has arisen, under the influence of the common-schools, magazines, newspapers, and the rapid acquisition of wealth, who are not only engaged in enjoying themselves after their fashion, but who firmly believe that they have reached, in the matter of social, mental, and moral culture, all that is attainable or desirable by anybody, and who therefore tackle all the problems of the day—men's, women's, and children's rights and duties, marriage, education, suffrage, life, death, and immortality—with supreme indifference to what anybody else thinks or has ever thought, and have their own trumpery prophets, prophetesses, heroes and heroines, poets, orators, scholars, and philosophers, whom they worship with a kind of barbaric fervor. The result is a kind of mental and moral chaos, in which many of the fundamental rules of living, which have been worked out painfully by thousands of years of bitter human experience, seem in imminent risk of disappearing totally.

"Our Aim and Name," Prang's Chromo 1 *(January 1868).*

For many years, it has been our dream, by day and by night, to popularize art and art ideas in the homes of our America,—not alone because of any financial benefit likely to accrue from it, but from the higher aim of contributing our share to promote the social pleasures of our countrymen. It may be that we are too enthusiastic in our hopes; but, as far as we have gone, we have been strengthened in our aspirations by the cordial, prompt, and wide appreciation with which our efforts have been received by the American people. The best things that we have done, in reproducing works of art in a popular form, have been the most eagerly and the most warmly applauded, both by friendly voices and by rapid sales. We trust that we have been found not wholly unworthy of this gladdening welcome. We know, at least, that we have never pandered either to a vicious or a meretricious taste, but have zealously and constantly endeavored to improve our skill, and raise the standard of our beautiful art.

It has often been asked, "How shall a democracy be educated in art?" We answer, "By art." It is idle to teach without example. And yet art galleries in our country are few and far between. We have neither the treasures of the past nor a numerous class of painters, nor the means of supporting well-endowed academies of design. Without these agencies, we believe that, especially in a country of vast extent, but limited population, the only substitute for them, the only efficient educator of the people, is The Chromo.

This agent, in its present perfection, we have had the happiness of creating in America, and with the most flattering success. Beginning with humble attempts to reproduce autumn leaves and moths and butterflies, we can already point with pride to the "Groups" of Tait, the "Landscapes" of Bricher, the "Magdalena" of Correggio, and others.

James Parton, "Mr. Parton on Prang's Chromos," Prang's Chromo 1 *(January 1868).*

I have just received the exquisite specimens of your art which you have been so generous as to send me. The letter respecting them arrived last night.

It has been a favorite dream with me for years, that the time would arrive when copies of paintings would be multiplied so cheaply, and reduced so correctly as to enable the working-man to decorate his rooms with works equal in effect to the finest efforts of the brush. I could not see that there was any natural obstacle in the way of this, which science could not overcome. The works which are issued by your house, which have often and long detained me at the picture-shop windows in Broadway, show me that my dream is coming true.

I do not wonder at the enthusiasm with which you pursue your beautiful vocation. The busi-

ness of this age is to make every honest person an equal sharer in the substantial blessings of civilization; and one of the many means by which this is to be effected is to make the products of civilization cheap.

In prosecuting your business, therefore, you are aiding to bring about the essential equality of merit, opportunities, and circumstances. Besides, what a future is there for art where a great picture can adorn a hundred thousand homes, instead of nourishing the pride of one, and when an artist can draw a steady revenue from the copyright of his works, instead of eating up one picture while he anxiously and hurriedly completes another!

Louis Prang, "Art Critics Criticised," Prang's Chromo 1 *(September 1868).*

Chromo-lithography is not the art of producing original paintings, but simply the art of re-producing them in absolute or nearly perfect *fac-simile*. In a high sense, nothing is art which is not creative and original. From that point of view, chromo-lithography is simply a handicraft. But, from that point of view also, every painter, however eminent, ceases to be an artist, and becomes a mere workman (more or less skilful) the very moment that he begins to copy one of his own pieces, or the pictures of any one else. If there is no merit in copying a work of art with entire accuracy, both as to the form and sentiment, then chromo-lithography is a worth-less invention; but if there is merit, artistic merit,—in reproducing a work of art with fidelity, in drawing, color, or spirit,—there is at least as much credit due to the chromo-lithographer as to a copyist with brush or palette. As perfect a knowledge of the principles of drawing and coloring—as great a skill in manipulation—is required to produce a *first-class* chromo, as to copy a painting in the ordinary way. The slightest lack of skill or knowledge on the part of any one, artist or pressman, at any stage of the complex process, is instantly detected by the prac-ticed eye in the finished performance.

No "tricks" whatever are used in legitimate chromo-lithography to produce the legitimate effects of painting. "Loaded touches" produce effects in a painting which nearly all "smooth pictures" lack: it is absolutely necessary to reproduce these touches in a chromo in order to give the effect of the original. If your critic will examine a first-class chromo before and after what he calls the "embossing" process, he will see at once that it is one of the most important elements in an effective reproduction. There is no "deception" intended. All our chromos— all our best productions—have the name of our firm on the picture, with the name of the original artist, and the name also of the artist of our establishment who copied it and super-intended its publication; and there are only a very few exceptions to this rule in cases where our firm was accidentally omitted. Every chromo and every half-chromo issued by our house has also a conspicuous label on the back, which makes any attempt at deception impossible. Instead of attempting to palm off our chromos for paintings,—as seems implied in the arti-cle under notice,—we have published very extensively in our own "Art Journal," and in hun-dreds of leading papers, a clear explanation of "How Chromos are made." Neither in fact nor fancy, therefore, is it true that we "remain nameless," in "sublime negation," in order that we may be "true to art and his pocket." On the contrary, by every worthy and legitimate method, I take especial pains to be known only as a reproducer of works of art, and to let it be known that chromo-lithography aims, and aims only, to enable the people to possess worthy and artis-tic copies of genuine works of art. I claim, that what journalism is to literature, chromo-lith-ography is to art. And, as Richter says, "Why should one quarrel with the high because it is not the highest?"

The immense popularity of the table-top groups of John Rogers was a unique phenomenon in nineteenth-century America. Rogers worked at his catalogue of offerings for more than three decades, producing some eighty narrative groups, which were cast in an astonishing 80,000 copies. No other sculptor approached this level of public patronage.

Rogers went abroad in 1858, but his period of foreign study in Rome and Paris lasted only six months. In a series of candid letters to family members, he writes of his disenchantment with ideal statuary, preferring works that depict "human nature" and placing greater store in the narrative subject than in abstract form. He also recognizes that, whether high or low, art is still a "trade," requiring the skills of a salesman. These he forcefully exhibited upon his return to the United States, first for several months in Chicago, and then permanently in New York. The U.S. letters included here are mainly concerned with the conception and marketing of his Slave Auction *(1859), which, thanks to its "strong" political message, brought him great publicity but mixed sales.*

John Rogers, letters, New-York Historical Society.

[To John Rogers Sr., Rome, December 14, 1858]

Today was a public day for the Vatican galleries so I spent a long time there and saw all the original statues that are famous the world over. I was much interested in one of Demosthenes. He is represented with rather a small head but intellectual and full of life. A bust also has the same features. When you think how old some of these statues are how they have been found buried up in ruins it seems wonderful that they should now be so perfect. I shall go soon to the galleries of the Capitol &c. I don't think I shall ever get in to the classic style. I do not take to it. I think my best course is to pursue the path that I have begun—to improve my taste in that and make small figures in bronze or very nice plaster such as they have a way of making here and not attempt any high art for I shall certainly step out of my depth if I do. I think if I get my name up for that style and represent pure human nature I can make a living by it as well as enjoy it exceedingly.

[To Henry Rogers, Rome, January 9, 1859]

If any one can think of some good subjects please send them along. I should like to have a good selection in my mind to choose from. The success of a statue depends more on the subject than any thing else though it is very strange that the artists here don't seem to appreciate it. It seems strange to go into the studios here and see so much labor spent on so little thought. In fact, the *thought* is a very secondary consideration. They merely make a graceful figure and call it anything . . . That is not the way that I want to go to work. I want the idea *first* and then I will suit the statue to it.

[To Sarah Rogers, Rome, January 26, 1859]

I have not commenced any figure yet. I made several little rough designs in clay but they did not exactly suit Mr Spence and I have been trying to think of others. You have no idea how difficult it is. I used to think it was hard enough when I made designs for a group but this seems worse because according to the classical ideas prevailing here, and no doubt they are the true principles, statuary should be as simple as possible, with very little drapery and no accessories, as they

call all the little odds and ends that I used to put round my groups to help tell the story. You see when you leave all those out it is very difficult to make any particular action or position tell the story. It may be true in theory to leave all the accessories out but I don't believe in it altogether. Look at Powers Greek Slave. There is nothing in the world that has made that so popular but that chain. The chain showed that she was a slave and the whole story was told at once. There are a plenty of figures as graceful as that and it is only the effect of the chain that has made it so popular. I find it very hard to get out of my old tracks and leave such things out but I shall do just as they suggest to me while I am here and perhaps I shall see things differently by and by.

[To Henry Rogers, Rome, February 13, 1859]

I find that the artists business is a sort of trade. It takes the same qualifications that a good salesman has. Some of the poorest sculptors sell the most because they have a way of showing them off and praising the marble etc that makes them sell. Then many of them have reception nights every week so as to become known—in fact it requires qualifications that I don't possess to *sell* statues. Then the profit is small. The marble is immensely expensive. Then a high price is paid to the workmen to cut it and unless the artist can sell a number of copies from the same design he will hardly make enough to pay for the expense of modeling the original clay figure.

[To Sarah Rogers, Chicago, October 8, 1859]

I am anxious to . . . work on my next, The Slave Auction . . . I feel very much delighted with the design myself, and, if I finish it as I hope to, I think it will be far the most powerful group I ever made. Considering the subject & all, I think it will be very popular and I set my profits on it at five hundred dollars. I'm talking rather large I suppose you think but we shall see. My plan is to get subscribers for it here and then take it to New York and get it cast. I shall then send copies to all the large cities and dispose of them at fair prices so as to become known & have them popular. If I succeed in this, you need not doubt but I shall follow it up. My great mistake when I went to Europe was in turning my attention to "high art" instead of my particular *forte*. I have no doubt if I followed my specialty of treating *popular* subjects I could soon make it quite remunerative. I think I could secure a good many subscribers here for "The Slave Auction" to begin with and if it *takes* as well as I anticipate there will be no trouble in bringing it into notice elsewhere. The design is a man & his wife & two children who are standing before the desk of the auctioneer who is selling them. The sentiments expressed are the maternal affection of the mother and the sullen resignation of the man while the auctioneer is expressive of heartless calculation. The desk supports them all well and the group comes in very symmetrically.

[To Sarah Rogers, New York, December 16, 1859]

Fortune has smiled so far on Slave Auctions. The casts are a complete success and come out of the moulds almost as perfect as the models. I have only got five cast so far as the caster has been busy with other work. I must make some different arrangement so that I need not be delayed. I must get a man to come to my room & cast them there I think. I took a copy over to Mr. Beecher's with a note.[3] I shall hear from him in a day or two I suppose. I want to get him interested.

[3] Henry Ward Beecher was a famous Congregationalist preacher who fought against slavery.

[To Sarah Rogers, New York, December 24, 1859]

I find the times have quite headed me off for the Slave Auction tells such a strong story that none of the stores will receive it to sell for fear of offending their Southern customers. I have concluded it will not be wise to try & force it on the market but keep it in my studio & push the others along . . .

You don't know how I enjoy myself now. I am comfortably settled & feel that I see my way clear before me. I have so much to do that I have no time to get discontented & with a lump of clay before me I should not have a moment's lonely feeling if I did not speak to a human being for a week at a time. I get so absorbed in my groups that, for the time, I am connected with them & I have the same feeling that I am working out in the clay. All the figures in my last group are smiling or laughing & I have done the same thing from morning till night. My thoughts wander off to all the happy scenes of my life & I have caught myself repeatedly laughing out loud almost before I was conscious of it. I would not make a figure gaping for anything. These home scenes really give me more enjoyment than anything & I think I shall confine myself mostly to them & not make any more political pieces though the Slave Auction would have been a great take at the time I thought of it & it may be yet, but home scenes interest everybody.

[To John Rogers Sr., New York, January 8, 1860]

You ask what means I intend to take to bring my works into notice. I will tell you my present plans. In the first place I shall put them into some of the best stores on Broadway . . . Then another plan is one that I meant to start the Slave Auction with, but which I think is well to carry out with my other groups. It is to employ a good looking Negro to carry them round on a sort of tray, with an appropriate notice printed on the front. There is no license required. The black man will be a distinguished feature from the italiens & it will bring them more into notice than any other way I think. I can pay him a commission for what he sells. Then I shall try & get some of the hotels to accept of some to put in their sitting room with a notice stating where they can be had. It will attract the eyes of country people who will want a copy to take home with them.

[To Mary Peabody, New York, January 1860]

About the price I have some doubts. If I sell them here for $3 & anybody can send on & get one for that it is hardly fair to charge 5 in Boston. You know they are not intended for rich peoples parlors but more for common houses & the country. The abolitionists here have all advised me to put them at 3 dollars & many think that is too high. As I want them popular they must be put low or else nobody but the rich will buy them & they would not want them in their parlors. According to my present arrangement of getting them up, the profits are small, but when I can afford to have my own workmen the case will be different & as I do not depend on any one group or design but on the great variety I shall get up in due course of time, so I must be content to receive the small profits of this group. Large sales & small profits is the motto I must stick to.

[To Sarah Rogers, New York, February 1860]

I have commenced a group of the Checker Players which I think will make a popular subject. I only wish it was more original for I dont like to make anything that can be traced to a picture. But still this is only the *idea* that is copied. The arrangement is different.

[To Ellen Rogers, June 23, 1863]

I like what you said about my designs particularly well & assure you it coincides exactly with my own views. I never feel satisfied after I have finished a merely humorous design & feel just as one does after reading a trashy novel. But good designs are exceedingly hard to think of & then again I may think of a very effective one which would be unpopular & which would not do to undertake. Now the Slave Auction which you mention gave me probably more satisfaction to make than any other of my small groups, but I sell less of it than of almost any other group. By taking a subject on which there is a divided opinion, of course, I lose half my customers. I think I hit it more nearly than ever before in my Union Refugees which I hope you will have a chance to see before long in Boston but I can't expect always to get anything so much to my satisfaction. I feel the importance of being sure of a good design before going to work more & more & wish I had the mental capacity to think of them with greater ease. If you ever should think of a subject out of which a good design could be made I should be thankful to hear of it. I used to think that I should be overrun with suggestions for designs & it quite surprises me to think that I never have had a single suggestion that was of the least assistance to me.

THE TROUBLE WITH MONUMENTS

Debate about the proper way to memorialize the heroes of the Civil War began immediately after the conflict ended (see "Memorializing the War," chapter 7). At that time, few could have imagined just how many municipalities would choose to undertake a Civil War monument. Although some of these (particularly the commissioned statues of specific men) were hailed as masterpieces (see "Farragut Monument," chapter 14), most were generic soldier monuments—in stone or cheap metal—that could be catalogue-ordered from companies that produced them en masse. For hundreds of towns and villages these became the central (and only) example of public art. However, the patrician critic Mariana Griswold Van Rensselaer laments the cheapness, ubiquity, and lack of professionalism in this army of local effigies.

Mariana Griswold Van Rensselaer, "Fine Arts," Independent, August 4, 1887.

American sculpture cannot complain of lack of patronage, at least in so far as portrait-statues, and out-of-door monuments are concerned. The Garfield statue in Washington, and the Burnside statue in Providence, are but the most conspicuous of many which have been unveiled this summer; while the early autumn will see the dedication of the Chapin statue in Springfield, Mass., and the Lincoln monument at Chicago. And all over the land soldiers' monuments of one sort and other are being ordered right and left, either for village communities, or for battlefields at Gettysburg and elsewhere. But if patronage is great in quantity, it is unfortunately not often good in quality. There is nothing about which committees seem so much at sea—and they are usually at sea in all matters of art—as the characteristics of a good monument and the relative claims to respect of our sculptors. Even the fundamental distinction between a sculptor and a professed stone-cutter is not always respected. Very many soldiers' monuments in New England, for instance, and undoubtedly elsewhere too, have been ordered, not of a man, but of a company; of a quarry-company or of a stone-yard which contracts to furnish

materials at such a price, and throw in the "art" for so much more. The commission is then handed over to some more or less well-trained person in the company's employ; and such skill and conscience as he may have is usually quenched by the brief space of time that is allowed him to prepare a design and execute the work. A month, I am told, is considered a long time for such a designer to give to his clay: while I have heard great sculptors lament, after their clay has been two years in hand, that they did not have two years more to give to it. The natural results are so hideously striking, and so distressingly numerous, that it seems as though they should long ere this have worked their own cure; but such, alas! is not the fact. And this is all the more to be regretted as the rich opportunities of to-day will erelong be over. Great citizens we shall always have, we hope, whom their surviving admirers will delight to honor; but perhaps not soon another such great and greatly honored generation as is just passing away. And the war, which, even in the interests of art no one could hope to see repeated, will soon be commemorated over all the land. Every bad portrait of a Lincoln or a Grant, of a general or a statesman prominent in the greatest scenes of our history, which is now erected, is doubly unwelcome as destroying a peculiarly happy chance for a good and interesting work; and for the same reason every bad "ideal" composition or ugly "simple stone" which records towns-folks' patriotism, or marks the graves of a regiment's dead, is doubly a public misfortune and a private disgrace to its promoters. Of what credit to these promoters, of what honor to the slain whom it commemorates, and of what inspiration to coming generations will be such a soldier's monument as I recently read of—bought ready-made of a company, for some $2,000, and made of that stuff called "white bronze," which is, I am told, a composite metal, colored in imitation of marble?

WILLIAM HARNETT'S *AFTER THE HUNT* AND *THE OLD VIOLIN*

The Irish-born still life painter William Michael Harnett became famous in the 1880s for his precise, almost miraculously realistic paintings of artistic bric-a-brac and hanging objects. His work was uniformly successful on the popular level, though elite critics dismissed it as mere mechanics without a higher message. Clarence Cook, for example, wrote in April 1879 in the New-York Daily Tribune *that he saw no "thinking" in Harnett's "curiosities." He blamed the market and the low taste it inspired: "We know that the problem is largely a commercial one . . . Our artists for the most part keep on, year after year, painting down to the public instead of forcing the public up to a higher level by determined effort to give them the best work they can produce." A few years later, as presented below, Cook describes this "public" interacting with Harnett's impressive* After the Hunt *(1885).*

Harnett's masterpiece in this category of art so offensive to Cook was The Old Violin *(1886, fig. 12), a tour-de-force example of trompe l'oeil painting, which was shown in industrial expositions in Cincinnati and Minneapolis. Two accounts of the success of* The Old Violin *among Cincinnati fairgoers stress its incredible verisimilitude and the antics of the visitors, who had to be restrained by a policeman posted in the gallery. In contrast, Minneapolis Baptist minister F. T. Gates singles out Harnett's work as low, egotistical painting, designed to trick rather than teach. Harnett's continued popularity throughout the century among non–art professionals suggests that few viewers took Gates's warning to heart.*

Clarence Cook, "Art's Counterfeiting: Some Notable Examples of Deceiving the Eyes by Pictures," **New York Daily Star,** *December 30, 1885.*

There is on Warren street a famous lunch and liquor place, whose glory is a panel picture of large size named "After the Hunt." It is apparently painted upon a panel door of black oak, which is draped with crimson velvet hangings standing out some way from it, so as to permit the introduction of concealed gas jets which light up the picture. These are obviously necessary because the position of the panel is a dark one, between the fore part of the store and the immense bar and counter in the center of the place. On the supposed panel door is painted a hunting trophy of weapons, birds, a rabbit, a hunting horn of brass, a drinking cup made from an ox horn, a man's hat, and above all a pendent bottle handing by a string, which is fasted to one of the objects above. The supposed panel door has immense rusty hinges of hammered iron, artistic in construction and of the fifteenth century in style. In the center, upon the left handside, is the key hole, with its plate of battered bronze. It is shaped like a halberdier and is greenish in parts with age, which gives it a quaint, queer aspect, so that it looks as if some one had dug up from the entrails of the earth an ancient Toltec bronze and punched into it a keyhole.

Men come and stand before this picture for fifteen minutes at a time, and the remarks passed upon it are curious indeed. As a rule, city men are enraptured with it, and go into ecstasies over the feathery plumage of the birds and the furry coat of the rabbit, over the wonderful representation of the butt end of an old soap-lock gun, over the extraordinary imitation of the brass work of the burn. But gentlemen from the country, and especially from Chicago, see it for the first time, declare that nobody can take them in, and that the objects are real objects hung up with an intent to deceive people. A drummer[4] from the city of sin was very angry over the obvious imposition, and wagered $5 that the thing was not a painting. "Feel it," said his friend. He felt it, and found that it was a flat panel. "Well," he said. "I admit that the rabbit and the birds are painted. I ought to have seen that from the first, because, although they are wonderfully lifelike, there is a sort of yielding of the muscles in a dead thing which you don't see in this. But what got me was the hanging up of that bottle, because I could see in a moment that the string was real." The crowd behind them burst into a roar of laughter, and the drummer made a dash for the bottle; but his hands met only the flat surface of a panel. He was dumbfounded. "Gee whittakers!" at last broke from his lips: "that beats Chicago—hang me if it doesn't! I understand it now. It's all painted, frame and all, and that's what makes the illusion so perfect." There was another roar from the crowd that was taking in the scene with huge delight. The man dashed at the frame, but this time found solid wood. The frame was *not* painted.

One of the artists of *Puck,* who is now, indeed, the leading artist of the *Judge,* went over the way to see the marvel, and found that he could very fairly resist the artist's endeavor to cheat him, save one particular. The key hole did look so natural that it was hard to believe it was not there. He looked at it in different ways; first from a front near view, then from a side view, then from a distance, and could not make up his mind absolutely whether it was a dummy or a real object introduced to heighten the deception. At last he bethought himself of a plan. He placed his hand close to the nearest of the side lights, and flashed a shadow upon the poor key hole,

[4] Drummer: a traveling salesman.

which at once showed itself to be a deception. Others who saw his maneuvers imitated him in high glee, and found that they, too, had a point upon the picture, and could prevent it from deceiving them. But this was an exceptional man, and it is safe to say that, out of the hundreds who visit the place daily, almost ever one believes, like the Chicago man, that the panel is a door upon which objects have been grouped to simulate a painting.

"The Art Gallery," Cincinnati Commercial Gazette, *September 16, 1886.*

The little collection of pictures secured by Commissioner Mehner a little too late to be catalogued, are now being placed in position and attracting great attention. One of these pictures especially, a study of still life, by W. H. Harnett, of New York City, is a remarkable bit of realism. It is called "The Violin". It is hung upon the north wall, but visitors need no guide-post; they will find it by following the crowd. It represents a rather shabby barn-door, hung by immense iron hinges, and against it hangs an old violin and bow and a sheet of time-stained music. Stuck in the edge of the frame is a foreign letter, in a dark blue envelope, and a little newspaper clipping is pasted upon the boards. So real is it, that one of Captain Wise's specials has been detailed to stand beside the picture and suppress any attempts to take down the fiddle and the bow.

While the iron hinges, the ring and staple and the rest are marvelous, the newspaper clipping is simply a miracle. The writer being one of those doubting Thomases who are by no means disposed to believe their own eyes, was permitted to allay his conscientious scruples by feeling of it, and is prepared to kiss the book and s'help me it is painted. Mr. Harnett is of the Munich school, and he takes a wicked delight in defying the possibilities.

Unidentified Cincinnati clipping, in an advertising brochure for F. Tuchfarber Co., c. 1887.

A painting has been added to the Art Gallery, which has created a furore. It has just been hung in the north end of the gallery, and has a crowd of bewildered gazers continually about it: It represents an old violin hanging on an old time-worn door. By it hangs the bow, and under the violin is a sheet of music with dog-eared corners. A blue envelope is stuck in the warped lower corner of the door, and above it is a newspaper clipping, that a man wanted to bet $10 last evening, was pasted on the board. The lower hinge of the door is partly broken off, and rust marks have run down from the old nail holes. An old gentleman stood and gazed at it last night, through his spectacles, and finally said: "By Jove, I would like to play on that violin," enthusiastically judging that many a touching melody had been wafted from its well resined strings. The gentleman never noticed the deception until he went closer to it and he was "completely got." A policeman stands by it constantly, lest people reach over and attempt to see if the newspaper clipping is genuine by tearing it off. They want to pull at the envelope as well.

Why, a wooden man would enthuse over such a painting.

F. T. Gates, "Choice of Pictures for the Home," Minneapolis Tribune, *September 12, 1887.*

I wish to speak of a single department of home training, the influence of pictures. God taught patriarchs, law givers, prophets, and apostles very largely by means of pictures. The Old Testament and the New are illumined by a profusion of vivid scenes let down from heaven and translated into language by the inspired men to whom they were originally given . . .

Good pictures possess a very high, an almost unmeasured educational value. But just because of the power of pictures, they should be selected for the house with very great thoughtfulness and care . . .

Because pictures are powerful educators let us have them. The Lord's money is wisely spent in anything which has a clear tendency to ennoble and refine. But unwholesome pictures are as potent for evil, as good pictures are for righteousness and worth. It is not a matter of indifference what pictures we hang on our walls. The choice of pictures needs to be made with exceeding care. Just now when we have on exhibition in the city nearly a thousand of the finest pictures to be seen in this country, and among them a very rich collection from Europe we have an opportunity to study the question of the choice of pictures for the home. It was with this view that I spent parts of several days last week in the art department of the Exposition. Not that many of us can afford to own pictures so expensive as most of those on exhibition. The fact is that a coarse wood cut, a steel engraving, a photograph of small expense, may be more valuable than many costly paintings. Pictures to be worthy and useful need not necessarily be expensive.

In the first place I think we should bear in mind that mere accuracy and vividness of delineation is of minor consideration in estimating the true worth of a picture. I am not speaking now of price, but of value. Here for instance is No. 103, The Old Violin. You will have to look long and closely and from different angles to assure yourself that this is a painting at all, and not a real violin hung on a pair of old wooden shutters with a broken hinge. In Philadelphia they employed a policeman to keep people from trying to settle the matter by putting their hands on it. Here the frame is set in a glass case. The delineation is perfect, the deception complete. And yet that picture is a specimen of the humblest function of the art of painting. The picture conveys no worthy thought or emotion. It is simply a trick. The thought in the mind of the artist is simply, "Only see how I can deceive you." "Just see me do it." There is nothing whatever in the picture to please or instruct or elevate you. It is nothing but an anonymous old fiddle. The purpose of the painting is just nothing else in the world than to make you admire the man who could depict so vividly. All the accessories of the picture—the rusty hinges, the cracks in the board, the ring and staple, the tacks, the printed slip, the crumpled envelope—are arranged with the single design of rendering the ocular deception perfect. The picture is unworthy, because its purpose is low and selfish . . .

Skill put to no worthy use is as bad as no skill at all. Suppose a preacher were to vent his powers for an hour in attempting to describe to you exactly how an old fiddle or a bag of oranges looks. Let it be granted that at the end of an hour you could almost see the fiddle and the oranges right on the platform, would it sufficiently justify to you such a prostitution of pulpit power, to say that this man had exhibited wonderful skill its description! But you say the artist is not a preacher, indeed a preacher he is, and a very powerful preacher. If he is not, he may be, he ought to be, he must be, if he is to come up to the level of his office and fulfill that mission of art which alone justifies the existence of art. Art is a servant, a minister to human weal. The picture is, or should be, not in itself an end, but the means to an end, the vehicle through which the thought and feeling of the artist is communicated to the beholder. Accuracy of delineation is desirable, just as good grammar, and an appropriate choice of words and clean cut and untrammeled utterance are desirable in a speaker. The point of chief interest, however, is the quality of the thought and emotion expressed. And the best art, whether it be in poetry or oratory or sculpture or painting is that in which the mind is so concentrated on the thought and the soul so kindled by the feeling of the artist, that we forget everything else. Works of delineation are a part of the training of a painter. They belong to his apprenticeship. But assuredly that is very mean and unworthy employment of powers which does nothing more in a picture than accurately delineate some meaningless thing.

One of the results of increased professionalization in the art world after the Civil War was a perception that a gulf had emerged between the "insiders" and the general public. Writer Theodore Davies combines an attack on the National Academy of Design with a plea for increased access to the fine arts by the nonelite—by doing away with exhibition entry fees. He longs for the day when crowds flock to the picture galleries, from the poor and "uncultivated" to the businessman and "flâneur"—incidentally, one of the earliest American usages of this term. Two years later, in 1872, the National Academy reversed a long-standing policy and kept its annual exhibition open on Sundays, a move hailed as friendly to "the masses."

Still, there were complaints. In a review published in 1878, a writer from the New York Times *bemoans the lack of recognizable, entertaining subjects in contemporary painting. For this author, the blame lies with the critics, who equate popularity in art with pandering and push artists toward the esoteric "studies" not easily comprehended by the public.*

Theodore Davies, "American Art," Aldine Press 3 *(January 1870).*

The Directors of the Academy of Design seem lately to be awaking, and realizing in some slight degree that the society is not merely an institution for the gratification of private feelings, but an instrument which, properly wielded, may be made to serve important social and educational uses. A great stride in the right direction was taken when the building was, on Saturdays, opened free to the public; but, in comparison to what might be achieved, this is a small step. All art is not only an educator, but a refiner and civilizer as well—particularly true is this with regard to paintings. At present a healthy love of pictures is confined to a few residents of the city who have gained their knowledge only by study and by travel abroad. The great mass of the people take pleasure in morbid sensational drawings and are entertained with the gross caricatures of life which abound in the flash papers, unhappily so abundant. And why? Simply because those who have, until recently, had in their hands the control of the Academy, have taken no trouble, made no efforts to interest the public or to call the popular attention to the works annually exhibited. The Academy has drifted on from year to year, holding the usual exhibitions, presenting the customary collection of simpering portraits, characterless landscapes and, in short, attracting as much notice as did Rip Van Winkle during the period of his slumber in the mystic recesses of the Kaatskills. When Rip, though, returned to his native village he found everything greatly changed; and now that the Academy is giving the preparatory yawns and rubbings of eyes, it will find, when fully awake, that everything in Art has greatly altered also.

There is a growing desire among all classes to gratify their tastes by the sight of good paintings. That this is true can be easily seen by a view of the crowds who jostle and elbow each other before the window of every picture or print-shop. The loafer, the *flâneur,* the business-man— all stop, though but for a moment, to regale themselves with the sight and thoughts of beauty. One principal reason why the lower classes in France, Germany, Spain and Italy are not given to the brawls which nightly disturb our streets, is because they have continual access to the grandest and most magnificent works of art ever achieved by the genius of man, in the shape of the wonderful relics of the days when "there were giants upon the earth." An intelligent, cultivated love of the fine arts diffused through society—from the highest to the lowest stratum, would work a complete change, effect a total and extremely beneficial revolution in the manners and

customs of the majority of our people. No man who has a lofty ideal can commit a low crime. No one whose thoughts are possessed by images of beauty can be guilty of offensive acts. Let our artists paint pictures which shall *touch* the people, which shall come home to the heart. Pictures that all can realize and that all can appreciate. Pictures that appeal equally to the rich and to the poor, to the cultivated and to the uncultivated. It needs no educational mental trituration to sympathize keenly with a fine emotion, to feel to the quick a tender or a beautiful sentiment— for "one touch of nature makes the world akin." Painting is not an end; a picture is not a result; it is but the means—the means for filling the mind of the beholder with high thoughts, for lifting him above the common plane of weary, everyday life, and for calling into action sentiments which would otherwise lie dormant.

The Brooklyn Art Association holds its exhibitions free. Why cannot the New York Academy be conducted upon the same liberal and generous plan? The almost insignificant revenue, derived from the charge for admission, is but a slight offset in comparison with the good this change would produce. If no fee were asked for admission, the galleries would be filled the greater part of the time, and the present generation, instead of lounging in billiard-rooms or chattering in milliners' shops, would find it more pleasant to study works of art, or at least to look at pictures. As it is now, people go there, if at all, as a mere matter of business, make a flying tour and precipitantly retreat. No more is seen in the galleries the shining splendors of the latest styles; no more do the gorgeous raiments of "le sexe à barbe et le sexe à chignon"[5] confront each other in astounded amazement; no more do the delicate patter of high-heeled kids, and the manly tread of stouter calf, resound along the echoing halls. The Academy is deserted. It becomes a howling wilderness, a barren waste, over which roam at intervals a few adventurous hardy individuals until they, too, become affrighted at the desolation, and flee in dismay before the horror of solitude. A dreary stillness broods over the building, and the portraits grin or glower with a dull fixedness. Dust collects upon the staircase, and the melancholy ticket-seller glares from the eye of Polyphemus, which serves as a box-window, with an air of mingled rage and disgust. It is, indeed, saddening that such a Barmacide feast[6] should be every year spread out before the public. Not but what some of the pictures are "sweet," "lovely," and other young-lady adjectives.—Far be it from me to lift an iconoclastic hand against the pretty little butterflies which spread their nicely colored wings upon the academic walls. But have we even "ten just and true" pictures offered us—pictures which seize the mind and hold it in relentless grasp until the whole being is permeated with a vague and rich delight; which shall teach the world-weary man that there exists a higher scale, a nobler range of thought than he has yet reached; that shall lead him to the ideal in a state of happy peace like the golden dreams of an opium-eater? No! The artist has not yet appeared who shall give to America what she so much lacks—a characteristic, distinctive, New World School of Painting.

This consummation—at present as far from us as was the Holy Grail from the brawling knights of Arthur's Court—might be quickly reached were the Academy to make its exhibitions free. Once free, the exhibitions would become more popular, and in the strife of competition which would then arise—so surely as Americans are Americans—a newer, fresher art would be formed from the ideas and theories floating and drifting about. This may, perhaps, seem a too eager view, but we all know the parable of the mustard seed, and every thoughtful

[5] "men and women."
[6] Barmacide feast: something that appears desirable but is actually illusory and disappointing.

man and woman cannot but hope for such an event which will advance the country, dignify our artists, and help the cause of humanity.

"The Academy Exhibition: Critics on the Fence," New York Times, *April 10, 1878.*

It was while speaking in a former notice about the portrait of Bonnat, which has been hoisted above a doorway in the East Room of the Academy of Design, that allusion was made to the wide gulf which lies between pictorial art regarded from the stand-point of the artist and from the stand-point of the public. What does the public care about high lights, chiaroscuro, luminous shadows, and all the rest of what the irreverent call "art twaddle"? The public wishes to be amused in one way or another, whether by the sight of beautiful things, or thrilling things, or even instructive things. The public may be likened to a little child which clamors: "Show me some pictures, show me pictures!" To this natural instinct in people who have either no taste or no leisure for becoming dilettanti in art, what do our artists respond? The Beards answer cleverly enough with monkeys and dogs dressed up like men, and going through human actions. Wordsworth Thompson paints George Washington on horse-back reviewing the ragged Continentals. (No. 483 South Room.) A thin line of backwoodsmen, half-breeds, and Indians takes the lead; after them come the musicians, officers of the line and the ranks of determined yeomanry. The whole scene is realistic. The General, his staff, and Army are not made pretty and impossible; neither is their raggedness overdone. Robert W. Weir has historical subjects as well as genre. The South Room contains a small canvas, (No. 536,) representing Columbus before the Council at Salamanca. It has enough dignity in the bearing of the actors to rescue it from commonplace. In the North Room is a picture of Titian in his studio, (No. 322,) and the East Room contains "The Microscope," (No. 373,) and "The Snow-plow at West Point," (No. 392.) All these may be fairly called popular in their aim. They have a story to tell which is obvious to the least informed. Julian Scott is another who seeks the popular pulse in "Prisoners from Saratoga on their Way to Boston." Winslow Homer occasionally hits a responsive chord in human breasts with a picture like that in the corridor called "Watermelon Boys," in which we are called upon to sympathize with the fun of eating stolen fruit. But the number of such pictures is insignificant compared with those which are either frankly nothing more than "studies," or are portraits, or are paintings called "of still life." Such an exhibition is therefore interesting enough to artists and amateurs, but what possible enjoyment can the general public extract there-from? Is there a single picture on these walls which will be sure to attract so much attention from both artists and public that it can be termed a universal favorite?

It may be answered to this that the critics in the newspapers are chiefly to blame for the present dearth of large pictures, which tell stories amusing to the public. The critics have so attacked, so derided both the subjects and the style of painters who attempted popularity, that they have driven them out of the field. The position of the critic is, indeed, a peculiar one. He is a kind of hybrid, neither on the side of the people nor of the atelier, but standing between the two. The more he knows of art the more technical become his judgments, and the more absurd he seems to people in general. On the other hand, the further he moves away from artists the more ridiculous he becomes in their eyes. They can point out a hundred blunders made through recklessness or ignorance. As one of the Academicians expresses it, "A critic consists of a little ink and unlimited cheek." To the artist absorbed in the manual labor of his profession, and exercised in mind concerning such technical details, as few even among good critics know the artistic side, assumes great importance, while that of the public sinks proportionately into insignificance. In other words, the public has no rights.

Nevertheless, the public asserts its rights by either staying away or only coming to admire what amuses it. The men who seek popularity, it will be noticed, are the older artists; those who belong to a former régime. The young men are here with studies, the young women with flower pieces and fruit, the best of them with portraits. This seems to mean that the new generation has discovered what a long and thorny path is that of art, and how much better it is to be humble and, beginning with studies, gradually work upward to something really great. The older men have not attained to anything great; perhaps it is because they have not begun with sufficient care, have not laid a ground-work thorough enough, have not made themselves good pupils before attempting to be masters.

JOHN GEORGE BROWN, THE PUBLIC'S FAVORITE

In the late nineteenth-century debate about refinement and high art versus sentimentalism and mass appeal, J. G. Brown occupies a conspicuous place (see also "Internationalist Backlash," chapter 11). An English-born genre specialist who emigrated to the United States as a young man in his mid-twenties, Brown established himself largely as a painter of children, a subject he mined repeatedly during an American career of some five decades. His pictures of carefree rural youth playing hide-and-seek and streetwise urban toughs interacting on the sidewalks of Manhattan were immensely popular, selling for prices (often over $1,000) that most of his fellow members of the National Academy of Design would have envied. His brand of cheerful idealism and Horatio Alger optimism was exactly the type of imagery that the chromolithography industry sought to market to its large audience, as illustrated by the following poem about some of Brown's tomboy characters, reprinted in the house organ of the Prang Company. Yet professional art critics regularly mocked the taste for Brown's repetitive creations, with one writer humorously suggesting that the artist used a "boot-black stencil" and a few gallons of tar-colored paint to churn out his innumerable canvases. The short excerpt from a review in the Nation *makes this point with characteristic sarcasm. A* New York Times *critic, in the paragraph also included here, coolly examines this clash of taste. Without in any way praising Brown's work, the author nevertheless suggests that there is a place for a wide range of artistic preferences in a democratic society.*

Earl Marble, *"The Three Romps,"* **Prang's Chromo** *(Christmas 1870).*

A trio of merry, boisterous girls,
　　As sunny with glee as a day in June,
With their flowing hair in crimps and curls,
　　And with every look to joy in tune.

The gleams of mirth that tighten each face,
　　As "like the boys" they stand in the swing,
Shine and shimmer all through the rural place,
　　Like the spots of gold that the sun's rays fling.

The first with her head thrown saucily back,
　　Shaking out her crimpy golden hair;
The second with brunette's curls of black;
　　The third with the auburn ringlets fair—

Ah! painter or poet might either dwell
 On the scene in the swing 'neath the forest tree,
And thrill at the glances that merrily tell
 Of the hearts o'erflowing with innocent glee.

All hail, say we, to the merry romp
 That dares be true to herself for aye,
And spurns the routine of fashion's pomp
 For the laughing glee of girlhood's play.

All hail to the romp of older years,
 Whose only range is the sun's bright rays!
Which deepens with age, and never scars
 The face with its final deathly glaze.

All hail to the romp, with broad, full chest,
 That shames Mother Grundy's sickly fraud!
Give me your Abigail, Jane, and the rest,
 And you are welcome to white skinned Maud.

The world has need of the romping girls,
 To be the morrow's mothers and wives—
Among earth's platitudes, all the pearls
 That are freed from the grasp of society's gyves.

"Fine Arts," Nation 38 (April 24, 1884).

Mr. Brown, with his eternal street boys, clean-washed and carefully ragged, street Arabs made out of Sunday-school children, in whom is no possibility of an interesting and picturesque wickedness—reminding one of the orphan children that rush across the stage in an English pantomime—of what world are they? Once, twice, or even now and then, art can tolerate such stage drollery, but *toujours perdrix*[7] is bad enough—always the spurious loafer-boy is too much. If it pays, and there is a public for such work, it is quite natural for Mr. Brown to go on painting him, but it is a pity that his public did not beg him to paint better ideals with the skill and sense of color which he certainly has.

"The Academy Exhibition," New York Times, October 29, 1882.

Mr. J. G. Brown shows two or three genre pictures of the kind that are eagerly sought by dealers for reproduction by photograph and lithograph, and accordingly have to be protected by copyright. They readily appeal to a wide and prosperous circle of people, while the art critic is apt to be wrought by them to a singular pitch of anger. This is because they generally represent comic situations, like those which make the fortune of the humorous weekly press. Such pictures, when elaborated in oils, are among the bugaboos of the art critic. On the other-hand, they are defective in the more difficult phases of the painter's art, such as a judicious variation in the painting of textures, an agreeable alternation of faces and expressions, a living, responsive touch in the brushwork, and a delicate manipulation which produces the effect of atmo-

[7] "partridge all the time."

sphere by one of the tricks with which clever artists know how to delude and charm our sight. Possibly it is narrow and one-sided to object to works of this kind, seeing that they are relished by so many thousands; seeing, moreover, that the Academy is once and for all the American Salon, the American Royal Academy, in which the worst and the best of pictures are comfortably installed side by side with an impartiality truly democratic.

IN THE MAGAZINES: THE NEW ILLUSTRATORS

IN DEFENSE OF ILLUSTRATION

The growth of the mass media in the last quarter of the nineteenth century presented new opportunities to American artists. The technological advances that facilitated the reproduction of high-quality images soon led to the dramatic upsurge of illustrations in books, magazines, and newspapers. Publishers, quick to realize that pictures were good for sales, established art departments, appointed art editors, and hired artists, in-house or freelance, to produce illustrations. The burgeoning field attracted large numbers of young men and women, who trained at the Art Students League, the Cooper Union, or the Drexel Institute. For the many artists working in the field, illustration offered the prospect of vast new audiences and financial security along with a new professional identity. Yet the status of the illustrator was ambiguous as well. The transparently commercial nature of the work sullied the romantic ideal of artistic autonomy and self-expression that still held sway. To be successful, an illustrator must compromise with editors, please the public, and bow to popular demand. In return, he or she might reap lucrative rewards—but at what cost to artistic integrity?

In the article below, the artist and writer William A. Coffin assesses a profession still evolving in 1892. He notes the progress made in recent years, pointing out that many of "our painters" have worked largely in illustration, while the work of the professional illustrators has shown steady improvement in quality. Coffin's major concern is to refute the assumption that illustration is "bad art" superfluous to any given text. Dismissing such arguments, he maintains that illustration (unlike the chromo) has been invaluable in opening the eyes of the masses to art. The fact that well-known figure painters have produced "the most serious" illustration work in the United States further legitimates this blossoming field of specialization.

Many prominent and rising painters indeed worked occasionally as illustrators, and professional illustrators also had a stake in the "high" art world. By the turn of the century, however, the gap between the fields had begun to widen. The establishment of the Society of Illustrators in 1901 demonstrated conclusively that painters and illustrators had failed to find common ground.

William A. Coffin, "American Illustration of Today," Scribner's Magazine 11 *(January 1892).*

Since the days of Albert Dürer and the Italian Renaissance, painters have been drawing for reproduction, until at the present time half of all those who use the brush have worked more or less in the field of illustration, as we use the term, and some have made in it reputations that outshine those gained in painting pictures. We have many worthy artists who do nothing but illustrations, and who rarely paint a picture or draw in color. In the United States great progress

has been made in the past twelve or fifteen years. Some of the best of our painters have devoted a large part of their time to illustration, and the work done by the "illustrators"—the artists who work almost exclusively in black and white for the magazines and illustrated journals—has steadily improved in quality. To-day illustration is the regular profession of a host of men and women, the *gagne-pain* [livelihood] of a number of painters, who find in it a source of income that permits them to paint pictures according to their individual tastes, without regard to the question of popularity with the public; and the serious occupation of others who find in some work of poetry or fiction subjects with which their temperament is in sympathy, and an opportunity to make drawings that are in no sense to be confounded with what is known as "hack work," even when it is of such excellence that it seems unjust to apply to it a name that suggests in itself a lack of true artistic interest.

In considering the subject of illustration we must say a word at the outset about the *dictum* of certain critics, who maintain that illustration, as such, is unnecessary, and that it is bad art. "If an idea or a scene is portrayed in words," they contend, "what reason is there for another man to attempt to do it over again in another form? If in a poem, a play, or a story, a thing is well done, the illustration will be inferior, or in a few cases, perhaps, it will be better as a work of art than the text which furnished the subject. In the first case the designer's work is superfluous, in the second the picture will live, and the original in its literary form will be forgotten, for the world will not want both. If this is not plain, reverse the proposition and fancy a man writing a poem about a picture. What can he tell that is not already told on the canvas, and how can he express in words what the artist has only been able to convey to the senses by means of form and color?" This is a specious argument, but it is not a sound one. While it may be true that a good deal of the current illustration is inferior, it serves a useful purpose in the propagation of a love of art among people who would not without it see any whatever worthy of the name. Woodcuts and photo-gravures from the designs of competent artists, in the illustrated papers and magazines, are far better food for the people in homes distant from the art-centres, than the cheap chromos and cheaper steel engravings that used to be about all there was in such houses in the way of pictures of any description. The relative merit of the illustration and its subject in literature are not in question. In our own country, at least, it is indisputable that more has been done through the medium of illustrated literature to make the masses of the people realize that there is such a thing as art, and that it is worth caring about, than in any other way. As to the best work in the field of illustration, when the artist has found in literature something that appeals to him as a subject he would like to treat in pictorial form, we are not forced to decide which is in our opinion the better, the author's word picture or the artist's interpretation of it. No better example of this can be found than Mr. Abbey's delightful drawings illustrating Herrick's poems. We shall not forget the sweet lines of Herrick because we have seen the charming pictures the artist has made to go with them, and if we remember best the poems, we shall not for that reason be blind to the beauty of the drawings. We shall have two things that please us where we had but one before. Further than this, a very large part of the world's art is illustration. Pictures depicting religious and historical subjects, even the frescoes of the Vatican, are in one sense illustrations. All the works of art in the great galleries, in which the subjects are drawn from mythology and legend, are illustrations in the same way. The only essential point of difference from what we call illustrations in our time, is that they were not made to accompany a text. Half the subjects that artists have treated, from the old masters down, have been drawn from literature in one form or another, and it is only in portraits, genre, and still life,

and in our modern schools of landscape painting and *plein air* treatment of figures, that the subjects have been found in nature.

In the United States the most serious work in illustration has been done by men already well known as painters of the figure. The two volumes of Keats's poems, "Lamia" and "Odes and Sonnets," with drawings by Will H. Low; Dante Gabriel Rossetti's "The Blessed Damozel," illustrated by Kenyon Cox; and "The Rubáiyát of Omar Khayyám," with decorative designs by Elihu Vedder, have contributed as much as their work in painting to the reputations of the artists.

HOWARD PYLE'S CREDO

One of the most renowned and successful illustrators of the late nineteenth century, Howard Pyle was also a highly influential teacher. Although he had some formal art training, Pyle learned the essentials of his trade through on-the-job experience illustrating for St. Nicholas, Scribner's, *and especially* Harper's Monthly Magazine. *An antiquarian who tried to achieve scrupulous accuracy in his historical scenes, Pyle also strove to immerse the viewer/reader in the pictorial action with images full of tension and suspense. Like other illustrators, he was sensitive to the issue of dependence on a given text and strove to negotiate some degree of artistic autonomy in his work. In letters to* Century *editor Richard Watson Gilder concerning illustrations to S. Weir Mitchell's novel* Hugh Wynne, Free Quaker *and to Henry Cabot Lodge, Pyle details an approach that frees him from strict fidelity to the author's vision and allows him to develop a parallel interpretation in pictorial terms.*

Howard Pyle, letters, in Charles D. Abbott, Howard Pyle: A Chronicle *(New York: Harper and Brothers, 1925).*

[To Richard Watson Gilder, September 23, 1896]

I think the trouble with my pictures arises in part because the first part of this story is descriptive rather than actional, and in part because I feel myself working with very much restraint. I am so especially anxious to do this work to your satisfaction and to that of Dr. Mitchell that I am constantly haunted by the fear that what I am doing I am doing amiss. And then, to confess the truth, I do not feel myself entirely fitted to illustrate stories.

I think the chief value—such as it is—of my work lies in the imaginative side, but where the text places the scene exactly as it occurred the artist is obliged to limit himself exactly to that text, and you can easily see that it is almost impossible to exercise the imagination freely.

In the illustration of the first part, for example, I suggested a point that I felt rather filled out the story than directly illustrated it. The sketch I sent you represented the little boy leaning over the parapet of the bridge with the surroundings, as I could imagine them, of quaint old Philadelphia. I think the subject was far more interesting and fulfilled the text much more than the picture of the mother welcoming the return of the little boy from school. But, as you may remember, it was deemed best by you that I should adhere strictly to the text. . . .

. . . I wish most heartily now that I had not undertaken to illustrate it. I quite agree with you that a story, especially one that is so dramatically told, is very much better without illustrations than with them—that is unless these illustrations be made to fill out the text rather than to make a picture of some scene described in it.

I do not feel that my ability in picture-making lies in illustrating stories. In such work I am hampered and confined by the text, and my talent (such as it is) can have no room in which to

play. It has always seemed to me to be better to choose for an illustration some point, if possible, not mentioned directly in the text but very descriptive of the text.

For example, in the first instance I was compelled to choose the return of the little boy from school welcomed by his mother. This, while perfectly charming in your description of it, was not a subject one could very well depict. You gave the idea of cool, dark interiors and wide spaces. In making the drawing I had to limit myself to the open door and a small vista outside; for in making a drawing one must make it with what one sees with the eyes and not with what one sees with the mind and thought, as you make in the text. If the story which I was illustrating had been mine, I would rather have chosen some impersonal subject to be called, perhaps, 'Mother and Son,' in which the mother, with her arm around the little boy, is walking down the dark room with such surroundings as you depict in the text.

There is no such scene mentioned in your story, but I think it would illustrate the feeling you intend to convey, and if correctly drawn, would carry forward the thought of the reader with some definiteness of purpose.

[*To Henry Cabot Lodge, December 28, 1897*]

I have read over very carefully your seventh historical paper, the first part of which treats of the conquest of the West under Clark and the second part of the opening of the campaign in the South.

I have given the matter a great deal of careful consideration, but prefer not writing definitely to *Scribner's* before consulting you. It seems to me that the proper part to illustrate in the article would lie in the first part—the conquest of the West, and my predilection is decidedly for the ballroom scene in which Clark presents himself to the eyes of the dancers and where the Indian raises the war-whoop—the sudden advent of Anglo-Saxon civilization into that remote and half-savage wilderness.

On second consideration, however, it seems to me that the ballroom scene would be a very dangerous thing for me to undertake. You have described it so entirely and with such few and well-chosen words that I fear my picture would be in the nature of an anti-climax. The illustrator's art is not capable of so much movement and vivacity as the littérateur's art. Pictorial art must represent some salient point that shall convey as in a whole view a certain given situation. It shall not require any text to explain it, but should explain itself and all the circumstances belonging to it . . . As a matter of illustration I would rather seek to represent an image of Clark's advance into the West . . .

Or else I should rather choose for an illustration a picture of the advance against Hamilton through that tragedy of the flood and ice and snow, of the melting winter—as typifying the dauntless energy of the Anglo-American purpose . . .

Perhaps the best subject of all, however, is one which you have barely touched upon, and that is some general incident of the bitter and savage warfare of the frontier settlers in Kentucky when the Indians were let loose upon them. There are hundreds of tragic incidents in this in which the pencil can produce an infinitely better result than the pen, and it seems to me that the possibility of some such picture as that might fill out and complete the circle of your history far more than the exact illustration of a text which you give me. In other words our two arts might thus round the circle instead of advancing in parallel lines upon which it is almost impossible to keep them perfectly abreast. I feel, for instance, that my drawing of the single figure of Jefferson, as I described it to you, added far more to your fine text than a more elaborate illustration of some definite point might have done.

Charles Dana Gibson was without question one of the most—if not the most—celebrated American illustrators of the 1890s. A native of Massachusetts, Gibson attended classes for two years at the Art Students League and then began to draw satirical pictures for the humor magazine Life. *Strictly an artist in black and white, he devoted all of his time and talent to cartooning the foibles of American high society in bold pen-and-ink sketches. The iconic Gibson girl, which evolved over the course of the 1890s, assured his fame, and in 1904* Collier's *offered him a six-figure salary to produce ten drawings a year for the magazine.*

Charles Belmont Davis's comments, below, represent prevailing opinion well and show the construction of Gibson as an authentic, industrious, all-American artist. Happily ignorant of trans-Atlantic trends, Gibson has won popular acclaim playing on simple, enduringly interesting themes: love, marriage, money, and status. Crowning his success, the impossibly perfect Gibson girl has become an ideal for all, male and female alike. Yet Gibson is not a free man: always under surveillance, he is at the mercy of public opinion. Davis's essay vividly demonstrates both the cult of celebrity and the growing power and authority of the commercial media at the turn of the century.

Charles Belmont Davis, "Mr. Charles Dana Gibson and His Art," Critic, *January 1899.*

He came to his life's work from a clean, country home; his capital—good health, a tremendous capacity for work, and an invaluable ignorance of the work of the modern Parisian and Viennese cartoonists. In addition to these virtues, there must have lain dormant somewhere in Mr. Gibson's system the idea of a beautiful woman, because he began to draw her very early in his career, and it was she who years ago first attracted the attention of the American people to his work, and it is she whom to-day we still love . . .

. . . His taste in art touched the popular chord. He was chosen the official chronicler, so far as illustrations went, of the doings of smart society . . . It matters little whether they are of it, or above it, or beneath it; it is unquestionably this one clique whose doings are forever interesting to the masses, and it is a curious fact that no class of people has had so few worthy chroniclers either of pen or pencil. How many novelists or short-story writers have we to-day who can depict "smart society" (an unpleasant but necessary expression) as it really exists? . . .

. . . Mr. Gibson, as a depicter of the foibles of this set of society, has for a number of years been ranked quite alone, far in advance of his fellow-workers. At the outset of his career his position was a most unusual, and in some ways perhaps a not altogether enviable one. At the very beginning his drawings became a feature of our periodicals; his work was looked for, and there is no master so difficult to serve or please as the great public who read periodicals. Fortunately, to offset his youth, he was a keen observer of people, and had a quick insight into character and a rare taste for picking out the characteristics which could be transferred to paper. Always a believer in experience as the most valuable of teachers, he toiled on, accomplishing a tremendous amount of work. There must have been moments when he would have almost courted a little less fame. He had many experiments to make, but the search-light of an acquired success was always upon him—the public who had patted him on the back was forever looking over his shoulder down on his easel to see that he did not play their judgment false. There was no incognito, no unsigned bait for their approval; the stroke of his pen was known throughout the land, and as his technique and mind developed and matured with hard work and ex-

perience, it was necessary to lay his new ideas coldly before them for their judgment. Almost since the days of his first work, the audience has always been before him, and he has had to change his scenes with the curtain raised.

For several years his work, save in the lengthy strides he made in his technique, varied but little. He played on the simplest chords, and those which would naturally appeal to a young American,—simple love stories, and a strong protest against marriages for money and international alliances between foreign titles and American heiresses. To be sure, his women were becoming constantly more lovely to look upon and better gowned, and his men much finer specimens of the gentleman and athlete, but certainly their doings for several years showed no great variations. During this time he created a few types which he made all his own, particularly "the Bishop," and that fine type of womanhood, the Gibson girl.

It is very hard to say anything new about this young woman; she has been so much discussed and written of. In his earlier days, it is true that the artist drew much from one model, using certain variations, and I presume it was this type whom the public christened the Gibson girl. Since then Gibson has had many models of this and many other countries, and in each type one can always find something fresh—something very fine and always womanly, something that must needs breathe the fine ideals of the artist . . . I believe that every woman and every man who look on the fair, fine women of Gibson imagine that they see a possibility for themselves, or their wives or sweethearts. But . . . they are in fact not possibilities, they are only made so by the infinite art of the artist. The Gibson girl does not exist in real life; she is a finer thing than mere clay; she is at best an example, a forlorn hope for the dressmaker to hang her dresses on, and the hat-maker and the hair-dresser to strive after as best they may.

WOMEN IN ILLUSTRATION

By the late nineteenth century, the rapid growth of the publishing industry had converged with the dramatic increase of women artists to create unique new opportunities for women in book and magazine illustration. Although male artists remained dominant in that field as in others, women carved out a viable market niche as specialists in purportedly feminine subjects, notably (and predictably) child life. In a 1904 article, Elizabeth Lore North highlights several of the best-known and most successful women illustrators, including Alice Barber Stephens, Jessie Willcox Smith, and Elizabeth Shippen Green, all of whom exhibited an inborn, natural, and tender understanding of childhood in all its sweetness. Whether women exploited their reputed maternal instincts to succeed in a highly competitive profession or preconceptions forced them into that mold is an open question.

Elizabeth Lore North, *"Women Illustrators of Child Life,"* Outlook *78 (October 1, 1904).*

The illustrative work done by women in America, in recent years, is noticeable for its brilliant effect and sympathetic touch. Especially is this true among those artists who devote their talents, more or less, to the portrayal of child life.

A group of women have studied in the Pennsylvania Academy of Fine Arts, in Philadelphia, and have received their early training and inspiration from the ideals set before them there, going out into the world to pursue their art along their especial individual lines. Among these are prominent Alice Barber Stephens, Jessie Willcox Smith, Elizabeth Shippen Green, Florence Scovel Shinn, and Sarah S. Stilwell—all well known as successful illustrators of childhood . . .

While Alice Barber Stephens does not confine herself entirely to child portrayal, yet one immediately recalls her illustrations of Roy Rolfe Gilson's short stories, and the sweet, serious-faced little brother and sister are treasured memories. There is a peculiar tenderness in her conception of childhood, entirely free from prettiness or sentimentality. Mrs. Stephens's work appears almost without interruption in "Harper's Magazine." A bench full of country children in a recent number shows how completely the artist enters into the child mind and how charmingly she interprets it. Among this group of little people each face has a distinct individuality and all are true to life. Mrs. Stephens began her studies very young in the Philadelphia School of Design for Women, learning there to engrave on wood—an art in which she became proficient enough to work for the most critical publishers. After study in the Pennsylvania Academy of Fine Arts she began illustrating, and was very successful.

Although Mrs. Stephens has studied in Paris, she regards her development due to her Philadelphia instruction and experience in her own studio. In the beginning of her career she painted the portrait of a little child, three years old, putting into the picture all the force of her earnest, conscientious nature. When it was at last finished, she said to the child model, "Now, honey, you can get down and run about." The boy came and stood before his portrait and said, with childlike faith, "Little boy, can you speak?" Just this understanding of and truth to nature has continued and matured in the riper work done by Mrs. Stephens . . .

In Villa Nova, one of the suburbs of Philadelphia, there is a delightful retreat where three successful young women artists live. "The Red Rose" offers many attractions to even the ordinary lover of rural beauty. What it must be to the interpreters of beauty for others, as an inspiration and a rest, can be imagined. An old farm-house, at one time an inn, set beneath great trees, in a varied landscape carefully tended and developed along the lines of nature, guided by an educated and restrained art, and pervaded by the activities of successful work for the outside world, must possess a subtle atmosphere of its own. "The Red Rose" has been adapted to the needs of its present occupants, and large, simply furnished studios stand a little apart from the old house, about which are terraced lawns, clipped hedges, a formal garden, and beautiful old trees. A pergola quite covered with vines invites a stroll. Near by is a small lake, and upon a hillside in the background flourishes a vineyard. The contrast is great between these beautiful surroundings and those of an ordinary, or, indeed, an extraordinary, city studio.

Here Jessie Willcox Smith and Elizabeth Shippen Green live, in company with Violet Oakley, whose talent has led her away from the especial limits set for this article. One rarely takes up one of our larger magazines without seeing some illustrations signed by one of these two artists.

Miss Smith, we are told, found her talent almost by chance. She chose to be a kindergarten teacher, and, loving children, taught them until her health began to suffer. There are others who have found it hard to play for hours with tiny and imperious playmates, whose heads reach but part way up to the teacher's willing hands. At any rate, Miss Smith discovered that she could draw children in another way, and we congratulate ourselves. Who does not smile with a sense of intimacy upon such dear children as may be found in the beautiful plates of Betty Sage's "Rhymes of Real Children"?

One often lingers before opening a magazine to enjoy the dreamy yet perfectly natural figure of childhood which Miss Smith has painted on the cover. She infuses into every-day subjects a subtle decorative effect which is admirably reproduced by the excellent color printing now brought to so great perfection in our magazines. Her work has an individuality always immediately recognized, and impresses one with the wholesome vitality of a young and enthusiastic artist.

Elizabeth Shippen Green studied at the Pennsylvania Academy, guided and encouraged from

her childhood by her father, a lover of art, who, with her mother, lives also at the "Red Rose." Miss Green had, after some years of study in Philadelphia, six years abroad. Beginning, as many young artists have done, by illustrating for advertisements, she soon found a more congenial and far wider field, and drew pictures for children's poems and stories. She is constantly busy with the many demands that are the result of her success. She often puts a touch of fancy, of fairyland, in her illustrations, and in Carmen Sylva's "Fairy Tales" her love of the dainty mysteries of elves and fays has free expression. Her work appears in "Harper's" especially, but is not confined to the issues from that press.

Florence Scovel Shinn's name always brings a smile of anticipation or amusing reminiscence to any one who knows the sort of children that appeal to her imagination. Her keen sense of humor crops out in every group, and the turn of a line gives a comical effect . . . The peculiar gift that Mrs. Shinn is endowed with is that she can draw the most pitiful little figures, and yet infuse into the picture a happy, healthy atmosphere that impresses us with the worth and joy of living. Her drawings must be the expression of her personality to a marked degree.

AMATEUR OR ARTIST? DEBATES ON PHOTOGRAPHY

AMATEURS

The introduction of the daguerreotype, even though that process was extremely subtle and complicated, allowed large numbers of individuals who would not normally think of themselves as artists to enter into the imaging-making profession. Once the technical aspects of photography were simplified later in the nineteenth century, especially with the dry-plate gelatin process and the mass-produced Kodak box cameras, still more Americans caught the photographic bug. On the one hand, this meant a much greater cohort of visually sensitive American citizens producing images. On the other hand, the amateur phenomenon greatly threatened the professional autonomy of those who were making a living at photography. Debates raged as never before about who merited the designation "artist."

Robert Tramoh complains in his essay that amateurs have "degraded" the profession. He dismisses them as "point-and-click" know-nothings without any established standards for picture quality. Others argued that a misplaced vogue for soft-focus effects meant that amateurs actually tried to be technically "bad." For example, William Murray's "Too Well Done!" pokes fun at exhibition juries that value "fuzzytypes" and assume that any photograph that is well focused and clearly composed cannot be artistic.

A more charitable view of amateurism is found in Alexander Black's article, in which he explains some of the technical improvements in photography, including the hand-held camera and the concealed "detective" camera—a development that many felt violated individuals' rights to privacy. Finally, the author and journalist Theodore Dreiser profiles one of the largest amateur organizations, the Camera Club of New York. It is a somewhat utopian picture of the group, with fully realized artists supposedly tutoring ignorant tyros in group critiques and darkroom colloquies. Indeed, members of the Camera Club included such stand-out professionals as Alfred Stieglitz and Frances B. Johnston (see also "Advice for Women Photographers," chapter 11), even if the former, in particular, was not always welcoming of newcomers.

Robert T. Tramoh, "Thoughts about Amateurs," Philadelphia Photographer 21 *(June 1884).*

Now, if the amateurs are going to increase so rapidly, and follow the course of the sparrow, I think it is high time for the photographer to stand up for his rights. While we agree with Dr. Vogel that we are indebted to amateurs for the amount of knowledge we have accumulated, we do most emphatically say that we have something to fear, and we cannot say, God bless them as a class, for the most of them, instead of elevating our profession, have degraded it. I hardly think that, within the last half a dozen years, any other profession has been so raided upon by a class of conceited individuals as has photography; and yet the majority of this class, after a little experience, claim that they have been duped, and are the loudest in their cry that all photographers are frauds . . .

The class which I am bitterly opposed to, and which is increasing rapidly, and must ere long force the profession to retire in disgust, will be found at watering-places and pleasure resorts in the summer time. You see them with their outfits, ranging in value from $10.00 to $125.00, firing away at anything they may fancy, no matter in what position the sun may be. They cannot develop their plates, or print from the negatives; so they get some poor inland photographer to develop, print, mount, and finish for them at the exceedingly low rate of eight and a half cents apiece. This is not exaggeration; I know it to be a fact, for I have seen and heard the same offer made repeatedly. When these prints are finished, he (the amateur) takes them to his friends, who tell him that they are excellent (the professional would have thrown them in the waste), and really excel those of the men who make a living by making pictures . . .

This is the class that is robbing our customers, and causing them to look with disgust upon our best work. What, then, is the cause of all this trouble? Is it dry plates? No. What then? Is it the stock-dealer? No! Yes; when they advertise that anybody can make pictures, they advertise that which is false. Everybody cannot make pictures. Successful photographers are born; the art is born into them.

Alexander Black, "The Amateur Photographer," Century Magazine 34 *(September 1887).*

The subtle alchemy of the hobby has never worked more interesting results than in the case of the amateur photographer. That gentle madness which has given a triteness to the phrase "enthusiastic amateur," is especially engaging in the person of one who has succumbed to the curious contagion of the camera. And there is something so communicable in this enthusiasm, that it behooves no one to regard the phenomenon with disrespectful flippancy. Who is to know that his best friend has not been taken down over night? In the street a man feels a hand upon his shoulder, and is served by Banks or Temple with a moral subpœna for a sitting.

Once acquired, the photographic passion is easily gratified. The inventive genius of the century seems to have conspired for its encouragement. The daintiest devices in wood and brass, the coyest lenses, the airiest tripods, the snuggest carrying-cases,—all seem especially endowed with that peculiar quality which tempts one who has straddled a new hobby to plant the spurs impetuously. A few years ago matters were very different. The keynote of amateur photography, the "dry-plate," has been supplied within eight or ten years, since the dry-plate process, though in use for more than a decade, was not brought to trustworthy perfection until it had undergone several seasons' trial. There were, indeed, "wet-plate amateurs," and there are today some who follow the example of many professionals in adhering to the older method. But amateur photography now practically means dry-plate photography. It was the amateur who welcomed the dry-plate at a time when the professional was yielding it only a cautious tolerance. Why he welcomed it may scarcely require explanation.

The principle of the wet-plate process is suggested by its name. The glass negative-plate is coated with collodion, exposed in the camera while wet, and developed at once. This implies the presence of appliances within a short distance of the place where the exposure is made. In order to make views out-of-doors the photographer was obliged to carry an outfit which in these times would look lugubriously elaborate. I have seen a "home-made" amateur wet-plate apparatus, made very ingeniously of telescoping boxes, with an eyehole at the top, an arm-hole at each side, an orange-light window in the front (for all the tinkering with the moist plate had to be done without white, actinic light), and the whole, with its trays, baths, solutions in bottles, etc., could be reduced to a relatively small bundle.

When the dry-plate arrived it became possible to do away with all this ponderous machinery. The dry-plates, bought ready prepared, can be kept for months before use, and for months again after exposure before they are developed—a phenomenon of which the wonder is always new. Thus one may carry a camera with him through Europe, pack up the exposed plates, and, unless some customhouse official, to the amateurs unspeakable despair, insists upon opening a few of the packages to discern the meaning of their ominous weight, develop them all on his return home.

This element of portability is not the only feature of the dry-plate process which had an immediate influence upon the development of amateur photography. A capacity for rapid work was from the outset an important characteristic of the process. By continued experiment the sensitiveness of the gelatine film with which the plates are coated was from time to time increased, until now an exposure for the two-hundredth part of a second is sufficient to secure an adequate negative . . .

A novel result of the instantaneous process is seen in the camera without legs. "There is only one way to get along without a tripod," said a well-known New York photographer. "You must focus, and for this purpose a stick, inserted in the bottom of the camera and resting in the ground, might be used." After being assured by excellent authorities that the idea was absurd, Mr. William Schmid, of Brooklyn, N.Y., made the first of the "detective" cameras . . .

Nothing connected with photography has proved so fascinating as this "detective" camera. Disguised in a small, inconspicuous box, which might readily be taken for a professional hand-satchel, it is indeed a "witch-machine," as it was named last summer by an astonished resident of the Tyrol, when, under its inventor's arm, it was winking its way through some of the quaintest towns of Europe. In the open air nothing is closed against the "detective." In the rigging of a tossing ocean steamer, or in a crowd on the Bowery, it is always prepared, with one eye open and the other shut. Fragments of street scenery, little *genre* bits in out-of-the-way corners, tableaux in rustic or town life, requiring instant capture, all impossible to the ordinary camera, are caught by the "detective" in their very effervescence.

In the hands of police officials the "detective" has justified its name. It has already several times figured in court proceedings, and may well be regarded with uneasiness by those whose face is not their fortune. An English detective is described as having disguised himself as a boot-black and hidden a camera in a foot-box, with results very gratifying to the Police Department and very bewildering to the rogues.

Several varieties of the "detective," or portable, camera are in the market. Then there is the "vest camera," consisting of a false vest in which one of the false buttons forms the neck of the lens. For stealing portraits the arrangement is very ingenious, and ought to prove a valuable assistant to the caricaturist. The pictures, though small, are sometimes surprisingly good . . .

Portraits and all amateur indoor pictures are liable to have this characteristic of deep shadows, so repugnant to the business photographer. Yet these are the strong lights and shades the

artist loves. The effect is warmer, more individual, than in the so-called "well-lighted" portrait or interior. I have seen portraits that left a little too much to the imagination; there is a happy mean.

In many other respects amateur work has its own special charm. Freed from the commercial necessities which fetter the professional, the amateur need have nothing but the principles of art for guidance. In this delicious liberty he well may be, and is, envied by those who must yield something to the whim of the buyer, and who have a hard fight with the Philistines in every effort to elevate the standard of their art.

The amateur has an opportunity to infuse individuality into his products,—one is expert at portraiture; another at landscape; a third is noted for his city types and localities; a fourth takes up with natural-history subjects; a fifth with yachts and water views; the bicyclist screws a jaunty, elfin camera upon the cross-bar of his wheel; the canoeist stows one in his locker.

William M. Murray, "Too Well Done!" **Camera Notes 2** *(January 1899).*

"Too well done!" Such was the reason given by one of the judges in a recent local competitive exhibition for the rejection of certain entries of portraits and figure studies. Though evidently intended to be understood in an ironical sense, the verdict startled the good managers of the exhibition, to whom it was an entirely new principle on which to base the selection of works which were about to be hung on the walls of the National Academy of Design. Perhaps it was, but a consideration of the prints finally admitted to the exhibition, both in the portrait and other classes, will, I am sure, go far to convince the doubting that whatever of artistic or even scientific excellence is there displayed, is owing largely to the fact that not only the atrociously bad, and what is worse the mediocre, offerings were rejected, but also those which, as the examining judge expressed it, were "too well done." For a photograph may be spoiled by being too much done, just as well as roast beef. It is right, of course, it is even our bounden duty, to strive to be perfect in all things, but we are not expected to paint the rose or to gild refined gold . . .

Nothing is more tedious than the attempt of many honest and conscientious people to tell us the truth, the whole truth and nothing but the truth. A great deal of stress is sometimes laid on the righteousness, or the necessity, of presenting the whole truth. In a court of justice we are required to qualify ourselves as witnesses by swearing that we will so testify; but no man has ever tried to keep his oath to the letter without being shut up peremptorily by one of the counsel or by the magistrate sitting upon the bench. Even there, in the cold, matter-of-fact hall of justice, they want the history of events, not in the natural order, chronologically as they occurred or as they may be associated involuntarily in the minds of men in general, but in the poetic order; which is an arrangement calculated exclusively on effect and subject to the laws of dramatic poetry . . .

Let it not be understood that the preliminary examination of the photographs submitted to the judges in the late exhibition held by the American Institute, resulted in the rejection of all the examples in which fine detail was to be found and the elevation of "fuzzytypes" to the places of honor. All the schools, so called, were liberally and impartially dealt with, nor was private or eccentric preference allowed to exercise any weight in the selection . . .

Among the rejected pictures were many subjects that were well lighted and posed, fair in arrangement and composition, and, though somewhat over-finished, might still have been reckoned among the respectable members of photographic society, had they not failed to leave anything to the imagination, had they not been entirely lacking in suggestion, had not their authors insisted on presenting everything in sight, whether principal or accessory, with the same unvarying emphasis.

Theodore Dreiser, "The Camera Club of New York," Ainslee's Magazine 4 (October 1899).

The spirit of the Camera Club is compounded of a warm enthusiasm for the beauty and the sentiment of the world. And in accordance with the very strength of this feeling it has become a beneficent influence among those who love beauty in photography. Not strange, then, that it is dominated by men of more or less poetic inspiration. They have a great opinion of their art and a truly rare insight into the beauties of nature. They have striven to make the club the honored parent of a new delight; to give it a scientific and educational turn, and so to invest its doings as a body with an authority that it shall reflect credit upon photography the world over.

To appreciate the work being done here we should know something of the new aspiration which actuates the masters of the camera. They desire to take rank in the eyes of the world as great artists. They believe that artistic photographs are only secured by artistic natures, and that great photographs are made only by great men. The camera is nothing, a mere implement, like a painter's brush. It is the soul of the man who manipulates it that gives every picture secured its value. These leaders of the photographic art propose to force the world to accept their contention that photographs may be artistic treasures, and their labors are unswervingly directed toward this end. They teach their doctrine of superiority to the photographic beginners of the club. They set it forth in lectures and criticisms, and a club journal. They argue for it with directors of museums, and the officers of the various art bodies throughout the land, which make exhibitions of paintings and art treasures. Their one desire is to make the club so large, its labors so distinguished and its authority so final, that they may satisfactorily use its great prestige to compel recognition for the individual artists without and within its walls. Like all promulgators of a new idea, they are enthusiasts, and their claims more or less exaggerated . . .

The present quarters of the club are in Twenty-ninth street, near Fifth avenue, where they occupy an entire floor of the building. The members are pleased with what most clubmen would object to—the fact that all the club's rooms are on one floor and not scattered, variously, as in the more purely social organizations. The space which it covers—5,000 square feet—is divided into one general reception and lounging room, a suite of offices for the executives, a library, a huge working room, filled with cameras and lockers, and twelve dark rooms. There is, in addition, a well-appointed studio on the roof of the building which offers the members facilities for portraiture under ideal conditions.

The paraphernalia of the club is simple enough, almost severe, but the equipment is not in furniture. More attention has been paid to the arrangement of five hundred lockers, where each member keeps whatever relates to his work. Practical judgment has been exercised in equipping the dark rooms with every convenience which aids in the proper development and printing of a picture. Here are electric lights arranged so that the most perfect gradation of development may be had. Whatever chemicals are necessary are also present and free. Best of all, there is what no home-equipped dark room could have, a vast amount of experience and knowledge, ready outside the door. Several of the most able and justly famous artists are connected in an official capacity with the club, and upon their wisdom the perplexed worker in the dark room is free to draw. There are a dozen cameras scattered about the room, large and small, which any member may use at any time; and, lastly, there is always an exhibit of some artist's work on the walls, which constitutes in itself a lexicon of photographic wisdom . . .

One evening of each week the club holds its weekly test of lantern slides, where new work in this line may be seen and the criticism of the club's experts on the same be heard . . .

The lantern slide tests are most important, as they include an assemblage of half a hundred amateurs, some of them the most expert in the land, who offer freely of their advice and expe-

rience. The student who may be new to the field meets with men who are most distinguished—stars of a heretofore unreal world—who extend to him a serviceable and wholesome opinion. His lantern slides may be critically torn to pieces, but his store of knowledge will be proportionately enlarged. He has also the consolation of knowing that, if in this instance he has endured the rack, all those who have gone before, or who may follow, will scarcely fare better. Very few photos are perfect, and the critical zeal of the camera masters is exacting far beyond the pale of humble human accomplishment.

PICTORIALISM

In many ways, Alfred Stieglitz was the avatar of pictorialism. He defined it in a series of influential essays (such as the article in Scribner's, *below), he modeled it through his own practice as both a photographer and a dealer, and he embodied it as the subject of several arresting portraits taken by his friends in the movement. Having launched* Camera Notes *in 1896, Stieglitz used the magazine to establish his cultural authority and promote his views on artistic photography. Critic Sadakichi Hartmann, enthusiastically embracing Stieglitz's cause, became a prolific contributor. Writing about portraiture, Hartmann divides photographers into three classes: amateur, professional, and artistic. Only the third group interests him, although in it he finds a diversity of approaches: F. Holland Day, Gertrude Käsebier, Zaida Ben Yusuf, and others.*

In the second article by Hartmann included here, he urges pictorial photographers to abandon safe, formulaic subjects and open their eyes to the beauty of modern New York; he asks them not to document the city so much as to aestheticize it, just as Whistler preached in his "Ten O'Clock" lecture (see "James McNeill Whistler's Platform," chapter 11). Stieglitz himself had already begun to exploit the city's potential. Indeed, in exhorting photographers to discover the beauty of Madison Square on a rainy night, Hartmann retraces Stieglitz's own photographic steps. In his lengthy and detailed catalogue of photogenic urban places and subjects, Hartmann urges photographers to see pictorially rather than socially, to appreciate atmosphere, lights and shadows, line and plane, pattern and color. Even though he nods in the direction of social concern in his brief consideration of the slums, ultimately even hunger and filth are of interest chiefly as spectacle.

An exponent of this approach on the West Coast was Arnold Genthe, a German-born photographer who came to San Francisco in 1895 and specialized in street scenes in Chinatown. Genthe's essay similarly preaches patience (hours of waiting with the hand camera), and he abhors the overly posed, "commercial" composition. The racial issues that arise in a white man's act of depicting Asian immigrants also inflect Genthe's article, adding a sociopolitical edge to the important dynamic—always present in photography—of the viewer and the viewed.

Alfred Stieglitz, "Pictorial Photography," Scribner's Magazine 26 (November 1899).

About ten years ago the movement toward pictorial photography evolved itself out of the confusion in which photography had been born, and took a definite shape in which it could be pursued as such by those who loved art and sought some medium other than brush or pencil through which to give expression to their ideas. Before that time pictorial photography, as the term was then understood, was looked upon as the bastard of science and art, hampered and held back by the one, denied and ridiculed by the other. It must not be thought from this state-

ment that no really artistic photographic work had been done, for that would be a misconception; but the point is that though some excellent pictures had been produced previously, there was no organized movement recognized as such . . .

Pictures, even extremely poor ones, have invariably some measure of attraction. The savage knows no other way to perpetuate the history of his race; the most highly civilized has selected this method as being the most quickly and generally comprehensible. Owing, therefore, to the universal interest in pictures and the almost universal desire to produce them, the placing in the hands of the general public a means of making pictures with but little labor and requiring less knowledge has of necessity been followed by the production of millions of photographs. It is due to this fatal facility that photography as a picture-making medium has fallen into disrepute in so many quarters; and because there are few people who are not familiar with scores of inferior photographs the popular verdict finds all photographers professionals or "fiends."

Nothing could be farther from the truth than this, and in the photographic world to-day there are recognized but three classes of photographers—the ignorant, the purely technical, and the artistic. To the pursuit, the first bring nothing but what is not desirable; the second, a purely technical education obtained after years of study; and the third bring the feeling and inspiration of the artist, to which is added afterward the purely technical knowledge. This class devote the best part of their lives to the work, and it is only after an intimate acquaintance with them and their productions that the casual observer comes to realize the fact that the ability to make a truly artistic photograph is not acquired off-hand, but is the result of an artistic instinct coupled with years of labor . . .

In the infancy of photography, as applied to the making of pictures, it was generally supposed that after the selection of the subjects, the posing, lighting, exposure, and development, every succeeding step was purely mechanical, requiring little or no thought. The result of this was the inevitable one of stamping on every picture thus produced the brand of mechanism, the crude stiffness and vulgarity of chromos, and other like productions.

Within the last few years, or since the more serious of the photographic workers began to realize the great possibilities of the medium in which they worked on the one hand, and its demands on the other, and brought to their labors a knowledge of art and its great principles, there has been a marked change in all this. Lens, camera, plate, developing-baths, printing process, and the like are used by them simply as tools for the elaboration of their ideas, and not as tyrants to enslave and dwarf them, as had been the case . . .

Consider, for example, the question of the development of a plate. The accepted idea is that it is simply immersed in a developing solution, allowed to develop to a certain point, and fixed; and that, beyond a care that it be not overdeveloped or fogged, nothing further is required. This, however, is far from the truth. The photographer has his developing solutions, his restrainers, his forcing baths, and the like, and in order to turn out a plate whose tonal values will be relatively true he must resort to local development. This, of course, requires a knowledge of and feeling for the comprehensive and beautiful tonality of nature. As it has never been possible to establish a scientifically correct scale of values between the high lights and the deep shadows, the photographer, like the painter, has to depend upon his observation of and feeling for nature in the production of a picture. Therefore he develops one part of his negative, restrains another, forces a third, and so on; keeping all the while a proper relation between the different parts, in order that the whole may be harmonious in tone. This will illustrate the plastic nature of plate development. It will also show that the photographer must be familiar not only with the positive, but also with the negative value of tones. The turning out of prints likewise is a

plastic and not a mechanical process. It is true that it can be made mechanical by the craftsman, just as the brush becomes a mechanical agent in the hands of the mere copyist who turns out hundreds of paint-covered canvases without being entitled to be ranked as an artist; but in proper hands print-making is essentially plastic in its nature.

An examination of either the platinum or the gum process, the two great printing media of the day, will at once demonstrate that what has already been asserted of the plate is even more true of these. Most of the really great work of the day is done in one or the other of these processes, because of the great facility they afford in this direction, a facility which students of the subject are beginning to realize is almost unlimited. In the former process, after the print has been made, it is developed locally, as was the plate. With the actual beauties of the original scene, and its tonal values ever before the mind's eye during the development, the print is so developed as to render all these as they impressed the maker of the print; and as no two people are ever impressed in quite the same way, no two interpretations will ever be alike. To this is due the fact that from their pictures it is as easy a matter to recognize the style of the leading workers in the photographic world as it is to recognize that of Rembrandt or Reynolds. In engraving, art stops when the engraver finishes his work, and from that time on the process becomes a mechanical one; and to change the results the plate must be altered. With the skilled photographer, on the contrary, a variety of interpretations may be given of a plate or negative without any alterations whatever in the negative, which may at any time be used for striking off a quantity of purely mechanical prints. The latest experiments with the platinum process have opened up an entirely new field—that of local brush development with different solutions, so as to produce colors and impart to the finished picture all the characteristics of a tinted wash-drawing. This process, which has not yet been perfected, has excited much interest, and bids fair to result in some very beautiful work. By the method of local treatment above referred to almost absolute control of tonality, atmosphere, and the like is given to the photographer, on whose knowledge and taste depends the picture's final artistic charm or inartistic offensiveness.

In the "gum-process," long ago discarded by old-time photographers as worthless, because not facile from the mechanical point of view, but revived of recent years, the artist has a medium that permits the production of any effect desired. These effects are invariably so "unphotographic" in the popular sense of that word as to be decried as illegitimate by those ignorant of the method of producing them. In this process the photographer prepares his own paper, using any kind of surface most suited to the result wanted, from the even-surfaced plate paper to rough drawing parchment; he is also at liberty to select the color in which he wishes to finish his picture, and can produce at will an india-ink, red-chalk, or any other color desired. The print having been made he moistens it, and with a spray of water or brush can thin-out, shade, or remove any portion of its surface. Besides this, by a system of recoating, printing-over, etc., he can combine almost any tone or color-effect . . .

The field open to pictorial photography is to-day practically unlimited. To the general public that acquires its knowledge of the scope and limitations of modern photography from professional show windows and photo-supply cases, the statement that the photographer of to-day enters practically nearly every field that the painter treads, barring that of color, will come as something of a revelation. Yet such is the case: portrait work, genre-studies, landscapes, and marine, these and a thousand other subjects occupy his attention. Every phase of light and atmosphere is studied from its artistic point of view, and as a result we have the beautiful night pictures, actually taken at the time depicted, storm scenes, approaching storms, marvellous sunset-skies, all of which are already familiar to magazine readers. And it is not sufficient that these

pictures be true in their rendering of tonal-values of the place and hour they portray, but they must also be so as to the correctness of their composition. In order to produce them their maker must be quite as familiar with the laws of composition as is the landscape or portrait painter; a fact not generally understood. Metropolitan scenes, homely in themselves, have been presented in such a way as to impart to them a permanent value because of the poetic conception of the subject displayed in their rendering. In portraiture, retouching and the vulgar "shine" have been entirely done away with, and instead we have portraits that are strong with the characteristic traits of the sitter. In this department head-rests, artificial backgrounds, carved chairs, and the like are now to be found only in the workshops of the inartistic craftsman, that class of so-called portrait photographers whose sole claim to the artistic is the glaring sign hung without their shops bearing the legend, *"Artistic Photographs Made Within."* The attitude of the general public toward modern photography was never better illustrated than by the remark of an art student at a recent exhibition. The speaker had gone from "gum-print" to "platinum," and from landscape to genre-study, with evident and ever-increasing surprise; had noted that instead of being purely mechanical, the printing processes were distinctly individual, and that the negative never twice yielded the same sort of print; had seen how wonderfully true the tonal renderings, how strong the portraits, how free from the stiff, characterless countenance of the average professional work, and in a word how full of feeling and thought was every picture shown. Then came the words, *"But this is not photography!"* Was this true? No! For years the photographer has moved onward first by steps, and finally by strides and leaps, and, though the world knew but little of his work, advanced and improved till he has brought his art to its present state of perfection. This is the real photography, the photography of to-day; and that which the world is accustomed to regard as pictorial photography is not the real photography, but an ignorant imposition.

Sadakichi Hartmann, "Portrait Painting and Portrait Photography," Camera Notes 3 *(July 1899).*

There is no art which affords less opportunity to executive expression than photography. Everything is concentrated in a few seconds, when after perhaps an hour's seeking, waiting and hesitation, the photographer sees the realization of his inward vision, and in that moment he has one advantage over most arts—his medium is swift enough to record his momentary inspiration. Right at the start I must confess that I have never met such spontaneity of judgment in a man, who was a competent character reader, artist and photographer in one person.

At present the art of portrait photography can be divided into three distinct classes, the amateur, the professional and the artistic photographers.

About the first class, consisting of all those hundreds of thousands who press the button or hide themselves under the focusing cloth for their own amusement, I have nothing to say. The second class, made up of those who are willing to photograph us for money, from 25 cents upwards, figure very prominently in the thoroughfares of our metropolitan life. But they have, excepting two or three, nothing whatever to do with art. They merely reproduce our face and figure in the most innane aspects, and retouch the plate until all resemblance is lost. Hollinger, with his delicate modeling of half tones in light tinted grays, is one noteworthy exception. The third class is the one which interests me. They endeavor to make photography an independent art, a new black and white process to represent the pictorial elements of life. There is much agitation among them. There are clubs and leagues and societies of artistic photography, and lectures and debates on the subject. There are dozens of magazines exploiting artistic photography, and exhibitions galore. An artistic photograph is, nevertheless, the rarest thing under the sun.

The majority of these ladies and gentlemen represent objects indiscriminately, or take bad painters as models for their compositions, and the results, of course, are dire. Others imitate, by all sorts of trickery, black and white processes and the pictorial side of painting in general, and produce something which in my opinion is illegitimate . . .

I also do not like their peculiar attitude. Instead of simply managing their business like ordinary professionals they avoid advertising, and act as if money is of no consequence to them, and yet contradict themselves by charging twenty-five dollars per dozen. They bother celebrities to come to their studio, as they would be ever so proud to focus the author of such and such a book and give them, after long waiting, two or three prints as a reward. These photographs are shown to the other customers, and, of course, if this great man had himself photographed by so and so, why should not the humble Mrs. X have herself depicted by the same photographer for twenty-five dollars.

Equally absurd it seems to me is that a limited number of prints of a photograph should make it more valuable. The producing of prints from a plate is an exceedingly delicate art, but after all, a mechanical process. One can make several hundred just as well as one (perhaps not all up to one's standard, but they can be made), and it would therefore fall into the vocation of photography to exercise its influence in an unlimited instead of a limited edition. A good photograph does not get less valuable because a hundred other copies of it are scattered throughout the world. With a painting or even a general drawing it is quite different; that can't be repeated, just as little as a photographer can pose a sitter twice in exactly the same way. But after the plate has once been made, the rest should be an ordinary printing process. That the plates have not yet reached the state of perfection to accomplish this may be an excuse for the present mania of retouching. I have a great weakness for artistic photography, but I must confess that I do not like its present ways of asserting itself, although I give due admiration to works of such portrait photographers as F. H. Day, Mrs. Gertrude Käsebier, J. T. Keiley and Frank Eugene.

F. H. Day, apparently a man of wide æsthetic culture and of genuine, highly developed, artistic insight, has the peculiar gift to render everything decorative. Sensitive to a high degree (I fear even over-sensitive), he can only satisfy his individual code of beauty by arranging and rearranging his subject with all sorts of accessories and light effects, which show an extensive knowledge of classic, as well as contemporary, art. There is no photographer who can pose the human body better than he, who can make a piece of drapery fall more poetically, or arrange flowers in a man or woman's hair more artistically . . .

There are passages in his portraits which are exquisite, but all his representations lack simplicity and naturalness. He has set himself to get painter's results, and that is from my viewpoint not legitimate. He has pushed lyricism in portraiture as far as it can be without deteriorating into a mannerism; even his backgrounds speak a language of their own, vibrant with rhythm and melody; they are aglow in the darkest vistas. Day is indisputably the most ambitious and most accomplished of our American portrait photographers.

Lately he has managed to astonish the photographic world by making a series of photographic representations of the Crucifixion, of scenes at the Sepulchre, and the dies of Christ's head. In depicting this extremely difficult subject he has followed as far as conception goes, absolutely conventional lines; I mean he has not interpreted Christ in a new manner, as, for instance, Uhde and Edelfeldt have done. For such an innovation he had probably neither the inclination nor the nerve. His is, nevertheless, an innovation in the photographic field worthy of unlimited praise. Anything to deliver us from the stagnancy of commonplace, stereotyped productions! And Day took a step, however short and faltering, toward Parnassian heights. Pictorial repre-

sentation of a classic subject on classic lines has spoken its first word in artistic photography, and no one knows where it may lead to.

Mrs. Gertrude Käsebier brought her art to a degree of interpretative perfection which it never before attained. She *imitates* (Day does not imitate but adapts) the old masters with a rare accuracy. Her management of tonic values is at times superb; she also understands the division of space and the massing of light and shade. But she is absolutely dependent on accessories. Without a slouch hat, or a big all-hiding mantle, a peculiar cut and patterned gown, a shawl or a piece of drapery, she is unable to make a satisfactory likeness. She utterly fails to master the modern garb; only in rare cases, as for instance her Twachtman, or the Girl with the Violin, she succeeds, and solely because the sitters have themselves individuality enough. It is, comparatively, an easy task to get a good portrait of a personality, as the camera is sure to produce some of the individuality without the aid of the photographer. People will say that merely her Mother and Child pictures are free from these mannerisms, yet they have many fine qualities; but I, for my part, associate maternal joy rather with an outburst of gay sunlight than the stifling artificial atmosphere in which Mrs. Käsebier places them. Her skillful schemes of light and shade lack luminosity. Besides the subject in itself contains so much poetical charm, it suggests poetry even without the help of the artist. Such people as Mrs. Käsebier depicts are very scarce on our streets, and whenever they appear they do it to the great sorrow of the rest of humanity. Why should a respectable citizen be transformed into such an eyesore? But Mr. Day, as well as Mrs. Käsebier, pre-eminently wish it so, as they are eminently fit to represent that class of human beings who wear slouchy drapery instead of tailor-made costumes, and carry sunflowers, holy Grail cups or urns, filled, I presume, with the ashes of deep thoughts, in their hands. People do not seem to comprehend that it may suit an idol-woman like Sarah Bernhardt to be represented with a statuette in her hand (besides she is a sculptress herself), but that it would be absurd to represent an ordinary society girl (third generation of a parvenu who married a washerwoman) in the same way. It merely shows the incompetence of the photographer to tell character . . .

These photographers I am going to mention now, I believe are all—perhaps not as fanatically as myself—adherents of photography "pure and simple." They disdain the assistance of retouching, by which Demachy in Paris, and Einbeck in Hamburg have attained some of their most marvelous results. They realize that artistic photography to become powerful and self-subsistent must rely upon its own resources, and not ornament itself with foreign plumes, in order to resemble an etching, a poster, a charcoal or a wash drawing, or a Käsebier reproduction of an old master.

Miss Zaida Ben Yusuf, G. Cox, R. Eickemeyer, Jr., and, I believe also C. H. White, work in that direction. They are less burdened with æsthetic lore, and for that very reason better adapted to photography. They want likenesses, and that alone can make portrait photography great.

Of C. H. White I have seen only one print, his "Mrs. H," which alone ranks him among the best portrait photographers. A modern girl, in a summer dress, conventional even to the crease in front, that is all. The figure is as well posed as a Sargent. The tonal quality is admirable in its delicacy and clearness. The only faults I have to find, are that the parasol is not rendered as interesting as it could be, and that the picture on the wall would have improved the portrait if it had been a landscape or Japanese print instead of a head.

Miss Ben Yusuf, of all photographers I know, relies most on her camera. She is wise enough not to retouch. She is a fairly good character reader, and understands posing. She composes her pictures with the simplest means, without applying any special artistic arrangement; good taste and common sense seem to her sufficient. Her simplicity of purpose, the absence of af-

fectation and of the display of great stores of knowledge is refreshing. She pursues her art on the right lines. It is only to be deplored that her work at present is so frightfully uneven. Many of her portraits are as bad as those of a Bowery photographer, while others, for instance her Anthony Hope (standing), is one of the most masterly plates in existence . . .

Letting all these artists pass once more in review in my mind's eyes, it seems to me that after all the genius of the painter, comparatively speaking, is more successful in getting an artistic likeness than the mechanism of photography.

This is largely due to the fact that, with a very few exceptions, only mediocre talents have been drawn to the rubber bulb and focusing cloth. Artistic temperaments have avoided photography in fear of its restrictions, and so it has come to pass that until now the word genius could never yet be applied to any craftsman in this special branch of artistic photography.

The range of the technical expression of photography, in comparison with painting, is indeed very limited. First of all it lacks color . . .

Also in representing texture, photography is handicapped. Of course the camera reproduces only too faithfully certain unimportant details, but the surface is always the same, unless where you retouch it so cleverly that it will suggest variety. It commands, however, tonality, but that also other arts convey equally well, and if photography is ever expected to assert itself as one of the independent—probably for a long time to come—minor arts, it has to develop that quality, which no other medium has in common with it. The beauty of blurred lines, produced by the action of light, for photography does not draw lines but rather suggests them by painting values, may be compared in importance to the linear expression of etching or wood engraving, and the massing of black (viz, Goya) and the moss-like gradations of gray (viz. Whistler) in lithography. These arts, although allowing big scope to creative power, are exposed to a certain restriction in regard to subjects. This is not the case with photography, as it has the power to express *movement,* for instance the spontaneity of facial expression, which no other art can do in the same degree and with the same ease.

What artistic photography needs is an expert photographer, who is at the same time a physiognomist and a man of taste, and great enough to subordinate himself to his machine; only a man thus adequately endowed could show us a new phase in portraiture, with which even the eye and hand of the painter would find it difficult to compete.

However, only when color photography has been made possible, and kinetoscope photography in the hand of artists has developed to that extent that full justice can be done to the spontaneity of *actual* movement, to the continuous, almost undiscernible, changes in a human face, the delicate nuances in the evolution of a smile, or any other human sentiment, passion or common every-day expression of routine life, artistic portrait photography will fulfill its highest vocation. For would we not prefer a fragment of our children's life represented in actual movement, just as if they were alive, to any representation of one stereotyped position by a painter, no matter how skillful? A child looking roguishly at us, quickly changing its facial expression into a smile, would mean infinitely more (and it could be equally artistic) than if a Sargent would place the same child like a big doll under a still bigger vase in a hall vibrant with emptiness (viz., Sargent's "Hall of the Four Children"). And a characteristic gesture, a pensive attitude, or furtive movement of one's wife, as expressed by the kinetoscope of the future, would be much more valuable than the rare æsthetic pleasure of letting Watts wrap her up in a pre-Raphaelite soul-mist, or Lenbach draw her picture in lines worthy of a Herodotus, or Boldini make her look like a languid bachantee of modern joy.

But artistic kinetoscope photography in color is so far off! We have to deal with the present,

have to make the best of the existing conditions, and form from them, if we possess the power and are unselfish enough, those foundations, on which the photography of the future will construct itself.

Sadakichi Hartmann, "A Plea for the Picturesqueness of New York," Camera Notes *4 (October 1900).*

At every exhibition I am astonished at the limited range of subjects which the artistic photographers attempt to portray. One invariably finds numerous portraits, and studies of heads or draped figures, a number of landscapes, interiors and out-of-door snap-shots, and a few—very few—serious compositions, mostly genre subjects, which can claim a general pictorial quality. This paucity of ideas is really embarrassing to the lover of art, who is interested in the sights and scenes of our own times . . .

They seem unaware that the best art is that which is most clearly the outcome of the time of its production, and the art signifying most in respect to the characteristics of its age, is that which ultimately becomes classic. To give to art the complexion of our time, boldly to express the actual, is the thing infinitely desirable . . .

All these years our artistic photographers—and painters and sculptors as well—with a few exceptions have been mumbling old formulas, and have apparently combined in a gigantic trust of imitation.

The dignified vigor of the old masters, the restless desires of modern art, the incomparable suggestiveness of the Japanese, have all been mortgaged. No past effort has escaped their versatility for reproducing. Everything seems to have struck their fancy, even that which is only questionably good.

I know that a large majority will object to my arguments; those who do not feel that there is an imposing grandeur in the Brooklyn Bridge; who do not acknowledge the beauty of the large sweeping curves in the new Speedway, which would set a Munich Secessionist wild; who do not feel the poetry of our waterfronts, the semi-opaque water reflecting the gray sky, the confusion of square-rigged vessels with their rusty sides and the sunburnt faces peering from the deck; and who would laugh outright if anyone would dare to suggest that Paddy's market on Ninth Avenue or the Bowery could be reduced to decorative purposes.

Such men claim that there is nothing pictorial and picturesque in New York and our modern life, and continue their homage to imitation. The truth is that they lack the inspiration of the true artist, which wants to create and not merely to revive or adapt. They are satisfied with an incongruous mixture of what they know and see with what they have learned in school and what comes to them easily; no matter whether at second or at third hand; it saves them experiments and shields them from failures. They work as do the journalists, who write of things they know nothing about, and whose superficial knowledge is concealed by the rapid succession of publications. But for that reason their work can also be likened to the wake of a ship, it foams a little, to be seen no more.

To open new realms to art takes a good share of courage and patience. It always takes moral courage to do what the rest of the profession does not; that of course the man possesses who starts out to conquer the beauties of New York. It takes actual physical courage to go out into the crowd with your camera, and to be stared and laughed at on the most inopportune occasions. But that even Mr. J. G. Brown braved; why not you. It takes also a marvelous amount of patience to stand for hours at the same spot, perhaps in very bad weather—in rain, snow, or even in a thunder-storm—until at last one sees before him what he considers essential for a picture; or persistently to return at every opportunity to a subject—perhaps to something that

may recur only once in a year, as the "May Festival" in Central Park—until he has at last mastered it . . .

I am well aware that much is lacking here which makes European cities so interesting and inspiring to the sightseer and artist. No monuments of past glory, no cathedral spires of Gothic grandeur, no historic edifices, scarcely even masterpieces of modern architecture lift their imposing structures in our almost alarmingly democratic land.

Despite this, I stick to my assertion, and believe that I can prove its truth. For years I have made it my business to find all the various picturesque effects New York is capable of—effects which the eye has not yet got used to, nor discovered and applied in painting and literature, but which nevertheless exist.

Have you ever watched a dawn on the platform of an elevated railroad station, when the first rays of the rising sun lay glittering on the rails? This Vance Thompson compared to the waterways of Venice in pictorial effect. The morning mist, in strange shapes and forms, played in the distance where the lines of the houses on both sides of the street finally united.

Have you ever dined in one of the roof-garden restaurants and watched twilight descending on that sea of roofs, and seen light after light flame out, until all the distant windows began to glimmer like sparks, and the whole city seemed to be strewn with stars? If you have not, you are not yet acquainted with New York.

Then take Madison Square. Place yourself at one of its corners on a rainy night and you will see a picture of peculiar fascination: Dark silhouettes of buildings and trees, surrounded by numerous light reflections, are mirrored in the wet pavement as in a sheet of water. But also in daytime it is highly attractive. The paths are crowded with romping children, and their gay-colored garments make a charming contrast to the lawn and the foliage of the trees, to which the Diana's tower and the rows of houses with windows glittering in the sun, form a suitable background.

The Boulevard has many interesting parts. The rows of trees in the middle, the light brick fronts of the new apartment houses, and the many vehicles and bicyclists on a Sunday afternoon offer ample opportunity for snap-shots.

Comparing New York with other cities, it can boast of a decided strain of gayety and vitality in its architecture. The clear atmosphere has encouraged bright colors, which, when subdued by the mist that hovers at times over all large cities, afford delightful harmonies that can be suggested even by the photographer's black and white process.

Almost any wide street with an elevated station is interesting at those times when the populace goes to or returns from work. The nearer day approaches these hours, the more crowded are the sidewalks. Thousands and thousands climb up or down the stairs, reflecting in their varied appearance all the classes of society, all the different professions, the lights and shadows of a large city, and the joys and sorrows of its inhabitants.

In Central Park we meet with scenes of rare elegance and dignity. Many a tourist will find himself transported to the palace gardens of the old world, as his eyes gaze on these quiet lakes peopled with swans and on the edifices shimmering in the sun and rising from the autumnal foliage into the sky.

A peculiar sight can be enjoyed standing on a starlit night at the block house near the northwest entrance of the Park. One sees in the distance the illumined windows of the West Side, and the Elevated, which rises at the double curve at One Hundred and Tenth Street to dizzy heights, and whose construction is hardly visible in the dimness of night. A train passes by, like a fantastic fire-worm from some giant fairyland, crawling in mid-air. The little locomotive emits a cloud of smoke, and suddenly the commonplace and yet so mystic scene changes into a tu-

mult of color, red and saffron, changing every moment into an unsteady gray and blue. This should be painted, but as our New York artists prefer to paint Paris and Munich reminiscences, the camera can at least suggest it.

A picture genuinely American in spirit is afforded by Riverside Park. Old towering trees stretch their branches towards the Hudson. Almost touching their trunks the trains on the railroad rush by. On the water heavily loaded canal boats pass on slowly, and now and then a white river steamboat glides by majestically, while the clouds change the chiaroscuro effects at every gust of wind.

Another picture of surprising beauty reveals itself when you approach New York by the Jersey City ferry. The gigantic parallelograms of office buildings and skyscrapers soar into the clear atmosphere like the towers, turrets and battlements of some ancient fortress, a modern Cathay, for whose favor all nations contend.

The traffic in the North and the East rivers and the harbor offers abundant material; only think of the graceful four-masted East Indiamen that anchor in the bay, laden with spices which recall even in these northern climes quaint Oriental legends, of indolent life under tropical suns. I am also very fond of the vista of the harbor from Battery Park, particularly at dawn. How strange this scene looks in the cold morning mist. There is no distance and no perspective; the outlines of Jersey City and Brooklyn fade ghost-like in the mist; soft shimmering sails, dark shadows and long pennants of smoke interrupt the gray harmony, and are in their uncertain contours not unlike the fantastic birds which enliven at times the background of Japanese flower designs.

Whoever is fond of panoramic views should place himself at the High-bridge Reservoir and look northwards. At sunset this scene—the wide Harlem River sluggishly flowing through a valley over which two aqueducts span their numerous arches—reminds one involuntarily of a landscape by Claude Lorraine.

For the lovers of proletarian socialism—who like Dudley Hardy and Gaston Letouche, and would like to depict the hunger and the filth of the slums, the unfathomable and inexhaustible misery, which hides itself in every metropolitan city—subjects are not lacking in New York. Only it is more difficult to find them than in European cities.

Rafaelli, the French painter, once asked me to show him the poorest quarters. I took him through Stanton, Cherry, Baxter and Essex Streets. I could not satisfy him. But when he saw a row of dilapidated red brick houses with black fire-escapes covered all over with bedding, clothes lines, and all sorts of truck, he exclaimed: *"C'est fort curieux!"* and like a ferret ran from one side to the other to take a number of snap-shots.

True enough we have not such scenes of extreme poverty as Rafaelli found in the outskirts of Paris, at least not so open; but one only needs to leave the big thoroughfares and go to the downtown back alleys, to Jewtown, to the village (East Twenty-ninth Street), or Frog Hollow, to prove sufficiently that many a portfolio could be filled with pictures of our slums, which would teach us better than any book "how the other half lives." . . .

Wherever some large building is being constructed the photographer should appear. It would be so easy to procure an interesting picture, and yet I have never had the pleasure to see a good picture of an excavation or an iron skeleton framework. I think there is something wonderful in iron architecture, which as if guided by magic, weaves its networks with scientific precision over the rivers or straight into the air. They create, by the very absence of unnecessary ornamentation, new laws of beauty, which have not yet been determined, and are perhaps not even realized by the originators. I am weary of the everlasting complaint that we have no modern style of architecture. It would indeed be strange if an age as fertile as ours had produced noth-

ing new in that art which has always more than others reflected the aspirations and accomplishments of mankind at certain epochs of history. The iron architecture is our style.

I still could add hundreds and hundreds of suggestions for pictures, but I fear I would tire my readers. I will therefore only mention a few haphazard. There is the Fulton fish market, a wonderful mixture of hustling human life and the slimy products of Neptune's realm, at its best on a morning during Lent; then the Gansevoort market on Saturday mornings or evenings; the remnants of Shantytown; the leisure piers; the open-air gymnasiums at Stryker's Lane and the foot of Hester Street; the starting of a tally-ho coach from the Waldorf-Astoria on its gay drive to Westchester; the canal-boat colony at Coenties Slip; the huge storage houses of Gowanus Bay. Another kind of subjects now comes to mind—the children of the tenement districts returning from school; or the organ-grinder, and little girls showing off their terpsichorean skill on the sidewalk to an admiring crowd.

But really what would be the use of specifying any further? Any person with his eyes open, and with sympathy for the time, place and conditions in which he lives, has only to take a walk or to board a trolley, to find a picture worthy of depiction almost in every block he goes.

I am perfectly aware that only a few of my readers endorse my assertions, and see something in my ardent plea. In thirty years, however, nobody will believe that I once fought for it, for then the beauty of New York will have been explored by thousands.

But who will be the first to venture on these untrodden fields and teach New Yorkers to love their own city as I have learned to love it, and to be proud of its beauties as the Parisians are of their city? He will have to be a great poet and of course an expert photographer.

May he soon appear!

Arnold Genthe, "The Children of Chinatown," Camera Craft 2 *(December 1900).*

Some one has said that the chief difficulty in obtaining good photographs in Chinatown, that most picturesque quarter of San Francisco, undoubtedly lies in the fact that the Chinamen have a very pronounced aversion to the camera. They believe that to be photographed by a white man means bad luck for them, and as soon as they see the ominous black box of the "White Devil" they run, protecting their faces with upheld arms. It might comfort them to know that the bad luck is mostly on the side of the enthusiastic camera fiend, who bravely and indiscriminately snaps his camera as they run angrily away, and who does his part of the swearing later on in the darkroom. But evidently they consider the man with the camera always a dangerous enemy, who has to be carefully avoided, a rather flattering tribute to the photographic ability of the many amateurs who make Chinatown their hunting grounds for scenes picturesque and novel.

Even the children are taught to run away from the black box, and it is indeed amusing to see the youngsters disappear with almost supernatural rapidity at the approach of a camera, be it a pocket kodak or an instrument of larger proportions. Even the very little children soon learn to know the camera, and let themselves willingly be carried to a place of safety by their big sisters and brothers.

The superstitious fear and, on the other hand, the bad light—the bright sunlight with the impenetrable shadows in the narrow alleys giving hard, contrary effects—make the photographing of "Young China" a rather difficult but not the less interesting task. Indeed, I do not know of a more picturesque subject for the hand camera than the "Children of Chinatown," with their clear and smooth olive skin, their mysterious black eyes, and the rich silk dresses worn on festival occasions with such natural grace and wise dignity. There is one easy way of secur-

ing good negatives of Chinese children, and that is by simply going to the Mission and have them pose there in the garden. But these photographs lack, to a certain degree, the pictorial and also the human interest which pictures made on the street without any posing may possess.

A few remarks as to how to obtain the best results may be of interest to those who do not mind using a couple of dozen plates or films to secure one or two good pictures. Any hand camera will answer the purpose so long as one knows how to handle it . . .

A great deal of attention must necessarily be paid to the light. One must correct the glaring whites and inky shadows which a great many Chinatown pictures show. If the exposure has to be made on a clear, sunny day, the plate ought to be developed with a very diluted metol developer, which will bring out the detail in the shadows before the high lights are too dense. The best light for Chinatown is on a gray day, with the sun just about to appear. Persulphate of ammonia will be very efficient in producing more harmonious tone values.

It is not at all sufficient, however, to keep your eye on the figure you intend photographing and to watch the effect of the light. You have, at the same time, to look for the background against which the figure will show. An otherwise good composition will be spoiled by a spotty background, or by a sign advertising "The Beer That Made Milwaukee Famous." Chinatown is a part of San Francisco, and the signs, so prominent a feature of the city streets, also spoil this picturesque quarter.

Of almost greater importance than the knowledge of how to handle the camera is the amount of truly Christian patience which the worker must possess if he wants to get a group of children that, as a composition, will have some pictorial value. It may be necessary to have to wait at a street corner for hours before you see a picture worth while taking, but when the good moment has arrived, be ready and act quickly, and try and hide your satisfaction at having made a good photo without their knowing it. Do not poke your camera triumphantly into the faces of your unsuspecting victims, as I have often observed people doing. In the first place, you may not have on your plate the picture you want at all, and then it is a small merit, indeed, to make the inoffensive little Mongolians feel uncomfortable. Rather try not to be seen by them at all. In fact, I think it is only the photographer who understands the art of making himself invisible who will obtain pictures in Chinatown that will have artistic value.

It is infinitely better to waste a lot of films and plates and finally get a simply composed picture, as, for instance, the one of the "Toy Peddler," than to pose the children (in case they could be induced to do so at all by the generous distribution of ten-cent pieces) and have them look at the camera with an unnatural or frightened expression that would destroy all the charm and grace only to be obtained by a negative stolen, as it were, while the unsuspecting subjects are occupied in the enjoyment of some innocent prank conceived by a mind wholly free from the fear of the ever-present black box in the hands of the inquisitive amateur.

It is a pity that the camera cannot give an idea of the tastefully combined and exquisitely delicate colors of the costumes worn by the children on festival days, as it is then the proud father spends his money with great prodigality to procure the lavishly embroidered suits so pleasing to the Oriental eye. This is to be regretted all the more as it leads photographers to tint their otherwise good photographs with violent aniline colors, thereby giving an absolutely wrong and barbarous impression of what in reality is a thing of rare beauty.

Fig. 13. Childe Hassam, *Cab Stand at Night, Madison Square,* 1891, oil on panel. Smith College Museum of Art, Northampton, Massachusetts, Bequest of Annie Swan Coburn (Mrs. Lewis Larned Coburn).

13 BEAUTY, VISION, AND MODERNITY

THE AESTHETIC MOVEMENT

OSCAR WILDE'S AMERICAN TOUR

Inspired by the British designer William Morris and catalyzed by the exhibition of British arts and crafts at the 1876 Centennial Exposition in Philadelphia, the Aesthetic movement in America aimed to refine taste and restore meaning to work by promoting a revival of handicrafts as antidote to industrial production, which had degraded labor and flooded the market with shoddy goods. Its primary objective was to reform the domestic interior by promulgating new ideals of harmony and sensuous beauty, based on a design ethos in which nature, not history, served as model. The Aesthetic movement was also associated with the cult of beauty in art, unencumbered by narrative, sentiment, or morality. Prominent among those who publicized the refined pursuit of art for art's sake were the British poet and critic Oscar Wilde and the American expatriate artist James McNeill Whistler (see chapter 11). In practice, the pursuit of beauty and the reform of craft more often than not converged.

Oscar Wilde spent the year 1882 touring America, where he lectured in major cities and small towns from New York to Omaha and San Francisco. Born in Dublin, Ireland, and educated at Oxford, Wilde was a highly visible proponent of the aesthetic lifestyle. He fashioned a theatrical public image that attracted attention to his aesthetic credo while inciting frequently venomous mockery. A disciple of Whistler, Wilde dedicated himself to spreading the gospel of beauty and good taste. Thanks to the parody of aestheticism presented in the popular Gilbert and Sullivan operetta Patience, *then playing in New York, he was already notorious when he stepped ashore in that city early in January 1882.*

The newspaper articles below illustrate Wilde's standing as a controversial and ambiguous figure whose effeminate eccentricities occasioned sarcasm at the same time his aesthetic message commanded respect. In his lecture, Wilde outlines the cardinal points of his reformist crusade: beautify the environment both public and private, honor the workman, and strive to make the useful beautiful and the beautiful, useful.

"A Talk with Wilde: The Apostle of the Aesthetes Enunciates His Views," Philadelphia Press, *January 17, 1882.*

As a Pennsylvania ferry-boat swung into her slip at Jersey City at a few minutes before one o'clock yesterday afternoon, the crowd scattered about the dock exclaimed in subdued tones: "There he is; see him, that's Oscar Wilde." The tall figure of the apostle of Æstheticism, clad in his olive-green overcoat with its otter trimmings, and with his large face brightened by a smile and framed in long brown locks, blown about by the wind, was a conspicuous figure, as he stood in the very front of the crowd of passengers pressing against the gunwales of the boat. He had evidently been enjoying a breezy trip across the tawny Hudson, for his eye sparkled and his face was flushed with pleasure as, with a long stride which kept him far in advance even of the eager rush with which a New York crowd escapes from a ferry, and which left his valet struggling hopelessly in the rear with a burden of baggage, he entered the Pennsylvania station, and passed to the wait-ing Philadelphia express. His sole companions were W. F. Morse, business manager for D'Oyly Carte, and a PRESS reporter. The party took seats in the smoking compartment of the Pull-man car "Jupiter," and shrinking from curious eyes into a corner, Mr. Wilde alternately read "Fors Clairgera" and "The Poetry of Architecture," until the train had fairly started.[1] Then, as he saw through the window the dismal marshes which skirt Jersey City, his eye became melan-choly and he contemplatively puffed a cigarette. As the train sped on its way through New Jer-sey, he scanned the flitting landscape closely, sometimes smiling like a child at a glistening stream or a stretch of yet green meadow, and again seeming to find the sorrow of old age in the fre-quent expanses of brown country and dripping black undergrowths, made more dreary by the overcast sky. The truth is, the poet had not had his breakfast; and thus unfortified against the horrors of a New Jersey landscape on a rainy day, it was no wonder that he finally relapsed into a state of hopeless dejection. Incredible as it may seem, the most non-aesthetic object on earth, a way station sandwich, restored his spirits enough for him to enter into an animated conver-sation with the PRESS reporter . . .

"This is your first railway ride in America, is it not?"

"Yes, this is the first time I have ever been in an American railway car. We go so swift—much faster than in England. There are but a few fast trains there—the Edinburg and Liverpool trains. And then there isn't any such comfort as this. There are but two or three cars like this," indi-cating the sumptuous Pulman with a sweep of the arm, "in the country. I hate to fly through a country at this rate. The only true way, you know, to see a country is to ride on horseback. I long to ride through New Mexico and Colorado and California. There are such beautiful flow-ers there, such quantities of lilies and, I am told, whole fields of sunflowers. Your climate is so much finer than that of England, so bright, so sunny, that your flowers are luxuriant," said Mr. Wilde, with a polite disregard of the clouds, and with a delightful ignorance of how hothouses are robbed of their treasures to let him breathe an atmosphere of fragrance . . .

. . . The poet gazed thoughtfully out of the window, and the reporter suggested that his im-pressions of American scenery must be as yet very limited. "Yes," was the reply, "but I enjoy very much what I have seen. But one cannot expect color in winter, when everything is so drear and brown. How dreadful those marshes are this side of New York. What a pity! and how un-necessary. They might plant them with something, so many beautiful things will grow in a marsh. Why, they might have great fields of callas growing there! Do you understand my line for lilies,

[1] "Fors Clairgera" is a misspelled reference to John Ruskin's *Fors Clavigera* ("Fortune the Club Bearer"), a series of educational and inspirational letters to workmen.

and roses, and sunflowers? No? O, don't you know, there is no flower so purely decorative as the sunflower. In the house, it is perhaps too large and glaring. But how lovely a line of them are in a garden, against a wall, or massed in groups! Its form is perfect. See how it lends itself to design, how suggestive it is. So many beautiful, very beautiful wall papers have been designed from the sunflower. It is purely decorative," and the sunflower worshipper became lost in reverie. Then, opening his eyes wide, his whole face radiant, he resumed: "And the lily. There's no flower I love so much as the lily. That, too, is perfect in form, and purely decorative. How graceful, how pure, how altogether lovely its shape, its tender poise upon the stem. And you have such beautiful lilies in America. I've seen a new one that we do not have in England, that star-shaped lily. I always loved lilies. At Oxford I kept my room filled with them, and I had a garden of them, where I used to work very often. As for roses, they are so full of color, so rich, so passionate. They suggest the feeling where the others suggest the form. They richly fill what the others outline. Why do not people grow them everywhere. I was pleased with the Raritan back there, with its brown current and brown banks; but still, those banks ought not to be bare and bleak— cover them with hardy lilies. Did you ever see those wonderfully beautiful books William Blake published so magnificently illuminated? In one of those books, enclosed in a charmingly appropriate border, are three lively poems—one on the Sunflower, one on the Lily, and one on the Rose. It is a page altogether exquisite." . . .

. . . During the approach to Philadelphia, Mr. Wilde showed an eager interest in the many novel things he saw. He listened with wide-open eyes to an explanations of a long train of oil cars, but did not say whether he found any beauty in them. A glimpse of Fairmount Park brought back his happy smile, and he was greatly pleased with the ride over the elevated tracks and with the Broad street station. As his conspicuous figure walked through the waiting room, many a whispered comment flew about; but the aesthete dived into a cab, and was whirled quickly away to his quarters at the Aldine Hotel.

"The Aesthetic Craze," Louisville Courier-Journal, *January 23, 1882.*

Mr. Oscar Wilde, the long-haired, tallow-complexioned apostle of aestheticism, has not created the least bit of a furore here. He has been almost ignored, except by newspaper callers. The people of Washington are too much accustomed to all sorts of celebrities to pay much attention to a small-sized notoriety like Mr. Oscar Wilde. No one, as in New York and Philadelphia, has rushed forward to dine, and he has been invited to no receptions. In short, he is not toadied at all here. If Washington people were unused to what are called "lions," Mr. Wilde might have had a different reception, and might have been quite an attraction. The COURIER-JOURNAL man has seen him and talked with him. He has a good flow of English and French, and when he talks to the scribe of the great daily he isn't at all too-too. He has the English drawl, to which is to be added an effeminacy of delivery, best described as "Sissy." He does not pose to the newspaper, though he dresses in the aesthetic manner. The cartoons that Punch has made of him are true to nature. He is a very effeminate, overgrown youth of twenty-five, except that manhood is absent from his composition. He is neither a man nor a woman. He is between the two. He is not even intellectual-looking, but he has brains. He is an ass with brains. In response to an inquiry from the COURIER-JOURNAL man, he said that he found a great deal more interest taken in this country in matters aesthetic than he expected. "There is," he said, "much more true art here than I supposed, and true art, you know, is aestheticism. I have had a great many inquiries from people who want to learn in art, and have seen a great many who have our ideas almost perfectly. I am doing all I can to encourage the spread

of true taste. What I could like to see is a permanent standard of taste among the people in their lives and in all they do." . . .

"What is your particular object in visiting America?"

"I want to see the country, and then I want to see how far the people here can love art and how far they can be led to love art. I would like to spread the truth of art and aid humanity to form the right idea of the true relations of art to life and of life to art." . . .

There was a picture of Walt Whitman on the table. Mr. Wilde was asked what he thought of America's rugged poet.

"The most delightful day I have spent," he answered, "was in Mr. Whitman's little bare room in Camden. I think Mr. Whitman is in every way one of the greatest and strongest men who have ever lived; he is the simplest and strongest man I ever met; eccentric he is not. You can not gauge great men by a foot rule; the people in England, for whose opinion he would care, read him and read him, and wonder at him." . . .

. . . During the interview Mr. Wilde reclined upon the sofa, over which was spread a buffalo robe; one leg was stretched a length on the buffalo robe, his right arm was thrown over the back of the sofa, upon his left hand he rested his head when the hand was not making slight gestures.

Oscar Wilde, "House Decoration," text of lecture given on Wilde's American tour, in **Complete Writings of Oscar Wilde,** *vol. 6 (New York: Nottingham Society, 1905).*

When I appeared before you on a previous occasion, I had seen nothing of American art save the Doric columns and Corinthian chimney-pots visible on your Broadway and Fifth Avenue. Since then, I have been through your country to some fifty or sixty different cities, I think. I find that what your people need is not so much high imaginative art but that which hallows the vessels of everyday use. I suppose that the poet will sing and the artist will paint regardless whether the world praises or blames. He has his own world and is independent of his fellow-men. But the handicraftsman is dependent on your pleasure and opinion. He needs your encouragement and he must have beautiful surroundings. Your people love art but do not sufficiently honour the handicraftsman. Of course, those millionaires who can pillage Europe for their pleasure need have no care to encourage such; but I speak for those whose desire for beautiful things is larger than their means. I find that one great trouble all over is that your workmen are not given to noble designs. You cannot be indifferent to this, because Art is not something which you can take or leave. It is a necessity of human life.

And what is the meaning of this beautiful decoration which we call art? In the first place, it means value to the workman and it means the pleasure which he must necessarily take in making a beautiful thing. The mark of all good art is not that the thing done is done exactly or finely, for machinery may do as much, but that it is worked out with the head and the workman's heart. I cannot impress the point too frequently that beautiful and rational designs are necessary in all work. I did not imagine, until I went into some of your simpler cities, that there was so much bad work done. I found, where I went, bad wall-papers horribly designed, and coloured carpets, and that old offender the horse-hair sofa, whose stolid look of indifference is always so depressing. I found meaningless chandeliers and machine-made furniture, generally of rose-wood, which creaked dismally under the weight of the ubiquitous interviewer. I came across the small iron stove which they always persist in decorating with machine-made ornaments, and which is as great a bore as a wet day or any other particularly dreadful institution. When unusual extravagance was indulged in, it was garnished with two funeral urns.

It must always be remembered that what is well and carefully made by an honest workman, after a rational design, increases in beauty and value as the years go on. The old furniture brought over by the Pilgrims, two hundred years ago, which I saw in New England, is just as good and as beautiful to-day as it was when it first came here. Now, what you must do is to bring artists and handicraftsmen together. Handicraftsmen cannot live, certainly cannot thrive, without such companionship. Separate these two and you rob art of all spiritual motive.

Having done this, you must place your workman in the midst of beautiful surroundings. The artist is not dependent on the visible and the tangible. He has his visions and his dreams to feed on. But the workman must see lovely forms as he goes to his work in the morning and returns at eventide. And, in connection with this, I want to assure you that noble and beautiful designs are never the result of idle fancy or purposeless day-dreaming. They come only as the accumulation of habits of long and delightful observation. And yet such things may not be taught. Right ideas concerning them can certainly be obtained only by those who have been accustomed to rooms that are beautiful and colours that are satisfying.

Perhaps one of the most difficult things for us to do is to choose a notable and joyous dress for men. There would be more joy in life if we were to accustom ourselves to use all the beautiful colours we can in fashioning our own clothes. The dress of the future, I think, will use drapery to a great extent and will abound with joyous colour. At present we have lost all nobility of dress and, in doing so, have almost annihilated the modern sculptor. And, in looking around at the figures which adorn our parks, one could almost wish that we had completely killed the noble art. To see the frockcoat of the drawing-room done in bronze, or the double waistcoat perpetuated in marble, adds a new horror to death . . .

And how shall men dress? Men say that they do not particularly care how they dress, and that it is little matter. I am bound to reply that I do not think that you do. In all my journeys through the country, the only well-dressed men that I saw—and in saying this I earnestly deprecate the polished indignation of your Fifth Avenue dandies—were the Western miners. Their wide-brimmed hats, which shaded their faces from the sun and protected them from the rain, and the cloak, which is by far the most beautiful piece of drapery ever invented, may well be dwelt on with admiration. Their high boots, too, were sensible and practical. They wore only what was comfortable, and therefore beautiful. As I looked at them I could not help thinking with regret of the time when these picturesque miners would have made their fortunes and would go East to assume again all the abominations of modern fashionable attire. Indeed, so concerned was I that I made some of them promise that when they again appeared in the more crowded scenes of Eastern civilisation they would still continue to wear their lovely costume. But I do not believe they will . . .

You have too many white walls. More colour is wanted. You should have such men as Whistler among you to teach you the beauty and joy of colour. Take Mr. Whistler's 'Symphony in White,' which you no doubt have imagined to be something quite bizarre. It is nothing of the sort. Think of a cool grey sky flecked here and there with white clouds, a grey ocean and three wonderfully beautiful figures robed in white, leaning over the water and dropping white flowers from their fingers. Here is no extensive intellectual scheme to trouble you, and no metaphysics of which we have had quite enough in art. But if the simple and unaided colour strike the right keynote, the whole conception is made clear . . .

The fault which I have observed in most of your rooms is that there is apparent no definite scheme of colour. Everything is not attuned to a key-note as it should be. The apartments are

crowded with pretty things which have no relation to one another. Again, your artists must decorate what is more simply useful. In your art schools I found no attempt to decorate such things as the vessels for water. I know of nothing uglier than the ordinary jug or pitcher. A museum could be filled with the different kinds of water vessels which are used in hot countries. Yet we continue to submit to the depressing jug with the handle all on one side. I do not see the wisdom of decorating dinner-plates with sunsets and soup-plates with moonlight scenes. I do not think it adds anything to the pleasure of the canvas-back duck to take it out of such glories. Besides, we do not want a soup-plate whose bottom seems to vanish in the distance. One feels neither safe nor comfortable under such conditions. In fact, I did not find in the art schools of the country that the difference was explained between decorative and imaginative art . . .

To you, more than perhaps to any other country, has Nature been generous in furnishing material for art workers to work in. You have marble quarries where the stone is more beautiful in colour than any the Greeks ever had for their beautiful work, and yet day after day I am confronted with the great building of some stupid man who has used the beautiful material as if it were not precious almost beyond speech. Marble should not be used save by noble workmen. There is nothing which gave me a greater sense of barrenness in travelling through the country than the entire absence of wood carving on your houses. Wood carving is the simplest of the decorative arts. In Switzerland the little bare-footed boy beautifies the porch of his father's house with examples of skill in this direction. Why should not American boys do a great deal more and better than Swiss boys?

There is nothing to my mind more coarse in conception and more vulgar in execution than modern jewellery. This is something that can easily be corrected. Something better should be made out of the beautiful gold which is stored up in your mountain hollows and strewn along your river beds. When I was at Leadville and reflected that all the shining silver that I saw coming from the mines would be made into ugly dollars, it made me sad. It should be made into something more permanent. The golden gates at Florence are as beautiful to-day as when Michael Angelo saw them.

We should see more of the workman than we do. We should not be content to have the salesman stand between us—the salesman who knows nothing of what he is selling save that he is charging a great deal too much for it. And watching the workman will teach that most important lesson—the nobility of all rational workmanship.

I said in my last lecture that art would create a new brotherhood among men by furnishing a universal language. I said that under its beneficent influences war might pass away. Thinking this, what place can I ascribe to art in our education? If children grow up among all fair and lovely things, they will grow to love beauty and detest ugliness before they know the reason why. If you go into a house where everything is coarse, you find things chipped and broken and unsightly. Nobody exercises any care. If everything is dainty and delicate, gentleness and refinement of manner are unconsciously acquired. When I was in San Francisco I used to visit the Chinese Quarter frequently. There I used to watch a great hulking Chinese workman at his task of digging, and used to see him every day drink his tea from a little cup as delicate in texture as the petal of a flower, whereas in all the grand hotels of the land, where thousands of dollars have been lavished on great gilt mirrors and gaudy columns, I have been given my coffee or my chocolate in cups an inch and a quarter thick. I think I have deserved something nicer . . .

. . . What we want is something spiritual added to life. Nothing is so ignoble that Art cannot sanctify it.

The heyday of the Aesthetic movement in the 1870s and 1880s saw the proliferation of decorating advice books and magazines dedicated to the diffusion of Aesthetic precepts to the middle class, or at least its upper tiers. The critic Clarence Cook was among the earliest and most vocal spokespersons for the ideals of the Aesthetic movement (see also "The American Pre-Raphaelites," chapter 7). In the 1870s, coincident with the emergence of interest in the American colonial past, Cook took up the subject of home decoration in a series of articles in Scribner's Magazine, *published in book form as* The House Beautiful *in 1878. On the model of the British designer Charles Eastlake's popular* Hints on Household Taste *(1868), Cook urges readers to eschew the opulence and overembellishment of high Victorian rooms in favor of simplicity, fitness, beauty, and utility and recommends that readers look to the "best bits" of Japanese art as well as American colonial furniture to learn the durable principles of visual economy. Upholding authenticity over imitation and intrinsic quality over crass embellishment, Cook's guidelines highlight as well a fundamental shift: erstwhile nursery of moral education, the domestic interior now serves to instill principles of taste and connoisseurship in the minds of budding aesthetes.*

One of the most progressive young artists of the 1870s, Maria Oakey Dewing was enrolled for a year at the Cooper Union School of Design for Women. She became a protégé of John La Farge and studied as well with the Boston painter William Morris Hunt and in Paris under Thomas Couture. One of the earliest members of the Society of American Artists, she married fellow painter Thomas Wilmer Dewing in 1881 and in the 1880s moved from figure and portrait painting to concentrate almost exclusively on floral still lifes. Dewing expressed her commitment to principles of the Aesthetic movement in Beauty in the Household *(1882), in which she articulates the importance of cultivating a refined and educated sense of color, form, and proportion.* Beauty in the Household *manifests Dewing's allegiance to the principles of art for art's sake espoused by James McNeill Whistler, whose own writings steadfastly argue for the artist's unique capacity to create harmony and beauty out of nature's raw materials.*

Clarence Cook, The House Beautiful: Essays on Beds and Tables, Stools and Candlesticks *(New York: Scribner, Armstrong and Company, 1878).*

One might put in a word for that heterogeneous catalogue of things for which the word *bric-à-brac* has been invented.

These objects, which are coming to play the part in our external life that they have played these many years in Europe and Asia, have really, if one wishes to find a side on which to regard them that shall commend itself to more serious consideration than trifling, however sanctified by fashion, can deserve—these objects, when they are well chosen, and have some beauty of form or color, or work manship, to recommend them, have a distinct use and value, as educators of certain senses—the sense of color, the sense of touch, the sense of sight. One need not have many of these pretty things within reach of hands and eyes, but money is well spent on really good bits of Japanese workmanship, or upon good bits of the workmanship of any people who have brought delicacy of hand and an exquisite perception to the making of what are in reality toys. A Japanese ivory-carving or wood-carving of the best kind,—and there is a wide field for choice in these remarkable productions,—one of their studies of animal life, or

of the human figure, or of their playful, sociable divinities, pixie, or goblin, or monkey-man, has a great deal in it that lifts it above the notion of a toy. It is a toy, a button, a useless thing, or nearly useless, but it is often as poetically or wittily conceived as if the artist had a commission from the state. Then it is sure to be pleasant and soothing to the touch; it was made to be clasped by the fingers, felt with the finger-tips, rolled in the palm; for the general use to which they are put is being fastened to the pipe-case to serve as a button to keep it from slipping from the belt, and in this place they offer a natural rest and solace to the hand; their character has been developed by necessity. A child's taste and delicacy of perception will be more surely fed by the constant habit of seeing and playing with a few of the best bits of ivory carving his parents can procure—and very nice pieces are often to be had for a small sum of money—than by a room full of figures like those of Mr. Rogers, for example, or the great majority of French bronzes. Of course, a bronze by Barye, or by Fremiet, would do as much or more for the child's taste, and by all means let the money go for that if it can be afforded; but I am speaking now of trifles that, in a serious consideration of art, have no place perhaps, and which yet do nothing but help us in learning to know and admire the best art. Perhaps it is fanciful; but suppose that one of the Japanese spheres of polished crystal were put within the daily reach of a child, and that he were pleased enough with it to often look at it, handle it, and let the eye sink into its pellucid deeps, as from time to time he stopped in his reading of Froissart or King Arthur. Would not the incommunicable purity and light of the toy make a severe test for the heroes and the heroines in the boy's mind; and could his eye, cooled in such a bath of dew, get pleasure any more from discordant color or awkward form? Our senses are educated more by these slight impressions than we are apt to think; and *bric-à-brac,* so much despised by certain people, and often justly so, may have a use that they themselves might not unwillingly admit . . .

There is hardly anything with which we can produce a prettier effect in rooms where we want to break up the wall, and yet have nothing particularly good, as engraving or picture, to hang upon it, than these Japanese paintings of birds and flowers, and native men and women which come painted on gauze, and with which the Japs themselves ornament their screens. Secured to the wall by a drawing-pin at each of the four corners, they give a bright and cheerful look to a dull room, and are always pleasant to see, even when they are of the cheaper sort. The best ones are often much better worth having for spirited design, and the mastery of their painting, than any work done by the professed decorators; indeed, for their flowers and birds there is no decorative work of our day that can at all compare with them. One of the prettiest modern rooms I ever saw was in the house of a distinguished artist in one of the London suburbs, and the sole decoration on the walls was one of these screen pictures in each of the wall divisions; but these were of very rare beauty, both in design and execution, and the tone of the room had their color for its key . . .

Hardly anything in the modern parlor is so uninteresting as the mantel-piece. It is such a trouble to most people to think what to put on it, that they end by accepting blindly the dictation of friends and tradesmen, and making to Mammon the customary sacrifice of the clock-and-candelabra suite . . .

The mantel-piece ought to second the intention of the fire-place as the center of the family life—the spiritual and intellectual center, as the table is the material center. There ought, then, to be gathered on the shelf, or shelves, over the fire-place, a few beautiful and chosen things— the most beautiful that the family purse can afford, though it is by no means necessary that they should cost much, the main point being that they should be things to lift us up, to feed thought and feeling, things we are willing to live with, to have our children grow up with, and

that we never can become tired of, because they belong alike to nature and to humanity. Of course, if one were the happy owner of a beautiful painting,—but that is so rare a piece of good fortune we need hardly stop to consider it,—the problem would be easily solved, but we are happy in knowing that in these days there can always be procured, at trifling expense, some copy of a noble picture—the "Sistine Madonna" of Raphael, the "Madonna of the Meyer Family," by Holbein, or some one of the lesser, yet still glorious, gifts of Heaven to man . . .

Of course, the two or three "great" things having been installed, there is room enough for the pleasant little things that always find a hospitable place at the feet of greatness, and which, as they cannot derogate from the master's dignity, so neither does his dignity crush them, nor make us think them out of keeping. Here is the bit of Japanese bronze, or the Satsuma cup, or the Etruscan vase, or the Roman lamp, or the beautiful shell, or the piece of English or Venetian glass. Here, too, is the tumbler filled with roses, or the red-cheeked apple, or the quaintly painted gourd, or the wreath of autumn leaves. And here, too, must be the real candlesticks, with real candles to be lighted at twilight, before the hour for the lamps, in the hour of illusion and of pensive thought, casting a soft, wavering gleam over the down-looking picture and the mysterious cast, and bringing a few moments of poetry to close the weary working-day . . .

One trick of our time I should like to have a word with, and that is, the habit of over-ornamenting everything. It is not merely that we over-ornament; where ornament is advisable at all this is a natural enough fault to fall into, but we ornament a thousand things that ought not to be ornamented. It is hard to find an object of merchandise to-day that has not ornament (so called) of some kind stuck or fastened upon it. That terrible word "bare" seems to have frightened us all, and driven us to cover the nakedness of things with whatever comes to hand. We cover our note-paper with clumsy water-marks, we put "monograms" (though "many grams" would express better the multitudinousness and intricacy of these illegible devices) on our clothing, on our bed-linen, on our table-linen, on our books and title-pages, on our carriages and silver—our silver! Oh, was there ever silver like unto ours for knobs and welts, and wrinkles and spikes, and everything that silver shouldn't have! If the reader will look about him as he reads this, he will certainly find in his own surroundings—for we can none of us wholly escape—the justification for this criticism. The architects cannot design a house or a church but they must carve every stone, cover the walls with cold, discordant tiles, break up every straight line with cuts and chamfers, plow every edge into moldings, crest every roof-ridge and dormer-window with painted and gilded iron, and refuse to give us a square foot of wall on which to rest the tired eye. Within, the furniture follows in the same rampant lawlessness. The beauty of simplicity in form; the pleasure to be had from lines well thought out; the agreeableness of unbroken surfaces where there is no gain in breaking them; harmony in color, and, on the whole, the ministering to the satisfaction we all have in not seeing the whole of everything at once,—these considerations, the makers of our furniture, "fashionable" and "Canal street" alike, have utterly ignored, and the strife has long been, who shall make the loudest chairs and sofas, and give us the most glare and glitter for our money.

Just as I had written these deprecating words, I took down my overcoat from where it had been hanging, and, as the loop hesitated a little about slipping off, I gave a closer look at the hook. It was as ill-adapted to its use as the maker could contrive; cut out apparently from a thick sheet of brass with a dull chisel, the edges left as sharp as the tool would allow, so as to give the loop every opportunity to fray and cut itself free, and each of the branches armed with a little round at the end so as to prevent your getting your coat off in a hurry. However, as a make-weight for all this want of consideration for the utilities, the flat sides of the hook (which,

to tell truth, was cast, and not cut out of a thick sheet of brass) were ornamented with an extremely pretty pattern, so that if you had plenty of leisure, or if your coat should detain you some seconds in getting it off the hook, you could improve the time in studying "how to apply art to manufactures." . . .

"Picking up" at home is a much pleasanter, if it be a more difficult task, and a lady the other day hit, with a woman's tact, upon the reason. She was talking, to be sure, of china, and not of furniture; but the argument applies as well to one as the other. She said the things we come upon in our own country are soon at home in our houses, because they were used by our own ancestors or our own people. They were to the manor born. They neither look affected, nor strange, nor pretentious, but native and natural. And one reason why it is not so easy to pick up the furniture of by-gone times in America is, that those who have inherited it are learning to value it, and are less and less willing to part with it. As our readers know, old furniture is "the fashion" in some parts of our country. In Boston a polite internecine warfare has for some time raged between rival searchers after "old pieces," and the back country is scoured by young couples in chaises on the trail of old sideboards and brass andirons. It is a pursuit highly to be commended, but it is apt to become fanatically fascinating, and, in their blind admiration, the young things buy many articles that even Mrs. Toodles would have had the judgment to resist. It is surprising to learn to what strange uses things may come at last! In the suburbs of Boston, the best places in which to look for Jacobean sideboards and cupboards that came over in the "Mayflower" are found to be the hen-yards, the closets and drawers having been for years given over in fee-simple to the fowl. Several handsome oak cupboards that now adorn pretty Boston dining-rooms had to be feathered and singed before they could be made presentable. The way in which they have stood this usage is creditable to their makers; so far from being hurt by it, they are really improved by their adventures. Experience of the mutabilities of fortune has been good for them, as it is good for everybody. They are well seasoned; they have a good healthy color, and their angles are enough rubbed down to take away the disagreeable look of newness which troubles us in things just out of the shop. Besides, in most cases this newness has to be rubbed off by human beings, and its loss represents just so much wear and tear of our muscle and heart-strings; but with these latest treasure-troves of Boston, all this has been done for them by proxy—by the hens.

In the rage that has sprung up of late for "grandfathers" and "grandmothers,"—a kind of thing till very lately ignored, if not despised, in the bumptious arrogance of our social youthfulness,—it adds inestimably to the value of sideboards, andirons, and old china . . .

This mania, as it is called by the scoffers, for old furniture is one of the best signs of returning good taste in a community that has long been the victim to the whims and impositions of foreign fashions. The furniture which was in use in this country in the time of our grandfathers (of the great-grandfathers of the girls who, I please myself with thinking, sometimes look over these pages for the sake of the pictures) was almost always well designed and perfectly fitted for the uses it was to be put to.

Maria Oakey Dewing, Beauty in the Household *(New York: Harper and Brothers, 1882).*

We are very often asked what is a "warm" and what a "*cold*" color.

All colors that approach *yellow* in their tone are *warm*. The *coldest* of the simple colors is *blue.* Red is colder than yellow, and warmer than blue. If we mix a little yellow with blue (thus making it a somewhat greenish blue) it is a warm blue; mixed with a little red it approaches purple, but is still a cold blue, but not so cold as pure cold blue that has no suggestion of green. Red

mixed with a little yellow (though it be not yellow enough to be called orange) becomes a warm red; mixed with a little blue it inclines to purple, and is a cold red. Yellow is a warm yellow when mixed with red, and a cold yellow when mixed with blue, thus becoming slightly greenish. Pure white mixed with pure yellow also makes a cold yellow. The purples are cold as they approach blue, and warm as they approach red. The greens are cold as they approach blue, and warm as they approach yellow. White may be cold or warm. A warm white is yellowish; a cold white is bluish. Lavender is a cold color, being a purple that is much mixed with cold white and blue . . .

Blue stands more alone than any other color. It is less akin to red or yellow than either red or yellow to each other. This is, indeed, its great value as a color. It is a little out of tone, and makes a brilliant, telling note, like cymbals introduced among other instruments . . .

Yellow is, in truth, warmth itself; and to speak of "cold yellow" is to speak of it comparatively, not intrinsically; for the coldest yellow is warm compared with the warmest blue. Yellow is a color that can be contrasted with various shades of itself more unerringly than any other color. There is no tone of yellow that is inharmonious with any other, which cannot be said of any other color.

It is one of the most difficult things to lay down exact rules for color, partly from the impossibility of explaining in words so as to be comprehensible the very delicate shades of difference. One finds set down in books on this subject the statement that red, blue, and yellow are the primary colors, and that complete harmony demands a combination of the three—thus, that blue demands for contrast orange, because orange is composed of red and yellow, and thus complements blue; that red demands green, because green is composed of blue and yellow, and thus complements red; that yellow demands purple, because purple is composed of blue and red, and thus complements yellow.

In fact, this is a falsity. In this way we attain a "screeching" contrast that is painful to an educated eye. There are, indeed, blues that may be contrasted well with orange, but they are by no means the pure blue; nor can the orange be of equal parts of yellow and red. There are tones of green-blue, usually pale tones, that may be used with small quantities of orange in which either the red or yellow predominates. Pure yellow contrasted with purple composed of equal parts of red and blue is unbearably harsh; while a dark purple that is almost blue is rich and beautiful with gold color; and yellow contrasted with a purplish brown is most harmonious; while brown, which is a composition of black, yellow, and red, is even more harmonious with green than with blue, which ought, according to the received rule, to be its only proper complement.

We may take a lesson from Nature in color, and see how she disregards this manufactured theory of complementary colors—how boldly she gives a green calyx and leaves to the purplish-blue fringed gentian; how her blue morning-glories turn purple on their edges and lie close to their green leaves; how her bright yellow daffodils dance on their green stalks, unconscious of any fault. The red poppy has a brownish purple centre; the sweet-pea mixes purple, rose, creamy white, and blue-white without fear. The red cactus has a leaf that is rather blue than green; and we surely feel no inharmony in the green trees seen against the bluest sky.

In fact, harmony of color often depends more on repetition than on contrast. Pale people sometimes wear red, in the mistaken idea that it gives them color. Unless there is red in the hair or complexion, as often there is dormant red, to be waked by bringing red into juxtaposition, the red makes the pale person appear only the paler. And this is as true in other decoration as in personal adornment. Red and gray have always been accepted as a tasteful contrast. Really they are, in nine cases out of ten, painfully glaring; while gray with purple is soft and beautiful, and gray with yellow is one of the most elegant of harmonies.

Black and white are generally supposed to be available with any color, or with each other, being *neutral*. Now, it is to be remembered that they are the two extremes of what the artists call "value." They are the Alpha and the Omega—farther apart from each other than any other color is from either of them; and together they must be used in judicious quantities, a warm white being better than a cold white with black, and solid or opaque black being very inharmonious with some colors. Dark blue and black being but a gloomy contrast—light blue needing to be of a greenish tone to be beautiful with black, and greens—especially the olive greens, which are composed of blue and yellow and red—are more harmonious with black than any other color . . .

There is such a thing as elegance and vulgarity in color, though it is not easily described in words. Brilliant yellowish pink with black cannot be said to be distinctly inharmonious, yet it has this vulgarity; while, contrasted with brown or with gold, or some other yellows, with deep olive-green or with certain fawn colors, it has both richness and elegance . . .

Form is quite as necessary to beauty (if not more so) as color; and the word "picturesque," which is the opposite of "classic," has done more harm, in the acceptance of the unintelligent, to modern art, especially household art, than, in its intrinsic sense, it could be held responsible for. Picturesque means, to most people, the chaotic, the ugly—recommended by brilliant color—the uncouth, the clumsy. Now, the picturesque, properly speaking, means the opposite of the severe and sculpturesque. It means the original and characteristic; but it means, also, the beautiful, and must be no chaos, but a new, unconventional revelation of law . . .

Proportion is the first element of form; line comes next. Most of us have to accept such forms as we find already made in the rooms we furnish; but we may apparently alter the proportion greatly by our arrangement of line and mass . . .

Harmonious color alone will not make a room beautiful. One must guard against two extremes—first, that lack of repose which too many and too striking forms produce; then the effect of weakness that too minute and ineffective forms produce. To imagine an extreme instance: a large wall covered with a paper designed in a small check would be painfully monotonous; while the same wall covered with strong-colored, irregular forms, that catch the eye like crooked rustic boughs tied with ribbons (we have seen such a paper), is worse in the opposite direction . . .

There are certain very simple principles to be observed in furnishing in the matter of proportion and form, after which all rules must have many exceptions, being modified by the condition of the surroundings. One invariable rule is not to have the objects in a room too uniform in size; neither must each one differ from every other in size. The first mistake makes your furniture appear like a regiment of regular troops, the second like a company of fantasticals, in which the eye finds no rest . . .

There is a modern fashion which passes our understanding—that of using as ornaments in a room china dogs and cats, sometimes so realistic as to be mistaken for life. The larger and the uglier they are the more their collectors seem to admire them, but must also have a pack of small ones filling their tables or cabinets. The pug-dog, the ugliest of animals, is the favorite; and of cats, those with malign, green eyes, that glare at one even when the twilight gives one hope of repose, and when a soft, warm, living cat would close her eyes and present a smooth back to your sympathetic hand.

We know that the fair purchasers of these hideous china objects do not pretend to be gratifying their sense of the beautiful or sentimental. We know that their object cannot be scientific. We give up the riddle.

Cheap imports and mass-produced imitations popularized the Aesthetic style of decoration while dismantling its credo of discriminating taste and exquisitely calibrated harmony. In his novel A Hazard of New Fortunes, *the realist writer William Dean Howells parodies the vogue for Aesthetic décor in his description of Mrs. Grosvenor Green's apartment as seen through the eyes of prospective tenants, Basil March and his wife. In his description, Howells dwells satirically on the display of gaudy accessories, which in their sheer, cluttered abundance expose good taste gone bad.*

William Dean Howells, A Hazard of New Fortunes *(New York: Harper and Bros., 1890).*

They . . . faltered abashed at the threshold of Mrs. Grosvenor Green's apartment, while the Superintendent lit the gas in the gangway that he called a private hall, and in the drawing-room and the succession of chambers stretching rearward to the kitchen. Everything had been done by the architect to save space, and everything to waste it by Mrs. Grosvenor Green. She had conformed to a law for the necessity of turning round in each room, and had folding-beds in the chambers; but there her subordination had ended, and wherever you might have turned round she had put a gimcrack so that you would knock it over if you did turn. The place was rather pretty and even imposing at first glance, and it took several joint ballots for March and his wife to make sure that with the kitchen there were only six rooms. At every door hung a portière from large rings on a brass rod; every shelf and dressing-case and mantel was littered with gimcracks, and the corners of the tiny rooms were curtained off, and behind these portières swarmed more gimcracks.[2] The front of the upright piano had what March called a short-skirted portière on it, and the top was covered with vases, with dragon candlesticks, and with Jap fans, which also expanded themselves bat-wise on the walls between the etchings and the water-colours. The floors were covered with filling, and then rugs, and then skins; the easy-chairs all had tidies, Armenian and Turkish and Persian; the lounges and sofas had embroidered cushions hidden under tidies. The radiator was concealed by a Jap screen, and over the top of this some Arab scarfs were flung. There was a superabundance of clocks. China pugs guarded the hearth; a brass sunflower smiled from the top of either andiron, and a brass peacock spread its tail before them inside a high filigree fender; on one side was a coal-hod in *repoussé* brass, and on the other a wrought-iron wood-basket. Some red Japanese bird-kites were stuck about in the necks of spelter vases, a crimson Jap umbrella hung opened beneath the chandelier, and each globe had a shade of yellow silk.

March, when he had recovered his self-command a little in the presence of the agglomeration, comforted himself by calling the bric-á-brac Jamescracks as if this was their full name.

The disrespect he was able to show the whole apartment by means of this joke strengthened him to say boldly to the Superintendent that it was altogether too small.

AESTHETIC AND INDUSTRIOUS WOMEN

Creating new roles for artists as designers of social space, the Aesthetic movement catalyzed the establishment of workshops and small firms that designed and produced tex-

[2] Elaborately embellished curtains hung over doorways, portières became a cliché of Aesthetic style, as Howells's satire indicates.

tiles, ceramics, tiles, stained glass, furniture, metalwork, and wallpaper. Many of these enterprises, notably Candace Wheeler's Associated Artists in New York and the Rookwood Pottery in Cincinnati, afforded new opportunities for women seeking viable and marketable skill as well as a new medium of artistic expression.

At the age of fifty, Candace Wheeler launched a successful and influential career as textile designer and activist working to help women achieve financial independence. Resolved to establish an organization that would train them in useful crafts and help market their wares, Wheeler cofounded the Society of Decorative Art of New York in 1877, recruiting artists and designers to teach classes there. In 1878 she joined Louis Comfort Tiffany's pioneering interior decorating firm, Associated Artists. After the firm broke up in 1883, Wheeler continued with her own textile company under the same name, employing a large staff of women workers and producing wallpaper and textile patterns for mass production. In business until 1907, Associated Artists made an important contribution to the professionalization of interior decoration and created viable opportunities for women to achieve self-sufficiency. The article from Harper's *below offers a colorful picture of Associated Artists in action.*

The art pottery movement had its inception in china painting, a popular and almost exclusively feminine pursuit. Already a center of ceramic manufacture because of the abundance of fine clay deposits in the Ohio River valley, Cincinnati became the thriving hub of experimentation in the production of wares by women, professional and amateur alike. M. Louise McLaughlin and Maria Longworth Nichols were but two of the more prominent ceramic artists working there, and the writer of the article excerpted below marvels at the wide range of women who succumb to the "fascinating contagion" of pottery making and marking. Nichols had just launched her own company (Rookwood Pottery), which was soon to become a thriving business renowned for innovative glazing techniques, exquisite artistry, and the finest craft.

Mrs. Burton Harrison, *"Some Work of the 'Associated Artists,'"* Harper's New Monthly Magazine 69 (August 1884).

A few years ago a little band of artists of New York, headed by Mr. Louis C. Tiffany, determined to inaugurate a new era in house decoration, where each member of the advisory firm should be a specialist of skill and ripe culture. This was done; and the results they have brought about may, without exaggeration, be called the first-fruits of the American Renaissance. Very little was attempted by the association to secure the attention of the public that throngs and wonders. Their work, principally executed to beautify certain elaborate interiors, has been hurried by the owners from work-room or atelier into jealous seclusion as soon as it was finished . . . the artists have been enabled, by repeated efforts in combinations, through advanced skill on the part of their work-people, and with successful development of native industries, to show continual progress . . . In their hands wood, metals, glass, mother-of-pearl, gold and silver, canvas, silk, serge, "cloth o' gold and cloth o' frieze," dyes and pigments, threads of silk and gold and wool, have been alternately treated to the action of tool, brush, or needle, and dismissed bearing unmistakable evidence of their artistic birth-place.

In this development of combined industries it was soon found that the department of tapestries and embroideries had assumed a character of distinct national and commercial importance, requiring for development certain conditions materially hindered by an association for the production only of combined forms of decorative work. After three years of co-operative

study and fruitful experiment it was decided, therefore, to detach this department of artistic needle-work, allowing it to convene a new group of artists having taste and gifts especially adapted to its growth. The original scheme of the enterprise was continued under the name of Louis C. Tiffany and Co., its offshoot retaining the impersonal title of Associated Artists as better suited to the requirement of an enterprise under feminine control. Of these artists themselves it is permitted me to say little. That the association is directed and inspired by Mrs. Wheeler, Miss Dora Wheeler, and Miss Rosina Emmet is to Americans an earnest of the results attainable, as well as an explanation of those attained. And it is pleasant to record here a tribute to the progressive excellence of the designs furnished by Miss Ida Clark, formerly a pupil, and now an active worker in the councils of the Associated Artists.

It is in the blending of art and manufacturing industry that we Americans are vitally interested, and we shall now see how far into this fresh field the footsteps of a few brave women have led the way. One who is fortunate enough to possess an open sesame to the modest dark green portal in East Twenty-third Street behind which the Associated Artists conjure into existence so many marvels will at the out-set be forcibly struck by the fact of the growth in American taste making such an establishment not only possible, but remunerative. Here, under Mrs. Wheeler's inspiring rule, are produced the beautiful pieces of embroidery of which this paper designs to treat. To describe the furniture, inlay-work, ceilings, wall-papers, panellings, parquetry floors, and glass mosaics originating in the fertile brain of Mr. Tiffany and his coadjutors in the ateliers of Fourth Avenue close by would be a chapter apart . . .

Remembering the gallant struggle made, during the last twenty years especially, by the silk weavers of the United States, who have tried in the face of so many obstacles to obtain for their products footing with imported goods, it is pleasant to record to their honor an unqualified success. One of the first problems the Associated Artists set themselves to encounter was how to lighten the cost and extend the variety of silk and woolen stuffs. American women have as a rule withheld their patronage from American silks; but it is safe to say that any one examining the recent products of Connecticut and New Jersey looms, woven to the order of the Associated Artists, after designs furnished by them, will go away repenting past omissions, and zealous of future purchase. These fabrics include filmy "India" silks, silk sail cloths of great lustre and durability, silk canvases, and damasks like those in which Paul Veronese clothed his golden blondes.

For hangings of all kinds, and for "picture" dresses, these materials are not to be surpassed. The designs where a pattern is employed are admirable, and the tints supplied range from silver white to amber, gold, and orange, from blush pink to copper and pomegranate, with many greens and blues, in some cases intermingled . . .

Not satisfied, however, with producing stuffs to exchange for the plentiful shekels of American plutocracy, the artists have wisely carried their experiments into the region of cheap materials. One result is a fabric of raw silk, serving to utilize the waste of costlier webs, and dyed in the skein, in varied tints of the same color, giving it when woven all the effect of the Eastern hand-dyed, hand-woven stuffs so much admired. This is sold at a very moderate price. Chintzes and cottons receive as much care in the design as their expensive brocades, and Kentucky jean or denim has been known to take upon itself the semblance of Oriental drapery for wall or door. A sort of dado of this homely dark blue stuff (so familiar to the eyes of Southern or of Western people in the common garments of their negro population) has been decorated with interlaced rings of chestnut plush, a space on the wall above covered with blue and white striped awning stuff, and the frieze painted in reds and pinks above. Always design is studied with ref-

erence to use. A woven stuff designed by Miss Ida Clark for the hangings of a palace car has for its pattern a peal of bells, scattered as if driven by the wind, with a border of coupled car wheels, and drifting smoke between.

Thus it will be seen that the aesthetic housekeeper ambitious to adorn her room of state, the modest mother of a household who can spare this much and no more for a thing of beauty in her home, and the embroiderer seeking fresh fields for the vagaries of her needle, need no more look to sources over sea for their material.

Embroidery silk, to take the place of filoselle, is another industry of this busy hive. Brilliant as floss, it is expected that in time this silk will cost less than imported filoselle.

To properly classify the methods of embroidery used by the Associated Artists I have no hesitation in placing at the head of the list a needle-woven tapestry illustrating a distinctly new departure in decorative needle-work, which will probably take the name of the originator, and be known to collectors of the future as the Wheeler tapestry . . .

The method of working this tapestry . . . may be best understood by calling to mind the much-neglected domestic art of stocking darning, which, in these days of machine-made hosiery, has been tossed into the waste-basket of oblivion. This homely stitch is still seen in some Turkish embroideries, and was once made famous by old Flemish workers, as well as by those of Italy and Germany. In the Wheeler tapestry the darned threads are carried across either the woof or warp of the ground according to the desired effect of texture, and are *not* crossed by a returning thread, as in ordinary basket darning. When finished it is difficult even for a practiced eye to discern how they have apparently become incorporated with the stuff. The impression gained is that of a vignette, where the atmosphere fades into the ground tint of the stuff. In many cases the last range of stitches is supplied by using the ravelled silk of the original material.

The general effect of color aimed at in these needle work pictures is flat, but the artist who continually oversees them while under the worker's hand can not resist a suggestion of light or shadow here and there, a deepening of tone in the hollow of plait or fold, a loving touch of the brush, as it were, supplying the gradations of tint that transform a lifeless surface of needlework into a spirited portrayal, as by pigments, of some form of natural beauty. What will no doubt recommend it to the artistic amateur is that there are no fixed rules for the stitches to be taken. Wherever, by changing the direction of them, a good effect can be rendered, it is done unhesitatingly. But, at the same time, experienced workers will see how impossible would be the undertaking of such a labor as one of these tapestries without constant supervision from the eye of a trained artist.

After the design is sketched upon the canvas, a strong outline in silks is supplied, unlike that made with the brush in china painting in that it precedes instead of finishing the work. The worker is supplied with a carefully colored sketch of the subject, and some idea of the labor necessary to complete a piece of this tapestry may be gained from the fact that the "atmosphere" alone, surrounding a breezy nymph now being clothed with substance upon the frame, will require to perfect it fully four months' time of a steady work-woman.

The most conspicuous achievement in hand-wrought tapestry yet sent out by the Associated Artists, and certainly the most important order in needle-work ever executed in this country, is the Vanderbilt set of wall-hangings already alluded to as having excited favorable notice in the recent Loan Collection at the Academy of Design. These tapestries, eleven in number, were executed after designs from Miss Dora Wheeler, representing phases of life in its holiday aspect. They include groups of dancing figures: an Undine seated beneath the curve of a wave

holding a shell, from which drop garnered pearls; her comrade, a creature of the air, summoning birds, which come swiftly at her call; nymphs with musical instruments; amorini swinging upon ropes of roses, or playing at hide-and-seek amid flowers; together with a design full of poetic beauty, entitled "The Birth of Psyche." . . .

In the department of appliqué embroidery the Associated Artists have originated many interesting pieces of work. One of their earliest efforts was a portière for the Veterans' Room of the Seventh Regiment Armory, made of dull Japanese brocade, bordered with plush representing leopard-skin. Upon the main space of the curtain are worked square appliqués of velvet, each one embodying some design suggesting the days of knighthood and romantic warfare. The intermediate spaces of the brocade are covered with overlapping rings of steel, to represent a coat of mail.

For the solace of those pathetic wanderers from home compelled to seek the shelter of a clubhouse, the artists have invented more than one noteworthy piece of decorative embroidery. Among those at the Union League is a large curtain for the library window. This is made of cloth of gold, and is framed in massive plush. Upon the central panel is embroidered a net, in whose meshes are entangled fish with jewelled scales. At intervals the stuff is cut from beneath the fish, leaving, when the curtain hangs against the light, the effect of an illuminated transparency.

A favorite bit of embroidery is known as "The Sermon." On a curtain of ordinary brown holland appear appliqué disks containing groups of field flowers, bees, or butterflies, with connecting traceries of silk thread. It was devised as a reminder no less than a proof of the fact that true art in needle-work depends not upon stuffs and mere externals, but upon the worker's artistic intuition. This delicate admonition is enforced by the materials employed to produce this pleasing result in decoration, none of them soaring beyond the ranks of ordinary use, or exceeding the possibilities of the humblest worker.

Thus it will be seen that although appliqué work in the original form is classed among the antiquities of needle lore, the Associated Artists have contrived to throw around it a mantle of originality . . .

. . . The artists have continually striven to make the development of color schemes depending upon the inspiration of the worker a distinguishing characteristic of their productions.

Mrs. Aaron F. Perry, "Decorative Pottery of Cincinnati," Harper's New Monthly Magazine 62 (May 1881).

The first occasion on which the decorated ware of Cincinnati was shown in a quantity to be specially remembered was in May, 1875, at the "International Entertainment" given by the "Women's Centennial Executive Committee of Cincinnati," in the old Elm Street Exposition building, on the site of which the College of Music now stands. In the general aim of this committee to make a creditable addition to the work of women at the Centennial Exposition, the specialty of china-painting, then exciting some interest among the women here and in other parts of the country, was looked upon as promising a possible field of lucrative work for women. The exhibit, prepared by a few ladies of Cincinnati for this occasion, consisted of several dozen pieces—cups and saucers, pitchers and plates. The excellence of its execution excited attention, and many of the articles, together with subsequent work, were sent to the Centennial Exposition the next year . . .

The origin of the movement can not be more precisely told, perhaps, than by saying that in the summer of 1874 Mr. Benn Pitman, of the Cincinnati School of Design, started a class of ladies (who had had some practice in water-color painting) in china-painting. The specialty of china-painting was not included in the curriculum of the School of Design, and could not, un-

der the rules, be taught there. Mr. Pitman procured the necessary materials, invited the ladies to meet at his office for instruction, and engaged the late Miss Eggers as teacher . . .

Among the efficient means of popularizing china decoration in Cincinnati at an early day were the establishment of a small oven, and the teaching of overglazed painting, by Mr. Edwin Griffith, in the spring of 1877. He visited the New Jersey potteries, learned something of the processes of using the oxides and of firing, and being skillful in the use of the brush, and pleasant in his ways, he became a successful teacher. The classes of Mr. Griffith were taught, and the process of firing was carried on, in the third story of the old building on the southwest corner of Fifth and Race streets . . .

From 1874 to 1877, the attention of the ladies was exclusively given to overglaze painting.

In 1877, Miss M. Louise McLaughlin, who had been among the foremost in her success in china-painting in 1875, published a hand-book on china-painting, for the use of amateurs in the decoration of hard porcelain, and also began to experiment in her search for the secrets of the Limoges faience . . .

. . . At about the same time, or soon after, Miss McLaughlin painted the first successful piece of blue underglaze on white ware.

It is said that unsuccessful efforts have been made in different parts of Europe to imitate or reproduce the faience of Limoges. However this may be, there is no doubt that in the United States we are indebted to the intelligent interest and persistence of Miss McLaughlin for its accomplishment. Months of labor and considerable money were spent before success was achieved: the preparation of clays, the adaptation of colors, suitable firing for underglaze decoration, were all matters of vital importance in the accomplishment of the new decorative process. Down to this time there were no facilities for firing decorated wares beyond the very imperfect means used for firing the overglaze work of jars, and the ordinary kilns of the potters . . .

In the latter part of 1879, two kilns for firing decorated wares were built at the pottery of Frederick Dallas, one for underglaze, the other for overglaze work, the latter said to be the largest of its kind in the United States. The cost of these kilns was advanced by two ladies, respectively Miss McLaughlin and Mrs. Maria Longworth Nichols. During the year 1879, the work of Miss McLaughlin was transferred to the Hamilton Road pottery of Frederick Dallas.

In her specialty, which may be called Cincinnati faience, Miss McLaughlin has been constantly at work, month by month increasing her knowledge of methods, etc., until the results show a high degree of excellence and beauty. Many of her pieces have found homes in New York and other cities, but some of her largest and most successful specimens have not been seen outside of Cincinnati. Her "Ali Baba" vase, forty-two inches high, was produced in the winter of 1879–80, and has been presented by Miss McLaughlin, with other pieces, to the Women's Art Museum Association of Cincinnati. In the rooms of the association, with other ceramic work, it forms the nucleus of a collection probably destined to have historic interest in future years. This "Ali Baba" vase, or jar, has a groundwork of sage green, blending the gradations of color from the full tone up to a fleecy, cloud-like greenish-white; the decoration is a Chinese hibiscus, the colors being held in subdued tones. The potting of this piece, said to be the largest made down to that time in the United States, is the work of Frederick Dallas . . .

In the spring of 1879, a "pottery club" of ladies was organized, with twelve active and three honorary members. Each one of the ladies is at work upon some specialty, or at least bringing to her work so marked an individuality as to characterize it with distinctive features. All have painted, and still paint, overglaze; each works in incised design, in relief decoration, and in underglaze color.

The Pottery Club has rented a room at the pottery of Frederick Dallas, where it is convenient to work in the various specialties in the "green" clay and "biscuit" ware . . .

While it would be difficult to describe in this article the character and quality of the work of each member of the Pottery Club, any sketch of the decorative pottery-work of Cincinnati would be incomplete and unjust which failed of a due recognition of its excellence. Calling the roll of its membership brings into review much of the best of the enameled faience, of the underglaze color, of the incised design, of the relief-work in clay, and of the exquisitely finished overglaze painting, which have given reputation to the work done in Cincinnati.

To a smaller room, perhaps ten by twelve feet in size, also in the second story of one of the buildings of the pottery, two ladies, not of the Pottery Club, daily take their way through the dusty floors, piled high with partially dried "biscuit" and glazed wares. For them the hours of daylight are too few and short. From this dim and unattractive little nook comes a succession of creations unique in character and beauty. The vase of "green" clay, brought up from the hands of the thrower below, is submitted to the artistic fingers of Mrs. William Dodd and Mrs. Maria L. Nichols, who practice every style of work on "green" and "biscuit" ware, from incised design as delicate as the spider's web, to Cincinnati faience, and relief-work in clay so bold that one is tempted to reach forth her hand and take the bird from the bough . . .

The work of Mrs. Nichols is shown in vases of all sizes, and in wonderful variety of style, for her talents enable her to throw off work with uncommon rapidity. Among her pieces, during the last year, has been a succession of vases, each some thirty inches high. The body is of Rockingham in some cases, in others a mixture of Rockingham and white pastes, giving a soft buff color in some pieces, in others a rich cream. A majority of the large pieces of Mrs. Nichols are Japanese grotesque in design, with the inevitable dragon coiled about the neck of the vase, or at its base, varied with gods, wise men, the sacred mountain, storks, owls, monsters of the air and water, bamboo, etc., decorated in high relief, underglaze color, incised design, and an overglaze enrichment of gold. The large vases are thirty-two and thirty inches high.

Other pieces of Mrs. Nichols are in the fine-grained red clays of Ohio, decorated in incised and relief work, and an illumination of dead gold; surface finished with semi-glaze; also in a mixture of blue and yellow clays, producing charming tints of sage green, blue-gray, etc.

It is an interesting commentary upon the occupations of our women that the dusty quarters of the manufacture of iron-stone and Rockingham should be the point of attraction for so many of the refined and cultivated women of the city.

So much interest has been felt by the public in the practical work of the Pottery Club, that to avoid inconvenient interruption they decided to give an occasional reception, to which visitors would be admitted by cards of invitation. The first of the series was held in May, 1880. On this occasion not less than two hundred pieces were shown, which, from their variety of style and excellence of execution, formed a most interesting exhibit.

Early in 1878 the first effort in underglaze color in the Lambeth style, or, as it should be called, the "Bennett" style, was made by Miss McLaughlin . . .

The interest in this part of the country is not confined to Cincinnati, but to some extent pervades the towns and cities of Ohio generally. Ladies from Dayton, Hillsborough, and more distant points come here for lessons, send to the potteries for clay and "biscuit" ware, and return their decorated work for firing and glazing. Decorated work is sent here to be fired from New York, Iowa, Kentucky, Michigan, Minnesota, and Indiana. The number of amateurs in the city alone whose work is fired at the pottery of F. Dallas is more than two hundred, and of this large number all but two are women.

It is curious to see the wide range of age and conditions of life embraced in the ranks of the decorators of pottery: young girls twelve to fifteen years of age find a few hours a week from their school engagements to devote to over or under glaze work, or the modeling of clay; and from this up, through all the less certain ages, till the grandmother stands confessed in cap and spectacles, no time of life is exempt from the fascinating contagion. Women who need to add to their income, and the representatives of the largest fortunes, are among the most industrious workers; and it is pleasant to know that numbers of these self-taught women receive a handsome sum annually from orders for work, from sales, and from lessons to pupils.

As a purely social and domestic entertainment, much is to be said in its favor as an educating and refining influence. Taking the broader view, we are led to the conclusion, from the signs everywhere pervading the country, that the times are ripe for the introduction of a new industry in the United States, in which the feeble instrumentality of women's hands is quietly doing the initial work . . .

Looking back through six or seven years to the beginning, as it may be called, of the movement in china-painting, or the decoration of pottery, in the United States, we can not fail to be struck with its significance, taken in connection with the steady growth in the pottery trade, and the improvement in American wares . . .

Begun by a few thoughtful women of taste and social influence, who foresaw possible results of importance to their city, as well as pleasant occupation to women of leisure, and a solution, to some extent, of the problem of self-support and independence for women, the work has gone on, one successful experiment after another marking its advance.

If, in the earlier part of the movement, clays from distant parts of the State were wanted, a woman sent for them; if kilns for firing decorated wares were needed, the money was provided by women. A young woman, after patient experimenting, and the bestowal of time and money, discovered the process of making Limoges faience; an amateur, self-trained, she has published a little volume of instructions to amateurs on overglaze painting, now in its ninth edition; and a similar handbook from the same pen, "*Pottery Decoration Under the Glaze,* by Miss M. Louise McLaughlin," has recently been issued from the press of Robert Clarke and Co . . .

In Cincinnati, the crowning result of the six years' work by women, and the earnest of the future, is also inspired and executed by a woman. During last autumn a new pottery for decorative work went into operation in the suburbs of the city. In addition to toilet sets, pitchers, etc., to which attention will be given, it is the intention to manufacture gray stone-ware, which is not now made in Cincinnati, and to put upon the market a class of articles for which there is a practical and constant demand, of shapes so good that the simplest article of household use shall combine the elements of beauty.

These are pleasant times and places, when women give their leisure and means to the founding of an artistic industry. Mrs. Maria Longworth Nichols, by this use of time and money, practically opens a path in which unlimited work for women may eventually be found.

JAPONISME

Japanese art was a powerful agent of change in Western art of the nineteenth century. Long sealed off from most contact or trade with Western powers, Japan opened its doors to foreign commerce as a result of Commodore Matthew Perry's coercive expedition there in 1852–54. Four years after the conclusion of the U.S. war with Mexico, Perry's expedition represented another stage in the imperial expansion mandated by American

manifest destiny. Once trade began to flow, Japanese prints soon appeared in Europe, England, and America, along with screens, ceramics, and textiles. European and American artists alike experienced Japanese art as a liberating and purifying source of inspiration, freeing them from the tyranny of realism and the mimetic imitation of nature.

John La Farge began to collect Japanese prints in Paris as early as 1856, and he married Margaret Perry, the commodore's niece, in 1860. He eventually went to Japan with the writer Henry Adams in 1886, spending months traveling, observing, and recording his impressions in prose and sketches. In his writings, La Farge figures Japanese art as an overflowing storehouse of ideas for Western artists. He finds that Japanese artists, unlike Westerners, are not slaves to appearances; in aiming for synthesis rather than analysis, they offer a model for the Western artist to follow. As other remarks suggest, however, La Farge, like many Westerners at the time, regards the Japanese as the child-like and simple inhabitants of an earlier and more innocent world. Their art is free for the taking as imperial cultural plunder, appropriated in the interest of regenerating and advancing Western art.

An influential educator, the painter and printmaker Arthur Wesley Dow introduced Japanese aesthetics to the classroom in Composition, *which for decades remained the standard text for teaching art and design. Through this book and his teaching career at Pratt, the Art Students League, Columbia University Teachers College, and his own school in Ipswich, Massachusetts, Dow played a key role in establishing formalist values as the basis of modern art and design. Urging students to reject the literal imitation of nature, Dow, in the excerpt below, endorses the Japanese concept of Notan, or dark-and-light, as the means to achieve mastery of tonal relations. By adopting this principle to landscape, the student will be able to create a harmonious and decorative design based on nature while avoiding the accidental and the merely transitory. Dow recommends that students study Japanese books and prints closely. From them, aspiring artists will learn that for the Japanese there is no line dividing description from decoration. Finally, Dow's remarks concerning Zen thought and the spiritual interpretation of nature recapitulate major themes in American landscape art, now filtered through an Orientalist lens.*

John La Farge, "An Essay on Japanese Art," in Raphael Pumpelly, Across America and Asia *(New York: Leypoldt and Holt, 1869).*

Interest in Japanese art must have much increased, to have made Mr. Ruskin fear some malign influence upon his artists coming from this heathen source; and it is true that many artists are in the habit of looking to it for advice and confirmation of their previous tendencies and efforts in art . . .

Great beauty of color is apt to obscure the structure upon which it rests, and excellence of design is not seldom unrecognized in the works of great colorists. Little as this is felt in the harmonious synthesis of Japanese decoration, Japanese drawings and wood-cuts in black and white allow us to gauge their abstract power of design, and their knowledge of drawing. Stripped of those other beauties of color and texture so peculiar to their precious work, these drawings give us in the simplest way their control of composition, that power in art which affects the imagination by the mere adjustment of lines and masses. Herein their work can be compared to the best . . . Japanese composition in ornamental design has developed a principle which separates it technically from all other schools of decoration. This will have been noticed by all who have

seen Japanese ornamental work, and might be called a principle of irregularity, or apparent chance arrangement: a balancing of equal gravities, not of equal surfaces. A Western designer, in ornamenting a given surface, would look for some fixed points from which to start, and would mark the places where his mind had rested by exact and symmetrical divisions. These would be supposed by a Japanese, and his design would float over them, while they, though invisible, would be felt beneath. Thus a few ornaments—a bird, a flower—on one side of this page would be made by an almost intellectual influence to balance the large unadorned space remaining.

And so, by a principle familiar to painters, an appeal is made to the higher ideas of design, to the desire of concealing Art beneath a look of Nature . . .

. . . The two opposites of realism and decoration form the art of Japan, and that in this successful blending, it takes a distinct place, never before filled in the logical history of art.

Some of the compromises made necessary by this combination are interesting. Chinese art is often ridiculed for its complete absence of perspective; but our own practice of copying paintings, imitated in all their modelling and light and shade, upon the curved surface of our vases, is itself an utterly barbaric notion.

The perspective of the vase destroys the perspective of the ornament, which it is impossible even to see from a proper point of view. The treatment of perspective in Chinese decoration is, therefore, the result of a very sensible idea. But the Japanese have improved upon the usual Chinese manner, and have invented an interesting compromise, in which certain rules of linear or isometric perspective are used with a deep feeling for the actual appearance of nature: and by the use of high horizons, so that the different planes shall come one above the other, they manage to frame large compositions within quite an illusive effect. It is owing to this bird's-eye view that they are able to represent crowds and masses of people with enviable felicity, and give the feeling of open air and expanse to their smallest landscapes.

In the gradual separation of decoration and pictorial art with us there was at least this advantage, that the artist was impelled to the individual study of nature that he might mirror the great world in the little world of his picture.

To different origins we shall reasonably look for the causes which have kept the Japanese artist to flat tints and boundary lines in drawing, and have prevented his pursuing others of nature's appearances, and attempting to give the forms of things by the opposition of light and shade, or the influence of colored light. With the harmony which belongs to all good art, Japanese works, if they do not solve the latter problem, offer at least very successful sketches of such solutions. Their colored prints are most charmingly sensitive to the coloring that makes up the appearance of different times of day, to the relations of color which mark the different seasons, so that their landscape efforts give us, in reality, the place where—the illuminated air of the scene of action; and what is that but what we call tone? Like all true colorists, they are curious of local color, and of the values of light and shade; refining upon this they use the local colors to enhance the sensation of the time, and the very colors of the costumes belong to the hour or the season of the landscape. Eyes studious of the combinations and oppositions of color, which must form the basis of all such representations, will enjoy these exquisite studies, of whose directness and delicacy nothing too much can be said in praise . . .

I have no space to consider whether, if the Japanese have an ideal, it can be contained, as with the Greeks, in the dream of a perfected beauty. The sufficient ideal of realism is character. Nor, any more than in Pagan antiquity, need we expect to find in Japanese art that deeper individual personality—the glory of our greatest art . . .

Inquiry into Japanese art would give material for appreciation of the social state of the artist-

workman in mediæval times and in a military race, or again in Pagan antiquity, and for a study of the advantages and disadvantages connected with a fixed social condition: to which comparison the analogies and differences with their Chinese brethren will add help. But it must now be sufficient to have helped, in any way, to call attention to this art, which helps to bridge the gulf between us and the Eastern gardens. It can be the source of useful influences from a living school, equal to any in the study of nature and the use of decoration; and it offers, to all those willing to put themselves in the proper mood, a new and fresh fountain of imaginative enjoyment.

John La Farge, An Artist's Letters from Japan *(New York: Century Co., 1897).*

From all this poor stuff exhales the faded scent of a greater art and refinement, which is now invisible, or destroyed, or subsisting only in fragments, difficult of access, or which are far away. And there is a peculiar unity in the arts of the extreme East. We must remember that this very sensitive Japanese race has developed in its art, as in everything, without being subjected to the many direct and contradictory influences which have made our Western art and civilization. There have been here, within historic times, no vast invasions of alien races, bringing other ways for everything in thought and in life, and obliging an already complex civilization to be begun over and over again on readjusted bases; no higher living and advanced thought obliged to yield for times and half times, until the grosser flames of energy could be purified; no dethronement, within society tried by every other calamity, of the old primeval faith. Instead of a tempest of tastes and manners of feeling blowing from every quarter, and in which the cruder dislikes have held for centuries the balance against cultured likings and devotion, Japan has been carried on in one current, in which have mingled, so as to blend, the steady influences of the two most conservative civilizations of India and of China . . .

This impressionable race found, contrasting with and supporting its nature, secure, steady, undeviating guides, so that these foreign ideals have persisted here with a transplanted life . . . The limits and definitions of each may be clear to the Japanese critic, but to our casual Western eye they merge or derive one from the other, like some little-known streams which make one river . . .

All that our great men have done is exactly opposite to the tendency of our modern work, and is based on the same ground that the Japanese has lived and worked on—*i. e.,* the reality and not the appearance, the execution and not the proposition of a theme . . . We value material or the body instead of workmanship or the right use of the body; and instead of style and design, the intellect and the heart. To us a gold object seems spiritually precious, and we hesitate at working in other than costly materials. To the Japanese workman wood and gold have been nothing but the means to an end. We had rather not do anything than do anything not enduring, so that when our materials are difficult, the life has flown that was to animate them; the Japanese is willing to build a temporary architecture, and make a temporary lacquer, which holds more beauty and art than we to-day manage to get in granite or in metal.

And when the Oriental workman takes the hardest surfaces of steel or of jade, he has had the preparations for using it with mastery; it is again plastic and yielding for him, as the less abiding materials have been before. Nor would the Japanese artist understand the point of view of many of our men, who do their best to put an end to all art, so lost are they in our vanity of "advertisement." The Japanese would never have invented the idea of doing poorly the work one is forced to do to live, so as to reserve vast energy for more important or influential work that might draw attention to him. The greater part of our "decoration" is carried out just the contrary way to his . . .

Nor have the Japanese *left out* things. They have not been forced to overstudy any part, so as to lose the look of free choice, to make the work assume the appearance of task-work—the work of a workman bored, nobly bored perhaps, but still bored, a feeling that is reflected in the mind of the beholder. The Japanese artist makes his little world,—often nothing but an India-ink world,—but its occupants live within it. They are always obedient to all the laws of nature that they know of.

However piercing the observation of actual fact, its record is always a synthesis. I remember many years ago looking over some Japanese drawings of hawking with two other youngsters, one of them now a celebrated artist, the other a well-known teacher of science. What struck us then was the freedom of record, the acute vision of facts, the motions and actions of the birds, their flight, their attention, and their resting, the alertness and anxiety of their hunters, and the suggestions of the entire landscapes (made with a few brush-marks). One saw the heat, and the damp, and the dark meandering of water in the swamps; marked the dry paths which led over sounding wooden bridges, and the tangle of weeds and brush, and the stiff swaying of high trees. All was to us realism, but affected by an unknown charm.

Now this is what the artist who did this realism has said, as well as I can make it out: "The ancient mode must be maintained. Though a picture must be made like the natural growth of all things, yet it lacks taste and feeling if it simulates the real things."

Evidently the painter had not learned our modern distinctions of the realist and the idealist . . .

. . . Our arts have undertaken an enormous accession of truths and ambitions upon which the arts of the extreme East have never ventured. They have attained their end, the end of all art, at an earlier mental period. They are younger, perhaps even more like children, and their work cannot involve the greater complications of greater age; but it has also all that grasp of the future that belongs to youth, and that has to be accompanied by deficiencies of knowledge; that is to say, of later acquirement and the practice of good and evil. And it is impossible to look at the expression of nature, or of any intention made by the child in full sincerity, without realizing that the aim of the artist, be he even Michael Angelo, is to return to a similar directness and unity of rendering. Not that the Eastern artist, any more than the child, could be conscious of deficiencies of which he had not thought . . .

. . . The Japanese have not come to the work from the "model," which has at so many periods and so long been ours. Theirs are types of types; they are not, as with us, persons, and the pursuit of beauty in the individual has not been followed apparently by the art of the far East. The personal love and preference of the artist embodied in another person their art does not show; nor have their artists given a nameless immortality to certain human beings, so that for ages their types, their images, their moods, their characters, their most transitory variations of beauty, have been proposed to us as an example . . .

. . . The Eastern artists have suggested, and implied, and used light and shade, and perspective, and anatomy, and the relations of light to color, and of color to light, only so much as they could take into their previous scheme.

In many cases their success is still an astonishment to us. Certainly their records of motion, their construction of plants and flowers and birds, we have all appreciated; and their scientific, easy noting of colored light in landscape made even Rousseau dream of absorbing its teaching into his pictures, which certainly represent the full Western contradictory idea, in the most complicated acceptance of every difficulty.

The artist here, then, has not made separate analytical studies of all the points that trouble us, that have cost at times some acquirement of the past, in the anxiety for working out a new

direction; as to-day, for instance, in learned France, where the very art of painting, as a mirror of the full-colored appearance of things, has for a quarter of a century been in peril, under the influence of the academy drawing-school, the model in studio light, and the vain attempt to rival the photograph. And perhaps it is needless to repeat again how we have lost the sense of natural decoration and expression of meaning by general arrangement of lines and spaces, so that again in France we are astonished at M. Puvis de Chavannes, who uses powers that have once been common to almost all our race.

Here the artist does not walk attired in all the heavy armor which we have gradually accumulated upon us. His learning in side issues is not unnecessarily obtruded upon me, so as to conceal the sensitiveness of his impressions or the refinement of his mind. As for us, we have marched on in a track parallel to science, striving now for centuries to subdue the material world—to get it into the microcosm of our paintings. Each successive great generation has taken up the task, heavier and heavier as time goes on, halting and resting when some new "find" has been made, working out a new discovery often with the risk of the loss of a greater one.

But how often the processes have covered up what is most important,—to me at least,—the value of the individual, his aspirations, and indeed the notions or beliefs that are common between us.

Sometimes this covering has been sordid and mean, pedantic or unesthetic, sometimes most splendid. But how difficult it has been always for the many to read, for instance, in our great Rubens, the evidences of a lofty nature, the devout intentions of a healthy mind!

Not that we can turn back to-day and desert. From the time when the Greek first asserted in art the value of personal manhood to the date of the "impressionist" of to-day, the career has been one. And certainly in the art of painting a vaster future lies before us, whenever we are ready to carry the past. But remember that whatever has been really great once will always remain great.

Even if I were competent to make more than approaches to reflection, this place of dreams is not well chosen for effort. I feel rather as if, tired, I wished to take off my modern armor, and lie at rest, and look at these pictures of the simplicity of attitude in which we were once children. For, indeed, the meaning of our struggle is to regain that time, through toil and the fullness of learning, and to live again in the oneness of mind and feeling which is to open to us the doors of the kingdom.

Arthur Wesley Dow, Composition: A Series of Exercises in Art Structure for the Use of Students and Teachers *(New York: Baker, 1899).*

As there is no one word in English to express the idea contained in the phrase "dark-and-light," I have adopted the Japanese word "notan" (dark, light). It seems fitting that we should borrow this art-term from a people who have revealed to us so much of this kind of beauty. "Chiaroscuro" has a similar but more limited meaning. Still narrower are the ordinary studio terms "light-and-shade," "shading," "spotting," "effect" that convey little idea of special harmony-building, but refer usually to representation.

Notan, while including all that these words connote, has a fuller meaning as a name for a great universal manifestation of beauty . . .

The Orientals rarely represent shadows; they seem to regard them as of slight interest— mere fleeting effects or accidents. They prefer to model by line rather than by shading. They recognize Notan as a vital and distinct element of the art of painting.

The Buddhist priest-painters of the Zen sect discarded color, and for ages painted in ink, so

mastering tone-relations as to attract the admiration and profoundly influence the art of the western world . . .

Landscape is a good subject for notan-composition, to be treated at first as a design, afterward as a picture . . .

Notan in landscape, a harmony of tone-relations, must not be mistaken for light-and-shadow which is only one effect or accident. Like all other facts of external nature, light-and-shadow must be expressed in art-form. The student under the spell of the academic dictum "Paint what you see and as you see it" feels that he must put down every accidental shadow "just as it is in nature" or be false to himself and false to art. He finds later that accurate record is good and right in studies or sketches but may be wrong in a picture or illustration. No accidents enter into pictures, but every line, light, and dark must be part of a deliberate design . . .

The academic system has adopted the word "decorate" for flat tone relations and non-sculpturesque effects, as if everything not standing out in full relief must belong to decoration. This use of the word is misleading to the student; we do not speak of music and poetry as "decorative". Lines, tones and colors may be used to decorate something, but they may be simply beautiful in themselves, in which case they are no more decorative than music. This word should be dropped from the art vocabulary . . .

. . . Japanese art comes to the aid of the student of composition with abundant material—sketch books, design books, drawings and color prints. The learner should seek for genuine works of the best periods, avoiding modern bad reproductions, imitations, carelessly re-cut blocks, crude colors, and all the hasty and common-place stuff prepared by dealers for the foreign market.

The Japanese knew no division into Representative and Decorative; they thought of painting as the art of two dimensions, the art of rhythm and harmony, in which modelling and nature-imitation are subordinate. As in pre-Renaissance times in Europe, the education of the Japanese artist was founded upon composition. Thorough grounding in fundamental principles of spacing, rhythm and notan, gave him the utmost freedom in design. He loved nature and went to her for his subjects, not to imitate. The winding brook with wild iris . . . the wave and spray, the landscape . . . were to him themes for art to be translated into terms of line or dark-and-light or color. They are so much material out of which may be fashioned a harmonious line-system or a sparkling web of black and white.

The Japanese books of most value to the student of composition are those with collections of designs for lacquer, wood, metal and pottery, the Ukiyo-ye books of figures, birds, flowers and landscape, and the books by Kano artists, with brush-sketches of compositions by masters . . .

Supreme excellence in the use of ink was attained by the Chinese and Japanese masters. Impressionism is by no means a modern art (except as to color-vibrations) for suggestiveness was highly prized in China a thousand years ago. The painter expected the beholder to create with him, in a sense, therefore he put upon paper the fewest possible lines and tones; just enough to cause form, texture and effect to be felt. Every brush-touch must be full-charged with meaning, and useless detail eliminated. Put together all the good points in such a method, and you have the qualities of the highest art; for what more do we require of the master than simplicity, unity, powerful handling, and that mysterious force that lays hold upon the imagination.

Why the Buddhist priests of the Zen sect became painters, and why they chose monochrome are questions involving a knowledge of the doctrines of Buddhism and of the Zen philosophy. It is sufficient to say here that contemplation of the powers and existences of external nature, with a spiritual interpretation of them, was the main occupation of Zen thought. Nature's lessons could be learned by bringing the soul to her, and letting it behold itself as in a mirror; the

teaching could be passed on to others by means of art—mainly the art of landscape painting. Religious emotion was the spring of art-power in the East, as it was in the West. Landscape painting as religious art, has its parallel in Greek and Gothic sculpture, in Italian painting of the world-story, of the Nativity, the Passion, and the joys of heaven.

Some of these priest-artists of the Zen, Mokkei, Kakei, Bayen in China; Shubun, Sesshu in Japan, rank with the great painters of all time. They, and such pupils as Sesson, Soami, Motonobu and Tanyu, were classic leaders who have given us the purest types of the art of ink-painting. To them we look for the truly artistic interpretation of nature; for dramatic, mysterious, elusive tone-harmony; for supreme skill in brush-work.

JOHN LA FARGE'S REVOLUTION IN STAINED GLASS

Although stained glass is often associated with religious architecture, the most important developments of the medium in the United States occurred in a domestic context—specifically, the lavish, East Coast mansions equipped with floral windows designed by John La Farge. The story of the artist's awakening to the possibilities of stained glass is serendipitous: Sick in bed, La Farge looked up one day to see sunlight streaming through the cheap glass of a translucent tooth-powder jar on his windowsill. The accidental imperfections in the material were beautiful, and, soon after, he convinced glassmakers to fabricate "opalescent" glass for him—sheets that were semi-opaque and filled with multicolored streaks. He patented the procedure in 1880, and it became all the rage among an influential group of wealthy patrons. The early windows he designed—such as one depicting a peony bush in the wind for the Henry Marquand house in Newport, Rhode Island (1879)—used the new glass in plated layers and featured rich textural effects thanks to the introduction of semiprecious stones and rippled patterns imprinted in the sheets. The following review of these early efforts begins with an appeal for "the decorative point of view" in domestic architecture. It goes on to extol La Farge's glass designs as wonders of color and design—at once delicate and bold, traditional in medium but utterly original in execution.

"*Something New in Stained Glass,*" Boston Evening Transcript, *October 31, 1881.*

It is no unnoteworthy sign of the times that several American artists, among them Mr. Lafarge, have wholly or almost wholly abandoned the pursuit of their art in its higher and highest phases, and given themselves up to the productive study of art from a decorative point of view. The thinking art-lover cannot be sorry for this; it can hardly be doubted that the most potent agent in the artistic education of a people not yet quite out of its æsthetic leading strings is constantly to place them in the presence of beautiful objects, so to habituate their eyes to beauty, that it at last becomes an indispensable element in the *mise-en-scène* of their daily life. It is especially important, in the case of so essentially domestic a people as the American, that the house, the home, which plays so very prominent a part in our life, should be made as fair to look upon as possible. The more we think on this matter, the more firmly do we become convinced that decorative art is destined to be the great primary educator of our country in an æsthetic direction. The artistic sense is cultivated by habitual propinquity to the beautiful, even if such beauty do not manifest itself in the highest ideal phase of art, far more surely than by occasional, or semi-occasional converse with great pictures and statues. Rational decorative art is much easier to be made to follow the average American to his very fireside, than the higher and more ideal forms of painting and sculp-

ture, which latter are generally far beyond his means. And it is peculiarly needful that men of genuine talent and thorough artistic culture should give the right bent to fashion in matters of decoration. In no department of art is the artist more in danger of falling into—we will not say the commonplace, but the purely conventional, than in decoration. In no department are the decrees of fashion so likely to exert a strong influence for good or for evil, and in none is there so imperious a need for the display of that final blossom of artistic culture which we call good taste.

It was with a certain feeling of enthusiasm *ab initio* that we went the other day to look at Mr. Lafarge's exhibition of stained-glass windows at the Art Museum. Well, we must confess that at first sight of them we were completely dazed. Mr. Lafarge's work was so new, so unexpected, so utterly apart (saving in the matter of beautiful color) from anything previously associated in our mind with stained glass, that it took some time for us to come to our bearings, so to speak.

First and foremost, one notices the total absence of architectural elements in the designs; plain squares and parallelograms, that is all; no architectural devices, no pointed arches. The windows are stained-glass pictures in the most literal sense. The subjects, too, have not the faintest suggestion of mediævalism. The largest one in the middle shows us a rosebush, treated as unconventionally as possible, save that the bush bears roses of different hues, ranging from the deep red Jacqueminot to the delicate Souvenir. This is on a ground of deep blue, with fluorescent lights shooting through it, as in a transparent sapphire hoar frost. The whole is framed in by concentric bands of variegated color, in which the same deep blue tint is, however, predominant, relieved in the outer band by frequent flashes of deep red. After once getting over a feeling of wonder at the artist's daring in using such heavy masses of so unmanageable a color as deep blue, one cannot but be struck with the gorgeous richness and depth of tone of the whole. In spite of the boldly realistic treatment of the roses—which, except for their jewel-like flashes of colored fire are quite as real flowers as we see in any flower-painting—there is a harmony of coloring in the whole which infallibly delights the eye. The delicate shading of the petals of these flowers is produced by the same process as in those little biscuit transparencies which were once much in vogue; the glass, which is very thick in places, is in others cut to the due thinness to produce the effect of light and shade.

The other specimens are much smaller, but are all singularly beautiful. Very striking are the jewelled panes, in which round or roundish knobs of rich-colored glass are set at random, like precious stones, in a neutral ground. There are also some exceedingly lovely specimens of opalescent glass. In general the smaller designs are subdued and delicate, rather than brilliant in color.

IMPRESSIONISM: CRITICAL RECEPTION

AMERICAN ARTISTS CONFRONT IMPRESSIONISM

Several years before the American public was able to view French impressionist paintings, some of the American students resident in Paris were awakened to this new movement. J. Alden Weir and Ellen Day Hale—both from cultured, artistic families—were following conventional courses of study in Paris when they happened into the impressionists' exhibitions and recorded their adverse reactions. Weir had been in the atelier of the highly academic painter Jean-Léon Gérôme for several years at the time he visited the Third Impressionist Exhibition, in 1877, which he described in a letter home, below (see also "J. Alden Weir Writes Home about Jean-Léon Gérôme," chapter 11). The fifteen minutes he spent there could not have allowed him sufficient time to contemplate

the 230 works on view, which included Auguste Renoir's Bal au Moulin de la Galette *(1876), a* Bathers *(1875–76) by Paul Cézanne, and eight views of the Gare St. Lazare by Claude Monet. Hale, a student of society portraitist Carolus-Duran, saw the slightly smaller Seventh Impressionist Exhibition five years later. It featured thirteen works by Paul Gauguin and thirty-six by Camille Pissaro, among others. Though her initial reaction did not differ largely from Weir's, she was able to find some words of praise for Monet and, especially, Berthe Morisot.*

Ironically, both Americans' palettes would lighten and loosen in later years, and Weir would become known as one of the staunchest of the American impressionists. Others found it harder to change and leave behind their academic training. J. Carroll Beckwith (see also "Art World Diaries: Jervis McEntee and J. Carroll Beckwith," chapter 9), in a memorandum written after dining at Monet's house in Giverny, speaks despairingly of his own tendency to overfinish his paintings; he struggles to give up his conceptual approach (what he knows he should do) in favor of a perceptual manner (what he actually sees).

J. Alden Weir to his parents, April 15, 1877, Archives of American Art.

I went across the river the other day to see an exhibition of the work of a new school which call themselves "Impressionalists." I never in my life saw more horrible things. I understand they are mostly all rich, which accounts for so much talk. They do not observe drawing nor form but give you an impression of what they call nature. It was worse than the Chamber of Horrors. I was there about a quarter of an hour and left with a head ache, but I told the man exactly what I thought. One franc entrée. I was mad for two or three days, not only having paid the money but for the demoralizing effect it must have on many.

Ellen Day Hale to her family, March 16, 1882, Sophia Smith Collection, Smith College.

In the afternoon I had been with Mrs. Greene at the Exhibition of Indépendants, or Impressionist painters. It has the oddest effect as you enter it, next to no values. And a great deal of blue and green being the predominant features at first; purple also is a very favorite color. It all makes you feel rather sick the first minute; but on looking at the pictures separately you find that you like a great many of them. There were some effects of snow and thaw, and some skies and seas which were very well worth seeing indeed, especially those by a man named Monet (not Manet, he's different) but most of the brethren I'm sorry to say drew the figure in the most evil manner you can possibly imagine, and painted it disgustingly, as if they were little boys and girls. A very striking exception to this bad drawing is Mlle. Berthe Morisot's work, which is strong & frank though sketchy . . . Her color is charming, her values delicate but sufficiently forcible. She understands drawing the figure and everything else very well. And it seems to me she's by all odds the strongest of the Groupe de Peintres Indépendants . . . They seem, these Independents, to combine the principles of the Pre Raphaelites with our own disregard of detail, in a most astonishing manner. They feel so entirely that whatever is is right, that they insist on painting large pictures of French villas, the ugliest country houses in the world, beside the sea, with roofs of the most heartrending purple, and one of them has a street view . . . the people in it being seen from above, across the shoulders.[3]

[3] The street view mentioned by Hale is Caillebotte's *Boulevard vu d'en haut* (1880).

Impressions after dining chez Claude Monet and seeing his work as well as that of Manet, Degas, Renoir and others. Men of conviction. Painters who have endeavored to search a road removed from the recognized systems of the schools. What pleases me largely is the disregard of method. The earnest endeavor to place on canvas what they see regardless of any preconceived notion of *how* it should be done. The earnest grasp of the indivisible, the character without regard to detail of a trifling or presumably *pleasing* character. If I could only shake off my *habits* of working, the laborious and stupid search for a completion which kills, which makes a work after the first or second sitting simply a mechanical process without élan and bite. It is evident in the work of Monet who falls into a granular texture loosing the connectiveness of the touch. My own work has been a search for light and herein I have fallen often into the error of producing light by strong contrasts of dark instead of keeping the entire canvas luminous. I feel my work banal, dreary escaping sadly both dignity of subject or beauty of color. I have learned how to paint and now I wish that I did not know, but that I could have a simplicity of conviction and strive to do a thing as it appears to me regardless of how I have learned to do it, forget all my method. Four weeks we have passed in Giverny now . . . if it would only have some effect.

FRENCH IMPRESSIONISM COMES TO AMERICA

Although metropolitan art galleries in New York in the 1860s and 1870s regularly displayed work by modern French painters, these tended for the most part to be academic figurative or landscape painters such as Jean-Léon Gérôme, Ernest Meissonier, or Adolphe-William Bouguereau. As documented above, some Americans abroad chanced to see the more experimental and (to some) subversive art of Edouard Manet, Claude Monet, Edgar Degas, and others associated with impressionism, but it was not until the 1880s that French impressionist paintings crossed the Atlantic in significant numbers. Manet's Execution of Maximilian *(1867) was shown in Boston and New York in 1879; in 1883 the impressionists' dealer, Paul Durand-Ruel, sent a collection of modern paintings to the Bartholdi Pedestal Fund Exhibition, held to raise money for the Statue of Liberty's base. In 1886 Durand-Ruel sent another large group of paintings, pastels, and watercolors to New York, where they were installed first in the American Art Association Galleries and subsequently at the National Academy of Design. The catalogue included a translation of Théodore Duret's defense of impressionism, explaining the artists' commitment to open-air painting and fresh, luminous color.*

Critical reaction in 1886 and after shows confusion, hostility, and misunderstanding. The New York Times *derides the "polychromatic daubs" of the "extremists," yet some writers, notably Clarence Cook, endorse and even celebrate the more innovative painters, seeing their work as truthful, spontaneous, and alive. Others, like the more conservative Boston art writer William Howe Downes, disparage the crusty paint and childish crudity of impressionist effects while lamenting the effect of the "purple mania" on American artists. Not surprisingly, George Inness weighs in with his undated critique of impressionism as an art of superficial appearances; in its materialism, it can never tap into the spiritual essences that the older painter seeks to suggest in his own broadly brushed and coloristically heightened landscapes (see "George Inness and the Spiritual in Art," chapter 8).*

The collection of works in oil and pastel by the "impressionists" of Paris, which was lately on view at the American Art Galleries, has been transferred for exhibition to the National Academy of Design, where it may be seen until further notice, together with a few additional specimens of the artist's craft, loaned for the occasion by the owners, who happen to be residents of the United States. The theories of the impressionist faction and their performances have been discussed so often in this place that to revert to either subject would be to traverse ground that has already been trodden, and with few or no results. While there is no danger that the practices of the extremists of the school will find many imitators, and still less likelihood that mediocre painters, anxious to conceal their weakness through boldness or eccentricity, will delude the public into disregard of the powers of other artists and admiration of their own, the broad declaration underlying the mountain of painted, written, and spoken rubbish remains that nature is the foundation of pictorial art, and that artificiality and conventionality are its most destructive foes. The most successful achievements of painters that loudly denounce the preachings and products of the impressionists show a recognition of this fact, while the best of the impressionists conceal in their pictures any tendency they may possess to indulge in the orgies of drawing and color that in public exhibitions of the order now referred to call forth alternate ridicule and anger. In the collection inviting inspection at the Academy there are, of course, some canvases whereof the contemplation amply repays a visit . . . There are no less than 19 small marines by Boudin, whose finesse of execution and cool, gray atmosphere stand out with delightful sharpness and naturalness amid the polychromatic daubs of the extremists of the school. There is Renoir's "Déjeuner à Bougival," (No. 185) a capital study of French faces and forms, and half a dozen works of the same artist, in which the conventional Frenchman and Frenchwoman are depicted with fidelity and comparative sobriety of color. Caillebotte, in addition to "The Planers," sends a delightful bit of perspective in "Paddling Canoe," (No. 186) although exception may be taken to some singularly substantial reflections of yellow sculls in the water over which the boat is skimming, a beautiful study of snow on rooftops . . . Other commendable achievements of Manet's are his "Boy with the Sword" (No. 303) and "Fifer of the Guard," (No. 22) and in a hurried enumeration of the best things in the gallery Lerolle's "The Organ" (No. 29) and "A Family Group," (No. 309) by Miss Cassatt, must not be forgotten. Genuine and startling specimens of the outcome of impressionist teachings are naturally not scarce, and some of them are positively startling. There are some effects that look as though they were produced by gluing segments of the whites of hard boiled eggs over two-thirds of the canvas, views of green fields with patches of sunlight and vegetation that remind one of a well-mixed mayonnaise of tomatoes, and country scenes in which the trees, the grass, and the rustic abodes recall the leaden farm houses and surroundings sold in the toy shops. Seurat's "Bathing" (No. 170) is among the most distressing paintings shown, because the largest in the collection, the blazing colors offering special offense. M. Guillaumin also contributes some dreadful examples of polychromatic dissipation, and so do M. Monet and M. Renoir, whose drawing in "Au Cirque" is as bad as his color is unnatural and ugly, and whose portrait of Wagner (No. 210) is more suggestive of a possible chromo-lithographic frontispiece to the song of "Grandfather's Clock" than of the great composer. A group of cast-iron figures, labeled "On the Balcony" and ascribed to M. Monet, should also be named among the distressing invoices to the exhibition. The Academy is far better suited, be it observed, to the display of the pictures than the locality formerly used for that purpose. One of the essentials to the apprecia-

tion of impressionist paintings is the beholder's getting as far away from them as practicable, and this he is able to do in the galleries at Twenty-third-street and Fourth-avenue. The impulse to remove one's self around the corner from a few of the samples of impressionist art can also be followed at the Academy, and may now and then be obeyed without fear of subsequent self-reproach.

"The Impressionist Exhibition at the American Art Galleries," Art Interchange 16 *(April 24, 1886).*

M. Durand-Ruel's collection of the works of the independent painters, now on exhibition in the galleries of the American Art Association, may be described briefly as interesting, if not profitable. The mantle of this vigorous young school of art has been stretched in this case farther even than Charity's in order to cover works so dissimilar in every respect as Jean Paul Laurens' noble "Death of Marceau" and the very eccentric productions of the esteemed M. Renoir. With commendable judgment the exhibitors have hung the saner and much more important examples in the large room which the visitor enters first, and reserved the most "advanced" specimens for the upper galleries . . .

. . . The principal examples of Manet in this first gallery are his "Race Course," a study of still life, of a young and red-trousered fifer, and his portrait of the baritone Faure as Hamlet—a big-headed and most unheroic little man in a very French translation of the "melancholy Dane." M. Manet's great talent constantly fails him in matters of detail, though he is not above having recourse to all those "tricks" of the trade which his followers claim to have so completely discarded. His white table cloth is neither white nor a cloth of any kind, the sword of his tragedian is not of steel but of black wood, the dark background against which he constantly poses his figures is neither wall nor atmosphere, but a mere matter of convention. His "Absinthe Drinker," in one of the upper galleries—a very strong painting—is not a man at all, but a projection of his mind, draped and posed and imagined in a weird and impressive theatrical light. And yet M. Théodore Duret claims for these painters, in his very clever defense, published at the beginning of the present catalogue, that "it is to them we owe the out-of-door study, the perception not only of colors, but of the most delicate shades of colors, the distinction of tones and the attempt to record truly the relation between the atmosphere which lights the picture and the tone of all the objects contained in it. . . . It is to these artists we owe the transparent painting of our day, in which we are fairly rid of the old-time nuisances—litharge, bitumen, chocolate-brown, tobacco juice, and the rest of the studio tricks." A lesser objection that may be urged against these works is their general unpleasantness; the connection between "realism" and ugliness is as intimate in art as in literature, and these painters portray even the most cheerful and frivolous themes in the most dyspeptic and suicidal manner that is conceivable. Degas' numerous ballet and chorus girls are all dancing in shrouded gloom; Poe's "Conquering Worm" was an opera bouffe performance compared to these theatrical representations. Manet's "Lola de Valence," which in many respects is one of his best pieces of painting, portrays an elderly Spanish woman of a forbidding cast of countenance, in a perfectly ugly and inartistic costume, posed against the backs of some scenic flats. In some of the lesser and further advanced men, like Renoir, this lack of decoration descends into a vulgarity of color and of types that is well-nigh bottomless.

The special qualities which these painters claim—the rendering of atmosphere and of transparent shadow—they certainly contrive to get in their pictures in a great measure, but in no greater measure than many of the great painters of the Renaissance and of the modern French school, who also get a hundred other qualities that the impressionists do not even try for. And

this one virtue they obtain by a liberal use of all the "tricks" which they denounce, by a waste of labor in many cases, and by a niggling, "tormented," ignoble technique that renders M. Duret's complacent comparison with "the art of Japan" a gratuitous insult to the pagan. The discovery that a glaize of cobalt would render a shadow transparent by no means originated with these heroes, but when they have painted in their shadows pure blue and thereby secured their transparency, at the distance of forty feet or so, they throw up their hats in triumph and care nothing that their shadows are false in every other respect. These are the lesser men of the baser sort; some of the work here exhibited is of a much higher value, and among them are one or two examples of Mme. Berthe Morizot, whose portrait of Mme. X. is a charming rendering of blacks and grays, and some of the soberer work of the very uncertain M. Claude Monet, such as his noble "Pavé de Chailly" and the large coast view, "Near Havre," not quite so true, but most beautiful in color.

Clarence Cook, "The Impressionist Pictures," Studio 1 (April 17, 1886).

In the large ante-room which receives the visitors and prepares them for the ascent to the galleries proper, the influences of the Academy and of the official art-world still make themselves felt in a few canvases, but even here the joyous song of the Bohemian is heard, and, once the stairs ascended, we are as well-rid of the Beaux-Art and the Salon as if we were on a coral island in the South-Pacific. It is more than a simple pleasure, it is exhilarating delight to find ourselves for once in a collection of pictures, and of French pictures too! in which not a single one of the black band appears—not a Meissonier, nor a Gérome, nor a Cabanel, nor a Bouguereau, nor an Alma-Tadema, nor a Vibert, nor a Jules Bréton—no, not one of the men who, backed by the solid army of the picture-dealers and their money-bag clients have ruled the roost so long and done so much injury to art.

Allow for all exaggerations, deduct for all the crudeness, and vain shooting at the sun, what every one must feel is here, is the work of men delighting in the exercise of their art, not working at a task for the sake of boiling the pot, nor weaving rhymes at a penny the line, but singing as they paint, and facing the new world with the leaping wine of discovery in their veins.

Of course it would be too much to expect of a public trained as ours has been, that it should at once accept such flagrant contradictions as these pictures present to the gospel of the tailors, modistes, and tract-distributors of the old school. From the polite comment of the courtier Gérome—"Sir, we are all floundering helplessly about in a puddle of hog-wash!" to the indignant looks of the O'Donovan dresses and Dorsey hats as they sweep from canvas to canvas with disdainful shrugs and protesting eyes—the whole gamut of disapprovel is heard, and the only encouraging word that greets us is the occasional "Very queer, certainly, but interesting!"

The artists, meanwhile, are necessarily of many minds. The older men walk about in limp amazement, or with ha! ha! smiles of high derision. For them, the whole thing is a smart trick on the part of some mischievous young chaps (of forty, or there-abouts!) to get themselves talked about. One of these gentlemen gravely demonstrates that the whole secret lies in leaving the canvas uncovered in spots, and in making every dab of color—for, 'tis all done in little dabs, you see!—of two or three colors at once! One does not wish to hurt so good-natured a man's feelings, and, so, forbears to express a wish that he would try the experiment of leaving his own canvases uncovered in very large spots, or in occasionally putting even so little as one color into his pictures, appropriately painted with shoe-blacking, mud, and tobacco-juice.

The younger men, while by no means unanimous in assent, are at least intelligent in their objections, and sympathetically critical. They have never been trained to hate color, nor are

they always insisting on academic correctness of drawing, knowing very well that drawing does not mean what the schoolteachers tell us, and that in the sense of these gentry there never was a great artist who drew correctly. The freer the art-atmosphere in which the younger men have been brought up, the greater the sympathy they have for those who, like them, breathe the air of all out-of-doors, and find their happiness in freedom . . .

How shall we look at these pictures; with the ends of our noses, or the tips of our fingers rubbed across the canvasses to feel how coarsely they are painted? Let a beetle run over the most finished work of a Meissonier or a Gérome, and he would lame his feet in the ruts. Nay, a microscope would show us a porous board daubed with ill-ground colors, if we looked through it at the polished ivory of Mrs. Morgan's Bargue. But the human eye, with a mind behind it, is made to see things as they are meant, and if we go off to the proper distance from these Impressionist pictures we shall see them as the artist sees them, and as he expected us to see them. So long as, at the proper distance the effect sought for is obtained, what matters it how the artist obtained it? . . .

The way to look at the true impressionists then, at Claude Monet, at Renoir, at Sisley, Seurat, Pissarro, Degas, and the rest, is, to regard them as men who are honestly bent on seeing things with their own eyes, and are trying the experiment of painting them by any method that will give back the effects they see. Do not expect to find, better still, do not ask to find, pictures, in the sense generally understood; there are few such here. These are, for the most part, rapid sketches, bits of life, bits of nature; things taken, as it were, on the wing, and all their value consists in the verity, the life with which the impression has been seized. In the work of the true Impressionist, not only must the thing be painted from the life, and wholly out of doors, if it be a landscape, but it must be painted at once, and finished, then and there. We cannot accept as an Impressionist picture, one that has been worked over, or warmed over!

It amuses us to see people going about in the pastel-room, and looking at some of Degas' things . . . flirting a disgusted fan, or poking a petulant parasol, with the whispered cry: "See there, now! What's that!" Of all evasive things in the world, Degas has taken to anatomize the ballet-dancer species, and if even an instantaneous photographer would find himself too slow to catch one of these ephemera on the wing, how can a man with only an eye, a bit of paper, and a crayon, hope to do more! These are not things for laymen's criticizing. They are only stray feathers, bits of legs or wings, brought down by the sportsman, for whom the whole bird was too quick! These studies do not, in fact, belong here at all, but in some reception-exhibition of the Students' League, or the Gotham Art-Club, where only artists, students or critics would see them, for such persons only do they concern.

Not that we are not glad to have them here, only we do not like to see them snubbed, by people especially who are much too bright-looking not to know better. Degas, as a rule, leaves the faces of his "scissors," as Carlyle called the ballet-girls, rough. Carlyle writes somewhere, in a letter, that he had been at the opera the night before, seeing scissors opening and shutting, and standing on their points! Millet also leaves the faces of his peasants merely blocked out, but he throws expression enough into their attitudes, and Degas shows us, somewhat brutally it is true, just how awkward and ungraceful these stage-fairies really are. For, of all the inventions of man, the ugliest is the ballet-girl in her stage-dress, and the awkwardest in each and all her poses! . . .

One of the most interesting among these painters is Pissarro, with his rural scenes, his peasants working in their gardens, tending their cows, talking in the village-streets. He shows here as a disciple of Millet, but with a charm and expression of his own, as if all that he drew came

out of his own experience and that had been a happy one, for his work has none, or little, of Millet's sadness in it. Neither has it Millet's imaginative sympathy, nor his antique nobleness. His drawings remind us of Millet only because the people are the same, and are sometimes doing the same things. The artist would seem to have been practicing for sometime on stooping figures; we have seven or eight drawings in the Pastel-room, in all of which the people are bent down at their work, and very naturally are they caught at it, too! Pissarro has here some landscapes which show a delicate observation of nature, as when in No. 71, "Hoar Frost"—in the Pastel-room—he tries to render the rare effect of the morning sun on the frosted field with the pearly iridescence produced by the level rays. On the whole, however, this artist shows best in his pastoral scenes.

Sisley's pictures will not at first attract the attention they certainly deserve. He is not the brilliant, versatile painter that Claude Monet is; he has not the rich effects of Boudin—his canvasses are so quiet, and the scenes he paints so little picturesque that at first we vote him tame. But, he has a solid charm, and we have not paid many visits to the gallery before we decide that Sisley is a name to be remembered. We find him first in a charming group of pictures in Gallery D, on the left-hand of the big fire-place, but his best work in this room is at the other end of the room, No. 201, "Rue de Marley in Winter," where the softness of the snow over the solid things is delightfully expressed. Upstairs in the long gallery there are nine of his pictures, and all worth looking at. No. 235 "Le Bac de l'Isle de la Loge," where nothing could be more unpromising than the subject—a flooded stream with a row of cottages at the back and the telegraph-poles in the foreground—but the artist makes much of it by not trying to make anything of it. What he would seem to have been attracted by was the full water loaded with mud, and so giving back only dulled reflections, a soft, velvety surface, delicately tinted . . .

Beside his frame of small "Studies" in Gallery C, No. 133, and his "Isle Grande Jatte" No. 112, in the same room, Seurat has only his "Bathers," which eats up nearly the whole end of Gallery D, and so makes amends. The "Bathers" is a hard bone for those to pick who insist on having in a picture what they themselves want, rather than what the artist wants. M. Seurat has painted this huge canvas solely and simply to secure an effect of light, air, and distance, and he has heroically denied himself, and us, an atom of unnecessary detail. If we can take what he gives us, and be thankful for it, that is well; we have no right to quarrel with him for not giving us something else. This is an experiment, and so far as it goes, it is successful. Does any one say that Raphael would not have been pleased with the two little boys at the right? Is not the man who could paint them, who knew enough to stop when he had finished, and who could make a hole in the wall through which we can see the North River and the sky over it, worth treating with respect?

And Claude Monet! What observation, what variety of execution, surprising us at every turn, what independence of all methods prescribed, and of his own, when he pleases! . . . He makes every other painter of water look like an apprentice. What could be more beautiful than the painting of the water and the mist in No. 198? Where is Turner, alongside of such magic play with the elements? The "Station at St. Lazare," No. 203, is another master-piece. It recalls Turner's "Rain, Steam and Speed," in the National Gallery; but as it is more real, so it is more full of varied life and contrasted effect than that. And what becomes of Mr. Stevens' query in the face of such variety as is presented in Claude Monet's pictures? Look at the beautiful Farm, No. 135, bathed in glowing mist, and then, with a turn through the door, at No. 168, all iridescent pearl, and as cool as the other is flushed and palpitating. If Mr. Durand-Ruel had done nothing more than to bring us the pictures of this artist, he would have rendered us a great service. For ourselves, we thank him heartily for the gift.

Renoir is another surprise, but he is so agressive, and leaps so like a matador into the arena, and faces with such gayety of heart the little black bull of convention, that he sometimes takes away our breath—with admiration! It is amusing to hear people who praised Vibert's eye-scratching "Missionary's Story" in the Morgan collection, for its "color," going about, whining and groaning over the "color" of Renoir; as if a person who had spent the winter in a potato-cellar should complain that his eyes hurt him when he came into a flower-garden in spring with its hyacinths and daffodils.

Renoir, like the English Pre-Raphaelites, has thrown his bitumen-pots and tobacco-juice out of the window, and has determined to paint colors as he sees them, but he has not a trace of the love of morbid colors for which they exchanged their old idols. He paints his daughter sitting in the green-house at her work, No. 149, herself the most brilliant flower, all scarlet, blue and gold, or another lady with a little child "On the Terrace," No. 181, where the same brilliant colors show against a network of delightfully suggested landscape—and except for those who insist that everything should be cooked after one receipt—it is hard to understand why such harmonious affluence of colors should not give pleasure. Is there any harm in a pretty woman wearing a scarlet Tam o'Shanter, if poppies and tulips are allowed the same liberty? And if a little girl looks like a pansy, who is going to be cross about it? To go back to Claude Monet for a moment, who that loves nature, or art either, for that matter, wouldn't prefer his "Poppies in Bloom," No. 270, to Gérome's "Tulips," in the Morgan Collection—tulips whose beauty, we are sure, would never have moved any one to madness. Flowers, women, children, all things of nature's making, and all things of man's, ought to be painted so as to interest us, and we are much mistaken if it be not found before this exhibition closes, that the work of Renoir, Monet, and the rest of the most ultra Impressionists does not interest and even please more people than it torments or leaves indifferent. Of course, Renoir is not always to be commended . . . But, why look at the failures, when here is this couple dancing at Bougival to lilt with, she, in her pretty, pink muslin, he in his easy blue flannel; this merry crew at Lovers Island to be gay with—and the little dog for our money!—and these fishermens children, real children, rosy, innocent, pretty—like all Renoir's people, good to be with!

William Howe Downes, "Impressionism in Painting," New England Magazine 6 (July 1892).

The term impressionism, used in reference to the art of painting, has acquired a special significance in these days. It defines a new fashion in the art, and may be best understood by a study of the works of those who call themselves impressionists. The thing is as new and pretentious as the word which stands for it. It had its origin in France, but it has gained a certain footing in the United States, and has exercised a positive influence over the minds of many American painters and a few American amateurs . . .

I think that it is a fair statement to say that the cornerstone of impressionism is the use of purple tints. There are other characteristics to be noted, but that this is the fundamental point is beyond question. The proof of it is to be seen in the works of all the impressionists, from Manet down . . .

Because genius is often eccentric, it does not follow that eccentricity is always accompanied by genius. One of the distinguishing marks of great art is its good sense.

The first impression made by the works of Pissaro, Monet, Renoir, and Sisley was that their mannerisms outweighed whatever merits they might possess; and a further acquaintance with those works leads to no different conclusion. In other words, the worth of what they have to say, be it greater or less, is utterly obscured by their way of saying it. That their methods of execu-

tion have any value as such is a claim which has never been established in practice. On the contrary, it is demonstrated that their mannerisms are so pronounced and obtrusive as to preclude style and to offend taste. They try to represent each subject and everything in it by the same impossible and painty texture of an old piece of tapestry. It is hard to take such work seriously, for it looks crude and childish. Does nature look so? Never. If only one man painted after this fashion, it might be said that his peculiar handling was an individual if faulty manner; but since all the true-blue impressionists employ the same method, it must be inferred that they have adopted it as a system. The result of it is the production of a mass of daubs which would not deserve serious consideration, were it not for the pernicious influence exerted upon the susceptible young painters who suppose that they must follow the latest fashion in painting . . .

Almost all the Impressionist paintings brought to the United States thus far have been imported by a certain dealer whose principal shops are in Paris and New York. The other picture dealers here have received them from him, and have made such a market for them as was possible. Very soon a considerable number of American artists began to manifest marked symptoms of sympathy for the purple mania and a tendency to the noisy effects which the Impressionists produce in their mistaken attempts at brilliancy. Of course the imitators exaggerate the faults of their models, and outherod Herod. Indeed, since I have used Hamlet's phrase, I may add that they tear a passion to tatters, they o'erstep the modesty of nature, and make the judicious grieve.

Impressionism is a fashion,—a fad, and, like all fashions, it will run its course; but art, which survives temporary vagaries,—Classicism, Romanticism, Realism, and all the rest of the isms,—will go on conquering and to conquer.

George Inness, letter to editor of the Ledger, *reprinted in George Inness Jr.,* Life, Art, and Letters of George Inness *(New York: Century Co., 1917).*

A copy of your letter has been handed to me in which I find your art editor has classified my work among the "Impressionists." The article is certainly all that I could ask in the way of compliment. I am sorry, however, that either of my works should have been so lacking in the necessary detail that from a legitimate landscape-painter I have come to be classed as a follower of the new fad "Impressionism." As, however, no evil extreme enters the world of mind except as an effort of life to restore the balance disturbed by some previous extreme, in this instance say Preraphaelism. Absurdities frequently prove to be the beginnings of uses ending in a clearer understanding of the legitimate as the rationale of the question involved.

We are all the subjects of impressions, and some of us legitimates seek to convey our impressions to others. In the art of communicating impressions lies the power of generalizing without losing that logical connection of parts to the whole which satisfies the mind . . .

Every fad immediately becomes so involved in its application of its want of understanding of its mental origin and that the great desire of people to label men and things that one extreme is made to meet with the other in a muddle of unseen life application. And as no one is long what he labels himself, we see realists whose power is in a strong poetic sense as with Corbet. And Impressionists, who from a desire to give a little objective interest to their pancake of color, seek aid from the weakness of Preraphaelism, as with Monet. Monet made by the power of life through another kind of humbug. For when people tell me that the painter sees nature in the way the Impressionists paint it, I say, "Humbug"! from the lie of intent to the lie of ignorance.

Monet induces the humbug of the first form and the stupidity of the second. Through malformed eyes we see imperfectly and are subjects for the optician. Though the normally formed

eye sees within degrees of distinctness and without blur we want for good art sound eyesight. It is well known that we through the eye realize the objective only through the experiences of life. All is flat, and the mind is in no realization of space except its powers are exercised through the sense of feeling. That is, what is objective to us is a response to the universal principle of truth . . .

. . . Since the beginning "The Art of the Future," as it is called, has developed in a great variety of impressionists whose works I have not seen, as I am not interested in painters who find it necessary to label themselves. I admire the robust ideas of Corbet, but not his realism; that was his curse. It appears as though the Impressionists were imbued with the idea to divest painting of all mental attributes and, overleaping the traveled road which art has created by hard labor, by plastering over and presenting us with the original pancake of visual imbecility, the childlike naïveté of unexpressed vision.

IMPRESSIONISM: AMERICAN PRACTICES

THE AMERICANIZATION OF IMPRESSIONISM

The mixed reception of French impressionism notwithstanding, younger American painters embraced, adapted, and in various ways Americanized the style and subject matter that characterized the art of Claude Monet, Camille Pissarro, and others. The visual rhetoric of impressionism connoted modernity, cosmopolitanism, and generational difference. In the American adaptation, however, impressionism was an eclectic mélange incorporating (in addition to the French) the dashing technique and rich color of the Munich School, the tonal harmony and flat patterning of James McNeill Whistler, and academic draftsmanship. In addition, American impressionists by and large eschewed the French focus on working-class leisure and lower-class women, opting instead for upscale urban views (see "Childe Hassam on Painting Street Scenes," this chapter), decorous park scenes, or views of fashionable summer haunts at the seaside or in picturesque New England villages. So successful was the process of adaptation that, despite initial resistance, impressionism in its American translation was an established and even conventional pictorial language by the turn of the century.

In the excerpts below, the sharply contrasting assessments of American impressionism by "Greta" and midwestern local-color writer Hamlin Garland (who first encountered impressionism in 1893 at Chicago's Columbian Exposition) exemplify the poles of the debate and the direction in which it ultimately swung. Whereas "Greta" objects to the dots and dashes of color that refuse to mix on the retina but instead remain a "mosaic," for Garland that mosaic is a "unified impression." For "Greta" impressionism is a fashionable import, appropriated by the younger painters to give them an edge in the market. For Garland it is a radical new discovery, born of the conditions of modernity itself and highly adaptable to the local American scene.

Greta, *"Art in Boston: The Wave of Impressionism,"* Art Amateur *24 (May 1891).*

The Impressionists have been exhibiting here in force lately. Curious paintings by young Bostonian disciples of Monet, or Manet, with unconventional, prismatic reddish hues for fields and trees, and streets and houses in pinks and yellows respectively, have appeared from time to time for a year or two. But these were ascribed to the enthusiasm and indiscretion of apostleship.

Once in a while, for even a longer period back, a single daring picture in broad masses of white and other high colors, evidently painted in the full light of out-of-doors, has startled the propriety of picture-shows, and its riotous effect among ordinary paintings has been explained by pointing to the well-known figures of the Salon catalogue number upon its frame. But at last the news is circulated that leading Boston buyers of paintings—the first buyers, in other days of Millets, Corots, Diazes and Daubignys—are now sending to Paris for this sort of thing, and Impressionism becomes the fashion. Some of our leading landscape artists praise it and preach it; many of the younger painters practice it. Mr. J. Foxcroft Cole imports a number of Monets for collectors of authority. Mr. F. P. Vinton lectures upon the new light in art at the St. Botolph Club. Mr. Fenellosa, expert in Japanese art, exults in numberless discourses on the increasing Japanese influence evident in the use of simple pure tints and unconventional composition. Mr. Vonnoh returns imbued with the new style, and backs it with earnest work and intelligent reasons. The old favorites, sticking to their own styles, take back seats, and one almost wonders if all the pictures of the past are going to be taken out into Copley Square and burned. Titian and Veronese and the old masters have faded, we are told; Rembrandt is brown; even Corot is stuffy, and as for Daubigny and the rest of the modern French school of landscape, they are virtually black-and-white. Courbet and Hunt couldn't see color in nature as it really is. Tone, so much prized and labored for in the past, must go; Motley and Monet are your only wear. Mr. Vinton says the theory is that colors must no longer be mixed on the palette, but are to be laid side by side, either in dots or dashes, in pure tints, and left to mix optically on the retina of the eye. Mr. Cole says the "values" are to be gained, not in shadings, but in colors. In a room full of the new pictures, therefore, there would be no prevailing color harmony; each picture would differ from every one of its fellows by the same artist, each representing faithfully the season, the hour, the light, the mood of the artist at the moment—nothing being done according to rule, or habit, or style.

These are some of the theories advanced. But are they ever realized? As a matter of fact do the dots and dashes of unmixed colors mingle "optically on the retina?" Do the pictures of the Impressionist differ constantly? On the contrary, do not the dots and dashes refuse to mingle optically? Do they not remain virtually a mosaic, tormenting the beholder with a sense of lack of finish, and obtruding the method in place of an effect. Above all, do not the pictures of an imitator of Monet have all a family similarity of color-effect, so that you instantly recognize them as "that stuff," as far as you can see them? Is there, then, any emancipation in the new style, except for the strong man who emancipates himself anyway? Is there anything in it for the rank and file of painters but the substitution of one set of conventions and prescriptions for another? And is it a gain for art, for beauty, for charm or refinement of popular taste, to substitute for harmony and tone wanton and impudent vagaries and crudities? Is it not an affectation of individualism where it is only the same old imitation and conventionalism after all, but in coarser forms and on lower planes both of technical accomplishment and artistic sensibility? It may safely be left for the future to decide.

Hamlin Garland, "Impressionism," in Garland, Crumbling Idols: Twelve Essays on Art Dealing Chiefly with Literature, Painting and the Drama *(Chicago: Stone and Kimball, 1894).*

The fundamental idea of the impressionists, as I understand it, is that a picture should be a unified impression. It should not be a mosaic, but a complete and of course momentary concept of the sense of sight. It should not deal with the concepts of other senses (as touch), nor with judgments; it should be the stayed and reproduced effect of a single section of the world

of color upon the eye. It should not be a number of pictures enclosed in one frame, but a single idea impossible of subdivision without loss.

They therefore strive to represent in color an instantaneous effect of light and shade as presented by nature, and they work in the open air necessarily. They are concerned with atmosphere always. They know that the landscape is never twice alike. Every degree of the progress of the sun makes a new picture. They follow the most splendid and alluring phases of nature, putting forth almost superhuman effort to catch impressions of delight under which they quiver.

They select some moment, some centre of interest,—generally of the simplest character. This central object they work out with great care, but all else fades away into subordinate blur of color, precisely as in life. We look at a sheep, for example, feeding under a tree. We see the sheep with great clearness, and the tree and the stump, but the fence and hill outside the primary circle of vision are only obscurely perceived. The meadow beyond is a mere blue of yellow-green. This is the natural arrangement. If we look at the fence or the meadow, another picture is born.

It will thus be seen that these men are veritists in the best sense of the word. They are referring constantly to nature. If you look carefully at the Dutch painters and the English painters of related thought, you will find them working out each part of the picture with almost the same clearness. Their canvases are not single pictures, they are mosaics of pictures, packed into one frame. Values are almost equal everywhere.

This idea of impressionism makes much of the relation and interplay of light and shade,—not in black and white, but in color. Impressionists are, above all, colorists. They cannot sacrifice color for multiple lines. They do not paint leaves, they paint masses of color; they paint the *effect* of leaves upon the eye . . .

This singleness of impression destroys, of course, all idea of "cooked up" pictures, as the artists say. There are, moreover, no ornate or balanced effects. The painter takes a swift glance at a hill-side, whose sky-line cuts the picture diagonally, perhaps. It has a wind-blown tuft of trees upon it, possibly. A brook comes into the foreground casually. Or he takes for subject a hay-stack in a field, painting it for the variant effects of sun-light. He finds his heart's-full of beauty and mystery in a bit of a meadow with a row of willows . . .

The second principle, and the one most likely to be perceived by the casual observer, is the use of "raw" colors. The impressionist does not believe nature needs toning or harmonizing. Her colors, he finds, are primary, and are laid on in juxtaposition. Therefore the impressionist does not mix his paints upon his palette. He paints with nature's colors,—red, blue, and yellow; and he places them fearlessly on the canvas side by side, leaving the eye to mix them, as in nature . . .

This placing of red, blue, and yellow side by side gives a crispness and brilliancy, and a peculiar vibratory quality to sky and earth which is unknown to the old method. And if the observer will forget conventions and will refer the canvas back to nature instead, he will find this to be the true concept.

I once asked a keen lover of nature who knew nothing about painting, to visit a gallery with me and see some impressionistic works which had shocked the city. I asked him to stand before these pictures and tell me just what he thought of them.

He looked long and earnestly, and then turned with an enthusiastic light in his eyes, "That is June grass under the sunlight." . . .

To most eyes the sign-manual of the impressionist is the blue shadow. And it must be admitted that too many impressionists have painted as if the blue shadow were the only distinguishing sign of the difference between the new and the old. The gallery-trotter, with eyes filled

with dead and buried symbolisms of nature, comes upon Bunker's meadows, or Sinding's mountain-tops, or Larson's sunsets, and exclaims, "Oh, see those dreadful pictures! Where did they get such colors."

To see these colors is a development. In my own case, I may confess, I got my first idea of colored shadows from reading one of Herbert Spencer's essays ten years ago. I then came to see blue and grape-color in the shadows on the snow. By turning my head top-side down, I came to see that shadows falling upon yellow sand were violet, and the shadows of vivid sunlight falling on the white of a macadamized street were blue, like the shadows on snows.

Being so instructed, I came to catch through the corners of my eyes sudden glimpses of a radiant world which vanished as magically as it came. On my horse I caught glimpses of this marvellous land of color as I galloped across some bridge. In this world stone-walls were no longer cold gray, they were warm purple, deepening as the sun westered. And so the landscape grew radiant year by year, until at last no painter's impression surpassed my world in beauty.

As I write this, I have just come in from a bee-hunt over Wisconsin hills, amid splendors which would make Monet seem low-keyed. Only Enneking and some few others of the American artists, and some of the Norwegians have touched the degree of brilliancy and sparkle of color which was in the world to-day. Amid bright orange foliage, the trunks of beeches glowed with steel-blue shadows on their eastern side. Sumach flamed with marvellous brilliancy among deep cool green grasses and low plants untouched by frost. Everywhere amid the red and orange and crimson were lilac and steel-blue shadows, giving depth and vigor and buoyancy which Corot never saw (or never painted),—a world which Inness does not represent . . .

Going from this world of frank color to the timid apologies and harmonies of the old-school painters is depressing. Never again can I find them more than mere third-hand removes of nature . . .

The impressionist is not only a local painter, in choice of subject he deals with the present. The impressionist is not an historical painter, he takes little interest in the monks and brigands of the Middle Ages. He does not feel that America is without subjects to paint because she has no castles and donjon keeps. He loves nature, not history. His attitude toward nature is a personal one. He represents the escape from childish love of war and the glitter of steel . . .

The impressionist does not paint Cherubs and Loves and floating iron chains. He has no conventional pictures, full of impossible juxtapositions. He takes fresh, vital themes, mainly out-of-door scenes. He aims always at freshness and vigor.

The impressionist is a buoyant and cheerful painter. He loves the open air, and the mid-day sun. He has little to say about the "mystery" and "sentiment" of nature. His landscapes quiver with virile color. He emphasizes (too often over-emphasizes) his difference in method, by choosing the most gorgeous subjects . . .

The impressionist, if he is frank, admits the value, historically, of the older painters, but also says candidly, "They do not represent me." I walked through the loan exhibition with a man who cared nothing for precedent,—a keen, candid man; and I afterward visited the entire gallery with a painter,—a strong and earnest man, who had grown out of the gray-black-and-brown method.

Both these men shook their heads at Inness, Diaz, Corot, Troyon, Rousseau, and Millet. The painter said, a little sadly, as if surrendering an illusion, "They do not represent nature to me any more. They're all too indefinite, too weak, too lifeless in shadow. They reproduce beautifully, but their color is too muddy and cold."

The other man was not even sad. He said, "I don't like them,—that's all there is about it. I don't see nature that way. Some of them are decorative, but they are not nature" . . .

It is blind fetichism, timid provincialism, or commercial greed which puts the works of "the masters" above the living, breathing artist. Such is the power of authority that people who feel no answering thrill from some smooth, dim old paintings are afraid to say they do not care for them for fear some one will charge them with stupidity or ignorance.

The time is coming when the tyranny of such criticism will be overthrown . . .

The old masters saw nature in a certain way,—right or wrong it does not matter; youth must conform. They saw nature in a sombre fashion, therefore youth must be decorous. Youth, in impressionism, to-day is saying, "I have nothing to do with Constable or Turner. Their success or failure is nothing to me, as an artist. It is my own impression of nature I am to paint, not theirs. I am to be held accountable to nature, not to the painters of a half-century ago.

"If I see plum-colored shadows on the snow, or violet shadows on the sand; if the clouds seen above perpendicular cliffs seem on edge; if a town on a hill in a wild wind seems to lean, then I am to paint it so. I am painting my love for nature, not some other's perception. If this is iconoclasm, I cannot help it." . . .

The iconoclast is a necessity. He it is who breaks out of the hopeless circle of traditional authority. His declaration of independence is a disturbance to those who sleep on the bosom of the dead prophets. The impressionist is unquestionably an iconoclast, and the friends of the dead painters are properly alarmed. Here, as everywhere, there are the two parties,—the one standing for the old, the other welcoming the new. A contest like that between realism and romanticism is not playful, it is destructive.

To a man educated in the school of Munich, the pictures, both of the Norwegian and of the Giverney group of Frenchmen and all other pictures with blue and purple shadows, are a shock. They are not merely variants, they are flags of anarchy; they leave no middle ground, apparently. If they are right, then all the rest are wrong. By contrast the old is slain . . .

Let the critic who thinks this a vogue or fad, this impressionist view of nature, beware. It is a discovery, born of clearer vision and more careful study,—a perception which was denied the early painters, precisely as the force we call electricity was an ungovernable power a generation ago.

The dead must give way to the living. It may be sad, but it is the inexorable law, and the veritist and the impressionist will try to submit gracefully to the method of the iconoclasts who shall come when they in their turn are old and sad.

For the impressionists rank themselves with those who believe the final word will never be spoken upon art. That they have added a new word to painting, no competent critic will deny. It has made nature more radiantly beautiful, this new word. Like the word of a lover, it has exalted the painter to see nature irradiated with splendor never seen before. Wherever it is most originally worked out, it makes use of a fundamental principle in an individual way, and it has brought painting abreast of the unprejudiced perception of the lover of nature. The principle is as broad as air, its working out should be individual.

WILLIAM MERRITT CHASE, SEEING MACHINE

William Merritt Chase's impressionism, combining elements of Munich and Parisian styles applied to modern American subjects, epitomized the contemporary sensibility. A proponent of art for art's sake, Chase modeled himself on James McNeill Whistler in expunging story and moral from his paintings, focusing instead on color, light, and air. The seeming absence of narrative, and of emotional or spiritual content in Chase's

work, however, was troubling for commentators like Kenyon Cox, who in his own paintings embraced the classical tradition and its high ideals (see "Kenyon Cox's Lonely Campaign for the Nude," chapter 11). Cox admits to the attraction of Chase's dazzling technique and inimitable powers of observation. But he worries that there is nothing beneath or beyond the surface. He describes Chase as a purely physical painter, a sort of human camera whose art is wholly objective. In this construction of the modern artist, Chase stands for the consummate materialism seen by many at that time as the defining characteristic of contemporary America.

Charles De Kay, an upper-crust art critic, credits Chase with the discovery of Central Park, not in the geographical but rather in a very modern artistic sense. This capacity is another trait for which Chase wins admiration: his extraordinary ability to detect beauty where the ordinary beholder sees little or nothing at all. The modern artist's all-seeing eye has become an essential component of his or her professional identity and authority (see also "Vacationing with Art in Shinnecock Hills," this chapter).

Kenyon Cox, "William Merritt Chase, Painter," Harper's New Monthly Magazine 78 (March 1889).

Of all our artists Mr. Chase is the most distinctively and emphatically a *painter,* marked for such both by his powers and by his limitations. His is not so much the art of the brain that thinks or of the imagination that conceives as of the eye that sees and the hand that records. He cares little for abstract form, less for composition, and hardly at all for thought or story; but the iridescence of a fish's back or the creamy softness of a woman's shoulder, the tender blue of a morning sky or the vivid crimson of a silken scarf—yes, or the red glow of a copper kettle or the variegated patches of clothes hung out to dry—these things he seizes upon and delights in, and renders with wonderful deftness and precision. He is, as it were, a wonderful human camera—a seeing machine—walking up and down in the world, and in the humblest things as in the finest discovering and fixing for us beauties we had else not thought of. Place him before a palace or a market stall, in Haarlem, Holland, or in Harlem, New York, and he will show us that light is everywhere, and that nature is always infinitely interesting. His art is objective and external, but all that he sees he can render, and he sees everything that has positive and independent existence. He is a technician of the breed of Hals and Velasquez; a *painter,* in a word. We have more imaginative artists, better draughtsmen, men of a subtler and more personal talent, but we have no such painter as Mr. Chase, and the world has to-day few better. It is in the hope of aiding to a wider appreciation of this fact that this article is written . . .

The first characteristic of his work that would strike a stranger to it is probably its versatility and wide range of subject . . . Whatever the bodily eye can see, Mr. Chase can paint, but with the eye of the imagination he does not see. By nature and instinct he leaves to others the attempt to give form and substance to the figments of the brain. He is content to rest upon the solid earth, and finds in the manifold aspects of external nature matter that shall occupy a lifetime in its setting forth. "Within this limit is relief enough," and with an eye trained to see and a hand trained to render the shifting many-sidedness of things, one has work enough cut out for one man.

The second notable characteristic of this work is the temper of technical experiment in which it is executed. Its subjects are not more varied than are its means of expression. Oil, water-color, gouache, pastel, are all in turn employed, and each with the same unerring sureness put to its best use. A canvas ten feet square or a panel five inches, a surface as rough as coffee sacking or as smooth as ivory—each is made to show that something can be done with it that can be done with nothing else.

These are the two great characteristics of your true painter wherever you find him: an impartial love for nature as it is, and an almost equal love for the tools of his art. He does not care to idealize or to torture himself in the search for the abstractly beautiful; the naturally beautiful is good enough for him . . . No man has such delight in his work as he. As he does not attempt the impossible, he is spared the agony of inevitable failure. His work is the healthy exercise of highly organized and highly trained faculties, and is as natural as the free play of a child, and as pleasurable as the exercise of an athlete.

And as the labor of love gives joy to the worker, so it has the greater chance of bringing joy to the beholder. We have had enough and to spare of the false criticism that blames an artist for not being something he is not; we can hardly have enough of the true criticism that heartily enjoys what he is. In the house of art there are many mansions, and room enough for many various talents. Each in its way can give us pleasure, and there is a very high and a very true enjoyment to be gotten from art of this objective sort—an enjoyment differing in kind, but perhaps not in degree, from that afforded by more imaginative art. The executive talent, the talent of the technician, is perhaps in its highest forms as rare as any other. The mission of the technician—of the painter *par excellence*—is the high one of showing us the beauty of the commonest and humblest objects. He shows us that, rightly considered, a battered tin pan is a thing of beauty and worthy of attention in its degree, and that there is something worth noting in a rotting post by the water-side or a "white sheet bleaching on the hedge." . . .

I have spoken of the painter as a wandering eye, and of his mission of finding out beauty in common objects and in unexpected places. It has so happened that for two years past Mr. Chase has foregone his trips abroad, and has passed his summers in Brooklyn. And being there, he has explored Brooklyn for paintable subjects, as he had explored Amsterdam and Venice, and with somewhat astonishing results. From these explorations he has brought back a series of small pictures of parks and docks which are veritable little jewels. It is new proof, if proof were wanted, that it is not subjects that are lacking in this country, but eyes to see them with. Let no artist again complain of lack of material when such things as these are to be seen at his very door, and let the public cease complaining of the un-American quality of American art at least until they have snatched up every one of these marvellous little masterpieces. They are far and away the best things Mr. Chase has yet done, and are altogether charming. Crisp, fresh, gay, filled with light and air and color and the glitter of water and dancing of boats, or the brightness of green grass in sunshine and the blue depths of shade upon gravel-walks, brilliant with flowers and the dainty costumes of women and children, they are perfection in their way, and could not be improved upon.

Charles De Kay, "Mr. Chase and Central Park," Harper's Weekly Magazine 35 *(May 2, 1891).*

In William M. Chase we have a painter who has slowly won away from entangling alliances with his masters in Paris and Munich until he has struck out a line for himself. Observe that of late years he has hit upon a discovery which is yet to be made by a very great proportion of the inhabitants of New York. He has discovered Central Park. Not that most New York people do not know there is such a place, and are not more or less proud of it, but comparatively few of them ever go into it, and when they go, they rarely see anything.

For there is need of much more than eyesight to see things and people. The Indian of the plains sees everything except what an artist perceives. The practical man wonders how much a piece of road in Central Park costs. The ward politician looks at the Park, and dreams of filching money from the taxpayers by the time-worn methods. But the artist sees the beauty of the

Park, watches the play of sunlight on lake, tree-top, and meadow, and picks out for its unexpected charm some corner neglected by the public. The impression these things make upon him he tries to fix on canvas with such power as his native talents and the false ideas that swarm in studios permit, and by so doing performs a service to the public which has been utterly ignored hitherto. It is no less a service than pointing out to citizens not only that they have a beautiful Park, but what things in that Park are worth examining more than others. It teachers them to look at the trees, lakes, and meadows with something more than a cow's gentle but hazy satisfaction in water, grass, and sunshine. We may not necessarily see things just as the painter does, but the stimulus he gives us to examine in order to agree or disagree is an intellectual act which is a tonic for minds weary of sordid ideas.

CHILDE HASSAM ON PAINTING STREET SCENES

French impressionists are often characterized by their fascination with modern urban life. In this, their "purest" American counterpart was undoubtedly Childe Hassam, who began his career with somber, tonalist paintings of Boston's Back Bay in 1884 and further developed his city views in Paris (1886–89), where his palette exploded with bright color and his brushwork became newly energized. However, New York would become Hassam's touchstone when it came to urban imagery. Returning from France to settle in Manhattan, Hassam took a studio at Fifth Avenue and Seventeenth Street, which perfectly positioned him to observe the varied street life of the commercial district between Union and Madison squares. In subsequent years he painted dozens of views of this neighborhood, usually from the vantage point of the pedestrian and often seen through evocative filters of rain, snow, or darkness. His was an experiential engagement with New York; he sought to capture not only optical but also kinesthetic impressions of the city. In the following interview, given only a few years after arriving in New York, Hassam articulates his working method, which involves getting as close to his subjects as possible, without interacting with them. This is the classic posture of the urban "flâneur"—an incisive but standoffish observer of the crowd—best exemplified by the artist's dry, analytical remark about cab drivers: "They interest one immensely" (fig. 13). Hassam also takes care to explain and defend his artistic style, judiciously contrasting it with the older "molasses and bitumen school" but also insisting that, far from being radical, his blue-toned canvases are realistic and historical.

A. E. Ives, "Mr. Childe Hassam on Painting Street Scenes," Art Amateur 27 (October 1892).

"I paint from cabs a good deal," said Mr. Childe Hassam, when asked how be got his spirited sketches of street life. "I select my point of view and set up my canvas, or wooden panel, on the little seat in front of me, which forms an admirable easel. I paint from a cab window when I want to be on a level with the people in the street and wish to get comparatively near views of them, as you would see them if walking in the street. When I want groups seen at a greater distance, I usually sketch from a more elevated position. This was painted from the second-story window in Dunlap's, about fifteen feet from the ground." . . .

"I cannot imagine," said Mr. Hassam, "how a man who sees fifty feet into a picture can paint the eyes and noses of figures at that distance. I should call such a painting a good piece of work—yes, good scientific work; but I should not call it good art. Good art is, first of all, true. If you looked down a street and saw at one glance a moving throng of people, say fifty or one hun-

dred feet away, it would not be true that you would see the details of their features or dress. Any one who paints a scene of that sort, and gives you such details, is not painting from the impression he gets on the spot, but from preconceived ideas he has formed from sketching studio models and figures near at hand. Such a man is an analyst, not an artist. Art, to me, is the interpretation of the impression which nature makes upon the eye and brain. The word 'impression' as applied to art has been abused, and in the general acceptance of the term has become perverted. It really means the only truth, because it means going straight to nature for inspiration, and not allowing tradition to dictate to your brush, or to put brown, green or some other colored spectacles between you and nature as it really exists. The true impressionism is realism. So many people do not observe. They take the ready-made axioms laid down by others, and walk blindly in a rut without trying so see for themselves.

"I suppose a great many people think my pictures are too blue."

The writer frankly admitted that many persons did. "Yes, no doubt. They have become so used to the molasses and bitumen school, that they think anything else is wrong. The fact is, the sort of atmosphere they like to see in a picture they couldn't breathe for two minutes. I like air that is breathable. They are fond of that rich brown tone in a painting. Well, I am not, because it is not true. To me, there is nothing so beautiful as truth. This blue that I see in the atmosphere is beautiful, because it is one of the conditions of this wonderful nature all about us. If you are looking toward any distant object, there will be between you and that object air, and the deeper or denser the volume of air, the bluer it will be. People would see and know this if the quality of observation was not dead in them. This is not confined to those outside of art: there are a good many painters afflicted with the same malady.

"So many of the older men are very far from being catholic in their views. They must walk in the old ruts, by the traditions of the elders, or not at all. I do not mean that there are no virtues in the old school. There are many, but there are also many mistakes, and we need not take the mistakes along with the virtues in our study of nature. The true artist should see things frankly, and suffer no trickery or artifice to anywhere distort his vision.

"I do not mean to convey the idea that you may at any minute find a subject ready at hand to paint. The artist must know how to compose a picture, and how to use the power of selection. I do not always find the streets interesting, so I wait until I see picturesque groups, and those that compose well in relation to the whole. I always see my picture as a whole. No matter how attractive a group might be, if it was going to drag my composition out of balance, either in line or color, I should resist the temptation of sketching it. I should wait, if it were a street scene, till the vehicles or people disposed themselves in a manner more conducive to a good effect for the whole."

"That group of cabs in the foreground of the Madison Square picture," said the writer, "is admirably managed to focus the attention there."

"That was my intention," the artist went on, "and you will notice how the lines in the composition radiate and gradually fade out from this centre. Of course all those people and horses and vehicles didn't arrange themselves and stand still in those groupings for my especial benefit. I had to catch them, bit by bit, as they flitted past.

"Do I paint the buildings and background first? Well where, as in this picture, they are quite as important as the people, as a general thing, yes. But I have no rule for that. Sometimes I stop painting a tree or building to sketch a figure or group that interests me, and which must be caught on the instant or it is gone. Suppose that I am painting the top of the bank building here, and a vehicle drives down to the left-hand corner, just where it seems to me a good place

to have something of this sort; perhaps the driver gets down and throws himself into some characteristic attitude; I immediately leave the roof of the building, and catch that group or single object as quickly as I can. You see, in pictures of this sort, where you are painting life in motion, you cannot lay down any rule as to where to begin or where to end. As to canvas, I prefer a clean one, just as it comes from the maker, or if it is a panel, the usual creamy white ground. I use an ordinary sketch book and pencil a great deal for making notes of characteristic attitudes and movements seen in the streets. If I want to observe night effects carefully, I stand out in the street with my little sketch-book, draw figures and shadows, and note down in colored crayons the tones seen in the sky, in the snow, in the reflections or in a gas lamp shining through the haze. I worked in that way for this bit of a street scene in winter under the electric light."

"What a Dickens flavor there is to those cabbies, settling themselves down into their greatcoats, trying to keep warm," put in the writer. "And how much character there is to this one's back."

"Yes," laughed Mr. Hassam; "there is no end of material in the cabbies. Their backs are quite as expressive as their faces. They live so much in their clothes, that they get to be like thin shells, and take on every angle and curve of their tempers as well as their forms. They interest one immensely.

"I believe the man who will go down to posterity is the man who paints his own time and the scenes of every-day life around him. Hitherto historical painting has been considered the highest branch of the art; but, after all, see what a misnomer it was. The painter was always depicting the manners, customs, dress and life of an epoch of which he knew nothing. A true historical painter, it seems to me, is one who paints the life he sees about him, and so makes a record of his own epoch. But that is not why I paint these scenes of the street. I sketch these things because I believe them to be æsthetic and fitting subjects for pictures. There is nothing so interesting to me as people. I am never tired of observing them in every-day life, as they hurry through the streets on business or saunter down the promenade on pleasure. Humanity in motion is a continual study to me. The scientific draughtsman who works strong and patiently may learn to draw correctly from a model a figure in repose; but it takes an artist to catch the spirit, life, I might say poetry, of figures in motion. I have been asked if I did not think photographic views were great helps to the artist in this branch of study. Undoubtedly they might be, but they have not been so to me. I never owned a camera or pressed the button of a Kodak in my life. I don't know why I have not. It has just happened so, I suppose. But I think on the whole, I prefer to make my own studies right from the life, without any assistance from the camera.

"Understand, in my allusion to the study from models, I do not for one instant depreciate the importance of a careful training in this direction. You surely cannot draw a figure in motion till you have first learned to draw it in repose. A good scientific groundwork is needed in all art. In saying this, I am not saying anything, and neither am I departing from the instructions of the old school when I urge the importance of studying figures in motion. So academic an artist as Gérôme used to say to his pupils, 'Go into the street and see how people walk.' Drawing from a figure in repose may be scientific, but good movement drawing is artistic."

Here the artist was asked how he came first to paint street life.

"I lived in Columbus Avenue in Boston. The street was all paved in asphalt, and I used to think it very pretty when it was wet and shining, and caught the reflections of passing people and vehicles. I was always interested in the movements of humanity in the street, and I painted my first picture from my window. Afterward I studied in Paris, but I believe the thoroughfares

of the great French metropolis are not one whit more interesting than the streets of New York. There are days here when the sky and atmosphere are exactly those of Paris, and when the squares and parks are every bit as beautiful in color and grouping."

IMPRESSIONISM: ECLECTIC PRACTICES

GENEALOGIES OF TONALISM

At the opposite pole from William Merritt Chase's perceived materialism and opticality were painters who dimmed and diluted impressionist color and technique to produce the style now known as tonalism. Though the name is of recent coinage, writers in the late nineteenth century recognized and grouped painters who seemed to share a mood, style, and sensibility, expressed through muted tones, delicate brushstrokes, and a preference for veiled or nebulous effects. In fact, tonalism embraces a wide range of styles, from the refined abstraction of James McNeill Whistler and his admirers to the earthy pastorals of Barbizon-inspired painters like Henry Ward Ranger and the transcendent landscape visions of George Inness.

New York Herald Tribune critic Royal Cortissoz identifies tonalist painters Thomas Wilmer Dewing and the latter's close friend Dwight Tryon with an imaginative and poetic idealism that represents a welcome process of refinement. In pointing to a "gradual evolution" of painting as manifest in the work of Dewing and Tryon, Cortissoz aligns himself with the English philosopher Herbert Spencer's model of evolution as progress from base material to finer and higher spiritual levels. Dewing and Tryon exemplify this pattern. Cortissoz also distances both artists from the empiricism of impressionists like Chase, praising the subjectivity that elevates their work far above the earthbound plane of mere technical facility.

Writing on the "Tonal School" a decade later, Clara Ruge assigns leadership to Ranger, founder of the artists' colony at Old Lyme, Connecticut, and devotee of Barbizon and Dutch landscape painting (see also "Summer Colonies," this chapter). Ruge insists that the aim of tonal painting is harmony of color, achieved by mixing tints directly on the canvas in order to express the poetry of personal response as opposed to the prose of objective description. In so privileging emotion and individuality, Ruge establishes the ideals of modern art as antithetical to the ideologies of conformity and mass consumption imposed by corporate culture.

Royal Cortissoz, "Some Imaginative Types in American Art," Harper's New Monthly Magazine 91 *(July 1895).*

It is only now becoming known that among the leading artists of America imagination is promising to be the leaven of the future, serving to transform our art, no matter what the subject—within limits, maybe—no matter whether they be figures of fairyland or earth that pass across the scene. It is because there is very little that is phantom-fair in American art, because there are very few men seeking the mysteries of another world, that it is desired to point out the imaginative power of some few men who dwell and work in this. It is because Mr. Dewing, Mr. Tryon, and Mr. Macmonnies are imaginative, without saying so in forms of dream or in weird abstractions, that they are chosen to represent a distinct phase of progress in our art. It might be said of them all that they stand for the refining process in this country, the gradual evolution of finer, more delicately balanced technical habits from the stress and ill-proportioned condi-

tions of our earlier painters and sculptors . . . In them is witnessed that instinctive uplifting of the senses to a higher plane which is of the essence of imagination, and is a personal possession. Thus they are able to create a new wonder, and to give beauty to old and even common things. It is a matter of inborn faculty, a matter of temperament, of inspiration.

Here in America the native impulse has been for many years obscured and diverted by the accretions of foreign experience, by the influence of foreign schools. The temperament has been slow in casting off the mannerisms adopted from abroad, and has rarely spoken out. Men like George Inness, Winslow Homer, and John La Farge have been scarce. The inspiration has come only to a few. Yet there is something in the art of Mr. Dewing, for example, as in that of each of the two artists associated with him here, to convince us that the number of men in the American school who have a touch of the divine fire is increasing. What is this something? It is most of all, I think, the power to charm without the aid of any adventitious appeals to either poetry or incident, without any reliance upon eccentricity or even marked originality of subject. In this Mr. Dewing utters an important word in American art. He sums up the growing indifference of the school to subject considered purely as subject. He paints the portrait of a lady standing with a volume in her hand, and calls it "Commedia." More than this in the literature, so to speak, of his art it is rarely worth while to ask. But mark how pointedly, how distinctly, Mr. Dewing detaches himself from that sterile school of craftsmen who have sought to establish in America the Parisian ideal of mere technical polish, irrespective of theme. The theme, it may be admitted, is slight in his work, but it is freighted with suggestion. Standing between art for the sake of art, and subject for the sake of subject, he reaches the only sound solution by cutting the Gordian knot. Choose your theme as you will, he says; an unimportant theme if you prefer. Keep your art. But make them both subjective.

Suiting the action to the formula which I have ventured to devise for him, Mr. Dewing has produced the various enchanting pictures by which he is known. The adjective is used advisedly . . . They do not widen our experience in romantic distant spheres, but in the world near at hand to which they introduce us they have an enchantment, a witchery, that only a man with poetic feeling could revive. They impress us through their extraordinary fineness of workmanship. Mr. Dewing is indefatigable in the tender, searching manipulation of his brush. Still more does he owe his fragile spell to the grace, the impeccable elegance, of his effect. That is unique. It is felt in a figure like the "Commedia," an embodiment of feminine subtlety, poise, and charm. It is felt to a remarkable degree in "The Hermit-Thrush," a painting of the purest simplicity, and yet more difficult of interpretation than many a crowded canvas. The episode is briefly described. Over a hill that slopes down to the foreground a gigantic tree is leaning, and hidden in its foliage is the bird to whom two women listen, one of the two seated, the other standing in the deep lush grass, both clad, oddly, in evening costume. Silvery grays and greens, purples that hesitate between the depth of shadowed leaves and the pale transparency of the violet—these with soft tawny browns and creamy rose hues in the figures make up the coloristic beauty of the whole. It is in a minor key as to color. But with the music of the thrush the picture fairly thrills. In this, it seems to me, we have one ideal of American art. The scene is not farfetched. The motive is in the last degree simple—merely two women listening to the thrush. It sounds almost trivial when some of the great pictorial conceptions of the past are recalled, but Mr. Dewing does not forget that he is working in the present, and he shows the realists what can be done with the substance of modern life, modern environment. Responding to the infinite poetic glamour in his subject, seeing clearly the loveliness, the sweetness, of his scene, he has put such lyric rapture into the picture he has made of it that he stands head and shoulders

above many a professed poet. Introducing no concrete emblems of imagination, he is nevertheless imaginative in very lofty measure. One extremely interesting proof of his inner grasp of his matter is the felicity with which he has bodied it forth, contriving within the limits of his canvas a beautiful unit of line, a perfect composition in the strict sense of that term. It is not an Academic symmetry that he has achieved. It is the natural, unforced symmetry of a constructive imagination . . .

Mr. Tryon . . . has not, any more than Mr. Dewing, sought to devise a complex, an esoteric work. He has preferred instead to do in landscape what Mr. Dewing has done in *genre,* to interpret nature with absolute simplicity, but with imagination, with subtlety refined to the furthest possible point. The point he has reached up to the present time is fruitful of no quality more striking than that which he shares with Mr. Dewing, his independence of picturesque invention cultivated for its own sake. The dramatic fire which so often bore George Inness on to a brilliant climax subsides or is altogether absent from Mr. Tryon's landscape. It is his belief that true art never enforces itself upon the beholder, but drifts as quietly as it does irresistibly into the mind. The theory would be inferred from his work, of which the principal characteristics are repose, suavity, moderation, and the gentle key of color synthetized to a tone as pure as it is transparent. The synthetic quality is perhaps the most remarkable in Mr. Tryon's work, for it has nothing in common with the excessive breadth of impressionism, and even differentiates itself by an extraordinary delicacy from the admirably solid naturalism which the Fontainebleau men introduced. He has masses in his pictures, as may be seen from the grouping of the trees in his "Dawn—Early Spring," yet he emphasizes the dictum that art gives you a vision of facts instead of the facts themselves by lifting his masses out of the realm of dense ponderable things. He secures, I think, a veracity of vision, of feeling, as distinguished from a veracity of direct contact. The same is true of any thorough landscapist: it is true of many of Mr. Tryon's countrymen; but his pictures are so consummate in this particular that he stands almost alone. His technical merits have often elicited the admiration of his colleagues. There is no more complete painter's painter in America to-day. Yet with the same quick and profound sensitiveness to what is finest in art that has been pointed out in Mr. Dewing, he leaves, less than most landscapists, a margin for delight in his brushing or workmanship, his modelling or his perspective. I do not mean that these things are unimportant in him. They are of account in the achievement of his aim. But the first consideration of that aim is to awaken the sense of nature's living loveliness, the sense of quivering grass and palpitating clouds, the sense of trees that feel the wind, although they do not bend beneath its weight. Executive adequacy is tacitly assumed when these impalpable truths are pursued, and it is with the impalpable that Mr. Tryon is almost exclusively concerned. This might easily be construed as a fault in him, for thinness lies that way; but, as a matter of fact, he escapes the charge of tenuity by remembering that the truths of nature are, after all, rooted in the solid earth as much as in the circumambient air. He has therefore not only the flamelike tremulousness which shakes the grass in the foreground of his "Dawn," he has also in that, and in all his pictures, the organic equilibrium and depth which speak of close observation, and a sense of the massy structure in field and wood.

If this structural side of Mr. Tryon's art is not aggressive, not conspicuous in its effect, it is because of his entire freedom from Academic habits, his reliance upon instinctive rather than formulated rules of composition. The point is forcibly illustrated by reference to Mr. Tryon's most important work, a series of landscapes and marines painted for certain spaces in the house of a collector in Detroit, Mr. Freer. For the hall in this house Mr. Tryon executed seven pictures, the largest a canvas of some eleven feet in length, and all of them in the neighborhood

of five feet high. I emphasize this question of scale because it bears upon the scheme in which the pictures are arranged. They were all conceived with a view to their final destination; they were all painted as panels in an architectural ensemble. Their proportion, in brief, was fixed by the plan and height of the hall. The occasion was here offered, if ever, for a decorative if not purely formal series of designs. Mr. Tryon might have used an Academic plan in the work had he chosen. He elected, however—and in the election lies the finest demonstration of his talent—to bring the unity of nature into the hall rather than to subdue his out-door inspiration to the hard and fast conditions of his space. He did not pile up his motives in designs that sought to harmonize themselves with the linear elements in the hall—a course that might easily have justified itself in the hands of a master of convention. He endeavored rather to preserve the intrinsic symmetry of landscape—the symmetry that falls instantly into line with the poise of architectural things, irrespective of where the place may be.

Before me is one of Elbridge Kingsley's masterly wood-engravings, a reproduction of the "Spring Morning" which figures in the Detroit series—a succession of pictures, by-the-way, devoted to the passage of the seasons. Reduced to the broad simplicities of a monotone, all the structural character of this work stands forth, and how noble it is! It is a lyric moment that is celebrated in this dainty vision of faintly moving, scarcely breathing nature, with the soft whites of the apple blossoms rendered still more diaphanous by the veiling half-lights of the dawn, but there is something almost stately in the measured lines of the composition. The few erect trees, half-way up the canvas, the inclined apple-trees in the middle distance, the thick groves and dark horizon of the straight-ridged hill beyond, everything in the scene is subtly, emotionally interpreted, yet everything is subject to the keen selective eye of the artist, and you feel that he has hit upon the unaesthetic secret of their pictorial relationship, that he has flung them into just that unified, almost isolated group which Nature herself intended. The details are welded into one spontaneous whole. The effect would not be so fine were it not due to a conscious fusion of varied material . . . One ends, as one begins, by praising Mr. Tryon for a synthetic gift which becomes more and more as you analyze it a matter of feeling, of inspiration, and less and less a matter of craft. He must be granted, I repeat, the deliberate fashioning power of the artist; but when you seek the bloom of his art, the sap that nourishes it and the beauty that it sheds, this question of form sinks into its proper relation, and the imaginative impetus of the painter comes to the front as the primal source of his power. This is reiterated because, as was stated in glancing at Mr. Dewing's work, it is for the slow but sure establishment of the imaginative principle that he and Mr. Tryon are to be especially thanked. They prove the great cardinal fact that, given a perfect balance between spiritual and technical qualities in a man's art, it is the higher of the two which goes swiftly to our consciousness and there refreshes and delights . . .

. . . But just as the first and last impression of Mr. Dewing is of a finely fibred nature, revealing the nameless beauty in things of familiar sight and sound, so Mr. Tryon must count for us as an intermediary between our half-sealed perceptions and nature's fathomless charm . . . It is the bleakness, it is the melancholy, it is the iron-bound earth in his "Winter" that we remember; it is the chill and the windy freshness of his New Bedford Harbor study that the mind will not forget; it is the spring-time of his "Dawn—Early Spring" that haunts the imagination like a breath from the dewy scene it mirrors with such art. The art is quiescent as a mirror. It is the scene that you feel, thinking perhaps of Matthew Arnold's fine resolution to step aside and give the idea free play. That, I take it, is the resolution of Mr. Dewing and Mr. Tryon; to render all their faculties pliant, flexible, by the exercise of imagination, and then, standing in the presence of Nature, to let her speak through them in such terms as their own rules of taste, of

reticence, and proportion show to be decorous and essential. There they are men of one ideal. The differences between them, such as they are, are obviously foreordained by their different fields. The range of a figure-painter is naturally richer in episodes that imply movement, if they do not directly illustrate it, than the range of a landscapist.

Clara Ruge, "The Tonal School of America," International Studio 27 (1905–6).

We have to-day a national school of landscape painting which is rapidly advancing in importance and originality. It is not indeed the first well-defined school in this country. The Hudson River school was distinct and characteristic. But the Tonal School is the first one, I believe, which is destined to leave a mark in the history of art.

Henry W. Ranger, the leader of the movement, gave it the name "Tonal" in designating the exhibition held at the Lotos Club fifteen years ago. The word is used for a quality in painting that is too old to be called an American invention. Emerson says that an idea is to be credited to the man who most fitly expresses it. In this respect, the Tonal method, if not primarily, is at least characteristically American . . .

Tone ordinarily signifies harmony in the colour scheme. It should not be confused, though it sometimes is, with the quality called value, which is a matter of the correct relationship between gradations of light. Yet if we apply this distinction alone to the work of the school we are wide of the mark.

The method of representing natural colours by pigment is often a touchstone to the secrets of technique. The earlier painters mixed their pigments on the palate, and brushing the combination on the canvas let it convey its message to the eye. The impressionists mixed their pigments in the eye. They put separate touches of pure contrasting colour line by line on the canvas and let the effect on the retina challenge comparison with the effects of sunlight. The tonal painters mix their tints, but mainly under the brush on the canvas direct. But this is far from being the whole story.

Again, the representation of colours implies a transcript from Nature. It has been maintained that the grass and foliage of this planet were green—bright green in the sunlight and deep green in the shade. This is on the whole a comfortable doctrine and much can be made of it. Yet, without throwing suspicion on the existence of chlorophil, any boy on the night of the Fourth of July may with a canister of red fire raise disturbing doubts. With much more pains and labour the *plein air* school has proved the same case—that colour is an external matter of light. Both these theories, however, serve of themselves only one purpose, that of transcribing facts. If we exchange brown shadows for purple shadows with a gain of truth we are only beginning to see. We have not by that alone arrived at poetry.

George Inness, who displayed in his later manner some of the qualities that became the boast of the succeeding school, and who had an admirably clear way of putting theories of art, said: "The purpose of the painter is simply to reproduce in other minds the impression which a scene has made upon him." Is this to reproduce form only? Colour and form only? Even values and tone? Clearly, there is something more in the transcript. "A work of art does not appeal to the intellect," continues Inness. "It does not appeal to the moral sense. Its aim is not to instruct, not to edify, but to awaken an emotion . . . Its real greatness consists in the quality and force of this emotion." And, as seldom happens between theory and performance, the work of Inness himself shows this distribution of emphasis. The brilliant colour of our autumn woods stands on his canvas warmly brushed in and still kept well in tone—a record full of the glory and the quiet of the season, but without a leaf to be seen anywhere. For he understood the truth in the

old complaint about not seeing the woods for the trees. It is obvious. In the work of his predecessors too often one cannot see the tree for the leaves.

Here, then, pronounced by Inness and carried forward by Alexander H. Wyant and Homer D. Martin, is the motive that the Tonal School has made its own. The arrangement of colours must be kept in harmony because it must reproduce not merely the facts of the landscape, either separately or in mass, but, rather, the effect of the scene upon the painter's feelings, the emotion it evokes. Not alone the grass and the trees, with whatever delicate recognition of gradation of colour, but the mood, of which they are the embodiment and cause, is to be transferred to the canvas.

R. A. Blakelock, to be reckoned with Homer D. Martin and the gentler Wyant as a pioneer in the Tonal method, laid this characteristic requirement upon his technique. Though his canvases are usually small, his handling is broad to a degree that makes the preference for the sights of the "inward eye" rather than the vision of the photographic lens a rule of thumb. George Fuller, to cite another instance, showed in the work of his best period the conceptions of an original mind rather than direct observation of Nature. His painting, by the way, is particularly interesting in a school so deeply engaged upon landscape, because unlike most of the men he inclines to introduce figure work in his studies, perpetuating in the midst of this transplanted Barbizon enthusiasm the spirit of Millet.

For there was an echo of Barbizon at Lyme. Düsseldorf, which had displaced the older English influence, had in turn given way to more vital influences from France. It was the transposition of the ideals of the Barbizon painters to American soil by American artists that, with an admixture of Dutch tendencies and habits and of French technical discoveries, produced, through the action of a different national temperament and with the material of a region that was in comparison to northern France and Holland half tropical in climate, the Tonal School of America.

Ranger's youthful spirit was fired by the sight of some Barbizon paintings which had been brought to New York, and throughout it has been the Barbizon men, with the old Dutchmen, who have influenced his conception. As a student he reached Paris after the day of the Fontainebleau painters. Monet's method interested him as a science, not an art. And after successive returns for years to the galleries of Europe, which he made his atelier—for he never entered an art school—he returned to his native land and attracted attention from the first with his warm-toned woods in wine-red and gold. He has not won full recognition quickly, however, largely because the *salon* idea, the miscellaneous grouping of unrelated work in an exhibition, is a thing he rejects. His forceful, beautifully composed paintings, with their rich colour harmonies and excellent structure of trees, have been seen in exhibitions only when alone by themselves or when grouped with the work of men whose theories harmonize with his own.

THOMAS WILMER DEWING, CHOICE SPIRIT

Like his friends Dwight Tryon and Abbott Handerson Thayer, the Paris-trained cosmopolitan Thomas Wilmer Dewing enjoyed the patronage of the wealthy industrialist and connoisseur Charles Lang Freer, also a major supporter of James McNeill Whistler. All—painters and patron alike—sought through art to escape and transcend the vulgarity of modern life. The sense of entitlement and elitism justifying such a goal finds definitive expression in Dewing's letter to Freer in which he explains his reasons for withholding a certain group of his paintings from the Panama-Pacific Exposition in Buffalo.

Thomas Wilmer Dewing to Charles Lang Freer, February 16, 1901, Charles Lang Freer Selected Papers, 1876–1931, owned by Freer Gallery of Art and Arthur M. Sackler Gallery Archives; microfilmed by the Archives of American Art/Smithsonian Institution.

I have come to a decision about my group of pictures of Buffalo and that is not to exhibit any landscapes. My pictures of this class are not understood by the great public who go to an exhibition like the Pan-American—they are above the heads of the public. My object in exhibiting at all is merely patriotic—to make the exhibition as strong as possible which I can do by showing eight or nine of my figures in interiors—these stand squarely on their technical excellence. My decorations belong to the poetic and imaginative world—where a few choice spirits live. Some time before long I will have an exhibition of decorations alone, not at this time and place, you must agree with me.

PRAISE FOR JOHN TWACHTMAN

Although the terms impressionism *and* tonalism *have distinct connotations, in practice many late nineteenth-century American painters merged aspects of both in their art to produce a distinctive blend taken by many commentators to be authentically American. Nowhere is this better illustrated than in the art of John Henry Twachtman, who fused abstraction and representation, glowing color and misty tone, earthiness and spirituality in his contemplative visions of nature. Twachtman was a member of the "Ten American Painters," who withdrew from the Society of American Artists in 1897–98 to protest what they perceived as the size, inclusiveness, and lax admission standards of Society exhibitions. Other members included impressionists William Merritt Chase, Frank Weston Benson, and Childe Hassam and tonalist Thomas Wilmer Dewing. Both Hassam and Dewing published tributes to Twachtman after his death in 1902.*

Childe Hassam's remarks suggest that by the turn of the century impressionism had been thoroughly naturalized. He praises the force and beauty of Twachtman's open-air canvases and points out their distinctively northern character. By twinning Twachtman with Henry David Thoreau, Hassam makes a further bid to establish the painter and his eclectic stylistic synthesis as genuinely American. Further, he insists on the manliness of Twachtman's work—in rebuttal to those who worried that American art and its makers would succumb to the feminizing influence of foreign styles and the insidious seductions of overcivilization. Finally, like Dewing, Hassam betrays characteristic elitism in his scorn for the "stupid" public while at the same time urging collectors to buy American.

Childe Hassam, "John H. Twachtman: An Estimation," North American Review *176 (April 1903).*

It is difficult to define, perhaps, what the charm is in a work of art, and in speaking here of Twachtman's work, which had so much charm and distinction, I shall probably parallel the thoughts of many of my fellow-painters, and possibly their words if they should speak of him.

The great beauty of design which is conspicuous in Twachtman's paintings is what impressed me always; and it is apparent to all who see and feel, that his works were sensitive and harmonious, strong, and at the same time delicate even to evasiveness, and always alluring in their evanescence.

His was surely the work of a painter too—a man's work. You felt the virile line. It was in his clouds and tree forms, in his stone walls and waterfalls, in his New England hillsides, and

in the snow clinging to the roof of an old barn or edging the hemlock pool. His use of line was rhythmic, and the movements were always graceful. The many landscapes that these words will recall—with their simplicity and breadth of treatment, and their handling, often of great force and beauty, of brush-work and painter-like assurance—were amongst the very handsome modern open-air canvases. Their breadth, with the swing and sinuosity of line in his rocky pastures, and in brooks set with boulders, with the swirl of little waterfalls, had something that was very large and noble in expression. All this, with his arrangement of forms (for the pleinærist does arrange forms when working from nature), made his work most valuable and interesting—designed, and with great beauty of design. By design I mean by no means conventional composition. The definition so often given of the work of modern painters in landscape—which is, that they take a *motif* anywhere, as if looking out of an open window, and paint it just as they see it—is partly erroneous, only a half truth. These painters do try to give you frankly the aspect of the thing seen in its fundamental and essential truths; but that they do not place things as they feel they should be placed to get the balance and beauty of the whole, well seen within the frame, is a mistaken idea. Twachtman might have painted, indeed he did paint, a tree in Nutley, New Jersey, with a distance and middle distance of Gloucester Harbor, Massachusetts.

A noble and expressive line, with a joyous feeling for nature, a frank and manly directness in presenting truths, by painting, however poetic and fleeting, must give value and distinction to any work in paint—or in any other medium in which we express ourselves in what is called Art.

Twachtman was a boy in the sunlight; and Thoreau, that other remarkable landscapist and pleinærist in words, says somewhere that "the Greeks were boys in the sunlight," and to me that is a complete description of the Greek nature. His work as color had delicate refinement and truth. His color is the color of northern nature in the changing envelopes of subtle gradation. There is nothing swashbuckler about his subjects or his color, and in these days of spurious old masters, of artificiality, of rainbows and sunbursts, that is refreshing. One gets tired of Alps and sunsets, at least in literature and painting; in music they can be better done. And in this province of the painter, Twachtman has, in his small, slight sketches, these same qualities of charm of line and delicacy of vision. True to our northern nature, too! Truths well told, interestingly told, just as a few words well chosen will tell a truth that a thousand cannot!

Twachtman felt very keenly the unrelenting, constant war that mediocrity wages against the unusual and superior things. The public are anxious to take the word of an office-boy in any art-shop, in preference to that of an American painter of recognized ability. Art has no frontiers, to be sure, but some of the dealers (not all) will assure you that there is a frontier and that it begins right here at the New York Custom House. It is curious how stupid the public can be about this! If the Celt and the Teuton cannot paint (and they have done the best painting) on this side of the ocean, then natural laws are changed . . .

The American people can at least go on record as having respected the art of their own country, which has been fully recognized abroad. Why should not the Metropolitan Museum have a gallery devoted to the work of American painters? The Metropolitan Museum should have an American room, and Twachtman should be well represented in it. We have an art! Let us respect it!

With such an estimation of the work of this American artist, a man who was an able painter and a joyous, energetic individuality, who worked for the love of it and worked well, one must feel that he has not yet been adequately appreciated.

*A founding member of the "Ten American Painters," Edmund Tarbell launched his
career with a series of brilliant open-air compositions but later turned inward, literally,
to concentrate on refined and peaceful interior scenes featuring gleaming antique furni-
ture and young women absorbed in quiet domestic tasks. These new works combined
sensitivity to the play of light with Whistlerian aestheticism and a conscious emulation
of the Dutch masters, Johannes Vermeer in particular. In the course of a long teaching
career, Tarbell (with codirector Frank Weston Benson) established Boston's Museum
School as a bastion of a distinctively refined and academic style of impressionism. In
his appreciation of Tarbell, Homer Saint-Gaudens (son of the sculptor Augustus Saint-
Gaudens) touches on the principal ingredients of the artist's eclectic synthesis, so con-
servative yet so contemporary in its smooth blend of styles and references.*

Homer Saint-Gaudens, "Edmund C. Tarbell," Critic *48 (February 1906).*

Edmund C. Tarbell creates in his paintings a nucleus of objects and thoughts so fused that
through the aspect of the visible the spectator comes to feel the sentiment of the intangible. The
artist's grasp of such a combination, the result of felicitous selection and presentation, has
reached its highest level in his most recent production, the "Girl Crocheting." Before the first
exhibition of the canvas Mr. Tarbell held his reputation chiefly through his interest in open-
air studies of landscapes and figure compositions. However, with this last effort, in treating a
room and its occupant, he has turned towards a new field, one that recalls the Dutch indoor
scenes of women about their household duties, so typical of Terborch and the men of his class.
In the present instance a girl, wearing a conventional modern shirtwaist and skirt, sits tran-
quilly beside a mahogany table, where she bends over her crocheting in silent absorption. The
light, from the window behind her, falls softly upon her hair and back, upon the rough surface
of the wall, across a copy of a Velasquez, and some Japanese prints that fade into the mellow
shadows, and over the highly polished table-top. The attitude of the figure remains both nat-
ural and realistic. The room certainly displays nothing uncommon. It should be a matter of
comparative ease for Mr. Tarbell, with his thorough technical training and original sense of
beauty, to create, by an anecdotal category of details, a simple likeness of such an unsophisti-
cated young woman, and such frank surroundings. His unusual qualities, in this case, lie in a
capacity to associate with the forms at his command thoughts and feelings that are tranquil.
For, by means of his insight into the possibilities of warm, modified lights, and by means of his
ability to deal with semi-opaque shadows and reflected color he has infiltrated a hum drum,
every-day situation with a poetical atmosphere strangely devoid of the usual accompanying mys-
tery. Perhaps much of the charm of his search for the thought in unaffected objects may be
credited to his apparent dislike of over-subtile but always-to-be-discovered tricks, employed
to reveal dexterity on the part of the artist rather than graciousness or strength on the part of
the art. Mr. Tarbell draws with a lovable touch that never fails to remain in keeping with his
clearly chosen shades and accents of light. He fills with breadth his delicate regard for color. In
his treatment of actual surfaces he exhibits a definite understanding and skill in dealing with
various textures, as when he succeeds in the unusual task of contrasting the clear reflected light
of the girl's shirtwaist against the dull, luminous glow of the wall. Again and again he repeats his
faculty of spreading suggestiveness and individuality of character without mannerisms. Yet that

he may more completely raise himself above the level of an imitator to the position where he may bind feeling and fact into a comprehensive whole, he works cleverly and sympathetically at his calling, that by nature must be one of deception. Nevertheless, he sees to it that the deception remains plausible, and in this plausibility he hides and yet expresses what he feels by what he sees.

THE SENSUOUS COLOR OF JOHN LA FARGE

In addition to his standing as a productive and influential artist in stained glass, John La Farge was also a muralist, illustrator, and still life painter renowned for his distinctively brilliant yet delicately calibrated color schemes. Not technically one of the impressionists, La Farge was closely aligned with that group in his use of prismatic, complementary hues and his desire to achieve glowing light effects in his paintings. Although La Farge envisioned the use of luminescent color as a vehicle for the cultivation of individual refinement that might in time help to achieve a more harmonious society, his glowing palette, according to William Howe Downes and Frank Torrey Robinson, ushers admirers into transcendent realms of purely sensuous pleasure, as the following comments testify.

William Howe Downes and Frank Torrey Robinson, "Later American Masters," New England Magazine n.s. 14, no. 2 (April 1896).

Let us now turn for a moment to the extreme limit of the range of our pictorial arts, and revel in the delicious color-mosaics of John LaFarge. When we call him one of our immortals we do not think there will be one jealous soul among the artists of the country, for they themselves would doubtless place upon his head the laurel wreath. From his earliest youth his art has had an even, uninterrupted and steady growth. The flowers were his companions in his boyhood; their colors enchanted him; he and they in some mysterious manner exchanged secrets. He has ever breathed the sweetest and most magnificent color, making it the powerful and persuasive vehicle of his imagination, and he has thus stirred the sensitive spirits of his kind the world over. He can be studied in his flowers—in the rose, the water-lily, and the lotus. We find the spiritual head of St. John the Baptist, painted early in his career, among the sixties; "The Madonna" and "The Crucifixion" and "The Ascension" followed, as monumental frescoes: and these works have, with other cathedral paintings, become the glowing records of his religious zeal in art. His "Wolf Charmer," so original and so human, so wonderful as a parable, reveals an almost divine insight into the nature of things. He makes this weird musician touch a chord which tames the ferocious beast, and at the same time he strikes a chord in us which responds. LaFarge is not only a creative artist, who sees for himself, and makes a world of his own. He is an artist also who paints as if inspired by pure feeling . . .

LaFarge's art is composed chiefly of two great elements, the one being his gift of celestial color, and the other being his love for beauty. This he has the joy to find in the simplest things, from the wild flower to the ecstatic expression on the saintly countenance—the blossom of the wayside bush and of human faith. Such are the open gates through which his art leads us, through which he passes freely, finding few fellow-travellers to elbow him on his way . . . In Japan, in Samoa, in France, in America, anywhere, LaFarge holds up the torch of flamboyant color, of light, of fire, giving new and thrilling sensations to the world of art.

ART COLONIES

Beginning in the early nineteenth century, American landscape painters habitually traveled during the summer, searching for subjects that would form the basis of their winter's work and exhibitions in the city. After the Civil War, artists' colonies began to develop in picturesque old villages, notably Cos Cob and Old Lyme in Connecticut, Gloucester in Massachusetts, and East Hampton on Long Island. Like other aspects of Gilded Age art life, the movement to establish art colonies was patterned on French precedents, notably the Barbizon school, whose members (including Camille Corot and Théodore Rousseau) celebrated ordinary rustic scenes and picturesque peasants.

Charles Burr Todd makes explicit reference to the French model in his essay on East Hampton in the early 1880s, which was home to the summer studios of Thomas Moran and several other well-known painters. The author dwells on features that typify the attraction of such places to artists in their retreat from the city. The village is old-fashioned and overflowing with picturesque subjects begging to be painted. It is antimodern as well, although precariously so, since the railroad is rapidly encroaching. In such havens the artist's work is also the work of the preservationist who seeks to record and idealize what is soon to disappear.

Old Lyme, Connecticut, summer base of operations for Henry Ward Ranger, Childe Hassam, and numerous others, competed with East Hampton for the title of "American Barbizon." Grace L. Slocum in the excerpt below points out many of the same rustic, antimodern characteristics in her description of the village. She also makes reference to Florence Griswold, who provided board and offered moral support to many summer visitors in her ancestral manse, irreverently dubbed "Holy House" by sojourners. Slocum's remarks on the Griswolds' ancient lineage, finally, evoke the veneration of ancestry intrinsic to the Colonial Revival and its nostalgic longing for a noble, mythic past to act as bulwark against the present threat of demographic change.

Charles Burr Todd, "The American Barbison," Lippincott's 5 *(April 1883).*

Barbison, the well-known resort of so many French artists and art-students, where Millet and a whole colony of painters have found inspiration and subjects worthy of their pencils, lies in the heart of the ancient forest of Fontainebleau, at an easy distance from the great capital. East Hampton, which we have ventured to call the American Barbison, is a village of Puritan origin, situated at the southeastern extremity of Long Island, in a little oasis of meadows and wheatfields, that owes some portion of its attractiveness to its surroundings of sand and scrub. Its one wide main street is so prodigal of land that it could only have been laid out by men with a continent at their disposal. Great elms and willows overarch it, and beyond their vistas the eye rests on the broad bosom of the Atlantic, flecked by summer sails. Northward one looks on orchards and green fields. The dwellings that line it for a mile please by their endless variety. There is the quaint old Puritan cottage, with its gables facing the street, and flanked by the wood-shed and mossy well-sweep and bucket. There are square, roomy, old-fashioned farmhouses, some newly painted, some dingy and moss-covered, with low stoops opening directly upon the street. There is a quaint old village academy, the first opened in the State. There are little shops that nobody knows the use of, an inn, a few summer villas, a fine old country-seat standing remote and grand behind a copse of maples and cedars, and at either end of the vil-

lage street a windmill,—gaunt, weather-beaten structures, that at the merest suspicion of a breeze throw their long arms as wildly and creak and clatter as noisily as those that Don Quixote attacked . . . The churchyard, once under the wing of the church, is now set lonesomely in the midst of the main street, its white tombstones looked down upon by all the neighboring dwellings and constantly reminding the villagers of the virtues of their ancestors. Still, it is an interesting spot, with its fence of palings, its quaint old-fashioned stiles, and mossy stones, whose legends tell of wrecks upon the coast, and of brave young spirits drowned at sea, killed by falling from the mast-head, crushed in the whale's jaws, or fever-stricken and buried in some tropical island. In a place so remote, it is natural that the quaintness and pastoral simplicity of country life a hundred years ago should still prevail. At sunset and sunrise herds of sleek, matronly cows, with barefoot boys in attendance, wind through the street; scythes and sickles hang in the willows by the wayside; and every morning the mail-coach rattles into the village with a musical flourish of the driver's horn, stops at the post-office for the mail-bag, calls all along the street for bags, baskets, and parcels, and at last rumbles away toward the railway-station, seven miles distant. Most truly rural are the orchard farm-yards, which abut upon the street without concealment, in front perhaps set thickly with apple- and pear-trees, and behind these showing open spaces covered with a deep green sward, with cart, plough, stack, wood-pile, sheep, and poultry, disposed in picturesque confusion.

Our village, in its two hundred years of existence, has gathered about it an atmosphere of legend and romance, and one may still see with the mind's eye some of the quaint figures and striking scenes of its early history . . . This charm of old associations combined with pastoral simplicity is evanescent, and will soon be gone. Already the railroad, rude iconoclast, is approaching, to destroy the relics of the past and change the whole aspect of the place. The limner, therefore, who succeeds in depicting such features as are best worth preserving will not have performed an unappreciated task.

The summer phase of the village is almost entirely artistic. What painter first discovered it is a subject for speculation; but when discovered its possibilities in the way of art rapidly became known, and it has been for several years the summer home of many favorites of the public . . . Two sketching-classes added a progressive feature,—one comprising several ladies of the Art Students' League of New York, who were domiciled at first in a cottage by the sea, and, later, in the village inn; while the other, also composed of ladies, met three times weekly in the former school-room of the academy. Dante alone achieved a studio. It was on the upper floor of the academy, and presented a medley of "studies," nets, rusty anchors, spoils of the sea, flowers, birds' nests, and trophies won from the village houses,—poke bonnets, stocks, perukes, faded gowns, arm-chairs, spinning-wheels, and other ancient furniture. This became a favorite gathering-place with members of the craft, and, during the summer, witnessed the reunions of many long-sundered friends. Besides the artists, a score or so of quiet families made the place their summer quarters; but its characteristic features remained the same,—in every quiet nook and coigne of vantage an artist with his easel, fair maidens trudging afield with the attendant small boy bearing easel, color-box, and other *impedimenta*, sketching-classes setting out in great farm-wagons carpeted with straw, white-aproned nurse-maids, rosy babies, and pleasure-vehicles in the streets.

The routine for the summer was tolerably uniform. Out-door work was usually done in the soft light and shade of early morning or evening. In-door work occupied a part of the intervening hours if the artist was industrious. At eleven there was a gathering on the bathing-beach, and an hour's wild sporting with the surges of the Atlantic. There was tennis for those who cared for it, straw-parties and sailing-parties, moonlight rides to the beach, excursions to Sagg, Hard-

scrabble, Pantago, and Amagansett. The students of the sketching-classes were the most industrious, wandering about the village, selecting their subjects, sketching, painting, and returning to the inn at night with their spoils. Sometimes the great carry-all carried them out to Tyler's for a day's sketching. Arrived there, one drew the quaint old dilapidated barn, another the farmyard, a third the mossy well-sweep, a fourth the crooked-necked duck leading her brood to water, a fifth the grain-fields, and so on, till all were supplied with subjects. At intervals the grave professor came to the inn and passed on the students' work with his pungent criticisms. There was a large wheat field on the southern rim of the town, near the sea, that attracted many visitors and gave rise to more day-dreams than any palace of the genii. Its black mould closed on the white sand of the beach, and there was little interval between the bearded wheat and the coarse bunchgrass of the dunes. It seemed a novel sight, this strong young daughter of the West drawing life and nourishment from the grizzled ocean. Such points of similarity as should exist between sire and daughter were often noted by imaginative visitors. When the wind blew, there were waves in the wheat as well as in the sea; argosies of cloud-shadows sailed over it, and it never lost a low, soft murmur, that seemed a faint refrain of the vast monotone of the sea. What weird imaginations and startling effects, to be elaborated in the studio on the return to the city, were suggested by it, cannot be told. The beach, with its broad reaches of sand and foaming surges, its wrecks, sand-storms, mirages, soft colors, and long line of sand-dunes cut into every variety of fantastic shape by the winds, was equally prolific of wild fancies.

Grace L. Slocum, "An American Barbizon," New England Magazine 34 *(July 1906).*

Old Lyme, long famous for its historic associations, has become yet more famous for its artist colony; for here, in this beautiful old town at the mouth of the Connecticut river, are gathered every summer, some of the most noted artists in America; and here, too, was established, under Mr. Frank Vincent Du Mond's leadership, the Summer School of the Art Students' League of New York. This was in 1903 but what is known as the Lyme School of Painters was founded some seven or more years ago by William Henry Ranger, and last year about eighty artists of established reputation made Lyme their headquarters. Mr. Ranger asserts that Barbizon offers nothing finer, nothing more paintable than the country round about Old Lyme and so the ideals of the Barbizon painters find an echo in this new Fontainebleu in Connecticut.

The first glimpse of the town from the top of Noyes Hills shows a little hamlet about a mile inland from the station, half hidden by great old trees, with the spire of the old church pricking through the foliage . . .

The main street of the venerable old town, which crosses the ferry road at right angles is a wide boulevard, overhung by great old elms, centuries old, than which there are few finer to be found in the country. "The Street," as it is called, is a mile and a half long, and on either side, with white façades glimmering through the greenery behind high hedges of box or evergreen, stand many historic mansions where the descendants of the men and women who have made the old town famous, dwell in elegant seclusion.

An Old World atmosphere pervades the town as though it had inherited the spirit of the English village, Lyme Regis, immortalized by Whistler, from which it took its name. Here the trolley has not yet penetrated, nor has the summer tourist marked it for his own. It is an ideal and idyllic spot for artists . . .

. . . The majority of the members of the artist colony make their home for the summer in an old colonial house at the upper end of "The Street," belonging to one of the descendants of the patrician Griswolds.

"Holy House," as it is irreverently dubbed by the students of the Summer School is one of the historic landmarks. It is also called "The Home of the Masters" and no students are admitted to its sacred precincts. It was built in 1888 by Captain Roger Griswold, a son of Governor Roger, and is now occupied by the sole survivor of this branch of the family, Miss Florence Griswold. It is a picturesque structure with hospitable front porch ornamented with Ionic columns made of trees which were floated down from Maine expressly for the purpose. The pillars have rotted away from the roof of the porch and stand as emblems of decayed grandeur, the "glory that was Greece and the grandeur that was Rome." Inside there is a wide hall with a vista of a vine covered porch at the rear where several of the artists take their meals. The rooms on the first floor form an unique art gallery. Every panel of the doors on this floor bears a signed painting by one of the noted artists who have made their home for several successive summers under this hospitable roof. In the front hall one door is decorated by a beautiful moonlight by Mr. Ranger . . .

In the dining room . . . is the eight foot panel painted by Mr. Henry R. Poor, over the old fireplace, depicting a fox hunt with the hounds in full cry across the fields and the artists following after, leaving overturned easels and unfinished pictures on the field. All the artists are caricatured and depicted in all sorts and conditions of costumes. The cow which Mr. Howe was painting has arisen in her fright and is in the act of flight, while in the distance Childe Hassam calmly surveys the scene. In the garden at the rear of the old mansion, several of the artists have erected little studios. Under the old apple trees at the end are the studios of Childe Hassam and Walter Griffin . . . The garden is a tangle of old fashioned flowers and shrubs, threaded by delightful walks wherein the artists loaf and invite their souls, and embody their dreams in terms of color . . .

The students of the Summer School are quartered here and there among the natives. The little band house, not far from the Inn, was engaged for the weekly criticisms, and every available barn within the radius of a mile of the centre has been preëmpted for indoor work. The majority of the students take their meals at a house next the Old Lyme Inn, which is a first class summer hotel, filled generally with guests who have relatives or friends in the town. The need of a central boarding house for the students is a pressing one, as the Inn hardly meets their requirements.

The summer of 1904 there were forty or fifty students in the Art School coming from all over the country from Maine to California, to work with Mr. Du Mond . . .

. . . The artist colony holds its annual exhibition at the close of the season and many familiar landmarks in Old Lyme are depicted on the canvases. Childe Hassam's picture of the old Christopher Wren Church, which stands at the intersection of "The Street" and the ferry road, is perhaps the most famous.

This historic structure was built in 1666, and is considered one of the most beautiful old churches in New England. It is of Ionic architecture with a porch supported by Ionic columns and the steeple which is the crowning feature of Christopher Wren's design. The interior is simple and dignified, with a circular dome in the centre and a half dome back of the pulpit with ribs picked out in gold. Originally there was a beautiful mahogany pulpit with carved panels but this was replaced, when the mania for remodelling old things invaded the town, by a modern contrivance. More than one old family is the possessor of a treasured relic of this old pulpit . . .

. . . The Griswolds . . . were of old English ancestry . . . and the coat of arms of the family now hangs in the old Governor Roger Griswold mansion at Black Hall . . .

The old mansion is indeed beautiful for situation, commanding a magnificent view of the Sound, whose waves break in foam on the beach within a stone's throw of the old porch. It is

a rambling old structure, which has been somewhat remodelled to suit modern demands with a modern bay window in front in close juxtaposition with the old porch, and a wide modern veranda in the rear. Inside there is the same mingling of modern and antique, but the general character of the rooms remains undisturbed, and evidences the most refined taste and sense of harmony. One might almost imagine it is Mistress Ursula, the stately, white-haired woman in black silk and laces who rustles softly forward to greet one and who pilots the visitor through the numberless rooms pointing out ancestral treasures on every hand. Old mahogany abounds in the fitments which have remained untouched for generations, while fine pictures adorn the walls and beautiful Oriental rugs and sumptuous textiles serve to bring the arrangements into harmony. In the drawing room whose chief architectural feature is the beautiful arches at one side, is a Longfellow chair in which the poet once sat, and other pieces of furniture, each of which has a history. One feels here as though one stood on holy ground and should put the shoes from off one's feet.

VACATIONING WITH ART IN SHINNECOCK HILLS

With the rise of art colonies came the summer school of art, which afforded extra income for painters while serving the swelling ranks of amateur and professional artists. Established by wealthy amateurs and launched in 1891, the summer school at Shinnecock Hills, Long Island, reflected burgeoning interest in open-air painting and capitalized on the ritual of summer vacation, by the 1890s a prerogative of all who could afford to leave the city for coastal or mountain resorts. At Shinnecock Hills, the principal instructor was William Merritt Chase, whose colorful personality and aphoristic teaching style attracted scores of aspiring professionals as well as dabblers.

Rosina Emmet (later Sherwood), one of Chase's own students, extols the many pleasures of the Shinnecock experience, where all except the professor himself are quartered in a quaintly rustic (and freshly built) Art Village, an ad hoc art colony of sorts. When not indulging in "fancy balls" and "witch parties," students attend Chase's Monday critiques, accompany him to some selected painting spot, or work on their own, their easels dotting the hills. Their various activities suggest multiple roles for art making in modern society, where art (like the vacation itself) connotes leisure, entertainment, therapy, and escape.

Rosina H. Emmet, "The Shinnecock Hills Art School," Art Interchange 31 *(October 1893).*

On all the low sandy tract known as Long Island, where so many people from New York and its surroundings flock with a sigh of relief, when they feel the first hot summer days creeping on them, there is no more unique spot than Shinnecock Hills. A visitor passing over them for the first time is apt to exclaim: "Oh, what a dreary place; and how hideous! Why under the sun should it be chosen for a Summer Art School?" Yet this spot, in spite of the way it very often impresses a stranger, is the one which for the past three years has been chosen for one of the most flourishing Art Schools in the United States. If a person is at a loss to find a reason for the selection of it, let him pack up his "traps" and go down to Shinnecock and spend a week there, breathe the air, watch the glorious atmospheric effects, and cautiously creep up behind the easels which dot the hills, and watch the absorbed artist at his or her work, and at the end of that time it is pretty safe to say that he will declare that, not only are the hills the most delightful place in the world, but that no greater profusion of material can be found any-

where to delight the eye of an artist, in spite of the fact that the whole of Shinnecock can hardly boast of one tree . . .

In the Summer of 1890 several of the ladies who lived there, and who were anxious to form an artistic circle, got together to discuss the feasibility of starting an Art School at Shinnecock the following Summer, for the advantage of those who wished to leave the city during the hot months, and at the same time keep up their art studies, and also those who wished merely to dabble in painting as a Summer pastime. The movement once set on foot, people began to take interest in the scheme, and by the following Winter enough money had been raised to build a studio and secure the services of Mr. Wm. M. Chase as instructor.

The studio is a large building built of logs. Around it are clustered a number of little cottages which are rented to the art students. The little community is known as the Art Village, and is odd and picturesque. Then a large commodious house on the hills was given by one of the generous promoters of the scheme for the accommodation of women art students only. It is known as the Art Club, and from the first has been a wonderful success. It opens the first of June and closes the first of October, and through the four Summer months is the scene of continual fun and frolics, such as fancy balls, witch parties, etc. All the farm-houses and boarding-houses in the neighborhood are filled with art students of both sexes and all ages, who pursue their chosen study with a vim which is a delight to the observer. How much more so must it be to their teacher?

It is very interesting to watch Mr. Chase's method of teaching his class. Every Monday morning at ten o'clock the class meets in the studio, and the different sketches that have been made during the week are placed on a large board in the centre of the room, while Mr. Chase, standing in front of them, criticises his pupils' work. The class is a large one and each scholar generally makes two or more sketches, so criticism takes all the morning. Mr. Chase is wonderfully kind in his criticisms, and very gentle in lowering the hopes of the would-be artist, who often has little enough talent to support him in his artistic career. His comments are terse, expressive and to the point, and sometimes amusing. Before one—a weakly executed study of pale water and sky—he remarked: "That reminds me of nothing so much as skimmed milk!" A little later, coming to another study highly colored and done in bold, careless strokes, he said: "That does very well, but it is shouting! However, I would rather have it shout than whisper."

Another day in the week is spent in some selected spot where the entire class go to paint. Mr. Chase accompanies them, and goes from easel to easel giving hints and directions as the work goes on, often snatching a few minutes between whiles to make some delightful little open-air study himself . . .

The aim in painting to-day is truth, and the object of all modern painters is perfect atmospheric effects. The technique of a painter, of course, can be acquired in Winter in the confinement of four walls; but the use of these open-air Summer schools is to teach the scholar to portray the outer world in the strong, vivid lights, which dazzle us on brilliant Summer days. No more desirable place can be found for this line of study than the Shinnecock Hills. Watch an artist plant his easel in front of one of the low hills on an absolutely clear morning; with what a mixture of despair and delight he regards the beautiful rainbow tints of the furze bushes and heather which cover it. To get these colors accurately, with the breezy, sunlit effect which pervades the whole scene is his aim, and you think as you watch him work that to be accurate he cannot fill his brush with mauves too deep or yellows too brilliant.

There are many phases of life in an artistic atmosphere of this sort. In fact, too many to attempt to describe half of what is going on every day. Enough to say, that there is no more thor-

oughly delightful way of passing a Summer, to a person of an artistic temperament, than to forget the world for a few months, and join Mr. Chase's class. By this means one will combine pleasure and study, and when he declares in the Autumn that he has never put in a more delightful Summer he will also realize that he has made wonderful strides along the rough road of an artistic career.

LIVING THE LIFE OF ART IN CORNISH

The town of Cornish, New Hampshire, had its beginnings as a summer art colony in 1885, when sculptor Augustus Saint-Gaudens rented a property there. It became home to (among others) the painters Thomas Wilmer Dewing, Maria Oakey Dewing, George de Forest Brush, and Abbott Thayer; the sculptors Frances Grimes and George Gray Barnard, and the poet Emma Lazarus. Unlike colonies that centered on summer schools of art, Cornish was a haven where the summer residents attempted to create an artistic Arcadia of exquisite order and refined pleasure; activities included artistic banquets, musical interludes, and elaborate classicizing masquerades in which participants dressed up as gods, goddesses, and ideal allegorical figures. Frances Grimes's "Reminiscences" conveys the rarefied flavor of Cornish life, where no one had window screens because they spoiled the view, and women were admonished to wear white or bright colors to a picnic in order to create an attractively harmonized living picture.

Frances Grimes, "Reminiscences," c. 1950s, Augustus Saint-Gaudens Papers, Rauner Special Collections, courtesy of Dartmouth College Library.

In 1894 I went to Cornish for the first time and spent June and part of July with Mr. and Mrs. Herbert Adams. The summer of 1895 they were abroad but from 1896 until 1900 I was always there with them in summer. In 1901 I began working as an assistant to Augustus Saint-Gaudens and from then until 1909 I lived in Cornish the year around . . .

The artists had parties and dinners but not the matter of course dinners and parties which are so easily arranged almost any morning after breakfast now; they were planned days beforehand and were always for eyes to look at more than affairs where friends met to talk or young people to dance. Palates were considered too (artists are usually interested in food; there is some relation between the palate and the eye); many of these then young people were lately returned from Paris where they had learned the charm food can have even in inexpensive restaurants and the food was reminiscent of French food. The talk even when not frankly "shop" was usually visual in content or concerned with some question of taste, taste in a general sense as well as the particular, or a kind of gibing gossip. Later when Cornish had changed, Arthur Whiting spoke regretfully of these days, he longed for the time when artists met and talked of beauty. As I remember this word was not often used, things were interesting, amusing, not bad (the pas mal of the Paris studios), and always, I think, something in particular was discussed, not beauty in the abstract. Except that it was lively and witty, the talk would not be called good by any of the people now living in Cornish nor would it, I think, interest artists of the present day; there was wit, for these artists were witty, of that I am sure although I cannot prove it . . .

Dewing liked theatricals, and the artists gave short plays or skits which he composed and directed. For a time they were interested in tableaux, living pictures. A large picture frame was set up at one end of a room, covered with black gauze stretched tightly and so lighted as to flatten the appearance of the figures seen through it in the frame. Old masterpieces were imitated,

the sitters selected because of their resemblance to the figures in the paintings. Costumes were carefully copied. These tableaux were many of them very successful, they were discussed critically, improved and felt to be worthy of the time spent on them.

But they became too popular and several of the hospitable Philistines, delighted that they knew a form of amusement that pleased the artists, arranged parties with these living pictures as the special feature. They missed the point of the artists' tableaux. These hosts had not realized that the tableaux were seriously studied compositions. They thought a handsome woman sitting in a graceful position was inevitably a picture.

I do not know when the first charades (which were not skits or plays) were given. They expressed the spirit of derision which was constantly woven with serious comment on art in the talk. No one has ever been able to describe these charades, as all depended on seeing the faces and gestures of the actors and catching the improvised words as they came spontaneously, flashes of wit struck off at the moment and not to be reproduced. The ideas were settled on beforehand and the general scheme decided on and sometimes the costumes—but what was to be said or done depended on what came into the actors' heads as they revelled in their idea, enlarged on it and vied with each other in presenting it as absurdly as possible . . . The audience was as carefully selected as the cast.

But social life was for afternoons and evenings; the days and the strength of the days were for work. We were a little distance from the others and our hours of recreation were most often spent in walking about the nearby fields and woods (and how lovely they were). Rain did not keep us indoors, and almost best I remember walking under the great old pines when the water was running off the brim of my hat, adding to the mystery of what I saw. Seeing was what we were doing all of the time. Once when we had returned from a picnic, Adams said women should be careful what they wore to picnics, it made such a difference; they should wear white or bright colors. I made a mental note, always white or bright colors to a picnic.

What was seen in the sense, the pictorial sense, was so important. Gowns that were praised there would not have been praised on Fifth Avenue. They were gowns that painters would like to paint. This point of view perhaps explains why so many of the women in Cornish had unusual beauty, for I am as sure they had unusual beauty as I am sure the men were witty . . .

The most beautiful of all was Charlotte Houston when she was young and unspoiled. I like to remember her as I saw her once in their living room in a long ruffled white gown, leaning back in a deep chair. Her lovely head with its fine, black hair, large dark eyes that stirred you as music does and slender cheeks, began what continued so beautifully down to her feet, which I remember had black, patent leather slippers on them. There were others not so obviously beautiful but one could see in them material for painters and sculptors . . .

In these days many of us rode bicycles and Mrs. Dewing, the last person one could imagine on a bicycle, rode, too. The Dewings had no horses and made us feel it was Philistine to have one, but there were many practical reasons why it was sometimes necessary to get about more quickly than one could walking. The bicycle as used by her became an enobled machine. She rode to see the Adamses one day with Prellwitz, which, up our long, steep hill, was difficult. Arrived there she showed us how it was possible to ride in a gown with a train; she looped her skirt over the handlebar and demonstrated that it was possible to get to a dinner party on a bicycle. When they were leaving, just as they started downhill she fell; no, she was thrown over the handlebars and the whole machine, and we had a moment of terror, were afraid to see how badly hurt she was. But she was not at all hurt. She got up, brushed her gown and it was immediately as if she had not fallen. Prellwitz, in an aside to Adams, said she had fallen seven times

coming over, each time instantly regaining her calm dignity; an illustration of her attitude toward the facts of life. She was a good painter, a true artist, but lingered so long over her large canvases that she produced little.

Dewing was the dominating person in the community. Every one was afraid of his ridicule and in awe of his artistic judgment. He was constantly quoted; his jests at the expense of the other artists were called "nuggets" and one trod carefully for fear of being the subject of a nugget. Now it is difficult to understand why no retaliation was possible. He was sensitive to an unusual degree, fearing ridicule beyond anything and therefore intent on forestalling ridicule by doing it better than anyone else could. The knowledge that he was a rare artist with an incorruptible love of beauty as well as a malign wit gave him authority . . .

Most of the artists had one servant in the house and a man to take care of the horse and mow the lawn. The women did much of the gardening, and what lovely gardens they made, the beginning of those which later were to be talked and written of as the Cornish Gardens. There were few bath tubs—none in our cottage (large tin-hat tubs took their place); there were no fly-screens; they injured the appearance of the landscape seen through the windows; almost every one had a horse, but everyone walked, the only exercise taken by the artists. (One summer women at the Dewings played battledore and shuttlecock, but Dewing was painting women playing battledore and shuttlecock.) There was little talk of lack of money; only once do I remember hearing anyone say something could not be afforded—that was when Mrs. Dewing, at the house of a friend where there were many examples of work by that friend's husband on the walls, said, "We cannot afford a Dewing."

The women were all proud of their husbands' work; each household was more of a unit as presented to outsiders than households are now. Victorian standards were, even here, the rule when it came to what was considered presentable, although no one then knew they were Victorian. Unconventional they were, but also in a way formal, with a chosen formality like that of their pictures . . .

Saint-Gaudens was not there when I first came. He had been there earlier. His house had been made over from an old inn by Babb—porches, painted white, added to the handsome red brick original. Stanford White was another architect who did work in Cornish . . . How much White helped Dewing with his house, which was an old farmhouse, I do not know. I know he designed the living room, salon, I think it should be called. This was sparsely furnished, but what furniture was there, was arranged to emphasize its fine proportions and give it stateliness. My most vivid memory of this room, now used as a dining room, is of one evening I dined with the Dewings when there were no other guests and their little daughter, Elizabeth, dined with us. Soon after dinner she went to the mantel and took down one of the tall, lighted candles on her way to bed. Her parents followed this red-haired child with their eyes until she was out of sight. I knew this was a rite they watched every evening, delighting in the color of her hair in the candle light and the outlines of her young cheeks as she slowly turned toward the stairway . . .

. . . Saint-Gaudens was not involved in the life of Cornish as the others were, then or ever when I knew him. He may have been more intimately in it before I came when the Brushes lived in a tent on his place, but I heard no stories of his having part in any of the early feuds. Mrs. Saint-Gaudens was unassimilated; with her extreme deafness, her barbaric manners and temper, she was too difficult to get on with. So she was called on and returned the calls, asked to dinner and had people for dinner, but all quite on the outside. Saint-Gaudens brought his friends from town, architects, clients and others, and was not dependent upon the Cornish people for companions . . .

. . . I do not remember the year when Dewing went away, about the beginning of 1900, I think. He had become discontented. Too many new people had come; he could not paint there; he had bought a place in Maine away from every one, with a beautiful view of mountains. One day he said, "Adams, I met men with tennis rackets on the road by my house," and that was the end of Cornish for him. His going was the end of old Cornish, if one can mark an end in a stream which, slowly changing, becomes as it flows on, quite different in character.

BEYOND THE THRESHOLD: VISIONARIES AND DREAMERS

WILLIAM RIMMER: ANGELS AND DEMONS

Realism, aestheticism, and impressionism in shifting constellations held sway over the course of the later nineteenth century. But some artists fashioned highly idiosyncratic alternatives to the mainstream, opting to plumb the realm of dreams, fantasy, and the ideal. Stylistically eclectic, such artists ran counter to the perceived materialism of the era in their pursuit of intensely personal and introspective visions.

Of these, the Boston artist William Rimmer was an art world misfit who failed despite his best efforts to achieve significant success during his lifetime. Rimmer's father was an émigré shoemaker who believed himself heir to the French throne, a conviction (or delusion) he instilled in his son. For the most part self-taught, William Rimmer was a doctor, sculptor, painter, teacher, and noted authority on anatomy. In his art, he used the energized nude as vehicle for subjects ranging from heroic conflict to despair and tragic doom.

The theme of duality—good and evil forces warring within and without the self— preoccupied Rimmer. His philosophical narrative "Stephen and Phillip" is the expression of that abiding obsession. Long, rambling, and passionate, Rimmer's chronicle, written sporadically over the course of twenty-five years, casts the two protagonists as angels symbolizing the light and the dark side of the soul, perpetually in conflict. Mystical and often obscure, "Stephen and Phillip" offers insight into the emotions and internal struggles to which Rimmer in his art strove to give symbolic expression.

Only after Rimmer's death did he become better known as a practicing and prolific artist. Fellow Bostonian Truman Howe Bartlett, also a sculptor, notes that the Rimmer memorial exhibition at the Museum of Fine Arts, Boston, was a revelation not only to artists and art lovers but also even to his students. Interpreting Rimmer's St. Stephen and Falling Gladiator *in light of events in the artist's own life, Bartlett constructs his subject as a tragic, alienated, misunderstood romantic, a visionary possessed of "marvelous insight" into the physical and spiritual alike.*

William Rimmer, "Stephen and Phillip," transcribed by Jeffrey Weidman, manuscript [n.d.] [B MS b44.2], Boston Medical Library in the Francis A. Countway Library of Medicine.

Alas! for adulterers and thieves and murderers oh who can fancy the shadows that follow them? things of another world foul like themselves . . . Half on earth, ten fold in hell, whose only rest is in the passion that begets the blackest crimes! Demons that once were men, whose heavy load of wickedness, from evil fortune, or evil hearts, or both, keeps them down to the dread level of their sad experience, burning red, hot and full of wrath against their kind, for better merit or better circumstances: who feel no mercy, and without fellowship save to those in hell of their

own kind from their own estate, grant none. Blacker than death, sunk even beyond the grave, shaped to the resemblance of the beasts they simulate, and colored with that that most antagonizes the illuminating glory of the just: who sit beside us in our loneliness, or at midnight as we shudder, walk behind us; or in it[s] blackness rub their cursed bodies against us to rouse our passions . . . Aye! rub their bodies against us, or breathing on us to taint our blood with their foul desire; haunt us who are so disposed, with malarious envelope of evil thought, haunt us, haunt us, haunt us till we fall sick, and our souls are wasted in the consuming fire that the fever of evil passions generate.

What linking, may be, is there of Heaven and Hell to Earth, who knows the tender and the just, even in the womb calling down the looks of angels, while the upturned eyes of demons watch the cradles of those who are prone to sin. Oh Blessed is the mother who prays for her child! Blessed is any one who would keep the innocent guiltless! and blessed is every one who would bring the sinner to repentance! Aye, ye common laborers for the common good, by whatsoever names ye are called or kept apart, blessed are ye all! There is a sin and its sorrow in the heart of every man; a sin and its sorrow in every land; a sin and its sorrow in all the world; and night is the season when these extremes do battle for the Soul. Oh! that ever we were born . . . That primeval fires and crystalline forms should have brought us forth from nature's womb but to struggle against the passions that perpetuate our lives; [Energies?] that found empires, build cities, conquer forests, master seas, level mountains, and sake the elements obedient to the will; that it should have divided the house of the soul against itself, and on everything it bade it have, have stamped the thought, word Beware! oh What [Plutonian?] quality is there in being that evil ever present, like form to matter, or opposite in form, sides to end, or center to circumferences share in empire with its natural foe?

Whose air is this we breathe? Whose earth is this we tread? Who rules by day, who is Lord of Night? Tell me e'er the twilight's gone, while darkness turns and light appears, now while beasts of prey retire and slimy lizards and creeping things that crawl upon a thousand legs, when those that have had their fill lie down, and those that have not, prepare to rise: tell me who ever can, who rule?

And as I stood there alone musing within my Soul in this all absorbing time more full of thought than all my words can testify, whirling in myself by force of passion like some disordered atom that had burst from a quiet world, with my face to the coming day, and my hands upon my breast, there as I stood listening, wrapped in an ecstasy of contemplation, Lo, the ocean from afar lifted up its voice, and answered me in its own way, and I heard its waves roar, and caught the sound of its fury as it lifted its hands against the hurricane, and of its rejoicing in the long night of winter, when it had the lone ship to itself in its fastness. And its voice was from the depths of its breast, as it sang too of its grief, and all its struggles with the rocks below and their fires; with the blazing Sun and the chilling winds, and the monsters that ploughed through its breast, that have tormented it for ever and for ever.

And the air of the dim uncertain morn was full of its sorrow as it shed its tears upon the lonely sand: and I listened, and listened, and listened and then I thought I could hear the voice of demons.

But when that came, silence had returned, when waiting awhile, the sound begin anew, and then I would catch their tongues again.

And I listened till I could hear it no longer, and from out my inmost heart I cried aloud, "This infernal chant comes not from the seas but is the product of my own madness, the disorder of my soul changing the sweet melody of nature['s] voice into melancholy groans, as par-

ent's pitying words by fever's fury are turned to threatening malediction in the ear of their phren-
zied child."

But at length I came to myself and as I overcame terror that oppressed me, keeping courage
like some timid maid, by the sound of mine own voice . . .

. . . For if good men are besides themselves who have visions of joy for all, why should they
not have their madness, in the vice and vanity that makes them what they are? Behold him and
his works. Then, here, thought I, mayhap, within us hath nature opened a way for angels or
demons, if there be any such, to come into our ears, our hearts, aye! into the very marrow of
our Sense from heaven and from hell! And now, as I am to myself unknown, unable to answer
from that trial of the soul that hath in it every temptation, whether I am good or bad, from
which fewer than kings do rise approved, here then, I ope my heart, here do I lend mine ear,
and listening on every hand bid that enter freely which I do love the best, praying that it may
be an angel . . .

But alas Angels and demons both take their own time coming to us on their own occasion
and not ours and instead of what I hoped to see my insecurity went on with me in its own there
in the lonely desert.

T. H. Bartlett, "Dr. William Rimmer," in Walter Montgomery, ed., American Art and American Art
Collections, *vol. 1 (Boston: E. W. Walker and Co., 1889).*

In the Museum . . . there were exhibited one hundred and forty-six of Dr. Rimmer's paintings,
drawings, water-colors, and sculptures, embracing studies of animals, heads, figures, and elab-
orate compositions. They were a surprise to artists and art lovers, and even to his pupils; for
few of them were aware that he produced anything outside of the school-room, or that his pow-
ers went beyond his knowledge of anatomy and the facility of suggestion that such a knowl-
edge gives to some minds. It was the first exhibition of works of this kind produced in this coun-
try. In art interest it had one rival only,—the Hunt Exhibition of the winter before. It awakened
a deep feeling among serious people, and excited much wonder that an American could have
produced such work; for it is generally believed that Dr. Rimmer was a native of Boston, an
outgrowth of her soil, her life, and her institutions. If this were so, he would have to be accepted
as a prodigy,—an anticipator of ordinary art growth by a hundred years; for there were works,
ideas, and possibilities in this exhibition not to be looked for in the first century and a half of
any country's art . . .

Certain explanations are here necessary in order that a better understanding may be had of
the causes of the existence of the *St. Stephen* and *The Falling Gladiator.* Family misfortune, the
breaking up of old ties, emigration to a new and strange country, limited means, and hard la-
bor in a humble walk of life enforced upon high-bred and sensitive natures,—such was the fate
that fell to the lot of the family of Dr. Rimmer's father, and he himself inherited a full share of
life's bitterness. Perceptive natures do not live unconsciously; they see not only the immediate,
but they see and feel the future. Dr. Rimmer possessed a proud, sensitive, retiring nature: he
was certain of his capacity; but, do what he might, he felt and knew that he stood alone. He
knew it from boyhood. The gypsum figure before alluded to is the key-note to his life. It rep-
resents a young man seated, with his knees drawn up and held by one arm to the very chin,
while with the other hand he grasps the lower part of his face. The eyes have a strange expres-
sion. The figure is gathered together in wondering despair. Having a right to a life among the
great artists, possessed of a genius which made him fit to enter into an intimate relationship
with their loftiest activities, and a power of production ample enough to have honored a na-

tion, Dr. Rimmer found himself in a desert, and away from men of his kind. Four of his children, all boys, died suddenly, and mourning filled his cup. Through the uncertain distance of years he had hoped that his sons would bring the fruition for which one generation waits upon another. Out of all this came the *St. Stephen.* Out of the spirit of unwelcomed, enforced, and unexplainable suffering came it, and not out of stone. It represents the head of a man past middle age, in great agony, thrown upward and back, as if vainly appealing for protection, while the raised right shoulder indicates the arm uplifted in defence. It was a cry to Heaven for help when he knew that his doom was sealed,—not to be yielded to, however, without a protest, for *The Falling Gladiator* was begun immediately after the completion of the *St. Stephen,* in the month of February, 1861, in the low-windowed basement of a house in Milton . . . No adequate idea can be formed of the sad circumstances surrounding the production of this statue, until the diary of its author is given to the world. He often worked upon it by candle-light, had to do over many times parts that had fallen down, or had been frozen by extreme cold, and he was finally compelled to have it cast in plaster before it was completed, and to finish it in that material, as it was in danger of entire destruction for the want of sufficient support.

. . . As it is, it taxes the credulity to the utmost to believe that any one, however strong, could have got so much out of the limited facilities enjoyed by Dr. Rimmer. It can only be made credible by the fact that he possessed a marvellous insight into things physical and spiritual. He saw without his eyes, and this kind of seeing was developed to a high degree in his art work, partly, no doubt, because living models could not then be had at any price . . .

It will be a long time before we have a right to expect as good a work from any American. Many will ask now, and more will ask hereafter, why it is that such a specimen of sculpture has not been, and even now is not, better appreciated; why it has not been reproduced in some lasting and worthy material for some honorable public place; why it has not been duplicated, so as to enable it to find a more general recognition among artists and lovers of art; why it has been suffered to lie in utter obscurity these many years. There is only one answer. We have not yet begun to care or know what form in sculpture or sculpture in form is or means. Bulk contents us. Any image with a name, any attractive personality, we like better than we do art in sculpture. Here and there some one makes a true contribution to our art, but for its own sake, or for our own sakes, we do not seem to take hold of it. The *St. Stephen* mocks us in our own house. Who will ever look at *The Falling Gladiator,* conscious of its history, without feeling that when it was made its author knew that he also was falling in the combat? What is art but the life of a man!

ELIHU VEDDER, MYSTICAL JOKER

Winslow Homer's exact contemporary, Elihu Vedder inhabited a dramatically different world. A New Yorker, he traveled to Italy as an aspiring young artist, and although he returned to the United States periodically he spent most of his working life in Rome. Vedder created his work for an American clientele. Actively exhibiting in New York and Boston, he cultivated a loyal following. In addition to painting, he produced a set of illustrations for a lavish edition of Omar Khayyám's Rubáiyát *in the 1880s, designed murals, and made forays in the decorative arts.*

Fascinated by the occult, Vedder—especially in his early work—specialized in enigmatic, fabulous, and brooding subjects that strongly appealed to the spiritual anxiety and unrest then pervading American intellectual circles. Reviewing the painter's large

retrospective exhibition in 1880, the Boston Journal *critic appreciates the morbid power of the works, at once attractive and repulsive. More skeptical, the* Art Review *suggests that Vedder deliberately plays on the Oriental, the esoteric and the obscure, in order to enthrall those so infatuated with mysticism that they have elevated the artist to cult status. Whether genuine or phony, Vedder's art clearly satisfies needs that other painters fail to address.*

Jocular and often tongue in cheek, Vedder's old-age memoir—fittingly titled Digressions—*often seems to be a performance in evasion, designed to keep one guessing: is the man sincere, or is he playing the reader for a fool? Nonetheless, in certain passages Vedder hints at the reality and even profundity of his own visionary experiences. Always, Vedder leaves the reader guessing, but he divulges enough to suggest that like many contemporaries he is a doubter who hungers for authentic spiritual experience in a scientific age.*

"Art Gossip at Home and Abroad," Boston Journal, *March 27, 1880.*

The visitor to the gallery will first be attracted to the mythological and imaginative work of Mr. Vedder, which is so strong and unusual as to rivet the attention in something of the same way as a catastrophe might do. There is a morbid and strange genius in the pictures which fascinates, and which has at once something of both attraction and repulsion. There is nothing grotesque in the paintings, however weird or fanciful the idea, and in rescuing his work from that characteristic Mr. Vedder has achieved a remarkable success, and shown himself to be an artist of great power. In the present absence of catalogues, we are unable to furnish the names of many of the pictures here shown, and of those which seem most remarkable, we can only describe the appearance. One of the most prominent of the smaller works—and very few of the paintings are on large canvas—is a picture of a strange creature, half leonine, half woman, with a pallid, wild, absorbing face, surrounded by wind-blown hair of inky blackness; reclining on the wreck-strewn shore of the stormy sea and holding between its feet a human skull . . . There is also a superb, cameo like profile of what seems to be a Medusa, which displays a union of straightforward and sentimental work rarely seen together. A strange picture of two spirits, meeting amazedly after death, is one of the strangest and most fascinating things ever exhibited in this city. Another work of rare excellence is a picture of an old and wrinkled Arab, who looks like some prophet or dervish of his tribe, kneeling before the Sphinx and pressing his ear to the broad lips of the defaced figure, in an effort to learn its oracles . . . The principal works in the collection are of the Young Marsyas and the Cumæan Sibyl. In the former the youthful satyr sits beneath a tree, in the midst of a cool and brilliant landscape, and pipes through two long reeds to a congregation of hares that have gathered around him, and in the latter the prophetess, clutching her scrolls, hurries through a strange, windy landscape, with a fire running before her, which her eye seems to have kindled. We have spoken of but few of the works shown here, but these indicate well enough the quality of Mr. Vedder's talent, and show him to be a strong and intelligent artist, as well as a wholly original one. No one can fail to be impressed with his abilities, although he will probably find very few admirers enthusiastic enough to say that all his pictures are pleasing. They are to art somewhat as Poe's works are to literature, the products of a mind which sacrifices the beautiful to the strange, and which is carried through all its manifestations by a sort of insane impulse with which not many can sympathize. In the few landscapes which Mr. Vedder shows, he appears in more subdued tones, although even in these he describes the melancholy, rather than the joyous, side of nature. There are in-

dications in his landscapes, also, it seems to us, that he has followed but little this branch of his art, and that the supression of strangeness which they convey is but the reflection of the method he employs in his other works. We should not care to sleep in a room decorated exclusively with Mr. Vedder's pictures, but we can admire his talent, and confidently commend the study of it to all lovers of art.

"Art Notes," Art Review *1, no. 5 (1887).*

Mr. Vedder has recently returned from Rome and has presumably brought new work with him. He has long since gained for himself an individual place in our art, and this of itself is proof of a considerable and peculiar native force, as well as of certain general deficiencies on the part of American artists. Our artists have not been distinguished by intellectual power, by dramatic vigor, nor by imaginative force. Neither culture nor pure creative ability has been a general characteristic of American art, and an artist whose work has shown thoughtful purpose and, if not the higher order of imagination, at least a brooding and peculiar fancy, has been conspicuously differentiated from his brethren. His fancy, however, has always been subordinate to his intellect. What was called the imaginative tendency in an earlier generation expressed itself in allegories and symbolism. Mr. Vedder in some of his better-known works has attempted to suggest the mental unrest and spiritual questionings of his time. His "Arab Listening to the Sphinx" may personify man's persistent eagerness to solve the problem of infinity; his "Lost Mind," as the chaos of the human soul; his "Death of Abel," as the embodiment of crime against nature; and his "Cumæan Sibyl" has almost become an avenging Fury. It is easily possible to imagine a variety of meanings in work like this, which is unusual and for this reason impresses a portion of the public—those who are given to inferring a mysterious potency in that which they find it difficult to understand. For example, Mr. Vedder's "Lair of the Sea Serpent," if analyzed, amounted to very little, and yet it has probably called forth more incoherent imaginings than any of his works with the exception of the Rubáiyát drawings . . . In his later work Mr. Vedder has relied more upon design, and here his faulty technique and inexpressive, imperfect drawing have been a serious drawback. There was some nobility of form and sculpturesque dignity in his Rubáiyát figures, but their heavy inertia, melancholy, mannerism and weakness of form were revealed without searching examination. Nevertheless there must be recorded for them a considerable degree of popular approval. They had little to do with the poem, as we believe the artist has since acknowledged, but they were to be recognized as thoughtful work, entitled to respect. Those who were infected with a love of mysticism promptly worshiped Mr. Vedder as the prophet of the unknowable and the drawings as marvelous "searchings after the infinite." But this was a very different thing from the exalted "mysticism" of William Blake, and moreover Blake was a creative artist. It is impossible not to feel that Mr. Vedder is largely indebted to others and that the process of assimilation is not always completed. Japanese motifs are of frequent occurrence in the Rubáiyát drawings; indeed Vedder would hardly be Vedder without a profusion of streaming tresses and draperies flying out in long curves. He has evidently studied closely the types upon Roman and Greek coins, and his head of Samson was very like a head upon a coin of the city of Larissa. In short, without attaching too much importance to resemblances, it seems clear that Mr. Vedder is very largely indebted both to classic antiquity and to the Orient, and a more serious drawback is his imperfect sense of beauty. This is not said without recognition of the artist's real merit, but the popular tendency to magnify whatever appears mysterious has developed a Vedder cult, often so ridiculous in its expressions that the artist himself, if he has a sense of humor, must have obtained therefrom no little amusement.

Elihu Vedder, The Digressions of V. Written for His Own Fun and That of His Friends *(Boston: Houghton, Mifflin, 1910).*

It was in this bare room, kneeling at the window one night, that I made my great prayer—the last. I only asked for guidance, not for anything else, and it was an honest prayer. The only answer was—the brick walls and iron shutters. Long after, I did indeed make one more prayer in my deepest distress, but that was for another—an innocent life; but it was found that the great laws could not be disturbed for such a small matter,—in fact were not disturbed in the least,— and I have never prayed since. Lack of faith, perhaps? Perhaps . . .

I am not a mystic, or very learned in occult matters. I have read much in a desultory manner and have thought much, and so it comes that I take short flights or wade out into the sea of mysticism which surrounds us, but soon getting beyond my depth, return, I must confess with a sense of relief, to the solid ground of common sense; and yet it delights me to tamper and potter with the unknowable, and I have a strong tendency to see in things more than meets the eye. This tendency, which unduly cultivated might lead me into the extravagant, is held in check by my sense of humour, and has enabled me at times to tread with safety that narrow path lying between the Sublime and the Ridiculous,—the path of common sense, which in its turn is dangerously near to the broad highway of the Commonplace. There is another thing— the ease with which I can conjure up visions. This faculty if cultivated would soon enable me to see as realities most delightful things, but the reaction would be beyond my control and would inevitably follow and be sure to create images of horror indescribable. A few experiences have shown me that that way madness lies; and so, while I have rendered my Heaven somewhat tame, at least my Hell remains quite endurable.

ALBERT PINKHAM RYDER: THE MYTH OF THE ROMANTIC PRIMITIVE

Seen by a select following as a genuine, otherworldly romantic, Albert Pinkham Ryder occupied a special niche in the late nineteenth-century New York art world. A native of New Bedford, he studied at the National Academy of Design and in 1877 became one of the founding members of the Society of American Artists. In his early career, Ryder favored atmospheric, pastoral scenes in a manner reminiscent of the French Barbizon painters, but later and more characteristically he painted poetic subjects and moonlit seascapes, rendered in a style that combined abstract patterning with thick encrustations of richly toned paint. Though a good many thought Ryder's art incomprehensible, it had powerful appeal for a select few, including Helena De Kay Gilder and her circle—elites in need of an antidote to the material and commercial values shaping modern society. Among such individuals Ryder found ample support for his undomesticated, bachelor lifestyle.

The appreciative article below, by Gilder's brother, Charles De Kay (writing under a pen name), suggests what he and like-minded contemporaries valued in Ryder's art: its poetic mystery, obscure magic, and enchanting color, all of which soothed overwrought nerves and transported the mind to the higher planes where the reclusive artist himself wrought his spells. The critic Sadakichi Hartmann's account of a visit with Ryder reinforces and amplifies De Kay's portrait of an eccentric and dreamy bohemian worshipping at the altar of his art and oblivious to his squalid surroundings. For Hartmann as for De Kay, the sensuous aesthetic experience afforded by Ryder's paintings leads to purely spiritual gratification and transcendence.

Ryder's oracular pronouncements solidified the mythic status of the painter as a romantic primitive dwelling in the realms of the ideal and exempt from the codes of decorum and self-restraint that applied to middle-class professionals. Particularly striking is the passage in which Ryder describes the moment when he abandoned all rules and began to smear pure color onto his canvas. Exhilarated beyond inhibition, he raced madly around the field, bellowing for joy. Stating that the artist must work with his "face turned toward the dawn," Ryder endeared himself to the modernist avant-garde, who would embrace him as an avatar.

Henry Eckford [Charles De Kay], "A Modern Colorist: Albert Pinkham Ryder," Century Magazine 40 (June 1890).

It is no longer possible to bunch artists together as we used. In America we try to fit the painters into Düsseldorfers, the Munich men, or those of the Hague or Paris, according as they chose one or another of those cities in which to pass their apprenticeship. But even in these the old uniformity is on the wane, and apprentices often pass from the ateliers of one to those of the other town. Still, something by way of classification can be done with artists who show a trace of foreign schooling. But each year adds to the number of humble and by no means popular workmen who owe very little to Europe directly and whose work shows no trace of foreign masters. How can they be classified? They are extremely irritating to the critic. There are his round holes fairly punched in his board and duly and decently labeled. Here is a square peg that will not in. A parlous plight! But obviously the only escape from the difficulty is not to throw away the square peg, saying that pegs have no right to be square, but to examine the board and answer the mute question, why should there not be square holes as well as round?

The parable fits to a young painter who slowly and with endurance of insulting pity, of ridicule and of inappreciation, has worked his way to a small but very enthusiastic practice. In the Academy exhibitions your eyes, if they are sensitive to beauty in color, may suddenly fall with surprised delight on a small square canvas or panel, unsigned, modest,—a landscape, a marine, a moonlight with cattle,—the color of which makes most of the surrounding pictures cheap and tiresome. With some difficulty you find that this "queer" little picture is by Albert Ryder. Who is he? you ask.

"Oh," answers a certain kind of painter, "he's a mannerist who doesn't know how to draw." "An impressionist!" cries another, glad to use a word that his hearers understand but vaguely. "I could make pictures like that," says another sort of artist, "a dozen a day." "He has some idea of color," speaks up a critic, "but such slovenliness of execution will never do!"

With all this adverse comment it is remarkable that art students may often be found imagining that Albert Ryder's pictures are peculiarly delightful to them, wondrous stimulating, and also that painters who have twice his reputation, "strong painters," "realists," as the able critics call them, are fond of owning one of his little pieces, and sometimes will show that they cherish it with a peculiar playful affection. They come to laugh and stay to pray. In themselves are not these facts regarding any artist enough to warrant the belief that to study his work a little deeper will be not entirely a waste of time? . . .

. . . His pictures glow with an inner radiance, like some minerals, or like the ocean under certain states of cloud, mist, wind. Some have the depth, richness, and luster of enamels of the great period. He is particularly moved by the lapis lazuli of a clear night sky and loves to introduce it with or without a moon. The yellow phase of the moon when she is near the horizon, and also occasionally when she is on the zenith,—in Indian summer, or when fine smoke

or dust is distributed through the air,—finds him always responsive. The mystery and poetic charms of twilight and deeper night touch him as they do poets; Ryder attempts to reproduce their actuality in colors. A man should be judged partly by the magnitude of his attempt. Ryder has to be considered by standards very different from those for prudent souls who avoid the dangers of untrodden paths and find a steady income by adhering to formulæ of subject and technique which the world of amateurs and picture buyers has agreed to accept as truthful transcripts of nature . . .

Mr. Ryder is a native of Cape Cod, of mixed ancestry, English, Scottish, and Irish, and his name is one often seen in that part of Massachusetts. Pretty much always, as indeed at the present time, some members of his family have followed the sea. His boyhood was passed at Weymouth; his father was for several years boarding officer of the port of New Bedford, but his formative years fell in the period when his family moved to New York. Without having suffered hardship the artist has undergone the usual amount of incredulity which befalls, or until lately befell, the youth who tries to open up a new career in which rewards are very rarely immediate and very commonly absent. So uneventful outwardly has been his life that a month's stay in London years ago and a hurried trip through England, Italy, Spain, and Holland in the summer of 1883 are the only facts to record. What is most curious in this connection is the little liking he showed for travel, the strong dislike for hurry, the comparative weakness of the impression made on him by the old galleries, and his almost complete rejection of modern art in Europe. To his companions, Messrs. Warner the sculptor and Cottier the art dealer and connoisseur, this natural chauvinism was entertaining. Nine persons out of ten will call it weakness. Perhaps the tenth, if he ponders on what it can mean, will come to the conclusion that an artist completely saturated with his own conceptions of things, his own ways of looking at nature and evolving a picture, would be likely to be somewhat obtuse, and, what is more, would be all the healthier in consequence . . .

It would indeed be difficult to find a more thoroughly native workman than Ryder. The traits on which most European artists plume themselves—smart drawing and smart grouping—are found in Ryder at a minimum. Those of which the vast majority seem to have not a suspicion, viz.: color and harmony, poetic perception of nature, sensuousness pure-minded to a surprising degree, are seen in him as in no other living painter. In some respects he suggests Millet—not by the way he paints or the subjects he chooses, but along more intricate channels of resemblance: by his humble boldness, if one may be forgiven the seeming paradox; by his imagination, seriousness, and childlike temperament. Yet his popularity is so small that the editors of "Artists of the Nineteenth Century and their Works," published at Boston in 1879, have ignored his existence.

Like most artists who move on higher planes of thought and emotion, Ryder has little financial fame. Art dealers for the most part shrug their shoulders over his pictures. The regular buyers at the sales would much sooner "handle," as they express it, the worst daub by a modern Italian, staring and in horrible taste, than touch one of Mr. Ryder's little jewels. It should be said, however, that such a thing as a picture by him at an auction has rarely occurred since he became an exhibitor. Small pictures, generally gifts made during his student life, have been shown in bric-à-brac shops, but not long. Curiously enough, the very persons who laugh a little at his work will not part with a specimen if they gain possession of it. What can this mean, except that, willy nilly, they value it? Though they may not fully understand it, ten to one it has a quiet intensity, an emotion in its color alone, which forces an owner at first to respect and then to love it. The picture may not be a great dramatic group, nor an historical fact, nor a remarkable

view, nor even an actual landscape, and yet it holds one with some hardly explicable charm. As near to it as anything would be a strain of lovely music which refuses analysis, or a string of simple-seeming words which forms by some enchantment a great little poem.

When one searches for the origin of these complex emotions, one comes inevitably upon the personality of the artist. And there we meet the specter that stands in the path of all criticism of art worth the name—thoroughly honest and serious criticism, without fear or favor, than which none other can ever hope to live beyond the day it is penned. It is the personality of the artist interwoven with his work which makes him sensitive to criticism to a degree that many persons consider childish. Such persons have never been artists or they would scoff less. None but an artist can understand the almost unbearable sense of injustice felt when the work of many weeks is judged adversely. A queer list might be drawn up to tabulate the different kinds of artists while under the fire of the critics. None, we may safely conclude, are quite indifferent. Some are burlesque in their wrath; others, angry with a passing irritation. Some take it sullenly, others coolly, others with deep and nearly always successful prudence. Lucky is the writer who has more good than bad to report. Mr. Ryder's personality, then, is tremendously involved in his work.

Take an artist who devotes himself to one field—to marines, to cats or dogs, to country and city children, to the family life of respectable people. He needs to put only a small proportion of his personality into a picture; the chief burden lies on the objects depicted. Are these well painted, like the reality, pleasantly grouped, reasonably and interestingly occupied? But with Mr. Ryder's works how different! For the most part they are creations of his own fancy. They have wings; they hardly touch earth at all. For Mr. Ryder is that rarest and at present most scorned artist, an idealist; not in the same sense as the painter of an "ideal head," but in a much higher and more difficult way. Before his pictures we find ourselves suddenly invited to enter fairyland. His color is an enchantress. We follow her lead and presently discover a new country, like earth and of it, but not earth exactly, in which the fancy can travel uncontrolled. In the truest sense of the word Mr. Ryder is a poet in paint.

Sadakichi Hartmann, "A Visit to Albert Pinkham Ryder," Art News 1 (March 1897).

Under what circumstances this name was mentioned I do not remember; there was, however, something about the manner in which it was mentioned that made an impression upon me. Then I recalled having seen an article in the *Century* a few years ago (June, 1890), in which several wood engravings from his pictures . . . interested me so much that I forgot to read the text. A tempting suggestion of some unexplored mystery rose within me, and I decided to visit Ryder.

This was not easy; more than a dozen times I called at the simple, old-fashioned house in East Eleventh Street where he used a third story back room as studio. Then I wrote him about my many fruitless calls, and received as reply a kind invitation with an excuse for not having been in, as he had been "absorbing the lovely November skies."

On the appointed evening, I met him in a tavern. I have a very bad memory for faces, and therefore do not dare to describe Mr. Ryder's appearance, as interviewers are apt to do. A reddish full beard, a dreaminess in his eyes; a certain softness, with a touch of awkwardness, in his general being seemed to me leading characteristics.

After a glass of beer and a cigar we strolled to his workshop near by.

As I entered the little two-windowed den—Mr. Ryder lighting the gas jet which could not even pride itself on having a globe—my eye met a great disorder of canvases of a peculiar dark turbid tone, lying about in every possible position, amidst a heap of rubbish and few pieces of

old, rickety, dusty furniture; everything spotted with lumps of hard, dry color and varnish. I involuntarily had to think of a dump in which street urchins might search for hidden treasures.

Mr. Ryder began to show me some of his half-finished pictures, and I was carried away into a fairyland of imaginative landscapes, ultramarine skies and seas, and mellow, yellowish lights, peopled by beings that seem to be all poetic fancy and soul:

A scene from "The Tempest;" a skeleton on horseback galloping through an empty racetrack in moonlight; a Desdemona; a scene of Arabs with camels and tents; a landscape with soft, greenish notes with a good deal of yellow in it; a few moonglade marines, little canvases that might serve as "permanent color inspirations;" a Christ and Magdalen, apparently undertaken more to express individual sensuousness than biblical glory . . .

I anxiously lay in wait for an opportunity to enter Ryder's individuality; to find a key to all its treasures. His sense for colors—gorgeous, ponderous as it is in his blues, soft, caressing in his yellows, and weird in his lilac greens—seems to me but an inferior quality. I fail to see that he is a great colorist; surely he is not a colorist in the sense of Titian or Delacroix, Turner, Makart, Böcklin, Chavannes—even La Farge and Newman are by far better colorists than he;—in my opinion he is not even a tone painter like Michel, Whistler, Maris; also, to Monticelli and Diaz he is related more in regard to method than color, Ryder is a chiaroscurist, an *ideal* black-and-white artist, with a special aptitude for moonlight effects. His technique, reminding me somehow of Blake's wood-cuts, is quite his own. The heavy "loading" of his canvases, the muddy, rather monotonous brushwork (holding the brush at the middle of the handle and hesitatingly dragging it across the canvas), the constant using of strong contrasts of dark and light colors, and the lavish pouring of varnish over the canvas while he paints, to realize lustre, depth and mystery . . .

Some artists accuse him of being dependent on the old masters. Probably they are right; everybody must get his inspirations somewhere, it really matters little how. True, Ryder's pictures are somewhat like old masters'; yet they rather look like old pictures in general, than resemble any particular master, and, therefore, this medieval appearance indicates no imitative, but, on the contrary, a creative faculty.

Also, in painting poetic subjects, he can hardly be called dependent. What have Chaucer's lines to do with that large boat floating mysteriously on moonlit waters? There is some female figure in the boat, but what matters it to us whether it be a heroine of Chaucer's or Ryder's imagination. Looking about the room I suddenly saw from a corner a life-size portrait gazing at me. The first glance told me that it was a man in United States uniform; after that I only saw the face: the tightened lips, *the eyes,* it was as if a soul were bursting from them, and then it seemed to me as if Ryder, his soul was steadily gazing at me.

This portrait immediately gave me a keener insight into his artistic character than any other picture. Everything was sacrificed to express the radiance of the innermost, the most subtle and most intense expression of a human soul. Perhaps my impulsive nature, the extraordinary hour, the gaslight's hectic glare o'er the lapis-lazuli spots on his canvases may explain a good deal of the enchantment I felt on that evening. One thing is sure, that my first visit to Ryder was one of those hours never to be forgotten.

It is Ryder's overflow of sentiment, curbed (sometimes even suppressed for the moment) by a sturdy awkwardness, which also now and then appears on the apparently so mild surface of his character; this patient waiting (running away from his studio to absorb November skies or moonlit nights, and returning to his canvases at all times of the day and night whenever a new idea suggests itself) until he can condense all the manifold inspirations of which a picture is

created into the most perfect under the reigning circumstances, makes his art so great, that it can hold its ground even in the company of illustrious masterpieces.

One must see his Siegfried riding along the Rhine, meeting the Rhinedaughters near a mighty oak, all bathed in a cold, armor-glittering moonshine, to realize how he can flood a picture with sensuous, bewitching poetry; and to fathom how far he can climb in grandeur of thought and composition one must study his Jonah.

And Vanderdecken's world-weary phantom ship, as Ryder conceives it, drifting on the tempestuous sea of time, with its colossal troughs bedizened with the lurid glamor of a goblin sun— and struggling in the left distance on a mighty wave, *upwards!* in an atmosphere laden with Good Friday gloom and glory: this upward movement is genius, pure and mighty, that will live for centuries to come (if no varnish slides occur).

It is a picture impressive like religion, which is the highest art.

Albert P. Ryder, "Paragraphs from the Studio of a Recluse," Broadway Magazine 14 *(September 1905).*

The artist should not sacrifice his ideals to a landlord and a costly studio. A rain-tight roof, frugal living, a box of colors and God's sunlight through clear windows keep the soul attuned and the body vigorous for one's daily work. The artist should once and forever emancipate himself from the bondage of appearances and the unpardonable sin of expending on ignoble aims the precious ointment that should serve only to nourish the lamp burning before the tabernacle of his muse.

I have two windows in my workshop that look out upon an old garden whose great trees thrust their green-laden branches over the casement sills, filtering a network of light and shadow on the bare boards of my floor. Beyond the low roof tops of neighboring houses sweeps the eternal firmament with its ever-changing panorama of mystery and beauty. I would not exchange these two windows for a palace with less a vision than this old garden with its whispering leafage—nature's tender gift to the least of her little ones.

Imitation is not inspiration, and inspiration only can give birth to a work of art. The least of a man's original emanation is better than the best of a borrowed thought. In pure perfection of technique, coloring and composition, the art that has already been achieved may be imitated, but never surpassed. Modern art must strike out from the old and assert its individual right to live through Twentieth Century impressionism and interpretation. The new is not revealed to those whose eyes are fastened in worship upon the old. The artist of to-day must work with his face turned toward the dawn, steadfastly believing that his dream will come true before the setting of the sun.

When my father placed a box of colors and brushes in my hands, and I stood before my easel with its square of stretched canvas, I realized that I had in my possession the wherewith to create a masterpiece that would live throughout the coming ages. The great masters had no more. I at once proceeded to study the works of the great to discover how best to achieve immortality with a square of canvas and a box of colors.

Nature is a teacher who never deceives. When I grew weary with the futile struggle to imitate the canvases of the past, I went out into the fields, determined to serve nature as faithfully as I had served art. In my desire to be accurate I became lost in a maze of detail. Try as I would, my colors were not those of nature. My leaves were infinitely below the standard of a leaf, my finest strokes were coarse and crude. The old scene presented itself one day before my eyes framed in an opening between two trees. It stood out like a painted canvas—the deep blue of a midday sky—a solitary tree, brilliant with the green of early summer, a foundation of brown earth

and gnarled roots. There was no detail to vex the eye. Three solid masses of form and color—sky, foliage and earth—the whole bathed in an atmosphere of golden luminosity. I threw my brushes aside; they were too small for the work in hand. I squeezed out big chunks of pure, moist color and taking my palette knife, I laid on blue, green, white and brown in great sweeping strokes. As I worked I saw that it was good and clean and strong. I saw nature springing into life upon my dead canvas. It was better than nature, for it was vibrating with the thrill of a new creation. Exultantly I painted until the sun sank below the horizon, then I raced around the fields like a colt let loose, and literally bellowed for joy.

It is the first vision that counts. The artist has only to remain true to his dream and it will possess his work in such a manner that it will resemble the work of no other man—for no two visions are alike, and those who reach the heights have all toiled up the steep mountains by a different route. To each has been revealed a different panorama.

The artist should fear to become the slave of detail. He should strive to express his thought and not the surface of it. What avails a storm cloud accurate in form and color if the storm is not therein? A daub of white will serve as a robe to Miranda if one feels the shrinking timidity of the young maiden as the heavens pour down upon her their vials of wrath . . .

The canvas I began ten years ago I shall perhaps complete to-day or to-morrow. It has been ripening under the sunlight of the years that come and go. It is not that a canvas should be worked at. It is a wise artist who knows when to cry "halt" in his composition, but it should be pondered over in his heart and worked out with prayer and fasting.

The artist needs but a roof, a crust of bread and his easel, and all the rest God gives him in abundance. He must live to paint and not paint to live. He cannot be a good fellow; he is rarely a wealthy man, and upon the potboiler is inscribed the epitaph of his art.

Fig. 14. Augustus Saint-Gaudens, *Farragut Monument*, 1877–80, bronze and bluestone. Madison Square Park, New York City.

14 IMPERIAL AMERICA

THE WORLD'S COLUMBIAN EXPOSITION

EXPERIENCING THE FAIR

There was no more potent and symbolic vision of imperial America (a reigning cultural and political power absorbing all the best that the world had to offer) than the World's Columbian Exposition, which opened in Chicago in 1893. An elaborate showpiece of Beaux-Arts planning and design, the fair employed the talents of dozens of American architects, painters, and sculptors, many of them recently returned and energized from study abroad. The concept of teamwork and the subordination of the individual artist's will to further the general effect of the whole allowed a magnificent dreamlike city to be erected on the banks of Lake Michigan. Artists hoped that their quickly executed murals and reliefs might serve to inspire the leaders of the nation's cities to commission more permanent adornments for public buildings across the country.

Indeed, the White City held lessons for everyone who made the journey to visit it. The critic Mariana Griswold Van Rensselaer gives advice to those visitors so that they might retain the greatest lasting benefit of the experience (see also "Mariana Griswold Van Rensselaer Assesses the Progress of American Art," chapter 12). Her prescription (which includes at least one day of bed rest between visits) depends upon the fairgoer not doing too much, not approaching the experience as an encyclopedic marathon. Instead, she uses such terms as "idler" and "flâneur" to suggest the leisurely pace and passive absorption of her ideal "human kodak." She sees the fair as a cosmopolitan urban experience, an international gourmet meal for the tempered, discerning palate. The designer Candace Wheeler (see "Aesthetic and Industrious Women," chapter 13) also offers an experiential paean to the exposition, stressing its evanescence as one of its rarest qualities. She effuses over the sculptural program of the fair, and she gives a picture of the community of artists who lived together for a short time, chatting and spurring each other on to bolder accomplishments. In the months following its opening, the fair received rave reviews from American critics, but a decade later the painter Samuel Isham, who wrote an important history of American painting (see "Surveying the Century: Samuel Isham and Charles Caffin," this chapter), looks back and views

it more as a halting beginning for an inexperienced but devoted cadre of decorative artists.

M. G. Van Rensselaer, "At the Fair," Century Magazine 46 (May 1893).

Long ago we stopped asking, "Who will wish to go to a Fair at Chicago?" To-day the question is, "What may we best do, what may we best choose to look at, when we get there?" Of course no one can see the whole of a Fair like this, inside and out; and time, energy, and disappointment will be saved if a plan of campaign is prepared in advance, and the mind is trained to feel that it must be followed.

It is not easy to follow any plan in such sight-seeing if one has the usual American mind, as alive with mere curiosity as it is with a craving for instruction—pleased to look at anything, discontented only to think that other people are seeing things with which it cannot make acquaintance. But a plan, and the power to stick to it, will be your only safeguards from disaster if, beneath your shifting, purposeless wish simply to see, there lies a genuine desire to profit by sights of a certain sort. If you are going to enjoy your visit to the Fair in the way that will leave the best residuum, that will best satisfy you when the prickings of mere rivalry in sight-seeing have died out, when the excitement of crowds and vast architectural panoramas will have faded, when the temptation to sit in the shade on a plausibly marble bench under a deceptively marble colonnade, and watch the sun shine on fluttering flags and party-colored awnings and reaches of shining water, will seem, in the retrospect, to have been a devil's drug narcotizing your sense of duty—if you are a conscientious person with a real practical interest in any one department of the Fair, you must take at least part of your pleasure in the Fair very sternly . . .

Take a day first to satisfy your curiosity, to gratify your sense of wonderment and your love of beauty, to get your bearings and discover how much exertion you can support. Go all over the Fair grounds, and to the top of at least one of the big domes or towers. See the Fair, as a Fair, from its various centers, and from different parts of its circumference, especially from the lake. I think you can do this in one or two days, if you start early and end late, if you are strong, and if you have yourself conveyed by all available means of conveyance,—encircling railways, boats, and rolling-chairs,—and if you do not step inside a single building except for the ascent in search of your bird's-eye view. Then go home, stay in bed the following day, if you are wise, and the next day spread the wings and stiffen the spine of your conscience, and go in search of the things you have come to study—steam-boilers or roses, fishes or stuffed birds, needlework or statistics of idiot asylums, methods of slaughtering men or cattle, or of preserving human life or edible fruits. Stay at this task until you have finished it, or until it has exhausted your powers of application. Then release and relax yourself. Go to see something else—palms if you have been studying plows, pictures if you have been studying electric motors. The things you know least about, and care least about, will then seem delightful, for you will have purchased the right to idle, and only its purchasers know the whole of the charm of idling. There are few pleasures like looking at things in which one feels no concern after looking with profit at those which concern one deeply. There is no exultation like the cry of the spirit when, tired but self-approving, it says to itself, "It doesn't matter an atom whether I understand this or not, whether I remember it always or forget it to-night." If you take your idling first and your working afterward, you will miss, I say, the fullness of the pleasure of desultory looking, and you will probably never get to your working at all in such an idler's paradise as our Fair will be.

Of course, after what your rustic fellow-countrymen would call a "good spell" of idling you will be ready to come back, refreshed, to your work again. Or, if you have completed it, you

will go home with the satisfactory feeling that you have enjoyed both sides of the Fair, its instructive side and its mere pleasure-giving side.

One more word: While you are trying to work,—to learn, to appraise, to remember, to profit,—be by yourself, or be sure that your comrade is exactly of the same mind as yourself. The Fair will be a safe place, and there will be so many people in it that no one individual will be annoyingly observed. You need not fear to part from your wife for a time, or, on the other hand, to let your husband part from you. Each of you has special tastes, special curiosities, and if you try, hand in hand, to examine ethnological antiquities and dolls dressed to represent the changes of fashion, or sporting goods and kindergarten methods, neither of you will see what you should as you should and both will be dissatisfied. Every woman knows that two women shopping together do not "accomplish" half as much as though they had shopped separately, while their tempers are doubly tried. The crowded galleries of the Fair will be like colossal shops with the counters for different wares sometimes a mile apart. If you want to accomplish anything there, you had better try by yourself. It is delightful to study interesting things just as one chooses; but although I have experienced both fates, I do not know which is more exasperating—to drag an unsympathetic soul about with you while examining anything, or to be an unsympathetic soul dragged about by some one else . . .

Some—chiefly born at the East, I think—have voices which refuse to join in the general chorus of anticipation. Although never so well assured that the Fair will be a "great success," they declare that the last thing they want to do is to visit it. They profess themselves *flâneurs* by nature—or by diligent cultivation. They know all they need to know about the world's progress in all directions, or they think that further knowledge would be bought too dearly by a long journey, probable discomfort, much fatigue, and a constant mingling with crowds. When their daily tasks do not claim them, what they crave is repose, refreshment, freedom from mental no less than from physical effort. When they seek their summer pleasuring they want to take their ease in the world's great inn, and so they think longingly of one of its quieter chambers. It tires and distresses them even to imagine this vast *table d'hôte des nations,* where preparation has been made for the daily entertainment of some two hundred thousand guests . . .

Often such people take great pride in their apathy. They think that it is banal to want to do what every one else is doing; and they say to themselves that it is not lack of intelligence which keeps them away from Chicago, but an especially keen degree of intelligence; they say that they can amuse and instruct themselves, and therefore need not try to profit by the biggest object-lessons, the showiest illustrative panoramas, the most emphatic lecturing to the eye, the most stupendous variety-show, that the times afford.

But such people, if they are true *flâneurs,* will make a great mistake in keeping away from Chicago. Of course there are dawdlers of an inferior sort, people who are simply stupid, and can enjoy nothing but doing and thinking nothing; and it makes no difference whether these go to Chicago or stay at home. But your true *flâneur* feels a genuine interest in one thing—his own capacity for the reception of such new ideas and emotions as may be received without exertion of any kind. He does not care for facts or objects as such, or for what they teach, but he does care for their momentary effect upon his eyes and nerves. He does not crave knowledge, but he delights in impressions. He likes to idle in the city because, if he keeps himself purely receptive, the city prints each instant a fresh picture on his brain; or to idle in the country because nature, or the contemplation of his own soul, more slowly does the same. He loathes the thought of Chicago, because it suggests hard work at sight-seeing, and his ideal is the easy work of holding himself passive yet perceptive . . .

But, if you belong to this guild, you had better stifle your mental conscientiousness altogether for a time, and go to the Fair. Certainly it will torment you if you take any last remnant of it with you; but if you go in perfect freedom, you will find such an idler's paradise as was never dreamed of in America before, and is not equaled anywhere in Europe to-day.

If, I say, you go wholly conscienceless,—not like a painstaking draftsman, but like a human kodak, caring only for as many pleasing impressions as possible, not for the analyzing of their worth,—you will be delighted in the first place by the sight of such crowds of busy human bees, and the comfortable thought that, thank heaven! you are not as they.

I have always wished for a chance to celebrate a certain friend of mine who, with great trouble, got himself a holiday and journeyed from the far West to see the Centennial Exhibition. He arrived on a very hot day; near the entrance of the grounds he found a Hungarian band playing delightfully in a delightful little restaurant; there he sat down for mental and physical refreshment; there he sat all day; and thither he returned each subsequent day during his hard-earned week of leisure, and sat till eventide. He saw no more of the exhibition than this, but he still declares that he got "more good" out of it than any one else, and looks back upon it with feelings of unmixed self-approval.

He, indeed, was a true *flâneur.* People of his kind will probably be tempted at Chicago to do a little more than he did at Philadelphia; there will be so many enchanting spots for placid contemplation that they will not remain for a week in one. But if they really are of his kind, they will not be tempted into overexertion, or disturbed by the conscientious activity of others; and the longer they stay, the oftener they pitch their mental camera on a new spot, the richer will be their feeling of pleasure and self-approval in after days of retrospection.

Candace Wheeler, "A Dream City," **Harper's New Monthly Magazine 86 (May 1893).**

The fair! The fair! Never had the name such significance before. Fairest of all the world's present sights it is. A city of palaces set in spaces of emerald, reflected in shining lengths of water which stretch in undulating lines under flat arches of marble bridges, and along banks planted with consummate skill.

Unlike any city which ever existed in substance, this one has been built all at once, by one impulse, at one period, at one stage of knowledge and arts, by men almost equally prominent and equally developed in power. The differences in their results are indications of individuality alone, and not of periods, circumstances, and influences.

No gradual growth of idea is to be traced, no budding of new thought upon a formulated scheme. The whole thing seems to have sprung into being fully conceived and perfectly planned without progressive development or widening of scope.

For the building of this city the privileged few have been called. It has been said to them, practically: Bring together all your dreams of beautiful architecture; remember the best work of the races who have lived and built before our time; recall all that has been dedicated to religion, or devoted to luxury, or given to national use,—and from them all devise something of to-day which shall take its place in all men's minds as a symbol of the power of to-day to imagine and construct. Let it represent the present as well as recall the past; make it shadow forth the highest tendencies as well as the practical uses of the present. You may have labor and material in limitless quantities, and the best skill of the world is at your disposal. If any man of American blood has special gifts, call him to you and command his power. Painters and sculptors and creators of beauty in landscape shall collaborate with you, and according as you express the ideal of a nation nobly, you shall be honored and praised.

And so the result stands to-day, under a blue or a cloudy sky, beside a lake which smiles one moment and rages the next, a vision and foretaste of how the world will one day build in earnest.

Some one, considering only the celerity with which this fairy spectacle was created, has called it *a sketch;* but it is not even that, for a sketch has at least a chance of preservation. It is a dream which will vanish when the purpose which called it into being is fulfilled. It is foredoomed to evanishment. The wood and the iron upon which it was shaped, even the creamy-white staff which covers all the skeletons of the palace-like structures, and gives them such a look of travertine as takes one back to Roman walls and streets, are already sold to the highest bidder; and when the fair is over, these imposing temples will come, one by one, to the ground, and their materials go into other uses, more in keeping with every-day mortal habitudes than these.

At first, this thought runs like a wail through all the delight of seeing; but gradually, very gradually, one falls into a mood almost of self-gratulation that the world has been vouchsafed one perfect vision which will never suffer from decay, but remain like a translated city, all its premeditated and accidental beauty preserved in the translucent amber of thought and memory.

I can imagine, too, that its impermanence is one of its charms. If it were to remain, one might gradually find flaws in its beauty; things which are least beautiful would grow more insistent, and the things which are most beautiful might become a matter of course, and so less and less an excitement to the senses, till as time went on, and one had learned to discriminate between good and best, he might grow critical or hypercritical enough to cease to enjoy the past-time miracle or to feel enthusiastic for its continual existence . . .

One of the first delightful surprises of the fair is the immense population of inhabitants whose flesh is plaster, whose sinews are flax, and whose bones are iron, a population as varied as the history, traditions, arts, virtues, and passions of mankind. It recalls the days of Greece, when men thought in marble, and bequeathed materialized fancies to all the after-time of the world. These imposing Columbian people will not all outlive the days of to-day, although some of them are almost beautiful enough to deserve eternity. Certainly no one could help wishing that the great statue of the Republic, modelled by Mr. French—a majestic woman, who stands against the columned peristyle looking over the sea—could live forever, and give to the future of America a national ideal of purity, simplicity, and greatness. But whatever else these plaster gods are or are not, they are *too many*—too many for even the lavish bounty of a dream. They cluster in porches; they stand in long processions along the lengthy façades, doing their decorative part with dignity and seriousness; they pose upon pedestals, they crouch in architectural corners, or gayly greet you from cornices and other coigns of vantage; or they are flattened into bass-relief, like skins of statues stretched upon some rare plain surface. In truth, all the bigness of the buildings is needed to repress and keep them in subordination. Gigantic inhabitants of a city of a dream, they people it so abundantly that the small human element is almost an impertinence, or, at most, something unnoticeable in the grand company of its own creation . . .

After the first delight and wonder at the lavishness with which sculpture is used in the grounds, there is still room for another sensation when one comes face to face with the tinted and bordered porticos, where delicate blues and shell pinks quiver behind the ivory shelter of pillars and cornices, and the figures on the Pompeian-like decoration of the Agricultural Building prance along its perfect frontage.

To my mind, also, the decoration of the half out-of-door domes of the Manufactures Building redeems it utterly from the impression of mere temporary use, which its enormous interior space suggests. Entering the building, as one must, under one of these richly colored domes,

the gold and the yellows, the purples and blues, accompany him, and a sense of luxury and prodigality enters with him, which all the largeness of the interior cannot dissipate.

Unfortunately the paintings will not outlast the brief life of the building, since the plaster upon which they are painted must inevitably crumble to powder when its day is done, but the vigorous and beautiful decorative pictures of Mr. Melchers and Mr. McEwen, which adorn the Art Building, are painted upon canvas, and therefore, happily, removable . . .

There were few trees in Jackson Park before it was chosen for the place of the fair, but there can be no want of trees where architectural features are so abundant and turf and water omnipresent. A few clumps of white-leaved swamp willows, which would be almost unnoticeable elsewhere, make quite a feature of themselves at one end of the long island which is a rose garden, and half hidden among the branches and reeds at the other end of it is a little long cabin known as The Hunter's Camp. It is just a little one-roomed cabin with a stick and mud chimney, but the sticks and mud hide a carefully built cone of brick, which makes roaring fires a safe possibility. The cabin is filled with hunters' weapons and traps, and lined with skins which seem by right to belong to the bears and catamounts and mountain lions which do their part of the great fair on the two bridges. It serves also to remind one that within the memory of a living generation hunting and trapping were sufficient and serious occupations for men whose lives were as like that of the Indian tribes as stationary could be like migratory ones.

During the months when the decoration of the building was in progress, this particular camp was a place where the painters and sculptors of the ideal city gathered at night to sit in the firelight, while pipes and cigars sent their curling incense to mingle with the smoke of the wood. It is needless to say how keen an enjoyment they found in the unwonted association of artistic labor. Each one being at work through the day in some improvised studio, or in the domes and vestibules which they were enriching, they gathered at night to discuss not only the relation of each other's work to the whole grand plan, but to consider principles and traditions of decoration, and to try them as applicable to the conditions obtaining in the ideal city. They exchanged opinions or theories, and gave each other the benefit of any little discovery of manipulation which made the difficult surface of the plaster more amenable to the application of pigments. The "master-painters" and the sculptors and the builders were a pleasant crowd in a pleasant place. Outside, the little steam-launch which brought them lay bobbing and lapping upon the water of the lagoon. The moonlight on moon nights rained white beams over all the city, the palaces shone with a still radiance, and the groups of statues seemed to beckon each other from cornice to cornice. In the darks and yellow lights of the cabin's interior the men who were all the day mounted on ladders and scaffolds painting the interiors of the eight domes of the Liberal Arts Building took their innings of ease and friendly companionship—Blashfield, Beckwith, Weir, Reinhart, Reid, Cox, Shirlaw, and Simmons; Maynard, who painted the corridors of the Agricultural Building; Turner, who had and has a hand in everything; Melchers and McEwen, who were called from Paris to join this band of painters; the sculptors French, Martiny, Taft, and Macmonnies; and in the centre, the very hub of the company, Millet, the man who brought all these makers of beauty together, and gave to each his opportunity and his task.

Samuel Isham, The History of American Painting *(New York: Macmillan, 1905).*

As the Centennial Exhibition of 1876 had turned the popular attention to the beauties of industrial art, so the Columbian Exhibition of 1893 gave an opportunity for a display of mural painting. The management, wise in that as in other departments, chose the best available men, regardless of local or personal considerations. F. D. Millet was made director with C. Y. Turner

as assistant, and under their influence Weir, Blashfield, Shirlaw, Reid, Reinhart, Beckwith, Simmons, Cox, Melchers, McEwen, and Lawrence Earle were chosen to decorate the Manufactures and Liberal Arts Building. The remuneration was small, but the men seized eagerly the chance to attempt a branch of art new to almost all of them. The conditions were such that the painting had to be done on the grounds. The sayings and doings of the group of enthusiastic artists were written up and illustrated in all the papers and magazines throughout the land, and when their work was finally disclosed, it was received with a chorus of praise. Looked at dispassionately across the intervening lapse of time it seems, while some of it was better and some worse, to have been as a whole rather bad. The men were inexperienced but the spaces were peculiarly difficult to decorate; and no skill could have solved the problem satisfactorily. In the dazzling whiteness of the huge colonnade that stretched for thousands and thousands of feet about the building, the eight little domes (they were in reality twenty odd feet across) could only be discovered with difficulty and studied with discomfort.

Apart from this, however, the four colossal figures, which each artist placed within his dome, rarely came together in a decorative harmony of line and color. Blashfield's were probably the best, and he alone among the painters of domes possessed previous experience in decorative work. Experience told also in Maynard's Pompeian decoration of the Agricultural Building, which without having the novelty of that of some of his *confrères* was probably the most effective of any on the grounds. For the work was not confined to any one building. William de Leftwich Dodge had a huge composition in the dome of the Administration Building, Millet had a ceiling in the New York Building, and the work of Miss Cassatt and Mrs. MacMonnies, of Miss Lydia Field Emmet, Mrs. Sewell, Mrs. L. F. Fuller, and Mrs. Sherwood in the Woman's Building, while the difficulties of execution may not have been so great, certainly averaged as good as that of the men.

All of this mass of decoration mercifully vanished with that "White City" which contained it, but it had served its purpose. It had aroused the interest of the public and had done something toward training the artists.

POPULAR ART AT THE FAIR

Nearly ten thousand international art works were on display in the Art Palace at the Columbian Exposition. For the Americans, the exhibition represented the chance to measure their progress and prospects in comparison with the art of France, Germany, and other European nations that had for so long reigned undisputed. Attended by millions, the art exhibition was the site of vigorous debate and disagreement among critics and viewers alike. The focus of much discussion was Thomas Hovenden's Breaking Home Ties *(1891), a highly sophisticated painting of an old-fashioned, down-home subject: the country boy leaving for the great city. Born in Ireland and trained at the National Academy of Design in New York and the Ecole des Beaux-Arts in Paris, Hovenden painted peasants in Brittany before returning to Philadelphia and devoting himself to purely American subjects.*

Among the Chicago Tribune's *many notices of the fair, two speak directly to the issues Hovenden's painting raised. The painting appeals to a certain demographic: the unsophisticated country folk who linger long before it. Almost unique among the other American paintings of foreign scenes, this one celebrates real American life. And yet because of its attraction for the many who love storytelling or humorous or sentimental*

subjects, rather than the few who seek aesthetic pleasure, it can never qualify as a "great work of art." In considerably more detail, the Chicago Inter-Ocean *illuminates the painting's appeal: it invites every viewer, critics included, to weave the narrative threads into a lush emotional tapestry, reading each character's thoughts and feelings and even putting doughnuts and a Bible in the boy's carpetbag. At a time when cosmopolitanism and art for art's sake represented the most modern movements, Hovenden's legible and appealing work became a rallying point for the many who found the new art alienating, incomprehensible, or meaningless.*

"Are Loaned to the Fair: Valuable Paintings from Private Collections in the Art Palace," Chicago Tribune, *May 11, 1893.*

Probably the most popular picture among those painted by American artists and given space in the United States section is Hovenden's "Breaking Home Ties." It is a simple study of the living-room of an old New England farmhouse, showing the table set with quaint old china, the mantel adorned with pieces of glazed ware, the high backed yellow chairs, and the ingrain carpet that every New-Englander in the Unites States can remember if he looks back far enough. Two figures in the foreground command most attention—those of a woman with a careworn, anxious face and a boy whose expression indicates half a longing to try fortune, half a home-sick lingering and loathing to leave home scenes. The boy's sisters, his father carrying away an old-fashioned carpetbag, and his dog are in the background. The country folk who visited the Art building yesterday lingered long before this painting, which is the more remarkable in its fidelity to American life in that it is surrounded by pictures of American artists representing, with scarcely an exception, foreign scenes.

"Popular Successes at the Art Palace," Chicago Tribune, *October 29, 1893.*

To enumerate the popular successes of the exhibition is an easy matter, but popularity is not always a proof of artistic merit. The qualities which contribute most to make a picture or statue popular with the multitude, such as sentiment, prettiness, humor, novelty, size, or excessive finish, are not those which are best calculated to make it a great work of art. The esthetic qualities of a picture or statue appeal to the minds of a few, while a work which tells a story or which speaks to the heart is appreciated by nearly every one. Yet it seldom happens that the selections of popular judgment are works which do not possess certain artistic as well as literary merit.

One of the most popular pictures of the Exhibition, and certainly the most popular in the American section, is Hovenden's "Breaking Home Ties." There is little in the picture which might be termed artistic, but there is a sturdy realism in it which is not to be depreciated. The types of the careworn mother and the green country lad to whom she is bidding good-by are admirably chosen, and the accessory figures are adequate. The subject, while it may be a trifle over-wrought, like a certain class of popular American dramas, is one which strikes a sympathetic chord on the heart-strings of every one who loves home and family. It is a picture which is full of truth, and it is in this that the greatest value of the work lies—even though there is a certain triteness about it.

"About the Studios," Chicago Inter-Ocean, *May 14, 1893.*

Eastman Johnson has four portraits and a canvas called "The Nantucket School of Philosophy." One full of light and interest is called "The Cranberry Season." The light on the bright bonnets

of the young folks who are "berrying" is so very effective that only an extreme realist will demand its source.

Not far from it is a picture by Thomas Hovenden, called "Breaking Home Ties," a simple subject honestly treated and full of the best feeling that can be expressed. In the low-ceilinged living-room of the farmhouse the folks are bidding the boy good-by as he is ready to leave home for his place in the city. The father is carrying the carpet-bag out to the wagon. You see his broad back with the stoop in it that farm work gives, and know that he already feels that he is going to miss that boy. An interested neighbor looks in. Grandmother still keeps her place at the breakfast table and watches the preparations calmly. She has been through it all. She has seen her children go; has caught the last backward look, the gleam of white handkerchief or brown hand, as one by one her children turned their steps away from the old home; she knows that it is the way of life.

The children are excited by the important event. One has suddenly remembered that there will be no one to make her sleds and whittle animals from blocks of wood to fill her stocking with at Christmas time, and the older sister who has had the rough, teasing lad for a companion would not tell how hard it is to have him go. The boy is ready and his mother has her hands on his shoulders and is telling him good-by. She has given him directions about taking care of himself and keeping his clothes in order. He knows what makes the carpet bag so lumpy and why it has such a spicy smell and is sure there is no danger of his ever running out of doughnuts or seedcakes, but—. There is a lump in his throat and he looks away from the care-seamed, tender face as his mother pleads with him to be a good boy.

"There is a little book in the carpet bag," she tells him. She wants him to read a portion of it every day.

Everybody understands it. Men with the marks of prosperity upon them, and men who have missed their aim and show the blight of failure in their countenances, linger before that picture, not thinking of the school of art it represents, but recalling the "heart-break" chapter of their own lives.

It is a good picture; the expression of one who had something to say; and the Pennsylvania artist has touched the chord which makes all hearts akin, sympathy.

MURAL PAINTING

EDWIN HOWLAND BLASHFIELD DEFINES MURAL PAINTING

Public art, especially mural painting, became a great concern of the larger municipalities in the United States in the late nineteenth century. Citizen art societies designed to promote civic beauty and decoration flourished in New York, Boston, Philadelphia, and Cincinnati, for example. Artists realized that they would need to educate this citizenry if they were to reap the benefits of increased public spending on the arts. In 1886 painter Frank Crowninshield wrote a series of pioneering essays on mural painting, but his friend Edwin Howland Blashfield, who had executed decorations at the World's Columbian Exposition and the Library of Congress, later emerged as the principal articulator of an American theory of murals. In the essay below, as well as others, Blashfield outlines what a mural painting should be: low-toned, planar, and subordinate to the architectural lines and masses. Decorative art, he asserts, is "the application of the

beautiful to the useful." It has the potential to teach cultural precepts to recent immigrants and longtime citizens alike; it will become a truly "National Art."

Edwin Howland Blashfield, "Mural Painting," Municipal Affairs 2 *(March 1898).*

MUNICIPAL ART—ITS PROVINCE.

In its important examples all municipal art should be at once a decoration and a commemoration. It *must* beautify and *should* celebrate; thus becoming a double stimulus, first to the æsthetic sense, second to the sense of patriotism.

MURAL PAINTING.

Mural painting is a subdivision of decorative art and consequently of municipal art. Architecture, sculpture and painting make up the logical sequence in which the house must first be built, then carved, then colored, whether upon its relieved or flat surfaces.

All painting should decorate, but decorative painting, strictly so called, may be broadly defined as the appropriate filling with lines, masses and colors of spaces which are imposed by the circumscribing architectural lines, and influenced by the juxtaposed architectural masses.

The very best art supposes not only the best painting, but also the best composition, drawing, modeling, the best comprehension of atmosphere, handling, etc., etc., all this goes without saying, but there are in decorative painting qualities which are essentially *mural,* and these qualities often exist at the expense of others.

MURAL QUALITIES.

These mural qualities are such because they fulfil the laws which govern decorative painting.

The first of these laws is the law of harmony. No scheme can be truly decorative unless harmony exists between its component parts; if it is only a knife or a spoon that we ornament, blade and bowl must be in good proportion to handle, and if instead of bowl or spoon we have a great building, then our column or architrave, or mural painting, or sculpture, must sound as a harmonious note in the chord which is made up of itself and of the other parts of the building to which it belongs. In a word it must be consonant with its surroundings. You may say any good art implies harmony, but decorative art is peculiarly exacting because it enlists so many different kinds of craftsmen in its service. Architect, painter and sculptor, all are called forward and each must be in complete harmony with his fellows, else, though you may have good architecture, good painting and good sculpture, you will have a bad *ensemble,* that is to say bad decorative art. Furthermore, in order to be in harmony with its surroundings a mural painting must, in artists' parlance, cling to the wall. It must neither start out from it nor make a hole in it, but must lie quietly and flatly in its place. This brings us to a second great law, the law of simplicity.

SIMPLICITY IN DECORATION.

A decoration should not be stereoscopic; it should not focus an effect in one place only, but, on the contrary, should tell as a whole from one corner of the subject to the other. Therefore, it should be simple, since a lack of simplicity is disturbing.

Now, simplicity does not mean emptiness, not a bit of it; it does not mean wholesale leaving out, but skilful leaving out. Indeed, there comes a point where an overcrowded subject may be made simple by crowding it still more; this sounds paradoxical, but if any panel which con-

tains many disturbing forms and lines is taken in hand and filled quite full of ornament or of close patterns or dotted background, it will *re-become* simple when seen at a distance, because the eye is again equally attracted to all the different parts of the panel, and not to one part at the expense of another.

HARMONY IN COLOR.

The attainment of harmony in color is even more difficult in decoration than in other branches of painting. Color is largely governed by lighting, and in decoration every problem is a new one as far as illumination is concerned.

A good decoration may be made without color at all with black and white masses, or even with lines without masses, but the moment color is called in the lighting must be taken into serious account. Thus, pure colors, strong ultra-marines and vermillions produce an admirable effect in the half light of churches, but would be garish in broad daylight; reds, blues and violets are dangerous and troublesome colors where certain greens and yellows are much more easily used, but these are questions for the practitioner, to be settled only by repeated experiment, since white, which means only one thing to the layman, means a hundred things to the artist, and the words red, green or blue are to the painter more potential in variety than even to the most inveterate feminine frequenter of bargain counters.

SIMPLICITY IN MODELLING.

Simplicity in modelling is another factor in decorative harmony—a factor of the greatest importance. An artist may in his studio model a torso or leg so that it is realistic and admirable; carried to the half light, reflected light or horizontal light, which his decoration has eventually to meet, the modelling in the torso or leg will probably prove to be all too strong, and will have to be subtly and skilfully reduced if a good effect is to be obtained.

Where an artificial light is used it must be used in the right quantity and placed at the right angle, or *any* painting will be canceled. No pigment can fight against fire whether of gas or electricity.

MURAL PAINTING AS AN EDUCATOR.

It has been said at the beginning of this paper that municipal art should be a double stimulus to the æsthetic sense and to the sense of patriotism . . .

The people of the past felt the value of art as a factor the commonwealths of Athens, Florence, Venice, the free burgs of Germany, the great trading towns of Flanders, the cities which have passed through a period of natural evolution in art, considered it a national glory, and used it both as a means and as an end in the truly democratic spirit, *pro bono publico*.

They believed that certain benefits arose from the cultivation of beauty; that the pleasures of private life, the dignity of public life were increased by the aid of the arts. It seemed only natural to such cities that the edifices which belonged to all should be the finest—the town hall, the palace of justice, the temple or the church; we may call them by what names we please, palace of the people of Sienna or Florence, Rathhaus, of German Hanseatic city; Houses of Parliament of London; cloth hall of Belgium; Hotel de Ville of France; Roman forum, Greek agora, Parthenon or cathedral or basilica, it was always the people's house that was finest of all.

And on the walls of these houses the artists were set to work to give a symbolical representation of good and bad government, to paint the city herself wearing her mural crown, with her magistrates at her feet. This apotheosis of the state seemed an important affair to her burghers. Here was the figure of the commonwealth; here the portraits of her defenders by word,

by act, by gift, and every citizen might aspire to the place on these walls among those portraits as to the greatest reward of a lifetime of labor. Go where you will among the great cities of the past, and you will find these carved and painted glories living still and telling their story of patriotic endeavor to our own time. Athens set the statues of her tyrannicides upon her holy hill; Florence, when she had driven out her despot, raised a warning statue of Judith with the head of Holofernes; Venice ringed round her great council chamber with portraits of the doges who had led her in battle, in commerce and in treaty; and where among them you will see the ominous empty frame that tells of treachery to the commonwealth. In English inns of court the judges and lawyers who fought Spain and France with diplomacy and argument almost as well as did Drake and Raleigh with their cannon, look down on the modern barristers; in the Hotels de Ville of Flanders, you see Egmont and Horn lying dead with the thin red and about their throats, and around them upon the walls are all the other men who withstood the inquisition for the state and the national faith. In Germany you climb the steps to their great Walhalla, where all those who have kept "The Watch on the Rhine," from Herrmann, in the first century, to Moltke, in the nineteenth, stand in bronze and marble . . .

In Europe the peoples of to-day have followed the example of the peoples of the past, and if the pictured lessons of the town-halls of Italy and Flanders and France are good for the uneducated Italians, French, and Flemish, such would be good to-day for the uneducated Irishman, German, Swede, who shall stroll into the new City Hall of New York.

Still more is such art helpful to the educated, since it becomes potential exactly in ratio to the receptiveness and intelligence of the onlooker, so that to learned and ignorant alike public and municipal art finds its highest expression for good in the fact that it is a public and municipal educator.

What Athens, Rome, Florence, Venice have done in the past, what Paris following their example is still doing in the present, New York, Boston, Chicago and a score of other American cities may do in the future.

Italy and France have celebrated *themselves* in celebrating their national art, and America may do likewise; she has much to celebrate: the settlement of the country; the exploration of its rivers; the achievement of independence; our inventions—Fulton and the steamboat, Morse and the telegraph, Field and the cable, Edison and electricity. If you say in regard to these latter that our ugly costume would make decorative celebration of modern achievement difficult, we have only to look at the decorations of the past to see that it is quite possible. The grand people of allegory, the men and women with swords and scales and trumpet of Fame and all that, belong to us as much as to the Renaissance . . .

The Fine Arts will not save a country if her commerce and manufactures are gone but they will dignify her and keep her from oblivion. Men's eyes are still upon her and at the first signs of her re-awakening from topor, her ancient activity is remembered and hands from every side are stretched out to help. But in a country like America which is intensely vital and progressive, whose principal business is *busy*-ness whose *summum bonum*[1] is to be found, like that of Voltaire and the Great Frederick, in activity mental and physical, what boundless opportunity there is for the celebration of this spirit of progress.

If the town hall stands for the heart of the people, the court and college for its active brain, the Hall of Records for its history, the library for its treasury of intellectual resource, every other

[1] "the highest good."

building that is public or corporate stands for some one cell in the great municipal thinking apparatus, and each building of them may become an instructor not only through its active functions but through the visible signs and symbols upon its walls. State house and town hall are the Walhalla, the Pantheon of great citizens, patriotism is celebrated there, good government and anarchy, incitement and warning may look down from the walls as in the public palace of Sienna.

As for the decorative possibilities of all these different buildings, they are *boundless*.

No one needs be told what opportunities are afforded by a great library, what evolutions of civilization by intellectual development may be unrolled upon its walls; what celebration of every sort of literary knowledge from the scrawl of the savage upon bark to the letters of Cadmus, and from the letters of Cadmus to the printing press and modern book.

No one for an instant doubts the possibilities offered by a court house, where all the attributes stand ready to march about the halls and show to all onlookers the wisdom, justice, power of the Law, the judgment, moderation, fortitude, clemency that sit about the deliberations of a court. In a Hall of Records which is the very throne room of civic history, the temple of exact knowledge, Clio rules supreme and may compel truth in the pictured teaching—truth to the uttermost detail—since there place and date, costume and feature belong to the recorded past; imagination may still find room in the symbols which surround the fact, but the fact must be as patent in pictured as in written record. In bank or clearing house or exchange, the history of money as a medium may find its legitimate expression from the earliest barter of savages to the first coin, from the first coin to the earliest letters of exchange carried safely by the mediæval traveler through a thousand dangers, where the smallest bag of gold would have been fatal to his peace, but where the scrap of paper meant nothing to the unlettered robber-noble or robber-peasants, and so on down through all the different developments of the intensely interesting history of exchange. Hand in hand with the latter goes Commerce, the early painters celebrated it in Italy. Tiepolo's huge caravans wind around the rooms in Würzburg in his pictures of the four quarters of the earth, and to-day the tribunal of Commerce in Paris has covered its ceilings and walls with allegories referring to the industry of the world.

Agriculture finds its place in the Produce Exchange, and from Triptolemus and the sharpened stake of Joseph's time down to the latest steam plough the entire chronicle of progress is at home in the palace where wheat is king. Post office and railway station are somewhat akin to each other. The history of transportation in its turn offers as much variety and picturesqueness as any other evolution . . .

To-day in America there is plenty of room for the celebration by our corporations of our great industries, and of those two tremendous factors which modern civilization has added to the evolution of science—steam and electricity. Add to these our mining and fishery interests (and there are plenty of others), and it is easy to see that the opportunities for a decorative art which should have a distinct commemorative, as well as æsthetic value, are practically boundless.

Not very long ago there were still in America people who believed that so-called decorative painting was meretricious as compared with other branches of art and was practised by superior men. This impression has passed away from the minds of those who have taken the trouble to either read art history or to seriously consider the decoration of any important surface with all the difficulties, intellectual and material, which are incident to the said decoration . . .

In conclusion something may be said of the men who, with measure and compass, hammer and chisel, palette and brush, are to write upon the walls of American buildings this history of intellectual and material development and to house it when written.

The province of the architect is well understood and is well nigh all-embracing; everything structurally built that makes any pretense to beauty is architecture.

The province of sculptor and painter is less defined, and there are still many who draw a sharp line between decorative and non-decorative art. But decoration in its true sense, simply means the application of the beautiful to the useful. It would be a great mistake to suppose that the mural painting of the country is to be confided wholly to a little group of specialists and that all other painters are to stand outside until the great wave of the decorative art movement shall have passed by. On the contrary, the more good decoration obtains the more good work there ought to be for all good artists. Mural painting has its special technique, its fixed laws and the men who best understand these will do the best wall pictures, but the principles which govern the different kinds of art are akin to each other and with temperament and patience any artist can learn to apply them to the kind of art for which he is fitted. And many kinds of art are open to him, for decoration includes pretty much everything from a town hall to a finger-ring, from the Parthenon to the Tanagra figurine. Certain art objects are not called decorative simply because they are not rightly applied; take for instance realistic portraits, they are magnificent decorations when property panelled into walls and not cut off by frames. If they are kept in their places and not unskilfully combined with decorative work of a different character, their value and beauty can easily be judged—witness the oak rooms of England, the carved walls of many Italian and French halls.

For monumental public buildings it is probable that the great symbolical ideal, call-it-what-you-will, picture will remain the highest expression of mural art as in the Vatican, the Ducal Palace, the Sorbonne, but besides this and the historical picture every other form of art finds place in decoration, the landscape and marine may be at once decorative and commemorative; the easel picture if properly placed, properly lighted, above all properly framed may decorate a room even more delightfully because more subtly than would earthen-ware or metal-work, and in the best periods of art every article of furniture must *decorate* harmoniously both in itself and in its relations.

The Greek, the mediaeval artisan, or the man of the Renaissance would not have understood your meaning if you had talked to him about *decorative* art, he would have said it is *art,* therefore the word decorative is superfluous.

For us to-day, in our new country of America where something has been done, but where *so much* is still to do, the work is not for a little circle but for all artists, and its name is not Decorative Art, but NATIONAL ART.

KENYON COX NEGOTIATES A COMMISSION

The mural movement was a boon to the career, if not the pocketbook, of Kenyon Cox; previously, his main employment had been teaching (see also "Kenyon Cox's Lonely Campaign for the Nude," chapter 11). Cox contributed to the decoration at the World's Columbian Exposition, the Walker Art Building at Bowdoin College, courthouses in New York and New Jersey, and several state capitols in the Midwest. He also painted murals for the Library of Congress, a commission discussed in the following letter to a government engineer. Cox's concerns about money were real. Mural commissions required artists to invest in assistants, large studios, and models. His other questions relate to the control he could claim over his designs—a constant point of negotiation

for muralists, who usually didn't mind supervision by architects but resented the veto power of laymen.

Kenyon Cox to Bernard R. Green, December 2, 1894, Library of Congress.

Your letter of Nov. 28th offering me the commission to paint two decorations for one of the Museum Halls in the new building of the Library of Congress was duly received; also a package containing blue-prints showing plans and elevations of hall and spaces to be decorated. I think it most encouraging to the prospects of art in this country that such work should be undertaken for the government, and I am most anxious to accept the commission offered me if I can see any way to do so. What prevents my accepting it at once is the grave question of whether or not I can afford to do so. The remuneration proposed ($5000 for two panels of such size) is not large, but it might suffice at a pinch if it were payable in installments. As it is, the question that confronts me is how I can live and execute the work with no prospects of payment for at least a year. I have no resources of my own except my daily work to supply my daily wants. The question therefore resolves itself into that of my being able to borrow money enough to undertake this commission on terms favorable enough to make it possible without eating up the small profit there may be in it. Until I can assure myself of the possibility of this it will be impossible for me to give you a definite answer and I must ask you for a little time for consideration.

If I should find myself able to undertake the work there are several things I should have to know and I may as well ask them now so that I may consider them in making my decision. Will you kindly answer the following questions:

1. Who will decide on the acceptance or rejection of sketches?

2. Will there be any question of the acceptance of the final work prepared in accordance with such sketches, and if so who will decide on this question?

3. Would the hall be ready for the placing of the first of the two decorations if it should be done by next summer?

4. Should I have to erect the necessary scaffolding at my own expense?

5. What kind of objects is the Museum of the Library expected to contain? (This bears on the selection of subject.)

6. Is it contemplated to use color in the general decoration of the hall and what will be the general tone of the surroundings of the contemplated decorations? (This is necessary to know in selecting a color scheme for the decorations.)

PUBLIC SCULPTURE

FARRAGUT MONUMENT

Augustus Saint-Gaudens was twenty-eight years old in 1876 when he received his first monumental commission: a memorial to Admiral David Farragut, to be erected in Madison Square Park in New York City (fig. 14). Saint-Gaudens would require five years to complete the work: a nine-foot bronze statue of Farragut in his wind-blown uniform atop a novel (and controversial) bench-cum-pedestal executed in New York bluestone and intended to evoke the sea. This base includes elaborate allegorical reliefs, a lengthy inscription carved in artistic letterforms by Saint-Gaudens, and a charming bronze crab

set in a pebbled pavement before the bench. His partner in designing the pedestal was architect Stanford White, who saw to all of the site-specific details while the sculptor was developing and completing the design in France.

The unveiling of the Farragut Monument, *complete with a parade, orations, and artillery, was an event in American sculptural history rivaled in importance only by the tour of Hiram Powers's* The Greek Slave *some thirty years earlier (see chapter 5). Ten thousand people gathered to witness the beginning of what nearly every critic described as a new era for American sculpture. Never before had an architect and sculptor worked together to achieve such novel results; this is the primary consideration of the* Tribune *reviewer below. The ensemble was a stylistic watershed, astutely combining realistic and allegorical forms and presenting the admiral in a naturalistic pose and contemporary dress, without a whiff of classicism. Sculpture, which seemed to many to be lagging aesthetically, had now caught up with the progressive developments in the medium of painting. Art writers immediately pronounced it the best American work of sculpture ever produced. Some enthusiasts, such as artist D. Maitland Armstrong, wrote privately to Saint-Gaudens and predicted that the* Farragut Monument *would be a catalyzing influence in art, and in the wider world beyond. But there were probably just as many public panegyrics, as in the reviews by William Brownell and Mariana Griswold Van Rensselaer. Both writers stress its "Americanness," the national and even racial components of the work. Although there were plenty of innovative formal features to discuss, they place greater stress on the intangibles of character, dignity, the "tang" of the sea, and the modern zeitgeist so effectively captured by Saint-Gaudens.*

"St. Gaudens's 'Farragut,'" New-York Daily Tribune, *May 25, 1881.*

As a work of art, this monument to Farragut differs in one important respect from most of the works of like general character that have been erected in our country. The statue and the pedestal on which it is placed make together a harmonious composition: they are not intended to be two separate things—they were designed to go together, and the architect and the sculptor have worked together in much the same spirit in which the composer sets "noble music unto noble words." At the same time, with a healthy instinct the pedestal is not allowed to obtrude itself, nor to dispute the spectator's interest with the statue. The statue is the work; the pedestal, however necessary as a structural feature, is made to keep its place as an accessory in the artistic design, and it may not be rash to predict that whatever faults criticism may feel itself obliged to find with certain features of the pedestal, the statue itself, so manly and simple, so alive and so self-poised, will be generally accepted as one of the best works in the kind that our times have produced . . .

With youthful confidence, the architect and sculptor, working together in a spirit that makes their shares in the result as inextricable as those of Beaumont and Fletcher in their plays (where still, keen ears can hear, or think they hear, the voice now of one and now of the other poet), have thrown themselves with ardor into the new time, and letting Greece, Rome, Italy go by, have rested in a treatment almost bald in its naturalism. From the study of all the forms and all the symbolism of the past, they have turned away.

> "At last no rose, and twitched his mantle blew.
> To-morrow to fresh woods and pastured new."

The idea of flowing water—"a wet sheet and a flowing sea"—is the foundation of the decoration, and all the forms of the stones of which the pedestal is composed are suggestive either

of the lines of waves or of the rounding and smoothing action of water. The face of the central block on which the statue stands is crossed by wave-lines flowing and curving upward with a swinging movement from the right, and breaking at the top into spray. The slope of the walls on either side the pedestal is not the same, but follows, though not obtrusively, the general direction of this wave that washes across the central block, and at the ends the blocks that make the arms of the seat take the form of dolphins plunging downward, and now seen, now hid, in the swirling water . . .

Whatever success may have rewarded their efforts, it is certain the artists of this monument have prayed that their symbolism might not swamp them, and even that the separate notes of their instrument might sound clear of all admixture. For, looked at as a whole, the pedestal is not a wave but a ship, and the statue of Farragut stands erect upon her victorious prow. That, without too much assistance—without our feeling obliged even to believe that this was in the sculptor's mind—it should nevertheless be the first and strongest impression made upon the mind of the beholder, is, to our thinking, high praise of the work as an imaginative creation, and places it at once above all the other monumental sculptures with which a well meaning Philistinism has stocked our parks and squares. Here is no gesture and no action, and yet the meaning of the statue reads itself to the passer-by . . .

And then, too, a more marked and studied insisting upon the symbolism of water would have turned these heroic figures of "Loyalty" and "Courage" into mere water nymphs—"Sabrinas fair, under the clear translucent waves, knitting the loose trains of their amber-dropping hair." And, therefore, though they are a part of the whole scheme of wave symbolism, they are kept apart from the active expression of it in the central stone, and are only held to it in an imaginative way by the flowing movement of their drapery and the nobly undulating lines of the forms of their bodies. To our own thinking more force of gesture would have been welcome— was indeed to have been expected—in these figures of "Loyalty" and "Courage." In spite of the largeness of their forms and the somewhat peasant strength of their build—the simple grandeur of the heads reminds us of some of Millet's women—in spite of these characteristics, there is— we hesitate to say the word—an undervitalized look about these two figures. But let us be thankful there is no prettiness about them . . .

The setting-up of a work of sculpture like this, so removed in character from everything of the sort thus far erected in our city; a work, if not of genius, yet of extraordinary talent, no way akin to the conventional progeny of the studios in general—marks clearly the birth of a new time; is an earnest of better days for art, not only in our city, but in the whole country. This is a statue that will make the rest of the feeble brood forgotten, and will perhaps hasten the day when a better taste and a higher respect for the great ones gone shall force us to replace them with monuments worthier of their fame.

[William C. Brownell,] "Notes," Nation 32 *(June 2, 1881).*

The figure is admirable in portraiture, and in point of art illustrates with sensitive nicety the union of reality with the heroic. It is, that is to say, the portrait of a man easily approached, and endued with no divinity, and, on the other hand, of an admiral in whose face and bearing are apparent the qualities of which actual heroism—such as that so often displayed by Farragut—is made up. Error from exaggeration of one or the other of these conceptions must have been difficult to avoid: in fact, it could only have been avoided by fixing the attention on a definite conception of the character to be represented, and dismissing all notion of attending difficulties. This—the most difficult thing of all—it seems to us the sculptor must have

done. The result is the portrayal of a character of simple dignity, of firm purpose, and of perfect security of self-confidence. You feel at once the correspondence between the actions which history records of Farragut and the capacity here disclosed. The statue, further, discloses the sailor, and the American sailor. Indeed, to our mind, the thoroughly American character of the entire work is the most conspicuous, as it is the most grateful, trait it has. It would be impossible, at all events, to mistake the nationality of the subject, and (though, of course, this is less verifiable) one would scarcely go astray about that of the sculptor. It is evidently modern work, a genuine expression without classic reflections, and it is evidently not French or Italian or German—as any one may see who will contrast it with the other sculptures the city possesses. And it avoids affectation of any kind at no expense of grace or quality. On the contrary it would require a nice analysis to decide whether charm or force predominated in the work. There is certainly plenty of power—the position, with the legs apart, breasting the breeze which blows back the drapery; the alertness of the whole figure: the intentness of the look and the nervous contraction of muscles. At the same time the repose accompanying this is relieved from austerity with so much elegance of treatment that the transition from the statue of an American sailor to the pedestal decorated with Renaissance grace involves no violence. The pedestal is exceedingly beautiful. It is in the form of a high-backed, semi-circular seat, in the middle of which is an engaged pier on which stands the statue. Across this pier sweeps a suggestion in sculptured lines of a swelling billow, carried just to the verge of conventionalization with a tact of whose refinement it would be difficult to say too much. On either side is a female figure of true poetic interest in itself, modelled in the low relief in which Mr. Saint-Gaudens has no rival, the flowing lines of which carry the wavelike movement to the dolphin-arms of the seat at the ends of the arc, where again, in reticent but unmistakable imitation of the element, it "suffers a sea-change."

M. G. Van Rensselaer, "Mr. St. Gaudens's Statue of Admiral Farragut in New York," American Architect and Building News 10 *(September 10, 1881).*

It may, I think, be claimed without hesitation for Mr. St. Gaudens's statue of Admiral Farragut erected in New York in the month of May last, that it is the best monument of the kind the city has to show . . .

The plaster cast of the figure of Farragut, which is only a part of the entire design, was exhibited at the *Salon* of 1880 and won much praise from Parisian critics. Supplementing their approval of the sculptor's technique, several of them commented upon one characteristic of the figure which to my mind also seems deserving of especial praise. I refer to its strong national accent—an accent which is present in all good portrait-art of every time and place, and which is something quite different from the correctness with which the mere individual traits may be rendered. We have had portraits for many years, of course, which were truly "American" in their flavor, but they have usually been wanting in the technical ability and the artistic taste which alone can elevate a rendering to the rank of fine art. When this manual dexterity, this cultivated taste, had been acquired by our artists,—almost invariably in foreign schools,—they were apt to produce a result in which the local flavor had been refined out of all recognition. A few noteworthy examples to the contrary, we may yet make the general statement that it is only of late years that we have seen the beginning of a national portraiture in which the strong general characteristics of the American man and woman are preserved under an accomplished technique and refined feeling for pictorial "style." That these beginnings should

persist and enlarge is absolutely indispensable if our art is to become at all characteristic of our-selves, if it is to be anything more than an echo of foreign schools, a reproduction of foreign impressions. When I say that the subtle qualities of race and national character are strongly prominent in Mr. St. Gaudens's statue, while the general canons which bind in all ages the sculp-tor's art have not been in the least transgressed, I note one of its best claims to approval and one of the points that were especially insisted upon at the time of last year's *Salon* . . .

The outline of the substructure has been well calculated, running neither into a conventional rigidity, nor into an evident effort to escape therefrom. Its decorations combine "representa-tive" with mere "decorative" work,—a difficult problem, but one which has been most cleverly met. The introduction of the sword which lies against the washing water on the central block has been somewhat criticised. But it cannot be doubted that some such rigid lines were needed just where they are introduced and, considering the symbolic nature of the whole scheme of ornament, it is difficult to see how they could better have been formulated. The modelling of the low-relief figures is especially to be praised. It is in work similar to this that Mr. St. Gau-dens has won a good part of his fame, and it is a fresh proof of his ability that he has been able here to harmonize such delicate work with the strong effect of the crowning statue . . .

When we pass to the consideration of the statue itself, we are struck first of all by the free-dom and spirit of the pose, combined as they are with great simplicity of outline and a frank-ness of aim that is far removed from all deliberate seeking for novelty or unconventionality. There is no attempt at "action" such as usually degenerates into affectation or theatricality or unrest; but there is no rigidity, and nothing commonplace or hackneyed or insipid. The statue stands well upon its feet and is as solid as could be wished—with the solidity of a living figure and not the mere avoirdupois of a lump of bronze. Moreover, the attitude, simple though it is, has been so well designed that the veriest land-lubber must at once recognize the poise of a sailor on a shifting surface. To secure this effect and yet not fall into the suggestion of insta-bility shows most forcibly the sculptor's power. Some fault has been found with the model-ling of the trousers, but in common with the rest of the habiliments they are evidently clothes clothing a man, and not mere corrugated surfaces of metal. The treatment of the coat-flaps lifted by the wind breaks the straight outline of the dress and aids the impression of place and circumstance primarily given by the pose of the figure. The poise of the head is spirited, and the features full of life and animation. Here one must notice the masterly modelling, broad yet delicate, vigorous yet full of refinement. The spectator should carefully compare the treat-ment of this face with that of the low-reliefs upon the stone below, if he would appreciate how the sculptor understands the problems of his art and how skilfully he treats them. Such com-parison will show not only the way in which the decorative elements of a monument should be subordinated to its main feature, but also the different modes of treatment proper, re-spectively, to bronze and stone. The last is the most elementary point in the art, perhaps, but it is nevertheless one with respect to which our monument-makers constantly go astray. From top to toe, this statue of Mr. St. Gaudens's is a fine work technically considered and it is a liv-ing portrait—not, as has so often been the case with our figures of a similar sort, the cast-iron imitation of what seems to have been a cast-iron original. That the figure is not only life-like and individual, but statuesquely agreeable, and this in spite of the stiff modern dress, is nat-urally the fact of especial interest . . .

In choosing the severe costume that he has, Mr. St. Gaudens has done more than give us one good statue. He has given strong encouragement to all his co-workers to meet, fairly and

squarely, the problems of characteristic expression and contemporary dress, has shown that the best results may be drawn therefrom—nay, that *only* therefrom can ever be drawn a work of art, fresh, original, and valuable in any other sense than as a more or less intelligent reproduction of what other men have already done. Mr. St. Gaudens has proved to the satisfaction of New Yorkers that in future commemoration of their dead they need not fall back upon "classic arrangements" of costume; nor, on the other hand, content themselves with the erection of such inartistic and unscholarly figures as have been set up by scores throughout the country since the Civil War, bearing the names of particular heroes or symbolizing the sailor or the soldier, as the case may be.

D. Maitland Armstrong to Augustus Saint-Gaudens, n.d., in Homer Saint-Gaudens, ed., The Reminiscences of Augustus Saint-Gaudens *(New York: Century, 1913).*

When I went over to see your statue this morning, and saw the whole thing there before me, it fairly took my breath away, and brought my heart into my mouth. It is perfectly magnificent. I haven't felt so about anything for years. The sight of such a thing renews one's youth, and makes one think that life is worth living after all. I felt as I have only done about a few things in my life, some of the fine old things, or as I did when I saw Bastien-Lepage's big picture in the Salon three years ago. Only more so, because here I love not only the work but the worker. I thought, too, of all your manful struggles through all these years, your fight against all odds, with only your heart and brains and will to help you, and I said to myself, "Well done!"

I think in a little while that it will begin to dawn upon you that you have done more for the world than you thought, that you have "builded better than you knew"—for I was surprised to see how the rabble about the statue spoke of it, and how they seemed to be touched by it. It is a revelation to them, and what is more, I feel that they are ready and longing for better art. It cheers one to think it. They seemed to be touched a little as the crowds in old Florence were touched, when some great fellow set up some stunning thing in the market-place. And I felt like one of the great old fellow's dear friends, who knew how great he was, and felt happy in the knowledge that at last the world knew it too, for I did not discover Saint-Gaudens, as most men did, yesterday. They all think that you are a great gun to-day, but I knew it before.

You have gone beyond art, and reached out and touched the universal heart of man. You have preached a small sermon on truth, honor, courage, and loyalty, that will do more good than all the reasonings of philosophers. You have brought great truths close to the hearts of men, truths that were, and will be, the same "yesterday, to-day and forever."

THE NATIONAL SCULPTURE SOCIETY

In May 1893 a group of sculptors came together to form the National Sculpture Society, an organization still active in the early twenty-first century. Sculptors had long complained of their lesser status in the dominant institution, the National Academy of Design, and a sometimes aggressive rivalry with the medium of painting is evident in some of the early literature of the Society. The main concerns of the group were to promote monumental, public sculpture and to exert control over the process of commissioning it, staging competitions for it, and executing it. They also sought to improve the design of American coinage, increase opportunities for the exhibition of sculpture, and offer criticism of existing public monuments. The following letter was sent out by the president and secretary of the Society in an effort to recruit members and supporters.

Unlike many artist organizations, this one welcomed the participation of sympathetic nonsculptors.

John Quincy Adams Ward and F. Wellington Ruckstuhl, circular for National Sculpture Society, May 1894, Albany Institute of History and Art.

About a year and a half ago a number of sculptors met in New York and agreed that, speaking generally, the condition of the art of sculpture in the United States was deplorable, and that the time had arrived when efforts should be made to better it.

The sculptors of the whole country have since been found equally ready to feel the deficiency and the need of improvement. Many artists not sculptors, and many citizens not artists, have been found who were in full sympathy with this movement.

The NSS is the result, and it is this Society which asks for your sympathy and co-operation.

The Country is being dotted over with memorial buildings and statues on pedestals in most of which structures a really lamentable lack of taste and of knowledge is felt to exist. Those, moreover, mostly soldier monuments, offer nothing, or very little, in the way of sculpture, other than effigies of soldiers in uniform, with or without horses, with or without flags, cannon and other military attributes. Otherwise, the chief demand for sculpture is in the way of portraiture. Sculpture somewhat less naturalistic and more purely sculpturesque, whether nude or draped, finds very little recognition.

The Society consists of men to whom sculpture seems a noble and exalted art, who know that modern times have much to show of a very lofty character in the way of achievement in this field, who are sure that more of this modern achievement might be American if only the community could be awakened to the need of encouragement and critical selection.

Good sculpture should be in demand, popular in a sense; to that end it should be cautiously selected and wisely and severely judged.

The government, the state governments, the municipalities, all should be encouraged to order works of art, but also their way of ordering them needs to be controlled.

Private persons must be encouraged to demand works of plastic art in connection with their buildings, exterior and interior, gardens, parks, etc., as memorials, or for pure aesthetic pleasure, but they also should be wisely aided in making their choice . . .

The Society has already in three important instances received and acted on applications for advice from persons or of committees who have had difficult undertakings to carry out in connection with sculpture. It is believed that in each of these cases the Society has done good service. It is believed that it can do great good in acting in this way, advising and suggesting, in a connection where little aid is to be had elsewhere . . .

The Society expects to offer prizes, and in this way, and in every way, to use all its influence in favor of ideal sculpture pursued as an independent fine art for the sake of pure beauty, and the giving of the highest aesthetic pleasure. And in aid of this the Society proposes to do all in its power to induce our museums to acquire the gems of American sculpture, thus giving our sculptors an incentive to produce more than mere portrait or memorial art.

KARL BITTER ON SCULPTURE FOR THE CITY

The Austrian-born sculptor Karl Bitter came to the United States in 1889 and quickly became known as a carver who was unusually sympathetic to collaborative work with architects. He worked often with Richard Morris Hunt on private and public buildings,

and he served as president of the National Sculpture Society. In the following essay, Bitter laments the neglect of sculpture in New York City and stresses the social utility and elevated mission of public figural art, easily understood by the populace. Ideal, public art that is integral with architecture is the highest art, according to Bitter, and in contrast he deprecates parlor sculpture and prosaic portrait monuments in modern dress. As an example of more enlightened planning, he cites James Lord's Appellate Court Building in New York (1900), with monumental figural sculpture by Daniel Chester French, Jonathan Scott Hartley, Augustus Lukeman, and Bitter himself, and he suggests that the great bridges of Manhattan might be the next sculptural frontier.

Karl Bitter, "*Municipal Sculpture,*" Municipal Affairs 2 *(March 1898).*

Within comparatively recent years the public buildings of New York, the buildings of its business and residence districts show a marked improvement in artistic merit and thus command public attention. Yet, while the engineer, the scholar, the architect and members of other honored professions, so far as outward incentives and public appreciation are concerned, see before them a brilliant future, dependent only upon sustained effort and personal achievement, the sculptor has cause to wonder and to lament that among the fine arts that of municipal sculpture has remained neglected. The art in which ancient Egypt recorded its greatness, which was so cherished in Greece and which proclaimed the triumphs of ancient Rome, which at a time when Europe boasted of the Renaissance received attention from princes and republics, from the clergy as well as from the patrician burghers producing masters like Michael Angelo, Donatello, the Della Robbias, has in our great city been accorded the growth and opportunity of a foster-child of accident. But municipal sculpture is more readily understood by the masses than architecture and by reason of its reproducing all living forms it appeals more directly to them. It is above all the art for out of doors, appealing to every one as a permanent public possession and impressing all under the influence of its teachings.

One reason why municipal sculpture has been neglected more than architecture in our community is because it was misunderstood. To the minds of many it is of little or no usefulness, but rather a very expensive luxury. It has long been conceived as an art producing statuettes or busts intended to ornament the parlors and drawing rooms of the wealthy, there to be covered with white muslin during the summer months. If the piece happened to be of a larger size it was considered a fitting object to donate to a museum. In this manner the figures of little boys with upturned trousers, fishing rod in hand, or groups of a boy and girl under umbrellas or asleep, became the typical sculptural ornaments of the homes of many who fondly believed these possession to be works of art. While such crude notions about the artistic scope of sculpture were but the product of popular ignorance, it is not surprising that this art under such auspices gained but a scant foothold in the community.

Then again, the American citizen had before him the monuments distributed through his city parks and squares. Here he could see the likenesses of men prominent in the history of his country or community, attired, in more or less ungainly garments, planted on pedestals inscribed with the names of the persons represented, or preferably with the names of those instrumental in their erection. To the majority of those passing the attitudes and expressions of these likenesses were insufficient to supplement the imagination concerning their possible characters or achievements. And many went by, or turned away with no more vivid recollection than that the man was stout or slender, that he held a book or scroll in his hand, or that he was wrapped about with the folds of a voluminous cloak . . .

With a few exceptions such are the average surroundings in which the masses of our people have received their ideas of sculpture.

Sculpture is a tender plant, but, when guarded, nourished and protected it grows to be a mighty tree that well repays the care expended on it. To be beautiful in mind and body has been the ideal of mankind in all its best ages, and what better incentive to this could be found than in the creations of this art?

We strive to make our homes beautiful, and yet we neglect our common and larger home— our city. We educate our children and our people, but book learning and such inspiration for gentle manners and high thoughts as are furnished by words alone do not suffice. Far more permanent is the impression left upon the mind by the historic, dramatic and ethical lessons of art. True religious feeling, as was recognized by the ancients and in gothic times, is directly evoked by the pious creations of chaste sculpture. The philosophical ideas of our age are accessible to few persons only, so long as we store them in books and libraries; but the expression which they find through sculpture is permanently visible to all.

Like the men of other races we too have a past as well as present, with its great and honored men, living and dead. Then why not express our gratitude and veneration in such lasting form as that of memorial and votive sculpture, which has outlived nations and races? . . .

It would be unreasonable and unjust to draw a parallel between New York, with its recent and enormous growth, and any of the older cities which have reached their present state of development by gradual growth in the course of many centuries. If, in the case of such older cities, we found the advancement of art and beauty going hand in hand with their gradual extension and development, we must not forget that there is not one among them is the outcome of either rapid or spontaneous growth . . .

However, it will not suffice to consider only monuments and fountains and the like when speaking of our public places. They form essential features but nothing gives so much character to a square as public buildings fronting upon it. This should be well considered by our municipality for all the new buildings contemplated, as has been done in case of the new home of the Appellate Court, which will be a very striking example of what a public building should be. Its situation on Madison Square is commensurate to the importance of a building devoted to the administration of justice, and on the other hand its architecture will be worthy of one of the finest squares of our city. For the first time we shall have figures, statues and groups adapted to and expressive of the purpose of the building. Full credit is due to the men who have obtained this laudable achievement in the interest of the city. Few know what difficulties they had to surmount. To the majority of our population, who have rarely anything to cast their eyes upon but the fronts of factory buildings and tenement vistas, a visit to such a building will be an event. And all the eloquence of sculpture is needed to direct and lead their minds towards the better and higher. Such buildings should be made to be an educational factor for the lower population which lacks opportunities and means to surround itself with the beautiful, to which it is entitled and which the community owes to it. No boy reared in the lower part of the town will ever forget Washington's heroic statue in front of the Sub Treasury, and his conception of the *pater patriae* will be a noble one . . .

In one respect our great city has opportunities that are rivalled by no other. The great waterways of the Harlem and the Hudson Rivers are about to be crossed by bridges of enormous span, and those bridges must be made not only an ornament to the city, but a monument at the same time giving fair expression to the spirit of our country and of our days. Since we see how grand and imposing some of these structures are in foreign countries, since we have a

most striking example in our own Brooklyn Bridge, we should not permit the artistic side of these problems to remain so utterly neglected as in the case of a bridge recently erected across the Harlem River. A well-constructed suspension bridge is itself not only a fine example of engineering but also a work of art. It would be so even more were the designers not merely alive to the technical questions, ignoring everything else. The towering supports of the cables may be as grand a piece of architecture as any other public edifice. They could and should be adorned by sculpture. Abroad we see crouching lions, heroic groups, equestrian statues, etc., emphasizing the entrance to a bridge; we see the pillars crowned by eagles, coat of arms, or other symbolic sculpture; we find the candelabra, balustrades, etc., of carefully selected designs, all intended to make so costly an undertaking as a bridge harmonious in every part. And in the cases where we find this, the distances spanned are small in comparison with our demands, the rivers unimportant and not alive with craft as are ours, and the districts which are to be connected not as populated as the boroughs of our immense community. Neither do they in most cases serve such commercial and other interests as those existing between New Jersey and our metropolis. The bridges that we will have to erect sooner or later across our great rivers will not only count among the greatest undertakings of our country, but will stand in line with the greatest things mankind has yet produced. They should be perfect in every particular.

The closer we observe our city and the better acquainted we become with it, the more we come to an appreciation of its peculiarities and the more we come really to like the city.

Unlike Paris or Washington, New York has no streets radiating in different directions from a central circle or square, and affording such excellent and enviable opportunities for the placing of public buildings, theatres and monuments where they can be seen from afar and from any side. The æsthetic disadvantages of our rectangular system of streets can scarcely be overcome. However, we have places and squares of enormous size, thronged by a great active people, and some of them will in time be surrounded by costly, handsome and imposing buildings. These places differ markedly from those of other cities and it remains the task of civic sculpture to cultivate their local character in a noble manner.

In particular is it imperative that all our large squares, such as Union Square and Madison Square, should hereafter be treated in conformity with a definite program or system which would bring about an artistic and harmonious development of these public squares. For such a purpose it will be impracticable to use the conditions and arrangements existing at present as a basis upon which to build. Momentary needs have dictated the present plan and we accordingly find statues, fountains for man and beast, toilet facilities and other huts, hydrants and lampposts planted about in a most empirical manner without the slightest consideration or reference to each other, like dice cast from a dice box.

To produce monumental effects, it will be necessary for the landscape gardener, the architect and the sculptor to go hand in hand to develop, decide upon and lay down the required measures to which every change and every innovation shall conform . . .

Such labors will demand intelligence and energetic collaboration or the highest order of men, well aware of their responsibility. Before all we must arouse the required civic pride, and foster unanimity of purpose where the common interest is set above private or individual interests— civic pride more powerful, if possible, than the vaunted might of monarchs and all powerful aristocracies.

A city, in its public works, if anywhere, is bound to prove what power and strength it pos-

sesses. Its monuments must tell of its history, and the quality of its sculpture must be taken as the most enduring standard of the culture of its people.

A VICTORY MONUMENT OVER FIFTH AVENUE

In the spring of 1898 Admiral George Dewey presided over a definitive naval victory against the Spanish in the Philippines, resulting in these islands becoming an American colonial possession. A year and a half later, New York City hosted a mammoth celebration, which included a parade in Dewey's honor and a temporary arch festooned with allegorical sculpture (by Daniel Chester French, J. Q. A. Ward, and others) celebrating the nation's imperialistic triumph. The following article, describing the arch and the process of constructing it, is written in the enthusiastic spirit of the day. It allies fine art with labor and extols the cooperative undertaking, confidently calling it "a challenge to the pessimists."

W. A. Rogers, *"The Making of the Dewey Triumphal Arch,"* Art Amateur *41 (October 1899).*

When the news came on a May morning eighteen months ago that Dewey had sunk the Spanish fleet at Manila Bay without the loss of a single man, the story was declared a canard, such a feat being considered an impossibility. And when the triumphal arch at Madison Square, erected in honor of that memorable day, looms up in all its grandeur of proportion, covered with its lavish gifts of sculpture, all the work of two short months, a second feat of professional skill almost as miraculous as that of the admiral, will have been performed.

By the time this number of The Art Amateur is in print all the colossal figures, now in process of construction in the Madison Square Garden, will be poised against the sky, a challenge to the pessimists who declare that Americans are wholly given up to material pursuits and a lesson for those Americans to whom such a criticism justly applies. Never in the history of art in New York has there been seen such an inspiring sight as in the Madison Square Garden during the time when the great "staff" figures were being built up and modelled. Here one might see a sculptor, known the world over, his trousers covered with spots of plaster, an old slouch hat down over his eyes, standing on top of a ladder, and with marvellous certainty and skill chopping out a colossal plaster face with a hatchet. You might hear him call over to a fellow-workman, dressed in very fair imitation of a hod-carrier, to know if he would run up and have a bite with him after a while at the Century Club. It was a common sight to see elegantly dressed men and women threading their way through the scaffolding and framework of incomplete figures, delighted to be greeted by some man in overalls and with, perhaps, a patch of plaster on his nose. Here was the true "dignity of labor:" labor combined with intelligence and skill.

The comradeship engendered by this great undertaking will undoubtedly prove of great benefit to the American sculptors. For six weeks they have practically had a great general studio, in which they, in conjunction with their pupils and artisans, have participated in a great carnival of work. The preliminary designing and executing of the small models for the various groups was performed in the studios, but most of the sculptors have given their time and attention to the superintending of their reproduction on a colossal scale in "staff," adding, themselves, the little touches that make the great differences in art.

The process of building up a "staff" figure is most interesting. The small model in plaster is set up on a rough stand with a board, marked off in squares, behind it. Then a rough frame-

work of wood is built, to scale, as the skeleton of the "staff" figure, the plumb-line and square being carefully used to verify every line by reference to the marked squares back of the model. Then bags of "excelsior" are used to roughly fill out parts of the form, large surfaces being covered with coarse wire net. The wings of the great central figure of Victory have a framework of 3×3 scantling, covered first with wire net and then with "excelsior" and plaster mixed.

The sketches of the two great horses' heads, one complete and the other just begun, will show the methods used. When the figure has been roughly blocked out, the sculptor, with a bowl full of half-set plaster at hand for building up, and a lather's "half hatchet" for trimming down, proceeds to sharpen the form to the standard set by the plaster model.

While the work on these groups has been very fatiguing, yet the sculptors have kept at it with the enthusiasm of a set of boys. There were singing and whistling and chaffing going on that must have recalled to many a man his student days in Paris.

Apart from the effect of this great working convention on the sculptors themselves is the effect of their work on public taste and sentiment. It is to be hoped that the arch will be allowed to remain a sufficient time for the people to get used to it, so that its removal will be a distinct personal loss to every citizen of New York.

No man can foresee what new impetus may be given to the fine arts by such an object lesson. There are signs that the sky-scraping office-building may die in the near future of inanition, and architecture come back from engineering to art. Then sculpture, architecture's hand-maid in all history, may be restored to her ancient place.

RETROSPECTIVES AND PROSPECTS

CALIFORNIA VS. THE EAST COAST

In 1893 the World's Columbian Exposition celebrated the cultural coming of age of the United States, and three years earlier the U.S. Census Bureau had announced the "closing" of the American frontier. Yet at century's end, many felt that the West Coast was not yet equal to the East in artistic development. In this essay, the deaf sculptor Douglas Tilden celebrates individual achievements in San Francisco but argues that much more civic patronage is necessary before California can rival the Atlantic urban centers.

Douglas Tilden, "Art, and What California Should Do about Her," Overland Monthly and Out West Magazine 19 *(May 1892).*

California is today not much of a patron of art. She is still unripe for a spontaneous interest in the beautiful. The high noon of culture and repose has not yet come. Her architecture has no type, her music has not the enthusiastic disciples of the older cities, her painting is confined to the works of about two landscapists of some power and one Rosenthal, her sculpture is simply in the embryo. No public museum of fine arts exists in San Francisco; studios built expressly for artists are an unheard-of thing; exhibitions are indifferently patronized; the San Francisco School of Design gets into debt. The few struggling artists complain of the public indifference, and threaten to emigrate, and nobody blames them. The unwelcome truth is: California is young, and does not understand art.

It is but a few years since California had to reclaim herself out of a wilderness, and to shake off the feverish disquiet of the early days of settlement. Where there were only sandhills, she

had planted a beautiful city; and where the plashing of the mountain trout alone once broke the silence of the forest, and ground squirrels blinked undisturbed in the sunshine, she has erected sawmills and spread smiling fields . . .

But we are anxious that California should have made a beginning. Before it is right to accuse a people of indifference to art, it is necessary to educate them. Has California already taken the initiative? It would be a mistake to say no. Our rich citizens have their own private galleries which they continually increase, to the end, we hope, that we may be inheritors of their taste and munificence; but it is especially to the statuary of the Golden Gate Park that we can today point with just pride. Though older in years and richer in resources, the Central Park of New York itself has but one monument that approaches in size the Garfield Monument, and certainly none that comes up to the magnitude and costliness of the Key Monument; much less has she anything to show like the collection of outdoor statuary on the Sutro Heights . . .

When Athens had her ten thousand statues, she was at her height of glory. Sculpture is an unerring exponent of civilization; its rises, zeniths, and decays show exactly the fluctuations of a nation's culture and greatness. We have made a healthy beginning. But is it sufficient? Have we a home for contemporary art? Do we go abroad and buy pictures and statues, and gather them into a place that the public is free to visit? New York has her Metropolitan Museum, Philadelphia her Corcoran Building, Boston her Academy of Fine Arts,—and is not San Francisco a city of three hundred thousand?

If it is clearly high time that our city should have a public museum of fine arts, what sort of a building should it be? Should it be a palace with many columns, or can we make a humble beginning? Would the latter recommend itself more to one's judgment by its greater reasonableness, or would it be a reproach to our sense of self-importance and our prestige as a wealthy and prosperous State? In short, how should we begin?

THE CLARKE SALE CEMENTS THE VALUE OF AMERICAN ART

Thomas B. Clarke, a shirt-collar manufacturer from Troy, New York, was one of the rare late nineteenth-century American collectors to invest heavily in American art. When he sold the collection at auction in 1899, the unexpectedly high prices made headlines and seemed at last to validate the worth of American painting.

The critic and music historian Gustav Kobbé comments thoughtfully on the sale and its aftermath. Although he finds it regrettable that commercial value must be a factor in discussing American art, it cannot be ignored. The Clarke sale, in which one painting by George Inness realized more than $10,000, has suddenly awakened the public to the aesthetic and commercial value of native art and established a benchmark for the future. Kobbé sees other signs of positive change: a recent exhibition of portraits has revealed the strength of American art in contrast to "foreign productions." The Clarke sale, he hopes, marks a turning point: American art is finally coming into its own.

Gustav Kobbé, *"American Art Coming into Its Own,"* Forum 27 *(May 1899).*

Some years ago a group of artists, one of them an American, stood at the end of a salon in Paris. A tall and exceptionally handsome man chanced to cross the room.

"Who is he?" asked one of the artists.

"Oh," said another, shrugging his shoulders, "he's only a banker."

What a world of difference this answer shows between the position of art abroad and here.

Suppose the scene to have been laid in this country, a group of bankers standing at the end of a parlor, and an artist crossing the room. Would he not be "*only* an artist"? I am sure such would have been the case a few years ago. But now matters look more hopeful for American art; and were the American artist who is now recognized as one of the greatest landscape painters of his time still alive, and were he to appear at a gathering of men having the slightest claim to culture, a whisper would pass through the room: "That is George Inness." During the past few years American art has been coming into its own more and more; and certain events during the past twelve months have caused the nation to realize that there is such a thing as native art and that it is worthy of patronage.

That the awakening of national pride by the Spanish-American war has had something to do with this new attitude toward native art, there can be no doubt. Prominent artists themselves have admitted as much to me. But a far greater factor in awakening popular interest in American art was the Thomas B. Clarke sale of American paintings last winter. Then was shown for the first time a collection of canvases—formed in the course of many years by a man of acknowledged taste in art, a real connoisseur—all by American artists, most of them painted in this country and typically American in subject. That in itself was enough to arrest public attention. When it was observed that the average artistic quality of these pictures was very high, that many of them were obviously far superior to the foreign "pot-boilers" in which American millionaires had been investing for the past twenty-five years, and that there were several canvases unsurpassed by anything painted abroad within recent years—these considerations (or shall I say realizations), which were actually *forced* upon all who saw the collection, could not fail to have an inspiring influence upon American art. Fortunately, too, the prices realized at the sale proved that American paintings were valuable investments.

It is indeed a pity that commercial value must enter into any consideration of art. It would be much pleasanter to say that a picture is great simply because it is great. Fortunately, that is the result ultimately arrived at. Unfortunately, however, the general public has no means of gauging the value of a work of art except through the price which it brings in a competition between connoisseurs for its possession. Therefore, when, on the morning following the third night of the Clarke sale, newspapers all over the country chronicled in large headlines the fact that George Inness's small canvas, "Gray Lowery Day," had brought $10,150, the American public realized for the first time that America had produced a great artist. When the picture began to be discussed in the newspapers, it was learned that it had been originally bought for about $300. The enormous profit netted the collector naturally appealed to the American commercial sense. Prices of many other paintings sold at the Clarke sale ruled high, and showed a great advance in value over the amounts originally paid by Mr. Clarke. Probably nothing appeals so much to the practical American mind as "a good thing" financially. Consequently, the Clarke sale impressed upon the public the double value of native art—its aesthetic and its commercial value. Moreover, the grand total of the sale startled many who had never heard of such a thing as American art; for the pictures footed up a small fortune—nearly a quarter of a million dollars.

In addition to this, there was the fact, to which I have already referred, that the subjects of the paintings bringing the highest prices were typically American. During his "great period" Inness lived and worked at Montclair, New Jersey. His "Gray Lowery Day" was painted at that place. Another of his canvases, which the New York Metropolitan Museum of Art bought for $8,100, was the "Delaware Valley." A landscape painter whose work attracted great attention at the sale was Homer Martin, who did much of his painting in the Adirondacks. During his life-

time Martin was glad to get $100, or even as little as $50, for his canvases. The prices realized by his paintings at the Clarke sale went into the thousands. Then there were Winslow Homer's "Eight Bells" and "The Life Line," painted on the New England coast. As I already have indicated, it is distasteful to me to speak of the money value of works of art. But, in connection with American paintings, such prices as I have quoted are rays of light in the gloom through which our brave native artists have been struggling. It is not exaggerating conditions to call the Clarke sale a sunburst for American art. It was clean, above-board, and conducted with the most scrupulous integrity; and it established something which had been lacking—a standard.

When Mr. Clarke decided to sell his collection, he was warned that he was inviting "slaughter." Everything about it seemed problematical to those who realized the discouragement under which our artists had been working. The collection did not consist of a handful of paintings which could be disposed of in an hour. Its sale would occupy four evenings. Could a collection of native art stand the strain? The result speaks for itself. At the end of the fourth evening, the auctioneer, who has had the widest possible experience in such matters, addressed the audience from the platform; stating that it was the greatest sale which he had ever conducted, and that it would be more far-reaching in its results than any other sale ever held in this country . . .

It was the prosperity that set in after the Civil War, coupled with the ignorance of many of those who acquired wealth at that time, which tempted the importation of foreign paintings. The name attached to the canvas meant more to the ignorant buyer than the canvas itself. Occasionally, a customer would ask the dealer if he had any American paintings. The dealer would say "Oh yes," and bring out the typical winter scene showing a church with an illuminated steeple and stained-glass windows reflecting colored light on the snow. Then his customer would say, "Guess not," and continue to look at foreign "pot-boilers." . . .

Pictures of sheep huddled together in a snow-storm have probably started more art collections in this country than any other class of canvas. It is said of a well-known collector, now dead, that he was induced by a canvas of this kind to enter an art store. He was very plainly dressed; and the clerk who showed him around was barely polite to him. He kept asking the price of one canvas after another. When he had made the round of the store, he told the clerk that he would like to see the proprietor. The latter was informed by his clerk that "there's a countryman out there who's been looking at some pictures and wants to see you." When the proprietor came out, the "countryman" remarked: "The prices of these pictures that I have been looking at foot up $149,000. I'll give you $100,000 down for them." Needless to say the sale was made on the spot.

Some time afterward, Thomas B. Clarke was invited by the purchaser to view his collection. After Mr. Clarke had looked at the pictures he asked:

"Haven't you any American paintings?"

"American!" exclaimed the collector, "are there any?"

Mr. Clarke took this collector to the Academy exhibition, which was then open; and he became a liberal patron of American art. It was one of Mr. Clarke's great pleasures, in making his collection, that he induced others to patronize American art. But a few collectors are not enough to stimulate interest in national art. The movement must be more widespread . . .

It is hoped that at last American art is coming into its own—that the public recognizes the value of the distinctly native note in native art. Let us hope that collectors will no longer consider it necessary to fill their galleries with lavender Cazins, and that millionaires will not deem it indispensable that their features should be perpetuated by foreign hands. By native art how-

ever, I do not mean the old panoramic "Hudson River School" with its photographic attention to detail, nor pictures of cows standing beneath convenient oak-trees near accommodating looking-glass pools. That is not typical American art. It is simply bad art.

Nothing better illustrates the far-reaching effect of the Clarke sale than the steps that are being taken by various art institutions to develop the representation of native art in their galleries. The Chicago Art Institute is preparing a special gallery for American paintings; and the Trustees of the Metropolitan Museum of Art in New York are discussing similar plans. Institutions in nearly all the other large cities in the country are showing similar interest in native art. There is every indication that a wave of development in American art is now sweeping over the country, and that the day when the American painter was "only an artist" has passed.

AMERICAN ART POISED FOR A NEW CENTURY

In the following confident, ambitious essay, painter Will Low (see also "The Return from Europe" and "Will Low Remembers Barbizon," chapter 11) describes a world situation in which Europe has reached the peak of its artistic power but is unable to translate its means of expression into the modern era. America, on the other hand, is poised for greatness, even if it has not yet found its national voice. He describes a hybrid nation, using the image of the grafting of a strong new vine onto Old World roots. For Low, public art is the most important future enterprise; he offers scathing remarks about the "unrelated, detachable work of art"—paintings and statues that become objects of exchange, bought and sold by venal traffickers. Interestingly, he likens high-minded decorative art to recent developments in illustration and poster design. These represent the "universal speech" that will address all Americans. He also provides a somewhat ambivalent catalogue of what artists might draw upon in contemporary American life for this imagery.

Will H. Low, "National Expression in American Art," International Monthly 3 (March 1901).

The closing year of the century has seen gathered within the walls of the new Palace of Fine Arts at the Paris Exhibition the most notable collection of works of art, which the world has ever witnessed. Most notable, at least, in point of numbers and in diversity of the countries represented; eager to respond to the invitation of France, who has exerted for the last hundred years every effort not only to stimulate the production of her own artists, but to stand as protector of the arts, ready to encourage and reward with honors the artists of the entire world.

Nor has this encouragement been allotted alone to the master-workman; the art schools of France have welcomed the neophyte, whatever his nationality, and to a large number of the exhibitors in the section of Fine Arts at the Universal Exposition it was a return to Alma Mater to exhibit there. The universality of French art education entails, therefore, throughout the various sections, a certain uniformity of presentation, as though the art world spoke French, the difference of accent alone betraying the country of origin; and the distinctions which in former times gave character to the varying schools of art have well nigh disappeared. Owing to their mutual isolation, it was possible in the fifteenth century for Florence and Venice to be further apart in an art sense than are to-day New York and Buda Pesth.

In this vast, cosmopolitan family of art, the section of the United States, the child of yesterday, has been given a man's share of the honors bestowed; and though our representation was far from complete, for reasons to be noted later, the progress which we have made in the last

twenty years, and the prospects of the immediate future would seem to indicate that in art, as in other directions, the march of empire tends westward.

In the hurry and bustle of our daily life, in the state of surprise where rapidly occurring events cause us to dwell, we are apt to forget that while the scenes shift, the action of the drama remains based on tradition, and our young Republic is simply repeating the history of the world, and will take its place in art in obedience to the same natural laws, and in the evolutionary order that governed the birth, the growth, and, later, the decadence of the arts in Greece. It is not necessary here to attempt to prove so trite an assertion, nor to follow step by step the pathway of art in its western progression.

It will suffice to note the fact that art in the old world has arrived at its maturity in certain directions and that further advance is difficult. It is evident to a student in this Exposition that, in so far as Europe is concerned, art is at the summit of technical achievement, and that the task before it is not to establish but to reconstruct. In the ten years that have elapsed since the exhibition of 1889, no notable technical progress has been made; and, virtually, no new man has appeared, to invent and impose new features of advance in that direction. A great future still lies before Europe in the direction of sentiment and taste; much that has been done in the decoration of public edifices, for instance, could be reconsidered with advantage, and, as was so often the case in the Italy of the renaissance, new work of a more chastened taste, more in conformity with its surroundings, with greater harmony in its several features, and of more significance of subject, could be made to take the place of some of the more recent decoration.

In a word, the artists of Europe having at their command a method of expression, perhaps more perfect than any the world has heretofore known, have yet to learn to use it to express to the modern world all that art in the past meant for their predecessors in the great human family.

To a degree, our art has the same merits and the same fault; only to a degree, however, for it would be hazardous to claim for the American artist the same excellence of technical expression as that of his European, and we must not forget, his elder brother. It is, indeed, only our new world faculty of beginning where others leave off that has endowed our nascent school with its very high degree of proficiency in handling the tools of its craft.

But our public, as yet very largely indifferent to (when not altogether ignorant of), the importance of art as a factor of civilization, has no such standard as that of Europe by which to judge the artist, and to exact from the probationer a knowledge of his tools before he is allowed to practice.

For if the art of the painter or sculptor has as its final intention the conveyance of a thought, it is also of its essence that it is a skilled craft. Inasmuch as the skill required is not, like that of the mechanical arts, one which can be mathematically measured, there is room for wide divergence of individual opinion in the matter of its judgment. Consequently, while our country possesses, in considerable number, men capable of reasoned and reasonable criticism, it is not enough to establish that standard of judgment with which centuries of interest in art, permeating every walk in life, has endowed Europe.

Hence it is common with us that the desire of expression unaccompanied by executive ability not only finds tolerance but ill-judged encouragement. The honors received by our men in Paris, however, are not open to this reproach. Though the technical standard of our work was not as high as the best of other sections, with the possible exception of one of our painters, it was sufficient; while the temperamental, artistic qualities of our men were beyond question.

It may be judicious, nevertheless, to qualify our satisfaction with a recognition of the fact

that our European judges are satiated with mere excellence of workmanship, and are inclined to generously encourage possible indications of artistic perception with tendencies foreign to their own.

I say possible, as an expression of hope, for it would augur favorably for our future if the international jury found in our work strong national characteristics. But in comparison with nations favored by art interest, long established and firmly rooted in the habits of the people, it would be folly to carry patriotism so far as to claim that we have a distinct school. To continue the simile already employed, art is a foreign language which we speak with fluency and expression; but we still lack a method of expression which is unmistakably our own.

Except in so far as technical considerations extend, in which direction we will undoubtedly share in whatever progress the future may hold, it is a question whether a civilization like ours, made up of a fusion of such cosmopolitan elements, will ever have a voice which will be geographically local and national. For, situated on the nether side of the Atlantic, we receive with equal impartiality the gifts of the cradle lands of the Arts; and in making them our own, despite the common reproach of irreverence, we have as yet respected their identity.

This is so true that we are to-day the surviving depository of the classic spirit in Architecture, which Europe under the banner of *l'Art Nouveau* affects to treat in iconoclastic spirit. Again, in France the great majority of the artists and critics clamor for the abolition of the Roman school, which for two hundred years they have maintained; and this decade has seen for us, on a small scale, due to private encouragement to be sure, the establishment in Rome of a school of similar aims . . .

We, of the West, have many elements in our composition; the Anglo-Saxon predominates, but the Teuton and even the Scandinavian is to be counted with. So far, however,—though our Gallic cousins, themselves but a small fraction Latin, in the heat of economic discussion, dub us "merchants of pork," and refuse us our share in the common heritage of art,—our painting and sculpture are strongly tinctured by classic tradition. It remains with us, therefore, to make of this influence another link in the long chain which brings art from Greece through Italy and France to shore on our western hemisphere.

Though Byzantium is for us but a name, we can graft on the art which we have received in this century, almost in this generation from France, as living and fruitful a blossom as that which Giotto in Italy forced to bloom on the moribund root of Byzantine art.

To leave out of consideration the tentative efforts of our artists constantly growing in numbers and power since the first establishment of the Republic, and to consider the section of the United States at the late universal exposition only as an indication of the manner in which we have learned to solve the technical problems of art, there remains resident in our possibilities that, which it is not optimistic to term the greatest future for art that any country possesses to-day. For we have unlimited pride in and hope for our country, abundant wealth and prospect of its continuance, and a field which is, virtually, virgin . . .

I have already said that the art section of the United States was not characteristically comprehensive. It is impossible to show upon the walls of the ordinary gallery specimens of work which depends upon its fitness for a special place for which it was executed; and our stained glass, perhaps our most notable contribution to modern art, was but meagrely represented and our mural painting not at all.

Hence our representation was limited to painting and sculpture complete within themselves. Here we touch upon the fundamental distinction to be made between the unrelated easel picture or the detached statue, and those which exist for their utility as related parts of a compre-

hensive whole,—a class which we know as decorative art. The world has seen many great easel pictures, many single statues and groups full of import to humanity; but with the thought of many such strong in my memory, I am constrained to believe that the truly great art of the past and that of the future depends on that intermarriage of beauty and use, which alone exists in decorative art.

The unrelated, detachable work of art is a comparatively modern product born since the days when art was truly great in significance and influence. It sins too frequently by a desire to please at all hazards and by the facility by which it can be made an article of barter to be classed with jewels, mere luxuries.

It has thus given rise to the trafficker in works of art, the man who, on the one hand, stifles the independence of the artist; and, on the other, by the jugglery of commerce, makes of that which by right belongs to the world an object of exclusive possession. The artist loses dignity in this prostitution of his work and often enough, dazzled by the fictitious value given to his product, loses the old simplicity of the workman who espouses his art as St. Francis espoused poverty, content in the possibility of continuance of production and the esteem of his fellow citizens.

The expression of this thought should not be taxed with sentimentality, for the history of art is full of instances of men, like those of to-day, of very much the same virtues and faults, who have made of their art a sacred calling; and my craft can and does still honor many such in more recent times.

But the evident fault of the unrelated work of art undoubtedly lies in its appeal to a special and limited class, which has given it the bad name of a luxury, and the facility with which it can be made to reflect a fugitive and trivial mood, as it exists only for itself. This is seldom or never the case with a work of decorative art if it at all fulfills its conditions as such. If it be of even the minor forms it is part of and enhances the value of the object decorated, as the pattern on a piece of silk becomes inherently a part of the fabric. If of larger import it, again, exists as a part of the whole and shares its merits.

In its larger scope it has for the modern artist the advantages which made his predecessor,—as a worthy companion of the recognized crafts of utility, of the carpenter, mason, cabinet-maker, and builder,—honored among men.

As his work forms an integral part of a building, presumably destined to remain, triviality of subject, conception, or execution is debarred. If it is in a public place it does not depend for appreciation on the restricted few that frequent special art exhibitions; for the people intent on their affairs will cast a passing glance, and he who runs may read the message which the artist's mind has conceived, and judge the measure in which his hand has conveyed it. A part of the nobility which from the time of the Pyramids attaches itself to solid construction, is shared by the work which decorates wall or pediment. Again, the work as conceived for its special surroundings is not liable to change of place, the light for which it was executed remains constant, and the dignity of its environment enhances its grace. Finally, the artist working with this aim is not led astray by mere virtuosity; he is not tempted to hide grave faults under facile felicities of execution; and in the measure that he is enfranchised from the necessities of realistic rendering, his attention can be given more wholly to the intention of his work and it will grow in dignity and sentiment.

The decorator, in a word, works for the world; his production, no longer conceived for the stifling atmosphere of the studio or gallery, breathes the open air; and art, instead of being as it is too often a thing apart, becomes a portion of our daily life.

The artist no longer an exotic flower, exhaling a faint perfume of personality like a priceless orchid, blooms in the sun which shines for all; and takes on a robust joyousness which, as we read the lives of the old painters, strikes us as the characteristic note of the best days of art . . .

We already have the battle partly won, for unconsciously the leaven has been working for years. Who can estimate the appreciation of art which has grown through the perfecting of processes of reproduction in our magazines? We smile kindly at the profusion of color and design to which the poster has accustomed us. We have goods to sell, and we believe in a wide publicity, and the illustrated advertisement has enlisted the services of capable men, who have drawn more wisely than they knew; for each and all of these elements have entered into our national life and have grown to be a force. The decoration of a public monument like the Congressional Library at Washington was rendered possible, to a large degree, by the slow infiltration of the art idea through these humbler means. And, though a remnant of tradition prompts one to qualify the means as humble, are they really so? Is the artist who is capable to arrest the citizen on his way to work, by an assemblage of form and color in a poster, and give him a vision which radiates through his hum-drum day, inferior to him who, within a frame in an exhibition, shows a work whose chief interest lies in the manner in which it is painted, which, having achieved, the artist in Europe petitions his government to buy, which at home, the exhibition over, he generally adds to his private collection of his own works—and turns, to earn an honest living, to teaching or illustration?

For if our artists, so far in our brief art history, have found a wide circle, (thanks to the reproductive methods), and have produced works which have interested our public, it is, on the other hand, an open secret that for the past decade our exhibitions of painting and sculpture have had a constantly diminishing attendance. This is due, paradoxical as it may seem, to the fact that our exhibitions are too artistic, using the word in its limited sense. They are not unlike trade school exhibits, attractive only to a restricted class interested in the technical side of art.

There are reasons for this, reasons which to a practicing artist tend to excite a feeling of admiration for his fellows, who with one mind have maintained that they must first of all, even at the sacrifice of the interest which subject and sentiment lend, acquire a mastery of their tools. So, for the time, the ultimate object of a work of art has been put aside, and it yet remains to be seen if, the technical means at hand, we are capable of adding these other qualities and using them to impress our public.

Meanwhile the illustrator and the designer of posters, possibly taking himself less seriously, though in point of fact our best men have lent their talent to these so-called minor works, have found their public.

And in due course the mural painter and the decorative sculptor have, through the alliance of their arts to utilitarian purposes, so impressed their more appreciated brother, the architect, that he has called in their aid to adorn and complete his work. Here our artists have found their opportunity to express in its fullest sense and under the most dignified conditions their message to their time and their people, and, as much has been granted them, much may be demanded . . .

One crucial test yet remains, however, before we can count the new interest in decorative art as a permanent accretion to our native and national artistic wealth. Our artists must make haste to prove that with the newly acquired means of speech they have something to say of vital interest to our public.

So far, in the maze of newly required technical qualities through which they have struggled, it is, perhaps, but natural that their utterance has been less than vernacular. The crowds who

work within or come as visitors to the public buildings which our new decorators have adorned are not critical; and for the nonce are willing to accept the work therein with admiration for its charm of color and line; in which the surprise of seeing, for the first time and on our soil, buildings which through the alliance of the arts are *complete,* counts for much.

But is this likely to be of long duration? For the artist in this new work has no longer to deal with the collector, whose own education leads him to an appreciation of art akin to that of the artist. He has or will have to paint for the great public. He must meet with the man whose hand is at the outlet of the public purse, and must prove to him and to the taxpaying masses behind him, that his art is a force which the wise legislator can employ. He must convince bank presidents that public confidence in the security of deposits will be stimulated by the presentation of fundamental truths upon their walls. He must show hard-headed business men that their various enterprises can be so pictured that the public of whom they seek support will understand at a glance the advantages which they offer.

All this has little to do with art as we have known art in these latter days, but much as art was in the day when it spoke to humanity at large. And this universal speech it must once more acquire if it would be a vital force.

The painters,—here let me use the personal pronoun,—we painters must leave the commonplace and the trite; we must learn to distinguish in the complex and cosmopolitan civilization, where we find ourselves, the essential qualities which are at once pictorial and national. The writer can hardly be accused of partiality for the modern costume in art or the representation of the ordinary daily life, which surrounds us; which is nearly always more local than typical (subject to change so that the actuality of to-day becomes the historical event of to-morrow), and lacks pictorially the dignity of history more remote. But though in critical fairness I cannot recall an essentially decorative representation of modern life in the setting of architecture, which always reflects a distinct and historic style; yet it is theoretically possible, and the locomotive and the trolley car may well be decorative motives of the future. But in addition to these ultra and obvious subjects we have the larger elements of earth, air, and water, which, while common to the whole world of speech, intelligible to all humanity, take on, in our latitudes, a character proper to our own country. Out of our cosmopolitan population there has already been evolved a type of American woman, unmistakably our own; and, while our typical man seems to be still, pictorially, in process of evolution, we have in our logging camps, on our fishing smacks and canalboats, and even in our fields and workshops, types which are recognizably national. We have as backgrounds for these figures, or for allegorical figures which shall retain a flavor of our soil, a landscape which is as varied and as beautiful as that of any land.

For the old world, at least, where Cooper and Chateaubriand are not forgotten words, we have a pictorial element which Europe lacks; and if we can overcome our repulsion for the red man of our frontier agencies—a creature of our own creation—we can find in the old life of our forests and in the mythology of our native Americans, subjects more near to us than the echoes of another and foreign mythology. Our South, the bayous and the everglades, the canebrakes and the cotton-fields; the West with its wheat-fields and mines, the romance of bread and of gold; all of these, realistically treated or translated through the imagination of the artist into the figurative language often stronger than direct speech, are themes which we may treat, the words of the vernacular which we must speak to our people, who—never fear—will listen and understand. Not that we should be debarred from the pride of long descent and limited to subject indigenous to our soil; for the past is ours by heritage, and we can, like Molière, recover our belongings wherever we find them; but the complacent acceptance of threadbare allegory

or conveyance of ready-made solutions of problems, which we should solve for ourselves, should no longer prevail.

The turn of the century is inevitably a time of assessment, and the dawning of the twentieth century prompted a series of books with the goal of charting the progress of the arts in the United States. The artist Samuel Isham and the critic Charles Caffin were among this group of authors, and excerpts from their concluding chapters leave an impression of some ambivalence. Both writers characterize American art as wholesome and cheerful, moderate and sane. Isham notes a penchant for avoiding painful subjects, and Caffin writes of a "trite propriety" in subject matter that is easy and pleasing. Isham describes a feeling for color that is uniquely American, but Caffin sees the vast United States as too diverse for synthesis. Modern art, he feels, now engages in an international "free-trade in motives and methods." Isham ends by lamenting that American artists have yet to penetrate deeply into the popular taste and, as a result, are not adequately supported—which sounds remarkably like Benjamin Latrobe (see "Quaker City Arts Organizations, c. 1810," chapter 2) or William Dunlap (see "William Dunlap Champions the Arts," chapter 3) at the beginning of the nineteenth century. Caffin is less sanguine, claiming that American artists are too emotional and pampered and have failed to ally their work with a modern sense of morality.

Samuel Isham, The History of American Painting *(New York: Macmillan, 1905).*

Ten years and more ago Dr. Bode noted that "American artists have in common the avoidance of any kind of excess," and this quality has increased rather than diminished during the intervening period. Art is still so new an interest with us that we have not yet had time to weary of the simple, natural things of life, and so be forced to go in search of the abnormal and eccentric in order to stir a jaded taste. Moreover, we are notably free from the baleful influence of the "Salon picture," the great "machine" swollen to impracticable dimensions and striving to attract attention by its strangeness or violence. From this follows also the second characteristic of our art, its cheerfulness, its optimism. We are sentimental. We feel profoundly the tender melancholy of the autumn woods or the twilight sky; but we do not like pain nor misery. The blood and terrors of certain pictures of the Paris Salons are as adverse to our tastes as the pitiful dying children and starving paupers of the Royal Academy. Our annual exhibitions tell of the joy and beauty of life with hardly a discordant note.

Besides this it is observable that the aim of the great majority of our painters is for purely artistic qualities rather than for intellectual or anecdotic ones, for beauty of line or form or composition or tone or color. There seems to be a special feeling for pure, sweet color. A gallery of American pictures is apt to have an unusual number of canvases noticeable for their excellence in this respect, and the persistence of the quality for nearly half a century, as well as its generality, suggests that it results to some extent from our clear air and warm sunlight, and may become a permanent characteristic of the school.

The present condition of painting in the country is thus, on the whole, sound and satisfying. What its future is to be is uncertain, and any specific prophesying would be futile. No generation has ever foreseen what the art of its successor was to be like. The portrait painters, trained under West, had no premonition that there was to be a Hudson River school, and the Hudson

River school denied the existence of certain later influences even after they had become accomplished facts. It seems probable, however, that we are on the eve of a great increase of artistic appreciation among the people. As yet the nation as a whole is profoundly indifferent to such matters. If Mrs. Trollope were to revisit us, she would find an enormous advance in the "Domestic Manners of the Americans," but she could still write with some truth of the "utter ignorance respecting pictures to be found among persons of the *first standing* in society."

This ignorance and indifference is, perhaps, the reason why the artists are permitted to paint in their own way. The very few people who buy original oil paintings either have the same tastes as the painters or follow their advice; while the great outside multitude makes no attempt to impose their likes or dislikes. It is not to be supposed that in America, any more than elsewhere, the average man will ever become a discriminating art critic; but it is to be hoped that he may in time come to take more delight in beautiful surroundings, in painting and sculpture, than he does at present, while the steady increase of leisure, of wealth, and of collections of works of art should result in enlarging the body of cultured people throughout the country, in making their outlook wider and their judgments surer, so that any forward movement should not fail of friends to support and direct it.

A movement of this kind, if it occurs, cannot be confined to painting or to any one of the arts, but must include all, both the fine and the industrial. It seems as if such a movement on a great scale were just beginning. It has had to wait for more pressing matters. The country had to be settled and developed, roads had to be laid out before parks, cities had to be built before they could be made beautiful . . .

The magnitude of our coming art development may be greater than we think and may assume in part a public and political character. Already there is a rivalry between the different capitols and industrial centres, the inhabitants of each boasting themselves citizens of no mean city and vaunting their State Houses, Courts, Carnegie Libraries, or Soldiers' Monuments. Our natural resources and our optimism should last at least half a century more, and if we are granted peace at home and abroad we shall have before the end of that time wealth unparalleled in history. If our civic enthusiasm, now largely expressed by cheering the local ball nine, should take the form (as there are some indications that it may) of a struggle for superiority in civic improvement and adornment, the result might surpass the hopes of the most sanguine. We have now artists in every branch competent to direct and execute such works with constantly increasing skill. It took but a few decades to give to Paris the character which it now has and, with the exception of a few important buildings, most of the city which the tourist admires to-day is less than half a century old, and in another half-century we shall have a dozen cities able to lavish greater sums than the Baron Haussman[2] had at his disposal.

If so splendid a future should come, it is to be supposed that painting will have its share in it, both in adorning public buildings and gratifying private taste. "He who lives shall see."

Charles H. Caffin, **The Story of American Painting** *(New York: Frederick A. Stokes, 1907).*

Is there yet a distinctly American school of painting; and, if so, how does it compare with other schools? But, strictly speaking, there are no longer distinct schools anywhere, since the reasons which accounted for their existence in the past no longer exist to-day. As we have seen in the previous pages, the whole trend of modern art has been toward a free-trade in motives and

[2] Baron Georges-Eugène Haussmann was a politically powerful urban planner under Emperor Napoléon III.

methods, the clearing-house of which for all the world has been Paris. Yet, while the age of close communities of artists, following some distinct tradition or influenced by some one leader, and producing work which bears the stamp of a common sentiment and manner of expression, is past, it is unquestionably true that the local conditions of race temperament and natural environment do still stamp with a certain general distinction the work of each country. It is not difficult, for example, in the presence of a given picture, to be secure in the conclusion that it is Dutch or German, French or English. Is there, then, any corresponding mark by which we could feel equally sure that such and such a picture was by an American painter? I believe there is; but let us try to make this question answer itself.

The Dutch picture is readily identified; firstly, because the subject in almost every case is drawn from the natural and human life of Holland, the externals of which are so distinctly characteristic; and, secondly, because the spirit as well as the external is reproduced . . .

Recognising this, we see at once that there can scarcely be a similar unity of feeling in the work of American artists. Even if the devotion to the pictorial aspects of their own country were as single-hearted, the country itself presents no such compact synthesis of suggestion. Both in topographical features and in the still more significant matter of atmospheric conditions, wherein reside the moods and changes, the actual expression and spirit of the scene, the country offers a wide range of differences. The intelligent student of pictures, especially if he is also, as he should be, a student of nature, can recognise at once this scene drawn from California, that from the Middle West, another from Pennsylvania, and still another from the East. These are broad distinctions; nor are closer ones less recognisable. We use the general term New England, but the landscapes from each State in the group, both in form and feeling, differ from those of the others. When we realise this, and the further fact that it is in the subtle differentiation of these variations of natural and spiritual manifestations that the best art of to-day is displayed, we are admitting the impossibility of there being such family resemblance among American pictures as among the Dutch.

Then, again, there is the general resemblance that may characterise the work of painters of one country through idiosyncrasy of racial temperament. We recognise, for example, in the artists grouped about Munich, a prevalence of exuberant and original imagination, and a direct and often somewhat exaggerated mode of expression; traits of the Teutonic temperament, sufficiently prevalent to make it almost possible to speak of a Munich school. But you will find no counterpart of this among American painters. If anything they are rather distinguished for the opposite: a certain kind of cosmopolitanism of feeling, and an independence of one another in their methods.

On the other hand, although it might be impossible to discover any positive indications of uniformity, certain negative resemblances are notable. It did not escape the notice of careful observers at the Paris Exposition of 1900, when there was ample opportunity of comparing the art of different countries, that that of the United States made a very separate impression. Trying to analyse it, one found one's self recurring to phrases: capability, moderation, sanity, and perhaps a lack of individualism. There was a general high standard of craftsmanship, the equivalent of which was to be found perhaps only in the French and Dutch exhibits. But, unlike the French, our artists seldom, if ever, seemed to use their technical skill with ostentation, either to display mere prowess with the brush or to attract attention by the meretricious device of a startling subject; while, on the other hand, unlike the Dutch, they failed, as a group, to suggest a marked individuality. I say as a group; for, of course, there were particular examples of notable individuality. But the general impression of the *ensemble* was of a moderation, grateful

in comparison with the ostentation and vagaries that abounded elsewhere, but in itself open to the suggestion of being too negative a virtue, a little fibreless and lacking in marrow . . .

The actual plague spot of this disease centres around the relation of the sexes in literature and the use of the nude in art, but its morbid effects spread through the whole body of fiction and painting, inducing a flacid condition of self-consciousness and insincerity. It has taken such grip of artists and public that to a considerable extent moderation has been supplanted by repression, and tamely to hold back is esteemed worthier than to put forth with a reserve of power.

The effect of this condition which has become fluent in the public conscience is to be discovered in our painting. For its prevalence one can scarcely blame the painters. They represent a comparatively small number of men and women, in the midst of a community impregnated with this insincerity. With a few exceptions they are unable to resist the effect of what is in the atmosphere around them; and the less so because, as illustrators, a majority of the figure-painters, at any rate, have become directly infected with the prevailing pseudo-ethics of the publishers. The necessity of prettiness, of not giving offence to "the most fastidious," and of exploiting the obvious, has been urged upon them, until it is small wonder that a great deal of American painting is characterised, if I may be allowed the expression, by irreproachable table-manners rather than by salient self-expression; by a desire to be amiable rather than convincing. The portrait-painter, for example, if he would make a living, is tempted by the vogue of the pretty face in periodicals to sacrifice truth of art and of human character to the glib exploitation of prettiness of face and form and flashiness of costume. The figure-painter will meet his readiest reward if he confine himself to subjects of trite propriety, represented with insistent regard for the obvious; while even the painter of landscape is lured into the pleasant moods of innocuous sentimentality. The taste of our time, in fact, runs to superficial sentimentality, and consciously or unconsciously the painter is apt to respond to it . . .

Because a painter must be sensitive to certain aspects, such as those of colour and form, beyond the habit of men engaged in other pursuits, they take it for granted that he must be an emotionalist at the mercy of his sensibilities, and make allowances accordingly. Yet, if we study the lives and works of artists, not in painting only, but in music, sculpture, and literature, we shall find, perhaps without exception, that the greatest results, those, I mean, that endure and most appeal to the largest number of thoughtful students, are those which are the product of sensibility controlled. Not by any means has all strong work been the output of artists physically strong; indeed, the balance, if one carefully reckoned it, might be found on the other side; but whether physically weak or strong, they have been strong in character. They have had a mental poise that sustained them, and set the standard of their endeavour and accomplishment. And the mental poise is the product of a clear and vigorous mind remaining true to itself and enlarging its scope by contact with what is sane and true in surrounding art and life.

It is on this ground that art and morality really meet; namely, in the person of the artist himself. For I will not admit that view held by many, that art must be moral in its purpose and suggestion; by which, apparently, it is meant that art must directly assist the cause of morality by presenting subjects in which the virtue of morality is explicitly set forth. Although, at one time, art did splendid service for the church in picturing the truth of doctrine and the beauty of the Bible story and of holy living, that was only one of the glorious incidents in its career. But the real domain of the arts is not that of the preacher, the philosopher, or the moralist. It is to make known, not the beauty of holiness, but the holiness of beauty, to a world overmuch occupied with the material or purely intellectual sides of life. It is, if you will, to sanctify the senses by drawing them off from merely carnal and material gratification, to a realisation of the abstract

essence of beauty that pervades nature and human life. Viewed in this light, it is as important a factor in the betterment of the whole man, the body, mind, and soul that are in all of us, as are the labours of the preacher, the philosopher, the moralist, and the purveyors of the material necessaries and embellishments of life. The labours of all are necessary to the nurturing of the whole man, of the full life. They work mutually, and often in aim and result impinge upon one another's domains. But each is separate.

Yet, even if this be so, there is a definite alliance between art and morality, if by the latter we understand the being true to what is best in us and the reaching after the best of which we are capable. And the highest form of this, as I have already hinted, is based upon superior mental qualities, controlled by strength of mind. A man may be faithful unto death, but unless his acts are prompted and controlled by strength of mind, his faithfulness differs in degree, perhaps, but not in quality, from that of a dog. It would be idle to affirm that mental form is of small account in the qualification of a preacher, a philosopher, or a business man. All our experience is to the contrary. Yet in an artist we customarily overlook both the need and the lack of it, and are content to regard him as a chartered emotionalist. His training tends to affirm the emotionalist in himself. Early discovering an aptitude for drawing and a peculiar sensitiveness to beauty, he enters upon a course of instruction, too much limited to the promotion of these qualities, and escapes from rough contact with men and things and the discipline which it involves. He learns, not to repress, but to express himself; to take his feelings as a guide to conduct, and to nurse and pamper them as his most valuable assets in life. But in art, as in other vocations of life, it is the man who is endowed with intellectuality and by self-discipline preserves the integrity of this endowment, that accomplishes the vital thing. He is in his treatment of himself a moral man, and his morality is declared in the poise and vigour of his art.

ACKNOWLEDGMENTS

We begin our thanks with our remarkable editor, Stephanie Fay, whose work has done so much to advance the field of American art history and who immediately saw the potential of this project, advocated for it at the University of California Press, and helped us over the years of its gestation to refine our thoughts, overcome production hurdles, and realize our vision. Early in that process, Stephanie and her colleagues coordinated a survey of twenty-three anonymous historians of American art, whose enthusiastic responses and comments were extremely helpful as we formed our table of contents. Another early source of support was the Henry Luce Foundation. Ellen Holtzman, program director for the arts at the Luce Foundation, encouraged us to think big and made it possible for us to do so with a generous research grant and publication subvention.

Our home institutions, Indiana University and Smith College, also provided necessary scholarly support and, even more important, the student research assistants who assisted in what seemed at times like an insurmountable series of tasks, from the initial gathering and vetting of sources to the final cutting and pasting. These students, Annie Loechle, Elizabeth McGoey, Maeve Montalvo, Jess Paga, Gena Schwam, and Laura Smith, played a crucial role in the production of this book, and we are most grateful for their time and effort. Special mention should be made of Amanda Glesmann and Nancy Palm, who functioned more as collaborative partners than as research assistants. It has been a pleasure and a privilege to work with these two fine scholars. And for their personal support, we can't thank Dennis Gannon and Jason Heffner enough.

This volume is, in many ways, the collective result of several generations of scholarship in American art history. The creative investigations of the ever-growing cadre of Americanist scholars and the documentary riches that have come to light in their articles, books, and museum catalogues are the foundation of *American Art to 1900: A Documentary History*. In a book containing hundreds of individual documents, it would be impossible to give proper credit for each instance of scholarly sleuthing, and an exhaustive bibliography would be unwieldy (and soon out of date). Instead, we gratefully list the names of those whose scholarship led us to primary documents or who answered our questions, guided us, read our manuscript, and helped us with specific problems. To these scholars and the many others in the field of American art history who are not named here, we dedicate this book.

Kevin Avery	David Brody	Melissa Dabakis
Georgia Barnhill	Jennifer Bryan	Keith F. Davis
Carrie Rebora Barratt	Patricia M. Burnham	David Dearinger
Wendy Bellion	Nicolai Cikovsky	Raechel DeLue
David Bjelajac	Michael Clapper	Lois Dinnerstein
Michele Bogart	Charles Colbert	Dorinda Evans
Paul E. Bolin	Margaret Conrads	Linda Ferber
David Brigham	Wayne Craven	Merry Foresta

Kathleen Foster

Vivian Fryd

William Gerdts

Lucretia Giese

Sarah Gordon

Arleen Pancza Graham

Randall Griffey

Neil Harris

Sidney Hart

Patricia Hills

Joy Kasson

Liza Kirwin

Jennifer Kittlaus

Elizabeth Kornhauser

Jill Beute Koverman

Jason LaFountain

Amy Kurtz Lansing

Cheryl Leibold

Dana Leibsohn

Diana Linden

J. M. Mancini

Katharine Martinez

Stephanie Mayer

Leo Mazow

John McCoubrey

Garnett McCoy

Ellen Miles

Lillian Miller

Mark Mitchell

Merl M. Moore

H. Wayne Morgan

Kevin Muller

Mary-Louise Munill

Barbara Novak

Kimberly Orcutt

Stephen E. Patrick

Diane Pilgrim

Barbara Polowy

Richard Powell

Sally Promey

Susan Rather

Ethan Robey

Richard Saunders

Kirk Savage

Susanne Scharf

Rona Schneider

Gwendolyn DuBois Shaw

Marc Simpson

Paul Staiti

Roger Stein

David Steinberg

Paul Sternberger

Mark Tabbert

Veerle Thielemans

Judy Throm

Ellen Wiley Todd

Thayer Tolles

Amy Torbert

Robert Torchia

William Truettner

Bailey Van Hook

David Ward

Carolyn Weekley

Colin Westerbeck

Jochen Wierich

Deborah Willis

Saul Zalesch

ILLUSTRATIONS

INDEX

Note: Page references in italics indicate illustrations.

Dunlap, William: and Cummings, 348; "Essay on the Influence of the Arts of Design," 189–92; etchings by, 883; *History of the Rise and Progress of the Arts of Design,* 38, 100–102, 106–7, 206–8, 348–51, 393–94; Shinn on, 742–43; on Stuart, 90

Dupré, Jules, 849, 851

Durand, Asher Brown, 287; on competition from foreign artists, 556; critical reception of, 297–300; and Hudson River school, 290; influence of, 625; "Letters on Landscape Painting," 290–97; as National Academy of Design president, 215, 217, 290; *Progress,* 297, 300

Durand, John, 28, 170–71, 170n, 290

Durand-Ruel, Paul, 970, 972, 975

Dürer, Albert (Albrecht), 898; *Knight, Death, and the Devil,* 899; *Melencolia,* 899

Duret, Theodore, 970

Düsseldorf Academy (Germany), 413, 415, 432, 502, 993

Düsseldorf School (New York), 387, 413–16, 473

Dutch art, 264, 307, 311, 569, 577, 876, 980, 1058; old masters, 618, 759–60, 764, 996

Duveneck, Elizabeth Boott, 770–74

Duveneck, Frank, 72, 759, 761–64, 891; *Coming Man,* 762, 859; *Turkish Page,* 760, 762, 858–59

Dwight, Timothy, 133; *Greenfield Hill,* 134–36

Eagles, Thomas, 38

Eakins, Thomas: on art instruction, 709–10, 712–15; critical reception of, 754, 761; Downes and Robinson on, 864; letters from Europe, 589–92; and Muybridge, 599–600; at Pennsylvania Academy of the Fine Arts, 709–10, 712–15; scandalous/unconventional behavior of, 710, 715–18; and School of Industrial Art, 718; Van Rensselaer on, 597–99; WORKS: *The Crucifixion,* 597; *The Gross Clinic (The Anatomist),* 562, 592–97, 599; portrait of Leslie Miller, 718

Earl, Ralph, 81–82

Earle, Lawrence, 1026–27

East Hampton (Long Island), 998–1000

Eastlake, Charles: *Hints on Household Taste,* 947

Eaton, Charles Warren, 677, 683–87, 761; *Grey Autumn,* 684; *Hester Prynne,* 684; *November,* 684; *Spring Twilight,* 684

Eaton, Wyatt, 724–25, 765, 859

Eckford, Henry. *See* de Kay, Charles

Ecole des Beaux-Arts, 768–69, 774–83, 780–83

Eden Musée (New York), 636, 636n

education: European, 44–45; French (*see* French art); German, 759–64; in Gilded Age, 689–723 (Art Institute of Chicago, 700–701; Art Students League, 655, 691–92, 705–9; of deaf artist d'Estrella, 718–21; Eakins on, 709–10, 712–15; by Hunt, 693–97; Koehler on, 689–93; life classes, 703–5, 711–12; Massachusetts Drawing Act, 697–99, 857–58; Pennsylvania Academy of the Fine Arts, 709–18;

Pennsylvania Museum and School of Industrial Art, 718–21); Haidt on, 18–19; in Paris, 774–85, 858

Eickemeyer, R., Jr., 932

Ellet, Elizabeth F., 328

Emancipation Proclamation, 530

embroidery, 957

Emerson, Ralph Waldo: "The American Scholar," 309–10; aphorisms of, 433; "Art," 192–96; "The Poet," 310; transcendentalism of, 192, 286–90

Emmet, Lydia Field, 1027

Emmet (Sherwood), Rosina, 678, 955, 1002–4, 1027

engraving, 178. *See also* wood engraving

"Ephebos," 62–64

etching, 883–93

Eugene, Frank, 932

Evening Post, 570–71

Evening Sun, 838–39

Everett, Alexander H., 360, 365–67

Everett, Morris T., 889–91

expatriate artists, 755–59, 794–821; Child on, 755–59; in Italy, 416–24; returned, 752–53; Sargent, 3, 813–21. *See also* Cassatt, Mary; Copley, John Singleton; international travel and exchange; West, Benjamin; Whistler, James McNeill

Ezekiel, Moses Jacob: *Christ,* 572; *Religious Liberty,* 572

Faber, John, 33

fan painting, 34, 37

Farragut, David, 1035

Farrer, Henry, 884

Farrer, Thomas, 493, 496–98, 556

Fern, Fanny (Sara Willis Parton), 473–75

figure drawing/painting, 16–17, 182, 574

First American School of Sculpture and Gallery of Eminent Personages (Boston), 171–73

flâneurs, 911, 985, 1021, 1023–24

Fogelberg (Vogelberg), Bengt Erland, 824

Fontainebleau (France), 765, 998

Forbes, Edwin, 523, 883

Ford, Sheridan: *Art: A Commodity,* 647, 649–50

Fors Clavigera, 796–97, 942, 942n

Fort Marion (St. Augustine, Florida), 637–39

Fortuny, Mariano, 578–79, 677

Foster, John, 25

Fowler, Orson, 316–18

Frankenstein, John, 516–17

Frank Leslie's Illustrated Newspaper, 567–68

Franzoni, Giuseppe, 66

Fraser, Charles, 186–89

Frederick I, Holy Roman emperor ("Barbarossa"), 432, 432n

Freer, Charles Lang, 993–94

free trade, 747–48

French, Daniel Chester, 701, 1026, 1045

French art, 764–85; vs. American, 647–49; American taste for, Gilded Age, 563; Barbizon, 569, 615, 617–

Haussmann, Baron Georges-Eugène, 1057, 1057n

Hawthorne, Nathaniel: in Italy, 416, 419–24; *The Marble Faun,* 828–30

Hayden, Ferdinand, 627–31

Headley, Joel, 199–202

Healy, George, 368, 370–71

Hector (slave), 331–32

Heisterborg, Christianus Fredericus, 26–27

Hennessey, William J., 545, 548–49

Henry, Edward L., 523, 738–39

Herzog, H., 744

Hesselius, Gustavus, 32–33

Hill, Thomas, 506, 723; *Donner Lake,* 744; *Royal Arches of the Yosemite,* 507–8

Hiller, Abigail, 29

Hills, Patricia, 2

history painting: antebellum, 428–38; Civil War, 523–28; Durand on, 28; government patronage of, 73–75; Haidt on, 17–18; by Leutze, 431–38; Morse on, 177–78; religious, 431; status of, 182. *See also* Trumbull, John (painter)

Hitchcock, George: *The Annunciation,* 757; *Maternity,* 756–57; *Tulip-Growing in Holland,* 756

Hitchcock, J. R. W., 884

Hoeber, Arthur, 833, 837–38

Holbein studios (New York), 677

Holley, Horace, 90–92

Holmes, Oliver Wendell, 405–8, 473–74, 519, 521

Home Book of the Picturesque, 258–60

Homer, Winslow: African American subjects painted by, 605–8; on Bouguereau, 578–79; history painting by, 523; home subjects painted by, 565, 567; isolation of, 587–88; James on, 574, 576–78; realism of, 572–78; savage nature/primal scenes by, 585–89; studio of, 545, 548–49; in Tile Club, 679–80; transformation in art of, 582–85; watercolors by, 578–82, 585–89, 870; working methods of, 578–82; WORKS: *Adirondack Camp-Fire,* 579; *Book,* 581–82; *Campaign Sketches,* 512; *Cannon Rock,* 588; *Cotton Pickers,* 605, 607; *The Country School,* 574; *Eight Bells,* 587–88, 1049; *The Fog Warning,* 588; *The Gulf Stream,* 588, 605, 607–8; *High Tide,* 573; *Huntsman and Dogs,* 585; *Inside the Bar,* 583–84; *Lemon,* 581; *The Life Brigade,* 588; *The Life Line,* 1049; *The Lookout,* 588; *Manners and Customs at the Seaside,* 573–74; *One Boat Missing,* 588; *Prisoners from the Front,* 526–28; *The Ship's Boat,* 588; *Snapping the Whip,* 581; *Storm-Beaten,* 588; *A Summer Night,* 588; *Sunday Morning in Virginia,* 605; *Taking a Sunflower to the Teacher,* 605; *Tynemouth,* 584, 588; *Undertow,* 588; *Visit from the Old Mistress,* 605–6; *The Voice from the Cliffs,* 583–84; *Watermelon Boys,* 913; *The White Mountains,* 573–74

Hone, Philip, 389–90

Hopkinson, Francis, 42–43, 78, 151–52

Hosmer, Harriet: Lydia Maria Child on, 826–28;

critical reception of, 821–23, 825–26, 832; and Cushman, 821; masculinity of, 840; "The Process of Sculpture," 823–25; WORKS: *Ænone,* 827; *Daphne,* 827; *Medusa,* 827; *Puck,* 825, 827; *Sleeping Faun,* 825–26; statue of Beatrice Cenci, 827–28; *Waking Faun,* 826; *Zenobia,* 825

Hotchkiss, Thomas, 416

Hotel Siron (Barbizon, France), 765–67

Houdon, Jean-Antoine, 359, 361, 364

Houston, Charlotte, 1005

Hovenden, Thomas: *Breaking Home Ties,* 1027–29

Howells, William Dean: *A Hazard of New Fortunes,* 952, 952n

Howitt's Journal, 459–61

Hoxie, Vinnie Ream, 821–22, 822n

Hubbard, R. W.: *Afternoon in Autumn,* 487

Hübner, Carl, 515; *God Save the Union,* 524

Hudson River school, 297–300, 509, 852, 854, 1050, 1056–57. *See also* Cole, Thomas; Cropsey, Jasper; Durand, Asher Brown; Gifford, Sanford; Kensett, John Frederick; Tenth Street Studio Building

Hughes, Ivy, 655–56, 662–63

Hunt, Richard Morris, 545, 1041–42

Hunt, William Holman, 744

Hunt, William Morris, 484; on art instruction, 689–90; and Barbizon school, 615–19; on earning living from art, 691; influence of, 858; influences on, 860; *Talks on Art,* 693–97

Huntington, Daniel, 556, 739, 750; *Christiana and Her Family Passing through the Valley of the Shadow of Death,* 395–96, 431; *Christian Martyrs,* 742; *Mercy's Dream,* 395–400, 431, 742

Iardella, Francesco, 66

icons/idolatry, 11–12

Illustrated Magazine of Art: on Durand, 297, 299

illustration, 916–23; Coffin on, 916–18; by Gibson, 920–21; Low on, 1050; by Pyle, 916–18; by women, 921–23

impressionism, 968–97; Americanization of, 5, 978–82; Champney on, 872–74; of Chase, 982–85, 988; critical reception of, 968–78; exhibitions of, 725–26; Hassam on street scenes, 985–88; vs. pastel, 883; tonalism in, 988–93

Indian Removal Act, 439

Indians. *See* Native Americans

Ingham, Charles Cromwell, 512

Ingraham, J. H., 400–402

Inman, Henry, 368

Inness, George: on art organizations, 736–38; Constant on, 677; Downes and Robinson on, 864–67; on impressionism, 970, 977–78; Jarves on, 479, 484; personality/work methods of, 623–27; spiritualism of, 620–23, 625; studio of, 677; tonalism of, 988, 992–93; on wood engraving, 894–95; WORKS: *After a Spring Shower,* 866; *Delaware Valley,* 1048; *Gray Lowery Day,* 866,

National Sculpture Society, 1040–42

Native Americans: anthropological study of, 637; art/picture writing by, 637–41; Catlin's portrayals of, 439–48, 452; "civilizing" of, 637–38; forced removal to reservations, 439, 637; in history paintings, 430; Maximilian and Bodmer on, 448–51; phrenology applied to, 317–18; Remington's portrayals of, 634–37; seen as noble savages/vanishing race, 439–54; seen as picturesque, 453–54; seen as spectacle, 452–53; under Spanish rule, 20–23. *See also individual tribes*

nature: laws of, 589; Ruskin on fidelity to, 290; spiritual interpretation of, 963, 966–67; Whistler on, 803–4; wild vs. tame, 255, 290–97. *See also* scenery; transcendentalism; wilderness

Navajo sand painting, 640–41

Neagle, John, 328–30

Neal, David, 858

Neal, John, 77–78, 384

New Path: founding/goals of, 493–96; on true vs. false schools of art, 498–500; on Ward's *Freedman,* 530, 532; on Whitney's *Africa,* 534–35

Newport (Rhode Island), 682

Newton, Stuart, 743

New York: artists' studios in, 545–49, 650; Benson on private galleries, 849–52; Bisland's tour of studios in, 676–79; competitive art market in, 323–24; Dewey triumphal arch in, 1045–46; Draft Riots in, 479; early institutions, 162–71 (*see also* American Art-Union; National Academy of Design); education in, 701–9; French art in, 643–44; galleries lacking in, 485; labor/art on lower East Side, 701–3; photographs of, 928, 935–38; sculpture's neglect in, 1042–45; young artists in (Gilded Age), 665–68

New York Academy of the Fine Arts. *See* American Academy of the Fine Arts

New York Commercial Advertiser, 378–80

New York Courier and Enquirer, 379

New-York Daily Tribune, 533–34, 1036–37

New-York Drawing Association, 206–8. *See also* National Academy of Design

New York Etching Club, 869, 883–84, 888–90

New York Evening Mail, 511

New York Evening Post, 30, 536, 607

New-York Gazette, 29–31

New York Herald: on American Art-Union, 222; on Church's *Heart of the Andes,* 463, 468–69; on number of portraits, 384–85; on religious art, 525–26

New-York Historical Society, 486

New-York Mirror, 274–76, 382–83

New York Quarterly, 416, 418–19

New York Society for the Suppression of Vice, 788–89

New York State Tourist, 276, 279–82

New York Sun, 607–8

New York Times: on African Americans as picturesque, 605–6; on American Museum, 410–11; on art receptions, 651–52, 675–76; on Brown, 915–16; on Chase, 675–76; on Church, 464; on Civil War photographs, 519–20; on commerce in art, 653–54; on Eakins, 594; on exhibition hanging levels for paintings, 683–86; on Homer, 605–6; on impressionism, 970–72; on Page, 560; on professionals vs. the public, 913–14; on selling out, 654–55; on Society of American Artists vs. National Academy of Design, 724, 730–31; on Ward, 530–32; on Whistler, 807–8; on White, 557

New York Tribune: on National Academy of Design, 217–19; on number of portraits, 385–86; on Powers, 377–78; on Saint-Gaudens's use of nude models, 792–94; on Spencer, 322–23, 325–26

New York Water Color Society, 869

New York World, 509

Nicholls, Rhoda Holmes, 678

Nichols, Maria Longworth, 954, 958–60

Nieriker, May Alcott: *Studying Art Abroad,* 774–80

Nimmo, Mary. *See* Moran, Mary Nimmo

Noble, Louis, 463, 469–71

Noble, Thomas Satterwhite: *The Contraband Still,* 536; *Margaret Garner,* 536

noble savage/vanishing race, 439–54

Nonquitt (Massachusetts), 683

North, Elizabeth Lore, 921–23

North American Review, 549–52

North Star, 332–33

Notan (dark and light), 963, 965–66

nudes, 785–94; Americans' distaste for, 124–25, 249–50; in coed life classes, 792–94; Comstock vs. Knoedler regarding, 788–92; Cox on, 785–88; Eakins on, 716–17; life classes, 703–5, 711–12, 792–94; models for, 669, 786; moral sentiment against, 382–83; Native Americans' response to, 69; as obscenity vs. art, 788–92; Charles Willson Peale on, 68–69; photographic, 788–89, 791; public display of, 382–83; religious societies' response to, 68–69; Saint-Gaudens resigns over, 792–94; Wertmüller's *Danaë,* 68–70; women's studying/viewing of, 68, 541, 545, 716, 779–80. *See also* Powers, Hiram, *The Greek Slave*

Oakley, Violet, 922

obscenity, 788–92

Ojibbeways, 442–43

Old Lyme (Connecticut), 988, 993, 1000–1002

oleographs, 899

open-air painting, 578–80, 765, 970, 996, 1002

opsimathy, 756–57, 757n

O'Sullivan, John L., 424–26

O'Sullivan, Timothy, 519

Overland Monthly, 507–8

trompe l'oeil painting, 907. *See also* Harnett, William M.

Trumbull, John (cousin of painter), 40

Trumbull, John (painter), 4, 367; and Adams, 59; as American Academy of the Fine Arts president, 206; *Declaration of Independence,* 57, 103, 170–71, 170n; failures of, 105–6; influences on, 34; plan for government-sponsored history paintings, 73–75; portrait of George Washington, 81, 105; Revolutionary War history paintings by, 102–6, 429–31

Truth, Sojourner, 528–30

Tryon, Dwight, 752–53, 988, 992–93; *Dawn—Early Spring,* 989, 991; *Winter,* 991

Tuckerman, Henry T.: *Artist Life,* 393–94; *Book of the Artists,* 485–90, 557–59; on Deas, 452–53; on Johnson, 536–37; on Kensett, 305–7; on Leutze, 432–34; on religious art, 557–59

Turner, C. Y., 1026–27

Turner, Frederic Jackson, 634

Turner, J. M. W.: *Rain, Steam and Speed,* 865, 975; *Slave-ship,* 625

Turner, James, 463, 505, 631, 802

Twachtman, John Henry, 858, 994–95

Twain, Mark (Samuel Clemens), 469

Uhde, Fritz von, 611

United States Magazine and Democratic Review, 424–26

Unity of Brethren (Moravian Church), 16

Universal Exhibition (1878), 755

Universal Exhibition (1889), 755–56

University Building (New York), 545, 547–49

Urban VIII, pope, 20

U.S. Art Commission, 374–76

U.S. Geological Survey, 627–31

U.S. government: Congress imposes tariff on foreign art, 747; imperialism of, 960–61; as patron (*see* Capitol's decoration)

Valentine, Edward V., 571; *Andromache and Astyanax,* 572; *Knowledge Is Power,* 572; *Nation's Ward,* 572

Van Buren, Amelia, 710, 717–18

Vanderlyn, John, 367; failure of, 127–28; fame sought by, 124–25; history paintings by, 430; portrait of Monroe, 91–92; Shinn on, 739, 742; Versailles panorama by, 127–28; WORKS: *Antiope,* 124–25; *Ariadne Asleep on the Island of Naxos,* 124, 742; *The Death of Jane McCrae,* 126; *The Landing of Columbus,* 127–28; *Marius amidst the Ruins of Carthage,* 124–25

van Dyck, Anthony, 90

Van Rensselaer, Mariana Griswold: background/reputation of, 854–55; on Cox, 785–87; on Eakins, 597–99; on etching, 884–87; on Homer's English work, 582–85; on monuments, 906–7; on pastels, 878–81; on progress in American art, 855–57; on returnees from Europe, 752–53; on Saint-

Gaudens, 1038–40; on Society of American Artists, 724, 728–30, 856; on World's Columbian Exposition, 1021–24

Vasari, Giorgio, 690

Vedder, Elihu, 484, 918, 1010; *Arab Listening to the Sphinx (The Questioner of the Sphinx),* 1011–12; *Cumæan Sibyl,* 1011–12; *Death of Abel,* 1012; *Digressions,* 1011, 1013; *Lair of the Sea Serpent,* 1012; *Lost Mind,* 1012; *Young Marsyas,* 1011

Velázquez, Diego, 592, 652, 816

Venus de Medici, 423–24

Vermeer, Johannes, 996

Vernet, Horace: *Joseph and His Brethren,* 644

Verplanck, Gulian, 163, 168–71

Vertue, George, 34–35

Vinton, F. P., 979

Virgil, 362n

Vogelberg (Fogelberg, Bengt Erland), 824

Wadsworth, Daniel, 234–35, 238–40, 257

Wadsworth, Jeremiah, 235

Wadsworth Gallery/Atheneum (Hartford), 486

wallpaper, 953–54

Walton, William, 833–37

Ward, Edgar, 576, 652, 761; *Washing Place, Brittany,* 859

Ward, John Quincy Adams, 1041, 1045; *The Freedman,* 472, 484, 530–33

Washington, Booker T., 608–10

Washington, Bushrod, 76–77

Washington, George: Delaware crossing, historical account of, 436–37; Leutze's *Washington Crossing the Delaware,* 387, 436–38, 523; monuments/statues of, 359–67, 417, 421, 487; portraits of, 77–81, 78–81, 105, 739

watercolors, 349–50, 349n; American taste for, 869–71; Champney on, 871–77; by Homer, 578–82, 585–89, 870

Watson's Weekly Art Journal, 509–11, 524–25

Weekly Missouri Statesman, 456–57

Weeks, Edwin Lord: *Le Dernier Voyage,* 758; *Hindoo Marriage Procession,* 758–59; *Rajah of Jodhpore,* 758–59; *The Return of the Mogul Emperor,* 758

Weir, J. Alden, 679–80, 761, 763, 859; at Art Students League, 705–6; Columbian Exposition decoration by, 1026–27; on Ecole des Beaux-Arts, 768–69; on Gérôme, 767–69; on impressionism, 968–69; on originality, 769

Weir, John F., 526, 528, 767

Weir, Robert, 367, 430–31, 767, 913

Wertmüller, Adolph Ulrich: *Danaë and the Shower of Gold,* 68–70

West, Benjamin: on Apollo Belvedere, 96, 98–99; and Copley, 45–49, 51; *Death of Wolfe,* 99–100; Dunlap's biography of, 100–102; Galt's biography of, 96–100; as historical painter to George III, 96, 101; influences on, 42; in London, 96; physical

Text:	10/13 Minion
Display:	Minion
Sponsoring editor:	Stephanie Fay
Assistant editor:	Eric Schmidt
Project editor:	Sue Heinemann
Editorial assistants:	Erica Lee, Lynn Meinhardt
Copyeditor:	John Thomas
Indexer:	Carol Roberts
Designer:	Janet Wood
Production coordinator:	Pam Augspurger
Compositor:	Integrated Composition Systems
Printer and binder:	Maple-Vail Book Manufacturing Group